American Paintings and Sculpture to 1945

IN THE
CARNEGIE MUSEUM
OF ART

BY DIANA STRAZDES

assisted by
GILLIAN BELNAP, REBECCA BUTTERFIELD,
LISA ANN HUBENY

with contributions by
JANET MARSTINE, ELIZABETH MORGAN, JULIA R. MYERS,
KENNETH NEAL, GAIL STAVITSKY, RINA C. YOUNGER

and Marianne Berardi, Nancy Brown Colvin, Lauretta Dimmick,
Lynn Boyer Ferrillo, Wendy Greenhouse,
William D. Judson, John R. Lane, Mary McKenna,
Laura Meixner, Kathleen Pyne, Suzanne Tise

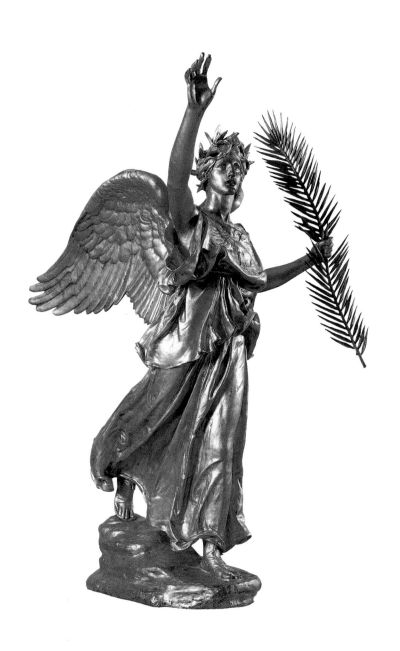

American Paintings and Sculpture to 1945

IN THE

CARNEGIE MUSEUM

OF ART

HUDSON HILLS PRESS, NEW YORK
in association with
THE CARNEGIE MUSEUM OF ART

American Paintings and Sculpture to 1945

IN THE
CARNEGIE MUSEUM
OF ART

FIRST EDITION

© 1992 by The Carnegie Museum of Art, Carnegie Institute

Published in the United States by Hudson Hills Press, Inc., Suite 1308, 230 Fifth Avenue, New York, NY 10001-7704.

Distributed to the trade in the United States, its territories and possessions, Canada, Mexico, and Central and South America by National Book Network, Inc.

Distributed in the United Kingdom and Eire by Shaunagh Heneage Distribution.

Distributed in Japan by Yohan (Western Publications Distribution Agency).

Editor and Publisher: Paul Anbinder

Proofreader: Lydia Edwards

Indexer: Karla J. Knight

Designer: Binns & Lubin/Betty Binns

Composition: High Text Graphics/Brad Walrod

Manufactured in Japan by Toppan Printing Company

Initial research for this catalogue was supported by a grant from the National Endowment for the Arts, supplemented by the Allegheny Foundation, the Pennsylvania Council for the Arts, and the generosity of Mr. and Mrs. James M. Walton. The remaining research and much of the writing were made possible by assistance from the National Endowment for the Humanities and by a generous grant from the Luce Fund for Scholarship in American Art, a project of the Henry Luce Foundation, Inc. Publication costs were underwritten in part by the National Endowment for the Arts, Sotheby's, and the James H. Beal Publication Fund of The Carnegie Museum of Art.

Library of Congress Cataloguing-in-Publication Data

Strazdes, Diana J.
American paintings and sculpture to 1945 in the Carnegie Museum of Art / by Diana Strazdes ; assisted by Gillian Belnap, Rebecca Butterfield, Lisa Hubeny; with contributions by Janet Marstine ... [et al.].—1st ed.
 p. cm.
Includes bibliographical references and index.
ISBN 1–55595–055–8
1. Art, American—Catalogues. 2. Art—Pennsylvania—Pittsburgh—Catalogues. 3. Carnegie Museum of Art—Catalogues. I. Carnegie Museum of Art. II. Title.
N6505.S87 1991
759.13'074'74886—dc20 91-3264
 CIP

Contents

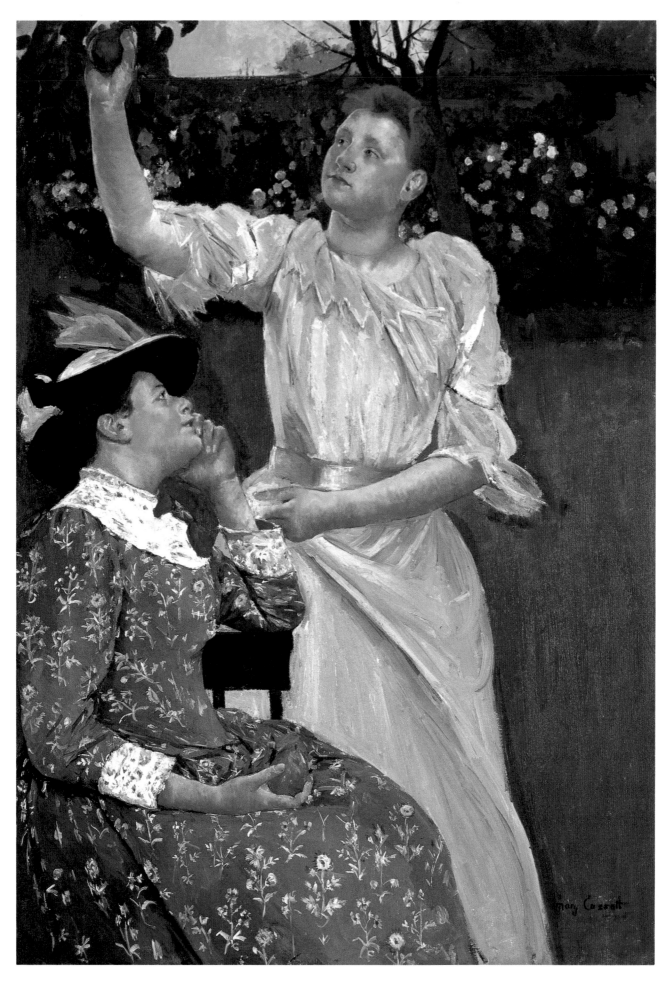

Color Plate A: Mary Cassatt, *Young Women Picking Fruit*, 1891 or 1892

Foreword

Andrew Carnegie, philosophical positivist that he was, fancied a gallery of American painting in the Pittsburgh institute bearing his name that would be represented by two canvases for each year and would stand as a chronology of recent American culture. The plan was never quite fulfilled, for the collection of Carnegie Institute's Department of Fine Arts grew more rapidly and more diversely than its founder had anticipated. In its seventh year the department had fifty-four European and American paintings. In another fifteen years it possessed 120 paintings, 13 bronzes, 157 drawings, and 140 Western and non-Western prints, and with passing decades the collection diversified still more; yet the Department of Fine Arts never lost the affinity for American art made evident by its first purchase, Winslow Homer's *The Wreck*, in 1896. Today, The Carnegie Museum of Art has in its care approximately four hundred American paintings and sculpture dating from the late eighteenth century to the end of World War II, and it stands among the nation's dozen or so most significant American art collections.

The Carnegie International, itself a fascinating cultural phenomenon, regularly supplied the Department of Fine Arts with recent American paintings. The permanent collection is still spiced with the distinctive flavor of early Internationals, which were showcases for cosmopolitan stylishness and turn-of-the-century aestheticism. As the collection evolved, it also came to have a strong contingent of earlier twentieth-century American modernism and an extensive collection of western Pennsylvania paintings, including the largest single holdings of works by David Gilmour Blythe and John Kane.

A comprehensive catalogue of the museum's American paintings and sculpture was the initiative of my predecessor, John R. Lane, who, soon after arriving in Pittsburgh in 1980, saw a need to make the collection and the almost-forgotten aspects of its early development better known to both scholars and the public. The catalogue also afforded an opportunity to reassess the holdings and to conduct long-overdue basic research on them. It takes its place beside two previous publications, *Museum of Art, Carnegie Institute Collection Handbook* (with introduction by John R. Lane, 1985) and *American Drawings and Watercolors in the Museum of Art, Carnegie Institute* (with introduction by Henry Adams, 1985), both of which likewise sought to give fresh consideration to areas of the permanent collection.

The current project had its beginnings in 1982 under the museum's Curator of Fine Arts, Oswaldo Rodriguez-Roque, who did the first creative thinking about the collection's significance and helped the museum obtain a research grant from the National Endowment for the Arts—seed money that ensured the project's ultimate completion. The research and writing of the catalogue began while

Henry Adams served as Curator of Fine Arts. Primary credit for the accomplishment of the catalogue, however, must be given to Diana Strazdes. She is the principal author of the catalogue and, in addition, she has effectively coordinated the efforts of contributing authors. I am immensely grateful to her for her unflagging commitment to this project. I join Diana Strazdes in expressing profound gratitude to our colleagues on The Carnegie Museum of Art staff and the many others who over the past decade have contributed their time and expertise to this project.

Initial research for this catalogue was supported by a grant from the National Endowment for the Arts, supplemented by the Allegheny Foundation, the Pennsylvania Council for the Arts, and the generosity of Mr. and Mrs. James M. Walton. The remaining research and much of the writing were made possible by assistance from the National Endowment for the Humanities and by a generous grant from the Luce Fund for Scholarship in American Art, a project of the Henry Luce Foundation, Inc. Publication costs were underwritten in part by the National Endowment for the Arts, Sotheby's, and the James H. Beal Publication Fund of The Carnegie Museum of Art.

The collections in institutions like The Carnegie Museum of Art inevitably track a community's cultural ambition and can be said to represent its collective self-image. We owe a great debt to the donors, directors, and curators, past and present, whose liberality and vision have made this museum's collection of American paintings and sculpture to 1945 the notable achievement it is today.

PHILLIP M. JOHNSTON
Director
The Carnegie Museum of Art

Acknowledgments

Collection catalogues, as anyone who has attempted them knows, can scarcely be produced without the collaborative efforts of many individuals. The preparation of this catalogue has spanned ten years and two administrations at The Carnegie Museum of Art: that of John R. Lane, who conceived the project and gave it a place of priority in the museum's activities, and that of Phillip M. Johnston, who saw it to completion. I thank both directors for their steadfast encouragement and for ensuring that the endeavor never lacked the resources it required. I am indebted to two heads of publications of The Carnegie Museum of Art: Barbara L. Phillips, who took on the project's administration from 1983 to 1987, and Vicky A. Clark, who has since guided it to publication with enthusiasm and immense good sense.

In 1983 and 1984 Henry Adams directed a team consisting of Kahren Arbitman, Marianne Berardi, Nancy Brown Colvin, Lauretta Dimmick, Lynn Boyer Ferrillo, Gloria Gilmore-House, Richard Goldman, Wendy Greenhouse, Janet Marstine, Mary McKenna, Kenneth Neal, Elizabeth Sargent, Gail Stavitsky, Suzanne Tise, James L. Weiss, and Rina C. Youngner, who prepared bibliographies, combed the museum's vast early correspondence, and gathered a great deal of documentation concerning the American paintings and sculpture in the collection. Joined by Laura Meixner, Kathleen Pyne, and Eric Rosenberg, they also wrote preliminary drafts for numerous entries. Gloria Gilmore-House merits special thanks for her role in managing the group effort and for coordinating the vast amount of information brought together during this phase of the project.

In early 1986, as the museum's Associate Curator of Fine Arts, I took on the task of turning a filing cabinet of notes and preliminary drafts into a complete and consistent text. I was fortunate indeed to have the assistance of Gillian Belnap, Rebecca Butterfield, and Lisa Ann Hubeny, who wrote and supplemented biographies and entries, checked innumerable facts, corrected errors, and, along with Elizabeth Morgan and Susan Peace Geisel, reconstructed the exhibition histories, references, and provenances. The early entry writers who were willing to review their texts, Marianne Berardi, Lauretta Dimmick, Lynn Boyer Ferrillo, and Kenneth Neal, have my thanks. I am particularly grateful to Janet Marstine, Gail Stavitsky, and Rina C. Youngner for rejoining the project. They and Julia R. Myers provided additional research and expertise when these were most needed.

Marcia Thompson Whitehead served as administrative coordinator from 1984 through 1987, ensuring that the catalogue proceeded smoothly toward production. Susan Peace Geisel masterminded the gathering of photographs, color transparencies, and reproduction permissions, and supervised the photographic

sessions. Richard A. Stoner, the catalogue's principal photographer, deserves considerable thanks for obliging numerous special requests, which often came on short notice. John Caldwell acted as advisor-in-residence, and his suggestions and friendly warnings were always welcome. He also served as reader for the manuscript, and I am indebted to him for the scrutiny he gave it.

The catalogue's text benefitted from the attentions of several copy editors. Kate Maloy and Andrea Belloli have our thanks for the editorial guidelines they provided early in the project. Bringing order to the eventual 1700-page typescript was the achievement of the Association of Freelance Art Editors. Grateful acknowledgment goes to Brenda Gilchrist, who coordinated the group; to Lory Frankel, Eve Sinaiko, and Sarah Sherrill, who took charge of the various stages of the copy editing; and to Ellyn Allison, Barbara Anderman, Margaret Aspinwall, Nora Beeson, Joanne Greenspun, Tom Repensek, Sheila Schwartz, and Virginia Wageman, who assisted them. Vicky A. Clark and Gillian Belnap ably supervised the manuscript's long, final editing process, and I thank them warmly for executing an arduous task with such patience and good cheer. I would like to add a word of thanks to several staff members of The Carnegie Museum of Art who spent many hours typing the manuscript so that we could meet our deadlines: Laureen Bisbee, Elissa M. Curcio, William Florkowski, Mary Hendley, Genevieve A. Long, Lisa Miriello, Nancy J. Panko, and Janet S. Smith.

We are fortunate to have Hudson Hills Press as our partner in the catalogue's publication. The collaboration among Paul Anbinder, president of Hudson Hills Press; Vicky A. Clark, and Betty Binns, of Binns & Lubin, the catalogue's designer, has ensured a beautiful and finely crafted book.

To those who shared their knowledge of specific artists I offer my thanks: Elizabeth Broun and William I. Homer on Albert P. Ryder; Kathleen Burnside on Childe Hassam; Trevor Fairbrother on John Singer Sargent; Barbara Dayer Gallati on James Jebusa Shannon; Raymond Kass on Morris Graves; Sigrid Nama on Martin Leisser; Murray Z. Rosenberg on his father, Samuel Rosenberg; Elizabeth Sargent on James Reid Lambdin; and David Wilkins on David Gilmour Blythe. For particular kindness in answering queries I thank Debra Balken, Abigail Booth Gerdts, William H. Gerdts, Nancy Little of M. Knoedler and Co., Nanette Maciejunes, and M. P. Naud of Hirschl and Adler Galleries. At The Carnegie Museum of Art, Elizabeth Tufts Brown, Judy Haraburda, Frances Levin, Annegreth Nill, Nancy Noyes, Marilyn M. Russell, Eleanor Vuillemier, and the art reference staff of The Carnegie Library of Pittsburgh all provided assistance beyond the call of duty. I especially appreciated the frequent help of William A. Real, the museum's conservator, regarding questions of materials, technique, and condition.

During my writing of the introductory essay, Leon Arkus graciously answered many questions and provided valuable insights into his years as Assistant Director, Associate Director, and Director of the museum. David Wilkins offered astute observations about the museum's past, and at the manuscript division of the Library of Congress, Jeffrey Flannery helped me sort through Andrew Carnegie's volumes of correspondence. Finally, I would like to thank my husband, Jeffrey Williams, for his considerable interest in the substance of my essay and for the encouragement he provided during a project that took far more of my time than expected.

The preparation of the present catalogue has made demands upon virtually every staff member, volunteer, and associate of The Carnegie Museum of Art, and the list of those to whom this publication is indebted is much longer than the limited space for acknowledgments allows. To all I extend sincere gratitude.

DIANA STRAZDES

The Development of a Collection
by Diana Strazdes

Given the premise that museum collections are historical records, presenting at any one time the aesthetic values of their caretakers, the chronicle of The Carnegie Museum of Art's collection of American paintings and sculpture reveals much. Long the most visible component of Pittsburgh's largest public art museum, the collection was created, selectively and deliberately, as a vehicle for public instruction and an embodiment of that public's artistic ideals. It has been reshaped repeatedly, yielding at each juncture changes that were unmistakably marks of their time.

The collection of American paintings and sculpture to 1945 was built primarily through the purchases of directors whose chief interest was recent art. Seeing little need to present a thorough representation of American art, they felt free to indulge their personal preferences to the extent that money and space allowed. They did not view the Carnegie's holdings as an entailed inheritance but as flexible investment capital. Consequently, works came and went, and only in the last ten years has the collection acquired the relatively protected status of a historical document.

The vicissitudes of the Carnegie's art collection were always interwoven with those of the larger institute of which it is a part. That institute was Andrew Carnegie's first great philanthropic endeavor and his most grandiose tribute to the city of his youth. His brainchild, it grew rapidly during its first decades to become, as he wrote in his autobiography, "one of the chief satisfactions of my life."[1]

The beginnings of Carnegie Institute have been retold many times by Carnegie, his biographers, and local historians. In 1881 he offered $250,000 to Pittsburgh for a library building, which the city declined because it was unable to raise operating funds. The neighboring city of Allegheny accepted the offer instead. When a library containing an art gallery, a lecture room, and a small music hall was completed there in 1890, Pittsburgh asked Carnegie to renew his original offer. Carnegie replied by quadrupling his pledge to $1 million to build not only a library but an art gallery, a music hall, assembly rooms for educational and scientific societies, and a museum of natural history.[2] Pittsburgh, fast dominating the nation in steel manufacturing and heavy industry, was acquiring a vast working-class population; this constituency Carnegie Institute was intended to serve.

Andrew Carnegie, His Institute, and Its Art Collection

Pittsburgh accepted Andrew Carnegie's plan in May 1890. The building, designed by the Boston architectural firm of Longfellow, Alden, and Harlow,

and set on the edge of nineteen acres of park land near the city's periphery, was dedicated in November 1895. In 1896 two Pittsburghers, the clergyman and naturalist William Holland and art educator John Beatty, were appointed directors of the natural-history museum and art gallery, which were allotted space within the library. The natural-history museum—devoted to archaeology, anthropology, and the applied arts as well as paleontology, geology, and zoology—was designated the Department of the Museum and quickly built up a distinguished array of specimens through its scientific expeditions. The art gallery, named the Department of Fine Arts, had as its main activity an annual exhibition of international contemporary painting, established in part because Carnegie was so impressed by the loan exhibitions that had inaugurated Allegheny's and Pittsburgh's library buildings.[3] In 1896 the first annual exhibition (today known as the Carnegie International) was held in three galleries in the library building.[4] Those spaces also housed the department's permanent collection in a large central room for paintings and two adjacent rooms—one for plaster casts and another for reproductions of ancient bronzes.[5]

Within two years the art gallery and natural-history museum needed larger facilities, and in 1897 Carnegie increased his pledge to $5 million for the expansion. Adjacent ground was procured in July 1904, and construction commenced once more.[6] In 1905 the building of affiliated technical schools (Carnegie Institute of Technology) began, and a considerably expanded Carnegie Institute was dedicated in April 1907, by which time the endeavor had absorbed $20 million.[7]

The 1907 addition to Carnegie Institute, designed by Alden and Harlow, included a lavish green-marble foyer for the music hall and a new facade, adorned with bronze figures by the New York sculptor John Massey Rhind. Part of the new interior was given over to a majestic stairway whose surrounding walls bore murals by John White Alexander. The new space also offered a large hall for architectural casts from antiquity to the Renaissance, a Hall of Statuary (modeled on the interior of the Parthenon) to house the institute's collection of plaster reproductions of famous sculpture, and a large Hall of Bronzes for 313 reproductions of ancient bronzes from the Naples Museum, which had been presented by Carnegie between 1896 and 1901. Three galleries were designated for the permanent collection of paintings, while seven galleries were set aside for the annual exhibition of contemporary art.

Such an organizational assemblage, which Carnegie believed to be unique,[8] was in fact a straightforward elaboration on established precedents in the history of museum building. The melding of libraries, picture galleries, and natural-history collections had already found a place in the athenaeums of the early nineteenth century, which sprang up in cities from Boston to Cincinnati. At the end of the nineteenth century they reemerged on a grand scale, along with such other omnibus facilities as the grand hotel, the railway terminal, and the department store. Among the immediate precedents for Carnegie's plan are the British Museum, London, or the municipal museum of Lausanne, Switzerland, built in the late 1880s, which joined in a single building a public library, art gallery, university, and museum of geology, paleontology, archaeology, and zoology.

What Carnegie called his "monument"[9] referred to the all-encompassing goal of education for the masses enshrined by the institute. Music, literature, science, and art would together be a vehicle for the betterment of people who otherwise had little access to such resources. These would stir, as Carnegie put it, the "latent desire for the things of the spirit which lay inert in the hearts of our fellow citizens of the industrial hive."[10]

From the beginning Carnegie Institute was known for its aggressive educational programs, which included reading clubs for children in poor neighborhoods, a Young Naturalist Club for boys, and twice-weekly free organ concerts funded by profits from the music hall's "high class entertainments."[11] The Department of Fine Arts organized gallery talks and lecture series for adults; it sponsored extension programs in the schools, including tours through the Carnegie International for all Pittsburgh high-school students. Until 1941 the galleries kept impressively long hours—ten in the morning to ten at night daily and two to six on Sundays—so that every worker in Pittsburgh would be able to visit.

Andrew Carnegie was a predictably enthusiastic museum founder who, at least initially, engrossed himself in the organizational details of his institute's by-laws, building, and collections. In 1894 he and Mrs. Carnegie were in Europe and the Middle East, buying and sending back to Pittsburgh, among other things, two mummies from Cairo and ten cases of marble reproductions from Florence.[12] As time passed, this personal involvement lessened and Carnegie became content to leave purchases, aesthetic decisions, and daily operations to others. He did, however, have specific preferences concerning the scope of his institute's art collection and, since he continued to insist upon them, they had a long-lasting effect.

For one thing, he avoided the designation "art museum" when referring to the permanent collection of the Department of Fine Arts. Unlike other founders of museums, Carnegie did not build his enterprise around a personal art collection, and he went to some lengths to keep the department from becoming a repository of art treasures in the style of most museums.[13] Instead his concept was similar to that of an art academy's gallery: plaster casts of classical statuary supplemented with paintings by contemporary artists. Like an academy gallery, the works presented within were meant to teach artistic excellence. Unlike an academy gallery, however, the Carnegie collection did not train would-be artists but rather the citizenry of Pittsburgh.

Carnegie saw nothing wrong with deferring to the propriety of the average citizen. When he purchased sixteen plaster casts in 1895 (in emulation of the Department of Casts that the Metropolitan Museum of Art had established in the late 1880s), he directed that they be shown draped, in consideration of the sensibilities of the masses. "We should begin gently to lead people upward," he telegraphed the president of his board. "I do hope nothing in [the art] gallery or [music] hall will ever give offense to the simplest man or woman. If we are to work genuine good we must bend and keep in touch with the masses. Am very clear indeed on this question."[14]

For the paintings collection Carnegie wanted a gallery consisting of two American pictures for each year beginning with 1896, all hung in chronological order so as to show the progress of art in the United States. At least two American paintings (he apparently saw no point in having more than one work per artist) were to be purchased annually from the Carnegie International or, failing that, from other exhibitions.[15] If two paintings were not selected in any one year, then two could be selected the next year for the missing year, so that a chronological collection would be acquired.[16] His stipulation that purchases be accepted in advance by a jury was, in effect, a quality-control device, ensuring that the founding collection would be true to mainstream tastes.[17]

Perhaps the most intriguing aspect of the founding collection was Carnegie's aversion to the purchase of earlier works of art. Instead, the Department of Fine Arts owned (and listed in its first catalogue) a study collection of 146 photo-

graphs of old-master paintings. Even after the department moved into larger quarters, Carnegie insisted that no attempt should be made to add older paintings to the collection. In a letter of 1907 to his board of trustees he wrote:

The Art Department should not purchase Old Masters, but confine itself to the acquisition of such modern pictures as are thought likely to become Old Masters with time. The Gallery is for the masses of the people primarily, not for the educated few.[18]

By concentrating on antiquities and recent painting while excluding the periods in between, Carnegie rejected the stuff that formed the backbone of other American art museums. Possibly his opposition to the collecting of old masters stemmed from an industrialist's belief that progress and innovation should not be beholden to the past. Carnegie would surely have been a subscriber to the late-nineteenth-century tenet that recent art is as good or better than older art, recent artists having the opportunity to learn the lessons of all earlier schools and therefore improve upon them.

Yet the founder's advice to look to the old masters of the future suggests something more than an aversion to oldness and a belief in progress. Carnegie seems to have harbored a distaste for the social exclusivity bound up with the collecting of old-master paintings. He did not care to propose to the workers of Pittsburgh that art was merely the booty of the wealthy and powerful. At a time when magnates such as J. Pierpont Morgan were willing to pay almost anything for a rare old treasure, Carnegie evidently did not want Pittsburghers to believe that the greatest virtue of a work of art was its high price. On a practical level, old-master paintings had become notoriously expensive and simply may not have been cost-effective for the function Carnegie had in mind. His unspoken assumption may have been that a public never previously introduced to the fundamentals of aesthetics could learn just as well from less costly art.

John Beatty and the Collection of American Paintings and Sculpture

The man who advanced Andrew Carnegie's cause in the Department of Fine Arts was John Beatty. At the time of Carnegie Institute's founding, he was the city's most distinguished art educator, having been secretary of the Art Society of Pittsburgh and director of the Pittsburgh School of Design. A painter, illustrator, and etcher who had studied in Munich, he was on familiar terms with the European-trained artists of the American mainstream. Beatty was also experienced in the organization of art exhibitions. He served on the advisory committee of the 1893 World's Columbian Exposition in Chicago, organized the exhibition of European art held on the occasion of the opening of the Carnegie Library of Allegheny City in 1890, and mounted the loan show of 321 works held in connection with the opening of Carnegie Institute in 1895. In 1896 he became director of the Department of Fine Arts and served in that capacity until retiring in 1922.

Beatty sympathized with Carnegie's idea of a permanent collection that focused on recent art, particularly recent American art. Selecting regularly from the Carnegie Internationals, and benefitting from the occasional advice of such artist-friends as Henry Ward Ranger and Childe Hassam, Beatty soon assembled a homogeneous collection possessed of a clear Francophile and Anglophile bias. By 1903 the Department of Fine Arts owned nineteen American and thirty-one European paintings. They reflected a taste for the "advanced" schools of the late

nineteenth century along the lines favored by such collectors as Isabella Stewart Gardner and Charles Freer.

Beatty was less interested in carrying out Carnegie's restrictive concept of the permanent collection and tried to broaden the schools and media it encompassed. In 1904 he began to acquire drawings, most of them recent American examples, purchased in consultation with the art critic Sadakichi Hartmann.[19] In 1906 the department began to collect Japanese woodblock prints, and in 1911, etchings and engravings, which were about evenly divided between recent etchers such as Charles Meryon, Francis Seymour Haden, and James McNeill Whistler and old-master engravers such as Albrecht Dürer, Heinrich Goltzius, and Robert Nanteuil.

In 1916 Beatty began to address the department's lack of original sculpture, for which the Carnegie International, a paintings exhibition, did not provide. In the next three years he bought fourteen bronzes by such American sculptors as Anna Hyatt Huntington, Abastenia Eberle, Augustus Saint-Gaudens, Frederick Macmonnies, and Hermon MacNeil—all French-trained disciples of high finish and graceful line who reinforced the visual preferences found among Carnegie Institute's paintings. In 1919 he added two marbles by George Grey Barnard, and in 1920, three bronzes by Barnard's mentor, Auguste Rodin.

By 1917, when Beatty published his last collection checklist, the Department of Fine Arts possessed a tidily compartmentalized permanent collection. The ancients were represented by plaster casts and marble copies, the old masters by etchings and engravings, and non-Western aesthetics by Japanese prints, while the moderns held sway over the collections of drawing and painting.[20] The paintings collection had grown steadily to 118 canvases, of which 60—the largest single national group—were by Americans.

From time to time, paintings arrived as gifts. Henry Clay Frick, for example, purchased Pascal-Adolphe-Jean Dagnan-Bouveret's large *Christ at Emmaus* of 1897 and gave it to the permanent collection in 1898, and James B. Laughlin, another of Pittsburgh's industrialists, contributed a few smaller works of art at about the same time. A sprinkling of gifts arrived from outside Pittsburgh, the most notable being twelve small oils by Winslow Homer, donated by Mrs. Charles Homer in 1918. Other works of art were offered but rejected as unsuitable.[21] On the whole, the donations were not numerous; nearly all acquisitions were purchases whose financing was a single-handed endeavor by Carnegie.

The operating budget of the department had been increased from $25,000 to $50,000 in 1901. Considering that this financed not only purchases but the International and all other loan exhibitions, the sum was not lavish. A 1906 magazine review described the annual fund as consisting "only of $50,000, but the director, Mr. John W. Beatty, has done wonders with it."[22] Normally, Beatty spent between $1,500 and $3,500 on a painting and bought directly from the artist. Occasionally he spent from $5,000 to $9,000, a range that enabled him to buy George Inness's *Clouded Sun*, Edwin Austin Abbey's *Penance of Eleanor, Duchess of Gloucester*, Hassam's *Spring Morning*, and Homer's *The Wreck*. He rarely spent more for a single work; George de Forest Brush's *Mother and Child* (now in the Metropolitan Museum of Art), at $16,500, was by far his most expensive purchase.

Beatty sometimes found himself at loggerheads with the Fine Arts Committee regarding the policy that the permanent collection have only one work by each artist, like an array of specimens in which "duplicates" were undesirable. He naturally wished to expand the representation of the artists whom he considered to have the greatest talent, and a few exceptions were eventually made: by 1913

Carnegie Institute owned three landscapes by John Twachtman; in 1916 it purchased a second painting by William Merritt Chase (*English Cod*, sold in 1966), and in 1917, after much lobbying, a third Chase (*Tenth Street Studio*) entered the collection.

To boost an artist's representation in the permanent collection, Beatty, always a practical administrator, resorted to the practice of returning a painting to the artist with an additional cash payment for a newer and more ambitious work. In 1905 Henry O. Tanner's *Judas* of 1897 was exchanged for *Judas Covenanting with the High Priests*, which in turn was swapped for *Christ at the Home of Mary and Martha* in 1907. Also in 1907 Twachtman's *Greenwich Hills*, acquired in 1905, was exchanged for *River in Winter*. In 1909 Chase's *Did You Speak to Me?*, acquired in 1899, was replaced by *Mrs. Chase*. In 1912 Gari Melchers's *Sailor and His Sweetheart* of 1899 was swapped for his *Mother and Child*. Beatty's method of upgrading also applied to European painters—Claude Monet, for example, whose works were swapped twice.

In a collection formed almost entirely of director's purchases, Beatty's personal taste was evident nearly everywhere. As can be seen by his first three acquisitions (Homer's *The Wreck*, Whistler's *Arrangement in Black: Portrait of Señor Pablo de Sarasate*, and John Lavery's *Bridge at Grèz*), he believed ardently in the validity of naturalism and art-for-art's-sake aestheticism, and he found those schools to be natural, mutually reinforcing allies.

Munich-school and Barbizon naturalism had long attracted Beatty's sympathy. An art student in Munich in the late 1870s, he joined the local Scalp Level artists upon returning to Pittsburgh and painted Barbizon-like pictures of woodsmen with their workhorses in forest clearings or on country roads. He developed an abiding admiration for Homer's landscapes and became a friend of the American proponents of Barbizon naturalism, Henry Ward Ranger and Charles Harold Davis. As director of the Department of Fine Arts he purchased works by Eugène Boudin, Charles Jacque, and Anton Mauve as well as their American counterparts Davis, Ranger, Inness, and Dwight W. Tryon.

Beatty's affinity for fin-de-siècle aestheticism was evident in his rhetoric, for he constantly spoke of painting in terms of color notes, harmony of tone, and beauty of line, and declared the irrelevancy of subject matter. He lionized Whistler, was a lifelong friend of John White Alexander, and counted Hassam and J. Alden Weir among his good friends. Significantly, his largest single expenditure as director (Alexander's mural program for the Institute's central stairway) and his most expensive painting purchase (Brush's *Mother and Child*) were paradigms of the Aesthetic Movement in America.

A controlling influence on Beatty's decision making was his ardent belief in artistic internationalism. The paintings in the annual exhibitions were arranged without regard to national boundaries, and the permanent collection likewise presented international homogeneity. Monet, Julius Paul Junghanns, and Edmond François Aman-Jean were intentionally placed with their counterparts Twachtman, Inness, and Alexander. "Seeing the strongest American works intermingled with many of the powerful pictures of Europe" was an experience, Beatty was convinced, that deeply impressed viewers with the strength of American painting.[23]

Beatty's artistic point of view also permeated the educational activities of the Department of Fine Arts. Its most ambitious expression was in a program he developed of lessons in the appreciation of architecture, sculpture, and painting for all eighth-grade students in the Pittsburgh public schools. As Beatty explained,

The purpose is to give the students a true point of view with reference to some of the essential qualities of art. The average young person, indeed the average old person, sees in painting only the story told, and this is of very slight importance; or they note the merely technical quality . . . while the essential qualities secured by the artist—character, tone and harmony—few people either understand or appreciate.[24]

By 1917 the program incorporated three ninety-minute gallery talks, follow-up classroom discussions, and three illustrated booklets for students to take home. Those booklets, Beatty was proud to note, entered eight thousand households in the city each year.

In his lesson on painting, Beatty maintained that great works of art did not depend on the story told, as he demonstrated by ample reference to recent landscape. Inness's *Clouded Sun* presented no story, he asserted, while the artistic merit in Homer's *The Wreck* "is dependent upon the color and harmony of the painting without regard to the story."[25] Paintings were about beauty of line and the harmonious relationship of the color notes that he referred to as "tone." The superiority or inferiority of all sculpture was determined by criteria similar to those that applied to painting: beauty attained by balanced proportion and grace of line.[26]

Beatty regretted that the permanent collection did not contain "works by some of the great painters of earlier days."[27] He would almost certainly have liked to see John Constable and members of the Dutch and Spanish schools of the seventeenth century represented in the galleries. Beatty did manage to assemble a handful of what he called "historical" paintings from the eighteenth and early nineteenth centuries. He bought two American works for that purpose, Benjamin West's *Venus Lamenting the Death of Adonis* and Gilbert Stuart's portrait of Henry Nicols, which continue to be the earliest American paintings in the collection. The cool elegance of the West and the painterly naturalism of the Stuart fit well with his aesthetic preferences within contemporary painting.

To the end of his life Beatty continued to promote the principles of tone, harmony, and beauty of line, although such ideas grew increasingly outdated. In an article published in the *North American Review* the year of his death, he stated unequivocally that the recent radical art movements were mere fads, being the product of weak artists who overemphasize some eccentric technical quality or seek notoriety for its own sake.[28] Given that most art students are incompetent, it was not surprising, according to Beatty, that Paris—the mecca for so many would-be artists, good and bad—should be the wellspring of new schools at every turn. He asserted that the often-named founders of the modern school, Paul Cézanne, Vincent van Gogh, and Paul Gauguin, had created nothing new. Cézanne's work relied on the harmonious arrangement of color notes, but so did Whistler's. Van Gogh's sought to visualize the truth in nature, but so did Homer's. Gauguin eliminated all nonessential details from his South Seas paintings, but so did John La Farge. "Technical merits change, national characteristics change," Beatty concluded, "but art remains true to its chief purpose, the interpretation of character, beauty, grace, and harmony."[29]

The Homer Saint-Gaudens Administration

The second Director of the Department of Fine Arts was well positioned by ancestry to step into his predecessor's shoes. Homer Saint-Gaudens was the son of the sculptor Augustus Saint-Gaudens and, as he liked to point out, was related on his mother's side to Winslow Homer. After graduating in 1903 from

Harvard College, where he had been interested in architecture, he pursued a journalistic career, working briefly as a reporter for the *New York Sun*, as an assistant editor of *The Critic*, then as managing editor of *Metropolitan Magazine*. He also wrote feature articles on theater, art, his father, and his father's contemporaries for such publications as *Harper's Weekly*, *International Studio*, and *World's Work*. He then worked as a theatrical director and had three Broadway plays to his credit before going to Pittsburgh in December 1920 as John Beatty's assistant, succeeding Beatty in July 1922. His twenty-eight-year tenure was even longer than Beatty's and considerably bumpier, for Saint-Gaudens was obliged to endure budget crises, an economic downturn, a world war, and aesthetic turmoil more troublesome than his predecessor had faced.

Saint-Gaudens benefitted from a metamorphosis in the permanent collection that began soon after Andrew Carnegie's death in 1919. Gifts of art, usually individual objects but on occasion entire collections, finally began to come to Carnegie Institute. A good many of the single works were American paintings and sculpture, sometimes contributed by the artists or their widows. More often than not, though, they were old family portraits or art from an earlier generation that had lost its appeal. As for the collections, their diversity is noteworthy, for most would not have found a place in the Department of Fine Arts in a previous day: ceramics in 1920, English silver and American miniatures in 1922, old-master drawings in 1923, and old-master paintings (mainly Dutch and British portraits) in 1926 and 1929. Carnegie's initial concept of an academy gallery, which was already somewhat compromised under Beatty, eroded further, and the range of the collection finally began to resemble those of other art museums.

Saint-Gaudens himself desired an expanded sculpture collection, new galleries for prints and recent accessions, period rooms like those at the Brooklyn Museum and Boston's Museum of Fine Arts, and a children's room. He also wanted the large, red-walled main galleries to be redesigned "entirely along modern lines" with, for example, intimate alcoves for small canvases (like those recently added to Dresden's museum) and walls "tinted in dull grays, browns and greens, and trimmed with dark walnut woodwork" (like the new galleries at the Prado).[30]

Unfortunately, these expectations were thwarted by the financial difficulties that loomed over the department from the early 1920s on. By the end of the Beatty administration, even after Carnegie had doubled the annual departmental funds in 1917, rising overhead costs and exhibition expenses had seriously compromised the director's ability to purchase art. In 1922 Beatty announced a $130,000 paintings purchase fund established by thirteen Pittsburgh patrons, which he hoped would finally ease the constraint on acquisitions.[31] Just two years later, however, endowment income barely covered expenses, and the supposedly supplementary Patrons Art Fund became the sole source of revenue for the purchase of art. By 1926 the Department of Fine Arts was operating at a deficit and Saint-Gaudens pleaded, "We must call upon the people of Pittsburgh for funds which will meet the present day cost of maintenance; funds for redecorating and remodeling the galleries; funds for the purchase of . . . pictures, prints and sculpture; funds for carrying on of the educational work."[32] Throughout the 1930s the director's annual report tells a tale of the burden of inadequate capital and economies reluctantly taken.

Accessibility to the public was the key to Saint-Gaudens's ambitions for the Department of Fine Arts. He felt it important to emphasize its use to the community, and for this reason considered temporary exhibitions more essential than collection building. When the Great Depression struck and the canceling

of the Carnegie International became a possibility, he argued that the exhibition was a "wise extravagance" whose annual cost was "less than half that of an important Old Master" and, in his opinion, a better value for the money.[33] The Department of Fine Arts "should not be . . . a mausoleum of dead riches, but a means by which we may stimulate our emotions and exercise our imaginations."[34]

Not surprisingly, the educational program was the activity that expanded the most under Saint-Gaudens. Beatty's offerings of guided tours, public lectures, photographs lent to schools, and art-appreciation lessons for students in the eighth grade all continued. To those were added an essay contest for school children, sketching classes on Saturday mornings and Tuesday evenings, a department-sponsored music-appreciation class, creative-arts instruction for teachers, and a lecture series to accompany most larger exhibitions.

These educational offerings corresponded to those elsewhere in Carnegie Institute which, from the 1920s to the 1940s, took on the role of a general community educational resource. It launched *Carnegie Magazine*, community forums, and a weekly radio program called "Free to the People." The Carnegie Museum of Natural History, meanwhile, conducted its own full program of classes, contests, and clubs. These free activities became a haven during the Great Depression. In those years Saint-Gaudens reported burgeoning enrollments in his department's educational programs; attendance in the Saturday morning sketching class alone grew from 12 children in 1923 to an astounding 25,541 children and adults in 1935.[35]

Saint-Gaudens judged art itself by its ability to serve ordinary people. When he was the newly appointed director he wrote:

There is little intrinsic value in walls lined with canvases bearing paint upon them aside from the delight and the imaginative stimulus they give the onlooker. This delight has been checked in many communities of late years by what has been called "the agony and deep breathing of art." Therefore, the first concern of the Department should be to convince the public of Pittsburgh that the artists of today are, as were the artists of the past, the friends and associates of the public, different from the public [only] in that they possess clearer seeing eyes and more skillful fingers.[36]

In his subsequent years as a public speaker, he emphasized again and again that art should be readily understood by members of the public and should stimulate viewers' enjoyment of life around them.[37]

Saint-Gaudens presided over the nettlesome moment when Carnegie Institute finally had to face the encroachment of modernism. His predecessor had simply ignored modernist movements for most of his administration, assured that his artistic priorities were shared by the most knowledgeable connoisseurs and critics. By the early 1920s the situation had changed. European avant-garde art achieved a higher profile in this country; its supporters and critics were more numerous and vocal, and art museums could no longer exempt themselves from the debate.

In Pittsburgh the battle's opening salvo actually occurred in the last months of Beatty's term, while Saint-Gaudens was assistant director. On January 24, 1922, Royal Cortissoz, art critic of the *New York Tribune* and staunch adversary of modernism, lectured on "The 'Modernists'" at the invitation of the Department of Fine Arts. Repeating his well-known description of Marcel Duchamp's *Nude Descending a Staircase* as "an explosion in a shingle factory," Cortissoz derided the painters of the new school—including Paul Cézanne, Vincent van Gogh,

Paul Gauguin, and Henri Matisse—as sickening absurdities. One local reporter commented,

Those who disapprove of the new style are sneered at as "mid-Victorian," and unfortunately many of them are moral cowards who would submit to almost anything rather than be sneered at; so they hop aboard the band-wagon and join in applauding work which they know in their hearts is an offense against artistic decency, but which appears to be in vogue. More power to the art authorities of the Carnegie Institute, who have steadily set their faces against the modernist atrocities and refused to let themselves be stampeded, as other museums have been, into according recognition to the Bolsheviki of the brush and palette.[38]

Although he presented himself as a champion of contemporary artists, a firm believer in the sanctity of the creative spirit, and a supporter of artistic heterogeneity, Saint-Gaudens harbored a deep suspicion toward recent modernist movements. Without going so far as to say modernism was seditious, he considered it so superficial and inconsequential that he could dismiss Wassily Kandinsky, for example, as a "harmless eccentric."[39] At worst, Saint-Gaudens found modernism unintelligible and annoyingly abusive of both past tradition and the goodwill of the middle classes who support the arts, "the ones who in the theater appreciate Maxwell Anderson, or the Lunts in a play by Robert Emmet Sherwood, [and] when they read . . . turn the pages of Willa Cather."[40] Saint-Gaudens saw himself as an advocate for a middle road for traditional quality in art. Art should neither sell itself out to the masses, nor should it be a means for intellectuals to tyrannize the average viewer.

The first five or six years of Saint-Gaudens's artistic program were almost indistinguishable from those of Beatty.[41] The paintings bought were by American Impressionists (Mary Cassatt, Richard E. Miller, Edward Redfield, Charles Jay Taylor), by recent European painters who varied upon Impressionist conventions (Marius A. J. Bauer, Antonio Mancini, Italico Brass), or by purveyors of turn-of-the-century academic elegance (Alfred J. Munnings, Bernard Boutet de Monvel). Saint-Gaudens's loan shows conveyed a similar taste. Typical of them were an exhibition of Boston-school paintings in 1922, paintings by William Merritt Chase in 1923, a retrospective of Frank Benson in 1924, watercolors by Arthur B. Davies in 1925, and paintings by Willard Metcalf in 1926.

It was left to the Carnegie Internationals to monitor contemporary aesthetics more accurately. Saint-Gaudens reorganized the International so that paintings would be arranged by national school and thus "add to an understanding of the tendencies of each separate nation."[42] His selection committees were deliberately diverse, often including some odd bedfellows, such as Pierre Bonnard and Charles W. Hawthorne in 1927; Karl Hofer, Maurice Denis, and Eugene Speicher in 1928; Matisse and Bernard Karfiol in 1931. Major realists won their share of first prizes, and so did major modernists, Matisse in 1928, for example, Pablo Picasso in 1931, and Georges Braque in 1937. Although modernist works dismayed large numbers of Pittsburghers, as became evident by the furor in the press over Matisse's 1928 first prize, Saint-Gaudens himself welcomed the more controversial elements of the Internationals. He just did not want those controversial elements in the permanent collection.

From the later 1920s to the later 1930s Saint-Gaudens developed a strong interest in the realist revival at home and abroad. He organized a steady stream of solo shows for proponents of the new realism and at the same time he added as many examples of it as he could to the permanent collection. The type of work that attracted him is easier to recognize than to describe, but it can be said that he preferred either a slightly symbolic, slightly classical approach (as prac-

ticed by Paul Manship, Arthur B. Davies, Rockwell Kent, and Leon Kroll), or an austere, yet rugged manner of representing subjects from ordinary life (as in the paintings of Speicher, Hawthorne, George Bellows, and Edward Hopper). Saint-Gaudens had a particular liking for Speicher who, to his mind, stood in the forefront of "authentic" painting.[43]

The European paintings purchased were similar to their American counterparts. Saint-Gaudens built his collection around British, Italian, and Spanish painters: Augustus John, Colin Gill, Gerald Brockhurst, Ferruccio Ferrazzi, Felice Carena, Valentin de Zubiaurre, Ignacio Zuolaga. Their names scarcely appear in today's collective memory of twentieth-century masters, but these were Saint-Gaudens's preferred ambassadors of world painting in Pittsburgh.

Like many observers of American art at the time, the second director took an interest in those Americans of the past who could be perceived as predecessors of the realist revival. The large-scale centennials at Carnegie Institute for Homer in 1936 and for Thomas Eakins in 1945 were expressions of this interest. So too, were the purchases during the 1930s of Eakins's *Joseph R. Woodwell* and John Singer Sargent's *Portrait of a Boy*. Another such purchase was William M. Harnett's *Trophy of the Hunt* (which came from Edith Halpert's Downtown Gallery in 1941, in trade for twelve small Homer oils given by Mrs. Charles Homer).

With the onset of World War II Saint-Gaudens was called to active military duty as a lieutenant colonel and an authority on camouflage in the War Department; he left the Department of Fine Arts to its assistant director, John O'Connor, Jr., from 1941 to 1945. The war also halted the Carnegie Internationals, whose replacements, because of interrupted travel abroad, were exhibitions of American art. "Survey of American Painting" in 1940 was a mammoth show of 367 works ranging from the seventeenth century to the present day. It was followed, in 1941, by a juried exhibition called "Directions in American Painting." The year 1943 began an annual series, "Painting in the United States," an invitational show of contemporary work whose popularity and low cost (it could be mounted for about one third of the expense of the International) made it the International's replacement through 1948.

Not surprisingly, the war years also facilitated the purchase of American art. The savings realized from the suspended Carnegie International permitted the purchase in 1942 of *Noli Me Tangere* by Albert P. Ryder and *Post Office* by David Gilmour Blythe, the latter being the first work in the collection by an artist whom O'Connor described as "one of America's old masters."[44] Subsequent purchases turned once more to recent American painting: thanks to additional contributions to the Patrons Art Fund, O'Connor bought Robert Gwathmey's *Hoeing*, Marsden Hartley's *Young Hunter Hearing Call to Arms*, and Max Weber's *Quartet* in 1943 and Yasuo Kuniyoshi's *Mother and Daughter* in 1945. These four works, like Georges Rouault's expressionistic *Old King*, purchased in 1940, were the most "modern" acquisitions of the Saint-Gaudens era.

In the purchases of Saint-Gaudens's administration an attentive observer can read subtle and interesting changes in attitude toward American art. It is evident, however, that costly acquisitions were avoided and that far fewer works were bought than during the Beatty years. Under Saint-Gaudens's directorship, the Department of Fine Arts operated much like a large community art center, offering temporary exhibitions along with art classes and other activities to which the prestige of the permanent collection generally took second place.

The permanent collection's stagnation from 1922 to 1950 can in part be attributed to circumstances beyond Saint-Gaudens's control. The director found his last years in office to be not very different from his first. Budget shortfalls

limited his purchases to a single painting a year; he complained frequently that the Institute's facilities were inadequate. At the same time the Department of Fine Arts was hampered by the lack of a natural constituency of art patrons in Pittsburgh, then a sooty metropolis of mills and workers, whose citizens of greatest means tended to live and have interests elsewhere.

Nonetheless, at least some fault rested with Saint-Gaudens's aesthetic preferences, which distanced him from much of the art of his own time. During his directorship he witnessed the steady demise of those virtuoso practitioners of naturalistic art among whom his father had been a leading figure, yet he saw no present art movement that represented a viable alternative. "Our former culture, artistically, was deep but narrow," he wrote in 1941. "Our present culture is wide and thin."[45] Steadfastly believing that art should be judged by traditional standards of craftsmanship and by universally understood rules of representation, he was reluctant to transfer his loyalties to anyone whose creations were confrontational, difficult to look at, or threatening to middle-class values. He had little use for radical Social Realism and none at all for avant-garde art such as that in the collections of Albert Gallatin and Pittsburgh-born Walter Arensberg (which Fiske Kimball successfully solicited for the Philadelphia Museum of Art during the 1940s). Tellingly, Saint-Gaudens did not accession a single work of abstract art, even forty years or more after abstraction appeared. Over time his policy contrasted with that of an increasing number of American museums, and when he retired in 1950 at the age of seventy, a change was clearly in order.

The Collection after 1950

Modernization became the watchword for Homer Saint-Gaudens's successors, who concentrated on expanding the permanent collection and counteracting Carnegie Institute's previous parochialism. Gordon Bailey Washburn, director from 1950 to 1962, set the pace for this change. He had headed the Museum of Art, Rhode Island School of Design from 1942 to 1949 and, before that, Buffalo's Albright Art Gallery. Washburn arrived in Pittsburgh determined to reshape and revitalize Carnegie Institute's art collection and bring the Department of Fine Arts into the ranks of major metropolitan museums. His vision fit eminently well with the renewed growth of Pittsburgh, and it established the department's direction for the next twenty-five years.

Washburn wanted ambitious exhibitions, innovative display techniques, and a Carnegie International that would champion artistic modernism. Toward these ends he created an experimental gallery to explain a single work in depth and brought to the Institute broadly focused exhibitions such as *French Painting: 1100–1900* (1951), *What Is Abstract Art?* (1952), *Pictures of Everyday Life: Genre Painting in Europe, 1500–1900* (1954), and *American Classics of the Nineteenth Century* (1957). He also transformed a third of the exhibition space into a gallery for contemporary art, whether provisional purchases or extended loans. Meanwhile, funding from the A. W. Mellon Educational and Charitable Trust in 1950 regenerated the Carnegie International from its twelve-year lapse. Washburn rescheduled it as a triennial, eliminated its previous division into national schools, and rebuilt it as a showcase for international modernism.

Washburn is best remembered in Pittsburgh as an advocate of abstract art— "that crazy modern," as he put it.[46] He made it his duty to convince the Carnegie Institute's public of the complexity and depth of abstract art and he tirelessly promoted its virtues on television and in print. The articles he wrote for *Carnegie Magazine* during each International are eloquent essays on the relation-

ship between the viewer and the work of art. Washburn reminded readers that all art of any value, abstract art included, is a strange and disturbing experience that does not help one escape life's conflicts, but instead makes one more deeply aware of them.[47] To follow artists into "those mysterious regions of the spirit they have visited" demands attention, an open mind, and a willingness "to submit wholly and without resistance."[48] He scolded those who resist abstract art because they do not understand it:

Yet you put your heart into equally uncertain and incomprehensible things: your family, your work, your house, and your garden. Must you withhold your love from today's art on the pitiful excuse of not understanding it? What do you think you understand? Yourself? Your children? Your mysterious and numbered days?[49]

Contemporary abstraction became the nucleus around which Washburn expanded the permanent collection. By the mid-1950s, as Abstract Expressionism became a prominent feature of the Carnegie Internationals, the works of the New York School—including those of Franz Kline, David Smith, Jackson Pollock, Willem de Kooning, and Ellsworth Kelly—began to enter the permanent collection. Equally interested in Abstract Expressionism's European counterparts, Washburn bought for the permanent collection works by such artists as Alberto Giacometti, Carl-Henning Pedersen, Asger Jorn, Afro Basaldella, and Alfred Manessier.

Washburn's purchases of American art prior to 1945 numbered merely eleven. The paucity is not surprising, considering that his goal was to move Carnegie Institute's aesthetic priorities toward European and contemporary art. His few acquisitions of earlier American art projected values that were congenial to someone who had embraced modern art in general and Abstract Expressionism in particular. All could lay claim to some degree of anti-academicism, if not avant-garde spirit. Some offered a ruggedly self-taught style (Edward Hicks's *Residence of David Twining*, Ralph Albert Blakelock's *Hawley Valley*, and John Kane's *Larimer Avenue Bridge*), others helped to fill the void in abstract art left by Saint-Gaudens (Stanton Macdonald-Wright's *Sunrise Synchromy in Violet* and Patrick Henry Bruce's *Abstract*), and still others presented an American equivalent of Post-Impressionist painterliness. In this last category were some adventurous acquisitions, tributes to Washburn's eye for innovation: William Glackens's *La Villette*, Thomas P. Anshutz's *Steamboat on the Ohio*, and Alfred H. Maurer's *Landscape*.

Convinced that a familiarity with earlier art is necessary to the proper understanding of modernism, Washburn deplored the lack of old-master paintings at Carnegie Institute and urged strengthening that part of the collection.[50] In 1954 the galleries devoted to non-contemporary art were rehung so that, for the first time, they were arranged with regard to school and chronology. To fill some of the voids Washburn brought in numerous extended loans.

The beginning of the most significant change in Carnegie Institute's collecting history occurred in the last two years of Washburn's administration when Sarah Mellon Scaife, Andrew Mellon's niece, offered to purchase important European paintings of distinction for the permanent collection. Bidding unsuccessfully for Rembrandt's *Aristotle Contemplating the Bust of Homer* at auction in 1961—she bought instead Frans Hals's *Pieter Cornelisz. van der Morsch (Man with a Herring)* and Pietro Perugino's *Saint Augustine with Members of the Confraternity of Perugia*—and purchasing Walter Chrysler's *Nymphéas (Waterlilies)* by Monet in 1962, Mrs. Scaife began a remarkable buying campaign that, continued by her family after her death in 1965, lasted seventeen years. It gave

Carnegie Institute forty-three mostly European paintings of the late nineteenth century, including the Impressionist and Post-Impressionist canvases that are now its best-known works. Washburn's purchases with Mrs. Scaife (Perugino, Hals, Edgar Degas, Pierre-Auguste Renoir, Edouard Vuillard, Monet, and Matisse) formed the beginning of a systematic representation of key schools of world art. They also indicated the kind of remedial collection that Washburn felt the Department of Fine Arts most needed, for all were by artists to whom line, color, and form seemed paramount, who therefore echoed the concerns of modern art and could be seen as its forerunners.

In 1961, in accord with the Department of Fine Arts' new alliance with modernism, the principal galleries of its 1907 building were given a new design by Paul Schweikher, head of the department of architecture at Carnegie Institute of Technology. Dados were removed, the old gallery walls were painted white, and flexible, freestanding wall panels and a trussed aluminum ceiling grid were installed. The result was the sort of ahistorical environment so essential to the ethic of international modernism, which encouraged viewers to consider the work of art in pristine isolation.

Washburn was succeeded by Gustave von Groschwitz, formerly senior curator at the Cincinnati Art Museum, who served as director from 1963 to 1968. At the outset of his administration, the Department of Fine Arts was renamed the Museum of Art, Carnegie Institute, and with the discarding of Andrew Carnegie's confusing, quasi-academic nomenclature, it became apparent that the enterprise was indeed a museum whose mission was its collection. Von Groschwitz continued to transform the permanent collection along the pattern that Washburn had initiated. Its most visible areas were abstract art after World War II and French Impressionist and Post-Impressionist paintings, and thanks to the availability of generous funds, Von Groschwitz was able to make a number of lavish purchases in these areas. While the collecting of prints, drawings, and non-Western art continued under Von Groschwitz, the number of old-master paintings and sculpture also grew appreciably, Howard Noble's bequest of twenty-six old-master paintings in 1964 being the most significant single addition. Von Groschwitz's purchases of American art prior to 1945 were negligible, however—an indication once more of energies directed toward European and contemporary art.

It is worth remembering that the expansion of Carnegie Institute's art collection into other areas was undertaken implicitly to counterbalance an abundance of American art already there. At the same time, the relationship of the existing American art to the new core of the collection was ambiguous. Therein lay a problem that affected Carnegie Institute more than perhaps any other American public art collection.

In the 1950s and 1960s museums were using the example of the avant-garde, so dominant in contemporary art, as the basis for determining among their earlier holdings what was aesthetically progressive and therefore worthy of display and what was to remain in the storage rooms. These were decades in which, for example, Victorian art and French academicism were classified as exemplars of aesthetic degeneracy, useful only as a foil for the innovations of the avant-garde.[51] The standard of judging earlier American art placed great stock in the concept of a native school fostering a uniquely American artistic vision and in the self-made master who seemed to owe nothing to previous ways of doing things and whose work could be appraised according to the criteria of abstract art. The list of worthies is familiar to anyone conversant with the writings on American art of the late 1940s to the mid-1960s: John Singleton Copley, Charles Willson Peale,

members of the Hudson River School, George Caleb Bingham, Homer, Eakins, Blakelock, and Ryder. Confirming these artistic judgments were the extended loans that Washburn obtained (a portrait by Copley, a landscape by Asher B. Durand) and the loan shows that Carnegie Institute hosted: *Nineteenth-Century American Paintings, Collection of Maxim Karolik* (1956), *American Classics of the Nineteenth Century* (1957), and *Primitive Paintings from the Collection of Edgar William and Bernice Chrysler Garbisch* (1963). Omitted were those artists who seemed too close to their European academic counterparts, including many of those now described as American Impressionists.[52]

The problem that the Carnegie's directors of the 1950s and 1960s faced was that the bulk of the American art collection did not fit into reigning standards of museum-worthy art. The turn-of-the-century aestheticism that had so captivated John Beatty appeared derivative, academic, and sentimental, while the representational art of the 1920s and 1930s that had interested Saint-Gaudens seemed visually trivial if not regressive. Both styles had become liabilities to a museum that was allying itself with the aesthetic standard of international modernism.

A logical solution was deaccessioning. From virtually its beginning, in fact, Carnegie Institute had sold unwanted works in order to buy others more pertinent to present needs and, from 1957 onward, deaccessioning campaigns occurred periodically. The largest of these campaigns, and perhaps the most interesting from the point of view of changes in taste, took place in 1966, when twenty-seven American paintings and sculpture were sent to auction. The casualties had been acquired mostly during the last decade of the Beatty administration. Both large and small works, many were sold for less than their original purchase prices. Brush's *Mother and Child* left the collection in that year, as did canvases by Theodore Robinson, Frank Millet, Metcalf, and Chase, along with most of the American academic bronzes Beatty had collected. Although Beatty's influence still seems to run so visibly though Carnegie Institute's American art collection, in fact only forty paintings and sculpture remain of the ninety-seven he acquired.

Nearly as hard hit were Saint-Gaudens's acquisitions. Some were jettisoned in 1966; even more left the collection in 1979, among them canvases by J. Carroll Beckwith, Arnold Blanch, Henry McFee, and two paintings that the second director considered to be jewels of his administration: Speicher's *Babette* and Kent's *Annie McGinley*. Only sixty percent of the American paintings and sculpture purchased or given during Saint-Gaudens's directorship remain, and the works that represented his tastes have not benefitted nearly as much from a resurgence of interest in recent years as Beatty's have.

Leon Anthony Arkus, who had been Washburn's assistant director and Von Groschwitz's associate director, became director of the Museum of Art in 1968. During Arkus's twelve-year tenure, the museum's public programs broadened, as they did at museums throughout the country. The scope of the museum's collections also expanded considerably, to encompass Asiatic, African, Meso-American, and Oceanic art, and photography as well. In 1969 a department of film was established; a year later a gift of over 2800 objects from the estate of Ailsa Mellon Bruce greatly enriched the collection of decorative arts.

Donations of paintings and sculpture came from the broadest base of local collectors yet in Pittsburgh's history, while the availability of generous purchase funds permitted a number of ambitious acquisitions of nineteenth- and twentieth-century art. A determination to create an art museum of national prominence arose among Pittsburgh's citizens, an ambition well suited to a city

that had by the 1960s transformed itself from a steel town to a corporate capital. The Museum of Art stood as an example of the remarkable degree to which a city's stature can be correlated with the art owned by its museums.

The predominant accomplishment of the Arkus administration was the construction of a new building for the Museum of Art, the first expansion of its physical plant since 1907. A new building had been anticipated since the mid-1960s, and an initial set of plans was commissioned in 1968. After a two-year halt in the project, Edward Larrabee Barnes, who had designed the Walker Art Center in Minneapolis, was selected as architect, and in 1971 ground was broken for a new building adjacent to the old. In November 1974 the Sarah Scaife Gallery, a spacious, conspicuously modern granite-and-glass building opened its doors to the public amid national publicity and a conviction locally that it embodied the Museum of Art's coming of age.

The new structure tripled the old building's exhibition area and greatly amplified what could be called the recreational space of the museum. It incorporated a café, a gift shop, a theater, a children's room, and a glass-walled promenade on its two lower floors.[53] As in the 1907 building, the upper floor was reserved for galleries. In contrast to cramped conditions and fluorescent lights of the old galleries, these struck visitors as being serene, elegantly simple, and beautifully lit by reflected sunlight (Arkus had insisted that there be as much natural light as possible). With high ceilings like the old, they were arranged in a continuous zigzag progression, their off-white walls and floors of milky terrazzo giving the impression of "long white vistas."[54] Housed within them was a recently overhauled permanent collection, for more than sixty percent of the paintings on view had been acquired in the previous dozen years.

The intention behind the galleries' great white space was to allow neither color nor structural elements to compete with or distort the work of art. Arkus took pains to arrange works in the galleries so that each would receive the least visual interference from surrounding works. His philosophy applied equally to the old-master paintings, the separately exhibited American nineteenth-century paintings, and the modern-art galleries in which American and European works were combined. In suggesting how visitors should look at the art, Arkus advised, "don't work too hard to fathom the 'meaning' of a given piece," adding, "study all you want to but keep your vision fresh. Georges Braque once wrote, 'the only thing of value in a work of art is that which cannot be explained.'"[55]

Despite having a gallery plan that provided for paintings and sculpture to be arranged in an uninterrupted sequence, Arkus considered it a convenience, not a necessity, and averred,

Art has no period. It may be created in a specific year, but art, to be worthy of that name, is timeless. The works of major artists can always be hung together though there may be a span of half a millennium between the dates they were created.[56]

This represented the approach of the modernist, who, typically, is disinclined to place a work of art on view for the sake of its historical context and instead insists on its absolute autonomy.

The new, larger galleries inevitably spurred the acquisition of works to fill them. That, along with the impending American bicentennial and the growing interest in American art, encouraged the expansion of the permanent collection's American paintings and sculpture. Arkus ranked American art next to Impressionism and Post-Impressionism in its importance to the Museum of Art, and in fact this part of the collection grew more rapidly during the 1970s than it had for many years. During Arkus's tenure, over 120 American paintings that

date prior to the end of World War II were either purchased by or given to the Museum of Art, a number exceeding Beatty's acquisitions by one-third.

The most visible American art purchases were from the general era of American Impressionism: Hassam's *Northeast Headlands, Appledore*, Thomas Wilmer Dewing's *Morning Glories*, and Maurice Prendergast's *Picnic*, which was purchased with the proceeds from a memorable "penny campaign" orchestrated by the Women's Committee of the Museum of Art in 1972.[57] Works by several American modernists entered the collection: John Graham, Georgia O'Keeffe, Augustus Vincent Tack, Arthur G. Dove, John B. Flannagan, and John Storrs. The Blythe and Kane holdings also increased impressively, to the extent that The Carnegie Museum of Art is today the largest single repository of these two artists' work. In fact, the area of the collection that increased with the least bias toward period or style was the representation of western Pennsylvania artists.

The largest single increase that Arkus made in the collection of American paintings was what might be called the "American school," mostly landscapes dating from 1845 to 1890, which Arkus built in partial compensation for the Hudson River School paintings that the Museum of Art never had. These purchases, made possible largely through funds established by Howard N. Eavenson, included modest but representative examples of works by such artists as Frederic E. Church, Worthington Whittredge, Martin Johnson Heade, Albert Bierstadt, George Catlin, William Ranney, Bingham, and Ryder. As a result the permanent collection offered for the first time more than a glancing representation of the two generations before Beatty.

A significant change from previous years was the increased role of individual collectors as shapers of the collection of earlier American art. Edward Duff Balken, a print collector and curator of prints under Beatty and Saint-Gaudens, bequeathed a number of Maurice Prendergasts, including the panel painting *Women at Seashore*. Charles J. Rosenbloom, whose old-master print collection is now the highlight of the museum's own, gave a number of idiosyncratic American paintings, notably Edward Hicks's *Peaceable Kingdom*. Mr. and Mrs. James Beal brought together an outstanding collection of American watercolors of the early twentieth century, had an interest in American painters that ranged from Jacob Eichholtz to Charles Burchfield, and during the 1960s and 1970s donated a number of their canvases, including Edward Hopper's early *Sailing* and Arthur G. Dove's remarkable pastel-on-panel *Tree Forms*. Such gifts added a stylistic diversity and depth to the collection of American art that would probably not have existed otherwise.

Arkus was succeeded by John R. Lane, who served as director from 1980 to 1986. Lane differed sharply from Arkus on a number of aesthetic issues, particularly those regarding contemporary art, which led to a radical revamping of that area of the collection. He also sought to return the Carnegie International to its historical place as one of the institute's central activities. He revived the exhibition itself (which had been discontinued by Arkus) as well as the tradition of buying works from it, adding significantly to the museum's contemporary holdings. Other changes that the Lane administration brought to The Carnegie Museum of Art (it was renamed again in 1986) included a new arrangement of the permanent-collection galleries.[58]

The reinstallation traded the uniformly white spaces for walls painted in different hues, and the austere simplicity of the previous system of partitions and lighting for one that was more varied. Such modifications were a small but telling indication of the passing dominance of the International Style. Some of the new historical emphasis at other art museums (the Philadelphia Museum of

Art, the Mabel Brady Garvan Collection at the Yale University Art Gallery, the American wing of the Metropolitan Museum of Art) was apparent in The Carnegie Museum of Art's reinstalled galleries. Explanatory labels were added and works of art juxtaposed so that a viewer's point of view would be affected by adjacent works. To further this end, decorative arts were introduced to the galleries. The furniture, ceramics, and metalwork were treated as if they were pieces of sculpture, but their presence was meant—this was especially true in the American art galleries—to provide essential points of reference for the paintings and sculpture there.

To accompany the new installation, Lane and his curators brought from storage some of the more academic examples of the museum's nineteenth-century paintings, among them Pascal Dagnan-Bouveret's *Christ and the Disciples at Emmaus*, Jules Bastien-Lepage's *Peasant*, Elihu Vedder's *Keeper of the Threshold*, and Edwin Austin Abbey's *Penance of Eleanor, Duchess of Gloucester*. This practice reflected the strong interest in Victorian and French academic painting that had arisen among scholars and collectors during the 1970s and echoed the Metropolitan Museum of Art's 1980 reinstallation of its André Meyer Galleries, in which nineteenth-century French academic canvases were hung in prominent locations.

Lane agreed heartily with Arkus's assessment that American art of the nineteenth and twentieth centuries was one of the principal strengths of the permanent collection, stating on his arrival that he wished to add depth to it.[59] He did so: the collection of American paintings dating to the end of World War II increased by seventy works during his administration. Lane's most notable addition was the purchase, made possible in large part by the Edith Fisher Fund, of paintings and sculpture by the American abstract artists of the 1930s and 1940s, among them Burgoyne Diller, Ilya Bolotowsky, Charles Biederman, Harry Holtzman, John Sennhauser, and Gertrude Greene. These were juxtaposed against Leon Kroll's *Morning on the Cape* and a sampling of other realist works from the 1930s that were retrieved from storage. Lane also set out to "reclaim" for the collection some of the aesthetic that typified the early years of the Department of Fine Arts: he purchased Brush's *Blue Madonna*, John La Farge's *Roses on a Tray*, Richard E. Miller's *Reflections*, and John Sloan's *Coffee Line*, along with works by John Frederick Kensett, John F. Peto, Thomas Crawford, and Hiram Powers that filled other chronological gaps in the permanent collection.

Particularly troublesome after 1980 was the rapid rise in market value of nineteenth- and twentieth-century American art. Ironically, strong public interest in American art made obtaining more of it for the museum's walls difficult. Because Carnegie Institute always had less money to spend on art acquisitions than larger museums, its directors, from Beatty on, have been aware of the need to "work wonders" with their funds, since the flashiest and costliest art on the market has been chronically beyond reach. The Carnegie Museum of Art's American art collecting during the 1980s testifies to the resourcefulness that can be mustered by a medium-sized museum wishing to build its collections while constrained by limited funds.

The Carnegie's attitude during the past decade toward its American paintings and sculpture can be summarized as an enthusiastic rediscovery of the core of the permanent collection. It indicates a new historicism—a desire to accept mutually contradictory past styles, to observe them together, and to present the works as highly valued objects. This publication is a measure of that attitude.

Notes

1 Andrew Carnegie, *Autobiography of Andrew Carnegie* (Boston, 1920), p. 337.

2 Sarah H. Killikelly, *The History of Pittsburgh: Its Rise and Progress* (Pittsburgh, 1906), p. 551.

3 John O'Connor, Jr., "Carnegie Institute International Exhibition," *Art and Archeology* 4 (November–December 1922), pp. 301–2.

4 On the relationship between the Carnegie International and the permanent collection, see Vicky A. Clark, "Collecting from the Internationals," *Carnegie Magazine* 56 (September–October 1982), and Gabriel Weisberg, "Tastemaking in Pittsburgh: the Carnegie International in Perspective, 1896–1905," *Carnegie Magazine* 57 (July–August 1983), pp. 20–26, 40.

5 The art galleries as they existed in the first building appeared in the first checklist of the art collection, *Carnegie Institute Catalogue of Paintings, Sculpture and Other Objects in the Department of Fine Arts* (Pittsburgh, 1903).

6 Killikelly, *History of Pittsburgh*, p. 552.

7 By the time he died in 1919, Carnegie's gifts to Carnegie Institute amounted to $28 million, as reported in his autobiography, Andrew Carnegie, *Autobiography of Andrew Carnegie* (Boston, 1920), p. 249. Another biographer placed that figure at $36 million; Burton J. Hendrick, *The Life of Andrew Carnegie* (New York, 1932), vol. 2, p. 252.

8 Andrew Carnegie, "Address," in *Memorial of the Celebration of the Carnegie Institute at Pittsburgh . . . Comprising a Complete Description of the Exercises Connected with the . . . Opening of the Enlarged Carnegie Library Building* (Pittsburgh, 1907), p. 55.

9 Carnegie, *Autobiography*, p. 336.

10 Carnegie to the President and Trustees of Carnegie Institute, October 1897, Andrew Carnegie Papers, Library of Congress, Washington, D.C., quoted in Joseph Frazier Wall, *Andrew Carnegie* (New York, 1970), p. 817.

11 Andrew Carnegie in a letter to William E. Gladstone, February 3, 1897, quoted in Hendrick, *Life of Andrew Carnegie*, vol. 2, p. 255.

12 Andrew Carnegie's correspondence from March to December 1894, in the Library of Congress, Washington D.C., reports a visit to Lelli's manufactory of plaster casts in Florence, and contains invoices from two other Florentine firms: Antonio Frilli, a dealer in marble reproductions, and Cost & Conti, "the largest collection of the most famous modern original pictures and first-rate copies from the old masters."

13 Carnegie had a gallery of portraits of famous men and a print collection. He also built a collection of recent genre and landscape paintings for which John Beatty regularly made suggestions. Their correspondence about Carnegie's personal buying is divided between the Andrew Carnegie Papers in the Library of Congress and the Carnegie Institute Papers, Archives of American Art, Washington, D.C.

14 Telegrams from Andrew Carnegie to William Nimmick Frew, 24 October 1894 and 4 November 1895, Andrew Carnegie Papers, Library of Congress, Washington, D.C.

15 Robert M. Lester, *Forty Years of Carnegie Giving* (New York, 1941), p. 108.

16 Carnegie Endowment for International Peace, *A Manual of the Public Benefactions of Andrew Carnegie* (Washington, D.C., 1919), p. 43.

17 This limiting of purchases to artists who would submit their work to juried exhibitions happened to occur at a time when the watchword of avant-garde movements was a refusal to submit to such juries. The result, intended or not, was an institutional blindness to those artists who worked outside established channels.

18 Lester, *Forty Years of Carnegie Giving*, p. 5.

19 For a history of this aspect of the permanent collection, see Henry Adams's introductory essay in *American Drawings and Watercolors in the Museum of Art, Carnegie Institute* (Pittsburgh, 1985), pp. 8–19.

20 *Supplementary Lists of Paintings, Drawings, and Japanese Prints in the Permanent Collections of the Department of Fine Arts, Acquired since 1912* (Pittsburgh, 1917). Preceding it was the checklist, *Lists of Paintings, Drawings, and Japanese Prints in the Permanent Collections of the Department of Fine Arts: A Preliminary Publication, Subject to Revision* (Pittsburgh, 1912).

21 At some time during the Beatty administration the Carnegie Institute became an unofficial depository for old Pittsburgh paintings no longer wanted by their owners. The Department of Fine Arts refused to accession the cast-offs but continued to store them. Among those works, found in storage in recent years and now accessioned, were paintings by early Pittsburgh painters Russell Smith, Trevor McClurg, and Isaac Craig.

22 "Studio Talk: Pittsburgh, Pennsylvania," *International Studio* 29 (September 1906), p. 262.

23 O'Connor, *Art and Archaeology*, p. 304.

24 John W. Beatty, *Paper Read before the Fourth Annual Meeting of the Association of Urban Universities, Pittsburgh, November 15, 1917* (Pittsburgh, 1917), unpaginated, [p. 1].

25 John W. Beatty, *A Brief Lesson on Some Important Qualities in Paintings, Prepared for the Instruction of Students of the Eighth Grade of the Public Schools of the City of Pittsburgh* (Pittsburgh, 1917), p. 7.

26 John W. Beatty, *A Brief Lesson on the Importance of Proportion and Grace of Line in Sculpture, Prepared for the Instruction of Students of the Eighth Grade of the Public Schools of the City of Pittsburgh* (Pittsburgh, 1917).

27 John W. Beatty, *A Brief Lesson . . . on Painting*, unpaginated insert, "What the Visitor May See in the Galleries of the Permanent Collection of Paintings," 1917.

28 John W. Beatty, "The Modern Art Movement," *North American Review* 219 (February 1924), pp. 251–64.

29 Ibid., p. 264.

30 Carnegie Institute, *Twenty-ninth Annual Report of the Department of Fine Arts* (Pittsburgh, 1925), p. 18.

31 Carnegie Institute, *Twenty-sixth Annual Report of the Department of Fine Arts* (Pittsburgh, 1922), pp. 8–9.

32 Carnegie Institute, *Thirtieth Annual Report of the Department of Fine Arts* (Pittsburgh, 1926), p. 9.

33 Carnegie Institute, *Thirty-fifth Annual Report of the Department of Fine Arts* (Pittsburgh, 1931), pp. 9–10.

34 Ibid., p. 17.

35 Carnegie Institute, *Thirty-ninth Annual Report of the Department of Fine Arts* (Pittsburgh, 1935), p. 16.

36 Carnegie Institute, *Twenty-seventh Annual Report of the Department of Fine Arts* (Pittsburgh, 1923), p. 9.

37 See Homer Saint-Gaudens, "The Unshackled Painter," a speech delivered to the Associated Artists of Pittsburgh, *Carnegie Magazine* 5 (February 1932), pp. 270–71.

38 "Making a Mockery of Art," *Pittsburgh Sun*, January 26, 1922, scrapbook clipping, museum files.

39 Homer Saint-Gaudens to John O'Connor, Jr., Assistant Director, Department of Fine Arts, Carnegie Institute, 23 April 1938, Carnegie Institute Papers, Archives of American Art, Washington, D.C.

40 Homer Saint-Gaudens, *The American Artist and His Times* (New York, 1941), p. 7.

41 Saint-Gaudens's purchases between 1922 and 1940 were listed and illustrated in a small catalogue published by Carnegie Institute, *The Patrons Art Fund Paintings* (Pittsburgh, 1940).

42 Carnegie Institute, *Twenty-seventh Annual Report of the Department of Fine Arts* (Pittsburgh, 1923), pp. 14–15.

43 Saint-Gaudens, *The American Artist and His Times*, p. 6.

44 Carnegie Institute, *Forty-sixth Annual Report of the Department of Fine Arts* (Pittsburgh, 1942), p. 11.

45 Saint-Gaudens, *The American Artist and His Times*, p. 318.

46 Gordon Bailey Washburn, "Without the Implements of Memory," *Carnegie Magazine* 29 (September 1955), p. 224.

47 Gordon Bailey Washburn, "I Know What I Like," *Carnegie Magazine* 25 (February 1951), pp. 42–44.

48 Gordon Bailey Washburn, "Where the Blue Begins," *Carnegie Magazine* 29 (October 1955), p. 257.

49 Gordon Bailey Washburn, "Popular Questions and Unpopular Answers on Modern Art," *Carnegie Magazine* 35 (November 1961), p. 300.

50 Washburn, "Without the Implements of Memory," pp. 222–23.

51 A memorable example of just this bias was the Book-of-the-Month Club's 1965 advertising campaign for John Canaday's *Metropolitan Museum of Art Seminars in the Home*, which juxtaposed an Expressionist painting by Oskar Kokoschka with a late-nineteenth-century academic picture by Pierre-Auguste Cot and challenged, "'GOOD ART' or 'BAD ART'. . . what would *your* judgment be?"

52 The lack of interest in the American Impressionists at Carnegie Institute was symptomatic of a general neglect of these painters during the 1950s and 1960s. See William H. Gerdts's essay, "American Impressionism in Context," in Henry Art Gallery, University of Washington, Seattle, *American Impressionism* (1980), exh. cat., pp. 9–15.

53 The most complete published description of the gallery's design is Gerald Allen, "The Scaife Gallery," *Architectural Record* 158 (November 1975), pp. 87–91.

54 Donald Miller, "The New Scaife Gallery: At the Carnegie Institute, a Happy Occasion," *Art News* 73 (November 1974), p. 55.

55 [Robert J. Gangewere], "An Interview with Leon Anthony Arkus," *Carnegie Magazine* 48 (October–November 1974), p. 312.

56 "Three Hundred Paintings Waiting to Be Hung in New Scaife Art Gallery," Kittanning, Pennsylvania *Leader-Times*, July 27, 1974, p. 8.

57 "Pennies Buying 'The Picnic,'" *Pittsburgh Press*, February 14, 1973, p. 50.

58 See the introduction by John R. Lane in *Museum of Art, Carnegie Institute Handbook* (Pittsburgh, 1985), published on the occasion of the reinstallation and to commemorate the centenary of Andrew Carnegie's birth.

59 [Robert J. Gangewere], "Interview: John R. Lane," *Carnegie Magazine* 55 (April 1981), p. 13.

Color Plates

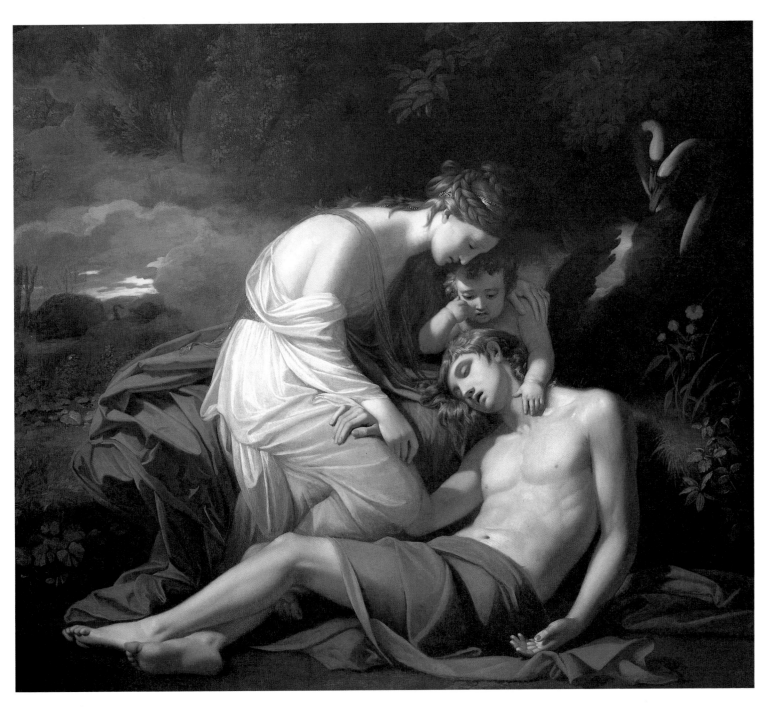

Color Plate 1: Benjamin West, *Venus Lamenting the Death of Adonis*, 1768, retouched 1819

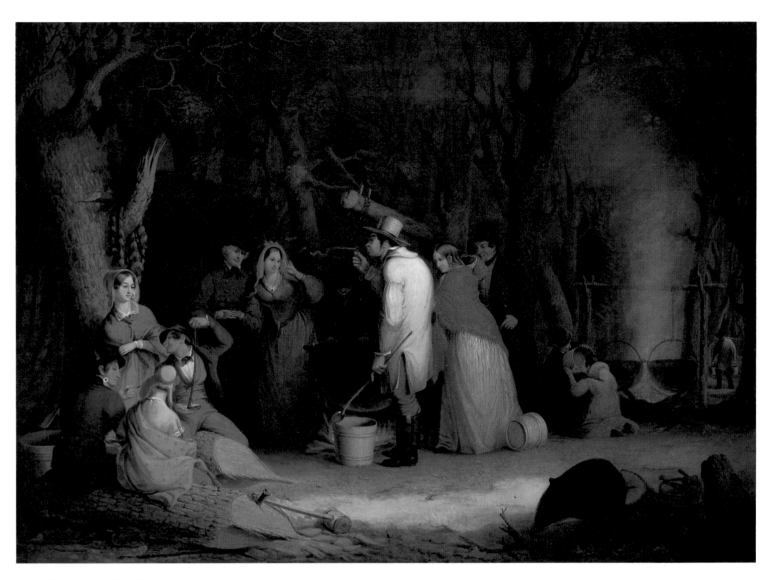

Color Plate 2: Tompkins H. Matteson, *Sugaring Off*, 1845

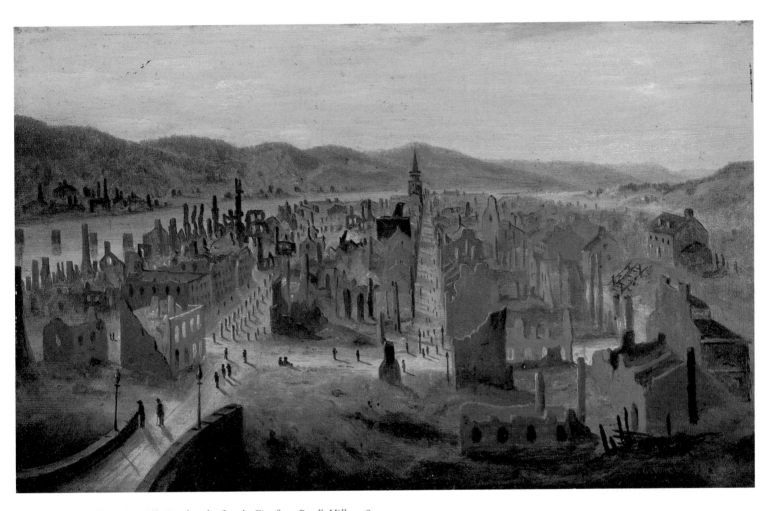

Color Plate 3: William C. Wall, *Pittsburgh after the Fire from Boyd's Hill*, c. 1845

3

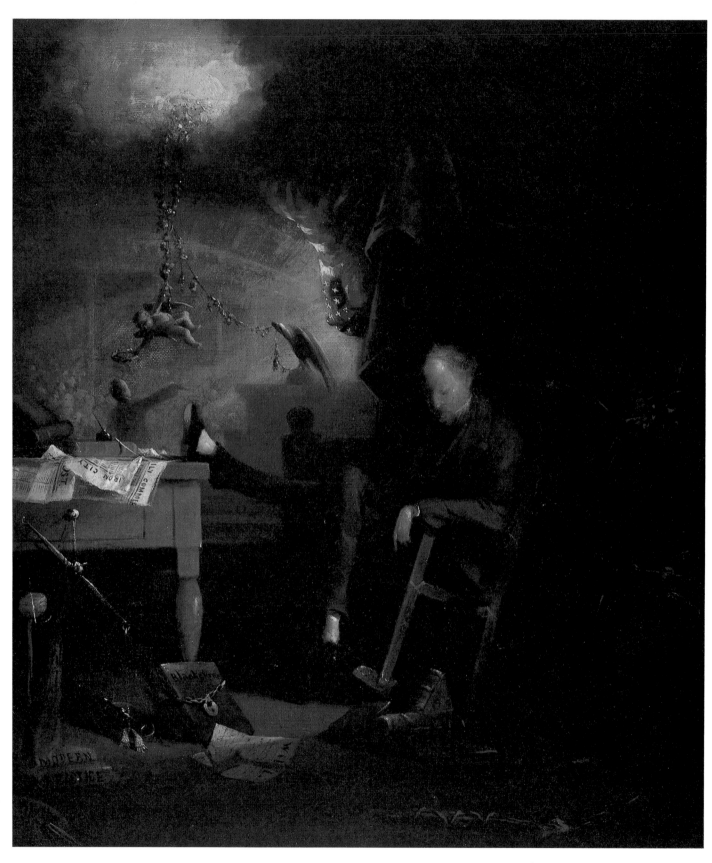

Color Plate 4: David Gilmour Blythe, *The Lawyer's Dream*, 1859

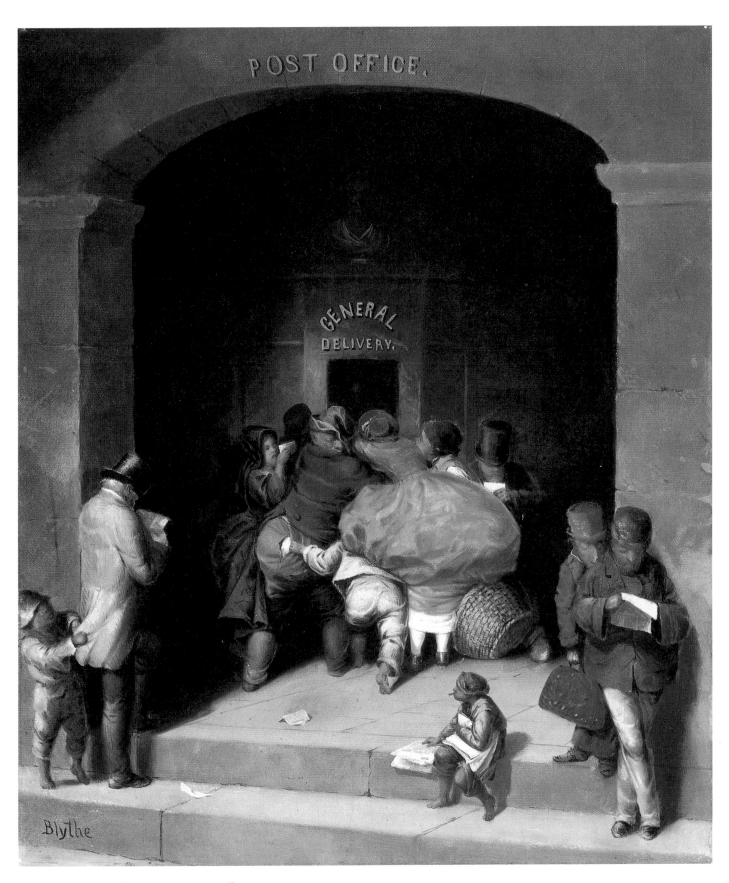

Color Plate 5: David Gilmour Blythe, *Post Office*, c. 1859–63

Color Plate 6: Fitz Hugh Lane, *View of Gloucester from Brookbank, The Sawyer Homestead*, c. 1856

Color Plate 7: John Frederick Kensett, *Long Neck Point from Contentment Island*, c. 1870–72

Color Plate 8: Martin Johnson Heade, *Thunderstorm at the Shore*, c. 1870–71

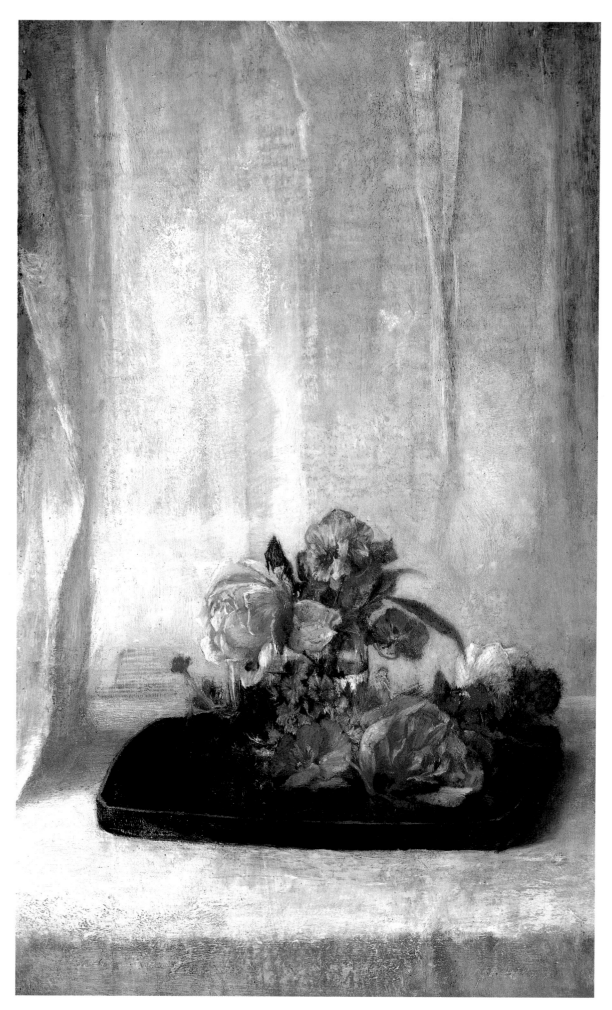

Color Plate 9: John La Farge, *Roses on a Tray*, c. 1861

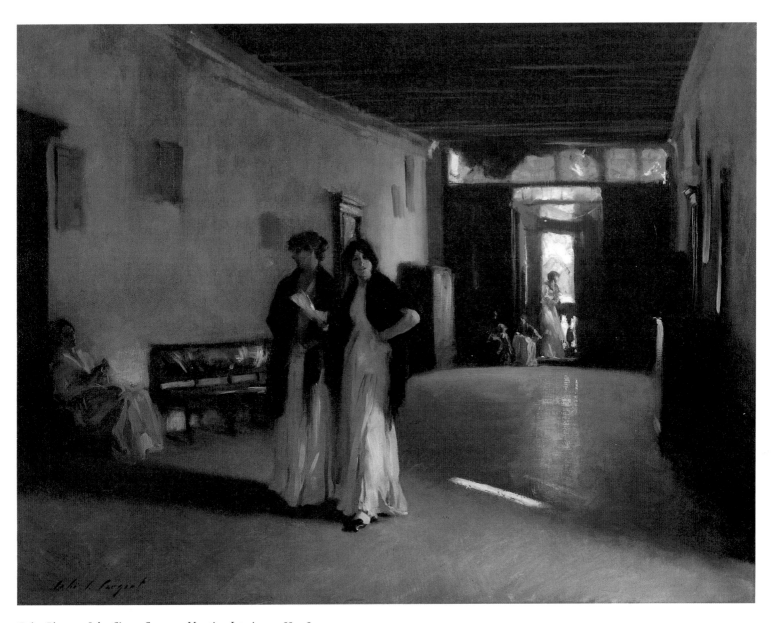

Color Plate 10: John Singer Sargent, *Venetian Interior*, c. 1880–82

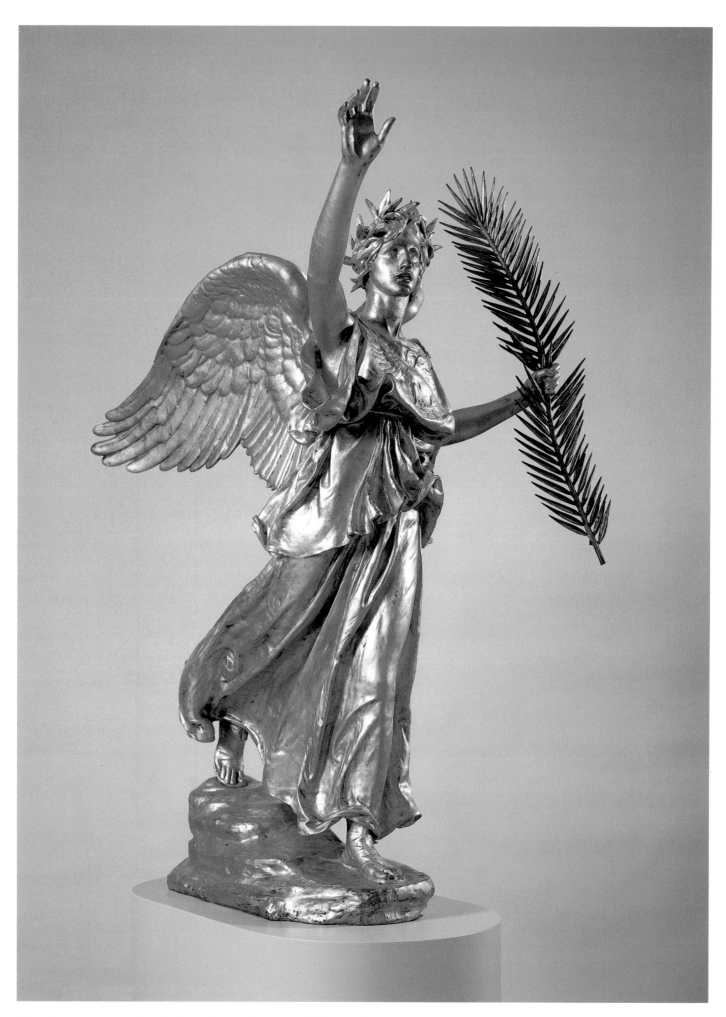

Color Plate II: Augustus Saint-Gaudens, *Victory*, 1892–1903, probably cast after 1912

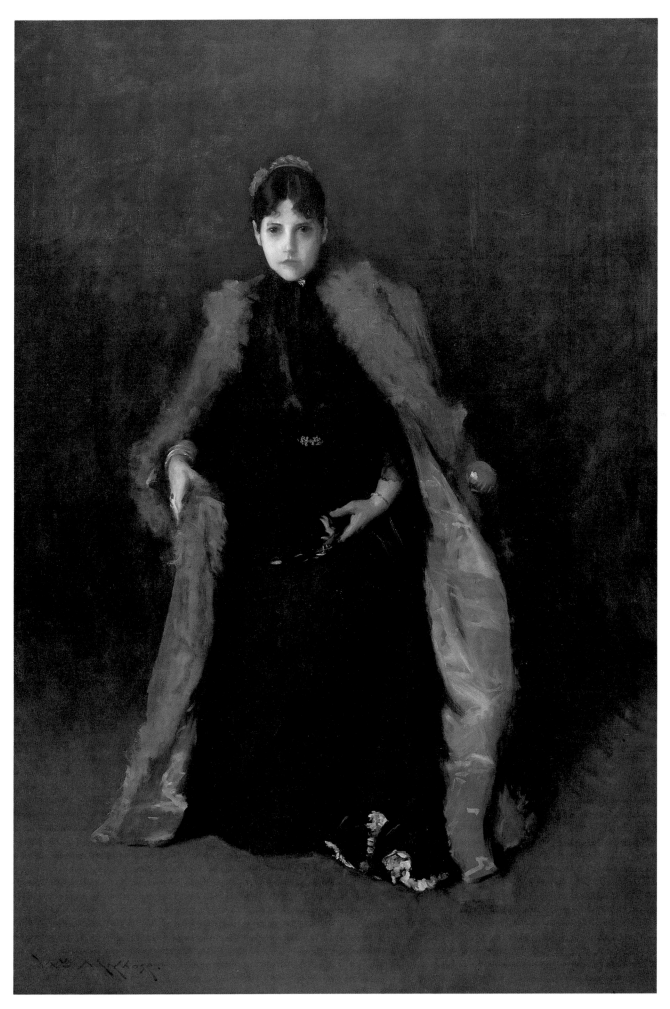

Color Plate 12: William Merritt Chase, *Mrs. Chase*, c. 1890–95

Color Plate 13: William M. Harnett, *Trophy of the Hunt*, 1885

Color Plate 14: Albert F. King, *Late Night Snack*, c. 1900

Color Plate 15: George Inness, *The Clouded Sun*, 1891

14

Color Plate 16: Winslow Homer, *The Wreck*, 1896

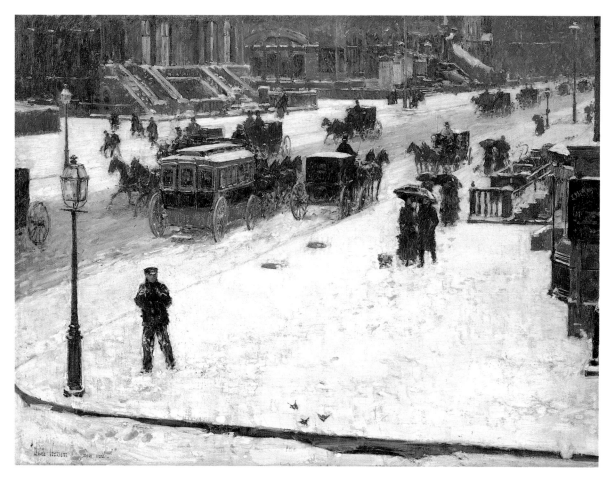

Color Plate 17: Childe Hassam, *Fifth Avenue in Winter*, c. 1892

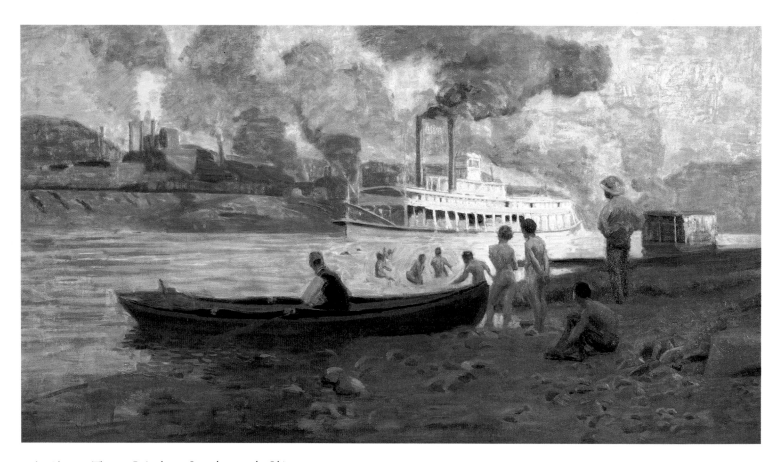

Color Plate 18: Thomas P. Anshutz, *Steamboat on the Ohio*, c. 1896

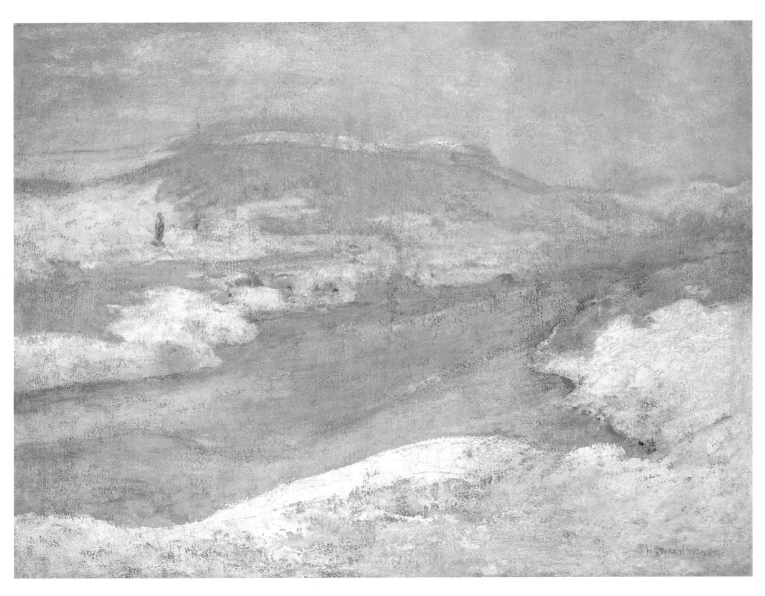

Color Plate 19: John Twachtman, *River in Winter*, c. 1890–1900

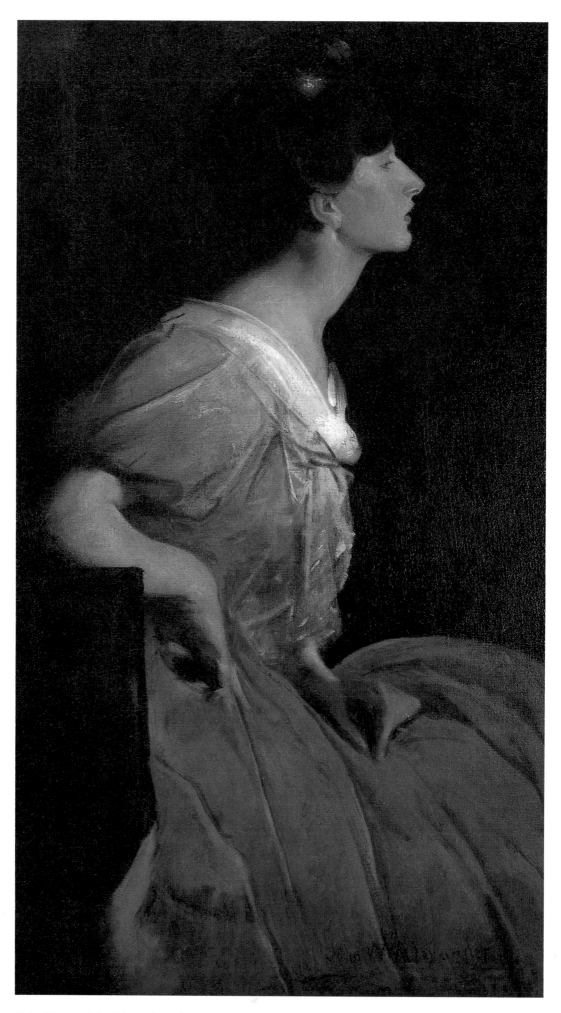

Color Plate 20: John White Alexander, *A Woman in Rose*, c. 1901

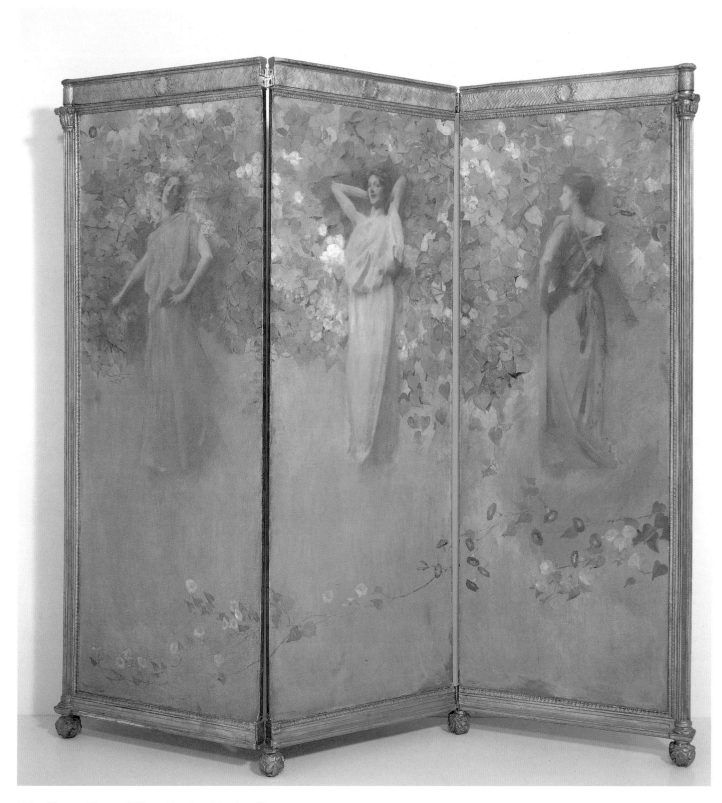

Color Plate 21: Thomas Wilmer Dewing, *Morning Glories*, 1900

Color Plate 22: Stanton Macdonald-Wright, *Sunrise Synchromy in Violet*, 1918

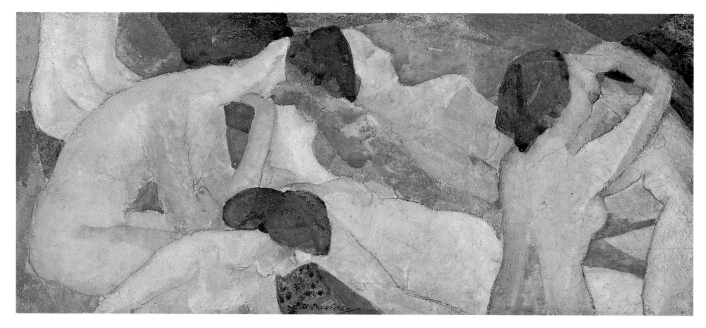

Color Plate 23: Arthur B. Davies, *Nudes*, c. 1916–17

Color Plate 24: Arthur G. Dove, *Tree Forms*, c. 1928

Color Plate 25: John Storrs, *Panel with Mirror Insets*, c. 1920

Color Plate 26: Patrick Henry Bruce, *Abstract*, c. 1928

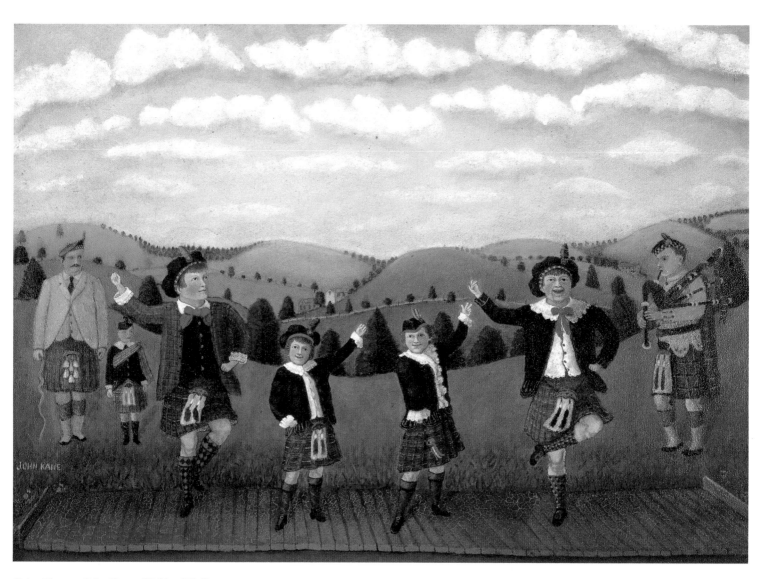

Color Plate 27: John Kane, *Highland Hollow*, c. 1930–35

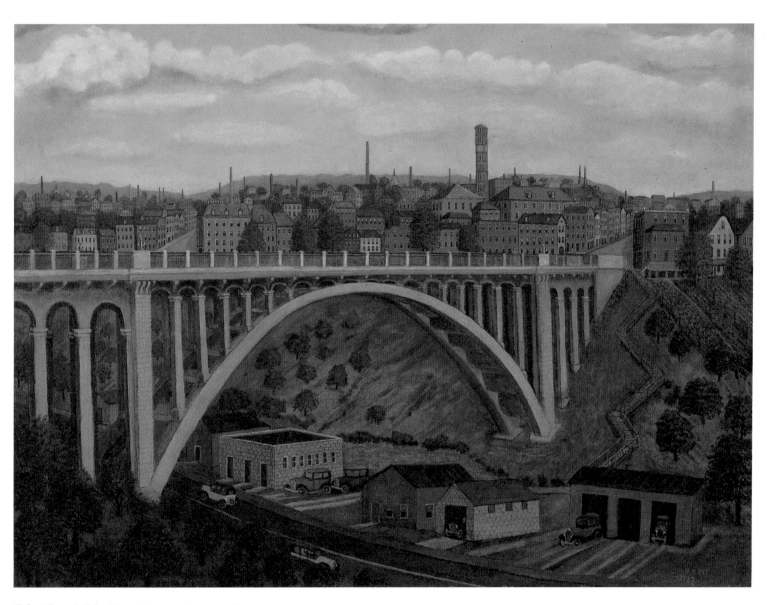

Color Plate 28: John Kane, *Larimer Avenue Bridge*, 1932

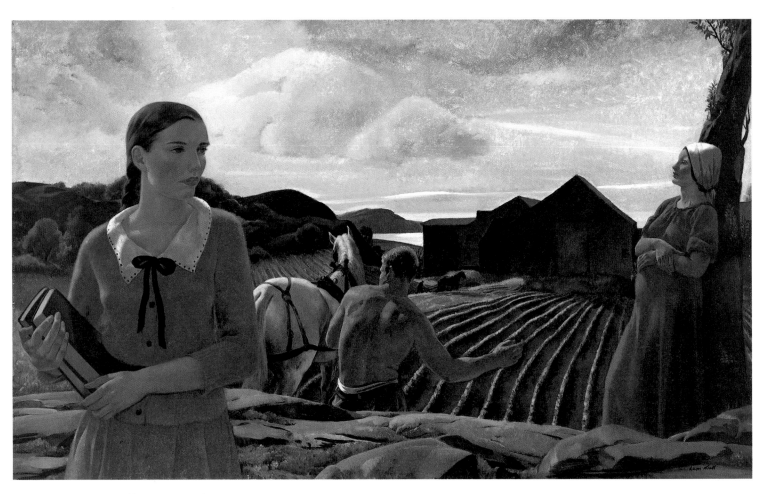

Color Plate 29: Leon Kroll, *Morning on the Cape*, 1935

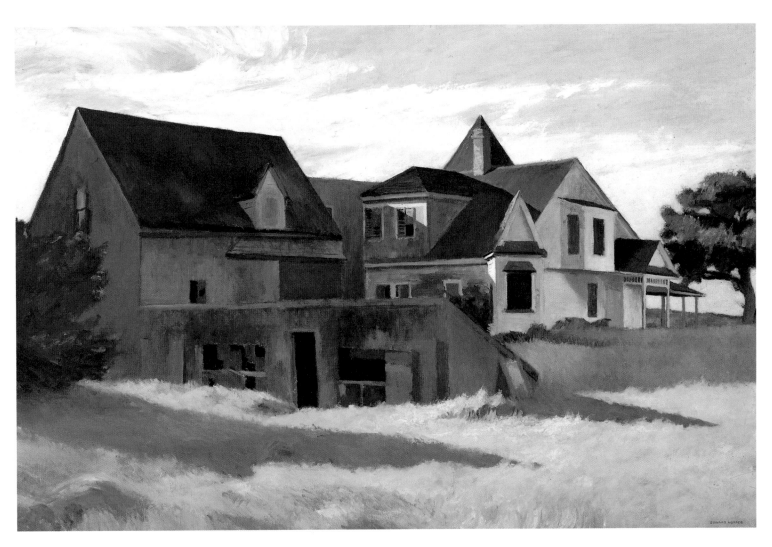

Color Plate 30: Edward Hopper, *Cape Cod Afternoon*, 1936

Color Plate 31: Charles Biederman, *No. 11, New York, 1939–40*, 1939–40

Color Plate 32: Burgoyne Diller, *Untitled No. 21 (Second Theme)*, c. 1943–45

Color Plate 33: George L. K. Morris, *Stockbridge Church*, 1935

Color Plate 34: Marsden Hartley, *Sustained Comedy*, 1939

Color Plate 35: John Graham, *Woman in Black (Donna Venusta)*, 1943, reworked 1956

Color Plate 36: Clarence Carter, *War Bride*, 1940

American
Paintings
and
Sculpture
to 1945

IN THE
CARNEGIE MUSEUM
OF ART

Notes to the Reader

The works in this catalogue were acquired from 1896 to 1989 for what Carnegie Institute initially called its Permanent Collection Gallery. In addition, we include two works that are part of the institute's 1907 building: John White Alexander's mural cycle *The Crowning of Labor* and Paul Manship's memorial tablet to John Beatty, first director of the institute's Department of Fine Arts. We also include the portraits of officers of Carnegie Institute and its Department of Fine Arts commissioned by 1945.

Entries are arranged alphabetically by artist; they are chronological within groups of works by a given artist, and works of the same date are arranged alphabetically. Preceding each group of entries is a biography of the artist, followed by a brief bibliography.

Each work is illustrated in black and white in the body of the entry. A selection also appears in color at the front of this book. The reader will find the arrangement of the color plates to be roughly chronological.

The entries themselves include the following information:

Artist's name and dates

The name by which the artist was usually known is used here; the artist's full name appears in the first paragraph of the biography. The places of the artist's birth and death are incorporated into the body of the entry.

Title of work

The work bears its original title whenever it can be determined. Other titles by which the work has been known are listed in parentheses.

Date of work

Medium and support

Here, painting mediums include not only oil and tempera but also such materials as pastel and pencil when applied to traditional painting supports such as canvas and panel. Specific fibers and woods are occasionally identified. Descriptions of the supports exclude backings and linings added by restorers.

Dimensions

Dimensions are given in inches and centimeters, height preceding width, which precedes depth. Sculpture is measured at its widest point, paintings from the lower left corner of the stretcher or panel. Stretchers and panels are rectangular unless stated otherwise. The framed dimensions of a painting are listed when the artist created the frame. Likewise, when the base of a sculpture is integral to its design, the dimensions of the base are included in those of the work.

Signature and inscriptions or markings

Roman type indicates information that is printed, whether mechanically or by hand. Italics indicate cursive script. The heading "markings" makes note of all signatures, inscriptions, and notations on a sculpture.

Remarks

When the condition of a work has markedly affected its appearance, an explanation has been supplied here.

References

This section is selective. For considerations of space, we have chosen to list published references and, with a few exceptions, have excluded those in which the work is simply illustrated or its title merely listed. Publications that appear in the artist's bibliography appear in abbreviated form here. Exhibition catalogues are included here only when the work was not also part of the exhibition.

Exhibitions

This section is also selective. We have listed all verifiable formal exhibitions of each work, but exclude the display of works in settings that would not be considered conventional art exhibitions. For example, loans of individual works to offices and government residences have been omitted. We have noted an exhibition's dates, whether it traveled, and the work's catalogue or checklist number. If the exhibition had no catalogue, the notation "no cat." appears.

Provenance

Each work's provenance lists its owners chronologically, with the years of acquisition when known. For works commissioned by Carnegie Institute, we have also included the date of the commission.

Donor or fund, date, and accession number

To differentiate donors who financed the purchase of a specific work from those who had owned the work they gave, we use the designation, "Museum Purchase: gift of —." The year of acquisition and the work's accession number follow. In the case of a few commissions, the accession number was assigned prior to the work's completion.

Names of institutions

Many institutions mentioned in this catalogue have changed their names over the years. In the entries we have referred to museums, universities, and periodicals by their names during the time under discussion. We have made an exception to this rule in the provenances where, for the convenience of the researcher, we refer to art dealers by the firms' most recent names.

The Carnegie Museum of Art has changed its name twice. It was established in 1896 as the Department of Fine Arts of Carnegie Institute. In 1965 it became the Museum of Art, Carnegie Institute, then in 1986 The Carnegie Museum of Art. The annual exhibitions of contemporary art begun in 1896 (and from which numerous works in the permanent collection were purchased) underwent frequent changes in title and format. They were interrupted during World War I, were suspended again in 1940, and from 1941 to 1949 were confined to American art. In the exhibition sections we cite these shows by their actual titles, but elsewhere we refer to them generically as the Carnegie International, the exhibition's present name.

Previous Carnegie Institute Collection Checklists

The intention of this publication is to provide, for the first time, a comprehensive and fully annotated catalogue of this museum's American paintings and sculpture to 1945. However, its American paintings and sculpture appear in five previously published

checklists of the museum's collections. Since we have not, for reasons of space, referred to these checklists in the entries, we list them here:

Carnegie Institute, *The Carnegie Institute Catalogue of Paintings, Sculpture, and Other Objects in the Department of Fine Arts* (Pittsburgh, 1903)

Carnegie Institute, *Lists of Paintings, Drawings, and Japanese Prints in the Permanent Collections of the Department of Fine Arts: A Preliminary Publication, Subject to Revision* (Pittsburgh, 1912)

Carnegie Institute, *Lists of Paintings, Drawings, and Japanese Prints in the Permanent Collection of the Department of Fine Arts* (Pittsburgh, 1917)

Department of Fine Arts, Carnegie Institute, *Permanent Collection of Paintings Checklist* (Pittsburgh, 1936)

Museum of Art, Carnegie Institute, *Catalogue of the Paintings Collection* (Pittsburgh, 1973)

Contributing authors

GILLIAN BELNAP	GB	MARY MCKENNA	MM
MARIANNE BERARDI	MB	LAURA MEIXNER	LM
REBECCA BUTTERFIELD	RB	ELIZABETH MORGAN	EM
NANCY BROWN COLVIN	NBC	JULIA R. MYERS	JRM
LAURETTA DIMMICK	LD	KENNETH NEAL	KN
LYNN BOYER FERRILLO	LBF	KATHLEEN PYNE	KP
WENDY GREENHOUSE	WG	GAIL STAVITSKY	GS
LISA ANN HUBENY	LAH	DIANA STRAZDES	DS
WILLIAM D. JUDSON	WDJ	SUZANNE TISE	ST
JOHN R. LANE	JRL	RINA C. YOUNGNER	RCY
JANET MARSTINE	JM		

Authors' initials appear following the discussion of each work. The artist biographies preceding the entries were prepared by the author or authors of the entries, except for the following: Rebecca Butterfield wrote the biographies for Albert Bierstadt, Morris Graves, Robert Gwathmey, and George Inness. Lisa Ann Hubeny wrote those for Charles Biederman, Ilya Bolotowsky, Burgoyne Diller, and J. Alden Weir. Kenneth Neal wrote those for Thomas Hart Benton and Alburtis del Orient Browere. Diana Strazdes wrote those for John White Alexander, George Grey Barnard, George Bellows, Arthur G. Dove, Marsden Hartley, Edward Hopper, Elie Nadelman, Robert Loftin Newman, Augustus Saint-Gaudens, and Elihu Vedder. Suzanne Tise wrote the biography for Mary Cassatt.

Edwin Austin Abbey
1852–1911

EDWIN AUSTIN ABBEY, whose popularity spanned both sides of the Atlantic, was one of the most prominent commercial illustrators of the late nineteenth century and an enormously successful painter of literary narrative. He was born in 1852 in Philadelphia, where he began to study art, in a modest way, with the portrait and landscape painter Isaac L. Williams. By 1868 he was working as an apprentice draftsman in the publishing house of Van Ingen and Snyder and attending night classes at the Pennsylvania Academy of the Fine Arts. There Abbey developed his abiding enthusiasm for the work of the English Pre-Raphaelites. Three years later he joined the staff of Harper and Brothers in New York, beginning a long relationship with that publishing firm. In 1878 his employers sent him to England to illustrate the poems of Robert Herrick, a project that helped establish the elegant, sketchlike style of illustration for which he became famous. England became the artist's permanent home, although he often returned to the United States during the 1880s and 1890s.

Abbey turned to oil painting in 1889 and in the following year sent his first major work in this medium, *May Day Morning* (Yale University Art Gallery, New Haven), to the Royal Academy of Arts in London for exhibition. He specialized in costume pieces encompassing the various period revivals then in fashion: medieval, Shakespearean, seventeenth-century, and rococo, each depicted with archaeological accuracy. "I feel it is my duty as well as my pleasure," he wrote in 1902, "to be guilty of as few historical inaccuracies as this antiquarian age permits."[1] His vast studio at Morgan Hall, Fairford, Gloucestershire, which Henry James called "the most romantic place in this prosaic age,"[2] contained hundreds of costumes, artifacts, and architectural casts and models, as well as a complete reference library. Abbey's painstakingly researched re-creations of the past advanced his reputation in the British artistic establishment. He was elected an associate of the Royal Academy in 1896 and an academician two years later. In 1902 he became the official court painter for the coronation of King Edward VII.

Despite his successes and continued residency abroad, Abbey retained his American citizenship and received numerous commissions from his native country. Between 1890 and 1901 he painted murals of the *Quest of the Holy Grail* for the Boston Public Library, and in 1902 he undertook a series of murals for the Pennsylvania State Capitol at Harrisburg. After Abbey's death in London, these were completed by his close friend John Singer Sargent. Abbey exhibited at Carnegie Institute's annual exhibitions of 1897, 1901, and 1907, and he served on the institute's London Foreign Advisory Committee from 1897 until his death in 1911.

1 Lucas, *Edwin Austin Abbey*, vol. 2, p. 381.
2 Ibid., p. 360.

Bibliography Edward Verrall Lucas, *Edwin Austin Abbey, Royal Academician: The Record of His Life and Work*, 2 vols. (London, 1921); Yale University Art Gallery, New Haven, *Edwin Austin Abbey, 1852–1911* (1973), exh. cat. by Kathleen A. Foster and Michael Quick.

The Penance of Eleanor, Duchess of Gloucester, 1900

Oil on canvas
49 x 85 in. (124.5 x 215.9 cm)
Signature, date: E. A. Abbey 1900 (lower left)

The subject of this large narrative painting comes from Shakespeare's *Henry VI, Part II*, act 2, scene 4. Eleanor, having vainly urged her husband, the Lord Protector, to usurp the throne, has committed the treasonable offense of consulting sorcerers about the length of the

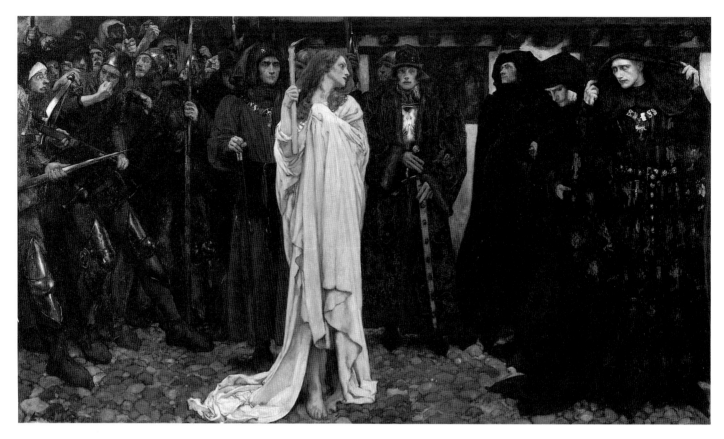

king's life. For this crime she has been condemned to do three days' public penance by walking barefoot through the streets of London. In the painting, Eleanor stands in the center of the picture clad only in a white sheet, flanked by the sheriff of London on the left and Sir John Stanley on the right. Officers restrain the menacing crowd. Eleanor turns her head to her husband, Humphrey, Duke of Gloucester, who stands beside members of his entourage dressed in mourning cloaks, and tells him that he, too, is the object of the people's fury:

> Come you, my lord, to see my open shame?
> Now thou dost penance too. Look how they gaze!
> See how the giddy multitude do point,
> And nod their heads, and throw their eyes on thee!
> Ah! Gloucester, hide thee from their hateful looks,
> And, in thy closet pent up, rue my shame,
> And ban thine enemies, both mine and thine.

Abbey's interpretation of the Shakespearean environment as something tense and hallucinatory had appeared in

earlier canvases, such as *The Play Scene in Hamlet* of 1897 and *Richard, Duke of Gloucester and the Lady Anne* of 1896 (both Yale University Art Gallery, New Haven). He captured that same eerie tenor in the pen illustrations of Shakespeare's plays, which were published in *Harper's Monthly* between 1902 and 1905. The painting's shallow, crowded frieze of monumental figures is typical of Abbey's work of the late 1890s, and it reflects both medieval and English Pre-Raphaelite prototypes. Large areas of black, white, and red dominate the canvas in accordance with the artist's belief that these were the basic colors used by all great painters. Abbey's preference for this palette was surely also due to the boldness and coherence it gave to his paintings, which might otherwise have suffered by their profusion of detail.

According to E. V. Lucas,[1] Abbey began work on *The Penance of Eleanor* in March 1899. On February 17, 1900, he wrote to his brother William that he intended to send it to that year's Paris Exposition Universelle, but instead he sent it to the Royal Academy of Arts, London, together with *The Trial of Queen Catherine* and *A*

Lute Player. After seeing it at the 1901 Pan-American Exposition in Buffalo, where it won a gold medal, John Beatty, Carnegie Institute's director of the Department of Fine Arts, invited Abbey to show *The Penance of Eleanor* in the Carnegie annual exhibition. It received the chronological medal representing the year 1900 and was thereupon purchased for the institute's permanent collection.
KN, DS

1 Lucas, *Edwin Austin Abbey*, vol. 2, p. 344.

References F. Rinder, "The Royal Academy of 1900," *Art Journal* (June 1900), pp. 179–80; C. H. Caffin, "Brief Appreciation of Some American Painters, VI: E. A. Abbey," *New York Sun*, Nov. 24, 1901; C. H. Caffin, *American Masters of Painting* (New York, 1902), pp. 91, 94; H. Saint-Gaudens, "Edwin Austin Abbey," *World's Work* 16 (May 1908), p. 10, 203; M. C. Salaman, "Shakespeare in Pictorial Art," *Studio* supplement (1916), p. 46; Lucas, *Edwin Austin Abbey*, vol. 2, pp. 344, 346, 349, 351–52; H. Saint-Gaudens, "The Carnegie Institute," *Art and Archaeology* 14 (Nov.–Dec. 1922), p. 292; J. Walker McSpadden, *Famous Painters*

of America (New York, 1926), p. 324; R. Cortissoz, "The Art of Edwin Austin Abbey," *Scribner's Magazine* 85 (Feb. 1929), p. 238; L. W. Sipley and M. L. Brady, eds., *Paintings by Later American Artists: Masterpieces in Pennsylvania Galleries* (Philadelphia, 1939), p. 28; Yale University Art Gallery, *Edwin Austin Abbey*, p. 10.

Exhibitions Royal Academy of Arts, London, 1900, *One Hundred Thirty-second Exhibition of the Royal Academy of Arts*, no. 147; Albright Art Gallery, Buffalo, 1901, *Pan-American Exposition*, no. 54; Department of Fine Arts, Carnegie Institute, Pittsburgh, 1901, *Sixth Annual International Exhibition*, no. 1; Pennsylvania Academy of the Fine Arts, Philadelphia, 1902, *Seventy-first Annual Exhibition*, no. 25; San Francisco, 1915, *Panama-Pacific International Exposition*, no. 2, 653; Dallas Museum of Fine Arts, 1922, *Third Annual Exposition: American Art from the Days of the Colonists to Now*, no. 77; Corcoran Gallery of Art, Washington, D.C., 1925, *Commemorative Exhibition by Members of the National Academy of Design, 1825–1925*, no. 5; California Palace of the Legion of Honor, San Francisco, 1926, *First Exhibition of Selected Paintings of American Artists*, no. 1; Newark Museum, N.J., 1930, *American Painting from 1700 to 1900*, no cat.; Baltimore Museum of Art, 1934, *A Survey of American Painting*, no. 7; Virginia Museum of Fine Arts, Richmond, 1936, *The Main Currents in the Development of American Painting*, no. 79; Dayton Art Institute, Ohio, 1976, *American Expatriate Painters of the Late Nineteenth Century*, exh. cat. by M. Quick, no. 2; National Portrait Gallery, Washington, D.C., 1979, *Return to Albion*, no cat.; Montgomery Museum of Fine Arts, Ala., 1986, *A Brush with Shakespeare: The Bard in Painting, 1700–1910*, no. 2.

Provenance The artist, until 1902.

Purchase, 1902, 02.1

Ivan Albright
1897–1983

IVAN LE LORRAINE ALBRIGHT was born in North Harvey, Illinois, on the southeastern border of Chicago. He was the son of Adam Emory Albright, a painter who had studied under Thomas Eakins and had exhibited a number of times in the Carnegie International. The elder Albright began to tutor Ivan and his twin brother, Malvin (who later became a sculptor under the name Zsissly), in art at an early age, following the disciplined program of drawing he had learned at the Pennsylvania Academy of the Fine Arts in Philadelphia. In their childhood the twins posed for their father's sentimental paintings of young boys fishing.

Albright attended Northwestern University in Evanston, Illinois, from 1915 to 1916 and the University of Illinois at Urbana the following year. In World War I he became a medical illustrator at an army base hospital near Nantes, France, where he attended the Ecole des Beaux-Arts for a short time. In 1919 Albright was made chief draftsman for the American Expeditionary Force Medical Corps in France. In this capacity he made watercolor illustrations of surgical and war wounds. Although critics have often speculated that this experience influenced the painter's later interest and skill in depicting minute anatomical details and morbid subjects, Albright denied its effect on his later painting.[1]

After the war Albright tried his hand briefly at architecture and advertising but rejected both because, as he said later, "I figured I might also have to become a salesman."[2] He entered the School of the Art Institute of Chicago in 1920 and graduated in 1923 with an honorable mention in life and portrait painting. Subsequently, he spent one term each at the Pennsylvania Academy of the Fine Arts in Philadelphia and the National Academy of Design in New York. It was only in 1926, however, after winning an honorable mention in the *Annual American Exhibition* of the Art Institute of Chicago for *Paper Flowers* (1926, collection Mrs. Chris M. Varde, Illinois), that he decided to devote his life to art.

Albright's career can be said to have begun in earnest in 1927, when he established himself in Warrenville, near Chicago, and began sharing a studio in an abandoned church with his brother, Malvin, and his father. Ivan began exhibiting in the Carnegie International in 1928 and contributed a work each year (except 1931, when he was given a solo exhibition at the Art Institute of Chicago) until 1939. He participated in Carnegie Institute's 1940 *Survey of American Painting* and also in the entire *Painting in the United States* series held in the years 1943 through 1949. In 1982 the institute held a solo exhibition of his works entitled *Travels of an Artist*.

Though he was never fashionable in New York art circles, Albright began to receive much critical and popular recognition during the 1940s. In 1942 he won both the Temple Gold Medal at the Pennsylvania Academy and the medal for best picture in the *Artists for Victory* exhibition at the Metropolitan Museum of Art, New York, for *That Which I Should Have Done I Did Not Do* (1941, Art Institute of Chicago), probably his best-known work. Albert Lewin of Metro-Goldwyn-Mayer must have seen Albright's work at the *Artists for Victory* show, for he commissioned him in 1943 to paint the image of the degenerate *bon vivant* for the movie *The Picture of Dorian Gray*. The next year Albright painted a *Temptation of Saint Anthony* (1944–45, Art Institute of Chicago) for the film *Bel Ami*.

After his marriage to the newspaper heiress Josephine Medill Patterson Reeve in 1946, Albright divided his time between Chicago and his Wyoming ranch. He was awarded fourth honorable mention in the Carnegie International of 1950 for *The Purist* (1949, Solomon R. Guggenheim Museum, New York), and he again exhibited in the 1964 International. The previous year, he had moved with his family to Woodstock, Vermont. There he continued to paint, write poetry, sculpt, and produce graphic works until his death.

Although Albright's style is too individual to be neatly categorized, he is most closely associated with Magic Realism, a term coined for an exhibition at the Museum of Modern Art, New York, in 1943. Albright relied on detailed drawing, sharp contrasts of light and dark, and garish colors to create symbolic, often mournful images that have a battered, decaying quality about them. He came to favor long, ambiguous, poetic titles for the moral questions he posed through these works. Financial independence allowed him to indulge his painstaking working method—at times he took as long as ten years to produce a finished picture—resulting in a relatively small life's production.

1 Katherine Kuh, *The Artist's Voice* (New York, 1962), p. 23.

2 Ibid.

Bibliography Daniel Catton Rich, "Ivan Le Lorraine Albright: Our Own Jeremiah," *Magazine of Art* 36 (February 1943), pp. 48–51; Art Institute of Chicago and Whitney Museum of American Art, New York, *Ivan Albright: A Retrospective Exhibition* (1964), exh. cat. by Frederick Sweet and Jean Dubuffet; Jan van der Marck, "Ivan Albright: More than Meets the Eye," *Art in America* 65 (November–December 1977), pp. 93–99; Michael Croydon, *Ivan Albright* (New York, 1978).

Among Those Left, 1928–29
(The Blacksmith; The Wheel-wright)

Oil on canvas
73 x 36 in. (185.4 x 91.4 cm)
Signature: Ivan Le Lorraine Albright
(lower right)

Painted during the summers of 1928 and 1929 in the artist's Warrenville, Illinois, studio, *Among Those Left* belongs to a series of three tall, narrow, strongly symbolic portraits representing men at their vocations; the other two—both at the Art Institute of Chicago—are *The Monk* (1926–27) and *The Lineman* (1927). Albright's model for the Carnegie's painting was Hugo Kleinwachter, an immigrant blacksmith in Warrenville.[1] The title *Among Those Left* refers, perhaps, to the disappearance in America of simple craftsmen like Kleinwachter, of whom the artist wrote:

> At the time I painted him he could speak very little English which was a blessing. . . . His eyes were always sort of shedding tears and he had a very imitative habit of pawing the floor, a habit I think taken from long and close association [*sic*] with the horses he shod.[2]

In *Among Those Left,* a sense of pathos, of sympathy for the manual laborer is evoked by the blacksmith's dull eyes and rumpled clothing. The limited palette of browns and blues also lends a somber mood to the portrait. Albright's conception usually centered on the transience of matter expressed through its apparent decomposition. That quality is also present here, in the textures of the metal, the cloth, and the blacksmith's flesh.

The frontal presentation of a full-length figure set against a dim, shallow background is intentionally reminiscent of icons and gives the painting a quasi-religious quality. This symbolic aura was noted by Michael Croydon when he observed:

> All three subjects stand like Baroque saints in their niches displaying their special

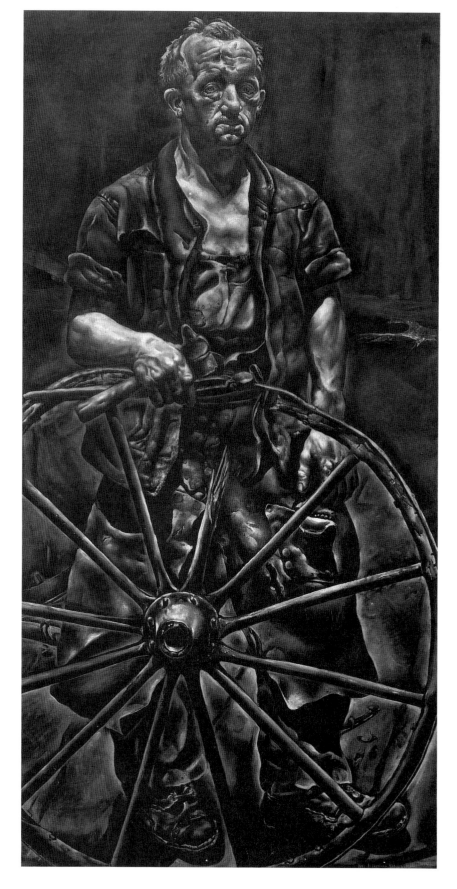

attributes and bathed by an overhead light. It is tempting to imagine them as separate panels of a dismantled altarpiece.[3]

The workman, holding a hammer and tongs and resting his hand on the iron rim of a splintered wagon wheel, faces the viewer squarely and without emotion. Vague brown shadows in the background throw his features into sharp relief, while to his left a glistening spider awaits its prey. A harsh, eerie light falls on the smith's ruddy face and torso and on the wheel, which seems to press against the confines of the picture plane.

In order to light his model properly, Albright cut a small skylight in the roof of an old barn loft and then closed off all other openings.[4] Thus he obtained a strong, concentrated beam of light on Kleinwachter. By underpainting with black, adding blue to the flesh tones, and then highlighting the agitated contours of the objects in the picture with white, Albright created an almost ghostly image that recalls the work of El Greco.

Among Those Left is one of the first paintings to show Albright's growing interest in manipulating optical effects. In the previous year he had begun to shift constantly around his model as he painted, so that every part of the figure and the setting could be seen and depicted from a different angle. Here, the floorboards of the smithy have been tipped up toward the picture plane, flattening the figure's legs between the wagon wheel and the background. The resulting irrational spatial relationships intensify the dizzying hyperrealism of the blacksmith's clothing and physiognomy.

In paintings such as *Among Those Left*, the disturbing aspect with which Albright has invested the commonplace shocks us into reevaluating ourselves and our surroundings, as the artist intended. "I'm not," he once said, "trying to make a pleasant aesthetic experience; I want to jar the observer into thinking—to make him uncomfortable. But," he continued, "I'm not telling him what to think."[5] In this enigmatic sense, *Among Those Left* stands as an early example of Albright's mature style.

Among Those Left also illustrates the rocky beginnings of Albright's career, for when it was submitted to the Carnegie International of 1930, it was rejected, as were thirteen of his seventeen submissions between 1927 and 1931. By 1939, however, the assistant director of the Department of Fine Arts, John O'Connor, Jr., was writing, "You are always such a favorite here that even at this early date I want to make sure of the fact that we can count on a painting from you in our next International Exhibition."[6] The artist responded by sending *Among Those Left*. Because of his long and cordial relationship with Carnegie Institute and, as his dealer wrote, "because he [Albright] is impressed with the fine job of representing contemporary art which he feels you have done,"[7] Albright presented the work to the Department of Fine Arts in 1949. He asked that his gift remain anonymous.[8]

MM, RB

1 N. Carrigan to H. Teilman, note, 1978, museum files, The Carnegie Museum of Art, Pittsburgh. Albright apparently misspelled Kleinwachter's name in a letter to O'Connor, December 26, 1949, museum files; the error has not heretofore been corrected in the Albright literature.

2 Ivan Albright to John O'Connor, Jr., December 26, 1949, museum files, The Carnegie Museum of Art, Pittsburgh.

3 Croydon, *Ivan Albright*, p. 39.

4 Ibid.

5 Katherine Kuh, *The Artist's Voice* (New York, 1962), pp. 24–25.

6 John O'Connor, Jr. to Ivan Albright, February 10, 1939, Carnegie Institute Papers, Archives of American Art, Washington, D.C.

7 Earle Ludgin to John O'Connor, Jr., November 28, 1949, museum files, The Carnegie Museum of Art, Pittsburgh.

8 Ivan Albright to John O'Connor, Jr., December 26, 1949, museum files, The Carnegie Museum of Art, Pittsburgh.

References O. F. Sweet, "Village Smith Put on Canvas in New Manner," *Chicago Daily Tribune*, sec. 7, June 5, 1932, p. 3; J. W. Lane, "The U.S.A. Wins the Carnegie Stakes," *Art News* 38 (Oct. 1939), p. 8; Rich, "Ivan Le Lorraine Albright: Our Own Jeremiah," pp. 49–50; "Institute Shows New Painting: Portrait of Smithy Is Anonymous Gift," *Pittsburgh Press*, June 1, 1950, p. 27; J. O'Connor, Jr., "*Among Those Left* by Ivan Le Lorraine Albright," *Carnegie Magazine* 24 (June 1950), pp. 384–85; D. Bridaham, "The Paintings of Ivan Albright," *Chicago* 1 (Apr. 1954), p. 23; P. A. Chew, "The Founder's Day Exhibition of 1961," *Bulletin of the Westmoreland County Museum of Art* 3 (Fall 1961), pp. 8–9; Croydon, *Ivan Albright*, pp. 39–40; H. Adams, in Museum of Art, Carnegie Institute, *Collection Handbook* (Pittsburgh, 1985), pp. 250–51.

Exhibitions Art Institute of Chicago, 1928, *Forty-first Annual Exhibition of American Paintings and Sculpture*, no. 3, as *The Blacksmith;* Corcoran Gallery of Art, Washington, D.C., 1930–31, *Twelfth Exhibition of Contemporary American Oil Paintings*, no. 43, as *The Wheel-wright;* Buffalo Fine Arts Academy, Albright Art Gallery, Buffalo, 1931, *Twenty-fifth Annual Exhibition of Selected Paintings by American Artists*, no. 3, as *The Wheel-wright;* Pennsylvania Academy of the Fine Arts, Philadelphia, 1932, *One Hundred Twenty-seventh Annual Exhibition*, no. 178, as *The Wheel-wright;* Old White Art Gallery, White Sulphur Springs, W.Va., 1935, *Ivan Le Lorraine Albright*, no. 13, as *The Blacksmith;* Department of Fine Arts, Carnegie Institute, Pittsburgh, 1939, *The 1939 International Exhibition of Paintings*, no. 35; National Academy of Design, New York, 1942, *One Hundred Sixteenth Annual Exhibition of Contemporary American Painting and Sculpture*, no. 231; Museum of Modern Art, New York, 1943, *American Realists and Magic Realists*, no. 25; Columbus Museum of Art, Ohio, 1952, *Paintings from the Pittsburgh Collection*, no cat.; Westmoreland County Museum of Art, Greensburg, Pa., 1961, *Founder's Day Exhibition*, unnumbered; Art Institute of Chicago and Whitney Museum of American Art, New York, 1964–65, *Ivan Albright: A Retrospective Exhibition*, no. 5; Fine Arts Gallery of San Diego, 1968, *Twentieth Century American Art*, no. 1; University Museum and Art Galleries, Southern Illinois University, Carbondale, 1976, *Iron Solid Wrought/USA*, no. 81; Saint Louis Art Museum, 1977, *Currents of Expansion: Painting in the Midwest, 1820–1940*, no. 96; Städtische Kunsthalle, Düsseldorf, 1979, *2 Jahrzehnte amerikanische Malerei, 1920–1940* (trav. exh.), unnumbered.

Provenance The artist, until 1949.

Gift of the artist, 1949, 49.24

John White Alexander
1856–1915

AT THE TURN OF the century, John White Alexander was considered to be one of America's great expatriate painters, his artistic accomplishment being comparable to that of James McNeill Whistler, Edwin Austin Abbey, and John Singer Sargent. Born in Allegheny City (now Pittsburgh's North

Side) in 1856, he taught himself to draw by copying illustrations from *Harper's Weekly*. In 1874, determined to become an illustrator for *Harper's*, he went to New York and took a job as an office boy with the firm. He soon obtained a position in the illustration department, working with such talents as Abbey, Thomas Nast, Charles Stanley Reinhart, and Arthur B. Frost.

In 1877 Alexander traveled to Europe to further his training. After spending a few months at Munich's art academy, he joined J. Frank Currier and the other "Duveneck Boys"—a group of American students working under the leadership of Frank Duveneck—at Polling, Bavaria. Having assimilated Duveneck's dark, painterly, Dutch-inspired brand of realism, Alexander in 1879 accompanied him to Florence and Venice, and while in Venice met Whistler.

Following his return to the United States in 1881, Alexander set up a studio in New York and began to establish himself as a portrait painter. He also resumed his career as an illustrator, working on assignment for *Harper's Weekly* and *Century Magazine*. In 1890, in order to speed his recovery from a severe attack of influenza, he moved with his wife and child to Paris. There he exhibited with great success at the progressive Société Nationale des Beaux-Arts and became a leading member of that organization. He formed friendships with many of the artistic and literary celebrities who came to or lived in the city—such as Whistler, Auguste Rodin, Octave Mirbeau, Stéphane Mallarmé, Henry James, and Oscar Wilde.

Alexander established his reputation and his mature style in Paris, in the spring of 1893, when three paintings exhibited at the Salon du Champ de Mars created an immediate sensation. He became known for his evocative style of nonportrait figure painting, which emphasized sweeping lines, decorative color harmonies, and almost abstract rhythms. These works acknowledged a stylistic debt to Symbolism and Art Nouveau, yet they never became completely alienated from the formal conventions of the artistic mainstream. By the mid-1890s, his figure paintings had won him substantial renown on both sides of the Atlantic.

In America, Alexander's style appealed to patrons who saw its bold design and indeterminate content as cosmopolitan and artistically advanced. In 1895 one of those patrons was the Library of Congress, Washington, D.C., which awarded him the commission to paint the *Evolution of the Book* murals for its new building. Two years later, the Pennsylvania Academy of the Fine Arts, Philadelphia, awarded him its Temple Gold Medal, the first of many such honors bestowed upon the artist.

In 1901, having been made Chevalier of the Legion of Honor by the French government, Alexander returned to New York, where he lived for the rest of his life. He became an associate of the National Academy of Design that same year and an academician in 1902. In 1909 he was elected president of that institution, a position he held until his untimely death in 1915.

Alexander was a regular exhibitor at Carnegie Institute's annual exhibitions from their beginning in 1896. He won a first-class medal in 1911, presided over the exhibition's Paris Foreign Advisory Committee from its inception in 1897 until 1903, and served on the jury of award in 1901, 1905, 1907, 1909, 1912, and 1913. He was again elected to the jury in 1914, but illness prevented him from coming to Pittsburgh. His close association with Carnegie Institute grew from his long-standing friendship with John Beatty, director of the Department of Fine Arts; they had known each other while growing up in Pittsburgh and as art students in Munich.

During Alexander's later visits to Pittsburgh he frequently stayed at the Beatty home. Beatty often sought Alexander's opinion, relied on his judgment, and asked his assistance in numerous small matters related to Carnegie Institute, such as acting as its agent at auction and giving his opinion on prospective purchases for the permanent collection.[1] Alexander gladly obliged Beatty whenever possible; in turn, Beatty obtained local portrait commissions for Alexander, and he repeatedly—though for the most part unsuccessfully—urged the Fine Arts Committee to purchase the artist's work.

In 1905 Beatty probably played a major, though undocumented, role in securing for his friend the commission to decorate the institute's new three-story entrance hall; this was Alexander's most ambitious

project and, up to that time, the largest mural commission ever given to an American artist. After Alexander's death in 1915, Beatty arranged a memorial exhibition in his honor. This exhibition, which included eighty-two paintings and was accompanied by an elaborate catalogue, opened in March 1916 and traveled to eleven institutions during the next year and a half.

1 John Beatty to John White Alexander, January 20, 1910; February 11, 1912; October 18, 1912; November 5, 1912; March 24, 1913, Carnegie Institute Papers, Archives of American Art, Washington, D.C.

Bibliography Department of Fine Arts, Carnegie Institute, Pittsburgh, *Catalogue of Paintings, John White Alexander Memorial Exhibition* (1916), exh. cat. by John W. Beatty; Joseph Walker McSpadden, "John White Alexander: The Painter of the Flowing Line," in *Famous Painters of America* (New York, 1916), pp. 355–76; *American Magazine of Art*, John White Alexander memorial number, 7 (July 1916); National Collection of Fine Arts, Washington, D.C., *John White Alexander, 1856–1915* (1976), exh. cat. by Mary Anne Goley; Graham Gallery, New York, *John White Alexander, 1856–1915: Fin-de-Siècle American* (1980), exh. cat. by Sandra Leff.

A Woman in Rose, c. 1901
(Portrait in Rose; Girl in Pink; Femme Rose)

Oil on canvas
40 x 22½ in. (101.6 x 57.2 cm)
Signature: John W. Alexander (lower right)

When Alexander was in Paris in the 1890s, he came to share many values of the vanguard art world, particularly the ideas circulating as Symbolism, on which his mature style was loosely based. Like the Symbolists, who often used woman as the subject of their poetry, he painted idealized and ethereal evocations of elegant, aristocratic, and at times almost mythic womanhood, and strove to create an indefinite mood in his figural pieces, sacrificing psychological observation to achieve that end.

A Woman in Rose exemplifies those concerns. A work done in Alexander's few, highly productive Parisian years, it followed on the completion of his ambitious

painting *Isabella and the Pot of Basil* (1897, Museum of Fine Arts, Boston). From 1898 to 1900 he painted a number of smaller variations on the general format of *Isabella* in which he suppressed narrative or thematic concerns and concentrated, with restricted color, on the subtle interplay of sinuous lines and black and white. These works are akin to James McNeill Whistler's portraits and to the idealized women shown by the painters of the English Aesthetic movement and by American artists such as Thomas Dewing, Joseph De Camp, and Edmund Tarbell.

In *A Woman in Rose*, the figure fills the canvas, occupying a shallow space before a blackened background. The subject appears in profile, her eyes averted from the spectator so that her silhouette, throat, and neck become the focus of the work. These parts of the female anatomy are emphasized in some Japanese woodblock prints which are similarly flat, geometrically abstract, and lacking in volume; Alexander, who admired Japanese prints, may have been inspired by them.[1] The gorgeous and distinct outline of this area contrasts with the cursory treatment given to the arm, hands, dress, and the chair upon which she sits.

The title of the painting reveals Alexander's intent to evoke a mood by modulating a single color, and thus relates his work to that of his friend Whistler, even though Alexander was not ready to substitute color labels completely for human presence in his titles. Like Whistler, Alexander used coarsely woven canvas which he saturated with thin paint, allowing the grid of the weave to become an integral part of the surface.

The work is somewhere between an image of a psychological state and a transformation of human form into an otherworldly harmony of abstract colors and shapes.

A Woman in Rose was, indirectly, the subject of some characteristically good-natured repartee between the artist and John Beatty, Carnegie Institute's director of the Department of Fine Arts. On July 24, 1909, Alexander wrote Beatty:

> Reading Miss Levy's address before the American Federation of Arts in Washington last May, I find that "the Art Department of the Carnegie Institute has large carbon reproductions of their best paintings in its permanent collection" and I write at once to know if mine (*A Woman in Rose*) is one of them—Bess called my attention to the "best

paintings" and says I will probably find that mine is not considered worthy. . . but if it is ever included I want a copy. . . .[2]

Beatty arranged to have a proof of *A Woman in Rose* sent, but only after he quipped:

> Of course your painting entitled "Woman in Pink" is included in the school set of photographs; it heads the list under the absurd rule which arranges these matters in alphabetical order. I am going to apply to the State Legislature to have your name changed. . . .[3]

LD, DS

1 Leff in Graham Gallery, *John White Alexander*, p. 13.

2 John White Alexander to John Beatty, July 24, 1909, Carnegie Institute Papers, Archives of American Art, Washington, D.C.

3 John Beatty to John White Alexander, July 29, 1909, Carnegie Institute Papers, Archives of American Art, Washington, D.C.

References C. H. Caffin, "John W. Alexander," *World's Work* 9 (1905), p. 5,694, as *Portrait in Rose;* Obituary, *American Art Annual*

See Color Plate 20.

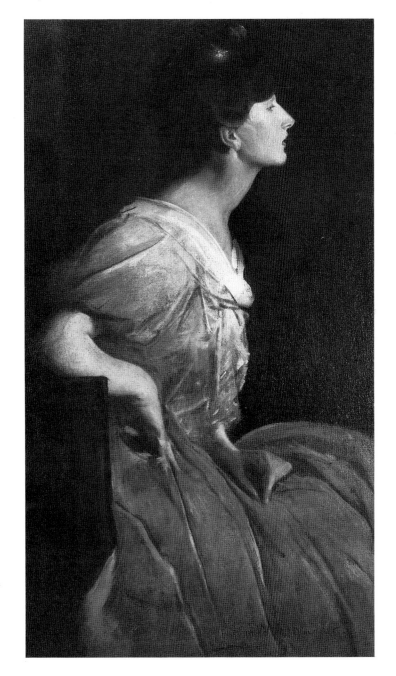

12 (1915), p. 255, as *Girl in Pink*; *The National Cyclopedia of American Photography* (1967), vol. 2, p. 297, as *Femme Rose*.

Exhibitions Department of Fine Arts, Carnegie Institute, Pittsburgh, 1916, *John White Alexander Memorial Exhibition*, no. 9; Art Gallery of Toronto, 1927, *A Loan Exhibition of Portraits*, no. 1; National Academy of Design, New York, 1939, *Special Exhibition*, no. 174; Pennsylvania State University, University Park, 1955, *Pennsylvania Painters* (trav. exh.), no. 39; Brooklyn Museum, New York, 1957, *Face of America*, no. 74; American Federation of Arts, New York, 1962–63, *American Traditional Painters, 1865–1963* (trav. exh.), no. 1; University Art Gallery, University of Pittsburgh, 1978, *Art Nouveau 1880–1920*, unnumbered; William Penn Memorial Museum, Harrisburg, Pa., 1979, *Pennsylvania Painters from Commonwealth Collections*, no. 1; Westmoreland County Museum of Art, Greensburg, Pa., 1981, *Southwestern Pennsylvania Painters, 1800–1945*, exh. cat. by P. A. Chew and J. A. Sakal, no. 2.

Provenance The artist, until 1901.

Purchase, 1901, 01.2

Aurora Leigh, c. 1904
(Other Days; A Portrait of Miss B)

Oil on canvas
76⅜ x 52⅜ in. (194 x 133 cm)
Signature: J. W. Alexander (middle left)

Aurora Leigh was the heroine of Elizabeth Barrett Browning's verse novel of the same name, published in 1856. It is a relatively late example of the literary subjects that Alexander occasionally painted, although little more than the title links *Aurora Leigh* to its literary source.

Painted by the fall of 1904, when it was exhibited in Carnegie Institute's ninth annual exhibition, *Aurora Leigh* is a relatively straightforward costumed image of a young woman (Anne Bradley, the model for a number of Alexander's paintings) perched upon a green, high-backed settee. Shades of green, blue, gray, and peach emanate from the sheen of her paneled satin dress. Her voluminous skirts fill the lower half of the canvas, spreading over the floor; a collie lies on her hem at her feet. The young woman, who is as sleek as her dog, peers out at

the spectator from beneath her wide-brimmed white hat, which is trimmed with roses and has long streamers.

Characteristically, facial features are only cursorily depicted. The painting is a study of tonal values and surface design, not of the sitter's psychology.

The title under which Alexander exhibited the work in 1904, *Aurora Leigh*, acknowledges the inspiration of Elizabeth Barrett Browning. During the artist's lifetime, however, and presumably with his knowledge, it was exhibited as *Other Days* and was on occasion illustrated as *A Portrait of Miss B.* These alternate titles suggest that the painting's link with its literary source is so loose as to be unnecessary.

LD

References Buffalo Fine Arts Academy, *Academy Notes*, American exhibition number, 9 (July 1914), p. 90, as *Other Days*; Department of Fine Arts, Carnegie Institute, *Catalogue of Paintings: John White Alexander Memorial Exhibition*, p. 59; J. O'Connor, Jr., "Aurora Leigh," *Carnegie Magazine* 14 (May 1940).

Exhibitions Department of Fine Arts, Carnegie Institute, Pittsburgh, 1904, *Ninth Annual Exhibition*, no. 8; Pennsylvania Academy of the Fine Arts, Philadelphia, 1905, *One-hundredth Anniversary Exhibition*, no. 450; Buffalo Fine Arts Academy, Albright Art Gallery, Buffalo, 1909, *Fourth Annual Exhibition of Selected Paintings by American Artists*, no. 1; Buffalo Fine Arts Academy, Albright Art Gallery, Buffalo, 1909, *Retrospective Exhibition of Paintings by John W. Alexander*, no. 8, as *Other Days*; National Arts Club, New York, 1909, *John W. Alexander Retrospective Exhibition*, no. 63, as *Other Days*; Worcester Art Museum, Mass., 1912, *Summer Exhibition*, no. 1, as *Other Days*; Buffalo Fine Arts Academy, Albright Art Gallery, Buffalo, 1914, *Ninth Annual Exhibition of Selected Paintings by American Artists*, no. 4, as *Other Days*.

Provenance The artist, until 1915; Charles V. Wheeler, 1915 (sale, American Art Association-Anderson Galleries, New York, Nov. 1, 1935, as *Aurora Leigh*); William Randolph Hearst, New York, 1935; C. Bernard Shea, Pittsburgh, 1940.

Gift of C. Bernard Shea in memory of Joseph B. Shea, 1940, 40.4

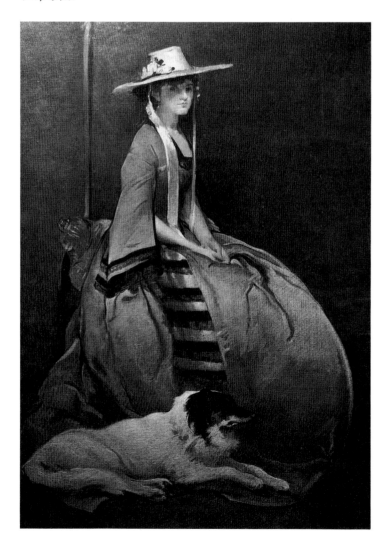

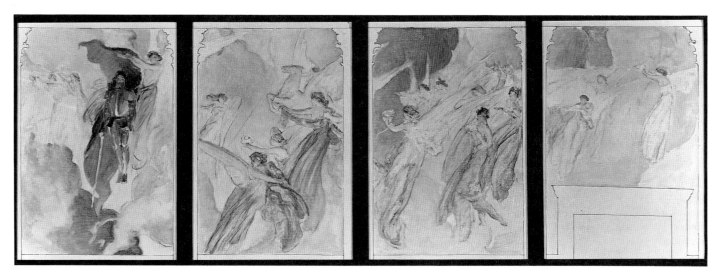

Apotheosis of Pittsburgh: Studies for Carnegie Institute Murals,
c. 1905

Oil on linen
18½ x 47 in. (47 x 119.4 cm) overall

On May 24, 1905, William N. Frew, president of the Board of Trustees of Carnegie Institute, wrote to John White Alexander:

> In the great extension of our Library Building in the large entrance hall of the Art and Science Departments, there seems to be a fine opportunity for some first class mural decoration and I write to you to know if you are willing and able to undertake it for us. I can make you no definite proposition at this time as the matter is only in my own mind. I have not consulted the members of our Building Committee, but feel quite sure they would gladly follow me in the matter.

Frew thought it "eminently fitting that on the walls of our splendid building should appear the work of a Pittsburgher who has greatly distinguished himself."[1] This oil sketch of the focal image of the mural program was Alexander's gift to Frew, a way of thanking the man who initiated his largest commission.

Alexander left only two oil sketches of the Pittsburgh project, both of its central image, the *Apotheosis of Pittsburgh*. These oil sketches are unique in Alexander's work, for he is not known ever to have relied on detailed sketches in the normal course of his painting. His habit was to work directly on the canvas, sketching in a few charcoal lines to guide him, but relying on no other compositional aids except for occasional cursory pencil sketches.[2] The Carnegie's sketch consists

of four panels; the other sketch (location unknown), which included a fifth panel, remained in the Alexander family.

The special formal requirements of *Apotheosis of Pittsburgh* may have dictated Alexander's departure from his usual working method, for this particular area of the mural program required continuous movement through several distinct panels. Here, each panel sounds a different note, as in a musical phrase that has a beginning, a climax, and a close. Alexander may have felt impelled to test that relationship by means of a small model, whereas the other parts of the mural did not make the same demand.

The movement of the sketch begins on the right with a few smaller figures in the panel above the door frame. Alexander organized the two middle panels on diagonals running from upper right to lower left; the figures in both panels mass to the right. In the fourth panel, a knight is crowned just to the right of center. The colors of the composition change from pale pinks and blues to the darker green, red, and gray-black of the fourth panel. This sketch does not include the fifth panel of the *Apotheosis*, which is filled with red smoke and agonized faces. There is nothing tentative about the movement in the four panels of the Carnegie oil sketch; it possesses spontaneity and is true to Alexander's easel painting technique of the period.

Elizabeth Alexander remembered that her husband gave this oil sketch—she mistakenly called it a watercolor—to Mr. Frew.[3] The frame of finely crafted walnut suggests the architectural setting of the murals without duplicating the actual color scheme (yellow and pink Hauteville marble pilasters). Alexander was too concerned with color relationships to have been responsible for the frame. Frew

probably ordered it, a mark of the value the sketch had for him as the initiator of the commission.

RCY

1 Carnegie Institute Papers, Archives of American Art, Washington, D.C.

2 See, for example, William Walton, "Alexander's Decorations: *The Crowning of Labor* in the Carnegie Institute, Pittsburgh," *Scribner's Magazine* 45 (January 1909), p. 56.

3 Elizabeth Alexander, "'The Crowning of Labor,' the John W. Alexander Mural Paintings in the Carnegie Institute, Pittsburgh," *Mentor* (May 1925), p. 28.

References C. H. Caffin, "The New Mural Decorations of John W. Alexander," *Harper's Monthly* 114 (May 1907), pp. 845–56; W. L. Harris, "John White Alexander: His Influence on American Art and Industry," *Good Furniture* 5 (Aug. 1915), p. 66; D. C. Johnson, *American Art Nouveau* (New York, 1979), p. 248; H. Adam in Museum of Art, Carnegie Institute, *Collection Handbook* (Pittsburgh, 1985), p. 226.

Exhibitions National Collection of Fine Arts, Washington, D.C., 1976–77, *John White Alexander, 1856–1915*, exh. cat. by M. A. Goley, no. 44; Fine Arts Program, Board of Governors of the Federal Reserve System, Washington, D.C., 1977, *John White Alexander*, no cat.; University Art Gallery, University of Pittsburgh, 1978, *Art Nouveau*, no. II–3; Westmoreland County Museum of Art, Greensburg, Pa., 1981, *Southwestern Pennsylvania Painters, 1800–1945*, exh. cat. by P. A. Chew and J. A. Sakal, no. 1.

Provenance William N. Frew: estate of William Frew; Haugh and Keenan Storage Co., Pittsburgh.

Gift of Haugh and Keenan Storage Co., 1948, 48.18

The Crowning of Labor, 1905–8

Oil on canvas
48 panels, approximately 3,900 square feet

The project of decorating the new entrance hall of the expanded Carnegie Institute was the high point of John White Alexander's career. The "stupendous" commission, as the *Pittsburg Dispatch* phrased it, consisted of a mural program to cover 5,100 square feet of wall, the largest space yet commissioned in America. The artist was offered the handsome fee of $175,000, the most yet offered to any artist for any mural.[1] The contract between Alexander and the Building Committee was formally signed on July 5, 1905. All three stories surrounding Carnegie Institute's central stairway were to be decorated, as well as the main hall of its third floor; the subject was left entirely to the artist.

It is uncertain whether Alexander was paid in full for this project. It was a huge undertaking that Alexander could not complete, for he died before starting the third-floor panels. However, the first-floor frieze and the *Apotheosis of Pittsburgh*, the central image of the second floor, were completed and installed in 1907. The rest of the second-floor and the upper-staircase frieze were installed in 1908.

Alexander was the logical choice for the job on several counts: he was a celebrated native son, he represented an advanced international painting style, and he had already executed a mural project—six lunettes for the Library of Congress, Washington, D.C., in 1896. At the time the Carnegie commission was offered, he was researching Pittsburgh industry for another mural project in the state capitol at Harrisburg, which would depict the development of Pennsylvania.[2] He never started the Harrisburg commission, which was eventually turned over to Violet Oakley and Edwin Austin Abbey. However, he did carry over his interest in the subject of Pittsburgh industry, making it the leitmotif of the Carnegie Institute murals.

Alexander worked out a program that united the theme of Pittsburgh industry and the theme of the arts and sciences, to which Carnegie Institute was dedicated. At the same time, the program pays homage to Andrew Carnegie, the patron of the institute. The murals remind the viewer of the basis of Carnegie's benefaction and reflect his desire to elevate the cultural life of the common man.

The message of the mural program is that hard work brings wealth and progress. On the first floor, a fifteen-panel frieze lines the upper wall, presenting the hard labor in the steel mills as the foundation of Pittsburgh's wealth. Groups of men work at tasks that are abstractions of jobs in a steel mill. Iron beams, trellis bridgework, a hanging hook, a spoke wheel, and a battering ball suggest the environment of a construction site. Industrial smoke—gray-green, pink, or buff—envelops the workers, hides the background, and keeps the space shallow and undefined. The men, often heroically stripped to the waist, are close to the picture plane.

The smoke and steam of the first floor rise to the story above, where they become the celestial clouds of the five panels known as the *Apotheosis of Pittsburgh*, which dominates the second-floor landing. This image constitutes the climax of a movement that begins across the gallery on the opposite wall. There, winged female figures flanking the third-floor stairs announce the power of Pittsburgh and unify the program by pointing to the first and third floors.

Each side wall begins and ends with a panel of these winged female figures turned to the central crowning of Pittsburgh. Some bear gifts, some play instruments, and one holds a palm leaf of victory. On each side wall, these symbolic panels flank a shallow, wide alcove decorated with an industrial scene.

The narrow side walls of the alcoves contain panels depicting men working among iron girders and bridge trellises. Like the men in the first-floor murals below, they are close to the picture plane and life-size. The wide back wall of each alcove is decorated with an industrial scene painted on three panels that span the gallery doors. One composition depicts a steel mill with smokestacks, hot-air boilers, a blast furnace, and a low, red factory shed, all emerging from clouds of pink and gray-green smoke.

Across the hall, on the corresponding side wall, is a landscape dominated by locomotives chugging in different directions at a siding. To the left, a steel skyscraper is under construction, reminding the viewer that Carnegie Steel Company manufactured the structural beams for the first skyscraper office building (the Home Insurance building of Chicago). The specific building invoked here may be the Carnegie Building, built in 1894 as headquarters of Carnegie Steel Company, and Pittsburgh's first structural steel building. Behind the river, busy with coal barges and river boats, rise dark hills. Through the strong white verticals of locomotive smoke, the viewer recognizes a generalized scene of the Monongahela River and the hills south of Pittsburgh. Alexander placed the Carnegie enterprises—steelmaking, bridge building, the manufacture of steel construction beams and railroads—in juxtaposition to the winged female figures heralding the apotheosis of Pittsburgh on the fourth and central wall.

On that center wall, five panels reading from right to left unite industry and culture. The first panel on the far right contains a few female figures advancing toward the picture plane. A line of dancing girls connects this panel to the second one. There, the main figures, close to the picture plane, are differentiated: one has dark hair and another wears a dark skirt, worked in a rose pattern, and has a rose in her hair. The one who wears a close-fitting turban strongly resembles a sketch of an Oriental woman that was found among Alexander's papers at the Archives of American Art.[3] The closest figure has red hair and extends a blunt object to the next panel. These women may well be an allusion to the foreign markets that the Carnegie Steel Company developed in the 1890s, when the firm began selling rails in Japan and China and broke into Latin America.[4] If the message is that wealth was pouring into Pittsburgh from the four corners of the world, the agent was Andrew Carnegie.

Following the second panel, which alludes to commerce, the central panel refers to the arts. The winged horse accompanies a figure holding a wreath, and another one extends a small Winged Victory toward the fourth panel, where, suspended in the air, a black-armored knight holds a white sword in his lowered left hand. He receives a gold-leaf crown from a seminude winged figure in green.

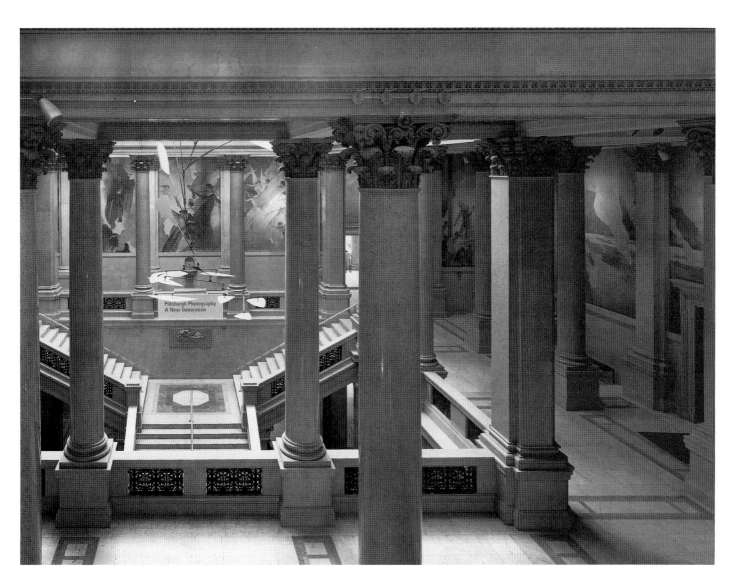

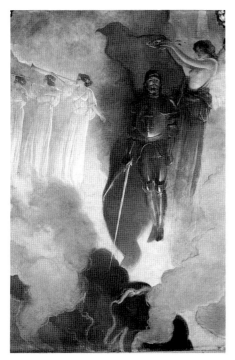

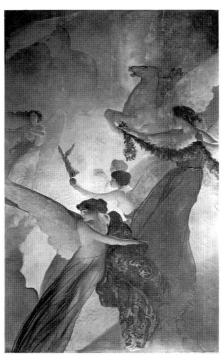

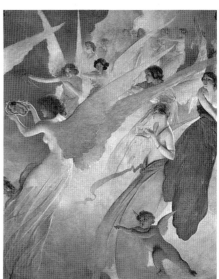

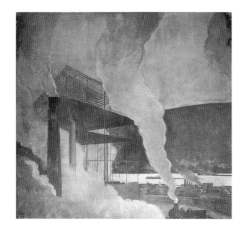

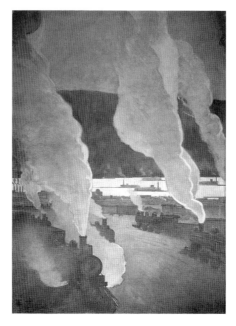

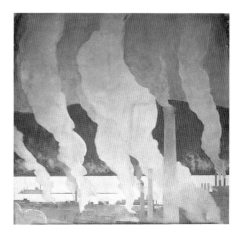

Behind him, at the top left, a line of female trumpeters announces his coronation. Lit from below, as if from the furnaces on the first floor, he hovers above the dark cloud at the bottom of the panel, with a red mantle fluttering behind him. Dark red, smoky clouds fill the fifth and last panel; from the fiery haze emerge grotesque and suffering faces. Above this hellish smoke, the line of female trumpeters continues from the previous panel, rolling away the smoke and its suffering.

The mural indicates that industrial wealth brought cultural gifts to the city. Indeed, in "The Gospel of Wealth" Carnegie articulated his conviction that the rich man justifies his wealth only by using it to uplift the general populace; the wealthy man should be the agent of community amelioration.[5] In visualizing this concept, Alexander broke artistic precedent by using a knight in armor instead of the conventional female personification for a city. The knight conflates two meanings: he embodies Pittsburgh, the Steel City, and Carnegie, the Steel Magnate. It seems natural that the face of the knight in black armor is an idealization of a younger, leaner Andrew Carnegie; it has been suggested that it is also Alexander's self-portrait.[6] Even if Alexander did incorporate his own features into the idealized figure, the logic of the program makes the identification with Carnegie inevitable.

The murals of the stairwell to the third floor are a denouement after the climax. Elizabeth Alexander called this frieze *The March of Progress*, but the reference is more specific. A crowd of working-class people moves toward the third-floor gallery where Alexander had intended to depict the departments of Carnegie Institute—music, science, literature, art, and history. They embody the mission of the institute that Andrew Carnegie had enunciated on May 8, 1907, in a letter to the Board of Trustees: "The gallery is for the masses of the people primarily, not for the educated few."[7] Alexander had wanted the paintings here to be beautiful and fantastic. However, the artist died just as he started this part of the project.

As it stands, the stairwell frieze of twelve large panels is the last part of the program. More than four hundred people—all, notably, of Northern European stock—walk in one direction, from left to right. All look ahead, serious and neatly dressed. They represent the laborers, the masses after working hours, and personify Andrew Carnegie's motto, "All is well since all grows better."[8]

When the remodeled Carnegie Institute opened on April 6, 1907, the project was only half finished. The frieze panels had been sent on specially constructed stretchers from New York. The large canvases concerned with the knight had been sent in great tubes. Having done his work in Charles Dana Gibson's large studio in Carnegie Hall in New York in order to accommodate the huge canvases, Alexander came to Pittsburgh on March 4, 1907, to superintend the mounting of his works. On October 8, 1908, he supervised the mounting of twenty-eight more panels; this is the program as it now exists.

The backs of the canvases and the walls were coated with white lead, and the canvases were hung like wallpaper. Although Alexander had actually painted the panels in New York rather than on the site, their opaline colors harmonized with the pink marble of the staircase. Originally, the light blues and pinks gave a joyous effect to the hall, but over the years, the accumulation of grime has substantially dulled the effect of the light, warm tones Alexander had chosen.

For this project, Alexander switched from his usual rough canvas to a smooth canvas that would not catch the sooty dirt in the Pittsburgh air. Moreover—again to protect the murals—they were varnished and coated with dissolved oil wax to soften the glazes.[9] This wax, to be washed off and reapplied every three years, was meant to capture the dirt and protect the pigments.

The murals attracted favorable national attention. Alexander had consciously kept his compositional elements close to the picture plane, creating an effect that was more decorative than that achieved in his murals for the Library of Congress. In addition to their color and decorative qualities, they were praised for their modernity. When Charles H. Caffin saw the murals at the 1907 opening, he especially praised this quality:

> It is not only that the male types are a conception of the rights and possibilities of labor that is a part of our present-day understanding of democracy, nor that the girl types are drawn from such as we can see around us . . . the painter has [abandoned] the old method of piled up . . . balanced composition.[10]

These murals paid tribute to the archetypal modern industrialist—Andrew Carnegie—and to Pittsburgh, which became the city where the modern theme of industrialism was sounded early.

RCY

1 "To Receive $175,000 for Decoration in Carnegie Institute," *Pittsburg Dispatch*, June 10, 1905, p. 1.

2 "Want Murals for Library; J. W. Alexander, Pittsburg's Noted Artist, to Consult with Building Committee," *Pittsburg Post*, June 9, 1905 [p. 12], in *Frew Scrapbook, 1904–5*, Archives of Carnegie Library, Pittsburgh.

3 John White Alexander Papers, Archives of American Art, Washington, D.C.

4 Harold C. Livesay, *Andrew Carnegie and the Rise of Big Business* (Boston, 1975), p. 165.

5 Andrew Carnegie, "The Gospel of Wealth," *North American Review* 148 (June 1889), pp. 653–64, and 149 (Dec. 1889), pp. 682–98.

6 Donald Miller, "The Man in the Iron Suit: John White Alexander's Self-Portrait," *Carnegie Magazine* 51 (December 1977), pp. 10–16.

7 Andrew Carnegie Correspondence, box 3, 1906–10, Archives of Carnegie Library, Pittsburgh.

8 Andrew Carnegie, *Autobiography*, quoted by Edward C. Kirkland in introduction to Andrew Carnegie, *Gospel of Wealth* (Cambridge, 1962), p. xi.

9 "To Guard New Frescoes from Pittsburgh Dirt," *Pittsburgh Post*, April 10, 1907, p. 6.

10 Charles H. Caffin, "The New Mural Decorations of John W. Alexander," *Harper's Monthly* 114 (May 1907), pp. 845–46, 855–56.

References P. T. Farnsworth, "John W. Alexander, Artist: A Study in Determination," *Craftsman* 10 (Apr. 1906), pp. 46–53; C. H. Caffin, "The New Mural Decorations of John W. Alexander," *Harper's Monthly* 114 (May 1907), pp. 845–46; "Alexander's Crowning of Labor," *American Architect* 94 (Nov. 11, 1908), p. 155; W. Walton, "Alexander's Decorations," *Scribner's Magazine* 45 (Jan. 1909), pp. 45–57; Elizabeth Alexander, "John W. Alexander's Mural Decorations Entitled 'The Crowning of Labor,'" unattached insert in Department of Fine Arts, Carnegie Institute, *Catalogue of Painting: John White Alexander Memorial Exhibition*, 1916, pp. 11–28; W. Pach, *Ananias or the False Artist* (New York, 1928), pp. 110–11, 251; E. Alter, "The Alexander Murals," *Carnegie Magazine* 7 (Sept. 1933), pp. 103–11; J. Van Trump, "The Tenth Muse: Alexander

Murals at Carnegie Institute," *Carnegie Magazine* 39 (Feb. 1965), pp. 63–68; D. Miller, "The Man in the Iron Suit: John Alexander's Self Portrait," *Carnegie Magazine* 51 (Dec. 1977), pp. 10–16; H. Adams, in Museum of Art, Carnegie Institute, *Collection Handbook* (Pittsburgh, 1985), pp. 226–27; M. Banta, *Imaging American Women* (New York, 1987), pp. 675–77.

Provenance commissioned from the artist, 1905.

Purchase, 1907, 07.08

Thomas P. Anshutz

1851–1912

THOMAS POLLOCK ANSHUTZ is best known as the gifted Philadelphia teacher who led students as diverse as Robert Henri, John Marin, and Charles Demuth from late nineteenth-century academic realism toward the brasher objectivity of the Ashcan school and the simplicity of geometric structuralism. Perhaps Anshutz's own innovative achievements have been overlooked because of his devotion to the classroom. Nevertheless, his experimentations are notable: he explored at an early date the controversial and then-ignored theme of American industry; he was a pioneer in the use of photography as a compositional tool; and numerous late pastel and watercolor sketches display his interest in advanced theories of color and light.

Born in Newport, Kentucky, Anshutz grew up along the Ohio River. The smoky factories along its banks must have left a deep impression on him, for he incorporated their industrial motifs into his work intermittently throughout his career. In 1872 he went to New York to pursue a career in art; he opened a studio in Brooklyn, joined the Brooklyn Art Club, and entered the National Academy of Design. Under the instruction of William Rimmer and Lemuel Wilmarth, Anshutz developed an able but dry academic style, but in 1875 he rebelled against the academy's emphasis on drawing from antique casts.

Anshutz subsequently moved to Philadelphia to draw from life with Thomas Eakins at the Philadelphia Sketch Club while the new facilities for the Pennsylvania Academy of the Fine

Arts were being built. As soon as the academy's new buildings opened in 1876, Anshutz enrolled in classes with Eakins and Christian Schussele. Life study and anatomical instruction took precedence with these teachers, particularly with Eakins, whose lessons concentrated on painting solid, naturalistic figures in three-dimensional space. Anshutz thus developed a style of strong anatomical draftsmanship, simplification of form, and emphasis on structure.

In 1880 Anshutz served as assistant demonstrator in the Pennsylvania Academy's dissecting room and was promoted to chief demonstrator the next year. He subsequently became an assistant professor in painting and drawing and, along with other faculty members, began to participate in the photographic motion experiments of Eakins and Eadweard Muybridge. Though his debt to his mentor was obvious, Anshutz sided with the officials when the Pennsylvania Academy forced Eakins to resign as director.[1] Within the academy he continued to uphold convention and defend academic conservatism. It seems ironic that the same individual trained some of the most avant-garde students of the next generation.

Anshutz's own style changed after a year-long stay in Europe in 1892–93. Although he studied at the Académie Julian with conservative painters (Lucien Doucet and William-Adolphe Bouguereau), it was the Impressionists and Post-Impressionists who had the greater effect on him. He admired the Impressionist-inspired work of Paul Besnard and may have seen the Georges Seurat retrospective at the Salon des Indépendants as well as exhibitions of Pierre-Auguste Renoir, Camille Pissarro, and Edgar Degas at Galeries Durand-Ruel.[2] His late landscape sketches and oils, perhaps his best work, probe French color theory and reveal a concern for abstract pictorial structure reminiscent of Paul Cézanne.

Anshutz remained a teacher at the Pennsylvania Academy for over thirty years. In 1898 he cofounded the Darby School of Art in Fort Washington, Pennsylvania, and began spending his summers teaching there. In 1909 he became director of the academy, and in

1910 served as president of the Philadelphia Sketch Club. Soon afterward, however, his health failed; he died in Fort Washington of bronchial illness and heart trouble.

Anshutz submitted seven works to the Carnegie International from 1905 until his death, but only three were accepted. In 1912 two were exhibited posthumously: *The Incense Burner* (c. 1912, Pennsylvania Academy of the Fine Arts, Philadelphia) and *The Iris* (c. 1912, location unknown). A third, the handsome portrait *Tanagra* (c. 1909, Pennsylvania Academy of the Fine Arts), was exhibited at the 1909 International, while in the same year it won the Pennsylvania Academy's Temple Gold Medal and Walter Lippincott Prize. As a tribute to Anshutz's gift for teaching, his students bought *Tanagra* and donated it in his honor to the academy.[3]

1 Katz, "The Breakthrough of Anshutz," p. 16.
2 Heard in Pennsylvania Academy of the Fine Arts, *Thomas P. Anshutz*, p. 13.
3 Bowman, "Nature, The Photograph and Thomas Anshutz," p. 39.

Bibliography Francis J. Ziegler, "An Unassuming Painter—Thomas P. Anshutz," *Brush and Pencil* 4 (September 1899), pp. 277–84; Leslie Katz, "The Breakthrough of Anshutz," *Arts* 37 (March 1963), pp. 26–29; Pennsylvania Academy of the Fine Arts, Philadelphia, *Thomas P. Anshutz, 1851–1912* (1973), exh. cat., essay by Sandra Denney Heard; Ruth Bowman, "Nature, The Photograph and Thomas Anshutz," *Art Journal* 33 (Fall 1973), pp. 32–40.

Steamboat on the Ohio, c. 1896

Oil on canvas
27¼ x 48¼ in. (68.2 x 122.6 cm)

Steamboat on the Ohio is concerned in part with the intrusion of the machine upon an idyllic landscape. With the Ohio River as a backdrop, a group of young boys undress and swim, while a man casually sets off from the rocky bank in a rowboat. Juxtaposed on the far shore are signs of industrial progress: factories, a steamship, and heavy pollution. Murky clouds of smoke—symbols of a disquieting future—hover menacingly over the bathers. Here, Anshutz created a clear dichotomy: purity and innocence versus defilement and violation.[1]

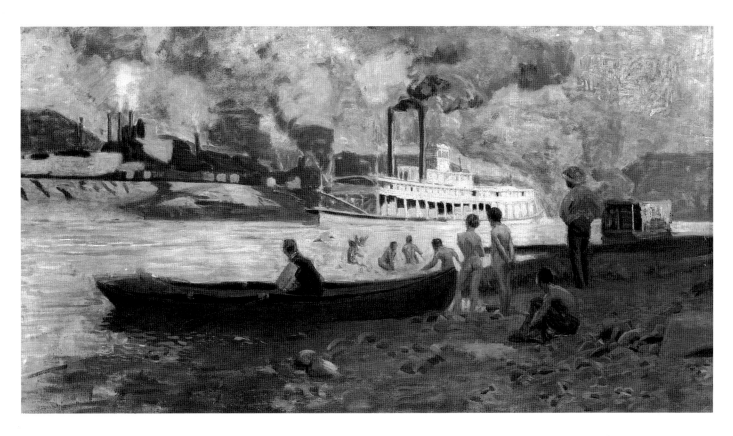

Fig. 1 Thomas P. Anshutz, *Study for Steamboat on the Ohio*,
c. 1896. Pastel, 7½ x 11 in. (19 x 27.9 cm). Westmoreland
Museum of Art, Greensburg, Pa., William A. Coulter
Purchase Fund, 1959

Fig. 2 Thomas P. Anshutz, *Study for Steamboat on the Ohio*,
c. 1896. Oil on cardboard, 8 x 15 in. (20.3 x 38.1 cm). Mr. and
Mrs. Richard Waitzer, Norfolk, Va.

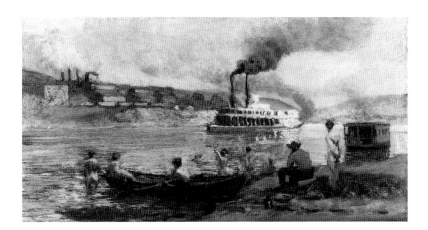

At the same time Anshutz exploited the purely visual spectacle wrought by modern industry. Belching smoke provided a perfect vehicle for the artist to explore color and light. Splashes of flaming orange and yellow emanate from the mills and reflect streaks of gold in the water. Other dots of pure color, ably and spontaneously applied over earth-toned passages, demonstrate Anshutz's knowledge of Post-Impressionist color theory.

When he painted *Steamboat on the Ohio*, Anshutz had recently returned from Europe, where he had arrived at a new coloristic freedom. He drew preparatory sketches in pastel from pure chalks, which he made himself (fig. 1; a second chalk study, of the approaching steamboat only, is in the collection of Valentine Hoffmann, New York). He then translated his impressions to a preliminary composition sketch in oil (fig. 2) with remarkably little loss of freshness. *Steamboat on the Ohio* itself possesses the visual quality of a pastel; in fact, when comparing it with his preparatory pastel studies, a similar looseness and purity of tone are evident, yet the colors are more vibrant in the painting. The artist delighted in the paint as paint and played with thick and transparent brushwork. With a minimum of strokes he captured the essence of figures, landscape, and architecture to reveal their solid inner structure.

In creating this painting, Anshutz also relied on photography as a structural and compositional tool. From among six photographs taken along the Ohio River near Wheeling (fig. 3), Anshutz directly selected figures and objects for *Steamboat on the Ohio*.[2] The use of photographs probably encouraged Anshutz to render the landscape with a certain harshness, but it

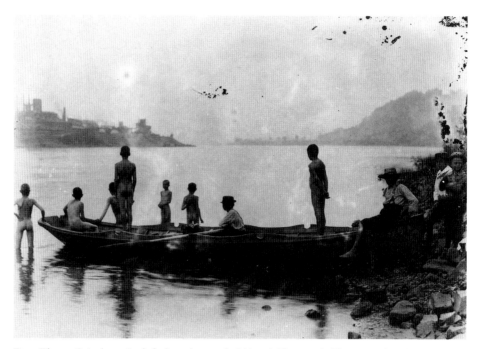

Fig. 3 Thomas P. Anshutz, *Study for Steamboat on the Ohio*, n.d. Photograph. Thomas Anshutz Papers, Archives of American Art, Smithsonian Institution, Washington, D.C.

hardly tied the artist to a naturalistic rendering. The coloring of the painting is an unexpected mixture of vivid green, orange, blue, and lavender, which is alien to the more naturalistic tones of his preparatory oil sketch and to observed nature.

JM

1 Cleveland Museum of Art, *American Realism and the Industrial Age* (1980), exh. cat., essay by Marianne Doezema, p. 30.

2. Bowman, "Nature, The Photograph and Thomas Anshutz," p. 33.

References Katz, "The Breakthrough of Thomas Anshutz," p. 29; R. Bowman, "The Photographs of Anshutz," *Art Journal* 33 (Fall 1973), pp. 33–35; P. A. Chew, ed., *The Permanent Collection, The Westmoreland County Museum of Art* (Greensburg, Pa., 1978), pp. 19–20.

Exhibitions Westmoreland County Museum of Art, Greensburg, Pa., 1961, *Founder's Day Exhibition,* unnumbered; American Federation of Arts, New York, 1962–63, *American Traditional Painters* (trav. exh.), no cat.; Three Rivers Arts Festival, Pittsburgh, 1968, no cat.; Cleveland Museum of Art, 1980–81, *American Realism and the Industrial Age* (trav. exh.), exh. cat., essay by M. Doezema, no. 7.

Provenance Victor Spark, New York, by 1957.

Patrons Art Fund, 1957, 57.36

See Color Plate 18.

George Grey Barnard
1863–1938

ONE MIGHT DESCRIBE George Grey Barnard as having had an interest in sculptural form from childhood, since his boyhood avocations were taxidermy and modeling small clay figures. A Presbyterian minister's son, he was born in Bellefonte, Pennsylvania, and passed his childhood in several different midwestern towns. He became the major American Symbolist sculptor of the late nineteenth and early twentieth centuries. An almost mystical vision marks Barnard's work. He sought to give heroic visual form to man's inner spirit, and he steadfastly maintained that goal throughout his life.

When he was seventeen, Barnard was apprenticed to a jewelry engraver. He worked his way through the School of the Art Institute of Chicago, where he had the opportunity to study the Institute's large collection of plaster casts of Michelangelo's sculptures; thus began a lifelong emulation of the Renaissance master's powerful and dramatic work. Barnard received his first sculptural commission in Chicago, the proceeds of which allowed him to make a trip to Paris.

In 1883 the young sculptor entered the Ecole des Beaux-Arts as a student of Pierre-Jules Cavelier. During his early years in Paris, Barnard lived in near-poverty while working with intense dedication and keeping largely to himself, despite the presence of a number of other young American sculptors there. In 1886 he was discovered by an American collector, Alfred Corning Clark, who provided Barnard with the means to realize his first full-length marble sculpture and remained his patron until his death ten years later. Clark also helped secure Barnard's first major commission, a memorial to the Norwegian poet Severin Skovgaard called *Brotherly Love* (1887, Langesund, Norway). The two male nude figures who grope toward one another while still partially sunk in the stone block at once suggest Barnard's two mentors, Michelangelo and Rodin.

By 1887 Barnard had opened his own studio in Paris; the next year he began a large marble sculptural group, *The Struggle of the Two Natures in Man* (Metropolitan Museum of Art, New York). Showing two male nudes, one supine, the other standing over him, it was based on a quotation from Victor Hugo, "Je sens deux hommes en moi" (I sense two men within me). It was exhibited at the 1894 Paris Salon, where it was spectacularly successful: Rodin praised it, and the French press hailed it as the work of a new artistic genius.

When Barnard returned to New York in 1894, he did not find his art received as

readily or with as much enthusiasm as it had been in Paris. His work during the next five years included a languishing, muscular bronze figure of Pan (commissioned by Clark just before his death in 1896, now on the campus of Columbia University, New York) and an ambitious, but never completed, group of over-life-size marble figures entitled *Primitive Man*. Barnard exhibited at the Paris Exposition Universelle of 1900 and the Buffalo Pan-American Exposition of 1901. At the latter he also contributed two groups, *Primeval Niagara* and *Niagara Today*, for a tower on the grounds.

In 1900 Barnard assumed Augustus Saint-Gaudens's teaching post at the Art Students League. Two years later he received the most important commission of his career: an enormous sculptural program for the new Pennsylvania State Capitol building at Harrisburg. He originally had in mind a vast panorama of Michelangelesque figures surrounding the building, but scaled the project down to a program he called *Love and Labor*, which consisted of two sculptural groups, *The Unbroken Law* and *The Broken Law*, flanking the Capitol's entrance.

Having developed the Harrisburg program's final design by 1904, Barnard set up a barn-size studio at Moret-sur-Loing, near Paris, where, assisted by as many as fifteen men, he worked on clay models for the marble figures. In 1906 Barnard's payments were suddenly interrupted,

forcing him to raise his own capital for the project; this he did through buying and selling medieval art. The sculptural groups reached completion in 1910 and were exhibited at that year's Paris Salon. They were installed at Harrisburg during the winter of 1910 and were unveiled, with much pomp and celebration, the following October.

Five of Barnard's marbles were exhibited at the 1913 Armory Show; they were among the few American works there that seemed at home among the European Symbolist and modernist movements. From 1913 to 1917 Barnard executed the sculptural decoration for the Fifth Avenue facade of the New York Public Library. In 1917 he embarked on a new direction, with an over-life-size bronze *Lincoln*, which was unveiled in Lytle Park, Cincinnati. It was not sympathetically received; many found its deliberate awkwardness and exaggerated realism offensive and inappropriate in a public memorial to a national hero.

Barnard had an abiding interest in the art of the Middle Ages, finding its symbolic nature and austere expressiveness close to his own sensibilities as a sculptor. While in France he dealt in French antiquities; he thus amassed an extensive personal collection of medieval art, which in 1925 was purchased by John D. Rockefeller. In 1937 Rockefeller presented it to the Metropolitan Museum of Art, where it became the foundation of the collection at the Cloisters at Fort Tryon Park, New York.

The last years of Barnard's career, spent in New York City, were occupied with a colossal project, *Rainbow Arch*, which he financed himself and hoped to locate near the Cloisters. The site would have been a 350-foot-wide plaza, dominated by an arch one hundred feet high, curving over a forty-foot bronze *Tree of Life*. On Armistice Day 1933, he placed a full-size plaster model of the arch on exhibit in the 216th Street Powerhouse in New York, but lack of funds prevented the execution of the figures in marble and eventually thwarted the project's completion.

Bibliography Alexander Blair Thaw, "George Grey Barnard," *World's Work* 5 (1902), pp. 2,837–53; Mary Twombly, "George Grey

Barnard," *World's Work* 17 (1909), pp. 11,256–67; William M. Van der Weyde, "Dramas in Stone: The Art of George Grey Barnard," *Mentor* 11 (March 1923), pp. 19–34; Lorado Taft, *The History of American Sculpture* (New York, 1924), pp. 356–72; Wayne Craven, *Sculpture in America* (1968; rev. ed. Newark, Del., 1984), pp. 442–50.

Urn of Life, c. 1898–1900, reworked 1918

Marble
37⅞ x 32¼ x 30¼ in. (96.2 x 82 x 77 cm)

The Carnegie Museum of Art's *Urn of Life* is the unfinished repository intended for the ashes of Anton Seidl (1850–1898), the Hungarian composer who was conductor of the Metropolitan Opera in New York. At his unexpected death, a group of Seidl's friends asked Barnard to design his cinerary urn. Barnard worked on it for two years, but the original patrons reportedly declined the piece as too large, and accepted instead a replica of one of the details of it.[1] The unfinished urn remained in Barnard's studio, and in 1908 it was included in the exhibition of his work held at the Museum of Fine Arts, Boston, where it was mistakenly assigned 1895–97 as its date.

Barnard once explained that he intended to carve twenty-seven figures on the urn.[2] That would have meant a second register of eight more below those already there, the final effect being an egg shape encrusted with figures in a manner reminiscent of late Classical vases and sarcophagi. Barnard transformed those figures into refined, mystical beings who represented stages in the cycle of birth, procreation, death, and transfiguration. The figures move to the left in a rhythmic pattern of alternating standing and reclining postures. As if still being formed, they are partly immersed in the rough stone, emerging so fluidly shaped that each symbolic vignette passes seamlessly to the next.

Obviously, Barnard devoted a great deal of effort to working out the iconographic program of the urn. His lengthy explanation has the same labored exactitude that characterized his other ambitious figural programs.

> The starting point is the veiled figure holding a small urn in her hands. This figure represents the Mystery of Life—a veiled mystery. Beneath the urn, held in the hands of Mystery, twines a lily which symbolizes

life, and beneath it is a poppy which symbolizes death. The figure of the woman to the right represents woman as understanding the mystery of life better than man, and through motherhood in a way that man cannot. Her attitude, with her fingers to her lips, suggests inquiry with reference to this mystery. In her right hand she holds the flowers that symbolize beauty and eternity—they are falling at the feet of Death. The man to the left, in the midst of his labor, reaches forth in an effort to understand or touch the Mystery of Life.

> The group to the left of the man represents life and the birth of a child. The Winged Angel of Life holds in her arms the bambino, or child. The father kneels by the head of the mother expressing his love and sympathy by the touch of a kiss. The figure above the kneeling father represents man carving the wing of the Angel of Life.

> Next to the kneeling father is a group composed of a man and a woman expressing the thought that while they are one in love and spirit, nevertheless they are separate souls.

> Continuing to the left, the group represents a man at labor, and the figure represents the love and sympathy of the wife.

> Continuing to the left, is a group representing the complete family—the father, mother, and child.

> Continuing to the left, the next group represents the silent, inward voice which inspires us to nobler efforts. The winged harp symbolizes the music of the soul.

> Next, continuing to the left, the group symbolizes the end of life. The Angel of Death closes with his right hand the lips of the aged man, while, as a benediction, he kisses the clasped hands of those who have been faithful unto death.[3]

Barnard created his composition by first modeling each figure group separately in plaster. Perhaps as a way of then salvaging an abandoned commission, he carved separate marble reliefs of at least six of those figure groups, four of which were exhibited at the 1913 Armory Show in New York. He planned to adapt the urn itself as a fountain sculpture for a European client, but the onset of World War I brought an end to that venture.[4] In 1918 Barnard persuaded Carnegie Institute to purchase the work. He agreed to finish certain details for the new owner, specifically to smooth its roughly chiseled lower portion. "My intention is to leave the bottom of the 'Urn' perfectly simple, just as Columbus left his egg when he stood it on the table."[5]

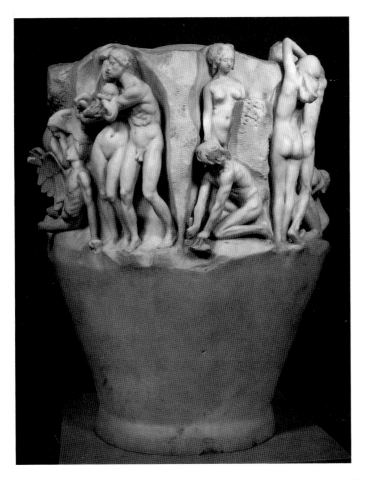
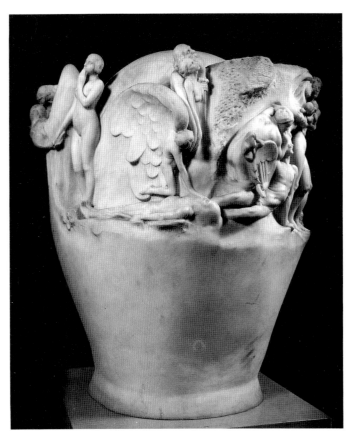

Although not especially large, the *Urn of Life* is one of Barnard's key efforts, for its symbolism indicated the direction of his subsequent work. He went so far as to say, of the *Urn of Life,* "I found the seed which, when I planted, grew into the two compositions known as 'Labor' and 'Love' on either side of the Capitol at Harrisburg."[6]

DS

1 "The Urn of Life by George Grey Barnard," undated handbill, George Grey Barnard Papers, Archives of American Art, Washington, D.C.

2 Thaw, "George Grey Barnard," p. 2,852.

3 "The Urn of Life by George Grey Barnard," Barnard Papers.

4 George Grey Barnard to John Beatty, May 2, 1918, Carnegie Institute Papers, Archives of American Art, Washington, D.C.

5 Ibid.

6 George Grey Barnard to John Beatty, March 26, 1919, Carnegie Institute Papers, Archives of American Art, Washington, D.C.

Remarks The foot of the infant in the group representing the complete family was broken off during the early 1940s.

References Thaw, "George Grey Barnard," pp. 2,842, 2,852; K. M. Roof, "Barnard: The Spirit of the New World in Sculpture," *Craftsman* 15 (1908), pp. 270–80; Twombly, "George Grey Barnard," pp. 11,260–61; P. Clemen, "George Grey Barnard," *Kunst für Alle* 26 (1911), p. 407; Department of Fine Arts, Carnegie Institute, Pittsburgh, *The Twenty-third Celebration of Founder's Day* (1919), pp. 44–45; L. Taft, *History of American Sculpture* (New York, 1924), pp. 371–72.

Exhibitions Museum of Fine Arts, Boston, 1908, *Exhibition of the Work of George Grey Barnard,* no. 7; Westmoreland County Museum of Art, Greensburg, Pa., 1959, *Two Hundred and Fifty Years of Art in Pennsylvania,* no. 137.

Provenance The artist, until 1919.

Purchase, 1919, 19.7.1

The Prodigal Son, 1904–6

Marble
37 x 24½ x 18 in. (94 x 62.2 x 45.7 cm)
Markings: *Moret-sur-Loing*/1906 (base side, proper left)

The Prodigal Son is a reduced replica of the father-and-son group from Barnard's *Unbroken Law,* which, with its pendant, *The Broken Law,* flanks the entrance of the Harrisburg, Pennsylvania, State Capitol (fig. 1). It is the smaller of two marble versions prepared simultaneously at the studios Barnard set up at Moret-sur-Loing in 1904. The larger of the two (J. B. Speed Art Museum, Louisville, Ky.), made to the same scale as *The Unbroken Law,* appeared in the Armory Show in 1913.

While Barnard's assistants were completing the larger group in clay in 1904, he made a smaller model, had it pointed, and completed the marble in 1906. This smaller version has a more sensitively inflected surface. The sculptor called it

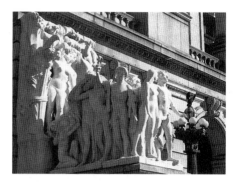

Fig. 1 George Grey Barnard, *Love and Labor: The Unbroken Law*, 1904–11. Marble, over life-size. Pennsylvania State Capitol Building, Harrisburg

"one of my most carefully finished marbles" and explained that he gave it "the delicate surfaces proper to a small figure, that are not necessary to the larger work."[1]

Barnard's *Prodigal Son* presents an interesting comparison with Auguste Rodin's sculpture of the same title (c. 1888, Musée Rodin, Paris). While Rodin chose to show the son alone, overcome with despair and yearning for forgiveness,

Barnard selected the moment of reconciliation from the biblical story and replaced Rodin's darker, more psychologically complex tone with a mood of hope and promise. Like Rodin, however, Barnard understood how an idea or emotion could be expressed through suggestive form and capitalized on it. Here, the father bends protectively over the son. The embrace of their arms makes a complete circle; the two bodies intertwine as one, successfully symbolizing the idea of forgiveness and humility in the face of love.

Within the larger Harrisburg sculptural program, *The Prodigal Son* served Barnard's juxtaposition of New Testament (and by extension, New World) redemption in *The Unbroken Law* with Old Testament (that is, Old World) transgression in *The Broken Law*. The program begins with Adam, Eve, and the Fall of Man, moves forward to allegories of despair and hope, and ends with Christ baptizing a family group and "a new Adam and Eve, who gaze wonderingly toward the West as though into the

future."[2] It was typical of Barnard's biblical imagery that he generalized his figures into representations of universal states of feeling, and that an aspect of these is the struggle to be freed from the restrictions of physical nature.

KP, DS

1 George Grey Barnard to John Beatty, May 2, 1918, Carnegie Institute Papers, Archives of American Art, Washington, D.C.

2 Harold E. Dickson, "Barnard's Sculptures for the Pennsylvania Capitol," *Art Quarterly* 22 (1959), p. 133.

Reference J. F. Martin, "The Story of the Prodigal Son," *J. B. Speed Art Museum Bulletin* 30 (Sept. 1976), pp. 14–24.

Exhibition Munson-Williams-Proctor Institute, Utica, N.Y., 1963, *Fiftieth Anniversary Exhibition of the Armory Show of 1913* (trav. exh.), no. 997, p. 148.

Provenance The artist, until 1919.

Purchase, 1919, 19.7.2

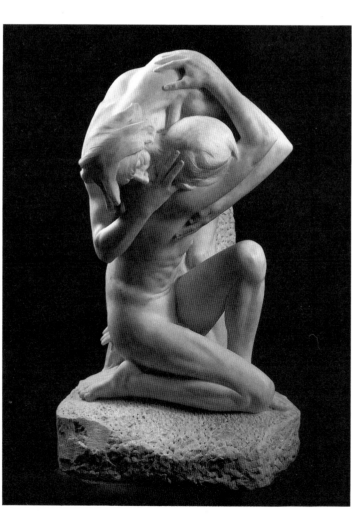

John Beatty
1851–1924

When the Pittsburgh landscape painter John Wesley Beatty began at middle age to pursue a second career as a museum director and writer, he found the work for which he would be best remembered. A businessman's son, Beatty was raised in Pittsburgh, where he frequented J. J. Gillespie's art shop during his boyhood. It was a meeting place for local landscape painters who took sketching trips, Barbizon-school fashion, into the nearby Allegheny Mountains to the area around Scalp Level, Pennsylvania. The group included George Hetzel, Joseph R. Woodwell, and Jasper Lawman; young Beatty accompanied them on their sketching trips, and was thus introduced to painting.

In 1876 Beatty went to study in Munich, the newly popular mecca for American art students. Its art academy, whose faculty was known for its sympathy toward painterly realism, was considered the most progressive in Europe. Frank Duveneck was the central figure of

Munich's colony of younger American painters, who tended to share an enthusiasm for free brushwork, rich, deep coloring, and bold naturalism. For slightly over a year Beatty was one of the "Duveneck Boys," alternating academy studies with excursions to Polling, Bavaria, to paint landscapes with Duveneck. Beatty capped his Munich stay with the exhibition, in 1877, of *Ploughboy's Reverie* (location unknown) at the Glaspalast, Munich, where it received a commendation.

On returning to Pittsburgh in late 1877 or early 1878, Beatty supported himself as a part-time engraver and magazine illustrator, working for local newspapers and occasionally for national magazines such as *Harper's Weekly*, *Leslie's Illustrated Newspaper*, and the children's periodical *Saint Nicholas*. After he associated once more with the Scalp Level artists, among whom the Barbizon influence was strong, he established himself as a landscape painter and etcher of like-minded sympathies, whose work—the majority produced between the early 1880s and the mid-1890s—attracted such local art patrons as Henry Clay Frick and George Westinghouse.

Beatty began teaching at the Pittsburgh School of Design, whose directorship he assumed in 1887. Probably in his capacity as an art-school director, he was invited to serve on the advisory committee of Chicago's World's Columbian Exposition of 1893. He began to organize art exhibitions, and in 1896 Andrew Carnegie asked him to become director of the Department of Fine Arts at the newly formed Carnegie Institute.

Beatty was well suited to Carnegie's requirements for a founding director of his art museum. Affable and diplomatic, he was a dedicated art educator who, in the words of one reporter, "would make the art galleries popular and would get plenty of publicity of the right kind for the institute."[1] He got along well with local artists and developed a congenial relationship with some of the country's most prominent painters, notably Winslow Homer, Childe Hassam, J. Alden Weir, and John White Alexander.

Among Beatty's accomplishments were the founding of the Associated Artists of Pittsburgh in 1911 and the initiation of annual purchases of art for the Pittsburgh public schools. His most visible legacy to the city of his birth was the formation of Carnegie Institute's paintings and drawings collection and its establishment of an annual juried paintings exhibition, known as the Carnegie International. Each of these endeavors promoted the ideals of painterly realism, turn-of-the-century aestheticism, and American art's international ties.

Beatty served as a director of the American Federation of Arts and advisor to major American expositions: in Buffalo (1901), Saint Louis (1904), and San Francisco (1915). He continued painting and occasionally exhibited at institutions other than his own until 1912, one year after the Art Society of Pittsburgh mounted an exhibition of his work. His writing career began in 1909 with *An Appreciation of Augustus Saint-Gaudens*, followed by *The Relation of Art to Nature* in 1922 and *The Modern Art Movement* in 1923. He was decorated Chevalier of the French Legion of Honor in 1921; in 1922 he retired to Clifton Springs, New York, where he died two years later.

1 "Essays on Our Leading Citizens: John Wesley Beatty," *Harpoon* (May 1913), quoted by Henry Adams in *American Drawings and Watercolors in the Museum of Art, Carnegie Institute* (Pittsburgh, 1985), p. 23, n. 10.

Bibliography Marion Knowles Olds, "John Wesley Beatty: Artist and Cultural Influence in Pittsburgh," M.A. thesis, University of Pittsburgh, 1953; Westmoreland County Museum of Art, Greensburg, Pa., *Southwestern Pennsylvania Painters, 1800–1945* (1981), exh. cat. by Paul A. Chew and John A. Sakal, pp. 15–16.

The Wood Gatherer, 1894

Oil on canvas
20 x 30 in. (50.8 x 76.2 cm)
Signature, date: John W. Beatty. 94 (lower left)

This painting is typical of Beatty's landscapes, which usually set a man and one or two horses in a meadow or by a path in the woods. Their activity was often simple and quiet, the landscape rather ordinary and unidealized. Here, two draft horses, hitched to a sled, stand at the center of the picture space; they are tended by a woodsman, who, unmindful of the viewer, fills the sled with tree branches.

Beatty was susceptible to the influence of two closely connected landscape painting styles: one practiced by Frank Duveneck at Polling, Bavaria, while Beatty was in Munich, and the other by Winslow Homer, whom Beatty greatly admired and who became his good friend.[1] Duveneck used vigorous brushwork and strong light-dark contrasts to depict a scrubby terrain, whose foreground clumps of grass and clods of earth seemed more important to the artist than background vistas. Homer's comparably rugged landscapes usually contained a human element, objectively seen and soberly portrayed. In *The Wood Gatherer*, Beatty took a cue from Duveneck's lighting and terrain and from Homer's mood and narrative.

There is, however, a flavor of 1870s Barbizon-style painting in the way his figures are sealed off from the viewer on one side and from any landscape vista on the

other. Their size and solemnity are specifically reminiscent of the outdoor images of peasants and farm animals by Anton Mauve, whose work was enormously popular during the 1870s and 1880s. The simple manner in which the draft horses are placed, just slightly off center, so that neither they nor the man loading branches actually confronts the viewer also recalls Mauve's compositions. Were it not for the higher key of Beatty's colors and his more orderly, more controlled brushwork, one would be hard pressed to label this a work of 1894 rather than of a decade and a half earlier.

DS

1 John W. Beatty, "Recollections of an Intimate Friendship," 1923–24, in Lloyd Goodrich, *Winslow Homer* (New York, 1944), pp. 222–23.

Exhibition Westmoreland County Museum of Art, Greensburg, Pa., 1981, *Southwestern Pennsylvania Painters, 1800–1945*, exh. cat. by P. A. Chew and J. A. Sakal, no. 10.

Provenance Charles Dickey Armstrong, Pittsburgh, until 1935; Valeria M. Pears, Pittsburgh, until 1941; her estate, Mrs. S. A. Hartwell, executrix, 1941.

Gift of Mrs. S. A. Hartwell, 1941, 41.2

Cecilia Beaux

1855–1942

CECILIA ELIZA BEAUX was America's dominant woman artist at the turn of the century and one of the most respected society portrait painters of her era. Born in Philadelphia, she was the second daughter of a French silk merchant who came to America to start a business; her mother, from a cultivated Philadelphia family, died twelve days after her birth. Her father returned to France, and she and her sister were reared by their maternal grandmother and two aunts.

From an early age, Beaux was encouraged to draw and paint. At sixteen she began private lessons in drawing and copying from Katherine Drinker, a local artist who was also a distant relative. The most significant of her early lessons and, in effect, her first professional training,

was with William Sartain between 1881 and 1883. Her uncle arranged for the New York painter to come to Philadelphia twice a week to give her and a fellow student from Miss Lyman's School instruction in painting from the model.

Beaux had been listed as a student at the Pennsylvania Academy of the Fine Arts, Philadelphia, in 1877 and also in 1878–79, but she said that she never attended classes there. While she was aware of Thomas Eakins's presence on the Pennsylvania Academy's faculty and expressed interest in his work, she was uncomfortable with the prospect of becoming one of his students. "I got strong food for my gleanings from his vividly impressed students," she wrote, yet she remained "out of reach of the obsession of his personality, which I would have been sure to succumb to, and this might have resulted in my being a poor imitation of what was in some ways deeply alien to my nature." [1]

From 1883 to 1884, in her studio on Chestnut Street, Philadelphia, Beaux painted her first major work, *Les Derniers jours d'enfance* (Mrs. Henry Saltonstall, Stratham, N.H.). It was a full-length portrait of her married older sister, Aimée, sitting with her toddler son in her lap. In 1885 the work was exhibited at the American Art Association, New York, and in the same year it won the Pennsylvania Academy's Mary Smith Prize for the best painting by a resident woman artist. It was accepted at the Paris Salon in 1887; a year later Beaux left for Paris herself.

Cecilia Beaux's first trip to Europe lasted a year and eight months. She arrived in Paris via Antwerp, enrolling first at the Académie Julian, then at the Atelier Colarossi, where she studied under Gustave Courtois and Pascal-Adolphe-Jean Dagnan-Bouveret. She developed an admiration for the painterly old masters such as Peter Paul Rubens and Diego Velázquez and honed her skill in drawing and composition.

When she returned to Philadelphia in 1889, Beaux reclaimed her status as one of the city's best portrait painters. In the next decade she received a number of honors, including her third and fourth Mary Smith Prizes from the Pennsylvania Academy, election to the Société

Nationale des Beaux-Arts, and a solo exhibition at the Saint Botolph Club, Boston. During this interval she also developed her mature style, which combined a sure composition with a light palette and bold brushwork. Prior to a second trip to Paris in 1896, she joined the faculty of the Pennsylvania Academy, where she taught through 1915.

During the early 1900s, Beaux was at the height of her powers, receiving a steady flow of portrait commissions from prominent individuals. She participated in numerous exhibitions and won gold medals from the major international expositions with a frequency that placed her among the country's most respected artists. She became the third woman to be admitted to the National Academy of Design and received honorary degrees from Yale University and the University of Pennsylvania. She befriended such well-known artists as Childe Hassam, William Merritt Chase, John La Farge, and Augustus Saint-Gaudens, all of whom frequented her New York studio and the summer home she built in Gloucester, Massachusetts, in 1905. Her reputation in Pittsburgh was considerable. She exhibited at almost every Carnegie International from the first in 1896 to the twenty-fifth in 1926, and was a valued four-time juror.

Although her accomplishments include a number of women's firsts, it is not surprising that Beaux disliked the label "woman artist." "Success is sexless," she insisted, "a woman's achievement depends upon the individual, her talents, her ability and her concentration." [2] Neither is it particularly surprising that in 1921 she shocked delegates to the international art congress in Paris when she declared that America had no national art and was still dependent for artistic inspiration on Europe. Her own work belongs firmly to the international tradition of society portraiture led by John Singer Sargent, with whom she was often compared. Cecilia Beaux died in Gloucester, Massachusetts.

1 Beaux, *Background with Figures*, p. 98.

2 Obituary, *New York Times*, September 18, 1942, p. 21.

Bibliography Cecilia Beaux, *Background with Figures: Autobiography of Cecilia Beaux* (Boston, 1930); Thornton Oakley, *Cecilia Beaux* (Philadelphia, 1943); Henry S. Drinker, *The Paintings and Drawings of Cecilia Beaux*

(Philadelphia, 1955); Frederick D. Hill, "Cecilia Beaux, The *Grande Dame* of American Portraiture," *Antiques* 105 (January 1974), pp. 160–68; Pennsylvania Academy of the Fine Arts, Philadelphia, *Cecilia Beaux: Portrait of an Artist* (1974), exh. cat. by Frank H. Goodyear, Jr., and Elizabeth Bailey.

Mrs. Andrew Carnegie, 1917–18

Oil on canvas
52 x 36¼ in. (132.1 x 91.7 cm)
Signature: Cecilia Beaux (lower left)

Louise Whitfield (1857–1946), daughter of a wealthy New York merchant, married Andrew Carnegie when she was almost thirty and Carnegie fifty-two. She became a dedicated companion, social secretary, and nurse to her husband. At Skibo, the Carnegies' castle in Scotland, she managed a staff of eighty-six during long summers of constant entertaining, and after Andrew Carnegie's death in 1919 Louise carried on his charitable interests.

In 1912 John Beatty, director of the Department of Fine Arts, Carnegie Institute, wrote to Cecilia Beaux of his "cherished plan" to commission a portrait of Mrs. Carnegie, which would realize both Carnegie Institute's desire to own a work by the artist and its wish to honor the wife of its founder. Beaux accepted the commission, but suggested a major alteration. She wished to include Margaret, Mrs. Carnegie's fifteen-year-old daughter and only child, in the picture.

> A much more interesting portrait for the Gallery would be reached by doing a double portrait, Mrs. Carnegie and her daughter. Strictly between ourselves Mrs. C is not exactly an effective person and as far as I am concerned—a picture that is a composition of the two figures would produce something much more representative than the single figure would be.[1]

Some of Cecilia Beaux's most effective compositions were double portraits, including *Mother and Daughter* (1898, Pennsylvania Academy of the Fine Arts, Philadelphia), a four-time gold-medal winner. The offer of a similar double portrait was doubtless also made to permit the artist to maximize her virtuosity and produce a distinctive "signature" piece.

Though Beatty took Beaux's suggestion "under advisement," he later wrote to the artist that "Mrs. Carnegie does not favor a combination portrait." He did not elaborate, and the idea was never mentioned again.[2]

For the next five years the proposed portrait's execution was constantly foiled by the busy schedules and occasional illnesses of the artist, the sitter, and her husband. By the spring of 1917, it at last appeared that the necessary arrangements could be made for work to begin; by then, however, Mrs. Carnegie was unsure of the reasons behind Carnegie Institute's insistence that the project be carried out. Beatty quickly answered her inquiries:

> We want this portrait for two reasons: first, because we want the portrait of the wife of our good founder, and, second, because we want a portrait in our permanent collection by Miss Cecilia Beaux, the most brilliant woman painter in the world at the present time and one of the ablest painters of modern times.... Besides being a remarkable painter, Miss Beaux is a brilliant and charming woman.[3]

By July, all were in agreement that the portrait should be undertaken as soon as possible; Mrs. Carnegie's suddenly amenable position was prompted, no doubt, by her husband's anxiousness that she comply with the "kind request from the Carnegie Institute."[4] Nevertheless, Mrs. Carnegie avoided meeting or corresponding with Beaux directly: Beatty acted as their patient go-between until the first sitting at Beaux's New York studio in December 1917. The portrait was completed in time to be exhibited at Carnegie Institute's Founder's Day celebration in April of the following year.

The portrait shows Cecilia Beaux's characteristically quick, sure brushwork and high-keyed coloring, here predominantly white and blue. Perhaps because it was an institutional commission, Beaux abandoned her accustomed intimate interior for a setting reminiscent of grand-manner portraits of eighteenth-century England. The backdrops of agitated clouds in official portraits by Joshua Reynolds and George Romney come particularly to mind.

Beatty reported to the artist that the Committee of the Department of Fine Arts "felt that the portrait represents the character of Mrs. Carnegie admirably," but he added that A. Bryan Wall, the artist on the committee, "thinks that the landscape background in comparison

with the figure is a little high or brilliant in key."[5] Beaux responded emphatically: "I do not think I should wish to alter Mrs. Carnegie's background. I considered it with the utmost care and step by step. Its vivacity is its most important asset." She added that the background colors gave the portrait an expression of pleasure that she wanted it to have.[6]

WG, DS

1 Cecilia Beaux to John Beatty, May 16, 1912, Carnegie Institute Papers, Archives of American Art, Washington, D.C.

2 John Beatty to Cecilia Beaux, February 28, 1913, Carnegie Institute Papers, Archives of American Art, Washington, D.C.

3 John Beatty to Louise Carnegie, June 22, 1917, Carnegie Institute Papers, Archives of American Art, Washington, D.C.

4 Louise Carnegie to John Beatty, July 2, 1917, Carnegie Institute Papers, Archives of American Art, Washington, D.C.

5 John Beatty to Cecilia Beaux, April 20, 1918, Carnegie Institute Papers, Archives of American Art, Washington, D.C.

6 Cecilia Beaux to John Beatty, May 1918, Carnegie Institute Papers, Archives of American Art, Washington, D.C.

Reference Drinker, *The Paintings and Drawings of Cecilia Beaux*, p. 31.

Exhibitions Dallas Museum of Art, 1922, *Third Annual Exhibition: American Art from the Days of the Colonist to Now*, no. 116; American Academy of Arts and Letters, New York,

1935, *Exhibition of Paintings by Cecilia Beaux*, no. 44; William Penn Memorial Museum, Harrisburg, Pa., 1979, *Pennsylvania Painters from Commonwealth Collections*, no. 4.

Provenance Commissioned from the artist, 1912.

Purchase, 1918, 12.8

George Bellows

1882–1925

THE ARTISTIC REPUTATION of George Wesley Bellows is closely linked to the development of early-twentieth-century realism, specifically to New York's so-called Ashcan school, whose membership included Robert Henri, John Sloan, George Luks, William Glackens, and Everett Shinn. Bellows was considerably younger than these men and did not participate in the 1908 exhibition of the Eight that brought them to prominence. Still, some of his youthful works—urban scenes such as *The Lone Tenement* and *Both Members of This Club* (both 1909, National Gallery of Art, Washington, D.C.)—are among the most artistically mature and profoundly expressive examples of the social consciousness of the Ashcan school.

Bellows was born in Columbus, Ohio, where his father was a building contractor, a Republican, and a practicing Methodist. Bellows attended but did not graduate from Ohio State University, where he was remembered as an athlete and an illustrator for the school newspaper. It seems that Joseph Russell Taylor, a young professor of English and an amateur painter, encouraged Bellows's artistic aspirations. In 1904 Bellows left Ohio for New York. There he played semiprofessional baseball and sang in a church choir to supplement the allowance from his father. He enrolled in life classes at the New York School of Art, where he was befriended by Robert Henri, the school's most popular teacher. Henri's considerable influence soon showed in Bellows's work: the young painter took as his subjects New York's streets, docks, building excavations, tenements, and boxing clubs, and heeding Henri's advice to free his style of derivative affectations, he turned

to a dark palette and made his brushwork more vigorous.

Like Henri, Bellows took the stance of an avant-garde artist. He helped organize the Armory Show in 1913, and became involved in the breakaway art organizations then being established: he was founding director of the Society of Independent Artists and a charter member of the Association of American Painters and Sculptors. His political consciousness and sympathy for the plight of the poor led him to join the art staff of the Socialist journal *The Masses*, where he worked from 1912 to 1917 under John Sloan. In 1916 he began working in lithography. He produced some masterful lithographs, including a notable group of prints depicting wartime atrocities, which helped spark a revival of interest in the print medium.

Around 1915 Bellows became concerned with theories of pictorial structure, and his canvases showed increasing evidence of compositional geometry, which tended to undercut the spontaneity and effectiveness of his urban scenes. After World War I, Bellows's continuing interest in human character found its most memorable outlet in numerous portraits of members of his family. His colors became sharper, his themes more eclectic, and the emotionalism of his works more subdued.

Bellows's art always enjoyed critical popularity. In 1909 he became the youngest associate ever elected to the National Academy of Design. From 1908 onward, he contributed to major national exhibitions and received numerous awards—from the National Academy of Design, New York; the Pennsylvania Academy of the Fine Arts, Philadelphia; the Art Institute of Chicago; and Carnegie Institute. He also taught for many years at the Art Students League of New York. In the public mind, he was viewed as a quintessentially American painter because his subject matter was lively, direct, and readily comprehended, and because he had never gone abroad to work or study.

Bellows's relationship with Carnegie Institute began in 1908, when his *Forty-two Kids* (1907, Corcoran Gallery of Art, Washington, D.C.) was exhibited in the institute's annual exhibition. He then contributed to almost every annual exhibition between 1908 and 1925 (when his widow submitted a posthumous entry). He received a bronze medal at the exhibition of 1914, juried at the 1921 exhibition,

and was awarded a gold medal in 1924. The institute also honored him with a solo exhibition of his works in early 1923. Two years later, in New York, the artist suffered a ruptured appendix, which led to his premature death.

Bibliography Emma S. Bellows, *The Paintings of George Bellows* (New York, 1929); "George Wesley Bellows—Painter and Graver," *Index of Twentieth Century Artists* 1 (March 1934), pp. 81–94; Donald Braider, *George Bellows and the Ashcan School of Art* (New York, 1971); Mahonri Sharp Young, *The Paintings of George Bellows* (New York, 1973); Charles H. Morgan, *George Bellows: Painter of America* (1965; reprint, Millwood, N.Y., 1979).

Anne in White, 1920
(Portrait of Anne)

Oil on canvas
57⅞ x 42⅞ in. (147 x 108.9 cm)
Inscription: Anne in White Geo. Bellows (on reverse)

Bellows did many portraits, and he frequently used family members and friends as subjects. He considered his portraits as themes taken from everyday life, like his landscapes, city views, and sporting scenes. "I paint my life," he told an interviewer in 1920.[1]

The years immediately following World War I were particularly productive ones for Bellows, and his artistic reputation was at its height. In this period he discovered Woodstock, New York, home to fellow artist and friend Eugene Speicher. The Speichers' rented house became a regular summer haunt; here the tranquil domestic atmosphere resulted in numerous portraits of Bellows's family, including his wife, Emma; his daughters, Anne, Jean, and Eleanor; his mother; and his Aunt Fanny. Anne Bellows (born in 1911), a quiet, thoughtful child, was the artist's eldest daughter and a favorite model, appearing in a half-dozen portraits between 1917 and 1921, among them *Eleanor, Jean and Anne* (1920, Albright-Knox Art Gallery, Buffalo), painted in the same summer as *Anne in White*.

Anne in White shows the girl of nine seated in a green rocking chair in the darkened interior of the house at Woodstock. Dressed in a simple white

A. Kistler, "We Are What We Are—," *American Magazine of Art* 28 (Oct. 1935), p. 619; J. O'Connor, Jr., "From Our Permanent Collection, *Anne in White* by George Bellows," *Carnegie Magazine* 23 (Oct. 1949), pp. 92–93; R. Brem, "The Real 'Anne in White,'" *Pittsburgh Press*, Sept. 3, 1961, pp. 14–15; Morgan, *George Bellows*, p. 238; Young, *The Paintings of George Bellows*, p. 128; H. Adams, in Museum of Art, Carnegie Institute, *Collection Handbook* (Pittsburgh, 1985), pp. 240–41.

Exhibitions Department of Fine Arts, Carnegie Institute, Pittsburgh, 1921, *Twentieth Annual International Exhibition of Paintings*, no. 17, as *Portrait of Anne*; Montross Gallery, New York, 1921, *Exhibition of Paintings and Drawings by George Bellows*, no. 22, as *Portrait of Anne*; Department of Fine Arts, Carnegie Institute, Pittsburgh, 1923, *An Exhibition of Paintings, Drawings and Lithographs by George W. Bellows*, no. 4; Metropolitan Museum of Art, New York, 1925, *George Bellows Memorial Exhibition*, no. 39; Art Gallery of Toronto, 1926, *The Inaugural Exhibition*, no. 46; Art Gallery of Toronto, 1927, *A Loan Exhibition of Portraits*, no. 5; Nemzeti Salon, Budapest, 1930, *Seventeenth Biennial Exhibition of International Art* (sponsored by the American Federation of Arts and the Hungary Society of America), no cat.; possibly Venice, 1930, *XVII Biennale Internazionale d'Arte Venezia*; M. H. de Young Memorial Museum, San Francisco, 1935, *Exhibition of American Painting*, no. 253; San Diego Museum of Art, 1936, *California Pacific International,* San Francisco, 1939, *Historical Paintings*, no. 1; Portraits, Inc., New York, 1944, *Portraits of Children by American Artists*, no. 6; Art Institute of Chicago, 1946, *George Bellows: Paintings, Drawings, and Prints*, no. 43; Dayton Art Institute, Ohio, 1950, *The Artist and His Family*, no. 2; Columbus Gallery of Fine Arts, Ohio, 1952, *Paintings from the Pittsburgh Collection,* unnumbered; Dallas Museum of Fine Arts, 1955, *Six Centuries of Headdress*, no. 48; Columbus Museum of Art, Ohio, 1957, *Paintings by George Bellows*, no. 48; National Gallery of Art, Washington, D.C., 1957, *George Bellows: A Retrospective Exhibition*, no. 45; Dallas Museum of Fine Arts, 1958, *Famous Paintings and Famous Painters*, no. 9; Oklahoma Art Center, Oklahoma City, 1958–59, *Inaugural Exhibition,* no. 4; Westmoreland County Museum of Art, Greensburg, Pa., 1961, *Founder's Day Exhibition,* unnumbered; Gallery of Modern Art, including the Huntington Hartford Collection, New York, 1966, *George Bellows: Paintings, Drawings, Lithographs*, no. 47; Akron

frock with loosely ruffled sleeves and collar, Anne rests a multicolored Japanese fan in her lap, while her left hand holds a broad-brimmed black hat. Through an open door at the right we see a vibrant summer landscape.

The portraits that Bellows made of his family in the late 1910s and early 1920s regularly showed unsmiling, seemingly apprehensive sitters placed in oddly contrived, often portentous domestic interiors. They are usually roughly painted. Some of the sitters appear to be in costume, and in some of the portraits the coloring is artificially bright. *Anne in White*, while clearly belonging to this group, is a comparatively straightforward image, painted in a rather subdued color scheme of grayed blues and greens, with touches of mauve and rust.

Although Bellows maintained a close relationship with Homer Saint-Gaudens, Carnegie Institute's director of the Department of Fine Arts, his work was not represented in the institute's permanent collection until a few months after his death, when Saint-Gaudens secured *Anne in White* from Emma Bellows, a tireless promoter of her husband's art.
WG, DS

1 G. Bellows, "The Relation of Painting to Architecture," *American Architect* 118 (December 29, 1920), p. 848.

References E. H. Ries, "The Relation of Art to Every-day Things," *Arts and Decoration* 15 (July 1921), p. 158; Bellows, *The Paintings of George Bellows*, no. 100; "George Wesley Bellows," *Index of Twentieth Century Artists*, p. 86;

Art Institute, Ohio, 1971, *Celebrate Ohio,* unnumbered; Mead Art Museum, Amherst College, Mass., 1972, *George Wesley Bellows,* unnumbered.

Provenance The artist, until 1925; his estate, 1925.

Patrons Art Fund, 1925, 25.7

Frank Benson
1862–1951

As one of the American painters who came under the influence of Impressionism in the last decade of the nineteenth century, Frank Weston Benson successfully transformed the Impressionist interest in outdoor light and open brushwork into a refined, elegant, stylish idiom, which remained popular in the United States from the 1890s through the 1930s. His sphere of influence centered around Boston, where his work was most heavily patronized. His sun-dappled portraits, scenery with waterfowl, and landscape etchings in a Japanese manner were well regarded among Boston audiences to the very end of his long career.

Born in 1862 in Salem, Massachusetts, which was also his home at the end of his life, Benson studied at the School of the Museum of Fine Arts in Boston from 1880 to 1883. He spent the years 1883 to 1885 abroad. His travels took him to London and Brittany as well as Paris, where he studied at the Académie Julian under Gustave Boulanger and Jules-Joseph Lefebvre before returning to New England. From 1889 to 1912, then again from 1913 to 1917, and 1928 to 1931, Benson taught at the School of the Museum of Fine Arts in Boston, most of the time alongside Edmund Tarbell, his former classmate and good friend. The two became influential teachers, credited with giving Boston's Museum School national prestige and establishing the city as a center for Impressionist-influenced painting in the early decades of the twentieth century.

Both the more daring and conservative aspects of the American Impressionist movement are reflected in Benson's career. In 1898 he joined several other well-established Boston and New York painters, including Tarbell, Childe Hassam, John Twachtman, J. Alden Weir, and Thomas Dewing, to form a self-styled secessionist group called the Ten American Painters. They withdrew from the Society of American Artists, New York, to protest its resistance to the aesthetics of such artists as the Impressionists and James McNeill Whistler. The Ten exhibited together in nonjuried, Impressionist-style shows until 1919. But in spite of their great interest in French-inspired aesthetics of light, color, and composition, the conventional illusionism the group practiced was, even by 1900, quite far from international avant-garde ideas.

Benson's affiliations and awards show him, in fact, as someone whom the artistic establishment of 1900 held in considerable esteem. He was the recipient of over thirty awards and honors for his work, including prizes from the National Academy of Design, New York, and the Society of American Artists in 1889 and 1896, silver medals at the Paris and Buffalo expositions of 1900 and 1901 respectively, two gold medals at the Universal Exposition, Saint Louis, of 1904, and the Temple Gold Medal at the Pennsylvania Academy of the Fine Arts, Philadelphia, in 1908. Elected academician at the National Academy of Design in 1905, Benson also belonged to the National Institute of Arts and Letters and the American Academy of Arts and Letters.

Like other members of the Ten American Painters, Benson enjoyed the admiration of Carnegie Institute's art director, John Beatty, particularly during the late 1890s and early 1900s. He exhibited thirty-three paintings in Carnegie Internationals from 1896 to 1933, and he contributed to the institute's wartime edition of the International, *Painting in the United States,* in 1943. He was awarded medals in 1899, 1900, and 1903, the last being the Institute's gold medal, which carried a $1,500 cash prize. He served on the jury of award for the Internationals of 1897, 1900, 1901, and 1904; in 1924 the institute presented a solo exhibition of his paintings, watercolors, and etchings.

Bibliography Minna C. Smith, "The Work of Frank W. Benson," *International Studio* 35 (October 1908), pp. 9–106; Charles H. Caffin, "The Art of Frank W. Benson," *Harper's Monthly* 119 (June 1909), pp. 105–14; Charles Lemon Morgan, *Frank W. Benson, N.A.* (New York, 1931); Museum of Fine Arts, Boston, *Frank W. Benson and Edmund Tarbell* (1938), exh. cat. by Lucien Price and Frederick W. Coburn; Patricia Jobe Pierce, *The Ten* (Concord, N.H., 1976), pp. 39–52.

Portrait of a Boy, 1896

Oil on canvas
30 x 26½ in. (76.2 x 67.1 cm)
Signature, date: Frank W. Benson/1896 (upper left)

Benson often used his wife and four children as models in his paintings. Such works were not intended to be viewed as portraits but as quietly evocative images whose subjects would be merely anonymous figures. For this particular painting the model was the artist's son George, then four years old. He is shown half-length and head-on, his hands in his pockets, gazing at the viewer with a gentle, wistful expression. Part of *Portrait of a Boy*'s appeal is the sensuous effect created through the blend of soft surfaces and pastel colors, especially the child's mound of lemon-yellow hair and the aquamarine sailor's jacket, which are set against a background of deep green.

The work has a companion piece of sorts, *Child Sewing* (fig. 1), which is dated a year later and has nearly the same dimensions. It portrays one of Benson's

Fig. 1 Frank Benson, *Child Sewing,* 1897. Oil on canvas, 30¼ x 24 in. (76.8 x 60.9 cm). National Academy of Design, New York

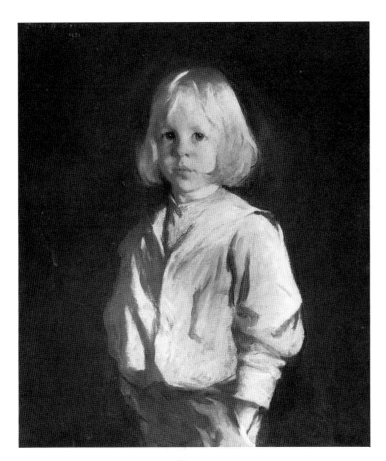

three daughters in a seated profile, which, being cut off just below the waist and set against a dark background like the subject of *Portrait of a Boy*, is whimsically imitative of the portraits of adult gentry from another era. In both works, the figures are broadly but deftly painted, using a pale palette to give the sensation of diffused outdoor light illuminating the figure, even though both are placed against a dark, blank studio backdrop.

Studio-posed figures of this sort recall the work of John Singer Sargent or William Merritt Chase, except that the colors here are clearer and lighter, and the general effect is somewhat fresher and more chromatic. Benson's dappled light falling over an isolated figure seems also to present a quieter mood, similar to the one Edmund Tarbell created for his figure compositions of the mid- and late 1890s, but it is hardly one the French Impressionists would have employed.

Portrait of a Boy indicates that Benson relied on non-Impressionist pictorial formulas. He continued to appreciate the drama of studio staging, artificially empty backgrounds, and sharp contrasts of light and dark, and in fact never became bound to a strict plein-air approach. Even though he took care to restrain his narratives, and to make the mood of his paintings subdued and rather sober, Benson

continued to rely on sentiment as the connective tissue between picture and audience. Indeed, such sentiment contributes in a large part to *Portrait of a Boy*'s charm.

This work was shown along with three other paintings by Benson in the 1897 Carnegie International; toward the end of the exhibition, it was purchased for Carnegie Institute's collection. In 1900 the trustees retroactively awarded the painting a chronological medal representing the year 1897.

DS

Reference J. O'Connor, Jr., "From Our Permanent Collection, *Portrait of a Boy*," *Carnegie Magazine* 25 (Nov. 1951), pp. 311, 318.

Exhibitions Department of Fine Arts, Carnegie Institute, Pittsburgh, 1897–98, *Second Annual Exhibition*, no. 17; Albright Art Gallery, Buffalo, 1920, *Fourteenth Annual Exhibition of Selected Paintings by American Artists and a Group of Small Selected Bronzes by American Sculptors*, no. 8; Butler Art Institute, Youngstown, Ohio, 1921, *Exhibition of American Paintings*, no. 4; Corcoran Gallery of Art, Washington, D.C., 1921, *Paintings, Etchings, and Drawings by Frank W. Benson*, no. 9; Akron Art Institute, Ohio, 1924, *Paintings,*

Watercolors and Etchings by Frank W. Benson, no. 20; Department of Fine Arts, Carnegie Institute, Pittsburgh, 1924, *Frank W. Benson,* no. 24; California Palace of the Legion of Honor, San Francisco, 1926, *First Exhibition of Selected Paintings by American Artists,* no. 11; Art Gallery of Toronto, 1927, *A Loan Exhibition of Portraits,* no. 6; Museum of Fine Arts, Boston, 1938, *Exhibition of the Work of Frank W. Benson and the Late Edmund C. Tarbell,* no. 2.

Provenance The artist, until 1898.

Purchase, 1898, 97.5

Thomas Hart Benton
1889–1975

THOMAS HART BENTON was born in the small town of Neosho, Missouri, a son of Maecenas E. Benton, United States attorney for western Missouri under Grover Cleveland who served in the House of Representatives from 1897 to 1905. While he was still in his teens, Benton worked as a cartoonist for the *Joplin American*. Having decided to become a newspaper illustrator, he enrolled at the School of the Art Institute of Chicago in 1907. There Benton's artistic interests quickly expanded to include painting. Even though he was not yet twenty years old, he convinced his family to send him to Paris in 1908, where he lived until 1911. After only a few months at the conservative Académie Julian, he began to experiment independently with a wide range of styles, from Neo-Impressionism to Cubism. He also studied the Renaissance and Baroque masters who were later to influence his mature style.

Benton continued his experiments with avant-garde styles after settling in New York in 1912. For a time he affiliated himself with the artistic circle of Alfred Stieglitz and painted a number of Synchromist works under the influence of his friend Stanton Macdonald-Wright. By 1920, however, he had rejected modernism; he devoted himself instead to "returning painting to its historic representational purpose and... to making it represent matter drawn from American life and meaningful to those living that life."[1] He specialized in rhythmic, boldly modeled figural compositions inspired by everyday life and popular history.

Rural themes appealed to him most, and in 1925 he began a series of summer sketching tours through the South and Midwest. In 1935, having tired of what he considered to be New York's narrow intellectualism, he moved to Kansas City, Missouri, and became director of painting at the local art institute.

Along with such like-minded artists as Grant Wood and John Steuart Curry, Benton achieved national fame in the 1930s. His penchant for controversy kept him in the public eye, though it cost him his position at the Kansas City Art Institute in 1941, following a published statement that he would rather exhibit in saloons and brothels than in museums. On the strength of his work of the 1930s and 1940s, Benton's name became virtually synonymous with the idea of creating an indigenously American style representative of the common man in America, in reaction to international modernism.

Benton's easel paintings were widely exhibited and influential, but his best-known works were his mural projects. These include *The Arts of Life in America* for the library of the Whitney Museum of American Art, New York (1932, now in the New Britain Museum of American Art, Conn.), *City Scenes* and *City with Subway* (1930, New School for Social Research, New York), and *A Social History of the State of Missouri* for the Missouri State Capitol (1935, Jefferson City). Although Benton described himself as returning to realism, these murals retain some of modernism's linear distortions, and the subjects have a largely mythic quality.

Benton's work appeared in every Carnegie International from 1931 to 1939 and in all the annual *Painting in the United States* exhibitions, which replaced the International from 1943 to 1949. *The Music Lesson* (1943, collection Mrs. Fred Chase Koch, Wichita, Kans.) won the popular prize for 1945. His work did not appear at the Internationals of the 1950s and 1960s, however, for during these decades most critics considered Benton provincial and outmoded.

Benton, in turn, condemned Abstract Expressionism, even that of his former friend and student Jackson Pollock, as "good for nothing but to release neurotic tensions."[2] Feeling out of touch with contemporary American life, he painted mainly still lifes, landscapes, portraits, and historical subjects. Despite a decline in critical favor, his work continued to

sell, and he received some important mural commissions, including *Independence and the Opening of the West* (1959–62) for the Truman Library, Independence, Missouri. In January 1975, a few hours after completing the mural *The Sources of Country Music* for the Nashville Music Foundation, he died in his Kansas City studio.

1 Thomas Hart Benton, *An American in Art* (Lawrence, Kans., 1969), p. 154.

2 Ibid., p. 186.

Bibliography Thomas Hart Benton, *An Artist in America* (1937; rev. ed. Columbia, Mo., 1983); Thomas Hart Benton, *An American in Art: A Professional and Technical Autobiography* (Lawrence, Kans., 1969); Matthew Baigell, *Thomas Hart Benton* (New York, 1973); Polly Burroughs, *Thomas Hart Benton: A Portrait* (Garden City, N.Y., 1981); Henry Adams, *Thomas Hart Benton* (New York, 1989).

Conversation, c. 1936

Oil on Masonite
24 x 27⅞ in. (61 x 70.8 cm)
Signature: *Benton* (lower right)

The shacks of black sharecroppers figure repeatedly in Benton's autobiography *An Artist in America* of 1937, particularly in the descriptions of his travels down the Mississippi and through Georgia. This dilapidated, white clapboard shack with two women in conversation on its porch is much like the sharecroppers' houses

that he sketched in his book. The same shacks subsequently appeared in the backgrounds of paintings depicting southern black farmers at harvest, notably *Roasting Ears* (1938–39, Metropolitan Museum of Art, New York) and *Weighing Cotton* (1939, private collection, Washington, D.C.).

The fate of southern tenant farmers and sharecroppers, black and white, impressed Benton as "one of the major sores of our civilization":

> For years in the back roads of the South I have come across the croppers and tenants sitting listlessly around their shacks. These slaves of an outmoded land system live a dull existence broken only by shouting camp meetings and for the whites by the occasional hullabaloo of a lynching party in which race hatreds and economic jealousies find awful satisfactions.[1]

KN

1 Thomas Hart Benton, *An Artist in America* (New York, 1937), p. 192.

Remarks In the 1930s Benton, like other painters of the time, had become interested in painting on panel with thin pigments, perhaps in emulation of the Flemish and Italian fifteenth–century "primitives." Here, he used a Masonite panel prepared with gesso as the support for a medium primarily of oil (at times he used tempera mixed or glazed with oil). The incompatibility of the paint and prepared panel has caused considerable flaking of the paint surface.

Exhibition Department of Fine Arts, Carnegie Institute, Pittsburgh, The *1936 International Exhibition of Paintings*, no. 58.

Provenance The artist, until 1936; Charles J. Rosenbloom, Pittsburgh, until 1974.

Bequest of Charles J. Rosenbloom, 1974, 74.7.1

Plantation Road, 1944–45

Oil and tempera on canvas mounted on plywood
28½ x 39⅜ in. (72.4 x 100 cm)
Signature, date: *Benton '44* (lower right)
Inscription: painted 1945 (on reverse)

During the early 1940s Benton created posters and paintings to promote America's war effort, though he eventually concluded that he could not deal with the war in a meaningful way and reverted to his familiar themes of rural life and labor. *Plantation Road,* painted in 1944–45 and exhibited at Carnegie Institute in 1946, dates from this period of his career. It depicts two young black workers loading cotton onto a mule-drawn wagon. Benton, though deeply

concerned with the plight of poor southern blacks and the threat that large mechanized cotton plantations posed to their livelihood, handled the subject with the reportorial objectivity that sets him apart from the openly didactic Social Realists of the 1930s. "My art," he wrote in the late 1960s, "was dedicated to a realistic representation of the American people and to the American social scene *as it was,* rather than to propagating ideas about how it should be." [1]

Two oil studies survive for *Plantation Road,* which differ from the final picture only in minor details. A small, rather summary sketch on paper (collection Mrs. Winter, Kansas City, Mo.) omits the telegraph poles. A larger, more finished sketch (1944, collection A. J. Singer, Manhasset Hills, N.Y.) includes a single pole at the left, replaces the clump of trees at the far right with a house, and omits the laborers in the background. The latter sketch originally belonged to the artist Arshile Gorky, who acquired it from Benton in 1946.

KN

1 Benton, *An American in Art,* p. 170.

References "Chicago Views Benton, The Midwest Dickens," *Art Digest* 20 (Mar. 1, 1946), p. 14; [J. O'Connor, Jr.,] "Benton's Plantation Road," *Carnegie Magazine* 20 (Jan.-Feb. 1947), pp. 195–96; "When American Artists Came Home," *Toledo Blade,* pictorial sec., Jan. 19, 1958, p. 16.

Exhibitions Department of Fine Arts, Carnegie Institute, Pittsburgh, 1946, *Painting in the United States,* no. 221; Columbus Museum of Art, Ohio, 1952, *Paintings from the Pittsburgh Collection,* no cat.; Miami University, Oxford, Ohio, 1959, *The American Scene in One Hundred Fifty Years of American Art,* no cat.; Bowdoin College Museum of Art, Brunswick, Me., 1964, *The Portrayal of the Negro in American Painting,* no. 69; Walters Art Gallery, Baltimore, 1980, *African Image,* no cat.

Provenance The artist, until 1946.

Patrons Art Fund, 1946, 46.22

Charles Biederman

born 1906

Born of Czech parents in Cleveland, Ohio, Charles Biederman developed his early knowledge of the history of art by frequent visits to the Cleveland Museum of Art. At the age of sixteen he worked as an apprentice in a commercial-art studio and from 1926 to 1929 was a student at the Art Institute of Chicago. During the early 1930s he remained in Chicago, where he painted in the manner of Paul Cézanne and became interested in Post-Impressionism, Cubism, and abstraction.

In September 1934 Biederman moved to New York and for the first time saw original works of the Cubists, Joan Miró, and Piet Mondrian. In 1935 he began work on a series of reliefs, some of which used geometric designs and others string, nails, and tacks. He participated in several exhibitions in 1936, which gave him the opportunity to show his reliefs, paintings, collages, and gouaches. In the same year he also had his first solo exhibition at the Pierre Matisse Gallery in New York. Simultaneously, the landmark show *Cubism and Abstract Art* opened at the Museum of Modern Art, New York. After seeing the exhibition Biederman began to feel that Europe was more sympathetic to artistic innovation and decided to move to France.

In Paris from October 1936 to June 1937, the artist met Mondrian, Fernand Léger, Antoine Pevsner, Jean Arp, Miró, Constantin Brancusi, Georges Vantongerloo, and César Domela. Of these, he found the painting style of Léger most closely akin to his own. But the abstract shapes Biederman painted on canvas seemed so three-dimensional that Christian Zervos, the art critic and founder of the influential Paris journal *Cahiers d'art*, called them not paintings but sculptures.[1]

After Biederman returned to the United States in 1937, the pronounced illusion of volume in his paintings no longer yielded the result he desired. So, using the methods of the Constructivists and the ideas of the de Stijl painters, he chose instead to create three-dimensional geometric reliefs that were neither painting nor sculpture but a structurally creative extension of both.[2]

Having married Mary Katherine Moore and returned to Chicago in 1940, Biederman took an apartment at the edge of a city park and began to incorporate elements of nature into his art. Following Cézanne's example, he sought solutions not merely through the visual study of nature but also through the re-creation of nature's structural processes. After the outbreak of World War II, he moved to Red Wing, Minnesota, where he worked on a wartime army medical project, and where he has resided since.

Once Biederman resumed his art career after the war, he grew closer and closer to nature, developing a creative theory and method he called structurism. He used this term to describe his own work from the 1930s onward. His brightly colored abstract reliefs attempt to synthesize qualities of painting, sculpture, and architecture and, according to Biederman, are created in accordance with the structural processes of nature. Rejecting Mondrian's viewpoint that the spirit is superior to nature, he continued to embrace the belief that nature and its structural processes gave abstract art its sustenance.

Like many of the New York–based artists who were oriented toward European abstraction, Biederman had little contact with Carnegie Institute during the 1930s and 1940s. The first appearance of his work there was in the 1964 Carnegie International, where he exhibited a structurist relief.

1 Minneapolis Institute of Arts, *Charles Biederman*, p. 16.

2 Ibid., p. 51.

Bibliography Charles Biederman, *Art as the Evolution of Visual Knowledge* (Red Wing, Minn., 1948); Stephen Bann, "The Centrality of Charles Biederman," *Studio International* 178 (September 1969), pp. 71–74; Minneapolis Institute of Arts, *Charles Biederman: A Retrospective* (1976), exh. cat., introduction by Gregory Hedberg, essays by Leif Sjoberg and Jan van der Marck; Jan van der Marck, "Charles Biederman," in Museum of Art, Carnegie Institute, Pittsburgh, *Abstract Painting and Sculpture in America, 1927–1944* (1983), exh. cat. ed. by John R. Lane and Susan C. Larsen, pp. 48–50.

No. 11, New York, 1939–40, 1939–40

Painted wood and glass
36⁹⁄₁₆ x 29¾ x 2¾ in. (92.9 x 75.6 x 7 cm) overall

Inscription: *MADE IN U.S.A./ALL RIGHTS RESERVED/Charles Biederman #11/1939–40/ ©COPYRIGHT CHARLES BIEDERMAN 1978* (in artist's hand on reverse)

The reliefs that Biederman created in the late 1930s and early 1940s are among the most sophisticated American responses to the art of the Russian Constructivists. Biederman has frequently and too modestly stated that these works represent just one stage in the growth of his understanding of modernism. They are, in fact, a significant American contribution to the international revolution in sculpture that began with Synthetic Cubism in painting and continued with the three-dimensional innovations of Constructivism. Constructivist sculptures were not carved or modeled but assembled out of wood, metal, paper, glass, or modern industrial materials. The assemblage of these materials created rather than displaced space.

The influence of this experimentalism can be seen in Biederman's relief *No. 11, New York, 1939–40*. Drawing on Constructivist devices, the artist set a transparent plane—a pane of glass with five vertical stripes painted on its surface—in front of a louverlike painted wood relief. Yet he used ideas taken from Neoplasticism in painting as well. Specifically, he adopted Piet Mondrian's disciplined adherence to the right angle and primary colors (the work is in blue, yellow, black, white, and gray).

While he relied on a European modernist vocabulary, Biederman employed it with uncommon elegance and lucidity. He has described his exploration of the ideas of the Constructivists and the members of de Stijl, and his incorporation of those ideas into his reliefs, in a recent letter:

> When I left Paris June 1937 I carried back with me the influences of de Stijl and Constructivism, and it was in the subsequent period in which falls the 39–40 work in your [Carnegie] museum. That work was largely influenced by Mondrian. . . .The most important disparaty I felt was, that the Dutch were in the direction of a correct way

to a non-mimetic form of art while the Russians had adopted the correct medium, the machine, as appropriate for a new art. After Paris I ceased painting, considering that medium obsolete.[1]

The results of Biederman's use of two distinct art movements were not only original but also characteristic of a creative personality whose life, aesthetic thought, and art have been strongly individualistic.

JRL

1 Charles Biederman to John R. Lane, August 20, 1984, museum files, The Carnegie Museum of Art, Pittsburgh.

References Biederman, *Art as the Evolution of Visual Knowledge*, p. 604; J. R. Lane, "American Abstract Art of the '30s and '40s," *Carnegie Magazine* 56 (Sept.–Oct. 1983), p. 18; J. R. Lane, in Museum of Art, Carnegie Institute, *Collection Handbook* (Pittsburgh, 1985), pp. 258–59.

Exhibitions Museum of Art, Carnegie Institute, Pittsburgh, 1983–84, *Abstract Painting and Sculpture in America, 1927–1944* (trav. exh.), exh. cat. ed. by J. R. Lane and S. C. Larsen, no. 42; Brooklyn Museum, N.Y., 1986–87, *The Machine Age in America, 1918–1941* (trav. exh.), exh. cat. by R. G. Wilson et al, unnumbered.

Provenance The artist, until 1982; Grace Borgenicht Gallery, New York, 1982.

Edith H. Fisher Fund, 1982, 82.24

See Color Plate 31.

Albert Bierstadt
1830–1902

ALTHOUGH NOT THE FIRST artist to record the American West on canvas, Albert Bierstadt is the painter who gained the most fame and fortune for doing so. His paintings portrayed a spectacular, idealized, unspoiled wilderness, a West that was in reality rapidly vanishing under the onslaught of farmers, ranchers, and railroads.

Bierstadt was born in Solingen, Germany, but at the age of two he immigrated with his family to New Bedford, Massachusetts. By the time he was twenty, he was advertising himself as a painting instructor in New Bedford. He exhibited locally and in Boston, then in 1853 he went to Düsseldorf to study art. He did not formally enroll at the academy there, but shared a studio with the landscape painter Worthington Whittredge. Bierstadt became acquainted with the works of the German landscapists Carl Friedrich Lessing and Andreas Achenbach; under their influence, he developed the technique he used throughout his career—preparing myriad studies on sketching trips that he later developed into highly finished paintings in the studio.

Bierstadt left Düsseldorf in the summer of 1856, and after touring Germany and Switzerland he went to Italy, where he remained for nearly a year, painting with Whittredge and other American artists. He returned to New Bedford, Massachusetts, in 1857. The following year, his works were first shown at the National Academy of Design, New York.

Bierstadt's first trip west in April 1859 had major significance for his art. Traveling with a railroad survey team, he was struck by the artistic possibilities presented by the wide-open western spaces. He returned east that fall, moved to New York City, and opened a studio in the Tenth Street Studio Building. Here Bierstadt painted his first western panoramas, which were based on sketches and stereoscopic views. His works fired the imagination of the public, gained him

membership in the National Academy, and established his reputation nationally.

After a second trip west in 1863 and the exhibition of *Rocky Mountains* (1863, Metropolitan Museum of Art, New York) at New York's Metropolitan Fair of 1864, Bierstadt vied with Frederic E. Church as the preeminent American landscape painter. The size and craftsmanship of his paintings were considered a metaphor for the quantity and quality of America's natural resources. It became fashionable for wealthy clients to commission Rocky Mountain pictures, and Bierstadt thereby achieved tremendous financial success.

In 1867 Bierstadt again traveled to Europe, where he and his wife remained for two years. Socializing with Europe's elite, he received honors from the French and Russian governments, and his works were eagerly purchased by wealthy patrons. But the peak of his phenomenal success was passing. After his return to the United States in 1869, American critics began to compare Bierstadt's grandly conceived canvases unfavorably with the smaller, more intimate works of the French Barbizon painters. They found his landscapes devoid of emotional content and too sensational in their exaggeration of natural elements, although his work continued to be admired by the general public.

In 1871 he returned to the West for a two-year stay. He built a studio in San Francisco and made extensive sketching trips, including a trip to Yosemite with the photographer Eadweard Muybridge in 1872. For the rest of the 1870s, he traveled frequently within the United States, as well as to Canada, Europe, and the Bahamas.

In 1882 Bierstadt's mansion on the Hudson River burned and many of his paintings were destroyed. His landscapes began to be turned down for exhibitions, which ultimately included the Paris Exposition Universelle of 1889 and the World's Columbian Exposition in Chicago four years later. In 1893 his wife died, and shortly thereafter the artist declared personal bankruptcy. Although his economic circumstances were improved by his 1894 remarriage to a wealthy banker's widow, he never managed to recover his prestige as an artist. He died, largely forgotten, in New York City.

Bibliography Henry T. Tuckerman, *Book of the Artists: American Artist Life* (New York, 1867), pp. 387–97; Richard S. Trump, "Life and Works of Albert Bierstadt," Ph.D. diss., Ohio State University, 1963; Santa Barbara Museum of Art, Calif., *Albert Bierstadt, 1830–1902* (1964), exh. cat. by Thomas W. Leavitt; Gordon Hendricks, *Albert Bierstadt, Painter of the American West* (New York, 1974); Matthew Baigell, *Albert Bierstadt* (New York, 1981).

Farallon Island, 1887
(Farallone Islands off Coast of California)

Oil on canvas
34⅝ x 52⅜ in. (87.9 x 133 cm)
Signature: ABierstadt (lower left)

Between 1871 and 1873, Bierstadt lived and worked in California. In the spring of 1872 he visited the barren, relatively inaccessible Farallon Islands, situated twenty miles west of San Francisco. He probably stayed with the lighthouse keeper, his family, and assistants, who, apart from the seals and sea birds, were the islands' only inhabitants.

He produced a number of oil sketches during his visit, including *Farallon Islands* (1872, The Fine Arts Museums of San Francisco) and *Seal Rocks, Farallones* (1872, Museum of Fine Arts, Boston). These sketches are fresh, objective, and freely painted. They provided the raw material for at least six oil paintings, all highly artificial studio compositions displaying the hard, dry facture associated with Bierstadt's finished work. The Carnegie painting, the last of the large Farallon Islands canvases, shares similarities with all of them: jagged rocks, pummeling waves, and sporting seals. The most closely related work is *Seals on the Rocks* (fig. 1); the compositions are virtually identical except for the addition of birds in the 1887 version.

The overall impression of *Farallon Island* is one of powerful energy and ceaseless motion. Land and sea seem locked in elemental combat as a foaming wave is poised to crash against Murr Bridge, a bizarre natural rock formation. In the midst of this conflict, myriad seals and sea birds cavort unconcernedly, evidently at home in this severe environment.

Bierstadt had routinely exaggerated striking landscape elements in his earlier paintings to heighten their dramatic

effect, but in *Farallon Island* exaggeration is carried to new extremes in the elongated bridge and the fanciful mountain. The result is artificial and unbelievable; theatrical presentation has completely overwhelmed nature. The painting is most successful in portraying the translucence of ocean water and the volatility of coastal air.

Another difference from his earlier works is the increased emphasis placed on genre elements. Although his landscapes had often contained humans or animals in spontaneous poses, previously these were minor intrusions in a vast, undisturbed panorama. Here, a vignette of seals eating, swimming, and playing vies with the landscape itself for the viewer's attention.

The difficulty that Bierstadt experienced in selling *Farallon Island* is partly a measure of the extent to which his popularity had waned by the late 1880s. A decade earlier, during the artist's heyday, the department-store magnate and noted collector A. T. Stewart had snapped up *Seal Rocks, San Francisco* (c. 1872, Hirschl and Adler Galleries, New York), and Bierstadt may have hoped to repeat this success with a very similar painting. Shortly after completing the work in July 1887, he wrote to Alphonso Taft of Cincinnati (father of the future President William Howard Taft), enclosing a photograph of the painting and offering to sell it to a friend of Taft for $3,500. "I do not recall any picture of importance of mine in your city," he wrote, "and would appreciate highly having this one there as it is a good gallery picture."[1] Taft's friend apparently did not agree.

In December 1887 the painting appeared at the monthly exhibition of New York's Union League Club. An anonymous reviewer for the *Art Amateur* found the exhibition as a whole "very

Fig. 1 Albert Bierstadt, *Seals on the Rocks*, c. 1873. Oil on canvas, 30 x 44 in. (76.2 x 111.7 cm). Hirschl and Adler Galleries, New York

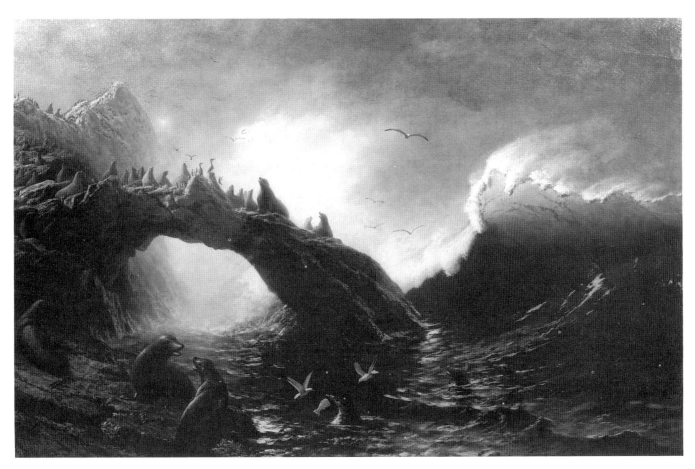

gratifying," above all the landscapes, but observed that "Albert Bierstadt's coarse painting of disporting seals on 'Farallon Island' and F. E. Church's gaudy 'Tropical Landscape' were interesting as examples of the dreadful things which were considered good art less than a generation ago."[2] Bierstadt failed to find a buyer in New York and had no better luck at the Jacksonville, Florida, Sub-Tropical Exposition in early 1888. *Farallon Island* eventually found a home with Brainard H. Warner, a Washington, D.C., banker. William Corcoran, founder of the Corcoran Gallery of Art, Washington, D.C., and a strong supporter of Bierstadt, probably persuaded his friend Warner to purchase the painting as a service to the artist.

RB, KN

1 Albert Bierstadt, New York, to Alphonso Taft, Cincinnati, July 18, 1887, William H. Taft Presidential Papers, Library of Congress, Washington, D.C.

2 Montezuma (pseud.), "My Note Book," *Art Amateur* 18 (January 1888), p. 28.

References Albert Bierstadt, New York, to Alphonso Taft, Cincinnati, July 18, 1887, William H. Taft Presidential Papers, Library of Congress, Washington, D.C.; Montezuma (pseud.), "My Note Book," *Art Amateur* 18 (Jan. 1888), p. 28; H. B. Teilman, "Recent Acquisitions, Museum of Art," *Carnegie Magazine* 47 (Oct. 1973), p. 343; D. Miller, "The Phenomenal Growth of the Carnegie Collection," *Art News* 72 (Nov. 1973), p. 42; G. Hendricks, *Albert Bierstadt*, p. 217; D. G. Wilkins, "The American Painting Collection at the Sarah Scaife Gallery, Carnegie Institute, Pittsburgh," *American Art Review* 2 (Mar.–Apr. 1975), pp. 97–98; Hirschl and Adler Galleries, New York, *Lines of Different Character: American Art from 1727–1947* (1983), p. 48.

Exhibitions Union League Club, New York, 1887, *December Exhibition*, unnumbered; Jacksonville, Fla., 1888, *Sub-Tropical Exposition*, no. 91, as *Farallone Islands off Coast of California*; Corcoran Gallery of Art, Washington, D.C., 1972, *A Bierstadt* (trav. exh.), unnumbered.

Provenance Brainard H. Warner, Washington, D.C., c. 1888; his daughter, Mary Warner Cooke, Washington, D.C., 1916; her daughters, Virginia Parker Cooke Woodward and Mary Warner Cooke Jones, Washington, D.C., 1970 (sale, Sotheby Parke Bernet, New York, 1973, no. 3498).

Acquired through the generosity of the Sarah Mellon Scaife family, 1973, 73.13

George Caleb Bingham
1811–1879

FEW WOULD ARGUE that George Caleb Bingham was the recorder and interpreter par excellence of nineteenth-century American frontier life. He is one of the genre painters whose work, to twentieth-century eyes, came to embody the attributes of a truly native style. He was born in Augusta County, Virginia, but while he was still a boy, his family moved to the frontier town of Franklin, Missouri. There his father became a relatively prominent citizen—he owned a tobacco factory, operated a tavern, and was involved in politics. When Bingham's father died, the family moved to Arrow Rock, Saline County, Missouri.

Between 1827 and 1828, while Bingham was apprenticed to a cabinetmaker in Booneville, he became interested in painting. His first efforts were shop signs, but by 1833 portraiture was his means of livelihood and would continue to be for most of his life. By the time of his marriage in 1836, Bingham, through much itinerant work, was painting the leading citizens of Missouri and Mississippi.

A turning point in his career was a three-month visit in 1838 to Philadelphia. The opportunity to study at the Pennsylvania Academy of the Fine Arts introduced him to the old masters and allowed him to broaden his knowledge of contemporary American art. He was affected by the work of Gilbert Stuart, Thomas Sully, and William Sidney Mount, whose genre scenes particularly impressed him, perhaps because their subjects recalled his own home environment.

In Philadelphia, Bingham drew from casts of antique sculpture, acquired prints after Hogarth and others, purchased "gift books" that contained reproduction engravings after various artists, and consulted instruction manuals of drawing and painting. By visiting art dealers, galleries, and exhibitions (including the 1838 show of the Artists' Fund Society of Philadelphia), Bingham obtained a feeling for color and perspective and demonstrated less rigid modeling and more harmonious figure-ground relationships, all of which had so far been unresolved in his work. Bingham's subsequent painting showed marked improvement as a result of this informal training, and the time in Philadelphia also made him aware of the Easterner's appetite for scenes of frontier life.

Between 1841 and 1844, Bingham was in Washington, D.C., painting portraits (John Quincy Adams was one of his sitters), but his interest in genre painting had developed sufficiently that in 1844 he began to record seriously the life around the Missouri and Mississippi rivers. This fondness for scenes of fur traders, boatmen, and electioneers lasted for the next ten years. These paintings became well known in the East, having been engraved and distributed in connection with the lotteries of the American Art-Union in New York, and works such as *Fur Traders Descending the Missouri* (1845, Metropolitan Museum of Art, New York) and *The Jolly Flatboatmen* (1846, Saint Louis Art Museum) are the basis of Bingham's reputation today.

Bingham's character types and his simplified, geometric compositions gradually became more sophisticated, but they continued to display the idiosyncrasies of a largely self-taught artist. However, many of those qualities disappeared after his late 1850s trips to Düsseldorf, where his assimilation of academicism revealed itself in more ambitious works, in more fluid

figure groupings, and in more successful attempts to convey atmosphere. None of the historical portraits, which were the primary reason for Bingham's travel to Düsseldorf, exists today, but it is generally felt that the Düsseldorf canvases lack the freshness of his earlier works.

In his later years Bingham became politically active: he was elected to the Missouri legislature in 1848, was state treasurer in 1862, and became president of the Kansas City Board of Police Commissioners in 1874. In 1877 he became professor of art at the University of Missouri. He died in Kansas City.

Bibliography Fern Helen Rusk, *George Caleb Bingham: The Missouri Artist* (Jefferson City, Mo., 1917); John Francis McDermott, *George Caleb Bingham: River Portraitist* (Norman, Okla., 1959); E. Maurice Bloch, *George Caleb Bingham: The Evolution of an Artist,* 2 vols. (Berkeley, 1967); Albert Christ-Janer, *George Caleb Bingham: Frontier Painter of Missouri* (New York, 1975); E. Maurice Bloch, *The Paintings of George Caleb Bingham: A Catalogue Raisonné* (Columbia, Mo., 1986).

Colonel Thomas Miller, c. 1834

Oil on canvas on wood panel
27⅞ x 22⅞ in. (70.8 x 58.1 cm)

This likeness of Thomas Miller (1811–1841), first president of Columbia College (now the University of Missouri),

is one of Bingham's earliest extant portraits. The sitter was born in Hopewell Township in Washington County, Pennsylvania, where he attended Washington College (now Washington and Jefferson University); he graduated from Indiana University in 1831. In 1833 he received a law degree from Transylvania University in Lexington, Kentucky, where he afterward taught. Miller probably had his portrait painted by Bingham soon after arriving in Missouri in 1834 to begin his two-year presidency of Columbia College.

The portrait commission was apparently arranged by Major James Sidney Rollins, a Columbia lawyer who became Bingham's first patron and lifelong friend. He met Bingham soon after the artist arrived in Columbia and helped him establish a studio and find his first clients, including Miller. Rollins was also thought to be instrumental in securing the Columbia College presidency for Miller, who was his close friend and former classmate.[1] The friendship among Bingham, Rollins, and Miller is confirmed in two documents that are pasted to the back of this portrait. The first is a "true copy" of a letter from Rollins to the nephew of Thomas Miller:

I was present and saw it [the portrait] painted by the mutual friend of your uncle [Thomas Miller] and myself Genl. Geo. C.

Bingham, a man of great ability and splendid genius. . . . I have a miniature portrait of your Uncle Thomas painted also by Genl. Bingham, a splendid likeness, and presented to me, by Mr. Bingham, which I prize very highly and could not think of parting with it.[2]

The miniature mentioned by Rollins, dated 1837, is now in the collection of the State Historical Society of Missouri, Columbia.

The second document is a small piece of wood—apparently a fragment of the original stretcher—with an inscription signed by Rollins and evidently in his own hand. It reads:

To Miller—friend of my early days
None saw thee but to love thee
None knew thee but to praise!

The undated inscription may have been written after Miller's premature death in 1841, as it is a close paraphrase of a memorial poem by Fitz-Greene Halleck, "On the Death of Joseph Rodman Drake." It is also possible that Rollins inscribed it soon after the portrait was painted, referring to the friendship of their bygone school days.

Colonel Miller's portrait belongs to the earliest period of Bingham's portrait painting, when he neither signed nor dated his work. He relied on a limited repertoire of pictorial devices that made most of his portraits look alike: a bust-length format, a three-quarter view of the head, seen against a virtually flat, thinly painted brown background. Accessories are used sparingly. The undersized crest rail of a klismos-style chair appears along with two personal elements: a stickpin painted with a miniature of a woman's smiling face and the shelf of books at an odd angle in the upper-left-hand corner—the latter to identify Miller as a learned man.

This painting exemplifies a use of color that was characteristic in Bingham's work. Ross Taggart's analysis of Bingham's color may be aptly applied here:

One of the most typical of his chromatic idiosyncrasies is the use of an almost transparent red in the shadows. . . . It is most noticeable in his portraits, whether they were painted as early as 1834, or as late as 1877. This luminous, hot red shadow is most apparent under the nose and around the ears and hands. In strong contrast is the painting of cool, greenish half-lights in the flesh tones. This strange opposition of warm shadows, cool half-lights, and warm highlights fills the color with a vibrant energy and is so personal with Bingham as to amount almost to a signature.[3]

Despite its early date and its standardizations, *Colonel Thomas Miller* reflects surprising technical sureness and a striking feeling for design. The head is firmly and economically drawn. The lines around the mouth, the well-defined cheekbones, the broad bridge of the nose, and the severe, humorless mouth attest to Bingham's ability to record what he saw. Because he refrained from flattering his sitters, they seem to retain better their distinguishing characteristics, which gives strength and immediacy to his early portraits despite their compositional limitations.

MB, RB

1 Bloch, *The Paintings of George Caleb Bingham: A Catalogue Raisonné*, p. 134.

2 Copy of letter from James Sidney Rollins to Julius P. Miller, Office of the Board of Curators, University of the State of Missouri, March 21, 1881, pasted on back of portrait.

3 Ross E. Taggart, "'Canvassing for a Vote' and Some Unpublished Portraits by Bingham," *Art Quarterly* 18 (Autumn 1955), p. 231.

References C. B. Rollins, ed., "Letters of George Caleb Bingham to James S. Rollins," *Missouri Historical Review* 32 (Oct. 1937), p. 8; J. M. Rooney, "George Caleb Bingham," *Carnegie Magazine* 52 (May 1978), pp. 16–19.

Provenance Colonel Thomas Miller, until 1841; unknown collection, Booneville, Mo., 1881; possibly Maj. James Sidney Rollins, Columbia, Mo., by 1881; possibly Julius P. Miller (nephew of Thomas Miller), Columbia, Mo.; Dr. C. J. McNulty, Washington, Pa., by 1937; Washington County Historical Society, Washington, Pa., by 1977.

Howard N. Eavenson Memorial Fund and Director's Discretionary Fund, 1977, 77.39

Daybreak in a Stable, c. 1850–51
(*Cattle at Daybreak: Stable Scene*)

Oil on canvas
18 x 24⅜ in. (45.7 x 61.9 cm)
Signature, date: G. C. Bingham /1851 (lower right, on wheelbarrow)

Although paintings of farm animals in stable interiors were quite popular in America around 1850,[1] *Daybreak in a Stable* is an unusual work for Bingham. It is one of only three known stable scenes by him and the only one with cattle; indeed, interior scenes of any kind are rare among his genre paintings. In such works, Bingham focused his attention on the study of atmospheric effects caused by the juxtaposition of indoor and outdoor lighting.

Bingham treats the subject matter of *Daybreak in a Stable* as though it were a still life. The two cows are illuminated by diffuse yellow sunlight coming through the stable doorway at the left; beyond this we glimpse a nearby cottage. The morning light selectively illuminates each animal—one is cast in shadow, the other is well defined—and makes the forms of their bodies soft and believable. It distinguishes the different textures as it flickers over the hay and accentuates the wood grain of the stable wall. In the simple and stagelike composition, the cows occupy the center of an orderly enclosure formed of parallel horizontals and verticals broken only by the slight angle of a wheelbarrow handle and a board leaning against the doorway. The stillness and intimacy of the arrangement, one animal standing protectively over the other, recall the quiescence of nativity scenes.

As for the specific origin of Bingham's image, he seems to have relied on both life study and prints. A sheet from the Saint Louis Mercantile Library Sketchbook (c. 1844–49)—the largest collection of Bingham's drawings—showing a cow's head and a cow grazing suggests that Bingham placed a certain importance on studies from life. Even so, the cows in *Daybreak in a Stable* repeat exactly the positions of two cows in a Thomas Sidney Cooper lithograph entitled *Studies of Cattle.* The print is reproduced in Cooper's *Groups of Cattle, from Nature* (1839), a book Bingham may have owned.

The location of *Daybreak in a Stable* had been unknown for more than a century before it was given to Carnegie Institute in 1977. Its rediscovery has contributed significantly to our knowledge of Bingham's stable scenes. *Old Field Horse: Stable Scene* (c. 1856, Saint Louis Art Museum) shows an aging horse standing in a stable in a position very similar to that of the standing cow in the Carnegie painting. *Feeding Time* (1849, location unknown) was purchased from Bingham by the Western Art Union of Cincinnati in 1849 and sold to Joseph M. Dana of Athens, Georgia, in December of that year. The September 1849 Western Art

Union *Record* described it as "the interior of a stable, horses tied in their stalls, a groom feeding them, while another sleeps in the sunlight by the door."[2] It seems to have been characterized by a simple naturalism, perhaps much like *Daybreak in a Stable.* These rustic interiors immediately precede a more ambitious phase of Bingham's art in which atmosphere and light became of even greater importance.

Daybreak in a Stable is almost surely the work exhibited in January 1851 at the Philadelphia Art-Union. It is reasonable to assume, however, that the artist began the work sometime in 1850 but did not date it until 1851, when it was exhibited.
MB, RB

1 Bloch, *Evolution of an Artist*, p. 115.

2 Judith McCandless Rooney, "George Caleb Bingham," *Carnegie Magazine* 52 (May 1978), p. 19.

References Philadelphia Art-Union *Reporter* 1 (Jan. 1851), no. 46, p. 58; Philadelphia Art-Union *Reporter* 1 (Feb. 1851), p. 29; McDermott, *George Caleb Bingham: River Portraitist*, pp. 80, 416; Bloch, *George Caleb Bingham: The Evolution of an Artist*, vol. 1, pp. 113, 115, 116, 334, vol. 2, pp. 79–80; J. M. Rooney, "George Caleb Bingham," *Carnegie Magazine* 52 (May 1978), pp. 16–19; Bloch, *The Paintings of George Caleb Bingham: A Catalogue Raisonné*, no. 250.

Exhibition Philadelphia Art-Union, 1851, no. 46.

Provenance Philadelphia Art-Union sale, 1851; Joseph Weir, Philadelphia, 1851; Dr. and Mrs. Robert L. Kirkpatrick, Meadville, Pa., 1957.

Gift of Dr. and Mrs. Robert L. Kirkpatrick, 1977, 77.59

Ralph Albert Blakelock
1847–1919

RALPH ALBERT BLAKELOCK originally intended to follow his father's profession and become a physician. A native of New York, he entered the Free Academy of the City of New York (now City College) in 1864, but after three terms he left and began painting landscapes. He achieved his status as one of America's great artistic visionaries without the benefit of extensive formal training, European study, or, strictly speaking, fluency in more than a limited range of subject types.

Blakelock's brief study at the Cooper Union Art School in New York introduced him to the Hudson River–school style of landscape painting, and his earliest landscapes were correspondingly influenced by the Hudson River school. In 1867 he exhibited his first works at the National Academy of Design, New York. That early production consists of landscape views, which have, despite their literalness, a wild, enigmatic quality prophetic of his later painting.

Between 1869 and 1871 Blakelock traveled through the American West. The trip marked the beginning of a lifelong fascination with wilderness subjects and with the American Indian as emblem of the profound mystery of the wilderness. This western scenery eventually melded with an intimate scale and a personal,

somewhat naive interpretation of the sensual techniques of Barbizon painting to form his mature style.

The subjective, idiosyncratic work he produced from the late 1870s on was not particularly popular with New York critics. Most writers coupled him with Albert P. Ryder and either ignored or condemned his work. In 1884 a reviewer for the *Art Amateur* conceded that both men had "the redeeming element of true poetical feeling and sincerity," but concluded that "their art is a mistake and a needless sacrifice of qualities better than those they attain."[1]

Blakelock's failure to win an audience and the difficulty of supporting a large family on his meager earnings as a painter undermined his sanity: he experienced a mental breakdown in 1891 and was briefly hospitalized. Thereafter, he became increasingly eccentric and suffered from delusions of grandeur. In 1899 he was committed to Long Island State Hospital at Kings Park, New York, then transferred in 1901 to State Hospital, Middletown, New York, where he remained almost continuously until a few months before his death in 1919. Today, the painter's tragic and precarious existence is closely bound in the public mind to the shadowy, melancholy landscapes he created.

Recognition of Blakelock's work arrived only when it was too late for him to reap the benefits. In 1900 he received an honorable mention at the Paris Exposition Universelle, his first and only award. The National Academy of Design made him an associate in 1913 and an academician three years later. His paintings began to sell for extraordinarily high prices: in 1916, at the sale of the Catholina Lambert collection, Edward Drummond Libbey paid twenty thousand dollars for *Brook by Moonlight* (c. 1890, Toledo Museum of Art, Ohio). Forgeries of his work flooded the art market.

Blakelock died at a cottage in the Adirondack Mountains on August 9, 1919—the same day Andrew Carnegie died. This coincidence prompted the *New York Tribune* to observe:

> It is singularly ironic that not one day apart there died one of America's richest men and one who in his frequent moments of delusion believed that he was America's richest man. One was Andrew Carnegie, leaving behind him an inspiring career of success and hundreds of millions for philanthropy, the other was Ralph Blakelock, a penniless

old man . . . his brain strained and disordered, yet leaving a legacy to the world of art that cannot be measured.[2]

1 J. M. T., "The American Artists' Exhibition," *Art Amateur* 11 (July 1884), p. 30.
2 Obituary, *New York Tribune*, August 17, 1919, sec. 7, p. 2.

Bibliography Elliott Daingerfield, "Ralph Albert Blakelock," *Art in America* 2 (December 1913), pp. 55–68, expanded in Elliott Daingerfield, *Ralph Albert Blakelock* (New York, 1914), and reprinted, with changes, in *Art in America* 51 (August 1963), pp. 83–85; Lloyd Goodrich, Blakelock notes, 1946–47, Whitney Museum of American Art Papers, Archives of American Art, Washington, D.C.; Lloyd Goodrich, "Ralph Albert Blakelock, 1847–1919," 1946–47, Frick Art Reference Library, New York, manuscript; Whitney Museum of American Art, New York, *Ralph Albert Blakelock Exhibition* (1947), exh. cat. by Lloyd Goodrich; Sheldon Memorial Art Gallery, University of Nebraska, Lincoln, and New Jersey State Museum, Trenton, *Ralph Albert Blakelock, 1847–1919* (1974), exh. cat. by Norman A. Geske.

Hawley Valley, c. 1883
(A Panoramic View of Hawley, Pa.)

Oil on canvas
14½ x 52½ in. (36.8 x 133.4 cm)
Signature: R. A. Blakelock (lower right, beneath arrowhead)

This painting is a panoramic view of the small town of Hawley in northeastern Pennsylvania. The two-story crenellated building at the right is the mill built in 1880 by Catholina Lambert, a wealthy textile manufacturer and early patron of Blakelock. Although Blakelock's widow stated in 1947 that her husband had visited Hawley in the summer of 1891,[1] the artist's eldest son, Carl, recalled that this visit took place around 1883:

When I was a small boy about six years old (1883) I remember meeting Mr. Lambert in

his office. I was with my father. At that time he asked my father to go to Hawley. We, mother, father and I spent 2 or 3 weeks there.

I remember him painting and sketching and working on a picture showing part of a stone mill, but I do not remember seeing it finished.[2]

He considered the 1891 date unlikely:

I think I would have remembered more about Hawley in 1891 if I had been there then. I would have been fourteen years old. . . . In 1891 there were four other children and I have no recollection of the younger ones being there. . . . I am not positive of 1883 but I know I was a very small boy.[3]

The distinctive landscape features, together with Carl Blakelock's account of the visit to Hawley, suggest that the work was commissioned by Lambert, who would have required the artist to produce a recognizable likeness of the scene to specific dimensions. Blakelock may also have painted a companion piece, for a former employee of the Lambert family recalled having seen "this painting and a companion" hanging in its owners' home in Paterson, New Jersey.[4]

In its technique, *Hawley Valley* is representative of Blakelock's paintings of the 1880s. However, both the elongated format and the relatively objective handling of the subject are somewhat unusual in his works of this period. The ground is richly textured, and the color has been laid over it in thin washes. Details have been drawn over the paint surface in some areas, possibly in pen or pencil.

Landscape: View of a Town, an unsigned ink drawing owned by the University of Nebraska's Sheldon Memorial Art Gallery, Lincoln, appears to be a preparatory study for a portion of *Hawley Valley*.[5] The cluster of buildings in the lower left foreground of the painting occupies the

center of the drawing. The sketch is far more precise and detailed than the finished work. Blakelock may well have made a series of such sketches in Hawley, then assembled them in his studio to produce a complete panoramic view.

LD

1 Whitney Museum of American Art, *Ralph Albert Blakelock*, p. 29.
2 Carl Blakelock to Mrs. Frederick Suydam, February 8, 1957, museum files, The Carnegie Museum of Art, Pittsburgh.
3 Carl Blakelock to Mrs. Frederick Suydam, February 15, 1957, museum files, The Carnegie Museum of Art, Pittsburgh.
4 S. Morton Vose, Vose Galleries of Boston, to Gordon Washburn, Director, Department of Fine Arts, Carnegie Institute, June 12, 1957, museum files, The Carnegie Museum of Art, Pittsburgh.
5 Ink drawing reproduced in Sheldon Memorial Art Gallery, *Ralph Albert Blakelock*, no. 132, p. 97.

Remarks As it exists today, the painting displays considerable damage. Its impastoed surface has been weakened either by cleaning solvents or lining damage. There have been numerous paint losses as well as considerable overpainting—the sky, for example, is virtually overpainted. These alterations are masked by heavy yellow varnish.

References G. B. Washburn, "*Hawley Valley* by Ralph Blakelock," *Carnegie Magazine* 31 (Nov. 1957), pp. 306, 307, 309, 311; Vincent Price, *The Vincent Price Treasury of American Art* (Waukesha, Wis., 1972), p. 172; Sheldon Memorial Art Gallery, *Ralph Albert Blakelock, 1847–1919*, p. 21.

Exhibition Department of Fine Arts, Carnegie Institute, Pittsburgh, 1957–58, *American Classics of the Nineteenth Century* (trav. exh.), no. 85, as *A Panoramic View of Hawley, Pa.*

Provenance Catholina Lambert, Paterson, N.J., until 1922 (sale, Belle Vista auction, Paterson, N.J., 1922); Macbeth Galleries, New York; G. W. Young, New York, by 1923;

Dr. Walter Timme, Cold Spring, N.Y.; Vose Galleries of Boston, by 1957.

Museum purchase: gift of G. David Thompson, 1957, 57.37

Moonlight, c. 1890
(Landscape)

Oil on canvas
16⅜ x 24⅛ in. (41.6 x 61.3 cm)
Signature: R. A. Blakelock (lower left, within arrowhead)

Evocative moonlit landscapes dominated Blakelock's work of the 1880s and 1890s. As a group, these landscapes feature a few simple elements repeated, with variations, from canvas to canvas: a foreground of dark oaks forming decorative arabesques against a bright sky, a body of still water that reflects the light of the full moon, and distant trees and land forms half-dissolved in the atmosphere—all elements

that appear here. In their emphasis on mood, their limited use of color, and their richly textured paint surfaces, these scenes recall in a general way the work of the Barbizon school and its American followers.

Blakelock, however, differed from the Barbizon painters: instead of depicting specific locales, he evolved his images from his imagination. In the case of one painting, *Brook by Moonlight* (c. 1890, Toledo Museum of Art, Ohio), his model, insofar as he had one, was the pattern created by white paint flaking off an old zinc bathtub. In an early appreciation of the artist's work, the painter and critic Elliott Daingerfield wrote that a Blakelock night scene

has nothing to do with fact. It is a dream of the night. The painter's mood is melancholy, his heart is heavy and he looks into the far sky spaces with sadness. Yet the picture is not wholly sad—there is promise, hope even, and music. No moonlight sonata could more perfectly convey the shadowed

mysteries of the night, or suggest the witchery of fairy presence.[1]

Moonlight was among the paintings that Blakelock's patron Catholina Lambert sold at the American Art Association, New York, in 1916 in order to forestall personal bankruptcy. It was indicative of the demand for Blakelock's work that John Beatty, Carnegie Institute's Director of the Department of Fine Arts, went to New York specifically to "see the Lambert collection . . . with special reference to the Blakelocks," asking two of the leading artists of the day, William Merritt Chase and Childe Hassam, to accompany him.[2] Beatty arranged for William Macbeth to act as his agent at the auction and acquired *Moonlight* for $6,300, a sum far

beyond what Blakelock could have expected when he painted it.

LD

1 Daingerfield, "Ralph Albert Blakelock," pp. 67–68.

2 John Beatty to William Merritt Chase, February 19, 1916, Carnegie Institute Papers, Archives of American Art, Washington, D.C.

Remarks The painting exhibits evidence of old retouching and reinforcement, especially in the trunk of the tree, perhaps as a result of cleaning damage.

References E. V. Lucas, "Blakelock and Duveneck," *Ladies Home Journal* 44 (Feb. 1927), p. 28; V. Young, "Out of the Deepening Shadows: The Art of Ralph Albert Blakelock," *Arts* 32 (Oct. 1957), p. 29; D. L. Smith, "Romanticism and the American Tradition," *American Artist* 26 (Mar. 1962), p. 31; Sheldon Memorial Art Gallery, *Ralph Albert Blakelock, 1847–1919* (1974), p. 19, n. 17.

Exhibitions Young's Art Galleries, Chicago, 1916, *An Exhibition of Paintings by R. A. Blakelock and His Daughter Marian Blakelock,* unnumbered; Whitney Museum of American Art, New York, 1938, *A Century of American Landscape Painting, 1800–1900* (trav. exh.), no. 58; Department of Fine Arts, Carnegie Institute, Pittsburgh, 1939, *A Century of American Landscape Painting, 1800–1900,* no. 10; Whitney Museum of American Art, New York, 1947, *Ralph Albert Blakelock Centenary Exhibition,* no. 12, p. 35; Columbus Gallery of Fine Arts, Ohio, 1952, *Paintings from the Pittsburgh Collection,* no cat.; Department of Fine Arts, Carnegie Institute, Pittsburgh, 1957, *American Classics of the Nineteenth Century* (trav. exh.), no. 88; Munson-Williams-Proctor Institute, Utica, N.Y., and Root Art Center, Hamilton College, Clinton, N.Y., 1960, *Nineteenth Century American Painting,* no. 4; Grand Central Art Galleries, New York, 1982, *Tonalism: An American Experience* (trav. exh.), no. 3.

Provenance Catholina Lambert, by 1916 (sale, American Art Association, New York, Feb. 21–24, 1916, ill. as *Landscape*); William Macbeth as agent for Carnegie Institute, 1916.

Purchase, 1916, 16.6

Arnold Blanch
1896–1968

Born in Mantorville, Minnesota, Arnold Blanch attended the Minneapolis School of Art from 1914 to 1916 and the Art Students League in New York from 1916 to 1921. In 1923 he moved with his first wife, Lucille, to the artists' colony at Woodstock, New York, and for the next few years painted local landscapes and monumental, strongly modeled women influenced by Pablo Picasso, Pierre-Auguste Renoir, and his former teacher Kenneth Hayes Miller. He taught at the California School of Fine Arts in San Francisco in 1930–31, the first of many temporary teaching positions, which included the Art Students League and the University of Minnesota. Doris Lee, whom he married in 1941, was one of his pupils.

During the 1930s Blanch became well known as a Social Realist specializing in bitter, occasionally macabre, images of American poverty. A critic compared one of his canvases, *The Third Mortgage* (1935, location unknown), in which skeletons dangle from a blasted tree on a ruined farm, to a *Daily Worker* political cartoon.[1] Though Blanch's submissions to the Carnegie International had been rejected in 1929 and 1930, he appeared in all but three of the annual exhibitions between 1931 and 1947. He won third prize in the 1938 International for *People* painted that year (location unknown), which depicts a group of bleak-faced working-class figures whose leader, standing before the United States Capitol, holds a copy of the Bill of Rights. Blanch painted several post-office murals for the federal government and was active in the left-wing American Artists Congress.

After 1940 Blanch abandoned Social Realism. His later work was fanciful, decorative, and semiabstract. He exhibited at the 1952 and 1955 Carnegie Internationals and had a number of solo exhibitions at New York's Krasner Gallery during the 1950s and 1960s without exciting a great deal of critical notice. Blanch died in Kingston, New York.

1 Harry Salpeter, "Arnold Blanch: Bohemian," *Esquire* 9 (March 1938), p. 59.

Bibliography Harry Salpeter, "Arnold Blanch: Bohemian," *Esquire* 9 (March 1938), pp. 59–61, 113–14; Arnold Blanch, *Arnold Blanch* (New York, 1946); University Gallery, University of Minnesota, Minneapolis, *Arnold Blanch: The Years 1924–1949* (1949); obituary, *New York Times,* October 24, 1968, p. 47.

The Kansas Flower Garden, 1939

Oil on canvas
30⅛ x 46¼ in. (76.5 x 117.5 cm)
Signature: *Arnold Blanch* (lower right)

In 1939 Blanch traveled to South Carolina and Georgia, and to Colorado, where, from 1939 to 1941, he taught landscape

painting at the Colorado Springs Fine Arts Center's summer school. His trip occasioned a group of landscapes that interpreted, in somewhat symbolic fashion, scenery characteristic of the regions of the country he saw. In addition to *The Kansas Flower Garden,* this group of canvases from 1939 includes *Swamp Country* (1939, Brooklyn Museum, New York) and *In Colorado* (1939, location unknown). Utilizing the thin, sketchy brushwork and drab coloring characteristic of his work in the late 1930s, these landscapes present caricatured images of agrarian life that, on the surface, feature the traditional picturesque formula of simple folk, ramshackle buildings, and a panoramic view. However, they also hint darkly at the backwardness, isolation, and poverty of American rural life.

The Carnegie painting presents a generalized image of the Kansas dust bowl. A single lifeless tree, a menacing fissure in the parched earth, and a twister in the distance all disappoint the viewer's expectation of a peaceful bucolic scene. The intentionally ironic title refers to the half-starved farm wife who tends to a single, non-blooming flower on the drought-ravaged property—a futile attempt to brighten her dreary surroundings.

DS, KN

Reference H. Saint-Gaudens, "Charles J. Rosenbloom Collection," *Carnegie Magazine* 19 (Mar. 1946), p. 273.

Exhibitions Department of Fine Arts, Carnegie Institute, Pittsburgh, 1939, *The 1939 International Exhibition of Paintings,* no. 69, as *Flower Garden in Kansas;* Wichita Art Museum, Kans., 1981, *The Neglected Generation of American Realist Painters, 1930–1948,* unnumbered.

Provenance Charles J. Rosenbloom, Pittsburgh, 1939.

Bequest of Charles J. Rosenbloom, 1974, 74.7.4

Arbit Blatas
born 1908

BORN IN KAUNAS, Lithuania, Nicolai Arbit Blatas fled with his family to the Ukraine at the outbreak of World War I. He began his formal training in art in 1918 at a Soviet school, returned to Lithuania for three years beginning in 1921, then resumed his studies in Berlin at the academy there in 1924.

In 1925 Blatas moved to Paris to study at the Académie Julian and later at the Académie de la Grande Chaumière. He soon became a friend of many of the leaders of the school of Paris, including Pablo Picasso and Fernand Léger, but his style suggests he was never in sympathy with the more radical side of Parisian avant-garde painting. He appears to have drawn his inspiration from the postwar Expressionist painters, particularly the Russian-born Chaim Soutine. Blatas produced portraits, landscapes, interior scenes, riverscapes, and still lifes—all characterized by intense, vibrant colors and energetic brushwork.

Blatas had his first solo exhibition in Paris in 1933. In 1934 he exhibited for the first time in New York, and several American museums, including the Museum of Modern Art in New York, began to acquire his work. American critics praised his paintings for their rich, poetic color and their "smoldering, personal quality."[1] Later that year he returned to Paris, where he exhibited at the Salon d'Automne in 1935 and 1939.

In 1940, joining the exodus of artists from Europe, he settled permanently in New York and soon became an American citizen. His intimate, nostalgic views of Parisian life brought him popular and critical acclaim, and his works were purchased for private and public collections. Between 1943 and 1948 he participated in major exhibitions at Carnegie Institute, the Whitney Museum of American Art, New York, and the Corcoran Gallery of Art, Washington, D.C., among others.

After World War II Blatas traveled widely in Europe and North Africa, and he exhibited regularly in the United States, France, and Switzerland. In 1947 he was the only artist residing in America to be elected a member of the prestigious Salon d'Automne in Paris. He also exhibited at the Carnegie International in Pittsburgh in 1952, 1955, and 1958. In later years he added scenes of exotic cities and portraits of his artist friends to his repertoire, but his style has remained virtually unchanged throughout his career.

1 "The Color of Arbit-Blatas," *Art Digest* 9 (January 1, 1935), p. 15.

Bibliography Waldemar George, "Arbit Blatas et l'Ecole de Paris," *L'Art et les artistes,* n.s. 37 (February 1939), pp. 162–66; Yiddisher Kultur Farbeno, *One Hundred Contemporary American Jewish Painters and Sculptors,* essay by Louis Lozowick (New York, 1947), p. 26; Peter Hastings Falk, ed., *Who Was Who in American Art* (Madison, Conn., 1985), p. 60.

Still Life with Oysters, 1943

Oil on canvas
49⅜ x 39½ in. (125.4 x 100.3 cm)
Signature, date: A. Blatas./43 (lower left)

Still Life with Oysters, with its deep, glowing colors, expressive brushwork, and sensuousness, is a typical example of Blatas's work. Color is used to define shapes and textures, while broad, swirling brushstrokes suggest the solidity and weight of each object.

The painting presents an ordinary and—given the history of still-life painting—traditional subject. A table covered with a white cloth is the setting for a platter of oysters on the half shell. Immediately behind the shellfish stand smaller plates of fruit or vegetables, some glassware, and a cup and saucer. The far end of the table holds a large vase of flowers, a footed bowl heaped with fruit, and an undressed fowl.

The heavily laden table, its front and side edges cut off by the picture frame, nearly fills the large canvas. The close-up view and the dark, softly focused background create a sense of intimacy. Little attention is paid to perspective or depth. Apparently, the painting was intended to

showcase the artist's ability to portray a variety of textures: the moistness of raw oysters, the crispness of fresh carrot sticks, and the fragility of blossoms. In contrast, nonorganic objects are rather flat and awkwardly handled.

RB

Exhibition Colorado Springs Fine Arts Center, Colo., 1958, *New Accessions: USA*, no. 9.

Provenance Fine Arts Associates, New York, by 1956; Erwin D. Swann, New York, 1957.

Gift of Erwin D. Swann, 1957, 57.11

David Gilmour Blythe
1815–1865

D URING HIS LIFETIME, David Gilmour Blythe was regarded as a talented eccentric but was virtually unknown outside the Pittsburgh area; today he is recognized as nineteenth-century America's leading satirical genre painter. His upbringing laid the foundation for his work. As the son of an immigrant Scottish Presbyterian cooper from East Liverpool, Ohio, Blythe was raised with

an uncompromising sense of moral rectitude, and commitment to the ideal of individual liberty. The tradition into which he was born also valued education (his father once refused to trade a set of the *Encyclopedia Perthensis* for a valuable tract of land), and Blythe became acquainted early in life with British poetry. Throughout his career he expressed his deepest thoughts and emotions, as well as political opinions, in verse. Some of the letters he sent to his friend Hugh Gorley, a newspaper editor in Vermont, Illinois, were in the form of savage political verse satires.

In 1831 Blythe traveled up the Ohio River to Pittsburgh, where he was apprenticed to the Pittsburgh wood carver and cabinetmaker Joseph Woodwell. He undoubtedly came to know the leading painters in Pittsburgh—Chester Harding, James Bowman, and James Reid Lambdin. He had easy access to Lambdin's museum in the middle of town. Half of its collection consisted of portraits and the other half of landscapes, still lifes, antique heads, and religious and allegorical images in prints and paintings. The Flemish and Dutch schools, but not genre scenes, were favored.[1] Beyond a stint of house painting in 1834, Blythe was not immediately inspired to take up the brush. Instead, he joined his brother John, a riverboat captain, on a trip to New Orleans. In 1837 he went to New York, enlisted in the United States Navy, and spent the next three years as a ship's carpenter.

Shortly after returning to East Liverpool in 1840, Blythe began to work as an itinerant portrait painter. Although nothing distinguished his efforts from those of dozens of other itinerants, his works evidently found favor, and the number and range of his commissions increased. In 1847 he established himself in Uniontown, thirty miles south of Pittsburgh, where he painted portraits, received a commission to carve a wood statue of General Lafayette for the county courthouse, and occasionally turned out a piece of humorous genre, based, like much of his later work, on popular prints. By 1848 he felt financially secure enough to marry.

Disasters dashed the artist's bright prospects in the early 1850s. The death of his young wife in 1850 deeply embittered

him toward the world and may have precipitated the alcoholism that, despite his frequent literary and pictorial attacks on drunkenness, would claim his life. Blythe's second disaster was professional, the failure of his *Great Moving Panorama of the Allegheny Mountains* (1850–51). Painted panoramas could be immensely profitable, but they were expensive and risky ventures. Blythe's was confiscated in Cincinnati for unpaid freight charges after a short, unsuccessful tour.

Little is known of Blythe's movements between 1852 and 1854. He may have gone to Boston, seeing there the work of satirist David Claypoole Johnston, "the American Cruickshank," and David Teniers's *Peasants Drinking and Smoking: Interior of a Public House* (c. 1640, now Cleveland Museum of Art), which he copied (Historical Society of Western Pennsylvania, Pittsburgh). He may have visited New York and Philadelphia as well.[2] These two years were decidedly critical to his development, for by the time he returned to Ohio in 1854 his work had changed dramatically. His portraits were more expressive and technically accomplished, demonstrating a new mastery of draftsmanship, and his drawings mark the first appearance of his unique style of caricature.

In 1856 Blythe settled in Pittsburgh, where he created the body of work on which his present reputation rests. The emergence of his grotesquely satirical genre seems linked to his change of residence, for Pittsburgh in the 1850s was a showcase of urban horrors, a harbinger of the ills that would beset many other American cities. It was unspeakably filthy, suffocating under a pall of smoke and visited at short intervals by cholera epidemics. Owing to a stagnant economy, the immigrant laborers who arrived in ever-increasing numbers found either no work at all or poorly paid work under harsh conditions. Vagrants idled in the streets; the occurrence of theft, violence, and arson increased. The municipal government, corrupt and prone to demagoguery, did little to alleviate the city's problems.

Pittsburgh was an affront to Blythe's morality; he responded by squarely confronting and castigating the evils that surrounded him rather than by seeking

refuge from them. The distance separating him from other genre painters is most apparent in his treatment of childhood. Blythe's children were not "a redeeming presence, a harmonizing and hopeful element,"[3] but moral and mental defectives, ragged street urchins given to sadism and vice. Despite such bitter pessimism, Blythe never lacked patronage. His work was regularly bought by some of Pittsburgh's leading citizens whose moral and political opinions were, like Blythe's, predominantly Protestant and Republican.

With the outbreak of the Civil War, Blythe began making paintings that dealt savagely with those he perceived to be enemies of the Republic, among them the Confederacy, the Democratic party, and the Republican abolitionists. Often identical in format to the political cartoons of the day, they were shown in J. J. Gillespie's art-shop window. They reveal Blythe as a Republican who admired Lincoln and opposed slavery on economic grounds but had little sympathy or liking for the black man. Blythe also painted the activities of the Union troops in paintings such as *General Doubleday Crossing the Potomac* (c. 1861–64, National Baseball Hall of Fame and Museum, Cooperstown, N.Y.), *Battle of Gettysburg* (c. 1863–65, Museum of Fine Arts, Boston), and *Union Soldiers Crossing Mountains in the South* (c. 1863, private collection).

Blythe was declared to have died of *mania a potu*—delirium from drink—in Pittsburgh at Old Passavant Hospital. He remained an obscure figure until the 1930s, when major exhibitions at Carnegie Institute (1932) and the Whitney Museum of American Art, New York (1936), sparked national interest in his painting. The later twentieth century has admired him for the very qualities that made him an anomaly in the nineteenth: his brutal satire, his often nasty imagery, and his lack of technical finesse. Carnegie Institute began acquiring Blythe's work in the 1940s and has since become a major repository of his work.

1 Elizabeth Kennedy Sargent, "James Reid Lambdin's Pittsburgh Museum of Natural History and Gallery of Fine Arts, 1828–1832," senior thesis, Chatham College, Pittsburgh, 1984, pp. 56–57.

2 Chambers, in National Collection of Fine Arts, *World of David Gilmour Blythe*, pp. 32–36, 146.

3 Henry T. Tuckerman, "Children," *Galaxy* 4 (July 1867), p. 318.

Bibliography James Hadden, "Sketch of David G. Blythe: Reminiscences of a Queer Genius," Uniontown, Pa., *News-Standard*, seven parts, April 16–May 28, 1896; Dorothy Miller, *The Life and Work of David G. Blythe* (Pittsburgh, 1950); Bruce W. Chambers, "David Gilmour Blythe (1815–1865): An Artist at Urbanization's Edge," Ph.D. diss., University of Pennsylvania, 1974; National Collection of Fine Arts, Washington, D.C., *The World of David Gilmour Blythe, 1815–1865* (1980) (trav. exh.), exh. cat. by Bruce W. Chambers.

Landscape, c. 1842–45

Oil on canvas
25 x 30 in. (63.5 x 76. 2 cm)
Signature: Blythe (lower right)

Pastoral Scene, c. 1842–45

Oil on canvas
25¹¹⁄₁₆ x 31⅛ in. (65.2 x 79.1 cm)
Signature: Blythe (lower left)

Around 1855 Blythe gave these companion pieces to Edmund Watts, a Pittsburgh tailor, as payment for a suit.[1] They were probably painted about a decade earlier, following Blythe's return to East Liverpool from his naval tour of duty, so they are the earliest examples of his work owned by The Carnegie Museum of Art. Together they represent contrasting

approaches to landscape composition. One is a study of an actual place; the other relies on a European prototype as a model. In both cases, Blythe was teaching himself to paint.

Landscape is a picturesque view of a mill, possibly the one on property once owned by George Washington near Perryopolis, Pennsylvania.[2] In it Blythe struggled with the technical aspects of composition: the ruined stone mill lacks depth and its spatial relationship to the rest of the scene is unresolved. The foreground space, particularly the course of the millstream, is unconvincing. Only the background, in which the landscape recedes toward pale lavender-gray mountains, is more skillfully executed.

Though difficult to see because of holes, tears, and darkening of the paint surface, *Pastoral Scene* is a simpler, more unified composition. A goatherd with a staff, some goats, and a shepherdess wearing European peasant costume and playing a flute occupy the foreground. Behind them are a frieze of trees and a ruined temple. In contrast to the rustic energy of the old mill in *Landscape, Pastoral Scene* is ordered. Its composition probably derives, as Bruce Chambers suggests, from an Italian print in the classical landscape tradition.[3] This print would have provided some solutions to the difficulties of representation that Blythe experienced in painting *Landscape*.

RCY

1 William C. Arthur, grandson of Edmund Watts, to Leon Arkus, Feb. 7, 1962, museum files, The Carnegie Museum of Art, Pittsburgh.

2 The mill on Washington's Perryopolis property is illustrated in *Carnegie Magazine* 5 (February 1932), p. 263, in a 1905 watercolor by W. G. Armor.

3 Chambers, in National Collection of Fine Arts, *World of David Gilmour Blythe*, no. 97, p. 147.

Landscape

References W. C. Arthur to L. Arkus, Department of Fine Arts, Carnegie Institute, Feb. 7, 1962, museum files, The Carnegie Museum of Art, Pittsburgh; Chambers, "David Gilmour Blythe," pp. 248, 416, 417.

Exhibition National Collection of Fine Arts, Washington, D.C., 1980–81, *The World of David Gilmour Blythe, 1815–1865* (trav. exh.), exh. cat. by B. W. Chambers, no. 95.

Provenance The artist, until c. 1855; Edmund Watts, Pittsburgh, c. 1855; his grandson,

Edmund W. Arthur, c. 1911; his brother, William C. Arthur, Meadville, Pa., c. 1950–60.

Gift of William C. Arthur in memory of his grandfather Edmund Watts, 1962, 62.7

Pastoral Scene

Exhibition National Collection of Fine Arts, Washington, D.C., 1980–81, *The World of David Gilmour Blythe, 1815–1865* (trav. exh.), exh. cat. by B. W. Chambers, no. 97.

Provenance The artist, until c. 1855; Edmund Watts, Pittsburgh, c. 1855; his grandson, Edmund W. Arthur, c. 1911; Mary Helen Arthur by 1971.

Gift of Mary Helen Arthur, 1971, 71.24.1

The News Boys, c. 1846–52

Oil on canvas mounted on academy board
29¾ x 25¾ in. (75.6 x 65.4 cm)
Signature: Blythe (lower center left)

The News Boys is one of Blythe's earliest known genre pieces, and one of the first specifically about Pittsburgh. Judging by its hard contours and abrupt modeling, it must have been painted before 1854, when Blythe's style became more fluid and expressive. It cannot, however, have been completed before 1846, because the title of the Pittsburgh *Daily Commercial Journal,* founded in 1846, is partially visible. Although Blythe was living in

Uniontown during this period, he often visited Pittsburgh, where the original owner of the painting, Henry Miner, was the proprietor of a well-known bookstore and newsstand and publisher of the *Pittsburgh Almanac.*

The News Boys shows, at close range, two youths in confrontation over coins and newspapers in an undefined interior setting. The sly-faced and ragged newsboy to the right, the pictorial ancestor of the cigar-smoking urchins in Blythe's *Post Office* (see p. 89) and *The First Mayor of Pittsburgh* (see p. 94), is attempting to assert some advantage over the younger, better-dressed boy. Yet the expression of this boy betrays a certain shrewdness, and he makes a point aggressively with his finger—perhaps by indicating something in the text of the *Daily Commercial Journal.* The exact nature of the confrontation is difficult to decipher, but if the newsboys are comparing their earnings, the coins in the hand of the older boy clearly prove him the superior businessman.

KN, RCY

References Hadden, "Sketch of David G. Blythe," pt. 7, May 28, 1896; Miller, *Life and Work of David G. Blythe,* pp. 58–59, 129; Chambers, "David Gilmour Blythe," pp. 40–41, 109, 122, 137.

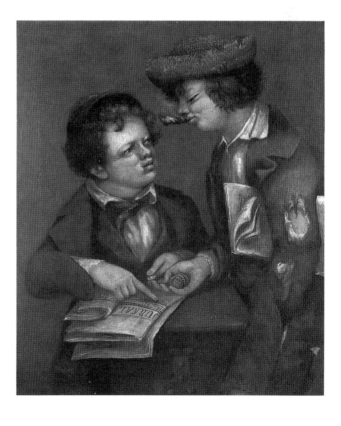

Exhibitions Pittsburgh Art Association, 1860, *Second Annual Exhibition*, no. 192; Mercantile Library Association of Pittsburgh, 1879, *Pittsburgh Library Loan Exhibition*, no. 120; Department of Fine Arts, Carnegie Institute, Pittsburgh, 1932–33, *An Exhibition of Paintings: David G. Blythe*, no. 28; Whitney Museum of American Art, New York, 1936, *Paintings by David G. Blythe, 1815–1865—Drawings by Joseph Boggs Beale, 1841–1926*, no. 48; Historical Society of Western Pennsylvania, Pittsburgh, 1950, *Exhibition of Works by Pittsburgh Artists*, no. 20; National Collection of Fine Arts, Washington, D.C., 1980–81, *The World of David Gilmour Blythe, 1815–1865* (trav. exh.), exh. cat. by B. W. Chambers, no. 96.

Provenance Henry Miner, Pittsburgh, by 1860; Mrs. Joseph Phillips, East End, Pa., 1879; Mr. and Mrs. John H. Ricketson, Jr., Pittsburgh, by 1932; Mrs. John H. Ricketson III, Pittsburgh, by 1955; Haugh and Keenan Galleries, Pittsburgh, by 1955.

Gift of Haugh and Keenan Galleries, 1956, 56.26

The Fiddler, c. 1854–58

Oil on academy board
11¾ x 8¾ in. (29.8 x 22.2 cm)

The Washerwoman, c. 1854–58

Oil on academy board
11¾ x 8¾ in. (29.8 x 22.2 cm)

These paintings originally belonged to Alexander McIlwaine of Pittsburgh and, like *Good Times* and *Hard Times*, also owned by McIlwaine, are companion pieces. Both are single-figure compositions of exactly the same dimensions, painted on the same type of support in a similar manner: each figure is set against a mottled background and looks to the viewer's right. The man with his violin

and the woman at her washboard wear hats and hold their implements in both hands. In the pair, Blythe utilizes the contrasts between play and work, male and female.

Though James Thomas Flexner has described the musician in *The Fiddler* as "bestial . . . yet inspired by divine fire,"[1] it is difficult to regard the work as anything more than a little genre piece. The musician's face, though hardly beautiful, is sympathetic, and his expression is altogether mild. The body and hands of this man are ineptly handled, however. In contrast, *The Washerwoman*, though less expressive facially, is more muscular, more active, better proportioned. Blythe ably rendered the foreshortening of her inclining torso. Her right arm casts a convincing shadow on the washboard, helping to create a sense of real space. The solutions to more complex problems in *The Washerwoman* suggest that Blythe based it on a print, while with *The Fiddler* he used a live model and relied on his own invention.

KN, RCY

1 James T. Flexner, *Nineteenth Century American Painting* (New York, 1970), p. 107.

The Fiddler

References Miller, *Life and Work of David G. Blythe*, p. 64; J. T. Flexner, *Nineteenth Century American Painting* (New York, 1970), p. 107.

Exhibitions Pittsburgh Art Association, 1859, *First Annual Exhibition*, no. 230; Department of Fine Arts, Carnegie Institute, Pittsburgh, 1932–33, *An Exhibition of Paintings: David G. Blythe*, no. 11; Whitney Museum of American Art, New York, 1936, *Paintings by David G. Blythe, 1815–1865—Drawings by Joseph Boggs*

Beale, 1841–1926, no. 24; Harry Shaw Newman Gallery, New York, 1948, *Nineteenth Century American Genre Painting*, no. 5; National Collection of Fine Arts, Washington, D.C., 1980–81, *The World of David Gilmour Blythe, 1815–1865* (trav. exh.), exh. cat. by B. W. Chambers, no. 120.

Provenance Alexander McIlwaine, Pittsburgh, by 1859; Alice T. and Jean M. McGirr, by 1932; Mrs. Edward Casey, Pittsburgh, 1948; Harry Shaw Newman Gallery, New York, 1948; Richard King Mellon Foundation, Pittsburgh, 1950.

Gift of the Richard King Mellon Foundation, 1972, 72.34.1

The Washerwoman

References Miller, *Life and Work of David G. Blythe*, pp. 69, 131; Chambers, "David Gilmour Blythe," no. 314, p. 435.

Exhibitions Department of Fine Arts, Carnegie Institute, Pittsburgh, 1932–33, *An Exhibition of Paintings: David G. Blythe*, no. 40; Whitney Museum of American Art, New York, 1936, *Paintings by David G. Blythe, 1815–1865—Drawings by Joseph Boggs Beale, 1841–1926*, no. 22; Harry Shaw Newman Gallery, New York, 1948, *Nineteenth Century American Genre Painting*, no. 1; Arthurs, Lestrange and Short, Pittsburgh, 1976, *City Bicentennial Celebration*, no cat.; National Collection of Fine Arts, Washington, D.C., 1980–81, *The World of David Gilmour Blythe, 1815–1865* (trav. exh.), exh. cat. by B. W. Chambers, no. 155.

Provenance Alexander McIlwaine, Pittsburgh, by 1859; Alice T. and Jean M. McGirr, Pittsburgh, by 1932; Mrs. Edward Casey, Pittsburgh, 1948; Harry Shaw Newman Gallery, New York, 1948; Richard King Mellon Foundation, Pittsburgh, 1950.

Gift of the Richard King Mellon Foundation, 1972, 72.34.6

Good Times, c. 1854–58

Oil on academy board
11⅝ x 8⅝ in. (29.5 x 21.9 cm)
Signature: Blythe (lower right)

Hard Times, c. 1854–58

Oil on academy board
11⅝ x 8⅝ in. (29.5 x 21.9 cm)
Signature: Blythe (lower right)

On March 14, 1855, Blythe wrote a didactic poem entitled "The Drunkard's Doom," which begins, "Didst ever seriously think/How awful is the drunkard's doom?" and ends, "The rest's soon told—

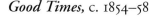

crime's putrid wave/soon sweeps him from the earth."[1] Blythe expressed this same idea pictorially in the companion pieces, *Good Times* and *Hard Times*. *Good Times* shows a repellent toper guzzling from a jug. He is less a man than a well-designed drinking machine: his mouth forms a perfect seal with the opening of the jug, ensuring that not a drop of the precious liquid will be lost; his great belly is both a capacious reservoir for liquor and a convenient armrest. His brightly lit face with its ecstatic heavenward gaze conveys his intense pleasure.

This pleasure, unfortunately, is short-lived, and in *Hard Times* he reaps the

inevitable consequences of his addiction. His coarse features are no longer suffused with joy; his clothes are ragged; his vast paunch has dwindled. Murky shadows engulf both the miserable drunkard and the constable who firmly grasps his coat to lead him away. Together, *Good Times* and *Hard Times* form Blythe's most explicit statement of a theme that recurs throughout his work.
KN, RCY

1 Chambers, "David Gilmour Blythe," p. 365.

Good Times

References Miller, *Life and Work of David G. Blythe*, pp. 64, 128; Chambers, "David Gilmour Blythe," no. 130, p. 412.

Exhibitions Pittsburgh Art Association, 1859, *First Annual Exhibition*, no. 229; Department of Fine Arts, Carnegie Institute, Pittsburgh, 1932–33, *An Exhibition of Paintings: David G. Blythe*, no. 15; Whitney Museum of American Art, New York, 1936, *Paintings by David G. Blythe, 1815–1865—Drawings by Joseph Boggs Beale, 1841–1926*, no. 46; Harry Shaw Newman Gallery, New York, 1948, *Nineteenth Century American Genre Painting*, no. 4; Westmoreland County Museum of Art, Greensburg, Pa., 1976, *Nineteenth and Early Twentieth Century Regional Painters*, exh. cat. by J. K. Maguire and P. A. Chew, unnumbered; National Collection of Fine Arts, Washington, D.C., 1980–81, *The World of David Gilmour Blythe, 1815–1865* (trav. exh.), exh. cat. by B. W. Chambers, no. 124.

Provenance Alexander McIlwaine, Pittsburgh, by 1859; Alice T. and Jean M. McGirr, Pittsburgh, by 1932; Mrs. Edward Casey, Pittsburgh, 1948; Harry Shaw Newman Gallery, New York, 1948; Richard King Mellon Foundation, Pittsburgh, 1950.

Gift of the Richard King Mellon Foundation, 1972, 72.34.3

Hard Times

References Miller, *Life and Work of David G. Blythe*, pp. 64, 128; Chambers, "David Gilmour Blythe," no. 138, p. 413.

Exhibitions Pittsburgh Art Association, 1859, *First Annual Exhibition*, no. 228; Department of Fine Arts, Carnegie Institute, Pittsburgh, 1932–33, *An Exhibition of Paintings: David G. Blythe*, no. 16; Whitney Museum of American Art, New York, 1936, *Paintings by David G. Blythe, 1815–1865—Drawings by Joseph Boggs Beale, 1841–1926*, no. 35; Harry Shaw Newman Gallery, New York, 1948, *Nineteenth Century American Genre Painting*, no. 3; Westmoreland County Museum of Art, Greensburg, Pa., 1976, *Nineteenth and Early Twentieth Century*

Regional Painters, exh. cat. by J. K. Maguire and P. A. Chew, unnumbered; National Collection of Fine Arts, Washington, D.C., 1980–81, *The World of David Gilmour Blythe (1815–1865)* (trav. exh.), exh. cat. by B. W. Chambers, no. 125.

Provenance Alexander McIlwaine, Pittsburgh, by 1859; Alice T. and Jean M. McGirr, Pittsburgh, by 1932; Mrs. Edward Casey, Pittsburgh, 1948; Harry Shaw Newman Gallery, New York, 1948; Richard King Mellon Foundation, Pittsburgh, 1950.

Gift of the Richard King Mellon Foundation, 1972, 72.34.4

The Coal Carrier, c. 1854–58

Oil on canvas
34¼ x 27¼ in. (88.3 x 69.9 cm)
Signature: Blythe (on handle of shovel)

According to an article in the *East Liverpool* (Ohio) *Tribune*, *The Coal Carrier* depicts "a once well known character about this city. . . an old but well-educated French man who found himself in this country but unable to speak the language. He found nothing better to do to earn a living than putting in coal."[1]

It is a highly sympathetic genre portrait. Blythe portrayed the subject as a man who is superior to his circumstances, yet cheerfully accepts his lot in life. The simple, direct composition endows him with a monumental dignity; the color scheme, in which grays, browns, and black predominate, is sober and restrained. Like the other portraits that Blythe painted following his return to East Liverpool, it demonstrates a considerable advance in both technique and in ability to convey character.

The *East Liverpool* (Ohio) *Tribune* reported that the painting was sold at auction for ten dollars.[2] This contradicts the testimony of one of the donors, Benjamin Page, who in 1971 told Leon Arkus, then director of the museum, that Leila Clarkson Black, a friend of his mother, had received it as a gift from Blythe.[3] However, Mr. Page later suggested that it had been acquired by one of Mrs. Black's ancestors, so the newspaper article may be correct.[4]
KN

Man Putting on Boots, c. 1856–60

Oil on canvas
14½ x 11 in. (36.8 x 27.9 cm)
Signature: Blythe (lower right)

This mildly satirical genre piece lampoons the exigencies of fashion and the folly of human vanity. Blythe portrays a fat man struggling to squeeze his stout legs into elegant riding boots that are obviously much too tight for him. This would-be dandy is a superb example of the type of caricature that began to appear in Blythe's work around 1856, a figural type "bereft of any internal skeletal order."[1] His rubbery, unnaturally mobile features grotesquely but eloquently express his pain, anger, and frustration, while the darkened surroundings reveal not the slightest bit of elegance or refinement.

Among the Blythe paintings owned by the Carnegie, *Man Putting on Boots* is most suggestive of the manner of seventeenth-century Dutch and Flemish genre painting. Its directness and coarseness in style and subject and its darkened coloring with bold highlights seem to

1 "Blythe's Work: A Sketch of a Strangely Gifted Character," *East Liverpool* (Ohio) *Tribune*, January 24, 1879; clipping in Blythe Papers, East Liverpool Historical Society, Ohio.

2 Ibid.

3 Stephanie L. Farrell to Mr. and Mrs. Benjamin Page, Morristown, N.J., August 10, 1971; museum files, The Carnegie Museum of Art, Pittsburgh.

4 Benjamin Page to Stephanie L. Farrell, September 4, 1971; museum files, The Carnegie Museum of Art, Pittsburgh.

References "Blythe's Work: A Sketch of a Strangely Gifted Character," *East Liverpool* (Ohio) *Tribune*, Jan. 24, 1879, clipping in Blythe Papers, East Liverpool Historical Society, Ohio; Hadden, "Sketch of David G. Blythe," pt. 7, May 28, 1896; E. Abraham,

"David G. Blythe: American Painter and Woodcarver," *Antiques* 27 (May 1935), pp. 180–83; Miller, *Life and Work of David G. Blythe*, p. 101; Chambers, "David Gilmour Blythe," pp. 87–89, 91–92, 107–8, 110–11; D. G. Wilkins, "The American Painting Collection at the Sarah Scaife Gallery, Carnegie Institute, Pittsburgh," *American Art Review* 2 (Mar.–Apr. 1975), pp. 104–5; "Blithe Spirit," *Apollo*, n.s. 113 (June 1981), p. 395.

Exhibition National Collection of Fine Arts, Washington, D.C., 1980–81, *The World of David Gilmour Blythe, 1815–1865* (trav. exh.), exh. cat. by B. W. Chambers, no. 112.

Provenance Leila Clarkson Black, Pittsburgh, by 1938; Mary LeMoyne Page, Pittsburgh, 1938; Mr. and Mrs. Benjamin Page, Morristown, N.J., 1938.

Gift of Mr. and Mrs. Benjamin Page in memory of Mary LeMoyne Page and Leila Clarkson Black, 1971, 71.33

have been the point of departure for Blythe's genre style. He had studied these effects closely when he copied David Teniers's *Peasants Drinking and Smoking: Interior of a Public House* (c. 1640, Cleveland Museum of Art); that copy, *Interior of an Inn* (Historical Society of Western Pennsylvania, Pittsburgh), could have been painted anytime between 1850 and 1856. Yet Blythe's tendency to isolate his figures and to paint them in a summary fashion give his canvases a noticeably eerie effect that is neither Dutch nor Flemish.

Blythe's habit of visual punning is also evident in this painting. The boots making the fat man uncomfortable actually refer to Blythe's own nickname Boots; he also used this reference to boots in *Ole Cezer* (see p. 87) and *The Firecracker* (1856, Duquesne Club, Pittsburgh).

RCY

1 Chambers, in National Collection of Fine Arts, *World of David Gilmour Blythe*, p. 57.

References Miller, *Life and Work of David G. Blythe*, p. 67; J. T. Flexner, "The Dark World of David Gilmour Blythe," *American Heritage* 13 (Oct. 1962), p. 26; F. McLaughlin, "Margaret Townsend Scully's Trunk," *Western Pennsylvania Historical Magazine* 53 (Apr. 1970), pp. 162–63; Chambers, "David Gilmour Blythe," pp. 131–32, 421.

Exhibitions Department of Fine Arts, Carnegie Institute, Pittsburgh, 1932–33, *An Exhibition of Paintings: David G. Blythe*, no. 26; Whitney Museum of American Art, New York, 1936, *Paintings by David G. Blythe, 1815–1865—Drawings by Joseph Boggs Beale, 1841–1926*, no. 25; Columbus Museum of Art, Ohio, 1968, *Works by David Blythe, 1815–1865*, no. 10; Westmoreland County Museum of Art, Greensburg, Pa., 1976, *Nineteenth and Early Twentieth Century Regional Painters*, exh. cat. by J. K. Maguire and P. A. Chew, unnumbered; National Collection of Fine Arts, Washington, D.C., 1980–81, *The World of David Gilmour Blythe, 1815–1865* (trav. exh.), exh. cat. by B. W. Chambers, no. 135.

Provenance Henry Rees Scully, Pittsburgh, by 1932; Margaret Jackson Townsend Scully, Pittsburgh; Donald Cadwalader Scully, Pittsburgh, by 1955.

Museum purchase: gift of Mrs. James H. Beal, 1955, 55.37.1

Temperance Pledge, c. 1856–60

Oil on board
15 x 12 in. (38.1 x 30.5 cm)

Orators such as William Lloyd Garrison and Wendell Phillips regularly visited Pittsburgh during the mid-nineteenth century to lecture on the evils of drink, and temperance groups like the Washingtonians, the Marthas, and the Sons of Temperance were active in the city.[1] Blythe (who was to die from the effects of alcoholism) joined in this campaign, attacking that vice in his poetry and in his art. *Temperance Pledge*, however, is not so much a diatribe against drink as a psychological study of an alcoholic contemplating reform.

Blythe depicted only the head and shoulders of his subject, whose forehead glows with reflected light. With heavily shadowed features rapt in thought, he solemnly weighs the joys of liquor against the virtues of abstinence and, no doubt, wonders whether he has sufficient willpower to live up to the pledge. An undated aphorism from a scrapbook of Blythe's poetry could be a comment on this sober image:

> There is a philosophy in the remark, "I've quit drinking." Yes; some people do quit some things: and some people quit quitting some things—and some people quit quitting to quit some things. There are a thousand things ought to be condem'd—a thousand things that to condem we must condem ourselves: a thousand things that condem'd condem their own condemnation, and ten thousand things that 'twere well if condemnation would damn—But when we hear a person say "I've quit"—a bad habit

"chalk" him: and when an opportunity occurs of "hitching" to him—hitch to something else.[2]

RCY

1 Miller, *Life and Work of David G. Blythe*, p. 65.
2 In Chambers, "David Gilmour Blythe," p. 333.

References Miller, *Life and Work of David G. Blythe*, pp. 65, 131; Chambers, "David Gilmour Blythe," pp. 131, 273, 434; Amon Carter Museum, Fort Worth, Texas, *Francis W. Edmonds: American Master in the Dutch Tradition* (1988), exh. cat. by H. N. B. Clark, fig. 53.

Exhibitions Whitney Museum of American Art, New York, 1936, *Paintings by David G. Blythe, 1815–1865—Drawings by Joseph Boggs Beale, 1841–1926*, no. 47; Butler Art Institute, Youngstown, Ohio, 1942, *Ohio Painters of the Past*, no. 45; Historical Society of Western Pennsylvania, Pittsburgh, 1950, *Exhibition of Works by Pittsburgh Artists*, no. 13; Columbus Museum of Art, Ohio, 1968, *Works by David Blythe, 1815–1865*, no. 12; State Museum of Pennysylvania, Harrisburg, 1972, *Pennsylvania Heritage*, no cat.; National Collection of Fine Arts, Washington, D.C., 1980–81, *The World of David Gilmour Blythe, 1815–1865* (trav. exh.), exh. cat. by B. W. Chambers, no. 150.

Provenance Henry O. Eichleay, Pittsburgh, by 1936; G. David Thompson, Pittsburgh, by 1936; Beverly Wyatt, Pittsburgh, by 1950; repurchased by G. David Thompson, Pittsburgh, by 1952.

Gift of G. David Thompson, 1953, 53.1.2

Youth and Sugar Bowl, c. 1856–60 (Boy Stealing Sugar)

Oil on canvas
25⅛ x 21⅛ in. (63.8 x 53.7 cm)
Signature: Blythe (lower left)

Until recently, this painting was considered the pendant to the lost *Man Peering from Jail*. A Pittsburgh newspaper published a detailed description of these companion pieces in 1877:

> Two paintings by Blythe are attracting much attention. They are the property of Judge Acheson, and are among the very best efforts of the queer old fellow, whose oddities are remembered by all middle-aged Pittsburghers. One painting shows an innocent-faced, curly-headed child in the act of

pilfering sugar from a bowl that stands before it on a table. The companion work reveals the blear[*sic*]-eyed countenance of a hardened old reprobate peering from the bars of a jail door. The two extremes in one life are here most strikingly shown—the first theft and the results. A life of dishonesty stretched between these two scenes, and the hardened features of the man find a resemblance in those of the child.[1]

In December 1981, however, a pair of small paintings answering this description, *Crime and Punishment: Youth and Sugar Bowl* and *Old Man Peering from Jail* (now in the Regis Corporation Collection, Minneapolis), were sold at a New York auction.[2] These are clearly the companion pieces that were originally owned by Judge Acheson. The child is indeed "curly-headed," unlike the ragged urchin in the Carnegie painting, and is a youthful version of the old man in the pendant. The Minneapolis *Youth and Sugar Bowl* also differs from the Carnegie work in that the tabletop and the sugar bowl occupy the foreground, and only the child's head and hands are shown.

In The Carnegie's *Youth and Sugar Bowl*, the contrast between the boy's ragged clothing and the shining, elegantly painted glass and silver of the tabletop still life indicates that he is not a child of the family, but an intruder into the alien realm of middle-class affluence. He gazes directly at the viewer, who is thus placed in the position of the adult who has caught him pilfering. The young thief clearly expects no mercy from his captor; his strangely appealing expression is eloquent of his fear and resignation. *Youth and Sugar Bowl* is one of Blythe's most sympathetic treatments of the poor children who haunted the streets of mid-nineteenth-century Pittsburgh.

KN, RCY

1 Unidentified newspaper clipping, c. August–November 1877, in Agnes Way, "Newspaper Cuttings Collected by Agnes Way," Scrapbook, c. 1870–1935, in Music and Art Division, Carnegie Library, Pittsburgh.

2 Christie, Manson and Woods International, New York, *American Paintings, Drawings, and Sculpture of the Eighteenth, Nineteenth, and Twentieth Centuries*, sale cat., December 11, 1981, pp. 50–51.

References Miller, *Life and Work of David G. Blythe*, p. 62; Chambers, "David Gilmour Blythe," pp. 109–10, 124, 421, 437; D. Killoran, "David Gilmour Blythe's America: A Paradise Lost," *Art and Antiques* 7 (Sept.–Oct. 1982), p. 96.

Exhibitions Department of Fine Arts, Carnegie Institute, Pittsburgh, 1914, *Fifth Annual Exhibition of the Associated Artists of Pittsburgh*, no. 2; Historical Society of Western Pennsylvania, Pittsburgh, 1950, *Exhibition of Works by Pittsburgh Artists*, no. 18; Department of Fine Arts, Carnegie Institute, Pittsburgh, 1959, *Paintings by David G. Blythe*, no cat.; National Collection of Fine Arts, Washington, D.C., 1980–81, *The World of David Gilmour Blythe, 1815–1865* (trav. exh.), exh. cat. by B. W. Chambers, no. 161.

Provenance The Spang family, Pittsburgh; John A. Harper, Pittsburgh, by 1914; his daughter Mrs. H. A. Byram, San Francisco, by 1950; his daughter Mrs. Franklin C. Irish, Pittsburgh, by 1959; her daughter, Mrs. Edward O'Neil II, Pittsburgh, by 1964.

Gift of Mrs. Edward O'Neil II, 1964, 64.2

Man Eating in a Field, c. 1856–63

Oil on canvas
10 x 14⅛ in. (25.4 x 35.9 cm)
Signature: Blythe (lower left)

Although variations on this theme of rustic contentment appeared frequently in American genre painting during the second third of the nineteenth century, its presence in Blythe's work is less expected because it contrasts so sharply with his biting satires of urban life. Like his other rural images, this painting is unsentimental yet accepting of country life.

A heavy-featured farmer rests from his labors in the shade of a haystack. The broad horizontals that dominate the scene serve to reinforce the mood of quiet and stability, much as in the works of Blythe's contemporaries of the Hudson River school. The vast expanse of sky and the soft, luminous haze of the background also have a flavor of the more fashionable and sophisticated manner of mid-nineteenth-century American landscape painting. The presence of the crude farmer, however, works against idealization of the scene.

Man Eating in a Field originally belonged to the artist's brother Thomas and may have been painted during a visit to East Liverpool, Ohio.

RCY

References Miller, *Life and Work of David G. Blythe*, p. 57; Chambers, "David Gilmour Blythe," p. 421.

Exhibitions Department of Fine Arts, Carnegie Institute, Pittsburgh, 1932–33, *An Exhibition of Paintings: David G. Blythe*, no. 25; Whitney Museum of American Art, New York, 1936, *Paintings by David G. Blythe, 1815–1865—Drawings by Joseph Boggs Beale, 1841–1926*, no. 7; Butler Art Institute, Youngstown, Ohio, 1942, *Ohio Painters of the Past*, no. 3; Butler Art Institute, Youngstown, Ohio, 1947, *An Exhibition of the Work of David G. Blythe*, no. 20; Columbus Museum of Art, Ohio, 1968, *Works by David Blythe, 1815–1865*, no. 15; Arthurs, Lestrange and Short, Pittsburgh, 1976, *City Bicentennial Celebration*, no cat.; National Collection of Fine Arts, Washington, D.C., 1980–81, *The World of David Gilmour Blythe, 1815–1865* (trav. exh.), exh. cat. by B. W. Chambers, no. 134.

Provenance The artist's brother, Thomas Blythe, East Liverpool, Ohio, c. 1856–c. 1863; his son, Heber H. Blythe, East Liverpool, Ohio; estate of Heber H. Blythe.

Museum purchase: gift of Mr. and Mrs. James H. Beal, 1954, 54.31.3

Ole Cezer, c. 1858–60

Oil on canvas
14⅜ x 11¼ in. (36.5 x 28.6 cm)
Signature: Blythe (lower right)
Inscription: Wm. B. Holmes to W. R. Thompson, Jan. 1, 1876 (on reverse)

The subject of this painting is the startlingly wizened, slight figure of a black man who stands in the open bulkhead of a shaky building, mostly obscured by darkness. With a bucket beside him, he is bathed in soft light which only barely illuminates the name "Ole Cezer" painted on the wall just behind him. Bruce Chambers has observed that *Ole Cezer* "possesses the ring of authentic street portraiture" and may depict "a familiar local denizen who was probably the butt of occasional jibes."[1]

Blythe's attitude toward his subject is difficult to ascertain. Is this painting simply another jibe directed against an aged black man? Are the bucket of whitewash and the sign reading "Whitwasn don hea" intended as tasteless jokes about Ole Cezer's skin color? While Blythe disliked blacks and abolitionists, and while it is thus tempting to regard this image as disparaging, it is difficult to reconcile such an interpretation with the activities of the painting's second owner, William Reed Thompson.

According to his granddaughter Mary D. Barnes, Thompson acquired this work "because of his family's concern for the Negro. . . . They were staunch abolitionists and it is rumored that they may have helped the Underground Railway."[2] Pittsburgh was an important "station" on the Underground Railroad (the system by which Northern abolitionists aided runaway slaves to reach Canada), and the fact that Ole Cezer emerges from a cellar may allude to this.

The pile of old clothes at the left refers to the sign "Ole cloves bot and sold." The boots hung on the wall are a punning reference to Blythe himself; he had acquired the nickname Boots while living in Uniontown.

RCY

1 Chambers, in National Collection of Fine Arts, *World of David Gilmour Blythe*, p. 66.

2 Mary D. Barnes to Leon Arkus, Carnegie Institute, February 1969, museum files, The Carnegie Museum of Art, Pittsburgh.

References Miller, *Life and Work of David G. Blythe*, p. 70; Chambers, "David Gilmour Blythe," pp. 131–32, 149, 277, 424.

Exhibitions Mercantile Library Association of Pittsburgh, 1879, *Pittsburgh Library Loan Exhibition*, no. 42; State Museum of Pennsylvania, Harrisburg, 1972, *Pennsylvania Heritage*, no cat.; National Collection of Fine Arts, Washington, D.C., 1980–81, *The World of David Gilmour Blythe, 1815–1865* (trav. exh.), exh. cat. by B. W. Chambers, no. 140.

Provenance William B. Holmes, Pittsburgh, before 1876; William R. Thompson, Pittsburgh, by 1876; his daughter, Helen Thompson Dilworth, Pittsburgh; her children, Mary D. Barnes and Lawrence Dilworth, Pittsburgh, by 1969.

Gift of Mary D. Barnes and Lawrence Dilworth in memory of their mother, Helen Thompson Dilworth, 1969, 69.4

The Lawyer's Dream, 1859

Oil on canvas
24¼ x 20¼ in. (61.6 x 51.4 cm)
Signature: Blythe (lower left)

In a verse epistle sent in 1857 to Hugh Gorley of Vermont, Illinois, Blythe wrote:

> Our courts with few exceptions,
> Are fit subjects for like objections.
> Public opinion first, Blackstone second.[1]

The Lawyer's Dream expresses this criticism in pictorial terms. A lawyer, his copy of William Blackstone's *Commentaries on the Laws of England* beside him, has fallen asleep while reading newspapers ("public

opinion"), and he dreams of glory. The complex iconography was fully explained in a contemporary newspaper account:

This eccentric but very talented Pittsburgh artist has recently completed another sketch which we think the best of all his curious productions. It represents a tipsy "limb of the law," sleeping and dreaming. He sits or dangles in his chair in the awkward helplessness of slumber; before him lies a table, with books and papers; his Blackstone lies closed and padlocked beside the table; "Common Law" is carelessly thrown down, the leaves spread wide open upon the floor beside his chair; other law books are scattered recklessly around; the trumpet of Fame lies beneath his chair on the floor, as if he had fallen asleep while doing a little modest self-trumpeting. The devil is seen behind him, reaching out from amid the murky background to tickle his ear with the temptation of political honors. A pair of scales are beside the table—in one scale a bleeding heart and in the other a purse and a bottle of something supposed to be strong. A demijohn is also seen in the apartment. The dreamer sees his own image before the assembled senate or other honorable body, delivering a "spread-eagle" address, "for Buncombe," probably; eagle visible, large as life; Fame is reaching down from the brilliant sky to crown him as he speaks, and he is supposed to have climbed the heights of ambition; sacrificing his profession, outraging his conscience, causing hearts to bleed, and doing other naughty things to attain political success. The sketch of which we have only given a portion of the details, has rather more finish than most of his productions, but is still rough, and the coloring is of that peculiar kind which makes it always easy to discern Mr. Blythe's handiwork. It must be a hit, for one of the witty members of the bar declares it "a rank libel on the profession." [2]

As Chambers points out, the only significant detail omitted from this description is the upside-down American flag, a maritime distress signal, in this context indicating the danger to the Republic posed by politically ambitious and unscrupulous lawyers.[3]

Chambers has suggested several graphic sources for this image, including William Hogarth's 1736 engraving *The Sleepy Congregation* and an anti-American cartoon by Richard Doyle, *The Land of Liberty*, published in *Punch* in 1847.[4] *The Lawyer's Dream* also recalls Honoré

Fig. 1 Unidentified artist, *The Assault in the U.S. Senate Chamber on Senator Sumner.* Wood engraving, from *Frank Leslie's Illustrated Newspaper,* June 7, 1856. Courtesy of the Library of Congress

Daumier's *L'Imagination*, a series of fifteen lithographs published in *Le Charivari* from January through August 1833.[5] These lithographs show sleeping or daydreaming figures, including a doctor, a clergyman, a miser, and a hypochondriac—but no lawyer—surrounded by tiny figures that act out their fantasies.

As Blythe's contemporary critic recognized, the dream background alludes to the United States Senate chamber with its plastered walls, railed balcony, coffered ceiling, and bright chandelier. Although the eagle is on the podium rather than above it, the resemblance is enough to make this image a comment on national politics as well as an attack on lawyers. Blythe may have relied on an image of the Senate chamber in the illustrated press (fig. 1), but he was also in Baltimore in 1859 and could have visited Washington just before painting this image.

RCY

1 In Chambers, "David Gilmour Blythe," p. 328.

2 Chambers, in National Collection of Fine Arts, *World of David Gilmour Blythe,* p. 71, quoted from typescript of an unidentified newspaper account, c. 1860, Blythe Papers, East Liverpool Historical Society, Ohio.

3 Chambers, in National Collection of Fine Arts, *World of David Gilmour Blythe,* p. 114, n. 97.

4 Ibid., pp. 58–59.

5 See Löys Delteil, *Honoré Daumier* (Paris, 1926), vol. 10, appendix, nos. 29–43.

References Miller, *Life and Work of David G. Blythe,* pp. 52–53; B. Arter, "Paradoxical Painter," *Columbus* (Ohio) *Evening Dispatch,* Mar. 10, 1968, magazine sec., p. 12; Chambers,

"David Gilmour Blythe," pp. 132–35, 151–52; W. H. Gerdts, "Daniel Huntington's *Mercy's Dream*: A Pilgrimage through Bunyanesque Imagery," *Winterthur Portfolio* 14 (Summer 1979), p. 179; B. W. Chambers, "David Gilmour Blythe's Pittsburgh: 1850–65," *Carnegie Magazine* 55 (May 1981), p. 21.

Exhibitions Pittsburgh Art Association, 1859, *First Annual Exhibition,* no. 193; Department of Fine Arts, Carnegie Institute, 1932–33, *An Exhibition of Paintings: David G. Blythe,* no. 23; Whitney Museum of American Art, New York, 1936, *Paintings by David G. Blythe, 1815–1865—Drawings by Joseph Boggs Beale, 1841–1926,* no. 38; Historical Society of Western Pennsylvania, Pittsburgh, 1950, *Exhibition of Works by Pittsburgh Artists,* no. 19; Columbus Museum of Art, Ohio, 1968, *Works by David Blythe, 1815–1865,* no. 13; State Museum of Pennsylvania, Harrisburg, 1972, *Pennsylvania Heritage,* no cat.; Los Angeles County Museum of Art, 1974, *American Narrative Painting,* no. 40; Westmoreland County Museum of Art, Greensburg, Pa., 1976, *Nineteenth and Early Twentieth Century Regional Painters,* exh. cat. by J. K. Maguire and P. A. Chew, unnumbered; National Collection of Fine Arts, Washington, D.C., 1980–81, *The World of David Gilmour Blythe, 1815–1865* (trav. exh.), exh. cat. by B. W. Chambers, no. 132.

Provenance George Finley, Pittsburgh, by 1859; by descent, Charles A. Finley, Pittsburgh, by 1932.

Museum purchase: gift of S. B. Casey and the Howard Heinz Endowment Fund, 1959, 59.46

See Color Plate 4.

Post Office, c. 1859–63

Oil on canvas
24 x 20 in (61 x 50.8 cm)
Signature: Blythe (lower left)

Post Office shows part of the exterior of the old Custom House and Post Office building that once stood at the corner of Smithfield Street and Fifth Avenue in downtown Pittsburgh. At the center of the composition, men and women fight for a place at the narrow General Delivery window. The press of the crowd destroys the normally dignified appearance of mid-nineteenth-century costume: a woman's pink crinoline assumes a fantastic balloonlike shape; the man next to her has had his hat crushed, and a dirty street urchin is ripping out the seat of the man's pants in an attempt to pick his pocket. To the left of the melee another street urchin deftly picks the pocket of a man absorbed

in a letter; at the right, a markedly sleazy character holding a carpetbag surreptitiously examines the correspondence of an unsuspecting man.

The first painting by Blythe to be acquired by Carnegie Institute, *Post Office* has been the most frequently exhibited and reproduced of the artist's works. It has generally been regarded as a simple, amusing genre piece, free of obscure topical allusions and Blythe's habitual bitterness. James Thomas Flexner has described Blythe's mood in this work as "unusually jocose,"[1] and Gordon Washburn, a former director of Carnegie Institute's Department of Fine Arts, emphasized its broadly humorous aspects: "I never look at David Blythe's *Post Office* without smiling—and often laughing out loud. . . . *Post Office* is, to me, an ideal sample of the earthy and jocose art of Blythe."[2]

The painting, however, makes a serious satirical comment. The neoclassical portrait bust over the delivery window alludes to the idealism and dignity of the American past, while the wizened, profoundly indifferent newsboy on the steps symbolizes the squalor of contemporary urban life. With these two figures, Blythe contrasts the noble ideals of the nation's Founding Fathers with the greed, self-interest, and venality of his own times.

A rather different view of the Pittsburgh Post Office appears in another of Blythe's works, *In the Pittsburgh Post Office* (c. 1859–62, Museum of Fine Arts, Boston). Considerably more sedate, it shows a group of men gathered about the "Gentleman's Window" in a colonnaded lobby.

RCY

1 James T. Flexner, "The Dark World of David Gilmour Blythe," *American Heritage* 13 (October 1962), p. 20.

2 Gordon Washburn, "Museum Director's Choice: A Pittsburgh Painter's Jocose Jam-Up," *Life*, June 4, 1956, p. 125.

References A. Burroughs, *Limners and Likenesses* (Cambridge, Mass., 1936), pp. 194–95; J. O'Connor, Jr., "A Pittsburgh Scene: 'Post Office' by David G. Blythe Purchased by the Carnegie Institute," *Carnegie Magazine* 16 (Jan. 1943), pp. 227–29; V. Barker, *American Painting* (New York, 1950), pp. 487–88; J. O'Connor, Jr., "From Our Permanent Collection: *Post Office* by David G. Blythe," *Carnegie Magazine* 24 (June 1950), pp. 376–78, 390; D. Miller, "David G. Blythe," *Museum Echoes* (Ohio Historical Society, Columbus) 27 (Sept. 1954), pp. 67–70; G. Washburn, "Museum Director's Choice: A Pittsburgh Painter's Jocose Jam-Up," *Life*, June 4, 1956, p. 125; J. T. Flexner, "The Dark World of David Gilmour Blythe," *American Heritage* 13 (Oct. 1962), pp. 20, 76–78; L. B. Miller, *Patrons and Patriotism: The Encouragement of the Fine Arts in the United States, 1790–1860* (Chicago, 1966), pp. 210–11; Chambers, "David Gilmour Blythe," pp. 141–44, 153, 301, 426; Whitney Museum of American Art, New York, *The Painters' America: Rural and Urban Life, 1810–1910* (1974), exh. cat. by P. Hills, p. 65; B. W. Chambers, "David Gilmour Blythe's Pittsburgh: 1850–65," *Carnegie Magazine* 55 (May 1981), pp. 19–20; H. Adams, in Museum of Art, Carnegie Institute, *Collection Handbook* (Pittsburgh, 1985), p. 174; W. G. Gerdts, *Art across America: Two Centuries of Regional Painting* (New York, 1990, vol. 1, p. 291).

Exhibitions Mercantile Library Association of Pittsburgh, 1879, *Pittsburgh Library Loan Exhibition*, no. 100; Department of Fine Arts, Carnegie Institute, Pittsburgh, 1932–33, *An Exhibition of Paintings: David G. Blythe*, no. 29; Whitney Museum of American Art, New York, 1935, *American Genre: The Social Scene in Paintings and Prints*, no. 11; Whitney Museum of American Art, New York, 1936, *Paintings by David G. Blythe, 1815–1865—Drawings by Joseph Boggs Beale, 1841–1926*, no. 23; Yale University Art Gallery, New Haven, 1937, *American Genre Paintings and Victoriana*, no cat.; Butler Art Institute, Youngstown, Ohio, 1947, *An Exhibition of the Work of David G. Blythe*, no. 27; Historical Society of Western Pennsylvania, Pittsburgh, 1950, *Exhibition of Works by Pittsburgh Artists*, no. 22; Cincinnati Art Museum, Ohio, 1955, *Rediscoveries in American Painting*, no. 10; Department of Fine Arts, Carnegie Institute, Pittsburgh, 1957, *American Classics of the Nineteenth Century*, no. 26; Newark Museum, N.J., 1957, *Of Other Days: Scenes of Everyday Life*, unnumbered; American Federation of Arts, New York,

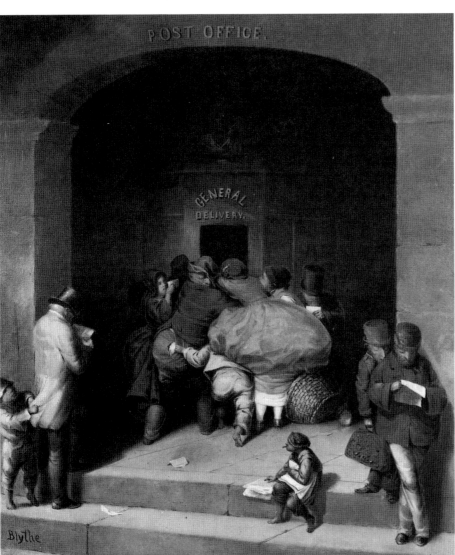

1958–59, *A Hundred Years Ago* (trav. exh.), no. 4; Fine Arts Gallery of San Diego, 1960, *War, Peace and Union,* no. 31; Milwaukee Art Museum, 1965, *Pop Art and the American Tradition,* no. 6; Butler Art Institute, Youngstown, Ohio, 1967, *Pageant of Ohio Painters,* no. 10; Montreal Museum of Fine Arts, 1967, *The Painter and the New World,* no. 256; Columbus Museum of Art, Ohio, 1968, *Works by David Blythe, 1815–1865,* no. 6; Metropolitan Museum of Art, New York, 1970, *Nineteenth Century America: Paintings and Sculpture, an Exhibition in Celebration of the Hundredth Anniversary of the Metropolitan Museum of Art,* no. 125; Museum of Art, Pennsylvania State University, University Park, 1972, *Masterworks by Pennsylvania Painters in Pennsylvania Collections,* no. 12; Finch College Museum of Art, New York, 1974, *Twice as Natural: Nineteenth Century American Genre Painting,* no. 6; National Collection of Fine Arts, Washington, D.C., 1980–81, *The World of David Gilmour Blythe, 1815–1865* (trav. exh.), exh. cat. by B. W. Chambers, no. 195; Westmoreland County Museum of Art, Greensburg, Pa., 1981, *Southwestern Pennsylvania Painters, 1800–1945,* exh. cat. by P. A. Chew and J. A. Sakal, no. 12.

Provenance George W. Hailman, Pittsburgh; Mrs. George W. Hailman, Pittsburgh; her son, James D. Hailman, Pittsburgh; his wife, Mrs. Johanna K. W. Hailman, Pittsburgh, by 1930; Francis P. Garvan, 1937; on loan in the Garvan Collection, Yale University Art Gallery, New Haven, 1937; with M. Knoedler and Co., New York, 1942.

Purchase, 1942, 42.9

See Color Plate 5.

Rebecca Describes the Battle to Ivanhoe, c. 1859–63
(*Prison Scene*)

Oil on canvas
27 x 22½ in. (68.6 x 57.2 cm)
Signature: Blythe (lower center)

Although this painting has been identified by the generic title *Prison Scene,* its details—a woman dressed in Oriental costume who furtively peers from a barred window while protecting herself with a shield—clearly refer to a specific literary episode: Rebecca visiting Ivanhoe, from the twenty-ninth chapter of Sir Walter Scott's *Ivanhoe* (1820).

Ivanhoe, severely wounded in a tournament, and Rebecca, a beautiful young Jewish woman skilled in the healing arts, have been taken prisoner by Ivanhoe's enemy, the brutal Front-de-Boeuf.

Richard the Lion-Hearted attacks Front-de-Boeuf's castle, and Ivanhoe, still weak from his wounds, laments that he cannot get up to view the battle. When Rebecca offers to describe it to him, he warns her against standing by an open window that will soon be a target for archers: "'Do not expose thyself to wounds and death, and render me for ever miserable for having given thee the occasion; at least, cover thyself with yonder ancient buckler, and show as little of your person at the lattice as may be.'"[1]

Blythe renders the scene with tolerable accuracy: Rebecca, wearing the Oriental costume described by Scott, stands on the "two or three steps, which led to the window"[2] and protects herself with a shield. Oddly, Blythe's Ivanhoe is older, darker, and considerably less handsome than Scott's hero, who is described as "a young man of twenty-five... [with] a profusion of short fair hair"[3]—a discrepancy that raises the interesting question of Blythe's source and his motive for painting the scene, since a reading of *Ivanhoe* evidently did not inspire him.

Blythe was by no means alone among nineteenth-century artists in turning to Scott for subject matter. Eugène Delacroix treated this very same incident in his lost *Ivanhoe and Rebecca in the Castle of Front-de-Boeuf* (1847).[4] The romantic theatricality of *Rebecca Describes the Battle to Ivanhoe* is, however, an anomaly in Blythe's work. It suggests that he drew this image from an as yet unidentified book illustration or print, perhaps as the result of a special commission.
RCY

1 Sir Walter Scott, *Ivanhoe,* Riverside Bookshelf edition (Boston, 1913), p. 389.

2 Ibid.

3 Ibid., p. 175.

4 See Alfred Robaud and Ernest Chesneau, *L'Oeuvre complet de Eugène Delacroix* (Paris, 1885), no. 1,000, p. 262.

Reference Chambers, "David Gilmour Blythe," no. 244, p. 426.

Exhibitions Columbus Museum of Art, Ohio, 1968, *Works by David Blythe, 1815–1865,* no. 9, as *Prison Scene;* National Collection of Fine Arts, Washington, D.C., 1980–81, *The World of David Gilmour Blythe, 1815–1865* (trav. exh.), exh. cat. by B. W. Chambers, no. 196.

Provenance Eleanor G. McCallum, Pittsburgh; Haugh and Keenan Galleries, Pittsburgh; Mrs. James H. Beal, Pittsburgh, by 1954.

Gift of Mrs. James H. Beal, 1954, 54.4

The Overturned Carriage, c. 1859–64

Oil on canvas
21⅞ x 30 in. (55.6 x 76.2 cm)
Signature: Blythe (lower left center)

In this vigorous, vulgar, comic genre piece, the driver and his indecorously sprawling female companion lie trapped beneath the body of an upset carriage, while their enraged horse wreaks havoc all around. The empty bottle in the foreground implies that the driver's drink-induced incompetence is responsible for the mishap.

A number of compositions related to *The Overturned Carriage* exist. *The Runaway* (1859–64, Duquesne Club, Pittsburgh) is a smaller, reversed version of this composition in which the body of the carriage remains upright and the landscape setting is suppressed.[1] In *Half-Way House* (c. 1860–64, Virginia Steele Scott Gallery, Huntington Library, San Marino, Calif.) and *The Smash-Up of the Confederacy* (c. 1864–65, Ohio Historical Society, Columbus), Blythe elaborated on the basic theme of the rebellious horse, substituting a ruined sleigh for the carriage. These last two paintings are virtually identical, except that *The Smash-Up of the Confederacy* includes a number of inscriptions that transform it from a

genre piece to a political cartoon about American-Canadian relations during the Civil War. The social comment in *The Overturned Carriage* and the political essay embodied in *The Smash-Up of the Confederacy* indicate how Blythe developed his images for moral and political meaning.

RCY, KN

1 *The Runaway* is oil on board, 18 x 24 in. (45.7 x 61 cm).

References B. Arter, "Paradoxical Painter," *Columbus* (Ohio) *Evening Dispatch*, Mar. 10, 1968, magazine sec., p. 12; Chambers, "David Gilmour Blythe," p. 424; D. G. Wilkins, "The American Painting Collection at the Sarah Scaife Gallery, Carnegie Institute, Pittsburgh," *American Art Review* 2 (Mar.–Apr. 1975), pp. 104–5; D. D. Keyes and L. Taft, "David G. Blythe's Civil War Paintings," *Antiques* 108 (Nov. 1975), p. 997.

Exhibitions Department of Fine Arts, Carnegie Institute, Pittsburgh, 1957, *American Classics of the Nineteenth Century*, no. 27; Columbus Museum of Art, Ohio, 1968, *Works by David Blythe, 1815–1865*, no. 17; State Museum of Pennsylvania, Harrisburg, 1972, *Pennsylvania Heritage*, no cat.; National Collection of Fine Arts, Washington, D.C., 1980–81, *The World of David Gilmour Blythe, 1815–1865* (trav. exh.), exh. cat. by B. W. Chambers, no. 193.

Provenance Gustav D. Klimann, Boston; G. David Thompson, Pittsburgh, by 1956.

Gift of G. David Thompson, 1956, 56.34

Abraham Lincoln, Rail–Splitter, 1860

Oil on canvas
30 x 40 in. (76.2 x 101.6 cm)
Signature: Blythe (lower center)

Abraham Lincoln, Rail-Splitter reflects the political attitudes and publicity efforts of its first owner, Captain Charles W. Batchelor, Pittsburgh entrepreneur and a founder of the Republican party.[1] It is possible that Batchelor commissioned this work from Blythe to generate publicity for the newly nominated Lincoln. Blythe, however, went beyond producing a campaign image. By surrounding an idealized image of Lincoln with vignettes of the gritty activities of practical politics, Blythe made an ironic comment on the American political process.

The image of Lincoln as rail-splitter—he was described as "the Rail Candidate"—provided the keynote of his presidential campaign and of this painting. Blythe presents this idealized image in the central panel of his painting where the future candidate rests from his labors and contemplates what is to come. On the ground lie a jug and his law textbook *Swan on Evidence*. The course of Lincoln's nomination is narrated in the surrounding vignettes, a widely used format of popular illustrations (fig. 1). The scenes read clockwise from lower left to lower right, beginning and ending with nostalgic, nonpolitical memories.

The left bottom square alludes to the flatboat trips Lincoln took down the Mississippi as a young man; such trips were significant events in the lives of many Americans, a point of identification that Lincoln's campaign imagery reiterated. The hazy atmosphere, the still water, and the lone man on the river make this one of Blythe's more poetic images.

The second square begins the narration of Lincoln's road to his party's nomination for the presidency; it depicts Lincoln, as rail-splitter, with his cousin John Hanks. The two men reenact the publicity image with the caricatured frenzy appropriate to a political cartoon. The third square takes up the Lincoln-Douglas rivalry of 1858 which brought Lincoln to national prominence. Because their debates in the United States Senate centered on the issue of slavery's expansion into the territories, Lincoln and Douglas are using the head of an apprehensive black man as the fulcrum of their seesaw contest.

In the squares across the top of the painting, Blythe selectively reviews the politics of the 1860 Republican National Convention in Chicago. Square four shows a man reading the *New York Tribune*, guarding a room piled high with the baggage of the contenders for the Republican nomination. (William Henry Seward's bag is on top, for he was Lincoln's strongest opponent and an early front-runner.) The guard's key is too small for the enormous keyhole in the

Fig. 1 Unidentified artist, *Lincoln Quickstep*, c. 1860. Lithograph, sheet-music cover. McLellan Lincoln Collection, John Hay Library, Brown University, Providence, R.I.

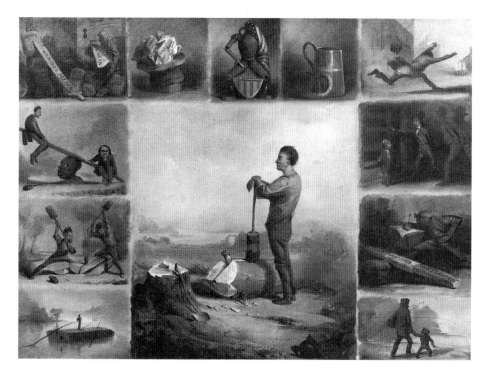

door behind him, perhaps signifying that candidates were "locked out" of the nomination by Lincoln, whose luggage is significantly absent. The incongruous sword so prominent in the vignette surely refers to a seven-foot-long bowie knife presented by a committee from Missouri to John F. Potter,[2] which Blythe, perhaps mistakenly, altered to "Hon. Alonzo Potter," an Episcopalian bishop who was a strong voice for the Union and abolition. The barrel labeled "Pure Young America" alludes to "Young America," the slogan associated with Douglas since 1852. The barrel, presumably full of liquor, may allude to the fact that Douglas—the likely Democratic nominee—was a heavy drinker.

The fifth square shows a hat on a brick, Blythe's emblem for drunkenness and a hangover.[3] The hat is filled with the ballots of the states needed to nominate Lincoln. Lincoln's partisans promised Simon Cameron, the Pennsylvania political boss, a cabinet post, and Samuel Chase, the Ohio candidate, whatever position he wanted. Blythe's image predicts the big headache in store for Lincoln because of his managers' rashness.

The figure in the sixth vignette, assembled from an assortment of drinking vessels and weapons, is a commentary on the Republican convention itself. Newspaper accounts of the event related stories of the undisciplined, intoxicated crowds. Lincoln's victory was announced with

cannon shot; one reporter noted that "minute, half-minute and quarter-minute guns were fired."[4]

Square seven, containing a beer stein and a pretzel, refers to the German vote, which played a crucial role in Lincoln's nomination. Recognizing the political usefulness of the highly organized and articulate German-American community, Lincoln had purchased control of Springfield's *Illinois Staats-Anzeiger* by buying the type. He then gave the editor free rein with the sole stipulation that the paper support the Republican platform. At the convention, German-American support for Lincoln insured Lincoln's nomination when enthusiasm for Seward waned.[5]

The top right square illustrates how news of his nomination reached Lincoln in Springfield. The May 22 edition of the Springfield, Illinois, *Daily Republican* printed a story that matches Blythe's vignette:

> When Cartter [*sic*] of Ohio announced the change of four votes, giving Lincoln the majority, and before the great tumult of applause in the Wigwam had fairly begun, it was telegraphed to Springfield. The telegraphic superintendent immediately wrote on a scrap of paper, "Mr. Lincoln, you are nominated on the third ballot," and gave it

to a boy who ran with it to Mr. Lincoln who was in the office of the *State Journal.*[6]

The outflung limbs of the figure emphasize his excitement.

Vignette nine, showing several top-hatted figures confronting a young boy, must record Lincoln's official notification of his nomination by a distinguished committee from the convention. They arrived at Lincoln's home where his son Will waited on the porch to greet them. Inside the house someone recited a tribute to "Glorious Old Abe, the Rail-splitter and Douglas Mauler," and Lincoln responded with a dignified acceptance.[7]

The next image is a shipping room where a harried clerk writes out an invoice for a rail bound for Pittsburgh's Republican Club via "Adam's Express," the well-known freight company. In fact, a brisk market had developed for rails supposedly mauled by Lincoln. They were sold for one to five dollars each, and "the supply seemed inexhaustible."[8] The rails became the ubiquitous symbols of Lincoln's candidacy. Parade floats included men splitting rails and campaign clubs called themselves "Rail Splitters" and "Rail Maulers."

The final scene on the lower right has no connection with the campaign. In a vaguely indicated landscape, a boy and a man are going fishing. Blythe arranged the composition so that both the large center panel and the small vignettes that begin and end the narrative represent simple life experiences.

Abraham Lincoln, Rail-Splitter juxtaposes two realms, one the quiet working life of the young Lincoln, the other the political convention of deals and compromises. Blythe's commentary lies in the thematic and stylistic contrast between a pensive Lincoln in the middle of the land and the vignettes of political maneuvering. The genre scenes are set in delicate landscapes while political life is conveyed through cartoonlike distortions, symbols, and labels. Blythe's familiarity with the nominating convention could have come both from newspaper stories and from the accounts of Batchelor, who had participated in it.

RCY

1 Charles W. Batchelor, *Incidents in My Life, with a Family Genealogy* (Pittsburgh, 1887).

2 William B. Hesseltine, ed., *Three Against Lincoln: Murat Halstead Reports the Caucuses of 1860* (Baton Rouge, La., 1960), p. 42.

3 Chambers, "David Gilmour Blythe,"
pp. 326–27.

4 Melvin L. Hayes, *Mr. Lincoln Runs for
President* (New York, 1960), p. 65.

5 James G. Randall, *Lincoln the President*
(New York, 1945), vol. 1, pp. 30–31.

6 Hayes, *Mr. Lincoln Runs for President*, p. 64.

7 Ibid., p. 65.

8 Ibid., p. 132.

References Frank E. Bradshaw to Department of Fine Arts, Carnegie Institute, Dec. 23, 1932, museum files, The Carnegie Museum of Art, Pittsburgh; Will J. Hyett to Juliana Force, Whitney Museum of American Art, New York, Feb. 5, 1936, exh. box no. 509, file no. 6, Whitney archives; Miller, *Life and Work of David Blythe*, p. 132; Chambers, "David Gilmour Blythe," pp. 153, 174–78, 201–3; D. D. Keyes and L. Taft, "David G. Blythe's Civil War Paintings," *Antiques* 108 (Nov. 1975), p. 994; H. Holzer, "The Making of a President: Engravings and Lithographs of Abraham Lincoln," *Connoisseur* 203 (Feb. 1980), pp. 78–79.

Exhibitions Mercantile Library Association, Pittsburgh, 1879, *Pittsburgh Library Loan Exhibition*, no. 158; Columbus Museum of Art, Ohio, 1968, *Works by David Blythe, 1815–1865*, no. 7; National Collection of Fine Arts, Washington, D.C., 1980–81, *The World of David Gilmour Blythe, 1815–1865* (trav. exh.), exh. cat. by B. W. Chambers, no. 162.

Provenance Captain Charles W. Batchelor, Pittsburgh, by 1879; W. W. Bradshaw, Pittsburgh, before 1905; his son, Frank Bradshaw, Thornburg, Pa., by 1932; his wife, Thornburg, Pa., by 1936; Mary J. R. Condon, Pigeon Cove, Mass.; Paul Mellon, Upperville, Va.

Gift of Paul Mellon, 1963, 63.19

Pittsburgh Piety, c. 1860–62

Oil on canvas
19½ x 23½ in. (49.5 x 59.7 cm)
Signature: Blythe (lower left)

It has been said that *Pittsburgh Piety* depicts the interior of Pittsburgh's First Presbyterian Church, which was completed in 1853.[1] However, David G. Wilkins has established that it is instead the interior of Second Trinity Church, built between 1823 and 1830. While minister to the Episcopalian community of Pittsburgh, the Reverend John Henry

Hopkins had designed and built this structure. Six years later, in 1836, he published a book detailing the distinctive aspects of his church. Blythe's painting corresponds precisely with a view of the chancel of Trinity Church in Hopkins's *Essay on Gothic Architecture*.[2] Both images indicate a chancel divided into three bays, each canopied with a cusped arch and decorated with elaborate pinnacles. In both, a raised pulpit occupies the central bay, and large plaques fill the walls of the side bays.

The minister presiding over the congregation in Blythe's painting is probably Cornelius S. Swope, rector pro tempore of the Second Trinity Church from 1860 to 1862 and rector from 1862 to 1867. Like the minister in the painting, Swope was young, beardless, and balding, with large sideburns. His presence indicates a date of about 1860–62 for this work, rather than the date of 1856–60 suggested by Chambers.[3] During the late 1850s the presiding rector at Trinity was the Reverend Theodore Benedict Lyman, an elderly, bearded man.

Pittsburgh Piety, which is an unusually rigid composition for Blythe, embodies sentiments similar to those he expressed in a poem-letter written in 1856 to his friend Hugh Gorley, a Vermont, Illinois, newspaper editor:

One-half our pulpits too are chuck
Full of vain, empty-headed truck
Ambitious only to have a stuck-
Up congregation to preach to and
Ten thousand or so at their command.[4]

In the painting, the minister's face is unanimated, his body stiff and wooden. He stands at the center of a symmetrical composition, addressing a faceless, immobile congregation. The rigid symmetry, however, is disturbed by the brightly illuminated head of the old man in the lower right-hand corner. He alone ignores the minister and devotes his attention to a

book, presumably the Bible or a book of prayer. Though both the rector and the old man are shown reading sacred texts, the latter does so with an intense expression wholly unlike the impassive countenance of the former. Blythe further emphasizes the contrast between the two men through technical means, depicting the rector in a constrained, linear manner while painting the old man with a freer, more exuberant brushstroke. His message, subtly conveyed without his usual brutal caricature, is clear: organized religion is often nothing more than empty ritual and superficial conformity; true religious faith lies in the individual's personal communion with God.

RCY

1 Miller, *Life and Work of David G. Blythe*, pp. 46–47, and Chambers, in National Collection of Fine Arts, *World of David Gilmour Blythe*, no. 142, p. 159.

2 John H. Hopkins, *Essay on Gothic Architecture, with Various Plans and Drawings for Churches; Designed Chiefly for the Use of the Clergy* (Burlington, Vt., 1836), p. 40, pl. 6, fig. 13.

3 *Past and Present of Trinity Episcopal Church* (Pittsburgh, 1848), frontispiece, pp. 24, 28.

4 In Chambers, "David Gilmour Blythe," p. 329.

References *Past and Present of Trinity Episcopal Church* (Pittsburgh, 1898), frontispiece, pp. 24, 28; J. O'Connor, Jr., "David Gilmour Blythe, 1815–1865," *Panorama* 1 (Jan. 1946), p. 43; H. Comstock, "Exhibition of Paintings by Martin J. Heade and David G. Blythe," *Panorama* 2 (Apr. 1947), p. 93; Miller, *Life and Work of David G. Blythe*, pp. 45–47, 74–75, 130; Chambers, "David Gilmour Blythe," p. 425; J. D. Van Trump, "The Gothic Revived in Pittsburgh: A Medievalistic Excursion," *Carnegie Magazine* 48 (Feb. 1974), p. 66.

Exhibitions Butler Art Institute, Youngstown, Ohio, 1947, *An Exhibition of the Work of David G. Blythe*, no. 40; Department of Fine Arts, Carnegie Institute, Pittsburgh, 1949, *Exhibition of Paintings, Drawings, and Prints of Pittsburgh, 1790–1949*, no cat.; Arthurs, Lestrange and Short, Pittsburgh, 1976, *City Bicentennial Celebration*, no cat.; National Collection of Fine Arts, Washington, D.C., 1980–81, *The World of David Gilmour Blythe, 1815–1865* (trav. exh.), exh. cat. by B. W. Chambers, no. 142.

Provenance Harry Shaw Newman Gallery, New York, 1946; Richard King Mellon Foundation, Pittsburgh, 1972.

Gift of the Richard King Mellon Foundation, 1972, 72.34.5

The First Mayor of Pittsburgh,
c. 1860–63

Oil on academy board
23⅜ x 19¾ in. (59.4 x 50.2 cm)
Signature: Blythe (lower left)

This composition, if one relies on Blythe's labeling and presentation, represents a session of a municipal court housed just inside the front door to the mayor's office. Such courts "accumulated the victims of the previous night's constabulary sweep," then tried them for a motley assortment of misdemeanors.[1] "The First Mayor of Pittsburgh" may have been an intentionally sardonic choice of title on the artist's part, since the main official—the judge seated at the left—is not Ebenezer Denny, who in 1816 became Pittsburgh's first mayor. Indeed, the man sits before the door to an apparently empty mayor's office. Traditionally, this figure has been identified as the first mayor's son, Harmar Denny, an attorney and a congressman. However, the younger Denny, who died in 1852, never served as mayor.

Apart from the title and its unresolved meaning, this painting tells a story that centers on the constable, the defendant, and the contact between them. All are satirized. The defendant has the vulnerable air and ragged finery of a man who has fallen on hard times. Blythe records his cringing stance and frightened gaze, his knock-knees and the way he hides his groin with his tattered hat. He depicts the arresting officer as a grotesque, pug-nosed (perhaps syphilitic) brute and the presiding magistrate as a withered, unsympathetic old man.

Originally, Blythe had shown a top-hatted man entering the courtroom at the right. He replaced this figure, still dimly visible beneath a layer of paint, with his trademark figure of a cigar-smoking, shrunken newsboy.
RCY

1 Chambers, in National Collection of Fine Arts, *World of David Gilmour Blythe*, p. 71.

Reference Chambers, "David Gilmour Blythe," pp. 152–53, 302, 409.

Exhibitions Department of Fine Arts, Carnegie Institute, Pittsburgh, 1959, *Paintings by David G. Blythe*, no cat.; William Penn Memorial Museum, Harrisburg, Pa., 1979, *Pennsylvania Painters from Commonwealth Collections*, no. 7; National Collection of Fine Arts, Washington, D.C., 1980–81, *The World of David Gilmour Blythe, 1815–1865* (trav. exh.), exh. cat. by B. W. Chambers, no. 175.

Provenance G. David Thompson, Pittsburgh, by 1952; John O'Connor, Jr., Pittsburgh, by 1959; Richard King Mellon Foundation, Pittsburgh, by 1959.

Gift of the Richard King Mellon Foundation, 1972, 72.34.2

The Woodcutter, c. 1860–64
(Sharpening the Axe; Clearing the Wilderness; The Woodchopper)

Oil on canvas mounted on board
18½ x 25⅜ in. (47 x 64.5 cm)
Signature: Blythe (lower center)

One of Blythe's late works, *The Woodcutter* presents an unexpected subject and style. Its serenity, open setting, low horizon, and thick, mottled application of paint were all new developments for the artist.

Blythe depicted a woodcutter who, having felled two trees and perhaps more that are not visible to us, sits on a trunk to sharpen the blade of his ax. The woodcutter is not idealized: his clothes are ragged and patched, his features coarse and unshaven. Nonetheless, the view

through the clearing with the cabin behind him to the low horizon and the slight backlighting endow this gruff fellow with a calm, dignified, unselfconscious symbolism. As in *Abraham Lincoln, Rail-Splitter* (see p. 92), Blythe associates the motif of the tree fallen next to its stump with the frontiersman, who in turn embodies such simple American virtues as independence, industry, and plain living. The resemblance between the woodcutter and Lincoln reinforces the identification with these virtues.
RCY, KN

References Miller, *Life and Work of David G. Blythe*, pp. 31, 131; J. T. Flexner, *That Wilder Image* (Boston, 1962), p. 224; Chambers, "David Gilmour Blythe," no. 57, p. 403.

Exhibitions Harry Shaw Newman Gallery, New York, 1946, *American Genre Painting*, as

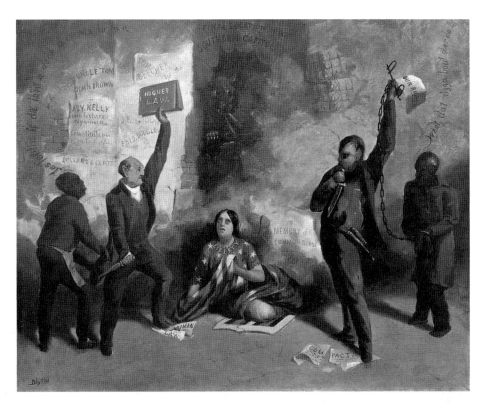

The Higher Law, 1861
(Southern Attack on Liberty)

Oil on canvas
20¼ x 24½ in. (51.4 x 62.2 cm)
Signature: Blythe (lower left)

This painting presents Blythe's view of the causes of the Civil War. At the center of the composition, American Liberty lies mortally wounded on her shield; stab wounds appear above each breast and on her throat. Behind her is the grave of Common Sense, bearing the date 1861. Liberty's attackers—a Northern abolitionist and a Southern slaveholder—stand on either side of her. Each has pointed ears, clutches a bloody dagger, and holds aloft a symbol of his political position.

On the left, the abolitionist holds aloft a volume labeled "Higher Law," a reference to Senator William H. Seward's 1850 speech against the Fugitive Slave Law, in which he declared, "There is a higher law than the Constitution." This statement reflected the radical abolitionist belief that the moral imperative of eliminating slavery took precedence over the law of the land. Blythe's abolitionist clearly subscribes to this view, for he tramples "Human Law" underfoot.

Handbills bearing the names of prominent abolitionists have been posted behind him on the left-hand wall. The inscription "Aby. Kelly will lecture against the Constitution of the United States" refers to Abigail Kelley, the prominent abolitionist, and her proposal to dissolve the Union in order to separate permanently the slave and the free states. The names of Frederick Douglass, the fiery black orator, and Joshua R. Giddings, the

Radical Republican congressman from Ohio, are joined in one poster. Five years earlier, Blythe had attacked Giddings in a poem to Hugh Gorley, his friend in Vermont, Illinois:

And the old plague spot Giddings, too,
Where stands he with his kink-haired crew?
Ready again, as usual, to strew
Their firebrands around wherever a few
Will be likely to act like a shower of mildew
On the good both themselves and their
 betters would do.[1]

It is not clear why the name of the abolitionist clergyman Henry Ward Beecher crosses that of Thomas Paine. Perhaps it is because Beecher's views would destroy Paine's view of national unity. Blythe may have known that while Paine was an eighteenth-century pioneer in urging the end of black slavery, he also forcefully urged the newly independent American colonies to unite under a written constitution. Even though Beecher spoke in favor of preserving the Union, Blythe would have regarded him as an extremist, for Beecher, like Seward, had advocated disobeying the Fugitive Slave Law in the name of a "Higher Law." In 1856, he had urged a New Haven audience to purchase rifles for some Kansas free-state emigrants on the grounds that guns in the hands of such emigrants were a greater moral argument than the Bible. "Uncle Tom" refers, of course, to *Uncle Tom's Cabin*, the 1852

antislavery novel by Beecher's sister Harriet Beecher Stowe. Blythe may have intended the words "Dollars & Cents" to imply mercenary motives on the part of many abolitionists.

Blythe's condemnation of the South is even more scathing. Unlike the elderly, bald abolitionist, the Southerner on the right has a dark, demoniac appearance. His eyes are in shadow, his dark hair and beard mask his face. In opposition to the abolitionist's "Higher Law," he holds aloft a pair of slave's shackles labeled "Our Rights" and tramples a torn "Compact" signifying the Constitution of the United States of America. Bales of cotton stacked behind him indicate that his motive is economic greed. The "Final Location of the Southern Capitol" is unambiguously identified as Hell by the flames and dragon. If the words mean the Confederate government's relocation from Montgomery, Alabama, to Richmond, Virginia, in May 1861, this painting would date after the bombardment of Fort Sumter on April 12. If, on the other hand, the phrase reflects Blythe's feeling that the Southern capital should go to hell, then the painting could have been done before the attack on Fort Sumter and thus expresses a warning to stop the assassination of the Union before it is too late.

One cannot escape Blythe's racism. He depicts the black, whose fate the abolitionist and the slave owner are struggling to decide to the detriment of the Union, as an unworthy object of contention. The servant's apron worn by the Northern black indicates that, though technically free, he still occupies a servile position in society. He has put his hand in the abolitionist's pocket, "Jes feelin if da isnt a deck a cards in hea." Is this a transparent excuse given by an untrustworthy servant, or does he suspect that his emancipators still have the deck stacked against him? The fettered Southern black keeps a sharp eye on his free brother and wonders "What dat nigga 'bout ober da." The implication is that he is curious about and, given the opportunity, would be all too eager to emulate the devious ways of the Northern black. Neither black man betrays any interest in the fight between North and South or in the principles involved.

Blythe's political outlook in this work is very close to the official position of the Lincoln administration. Though opposing the extension of slavery to the territories, Lincoln equally opposed abolishing it in the areas where it already existed. He believed it would eventually disappear of its own accord, without Northern interference. This view was shared by many Northerners who, like Blythe, blamed extremists on both sides of the slave issue for the dissolution of the Union.

The Higher Law was first exhibited under this title at the 1879 *Pittsburgh Library Loan Exhibition*. It is by no means an appropriate title, as it refers only to the abolitionist. David G. Wilkins has suggested that *The Southern Attack on Liberty* exhibited at the 1864 Pittsburgh Sanitary Fair was *The Higher Law* under a different name.[2] This earlier title is also inappropriate, but it is possible that Blythe or Charles W. Batchelor, the original owner, adopted it to reflect the partisan and patriotic attitudes of an event organized to raise money for the Union cause.

RCY

1 In Chambers, "David Gilmour Blythe," p. 327.

2 David G. Wilkins, "New Information on Works by David G. Blythe," *American Art Journal* 13 (Autumn 1981), p. 86.

References Miller, *Life and Work of David G. Blythe*, p. 103; Chambers, "David Gilmour Blythe," pp. 182–83, 203; D. G. Wilkins, "New Information on Works by David Gilmour Blythe," *American Art Journal* 13 (Autumn 1981), p. 86; D. Killoran, "David Gilmour Blythe's America: A Paradise Lost," *Art and Antiques* 7 (Sept.–Oct. 1982), pp. 93–97.

Exhibitions Possibly New City Hall, Allegheny City, Pa., 1864, *Exhibition of Painting and Statuary in Aid of the Pittsburgh Fair Fund of the United States Sanitary Commission*, no. 146, as *Southern Attack on Liberty*; Mercantile Library Association of Pittsburgh, 1879, *Pittsburgh Library Loan Exhibition*, no. 152; Westmoreland County Museum of Art, Greensburg, Pa., 1960, *Civil War Centenary*, no cat.; State Museum of Pennsylvania, Harrisburg, 1972, *Pennsylvania Heritage*, no cat.; Westmoreland County Museum of Art, Greensburg, Pa., 1976, *Nineteenth and Early Twentieth Century Regional Painters*, exh. cat. by J. K. Maguire and P. A. Chew, unnumbered; National Collection of Fine Arts, Washington, D.C., 1980–81, *World of David Gilmour Blythe, 1815–1865* (trav. exh.), exh. cat. by B. W. Chambers, no. 181.

Provenance Captain Charles W. Batchelor, Pittsburgh, by 1864; Captain Lawrence, Port Washington, N.Y., before 1950; Hirschl and Adler Galleries and Newhouse Galleries, New York, 1950; private collection, after 1950; Hirschl and Adler Galleries, New York, by 1958.

Museum purchase: gift of Mr. and Mrs. John F. Walton, 1958, 58.56.3

Confederate Soldier at the Well, c. 1861

Oil on canvas
11⅞ x 18 in. (30.2 x 45.7 cm)
Signature: Blythe (lower left)

This painting is one of a small group of Civil War genre pieces by Blythe. Some, including *Camp Scene* (c. 1861, collection Norton Asner, Baltimore) and *Man*

Putting on Socks (1861, collection Mr. and Mrs. Jackman S. Vodrey, East Liverpool, Ohio), were painted while Blythe was traveling with the Thirteenth Pennsylvania Regiment in 1861 and depict the activities of Union soldiers. *Confederate Soldier at the Well* is unique—and, in view of Blythe's Union sympathies, surprising—because it portrays a Confederate soldier. Perhaps Blythe intended the viewer to recall the biblical story in which Christ stops at a well in Samaria and requests and receives a drink from a local woman despite the long-standing hatred between Jews and Samaritans (John 4: 1–30). This allusion would enrich an otherwise unremarkable genre scene.

Confederate Soldier at the Well is thinly painted throughout: the features of the woman and the soldier are only sketchily rendered; the building and the well are almost wholly lacking in detail. It thus appears that Blythe abandoned it before completion. Like *Harvesting* (see p. 100) and *Man Eating in a Field* (see p. 86), this work originally belonged to Thomas Blythe, the artist's brother.

KN, RCY

References Miller, *Life and Work of David G. Blythe*, p. 81; Chambers, "David Gilmour Blythe," no. 70, p. 404.

Exhibitions Westmoreland County Museum of Art, Greensburg, Pa., 1960, *Civil War Centenary*, no cat.; Columbus Museum of Art, Ohio, 1968, *Works by David Blythe, 1815–1865*, no. 16; National Collection of Fine Arts, Washington, D.C., 1980–81, *The World of David Gilmour Blythe, 1815–1865* (trav. exh.), exh. cat. by B. W. Chambers, no. 170.

Provenance The artist's brother, Thomas Blythe, East Liverpool, Ohio; his son, Heber H. Blythe, East Liverpool, Ohio.

Museum purchase: Mr. and Mrs. James H. Beal Fund, 1954, 54.31.1

United States Treasury, c. 1862–63
(Foreign Loans)

Oil on canvas
16 x 18 in. (40.6 x 45.7 cm)
Signature: Blythe (lower left)

Exhibited at the 1864 Pittsburgh Sanitary Fair as *United States Treasury,*[1] this work has long been known as *Foreign Loans,* the title under which it appeared at the 1879 *Pittsburgh Library Loan Exhibition.* The painting's original owner was Charles W. Batchelor, who also purchased Blythe's *Higher Law* (see p. 95) and *Abraham Lincoln Writing the Emancipation Proclamation* (see p. 99). A Lincoln appointee, in his capacity as Surveyor of the Port and Depository of the United States in Pittsburgh, Batchelor worked under the Treasury Department and thus had firsthand knowledge of the scenario set forth by Blythe.

Although the work is arguably the most difficult of all Blythe's political-cartoon paintings to decipher, the scene depicted is, on the face of it, a simple one. It is the front room of a bank, with a satisfied customer at the counter, an unhappy one exiting from the front door, and a teller in the background counting money. Uncle Sam is the protagonist standing at the center of the scene, whittling at the counter as he waits for the bank teller to complete a transaction the two have just made. Uncle Sam grins, for he has made an exceedingly good deal, having traded a handful of paper money (being counted by the bank clerk) for a large sack of gold coins.

The gold represents the proceeds of the "individual and corporate loans" made to the government by northern cities, banks, and private citizens; the loans are posted behind the bank counter. They were the results of the Treasury's policy of raising money for the war effort without recourse to borrowing from foreign sources. Besides a string of cities from Boston to Cincinnati, the list of lenders includes two pro-Lincoln southern newspaper editors, George D. Prentice of the *Louisville* (Kentucky) *Daily Journal* and "Parson" William G. Brownlow of the *Knoxville* (Tennessee) *Whig,* as well as the Catholic archbishop of New York, John G. Hughes, who was one of Lincoln's emissaries to Great Britain.

Blythe intended, at least in part, to convey the virtue of not being beholden to foreigners. Sunlight entering the bank's open doorway divides the interior into sharply defined bright and dark areas, with Uncle Sam bathed in sunlight while various documents on the countertop, which refer to Britain's involvement with the Confederacy, are subsumed in shadow. The bound volume titled *Memorandum* probably refers to the one issued on October 13, 1862, by the British foreign secretary, Lord John Russell, which promoted a truce between the United States and the Confederacy and implied that the British government would recognize southern independence. Beneath it is a copy of the London *Times,* which endorsed a loan to the Confederate states, formulated by the South in September 1862 as a sale of certificates for southern cotton. The adjacent document labeled "Russell" may refer either to Lord Russell or to William H. Russell, the pro-South, American correspondent of the London *Times.* Another foreign presence is the bearded European, perhaps German or Austrian, who exits with his hand in his pocket and with a baleful expression on his face.

Himself inimical toward foreigners, Blythe probably shared the well-known antagonism to Britain's pro-South stance.[2] Nonetheless, his painting makes quite clear that the rejection of economic involvement with foreigners has a dark side. Among the adverse effects was inflated paper currency, the notorious "greenbacks" first issued by the Treasury

in 1862. Blythe was deeply suspicious of paper money, yet this is the medium of Uncle Sam's transaction: paper notes exchanged for the sack of gold on the counter. The seemingly unending demand on northern creditors is suggested by the gaping safe, the astronomical sums listed behind it, and the sack of gold, whose picturesque denomination, U.S. Puterinctums, readily transliterates as "put 'er in 'ems." Posted on the background wall, next to the immense sum owed to Pittsburgh, is a foreboding comment, "Sam will take all thats left." Indeed, the inadequate supply of specie incited a riot in November 1862 at the Pittsburgh customhouse, which had to be brought to order by "soldiers with bayonets."[3]

Blythe gave a caustic edge to his irony through the presence of the old, bearded European. Turned away from the bank where Uncle Sam has negotiated his loan, he glances at Treasury Secretary Salmon P. Chase's order, "No Foreign Loans Taken Here." Atop that sign is the evidence of the Confederacy's deals with Britain, the point being that foreigners who are discouraged from lending to the Union will have plenty of opportunity to invest with the Confederacy. If England can do so, why not Germany, Austria, or other nations on the Continent? Meanwhile, Uncle Sam's satisfaction at avoiding such

entanglements is achieved at a high price to his countrymen. Draped limply across the center of the counter, along the line of battle, as it were, is a promissory note to "the People" so large that the zeros run off the countertop.

DS, RCY

1 David G. Wilkins, "New Information on Works by David G. Blythe," *American Art Journal* 13 (Autumn 1981), pp. 85–86.

2 Chambers, in National Collection of Fine Arts, *World of David Gilmour Blythe*, p. 83.

3 Britta Dwyer, "A New Iconography for Two of Blythe's Paintings: The Interaction of Blythe and His Patron, Charles William Batchelor," Master's thesis, University of Pittsburgh, 1985, p. 6.

References Miller, *Life and Work of David G. Blythe*, pp. 103, 132; B. Arter, "Paradoxical Painter," *Columbus* (Ohio) *Evening Dispatch*, Mar. 10, 1968, magazine sec., p. 12; Chambers, "David Gilmour Blythe," pp. 178–82, 202; D. G. Wilkins, "New Information on Works by David Gilmour Blythe," *American Art Journal* 13 (Autumn 1981), no. 33, p. 85.

Exhibitions Pittsburgh, 1864, *Exhibition of Paintings and Statuary in Aid of the Pittsburgh Fair Fund of the United States Sanitary Commission*, no. 33; Mercantile Library Association of Pittsburgh, 1879, *Pittsburgh Library Loan Exhibition*, no. 163, as *Foreign Loans;* Westmoreland County Museum of Art, Greensburg, Pa., 1961, *Civil War Centenary*, no cat.; Columbus Museum of Art, Ohio, 1968, *Works by David Blythe, 1815–1865*, no. 11; State Museum of Pennsylvania, Harrisburg, 1972, *Pennsylvania Heritage*, no cat.; National Collection of Fine Arts, Washington, D.C., 1980–81, *The World of David Gilmour Blythe, 1815–1865* (trav. exh.), exh. cat. by B. W. Chambers, no. 176.

Provenance Captain Charles W. Batchelor, Pittsburgh, by 1879; Captain Lawrence, Port Washington, N.Y., before 1950; Hirschl and Adler Galleries and Newhouse Galleries, New York, 1950; private collection, after 1950; Hirschl and Adler Galleries, New York, by 1958.

Museum purchase: gift of Mr. and Mrs. John F. Walton, 1958, 58.56.1

Abraham Lincoln Writing the Emancipation Proclamation, 1863

Oil on canvas
21¾ x 27 in. (55.2 x 68.6 cm)
Signature: Blythe (lower left)

The Emancipation Proclamation, which Lincoln made public on January 1, 1863, granted freedom to the slaves in the ten seceded states. This freedom could not be enforced except by the conquering Union army, so Lincoln made this pronouncement as Commander in Chief. Like *Abraham Lincoln, Rail-Splitter* (see p. 92), *Abraham Lincoln Writing the Emancipation Proclamation* is a response to a major political event. In both paintings, Blythe focused on the character of Lincoln and surrounded him with allusions to the political situation.

The proclamation created much controversy in the North. Some Abolitionists and Radical Republicans found it too timid in not granting freedom to the slaves of the pro-Union border states. Some Democrats felt it changed the aim of the war from saving the Union to destroying slavery. Abroad, the proclamation had a great effect. In England it rallied the sympathies of the working classes: British workers forced the cabinet to stop building naval vessels for the Confederacy.[1] In Russia the czar, who had freed the serfs in 1861, sent warships to visit New York and San Francisco, while France was "unanimously for emancipation."[2] Blythe's *Abraham Lincoln Writing the Emancipation Proclamation* alludes to all this.

The clutter around Lincoln in the painting indicates the many issues and contradictory voices surrounding this moment. In the fireplace, two partly burned letters from James Buchanan indicate the defunct policies of the previous administration. They lie beside a petition from Wendell Phillips, an abolitionist orator. The window is curtained with an American flag that has been hung upside down—a traditional distress signal.[3] The table on Lincoln's right is piled with petitions and books, including volumes on the Constitution by Chief Justice John Marshall and Daniel Webster and *Records of the Administrative Policy of the Presidents of the United States Down to '60.* The dispatch from "Little Mc" is from General George B. McClellan, who checked Lee at Antietam and whose victory gave Lincoln the opportunity to present the second draft of the proclamation to his Cabinet: Lincoln had been waiting for a Union victory as he did not want his proclamation to appear to be a desperate bid for support in the face of Union losses.

To the right of the central figure, the cornice of the bookshelf quotes Lincoln himself, "Without slavery the war would not exist and without slavery, it would not be continued." The books *International Law* and *The History of England,* the globe, and the map of Europe with the sword in front of it refer to the rest of the world, especially England, and the support which came from the proclamation.

Presences from the past also surround Lincoln, one being the bust of George Washington on the mantel. Another bust, behind Lincoln, of Andrew Jackson, hangs by its neck in the shadows, presumably because Jackson had been a Democrat and a slaveholder. Nearby, the book *Taney's Decisions Vol. 40* alludes to the Dred Scott decision, which held that the federal government could not constitutionally exclude slavery from the territories. The petition from the ghost of John B. Floyd asking for an exchange alludes to a local incident in which Floyd, as Buchanan's secretary of war, arranged to ship munitions from the Pittsburgh Arsenal to the rebellious southern states after Lincoln's election. The shipment was blockaded, which led to Floyd's defection to the Confederate army.

Petitions from abolitionist churches and Union soldiers are strewn about, while Lincoln's open trunk is still unpacked, referring, along with the burned letters of Buchanan, to the untidy transition between administrations. In the midst of all the disarray, Lincoln sits writing the Emancipation Proclamation: his eyes are lowered, his expression is one of deep thought. On his lap are the Constitution and the Bible, on which he is depending to steer him through this turmoil. Above him is his oath of office; the key on the wall indicates that this is the key to the nature of his dilemma, for he has sworn to uphold the laws of all the states—including the slave states. At his feet are war maps—the rebel ("Reble") states held down by various symbols of Lincoln's power as the people's representative. Between his obligation to his oath and his problem (to win the war and preserve the Union) is his response, the Emancipation Proclamation.

Fig. 1 Unidentified artist, *President Lincoln, Writing the Proclamation of Freedom, January 1st 1863,* 1864. Color lithograph, 14 x 19 in. (35.6 x 48.3 cm). The Library of Congress, Washington, D.C.

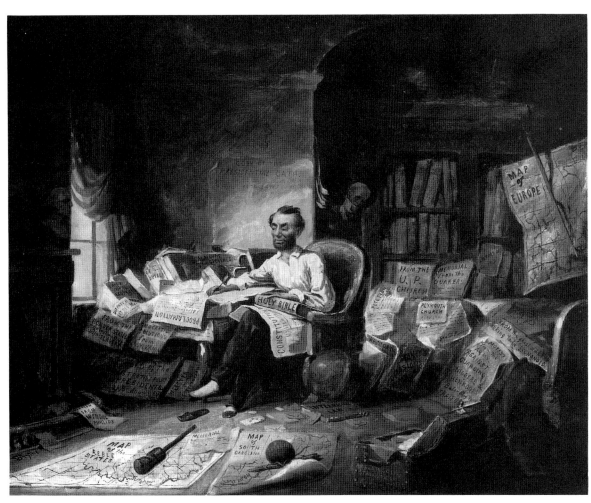

This painting clearly is not an observation of Lincoln but, rather, an accumulation of what Blythe knew about him. Lincoln, like Blythe, had a reputation for working in a disorganized mess. Disheveled, without a tie, he sits with one slipper on and the other off. Everyone knew that Lincoln had trouble with his shoes and often removed them for comfort. The portrayal of Lincoln's thoughtful face could be based on the lithograph printed by Louis Prang in 1861.

This is the only painting by Blythe to be translated into a print—a color lithograph entitled *President Lincoln, Writing the Proclamation of Freedom, January 1st 1863* (fig. 1). It was printed by Ehrgott, Forbriger and Co., Cincinnati, in 1864. Because there are alterations in the print that Blythe himself must have made or supervised and because Blythe is not listed in the 1864 residence list of Pittsburgh, it is almost certain that he was in Cincinnati in that year. The print was published the same year by M. Depuy of Pittsburgh. [4]

The changes in the print make it more pointed and topical. The fragments of Buchanan's letter are replaced by a letter

from Abigail Kelley (see *The Higher Law*, p. 95), whose abolitionist views were so radical that she advocated the breaking up of the Union. On the mantel, a bust of Andrew Jackson replaces George Washington and weighs down a paper that reads, "The Union must and shall be Preserved," referring to Jackson's opposition to disunion during the nullification crisis. Behind Lincoln hangs the bust of James Buchanan instead of Andrew Jackson, making the rejection of Buchanan clearer. On the table is an account of Libby Prison, where Union soldiers suffered as prisoners of war. Tilted scales of Justice on the wall refer to the situation that Lincoln is called to right.

This one excursion by Blythe into print publishing never approached the popularity of the engraving by Alexander Hay Richie, after Francis Carpenter's *First Reading of the Emancipation Proclamation Before the Cabinet* (1866, National Portrait Gallery, Washington, D.C.), a dignified, academic work that, unlike Blythe's image, tells the viewer nothing about the

circumstances and issues surrounding the writing of that famous document.
RCY

1 James G. Randall, *Lincoln the President* (New York, 1945), vol. 2, p. 180.

2 Ibid.

3 Chambers, in National Collection of Fine Arts, *World of David Gilmour Blythe*, p. 90.

4 Ibid., pp. 196–97.

References *Old Print Shop Portfolio* 2 (Feb. 1943), pp. 135–37; Miller, *Life and Work of David G. Blythe*, pp. 78, 86–88; Chambers, "David Gilmour Blythe," pp. 188–99, 201–4, 312, 396; D. D. Keyes and L. Taft, "David G. Blythe's Civil War Paintings," *Antiques* 108 (Nov. 1975), p. 995; H. Holzer, "The Making of a President: Engravings and Lithographs of Abraham Lincoln," *Connoisseur* 203 (Feb. 1980), pp. 82–83, 87–88; B. W. Chambers, "David Gilmour Blythe's Pittsburgh: 1850–65," *Carnegie Magazine* 55 (May 1981), pp. 21–22.

Exhibitions Mercantile Library Association of Pittsburgh, 1879, *Pittsburgh Library Loan Exhibition*, no. 156; Westmoreland County Museum of Art, Greensburg, Pa., 1961, *Civil War Centenary*, no cat.; Columbus Museum of Art, Ohio, 1968, *Works by David Blythe, 1815–1865*, no. 8; National Collection of Fine

Arts, Washington, D.C., 1980–81, *The World of David Gilmour Blythe, 1815–1865* (trav. exh.), exh. cat. by B. W. Chambers, no. 163.

Provenance Captain Charles W. Batchelor, Pittsburgh, by 1879; Captain Lawrence, Port-Washington, N.Y., before 1950; Hirschl and Adler Galleries and Newhouse Galleries, New York, 1950; private collection, after 1950; Hirschl and Adler Galleries, New York, by 1958.

Museum purchase: gift of Mr. and Mrs. John F. Walton, 1958, 58.56.2

Harvesting, c. 1863–64

Oil on canvas
10 x 14 in. (25.4 x 35.6 cm)
Signature: Blythe (lower right)

Harvesting, like *Man Eating in a Field* (see p. 86), originally belonged to Thomas Blythe, a brother of the artist. It, too, is a late work with an unusual emphasis upon a becalmed, panoramic landscape which, for Blythe, is markedly naturalistic and free in its treatment. Landscapes with figures had briefly attracted the artist early in his career, but not until the 1860s did he return to them, with renewed interest and far greater skill, in works such as *Farm Scene* (c. 1863–64, collection Virginia E. Lewis, Pittsburgh) and *Corn Husking* (c. 1863–64, Metropolitan Museum of Art, New York).

In many respects, *Harvesting* is the most successful of these landscapes. Long, sweeping diagonals made by boundary fences and slashes of sunlight draw the eye back to a horizon line. The space,

punctuated by a few farm buildings and storm clouds, creates a sense of broad immensity unparalleled in Blythe's oeuvre. The lighting and the atmospheric effects of the approaching storm are dramatic yet convincing. Deft and fluid throughout, Blythe's brushstrokes help give pictorial unity to this late canvas.
KN

References Miller, *Life and Work of David G. Blythe*, p. 57; Chambers, "David Gilmour Blythe," pp. 208, 318; B. W. Chambers, "David Gilmour Blythe's Pittsburgh: 1850–65," *Carnegie Magazine* 55 (May 1981), p. 25.

Exhibitions Department of Fine Arts, Carnegie Institute, Pittsburgh, 1932–33, *Exhibition of Paintings by David G. Blythe*, no. 18; Whitney Museum of American Art, New York, 1936, *Paintings by David G. Blythe, 1815–1865—Drawings by Joseph Boggs Beale, 1841–1926*, no. 17; Butler Art Institute, Youngstown, Ohio, 1942, *Ohio Painters of the Past*, no. 2; Butler Art Institute, Youngstown, Ohio, 1947, *An Exhibition of the Work of David G. Blythe*, no. 19; Columbus Museum of Art, Ohio, 1968, *Works by David Blythe, 1815–1865*, no. 14; Arthurs, Lestrange and Short, Pittsburgh, 1976, *City Bicentennial Celebration*, no. 14; National Collection of Fine Arts, Washington, D.C., 1980–81, *The World of David Gilmour Blythe, 1815–1865* (trav. exh.), exh. cat. by B. W. Chambers, no. 179.

Provenance The artist's brother, Thomas Blythe, East Liverpool, Ohio, by c. 1864; his son, Heber H. Blythe, East Liverpool, Ohio, by 1947.

Mr. and Mrs. James H. Beal Fund, 1954, 54.31.2

Formerly attributed to David Gilmour Blythe

Whoa, Emma!, c. 1865–76

Oil on canvas
16 x 12 in. (40.6 x 30.5 cm)

This canvas gained a certain amount of prominence as a work by Blythe after it appeared as an illustration in Oliver Larkin's book *Art and Life in America* in 1949. However, neither the hand nor the broadly comical approach is Blythe's. Nor, apparently, is the chronology; the subject matter suggests that the work may have been painted during Reconstruction, possibly by another Pittsburgh-area artist.
DS

References O. Larkin, *Art and Life in America* (1949; rev. ed., New York, 1960), p. 216; Miller, *Life and Work of David G. Blythe*, pp. 68, 131; National Collection of Fine Arts, *World of David Gilmour Blythe*, no. 289, p. 198.

Exhibitions Whitney Museum of American Art, New York, 1936, *Paintings by David G. Blythe, 1815–1865—Drawings by Joseph Boggs Beale 1841–1926*, no. 41; Historical Society of Western Pennsylvania, Pittsburgh, 1950, *Exhibition of Works by Pittsburgh Artists*, no. 21.

Provenance Johanna K. W. Hailman, Pittsburgh.

Bequest of Johanna K. W. Hailman, 1959, 59.5.2

Ilya Bolotowsky

1907–1981

BORN IN SAINT PETERSBURG, Russia, Ilya Bolotowsky spent his childhood in Baku, on the Caspian Sea, and in Constantinople before immigrating with his family to New York in 1923. There, in the following year, he began to attend the National Academy of Design and, although he described the school as "stodgy," continued to study there until 1930.[1] Initially Bolotowsky practiced an academic Impressionism using subdued brown tones, but when he attempted to inject bolder color into his work, he was labeled by his instructors as a bad example and a rebel.[2] Despite this dubious status, he won prizes for drawing from the academy in 1925 and 1926 and the Hallgarten Prize for painting in 1929 and 1930.

For ten months in 1932 Bolotowsky traveled in Europe, visiting France, Italy, Denmark, and Germany. His stay in Paris, where he saw the Louvre, contemporary paintings of Giorgio de Chirico, and Cubist works of Pablo Picasso and Georges Braque, made a lasting impression on him. Picasso's and Braque's example enabled Bolotowsky to move beyond the training he had received at the National Academy, for thereafter he dispensed with objective and figurative references in his painting and replaced them with an abstract style founded on European modernism. That style found itself in direct opposition to American scene painting, some of whose proponents were trying to banish such foreign influences from their art.

When Bolotowsky returned to the United States and settled again in New York at the end of 1932, he began visiting the Albert E. Gallatin Collection at the Gallery of Living Art, where he saw Piet Mondrian's paintings for the first time. Later he encountered the works of Joan Miró at the Pierre Matisse Gallery. These experiences resulted in Bolotowsky's adoption, from the 1930s on, of biomorphic Surrealism in combination with Mondrian's geometric Neoplasticism.[3]

Given the steady decline of the American economy after the stock-market crash of 1929 and the diffi-culty artists had finding employment, Bolotowsky was fortunate to work for the Public Works Art Project in 1934, painting realistic canvases of New York scenes. In 1936 he was transferred to the Mural Division of the WPA to paint a mural for the Williamsburg Housing Project. Organized by Burgoyne Diller, this project employed several other abstract artists, including Martin Craig, Balcomb Greene, Albert Swinden, and Willem de Kooning.

In 1935 Bolotowsky became a member of the Ten Who Were Nine, and in 1936 he joined another small New York group called the American Abstract Artists. This avant-garde association wished to promote the growing American modernist movement, but its members had difficulty exhibiting their work. Regionalists such as John Steuart Curry, Thomas Hart Benton, and Grant Wood were the artists who received exhibition space in the relatively few galleries that existed in New York at the time. Not accepted by museums, the American abstractionists succeeded in having their first show in 1937 at the Squibb Gallery in New York, and they managed to exhibit annually as a group for the next several years.

Still working for the WPA from 1939 to 1941, Bolotowsky completed two more abstract murals, one for the Hall of Medical Science of the 1939–40 New York World's Fair and another for the Hospital for Chronic Diseases on Welfare Island. After the war began he left the WPA to serve in the army as a technical translator for a Russian-English dictionary and then became a translator of Russian for the air force. Bolotowsky returned permanently to New York in 1945. He exhibited at several New York galleries and participated from 1945 to 1947 in the annual *Painting in the United States* exhibitions held at Carnegie Institute.

Bolotowsky developed his mature style through an increasing emphasis on interpreting the Neoplastic philosophy of Mondrian. His paintings from the 1940s on eliminate the biomorphic shapes of Miró seen in his earlier works and strive toward the creation of an ideal, balanced harmony. His evolved style was devoid of figurative images but filled with a great range of tensions finding resolution in a world of pure abstraction.[4] Beginning in the early 1960s, he added painting with three-dimensional elements to his areas of artistic exploration. Bolotowsky died in New York City.

1 Bolotowsky, interview with John R. Lane, March 29, 1981, museum files, The Carnegie Museum of Art, Pittsburgh.

2 Bolotowsky, "Adventures with Bolotowsky," p. 16.

3 John R. Lane, "Ilya Bolotowsky's *Abstraction*, 1936–37," *Carnegie Magazine* 55 (June, July, August 1981), p. 4.

4 Solomon R. Guggenheim Museum, *Ilya Bolotowsky*, p. 1.

Bibliography Solomon R. Guggenheim Museum, New York, *Ilya Bolotowsky* (1974); Ilya Bolotowsky, "Adventures with Bolotowsky," *Archives of American Art Journal* 22, no. 1 (1982), pp. 8–31; Deborah Rosenthal, "Ilya Bolotowsky," in Museum of Art, Carnegie Institute, Pittsburgh, *Abstract Painting and Sculpture in America, 1927–1944* (1983), exh. cat. ed. by John R. Lane and Susan C. Larsen, pp. 51–54; Robert L. Herbert et al., *The Société Anonyme and the Dreier Bequest at Yale University: A Catalogue Raisonné* (New Haven, 1984), pp. 75–80.

Abstraction (No. 3), c. 1936–37

Oil on canvas
28 x 36 in. (71 x 91.5 cm)
Signature: *Ilya Bolotowsky* (lower right)

Bolotowsky was never inclined to take too seriously the tendency of artists in the 1930s to become involved in politics, the polemics of art theory, or the use of art to convey symbolic ideas. Instead, he was a formalist deeply committed to nonobjective art, that is to say, an art deriving its forms not from nature but exclusively from his own invention. *Abstraction (No. 3)* is particularly interesting within his life's work because of the source of its inspiration and the relative specificity of its content, both of which are documented to an unusual extent for him.

Bolotowsky painted *Abstraction (No. 3)* as a result of having seen Alberto Giacometti's sculpture *The Palace at 4 A.M.* at the Museum of Modern Art's landmark exhibition *Fantastic Art, Dada, Surrealism*, which opened to considerable controversy in New York on December 9, 1936.[1] While Bolotowsky did not know Giacometti's elaborate iconographical explanation of *The Palace at 4 A.M.*, he may have read in the exhibition's catalogue about the Swiss artist's "marvellous sculpture . . . in wood, stone and plaster, settings of poetic precision,

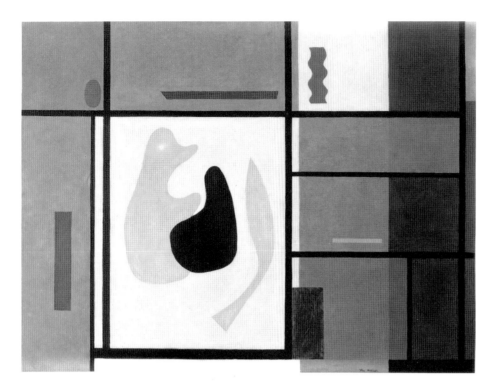

Exhibitions Zabriskie Gallery, New York, 1972, *American Geometric Abstraction of the 1930s*, no. 4; Washburn Gallery, New York, 1980, *Paintings from 1935 to 1945*, no. 3; Museum of Art, Carnegie Institute, Pittsburgh, 1983–84, *Abstract Painting and Sculpture in America, 1927–1944* (trav. exh.), exh. cat. ed. by J. R. Lane and S. C. Larsen, no. 11.

Provenance The artist, until 1980; Washburn Gallery, New York.

Museum purchase: gift of Kaufmann's and the Women's Committee of the Museum of Art, 1981, 81.14

palaces of sleep where mysterious dramas are enacted at daggers drawn, games whose bizarre and lucid rules are derived from dreams."[2]

Unlike Giacometti, Bolotowsky never associated himself with Surrealism and had no particular sympathy for its philosophies;[3] his interest was primarily in the "plastic values" of certain Surrealist painters' forms.[4] Still, he responded to the haunting, poetic tone created by Giacometti's juxtaposition of odd forms and wanted to recapture that mood using an imagery that was less specific and less identifiable.[5]

Bolotowsky replaced Giacometti's transparent skeleton of a house with a black grid of straight lines and right angles that he learned to use by studying Mondrian's paintings. He replaced the collection of strange but mostly recognizable objects inhabiting Giacometti's sculpture with biomorphic, Miróesque forms that float in compartments created by the grid. These abstract, colored shapes are placed in two-dimensional positions that refer to the locations of the three-dimensional objects occupying Giacometti's *Palace.*

Instead of Mondrian's palette of primary colors, Bolotowsky employed an unsettling complementary red-green, along with pale pink and pale yellow, blue and purple, and earth tones to allude to the forms of Giacometti's dream world.[6] As a result, *Abstraction (No. 3)* comes much closer to the specific narrative content of

Giacometti's Surrealist sculpture than to the straight lines, restricted palette, and universal language of Mondrian's nonobjective paintings.

This work by Bolotowsky is the clearest example of his having been drawn into the debate about significant subject matter that preoccupied so many American modernists who, during the 1930s, were wrestling with the problem of incorporating meaningful content into abstract art. JRL

1 Ilya Bolotowsky, interview with John R. Lane, March 29, 1981, museum files, The Carnegie Museum of Art, Pittsburgh.

2 Museum of Modern Art, New York, *Fantastic Art, Dada, Surrealism* (1936), exh. cat. ed. by Alfred H. Barr, Jr., p. 43.

3 Bolotowsky, interview with John R. Lane, March 29, 1981.

4 Bolotowsky, interview with John R. Lane, April 22, 1981.

5 Bolotowsky, interview with John R. Lane, March 29, 1981.

6 Bolotowsky, interview with John R. Lane, April 13, 1981.

References J. R. Lane, "Ilya Bolotowsky's *Abstraction, 1936–37,*" *Carnegie Magazine* 55 (June–Aug. 1981), pp. 4–7; Bolotowsky, "Adventures with Bolotowsky," p. 16; J. R. Lane, "American Abstract Art of the '30s and '40s," *Carnegie Magazine* 56 (Sept.–Oct. 1983), p. 17.

Louis Bouché
1896–1969

FROM THE 1930s to the 1950s, Louis Bouché was a popular artist appreciated for his lyric renditions of prosaic outdoor subjects, in which approving critics found gentle wit and good humor. His world view seemed essentially optimistic, even in the Depression years. His style was always visually palatable and eminently accessible, accommodating not only realism but the styles of the Impressionists and Paul Cézanne as well.

Bouché was born in New York City of French parents. His father was a painter and decorator, his grandfather a Barbizon landscape painter. From 1909 to 1915 he was in Paris, studying art at the various popular ateliers and at the Ecole des Beaux-Arts. Having returned to New York in 1915, and won his first award, from the National Academy of Design, that same year, he continued studying at the Art Students League until 1916, and soon came to know Alexander Brook, Walt Kuhn, and George O. "Pop" Hart.

In 1932 Bouché had his first solo exhibition at the Valentine Gallery in New York. By 1936 he was represented in that city by the Kraushaar Galleries, where he had ten more solo shows through 1964. In 1943 he joined the faculty of the Art Students League, where he became a much-respected teacher, remembered for urging young painters to appreciate and value what they saw in nature.

Bouché was the recipient of frequent awards, including a purchase prize from the Pepsi-Cola Company in 1944 for *Ten Cents a Ride* (1942, Metropolitan Museum of Art, New York), which is perhaps his best-remembered work. He also received awards from the Pennsylvania

Academy of the Fine Arts, Philadelphia, the National Academy of Design, and Carnegie Institute, as well as the grand prize at the exhibition *Art: USA* held at Madison Square Garden, New York, in 1958. From 1934 to 1950 he contributed regularly to Carnegie Institute's annual exhibitions and served as a member of the jury for its 1949 *Painting in the United States* show.

Bouché also worked extensively as a mural painter. His commissions included Radio City Music Hall in New York, the auditorium of the Department of the Interior and the Attorney General's office at the Department of Justice in Washington, D.C., and the Federal Building at the 1939 New York World's Fair. His largest mural commission was the depiction of scenes from World War II for the Eisenhower Foundation building in Abilene, Kansas. Late in life Bouché and his wife bought a farm in upstate New York, where he resided until his death.

Bibliography John Shapley and Frances M. Pollak, eds., "Louis Bouché," *Index of Twentieth Century Artists* 3 (April 1936), pp. 287–88; Peyton Boswell, Jr., *Modern American Painting* (New York, 1939), pp. 127–28; Ernest W. Watson, *Twenty Painters and How They Work* (New York, 1950), pp. 15–19; Obituary, *New York Times*, August 9, 1969, p. 25; Kraushaar Galleries, New York, *Louis Bouché: A Memorial Exhibition* (1970), exh. cat., introduction by Robert Coates.

The Promised Land, 1939
(Promised Land, Long Island)

Oil on canvas
18⅛ x 26⅛ in. (46 x 66.4 cm)
Signature, date: LOUIS BOUCHÉ/1939 (lower right)

This somewhat empty landscape, described by means of rough paint and selective coloring and dotted with toylike buildings, typifies Bouché's work of the late 1930s. His production of those years was thought to have distilled nature admirably, presenting its fundamentals without academic mannerism. After 1940 his open pictorial spaces gave way to brighter, more structured, and more obviously architectonic compositions that somewhat resemble Edward Hopper's style.

When Bouché was invited to submit a work to Carnegie Institute's 1943 *Painting in the United States* exhibition, he selected *The Promised Land*, which he considered to be one of his best.[1] After the exhibition, John O'Connor, Jr., the assistant director of the Department of Fine Arts commented, "I think you might like to know that when the jury was here, they spent quite some time looking at your canvas."[2]

This painting's title is a wry play on the name of a coastal stretch along Napeague Bay on eastern Long Island, which was indeed called Promised Land. It was a swampy, smelly, despoiled locale on which, from the mid-nineteenth century until the mid-twentieth, stood the area's fish-meal factories. Since the late 1800s it was the destination of bands of seasonal laborers, mainly recent European immigrants from New York City.[3]

Bouché shows Promised Land's fish factories during the deserted off season. A mixture of old shacks, newer tanks, and a beached boat are set against the trash-strewn shore, whose sole inhabitant is a stray dog. The gentle irony is, of course, that this unsavory site of a declining industry should bear the name Promised Land. One wonders whether the bare telephone pole in the foreground is meant, by its cruciform shape, to further the biblical allusion.

Probably around the same time, Alexander Brook painted a very similar composition of a nearby stretch of land off Lazy Point, East Hampton: *Hicks Island* (Guild Hall Museum, East Hampton, N.Y.). The site was a fish-

processing factory similar to those at Promised Land. It, too, showed an overcast sky, a low horizon, a littered shore, and lonely looking outbuildings in the distance.

DS

1 Louis Bouché to John O'Connor, Jr., July 30, 1943, museum files, The Carnegie Museum of Art, Pittsburgh.

2 John O'Connor, Jr. to Louis Bouché, November 11, 1943, museum files, The Carnegie Museum of Art, Pittsburgh.

3 Everett T. Rattray, *The South Fork: The Land and People of Eastern Long Island* (New York, 1979), pp. 105–17.

Reference [J. Lowe], "Colorful and Humorous Lyrics by Bouché," *Art News* 38 (Feb. 1940), p. 12.

Exhibitions Kraushaar Galleries, New York, 1940, *Recent Paintings by Louis Bouché*, no. 21, as *Promised Land, Long Island;* Department of Fine Arts, Carnegie Institute, Pittsburgh, 1943, *Painting in the United States*, no. 10; New Britain Museum of American Art, Conn., 1943, *The Exhibition of Nineteenth Century and Contemporary Watercolors and Paintings*, no. 23; Society for Contemporary American Art, Chicago, and Art Institute of Chicago, 1943, *Third Annual Exhibition of the Society of Contemporary Art*, no cat.; Guild Hall Museum, East Hampton, New York, 1976, *East Hampton Artists, 1850–1976*, no. 11.

Provenance Kraushaar Galleries, New York, 1939; Louise and Roland P. Murdock, Wichita, Kans., 1940; Kraushaar Galleries, New York, 1942; Charles J. Rosenbloom, Pittsburgh, 1943.

Bequest of Charles J. Rosenbloom, 1974, 74.7.5

George Henry Boughton

1833–1905

THE ART AUDIENCES of George Henry Boughton's time linked him to the other American painters who had chosen to study in France and work in England—James McNeill Whistler, Edwin Austin Abbey, John Singer Sargent, and James Shannon. Of these, Boughton was closest to Abbey in his artistic loyalties. Like Abbey, he was a successful magazine illustrator and popular genre painter in the Victorian academic mold. His specialty was carefully crafted costume pieces in oil, pen, and watercolor. His work appeared frequently on both sides of the Atlantic, in the large annual exhibitions and in magazines such as *Harper's Monthly* and *Pall Mall*.

Boughton was born near Norwich, England, but his farming family immigrated to the United States when he was an infant. He grew up in Albany, taught himself to draw by copying engravings, and by the age of nineteen exhibited his first picture, a genre scene, at the American Art-Union, New York. That year he began working professionally, as a landscape painter in Albany. In 1856 he toured England, Scotland, and Ireland, but returned to live for two more years in Albany. Beginning that year, he was able to exhibit his work at the National Academy of Design. He relocated to New York City in 1859, but after a year there decided the time had come to go to Europe for training.

In 1860 Boughton left for Paris, with the intention of staying two years abroad before returning to America. He studied briefly with Edouard May, a pupil of Thomas Couture, and became a follower of Pierre-Edouard Frère, who had become popular as a painter of French peasants. In 1862 Boughton visited London, where his submission to that year's British Institution exhibition drew unexpectedly favorable reviews from the press. Due to that encouragement, Boughton decided to pursue his career in England, where he remained for the rest of his life. He died in London.

His English production at first included many canvases of Breton peasants, which reflected the influence of Frère. Then, in 1867, he began to take up American colonial subjects. These were in step with a contemporary turn toward sentimentalized seventeenth-century costume pieces, but Boughton's choice of setting made him an early participant in the revival of genre based upon early American history, which became so popular in the United States in the 1870s. His best-known work in that vein was *The Early Puritans of New England Going to Worship* (1867, New-York Historical Society), shown under that title at the Royal Academy, London, in 1867, and since reproduced in numerous American schoolbooks. In the 1880s he turned to Dutch subjects—seventeenth-century and modern—and collaborated with Abbey on a book of drawings, *Sketching Rambles in Holland,* which was published in London in 1885.

Boughton began to exhibit at the Royal Academy in 1863, and continued to be represented there every year until his death. His work was also shown numerous times at London's Grosvenor Gallery and New Gallery. A willing participant in American art exhibitions, he continued until 1876 to send works to the National Academy of Design, where he had become a member in 1871. He participated in the Carnegie International in 1896 and again in 1898, and served on the International's Foreign Advisory Committee from 1897 to 1904. Like Sargent, Abbey, and Shannon, Boughton became a member of the Royal Academy; he was elected an associate in 1879 and an academician in 1896.

The style of Boughton's painting was described as delicate, sincere, charming, and refined. The main concern of his pictures seemed to be their narratives; consequently, the progression of his technique over time was not the most interesting aspect of his art. Its sentimentality and careful illustrator's manner changed little during his career, until after 1900, when his work took on some of the decorative symbolism of the Aesthetic movement.

Bibliography Alice Meynell, "G. H. Boughton, A.R.A," *Magazine of Art* 5 (1882), pp. 397–401; Wilfrid Meynell, ed., *The Modern School of Art*, 3 vols. (London, 1887), vol. 1, pp. 80–95; William Elliot Griffis, "George H. Boughton, The Painter of New England Puritanism," *New England Magazine* 15 (September 1896–February 1897), pp. 481–501; Rudolph de Cordova, "Mr. George Henry Boughton," *Strand Magazine* 20 (July 1900), pp. 3–15; Alfred Lys Baldry, "George Henry Boughton, R.A., His Life and Work," *Art Journal* (Christmas number, 1904), pp. 1–32.

Huguenot Fugitives Endeavoring Escape after Saint Bartholomew, c. 1879
(After Saint Bartholomew)

Oil on canvas
20 x 29¾ in. (50.8 x 75.6 cm)
Signature: G. H. Boughton. (lower left)

Inscription: Huguenot Fugitives/Endeavoring Escape after St. Bartholomew /"Along the western sea board,/at points where they felt/themselves unable to make/head against their persecutors,/they put to sea in ships and/boats and made for/England where they landed/in great numbers." (in artist's hand, on paper label glued to backing board)

Around 1880 Boughton was devoting much of his energy to painting northern French genre subjects and New England

Puritans. His interest in French settings and Protestant émigrés may have brought to mind the story of the sixteenth-century Huguenots. Boughton did not become a specialist in sixteenth-century subjects but was intermittently attracted, as was Edwin Austin Abbey, to the mix of flamboyance and sobriety he imagined that sixteenth-century life possessed.

This painting's title refers to the Saint Bartholomew's Day Massacre of August 24, 1572, in which Catherine de Médici caused over three thousand Huguenots to be murdered in France. The composition is built around a grim scenario of flight and pursuit. It is evident that a group of Huguenots has just fled to the shore, closely followed by a band of soldiers. In the background one can see a boat, crammed with refugees, being pushed into the water, as the soldiers on the beach fire upon it. The composition's focus is a Huguenot couple and their child, who for the moment have taken cover by a large boulder in the foreground. They wait tensely while one of the soldiers behind them searches the shore.

Boughton had the ability to bring outdoor settings and his story lines into sympathy with one another, as a way of subtly intensifying the drama of the scene. In this case he capitalized on a barren shore and overcast sky to encourage a feeling of abandonment and uncertainty. His highlighting of two or three figures against a background was fairly common to genre painting and magazine illustration by the 1870s. This was one of Boughton's favorite devices, especially for smaller exhibition pictures such as this one. It allowed the artist to project the emotions of isolation, anxiety, and fear, and thus bring a measure of modern naturalism and sophistication to invented characters and storybook episodes.

DS

References Earl Shinn, *The Art Treasures of America* (Philadelphia, 1879), vol. 1, p. 28, as *The Huguenots;* Baldry, "George Henry Boughton, R.A., His Life and Work," p. 9, as *After St. Bartholomew.*

Provenance Judge Henry H. Hilton by 1879; A. F. Eno (sale, American Art Association, New York, Feb. 13–16, 1900, no. 115); Grosvenor B. Clarkson, New York; Mr. and Mrs. Arthur Braun, Pittsburgh, 1925; their daughter, Elizabeth Braun Ernst (Mrs. Paul B. Ernst), 1976.

Gift of Mrs. Paul B. Ernst, 1978, 78.10.1

Monimia Bunnell Boyd
1824–1862

MONIMIA BUNNELL BOYD WAS a pioneer and folk painter from Indiana. She was born in Green Fork, the daughter of a physician. Displaying a talent for painting at a young age, she began to attract local attention as a portrait and landscape painter when she reached her teens.

After her marriage to one of her father's students, Samuel S. Boyd, she moved temporarily to Cincinnati, where her husband completed his medical education. There she found time to take painting lessons, but it is not known whether she received professional instruction or was taught by a local amateur. Throughout her life she continued to paint portraits and landscapes but also became interested in depicting narrative subjects. She exhibited her works at county fairs, often winning first prize. Among the works ascribed to her are a *Lord's Supper* (location unknown), a portrait of her father, Dr. William Bunnell, and a likeness of United States Senator George W. Julian from Indiana.

Settling finally in Dublin, Indiana, Boyd continued as an active and ambitious artist. Her paintings make a valuable contribution to Indiana's local history and to the folk-art tradition in America.

Bibliography Kate Milner Rabb, "Tragic Story of Young Artist behind Picture 'The Hoosier's Nest,' Cut Down at State Library," *Indianapolis Star,* July 7, 1929, p. 5; Wilbur D. Peat, *Pioneer Painters of Indiana* (Indianapolis, 1954), pp. 96–98, 227.

Hoosier's Nest, c. 1845

Oil on canvas
45⁹⁄₁₆ x 65½ in. (115.7 x 166.4 cm)

Hoosier, meaning native or resident of Indiana, may have made its first literary appearance in John Finley's poem "The Hoosier's Nest," written in 1830.[1] Boyd's husband, enamored of the poem, encouraged his wife to paint a canvas to illustrate this particular stanza:

> I'm told, in riding somewhere West,
> A stranger found a Hoosier's nest—
> In other words, a buckeye cabin,
> Just big enough to hold Queen Mab in;
> Its situation low, but airy
> Was on the borders of the prairie.

Boyd's painting shows a stranger arriving at a log cabin out on the sprawling prairie. As the man of the house helps the visitor with his horse, a woman and three small children stand in the doorway of the cabin looking on. The rest of the painting is a typical country scene—a cow feeding, a stone well with a dip pole, and smoke pouring from the cabin's chimney. Boyd's brushstrokes are hardly visible, and the subdued colors are in predominantly green and brown tones.

It took the artist several months to complete the work, which attracted the attention of state officials. A committee from the Indiana legislature decided it would like to have the canvas for the State Library and received it as a gift from Boyd in 1849.

In 1850 a critic for an Indianapolis newspaper published his appraisal of the

work as an inferior technical perfor-mance.[2] Boyd was extremely upset by the critic's harsh words, and urged her husband to retrieve the canvas, now the property of the state. Dr. Boyd's explanation to a librarian met with an unsympathetic ear. He was determined not to give up, so when the librarian left the room, he cut the canvas from the frame and took it home.

The Hoosier's Nest remained in Monimia Boyd's possession until her death. Shortly thereafter, her husband gave it to the Dublin, Indiana, high-school library, where it hung for the next sixty years.

LAH

1 Rabb, "Tragic Story," p. 5.
2 Peat, *Pioneer Painters of Indiana*, p. 97.

References Peat, *Pioneer Painters of Indiana*, p. 97; Rabb, "Tragic Story," p. 5.

Exhibition National Gallery of Art, Washington, D.C., 1957, *Second Exhibition of American Primitive Paintings,* unnumbered.

Provenance Indiana State Legislature for the State Library, 1849; the artist, 1850; the artist's husband, Dr. Samuel S. Boyd, 1862; Dublin, Ind., High School, 1865; unidentified descendant of the artist, c. 1929; Minnie E. Bunnell, Hagerstown, Ind., before 1954, until 1956; Edward Eberstedt and Sons, New York, 1957; Edgar W. and Bernice Chrysler Garbisch, New York, 1957–80.

Bequest of Edgar W. and Bernice Chrysler Garbisch, 1981, 81.21.17

Alfred T. Bricher
1837–1908

A PAINTER ASSOCIATED with the later generation of the Hudson River school and with the phenomenon of Luminism, Alfred Thompson Bricher is best remembered for his crystalline, serene, and detailed marine paintings. His work, which somewhat resembled that of John Frederick Kensett, made him well known and successful in his own time. Nonetheless, a revival of his reputation has come about only in the last decade and a half.

Relatively little is known about either Bricher's personal life or the details of his artistic development. Born to English émigrés in Portsmouth, New Hampshire, Bricher was raised in Newburyport, Massachusetts, about fifteen miles from his birthplace. At the age of eighteen, he was working as a clerk in a dry-goods store in Boston, and he began painting there. It is not known how he received artistic training—whether at the Lowell Institute or by self-instruction. However, by 1858 he was selling landscapes in Newburyport, and a year later he had opened a studio in Boston.

Until 1868 Bricher worked in Boston, where he attracted notice for his remarkably accurate and beautiful landscapes, and in his travels he made contact with such painters as William Haseltine, Benjamin Champney, and Kensett. His forest interiors and panoramas from this stage of his career are related to those of the Hudson River school, as were many of the sites he visited, such as Catskill Cove in the Hudson River Valley, Lake George, New York, and Mount Desert Island, Maine. His landscapes were exhibited at the Boston Athenaeum from 1864 to 1871 and were published as chromo-lithographs by Louis Prang beginning in 1866.

In 1868 Bricher married and moved to New York, establishing a studio in the Young Men's Christian Association building near the National Academy of Design. Although this location separated him from the landscape painters in the Tenth Street Studio Building, Bricher's interests and activities were similar to theirs. Traveling widely in search of landscape subjects, he took sketching trips to the popular corners of the North American "wilderness"—Rhode Island, New Hampshire, Maine, upstate New York, and Grand Manan Island and the Bay of Fundy off New Brunswick. He came to prefer the serene, uninterrupted horizons associated with Luminism and began to specialize in water views.

From the 1870s onward, Bricher's reputation as a painter of coastal scenes was well established. He exhibited at the National Academy of Design and the American Art-Union. He was elected an associate at the National Academy but was more active as a member of the American Watercolor Society. He was on its board and its hanging committee, and he contributed frequently to its exhibitions.

Although his later work—of the 1880s and afterward—showed some influence of the Barbizon school, Bricher's painting style remained highly finished, carefully composed, and essentially conservative. In 1882 he bought a home near the sea in Southampton, Long Island. In 1890 he moved his family to New Dorp, on Staten Island, where he painted until the year of his death.

Bibliography Alfred T. Bricher Papers, Archives of American Art, Washington, D.C.; John Duncan Preston, "Alfred Thompson Bricher, 1837–1908," *Art Quarterly* 25 (Summer 1962), pp. 149–57; Indianapolis Museum of Art, *Alfred Thompson Bricher* (1973), exh. cat. by Jeffrey R. Brown, assisted by Ellen W. Lee.

Near Newport, c. 1885–90

Oil on canvas
15 x 33 in. (38.1 x 83.8 cm)
Signature: ATBricher (lower left, in monogram)

Near-empty seas, parabolic coastlines, and horizons broken only by a headland in the middle distance appeared frequently in Bricher's work. Such compositions had been characteristic of John Frederick Kensett's views of Newport of the 1860s, and indeed were typical of Luminist painting generally. Bricher used that compositional solution into the 1890s. He applied it with minor variations to views of Baker's Island near Gloucester, Massachussetts; the Maine coast; Grand Manan Island, New Brunswick; as well as the beaches of Narragansett Bay.

When Bricher was in Rhode Island during the summer of 1871, he made numerous sketches of Narragansett Bay and the Newport shore, thereupon producing a number of easel paintings based on his sketchbook scenes. When *Near Newport* was acquired, it was assigned to the early 1870s on the strength of its Newport subject and the natural association with Bricher's well-known Newport views of the 1870s. But the somewhat broad brushwork of this painting, its signature, and the choice of props for the composition all suggest that its date is closer to 1885 or 1890.[1]

Near Newport shows a long, empty shoreline in bright sunlight. A low, grassy promontory extends partway along the horizon, where four small sailboats also appear. The potential storytelling elements in the picture—the sprinkling of boats, a flock of shore birds in the distance, and houses barely visible at the top of the promontory—only emphasize the

absence of narrative. In a corner of the foreground, an empty boat provides a visual metaphor for the emptiness of the scene.

Although Bricher's landscapes are dominated by water and air, they often display a solidity absent in the Luminist paintings of Kensett, Fitz Hugh Lane, and Martin Johnson Heade, and this tendency is present in *Near Newport*. The bluff and low clouds form a single visual mass whose coherence gives the work a sense of weight. Because this piece of land coincides exactly with the horizon, and because the water is considerably darker than the sky, the horizon line has unusual firmness. Combined with the artist's deep colors and clear light, the effect is palpable and earthbound. One could argue that this was a conservative tendency in Bricher's work—a sign, perhaps, that he preferred objective certainty to subjective vision.

DS

1 Indianapolis Museum of Art, *Alfred Thompson Bricher* (1973), exh. cat. by Jeffrey R. Brown, assisted by Ellen W. Lee, nos. 63, 64, p. 75.

Reference H. B. Teilman, "Recent Acquisitions, Museum of Art," *Carnegie Magazine* 47 (Oct. 1973), p. 343.

Exhibition Mansfield Art Center, Ohio, 1981, *The American Landscape*, no. 21.

Provenance Private collection, N.J.; Chapellier Galleries, New York, by 1973.

Anna R. D. and Mabel Lindsay Gillespie Fund, 1973, 73.10

Alexander Brook
1898–1980

Born in Brooklyn, New York, to Russian parents, Alexander Brook was introduced to painting at the age of twelve, after having been stricken with polio and confined to bed. To help him pass the time, an old man who made a living painting portraits from family photographs gave the boy a palette of oils and taught him how to use them. In his midteens, Brook entered the Pratt Institute in New York; then, from 1914 to 1918, he studied at the Art Students League, New York, under the esteemed art teacher Kenneth Hayes Miller.

Together with such painters as Yasuo Kuniyoshi, Eugene Speicher, and Raphael Soyer, Brook participated in the Fourteenth Street group, which was collectively concerned with depicting the street life of New York. In 1920 Brook married the graphic artist and caricaturist Peggy Bacon. He held a joint exhibition with her at the Brummer Gallery, New York, in 1922 and began to contribute articles and reviews to *The Arts* at this time. In 1925, as the assistant director of the Whitney Studio Club Galleries, he introduced a number of new talents to the New York art world, including Stuart Davis, Reginald Marsh, and, particularly, Soyer.

Toward the end of the 1920s, Brook became a full-time painter, preferring to treat—through portraits, still lifes, and nudes—more lyrical and intimate themes than his Social Realist colleagues. Unlike many of his peers, Brook remained popular and prosperous throughout the

Depression, flourishing in a critical climate that was still, for the most part, hostile to modernism.

Brook was a particular favorite of Carnegie Institute. He participated in every Carnegie International from 1930 through 1939 and in the annual exhibitions of American painting in the 1940s, and served on the jury of award in 1935 and 1948. In 1930 his *Interior* won two awards at the International. It was his second set of honors from a major juried exhibition, his first two having come from the Art Institute of Chicago the previous year. In 1939 *Georgia Jungle* took first prize, and *Unmasked* received honorable mention in the *Painting in the United States* exhibition of 1949 at Carnegie Institute, which also honored Brook with a solo exhibition in 1934, hailing him as a representative of "much of what is best and healthy in young contemporary American art."[1]

Brook's popularity continued through the early 1940s. His work was featured on the cover of the *Saturday Evening Post*, and in 1943 *Life* magazine commissioned him to paint portraits of four movie stars—Bette Davis, Ingrid Bergman, Merle Oberon, and Jennifer Jones. The rise of Abstract Expressionism, however, soon diverted critical attention to other artists and caused Brook to fall from critical favor. Although he received the Andrew Carnegie Prize in 1953 and had several solo shows at New York galleries during the next two decades, he was painfully aware that the mainstream of art had passed him by. Nevertheless, he still found satisfaction in the solitary act of painting. In a letter of 1958 he told the

director of the Museum of Art of Ogunquit, Maine:

> Painting trains an artist to be alone and like it; to be in tune with what he is doing, albeit the results of his labors are not always happy ones. It is his birthright, his choice, his misery and his pleasure. How can this be told to anyone, really? Who can witness it?[2]

Alexander Brook died in Sag Harbor, New York, at the age of eighty-one.

1 "Paintings by Alexander Brook," *Carnegie Magazine* 8 (April 1934), p. 18.

2 Museum of Art of Ogunquit, Me., *Americans of Our Times* (1962).

Bibliography Alexander Brook, "Alexander Brook, Painter," *Creative Art* 5 (October 1929), pp. 715–18; Edward Alden Jewell, *Alexander Brook* (New York, 1931); Harry Salpeter, "Unstruggling Artist," *Esquire* 4 (October 1936), pp. 105–8, 115–66; Alexander Brook, *Alexander Brook* (New York, 1945); Salander-O'Reilly Galleries, New York, *Retrospective Exhibition of Paintings by Alex Brook, 1898–1980* (1980), exh. cat. by Andrew W. Kelly.

Interior, 1929

Oil on canvas
60 x 36 in. (152.4 x 91.4 cm)
Signature, date: *A. Brook*/1929 (upper right)

Painted at Brook's summer residence at Cross River, New York, *Interior* was the artist's first contribution to a Carnegie International. It was an immediate success. The 1930 jury of award, which included Henri Matisse, gave it the second prize and the Albert C. Lehman Prize for the best purchasable painting of the exhibition (the first-prize winner, Pablo Picasso's *Portrait of Madame Picasso*, was not for sale). Brook's triumph at the International firmly established him as "one of the best of our younger American painters."[1]

Discussing Brook's 1934 solo exhibition at Carnegie Institute, a Pittsburgh reviewer explained the appeal to contemporary critics and connoisseurs of this somewhat Cézannesque still life:

> His *Interior* has all the elements of great painting: complete indifference to public appeal, aristocratic sobriety, and with these self-imposed handicaps, it yet achieves brilliance. A deal table, a cat, a bit of still life, and a strip of red cloth lending a largesse of color, and there is a painting that the indifferent may pass, but the initiated never.[2]

This exclusive appeal to the "initiated" caused Brook to run afoul of the rising school of American Scene painters, with their emphasis on regional, socially relevant themes, and he was sometimes accused of being a "studio painter," concerned only with formal issues. To this charge, Brook replied:

> I think it's true, but I can't help it. A painter can be a good painter if he's true to himself. Then it doesn't matter whether you're a studio painter, or an outdoor painter, or a social painter. One generation might consider Ryder a studio painter and another a romantic painter.[3]

However, in the late 1930s Brook would join the ranks of the American Scene artists with his most famous painting, *Georgia Jungle* (see p. 109).
MM

1 Jewell, *Alexander Brook*, p. 7.

2 Penelope Redd, "Alexander Brook's Works on Exhibition," *Pittsburgh Sun-Telegraph*, April 8, 1934, sec. 4., p. 5.

3 Salpeter, "Unstruggling Artist," p. 116.

References "Picasso First, But Americans Win Six of Nine Carnegie Honors," *Art Digest* 5 (Oct. 15, 1930), pp. 5–6; H. Saint-Gaudens, "The Artistic Idea," *Carnegie Magazine* 4 (Oct. 1930), p. 135; F. Watson, "The Carnegie Prizes," *The Arts* 17 (Oct. 1930), pp. 3–6; "Homer Saint-Gaudens on the Pittsburgh Jury and Prize Awards," *American Magazine of Art* 21 (Dec. 1930), pp. 697–702; P. Redd, "Alexander Brook's Works on Exhibition," *Pittsburgh Sun-Telegraph*, Apr. 8, 1934, sec. 4,

p. 5; "Paintings by Alexander Brook," *Carnegie Magazine* 8 (Apr. 1934), pp. 16–18; J. Lowe, "Brook: No Interferences," *Art News* 40 (June 1, 1941), pp. 26–27; J. O'Connor, Jr., "A Memorial Painting," *Carnegie Magazine* 15 (Dec. 1941), pp. 203–5; "Brook's Interior for Carnegie," *Art Digest* 16 (Jan. 1, 1942), p. 20; Santa Fe East Galleries, N.Mex., *Alexander Brook* (1981), exh. cat., essay by A. S. King, n.p.

Exhibitions Department of Fine Arts, Carnegie Institute, Pittsburgh, 1930, *Twenty-ninth Annual International Exhibition of Paintings*, no. 38; Whitney Museum of American Art, New York, 1931, *Alexander Brook*, no. 27; Department of Fine Arts, Carnegie Institute, Pittsburgh, 1932, *An Exhibition of Carnegie International Paintings Owned in Pittsburgh*, no. 52; Department of Fine Arts, Carnegie Institute, Pittsburgh, 1935, *An Exhibition of Paintings from the Collection of Albert C. Lehman*, no. 9; Department of Fine Arts, Carnegie Institute, Pittsburgh, 1935, *An Exhibition of Paintings Which Have Received Prize Awards in International Exhibitions at Carnegie Institute*, no. 61; Detroit Institute of Arts, 1942, *A Group Exhibition of Paintings by American Artists*, no. 6; Columbus Museum of Art, Ohio, 1952, *Paintings from the Pittsburgh Collection*, no cat.; Dayton Art Institute, Ohio, 1955, *Paintings by Alexander Brook*, no cat.; Museum of Art of Ogunquit, Me., 1962, *Americans of Our Times*, no. 2.

Provenance The artist, until 1930; Albert C. Lehman, Pittsburgh, 1930–35; Mrs. Lambert G. Oppenheim (formerly Mrs. Albert C. Lehman), Shaker Heights, Ohio, 1935.

Gift of Mrs. Lambert G. Oppenheim in memory of Albert C. Lehman, 1941, 41.3

Georgia Jungle, 1939

Oil on canvas
35 x 50 in. (88.9 x 127 cm)
Signature, date: *A. Brook* 1939 (lower right)

From 1938 to 1943 Brook lived and worked in Savannah, Georgia. He was particularly fascinated by the Yamacraw, a poor black district to the west of the city, where he spent much of his free time at a bar called the Silver Tavern. In *Georgia Jungle*, one of his rare forays into social commentary, he depicted the Yamacraw's bleakest spot, a shantytown built over what had been the city dump.

Exhibited at the 1939 Carnegie International—an exhibition given added significance from the general awareness that, owing to the war in Europe, it would be the last for many years—*Georgia Jungle* won first prize. For the most part, critics applauded the jury of

award's decision. According to Homer Saint-Gaudens, director of the Department of Fine Arts, this decision had been based largely on the work's formal qualities. "What intrigued the jury in the canvas," he wrote, "was the style in which the picture is painted, the quality of the sky and of the land. . . . Brook was wholly interested in showing how the rarely noticed simple forms of life are affected by light, shape and color."[1] It is clear from the critical response, however, that Brook scored his victory by applying his much admired technique to the type of socially relevant theme popular during the 1930s. Helen Buchalter, writing in the *Magazine of Art*, praised *Georgia Jungle* as

> one of the few genuinely poetic transcriptions of Americana to come out of the entire back-home movement. It is a sympathetic portrayal of a desolate bit of the South, conveying its emotion by the pure use of the painter's medium in which technique, emotion and subject are a harmonious blend.[2]

In his review of the year's art, Alfred Frankfurter, editor of *Art News,* declared *Georgia Jungle* the most important American painting acquired by a public collection in 1939.[3]

Amid the general chorus of praise, a few dissenting voices could be heard. *New York Times* art critic Edward Alden Jewell was lukewarm, at best, in his admiration, implying that the artist's technique, for all its merit, was unsuited to the subject. Brook, he observed, had handled "a rude, forlorn theme skillfully, though leaving it, in the end, characterized by a kind of soft and gentle studio refinement."[4] The reviewer for *Parnassus* found the International as a whole less than outstanding and condemned *Georgia Jungle* as "rather fuzzy and pointless."[5]

Five of the eight prizes offered at the 1939 International were awarded to Americans, signaling, according to some critics, the start of an era during which American art would rise to unprecedented world prominence. This is, in fact, precisely what happened, but the conservative realism of Brook would have no part to play in this triumph. Though Brook, ebullient at winning the first prize, saw no end to his success—"It all gets better and better," he wrote in a letter to Saint-Gaudens[6]—1939 marked the high point of his career. *Georgia Jungle* became his best-known work, but it has long been valued less for its aesthetic qualities than as a social and historical document.

In 1980 Salander-O'Reilly Galleries, New York, owned fourteen studies for *Georgia Jungle.* One of these, *Study for Georgia Jungle* (c. 1938, pencil on paper), was shown at their 1980 retrospective of Brook's work.[7]

MM

1 Homer Saint-Gaudens, "The Differences," *Carnegie Magazine* 13 (October 1939), p. 134.

2 Helen Buchalter, "Carnegie International, 1939," *Magazine of Art* 32 (November 1939), p. 629.

3 [Alfred M. Frankfurter], "The Editor's Review," *Art News* 38 (December 30, 1939), p. 11.

4 Edward Alden Jewell, "In the Realm of Art: Carnegie International Opens," *New York Times*, October 22, 1939, sec. 10, p. 9.

5 Howard Devree, "What to Do about the Carnegie," *Parnassus* 11 (November 1939), p. 12.

6 Alexander Brook to Homer Saint-Gaudens, November 11, 1939, Carnegie Institute Papers, Archives of American Art, Washington, D.C.

7 Salander-O'Reilly Galleries, *Retrospective Exhibition*, no. 36.

References E. A. Jewell, "U.S. Artists Get Five Carnegie Prizes; Alexander Brook Wins First Award," *New York Times*, Oct. 20, 1939, p. 25; E. A. Jewell, "In the Realm of Art: Carnegie International Opens," *New York Times*, Oct. 22, 1939, sec. 10, p. 9; "Art," *Time,* Oct. 30, 1939, pp. 37–38; J. W. Lane, "The U.S.A. Wins the Carnegie Stakes," *Art News* 38 (Oct. 21, 1939), pp. 7–8, 15; "Americans Capture Five of Eight Honors at Carnegie International," *Art Digest* 14 (Nov. 1, 1939), pp. 5–8, 34; H. Buchalter, "Carnegie International, 1939," *Magazine of Art* 32 (Nov. 1939), pp. 628–37; H. Devree, "What to Do about the Carnegie," *Parnassus* 11 (Nov. 1939), p. 12;

[A. M. Frankfurter], "The Editor's Review," *Art News* 38 (Dec. 30, 1939), pp. 9, 11; J. O'Connor, Jr., "Patrons Art Fund Purchase," *Carnegie Magazine* 13 (Dec. 1939), pp. 214–16; "Pittsburgh: The Carnegie Institute's Purchase of a Brook Painting," *Art News* 38 (Dec. 30, 1939), p. 16; "The Carnegie International Exhibition and the 1939 Awards," *Studio* 119 (Jan. 1940), pp. 12–13; A. Gruskin, *Painting in the U.S.A.* (Garden City, N.Y., 1948), p. 218; A. Eliot, *Three Hundred Years of American Painting* (New York, 1957), p. 237; M. Baigell, *The American Scene: American Painting of the 1930s* (New York, 1974), p. 74.

Exhibitions Department of Fine Arts, Carnegie Institute, Pittsburgh, 1939, *The 1939 International Exhibition of Paintings,* no. 71; Art Institute of Chicago, 1940, *Fifty-first Annual Exhibition of American Paintings and Sculpture,* no. 27; Department of Fine Arts, Carnegie Institute, Pittsburgh, 1940, *The Patrons Art Fund Paintings,* no. 15; John Herron Art Institute, Indianapolis, 1940, *American Paintings from the Carnegie International Exhibition,* no cat.; Berkshire Museum, Pittsfield, Mass., 1941, *Exhibition of Paintings and Studies by Alexander Brook,* no. 27; Telfair Academy of Arts and Sciences, Savannah, 1943, *Painting of the Month,* unnumbered; Museum of Modern Art, New York, 1944, *Art in Progress: A Survey Prepared for the Fifteenth Anniversary of the Museum of Modern Art, New York,* unnumbered; Columbus Museum of Art, Ohio, 1952, *Paintings from the Pittsburgh Collection,* no cat.; Dayton Art Institute, Ohio, 1955, *Alexander Brook,* unnumbered; Museum of Art of Ogunquit, Me., 1962, *Americans of Our Times,* no. 12; Bowdoin College Museum of Art, Brunswick, Me., 1964, *The Portrayal of the Negro in American Painting,* no. 70; University Gallery of Fine Art, Ohio State University, Columbus, 1968, *America, Circa 1930: An Exhibition of Paintings*

and Prints Illustrating the American Scene, no cat.; ACA Galleries, New York, 1981, *Social Art in America, 1930–1945*, no. 8; Virginia Museum of Fine Arts, Richmond, 1983, *Painting in the South, 1564–1980* (trav. exh.), no. 133.

Provenance The artist, until 1939.

Patrons Art Fund, 1939, 39.7

Alburtis del Orient Browere

1814–1887

ALBURTIS (ALSO SPELLED Albertus, Albertis, Alburtus) del Orient Browere was born in Tarrytown, New York, and raised in New York City. He was a self-taught painter of landscapes and genre subjects who worked on the fringes of the Hudson River school, although he never gave up the eccentricities of his primitive style. The only training in art he is known to have received was from his father, John Henri Isaac Browere, a painter and sculptor remembered today for his remarkable plaster busts made from life masks of such eminent Americans as Thomas Jefferson, James Madison, and John Adams.

The younger Browere's career began in New York and coincided with Thomas Cole's rise to fame. Browere first exhibited at the National Academy of Design in 1831, and in the following year won a silver medal for the "best original oil painting" from the American Institute of the City of New York. He was also an exhibitor at the American Art-Union, the American Academy of Fine Arts, and the Apollo Association. Sometime between 1837 and 1839 he worked in Washington, D.C., for the well-known phrenologists Orson and Lorenze Fowler, designing charts and applying his father's life-mask techniques to the production of phrenological busts. In 1840 he moved to Catskill, New York, with his wife and children, and supported himself by clerking in a drugstore.

Browere achieved his closest approach to fame in 1841, when his *Canonicus and the Governor of Plymouth* (location unknown) took first prize at the National Academy of Design. Though he continued to exhibit at the National Academy until 1846, his principal employment after 1842 was the painting of signs and carriages. In 1852 he made the first of two

trips to California, becoming the first New York–based artist to visit there. He settled near San Francisco in the boomtown of Columbia. Perhaps he hoped to make his fortune in the gold fields; perhaps, like other artists who visited the West at mid-century, he was searching for new and exotic subjects. He does not seem to have had much luck as a prospector, but he produced a large number of canvases while earning a living from odd jobs, sign painting, and the occasional sale of pictures.

Browere returned to Catskill in 1856, but two years later he went back to California, remaining there until 1861. The rest of his life he spent as a sign painter in Catskill, where he died of heart disease. Though success eluded him, Browere produced a large body of work. Much of it has a strongly regional character, drawing on the life and history of New York and the tales of Washington Irving. His landscapes reflect the sensibility of the Hudson River school, with which he is associated by time and place, though he probably had little personal contact with either Cole or the later leaders of the movement.

Bibliography A. D. O. Browere Papers, Archives of American Art, Washington, D.C.; Roscoe P. Conkling, "Reminiscences of the Life of Albertus del Orient Browere," *Los Angeles County Museum Quarterly* 8 (Spring 1950), pp. 2–6; Mabel P. Smith and Janet R. MacFarlane, "Discovery and Rediscovery: Unpublished Paintings by Alburtis del Orient Browere," *Art in America* 46 (Fall 1958), pp. 68–71; Charles G. Wright, "Alburtus D. O. Browere, 1814–1887: A Genre Painter of the Hudson River School and Resident of Catskill, N.Y.," Greene County Historical Society, 1971; rev. 1974, Coxsackie, N.Y., manuscript.

Prospector in the Foothills of the Sierras, California, c. 1852–56
(Prospector in California; Rocky Mountain Scene)

Oil on canvas
33⅛ x 48¼ in. (84.1 x 122.6 cm)

Although Browere may have gone to California more for the purpose of prospecting than painting, his two trips there did result in a number of canvases, making him one of the chief documentarians of the gold-rush era. The California paintings were of two types: genre scenes of miners or the mining camps and landscapes. The pictures of miners (many of which portray himself, and some of which must have been painted after he returned to New York) possess an inventive energy that place them among his most memorable figure subjects. But it is in the area of landscape painting that Browere has been said to have made his lasting contribution to American art.[1]

Between 1852 and 1861, he produced several large canvases inspired by California's mountain scenery. They rely on compositional schema that Browere had used since the 1840s in views of the Catskills, yet they retain the primitive artist's special sincerity and inventiveness. Among these landscape views are a sprinkling of almost startling panoramas of the Sierra Nevada mountain range, which sought to capture the vastness and grandeur of the Far West by elaborating on and intensifying the Hudson River school's visual formulas. Browere's panoramic views were oddly prophetic of Albert Bierstadt's and Thomas Moran's panoramas of the Far West, which in essence did the same thing more than a decade later.

Fig. 1 Alburtis del Orient Browere, *Prospectors of '49 in the Seven Hundred Hills of the Sierras,* c. 1855. Oil on canvas, 34½ x 60½ in. (87.6 x 153.7 cm). Location unknown

Prospector in the Foothills of the Sierras, California seems specifically based on the pictorial structure of Thomas Cole's landmark work *The Oxbow* (1836, Metropolitan Museum of Art, New York), a work that was exhibited not long before Browere's first trip to California at the immensely influential memorial exhibition of Cole's work held in 1848 at the American Art-Union. Browere almost certainly saw this exhibition, since a work of his own was also shown at the American Art-Union in 1848. The correspondence is not unique: among the landscapes of Browere's journey to California is *Crossing the Isthmus,*[2] a river view that is clearly modeled on Cole's *Voyage of Life: Youth* of 1839–40 (Munson-Williams-Proctor Institute, Utica, New York).

Browere never mastered the convincing naturalism and atmospheric perspective of Cole's *Oxbow:* one could argue that he decided to remain aloof from these pictorial properties. However, he did adopt the *Oxbow*'s distinctive foreground promontory, from which one experiences a sharp, deep drop before the limitless horizon, with its layer upon layer of hills, unfolding in the distance. Browere also created his own versions of the *Oxbow*'s fallen tree in the foreground and the tiny figure of an artist who gazes upon the panorama before him. Browere's figure is a red-shirted miner, whose swarthy features are those of Browere himself.

Perhaps the most interesting aspect of this painting is its combination of minute detail and bright, extremely smooth paint surface. This visual continuity and concern for detail seem to have had currency within the Hudson River school, which held that the painter should give himself over to the unity and specificity of nature and not sully its purity with the overt traces of his brush.

Browere also painted a larger, more elaborate version of this same view (fig. 1), which depicted two prospectors and two fallen trees on a slightly larger promontory.

DS, KN

1 Wolfgang Born, *American Landscape Painting: An Interpretation* (New Haven, 1948), p. 139.

2 Jeanne Van Nostrand and Edith M. Coulter, *California Pictorial: A History in Contemporary Pictures, 1786 to 1859* (Berkeley, 1948), pl. 29.

References H. B. Teilman, "Two American Paintings: Genre and Landscape," *Carnegie Magazine* 46 (June 1972), pp. 245–46; L. Chapin, "Unpolluted Freshness," *Christian Science Monitor,* July 11, 1972, p. 8; D. G. Wilkins, "The American Painting Collection at the Sarah Scaife Gallery, Carnegie Institute, Pittsburgh," *American Art Review* 2 (Mar.–Apr. 1975), pp. 96–97.

Exhibitions San Francisco Museum of Art, 1941, *Paintings of the Gold Rush,* as *Rocky Mountain Scene,* unnumbered; Cincinnati Art Museum, 1964, *American Paintings III,* no. 5; National Collection of Fine Arts, Washington, D.C., 1964, *American Landscape: A Changing Frontier,* unnumbered.

Provenance The artist's daughter, Maria Matilda Browere Bell, or his granddaughter, Ann Eliza Bell Boynton; her daughter, Elizabeth Boynton Millard (Mrs. Everett Millard), Highland Park, Ill., by 1941; M. Knoedler and Co., New York, as agent, c. 1950, then as owner by 1964.

Howard N. Eavenson Memorial Fund for the Howard N. Eavenson Americana Collection, 1972, 72.7.1

John George Brown

1831–1913

PERHAPS THE MOST prolific American genre painter of the late nineteenth century, John George Brown was best known for his sentimental portrayals of the urchins of lower Manhattan. Brown's images of newsboys and bootblacks, painted in a meticulous, academic style, depict shiny-faced yet tattered waifs living an enviable, carefree street life. These romanticized views brought the artist both acclaim and monetary reward, especially as they were widely disseminated through prints. The public found them highly appealing, due to their accessibility, optimism, and decidedly American subjects.

Brown was born of humble origins in Durham, England. At age fourteen he began an apprenticeship as a glass cutter while simultaneously attending evening drawing classes with the Pre-Raphaelite William B. Scott. Upon completion of his apprenticeship, Brown moved to Edinburgh, where he studied at the Trustees' Academy under Robert Scott Lauder. In 1853 he traveled to London to paint portraits, and later that year immigrated to the United States.

Brown found employment designing stained glass in Brooklyn and studied painting at the National Academy of Design under Thomas Cummings. Then, in 1860, he relocated to the Tenth Street Studio Building in Manhattan, where he shared work space with a number of New York's most ambitious artists. In this propitious environment, Brown quickly became established and in 1863 was elected a member of the academy. He remained at the Tenth Street Studio for nearly fifty years.

In the sixties and seventies, Brown painted primarily genre scenes of children

and portraits executed with a rather soft, freely applied stroke. These works were well received, and Brown began to exhibit widely at the academy, the Boston Athenaeum, and the Pennsylvania Academy of the Fine Arts, Philadelphia. In these early years, Brown also painted landscapes that frequently incorporated genre elements. He experimented with the effects of sunlight and shadow in works such as *Pulling for the Shore* (1878, Santa Barbara Museum of Art, Calif.), which manifest thematic and formal parallels to the contemporaneous genre subjects of Winslow Homer. Brown greatly admired Homer, referring to him in 1879 as "one of our truest and most accomplished artists."[1] Unlike Homer, however, Brown increasingly dwelt on detail and anecdote in both oil paintings and watercolors.

Around 1880 Brown developed his mature style, in which he depicted urban genre figures with photographic realism. His highly praised *Longshoreman's Noon* (1879, Corcoran Gallery of Art, Washington, D.C.) presents a melting pot of working-class ethnic types in an exacting, academic mode. The urban waif became Brown's major motif from the eighties onward. He churned out dozens of formulaic images of theatrically posed children, costumed in rags and lined up on a shallow stage. Meant to be read in the same way as popular illustrations, they lack critical social comment.

Though we see such images as romanticized, Brown—surprisingly—did not. He wrote: "Art should express contemporaneous truth which will be of interest to posterity. I want people a hundred years from now to know how the children that I painted looked. . . . I did precisely what a good newspaper reporter would have done."[2] The artist's portrayals of street urchins appeared in major periodicals, including *Harper's Weekly*, and some were reproduced as platinotypes and photogravures sold by catalogue. The distribution of the prints made Brown one of the most financially successful American artists of the nineteenth century.

Late in his career, Brown became quite active in the New York art community. A founding member of the American Watercolor Society, he served as its president from 1887 to 1904. He became vice president of the academy from 1899 to 1904 and president of the Artists' Fund Society in 1900. He submitted paintings to the Carnegie Internationals of 1899, 1900, and 1901, but only one of them, *To Decide the Question* (c. 1899, Metropolitan Museum of Art, New York), was accepted. Brown died in New York.

1 Linda S. Ferber, "Ripe for Revival: Forgotten American Artists," *Art News* 79 (December 1980), p. 72.

2 George W. Sheldon, *American Painters* (New York, 1879), p. 141.

Bibliography George W. Sheldon, *Hours with Art and Artists* (New York, 1882), pp. 148–52; S. G. H. Benjamin, "A Painter of the Streets," *Magazine of Art* 5 (1882), pp. 265–70; Patricia Hills, "The Painter's America: Rural and Urban Life, 1810–1910," *Antiques* 106 (October 1974), pp. 646–47; Robert Hull Fleming Museum, University of Vermont, Burlington, *John George Brown: A Reappraisal* (1975), exh. cat., essay by Philip N. Grime and Catherine L. Mazza; Katharine M. McClinton, "John George Brown: Sentimental Painter of the American Scene," *Connoisseur* 200 (April 1979), pp. 242–44.

The Last Edition, c. 1890–1910

Oil on canvas
44 x 32 in. (111.8 x 81.3 cm)
Signature: Copyright/J. G. Brown N.A. (lower left)

The Last Edition is a depiction of newsboys, an unusual variation on Brown's trademark street-urchin subject matter. Datable to the last decade of the nineteenth century or the first decade of the twentieth, the painting portrays a group of newsboys crowding around their supplier, who doles out papers from a cart. The majority of the boys grab for the papers, while one reads an article and another calls out the headlines as he begins to sell his lot. The boys' clothes are old and torn, and one child in the center has a bandaged hand. All, however, have the clean, well-fed, appealing look that Brown derived from the use of studio models, whom the artist posed and painted with painstaking realism. Here he set

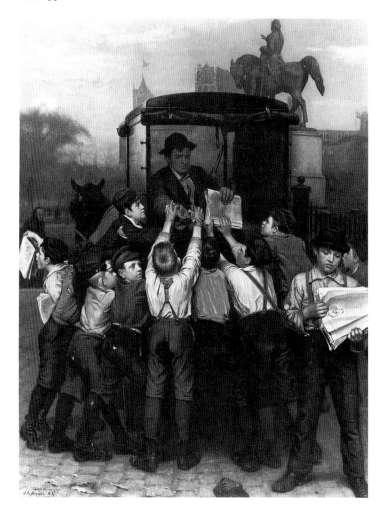

them in Union Square Park in New York City before the 1856 equestrian monument of George Washington by Henry Kirke Brown and John Q. A. Ward.

Brown expressed a nostalgic identification with poor and homeless children: "I do not paint poor boys solely because the public likes them and pays me for them, but because I love the boys myself, for I was once a poor lad."[1] Nevertheless, he demonstrated no indignation or sociological interest in their plight, and chose instead to portray the ideology of social mobility as propagated by the fictional heroes of Horatio Alger and the actual success of Andrew Carnegie and John D. Rockefeller. The boys in *The Last Edition* serve as graphic manifestations of those pursuing the American dream, the attainment of wealth and power through wit, perseverance, and luck. As they scramble for their papers, the newsboys are being initiated into the free-enterprise system. In light of this didactic, inspirational tone, it is not surprising that *The Last Edition* hung for many years in the reading room of the Carnegie Library of Pittsburgh.

Though sentiment dominates the composition, fine modeling and the play between light and dark show Brown's craftsmanship at its best. With great precision, Brown emphasized outline and detail. And, despite dark underpainting, strong highlights and creamy pastel tonalities create a glowing atmospheric quality. Most effective is the contrast between the precise control with which figures are rendered and the painterly dash of the cobblestone foreground and landscape background. As indicated above the signature, Brown copyrighted this painting to prevent it from being pirated. He copyrighted many of his works so that he could control distribution of his compositions and thereby continue to profit from his pictorial inventions.

JM

1 "A Painter of Street Urchins," *New York Times Magazine*, August 27, 1899, p. 4.

Provenance Sale of the artist's estate, American Art Galleries, New York, 1914; Mr. and Mrs. Henry J. Heinz II, Pittsburgh, by 1957.

Gift of Mr. and Mrs. Henry J. Heinz II, 1957, 57.6.2

Byron Browne
1907–1961

ONE OF THE FOUNDERS of the American Abstract Artists association, Byron Browne had made a radical conversion to abstraction during the late 1920s and became a forceful advocate for modernist art during the 1930s and 1940s. Born and raised in Yonkers, New York, he studied at the National Academy of Design in New York City from 1924 to 1928. In his final year there he became the youngest painter ever to win the coveted Third Hallgarten Prize, awarded at the National Academy's annual exhibition. At the same time, he discovered Cubism and became so attracted to it that he destroyed his Hallgarten Prize still life as a symbolic rejection of his conservative training and of academicism generally.

By 1929 he was incorporating Cubist techniques into his still-life paintings, already using the bright palette and opaque color planes that became his personal hallmark. But given the prevailing return to representational art, Browne, like most of the young American abstractionists, found it extremely difficult to find galleries or museums willing to show his work. On those rare occasions when abstract works were shown, the critical and popular response was overwhelmingly negative.

As a result, he and a small group of like-minded artists decided to create their own exhibition opportunities and formed the American Abstract Artists in 1937. The group's first exhibition that year was well attended and financially successful. However, the major critics were generally in agreement with the critic Edwin Alden Jewell's opinion that the works were accomplished but merely decorative and too dependent on the school of Paris.[1]

Although Browne also began to show his work at major museums and numerous galleries, he found it impossible to make a living from his paintings. Throughout the 1930s and early 1940s he supported himself with a variety of jobs, working as an elevator operator, hatcheck boy, longshoreman, lumber worker, gravestone designer, navy shipfitter, and guard at the Metropolitan Museum of Art. He also worked for the WPA's Federal Art Project during the Depression, producing between 1935 and

1940 some of the first abstract murals in America.

During the late 1930s Browne began to lose interest in the Cubist idiom and slowly turned toward a more geometric style of abstraction. His forms were still derived from nature, but the objects became virtually unrecognizable. Simultaneously, he was also exploring the art of primitive cultures, and their influence can be seen in his "classical" portraits of women and large, iconic heads of this period.

Browne achieved a measure of success in the early 1940s. He was a regular contributor to the annual exhibitions at the Whitney Museum of American Art and the Audubon Artists in New York. In 1946 his work was shown at Carnegie Institute's *Painting in the United States* annual and the following year at the Metropolitan Museum of Art in New York. The critics viewed him as "one of the most enterprising and talented of our younger generation of abstractionists."[2] He still produced both figurative and abstract works, but his abstract paintings became more organic and curvilinear, with biomorphic forms replacing strictly geometric shapes.

In 1947 the New York gallery owner Samuel Kootz arranged an exhibition at the Galerie Maeght in Paris for Browne and five other artists, including Carl Holty and Robert Motherwell. Unfortunately, French critics lambasted the American painters for their "pathetically derivative" works, obviously inspired by the school of Paris.[3] Shortly afterward Kootz closed his gallery; in 1951 he turned over hundreds of unsold paintings by Browne and Holty to the Gimbels department store. Gimbels' lurid promotion and shabby display of their works as bargain-priced housewares caused an uproar in the New York art world. It also devastated Browne, damaged his reputation, and caused financial difficulties that lasted to the end of his life. Three months after the sale, he suffered a heart attack from which he never fully recovered, although he continued to paint and exhibited in the 1955 Carnegie International. He died in New York of another heart attack.

Browne's contribution to American abstract art was recognized on several occasions. His work won seven purchase prizes between 1947 and 1960, and in 1961

he was nominated for grants by both the National Endowment for the Arts and the Institute of Arts and Letters, but both were voided by his death. The Art Students League, where he had taught for thirteen years, honored his memory with the Byron Browne Memorial Scholarship, which was awarded from 1962 until 1975.

1 Edward Alden Jewell, "American Abstractions," *New York Times*, April 11, 1937, sec. 11, p. 10.

2 Helen Boswell, "Byron Browne Exhibits," *Art Digest* 17 (March 15, 1943), p. 23.

3 Paul, "Introduction à la peinture moderne américaine," p. 66.

Bibliography Greta Berman, "Byron Browne: Builder of American Art," *Arts* 53 (December 1978), pp. 98–102; April J. Paul, "Byron Browne in the Thirties: The Battle for Abstract Art," *Archives of American Art Journal* 19, no. 4 (1979), pp. 9–24; Gail Levin, "Byron Browne in the Context of Abstract Expressionism," *Arts* 59 (June 1985), pp. 129–33; April J. Paul, "Introduction à la peinture moderne américaine: Six Young American Painters of the Samuel Kootz Gallery: An Inferiority Complex in Paris," *Arts Magazine* 60 (February 1986), pp. 65–71; Nassau County Museum of Fine Art, Roslyn Harbor, N.Y., *Byron Browne: Paintings from the 30s, 40s, and 50s* (1987), exh. cat., essay by Harry Rand.

Painting, 1936

Oil on Masonite
37⅞ x 30 in. (96.2 x 76.2 cm)
Signature: *Byron Browne* (lower left)

By 1936 the Cubist idiom Browne had used since 1929 gave way to an abstract style that allowed him to explore more fully the evocative qualities of line, color, shape, and rhythm. In *Painting* an assortment of triangles, rectangles, circles, and semicircles appears to explode from the center of the large canvas. Browne achieved this effect by keeping lighter tones close to the center of the picture: areas of pure white and pale yellow, accented with mauve and peach, are nearly surrounded by more somber hues of green, blue, black, and rusty brown. The shapes intersect at varying angles, contributing to the syncopated rhythm of the work. The heavy application of paint creates a richly textured surface; Browne

possibly incorporated sand or old paint flakes, as he is known to have done in later works.[1]

At first glance, *Painting* appears to be completely devoid of realistic imagery. However, as April J. Paul has noted, Browne rarely worked without reference to nature: he generally used shapes abstracted from still-life arrangements to create a symbolic language based on natural forms.[2] Close inspection reveals several elements characteristic of his personal iconography: the dot and circle "eye"; the tiny parallel wedges suggestive of teeth or claws; the slender, flattened ovals reminiscent of flower petals; and the boomerang shape that hints at bird wings.

Browne's debt to Pablo Picasso and Paul Cézanne is seen here in his use of angular color planes and in his emphasis on the two-dimensional nature of the picture surface. His interest in primitive art at this time is also apparent: the inclusion of highly stylized symbols is typical of much African and pre-Columbian art, while the dot and circle motif recalls the huge, round eyes found in Sumerian votive sculptures.

Browne consistently objected to the use of the words *abstract* or *nonobjective* as applied to his works. He clearly recognized his dependence on the visual world: "Those who wage the battle of nonfigurative versus figurative are falsifying the real issues in painting. Because a form is not readily recognized does not make it plastic. Every shape or form that is drawn, painted, sculptured, sawed, or pasted has its counterpart in Nature. . . . One cannot paint what one has not seen."[3]
RB

1 Berman, "Byron Browne," p. 101.

2 Paul, "Byron Browne in the Thirties," p. 18.

3 Artists Gallery, New York, *Byron Browne: Paintings* (1939), exh. cat. with introduction by Byron Browne, n.p.

Reference J. R. Lane, "American Abstract Art of the '30s and '40s," *Carnegie Magazine* 56 (Sept.–Oct. 1983), p. 14.

Exhibitions Whitney Museum of American Art, New York, 1937, *Annual Exhibition of Contemporary American Painting*, no. 4; Grand

Central Palace, New York, 1938, *The Twenty-second Annual Exhibition of the Society of Independent Artists*, no. 116; Whitney Museum of American Art, New York, 1938, *Annual Exhibition of Contemporary Painting*, no. 10; American Artists Congress, New York, 1939, *Art in a Skyscraper*, no. 29; Washburn Gallery, New York, 1975, *Byron Browne: Work from the 1930s*, unnumbered.

Provenance The artist's wife, Rosalind Bengelsdorf Browne, 1961; Washburn Gallery, New York, 1975.

A. W. Mellon Acquisition Endowment Fund, 1981, 81.32

Patrick Henry Bruce
1881–1936

Though the work of Patrick Henry Bruce has remained in obscurity until recently, he was one of the most accomplished American painters of the early decades of this century. This lack of recognition can be attributed to Bruce's dour personality, together with the fact that he destroyed all but about two dozen of his canvases from the 1920s, his mature period. Many facts about Bruce remain elusive, yet recent attention to his work has proven him to be a major artist.

Bruce was born in Long Island, Virginia, to a wealthy, distinguished, aristocratic family whose fortunes had been vastly diminished by the Civil War. The turn of the century found him in Richmond attending the evening art classes of Edward Valentine, an academic trained in Rome. In 1902 Bruce moved to New York City to study with William Merritt Chase and Robert Henri at the New York School of Art; his work of those years, which already showed talent and promise, reflected the training and interests of his teachers.

During the winter of 1903 Bruce moved permanently to Paris, returning to the United States only sporadically thereafter. In Paris he gradually shifted from his training under Chase and Henri toward the stylistic developments of French painting. He first absorbed the lessons of Impressionism, adjusting his brushwork and attending to color in ways that reflect his interest in Alfred Sisley, Camille

Pissarro, and Pierre-Auguste Renoir, yet by 1910 his paintings testify to his close attention to the work of Paul Cézanne. Meanwhile, Bruce became acquainted with the extensive circle of expatriate Americans in Paris, including Gertrude, Leo, Sarah, and Michael Stein. Through them he met Henri Matisse in 1907; Bruce was an organizer and original member of the Matisse School, which was started in early 1908.

The association with Matisse considerably increased Bruce's concern with color, a concern that intensified even more after Bruce met Robert and Sonia Delaunay in 1912. His move toward strongly pigmented, flat areas of color from 1912 to 1914 marks the beginning of his mature work. His six extant paintings from 1912 to 1916 (five others are known through photographs) were closely related to the Delaunays' work and thus shared the Synchromist style of American painters such as Morgan Russell and Stanton Macdonald-Wright.

By 1916, however, Bruce had taken up a different range of formal and conceptual issues, which determined his work for the next two decades. The intensity of his creative energies was directed toward painting abstract geometric forms, treated as still lifes. These careful and precise compositions of shapes and colors were aimed toward the achievement of an absolute: the perfect painting. This elusive objective, perhaps as much mystical as aesthetic for Bruce, had many echoes in the work of other artists, both past and contemporary. It reflected the goal of the absolute sought by artists as diverse as Piet Mondrian and Hans Richter.

Bruce's work did not bring him any measure of financial success. After the war he eked out a meager living by dealing in antique furniture. During these expatriate years in Paris, he became increasingly aloof, testy, and reclusive. He suffered from a digestive illness and other disorders, both real and imagined. The death of his dearest friend, the painter Arthur Burdett Frost, Jr., in 1917 and the final departure of his wife and son for America in the winter of 1919 were painful blows. Even more traumatic was the vehement rejection of his increasingly innovative paintings by the critics of the early 1920s.

From this time onward, Bruce worked in solitude, seldom exhibiting his work and mostly showing it to a few trusted friends, including the novelist Henri-

Pierre Roche, author of *Jules and Jim*. We owe to Roche both the preservation of Bruce's late works and much of the information on Bruce's life in these later years. In 1933 Bruce moved from Paris to Versailles, destroying most of the paintings in his possession, except about twenty-one canvases, which he gave to Roche. In the summer of 1936 he sailed for New York, where he lived with his sister before taking his own life in November of that year.

Bibliography M. Knoedler and Co., New York, *Synchromism and Related Color Principles in American Painting, 1910–1930* (1965), exh. cat. by William C. Agee, pp. 12–16 and *passim*; Tom M. Wolf, "Patrick Henry Bruce," *Marsyas* 15 (1971–72), pp. 73–85; William C. Agee, "Patrick Henry Bruce: A Major American Artist of Early Modernism," *Arts in Virginia* 17 (Spring 1977), pp. 12–32; William C. Agee and Barbara Rose, *Patrick Henry Bruce, American Modernist: A Catalogue Raisonné* (New York, 1979); William C. Agee and Barbara Rose, "The Search for Patrick Henry Bruce," *Art News* 78 (Summer 1979), pp. 72–75.

Abstract, c. 1928
(Peinture/Nature morte)

Oil and pencil on canvas
35 1/16 x 45 3/4 in. (89.1 x 116.2 cm)

The *Abstract* in the Carnegie collection is one of about twenty-five canvases that have survived from the artist's 1917–33 period. Because Bruce did not date his paintings and used only generic titles such as "painting" or "still life" when he exhibited them, the dating of his work from these two decades is based largely on stylistic grounds. The Carnegie's painting, like Bruce's others from the late 1920s, contains his basic repertory of geometric still-life forms, which read as objects on a tipped-up table but which have been made abstract beyond immediate recognition. Occasionally one can find a shape that might suggest an ashtray with a cigarette, or a mortar and pestle, while another might allude to a spherical cheese with a slice missing, or a piece of sectioned fruit. Some of the objects resemble architectural fragments or furniture details, recalling that Bruce was both a collector and dealer in furniture.

Representation, however, was not the aim of this painting. Bruce's works of the

1920s are carefully balanced compositions in which the acknowledged flatness of the canvas in some areas is played off against the illusion of depth in others. This illusion may be achieved by traditional perspectival means, or depth may simply be indicated by overlapping elements.

Quadrangles and other geometric forms become anchored to the edges of the painting, sometimes simply as two-dimensional forms, sometimes readable as background, sometimes as a table or other identifiable motif, and sometimes as an abstract structural form (as in the strong vertical on the left of this canvas, which runs off the edge at both top and bottom).

The colors in Bruce's paintings exist as themselves, avoiding any tendency toward representation. But the colors are balanced so as to shift our perception between object and area, flatness and depth. Here, black—which functions as color, not shadow or representation—interacts with muted pinks, greens, blues, yellows, and grays to contribute to the artist's goal of perfect composition. One can argue that in both the form and color, Bruce was paying homage not only to the early Italian and Renaissance painters he admired— above all, Andrea Mantegna—but also to Henri Matisse, with whom he studied in 1908–11.

Bruce drew his forms in pencil on the canvas before beginning to paint, and this drawing process, with its dual suggestion of flat surface and illusory depth, has often been left visible as a delicate and critical element in the formal balance of the paintings. In some paintings these penciled elements were erased after Bruce's death, apparently by a misguided dealer.

WDJ

References Agee and Rose, *Patrick Henry Bruce, American Modernist*, p. 15; Agee and Rose, "The Search for Patrick Henry Bruce," pp. 72–75; [W. D. Judson,] "*Peinture/Nature Morte* by Patrick Henry Bruce," *Carnegie Magazine* 54 (Oct. 1980), pp. 2–3; Sordoni Art Gallery, Wilkes College, Wilkes-Barre, Pa., *Students of the Eight American Masters, ca. 1910–ca. 1960* (1981), p. 19; W. D. Judson, in Museum of Art, Carnegie Institute, *Collection Handbook* (Pittsburgh, 1985), pp. 236–37.

Exhibitions Albright-Knox Art Gallery, Buffalo, N.Y., 1968, *Plus by Minus: Today's Half-Century,* no. 22; American Federation of Arts, New York, 1968, *From Synchromism Forward: A View of Abstract Art in America* (trav. exh.), no. 9; Dallas Museum of Fine Arts, 1972, *Geometric Abstraction, 1926–1942,* no. 10; Museum of Fine Arts, Houston, 1979, *Patrick Henry Bruce Retrospective, 1901–1932* (trav. exh.), no. 32.

Provenance Henri-Pierre Roche, Paris, by 1933; Rose Fried Gallery, New York, to 1956.

Museum purchase: Gift of G. David Thompson, 1956, 56.4

See Color Plate 26.

George de Forest Brush

1855–1941

Born in Shelbyville, Tennessee, in 1855, George de Forest Brush grew up in Danbury, Connecticut. His mother, an amateur portraitist, was the first to encourage his interest in the arts, which led to his enrollment at the age of sixteen in the National Academy of Design, New York, where he studied for three years before deciding to go abroad. Like many American artists of his generation, he went to Paris, where he attended the Ecole des Beaux-Arts.

From 1874 to 1880, Brush studied in the atelier of the successful French academic painter Jean-Léon Gérôme. For virtually the rest of his career, Brush's work remained true to the principles and practices of French academicism he had learned as Gérôme's pupil. Heroic, idealized, tightly painted figures became the focus of his paintings; characters from classical mythology, American Indians, and, later, madonnas with children were his trademarks.

It was the North American Indian that allowed Brush to transplant successfully Gérôme's interest in African and Near-Eastern subject matter. From 1881 to 1885 he and his brother traveled through the American West, gathering material to fulfill Brush's long-held ambition to portray in his art the nobility of the American Indian. In the years that followed, he executed numerous paintings of idealized Indian subjects, which exploited the contemporary taste for careful composition, attention to detail, and smoothly finished surfaces as well as current interest in the rapidly vanishing way of life of America's native peoples.

Brush exhibited in New York with the recently formed, progressive-minded Society of American Artists while also enjoying success at the more established and orthodox National Academy. There he won the First Hallgarten Prize and in 1888 was elected an associate, in 1908 becoming a full academician. In 1885 he began teaching at the Art Students League, and the following year he married one of his students. Pursuing Indian themes during the two years the couple spent in Quebec Province, he also gathered material for these subjects during a visit to Florida in 1887.

By the end of the decade, Brush had abandoned western genre and begun to accept portrait commissions. He also discovered that his wife and their seven children were congenial subjects. The many family portraits that followed usually presented tender, weary, patient mothers with energetic, innocent children, in the manner of Italian Renaissance madonnas. Such idealization of the female figure and evocation of the past accorded well with the artistic outlook prevailing in America at the end of the nineteenth century.

Brush showed his work at the Pennsylvania Academy of the Fine Arts, Philadelphia, where he received a Temple Gold Medal in 1897, and at the National Academy, which awarded him the Saltus Medal in 1909. In 1911 Carnegie Institute purchased *Mother and Child*, dated 1894 (deaccessioned in 1966, now in the Metropolitan Museum of Art, New York), from one of several Internationals in which Brush exhibited. His work won gold medals at international expositions in Chicago in 1893, Paris in 1900, Buffalo in 1901, and Saint Louis in 1904.

Accompanied by his family, Brush led a fairly nomadic existence. His residence in New York, where he continued to teach at the Art Students League, was interrupted by long stays in Europe and New England. Beginning in 1892, he joined the artists' summer colonies at Cornish and Dublin in New Hampshire, joining Augustus Saint-Gaudens and Thomas Dewing at Cornish, and Abbott H. Thayer, Douglas Volk, Edmund Tarbell, Frank Benson, and Birge Harrison at Dublin. In England in 1898, Brush briefly joined the Broadway Group led by the American figure painters Edwin Austin Abbey and Francis Davis Millet. He also went occasionally to Italy, mainly Florence, where he occupied the former studios of American sculptors Hiram Powers and Thomas Ball. During World War I he divided his time between New York and Dublin and helped promote Thayer's proposals for military camouflage. In the 1920s he returned for brief periods to Italy, and he also visited Spain. He died in Hanover, New Hampshire.

At the end of his career, Brush was honored by solo exhibitions at the Grand Central Art Galleries and the American Academy of Arts and Letters (to which he was elected in 1910), both in New York, and by an honorary degree from Yale University. Although an ardent devotee of idealistic and socialist thought, Brush's views on art were deeply conservative. In 1919 he complained that "artists are producing canvases today for which they ought to be arrested. . . . Real art is on the wane; it has become so enmeshed in the mad whirl and swirl of modern times that true artistic sense is deadened."[1] In his own work, he always remained faithful to the high finish and meticulous drawing he associated with immutable artistic tradition.

1 Obituary, *New York Times*, April 25, 1941, p. 19.

Bibliography Charles H. Caffin, *American Masters of Painting* (New York, 1902), pp. 120–40; Minna C. Smith, "George de Forest Brush," *International Studio* 34 (April 1908), pp. 47–56; Elliott Daingerfield, "George de Forest Brush," *Art in America* 18 (June 1930), pp. 214–18; Nancy Douglas Bowditch, *George de Forest Brush: Recollections of a Joyous Painter* (Peterborough, N.H., 1970); Berry-Hill Galleries, New York, *George de Forest Brush, 1855–1941: Master of the American Renaissance* (1985), exh. cat. by Joan B. Morgan.

The Blue Madonna, 1928

Oil on wood panel
45½ x 33³⁄₁₆ in. (115.6 x 84.3 cm)
Signature, date: GEO DE FOREST BRUSH/1928 (lower right)

Brush painted *The Blue Madonna* during his last visit to Italy. It shows his daughter Mary Brush Pierce (born 1898) holding her own daughter, Nancy. The combination of the mother-and-child theme with the family portrait had preoccupied the artist for several decades. Brush's earlier interpretations were vaguely evocative of the Renaissance but contemporary in costume and informal in pose. Here, however, the portrait is subordinated to a specifically religious image, deliberately couched in a venerable, and somewhat archaic, artistic vocabulary.

In *The Blue Madonna* Brush paid homage to the work of admired Italian Renaissance masters such as Raphael and Andrea del Sarto, whose Madonna in the Galleria dell'Accademia in Florence he said was "the most perfect picture in the

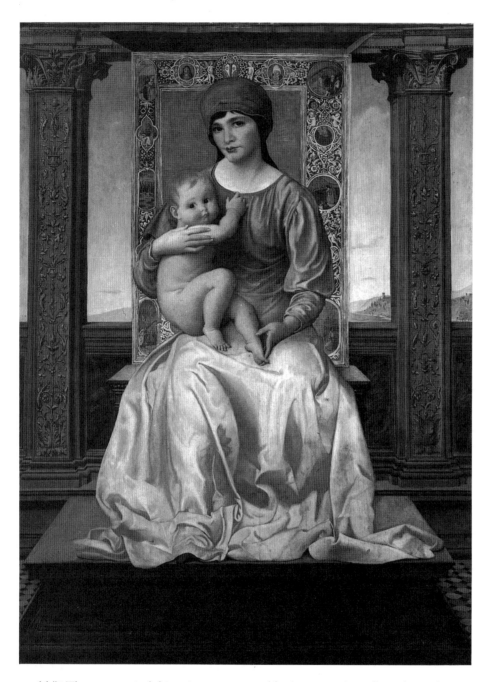

for unity of tone. Complementary hues of blue and orange predominate; the flesh tones are rendered in tiny flecks of blue and orange, which combine when seen from a distance, suggesting the influence of Impressionism.

In *The Blue Madonna*, Brush attempted to fuse the traditional religious icon with a sympathetic family portrait, at once honoring family ties and artistic ideals. The painting epitomizes his profound artistic conservatism: "We must not run after new things," Brush declared. "We must found [*sic*] out what the masters knew."[3]

A study for *The Blue Madonna* appeared in 1933–34 with the finished work in Brush's solo exhibition at the American Academy of Arts and Letters, New York. This may be identical with a faint sketch in pencil and chalk on reddish brown paper owned by Grace Pierce Forbes, the artist's granddaughter. It is apparently a preliminary sketch of the child, with only a few tentative lines to suggest the Madonna.

WG

1 Recollection by Brush's granddaughter, Polly Brush Pearmain Marlowe, in Bowditch, *George de Forest Brush*, p. 224.

2 "Artist Finds Inspiration for $18,000 Pictures within the Circle of His Own Family," *Pittsburg Dispatch*, May 2, 1920, sec. 6, p. 5.

3 Brush in Royal Cortissoz, *American Artists* (New York, 1923), p. 70.

References Bowditch, *George de Forest Brush*, p. 225; W. Greenhouse, "A Modern Madonna," *Carnegie Magazine* 56 (Mar.–Apr. 1983), pp. 16–17.

Exhibitions American Academy of Arts and Letters, New York, 1933–34, *George de Forest Brush: Exhibition of Paintings and Drawings*, no. 24; Berry-Hill Galleries, New York, 1985, *George de Forest Brush, 1855–1941: Master of the American Renaissance* (trav. exh.), exh. cat. by J. B. Morgan, no. 52.

Provenance The artist's daughter, Mary Brush Pierce (Mrs. Grenville Clark), Hanover, N.H.; her daughter, Grace Pierce Forbes, Cambridge, Mass., 1970.

A. W. Mellon Aquisition Endowment Fund, Paintings Acquisition Fund, George H. Taber Fund, Howard A. Noble Fund, Mrs. J. Willis Dalzell Fund, Mrs. George L. Craig, Jr., Mrs. Frank R. Denton, and Mrs. John Berdan, 1981, 81.49

world."[1] The symmetrical, hieratic composition, the framing architectural elements, the traditional blue of the Madonna's dress, even the use of panel rather than the more conventional canvas all recall Renaissance conventions. Accordingly, the formal painted architecture, reminiscent of Giovanni Bellini's Madonnas, complements the elaborate throne back on which various biblical scenes have been painted.

Yet *The Blue Madonna* is not simply an imitation of fifteenth-century precedents but a modern—and arguably somewhat odd—interpretation of a traditional image. Rather than imagine an ideal Madonna, Brush portrayed a real mother, for he believed that "no paid model can ever put quite the same heart and soul into her expression."[2] The Madonna's conventional pose contrasts with the direct gaze of this modern Mary. While the style and color of her dress are traditional, her hairstyle and headdress echo the fashion of the 1920s. Technically, the painting reflects contemporary concern

Theodore Butler

1860–1936

ONE OF THE YOUNGER generation of American Impressionists, Theodore Earl Butler was born and raised in Columbus, Ohio. He attended nearby Marietta College from 1876 until 1880, then left for New York, where he enrolled in the Art Students League in 1882. Between 1885 and 1887 he studied in Paris at the Académie Julian, the Atelier Colarossi, and the Académie de la Grande Chaumière. He exhibited his work at the Paris Salon of 1888 and won an honorable mention.

In 1888 Theodore Robinson, an American friend and fellow painter, took Butler to Giverny. Claude Monet had moved there in 1883, and from 1885 to 1888 eight American painters had also gone to Giverny for varying periods, Robinson chief among them. Robinson introduced Butler to Monet, and Butler became the youngest American Impressionist to be in direct contact with the master.

In 1892 Butler married Suzanne Hoschedé-Monet, Monet's stepdaughter, a marriage commemorated in Theodore Robinson's painting *The Wedding March* (1892, Terra Museum of American Art, Chicago). When she died in 1899 after a five-year illness, the artist married her sister Marthe, who had cared for the Butlers' two children during Suzanne's illness. Although Butler made several extended trips to the United States, he spent most of his time in Giverny and died there.

Influenced by Monet's style and subject matter, Butler began to paint Impressionist garden scenes and plein-air figure studies during his first years in Giverny. However, by the early 1900s, when he is considered to have done his best work, Butler departed from the palette and principles of Impressionism, using color in a subjective manner and transforming pictorial forms into individual patterns. While he made a few excursions into mural decoration, most of his works were easel paintings, in accord with the later developments of Impressionism and the aesthetics of Post-Impressionism.

In the early 1900s the artist was participating in the exhibitions that earned a place in the history of international modernism, including the Salon d'Automne and the Salon des Indépendants in Paris and the Armory Show in New York. In 1918 Butler was elected director of the Society of Independent Artists in New York. Although his production of notable work fell off in the years following 1918, he continued to act as host to the younger American artists who, in the tradition of the Impressionists, still came to Giverny to paint.

Bibliography Jean-Pierre Hoschedé, *Claude Monet, Ce mal connu, Intimité familiale d'un demi-siècle à Giverny de 1883 à 1926* (Geneva, 1960), pp. 19–31, 70–89, 99–105; Charles E. Slatkin Galleries, New York, *Claude Monet and the Giverny Artists* (1960), exh. cat. by Regina Slatkin; Signature Galleries, Chicago, *Theodore Earl Butler, 1860–1936* (1976), exh. cat. by Richard H. Love and Harold M. Rowe; Richard H. Love, *Theodore Earl Butler: Emergence from Monet's Shadow* (Chicago, 1985).

Girl in Lavender, Seated at a Desk, 1908
(Woman at Desk)

Oil on canvas
29 x 23¼ in. (73.7 x 59.1 cm)
Signature, date: *T. E. Butler* '08 (lower left)

This image of a slim, elegant woman seated at a writing desk is either of Butler's second wife, Marthe Hoschedé-Monet, whom he married in 1901, or of his

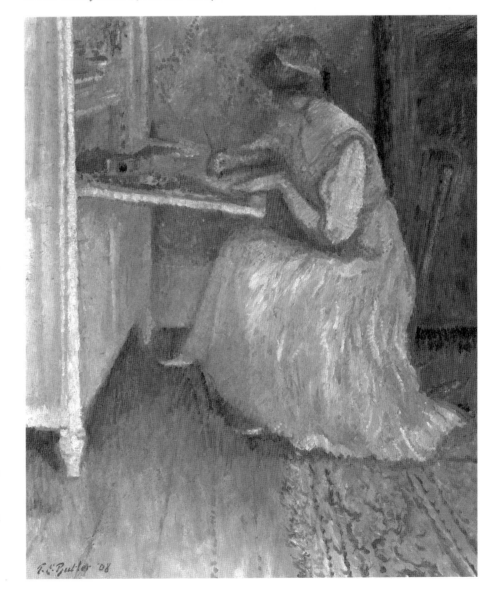

daughter Lili, whom he depicted reading or writing in numerous works. Marthe and Lili, along with the artist's son James, were frequently shown in the setting of their house in Giverny, as in this work. The sitter's white dress, mauve-toned skin, and golden hair combine with a white desk, lilac floor, and orange-flecked carpet and wallpaper to create a composition given over to pattern and brilliant color, the most vivid hue being the blue violet with which Butler outlined every shape.

Butler's selection of a domestic interior and his manner of presenting it is suggestive of the work of the Nabis, particularly Edouard Vuillard, who depicted quiet household activities in small, avant-garde paintings that are patchworks of dabs of color. Butler's bold patterning is a kindred venture. It may be, as Richard H.

Love believes, that this painting was exhibited at the *Salon d'Automne* of 1908 as *Jeune fille écrivant*.[1]

In two respects the sources for Butler's methods were closer to home. His colors—primarily lavender, cobalt blue, green, and yellow orange—are more intense and more thickly layered than those of Vuillard or the other Nabis. They derive instead from the opal-hued pigments that Monet favored around 1900. Butler's focus on an elegant figure is closely related to paintings by Phillip Leslie Hale, a Boston-based painter and friend of Butler who also came to Giverny in 1888. In paintings such as *Girls in Sunlight* (c. 1897, Museum of Fine Arts, Boston), Hale likewise interpreted contemporary women in an elegant, idyllic manner and defined his figures with glowing color.

DS

1 R. H. Love, *Theodore Earl Butler: Emergence from Monet's Shadow* (Chicago, 1985), pp. 307, 314, n. 5.

Reference Love, *Theodore Earl Butler*, pp. 305–6, 424.

Exhibitions Charles E. Slatkin Galleries, New York, 1960, *Claude Monet and the Giverny Artists*, no. 20; Janet Fleisher Gallery, Philadelphia, 1965, *Theodore Earl Butler*, no. 11, as *Woman at Desk;* Museum of Art, Carnegie Institute, Pittsburgh, 1982, *Directions in American Painting, 1875–1925: Works from the Collection of Dr. and Mrs. John McDonough*, exh. cat. by O. Rodriguez Roque, unnumbered.

Provenance Michel Monet, Giverny, France; Janet Fleisher Gallery, Philadelphia, until 1967; Dr. Albert Kaplan, Philadelphia (sale, Samuel T. Freeman and Company, Philadelphia, April 20, 1978); Dr. and Mrs. John J. McDonough, Youngstown, Ohio, 1978.

Gift of Dr. and Mrs. John J. McDonough, 1982, 82.96

Mary Callery

1903–1977

A SCULPTOR PRIMARILY OF lyrical forms in bronze and steel, Mary Callery is best known for the smooth, extremely attenuated arabesques of dancers and acrobats she produced during the 1940s and 1950s. Born in New York City, Callery was raised in Pittsburgh, where her father was a prominent leather-goods manufacturer and later board chairman of the Pittsburgh Railways Company. She attended school in New York and began to study sculpture there under Edward McCartan at the Art Students League. Having completed four years of study there, she left in 1930 for Paris, joining the atelier of Jacques Louchansky, a Russian-French sculptor. During her eight-year residence in Paris, Callery drew, by turns, on the styles of Aristide Maillol, Pablo Picasso, Henri Laurens, Amédée Ozenfant, and Fernand Léger. She particularly admired Picasso and Léger and collected their work.

After the invasion of France in 1940 Callery returned to New York. She exhibited actively throughout the 1940s and 1950s. The year 1944 marked her first solo exhibition, at the Buchholz Gallery (later the Curt Valentin Gallery), New York; subsequent exhibitions devoted exclusively to her work were mounted in 1946

(Arts Club of Chicago), 1949 (Galerie Mai, Paris), and 1954 (Galerie Cahiers d'Art, Paris). In addition to the figure groups that dominate her work, public sculpture also figured prominently in Callery's career. Commissions for the Alcoa Building in Pittsburgh and Public School No. 34 in New York yielded, respectively, *Three Birds in Flight* (1953), a monumental aluminum mobile, and *Fables* (1954), a decorative grille inspired by the well-known La Fontaine stories.

Callery's modernist interpretations of the figure in motion won frequent praise from New York critics, who reported that her work was refreshingly accessible to the general public.[1] Writers approvingly noted her transformation of the Cubist idiom into a lighter, more decorative style, often comparing her favorably with Léger and Jacques Lipchitz. According to one commentator, her technique was indicative of the "architectural simplicities that have come upon the whole modernistic world."[2] She died in Paris.

1 Henry McBride, in Curt Valentin Gallery, *Mary Callery*, pp. 2–4.

2 Ibid., p. 4.

Bibliography Buchholz Gallery, New York, *Mary Callery* (1950), exh. cat., essay by Christian Zervos; Curt Valentin Gallery, New York, *Mary Callery* (1952), exh. cat. by Henry McBride; "Mary Callery," in Marjorie D. Candee, ed., *Current Biography*, vol. 16, no. 7 (July 1955), p. 97; Philip R. Adams and Christian Zervos, *Mary Callery Sculpture* (New York, 1961); Obituary, *New York Times*, February 14, 1977, p. 30.

Small Ballet, 1944

Bronze
12¹³⁄₁₆ x 6¹³⁄₁₆ x 2½ in. (32.7 x 27 x 7 cm)
Markings: MC (lower right, in monogram)

Callery's *Small Ballet* and her comparable works of related themes drew the strong approval of American critics, one of whom, Margaret Breuning, praised Callery's "decorative silhouettes of rhythmic design" and the "fluidity of the arching bodies and curving limbs... resolved into a graceful symmetry of design."[1]

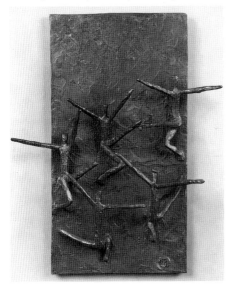

Callery's interpretation of the human form as linear pattern and her interest in presenting multiple views of the figure relate to her study of Cubism. Yet her composition, in its implied circularity, recalls Henri Matisse's *Dance* (1910, Hermitage, Leningrad) and its creation of silhouette, shape, and dynamic activity through linear movement. Although *Small Ballet* is affixed to a planar surface, the figures are nonetheless liberated from two-dimensional space and enlivened by the shadows they cast.

LM, DS

1 Margaret Breuning, "Rhythms of Callery," *Art Digest* 19 (October 15, 1944), p. 14.

Reference Adams and Zervos, *Mary Callery Sculpture*, p. 10.

Bequest of the artist, 1981, 81.56.6

Study for "Seated Ballet," 1945

Bronze
19⅞ x 13½ x 5½ in. (50.5 x 32.7 x 7 cm)

Study for "Seated Ballet" was Callery's bronze maquette for a larger version (64 x 46 in.) of the same subject, which she completed in 1946 (formerly collection Harold Johnson, Louisville, Ky.). Her figures are joined by fluid curves into a composition that circulates and recirculates within itself. Here, Callery succeeds in creating two rhythmic patterns, one

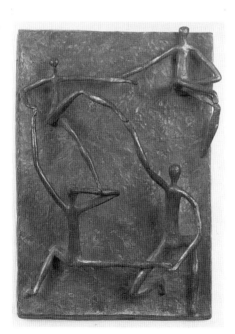

defining the perimeters of the composition and the other activating its interior.

Callery's study bears comparison with the Cubist sculpture of her contemporary Jacques Lipchitz. The figural style of both artists had an academic basis; both capitalized on clarity of silhouettes and the extreme, geometric simplification of anatomy; both shared a concern for the Cubist interpenetration of space and form; both also gave their shapes a linear quality. In Callery's sculpture, as in Lipchitz's openwork *sculptures transparentes*, form is seen as two-dimensional and three-dimensional simultaneously, animated by a twisting, intertwining aspect. The existence of such correspondences was surely one reason why *Seated Ballet*, like Callery's other work, was considered the fully legitimate offspring of French modernism.

LM, DS

Reference Adams and Zervos, *Mary Callery Sculpture*, p. 12.

Provenance The artist, until 1977.

Bequest of the artist, 1981, 81.56.7

Vincent Canadé
1879–1961

"PAINTING TRANSPORTS me into another world where I dream and fancy myself different and sometimes I forget my sorrows."[1] Thus wrote Vincent Canadé near the peak of his career as a painter. Indeed, sorrow and bitterness were the principal sources of Canadé's artistic inspiration, for although he painted for well over fifty years, his talents went largely unrecognized and unrewarded.

Canadé's interest in art began during his childhood in southern Italy. A reversal of his middle-class family's fortunes had caused him to move, at the age of thirteen, to Brooklyn, New York. He spent his adolescence and early adulthood struggling to earn a living by doing whatever odd jobs he could find. He supported his wife, six children, and mother by working, at various times, as a waiter, carpenter, barber, and house painter. Canadé was urged to attend classes at Cooper Union; he did so for one day, detested it, and never sought any further professional art training. Unable to secure regular

work because of his refusal to join the union of house painters and plasterers, the moody Canadé retreated further into his art, using it often as a means to express the despair and frustration he felt.

About 1919 Canadé was befriended by Joseph Stella, a fellow Italian immigrant to Brooklyn, who shared his artistic inclinations as well as his financial difficulties. Through Stella, Canadé came to the attention of the Manhattan art dealer Erhard Weyhe, who became his chief patron and in 1925 gave him his first solo show. Canadé continued to exhibit his work at the Weyhe Gallery and at a few other galleries and public collections over the next decade; he was represented in the 1928 Carnegie International.

Canadé painted austere, psychologically dark portraits and self-portraits in a flattened, stark, somewhat primitive style that remained resistant to the modernist ideas then current in New York. He clung to a relatively naturalistic manner and scorned "the prevalent fashion of painting imported from France" in favor of attention to "real personality,"[2] by which he meant the glowering self-portraits that had come to dominate his oeuvre. Perhaps as a result of being an outsider in the New York art scene, Canadé earned no more than a modest living as a painter. In reply to comments on the negative content of his works (a probable reason for their unpopularity), Canadé defended himself as "compelled by a superior force" to express his emotions, whether pleasant or not. His sense of artistic martyrdom became obvious in his plan "to paint a *Pietà*, with himself as the dead Christ."[3]

In the 1930s Canadé worked for the WPA Federal Arts Project, and in 1938 he was represented in the Museum of Modern Art's publication *Masters of Popular Painting*. Despite receiving some acclaim as a "primitive" artist, Canadé fell out of the public eye soon afterward. In New York he continued to produce landscapes and portraits in which he constantly scrutinized his own hardened features. Later in life he turned to pastels, even attempting a few still lifes. In spite of his many real and imagined hardships, Canadé lived to the age of eighty-four, driven by his conviction that "one paints for oneself, expecting no smiles and no praise. Time will judge."[4]

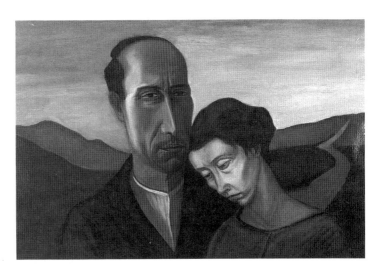

1 Canadé, "Self-Portrait," p. 29.

2 Ibid.

3 Eglinton, "Vincent Canadé," p. 32.

4 Canadé, "Self-Portrait," p. 29.

Bibliography Duncan Phillips, *A Collection in the Making* (New York, 1926), pp. 62–63; Vincent Canadé, "Self-Portrait," *Creative Art* 3 (July 1928), p. 29; Guy Eglinton, "Vincent Canadé," *Creative Art* 3 (July 1928), pp. 30–34; "Vincent Canadé—Painter," *Index of Twentieth Century Artists* 4 (January 1937), pp. 377–78; Dorothy C. Miller, "Vincent Canadé," in Museum of Modern Art, New York, *Masters of Popular Painting* (1938), p. 107.

Portrait of the Artist and His Wife, c. 1925

Oil on canvas
16 x 23⅛ in. (40.6 x 58.7 cm)

In 1950, when this painting was offered to Carnegie Institute, its director called it "a wonderful example of the work of a now forgotten artist." [1] Indeed, the double portrait combines Canadé's most frequent and compelling forms of expression, the self-portrait and the portrait of a family member, in this case his wife.

By the mid-1920s Canadé had shown his work in several exhibitions in New York and had obtained a small degree of financial security through the generosity of Erhard Weyhe and a handful of other art dealers. But his paintings did not sell well enough to provide him the comfortable life he had probably envisioned when he left Italy for America. Although he did not wish to be considered a "primitive," he also had no desire to keep pace with the abstraction of the European avantgarde. He grew increasingly defensive about his art, explaining that "the real artist does not ask for permission to paint or instruction how to paint, in order to captivate the praise of the critic, as so-called artists do who look for success at any cost." [2]

Through the 1920s Canadé doggedly continued to produce landscapes, lyrical evocations of the Italy he remembered, perhaps inspired by his contemplation of what fragments of countryside he could find near Brooklyn. His studies of trees and rocks reveal a man who delighted in the contours of nature, and who was a sincere if unsophisticated draftsman. He also continued to paint portraits, returning more and more frequently to his own image.

The evolution of the self-portrait in Canadé's work is a telling record of the artist's growing dissatisfaction. His earliest pictures of himself show a plain man dressed in neat but uncomplicated clothes, set close to the picture plane against a blank background. His expression seems a bit distrustful but otherwise benign. In the paintings of the twenties the suspicion in Canadé's glance turns into either introspective self-pity or agressive contempt. These two facets of Canadé's mature artistic personality appear repeatedly in his self-portraits, beginning about 1920.

A similar duality appears in the Carnegie's *Portrait of the Artist and His Wife*. Here, the subjects have been placed dramatically against a barren landscape of brown and green gray, beneath a somber sky. Behind the artist and his wife a road stretches into the distance, suggesting that the two have traveled the proverbial long road; their care-worn faces reinforce this implication. Canadé's wife, clad in a drab green frock, seems to lean on her husband in exhaustion, her downcast eyes and flyaway wisps of hair bespeaking a life of hardship and disappointment. The artist has painted himself, as both the source and the victim of these trials, in the white shirt and dark gray jacket in which he most often appears in his self-portraits. He wears an expression half of detachment, half of hostility, as if wearily pondering the metaphorical path ahead, while protecting his mate as well as he can and reproaching the observer.

The mixture of bitterness and sympathy in Canadé's *Portrait of the Artist and His Wife* creates an intense statement of personality, thus giving the rather simply executed work its power. No doubt this affecting quality in Canadé's work, which might be called primitive, or even expressionist, is what led Stella, Weyhe, and others to encourage him in his painting. The irony of the artist's life is that the frustration he encountered in his career gave his work its compelling sincerity of emotion, and therefore its significance in American painting.

MM

1 Gordon B. Washburn to G. David Thompson, December 22, 1950, museum files, The Carnegie Museum of Art, Pittsburgh.

2 Canadé, "Self-Portrait," p. 29.

Reference V. Raynor, "Vincent Canadé," *Arts* 39 (Jan. 1965), p. 59.

Exhibition Columbus Museum of Art, Ohio, 1952, *Paintings from the Pittsburgh Collection*, no cat.

Provenance Weyhe Gallery, New York, 1926; G. David Thompson, Pittsburgh, by 1951.

Gift of G. David Thompson, 1951, 51.6

Landscape, c. 1925–30

Oil on cardboard
5 x 7 in. (12.7 x 17.8 cm)

Represented here is an unencumbered view across a field that is marked, in the distance, by the brown foliage of a stand of trees and a winding river. At the horizon is a low range of bright blue mountains—the brightest spot in the composition. They, like the field and the sky, are

defined by horizontal bands of smooth paint, in repeated tones of green, blue, pink, and brown.
DS

Provenance The artist's son, Eugene Canadé, Paris, by 1961.

Gift of Eugene Canadé, 1985, 85.24.1

Multiple Self-Portrait, c. 1935–45

Oil on canvas mounted on board
13⅝ x 17¼ in. (34.6 x 43.8 cm)

Five heads of the artist—bald, and in the collarless white shirt and dark jacket that were his trademark—seem to float uncomfortably on the surface of this disquieting painting. The image is very much in the spirit of the double self-portraits Canadé had made throughout his career. Here, the effect is even more oppressive and brooding than in most.

The oil study is roughly painted, strongly lit, and deeply shaded in the manner Canadé took up during the

1930s. Three of the heads—those at the center—are fully formed and more or less completely colored. The remaining two seem vestigial. Shadowy, ill-formed, and placed at the edges of the pictorial space, they seem to have been added to the composition to throw it off balance and to increase its disturbingly hallucinatory aspect.

This quality is largely the result of the artist's insistence on repeating essentially the same close-up, hollow-eyed expression; it makes the image a peculiar one. Canadé chose not to show the face in different states of mind, or even from different angles, as one might expect from an artist making multiple portrait studies. Only the heavily shaded eyes gaze in slightly different directions.
DS

Remarks On the reverse there is an unfinished and partially defaced oil study of a seated female studio model on white ground.

Provenance The artist's son, Eugene Canadé, Paris, by 1961.

Gift of Eugene Canadé, 1985, 85.24.3

Still Life, c. 1935–45

Oil on canvas mounted on board
5⅝ x 9½ in. (14.3 x 24.1 cm)

This tiny study of four roughly painted peaches conveys much the same somber mood as Canadé's figural compositions. The colors range in hue from red-orange

to yellow to dull gray-green. The indeterminate surface is a light green; the background, a grayer shade of the same color.
DS

Provenance The artist's son, Eugene Canadé, Paris, by 1961.

Gift of Eugene Canadé, 1985, 85.24.2

Arthur B. Carles
1882–1952

ONE OF THE IMPORTANT avant-garde painters in America prior to World War II, Arthur Beecher Carles participated in the wave of American interest in European modernism that began around 1910. Through the 1920s he maintained contact with the European avant-garde and in the 1930s created works that foreshadowed the Abstract Expressionism of the next decade. Though Carles's style changed markedly in his almost four decades of painting (he shifted readily between abstract and representational styles), certain characteristics remained constant: sensuous involvement with paint, spirited movement, and intense color.

Carles's major subjects were flowers and the female nude. He chose these themes not merely as convenient means for painting experiments but because they embodied what one critic has called his "delight in the visual world and his joy in being alive."[1] Indeed, in 1928 he said, "If there's one thing in all the world I believe, it's painting with color. So damn few people paint with color, and what on earth else is painting for?"[2] Carles was not a man of moderation. He was compulsively attracted to women, smoked heavily, and

drank excessively. His alcoholism ultimately incapacitated him by 1941, at the height of his career.

Carles, a craftsman's son who was born and raised in Philadelphia, attended Central Manual Training High School and in 1900 entered the Pennsylvania Academy of the Fine Arts, where Cecilia Beaux, Thomas Anshutz, William Merritt Chase, Hugh Breckenridge, and Henry McCarter were his teachers. They gave Carles a familiarity with the academic Impressionism and art-for-art's-sake aesthetic that dominated turn-of-the-century American art, as well as something of the newer Post-Impressionist style.

Carles was in Europe in the summer of 1905, from 1907 to 1910, and again in 1912. During his second trip he visited Gertrude and Leo Stein in Paris and had his work critiqued by Henri Matisse. His painting began to show some of Matisse's vibrant color and Paul Cézanne's use of color to create form. By 1912 Carles had fully adopted a modernist aesthetic; he subscribed to the tenet that paint lies flat and that paintings are patterns in color, not illusions in light and shadow. In New York he associated with the artists of Alfred Stieglitz's circle and had a solo exhibition at his gallery, 291, in 1912.

Carles's work of the mid-to-late 1910s became more conservative in style, a change perhaps motivated by a desire for recognition at home. His color softened and his conventionally posed nude figures were set in illusionistic, if shallow, space. During these years he exhibited frequently; he became a highly regarded instructor at the Pennsylvania Academy of the Fine Arts, Philadelphia, a spokesman for modernism, and a prominent figure in the Philadelphia art community.[3]

In the 1920s Carles began to produce exuberant, sensuous still lifes and nudes that represent the fruition of the ideas he developed between 1907 and 1913. His renewed interest in pursuing an avant-garde style was apparently rekindled by exhibitions of modern art that he organized in Philadelphia in 1920, 1921, and 1923 and by a trip to France in 1922. Carles's paintings of this decade use vibrant, complementary colors, have a strong sense of movement, and show an increased tendency to abstraction.

The years 1925 to 1928 were particularly stressful for Carles. In 1925 he was dismissed from the Pennsylvania Academy; his drinking increased. He divorced his wife and suffered permanent eye damage from contaminated alcohol. Yet during this same period he painted some of his best works and continued to exhibit his paintings. Between 1923 and 1934 he participated in seven Carnegie Internationals as well as the annual exhibitions of the Art Institute of Chicago, the Art Club of Philadelphia, and the Pennsylvania Academy, where he won the Temple Gold Medal in 1930.

Around 1927 Carles began experimenting with Cubism, a new direction reinforced by a trip to Europe in 1929. His embrace of this painting style was especially daring at a time when many American artists were turning to realism and native subject matter. His initial Cubist works were still recognizable as still lifes or nudes, but by 1936 he was creating wholly abstract paintings in which he linked vibrant color to fragmented Cubist form and interpenetrating planes.

The influence of Joan Miró's biomorphic Surrealism and of Wassily Kandinsky's painting of the 1920s was evident in Carles's work between 1935 and 1941. In these last years of his painting career, he produced works whose spatial ambiguity and gestural energy foreshadow the work of the Abstract Expressionists. Indeed, at the time of his death in Philadelphia, he was recognized as one of the founders of that movement.

1 Pennsylvania Academy of the Fine Arts, *Arthur B. Carles*, p. 13.

2 Mielziner, "Arthur Carles," p. 35.

3 Barbara Ann Wolanin, "Re-emergence of an American Modernist: Arthur B. Carles," *Arts* 58 (February 1984), p. 122.

Bibliography Jo Mielziner, "Arthur Carles: The Man Who Paints with Color," *Creative Art* 2 (February 1928), pp. 30–35; Henry Clifford, "Prophet with Honor," *Art News* 52 (April 1953), pp. 21–23, 47–48; Henry Gardiner, "Arthur B. Carles: A Critical and Biographical Study," *Bulletin of the Philadelphia Museum of Art* 64 (January–March 1970), pp. 139–89; Barbara Ann Wolanin, "Arthur B. Carles, 1882–1952: Philadelphia Modernist," Ph.D. diss., University of Wisconsin, Madison, 1981; Pennsylvania Academy of the Fine Arts, Philadelphia, *Arthur B. Carles: Painting with Color* (1983), exh. cat. by Barbara A. Wolanin.

Composition, c. 1925–27

Oil on canvas
46¾ x 58½ in. (118.7 x 148.6 cm)
Signature: Carles (lower right, scratched into the paint)

Floral compositions and red-haired nudes were Carles's most frequently repeated subjects in the 1920s, and here he has combined them to create an ambitious painting that represents the culmination of his work of that decade. It depicts a partially draped, red-haired female figure placed next to a flower arrangement.

The woman stands before a drapery, while the flower arrangement is set against a tree. A wedge of sky and clouds separates the two halves of the bilateral composition, thus making an explicit connection between the beauty of the flowers and the beauty of the woman. Both are placed in front of kelly-green backgrounds. The red-and-pink color combination of the woman's hair is seen repeatedly in the flower arrangement and especially in the flowers directly above her head. Moreover, the windswept movement of the woman's hair is echoed in the turbulence of the flowers. Their vibrant quality is further enhanced by the placement of the flowers and the nude against dark backgrounds. Indeed, the flowers with their often spiky shapes look like fireworks in a dark sky.

The painting is a mix of abstraction and realism. The floral half of the picture is quite abstract. The flowers are set, ostensibly, on a table covered with a cloth. But the wild patterning of the cloth and the forms of the flowers are in places indistinguishable, and the flowers themselves are colorful shapes that seem to explode into space. The turbulent, highly abstract character of this still life is typical of Carles's work in that genre during the 1920s.

The influence of Wassily Kandinsky's Improvisations, perhaps particularly his *Improvisation 27* (1912, Metropolitan Museum of Art, New York), then owned by Alfred Stieglitz, is apparent in the swirling movement of Carles's forms unleashed in space.[1] Such interplay between objects and their surroundings was of great concern to Carles. He wrote, "The interval between the explosions of

flowers is like an interval in music—as vital as the flowers themselves."[2]

The nude in *Composition* is handled more realistically than the flowers, as were most of Carles's nudes of the mid-to-late 1920s. They are generally more three-dimensional than the nudes of the early 1920s, which have flat, white flesh modeled in often strident colors, set against backgrounds of abstract shapes or simple draperies. In *Composition* the woman's forms are rounded, voluptuous, and naturalistically colored. The light greens and blues used to model her shoulders create a tactile sense of the translucency of flesh.

Neither is the space in *Composition* flat. Its three-dimensionality is heightened by the vase that defines the foreground and establishes the spatial interval between it and the body and table. The richer surroundings also correspond to Carles's other nudes of the later 1920s, perhaps in emulation of Henri Matisse's contemporary *Odalisques*.

In its coloring, *Composition* is based on the green-red contrast so central to Carles's aesthetic. The effect is almost jarring in its juxtaposition of clashing and complementary colors, but this lack of harmony adds greatly to the vibrancy of the work. Carles was an astute analyst of color. He wrote:

> Green is the great surface slider. It skids—slips—makes blurred extensions. Green will move into anything except red. Outside of this color—in the center of the spectrum—colors generally go in pairs—at least red and black are the most stable stay-put pair. When white comes near, the black pairs up with it and seems equally brilliant. The red becomes sullen and absorbent, immovable. With yellow it shows its full blood, pours all its strength into it—makes it sing or yell. White among colors functions as blue—with black jammed against it or in it, it stays clear. Black and white are the strongest colors—the only two that can hold down yellow. Yellow is the vicious feminine color. Alone with white it seems happy. If red approaches, a greenish shudder runs through it—when red touches it, it deserts the white, leaving it sick and useless—if a black thin line comes between the yellow and white, the white is revived and the yellow pushed close to the red.[3]

The red-green and yellow-black-white color relationships discussed in this passage are clearly evident in *Composition*.

Composition was commissioned by Mr. and Mrs. Alexander Lieberman for their dining room (hence the discreet back view of the nude) in Elkins Park, a suburb of Philadelphia. Lieberman, a real-estate financier, was a major patron of Carles in the 1920s. Other large still lifes by Carles hung elsewhere in the Liebermans' house. The work's original title has yet to be determined; its date is based on its stylistic similarity to certain

Fig. 1 Arthur B. Carles, *Nude in Decoration (Nude with Flowers)*, c. 1925–27. Oil on canvas, 45½ x 56½ in. (115.6 x 143.5 cm). Janet Fleisher Gallery, Philadelphia

dated paintings, including *Flower Piece* of 1927 (collection Mr. and Mrs. Malcolm C. Eisenberg, Philadelphia).

Between 1925 and 1927 Carles painted a second, less abstract version of *Composition* titled *Nude in Decoration* (fig. 1). Although Barbara Wolanin believes the two versions were probably done simultaneously,[4] *Nude in Decoration* appears to be a preliminary effort because of its incomplete, sketchy quality and because Carles often worked in series from less abstract to more abstract versions of the same theme. Regarding this procedure, he wrote that the first in a series was realistically painted after nature, and subsequent versions were less realistic, "caught from the spirit of the first painting and set down and the third would be the mood, abstract and entirely detached from the first painting."[5] Another version of this same theme was exhibited at Wildenstein Gallery, New York, in 1927.

JRM

1 Wolanin, "Arthur B. Carles, 1882–1952," vol. 1, p. 202.

2 Mielziner, "Arthur Carles," p. 35.

3 Clifford, "Prophet with Honor," p. 48.

4 Barbara Ann Wolanin to Julia R. Myers, March 22, 1987, museum files, The Carnegie Museum of Art, Pittsburgh.

5 Pennsylvania Academy of the Fine Arts, Philadelphia, *Arthur B. Carles*, p. 69.

References "Seven Philadelphia Painters," *Art News* 26 (Oct. 29, 1927), p. 10; G. B. Washburn, "Three Gifts to the Gallery," *Carnegie Magazine* 27 (Dec. 1953), p. 339; Wolanin,

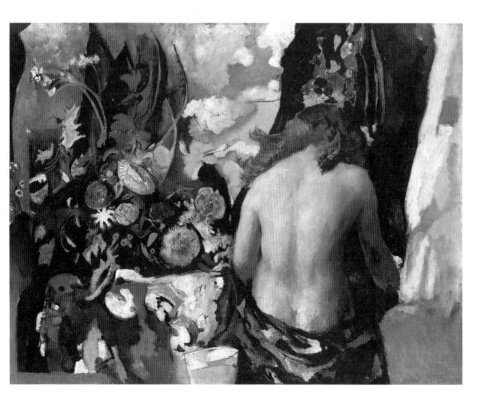

"Arthur B. Carles, 1882–1952," vol. 1, p. 274; vol. 2, p. 459.

Exhibitions Wildenstein Gallery, New York, 1927, *Seven Philadelphia Painters,* no cat.; Flint Institute of Arts, Mich., 1978–79, *Art of the Twenties,* exh. cat. by G. S. Hodge, no. 7.

Provenance Mr. and Mrs. Alexander Lieberman, Elkins Park, Pa., c. 1925–27; G. David Thompson, Pittsburgh, by 1953.

Gift of G. David Thompson, 1954, 54.16.1

Clarence Carter

born 1904

CLARENCE HOLBROOK CARTER's constantly changing style has made him one of the most difficult American painters to categorize. His landscape, portrait, still-life, and genre paintings have been included in exhibitions of Magic Realist, Surrealist, Regionalist, Symbolist, and Social Realist art. While an attempt to assess his overall contribution may be premature, his greatest contribution seems to have been as a painter of the American scene during the 1930s and 1940s.

Born and raised in Portsmouth, Ohio, the son of a postal clerk, Carter decided at an early age to become an artist and began his training with watercolor lessons and a home correspondence course in cartooning. Between 1923 and 1927 he studied at the Cleveland Institute of Art, where he was first attracted to the harmonious color and mysterious space of works by fifteenth-century Italian and Flemish painters. He caught the attention of William M. Milliken, then director of the Cleveland Museum of Art, when he won third prize at the museum's annual *Exhibition of Artists and Craftsmen* during his senior year.

With Milliken's help, Carter sold enough paintings to local patrons to finance a year of travel and study in Europe and Africa after his graduation. In Capri he attended the summer school of Hans Hofmann, but Carter's art, although well regarded by Hofmann at the time, appears to have been unaffected by this influence. In 1929, one year after his return to the United States, his works were shown at the Carnegie International and at international watercolor exhibitions at the Brooklyn Museum, New York, and the Art Institute of Chicago.

While living in Cleveland during the Depression, Carter supported himself and his family with a variety of jobs: he taught at the Cleveland Museum of Art, painted two murals for the Cleveland Public Auditorium, won two federally sponsored competitions for post-office murals, and served for two years as the district supervisor of the Northeastern Ohio Federal Art Project. Between 1938 and 1944 he was an assistant professor of art and design at Carnegie Institute of Technology (now Carnegie Mellon University) in Pittsburgh, and his work appeared in several national exhibitions.

Carter reached the height of his popularity during the 1930s and early 1940s. His realistic portrayal of recognizably American scenes, exemplified in *Jane Reed and Dora Hunt* (1941, Museum of Modern Art, New York), was in tune with the public's desire for a distinctly American art, one not influenced by foreign trends. He had fifteen solo exhibitions at major museums and galleries during this period, including one at Carnegie Institute in 1940. His work was championed by Edward Alden Jewell, the eminent art critic for the *New York Times.* In fact, Jewell even coined a new term for Carter, "Super Realist," in praise of *Poor Man's Pullman* (1930, Gimpel Weitzenhoffer Gallery, New York), a work that was one of five paintings by Carter rejected for the 1930 Carnegie International.

Carter was again rejected in 1931, but a few years later he was exhibiting regularly at Carnegie Institute. He participated in the annual exhibitions of 1938, 1939, and 1940, as well as the exhibition *Paintings by Pittsburgh Artists* in 1941 and the *Painting in the United States* series from 1943 to 1948. In 1943 his entry was voted the Popular Prize by the visiting public. Also in 1943 he won first prize in oils at the Associated Artists of Pittsburgh annual exhibition.

After World War II, with the rise in popularity of Abstract Expressionism, Carter's realistic and subtly symbolic works began to fall out of favor. He moved to Bucks County, Pennsylvania, and rather than change his style, he devoted most of his time through the 1950s to advertising projects and teaching assignments at various colleges and art

schools. When he began to exhibit his work in commercial galleries again in the early 1960s, his art had become more overtly symbolic and less descriptively realistic. Many of his late works depict the egg as a symbol of death and resurrection, with translucent ovoids floating over mysterious, rarefied landscapes. As Carter explained, "It is the mysterious and magical elements in life which have always captivated me, things suggested but only partly seen."[1]

1 Gordon Brown, "Two Worlds of Clarence Carter," *Arts* 41 (November 1966), p. 41.

Bibliography Department of Fine Arts, Carnegie Institute, Pittsburgh, *Exhibition of Paintings by Clarence H. Carter* (1940), exh. cat. by John J. O'Connor, Jr.; Clarence H. Carter, "I Paint as I Please," *Magazine of Art* 38 (February 1945), pp. 46–49; Gimpel Weitzenhoffer, New York, *Clarence Carter: A Retrospective View* (1976); Center for the Arts, Muhlenberg College, Allentown, Pa., *Clarence H. Carter* (1978); Southern Ohio Museum and Cultural Center, Portsmouth, *Clarence H. Carter: Fifty Years of Art* (1979).

War Bride, 1940
(Bride in a Mechanized World)

Oil on canvas
36 x 54 in. (91.4 x 137.2 cm)
Signature, date: *Clarence H. Carter* 40 (lower right)

The eerie, surrealist feeling of *War Bride* sets it apart from Carter's other paintings of this period, which, true to Regionalist aesthetics, were of ordinary subjects in believable settings and landscapes. *War Bride* presents a startling confrontation: a young bride, her back to the viewer, faces an aisle leading to a huge steel press rather than the expected altar. The dramatic incongruity is heightened by the contrast of bridal white with the harsh reds and greens of the machinery. This nightmare vision of man and machine was inspired by a dream Carter had after visiting a steel mill:

> The mills were going full blast and it made a great impact upon us. That night I dreamed I painted a picture that was very vivid in my mind. . . . Some of the girls in my senior painting classes were getting married before the boys would be leaving to go into the coming war. This got mixed into my dream of painting of the steel mill which became the sanctuary.[1]

Originally titled *Bride in a Mechanized World*, the new name was suggested by Carter's friend and enthusiastic supporter, critic Edward Alden Jewell. Although it had already been shown at a Carnegie Institute exhibition in 1941, Carter had doubts about future exhibitions, as it was so different from his other works. "I told [Jewell] that I had been invited for the Annual Exhibition of Contemporary Art at the Whitney Museum but did not know what to send. When he saw the *War Bride* which I was calling *Bride in a Mechanized World* he said send that and call it *War Bride* and it will be a hit, which it was."[2]

Although there may be a touch of hindsight in Carter's remarks about the inspiration for *War Bride*, since it was actually painted a year before America's entry into World War II, it is nevertheless a timeless distillation of the anxiety and loneliness of those war-torn years. In reviewing the Whitney exhibition, a critic found that Carter had given "real poignancy to the solitary white-veiled figure who kneels to invoke the blessing of a war production plant."[3] A more recent reviewer found it one of three paintings of the period that "are graphic realizations of the pain of separation and the grim, disrupted lives of those who remained at home."[4]

War Bride has all the hallmarks of Carter's Precisionist technique: the subject was first drawn on the canvas and then painted in bold, clear colors. As he virtually never reworked or painted over a canvas, his paintings have a distinctively smooth, flat finish and are remarkably true to his original conception. The striking design, juxtaposing human frailty with the machine's implacability, makes *War Bride* one of Carter's strongest and best works.

RB

1 Clarence Carter, "War Bride," *Dreamworks* 4 (1984–85), p. 107.

2 Ibid.

3 Rosamund Frost, "Encore by Popular Demand: The Whitney," *Art News* 42 (December 1–14, 1943), p. 22.

4 Barbara Gallati, "Social Art in America, 1930–1945," *Arts* 56 (November 1981), p. 7.

References "Mechanized Wedding," *Pittsburgh Sun-Telegraph*, June 22, 1941, sec. 4, p. 3; R. Frost, "Encore by Popular Demand: The Whitney," *Art News* 42 (Dec. 1–14, 1943), p. 22; "Whitney Museum Returns Home with Excellent American Annual," *Art Digest* 18 (Dec. 1, 1943), p. 6; M. Breuning, "Carter in Review," *Art Digest* 18 (Jan. 15, 1944), p. 8; Neuen Gesellschaft für bildende Kunst, West Berlin, *Amerika: Traum und Depression, 1920/40* (1980), p. 283; B. Gallati, "Social Art in America, 1930–1945," *Arts* 56 (Nov. 1981), p. 7; R. Pau-Llosa, "Clarence Carter: Maestro de la pintura del sueño," *Vanidades Continental* 22 (June 23, 1982), p. 60; P. Zirnite, "Famed Holland Artist Takes Honors in His Stride," *Hunterdon County Democrat*, Flemington, N.J., Aug. 5, 1982, p. 32; V. Raynor, "A New Carter Exhibition at Lafayette College Center," *New York Times*, June 10, 1984, p. 26: C. Carter, "War Bride," *Dreamworks* 4, no. 2 (1984–85), pp. 106–7; H. Adams, in Museum of Art, Carnegie Institute, *Collection Handbook* (Pittsburgh, 1985), pp. 254–55; E. Rubin, "Letting the Skeletons Out of the Closet," *Manhattan Arts* 4 (Jan. 1987), pp. 3, 15; A. Boney, *Les Années* 30 (Paris, 1987), vol. 2, p. 1500.

Exhibitions Department of Fine Arts, Carnegie Institute, Pittsburgh, 1941, *Exhibiton of Paintings by Pittsburgh Artists,* no. 31, as *Bride in a Mechanized World;* Whitney Museum of American Art, New York, 1943–44, *Annual Exhibition of Contemporary Art,* no. 16; Ferargil Galleries, New York, 1944, *Clarence Holbrook Carter,* no. 2; Whitney Museum of American Art, New York, 1975, *An American Dream World: Romantic Realism, 1935–1955,* no. 7; Gimpel Weitzenhoffer, New York, 1976, *Clarence Carter: A Retrospective View* (trav. exh.), unnumbered; Gimpel Weitzenhoffer, New York, 1976–77, *Clarence Carter: Early Oils and Water Colors,* unnumbered; Mead Art Gallery, Amherst College, and University Art Museum, Michener Gallery, University of Texas, Austin, 1977, *Clarence Carter Retrospective Exhibition,* no cat.; Center for the Arts, Muhlenberg College, Allentown, Pa., 1978, *Clarence H. Carter,* unnumbered; Southern Ohio Museum and Cultural Center, Portsmouth, Ohio, 1979, *Clarence Carter: Fifty Years of Art,* no. 8; Hirschl and Adler Galleries, New York, 1980–81, *Clarence H. Carter: Works from the 20s, 30s and 40s* (trav. exh.), no. 52; ACA Galleries, New York, 1981, *Social Art in America, 1930–1945,* no. 9; Westmoreland County Museum of Art, Greensburg, Pa., 1981, *Southwestern Pennsylvania Painters, 1800–1945,* no. 24; Rutgers University Art Gallery, New Brunswick, N.J., 1982, *Realism and Realities: The Other Side of American Painting, 1940–1960* (trav. exh.), no. 34; Brooklyn Museum, New York, 1986–88, *The Machine Age in America, 1918–1941* (trav. exh.), exh. cat. by R. G. Wilson et al., unnumbered.

Provenance Hirschl and Adler Galleries, New York, by 1982.

Richard M. Scaife American Painting Fund and Paintings Acquisition Fund, 1982, 82.6

See Color Plate 36.

Mary Cassatt
1844–1926

Mary Stevenson Cassatt enjoyed the distinction of being the only American invited to exhibit with the Impressionists. A native Pittsburgher, she was born in Allegheny City, now Pittsburgh's North Side. Despite parental opposition, Cassatt decided to pursue a career as an artist; between 1861 and 1865 she attended the Pennsylvania Academy of the Fine Arts in Philadelphia. In 1866 Cassatt went to Paris, where she studied with Thomas Couture and Jean-Léon Gérôme. In 1872 she traveled to northern Italy to study the work of Correggio and to take lessons in etching from Carlo Raimondi, director of the academy of Parma.

Cassatt settled permanently in Paris, where Edgar Degas first noticed her work at the Salon of 1874. He remarked to a friend: "Here is someone who feels as I do."[1] In 1877 Degas invited her to exhibit with the Indépendants, later called the Impressionists, with whom she showed her work until 1886. Degas remained her mentor; it was largely through his advice and encouragement that she forged her mature style and her artistic value system. "I admired Manet, Courbet and Degas," she remarked, "I hated conventional art. I began to live."[2]

By the mid-1880s Cassatt's work reflected her intimate study of Japanese prints. She moved increasingly toward dynamically patterned surfaces, bright colors, and linear arabesques. After seeing a large exhibition of Japanese prints at the Ecole des Beaux-Arts in 1890, she began to experiment with soft-ground etching and aquatint. Her prints represent an important contribution to the history of graphic art and stand as perhaps her most uniquely personal statements.

Until the end of her career Cassatt maintained the avowed Impressionist opposition to the jury system of awards, despite the art world's increasing desire to bestow such distinctions on her. In 1904, for example, she refused the Pennsylvania Academy's Lippincott Prize, though she did accept, with great pride, the title of Chevalier of the French Legion of Honor the same year. In 1905 Cassatt declined an invitation to serve on the jury of the Carnegie International, as she had declined similar invitations from the Pennsylvania Academy. On that occasion she explained that she had never served on an art jury,

> Because I could never reconcile it to my conscience to be the means of shutting the door in the face of a fellow painter. . . . In art what we want is the certainty that the one spark of original genius shall not be extinguished. . . .
>
> It was the idea of our [Impressionist] exhibitions [that there be] no jurys [sic], and most of the artists of original talent [who]

have made their debut there in the last decade . . . would never have had a chance in the official Salons. . . . Fancy a writer not being able to have an article published unless passed by a jury of authors, not to say rivals.[3]

However, she participated in eighteen Carnegie Internationals between 1899 and 1926 and served on the Foreign Advisory Committee for the International from 1897 to 1906 and in 1923.

Cassatt's talents in the connoisseurship of the arts played an important role in the development of many major American art collections. Her personal collection included hundreds of Japanese prints and objects, Persian miniatures, and Simon Vouet's *Toilet of Venus* (c. 1640, now in The Carnegie Museum of Art). She advised her close friend Louisine Havemeyer on purchases of modern and old-master paintings, many of which are now in the collection of the Metropolitan Museum of Art, New York. The purchase of an El Greco *Assumption* (1577, Art Institute of Chicago) by the Havemeyers was also due to her efforts. Apparently Cassatt also hoped to play a role in the acquisition of paintings for Carnegie Institute. "I hoped," she said, "I might be useful in urging the Institute to buy some really fine Old Masters to create a standard. In this hope, I was naturally disappointed."[4]

By 1914 cataracts had forced Cassatt to abandon her work. She died at Oise, twenty-seven miles north of Paris. Although success in France came early— by the late 1870s she had been recognized there as one of the finest Impressionist painters—appreciation of her work did not grow in America until considerably later. In her native country only one major exhibition of her work—at Durand-Ruel Galleries in New York— was held during her lifetime, though memorial exhibitions were held in 1926 and 1927 at Durand-Ruel, the Art Institute of Chicago, the Philadelphia Museum of Art, and at Carnegie Institute in 1928.

1 Hale, *Mary Cassatt,* p. 55.

2 Ibid., p. 56.

3 Mary Cassatt to John Beatty, September 5, 1905, Carnegie Institute Papers, Archives of American Art, Washington, D.C.

4 Hale, *Mary Cassatt,* p. 202.

Bibliography Achille Segard, *Un Peintre des enfants et des mères: Mary Cassatt* (Paris, 1913); Adelyn Dohme Breeskin, *Mary Cassatt: A Catalogue Raisonné of the Oils, Pastels, Watercolors and Drawings* (Washington, D.C., 1970); Nancy Hale, *Mary Cassatt* (Garden City, N.Y., 1975); Nancy Mowll Mathews, ed., *Cassatt and Her Circle: Selected Letters* (New York, 1984); Nancy Mowll Mathews, *Mary Cassatt* (New York, 1987).

Young Women Picking Fruit, 1891 or 1892

Oil on canvas
51½ x 35½ in. (130.8 x 90.2 cm)
Signature: Mary Cassatt (lower right)

In the 1890s, her mature period, Mary Cassatt's work began to give new emphasis to structure and design. Her colors became sharper and more selective than previously, and her compositions became more dignified and restrained. She infused with greater serenity and seriousness the casual activities of contemporary women that she had always depicted, while preserving a sense of the impermanence and awkwardness of daily life.

Between 1891 and 1893 she took a particular interest in the theme of women outdoors picking fruit. It was not an uncommon subject among Cassatt's peers; in 1881 she had seen the theme in a canvas by Courbet, *La Branche de cerisiers* (c. 1858, Metropolitan Museum of Art, New York), which she prevailed upon her friend Louisine Havemeyer to purchase.[1] Between 1881 and 1891 Edgar Degas, Pierre-Auguste Renoir, Camille Pissarro, and Berthe Morisot all used the theme, as did Pierre-Cécile Puvis de Chavannes, whose mural for the inaugural exhibition of the Salon du Champs-de-Mars, *Inter Artes et Naturam* (1890, Musée des Beaux-Arts, Rouen), depicts a pink-gowned female figure picking fruit.[2]

Cassatt made the subject of women picking fruit the center panel of her largest work, a three-part, twelve-by-fifty-eight-foot mural titled *Modern Woman,* which was commissioned in March, 1892, for the south tympanum of the Woman's Building of the Chicago World's Columbian Exposition. She also made it the theme of an unfinished oil, *Sketch of a Young Woman Picking Fruit*

(1892, private collection); a color print, *Gathering Fruit* (1893); and two canvases, *Baby Reaching for an Apple* (1893, Virginia Museum of Fine Arts, Richmond) and the Carnegie's *Young Women Picking Fruit.*

Young Women Picking Fruit was painted at the château that Cassatt rented at Bachivillers, approximately forty miles north of Paris. The picture shows two young women beneath an unseen pear tree, one reaching to pick a piece of fruit while the other sits meditatively, holding a pear in her lap. The two appear against a nearly airless garden backdrop consisting of a lawn, a row of flowering bushes, and a garden wall, arranged against the sharp sihouettes of the two women, whose solid, country physiques seem at odds with their fancy dresses. Despite their compelling presence, the women seem disengaged and, as in the artist's other work of this time, they are imbued with a solemnity suggestive of allegory.

Cassatt relied on two local models who appeared in some of her other works. The seated woman in a blue flowered dress is identified as *Celeste in a Brown Hat* in an oil portrait of c. 1891 (private collection). Her auburn-haired, pink-gowned companion is the woman portrayed in the pastel *Clarissa, Turned Right with Her Hand to Her Ear* (c. 1893, private collection). Clarissa was also the model for the intensely contemplative *Woman with a Red Zinnia* (1891 or 1892, National Gallery of Art, Washington, D.C.) and the aquatint *The Fitting* (1891). In both images, she wears the same striped dress as in a pencil sketch (Susan and Herbert Adler Collection) that appears to have been the preparatory study for *Young Women Picking Fruit.*[3]

In a letter written in 1922 to Homer Saint-Gaudens when the painting was purchased for Pittsburgh, Cassatt described her colleagues' reactions to it:

> It may interest you to know what Degas said when he saw the picture you have just bought for your Museum. It was painted in 1891, in the summer, and Degas came to see me after he had seen it at Durand-Ruel's. He was chary of the praises but he spoke of the woman's arm picking the fruit and made a familiar gesture indicating the line, and said no woman has a right to draw like that. He said the color was like a [illegible] which was not my opinion. He had spoken of the picture to Berthe Morisot who did not like it. I can understand that. If it has done the

test of time and is well drawn, its place in a museum might show the present generation that we worked and learnt our profession, which isn't a bad thing.[4]

Recently Nancy Mowll Mathews discovered that *Young Women Picking Fruit* was not inventoried in Durand-Ruel's stock books until August 1892.[5] Assuming that the artist sent the painting to her dealer immediately after she finished it, Mathews concluded that Cassatt's recollection must have been faulty, and redated the work to 1892. Mathews postulated that *Young Women Picking Fruit* and its contemporary, *Woman with a Red Zinnia,* were two of at least nine paintings, pastels, and prints, all based on figures in the mural and completed either while Cassatt worked on the Chicago mural or soon after it was finished, and then delivered in batches to her dealer.[6] Mitigating this interpretaion is the artist's own statement to the contrary, and the strong likelihood that Cassatt would remember, even after many years, the date and circumstances surrounding her work on the Chicago mural.

To know whether the work was painted in 1891 or 1892 is of interest on two fronts. If *Young Women Picking Fruit,* its preparatory study, the painting *Woman with a Red Zinnia,* and the Chicago mural were all executed in the summer of 1892, then that year would have been the most astonishingly productive of Cassatt's life. Alternatively, if the Carnegie's canvas dates 1891, and was merely sent to Durand-Ruel's in 1892, then, by extraordinary coincidence, Cassatt was already embarked on a pictorial investigation that suited precisely the format of the monumental mural she would be asked to undertake within a year's time.
DS

1 Hale, *Mary Cassatt,* p. 105.

2 Theodore Stebbins et al., *A New World: Masterpieces of American Painting 1760–1910* (Boston, 1983), entry by Carol Troyen, p. 316.

3 Illustrated in Breeskin, *Mary Cassatt: A Catalogue Raisonné,* p. 275, no. 818, and Mathews, *Mary Cassatt,* p. 84, fig. 72.

4 Mary Cassatt to Homer Saint-Gaudens, December 28, 1922, Carnegie Institute Papers, Archives of American Art, Washington, D.C.

5 Mathews, ed., *Cassatt and Her Circle,* p. 335, n. 3.

6 Mathews, *Mary Cassatt,* pp. 85–86.

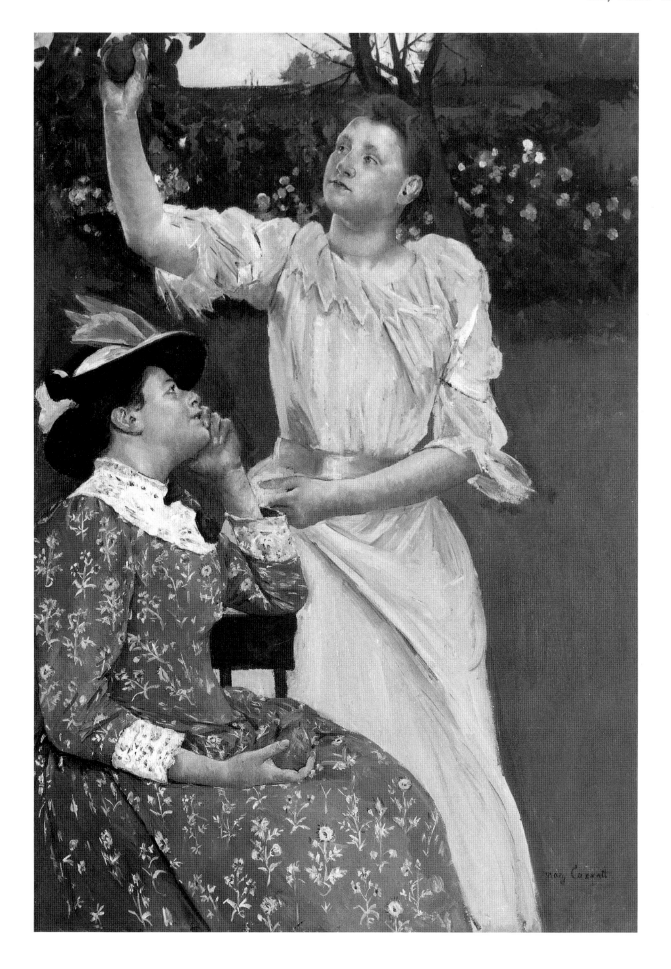

References F. B. Shaefer, "The Pittsburgh Exhibition," *Brush and Pencil* 5 (Dec. 1899), pp. 125–37; H. Saint-Gaudens, "The Carnegie Institute," *Art and Archeology* 14 (Nov.–Dec. 1922), p. 319; [J. O'Connor, Jr.], "The Mary Cassatt Group," *Carnegie Magazine* 1 (Mar. 1928), pp. 12–13; J. O'Connor, Jr., "The Patrons Art Fund," *Carnegie Magazine* 13 (Feb. 1940), p. 278; H. Saint-Gaudens, *The American Artist and His Times* (New York, 1941), p. 189; J. O'Connor, Jr., "From Our Permanent Collection, *Young Women Picking Fruit* by Mary Cassatt," *Carnegie Magazine* 23 (Nov. 1949), pp. 134–35; F. A. Sweet, *Miss Mary Cassatt, Impressionist from Pennsylvania* (Norman, Okla., 1966), p. 288; F. A. Myers, "Cassatt: *Young Women Picking Fruit,*" *Carnegie Magazine* 40 (Dec. 1966), pp. 352–53; Breeskin, *Mary Cassatt: A Catalogue Raisonné,* no. 197, p. 101; Hale, *Mary Cassatt,* p. 105; D. G. Wilkins, "The American Painting Collection at the Sarah Scaife Gallery, Carnegie Institute, Pittsburgh," *American Art Review* 2 (Mar.–Apr. 1975), p. 104; S. F. Yeh, "Mary Cassatt's Images of Women," *Art Journal* 35 (Summer 1976), p. 361; J. Roudebush, *Mary Cassatt* (New York, 1979), p. 74; F. Getlein, *Mary Cassatt: Paintings and Prints* (New York, 1980), pp. 98–99; R. H. Love, *Cassatt: The Independent* (Chicago, 1980), pp. 92, 361; Pittsburgh History and Landmarks Foundation, *Famous Men and Women of Pittsburgh* (Pittsburgh, 1981), pp. 87–102; V. A. Clark, "Collecting from the Internationals," *Carnegie Magazine* 56 (Sept.–Oct. 1982), p. 17; H. Adams, in Museum of Art, Carnegie Institute, *Collection Handbook* (Pittsburgh, 1985), pp. 198–99; Allentown Art Museum, Pa., *A Delicate Art: Flemish Lace 1700–1940* (1986), exh. cat., pp. 14–15; Mathews, *Mary Cassatt,* pp. 85, 91; *The Great Artists: Continuity Set,* ed. by S. Lyon and C. Gregory (London, 1987), vol. 9, pp. 50–51.

Exhibitions Galeries Durand-Ruel, Paris, 1893, *Exposition de tableaux, pastels, et gravures de Mary Cassatt,* no. 9; St. Botolph Club, Boston, 1898, *An Exhibition of Paintings, Pastels, and Etchings by Miss Mary Cassatt,* no. 16; Department of Fine Arts, Carnegie Institute, Pittsburgh, 1899, *Fourth Annual Exhibition,* no. 33; Durand-Ruel Galleries, New York, 1903, *Exhibition of Paintings and Pastels by Mary Cassatt,* no. 3; Atkins Museum of Fine Arts, Kansas City, 1915, *Exhibition of Paintings by French Impressionists,* no. 7; Durand-Ruel Galleries, New York, 1917, *Exhibition of Paintings and Pastels by Mary Cassatt,* no. 17; Art Association, Dallas, 1919, *First Annual Exhibition of Contemporary International Art,* unnumbered; Durand-Ruel Galleries, New York, 1920, *Exhibition of Paintings and Pastels by Mary Cassatt,* no. 18; Department of Fine Arts, Carnegie Institute, Pittsburgh, 1922, *Art and Science in Gardens,* no. 26; California Palace of the Legion of Honor, San Francisco,

1926, *First Exhibition of Selected Paintings by American Artists,* no. 27; Department of Fine Arts, Carnegie Institute, Pittsburgh, 1928, *A Memorial Exhibition of the Work of Mary Cassatt,* no. 48; Durand-Ruel Galleries, New York, 1935, *Exhibition of Paintings and Pastels by Mary Cassatt,* no. 10; Cleveland Museum of Art, 1936, *Twentieth Anniversary Exhibition,* no. 350; Department of Fine Arts, Carnegie Institute, Pittsburgh, 1940, *The Patrons Art Fund Paintings,* no. 7; Dayton Art Institute, Ohio, 1951, *America and Impressionism* (trav. exh.), unnumbered; Munson-Williams-Proctor Institute, Utica, N.Y., 1953, *Expatriates: Whistler, Cassatt, Sargent,* no. 20; Art Institute of Chicago, 1954, *Sargent, Whistler, and Mary Cassatt* (trav. exh.), exh. cat. by F. A. Sweet, no. 18; Grand Rapids Art Gallery, Mich., 1955, *Sargent, Whistler, Cassatt,* no cat.; Pennsylvania Academy of the Fine Arts, Philadelphia, 1955, *One Hundred Fiftieth Anniversary Exhibition,* no. 120; Detroit Institute of Arts, 1957, *Painting in America: The Story of Four Hundred Fifty Years,* exh. cat. by E. P. Richardson, no. 121; Munson-Williams-Proctor Institute, Utica, N.Y., 1958, *American Classics of the Nineteenth Century* (trav. exh.), no. 75; Society of the Four Arts, Palm Beach, Fla., 1959, *Paintings by John Singer Sargent and Mary Cassatt,* no. 42; Columbia Museum of Art, S.C., 1960, *Impressionism,* no. 6; Art Gallery of Toronto, 1961, *American Paintings, 1865–1905* (trav. exh.), exh. cat. by L. Goodrich, no. 8; Minneapolis Institute of Arts, 1964, *Four Centuries of American Art,* unnumbered; Whitney Museum of American Art, New York, 1966, *Art of the United States, 1670–1966,* no. 41; National Gallery of Art, Washington, D.C., 1970, *Mary Cassatt, 1844–1926,* exh. cat. by A. D. Breeskin, no. 48; Whitney Museum of American Art, New York, 1977, *Turn-of-the-Century America: Paintings, Graphics, Photographs, 1890–1910* (trav. exh.), exh. cat. by P. Hills, unnumbered; Portland Museum of Art, Me., 1979, *Miss Mary Cassatt: Impressionist from Pennsylvania,* no cat.; National Gallery of Art, Washington, D.C., 1980, *Post-Impressionism: Cross-Currents in European and American Painting,* no. 259; Isetan Art Gallery, Tokyo, 1981, *The Art of Mary Cassatt (1844–1926)* (trav. exh.), exh. cat. by A. D. Breeskin, no. 26; Museum of Fine Arts, Boston, 1983, *A New World: Masterpieces of American Painting, 1760–1910* (trav. exh.), exh. cat. by T. Stebbins et al., no. 93; Staatliche Museen Preussicher Kulturbesitz, Nationalgalerie, Orangerie des Schlosses Charlottenburg, Berlin, 1988–89, *Bilder aus der Neuen Welt: Amerikanische Malerei des 18. und 19. Jahrhunderts* (trav. exh.), no. 80; The Carnegie Museum of Art, Pittsburgh, Minneapolis Institute of Arts, Nelson-Atkins

Museum of Art, Kansas City, Mo., Saint Louis Art Museum, Toledo Museum of Art, Ohio, 1989–90, *Impressionism: Selections from Five American Museums* (trav. exh.), exh. cat. by M. Gerstein with an introduction by R. Bretell, no. 9.

Provenance Galeries Durand-Ruel, Paris, 1893; Durand-Ruel Galleries, New York, 1895.

Patrons Art Fund, 1922, 22.8.

See Color Plate A, p. vi.

George Catlin
1796–1872

T ODAY, GEORGE CATLIN is considered one of the most original of America's painter-naturalists and among the most colorful of its self-taught artists. Born in Wilkes-Barre, Pennsylvania, he first studied law in Litchfield, Connecticut, and then practiced briefly in Luzerne County between 1818 and 1823. However, in 1823 Catlin abandoned law and left for Philadelphia, where he began a second career as a painter. His untutored eye and primarily self-taught hand did not preclude creditable success as a portraitist, nor his election, in 1826, to the National Academy of Design.

While in Philadelphia, Catlin encountered a delegation of Plains Indians traveling to Washington, D.C. He claimed that this exotic entourage was the initial inspiration for his lifelong commitment to chronicling the life and customs of the American Indian, a task he began in 1828 with a series of Indian portraits, which he executed in Washington, D.C. In 1830 he went to Saint Louis, gateway to the West, and for the next six years traveled the Missouri and upper Mississippi rivers, the Southwest, and finally South Carolina, the home of the Seminoles.

The fruits of Catlin's successive tours came together as his Indian Gallery, approximately six hundred documentary portraits, which subsequently became the illustrations to his *Letters and Notes on the Manners, Customs, and Condition of the North American Indians* (1841). After his unsuccessful effort to have the government purchase his gallery, Catlin took his collection and a troupe of Indians on tour to Central and South America, England, and continental Europe. His art was

praised abroad. During the Salon of 1846, in Paris, Charles Baudelaire wrote, "Catlin has captured the proud, free character and the noble expression of these splendid fellows in a masterly way. With their fine attitudes and their ease of movement, these savages make antique sculpture comprehensible."[1]

Despite its popular and critical acclaim, Catlin's traveling exhibition plunged him into formidable debt. To relieve the artist's financial encumbrances, a businessman, Joseph Harrison, Jr., both paid Catlin's creditors and housed the gallery in his Philadelphia boiler works. Later, after Catlin's death, in Jersey City, New Jersey, Harrison's widow presented the collection as a gift to the Smithsonian Institution, Washington, D.C.[2]

Catlin's concern for the documentation and historic preservation of natural history and Indian culture places him among several contemporary artists who were attempting to accomplish the same thing. Among these were Seth Eastman, who illustrated Henry Schoolcraft's six-volume *Historical and Statistical Information Respecting the History, Condition and Prospects of the Indian Tribes of the United States* (1851–57), and Karl Bodmer, who worked with Maximilian, prince of Wied-Neuwied, to produce *Reise in das innere Nord Amerika in dem Jahren 1832 bis 1834.*[3]

1 *Art in Paris, 1845–1862: Salons and Other Exhibitions Reviewed by Charles Baudelaire,* trans. and ed. by J. Mayne (Ithaca, N.Y., 1981), p. 71.
2 Ross, ed., *George Catlin: Episodes,* p. xx.
3 Milton W. Brown, *American Art to 1900: Painting, Sculpture, Architecture* (New York, 1977), p. 357.

Bibliography Loyd Haberly, *Pursuit of the Horizon: A Life of George Catlin, Painter and Recorder of the American Indian* (New York, 1948); Harold McCracken, *George Catlin and the Old Frontier* (New York, 1959); Marvin C. Ross, ed., *George Catlin: Episodes from "Life among the Indians" and "Last Rambles"* (Norman, Okla., 1959); Marjorie Catlin Roehm, ed., *The Letters of George Catlin and His Family: A Chronicle of the American West* (Berkeley, 1966); William H. Truettner, *The Natural Man Observed: A Study of Catlin's Indian Gallery* (Washington, D.C., 1979).

Ambush for Flamingoes, c. 1856–57
(A Huge Flock or Gathering of Flamingoes)

Oil on canvas
19 x 26½ in. (48.3 x 67.3 cm)
Signature: G. Catlin. (lower right)

In 1852 Catlin's career assumed a new dimension when he traveled to South America in search of the lost gold mines in the Tumuc-Humac Mountains of northern Brazil, and like Frederic E. Church, found that the continent offered subject matter at once spectacular and instructive. Catlin directed his attention to South American Indian life, particularly around the Amazon River. After several expeditions in the 1850s, he produced a body of works he called "The Cartoon Collection." It contained a duplicate of his Indian Gallery of the 1830s (redrawn from memory and sketchbook notations), with the addition of on-the-spot scenes of South America executed on bristol board. Like the Indian Gallery, this collection was also refused for purchase by the government and was donated to the American Museum of Natural History, New York, after Catlin's death.[1]

Ambush for Flamingoes was one of six paintings the Colt Firearms Company commissioned from Catlin for lithographic reproduction to advertise the use of its guns. The six commissioned works are divided between North and South American hunting scenes. Here the artist portrays himself with the canny Indian guide who built their portable camouflage and "Sam," his trusted Colt shotgun. Catlin's written account of this scene is exceptionally complete and lively. Of the saline marshes of the Rio Salado, in Argentina, south of Buenos Aires, he wrote:

> The flamingo . . . is one of the most delicate and beautiful birds, . . . its chief color is pure white, with parts of its wings of the most flaming red. . . .
> [Their] nests stand in the mud . . . sometimes cover[ing] hundreds of acres, looking from a distant elevation like a mass of honeycomb. . . .
> It was truly a "Grand Exposition"—grand for its industry of millions, all busy, building, hatching, and feeding—grand for the beauty of its colors; for the sun was just up . . . catching upon the bending columns soaring in the air, and on the never ending group . . . the red, the black, and the white, glistening . . . with the sun's refracted rays.
> Reconnoitering the ground closely . . . I discovered a sort of promontory of grass . . . extending into the saline and very near to where the nests commenced. One of the little Indians . . . told me he could lead me near enough to shoot amongst them. . . .
> Advancing about half the way, we came to a bunch of alder and willow bushes, and in a few minutes he had cut and so arranged a screen of these, to carry in both hands before him, as completely to hide him from their view and also to screen me. . . . My hat was left behind, and my belt was filled with boughs rising higher than my head . . . so that we were ostensibly . . . nothing but a bunch of bushes.[2]

The thinly painted, blue-gray canvas provides an unobtrusive background for the rhythmic linear-curvilinear surface animation of the exotic birds. Its decorative nuance and graphic abstraction give

Fig. 1 George Catlin, *Shooting Flamingoes*, 1857. Oil on canvas, 19 x 26½ in. (48.3 x 67.3 cm). Memorial Art Gallery of the University of Rochester, N.Y., Marion Stratton Gould Fund, 1941

Ambush for Flamingoes an unusual, but not unique, place among Catlin's works.

The painting most likely dates to 1856 or 1857, as Catlin executed five similar works during this period. All of them show Catlin, his guide, and a flock of flamingoes on a broad plain. Three of the paintings, including the Carnegie's, show Catlin stalking flamingoes,[3] and three show him in the act of shooting the birds,[4] suggesting that the paintings were meant to be paired (fig. 1).

LM, RB

1 Ross, ed., *George Catlin: Episodes*, p. xx.

2 Ibid., pp. 101–2.

3 The other two are *Shooting Flamingoes on the Grand Saline, Buenos Aires* (1857, formerly collection Clarkson N. Potter, New York) and *Reconnoitering Flamingoes in the Grand Saline of Buenos Aires* (1856, Virginia Museum of Fine Arts, Richmond).

4 *Flamingo Shooting in South America* (c. 1856–57, formerly Bernard Danenberg Galleries, New York); *Shooting Flamingoes, Grand Saline, Buenos Aires* (1856, Virginia Museum of Fine Arts, Richmond), *Shooting Flamingoes* (1857, Memorial Art Gallery of the University of Rochester, N.Y.).

References M. C. Ross, ed., *George Catlin: Episodes*, pp. 101–2; H. B. Teilman, "Paintings by Noted Artist-Explorers," *Carnegie Magazine* 46 (Sept. 1972), pp. 280–83; D. G. Wilkins, "The American Painting Collection at the Sarah Scaife Gallery, Carnegie Insitute, Pittsburgh," *American Art Review* 2 (Mar.–Apr. 1975), pp. 105–6; J. Czestochowski, *The Pioneers: Images of the Frontier* (New York, 1977), p. 8.

Exhibition H. Williams [Gallery], New York, 1907, *Original Paintings by George Catlin*, no. 30, as *A Huge Flock or Gathering of Flamingoes*.

Provenance Leopold I, King of the Belgians, 1859; Richard Smithhill, Rockbeare, Hampshire, England; H. Williams [Gallery], New York, by 1907; Sir Edmund Osler, Toronto, by 1912; Royal Ontario Museum, Toronto, by 1912; Lee Pritzer, Canada, by 1953; Hirschl and Adler Galleries, New York, by 1953; M. Knoedler and Co., New York, 1953.

Howard N. Eavenson Memorial Fund for the Howard N. Eavenson Americana Collection, 1972, 72.7.2

Harry Chase

1853–1889

LITTLE IS KNOWN about this late-nineteenth-century painter from Vermont who specialized in marine and coastal subjects. Harry Chase studied in New York at the National Academy of Design before going abroad in 1876. He continued his training in Paris under the genre painter Paul Constant Soyer and in the Hague with Hendrik Mesdag, a marine painter noted for his fishing and harbor scenes. For a brief period Chase lived in Munich, where he attended classes at the academy there.

Cultivating a painterly, naturalistic style strongly influenced by the Dutch marine tradition, Chase began exhibiting his work in 1878, submitting pictures to both the Paris Salon and the National Academy of Design in New York, as well as to the Mechanics Fair in Boston. In 1880 he opened a studio in New York. In 1883 he was elected an associate member of the National Academy and in 1885 his painting *New York Harbor* (1885, Corcoran Gallery of Art, Washington, D.C.) was awarded the Hallgarten Prize. As other titles of his exhibited paintings indicate, he frequently returned to Europe to paint shoreline views along the coasts of France, Holland, and Wales. Chase died in Tennessee at the age of thirty-six.

Bibliography Maria Naylor, ed., *National Academy of Design Exhibition Record, 1861–1900* (New York, 1973), vol. 1, p. 156; Mantle Fielding, *Dictionary of American Painters, Sculptors, and Engravers* (Poughkeepsie, N.Y., 1986), p. 147; E. Bénézit, *Dictionnaire des peintres, sculpteurs, dessinateurs et graveurs* (Paris, 1976), p. 687.

Going to the Wreck, c. 1883

Oil on canvas
18 x 30 in. (45.7 x 76.2 cm)
Signature: H. Chase (lower right)

Although the location of this scene is not specified, *Going to the Wreck* captures the drama of the perilous conditions that affect all who make their livelihood on the sea. Here the focus is on a rescue

team that races across the beach in a horse-drawn lifeboat toward a schooner that has foundered in the shallow waters off the flat coast. A stiff breeze and a stormy sky heighten the suspense. While the touches of blue in the sky and the streaks of sunlight on the sand introduce a note of optimism, the dark-colored lifeboat in the center of the painting reinforces Chase's somber theme. In keeping with his Munich training, Chase used a painterly technique to further animate the composition and to impart a convincing tangibility to the threatening atmosphere.

GB

Remarks The canvas, damaged by a tear in the area of the sky, has been repaired.

Provenance Department of Fine Arts, Carnegie Institute, by 1912; on loan to Carnegie Library of Pittsburgh, 1912–78.

By appropriation, 1978, 78.18.1

William Merritt Chase
1849–1916

A N ASTONISHINGLY PROLIFIC and sought-after painter, William Merritt Chase was also the most accomplished American pastelist and influential art teacher of his time. He was considered the virtual embodiment of modern sophistication and cosmopolitan stylishness: his work presented an aesthetic comparable to John Singer Sargent's, while his extravagance, flamboyance, and personal style rivaled James McNeill Whistler's.

Chase was born in 1849 in Williamsburg in south-central Indiana. In 1861 his family moved to Indianapolis, where, between 1867 and 1869, he received his first art instruction from a local portrait painter, Barton S. Hays. Chase then left for New York and studied for two years at the National Academy of Design. After several months in Saint Louis as a still-life painter, where he was encouraged and supported by a group of businessmen, he decided to go abroad; in 1872 he entered Munich's art academy.

In Munich, Chase studied under the history painter Karl von Piloty, but the most important influence on his art became the dark, painterly realism of Wilhelm Leibl, an artist just five years older. For a time he shared a studio with another American follower of Leibl, Frank Duveneck. Duveneck and Chase became key members of the city's American expatriate community in the 1870s, producing works that are most associated with the Munich school of American Realism. Chase's Munich work consists of portraits, costume pictures with a seventeenth-century Dutch or Spanish flavor, and still-life paintings that recall the Netherlandish Baroque tradition.

In 1877 Chase spent nine months in Venice with Duveneck and John Twachtman. He was invited to teach at the academy in Munich the following year but declined the offer. Instead, he accepted a faculty position at the Art Students League in New York, thus beginning an American teaching career that lasted thirty-seven years.

Following his return to New York— which was to become his home for the remainder of his life, despite frequent travels to Europe during the summer— Chase quickly established himself as a leader of the progressive, cosmopolitan strain in American painting. He became active in the Society of American Artists, founded in 1877 to combat the conservative policies of the National Academy of Design, and served as its president from 1885 to 1895. He played an important role in introducing Impressionism to America, in 1881 assisting New York collector Erwin Davis in the purchase of Edouard Manet's *Woman with a Parrot* (1866, Metropolitan Museum of Art, New York) and *Boy with a Sword* (c. 1861, Metropolitan Museum of Art, New York)—the first works by Manet to enter an American collection. Two years later, as organizer of a loan exhibition to raise funds for building the Statute of Liberty's pedestal, he arranged the first major showing of Impressionist paintings in America. His own work, incorporating elements of Impressionism, Munich Realism, and Aestheticism, was both daring and fashionable. His portraits, landscapes, and genre pieces were extremely popular, and he enjoyed a long, successful career rich in honors.

Chase's influence as a teacher extended to the Art Students League (1878–96, 1907–12), the Brooklyn Art School, New York (1890–95), and the Pennsylvania Academy of the Fine Arts, Philadelphia (1896–1907). From 1891 to 1902 he conducted summer classes at his home at Shinnecock Hills, Long Island, and founded the Chase School of Art in New York in 1896. His students there were to become some of the most important contributors to twentieth-century American art, including Charles Demuth, Edward Hopper, Georgia O'Keeffe, Joseph Stella, and Alfred H. Maurer.

From 1896 until his death in 1916, Chase lent his enormous prestige and expertise to Carnegie Institute's annual exhibitions. He exhibited at all but one of the Internationals held during his lifetime and served on eleven juries of award (from 1897 to 1899 and 1907 to 1914). He was also quite active behind the scenes as an advisor to the director of the Department of Fine Arts, John Beatty, either to recommend a prospective exhibitor or jury member or to consult on artistic and administrative matters. These included visiting and reporting on contemporary art exhibitions abroad, lending advice on prospective purchases for the permanent collection, and even making recommendations on staff appointments.[1] Chase may have found his constant involvement with Carnegie Institute burdensome at times, but he continued it out of friendship for Beatty.[2] Beatty reciprocated these favors by securing local patronage for Chase, and one of his last acts as director was to mount a memorial exhibition of the artist's work in 1922.

1 William Merritt Chase to John Beatty, July 2, 1916, Carnegie Institute Papers, Archives of American Art, Washington, D.C.

2 William Merritt Chase to John Beatty, c. 1906–7, Carnegie Institute Papers, Archives of American Art, Washington, D.C.

Bibliography Katherine M. Roof, *The Life and Art of William Merritt Chase* (1917; reprint, New York, 1975); John Herron Art Museum, Indianapolis, *Chase Centennial Exhibition* (1949), exh. cat. by Wilbur D. Peat; Art Gallery, University of California at Santa Barbara, *First West Coast Retrospective Exhibition of Paintings by William Merritt Chase* (1964), exh. cat. by Ala Story; Ronald G. Pisano, *William Merritt Chase* (New York, 1979); Ronald G. Pisano, *A Leading Spirit in American Art: William Merritt Chase, 1849–1916* (Seattle, 1983).

Tenth Street Studio,
c. 1880–81 and c. 1910

Oil on canvas
46⅞ x 66 in. (119.1 x 167.6 cm)

In May 1917 John Beatty asked Childe Hassam to view the paintings being offered for sale by Chase's estate and to tell him if there was "anything of such supreme excellence... as to make it very desirable for our permanent collection."[1] A few days later Hassam replied: "Get the 10th St. Studio *by all means.* It is the best Chase in existence—very important and moreover an artistically historic canvas.... Don't let the interior escape you!"[2]

Hassam considered *Tenth Street Studio* "artistically historic" because it recorded the appearance of what was unquestionably the most famous studio in late nineteenth-century America. In 1878, while in Venice, Chase had told a friend that he intended "to have the finest studio in New York."[3] On his return to the

United States he rented several rooms in the well-known studio building on West Tenth Street, where some of New York's best-known artists, including Frederic E. Church and John Frederick Kensett, had kept their painting rooms.

Chase had three rooms in the Tenth Street building: an inner and an upstairs studio as well as the large space depicted here, which he acquired in 1879. This space had previously been Albert Bierstadt's, before that, William Page's, and originally it had been the building's communal art gallery. Fitted with gas ceiling lamps and skylights and situated on the ground floor, it was the grandest space in the building. Although Chase used it occasionally as a painting area, it functioned mainly as a suggestive atmosphere in which patrons could view Chase's work.

The artist lavished enormous quantities of time and money on this studio's décor. Inspired by the opulent painting rooms of successful European artists, Chase extravagantly filled his new quarters with rich furnishings, exotic bric-a-brac, and

works of art. Indeed, as Nicolai Cikovsky, Jr., has written, the studio itself was a work of art in which Chase created personal aesthetic order from a "myriad of objects that... are otherwise without logical system or rational program."[4] According to a former pupil, Chase kept the floors highly polished, but dust was deliberately allowed to accumulate elsewhere, creating "a gradual transition from the richness and brilliance near the floor up the side walls into the gray atmosphere of the ceiling."[5] The contents of the studio were finally auctioned off in 1896.

During the seventeen years Chase occupied his Tenth Street studio, it received a great deal of publicity. New York society flocked to the weekly receptions that Chase held there beginning in 1881. The general public learned of it from magazine articles (the first of which was published by the *Art Journal* in November 1879) as well as from the artist's depictions of it. The Carnegie's *Tenth Street Studio* is the largest and most impressive

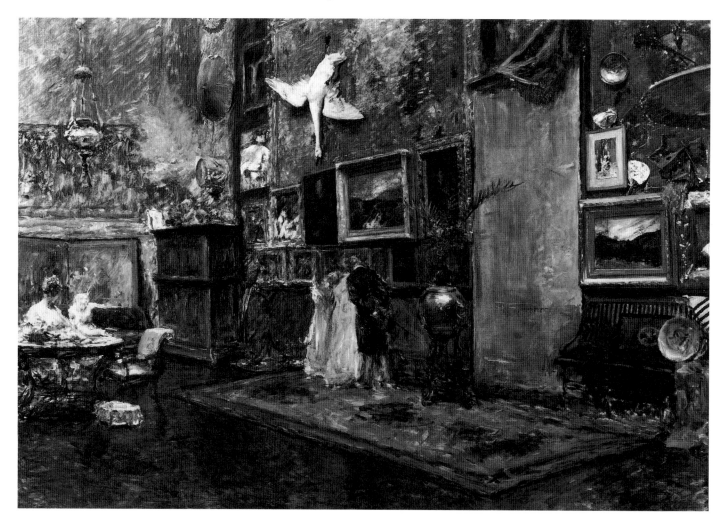

Fig. 1 William Merritt Chase, *View in the Studio of William M. Chase.* Preliminary sketch for a painting, from *American Art Review* 2 (1881): facing p. 138

of that interior's renditions. It shows the spacious gallery as a quiet, luxurious sanctuary of art, in which elegantly dressed ladies and gentlemen escape from the bustle of the city to spend a tranquil hour or two in aesthetic contemplation.

According to Chase's first biographer, Katherine Roof, this canvas was "an early sketch quite recently filled in."[6] He must have begun the painting around 1880, for Mariana Griswold Van Rensselaer wrote in 1881 that "a larger view of another portion of the studio is now on the easel, merely laid in with black and white. The accompanying reproduction will show my readers how good it is in plan, and what a satisfactory thing we may expect from its completion in color"[7] (fig. 1).

Although the work Van Rensselaer saw has been interpreted as a separate sketch, she apparently viewed a charcoal or grisaille underdrawing on the actual canvas. Her article was reprinted in 1889 in Walter Montgomery's *American Art and American Art Collections.*[8] Since that reprint was cited as the source for Van Rensselaer's observation in the Metropolitan Museum of Art's Chase retrospective in 1917, the erroneous inception date of 1889 became attached to the work when it was acquired by Carnegie Institute.

Exactly when Chase finished the painting in oils has not been a matter of great consensus. Ronald Pisano suggested the work was gradually completed over a long period of time.[9] In 1950 the museum assigned its execution to 1905–6. But the facture is similar to the *Studio Interior*

Chase exhibited at the 1910 Carnegie International (no. 43) and tried unsuccessfully to sell to Carnegie Institute.[10]

Photographs of the unfinished canvas in Chase's studio indicate that he painted the right-hand wall in the picture first, proceeding from right to left. The right third of this wall clearly shows the dense handling and rich coloring typical of Chase's work around 1880. A photograph of the canvas taken around 1891 shows the wall completed as far as the Dutch cupboard, leaving the floor, figures, and left-hand section of wall blank.[11] The canvas seems to have remained in this state until the last decade of Chase's life, when he finished the standing figures, floor, and entire left-hand third of the picture, using the thin, rapid brushwork and grayed palette characteristic of his late style.

In completing the picture, the artist made a number of alterations to his original design. He greatly enlarged the rug on the floor and replaced the easel at the left with an oriental screen and a woman seated at a table. He quickly filled in the wall at the left with soupy gray and brown paint and dissolved the objects atop the Dutch cupboard into a cloud of smoke. The result is a picture that only partially depicts Chase's studio, for the later portion of the painting becomes a fantasy evoked by his memory. The ultimate effect is an environment whose solid, enduring elements were the props he painted first—the Munich-school pictures on the walls, the Japanese prints and fans, the porcelains and silks, and the large swan (which seems an apparition from a Munich school still life but was

indeed suspended, against a maroon velour-covered wall, in the studio). The rest of the studio, including its occupants, appears to be diffracted in the light, as if merely so much atmosphere.

LD, DS

1 John Beatty to Childe Hassam, May 8, 1917, Carnegie Institute Papers, Archives of American Art, Washington, D.C.

2 Childe Hassam to John Beatty, May 11, 1917, Carnegie Institute Papers, Archives of American Art, Washington, D.C.

3 Roof, *Life and Art of William Merritt Chase,* p. 51.

4 Nicolai Cikovsky, Jr., "William Merritt Chase's Tenth Street Studio," *Archives of American Art Journal* 16, no. 2 (1976), p. 12.

5 Gifford Beal, "Chase—The Teacher," *Scribner's Magazine* 61 (February 1917), p. 258.

6 Roof, *Life and Art of William Merritt Chase,* p. 278.

7 Mariana Griswold Van Rensselaer, "William Merritt Chase—First Article," *American Art Review* 2 (January 1881), p. 136.

8 Van Rensselaer, "William Merritt Chase—First Article," reprinted in W. Montgomery, ed., *American Art and American Art Collections* (Boston, 1889), pp. 220–25.

9 Pisano, in Henry Art Gallery, *A Leading Spirit,* p. 188, n. 40.

10 William Merritt Chase to John Beatty, May 16, 1910, Carnegie Institute Papers, Archives of American Art, Washington, D.C.

11 Ishmael (pseud.), "Through the New York Studios: William Merritt Chase," *The Illustrated American* 5 (Feb. 14, 1891), p. 617. Mary-Patricia Mangan discovered and kindly shared this information.

References M. G. Van Rensselaer, "William Merritt Chase—First Article," *American Art Review* 2 (Jan. 1881), pp. 91–98, reprinted in W. Montgomery, ed., *American Art and American Art Collections* (Boston, 1889), pp. 220–25; Roof, *Life and Art of William Merritt Chase,* pp. 278, 327; "Paintings Sold at Auction 1916–1917," *American Art Annual* 14 (1917), p. 346; Buffalo Fine Arts Academy, *Academy Notes* 13 (1918), pp. 83–84; J. O'Connor, Jr., "From Our Permanent Collection: The Tenth Street Studio," *Carnegie Magazine* 24 (Feb. 1950), pp. 240–41; F. A. Myers, "The Tenth Street Studio," *Carnegie Magazine* 39 (Nov. 1965), p. 321; G. McCoy, "Visits, Parties, and Cats in the Hall: The Tenth Street Studio and Its Inmates in the Nineteenth Century," *Archives of American Art Journal* 6 (Jan. 1966), p. 3; M. S. Haverstock, "The Tenth Street Studio," *Art in America* 54 (Sept. 1966), pp. 56–57; A. D. Milgrome, "The Art of William Merritt Chase," Ph.D. diss., University of Pittsburgh, 1969, vol. 1, pp. 59–60; R. Lynes,

The Art Makers of Nineteenth Century America (New York, 1970), p. 409; S. Hunter, *American Art of the Twentieth Century* (New York, 1972), p. 24; N. Cikovsky, Jr., "William Merritt Chase's Tenth Street Studio," *Archives of American Art Journal* 16, no. 2 (1976), p. 5; G. Stavitsky, "Childe Hassam and the Carnegie Institute: A Correspondence," *Archives of American Art Journal* 22, no. 3 (1982), pp. 5–6; R. G. Pisano, *A Leading Spirit in American Art*, pp. 36, 44, 188; E. A. Prelinger, in Museum of Art, Carnegie Institute, *Collection Handbook* (Pittsburgh, 1985), pp. 224–25; Parrish Art Museum, Southampton, N.Y., *In Support of Liberty: European Paintings at the 1883 Pedestal Fund Art Loan Exhibition* (1986), exh. cat. by M. C. O'Brien, pp. 62–63; N. Cikovsky, "William Merritt Chase at Shinnecock," *Antiques* 132 (Aug. 1987), pp. 290–301.

Exhibitions American Art Gallery, New York, 1917, *Completed Pictures etc. Left by William Merritt Chase, Studio Effects etc., to Be Sold...*, no. 379; Metropolitan Museum of Art, New York, 1917, *Loan Exhibition of Paintings by William M. Chase*, no. 10; City Art Museum, Saint Louis, 1918, *Thirteenth Annual Exhibition of Selected Paintings by American Artists*, no. 17; Albright Art Gallery, Buffalo, 1918, *The Twelfth Annual Exhibition of Selected Paintings by American Artists*, no. 16; Dallas Art Association, 1923, *Fourth Annual Exhibition*, no. 15; Art Institute of Chicago, 1934, *A Century of Progress*, no. 386; Baltimore Museum of Art, 1934, *A Survey of American Painting*, no. 12; National Academy of Design, New York, 1939, *Special Exhibition from May 8th to July 25th, 1939*, no. 241; Lyman Allyn Museum, New London, Conn., 1945, *Exhibition of Works by the Members of the Tile Club*, no. 39; John Herron Art Museum, Indianapolis, 1949, *Chase Centennial Exhibition*, no. 26; Columbus Gallery of Fine Arts, Ohio, 1952, *Paintings from the Pittsburgh Collection*, no cat.; Department of Fine Arts, Carnegie Institute, Pittsburgh, 1957, *American Classics of the Nineteenth Century*, no. 97; Allentown Art Museum, Pa., 1983, *The Artist's Studio in American Painting*, no. 16.

Provenance The artist's widow, 1916–17; William Macbeth Galleries, New York, as agent, 1917.

Purchase, 1917, 17.22

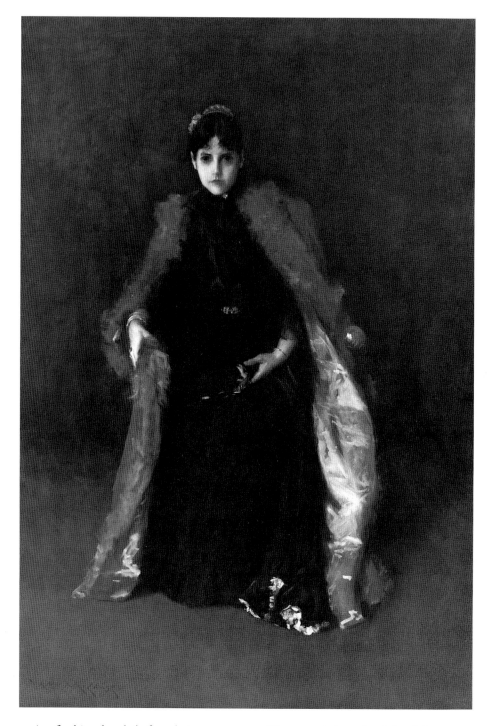

Mrs. Chase, c. 1890–95
(Portrait of Mrs. C.)

Oil on canvas
72 x 48 in. (182.8 x 121.9 cm)
Signature: Wm M. Chase. (lower left)

This portrait of Mrs. Chase is an example of the fashionable society portrait at which Chase excelled. Its subject, Alice Gerson Chase (1866–1927), was one of her husband's favorite models. She began posing for him shortly before their marriage in 1886 and subsequently appeared as an incidental figure in many of his genre pieces, including *The Open Air Breakfast* (c. 1888, Toledo Museum of Art, Ohio) and *For the Little One* (c. 1896, Metropolitan Museum of Art, New York). Alice Chase was the subject of many portraits, one of the best being this one—a grand-scale, deeply shadowed portrait, whose sitter, in a regally chic guise, gazes directly at the viewer.

The portrait is undated, but Mrs. Chase is clearly a young woman still in her twenties, and her evening dress and opera cloak can be dated to 1891–93. Despite having adopted a bright, Impressionist palette for his landscapes and genre scenes, Chase maintained a considerably darker tonality for his portraits, which bore a certain affinity to the portrait style of James McNeill Whistler. This work's composition and color harmony are strongly Whistlerian, as is the manner in which the sitter's form emerges

from the deep, dark background. However, the treatment of the pictorial elements—the refined but intense, intelligent face above a glistening, satin-lined cape, combined with unexpected, isolated flourishes at the hem of the skirt, a buckle at the waist, and a pin at the neck—is typical of Chase.

John Beatty first saw *Portrait of Mrs. Chase* on exhibit at the Corcoran Gallery of Art, Washington, D.C., in December 1908, and promptly invited Chase to send it to the next International.[1] He obviously admired the work, for in May 1909 he wrote to the artist, "We are all very much pleased with the 'Portrait of Mrs. C.'. Would you consider selling it to us, or exchanging it for the one we now own, painted by you?"[2] Chase would undoubtedly have preferred a sale to an exchange, as he felt that his work was inadequately represented at Carnegie Institute. "I presume you know that there are four of my pictures in the permanent collection of the Metropolitan Museum," he chided Beatty.[3]

The artist agreed, however, to an arrangement whereby Carnegie Institute received *Portrait of Mrs. Chase* in exchange for one thousand dollars and the painting *Did You Speak to Me?* (c. 1898, Butler Institute of American Art, Youngstown, Ohio), which had been purchased from the 1898 International for one thousand dollars, and which went to a Pittsburgh buyer, the collector Robert C. Hall. Chase asked that his payment be sent to him in Paris, adding, "I could use the money this summer most conveniently in fitting out my Italian palace."[4]

LD

1 John Beatty to William Merritt Chase, December 11, 1908, Carnegie Institute Papers, Archives of American Art, Washington, D.C.

2 John Beatty to William Merritt Chase, May 14, 1909, Carnegie Institute Papers, Archives of American Art, Washington, D.C.

3 William Merritt Chase to John Beatty, May 22, 1909, Carnegie Institute Papers, Archives of American Art, Washington, D.C.

4 William Merritt Chase to John Beatty, June 3, 1909, Carnegie Institute Papers, Archives of American Art, Washington, D.C.

References J. W. Pattison, "The Awarding of Honors in Art," *Fine Arts Journal* 23 (Aug. 1910), p. 81; "Notable Paintings from the Carnegie Art Galleries, and Something about

the Artists," *Pittsburgh Post*, Jan. 18, 1912, p. 6; Metropolitan Museum of Art, *Loan Exhibition of Paintings by William Merritt Chase* (1917), exh. cat., p. xxiv; Roof, *Life and Art of William Merritt Chase*, p. 327; H. Saint-Gaudens, "The Carnegie Institute," *Art and Archaeology* 13 (Nov.–Dec. 1922), p. 291; A. D. Milgrome, "The Art of William Merritt Chase," Ph.D. diss., University of Pittsburgh, 1969, vol. 1, no. 55, p. 203; E. Munhall, "Ein Palast fürs Volk," *Du* 2 (1983), p. 54; R. G. Pisano, *A Leading Spirit in American Art*, p. 114.

Exhibitions Corcoran Gallery of Art, Washington, D.C., 1908–9, *Second Exhibition of Oil Paintings by Contemporary Artists*, no. 13, as *Portrait of Mrs. C.*; Department of Fine Arts, Carnegie Institute, Pittsburgh, 1909, *Thirteenth Annual Exhibition*, no. 44; National Arts Club, New York, 1910, *William Merritt Chase Retrospective Exhibition*, unnumbered; San Francisco, 1915, *Panama-Pacific Exposition*, no. 3,750; Buffalo Fine Arts Academy, 1919, *Thirteenth Annual Exhibition of Selected Paintings by American Artists*, no. 21, as *Portrait of Mrs. C.*; Department of Fine Arts, Carnegie Institute, Pittsburgh, 1922, *Exhibition of Paintings by William M. Chase*, no. 12; California Palace of the Legion of Honor, San Francisco, 1926, *American Paintings Exhibition*, no cat.; Art Gallery of Toronto, 1927, *A Loan Exhibition of Portraits*, no. 12; Department of Fine Arts, Carnegie Institute, Pittsburgh, 1957, *American Classics of the Nineteenth Century*, no. 96; Department of Fine Arts, Carnegie

Institute, Pittsburgh, 1958–59, *Retrospective Exhibition from Previous Internationals*, no. 25; Henry Art Gallery, University of Washington, Seattle, 1983–84, *A Leading Spirit in American Art: William Merritt Chase, 1849–1916* (trav. exh.), unnumbered.

Provenance The artist, until 1909.

Purchase, 1909, 09.6

See Color Plate 12.

William Nimick Frew, 1915

Oil on canvas
48 x 40 in. (121.9 x 101.6 cm)
Signature: Wm M. Chase. (lower right)

William Nimick Frew (1854–1915) was the son of a wealthy Pittsburgh oilman. He graduated from Yale College, attended Columbia University Law School, and in 1879 was admitted to the bar of Allegheny County. A year later Frew fell heir to his father's extensive business interests. He attained prominence as the director of a number of important financial institutions and became involved with various educational, religious, and cultural institutions in Pittsburgh. In this last capacity he played an important role in the development of Carnegie Institute.

Frew was Andrew Carnegie's close friend and constant advisor in philanthropic endeavors. It was through Frew that Carnegie made known to the public his plans for the construction of Carnegie Institute.[1] In 1890 Carnegie appointed him a member of the original Board of Trustees of Carnegie Institute. From 1894 to 1914 he was its president.

On January 14, 1915, the Board of Trustees authorized the Department of Fine Arts to commission a portrait of Frew. Five days later the commission was awarded to Chase, probably at the recommendation of the artist's friend John Beatty, who was the director of the Department of Fine Arts at the time. Frew's poor health (he died the following October) may have prevented him from sitting for Chase, for the portrait was painted entirely from a photograph.

Chase seems not to have objected to the limitations he faced. "The photograph of Mr. Frew is here," Chase wrote to Frew's successor. "I find it *very good.* I am only sorry not to have a print in which the plate was not so much retouched. Do you mind finding out if a proof may not be had from the same negative with *no* retouching?"[2] The photograph from which Chase worked may have been from the same negative as the one used to illustrate the biography of Frew in the *Encyclopedia of Pennsylvania Biography.* That entry stated, "His clearly cut, well-formed features bore the imprint of a strong personality and the keen yet kindly glance of his eyes spoke of candor, penetration and, withal, a genial and generous disposition."[3]

A comparison of the portrait with the photograph reveals that Chase, though faithful to his model, made various small changes to create a trim, aristocratic elegance in his subject. He reduced the jowls and the roll of flesh around the neck, narrowed the nose, and broadened the forehead. Chase also expanded the image to show a portion of Frew's legs and the armchair in which he sat, and he used in these areas the broad brushwork he did not allow himself in the face and hands. The resulting image is an official portrait, a type that Chase painted on a number of occasions: a flattering yet constrained portrayal of one of the rich and powerful.
LD, DS

1 John W. Jordan, "William N. Frew," *Encyclopedia of Pennsylvania Biography* (New York, 1918), vol. 9, p. 194.

2 William Merritt Chase to Samuel Harden Church, January 23, 1915, collection of Ronald G. Pisano, New York.

3 Jordan, "William N. Frew," *Encyclopedia of Pennsylvania Biography*, vol. 9, p. 194; photograph ill. opp. p. 193.

References Metropolitan Museum of Art, New York, *Loan Exhibition of Paintings by William Merritt Chase* (1917), exh. cat., p. xxiv; Roof, *Life and Art of William Merritt Chase*, p. 327; A. D. Milgrome, "The Art of William Merritt Chase," Ph.D. diss., University of Pittsburgh, 1969, vol. 1, no. 52, pp. 193–94.

Exhibition Department of Fine Arts, Carnegie Institute, Pittsburgh, 1916, *City Charter Exhibition of Portraits, Views of Pittsburgh, and Historical Relics*, p. 25.

Provenance Office of the President, Carnegie Institute, 1915; transferred to the Museum of Art, Carnegie Institute, 1934.

Contingent Fund, 1915, 15.1

Frederic E. Church

1826–1900

NO PREVIOUS AMERICAN artist achieved the international acclaim and financial success of the landscape painter Frederic Edwin Church. As the dominant personality in the second generation of the Hudson River school, he was the architect of epic canvases that depicted the remotest reaches and the most powerful aspects of the American wilderness. Born in Hartford, Connecticut, Church first studied art with Benjamin H. Coe, a landscape painter and author of drawing manuals, and with Alexander H. Emmons, a portrait, miniature, and landscape painter. By far the most important artistic influence upon him, however, was Thomas Cole, founder of the Hudson River school and by 1840 the most important and prominent American landscape painter. Church studied under Cole from 1844 to 1846 and then maintained close contact with him until Cole's death in 1848.

By 1847 Church was launched on a successful painting career in New York City. Two years later he was elected associate member at the National Academy of Design, and the following year, academician, the youngest artist ever to receive either honor. In the early 1850s Church

embarked on his first travels. Tellingly enough, his itinerary did not involve the customary grand tour through Europe to Italy; it was instead to the remoter regions of the New World. During these same years, he developed his distinctive approach to landscape, which involved panoramic views of nature delineated with such meticulous fidelity that all trace of the artist's hand seemed to be erased.

In 1857 Church produced the painting *Niagara* (Corcoran Gallery of Art, Washington, D.C.), which seemed to thrust the viewer without visual mooring onto the precipice of the Canadian falls. It became his first international sensation, and a string of brilliant successes followed: *The Heart of the Andes* (1859, Metropolitan Museum of Art, New York), *Twilight in the Wilderness* (1860, Cleveland Museum of Art), *The Icebergs (The North),* (1861, Dallas Museum of Art), and *Cotopaxi* (1862, Detroit Institute of Arts). These canvases, displayed under near-theatrical conditions and accompanied by explanatory broadsides, toured the major American cities as well as London and sold for record-breaking sums.

Church's panoramic views of the natural world reflect the belief that nature was the visible expression of the divine; to study nature would bring one closer to God's handiwork and so to God's revelation. Church's simultaneous faithfulness to even the smallest details of nature corresponded to the recent theories of John Ruskin, which were gathering momentum in the United States, particularly New York, during the late 1850s.

To paint works of such extraordinary realism, Church made extensive use of on-site sketches in both pencil and oil. He also compiled a personal library of books and photographs on each of the places that interested him and sought to stay abreast of contemporary findings in natural history. A member of the American Geographical and Statistical Society, he was particularly influenced by the German naturalist Alexander von Humboldt, whose *Cosmos: A Sketch of a Physical Description of the Universe* first appeared in English translation in 1850. Humboldt claimed that by far-ranging travel one could intuit the scheme of the universe. Church's voyages included his trips to South America in 1853 and 1857,

his 1859 visit to Newfoundland and Labrador, and his 1865 voyage to the West Indies. Church's rendering of the terrain and weather conditions of each locale was so meticulous and seemed so truthful that viewers believed they felt the same awesome grandeur of God's nature experienced by the original explorers.

By the early 1860s, Church was at the peak of his fame and his creative powers. The landscape painting formula that he had developed by then—meticulous, panoramic, rich in atmospheric effects—he retained for the rest of his career. Between 1867 and 1869 Church traveled to Europe and the Middle East, which provided him with subject matter from the Eastern Hemisphere. During the 1870s, he spent much of his energy collaborating with the architect Calvert Vaux in building Olana, his Gothic and Persian-style villa in Hudson, New York. After 1877 rheumatism considerably reduced his creative activity, and although his output continued to diminish in the 1880s and 1890s, he did continue to exhibit his works, participating in the first Carnegie International exhibition in 1896. Church died in New York City.

Bibliography Henry T. Tuckerman, *Book of the Artists: American Artist Life* (New York, 1867), pp. 370–86; David C. Huntington, *The Landscapes of Frederic Edwin Church: Vision of an American Era* (New York, 1966); National Collection of Fine Arts, Washington, D.C., *Frederic Edwin Church* (1966), exh. cat. by David C. Huntington; Smithsonian Institution Traveling Exhibition Service, Washington, D.C., *Close Observation: Selected Oil Sketches by Frederic E. Church* (1978), exh. cat. by Theodore E. Stebbins, Jr.; Gerald L. Carr, *Frederic Edwin Church: The Icebergs* (Dallas, 1980), introduction by David C. Huntington.

The Iceberg, 1891

Oil on canvas
20 x 30 in. (50.8 x 76.2 cm)
Signature, date: F. E. Church 1891 (lower right)

In the early 1850s, the disappearance of Sir John Franklin and his crew during an attempt to locate the Northwest Passage stimulated public interest in the far north. That interest was bolstered by Elisha Kent Kane's *Arctic Explorations in the Years 1853, '54, '55,*[1] which detailed the author's efforts to discover the fate of Franklin and his party. Franklin's widow,

Kane, and Isaac Hayes, the surgeon on Kane's second voyage and a close friend of Church, inspired the artist to travel to Newfoundland and Labrador in the summer of 1859, accompanied by his friend Louis Legrand Noble, the Episcopalian clergyman and biographer of Thomas Cole.[2] This, perhaps Church's most difficult and most perilous sketching trip, led to his largest and most operatic exhibition piece, *The Icebergs (The North)* (1861, Dallas Museum of Fine Arts).

Noble's account of his voyage with Church, *After Icebergs with a Painter,* expressed many of the ideas about nature implicit in Church's mammoth painting. Noble, like Church, saw in icebergs, as in all natural phenomena, the hand of God. "Like all the larger structures of nature," he wrote, "these crystalline vessels are freighted with God's power and glory, and must be reverently and thoughtfully studied, to 'see into the life of them.'"[3] Comparing them to Gothic cathedrals and Greek temples, he dwelt at length on their awesome beauty.

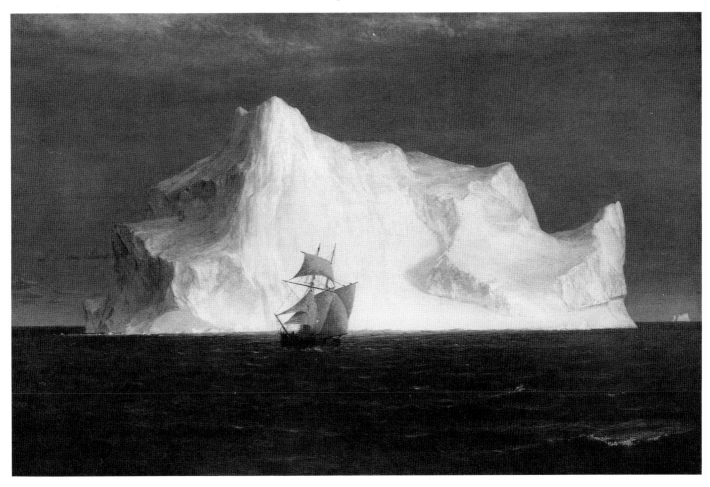

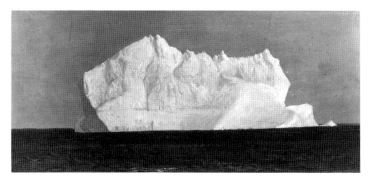

Fig. 1 After Frederic E. Church, *A Large Iceberg in the Forenoon Light Near the Integrity.* Lithograph, from Louis L. Noble, *After Icebergs with A Painter* (New York, 1861)

Fig. 2 Frederic E. Church, *Massive Iceberg*, 1859. Oil with pencil on paper, 7½ x 14⅞ in. (19 x 37.8 cm). Cooper-Hewitt Museum, Smithsonian Institution, National Museum of Design, New York, gift of Louis P. Church, 1917

The phenomenon of icebergs remained a presence in the public imagination into the 1880s, thanks to interpretations of the subject by such painters as George Curtis, William Bradford, and Albert Bierstadt. Two events in particular, Robert E. Peary's launching of an expedition to the Arctic in 1890 and Thomas Moran's exhibition in 1891 of his huge *Spectres of the North* (Thomas Gilcrease Institute of American History and Art, Tulsa, Okla.), may have reminded Church of his Arctic voyage and prompted him to revive it visually in 1891.

The Iceberg, one of the few works Church painted in the last two decades of his life, is a private statement and a memory image. It is a small, simple picture in which he dispensed with elaborate detail and obvious rhetorical devices. Instead, in the succinct juxtaposition of ship and iceberg, he economically conveyed the idea of nature's attraction and peril, and man's frailty in the face of nature. For his compositional idea, Church turned to a lithograph depicting his schooner, the *Integrity,* in Noble's 1861 book (fig. 1).

Church also relied on the most finished oil sketch from his 1859 trip, a massive iceberg painted in bright sunlight, probably from the Newfoundland shore (fig. 2).

In his 1891 painting Church retained the calm sea and distant vantage point of his earlier sketch, as well as the monolithic quality of its iceberg, but he changed the time of day to dusk. Gerald Carr has proposed that Church intended an autobiographical allegory: that the ship, with its one tiny figure on deck, refers to Church himself, approaching the end and his confrontation with the Eternal.[4] To be sure, the painter held the work in high regard, declaring it "the best I think I ever painted, and the truest."[5]

LBF, DS

1 Elisha K. Kane, *Arctic Explorations in the Years 1853, '54, '55* (Philadelphia, 1856).

2 Henry T. Tuckerman, "Frederic Edwin Church," *Galaxy* (July 1866), p. 428; Tuckerman, *Book of the Artists* (1867), p. 381.

3 Louis L. Noble, *After Icebergs with a Painter* (New York, 1861), p. 110

4 Carr, *Frederic Edwin Church: The Icebergs*, p. 105

5 Frederic E. Church to Erastus Dow Palmer, April 19, 1891, Olana State Historic Site, Hudson, New York; quoted in Huntington, *Landscapes of Frederic Edwin Church*, p. 110.

References O. W. Larkin, *Art and Life in America* (1949; rev. ed., New York, 1960), p. 211; Huntington, *Landscapes of Frederic Edwin Church*, pp. 110–11; E. Steven, "Frederic Church: An Observant Melodramist," *Arts* 40 (Apr. 1966), p. 26; J. Wilmerding, *A History of American Marine Painting* (Boston, 1968), pp. 83, 85; 2nd ed. (New York, 1987), p. 59; H. B. Teilman, "Paintings by Noted Artist-Explorers," *Carnegie Magazine* 46 (Sept. 1972), pp. 278–80; E. Lindquist-Cock, "Frederic Church's Stereographic Vision," *Art in America* 61 (Sept.–Oct. 1973), p. 74; Meade Art Gallery, Amherst College, Amherst, Mass., *American Painters of the Arctic* (1975), n.p.; R. Rosenblum, *Modern Painting and the Northern Romantic Tradition* (London, 1975), p. 68; D. G. Wilkins, "The American Painting Collection at the Sarah Scaife Gallery, Carnegie Institute, Pittsburgh," *American Art Review* 2 (Mar.–Apr. 1975), pp. 99–100, 108, nn. 5–8; Smithsonian Institution Traveling Exhibition Service, *Close Observation: Selected Oil Sketches by Frederic E. Church*, pp. 31–32; Carr, *Frederic Edwin Church: The Icebergs*, pp. 103, 105.

Exhibitions Brooklyn Museum, New York, 1948–49, *The Coast and the Sea: A Survey of American Marine Painting*, no. 29; Smith College Museum of Art, Northampton, Mass., 1964, *An Exhibition of American Painting for a Professor of American Art*, no. 14; National Collection of Fine Arts, Washington, D.C., 1966, *Frederic Edwin Church*, no. 109; Museum of Fine Arts, Boston, 1978, *The Paintings and Oil Sketches of Frederic E. Church*, no cat.; Hudson River Museum, Yonkers, N.Y., 1983–84, *The Book of Nature: American Painters and the Natural Sublime*, unnumbered.

Provenance The artist's son, Theodore Winthrop Church; his wife, by 1948; her niece, Frances Sauvalle, Galveston, Tex., by 1964; M. Knoedler and Co., New York, 1971.

Howard N. Eavenson Memorial Fund, for the Howard N. Eavenson Americana Collection, 1972, 72.73

Nicolai Cikovsky
1894–1984

NICOLAI CIKOVSKY was a painter most often associated with American Scene painting and New York Social

Realism of the 1930s and 1940s. His artistic roots, however, were with the post–World War I avant-garde. Born in Pinsk, Russia, he drew and painted as a child, then studied at the art school in Penza (1914–18) and at the progressive Moscow technical art institute (1921–23). In Penza Cikovsky met the rebellious and innovative painter Vladimir Tatlin, and in Moscow he studied with Vladimir Favorsky and Ilya Mashkow. His colleague Raphael Soyer recalled that Cikovsky was exposed to "all the isms that were prevalent in the early decades of this century in Russia—Cézanne-ism, cubism, constructivism, futurism."[1] Cikovsky taught between 1919 and 1921 at the institute of technical art in Ekaterinenburg and himself became part of the Russian avant-garde.

Having decided that Moscow was developing into an uncongenial environment for an artist, Cikovsky immigrated to New York in 1923. Forced to leave all his work behind, he began at the age of twenty-nine to establish himself anew. His painting of a Cubo-Futurist figure of an accordian player represented him in Katherine Dreier's avant-garde *International Exhibition of Modern Art* at the Brooklyn Museum, New York, in 1926. With the encouragement of the scholar and collector Christian Brinton, he began to exhibit at the Charles Daniel Gallery in New York, where he met Soyer, thus beginning his contact with Social Realist painting.

Cikovsky's paintings of the 1930s, as well as his active membership in the John Reed Club and later the Artists Union and the American Artists Congress, reflect his growing preoccupation with social content and the depiction of everyday life in terms of urban street scenes and domestic interiors. In 1939 he was quoted by Martha Candler Cheney in her *Modern Art in America*:

The trend towards reality, revolutionary content, and emancipation from Paris influences towards a pure American style, I consider an important development. I believe the future of American art will be more closely identified with the working class; that it will tend to the realistic and will gradually evolve more and more of its own form as well as its content.[2]

During a five-year sojourn in Washington, D.C., in the 1930s, Cikovsky taught at the Corcoran School of Art and executed murals for the Department of the Interior (1938). He also created murals for post offices in Towson and Silver Spring, Maryland.

During the 1930s Cikovsky won several awards for his work, including the Harris and Logan medals of the Art Institute of Chicago (1932 and 1933). Successful exhibitions at the Milch and Downtown galleries in New York and in Saint Paul, Cincinnati, and Washington, D.C., resulted in critical accolades. Cikovsky began to show his work regularly in Carnegie Institute's annual exhibitions of 1933 to 1935, 1937, and 1938; in the series *Painting in the United States* from 1943 to 1949; and in the Carnegie International of 1950.

Cikovsky thus established himself as a versatile American Scene painter who could create both monumental and small-scale works depicting a diversity of subjects: urban scenes, portraits, still-life and flower paintings, and rural landscapes. Starting in 1942 his light-filled landscape painting was stimulated by his summer vacations on Long Island. His European art background served as the foundation for an American art based on a vigorous, painterly, poetic interpretation of reality. Cikovsky died in Washington, D.C.

1 Soyer, *Diary of an Artist*, p. 221.

2 Cheney, *Modern Art in America*, pp. 133–34.

Bibliography Martha Candler Cheney, *Modern Art in America* (New York, 1939), pp. 133–34; John O'Connor, Jr., "Four Paintings Added to the Permanent Collection," *Carnegie Magazine* 18 (January 1945), pp. 246–47; Raphael Soyer, *Diary of an Artist* (Washington, D.C., 1977), p. 221; Parrish Art Museum, Southampton, N.Y., *Nicolai Cikovsky* (1980), essay by Helen Harrison, pp. 5–9; Jacques Cattell Press, ed., *Who's Who in American Art*, 16th ed. (New York, 1984), p. 166.

Woman in Red, c. 1942–43

Oil on canvas
30 x 23 in. (76.2 x 58.4 cm)
Signature: Nicolai Cikovsky (lower right)

In 1952 Cikovsky stated:

Though I work from nature and am guided in choice of subject chiefly by the lyrical and poetical, my paintings are always made in the studio where I endeavor to resolve all of the elements into a work of art. . . . Occasionally I prefer to concentrate on figure studies in interiors where the elements

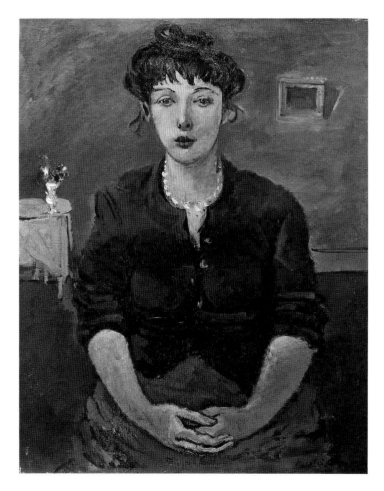

of form, space, and color relationships can be studied intimately, and a warm human quality infused into them.[1]

Woman in Red exemplifies Cikovsky's step toward a type of portraiture that is less involved with external appearance and more concerned with the evocation of mood and the exploitation of paint as a two-dimensional medium.

According to a letter of December 14, 1944, from the artist to John O'Connor, Jr., assistant director of the Department of Fine Arts, Carnegie Institute, the woman posing for this painting was a professional model who was also an art lover and collector.[2] Dressed in a red jacket, this woman with reddish brown hair is placed against a blue-gray wall in Cikovsky's East Fourteenth Street studio in New York. The partial view of the floor (which is the same size as the wall) and the collagelike additions of the picture and table with flowers all serve to reinforce the two-dimensionality of the painting, as does the broad, painterly rendition of the figure.

Raphael Soyer commented on Cikovsky's preoccupation with the art of Henri Matisse, which, arguably, exerted a certain influence on this painting. Although Cikovsky's style is considerably less radical than Matisse's in its spatial manipulations, the frontal, silhouetted position of the model, the simplification of her face and arms, and the emphasis on a lyrical, harmonious resolution of line, form, and color are all reminiscent of Matisse. The absence of preliminary studies for this painting is consistent with Cikovsky's usual practice of drawing portraits directly onto the canvas before painting.

Exhibited at the Associated American Artists Gallery in 1944, Cikovsky's *Woman in Red* was praised by Margaret Breuning of *Art Digest* as "one of the outstanding canvases [with] the stamp of integrity." She described it in terms of a "stark simplicity of portrayal relieved by the opulent color on the red jacket and the blue skirt—both acting as foils to the pale, grave face of the sitter."[3] *Woman in Red* was purchased by Carnegie Institute from its 1944 *Painting in the United States* exhibition.

GS

1 Associated American Artists Gallery, New York, *Nicolai Cikovsky: Oil Paintings* (1952), exh. brochure with statement by Nicolai Cikovsky, n.p.

2 Nicolai Cikovsky to John O'Connor, Jr., December 14, 1944, museum files, The Carnegie Museum of Art, Pittsburgh.

3 Margaret Breuning, "Eloquent Cikovsky," *Art Digest* 18 (March 1, 1944), p. 12.

References M. Breuning, "Eloquent Cikovsky," *Art Digest* 18 (Mar. 1, 1944), p. 12; J. O'Connor, Jr., "Four Paintings Added to the Permanent Collection," *Carnegie Magazine* 18 (Jan. 1945), pp. 245–47; Associated American Artists Gallery, New York, *Nicolai Cikovsky: Oil Paintings* (1952), n.p.; Soyer, *Diary of an Artist*, p. 221; Parrish Art Museum, *Nicolai Cikovsky*, n.p.

Exhibitions Associated American Artists Gallery, New York, 1944, *Nicolai Cikovsky*, no. 5; Department of Fine Arts, Carnegie Institute, Pittsburgh, 1944, *Painting in the United States*, no. 196; Columbus Gallery of Fine Arts, Ohio, 1952, *Paintings from the Pittsburgh Collection*, no cat.

Provenance Associated American Artists, New York, as agent, 1945.

Patrons Art Fund, 1945, 45.2

George Lafayette Clough
1824–1901

GEORGE LAFAYETTE CLOUGH was born and died in the town of Auburn, in Cayuga County, New York. His career path and artistic interests were typical of many American painters in the third quarter of the nineteenth century. As a painter of landscapes, genre subjects, and portraits, he spent much of his career in the orbit of New York City, tried his fortune in other cities, and experienced modest success from his various artistic endeavors. Also typical, perhaps, is the current obscurity of Clough's career, which at best can be glimpsed in the scattered listings of city directories and exhibition records.

The son of a banker, Clough learned painting from the portraitist Charles Loring Elliot, with whom he began to study in Auburn at the age of twenty. In 1847 he followed Elliot to New York, where Clough worked in Elliot's studio and began sending work to the National

Academy of Design. He exhibited two portraits there in 1848, and another two years later. In 1850 he spent a year in Europe. His itinerary included Paris, where he apparently copied paintings of the old masters before continuing onward through the standard landscape-sketching route from Holland and Germany to Italy.

By 1862 Clough had moved to Cleveland, where he was associated with J. M. Green's photographic firm, copying portrait photographs in oils. He also began to paint landscapes. He sent one to the National Academy of Design in 1859, and from that time onward retained an interest in that type of picture, which now accounts for the vast majority of his known work. Clough's earlier landscapes were in the Hudson River school manner, and most closely resemble those of John Frederick Kensett. From the 1870s onward, he adopted a style indebted to Barbizon landscape painting, as did numerous other American painters.

In 1866, probably after a brief stay in Cincinnati,[1] Clough returned to New York. He lived in Manhattan and Brooklyn, exhibited at the National Academy of Design and Brooklyn Art Association, and served as vice-president of the Brooklyn Art Club. Beginning in 1875 he began returning to Auburn from time to time, where by 1894 he had repaired permanently.

1 Mrs. Morrison Foster to John Beatty, August 27, 1919, museum files, The Carnegie Museum of Art, Pittsburgh.

Bibliography Terrence J. Kennedy, "Art and Professional Artists of Cayuga County," Cayuga [N.Y.] County Historical Society, 1878, manuscript; Brucia Witthoft, "George L. Clough, Painter," *Antiques* 122 (July 1982), pp. 133–37.

Stephen C. Foster, c. 1865

Oil on canvas
37 x 30 in. (94 x 76.2 cm)

This portrait of the songwriter Stephen Foster (1826–1864) was commissioned a year after his death by his brother Morrison, to whom he had been quite close. Morrison Foster was then living in Cleveland. He knew Clough as an artist who would make portraits from photographs, perhaps because the latter had already painted a portrait of Morrison's

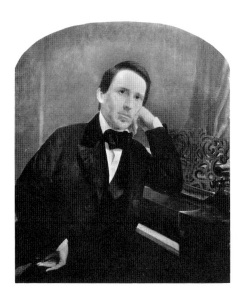

eldest daughter, copied from a photograph taken in J. M. Green's Cleveland studios.[1]

Morrison Foster prevailed upon the artist to execute a half-length portrait based on Stephen Foster's last photograph, an ambrotype taken in Pittsburgh in 1859 (fig. 1). It was a gift to Morrison, who received it with a note: "Yesterday my neighbor who has the Daguerreotype establishment invited me to have my picture taken. I think it is rather good and send it to you, my dear brother."[2]

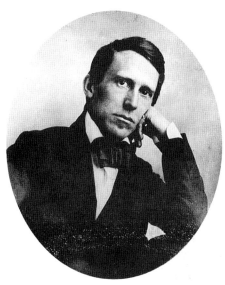

Fig. 1 Unidentified photographer, *Stephen Collins Foster*, 1859. Ambrotype, 2¾ x 3¼ in. (7 x 8.3 cm) framed. Foster Hall Collection of the Stephen Foster Memorial, University of Pittsburgh, Pa.

In painting this portrait, the artist faithfully transcribed the ambrotype's features and pose, but he enlarged the format slightly to include Foster's left hand (for which his brother posed). He also made the original furnishings grander, adding curtains and showing Foster leaning on a parlor piano, as if pausing in mid-composition, instead of a small table. The portrait's coloring is a rather dark, subdued combination of brown tones against black and white. Its painted surface is exceedingly smooth, reinforcing the unpretentious and somewhat self-effacing quality of the artistic product.

When Morrison Foster died in 1904, his widow offered the work to Andrew Carnegie, who purchased it in order to ensure that a portrait of Stephen Foster would remain in Pittsburgh. Although the artist's identity was not then known, the work was added to the paintings on permanent view and photographed for a circulating set of the notable artworks of the collection. Between 1916 and 1945, it was exhibited in conjunction with various memorial celebrations of Stephen Foster, long considered Pittsburgh's "first citizen."

DS

1 Evelyn Foster Morneweck to John O'Connor, Jr., September 1937, museum files, The Carnegie Museum of Art, Pittsburgh.

2 Stephen Foster to Morrison Foster, June 13, 1859, Stephen Foster Memorial, University of Pittsburgh.

References "Portrait of Stephen C. Foster by William [*sic*] Clough," *Pittsburgh Post*, Feb. 1, 1912, p. 6; J. O'Connor, Jr., "In Search of an Author," *Carnegie Magazine* 11 (June 1937), pp. 72–75; "Carnegie Gallery Mystery," Pittsburgh *Bulletin Index*, July 1, 1937, p. 7; D. L. Root, "Myth and Stephen Foster," *Carnegie Magazine* 67 (Jan.–Feb. 1987), p. 10.

Exhibitions Historical Society of Western Pennsylvania, Pittsburgh, 1916, *City Charter Centennial Exhibition of Portraits, Views of Early Pittsburgh, and Historical Relics*, unnumbered; University of Pittsburgh, 1943, *Stephen C. Foster Birthday Celebration and Seventeenth Annual Stephen C. Foster Memorial Program*, unnumbered; Historical Society of Western Pennsylvania, Pittsburgh, 1945, *1845–1945: An Historical Commemoration*, no. 18.

Provenance The sitter's brother, Morrison Foster, Cleveland, 1865; his widow, 1904; Andrew Carnegie, New York, 1904.

Gift of Andrew Carnegie, 1904, 05.6

Jon Corbino
1905–1964

JON CORBINO WAS born in Vittoria, Sicily, grandson of a prosperous farmer and winegrower. In 1911 he left Sicily with his mother, and they had settled in the United States by 1913. Corbino grew up in a tenement in the Italian section of the Lower East Side of New York; he never returned to Europe.

In 1920 he was awarded a scholarship to the Ethical Culture School in New York, where his talents for drawing and painting were encouraged. Corbino received most of his artistic training during the 1920s at the Art Students League in New York, where George Luks was among his teachers. In 1923 he studied with Daniel Garber at the Pennsylvania Academy of the Fine Arts, Philadelphia. Corbino earned his tuition for school through a variety of odd jobs, including a stint in a riding academy in Beacon, New York, where he made many studies of horses. These animals later became the trademark of his painting style. In 1928 Corbino had his first solo exhibition, and by the mid-1930s he had reached artistic maturity. In 1936 and 1937 he won Guggenheim Fellowships, which provided him the opportunity to devote himself entirely to painting and sculpture, but after 1937 he abandoned sculpture.

Corbino's action-filled, caricaturelike representational style is associated with Regionalism, even though his subjects do not strictly depict American urban or rural life. Instead, his artistic imagination was fired by his sense of the unrest in the world and by his studies of Italian, Flemish, Spanish, and French masters of the sixteenth to nineteenth centuries. His timeless, heroic paintings of massive, contorted figures amid earthquakes, floods, and rebellions particularly suggest the influence of Peter Paul Rubens and Eugène Delacroix, as does his dramatic use of warm, vibrant colors and chiaroscuro for emotional impact.

Memory images from his childhood played a part in Corbino's painting. He never forgot, for example, the earthquake in Messina and a hurricane at sea he survived en route from Sicily as a small child: a number of his paintings depict natural disasters and their impact on people and animals. His recollections, as well, of Sicilian family grape harvests served as inspiration for paintings depicting picnics, processions, and festivals. Likewise, the gang wars and other violence that often erupted in the New York neighborhood in which he was raised seem to have provided additional sources for the turbulence in his paintings.

After a solo show in 1937 at the Macbeth Galleries in New York, Corbino received numerous awards, including the Walter Lippincott prize of the Pennsylvania Academy of the Fine Arts in 1938. His work was purchased by many museums, and in 1940 he was elected to the National Academy of Design, New York. Along with William McNulty and Ann Brockman, Corbino conducted painting classes at the Cape Ann School in Rockport, Massachusetts. He also taught at the Art Students League, New York, from 1938 to 1956 and the National Academy of Design in 1945.

Corbino's association with Carnegie Institute began with the 1936 annual exhibition and continued until 1950. In 1939 he had a large solo exhibition at the institute; in its catalogue he was heralded as "the founder of a new school of Baroque-Romanticism."[1]

In the 1940s and 1950s Corbino turned from violent compositions to more lyrical depictions of circus and ballet figures. Still, his paintings retained heroic overtones, often suggesting humanity's struggles to come to terms with itself and the universe. Before his death, in Sarasota, Florida, Corbino created a series of crucifixion paintings, which depicted his confrontation and reconciliation with his own mortality.

1 Department of Fine Arts, Carnegie Institute, Pittsburgh, *An Exhibition of Paintings and Drawings by Jon Corbino* (1939), foreword.

Bibliography Ernest Brace, "Jon Corbino," *Magazine of Art* 30 (December 1937), pp. 705–9; Harry Salpeter, "Corbino: Artist on Horseback," *Esquire* 7 (February 1939), pp. 54–57, 110; Nancy Heller and Julia Williams, *The Regionalists* (New York, 1976), p. 195; Museum of Fine Arts, Saint Petersburg, Fla., *Jon Corbino: An Heroic Vision* (1987).

Rebellion, 1936

Oil on canvas
30¼ x 42⅛ in. (79.4 x 107 cm)
Signature, date: *Jon Corbino*/1936 (lower left)

Like many of his paintings of the 1930s, *Rebellion* exemplifies Corbino's propensity for romanticized, imaginary conflicts that were not tied to a specific time or place: the tanks of modern warfare are replaced by large, powerfully built horses reminiscent of Théodore Géricault's fiery steeds.

John O'Connor, Jr., conjectured that Corbino had imagined a dramatic episode of the Spanish civil war for the subject of this painting.[1] The indeterminate action is centered around two armed civilians on horseback who preside over an uprising under a stormy sky. Ernest Brace observed that, indeed, "the bulging muscles and the natural movements of the horses are of far greater significance than the outcome of any battle."[2] Corbino's massive, heroic, muscular figures and animals—which reflect his initial training as a sculptor—are elevated above everyday existence. They function as romantic symbols of conflict and action, while two shrouded men in the center of the painting are characteristic suggestions of death. The turbulence of figures and animals is heightened by Corbino's typically warm, rich palette of juxtaposed vibrant reds, yellows, blues, and greens, as well as his dramatic use of chiaroscuro. Although such effects look

spontaneous, they were apparently the product of many varied preliminary drawings through which his theme gradually developed.

Rebellion is one of Corbino's key works of the 1930s. It was presented to Carnegie Institute in 1942 by Charles Rosenbloom, a well-known Pittsburgh collector of old-master drawings and prints, who purchased it from the 1937 Carnegie International. A freely painted watercolor study for *Rebellion* from the estate of the Ball family is at the Ball State University Art Gallery, in Muncie, Indiana.
GS

1 John O'Connor, Jr., "Painting Presented: Charles J. Rosenbloom Gives 'Rebellion' by Jon Corbino to the Carnegie Institute," *Carnegie Magazine* 16 (December 1942), p. 203.

2 Brace, "Jon Corbino," p. 705.

References Brace, "Jon Corbino," p. 705; "Two Man Show," Pittsburgh *Bulletin Index*, May 18, 1939, p. 9; J. O'Connor, Jr., "Presenting Jon Corbino," *Carnegie Magazine* 13 (May 1939), pp. 51–53; "Corbino at Carnegie," *Art Digest* 13 (June 1939), p. 57; J. O'Connor, Jr., "Painting Presented: Charles J. Rosenbloom Gives 'Rebellion' by Jon Corbino to the Carnegie Institute," *Carnegie Magazine* 16 (Dec. 1942), pp. 203–4; F. S. Berryman, "Rebellion in Pittsburgh," *Magazine of Art* 36 (Jan. 1943), p. 32; "Carnegie Institute Keeps Corbino's 'Rebellion,'" *Art Digest* 17 (Jan. 1943), no. 7, p. 9; D. B., "Corbino: Home Grown to Maturity," *Art News* 42 (Jan. 15, 1944), p. 21.

Exhibitions Department of Fine Arts, Carnegie Institute, Pittsburgh, 1937, *The 1937 International Exhibition of Paintings*, no. 34;

Macbeth Gallery, New York, 1937, *An Exhibition of Recent Work by Jon Corbino*, no. 13; Toledo Museum of Art, Ohio, 1938, *Twenty-fifth Annual Exhibition of Selected Paintings by Contemporary American Artists*, no. 16; Department of Fine Arts, Carnegie Institute, Pittsburgh, 1939, *An Exhibition of Paintings and Drawings by Jon Corbino*, no. 23; Columbus Museum of Art, Ohio, 1952, *Paintings from the Pittsburgh Collection*, no cat.; Wichita Art Museum, Kans., 1981, *The Neglected Generation of American Realist Painters, 1930–48*, no. 59; Museum of Fine Arts, Saint Petersburg, Fla., 1986–87, *Jon Corbino: An Heroic Vision* (trav. exh.), no. 12.

Provenance Macbeth Gallery, New York, as agent, 1937; Charles J. Rosenbloom, Pittsburgh, 1937.

Gift of Charles J. Rosenbloom, 1942, 42.4

John Covert

1882–1960

JOHN RAPHAEL COVERT (the middle name was his own invention) was the first modernist painter to come from Pittsburgh. Born and raised there, he spent six years after high school as an art student at the Pittsburgh School of Design, where his principal art teacher was the Munich-trained landscape painter Martin B. Leisser. When Covert left Pittsburgh in 1908 to study art in Europe it may have been on Leisser's recommendation that he went first to Munich.

Covert spent nearly four years at the Akademie in Munich before moving on to Paris, where he lived nearly three years more, exhibiting at the salon of the Société des Artistes Français in 1914. He moved within the academically oriented circles that a foreign art student would be most likely to enter. Accordingly, his work tended toward idealized female figures and the decorative strains of *fin-de-siècle* Symbolism. Only in light of Covert's subsequent modernist interests is it curious that he was not particularly aware of the activities of the Parisian avant-garde. But this fact later astounded him. "I didn't get to know a modern artist, or see a modern show, or even meet the Steins," he recalled. "It's incredible, I must have lived in armor." [1]

In 1915 Covert returned to the United States, and he began to keep company with his older cousin Walter Arensberg, who was living in Manhattan. Arensberg had recently become an enthusiast of modernist art and literature, which gained a foothold in New York after the outbreak of World War I. Covert became closely associated with the artists who gathered around Arensberg and shared in a number of their projects. Among these were Katherine Dreier's Société Anonyme, founded in 1919, and the Society of Independent Artists, which Covert helped organize in 1916 and, along with his cousin, direct.

Covert's art changed in fundamental ways. He became critical of the validity of naturalistic representation and of traditional obligations to "style." Instead, he embraced pictorial art as a tool by which one might attack notions conditioned by society. A number of his works rely on visual puns, machine imagery, and non-traditional materials in a manner that reveals their spiritual kinship with Francis Picabia and Marcel Duchamp.

Thanks to Duchamp's influence, Covert began to make assemblages, arguably the first American artist to do so. These—for example, *Brass Band* (1919, Yale University Art Gallery, New Haven)—have become his best-known works. At the same time, Covert retained his interest in figure painting, producing large, broadly experimental compositions based on the studio nude.

Soon after Walter Arensberg moved to California in 1922, the New York members of Arensberg's circle dispersed. Covert, whose work never sold well, closed his studio in 1923, gave several of his pictures to Katherine Dreier, and abandoned art. He returned to Pittsburgh, where he worked in the sales department of Frank Arensberg's Vesuvius Crucible Company, the artist's family's firm. Upon retirement, he moved back to New York, where he lived for the remainder of his life. During the 1950s he once more took up the brush.

1 Rudi Blesh, *Modern Art USA* (New York, 1956), p. 21.

Bibliography George Heard Hamilton, "John Covert: Early American Modern," *College Art Journal* 12 (Fall 1952), pp. 37–42; Michael Klein, "The Art of John Covert," Ph.D. diss., Columbia University, 1972; Abraham A. Davidson, "Two from the Second Decade: Manierre Dawson and John Covert," *Art in America* 63 (September–October 1975), pp.

50–55; Hirshhorn Museum and Sculpture Garden, Washington, D.C., *John Covert, 1882–1960* (1976), exh. cat. by Michael Klein; Michael Klein, "John Covert's Studios in 1916 and 1923: Two Views into the Past," *Art Journal* 39 (Fall 1979), pp. 22–28.

Untitled, c. 1916
(Don Quixote)

Oil on canvas
44⅛ x 36⅛ in. (112.1 x 91.7 cm)

Before Covert closed his New York studio in 1923, he photographed the works on its walls. The majority were abstract, rather lyrical compositions based on the human figure. This canvas was among them. It shows the head and shoulders of two soldiers in sixteenth-century helmets and breastplates against a background of Futurist-inspired "lines of force," which read as beams of light emanating from tunnels or portals. The result is a fantasy environment whose partly visionary, partly fairy-tale quality is underscored by the predominantly bright green coloring Covert gave the picture.

There exists another version of this painting (fig. 1) virtually identical in size and composition but less carefully finished. The Carnegie picture has clearer-cut shapes, a brighter color key, and a

Fig. 1 John Covert, *Two Soldiers*, c. 1922. Oil on canvas, 45¼ x 36¼ in. (114.9 x 92 cm). Seattle Art Museum, gift of Paul Benby Mackie in memory of Kathleen Lawler and Nora Lawler Mackie, 1959

Fig. 2 John Covert, *Self-Portrait in Armor*, c. 1916. Photograph, 4¹¹⁄₁₆ x 3½ in. (11.9 x 8.9 cm). The Carnegie Museum of Art, Pittsburgh, gift of Charles C. Arensberg, 83.90.2

sharper juxtaposition of the old-fashioned armor against a dynamic, abstract background, whose glowing ovenlike elements are reminiscent of the blast furnaces the artist knew at Vesuvius Crucible Company.

In each canvas, Covert's pictorial experiment was to dissolve parts of his representational shapes and have them spontaneously re-form into abstract configurations. He used the same technique in other paintings between 1916 and 1919, notably *Water Babies* (1919, Seattle Art Museum) and seemingly also *The Temptation of Saint Anthony*, also in two versions (1916, Seattle Art Museum, and 1919, Yale University Art Gallery, New Haven). In this composition, the forms seem to stand generally for the old order (represented by the sixteenth-century military gear), transmogrified in the environment of the new (the dynamic environment of abstract lines and shapes).

Covert actually owned the soldier's costume; a photographic self-portrait in The Carnegie Museum of Art dating from about 1916 (fig. 2) shows him dressed in the same breastplate and helmet. It is tempting to see the image based on them as having an autobiographical element. Perhaps the old soldier is the old-fashioned artistic tradition, to which Covert belonged by virtue of his training, immersed in and yielding to the quite different environment of modernism, as Covert did when he arrived in New York. DS

Remarks A partially completed, cut-down, full-length painting of a woman in a long blue dress, painted about 1909–14, is on the reverse of the canvas.

Exhibitions Dallas Museum for Contemporary Art, 1961, *Paintings and Drawings in the Estate of John R. Covert*, no. 2, as *Don Quixote* (the title given by Charles Covert Arensberg); Salander-O'Reilly Galleries, New York, 1984, *John Covert, 1882–1960: Paintings and Photographs*, no. 5, as *Don Quixote.*

Provenance The artist, until 1960; his nephew, Charles Covert Arensberg, Pittsburgh, 1961.

Gift of Mr. and Mrs. Charles Covert Arensberg in memory of Charles F. C. Arensberg, 1983, 83.89

Model and Painter, c. 1916–23 (*Nude Standing with Figure of a Man*)

Oil on canvas
45 x 29½ in. (114.3 x 74.9 cm)

Between 1916 and 1923 Covert painted a considerable number of large canvases of studio nudes. Because they are quite different from his contributions to the Société Anonyme and are not easily linked with the aesthetic concerns of the Arensberg circle, their place in Covert's art has been a puzzle. Yet Covert seems to have produced them concurrently with the assemblages and abstractions for which he is better known, and there is every indication that he placed great stock in them. He did not give any of these canvases away when he closed his studio in 1923; he kept them until he died. Late in life he referred to them as his best work.[1]

It might be said that Covert's large nudes, such as *Model and Painter*, represent his attempt to forge a personal style, consistent with his background as a figure painter and with the philosophy of modernism, yet independent of other New York modernists. *Model and Painter* is dominated by a female nude seen from the back at three-quarter length. Her form easily dwarfs the other objects in the composition: a chair to the left and, farther away to the right, the profile of a bearded, hatted, somewhat cryptic male figure, who appears to be an artist working at an easel.

The model in a sense introduces the viewer to the picture's progressively

increasing flatness. She turns her back to the viewer, blocking much of the background and facing the pictorial space beyond. Her form is responsible for the sharp differences in scale that prevent the viewer from reading the room as real space. The artist in the background is shown in strict, two-dimensional profile; he is presumably working at an easel that we do not see. Behind him, deepest into the artist's invented space, is merely a vertical line. It is as if Covert sought to diagram the reductive transformation that occurs when making pictures.

DS

1 Salander-O'Reilly Galleries, New York, *John Covert, 1882–1960: Paintings and Photographs* (1984), exh. checklist by Lawrence B. Salander, n.p.

Exhibitions Dallas Museum for Contemporary Art, 1961, *Paintings and Drawings in the Estate of John R. Covert*, no. 5, as *Nude Stand-*

ing with Figure of a Man; Salander-O'Reilly Galleries, New York, 1984, *John Covert, 1882–1960: Paintings and Photographs*, no. 11, Governor's Residence, Harrisburg, Pa., 1988–89, *Director's Choice*, no cat.

Provenance The artist, until 1960; his nephew, Charles Covert Arensberg, Pittsburgh, 1961.

Gift of Mr. and Mrs Charles Covert Arensberg in memory of Charles F. C. Arensberg, 1986, 86.55

Isaac Craig

1830–1912

BORN NEAR PITTSBURGH, Isaac Eugene Craig studied art in Pittsburgh and Philadelphia. He sailed for Europe in 1853, probably intending to enroll at the art academy in Düsseldorf, but after a

visit to the Louvre he decided to remain in Paris. Although little is known of his activities there, he apparently knew the expatriate American painter William Babcock, a former pupil of Thomas Couture and friend to William Morris Hunt and Jean-François Millet.

After visiting Germany and Italy, Craig returned to the United States in 1855 or 1856. Between that time and 1868, his work appeared at the Pennsylvania Academy of the Fine Arts in Philadelphia, and occasionally at the National Academy of Design in New York and at Pittsburgh exhibitions. During these years he lived in Philadelphia (1856), Pittsburgh (1857–59), at the College of Saint James, Maryland (1860), and New Brighton, Pennsylvania (1861). Craig reportedly went to Munich in 1862, then settled in Florence the following year,[1] even though the Pennsylvania Academy's catalogue for 1864 listed Pittsburgh as his address.

From 1868 on he rarely exhibited his work, but one canvas—*Pygmalion*—is reported to have been sent to Dublin and London.[2] Craig taught in Florence at the Accademia di Belle Arti, where he became an honorary member and had American students. He died in Florence and was buried in Allori Cemetery.

Though only a few canvases have been identified as his work, catalogue entries show that Craig and his Pittsburgh colleague Trevor McClurg exhibited a wide variety of subjects, including portraits, landscapes, and especially biblical themes (*Our Lord and Nicodemus*, Pennsylvania Academy of the Fine Arts, Philadelphia, 1855, no. 77), genre (*Studious Child*, Pittsburgh Sanitary Fair, 1864, no. 145), and historical and literary subjects (*Washington Crossing the Allegheny River*, Pennsylvania Academy of the Fine Arts, Philadelphia, 1856, no. 101; *Signing the Bond—Merchant of Venice*, National Academy of Design, New York, 1868, no. 175).

1 Clement and Hutton, *Artists of the Nineteenth Century*, vol. 1, pp. 167–68.

2 Ibid., p. 168; the painting is unlocated.

Bibliography Clara E. Clement and Laurence Hutton, *Artists of the Nineteenth Century and Their Works,* 2 vols. (Boston, 1879), vol. 1, pp. 167–68; George C. Groce and David H. Wallace, *The New-York Historical Society's Dictionary of Artists in America* (New Haven, 1957), p. 152; Regina Soria, *Dictionary of Nineteenth-Century American Artists in Italy, 1760–1914* (Rutherford, N.J., 1982), p. 96.

The Captives, 1858

Oil on canvas
68 x 86 in. (172.7 x 218.4 cm)
Signature: IEC (lower left, in monogram)

In 1858, a reporter for the *Pittsburgh Gazette* prefaced a long description of *The Captives* with the observation that it was the artist's "best effort, and will surely enhance his reputation."[1] It followed and may well have been intended as a companion piece to Craig's previously exhibited *Release of the Captive.* That painting is lost, but it may be the same work listed as *The Rescue* in an 1858 Pennsylvania Academy of the Fine Arts catalogue (no. 260) and as *The Captive Maiden's Release* in an 1860 Pittsburgh Art Association catalogue (no. 107), exhibitions in which *The Captives* also appeared.

There are striking similarities between *The Captives* and Trevor McClurg's *Family, Taken Captive by the Indians* (see p. 351), painted nine years earlier. Both illustrate a commonplace of mid-nineteenth-century American popular literature, the frontier family captured by Indians. Craig, like McClurg, focused on the distressed women and children (the older males presumably have been killed), while the Indians, engaged in a scalp dance, are seen as shadowy figures in the left background.

The resemblance strongly suggests that *The Captives* is based on McClurg's work,

but there are some notable differences between the two. McClurg's painting represents an incident from the frontier days of western Pennsylvania; Craig's pioneers are identified as contemporary Americans by their dress, and their ordeal takes place, as the *Pittsburgh Gazette* observed, on the "ocean-like prairie" of the mid-nineteenth-century frontier rather than amid the forested hills and valleys of the long-civilized East.[2] Craig's technique, with its strong contrasts of highlight and shadow, its painterly scumbles and slightly blurred contours, is in sharp contrast to McClurg's hard, linear Düsseldorf style, and is probably the legacy of the artist's sojourn in Paris.

KN

1 "A Work of Art," *Pittsburgh Gazette*, April 3, 1858, [p. 3].
2 Ibid.

Reference "A Work of Art," *Pittsburgh Gazette*, Apr. 3, 1858, [p. 3].

Exhibitions Pennsylvania Academy of the Fine Arts, Philadelphia, 1858, *Annual Exhibition*, no. 153; Pittsburgh Art Association, 1860, *Second Annual Exhibition*, no. 47.

Provenance Joseph Woodwell, Pittsburgh; his son, Joseph R. Woodwell, Pittsburgh, by 1898; his daughter, Johanna K. W. Hailman, Pittsburgh, by 1911, until c. 1940.

By appropriation, 1972, 72.38

Bruce Crane
1857–1937

THE LANDSCAPE PAINTER Robert Bruce Crane was born in New York City, the son of Solomon Crane, an ornamental designer and amateur painter. Employed as a draftsman in an Elizabeth, New Jersey, architect-builder's office, Crane began to paint in his spare time. Between 1878 and 1882 he attended classes at the Art Students League, New York, and in 1879 studied with the landscape painter Alexander Wyant, who encouraged him to work in the Barbizon mode, which was increasingly admired by American artists.

Crane subsequently visited Paris; from there he frequented the nearby artists' colony at Grèz-sur-Loing. There he came under the influence of Jean-Charles Cazin, who, like Wyant, was a popular practitioner of Barbizon-style landscapes. Cazin painted poetic, spontaneously brushed views of the French countryside using a palette limited to tans, grays, and ochers. Crane admired the French artist's style, particularly his reliance on memory rather than direct observation. In a letter to his father, Crane wrote that in Cazin's work "tone is the thing sought for. . . objects are never modeled, everything is treated as a flat mass. He detests realism and is the best teacher I could have had as I have been inclined towards realism."[1]

Back in the United States, Crane began to achieve recognition in the early 1880s with his agreeable, though rarely remarkable, talents, and by the turn of the century he had become the epitome of the successful, sophisticated, and cosmopolitan landscape painter. He belonged to the leading New York art clubs and societies, exhibited at all the major exhibitions, and collected an impressive number of gold, silver, and bronze medals. A regular exhibitor at the Carnegie Internationals from 1896 to 1925, he won the third prize in 1909 for *November Hills* (see p. 151), and served on the prestigious jury of award in 1920. In 1927 Frederic Fairchild Sherman accurately assessed the character and quality of Crane's work:

He appreciates and interprets more than a little of the reality of nature but without emphasizing anything of the unusual in our

native landscape. Everyday scenes—the woodpile in the back lot, ploughed fields, an old stone fence, the morning mist in the hollows—suffice for the subject matter of his canvases. Those who care for "homey" pictures, whose hearts are forever turning back to the "old days on the farm," find real satisfaction in his works. They preserve something of the sense of freedom that we associate with "the back-country," the smell of fresh cut wood and the dewy, mist-jewelled atmosphere of treasured days of youth. . . . I rank Crane with the few better American landscape painters of today. While his pictures seldom rise to real importance they are not often definitely disappointing.[2]

The only blot on Crane's reputation was the artist's scandalous divorce of 1902, in which his wife named her own daughter (by a previous marriage) as corespondent. Crane married his stepdaughter in 1904, and neither the tranquillity of

his landscapes nor his popularity with collectors was significantly affected by this episode.

Crane was essentially a conservative artist, and his work changed little after 1900; he was wholly untouched by the modernist currents of the early twentieth century. Although his late works tended to be somewhat repetitious in composition and mood, the level of craftsmanship in each painting remained high. He died in New York City.

1 Clark, "Bruce Crane, Tonalist Painter," p. 1,061.
2 Sherman, "The Landscape of Bruce Crane," p. 212.

Bibliography "Bruce Crane," *Art Age* 3 (August 1885), pp. 8–9; Alfred Trumble, "A Poet in Landscape," *Quarterly Illustrator* 1 (October–December 1893), pp. 256–60; "Bruce Crane and His Work," *Art Amateur* 31 (September 1894), pp. 70–74; Harold T. Lawrence, "A Painter of Idylls—Bruce Crane," *Brush and Pencil* 11 (October 1902), pp. 1–10; Frederic Fairchild Sherman, "The Landscape of Bruce Crane," *Art in America* 14 (October 1926), pp. 211–15; Charles Teaze Clark, "Bruce Crane, Tonalist Painter," *Antiques* 122 (November 1982), pp. 1,060–67.

November Hills, c. 1908

Oil on canvas
45 x 46 in. (114.3 x 116.8 cm)
Signature: BRUCE CRANE. NA (lower right)

John Beatty, director of the Department of Fine Arts at Carnegie Institute, saw *November Hills* in Washington, D.C., at the Corcoran Gallery of Art biennial in 1908 and asked Crane to send it to Pittsburgh for the 1909 Carnegie annual exhibition.[1] After winning that year's

bronze medal, the painting was promptly purchased for the permanent collection.

A particularly fine example of Crane's mature style, *November Hills* is one of a number of scenes of steep, partially wooded hillsides that the artist painted between about 1905 and 1920. Other works of this type include *Autumn Uplands* (c. 1908, Metropolitan Museum of Art, New York), *Landscape* (c. 1910–15, Henry Francis du Pont Winterthur Museum, Delaware), and *December Uplands* (1919, National Museum of American Art, Washington, D.C.). Like many of Crane's best paintings, these are invariably late autumn or early winter scenes that allow the artist to restrict his palette to a narrow range of earth tones. Of this group, *November Hills* is by far the most abstract and decorative—indeed, it is the most extreme expression in Crane's work of the flatness that, in his youth, the artist had admired in the work of Jean-Charles Cazin. The high horizon and the absence of modeling tend to flatten the perspective, while Crane's practice of applying light pigments to a darker, roughly textured canvas with a "scrubby brush"[2] emphasizes the surface. Diagonal elements, such as gullies and stone fences, while they convey some sense of spatial recession, serve primarily to create decorative patterns.

According to Charles Teaze Clark,[3] *November Hills* probably depicts a scene in Herkimer County, New York, near Utica. Crane is known to have painted in this area between 1900 and 1920, but he traveled extensively at this time, and the identification is by no means certain.

LBF, KN

1 John Beatty to Bruce Crane, December 11, 1908, Carnegie Institute Papers, Archives of American Art, Washington, D.C.

2 Lawrence, "Painter of Idylls," p. 8.

3 Charles Teaze Clark to Lynn Boyer Ferrillo, July 8, 1983, museum files, The Carnegie Museum of Art, Pittsburgh.

Reference Clark, "Bruce Crane, Tonalist Painter," p. 1,065.

Exhibitions Corcoran Gallery of Art, Washington, D.C., 1909, *Second Exhibition of Contemporary American Oil Painting*, no. 303; Department of Fine Arts, Carnegie Institute,

Pittsburgh, 1909, *Thirteenth Annual Exhibition*, no. 62; National Academy of Design, New York, 1939, *National Academy Special Exhibition*, no. 64.

Purchase, 1909, 09.3

Thomas Crawford
1813(?)–1857

Thomas Crawford was one of America's most distinguished Neoclassical sculptors, along with Horatio Greenough and Hiram Powers. With them he was responsible for establishing Italian training, the marble medium, and idealized subject matter as the proper aspirations for American sculptors—aspirations that persisted until nearly the end of the nineteenth century. Although only the second American sculptor to go to Italy, Crawford was the first to settle there. He was also the first to make Rome the center of his artistic activity.

The son of Irish immigrant parents in New York City, Crawford was apprenticed as a stone cutter to John Frazee, one of America's first marble sculptors, and Frazee's partner, the Latvian-born, Roman-trained Robert E. Launitz. After spending about three years with Frazee and Launitz, and after studying and drawing plaster casts of antique sculpture, especially at the National Academy of Design, New York, Crawford left for Italy. He arrived in Rome in 1835 carrying a letter of introduction to the Danish Neoclassical sculptor Bertel Thorvaldsen from Launitz, who had been the venerable Dane's pupil. Thorvaldsen, who was then in the last decade of his life and recognized as one of Europe's most highly accomplished sculptors, accepted Crawford as a student.

By 1839 Crawford was producing his first work, the most ambitious of which was a plaster for the life-size, multifigured composition that is his masterpiece, *Orpheus and Cerberus* (1839–43, Museum of Fine Arts, Boston). Charles Sumner, a Bostonian visitor to Rome in 1839, persuaded a group of fellow connoisseurs to underwrite its translation into marble and subsequently its acquisition for the Boston Athenaeum. The marble was completed in 1843 and was shown at the

Athenaeum in 1844, in the first solo exhibition ever held for an American sculptor. Crawford was hailed as a native genius, and there followed a steady stream of American patronage.

In 1849 he won his first public commission—a monument to George Washington for the city of Richmond, Virginia, which would include an equestrian statue of Washington and pedestrian statues of several eminent Virginia statesmen, all cast in bronze. His most ambitious project was a commission for sculptural embellishment of the newly expanded United States Capitol, which included the pediment and portals for the Senate wing, the bronze *Armed Freedom* atop the dome, and the bronze doors to the Senate and the House of Representatives. A number of these and other commissions were left unfinished at the time of Crawford's death in London from an apparent brain tumor, and the work was completed by others.

Except for a visit to the United States in 1844 (on the occasion of his marriage to Louisa Ward, sister of Julia Ward Howe) and return trips in 1849 and 1856, Crawford resided in Rome, where he was an active, valued member of the city's international art community. The sculptural style he developed was more literal and also somewhat more sentimental than Thorvaldsen's, but it sought to achieve a similar level of seriousness, simplicity, and visual restraint. Crawford approached his sculptural themes with utmost dedication to the precepts of Greek classicism and to the manual and intellectual discipline that the Greek tradition implied. He was personable and idealistic, and he possessed absolute conviction in his vocation. In his relatively short career, he enjoyed substantial acclaim, and his influential friends and supporters would have been dumbfounded by the twentieth century's lack of sympathy for Neoclassical sculpture and for Crawford's considerable achievement as one of its practitioners.

Bibliography Charles Edward Lester, *Thomas Crawford*, Artists of America series (New York, 1846); [Hanna F. Lee], *Familiar Sketches of Sculpture and Sculptors* (Boston, 1854), pp. 173–77; Henry T. Tuckerman, *Book of the Artists: American Artist Life* (New York, 1867),

pp. 307–19; Lorado Taft, *The History of American Sculpture* (1903; rev. ed., New York, 1924), pp. 72–91; Robert L. Gale, *Thomas Crawford: American Sculptor* (Pittsburgh, 1964).

Hyperion, 1841

Marble

23¾ x 12½ x 12½ in. (59 x 31.8 x 31.8 cm)

Markings: HYPERION (above base, front); T. Crawford Fecᵗ. Rome—/1841 (back)

This bust of the sun god Hyperion is Crawford's earliest surviving marble rendition of a mythological subject. It is an intriguing document of the interval in which he waited for the opportunity to execute in marble his full-scale plaster model of *Orpheus and Cerberus* (fig. 1), the masterwork that haunted Crawford in his financially troubled years between 1839 and 1843.

Carved in the year Crawford ordered the marble for that large statue, *Hyperion* can be said to be the first realization in stone of the concept of *Orpheus* and conveys much of *Orpheus's* dynamism. The inclination of the head, the implicit forward movement of the upper torso, and the sweep of drapery around the shoulders all give *Hyperion* a boldness unusual for a Neoclassical bust.

The bust was purchased by Mr. P. T. Homer of Boston, who, according to Crawford's biographer, had requested from the sculptor a copy of the head of

Fig. 1 Thomas Crawford, *Orpheus and Cerberus,* 1843. Marble, 67½ x 36 x 54 in. (171.5 x 91.4 x 137.2 cm). Museum of Fine Arts, Boston, gift of Mr. and Mrs. Cornelius Vermeule III, 1975

Orpheus.[1] Yet the bust lent by Homer to the Boston Athenaeum in 1843 was titled instead *Hyperion,* suggesting that on this occasion, as on others, Crawford changed the subject matter of a requested work. Without Orpheus's striding body and his hand shading his eyes, the bust's forehead and blank gaze achieve a new prominence, and the disembodied head seems more rigidly hieratic. Thus Crawford may have chosen a new identity for the work.

It is an unusual identity: in Greek mythology, Hyperion was one of the Titans, that most ancient and awesome generation of gods who were the progenitors of the rest of the Greek pantheon. Because Hyperion's specific domain was the sun, he was often identified, like Apollo, as the sun god Helios, who rode the heavens in his chariot.[2] Here, his diadem is *Orpheus*'s laurel wreath, which is also appropriate to Apollo. By melding the identity of the sun god Apollo with his forebear Hyperion, Crawford cast Apollo in a more ancient light and also linked the work with the Neoclassical philosophies of his teacher Thorvaldsen, who sought to present an antiquity that was specifically Greek, and to interpret it as a simpler, more severe, and more remote art than previous revival movements had done. Crawford showed his allegiance to those ideas in *Hyperion*, for he chose a name that is exclusively Greek and which had the advantage of referring to an elemental, almost primeval stage of antiquity.

As to the actual execution of *Hyperion*, Crawford may have finished it himself, for only after 1842 was he apparently able to afford the cost of hiring workers to do the final carving, as was then the general practice among marble sculptors. (The practice emphasized an important operating principle in Neoclassical sculpture: that mental discipline, not mere manual labor, was the crucial element in the final work of art.) The carving here is rather crude, and repairs at the base indicate that the bust originally tilted upright until a splice of marble was added to bend the head downward, as the sculptor intended it to be. The hair at the nape of the neck is pulled to one side, the forehead is raised, and the mouth is smaller than that of Orpheus. Overall the circumference of the head is reduced about an inch—leaving open the possibility that these changes were made after the work was pointed to the dimensions of *Orpheus*'s head.

DS

1 Gale, *Thomas Crawford*, p. 25. Thomas Cole, who was in Rome from late 1841 to the spring of 1842, similarly requested a bust of *Orpheus* (location unknown), which was exhibited at the National Academy of Design in 1843.

2 Michael Grant and John Hazel, *Gods and Mortals in Classical Mythology: A Dictionary* (New York, 1979), p. 188.

References Boston Athenaeum, 1844, *Description of the Orpheus and Other Works of Sculpture by Thomas G. Crawford, of Rome*, p. 7; Gale, *Thomas Crawford*, p. 25; L. Dimmick, "Thomas Crawford's *Orpheus*: The American Apollo Belvedere," *American Art Journal* 19, no. 4 (1988), pp. 68–69, 73, 75, 82–83, n. 70.

Exhibitions Boston Athenaeum, 1843, *Annual Exhibition of Paintings and Sculpture*, no. 43; Boston Athenaeum, 1844, *Annual Exhibition of Paintings and Sculpture*, no. 247; Hirschl and Adler Galleries, New York, 1986, *From the Studio*, no. 3.

Provenance P. T. Homer, Boston, by 1843; private collection, Boston; private collection, Boston, in the late 1930s; Hirschl and Adler Galleries, New York, 1984.

Museum purchase: gift of Mrs. George L. Craig, Jr., and Patrons Art Fund, 1986, 86.36

Jasper F. Cropsey
1823–1900

BORN ON STATEN ISLAND, Jasper Francis Cropsey attended the Mechanics Institute of the City of New York, where at an early age he developed an interest in the mechanical and technical aspects of art. At fifteen, he began a four-year apprenticeship in the office of New York architect Joseph Trench. However, an illness and forced convalescence in the countryside led him to take up landscape painting. In 1843 he exhibited his first landscape at the National Academy of Design. His election in the following year as an associate of the academy made him one of that institution's youngest members.

In 1847, having made a name for himself in New York art circles as an artist of singular promise, Cropsey embarked upon the obligatory tour of Europe. He spent the summer of 1847 in England, Scotland, and Wales. He then went on to Rome, where he befriended William Wetmore Story, rented Thomas Cole's former studio, and became an active member of the American artists' colony.

Soon after his return to the United States in 1849, Cropsey established himself as one of the country's leading landscape painters. Many of his works during the 1850s suggest the influence of Cole.

Hawking Party in the Time of Queen Elizabeth (1853, Corcoran Gallery of Art, Washington, D.C.), for example, is an exercise in historical landscape painting strongly reminiscent of Cole's *The Return from the Tournament* (1841, Corcoran Gallery of Art, Washington, D.C.); *Storm in the Wilderness* (1851, Cleveland Museum of Art) closely followed Cole's wild, romantic views of similar wilderness sites.

In order to further his reputation, Cropsey in 1856 began a six-year stay in London. His American landscapes were well received there, particularly by the influential critic John Ruskin. Perhaps through Ruskin's influence in turn, his work became more sharply realistic. Cropsey scored a triumph in 1860 with *Autumn on the Hudson River* (1860, National Gallery of Art, Washington, D.C.), an enormous panoramic vista in the spirit of the work of Frederic E. Church, whose *Heart of the Andes* (1859, Metropolitan Museum of Art, New York) had been a great success with London audiences the year before.

Cropsey continued to paint glowing autumnal landscapes after his return to New York. In 1876 he exhibited what was to become his single most popular painting, *The Old Red Mill* (1876, Chrysler Museum, Norfolk, Va.), at the Philadelphia Centennial Exposition, where it received a special award for "Beauty." He practiced architecture—an interest that he had never abandoned—designing a number of private houses (including his own home in Hastings-on-Hudson, New York, where he died) and the passenger stations for the Sixth Avenue elevated railway.

Cropsey's pastoral views were always rather conservative in composition and subject matter and became relatively more so with time because they changed little. During the 1880s and 1890s, he, like many artists of his generation, experienced a decline in popularity, and the approach to painting that had made him so popular was considered old-fashioned by the time of his death.

Bibliography William H. Forman, "Jasper Francis Cropsey, N.A.," *Manhattan Magazine* 3 (April 1884), pp. 372–82; University of Maryland Art Gallery, College Park, *Jasper F. Cropsey: A Retrospective View of America's*

Painter of Autumn (1968), exh. cat. by Peter Bermingham; National Collection of Fine Arts, Washington, D.C., *Jasper F. Cropsey 1823–1900* (1970), exh. cat. by William S. Talbot; William S. Talbot, *Jasper F. Cropsey, 1823–1900* (New York, 1977).

Florence, 1875

Oil on canvas
12 x 20 in. (30.5 x 50.8 cm)
Signature, date: J. F. Cropsey/1875 (lower right)

Although American landscape artists of Cropsey's generation considered native scenery their first interest, both they and their patrons delighted in the rich historical and literary associations of European—especially Italian—landscape. Cropsey, given his special interest in architecture, was particularly attracted to these subjects because of the architectural elements they allowed him to introduce. He made his debut at the National Academy of Design with *Italian Composition* (c. 1843, location unknown) and had painted several such landscapes before he actually set eyes on Italy in 1847.

Following Cropsey's return from Europe in 1849, Italian subjects based on sketches and on memory became a permanent part of his repertoire. Two are *Evening at Paestum* (1856, Vassar College Art Gallery, Poughkeepsie, N.Y.) and *View of Lake Nemi* (1879, Newark Museum, N.J.). *Florence* is another example of that same genre.

Despite the high valuation placed in Cropsey's day on accuracy, detail, and immediacy in the transcription of landscape, the recreation of distant places years after the artist's firsthand experience of them was by no means an uncommon practice. In justification, Cropsey could have cited Thomas Cole's advice to "wait for time to draw a veil over the common details, the unessential parts, which shall leave the great features, whether the beautiful or the sublime, dominant in the mind."[1]

Florence is Cropsey's only known finished painting of the Tuscan city. His stay there was relatively brief—three or four weeks in the spring of 1849. But his visit was long enough to allow him to make a number of detailed sketches for later use. Pencil sketches of *Panorama of Florence* (1849, collection Mrs. John C. Newington, Hastings-on-Hudson, N.Y.) and *San Miniato* (1849, Museum of Fine Arts, Boston) still survive.

The view Cropsey created twenty-six years later centered on the city's major landmarks: Brunelleschi's Duomo, Giotto's belltower, the apse and tower of the church of Santa Croce, Orsanmichele, the tower of the Badia, and the Arno. It bears comparison with Thomas Cole's *View of Florence from San Miniato* (1837, Cleveland Museum of Art), for, like Cole's painting, Cropsey's combined a panoramic river view of the city with the rustic staffage of peasants and grazing animals. The effect was to increase the timeless and legendary aspect of the scene and

Fig. 1 Velma Friedman, *View of Florence from the South Bank of the Arno at Ponte San Niccolo*, 1987. Photograph. Courtesy of Jane Haskell and Velma Friedman

thus place it within the tradition of Italianate landscape painting.

To accommodate the foreground vignette of goats and fisherfolk, Cropsey cut away the southern bank of the Arno, thus providing the picture with a pastoral point of entry. This bank and the river itself show a rich handling of paint that creates an evanescent effect of minutely broken surfaces. However, the effect of true capriccio is diminished by the solidity and sureness that characterize the Florentine buildings themselves, for across the Arno the view is absolutely accurate.

The relation of the buildings to the horizon and to one another indicates that Cropsey's vantage point was the south side of the present Ponte San Niccolo, at the eastern edge of the old city, near the area that was developed in the nineteenth century (fig. 1). The view allowed Cropsey to see the tourist center of Florence from its modern quarter and at the same time turn his back on the latter.

This particular vantage point allowed the belltower of Santa Croce and Brunelleschi's Duomo to appear as if next to one another. Cropsey makes much of this juxtaposition. In playing off the tallness and verticality of the former against the roundness and radial balance of the latter, he treats them as paragons of all the qualities of the Gothic architectural style set against those of the Renaissance.

The belltower of Santa Croce, the "medieval" fixture on Florence's skyline, was just being built when Cropsey went to Italy in 1847. Interestingly enough, it is the one building Cropsey felt the desire to edit—perhaps because of his own professional experience with Gothic Revival architecture. In Cropsey's hands, this addition to Santa Croce is considerably taller and more slender than the one actually built, giving an air of medieval antiquity to the city that had perhaps the richest Renaissance heritage in Italy.

In *Florence*, Cropsey handled the medium of oil paint so that it creates more surface glimmer than shadow, recalling the flickering, fleeting quality of eighteenth-century Venetian painting. It may be that Cropsey intended this little picture as a remembrance not only of Italy's architectural and pastoral heritage but of its great age of *veduta* painting as well.

DS, KN

1 William Cullen Bryant, "Funeral Oration on the Death of Thomas Cole," in John McCoubrey, ed., *American Art, 1700–1960: Sources and Documents* (Englewood Cliffs, N.J., 1965), p. 97.

Provenance James Maroney, New York, by 1982.

Richard K. Mellon Family Foundation, Pre-Twentieth-Century Painting Fund; Mrs. George R. Gibbons Fund; and Paintings Acquisition Fund, 1982, 82.14

J. Frank Currier
1843–1909

A DOMINATING FORCE in the American artists' colony at Munich, Joseph Frank Currier espoused a realist style characterized by bold brushwork and strong chiaroscuro. In Munich he joined numerous American expatriates—including William Merritt Chase, Frank Duveneck, and John Henry Twachtman—in a revolt against academic painting. Currier was one of the most innovative of the group; his bravura experimental technique and psychologically intense subjects show a complete disregard of convention and lead toward abstraction. Most compelling are his broadly painted, poignant studies of young peasants.

Born and raised in Boston, Currier worked alternately in a bank and in his father's prosperous stonecutting business during his youth. When he reached his twenties, he became a painter, studying in the second half of the 1860s with Boston's preeminent teacher, William Morris Hunt. In the last years of the decade, he was also tutored by George Fuller, who gave him sound instruction in landscape painting. Then, in 1869, he left Boston to study abroad; he would not return for thirty years.

Currier first settled in Antwerp and enrolled at that city's art academy, where he developed a strong feeling for structure through drawing and painting from casts. He devoted his spare time to landscape painting, and in April 1870 visited Paris, Ecouen, and Barbizon in order to study the work of contemporary French landscapists. The approach of the Barbizon school most impressed him, especially the application of heavy impasto, as practiced

by Jules Dupré. Currier subsequently incorporated this novel treatment of paint into his own style.

With the onset of the Franco-Prussian War in August 1870, Currier left France for Munich, which became a mecca for American artists during the 1870s. He studied at the art academy in Munich until 1872 and then established an independent studio, where from 1873 to 1877 he produced his most successful works: brilliant characterizations of Bavarian peasants, painted with a dark, rich palette and a heavy, vigorous technique. Currier's style was indebted to the painterly realism of his Munich contemporary Wilhelm Leibl and to the seventeenth-century masters Frans Hals and Diego Velázquez. "His portraits are painted with the dexterity of an old master," wrote the art critic Sadakichi Hartmann—a quality that "destined [Currier] to become one of the greatest painters of his generation."[1]

Many of the younger Americans in Munich looked to Currier as a mentor. After Duveneck's departure for Florence, Currier took over leadership of the American expatriate colony, including the enclave in the Bavarian village of Polling, where Americans gathered during the summer to paint the native peasants, cattle, and countryside. While outdoors, Currier frequently experimented with watercolor, pastel, and even photography; his landscape watercolors of the late 1870s made a big hit in New York. Nevertheless, his technical bravura brought him more notoriety than income, and he had to rely on financial assistance from his father. He was, however, elected a member of the Society of American Artists in 1880, and he exhibited widely, most often at the Society of American Artists and the American Watercolor Society. At Pittsburgh's Carnegie International, Currier enjoyed great favor. He exhibited eleven works in the first annual in 1896, contributed to both the 1901 and 1909 annuals, and served as the Munich representative to the Foreign Advisory Committee in 1897 and 1898.

Currier felt very much at home in Munich, but in 1899 anti-American feeling elicited by the Spanish-American War forced him to return to New England.

Extremely alienated, he could not read-
just to life in the United States, and
although he sometimes exhibited, he
never painted again. Losses in the 1907
stock-market panic added to his melan-
choly until, after several bouts of severe
depression, he entered a sanitarium. He
finally committed suicide by throwing
himself under a train near Boston.

1 Hartmann, *History of American Art*, vol. 2,
pp. 202–5.

Bibliography Sadakichi Hartmann, *A History
of American Art*, 2 vols. (1901; rev. ed., Boston,
1934), vol. 2, pp. 198, 202–5; Nelson C. White,
The Life and Art of J. Frank Currier (Cam-
bridge, Mass., 1936); Lyman Allyn Museum,
New London, Conn., *The Art of J. Frank
Currier and the Painters of the Munich School*
(1958), exh. cat., essay by Nelson C. White;
Dayton Art Institute, Ohio, *American Expa-
triate Painters of the Late Nineteenth Century*
(1976), exh. cat., essay by Michael Quick,
pp. 92, 149.

A Munich Boy, c. 1873–77

Oil on canvas
27 x 20 in. (68.6 x 50.8 cm)
Signature: J. F. Currier. (lower left)

Currier painted *A Munich Boy* between
1873 and 1877, his most creative and suc-
cessful years.[1] With the sharp highlights
and thick impasto representative of the
Munich school, the work depicts a boy in
peasant costume. Removing himself from
his subject's potential narrative, the artist
focused on texture and on contrasts
beween light and dark, modeling the
image directly in paint and constructing
it without tonal transitions. From unde-
fined shadow emerge thick, wide strokes
of pink and white paint, controlled by
the palette knife to dissolve and mold
structure simultaneously. The slashing
brushwork above careful underdrawing
pays tribute to Frans Hals and Diego
Velázquez.

The model portrayed in *A Munich Boy*
seems also to have been employed by
Currier as the model for *Peasant Girl*
(c. 1873–77, collection Nelson C. White,

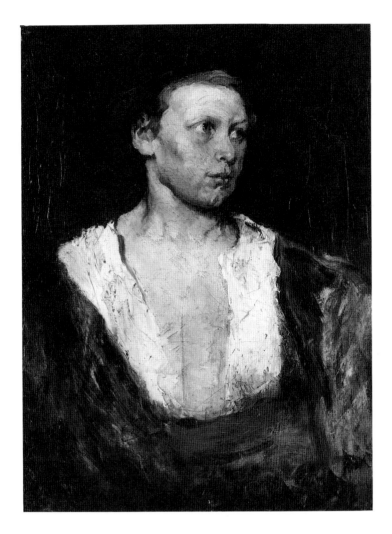

Waterford, Conn.). In his female incarna-
tion, the model is painted with large,
awkwardly rendered breasts, but he
retains the features, costume, and attitude
of the sitter in *A Munich Boy*. Each ver-
sion possesses the intensely sober mood
that came to characterize the work of the
American Munich school of the 1870s.
JM

1 White, *Life and Art of J. Frank Currier*,
p. 21.

References White, *Life and Art of J. Frank
Currier*, pp. 21, 54; *Christian Science Monitor*,
Jan. 28, 1936, p. 7.

Exhibitions Department of Fine Arts,
Carnegie Institute, Pittsburgh, 1909, *Thir-
teenth Annual Exhibition*, no. 63; Panama-
Pacific International Exposition, San Francis-
co, 1915, no. 2,529; Art Institute of Chicago,
1934, *Catalogue of a Century of Progress Exhibi-
tion of Paintings and Sculpture*, no. 387; M. H.
de Young Memorial Museum, San Francisco,
1935, *Exhibition of American Painting*, no. 82;
San Francisco Bay Exposition Co., 1939,
*Golden Gate International Exposition Historical
American Paintings*, no. 5; Lyman Allyn Muse-
um, New London, Conn., 1958, *The Art of J.
Frank Currier and the Painters of the Munich
School*, no. 12; Westmoreland County Muse-
um of Art, Greensburg, Pa., 1961, *American
Paintings, Eighteenth, Nineteenth, Twentieth
Centuries from the Collection of Carnegie Insti-
tute*, no cat.

Provenance The artist, until 1909; his estate,
1909.

Purchase, 1909, 9.4

Jo Davidson

1883–1952

THE PORTRAIT SCULPTOR Jo Davidson was born and raised in New York City and began to attend classes at the Art Students League there at the age of sixteen. At his parents' wishes he moved to New Haven to prepare for admission examinations for the Yale Medical School, but entered the Yale University School of Fine Art instead and soon became interested in sculpture. Between 1901 and 1904 he worked as a studio assistant to Hermon MacNeil, a sculptor known for his portrait statues and images of Indians, learning the technical dimensions of clay modeling.[1] In 1905 he completed his first commission, a statuette of *David*, which he exhibited at the Art Students League in New York.

Two years later Davidson traveled to Paris; he studied at the Ecole des Beaux-Arts for only three weeks before leaving behind formal training for the broader lessons offered outside academy classrooms. Although he returned periodically to the United States, France remained his residence of choice for the rest of his life. Davidson was represented in the Salon of 1909 and won the admiration and patronage of Gertrude Vanderbilt Whitney.

When he came to live in New York around 1913, he began to specialize in bronze portrait busts rendered in a bold but naturalistic style. He had a solo exhibition in 1911 at the Reinhardt Galleries, Chicago, followed by another in 1913 at the New York branch of the same gallery. He contributed seven sculptures and ten drawings to the 1913 Armory Show; however, in the face of growing modernity, he maintained his strong commitment to the tradition of representational imagery. During World War I, Davidson served as an illustrator at the front and then returned to the United States, where he executed a bust of President Woodrow Wilson. In 1918 he continued to portray political figures, among them General John Joseph Pershing and Field Marshal Ferdinand Foch.

Davidson became one of the distinguished naturalistic sculptors active during the period between the two world wars. He was responsible for likenesses of James Joyce, Rudyard Kipling, H. G. Wells, and other prominent writers.[2] Other portrait ensembles followed, including images of Latin American presidents and a planned series representing delegates to the United Nations. A subsequent heart attack interrupted Davidson's activities, but he continued to plan images commemorating leaders of the French Resistance during his recuperation at his home near Paris.[3] Davidson enjoyed a most prolific and honored career, distinguished by the Maynard Prize of the National Academy of Design (1934) and his installation as a Chevalier of the French Legion of Honor. He died near Tours, France.

1 Craven, *Sculpture in America*, p. 557.

2 Ibid., p. 559.

3 Ibid., p. 560.

Bibliography Jo Davidson, *Between Sittings: An Informal Autobiography* (New York, 1951); Wayne Craven, *Sculpture in America* (1968; rev. ed., Newark, Del., 1984), pp. 557–60; Whitney Museum of American Art, New York, *Two Hundred Years of American Sculpture* (1976), exh. cat. by Tom Armstrong et al., p. 266.

Gertrude Stein, Seated, 1923, cast 1949(?)

Bronze
7⅞ x 5¾ x 6¼ in. (20 x 14.6 x 15.9 cm)
Markings: J. DAVIDSON/PARIS (proper right hip)

Jo Davidson met Gertrude Stein (1874–1946) during his first trip to France. During the early 1920s he executed a full-length seated portrait of her, which exists today in bronze (modeled in 1920, cast in 1954, Whitney Museum of American Art, New York) and in terracotta (1923, National Portrait Gallery, Washington, D.C.). That same year, Davidson, who often created variations in size and mediums of a favorite subject, made a plaster model for a reduced

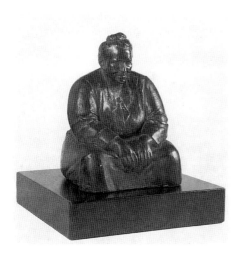

bronze version of the portrait. The Carnegie's sculpture is one of six reductions made during Davidson's lifetime; six more were cast posthumously in 1986.

Recalling his sitter, their friendship, and his portrait of her, Davidson wrote:

> To do a head of Gertrude was not enough—there was so much more to her than that. So I did a seated figure of her—a sort of modern Buddha. While I was doing her portrait, she would come around to my studio with a manuscript and read it aloud. "A rose is a rose is a rose," took on a different meaning with each inflection. There was an eternal quality about her—she somehow symbolized wisdom.[1]

In some respects Davidson's Buddhalike interpretation of Stein corresponds to the spirit of Pablo Picasso's pre-Cubist portrait of her (1906, Metropolitan Museum of Art, New York). Davidson's image, like Picasso's, was emphatically monumental. It stressed volume and closed plastic mass, while simplifying detail. Her ponderous shape embodies at once Stein's physical presence and her weighty intellect. Davidson's decision to show her with eyes downcast in reflection, hands resting against her skirt, allows the image to communicate psychic containment, physical equanimity, and a contemplative spirit. The result is dignity and simplicity of content and form.

LM, LAH

1 Davidson, *Between Sittings*, p. 175.

References Davidson, *Between Sittings*, pp. 174–75; Craven, *Sculpture in America*, p. 559; Whitney Museum of American Art, *Two Hundred Years of American Sculpture*, p. 266;

National Portrait Gallery, Washington, D.C., 1978, *Jo Davidson, Portrait Sculpture*, exh. cat., biographical entries prepared by M. Pachter and A. E. Henderson, [p. 8].

Provenance Charles J. Rosenbloom, Pittsburgh, c. 1950.

Bequest of Charles J. Rosenbloom, 1974, 74.7.30

Arthur B. Davies
1862–1928

A MEMBER OF THE Eight and a principal organizer of the Armory Show in 1913, Arthur Bowen Davies is better known today as a champion of modernism than he is for his own art, which remained tied to late nineteenth-century Symbolism. Born in Utica, New York, of British immigrants—his father was a Welsh Methodist minister—Davies displayed a youthful talent for drawing; at the age of fifteen he began taking lessons from Dwight Williams, a landscape painter who lived nearby. When his family moved to Chicago in 1879, Davies continued his training at the Chicago Academy of Design. Late in 1881 he joined an engineering firm as a draftsman, spending two years surveying a railroad line in Mexico. The long, low mountains that he repeatedly sketched during this trip became an enduring motif in his art. In the fall of 1883 he returned to the Midwest to enroll at the School of the Art Institute of Chicago, studying painting under Charles Corwin.

Lacking the funds to go abroad, Davies moved in 1886 to New York City, where he attended classes at the Art Students League and the Gotham Art Students. Until 1888, when he began exhibiting regularly, he derived a small income from contributing illustrations to various periodicals, including *Century Magazine* and *Saint Nicholas*. In 1892 he married Lucy Virginia Meriwether Davis, a physician, and lived at their farm in Congers, New York, north of New York City. Initially the country landscape engaged his attention, but he soon became dissatisfied with the isolation; in 1893 he took a studio in New York City, thereafter visiting the farm only on weekends.

After 1893 Davies was represented by the art dealer William Macbeth, whose gallery featured contemporary American art. A loyal friend and client, Macbeth was instrumental in arranging Davies's first trip to Europe in 1895, and in 1896 mounted the first solo exhibition of his work. (Important exhibitions of Davies's work were held at the Macbeth Gallery, New York, in 1897, 1901, 1905, 1909, and 1918.) At this time Davies was producing richly textured, intimately scaled landscapes with figures that were quite realistic in comparison with his later work. In 1897, as Macbeth's purchasing agent, Davies made a second trip to Europe, touring England, Germany, Italy, and the Netherlands. During this trip he eclectically absorbed ideas for his own art from sources that included the frescoes at Pompeii, Giorgione, the Pre-Raphaelites, James McNeill Whistler, Pierre Puvis de Chavannes, and Arnold Böcklin. Shortly after his return he met Albert P. Ryder, whose romantic fantasies he also admired.

By 1900 he had become estranged from his wife. He began to travel frequently, visiting places as diverse as Newfoundland, the Berkshires, and the redwood forests of California; his many oil sketches reflect a deep sensitivity to the changing landscape. After his return to New York, his compositions became more friezelike, punctuated by stylized nudes gracefully posed against mountainous backgrounds; his already poetic images became increasingly visionary. *Unicorns*, perhaps his best-known painting (1906, Metropolitan Museum of Art, New York), is an exemplar of the idyllic landscapes he produced at this time.

In 1905 he began living clandestinely with a dancer named Edna Potter, who was his frequent model; although the couple eventually had a child, Davies's second family remained a secret until after his death. During these years he continued to exhibit at Macbeth's, where he met Robert Henri and other young, innovative artists. He acted as an advisor to the modern-art collector Lillie Bliss, whose acquisitions eventually became the foundation of the Museum of Modern Art, New York.

Although his own painting was rooted in the Romantic tradition, Davies was an ardent promoter of the avant-garde. In 1908, to protest the restrictive policies of the National Academy of Design, he

exhibited with Robert Henri and the Eight, a group primarily composed of new urban realists. While Davies's idyllic visions had little in common with their imagery, he shared with them a distaste for academic standards. Five years later, as president of the Association of American Painters and Sculptors, Davies helped to organize the *International Exhibition of Modern Art*, better known as the Armory Show of 1913. This landmark exhibition overwhelmed Americans with a view of European Cubism, Fauvism, and other Post-Impressionist work.

Influenced by these movements and by the American Synchromists Morgan Russell and Stanton Macdonald-Wright, Davies transformed his lyrical nudes into prismatic figures, as in *Dances*, a mural-size work completed in 1915 (Detroit Institute of Arts). By 1917 Davies turned his attention to printmaking; using special inks and colored papers, he experimented with innovative techniques until the mid-1920s. He also worked as a sculptor before returning to his traditional painted images of elegant nudes in Arcadian landscapes, many of which were inspired by his theory of "inhalation," in which the vitality of the figure was attributed to the fact that it appeared to be taking in air.

In his last years Davies divided his time between the United States and travel in Europe, where he supervised the weaving of his tapestry designs at the Gobelins factory in France and painted evocative watercolors of the Italian countryside. In Pittsburgh he exhibited in every Carnegie International between 1924 and 1927, and was given a solo show in 1924. He died suddenly in Florence in 1928, of heart failure. The Metropolitan Museum of Art, New York, gave him a memorial exhibition in 1930.

Bibliography Phillips Memorial Art Gallery, Washington, D.C., *Arthur B. Davies: Essays on the Man and His Art* (Cambridge, Mass., 1924), essays by Duncan Phillips, Dwight Williams, et al.; Royal Cortissoz, *Arthur B. Davies* (New York, 1931); "Arthur Bowen Davies," *Index of Twentieth Century Artists* 4 (February 1937), pp. 385–400; Brooks Wright, *The Artist and the Unicorn: The Lives of Arthur B. Davies, 1862–1928* (New York, 1978); Joseph S. Czestochowski, *The Works of Arthur B. Davies* (Chicago, 1979).

Nudes, c. 1916–17

Tempera on plaster on wood panel
7⅛ x 16⅟₁₆ in. (18.1 x 40.8 cm)

Signature: A. B. Davies—(lower center)

Inscription: *To Ananda Coomaraswamy/Arthur B. Davies* (on reverse)

Nudes is one of several small tempera panel paintings related to Davies's brief experiments with Cubism and its variation Synchromism. The artist's exploration of these modern styles was stimulated by his contact with contemporary European art while organizing the Armory Show of 1913. By applying faceted areas of bright color to the human figure, Davies adapted the new abstract aesthetic to his favorite theme of nudes in lyrical processions.

This modernist phase of Davies's career culminated in 1915, when he executed a large mural called *Dances* (Detroit Institute of Arts), inspired by the Synchromist paintings of Morgan Russell. Russell's use of rhythmic shapes and harmonic color schemes chimed with Davies's own desire for visual equivalents to music and dance. Davies's adaptations, however, were more superficial and did

not change his art in a lasting way, and he gradually returned to his pre–Armory Show style.

Although *Nudes* is undated, its reduced fracturing places it near the end of Davies's modernist interlude, around 1916–17. The technique of this painting, too, is typical of Davies's later style, with pencil outlines, subtle modeling, and delicate washes. The result is comparable to works like *An Antique Orison* (c. 1915, Art Institute of Chicago) and *Figures* (c. 1916, Munson-Williams-Proctor Institute, Utica, N.Y.): the seven female figures in *Nudes* are placed close to the picture plane in an ambiguous space, their overlapping bodies cropped by the frame, so that they appear to be floating. The rounded contours, emphasized with pencil lines, heighten the sensuousness of Davies's theme.

Pale, opalescent colors shift over the planar surfaces of the figures, while more intense tones of gold, green, and red form abstract shapes between them. The repetition in the arrangements of the women's dark hair creates a decorative surface pattern reminiscent of Asian art.

The reverse of this painting carries an inscription to Ananda Coomaraswamy, then the curator of Asian art at the Boston Museum of Fine Arts and a popular writer on Hinduism and Buddhism. His acquaintance with Davies appears to have stemmed from a mutual friendship with a New York avant-garde couple, John and Mary Mowbray-Clarke. During the 1910s and 1920s Coomaraswamy was deeply involved in the contemporary art scene in New York, and he and Davies shared a number of special interests, including music and modern dance.
GB

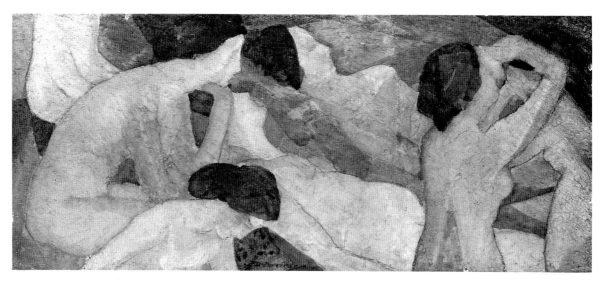

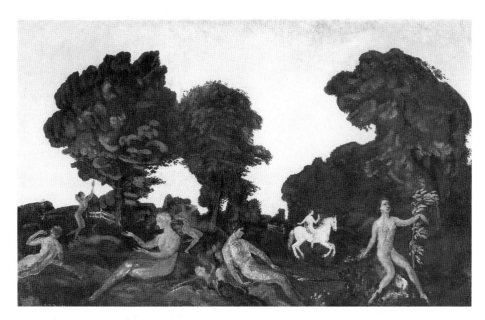

Reference C. C. Stewart, "New Accessions: Prendergast and Davies," *Carnegie Magazine* 44 (Mar. 1970), pp. 97–100.

Provenance Ananda Coomaraswamy; Weyhe Gallery, New York; Albert and Ruth McVitty; Ira Spanierman Gallery, New York.

Leisser Art Fund, 1969, 69.12

See Color Plate 23.

At the Chestnut Root, c. 1917
(Chestnut Root)

Oil on canvas
26 x 40 in. (66 x 101.6 cm)
Signature: A. B. DAVIES (lower left)

Painted primarily in reddish browns, deep greens, and rusty oranges, this large landscape, with its dark tonality, evokes the somber mood of late autumn; undulating masses of dense foliage, silhouetted against the gray-blue sky, contribute to an ominous feeling. Self-absorbed, the seven figures seem oblivious to the emotionally charged atmosphere surrounding them. Albeit obscure, the title of the painting suggests that this work may have had a personal meaning for Davies: in 1898 his infant daughter Sylvia (born July 1897) died of meningitis and was buried at the farm in Congers. A passage from Virginia Davies's diary indicates that the child's grave was beneath a chestnut tree: "The brown chestnut leaves lie close over my darling['s] grave—curled like a scroll, serried feathers over the darling breast."[1] For Davies, who was a spiritualist, this series of androgynous nudes may have symbolized the transmigration of Sylvia's soul.

While the motif of a youthful rider on a white horse appears periodically in Davies's art, it is most often associated with such early works as *Breath of Autumn* (c. 1897, collection Herbert Baer Brill, New York) and *On the Road to the Enchanted Castle* (c. 1895, collection Herbert Baer Brill, New York). Both of these are studies of childhood, painted while Davies's first marriage was still stable.

GB

1 Wright, *The Artist and the Unicorn*, p. 39.

References "Carnegie Buys Works by Davies and Eakins," *Art News* 29 (Feb. 28, 1931), p. 8; D. L. Smith, "Romanticism and the American Tradition," *American Artist* 26 (Mar. 1962), p. 32; C. C. Stewart, "At the Chestnut Root," *Carnegie Magazine* 39 (Mar. 1965), p. 105.

Exhibitions Department of Fine Arts, Carnegie Institute, Pittsburgh, 1927, *Twenty-sixth Annual International Exhibition of Paintings*, no. 33, as *Chestnut Root;* Department of Fine Arts, Carnegie Institute, Pittsburgh, 1940, *Patrons Art Fund Exhibition*, no. 23; Department of Fine Arts, Carnegie Institute, Pittsburgh, 1958, *Retrospective Exhibition of Paintings from Previous Internationals*, no. 42; Munson-Williams-Proctor Institute, Utica, N.Y., 1962, *Arthur B. Davies: A Centennial Exhibition*, no. 35; M. Knoedler and Co., New York, 1975, *Arthur B. Davies: A Chronological Retrospective*, no. 15.

Provenance Ferargil Galleries, New York, by 1927; Reinhardt Galleries, New York, by 1930.

Patrons Art Fund, 1930, 30.6

The South's Breath, c. 1920
(Two Nudes)

Oil on canvas
26 x 40 in. (66 x 101.6 cm)
Signature: A. B. DAVIES (lower left)

Silhouetted against a hilly background, the two nudes in *The South's Breath* stand on tiptoe, their backs to the picture plane and their arms curving gracefully over their heads in dancelike poses. The arching branches of the tree to the right and the flowing outlines of the landscape echo the sensuous movements of the figures. Davies's delicate color scheme, rendered in varying shades of green, enhances the feminine quality of the work, while his careful balancing of forms creates a calm image; typically, a linear rhythm unifies the composition. Using a technique analogous to his work in color graphics, Davies stained the canvas with washes of color, leaving no apparent trace of brushwork. This process, which can be seen in many of Davies's paintings after 1920, places greater emphasis on the decorative aspects of the design.

According to the dealer who initially handled this painting for Davies, the work was originally called simply *Two Nudes*.[1] The title change occurred sometime in the early 1920s. Although the

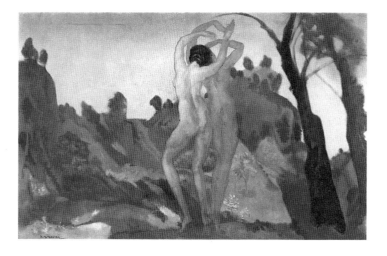

message is characteristically cryptic, it suggests a reference to Davies's theory of "inhalation" in art, adopted from the breathing practices central to dancers' conditioning, which he may have learned from Edna Potter. But given Davies's interest in the occult, the source for his ideas may have been in yoga, where breathing symbolizes the assumption of spiritual power. In *The South's Breath*, the nude figures rise up, lifting their arms as if to inhale the nurturing south wind, which here may be understood to mean the breath of nature at its most caressing and benign. Such a reading accords well with Davies's transcendental vision of a universal harmony between man and nature.

GB

1 Frederic Newman Price, Ferargil Galleries, New York, to John O'Connor, Jr., January 12, 1937, Carnegie Institute Papers, Archives of American Art, Washington, D.C.

References "Davies: A Second Oil by a Shy Modern Master Joins the Carnegie Institute's Permanent Collection," Pittsburgh *Bulletin Index*, Mar. 25, 1937, p. 16; J. O'Connor, Jr., "Gift of Stephen C. Clark: Painting by Arthur B. Davies Presented to the Carnegie Institute," *Carnegie Magazine* 10 (Mar. 1937), pp. 314–15; "Clark Gives Carnegie a Davies Rhythm," *Art Digest* 11 (May 15, 1937), p. 15.

Exhibitions Department of Fine Arts, Carnegie Institute, Pittsburgh, 1924, *Arthur B. Davies: Paintings, Drawings, Watercolors*, no. 33; Davenport Municipal Art Gallery, Iowa, 1939, *An Exhibition of American Art from Its Infancy to the Present*, no cat.; Columbus Museum of Art, Ohio, 1952, *Paintings from the Pittsburgh Collection*, no cat.

Provenance Ferargil Galleries, New York, until 1924, as *Two Nudes*; Stephen C. Clark, New York (after 1925 on indefinite loan to Carnegie Institute).

Gift of Stephen C. Clark, 1937, 37.2

Fred A. Demmler
1888–1918

PERHAPS THE ONLY Pittsburgh painter directly involved with the Boston school, Frederick Adolph Demmler pursued his brief career in his native city. The son of a successful businessman, he was raised in the Manchester district of Pittsburgh where, as a high-school student, he attended Saturday and summer classes at the H. S. Stevenson Art School. After graduating from Allegheny High School in 1907 he studied architecture for two years at Cornell University in Ithaca, New York. Then, having decided to become an artist, he entered the School of the Museum of Fine Arts in Boston.

In Boston his teachers included the noted Impressionists Edmund Tarbell and Frank Benson, under whose influence he turned to portraiture. Demmler still maintained close ties to his birthplace: he exhibited three paintings at the 1912 exhibition of the Associated Artists of Pittsburgh, and *The Black Hat*, in the style of Tarbell, appeared in the 1914 Carnegie Institute annual exhibition.

Demmler's friends in Boston included Lucien Price, an editorial writer for the *Boston Daily Globe*, who published a laudatory biography of the artist in 1919, and Alexander James, a fellow student at the Museum School and son of the philosopher and psychologist William James. Demmler and James traveled together to Europe in June 1914, intending to spend a year in London, Paris, and Munich. In London Demmler met Henry James and visited John Singer Sargent at his studio. The outbreak of World War I forced the artist to cancel his European tour; he returned to the United States just four months after his arrival.

Though Demmler's friends urged him to settle in Boston, he moved back to Pittsburgh. "I want to paint and I do not want to play social politics in order to get commissions, as I am afraid I would have to do in Boston," he explained. "Besides, in Pittsburgh, there are fewer painters to influence me. I stand more chance of being myself."[1]

Demmler exhibited annually with the Associated Artists of Pittsburgh from 1915 until 1918. In 1917 the young artist served as that organization's first vice president and as chairman of its jury of selection and award. Though primarily a portraitist, Demmler hoped to paint Pittsburgh and its steel mills "exactly as they are... not sentimentalized like the magazine covers; not made romantic, as Joseph Pennell has made them; but painted in all their horror."[2]

The artist never realized that goal. Drafted into the army in April 1918, he declined to serve as a noncombatant camouflage painter, instead joining a machine-gun batallion. On October 31 he was critically wounded in Belgium by an exploding shell and died in a field hospital three days later, just nine days before the Armistice. In the following year his contributions as a Pittsburgh artist were remembered by the Associated Artists of Pittsburgh, which assembled a retrospective exhibition of his work shown at the group's annual exhibition and at the Museum School in Boston; Carnegie Institute held a memorial exhibition of his work that year.

1 Price, *Immortal Youth*, pp. 29–30.
2 Ibid., p. 16.

Bibliography Lucien Price, *Immortal Youth: A Study in the Will to Create—A Memoir of Fred A. Demmler* (Boston, 1919); Ron Caplan, "Requiem for a Painter," *Pittsburgh Press*, June 9, 1968, pp. 10–11; Dorli Demmler McWayne, "Catalogue Raisonné of Fred A. Demmler," 1974, manuscript, Oscar Demmler family papers, Pittsburgh; Donald Miller, "Immortal Youth Remembered," *Carnegie Magazine* 52 (January 1978), pp. 24–30; Ruth Bener, "Fred Demmler," November 1978, manuscript for Women's Literary Club, Pittsburgh, museum files, The Carnegie Museum of Art, Pittsburgh.

The Black Hat, 1914

Oil on canvas
32 x 26 in. (81.3 x 66 cm)
Signature, date: Fred A. Demmler/14 (lower right)

Painted during a visit to Pittsburgh in the spring of 1914, *The Black Hat* was the only work by Demmler to appear in a Carnegie International. His model was a

friend, Mary Ethel Schreiner, whom he had known since high school. The painting hovers between a movingly truthful representation of an unassuming, ungainly young woman and an evocation of an ethereal, idealized feminine type. The latter was a class of image of which Demmler's teachers, Frank Benson and Edmund Tarbell, were leading exponents.

Demmler may have been influenced specifically by Benson's *Black Hat* (1904, Museum of Art, Rhode Island School of Design, Providence, R.I.) and Tarbell's *Black Hat* (1899–1923, private collection). Following Tarbell's example, Demmler set his figure at an angle against a plain background and emphasized the long neck and attenuated hands of the sitter, who, like Tarbell's figure, wears a dark dress trimmed in white and a plumed hat.

By 1914, however, Demmler had come to regard the work of his teachers as overly slick and lacking in vigor. "I don't say I shall ever be able to paint as well as they can," he told Lucien Price, "but I must be myself, not an imitation Tarbell."[1] Though the influence of Benson and Tarbell persists in *The Black Hat*, Demmler had begun to turn away from their superficial elegance. He embraced instead a more sober, direct psychology and some of the same grittiness visible in works such as John Sloan's *Yolande in a Large Hat* (1910, Whitney Museum of American Art, New York) and Alfred Maurer's *The Black Parasol* (see p. 349). Lucien Price was observing this dual aspect of Demmler's picture when he said, "The face is almost entirely averted, and yet you guess the girl's whimsical, independent personality by the nervous tapping of the long fingers of her right hand on the arm of her chair."[2]

KN

Gloria Gilmore-House conducted the archival research for this article.

1 Price, *Immortal Youth*, p. 9.

2 Lucien Price, "Afterglow of an Artist," *Boston Daily Globe*, November 2, 1919.

References L. Price, "Afterglow of an Artist," *Boston Daily Globe*, Nov. 2, 1919, Editorial and News Feature Section, p. 7; McWayne, "Catalogue Raisonné of Fred A. Demmler," 1974, no. 94; D. Miller, "An Artist Rescued from Oblivion," *Pittsburgh Post-Gazette*, Jan. 5, 1977, p. 41; D. Miller, "Immortal Youth Remembered," pp. 26–27.

Exhibitions Department of Fine Arts, Carnegie Institute, Pittsburgh, 1914, *Eighteenth Annual Exhibition*, no. 72; Department of Fine Arts, Carnegie Institute, Pittsburgh, 1919, *Tenth Annual Exhibition of the Associated Artists of Pittsburgh*, no. 41; Museum of Fine Arts, Boston, 1919–20, *Memorial Exhibition of Paintings by Fred A. Demmler*, no cat.; Westmoreland County Museum of Art, Greensburg, Pa., 1981, *Southwestern Pennsylvania Painters, 1800–1945*, exh. cat. by P. A. Chew and J. A. Sakal, no. 38.

Provenance Mary Ethel Schreiner and her daughter, Mrs. Herbert H. Baer, Arcata, Calif., until 1973; the artist's brother, Oscar W. Demmler, and his wife, Dorothy Demmler, Pittsburgh, 1973.

Gift of Oscar W. Demmler, 1976, 76.30.1

Vera, 1916

Oil on canvas
42¼ x 32 in. (107.3 x 81.3 cm)
Signature, date: Fred A. Demmler/1916 (lower right)

By 1916 Demmler had freed himself from the influence of Frank Benson and Edward Tarbell. While retaining their fluid brushwork and subdued palette, his approach became distinctly more direct and corporeal. Demmler's friend Lucien Price recalled that it had been his "ruling passion to transfer the secrets of human character from a face to a canvas."[1] The Pittsburgh poet and teacher Haniel Long, who sat for Demmler in 1917, was apparently in agreement. He paid a poetic tribute to the artist's ability to probe into his sitter's personality:

> You are six feet away
> yet you leap at me
> leap into my being
> with your eyes.
> …distances one cannot cross
> you cross
> and entrances one cannot enter
> you enter.[2]

Vera is a portrait of Vera Parsons, a young Canadian woman who was attending school in Pittsburgh when Demmler asked her to sit for him. According to Demmler's biographer, this portrait was an attempt to overcome the cliché associated with the depiction of women:

> There is a portrait painted at about this time which tells the story of the inner struggle which [Demmler] was fighting and winning. It is of a young girl, about his own age, with a wondrously sweet expression and sparkling eyes. The delicacy, the spirituality which shines through it makes it hard to

believe that the portrait could have been painted by a young man. Not a hint of sexuality. He later told me that the girl was afflicted with a lameness and he told how grateful he was to her for valuing him for his mind and not obtruding sex. I doubt if he knew how publicly yet with what delicacy he had thanked her.[3]

In the fall of 1916 Demmler exhibited *Vera* at the seventh annual exhibition of the Associated Artists of Pittsburgh, where it won third prize. It was the first painting purchased by the One Hundred Friends of Pittsburgh Art, an organization formed to donate works of art to the Pittsburgh public schools. By 1974 the school board had retired *Vera* from its active art collection and returned the painting to the artist's younger brother, Oscar Demmler. Demmler gave it, together with *The Black Hat*, to The Carnegie Museum of Art so that his brother's art would be permanently represented in his native city.

KN

Gloria Gilmore-House conducted the archival research for this article.

1 Lucien Price, "Afterglow of an Artist," *Boston Daily Globe*, November 2, 1919.

2 "The Poet Has His Portrait Painted," 1917, in Price, "Afterglow of an Artist," p. 7.

3 Price, *Immortal Youth*, p. 35.

References Price, *Immortal Youth*, p. 35; J. O'Connor, Jr., "One Hundred Friends Exhibition," *Carnegie Magazine* 16 (Nov. 1942), p. 168; McWayne, "Catalogue Raisonné of Fred A. Demmler," 1974, no. 112; D. Miller, "An

Artist Rescued from Oblivion," *Pittsburgh Post-Gazette*, Jan. 5, 1977, p. 41; Miller, "Immortal Youth Remembered," pp. 28–29.

Exhibitions Department of Fine Arts, Carnegie Institute, Pittsburgh, 1916, *Seventh Annual Exhibition of the Associated Artists of Pittsburgh*, no. 21; Department of Fine Arts, Carnegie Institute, Pittsburgh, 1919, *Tenth Annual Exhibition of the Associated Artists of Pittsburgh*, no. 44; Museum of Fine Arts, Boston, 1919–20, *Memorial Exhibition of Paintings by Fred A. Demmler*, no. cat.; Department of Fine Arts, Carnegie Institute, Pittsburgh, 1930, *Paintings by Local Artists Presented to Pittsburgh Public Schools by the One Hundred Friends of Pittsburgh Art*, no. 47; Department of Fine Arts, Carnegie Institute, Pittsburgh, 1942, *Exhibition of Paintings by Western Pennsylvania Artists Presented to the Pittsburgh Public Schools by One Hundred Friends of Pittsburgh Art*, no. 70; Westmoreland County Museum of Art, Greensburg, Pa., 1981, *Southwestern Pennsylvania Painters, 1800–1945*, exh. cat. by P. A. Chew and J. A. Sakal, no. 39.

Provenance Board of Public Education, Pittsburgh, 1916; the artist's brother, Oscar W. Demmler, Pittsburgh, 1974.

Gift of Oscar W. Demmler, 1976, 76.30.2

Thomas Wilmer Dewing
1851–1938

IN STARK CONTRAST to his delicate and refined paintings, Thomas Wilmer Dewing himself was a robust, gregarious, and witty individual who smoked heavily and swore loudly. Propelled, however, by his belief that "the purpose of the artist [is] to see beautifully,"[1] Dewing became a leading American exponent of Aestheticism, producing some of the most evocative and poetic paintings in late nineteenth-century American art.

Born in Boston, the son of a millwright, Dewing demonstrated a precocious talent for draftsmanship. While still in his teens he was apprenticed to a lithographer and attended classes in life drawing at Boston's School of the Museum of Fine Arts. He worked briefly as a portraitist in Albany, New York, before going to Paris in 1876 for further training. During the next two years he studied at the Académie Julian with Gustave Boulanger and Jules-Joseph Lefebvre, where he learned the precise figural style and controlled brushwork that

would earn him high praise from critics throughout his career.

In 1879, following his return to Boston, Dewing began to exhibit his finely drawn academic paintings in Philadelphia at the Pennsylvania Academy of the Fine Arts and at the National Academy of Design in New York. Late in 1880 he moved to New York, where he soon married Maria Oakey, an accomplished painter who had been a pupil of William Morris Hunt and John La Farge. The couple began to spend summers in Cornish, New Hampshire, along with Augustus Saint-Gaudens, helping to establish the area as a summer art colony. The verdant Cornish countryside provided inspiration for many of Dewing's landscapes.

For seven years, beginning in 1881, Dewing taught at the Art Students League in New York; in 1888 he was elected academician at the National Academy of Design there. Inspired by the British Aesthetic movement, his works during this interval consisted chiefly of allegorical figure paintings, often with literary allusions. These were executed with exquisite craftsmanship, their smooth surfaces and graphic accuracy reflecting Dewing's studies in France. The most important of them, *The Days* (1887, Wadsworth Atheneum, Hartford, Conn.), won the Thomas B. Clarke Prize at the National Academy in the year it was painted.

Around 1890, influenced by James McNeill Whistler and Japanese prints, Dewing began to create the images of elegant, introspective women that made his reputation. Isolated in decorative landscapes or seated in austere interiors, these women were invariably painted in soft, muted tones. In canvases such as *After Sunset* (1892, Freer Gallery of Art, Washington, D.C.) or *A Reading* (1897, National Collection of Fine Arts, Washington, D.C.), they evoke the mysterious, enigmatic mood that characterizes Dewing's mature manner. The artist sought similar effects in two graphic mediums, pastel and silverpoint, becoming perhaps the most distinguished American silverpoint draftsman.

Dewing was made a member of the Society of American Artists, New York, in 1880 and exhibited there until 1897. In that year he joined the Ten American Painters, a secessionist group oriented

mainly toward Impressionism, whose members sought more equitable exhibition practices. Dewing also exhibited frequently at Carnegie Institute. His paintings appeared in twelve Carnegie Internationals between 1904 and 1930, and in 1924 Carnegie Institute mounted a solo show of his work.

After 1891 Dewing enjoyed the patronage of Detroit industrialist Charles Lang Freer, who stimulated his interest in traditional Oriental art. Freer built a major collection of Dewing's work, now located at the Freer Gallery of Art, Washington, D.C. Another sizable collection, that of John Gellatly of New York, is now at the National Museum of American Art in Washington, D.C.

Dewing died in New York City. Highly regarded during the first quarter of the twentieth century, he was soon forgotten after his death; although his reputation has since revived, no major study of his life and work has yet been published.

1 Hobbs, "Thomas Wilmer Dewing: The Early Years," p. 5.

Bibliography Charles H. Caffin, "The Art of Thomas W. Dewing," *Harper's Monthly Magazine* 116 (April 1908), pp. 714–24; Royal Cortissoz, "An American Artist Canonized in the Freer Gallery—Thomas W. Dewing," *Scribner's Magazine* 74 (November 1923), pp. 539–46; Nelson C. White, "The Art of Thomas W. Dewing," *Art and Archaeology* 27 (June 1929), pp. 253–61; M. H. de Young Memorial Museum and California Palace of the Legion of Honor, San Francisco, *The Color of Mood: American Tonalism, 1880–1910* (1972), exh. cat. by Wanda M. Corn, pp. 4, 5, 10–12, 37; Susan Hobbs, "Thomas Wilmer Dewing: The Early Years, 1852–1885," *American Art Journal* 13 (Spring 1981), pp. 4–35.

Morning Glories, 1900

Oil on canvas mounted on three wood panels
64½ x 72 in. (163.8 x 182.9 cm) overall
Each panel 24 in. (61 cm) wide
Signature: T W Dewing (lower left of each panel)

This three-part folding screen depicts three female figures in classical dress, gracefully posed against a soft, atmospheric background amid morning-glory vines and blossoms; a long flowering tendril, painted diagonally across the lower third of the screen, unifies the design. Originally intended as a companion piece to a screen titled *Cherry Blossoms* (1900,

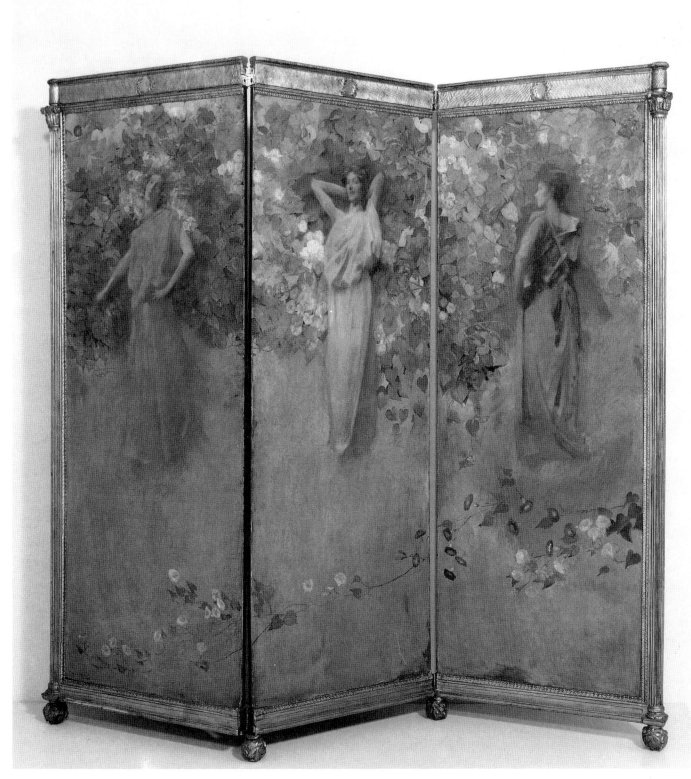

location unknown), *Morning Glories* was painted in the summer of 1900 for the Detroit residence of Colonel Frank Hecker, business associate and close friend of industrialist and collector Charles Lang Freer, Dewing's frequent patron. Hecker's French Renaissance–style house was designed by Louis Kamper, a protégé of the architect Stanford White.

By the late 1800s, screens were a common accessory in well-appointed households, promoted as a way of creating intimate corners or complex spatial views.

With its light, delicate tone and classical formality, *Morning Glories* was designed to harmonize with Hecker's house, in which the work probably functioned as a divider between the adjoining music and drawing rooms. The screen's frame,

Fig. 1 Thomas Wilmer Dewing, *Classical Figures*, 1897–98. Oil on panels; left and middle panels: 65 x 24 in. (165.1 x 61 cm), right panel: 65 x 23 in. (165.1 x 58.4 cm). The Detroit Institute of Arts, gift of Mr. and Mrs. James Keene in memory of their daughter Sandra Mae Long, 1972

designed by Stanford White, is embellished with traditional beaded moldings and fluted Corinthian columns—period motifs chosen to complement the gilded garlands and Louis XVI furniture that decorated Hecker's fashionable interior.

Morning Glories and its pendant, *Cherry Blossoms*, were commissioned to replace an earlier set of screens that Dewing had made for Hecker between 1897 and 1898. One of these screens, *Classical Figures* (fig. 1), is now in the Detroit Institute of Arts; the other is unlocated. Because the initial designs proved too dark to be displayed effectively in the low light of Hecker's drawing room, Dewing was asked to produce a second pair in a brighter palette. When Charles Freer saw the new screens installed in Hecker's home, he pronounced them "beautiful in the extreme."[1] In many respects, *Morning Glories* resembles the screen *Four Sylvan Sounds* (Freer Gallery of Art, Washington, D.C.), which Dewing had painted for Freer in 1896.

The figures in *Morning Glories* are the refined, sophisticated women who typically inhabit Dewing's enigmatic landscapes. In this instance their relaxed poses, with hands on hips or arms upraised, are transcribed from so-called Tanagra figurines, small terra-cotta sculptures of the Hellenistic period, which had been recently excavated in Greece. The statues were prized as decorative objects

and avidly collected during the late nineteenth century. Two such pieces stood in Hecker's drawing room where Dewing's screen was placed.

In *Morning Glories*, the variance between the loose, painterly treatment of the figures and the sharply defined and solidly painted flowers invites speculation that the floral elements may have been painted by Dewing's wife, Maria Oakey Dewing, a well-known flower painter who assisted him on occasion. Dewing often collaborated with other artists; he had earlier joined forces with the landscapist Dwight Tryon to create a triptych titled *Spring, Summer and Autumn* (1893, Detroit Institute of Arts) for the very residence for which *Morning Glories* was commissioned.

GB, KP

1 Charles L. Freer to John Gellatly, November 7, 1900, in Freer letterpress books, vol. 7, p. 7, Archives of American Art, Washington, D.C.

References Freer letterpress books, vol. 7, manuscript, Freer Gallery of Art, Washington, D.C., on microfilm in Archives of American Art, Washington, D.C.; H. B. Teilman, "Recent Acquisitions," *Carnegie Magazine* 47 (Oct. 1973), p. 340; K. Pyne, "*Classical Figures*, A Folding Screen by Thomas Dewing," *Bulletin of the Detroit Institute of Arts* 59 (Spring 1981), pp. 5, 8, 12, n. 20; S. Hobbs, "Thomas Dewing in Cornish," *American Art Journal* 17 (Spring 1985), pp. 2–32; H. Adams, in Museum of Art, Carnegie Institute, *Collection Handbook* (Pittsburgh, 1985), pp. 210–11.

Exhibitions Hirschl and Adler Galleries, New York, 1972, *Important Recent Acquisitions*, no. 17; National Gallery of Art, Washington, D.C., 1984, *The Folding Image: Screens by Western Artists of the Nineteenth and Twentieth Centuries*, exh. cat., essays by M. Komanecky and V. Fabbri Butera, no. 10.

Provenance Col. Frank J. Hecker, Detroit; his daughter, Louise H. Fletcher, Detroit, 1928; DuMouchelle Galleries, Detroit, 1959; Graham Williford, New York, 1971; Hirschl and Adler Galleries, New York, 1972.

Acquired through the generosity of the Sarah Mellon Scaife family, 1973, 73.3.1.

See Color Plate 21.

Lady in Black and Rose, c. 1905–9

Oil on wood panel
20 1/16 x 15 7/16 in. (51 x 39.2 cm)
Signature: *T. W. Dewing* (lower left)

This painting of an elegantly dressed woman seated in a sparsely furnished interior is characteristic of Dewing's figural manner after 1900. "His function," wrote the critic Royal Cortissoz in 1923, "is simply to evoke a presence and to envelop it in what I can only describe as a mood."[1] Here, quiet contemplation is expressed by a young woman holding an open book. Averting her eyes from the text, she stares into space, absorbed in her own thoughts; the heavy glazing over the model's face and the empty space that separates her from the viewer heighten the sense of psychic isolation, while the slender spindles of the Windsor chair underscore her femininity. Soft rose tones, accented with touches of cream and black, are echoed throughout the composition, enveloping the whole in the dreamlike atmosphere that typifies Dewing's mature work.

This enigmatic scene, evocatively lighted and mysteriously still, recalls not only the Dutch genre paintings of Jan Vermeer, which Dewing admired, but also Oriental art, to which Dewing had been introduced by his patron, Charles Lang Freer. These were not the only antecedents: the pose of the figure, seen almost in profile, the sharply tilted ground plane, and the asymmetrical composition were influenced by more contemporary sources, namely James McNeill Whistler's simplified compositions and popular Japanese prints. In emulation of Whistler, Dewing titled this painting according to its two dominant color tones; similarly, the inspiration for the figure's swanlike neck and exposed back is traceable to J.-A.-D. Ingres.[2] Dewing's vision, however, was distinctly individual. His scenes were never anecdotal, and the idealized faces of his models, submerged in veils of atmosphere, manifest depth of feeling.

This painting was among the twenty-one works selected for Dewing's solo exhibition at Carnegie Institute in 1924. In order to create the proper atmosphere for the viewing of his work, Dewing insisted on minimizing the natural light in the gallery; accordingly, curtains were hung at each door and black paper was placed over the windows.[3] In this subdued lighting, the subtle color harmonies of his paintings were displayed to best advantage.

GB

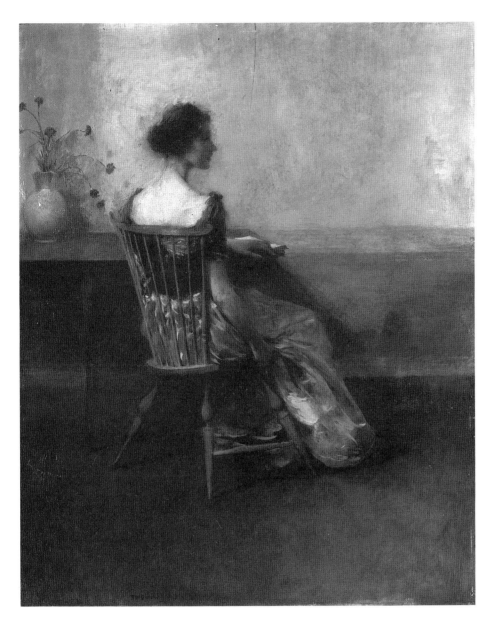

Burgoyne Diller

1906–1965

BORN IN NEW YORK, Burgoyne Andrew Diller grew up in Battle Creek, Michigan, and attended Michigan State University, East Lansing, on a track scholarship. While in college he spent many weekends visiting the Art Institute of Chicago, where he was first introduced to the paintings of Paul Cézanne. There Diller discovered Cézanne's exploration and illustration of structure and volume through the use of color rather than shade, light, or perspective. This inevitably influenced his future study of Cubism and abstract art.

Taught by several different teachers, including Hans Hofmann, Jan Matulka, William von Schlegell, and George Grosz, at the Art Students League in New York from 1929 to 1933, Diller experimented with Analytic and Synthetic Cubism, Constructivism, and other forms of abstraction. Incorporating a variety of modern styles into his work, he strove to reduce a three-dimensional object to its most abstract form. After leaving the Art Students League in 1933, he began to develop the geometric style with which he is most associated. His first solo exhibition was held in New York at the Contemporary Arts Gallery in 1933. The preface to the exhibition catalogue, written by Hans Hofmann, stated:

> Burgoyne Diller is one of the most promising of the young American painters. His work is based on this clear consciousness which he has attained through his own demand for an expression disciplined to the limitation of the medium. In his work we find not only a strong talent, but the capacity for a consecutive and full development, which is in itself, the source of every tradition.[1]

Diller actively pursued abstraction, looking to the Russian Constructivist ideas of Kazimir Malevich and El Lissitzky, and experimenting with elemental forms and lines and shapes on a white background. In 1934–35 he adopted the grid-based style of Piet Mondrian and the principles of Neoplasticism. Although Diller denied ever having seen Mondrian's work prior to 1934, it is very likely he saw

1 Cortissoz, "An American Artist," p. 544.

2 J. E. Luczko, "Thomas Wilmer Dewing's Sources: Women in Interiors," *Arts* 54 (November 1979), p. 153.

3 Correspondence with Thomas Wilmer Dewing, 1924, Carnegie Institute Papers, Archives of American Art, Washington, D.C.

Reference J. E. Luczko, "Thomas Wilmer Dewing's Sources: Women in Interiors," *Arts* 54 (Nov. 1979), pp. 152–57.

Exhibitions Royal Academy of Arts, Berlin, and Royal Academy, Munich, 1910, *Ausstellung amerikanischer Kunst*, exh. cat., introduction by Christian Brinton, no. 99; Buffalo Fine Arts Academy, Albright Art Gallery, 1920, *Fourteenth Annual Exhibition of Selected Paintings by American Artists*, no. 36; Carnegie Institute, Pittsburgh, 1924, *Exhibition of Paintings by Thomas W. Dewing*, no. 7; Durlacher Brothers, New York, 1963, *A Loan Exhibition: Thomas W. Dewing, 1851–1938*, no. 20; University Art Gallery, University of Pittsburgh, 1978, *Art Nouveau*, sec. II, no. 5.

Provenance N. E. Montross, New York; Hugo Reisinger, New York, 1909 (sale, Hugo Reisinger collection, American Art Association, New York, Jan. 13, 1916).

Purchase, 1916, 16.5.1.

Mondrian's paintings at Albert E. Gallatin's Gallery of Living Art at New York University in 1933.

Unable to sell a single work in the 1930s, Diller became the supervisor for the New York region of the Mural Division of the Federal Arts Project from 1935 to 1942. He was able to secure mural commissions for several of the most active abstract artists of the period, including Ilya Bolotowsky, Byron Browne, Willem de Kooning, Arshile Gorky, and Balcomb Greene. He joined the American Abstract Artists in 1936, the year of the group's formal inception, and exhibited with them annually from 1937 to 1939. With the opening of the Guggenheim Museum of Non-Objective Painting in 1937, the group felt that its aesthetic views had been confirmed by the large showing of Wassily Kandinsky's work. Like Kandinsky, the association members believed that geometric forms embodied a "universal truth" and inhabited a self-contained, self-sufficient world.[2]

During the 1940s Diller's output never exceeded a dozen canvases a year. He worked as the director of the War Service Art Section in New York and in 1941 became a lieutenant in the navy's visual aid division, designing a black-and-white signal system for ship-to-ship communication. Diller remained a resident of New York after World War II, but he retreated from the city's art scene. He taught at Brooklyn College, New York, as an instructor of design for the next twenty years. Nonetheless, he made a committed and lasting contribution to the development of abstract art in America. It was a measure of Carnegie Institute's interest in that tradition that Diller's work appeared in the Carnegie International in 1964. Diller died in New York the next year.

1 Contemporary Arts Gallery, New York, *Exhibition of Paintings by Burgoyne Diller* (1933), exh. brochure with introduction by Hans Hofmann, n.p.

2 Walker Art Center, *Burgoyne Diller*, pp. 6–7.

Bibliography Burgoyne Diller Papers, Archives of American Art, Washington, D.C.; Walker Art Center, Minneapolis, *Burgoyne Diller: Paintings, Sculptures, Drawings* (1972), exh. cat. by Philip Larson; Nancy J. Troy, "Burgoyne Diller," in Museum of Art, Carnegie Institute, Pittsburgh, *Abstract Painting and Sculpture in America, 1927–1944* (1983), exh. cat. ed. by John R. Lane and Susan C. Larsen, pp. 70–72; Robert L. Herbert et al.,

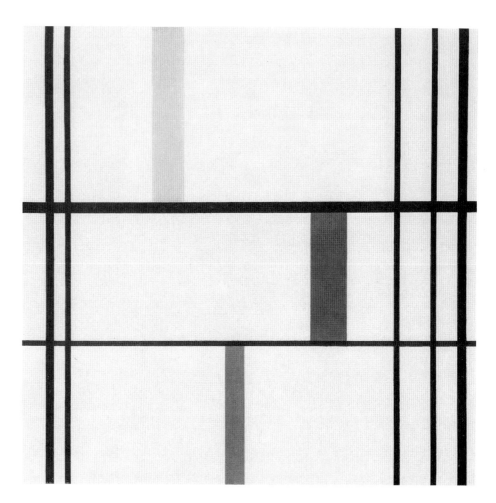

The Société Anonyme and the Dreier Bequest at Yale University: A Catalogue Raisonné (New Haven, 1984), pp. 182–92; Meredith Long [Gallery], Houston, *Burgoyne Diller and the Abstract Tradition in America* (1984), exh. cat., essay by William C. Agee.

Untitled No. 21 (Second Theme), c. 1943–45

Oil on canvas
42⅛ x 42¹⁄₁₆ in. (107 x 106.8 cm)

Although Diller was dedicated to Piet Mondrian, he was not interested in the latter's spiritualist leanings or utopian ideas about the content and function of art. Due, perhaps, to an American disinclination toward theory, Diller concentrated on art's formal rather than its philosophical issues. His art evolved into three series, each with generic formal characteristics. It was not, however, until the fifties that he actually assigned names to these series, calling them First, Second, and Third Theme. He then began to use them not only to title new work but also to name in retrospect earlier work.

The Second Theme can be described as a limited number of rectangles organized within a set of grid lines. It was Mondrian's Paris and London paintings of the thirties that provided the main stylistic precedents for *Untitled No. 21 (Second Theme)*. Bold rectangles of red, yellow, and blue are contained within a set of grids formed by the intersection of thin, straight black lines. A drawing (c. 1943–45, collection Mr. and Mrs. James A. Fisher, Pittsburgh), in which there is only one vertical black line on the left side, served as a study for the painting.

Diller emerged as the American artist who made the most original and vital use of Mondrian's limited but eloquent formal vocabulary of straight lines, right angles, primary colors, and black and white. In contrast to Mondrian's sensuous brushwork, there is an austerity of surface effect in this painting that makes it a precedent for American minimalist art of the sixties, a movement to which Diller himself made strong contributions.

Diller was an artist whose evolution was based on an empirical process. The resulting pictorial inventions cannot be mistaken by an informed eye as the product of any other practitioner of the Neoplastic aesthetic.

JRL

References V. P. Rembert, "Mondrian, America, and American Painting," Ph.D. diss., Columbia University, 1970, pp. 173, 425; J. R. Lane, "American Abstract Art of the '30s and '40s," *Carnegie Magazine* 56 (Sept.–Oct. 1983), pp. 16, 19; J. R. Lane, in Museum of Art, Carnegie Institute, *Collection Handbook* (Pittsburgh, 1985), pp. 256–57.

Exhibitions Walker Art Center, Minneapolis, 1971–72, *Burgoyne Diller: Paintings, Sculptures, Drawings* (trav. exh.), no. 10; Annely Juda Fine Art, London, 1973, *The Non-Objective World, 1914–1955*, no. 37; Museum of Contemporary Art, Chicago, 1973, *Post-Mondrian Abstraction in America*, unnumbered; Museum of Art, Carnegie Institute, Pittsburgh, 1983–84, *Abstract Painting and Sculpture in America: 1927–1944* (trav. exh.), exh. cat. ed. by J. R. Lane and S. C. Larsen, no. 42.

Provenance The artist, until 1965; Noah Goldowsky Gallery, New York, by 1971; private collection, Los Angeles; Marilyn Pearl Gallery, New York, by 1981.

Edith H. Fisher Fund, 1981, 81.44

See Color Plate 32.

Thomas Doughty
1793–1856

Thomas Doughty was instrumental in introducing landscape painting as a separate genre in American art. His intimate pastorals of the 1820s, depicting the scenery of the northeastern United States in a picturesque yet unaffected manner, made him a forerunner of the Hudson River school. Doughty's art was modest, unassuming, and in contrast to the work of his younger contemporary Thomas Cole, unrhetorical. As the editor of *Knickerbocker Magazine* explained, "Cole is epical, Doughty is epilogical; Cole, in his later studies, is the Painter of Poetry; Doughty, in study perpetual, is the Painter of Nature."[1] Nevertheless, Doughty was never truly nature's copyist; he invariably reordered it to make it, he hoped, more enduring. Although his significance cannot rival that of Cole, Asher B. Durand, and Frederic E. Church, it

was through Doughty's pioneering efforts that their work became so readily accepted.

Doughty was born in Philadelphia, the son of a ship carpenter. Although he demonstrated remarkable drawing ability at an early age, his family's finances precluded formal art instruction for him, and he served an apprenticeship as a leather maker. By 1820, however, Doughty abandoned this trade to pursue landscape painting as a profession. To train himself, he copied paintings and prints in the Pennsylvania Academy of the Fine Arts, Philadelphia, and from the collection of his early patron, Robert Gilmor of Baltimore. Doughty particularly admired English landscapes and adopted their stylistic conventions. He also studied instruction manuals, but he much preferred to sketch from nature. As one critic wrote, "From his earliest boyhood he loved the woods, the streams, the hills and the valleys. He dwelt with them—he felt their power—he made them his study and delight."[2]

Doughty associated himself with the Pennsylvania Academy and exhibited there often. With the help of more established artists such as Thomas Sully, Rembrandt Peale, and John Neagle, he was elected academician in 1824. The recognition was justifiable: critics and collectors prized Doughty's early topographical studies for their beguiling effects of light, their fine detail, and their truth to nature.

In 1828, hoping to find an even more receptive audience for his paintings, Doughty moved from Philadelphia to Boston. There he produced nineteen canvases for the Athenaeum's spring exhibition of 1829 and seventeen more for its exhibition of 1830. In addition, he studied lithography at the shop of Boston's first lithographers, John and William Pendleton. Doughty subsequently returned to Philadelphia, where he employed his newly acquired printmaking skills in a monthly periodical, *The Cabinet of Natural History and American Rural Sports*, a collaborative effort with his brother John. The magazine featured histories of North American wildlife, supplemented by Doughty's hand-colored lithographs.

When the periodical failed in 1834, Doughty returned to Boston, this time to produce landscape paintings in quantity. He expanded his repertoire to include Italianate pastorals, scenes inspired by contemporary American literature, and views based on English travel books. His

brushstroke became more painterly and his palette more restrained. The public apparently preferred this new idealizing style to his earlier, more keenly observed mode; his work sold widely and he exhibited regularly at the Apollo Association, the American Art-Union, and the National Academy of Design.

Doughty supplemented his income by teaching and saved enough money to travel to London in 1837. However, due to illness, he painted little while he was abroad, and the following year he settled permanently in New York. He did, however, take occasional sketching trips to the Catskills and the Adirondacks, and to New England, often accompanied by Alvan Fisher and Chester Harding. From late 1844 to 1845 he also traveled to Paris and London, but he painted few original compositions. Doughty's sales declined significantly in his last years, and he died in New York impoverished and unappreciated.

1 Goodyear, in Pennsylvania Academy, *Thomas Doughty*, p. 11, quoted from "The Fine Arts: Doughty's Landscapes," *Knickerbocker Magazine* (October 1848), p. 363.

2 Goodyear, in Pennsylvania Academy, *Thomas Doughty*, p. 15, quoted from E. Anna Lewis, "Art and Artists in America," *Graham's American Monthly* (November 1854), p. 483.

Bibliography Henry T. Tuckerman, *Book of the Artists: American Artist Life* (New York, 1867), pp. 506–7; Art Institute of Chicago, *The Hudson River School and the Early American Landscape Tradition* (1945), exh. cat. by Frederick A. Sweet, pp. 35–41; Virgil Barker, *American Painting: History and Interpretation* (New York, 1950), pp. 419–23; John K. Howat, *The Hudson River and Its Painters* (New York, 1972), pp. 32–33; Pennsylvania Academy of the Fine Arts, Philadelphia, *Thomas Doughty, 1793–1856: An American Pioneer in Landscape Painting* (1973), exh. cat. by Frank H. Goodyear, Jr.

Three Men Fishing, 1831

Oil on wood panel
14⅛ x 18½ in. (35.9 x 47 cm)
Signature, date: Doughty, 1831 (lower right)

Painted in a transitional year for Doughty, *Three Men Fishing* exhibits the fresh, lyrical quality of his early period in combination with a classical structure that became characteristic of his later work. The artist was concentrating primarily on his magazine, *The Cabinet of Natural History and American Rural*

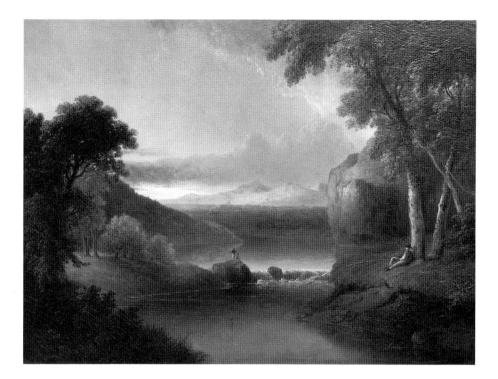

Sports, and it seems likely that he painted *Three Men Fishing* to offset the lack of income from his financially failing periodical.

Most appealing about *Three Men Fishing* is its expansive quality. Though it is a small canvas, its panorama of distant sky and mountains expresses a sense of the infinite and the divine, then considered inherent in the American wilderness. As the contemporary poet William Cullen Bryant explained:

> Our own scenery has its peculiarities... one of the most striking is the absence of those tamings and softenings of cultivation, . . . a far-spread wildness, a look as if the new world was fresher from the hand of Him who made it... suggested the idea of unity and immensity, and abstracting the mind from the associations of human agency, carried it up to the idea of a mightier power, and to the great mystery of the origin of things.[1]

The rather formulaic structure of *Three Men Fishing* includes a central body of water framed by a strong coulisse of trees and receding by a series of planar elements into low, distant mountains. A river cuts a winding path through a forest panorama, while a semiclouded sky casts a pink glow over the icy water and sandy banks, shaded by lacy trees. A sequence of arcs unites the parts into a tight geometric scheme in this nineteenth-century American interpretation of the seventeenth-century ideal landscapes of Claude Lorraine and Jacob van Ruisdael.

In Doughty's painting the trees, rocks, water, and sky predominate, embracing the three tiny fishermen, who pull the viewer into their space. Two of the three turn their backs to us, while the third reclines, wholly at ease. Here, man is at one with God and nature. The result is meditative stillness, which is reinforced by Doughty's thin, nearly transparent brushwork. Doughty presents us, however, with a nature that manifests visible signs of civilization's encroachment: a small yet recognizable cloud of smoke in the background of the painting suggests a settlement, and it has drawn the attention of the two standing fishermen.

Although some of Doughty's contemporaries believed that lumbering marred the American landscape and constituted a sin against God in nature, others maintained the opposite, that nature could be transformed through man's intervention into a new biblical Eden. The attitude expressed in *Three Men Fishing* seems ambiguous. Although the smoke from the settlement has caught the attention of the fishermen, the virgin landscape endures as the dominating force.

JM

1 Bryant in William Cullen Bryant and Asher B. Durand, *The American Landscape* (New York, 1830), reprinted in William Cullen Bryant II, "Poetry and Paintings: A Love Affair of Long Ago," *American Quarterly* 22 (Winter 1970), p. 865.

Provenance Private collection, New Jersey; M. Knoedler and Co., New York, 1973.

Howard N. Eavenson Memorial Fund, for the Howard N. Eavenson Americana Collection, 1973, 73.38.1

Arthur G. Dove
1880–1946

ONE OF THE PIONEERS and great individualists in the development of abstract art in America was Arthur Garfield Dove. Born in Canadaigua in the Finger Lakes region of upstate New York and raised in nearby Geneva, he attended Hobart College and graduated from Cornell University in 1903. Although his father had wanted him to pursue a career in law, Dove developed a strong preference for art while at Cornell. After graduation, he moved to New York City, married, and became a successful magazine illustrator whose work appeared in such publications as *Collier's*, *Scribner's*, and *Saturday Evening Post*. He continued to pursue commercial art work until 1930 but only as a way of supporting the painting that had become his primary interest.

By 1907 Dove had saved enough money for a trip to Europe, where he lived for two years, mainly in Paris. There he became friendly with several American artists including Alfred Maurer, Arthur Carles, Patrick Henry Bruce, and Max Weber. He developed a strong interest in Fauvism, as evidenced by his still life, *The Lobster* (1908, Amon Carter Museum, Forth Worth, Tex.), which he left in Paris for exhibition at the 1909 Salon d'Automne. On returning to the United States, he settled in Westport, Connecticut, a resort community not far from New York City, where he took up farming and lived simply. In 1910 Alfred Stieglitz, who probably became acquainted with Dove through Maurer, included Dove in his *Younger American Painters* exhibition at his gallery, 291. Henceforth Stieglitz regularly featured Dove's work in his galleries, and the two enjoyed a long friendship.

In 1910 or 1911 Dove created a series of small sketches that stand as the earliest abstractions by an American and foretold the principal direction of his art. Derived from landscape motifs, they were intuitive responses to natural stimuli, through which Dove hoped to make visible nature's animating power.

Dove, who worked extensively in pastel from 1912 through the 1920s, continually experimented with different graphic media. In the 1920s he made assemblages, or "things" as he called them, whose deliberate, often humorous illogic was similar to Dada collage. One example, *Portrait of Alfred Stieglitz* (1924, Museum of Modern Art, New York), included a lens, clock spring, and photographic plate mounted on plywood, while another, *Goin' Fishin'* (1925, Phillips Collection, Washington, D.C.), consisted of cut-up denim overalls and pieces of a fishing pole.

In 1924 Dove, estranged from his wife, moved to northern Long Island where he and the artist Helen Torr (whom he eventually married) lived on a yawl docked in Huntington Harbor. The rhythms of the sea and shore were constant sources of inspiration for Dove's abstractions of the later 1920s, through which he created expressive, almost mystical symbols for natural effects. He subscribed to the theory of synesthesia, the summoning of one type of sensory response through another, as one can see in his masterpiece of these years, *Fog Horns* (1929, Colorado Springs Fine Arts Center, Colo.).

By the early 1930s Duncan Phillips was regularly purchasing Dove's work. Although that patronage meant a great deal to Dove, it did not alleviate the episodes of wrenching poverty he experienced. In 1938, after six years of living once more in Geneva, New York, Dove moved into a small house in Centerport, near Huntington, Long Island, where he spent the rest of his life. Despite failing health that kept him houseridden, Dove's pictorial style became stronger and more expansive, his forms more geometric, and his coloring more brilliant. Canvases such as *Square on the Pond* and *That Red One* (1942 and 1944 respectively, Museum of Fine Arts, Boston) are endowed with architectonic dignity and an almost hallucinatory power.

The tremendous success of his 1940 exhibition at Stieglitz's gallery, An American Place, initiated a decade in which Dove's reputation steadily solidified. Carnegie Institute, for example, which had never previously made contact with Dove, solicited his work for its annual exhibitions of 1945 and 1946. After Dove's death, Edith Halpert of the Downtown Gallery vigorously promoted his art, and by the 1950s he was widely regarded as a major American master.

Bibliography Duncan Phillips, "Arthur Dove, 1880–1946," *Magazine of Art* 40 (May 1947), pp. 192–97; Andrew D. White Museum of Art, Cornell University, Ithaca, N.Y., *Arthur G. Dove* (1954), exh. cat. by Alan Solomon; San Francisco Museum of Art, *Arthur Dove* (1974), exh. cat. by Barbara Haskell; Ann Lee Morgan, *Arthur Dove: Life and Work, with a Catalogue Raisonné* (Newark, N.J., 1984); Ann Lee Morgan, ed., *Dear Stieglitz, Dear Dove* (Newark, N.J., 1988).

Tree Forms, c. 1928

Pastel and tempera on plywood
25¼ x 29¾ in. (64.1 x 75.6 cm)

Dove experimented with a wide range of materials and techniques during the late 1920s. The assemblages that he began creating in 1924 continued to interest him;

he also produced a great variety of paint-
ings characterized by their free execution,
patchy pigment, and energetic, calli-
graphic lines. *Tree Forms*, which makes
use of the pastel medium that Dove had
adopted as early as 1911, has both the free
linear movement of Dove's paintings at
this time and some of the quality of an
assemblage.

Around the time that he created *Tree
Forms*, Dove produced three other images
evoking trees: another pastel on wood,
Tree Forms and Water (1928, Metropolitan
Museum of Art, New York); a pastel on
canvas, *Tree Trunk* (1928–29, Museum of
Fine Arts, Boston); and *Silver Log* (1929,
Washburn Gallery, New York), an oil on
canvas. *Tree Forms* is the most dramatic of
these variants. A dark image of densely
packed, meandering whorls amid velvety
patches of gray, brown, and black, it alter-
nately suggests leaves, the knots and bark
of a tree trunk, and the growth patterns
of wood. Although nothing is rendered
illusionistically, the image creates the
unmistakable impression of a living
organism—an effect characteristic of
many of Dove's abstractions. By drawing
directly on a plywood panel, Dove cre-
ated an interplay between the wood and
his image of it, as in his assemblages. The
wood support enhances the tactile dimen-
sion of this work by adding its own
roughness to the textures created with
pastel chalks.

The precedent for *Tree Forms* reaches
back to the beginning of Dove's career, to
an experimental pastel, *Based on Leaf
Forms and Spaces* (c. 1911–1912, location
unknown). Writing to the Chicago col-
lector Arthur Jerome Eddy, Dove
described what he had tried to do in
Based on Leaf Forms and Spaces. It is
equally applicable to *Tree Forms*:

> I set out to analyze. . . principles as they
> occurred in works of art and nature. One of
> these. . . which seemed most evident was the
> choice of the simple motif. . . . A few forms
> and a few colors sufficed for the creation of
> an object. I gave up trying to express an idea
> by stating innumerable little facts, the state-
> ment of facts having no more to do with the

art of painting than statistics with literature.
The first step was to choose from nature a
motif. . . and with that motif to paint from
nature, the forms still being objective. The
second step was to apply this same principle
to form, the actual dependence upon the
object disappearing, and the means of
expression becoming purely subjective.[1]

LM, DS

1 San Francisco Museum of Art, *Arthur Dove*,
p. 134.

References　F. A. Myers, "Tree Forms, Arthur
G. Dove," *Carnegie Magazine* 41 (Feb. 1967),
p. 69; Morgan, *Arthur Dove: Life and Work*,
p. 165; E. A. Prelinger, in Museum of Art,
Carnegie Institute, *Collection Handbook* (Pitts-
burgh, 1985), p. 246.

Exhibitions　Downtown Gallery, New York,
1947, *Dove: Retrospective Exhibition*, no. 8; Art
Galleries of the University of California, Los
Angeles, 1958, *Arthur Dove*, no. 22; Museum
of Art, Carnegie Institute, Pittsburgh,
1971–72, *Forerunners of American Abstraction*,
no. 23.

Provenance　Estate of the artist; Downtown
Gallery, New York, 1946; Mr. and Mrs. James
H. Beal, Pittsburgh, 1947.

Gift of Mr. and Mrs. James H. Beal, 1960,
60.3.2

See Color Plate 24.

Tar Barrels, Huntington Harbor, 1930
(Oil Drums)

Oil on canvas
22¼ x 27¼ in. (56.5 x 69.2 cm)
Signature: *A. Dove* (lower right)

Tar Barrels, Huntington Harbor was
apparently painted in February or March
1930, as one of four last-minute entries
for Dove's solo exhibition which opened
on March 22 of that year at Alfred
Stieglitz's gallery, An American Place.[1]
Two of the other canvases, *Below the
Floodgates* (1930, private collection) and
The Mill Wheel, Huntington Harbor
(1930, The Regis Collection,
Minneapolis), have the same dimensions
as *Tar Barrels, Huntington Harbor*. All
three incorporate flattened fragments of
recognizable objects (rusting steel drums,
rushing water seen from above, a wheel
rim leaning against a shed wall). These
motifs are presented close-up, flattened
into a compressed space, and cut off by
the picture's frame. *Below the Floodgates*
and *Tar Barrels, Huntington Harbor* retain
the flowing, calligraphic line that marked
Dove's work in the late 1920s. In the case
of *Tar Barrels, Huntington Harbor*, he cre-
ates a cadence of irregular circles and

cylinders, filling the pictorial space and making it appear to oscillate with life.

The Carnegie's painting and *The Mill Wheel, Huntington Harbor* belong to a new category of subject for Dove: the abandoned mechanical equipment around the Long Island shore. Such images included storage tanks silhouetted against the empty sky, a silent derrick, and old barges. These subjects, some of them quite stark, like *Ferry Boat Wreck, Oyster Bay* (1931, Whitney Museum of American Art, New York), easily conjure up allusions to the human condition.

When *Tar Barrels, Huntington Harbor* was shown with other recent works in Dove's exhibition at An American Place, the ensemble garnered the enthusiastic praise of two New York art critics sympathetic to abstraction, Edward Alden Jewell of the *New York Times* and Murdock Pemberton of the *New Yorker*. Jewell, calling the paintings in the exhibition Dove's best work yet, thought *Tar Barrels, Huntington Harbor* "a stunning piece of decoration," and it led him to define Dove's present work as a liberated form of realism, equally as truthful as the conventional kind, but also eloquently evocative on its own terms.[2]

DS

1 Heckscher Museum, Huntington, N.Y., 1989, *Arthur Dove and Helen Torr: The Huntington Years*, exh. cat. by Anne Cohen DePietro, p. 30.

2 Edward Alden Jewell, "On the Fence with the Academy—Other Arts: Concerning Arthur Dove," *New York Times*, March 30, 1930, sec. 8, p. 12.

References Jewell, "On the Fence with the Academy—Other Arts: Concerning Arthur Dove," sec. 8, p. 12; Morgan, *Arthur Dove: Life and Work*, p. 183.

Exhibitions An American Place, New York, 1930, *Arthur G. Dove*, no. 26; probably J. B. Neumann, New Art Circle, New York, 1951, *Contemporary American Painting from Private Collections*, no. cat.; Museum of Art, Carnegie Institute, Pittsburgh, 1971–72, *Forerunners of American Abstraction*, no. 28, as *Oil Drums*; Heckscher Museum, Huntington, N.Y., 1989, *Arthur Dove and Helen Torr: The Huntington Years*, exh. cat. by A. C. DePietro, no. 13.

Provenance Mrs. Jerome Michaels, New York, 1930; J. B. Neumann, New York, c. 1951; G. David Thompson, Pittsburgh, by 1953.

Gift of G. David Thompson, 1953, 53.1.7

Guy Pène du Bois
1884–1958

THE PAINTINGS OF Guy Pène du Bois—artist, teacher, and critic—have come to symbolize the chic and sophisticated society of New York and Paris during the years between the two world wars. Born in Brooklyn, New York, du Bois was named after Guy de Maupassant, a close friend of his father, who was a writer. At the age of fifteen, he enrolled in William Merritt Chase's newly founded Chase School (later the New York School of Art), where he studied for three years under Chase, Frank Vincent du Mond, and Kenneth Hayes Miller. In 1902 he joined the art class Robert Henri had begun to teach there. He called Henri and his like-minded colleagues "natural men, liking life well enough to want to tear off the veil thrown so modestly or priggishly over it by prevailing good taste."[1]

In 1905, du Bois traveled to France with his father and studied briefly with Théophile Steinlen at the Atelier Colarossi. His Parisian paintings, depicting life on the boulevards and in the cafés, were sufficiently competent to be exhibited at the 1906 Paris Salon.

Returning to the United States in 1906, du Bois settled in New York. He first worked as a police reporter on the staff of William Randolph Hearst's *New York American*; his subsequent appointment as opera critic enabled him to observe the world of the rich and fashionable—subject matter that would become the hallmark of his painting. He wrote art criticism for the *New York American* and *Herald-Tribune* and served on the organizational committee of the 1913 Armory Show, where he exhibited six canvases. In the same year he became editor of *Arts and Decoration*.

During this period, du Bois painted New York life with dark tonalities and impasto brushwork that allied him to Henri and the Ashcan school. But around 1917 his realism became more stylized. He adopted a brighter palette and a distinctive figurative style that incorporated sleek, tubular forms and simple compositional arrangements. These small-scale yet biting satires, often represented as an encounter between two people, exposed the often ludicrous behavior of sophisticated cosmopolites.

In 1924, hoping to find a more tranquil environment in which to pursue his painting, du Bois moved to Garnes on the outskirts of Paris, where he spent five of the most successful and productive years of his career. There he began painting larger, multifigured canvases depicting the local scene, such as *Americans in Paris* (1927, Museum of Modern Art, New York) and *Racetrack, Deauville* (1927, see p. 174).

After returning from France in 1930, du Bois continued writing for art magazines. He also wrote important monographs on Edward Hopper, John Sloan, William Glackens, and others for the Whitney Museum of American Art's American Artists series. He was a perceptive critic on the issues facing American artists, and although sympathetic toward the realist tradition, he supported other contemporary art forms. Toward the end of his life, however, his attitude toward abstract art became sharply negative. Until 1932 he taught at the Art Students League, then conducted his own schools in Stonington, Connecticut, and New York, where one of his pupils was Reginald Marsh.

Du Bois's painting style turned somewhat darker and more mysterious during the 1930s. He became increasingly concerned with formal problems, creating compositions of striking geometric complexity, and adopted a looser brushstroke that lent a more atmospheric quality to his work. He produced several post office murals for the Treasury Relief Art Project: at Saratoga Springs, New York (1936), Rye, New York (1937), and Weymouth, Massachusetts (1942).

Guy Pène du Bois long maintained an association with Carnegie Institute. He exhibited regularly in its annual exhibitions between 1923 and 1950, served on juries in 1929 and 1936, and was given a solo exhibition in 1939. He published his autobiography, *Artists Say the Silliest*

Things, in 1940. By 1945, however, he had almost stopped painting because of ill health, although he remained active as a teacher. He died in Boston.

1 Du Bois, *Artists Say the Silliest Things*, p. 81.

Bibliography Guy Pène du Bois Papers, Archives of American Art, Washington, D.C.; Royal Cortissoz, *Guy Pène du Bois*, American Artists series (New York, 1931); Guy Pène du Bois, *Artists Say the Silliest Things* (New York, 1940); Parrish Art Museum, Southampton, N.Y., *Guy Pène du Bois, 1884–1958* (1964), exh. cat. by George Albert Perret; Corcoran Gallery of Art, Washington, D.C., *Guy Pène du Bois: Artist about Town* (1980), exh. cat. by Betsy Fahlman.

Racetrack, Deauville, 1927

Oil on canvas
28⅞ x 36⅜ in. (73.3 x 92.4 cm)
Signature, date: Guy Pène Du Bois '27 (lower right)

This work, painted during du Bois's five-year sojourn in France, depicts the "smart set" during Grand Prix day at Deauville, on the English Channel near Le Havre. The same setting appears in a second painting, *Approaching Storm* (1929, collection Mr. and Mrs. Irwin L. Bernstein). While the artist obviously delighted in depicting the gathering places of the rich and fashionable, he always injected a degree of tension into seemingly banal situations, a tension that characterizes his art.

Here, eight elegantly dressed men and women stroll along the racing grounds. Although fences neatly divide the composition horizontally, the spatial position of these spectators remains vague. They are scattered in stiff and awkward poses, creating a broken, staccato rhythm across the canvas. They seem to hover, each one physically and psychologically isolated from the others. Our attention is drawn to the woman on the left, who strides toward us, her face strangely disturbed; she is the only one of the eight figures given to us in full frontal view.

During the late 1920s, du Bois became increasingly interested in form, color, and composition at the expense of narration. He said that his concern was now to depict volumetric forms in space. Yet the weightless tubular figures, the flat band of vivid green grass, and the vertical patterning of the fence in *Racetrack, Deauville* convey surprisingly little sense of three-dimensional substance.

The painting, purchased from the 1928 Carnegie International by the Pittsburgh Athletic Association, was acquired by Carnegie Institute in 1949. At that time du Bois described the origins of the painting:

> [My] family used to spend the month of August at Villerville which adjoins Trouville which adjoins Deauville. We never missed the Grand Prix. The picture was painted in Paris in a studio in the rue Notre Dame des Champs which I had sublet from Ford Maddox Ford. Whistler once had a class in the same building. I doubt that I made any

sketches for the picture. I don't know how we, my wife and I, happened to be in Paris, but I remember that the picture followed a very special trip made to the Grand Prix with several Café du Dôme friends. . . . It used to be on the wall in the studio in Paris. . . . The caricatural element in my work has always been more pronounced to others than it has been to me. Americans are unable to see themselves as others [do].[1]

A similar painting, *Race Track* (1926, location unknown), was exhibited in Carnegie Institute's *Paintings by Guy Pène du Bois, 1908–1938*, in 1939.
ST

1 Guy Pène du Bois to John O'Connor, Jr., February 2, 1949, museum files, The Carnegie Museum of Art, Pittsburgh.

References H. Saint-Gaudens, "The International in Review," *Carnegie Magazine* 6 (Nov. 1932), p. 180; J. O'Connor, Jr., "Thirty Years of Guy Pène du Bois," *Carnegie Magazine* 12 (Jan. 1939), pp. 237–39; J. O'Connor, Jr., "Finally Acquired," *Carnegie Magazine* 22 (Mar. 1949), pp. 248, 249, 263.

Exhibitions Department of Fine Arts, Carnegie Institute, Pittsburgh, 1928, *Carnegie International Exhibition, Twenty-seventh Annual of Paintings*, no. 78; Columbus Museum of Art, Ohio, 1952, *Paintings from the Pittsburgh Collection*, no cat.; Corcoran Gallery of Art, Washington, D.C., 1980, *Guy Pène du Bois, Artist about Town* (trav. exh.), no. 45.

Provenance Kraushaar Galleries, New York, 1927; Pittsburgh Athletic Association, 1928.

Patrons Art Fund, 1949, 49.4

Frank Duveneck

1848–1919

THE PAINTER MOST often named as the guiding spirit of the Munich school of late nineteenth-century American Realism was Frank Duveneck. He was born Francis Decker to Westphalian immigrant parents in Covington, Kentucky, near Cincinnati, Ohio. His father died when Duveneck was quite young, and when his mother remarried, he assumed his stepfather's surname. At the age of fourteen he began working for a German church decorator and muralist, executing paintings on plaster for the interiors of churches and monasteries—

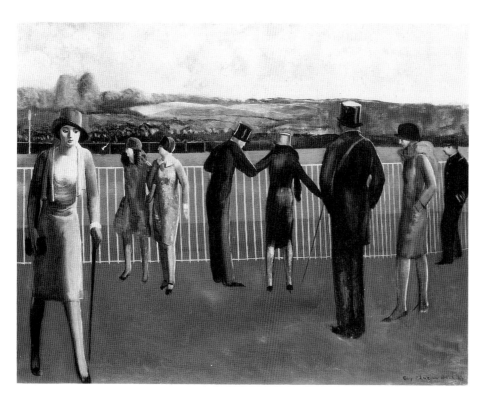

itinerant work that took him through Pennsylvania as far as New Jersey and to Quebec. In New Jersey, one of his church patrons encouraged him to go to Munich to study art. In 1869 he did so.

Duveneck was not the first American art student to come to Munich, but he was the first to benefit from the lively realist activity that in 1870 was just surfacing there. As a student at the art academy in Munich (he enrolled in January 1870), he patterned himself after the city's aggressive younger painters, Wilhelm Leibl, Ludwig Loefftz, and Wilhelm Truebner. Like them, he developed an affinity for seventeenth-century Netherlandish realism and a desire to mold that historical style into a bold idiom of his own.

Success came quickly. In 1871 Duveneck won a medal from the Royal Academy; two years later he was preparing his first solo exhibition at the Munich Kunstverein. By that time he had developed a forcefully objective style based on spontaneous brushwork and strong light-dark contrasts. His subject matter was a colorful, at times exotic, sampling of local people.

In 1873 Duveneck returned to the United States. He taught for a year in Cincinnati, showed his work there in 1874, then in 1875 had the exhibition that made his American reputation. It was held at the Boston Art Club, where the fearlessness of his pictorial expression created a sensation and won the enthusiasm of both Henry James and the city's most influential painter, William Morris Hunt. This success notwithstanding, the painter sensed greater opportunity in Europe, and so once more settled in Munich, while continuing to send work to the United States for exhibition.

It was during the late 1870s that Duveneck gathered about him a coterie of young Americans who shared his ideas about art. That group already included J. Frank Currier and William Merritt Chase, but by 1877 it had expanded considerably. At this time Duveneck created his strongest and most memorable works: *The Turkish Page* (1876, Pennsylvania Academy of the Fine Arts, Philadelphia), *The Cobbler's Apprentice* (1877, Taft Museum, Cincinnati), and *He Lives by His Wits* (1878, private collection).

In 1878 Duveneck decided to open his own school for the benefit of the English-speaking art students in Munich. Those students—some sixty of them—kept studios in the nearby village of Polling and frequently painted the landscape of that area. They became known as the "Duveneck boys" and came to share his passion for direct painting with a bold, forthright touch.

After a year Duveneck moved his school to Italy, where the students rented studios in Florence during the winter and in Venice during the summer. Duveneck had been to Italy twice before (he visited Venice in 1873 and 1877), but on his third trip there his palette began to lighten, his brushwork became somewhat more controlled, and his compositions became more expansive. In 1880 his student Otto Bacher introduced him to etching. The new medium interested Duveneck greatly and led him to produce etchings of Venetian scenery that rival Whistler's.

In 1886 the artist married Elizabeth Boot, one of his students; they went to Paris, where she died two years later. Duveneck returned to the United States, settled in Covington, Kentucky, and took a studio in nearby Cincinnati. Even though he no longer invested his work with the striking, personal vision it showed at the beginning of his career, he became a much-revered local presence. He served as dean of faculty at the Cincinnati Art Academy, where he was a respected and influential teacher until his death.

In late life Duveneck was also fairly active on the national art scene. He was elected to the National Academy of Design in 1905, and at intervals he participated in national exhibitions, among them six Carnegie Internationals. He was invited to be on five International juries and served twice, in 1897 and 1911. Carnegie Institute mounted a show of Duveneck's work in 1908. The exhibition that capped his career, however, was his retrospective at San Francisco's Panama-Pacific Exposition of 1915.

Bibliography Norbert Heerman, *Frank Duveneck* (Boston, 1918); Josephine W. Duveneck, *Frank Duveneck: Painter-Teacher* (San Francisco, 1970); Chapellier Gallery, New York, *Frank Duveneck* (1972); Cincinnati Art Museum, *An American Painter Abroad: Frank Duveneck's European Years* (1987), exh. cat. by Michael Quick; Robert Neuhaus, *Unsuspected Genius: The Art and Life of Frank Duveneck* (San Francisco, 1987).

Wistful Girl, c. 1877–79(?)
(Young Girl; Girl with Light Hair)

Oil on canvas
18⅜ x 15⅜ in. (46.7 x 39.1 cm)

This small, seemingly unfinished oil sketch would be a minor work for any artist. However, when it entered the New

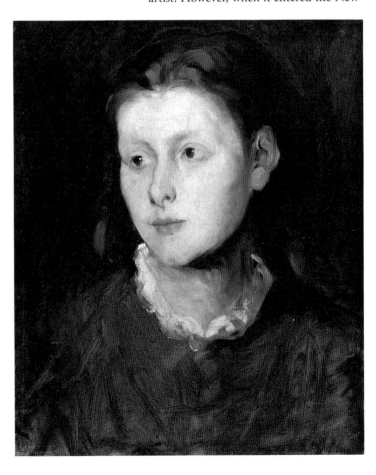

York art market in the late 1920s along with several other works by Duveneck, this canvas and *The Music Master* (1875, Phillips Collection, Washington, D.C.) were singled out repeatedly, both being described as masterfully handled portrayals of character. Similar praise was bestowed on most of Duveneck's Munich work, especially his portrait busts of various unidentified men and women. They were admired for their immediacy and originality and likened to the work of the old masters.

The direct antecedents of such images can be found in Wilhelm Leibl's portrait studies of local vagrants and peasants, which perhaps were inspired by Rembrandt's renditions of similar subjects. Duveneck's versions are technically bolder, emptier of context, and more enigmatic in intent. Their place is somewhere between portraiture and studies of anonymous studio models such as a history or genre painter might make. Too unfinished to serve properly as portraits, they were in a strict sense not studies either, because they were never intended as parts of a later painting. His was a distinctive subgenre of picture making, where experimental rendering existed for its own sake.

Wistful Girl is unusual among Duveneck's Munich busts because it is so thinly painted and apparently more sentimental than most. The thin paint seems appropriate to define the girl's sandy, loose hair, liquid eyes, and translucent skin, yet suggests that the painting is incomplete. The vulnerability and touch of melancholy in the sitter's expression are unusual for Duveneck and have come to be regarded as uncharacteristic enough to cast some doubt as to the painting's attribution, but clearly added to this work's appeal during the 1920s. One writer described it as a "portrait of a soul."[1] "A gem," concluded another, whose wistful, refined face was executed with "a searching tenderness" and "profound sensitivity."[2]

There has been a curious lack of interest in the chronology of Duveneck's paintings, as if the artist's best work simply issued from a single creative impulse. Not surprisingly, the only date associated with *Wistful Girl* was an erroneous "late 1880s" assigned in 1951. It should be dated a decade earlier than that, for in format, palette, and handling it suggests the rapidly executed heads of his second Munich period, even though Duveneck tended, after 1875, to leave behind the somewhat romantic qualities discernible in *Wistful Girl* in favor of a more forthright and impersonal approach.
DS

1 [Frank Washburn Freund], "A Great American Painter," *Sketch Book* 6 (February 1929), p. 40.

2 Royal Cortissoz, "The Field of Art," *Scribner's Magazine* 81 (February 1927), p. 220.

Remarks The canvas has been trimmed at the bottom, partially cutting off what appears to be the monogram FD in brown paint at the lower right.

References F. E. Washburn Freund, "The Problem of Frank Duveneck," *International Studio* 85 (Sept. 1926), p. 100; "Notes and Comments," *Art and Archaeology* 23 (Jan. 1927), p. 40; R. Cortissoz, "The Field of Art," *Scribner's Magazine* 81 (Feb. 1927), pp. 219–20; F. F. Sherman, "Frank Duveneck," *Art in America* 16 (Feb. 1928), p. 98; "A Duveneck Portrait," *Carnegie Magazine* 2 (Apr. 1928), p. 11; "Carnegie Acquires Duveneck Painting," *Art News* (Apr. 21, 1928), p. 6; "Duveneck's 'Wistful Girl' for Carnegie," *Art Digest* 2 (May 1, 1928), p. 7; [F. E. Washburn Freund], "A Great American Painter," *Sketch Book* 6 (Feb. 1929), p. 40; Cincinnati Art Museum, *Exhibition of the Works of Frank Duveneck* (1936), exh. cat. by W. H. Siple, p. 72; O'Connor, Jr., "From Our Permanent Collection: 'Wistful Girl' by Frank Duveneck," *Carnegie Magazine* 25 (Dec. 1951), pp. 350–51.

Exhibition P. Jackson Higgs Gallery, New York, 1928, [*Paintings by Frank Duveneck*], no cat.

Provenance Gustave Wiegand, New York, as agent for anonymous Munich collector and friend of the artist, 1927.

Patrons Art Fund, 1928, 28.11

Thomas Eakins
1844–1916

Today, Thomas Cowperthwait Eakins is acknowledged to be one of the giants of American art and one of the foremost contributors internationally to late nineteenth-century realism, but while he lived, he suffered the frustrations of one whose public never championed his cause. Controversy plagued him, and it did not become clear until a quarter century after his death that he held an undisputed place in the annals of American art.

Eakins's career centered around Philadelphia, where he was born, raised, and spent most of his life. The son of a drawing and writing teacher, he received his first formal art training in the mechanical drawing classes at Central High School. By the time he entered the Pennsylvania Academy of the Fine Arts in 1861, he was already a disciplined draftsman. At the Pennsylvania Academy, he drew from the customary plaster casts, but on his own time, he attended the anatomy lectures offered at Jefferson Medical College. This seriousness about the human body always remained with him.

In 1866 he traveled to Paris, where for three years he was enrolled at the Ecole des Beaux-Arts. He studied primarily with Jean-Léon Gérôme and briefly with Léon Bonnat and the sculptor Augustin-Alexandre Dumont. From the summer of 1868 to mid-1870, Eakins devoted much time to travel, which took him first to Italy, Germany and Belgium, then to Spain, where the work of Diego Velázquez and Jusepe de Ribera made lasting impressions upon him.

By the time he returned to Philadelphia in 1870, Eakins had adopted a sober palette along with the core skills of French academicism: facile brushwork, a mastery of anatomical form and pictorial structure, and a commitment to constant study and precise observation. Arguably, he also assimilated Gérôme's approach to subject matter, which he adapted to the "big painting" he himself wished to pursue. Just as Gérôme, in his canvases of Arabs and ancient Romans, shifted the context of history painting toward day-to-day existence, so Eakins turned to American life for commonly found incidents in which to invest the serious intentions of history painting.

Eakins's canvases depicted what he considered most noble and heroic in humans: physical discipline and the capacity for thought. His paintings overwhelmingly portrayed musicians, sportsmen, athletes, scientists, and craftsmen, many of whom were close friends or family members. Although his images show a realist's unwavering refusal to flatter or otherwise yield to convention, they nearly always contain an autobiographical aspect; thus, in a strict sense, they cannot be called objectively realist.

Among Eakins's earlier works is the painting generally regarded to be his masterpiece: *The Gross Clinic* (1875, Jefferson Medical College, Philadelphia), which represented the Philadelphia surgeon Samuel Gross demonstrating an operation before his students. Although the intention of the portrait was to portray the surgeon's skills as noble and heroic, the brutal explicitness of the surgery shocked most viewers. Rejected from the paintings exhibit at the Centennial Exposition in Philadelphia, the canvas was placed instead amid medical equipment in the army hospital pavilion.

In 1876 Eakins began teaching at the Pennsylvania Academy of the Fine Arts; he became professor of drawing and painting in 1879, then director in 1882. He urged students to aspire to the excellence of the ancients and the old masters by doing as they did: study nature. To accomplish this, he emphasized painting over drawing, and the detailed understanding of anatomy over all else. He used such unconventional study aids as dissection and photography, and he demonstrated his priorities by producing ambitious canvases that centered upon the nude human form. His insistence that even female students follow his rigorous

and graphic anatomical studies became a source of increasing tension between him and the academy's trustees, who in 1886 forced his resignation. A group of students left the academy in protest, formed the Art Students' League of Philadelphia, and invited Eakins to teach there instead.

The decade following his departure from the Pennsylvania Academy was a troubling one for Eakins, since his painting continued to be rather poorly received and he had few opportunities to earn money. His range of work narrowed until portraiture became his major activity, but even portrait commissions were scarce. The artist resorted to asking friends and family members to pose for him; the results were some of the most visually striking and psychologically intense images in the history of portraiture.

Toward the end of his life (he died in Philadelphia), Eakins gained a long-awaited measure of national recognition. After having nine works hung at the World's Columbian Exposition in Chicago in 1893 and a solo exhibition in Philadelphia in 1896, he was elected, in 1902, to the National Academy of Design, New York. He received gold medals at the 1901 Pan-American Exposition in Buffalo, the 1904 Universal Exposition in Saint Louis, and subsequently from the Pennsylvania Academy and the American Art Society in Philadelphia.

To judge from the number of works he submitted to salon-style exhibitions—from the annual of the Society of American Artists, New York, to the Carnegie International—Eakins must have believed in their efficacy. At the Carnegie International he was a five-time juror and, in 1907, winner of a second-class medal. But his exhibition record should dispel quick assumptions about his late-life success. Of twenty-seven works submitted between 1896 and 1913, two were accepted but not hung and seven more were rejected outright, including one of his most important images, *William Rush Carving the Allegorical Figure of the Schuylkill* (1908, Brooklyn Museum, New York). His talent as a painter and sculptor was formally recognized by Carnegie Institute in 1945, when a centennial exhibition of his work was held there.

Bibliography Lloyd Goodrich, *Thomas Eakins: His Life and Work* (New York, 1933); Gordon Hendricks, *The Life and Works of Thomas Eakins* (New York, 1974); Lloyd Goodrich, *Thomas Eakins* (Washington, D.C., 1982); Philadelphia Museum of Art, *Thomas Eakins, Artist of Philadelphia* (1982), exh. cat. by Darrell Sewell; Elizabeth Johns, *Thomas Eakins: the Heroism of Modern Life* (Princeton, N.J., 1983).

Study for "Arcadia": Youth Playing Pipes, 1883
(Youth Playing Pipes [Study]; Flute Player; Nude Figure Playing Pipes; Youth Playing Fife)

Oil on wood panel
10¼ x 8¼ in. (26 x 21 cm)

In 1883, one year into his directorship of the Pennsylvania Academy of the Fine Arts, Eakins decided to paint two major pictures that would demonstrate his artistic philosophy. The paintings depicted

groups of nude youths in outdoor settings. One, *The Swimming Hole* (1884–85, Amon Carter Museum, Fort Worth, Tex.), was a contemporary scene, its emphasis the human body in motion. The other, known as *Arcadia* (fig. 1), was set in the classical past and depicted a trio of youths who rest in a secluded meadow and make music with reed pipes. The two canvases present what Eakins considered the absolute constants through the ages: the human body, physical camaraderie, the outdoors.

Although Eakins had his students emulate the rigorous study that the Greeks gave to the human form, he opposed the prettified falsehoods so often created when classical stories were retold by modern artists. Not surprisingly, his own brief venture into classical subject matter differed greatly from that of his contemporaries. Around 1883–84, he made a bronze bas-relief of seven figures that vaguely evoked a classical frieze, took photos of

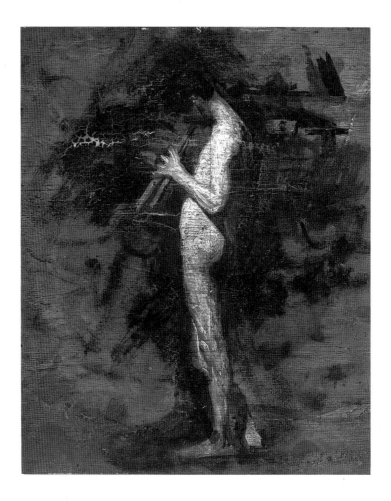

his students in ancient Greek costume, and partially completed the only pastoral subjects he ever attempted, the largest of which is *Arcadia*, although what title Eakins intended is uncertain. These are among Eakins's most aesthetically troublesome works, chiefly because they insist upon depicting a nonexistent past through a Realist's eyes. The bas-relief is roughly modeled, and the figures in his canvases appear under blazing sunlight. In neither did Eakins accept the notions that pastoral settings should be devoid of worldly imperfection and awkwardness.

Perhaps no single image displays Eakins's contrariness better than the standing figure of a young man playing the reed pipes in *Arcadia*, for which the Carnegie oil sketch was the preparatory study. The figure is gaunt, unathletic, and in no way representative of the physical ideal of classical antiquity. The model is generally agreed to be J. Laurie Wallace, a student of Eakins who often posed for him. Before he made the oil sketch, Eakins took photographs outdoors at his sister's farm in Avondale, Pennsylvania, of Wallace in this pose (fig. 2). It became the basis for this small oil sketch on panel.

The evident purpose of the oil sketch was to bring forth the figure's three dimensionality and unity in a way that flattened photographic images could not. As Eakins worked this panel, he gave most attention (and the thickest paint) to the highlighting along the figure's left side. This boldly highlighted rendition of Wallace's stooped, scrawny, and eminently unclassical physique Eakins transferred to the larger canvas, where it formed the work's insistent focal point. After painting it into his *Arcadia* canvas, Eakins made a somewhat more muscular version of the same figure into a bronze bas-relief.

The oil sketch's top layers of paint exhibit considerable crackling, which has exposed the artist's characteristic vermilion ground beneath. It appears he had used the panel for a previous sketch, this excess of paint beneath having caused the upper layer to crack.

DS

Remarks The underlying sketch resembles the coach in *The Fairman Rogers Four-in-Hand* (1879–80, Philadelphia Museum of Art). On the reverse is a landscape study (fig. 3). The panel was cut down on both sides, possibly by Charles Bregler after Eakins's death.

Fig. 1 Thomas Eakins, *Arcadia*, c. 1883. Oil on canvas, 38⅝ x 45 in. (98.1 x 114.3 cm). Metropolitan Museum of Art, New York, bequest of Miss Adelaide Milton de Groot, 1967

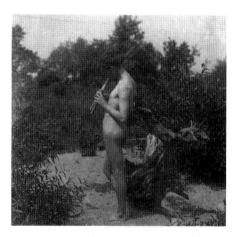

Fig. 2 Thomas Eakins, *Standing Piper (Study for Arcadia)*, c. 1883. Albumen print on paper, 3⁵⁄₁₆ x 2¼ in. (8.5 x 5.7 cm) irreg. Hirshhorn Museum and Sculpture Garden, Smithsonian Institution, Washington, D.C.; transferred from HMSG Archives, 1983

Fig. 3 Thomas Eakins, *Landscape Study*, c. 1881–83. Verso of *Study for "Arcadia": Youth Playing Pipes.*

References Goodrich, *Thomas Eakins: His Life and Work*, no. 198, p. 177, as *Youth Playing Pipes (Study)*; V. Barker, "Imagination in Thomas Eakins," *Parnassus* 2 (Nov. 1939), pp. 8–10, as *Flute Player*; "Sketches in Oils by Thomas Eakins," *Art in America* 28 (Apr. 1940), pp. 81–82, as *Youth Playing Pipes*; R. McKinney, *Thomas Eakins* (New York, 1942), p. 84, as *Nude Figure Playing Pipes*; F. Porter, *Thomas Eakins* (New York, 1959), no. 33, as *Youth Playing Fife*; M. M. Domit, *The Sculpture of Thomas Eakins* (Washington, D.C., 1969), no. 16, p. 48, as *Youth Playing the Pipes*; N. Spassky, *American Paintings in the Metropolitan Museum of Art* (New York, 1985), vol. 2, pp. 608–11, as *Youth Playing Pipes*; M. Simpson, "Thomas Eakins and His Arcadian Works," *Smithsonian Studies in American Art* 1 (Fall 1987), p. 78; D. Strazdes, "Thomas Eakins at The Carnegie: Private Vision, Public Enigma," *Carnegie Magazine* 59 (Jan.–Feb. 1988), pp. 26–27.

Exhibitions Department of Fine Arts, Carnegie Institute, Pittsburgh, 1945, *Thomas Eakins Centennial Exhibition, 1844–1944*, no. 76, as *Nude Figure Playing Pipes*; Corcoran Gallery of Art, Washington, D.C., 1969, *The Sculptures of Thomas Eakins*, no. 16.

Provenance Sale of Eakins estate, 1939; Babcock Galleries, New York, 1939; Maurice Horwitz, Butler, Pa., 1947.

Gift of Maurice Horwitz, 1986, 86.40

Study for "Salutat," 1898

Oil on canvas
20⅛ x 16⅛ in. (51.1 x 40.9 cm)

Inscription: Dextra Victrice/Conclamantes Salutat/To his friend/Sadakichi Hartmann/Thomas Eakins (on reverse, in the artist's hand)

Between 1898 and 1899 Eakins made three paintings about the sport of boxing: *Taking the Count*, a mammoth canvas (1898, Yale University Art Gallery, New Haven, Conn.), *Salutat* (fig. 1), and *Between Rounds* (1898, Philadelphia Museum of Art). The subject, although a new one for Eakins, was a natural extension of the sporting scenes he had painted earlier in life. Like them, it had an autobiographical element, for Eakins always enjoyed boxing, and he became an avid prizefighting fan who seldom missed the bouts at the Philadelphia Arena on Broad and Cherry streets. The individuals he met there were the protagonists in his three pictures, while his friends became the supporting characters.

To Eakins, the sport of prizefighting was disciplined and dignified. He chose to focus each of his three paintings on the

moment the boxer places his skills before the judgment of others, as, indeed, artists are obliged to do. *Salutat*, probably the last boxing picture to be begun,[1] was the first to be exhibited; it appeared at the Pennsylvania Academy of the Fine Arts, Philadelphia, in January 1899 and at the Carnegie International the following November. It is at once the most boldly experimental of the three compositions and the most explicit in presenting the prizefight as a classic art form.

Salutat's principal figure is the featherweight Billy Smith, who is also the central actor in *Taking the Count* and appears at ringside in the role of a second in *Between Rounds*. Here, he is leaving the

arena at the end of a successful fight, pausing to acknowledge the spectators' applause. His nearly nude body creates a striking contrast to the other figures in the picture, who are in street clothes, and indeed he appears displaced in time. His gesture recalls an ancient Roman gladiator. On the frame of the final painting and on the reverse of this oil sketch for it Eakins inscribed, "Dextra Victrice Conclamantes Salutat" (The Victorious Right Hand Salutes the Shouters). Eakins thus associates the modern athlete with his ancient counterparts, such as those in Jean-Léon Gérôme's history painting *Ave Caesar! Morituri te Salutant* (1859, Yale University Art Gallery, New Haven, Conn.), although, interestingly enough,

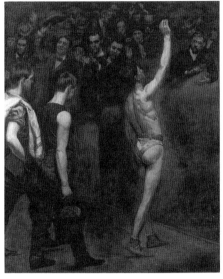

Fig. 1 Thomas Eakins, *Salutat*, 1898. Oil on canvas, 49½ x 39½ in. (125.7 x 100.3 cm). Addison Gallery of American Art, Phillips Academy, Andover, Massachusetts, gift of anonymous donor

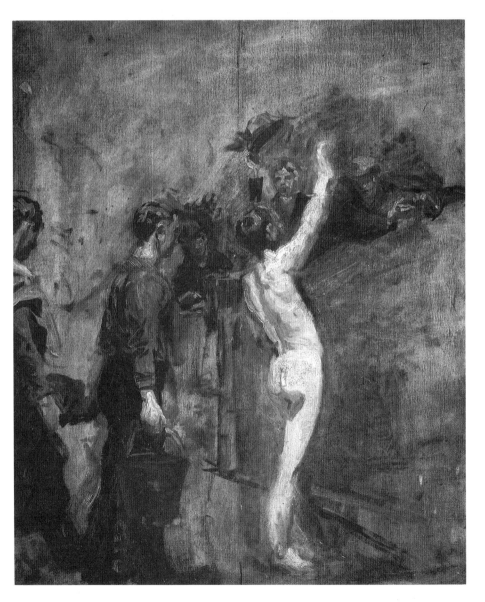

Eakins endowed his fighter with a far serener nobility.

The Carnegie's sketch, which the artist gave to the art critic Sadakichi Hartmann, is a preliminary outline of the entire composition, nearly identical in size and finish to the study made for *Taking the Count* (c. 1898, Yale University Art Gallery, New Haven, Conn.). With tones mainly of brown, Eakins quickly brushed in the fighter, his two seconds behind him, and three of what would ultimately become four spectators standing in the first row of the arena. Although he had not yet determined the identities of the spectators, it seems, judging from the boxer's small-boned physique, that Billy Smith's role in the painting was decided at the outset.

Perhaps the most interesting feature of this sketch is that its arrangement of figures is more awkward and more willfully antiheroic than that in the larger work. The victorious boxer, for example, is not only particularly scrawny but also shorter than the two figures who follow him out of the arena. This trio is in turn dwarfed by much more surrounding space than Eakins permitted in his final canvas.

This picture shows some telling stylistic changes when compared to earlier studies

such as the Carnegie's *Study for "Arcadia": Youth Playing Pipes* of 1883 (see p. 178). In this oil sketch, the figures are less systematically built into solid substance than in *Study for "Arcadia,"* with its numerous layers of paint. The thinner pigment of the *Salutat* study more closely approximates independent strokes of the brush, which do not immediately make themselves understood as three-dimensional form. Some of that indeterminate quality also enters the final canvas—by way of the scumbled arena wall and the uncertain perspective of the foreground—with a conviction that Eakins probably would not have possessed fifteen years earlier.
DS

1 Goodrich, *Thomas Eakins* (1982), vol. 2, p. 149.

References Goodrich, *Thomas Eakins: His Life and Work*, p. 189, as *Study;* Goodrich, *Thomas Eakins*, vol. 2, pp. 152, 155; D. Strazdes, "Thomas Eakins at The Carnegie: Private Vision, Public Enigma," *Carnegie Magazine* 59 (Jan.–Feb. 1988), pp. 27–28.

Provenance Sadakichi Hartmann, c. 1898; Mrs. Emil Carlsen, Falls Village, Conn., by 1933; Maynard Walker Gallery, New York, by 1958; Mrs. James H. Beal, Pittsburgh, 1958.

Gift of Mr. and Mrs. James H. Beal, 1981, 81.54.1

Joseph R. Woodwell, 1904

Oil on canvas
24 x 20 in. (61 x 50.8 cm)
Inscription: To my friend/Joseph R. Woodwell/ Thomas Eakins/1904. (lower right)

It is relatively easy to understand why Eakins was attracted to the painting of large portraits. Works such as *The Concert Singer* (1890–92, Philadelphia Museum of Art) and *Louis N. Kenton* (1900, Metropolitan Museum of Art, New York) demonstrate that such images can offer a history painting's scale and nearly its scope if one manipulates their pictorial possibilities to full advantage. Since the creative options of bust-length portraiture are far fewer, it is difficult to imagine what their artistic appeal to Eakins might have been. But it obviously existed, for late in his life, he produced them in considerable numbers, as if he felt at once liberated and reassured by their limitations.

Eakins's 1904 portrait of Joseph Ryan Woodwell (1843–1916) is such a work.

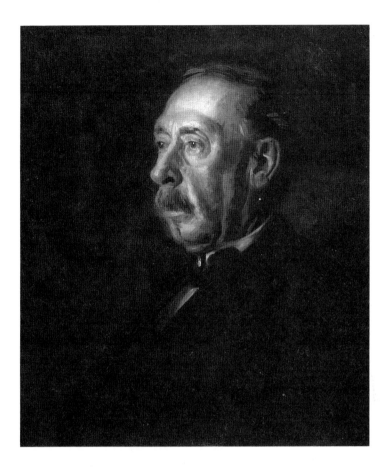

Woodwell was a Pittsburgh landscape painter nearly Eakins's age who had studied in Paris about the same time as Eakins. Since the two men had exhibited at both the Carnegie International and the Pennsylvania Academy of the Fine Arts, their paths would have crossed in Pittsburgh as well as Philadelphia. This portrait, a gift from Eakins to Woodwell, was one of four small portraits of artist-colleagues, all exactly the same size. The others are *William Merritt Chase* (c. 1899, Hirshhorn Museum and Sculpture Garden, Washington, D.C.), *Henry O. Tanner* (1900, Hyde Collection, Glens Falls, N.Y.), and *Frank B. A. Linton* (1904, Hirshhorn Museum and Sculpture Garden, Washington, D.C.).

In deference to the canvases' limited size, Eakins greatly simplified their background, costume, color, and compositional arrangement. In the portraits of Chase, Tanner, and Woodwell, he added another restriction: the sitters turn away from the viewer, so that the only engagement between subject and viewer is through the light that plays over the former's facial features. The result—a curious mixture of intimacy and remoteness—emerges strongly in the image of Woodwell.

In Woodwell's portrait, Eakins employed the same conceit that became the basis for larger efforts such as *Mrs. William D. Frishmuth* (1900, Philadelphia Museum of Art) and *The Old-Fashioned Dress* (1908, Philadelphia Museum of Art): he made it explicit that he was painting someone sitting for a portrait, by duplicating the stiff posture and blank expression that are the inevitable by-products of sessions in which one must sit still for long periods of time. This rather odd point of departure suggests that an individual's inner spirit lies deep within an unyielding and quite separate physical shell. By showing the retreat of one into the other, Eakins was able to provide a poignant metaphor for the weariness of life.
DS

References "Carnegie Buys Works by Davies and Eakins," *Art News* 29 (Feb. 28, 1931), p. 8; "New Patrons Art Fund Paintings," *Carnegie Magazine* 4 (Feb. 1931), pp. 280–81; Goodrich,

Thomas Eakins: His Life and Work, p. 200; R. McKinney, *Thomas Eakins* (New York, 1942), p. 101; J. O'Connor, Jr., "Thomas Eakins, Consistent Realist," *Carnegie Magazine* 19 (May 1945), p. 38; Hendricks, *The Life and Works of Thomas Eakins,* pp. 255, 348; N. Colvin, "Scalp Level Artists," *Carnegie Magazine* 57 (Sept.–Oct. 1984), p. 18; D. Strazdes, "Thomas Eakins at The Carnegie: Private Vision, Public Enigma," *Carnegie Magazine* 59 (Jan.–Feb. 1988), pp. 23, 26–27.

Exhibitions Department of Fine Arts, Carnegie Institute, Pittsburgh, 1945, *Thomas Eakins Centennial Exhibition, 1844–1944,* no. 8; Department of Fine Arts, Carnegie Institute, Pittsburgh, 1957, *American Classics of the Nineteenth Century,* no. 71; William Penn Memorial Museum, Harrisburg, Pa., 1983, *Pennsylvania Artists' Portraits,* no cat.

Provenance Joseph R. Woodwell, Pittsburgh, 1904; his daughter, Johanna K. W. Hailman, Pittsburgh, 1911.

Patrons Art Fund, 1930, 30.5

Jacob Eichholtz
1776–1842

Jacob Eichholtz numbered among those painters of fairly limited training who produced carefully made and sensitive portraits of modest size and conservative style during the first third of the nineteenth century. A native and longtime resident of Lancaster, Pennsylvania, Eichholtz learned the rudiments of art from a local sign painter. When his tutor committed suicide, he resigned himself to earning a livelihood as a coppersmith and tinsmith, but by 1806 he had taken up portraiture and in 1811 was being advised and encouraged by Thomas Sully. Following a consultation with Gilbert Stuart at Boston in 1811, he abandoned smithery for a full-time career as an artist. That same year, he began to exhibit at the Pennsylvania Academy of the Fine Arts, Philadelphia.

From 1820 to about 1823, Eichholtz worked in Baltimore, successfully competing with Sully and Rembrandt Peale for portrait commissions. He then moved to Philadelphia, where he became a leading portrait painter. He returned to Lancaster in 1832 and lived there for the remainder of his life, although he traveled frequently to Philadelphia and accepted commissions in Baltimore, Pittsburgh, and Harrisburg, Pennsylvania. His mature style can be described as direct and strong, with clear colors and smooth surfaces that convey a convincing sense of three dimensionality. It generally falls within the range of Romantic Neoclassicism and owes its greatest debt to Sully's manner of portrait painting. Although Eichholtz is known primarily for his work in portraiture, he also painted a small number of religious, historical, and landscape subjects. He died in Lancaster.

Bibliography William Dunlap, *A History of the Rise and Progress of the Arts of Design in the United States* (1834), Frank W. Bayley and Charles E. Goodspeed, eds., 3 vols. (reprint, Boston, 1918), vol. 2, pp. 384–86; William U. Hensel, *Jacob Eichholtz* (Lancaster, Pa., 1912); Rebecca J. Beal, *Jacob Eichholtz, 1776–1842: Portrait Painter of Pennsylvania* (Philadelphia, 1969), biographical essay by Edgar P. Richardson.

Portrait of a Man, 1815

Oil on canvas
29 x 24⅛ in. (73.7 x 61.3 cm)
Signature, date: Eichholtz/1815 (on reverse, now covered by relining)

Portrait of a Woman, 1815

Oil on canvas
29 x 24⅛ in. (73.7 x 61.3 cm)
Not known whether signature or date exists under relining

After 1811, Eichholtz's handling of paint became markedly more sophisticated, as did his ability to convey nuances of three-dimensional form. Though he was unquestionably influenced by Thomas Sully and Gilbert Stuart, his direct contacts with them were relatively brief, and it was probably his emulation of their work rather than their personal instruction that transformed his art. The existence of several copies by Eichholtz after Sully and Stuart (*Dr. William Barton* after Thomas Sully, after 1809, collection James A. Waller, Philadelphia; *Rev. William Smith* after Gilbert Stuart, 1810, Washington College, Chestertown, Md.) suggests that Eichholtz learned from the imitation of finished paintings.

The dignified sitters, who surely represent husband and wife, demonstrate the degree of proficiency that Eichholtz had achieved by 1815. The often coarse brushwork of the early portraits has become smooth and unobtrusive, colors are livelier and more varied, forms are convincingly modeled and appear to possess real

weight and volume. The artist is sufficiently confident of his ability to render form that he has replaced the profile with a three-quarter view. His most striking advance, however, is in the observation and delineation of character. In contrast to the deadpan expressions of his early subjects, the gaze of this solid citizen has a marked air of skepticism and suspicion, while the large, limpid eyes and subtle smile of his respectable wife bespeak a gracious and lively intelligence.

KN

Portrait of a Man

Reference Beal, *Jacob Eichholtz*, p. 195.

Exhibition Museum of Art, Carnegie Institute, Pittsburgh, 1973, *Art in Residence: Art Privately Owned in the Pittsburgh Area*, no cat.

Provenance Joseph Katz, Baltimore, until 1957; the artist's great-granddaughter, Mrs. James H. Beal, Pittsburgh, 1957.

Gift of Mrs. James H. Beal, 1972, 72.44.1

Portrait of a Woman

Reference Beal, *Jacob Eichholtz*, pp. 196–97.

Exhibition Museum of Art, Carnegie Institute, Pittsburgh, 1973, *Art in Residence: Art Privately Owned in the Pittsburgh Area*, no cat.

Provenance Joseph Katz, Baltimore, until 1957; the artist's great-granddaughter, Mrs. James H. Beal, Pittsburgh, 1957.

Gift of Mrs. James H. Beal, 1972, 72.44.2

Portrait of a Man, c. 1816–17

Oil on wood panel
Panel dimensions: 8⅞ x 6¾ in. (22.5 x 17.3 cm)

From the time he opened his studio on East King Street in Lancaster in 1808, small portraits on wood panel were a staple of Eichholtz's painting business. This one, an example of the near-ubiquitous profile bust in the Neoclassical fashion, is framed in an oval mat and is somewhat larger than the artist's early portraits of the same type. Its careful finish and attention to detail suggest that it was painted toward the middle of his career, perhaps in 1816 or slightly later.

A note in the files of the Garbisch Collection states that the sitter is "Mr. Taylor. . . said to be a signer of the Declaration of Independence." The man's youth and early nineteenth-century dress, however, rule out any possible identification with the signer George Taylor, who died in 1781 at the age of sixty-five.

However, the subject may well have been a member of the Taylor family whose likeness, by an error common in family tradition, was mistakenly assigned to a more illustrious ancestor.

KN

1 Beal, *Jacob Eichholtz*, p. xxv.

Provenance Edgar Sittig, Easton, Pa., before 1951; Edgar W. and Bernice Chrysler Garbisch, New York, 1951.

Bequest of Edgar W. and Bernice Chrysler Garbisch, 1981, 81.21.27

De Scott Evans
1847–1898

RECENTLY REDISCOVERED as a painter of trompe-l'oeil still lifes, De Scott Evans is still an artistic enigma. He seems to have worked under two different names, simultaneously producing "boudoir scenes and portraits of pretty women,"[1] tabletop still lifes in an academic manner, and hard-edged trompe-l'oeil pieces in a vernacular vein that would seem to be at odds with his other production.

Born David Scott Evans in the village of Boston, Indiana, he enrolled at Miami University, Oxford, Ohio, in 1863 but left the following year to enter the Cincinnati studio of Albert Beaugureau, a French drawing master and language teacher.

Evans's own early career was spent as an art instructor. After serving for a short time as professor of painting and music at Smithson College, Logansport, Indiana, he was elected in 1873 to the chair of fine arts at Mount Union College in Alliance, Ohio. At this period he painted a number of religious, literary, and allegorical scenes, in which his technique fell short of the pretensions of his subject matter. In 1874 he moved to Cleveland and opened a portrait studio.

In the spring of 1877, Evans went to Paris, where he studied for a year in the atelier of academic painter William-Adolphe Bouguereau. While there, he probably came to know the genre pieces of Alfred Stevens, for Evans's later scenes of society women in elegant interiors recall somewhat the work of the Belgian artist. At this time Evans altered his given names from David Scott to the more aristocratic De Scott.

When he returned to the United States in 1878, Evans became an instructor and codirector of the Cleveland Academy of Art. He held those positions until 1887, when he settled in New York. There, in spite of periodic attempts to try out various fashionable painting styles, Evans generally worked in a somewhat old-fashioned academic manner, producing portraits and genre paintings that were vaguely reminiscent of Eastman Johnson's later work. During the remainder of the 1880s and the 1890s, Evans exhibited regularly at the National Academy of Design, achieving a modest reputation and reasonable financial success as a portrait and figure painter.

In New York he also created the superb trompe-l'oeil still lifes for which he is best known today. These small, often strikingly eccentric pictures seem to owe a debt to William M. Harnett's later work. They depict either hatchets, apples, or pears hanging against unpainted wooden planks, or almonds, peanuts, or small animals in wooden niches, sometimes covered with broken panes of glass. Oddly, Evans signed most of these trompe-l'oeil pieces with pseudonyms such as "S. S. David" and "Stanley S. David," suggesting that in his persona as an academic figure painter, he did not want to be associated with them, possibly to protect his reputation from the hostile criticism provoked by trompe-l'oeil painting of this sort.[2]

In 1898, when Evans received a commission to decorate the music room of a Cleveland mansion, he set sail for France, planning to execute the suite of paintings in Paris. His ship, the *Bourgogne*, collided with an English vessel in the North Atlantic, and Evans and his daughters perished in the disaster.

1 Childe, "A Painter of Pretty Women," p. 282.
2 William H. Gerdts and Russell Burke, *American Still-Life Painting* (New York, 1971), pp. 167–68.

Bibliography "De Scott Evans," *Sketch Book* 1 (February 1883), p. 20; Cromwell Childe, "A Painter of Pretty Women," *Quarterly Illustrator* 1 (October–December 1893), pp. 279–82; Mary Q. Burnett, *Art and Artists of Indiana* (New York, 1921), pp. 50–52; Nancy Troy, "From the Peanut Gallery: The Rediscovery of De Scott Evans," *Yale University Art Gallery Bulletin* 36 (Spring 1977), pp. 36–43; Columbus Museum of Art, Ohio, *A New Variety, Try One: De Scott Evans or S. S. David* (1985), exh. cat. by Nanette V. Maciejunes.

Grandma's Visitors, 1883

Oil on canvas
24 x 36 in. (61 x 91.4 cm)
Signature, date: De Scott Evans/1883 (lower left)

Sentimental images of childhood and rustic life were probably the two most durable pictorial subjects in the late nineteenth-century American art market. De Scott

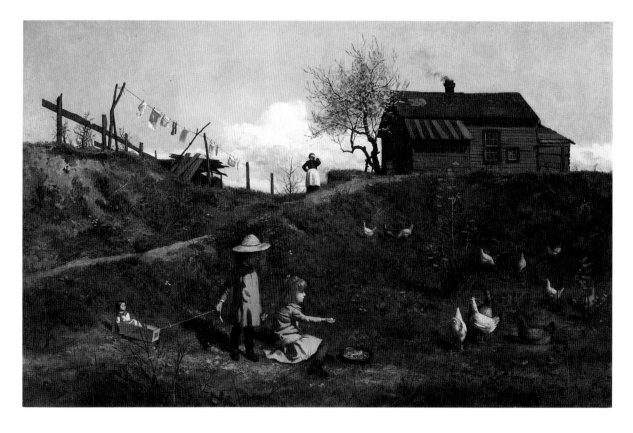

Evans's surviving paintings as well as contemporary accounts of his work indicate that he was a practitioner of subjects in both these categories during the nineteenth century. *Grandma's Visitors* is an example of the two genres combined.

This painting shows two children playing with chickens near a farmhouse on a sunny day; a woman in the distance looks on. The title suggests that the children are city dwellers visiting their grandmother in the country, a theme similar to Evans's *Cousin from Town*,[1] which depicts an elegantly, though inappropriately, attired young woman conversing with a boy milking a cow.

Painted in Cleveland, *Grandma's Visitors* marked the point in Evans's career after he returned from Paris but before he entered the relatively sophisticated and competitive atmosphere of New York. This fact may explain its odd combination of sophistication and primitiveness. The children—the older of whom is coaxing the chickens in the farmyard to eat bread crumbs from her hand as the younger one looks on—are given their own vignette in the foreground. The patched-up farmhouse and fallen-down fence that frame the upper part and background of the painting add a traditional rustic picturesqueness. But this background area is also remarkable for its sunlit freshness and tight, illusionistic handling. Although figures and setting are both rendered with skill, the children are not portrayed nearly so sensitively as the sunny landscape.

This peculiar unevenness between objects and human form characterizes Evans's work as a whole. The composition of his figure paintings always appears slightly disjointed. His greater skill lay in the rendering of inanimate objects, a sensibility that may well have led De Scott Evans to trompe-l'oeil still life. Of his known figure paintings, *Grandma's Visitors* provides the most convincing link between Evans's work as a genre painter and the trompe-l'oeil work he created under the identity of S. S. David.

KN, DS

1 Reproduced in Childe, "A Painter of Pretty Women," p. 282.

References "Evans, De Scott," in J. G. Wilson and J. Fiske, eds., *Appleton's Cyclopedia of American Biography* (New York, 1888), vol. 2, p. 380; M. Fielding, *Dictionary of American Painters, Sculptors and Engravers* (1945; rev. ed., New York, 1960), p. 113; W. H. Gerdts, *Art across America: Two Centuries of Regional Painting* (New York, 1990), vol. 2, p. 216.

Exhibitions Terra Museum of American Art, Evanston, Ill., 1981, *Life in Nineteenth Century America: An Exhibition of American Genre Painting*, no. 74; Columbus Museum of Art, Ohio, 1985–86, *A New Variety, Try One: De Scott Evans or S. S. David*, exh. cat. by N. Maciejunes, no. 7.

Provenance Beverley Dakan, Los Gatos, Calif., c. 1930.

Mrs. Paul B. Ernst Purchase Fund, 1981, 81.13.2

Lyonel Feininger
1871–1956

Lyonel Feininger was the only American painter (with the possible exception of Marsden Hartley) to be involved in the birth of a major early modernist art movement in Europe. His career was closely bound to avant-garde developments in Germany, where he made one of the most significant contributions of any American artist who worked there.

Born Charles Léonell Feininger in New York City to a father who was a prominent violinist and a mother who was a pianist, Feininger was intensely involved with music as a child. He began studying the violin at age nine, played with an orchestra at age twelve, and retained a lifelong love for the violin. That interest in music, some biographers argue, also made a visible mark on his painting. When he was sixteen he followed his parents to Germany, but rather than continue his musical training, he enrolled at Hamburg's Kunstgewerbe Schule, where he studied drawing and taught himself watercolor painting. He left for Berlin in 1888, after gaining admittance to the art academy there. He remained until 1892, taking time for a visit to Brussels in 1890. From 1892 to 1893 he was in Paris, studying at the Atelier Colarossi.

Feininger's first professional work was as an illustrator. By 1890 he was publishing cartoons for Berlin newspapers, and from 1893 to 1907 his chief artistic efforts were satirical cartoons for German humor magazines and for newspapers in Berlin, Paris, and Chicago. He began painting during a second residence in Paris from 1906 to 1908, when he became friendly with Jules Pascin and Robert Delaunay. His first oils reveal the influence of Vincent van Gogh and Paul Cézanne, while retaining the stylized caricature of his earlier illustrations.

An important stylistic shift was set in motion in 1911, when Feininger again visited Paris, this time to see the Salon des Indépendants, where he was an exhibitor. There he saw Cubist painting for the first time, which led him to use Cubist ideas as the basis for his own work. Back in Berlin he became involved with the city's avant-garde: in 1912 he met members of Die Brücke. The next year he made the acquaintance of Herwarth Walden, editor of *Der Sturm*, Germany's first avant-garde art magazine, and Franz Marc, who invited him to exhibit with the Blaue Reiter group, which included Marc, Paul Klee, Wassily Kandinsky, August Macke, and Alexei Jawlensky. In 1917 Feininger had his first solo show at Walden's Galerie der Sturm in Berlin.

In 1919 Walter Gropius invited him to join the Bauhaus as an artist-in-residence, an affiliation that lasted until 1932. In 1924 Feininger joined his surviving Blaue Reiter colleagues Klee, Kandinsky, and Jawlensky to form the Blaue Vier group. Their exhibitions enjoyed wide circulation, which included a tour to New York, Chicago, the West Coast, and Mexico City. In 1931, on his sixtieth birthday, he was given a large retrospective at the Nationalgalerie in Berlin.

The Nazi hegemony in Germany led to Feininger's decision, in 1936, to return to the United States. He had a solo exhibition at the East River Gallery, New York, in 1936, and settled permanently in New York in 1937, the same year his confiscated work was shown in the Nazis' Munich exhibition of "degenerate art." He executed murals for the 1939–40 New York World's Fair, won the acquisition prize from the 1942 *Artists for Victory* exhibition at the Metropolitan Museum of Art, New York, and in 1947 was elected president of the Federation of Modern Painters and Sculptors. From the late 1930s through the 1950s, he also exhibited in nine of Carnegie Institute's annual exhibitions, receiving second prize in 1950 for *House by the River* (1949, collection Mrs. Robert F. Windfohr, Fort Worth, Tex.).

Feininger's paintings—often seascapes and cityscapes made of broken, layered, transparent geometric shapes—have led to his reputation as a romantic modernist who combined Cubist-inspired visual form with his own subtly evocative color harmonies. He was considered, especially during the 1940s and 1950s, to have made a major contribution to the formal issues raised by modern art.

Feininger had a considerable interest in graphic art throughout his career; he created a large and important corpus of woodcuts, etchings, and lithographs, as well as drawings and watercolors. In 1959, three years after his death in New York, a major memorial exhibition of his work, organized by the San Francisco Museum of Art, made a three-year tour through the United States, England, and Germany.

Bibliography Hans Hess, *Lyonel Feininger* (1959; reprint, New York, 1961); Johannes Langner, *Lyonel Feininger: Segelschiffe* (Stuttgart, 1962); Pasadena Art Museum, Calif., 1965, *Lyonel Feininger, 1871–1956: A Memorial Exhibition* (trav. exh.), exh. cat. by James Demetrion; Haus der Kunst, Munich, *Lyonel Feininger, 1871–1956* (1973); June L. Ness, ed., *Lyonel Feininger* (New York, 1974).

Harbor Mole, 1913
(Hafenmole; Hafen)

Oil on canvas
31¾ x 39¾ in. (80.6 x 101 cm)
Signature, date: Feininger 13 (lower right)

Feininger began to experiment with Cubist fragmentation of planes in 1912; by 1913 those experiments had developed into a sophisticated technique that bore his own distinctive stamp. His preference for dynamic, emotionally expressive compositions probably derived from Robert Delaunay, but it was also in keeping with the tendencies of his Blaue Reiter colleagues, particularly Franz Marc. It would remain a hallmark of his art through the next two decades.

The subject of Feininger's first Cubist-inspired paintings tended to be landscapes in which both immaterial and solid substances were broken into facets of color. That process made light appear more solid, while solid objects lost their substance. The result was a view into an altered three-dimensional space in which all precise footing was lost, with nature's order yielding to the artist's. Thus Feininger set forth his answer to the problem of artistic creation, as expressed in a letter in 1917: "We have to overcome nature in order to be able to create freely."[1]

Harbor Mole is among the most accomplished of the artist's early works and one of the first fully formed statements of his mature aesthetic sensibilities. It is a seascape, as were several other paintings of 1913, notably *Side Wheeler* (Detroit Institute of Arts) and *The Beacon* (Museum Folkwang, Essen). Here, the subject is a mole, a stone breakwater set up on a harbor. The waves crashing

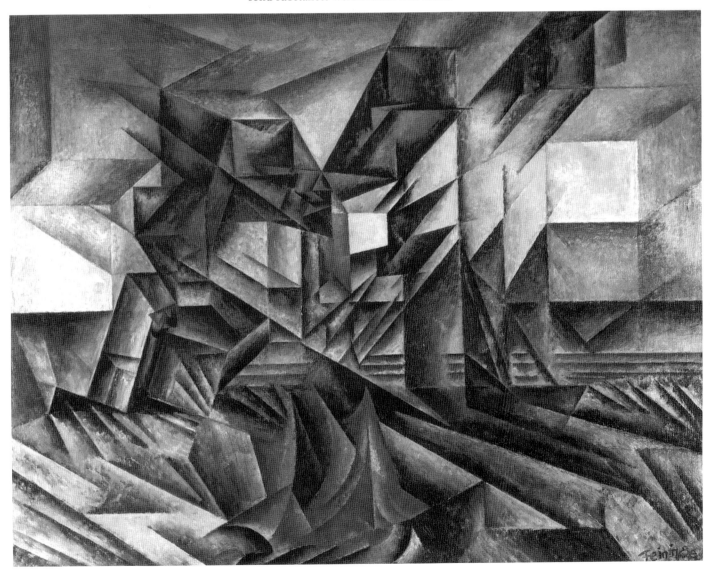

against its firm horizontal mass provide an abstract interplay of the elemental forces one finds at sea.

Feininger massed his fragmented forms at the center of the picture, a conceit he used in several works from 1913 to 1915. Here that central mass consists of a shattered sailboat and lighthouse, which are seen against waves that have taken on the aspect of large crystals. These closely packed forms create an unusual sense of ascending abstract power as one's eye approaches the composition's center. The palette, in the grayed tones characteristic of Feininger, favors yellow-greens and blue-greens, with orange to represent the lighthouse and boat. Interestingly, the true blues are reserved for the waves that rise well above the sea line.

Although this new visual matrix is both impersonal and dynamic, it is not created from objects that were themselves modern. Feininger generally depicted powerful things, but they were old—lighthouses, old boats, antiquated village churches. Perhaps he meant to enforce the message that the powerfully "modern" visual appearance comes from the artist, not his subject matter.
DS

1 Lyonel Feininger to Paul Westheim, March 14, 1917, in Hess, *Lyonel Feininger*, p. 27.

References H. Walden, *Einblick in Kunst: Expressionismus, Futurismus, Kubismus* (1916; reprint, Berlin, 1924), p. 51; Hess, *Lyonel Feininger*, no. 113, p. 258; H. H. Arnason, *History of Modern Art*, 3d ed. (New York, 1986), p. 131.

Exhibitions Galerie der Sturm, Berlin, 1913, *Erster Deutscher Herbstsalon* (indicated by label on back of painting), no cat.; possibly Galerie Ernst Arnold, Dresden, 1914, *Die Neue Malerei*, no cat.; probably Feininger's solo exhibition at J. B. Neumann Gallery, Berlin, 1919, no cat.; Kunstverein, Hamburg, 1932, *Lyonel Feininger*, retrospective exhibition, no. 506; Galerie Karl Nierendorf, Berlin, 1936, *Lyonel Feininger*, no. 60; Cleveland Museum of Art, 1960, *Lyonel Feininger Memorial Exhibition* (trav. exh.), no. 4; Whitney Museum of American Art, New York, 1966, *Art of the United States, 1670–1966*, no. 94.

Provenance F. R. Schon, Switzerland and Toronto, by 1936–40; Dominion Gallery, Montreal, 1943 or 1944; Mr. and Mrs. John Drew, Pittsburgh, by 1946.

Fractional gift of Frances L. Drew, M.D. (Mrs. John Drew), 1984, 84.106

Erastus Salisbury Field
1805–1900

TODAY, ONE OF THE best known of nineteenth-century American folk painters is Erastus Salisbury Field. He was born in Leverett, Massachusetts, where he began painting as a young boy. His parents, wishing to encourage that interest, sent him to New York City in 1824 to study under Samuel F. B. Morse. The apprenticeship was brief, for Field remained at Morse's studio only until early in 1825, not enough time to rid his style of its self-taught characteristics, but sufficiently long for his paintings to show noticeable stylistic changes. Thereafter his forms became surer and more expansive, and a more subtle facture replaced his enamel-like surfaces.

Returning to the Connecticut River valley in 1825, Field traveled from town to town, painting portraits of his relatives and their friends. In 1831 he married Phebe Gilmur, and one year later their daughter, Henrietta, was born. In the 1840s the rising popularity of photographic portraits prompted Field and his family to relocate to a more prosperous and populous locale—New York City—where the artist hoped that he could still obtain commissions for painted portraits.

Little is known about Field's life in New York, but it is believed that he studied photography, for upon his return to Massachusetts in 1849, he set up a studio with a camera for photographing his portrait subjects. His paintings from this time present a carefully calculated, refined surface, but they lack the spontaneity that characterized his work between his two New York sojourns.

In 1859 Field's wife died. Perhaps as a consequence, the artist began to concentrate less on portraiture and more on historical and biblical subjects. Notable examples of the latter were versions of the Garden of Eden (c. 1865, Museum of Fine Arts, Boston, and the Shelburne Museum, Shelburne, Vt.) and the plagues of Egypt (c. 1865–70, originally meant to decorate the walls of North Amherst Church in western Massachusetts; one is now in the Museum of Fine Arts, Springfield, Mass.).

Field's most ambitious work was *The Historical Monument of the American Republic* (1876, Museum of Fine Arts, Springfield, Mass.). Painted in commemoration of the hundredth anniversary of

American independence, it depicts an architectural fantasy of ten towers, each adorned with scenes from American history. It clearly demonstrates those characteristics that distinguished Field as an artist—his fertile imagination, his love of detail, and his interest in the traditional higher ambitions of artists. He died in Sunderland, Massachusetts, not far from his birthplace.

Bibliography Frederick B. Robinson, "Erastus Salisbury Field," *Art in America* 30 (October 1942), pp. 244–53; Abby Aldrich Rockfeller Folk Art Collection, Williamsburg, Va., *Erastus Salisbury Field, 1805–1900* (1963), exh. cat. by Mary C. Black; Mary C. Black, "Erastus Salisbury Field and the Sources of His Inspiration," *Antiques* 83 (February 1963), pp. 201–6; Mary C. Black, "Erastus Salisbury Field: 1805–1900," in *American Folk Painters of Three Centuries* (New York, 1980), pp. 74–81; Museum of Fine Arts, Springfield, Mass., *Erastus Salisbury Field, 1805–1900* (1984), exh. cat. by Mary C. Black.

Portrait of a Woman, c. 1840

Oil on canvas
26⅜ x 22 in. (67 x 55.9 cm) oval

This three-quarter-length portrait of an unidentified woman, perhaps in her mid-twenties, shows her dressed and coiffed in styles that suggest a date between the late 1830s and early 1840s. Her blue gown with full sleeves has an off-the-shoulder neckline, trimmed with white lace, and a wide white belt with a decorative buckle. Two delicately worked chains adorn her neck, earrings dangle from her earlobes, and there is a matching pin at the neckline of her dress. Her hair is pulled back loosely from the center part; there are curls over both temples.

In style and technique, the portrait corresponds to the type Field was painting from the 1830s to the 1840s. He reduced the amount of time he spent laying out his compositions by using a frontal format for most, with the sitter's head turned slightly to the viewer's right. He then sought to distinguish his sitters by capturing their own facial features and the decorative embellishments of their clothing. Field's technique of painting lace as black dots over a white ground and his use of softer, looser brushstrokes began in the 1830s, while the higher keyed colors of this portrait—principally bright blue and orange tan—correspond

to paintings such as *Miss Margaret Gilmore* (c. 1845, Museum of Fine Arts, Boston).

EM

Provenance Peter Kostoff; Edgar W. and Bernice Chrysler Garbisch, Cambridge, Md., 1962.

Bequest of Edgar W. and Bernice Chrysler Garbisch, 1981, 81.21.28

Ernest Fiene

1894–1965

BORN IN ELBERFELD, near Cologne, Ernest Fiene was eighteen years old when he left Germany to avoid conscription into the kaiser's army. From Holland he went to America and by 1914 entered the school of the National Academy of Design in New York City. During the next ten years he studied at the Beaux-Arts Institute under Leon Kroll and Thomas Maynard and in 1923 learned printmaking at the Art Students League.

Fiene's career was successful from the beginning. In 1923 he showed his work at the Whitney Studio Club in New York. The next year, when he had a solo exhibition at the New Gallery, also in New York, he sold all fifty-two of his paintings and was able to buy a home from the profits. He contributed frequently to Carnegie Institute's annual exhibitions between 1931 and 1950, winning a fourth-place honorable mention in 1939.

From his youth, Fiene was interested in the transformation of nature by modern

industry. An apprentice in mining construction at the age of fourteen, he initially wanted to become an engineer. Two paintings of the Brooklyn Bridge done in 1927 are harbingers of the themes of city and industry that later became his signature.

Fiene returned to Europe twice. In 1928–29 he rented Jules Pascin's studio in Paris and enrolled in the Académie de la Grande Chaumière. He knew Georges Braque and André Derain but was more influenced by the works of Henri Matisse. In 1932 he went to Italy on a Guggenheim Fellowship to study mural-painting techniques, but before leaving America he made this statement of his modernist allegiances:

> I am interested more in the future of American art than in the past of European art. Out of this new civilization, out of this machine age, a new school of painters will be developed.[1]

After his return to the United States, Fiene painted murals for the post office in Canton, Massachusetts, in 1937 and a four-panel mural for the Department of the Interior in Washington, D.C., in 1938. Among his finest works are two large murals unveiled in 1940 at the Central High School of Needle Trades, New York.

In addition to his work as a painter, Fiene made lithographs and etchings throughout his career, as well as book illustrations during the 1920s. He taught at the Art Students League from 1938 until his last years and wrote a book, *A Complete Guide to Oil Painting*, published in 1964. While completing a set of lithographs, Fiene died in Paris of a heart attack. His friends included George

Grosz, Pascin, Gaston Lachaise, Stuart Davis, and Thomas Hart Benton. The letters he exchanged with Benton are especially frank and lively. Perhaps it was this association with Benton that encouraged some critics to call Fiene an urban Regionalist.

1 New Rochelle, N.Y., *Standard-Star*, March 23, 1932, in ACA Galleries, *Ernest Fiene: Art of the City*, [p. 6].

Bibliography William Murrell, *Ernest Fiene*, Younger Artists series (Woodstock, N.Y., 1923); C. Adolph Glassgold, "Ernest Fiene," *Creative Art* 8 (June 1931), pp. 257–63; ACA Galleries, New York, *Ernest Fiene: Art of the City, 1925–1955* (1981), exh. cat. by Linda Hyman.

The Lucy Plant, Carnegie Steel, Pittsburgh, 1935–36
(Along the Allegheny)

Oil on canvas
29⅜ x 36½ in. (74.6 x 92.7 cm)
Signature: *E. Fiene.* (lower right)

In the winter of 1935, Fiene made an extensive trip through Pennsylvania and West Virginia as an art expert for the Federal Resettlement Administration. This painting, one of a series of images inspired by the urban and industrial landscape of the area around Pittsburgh, was the one he chose to exhibit at the Third Whitney Biennial in New York in November 1936, under the title *Along the Allegheny*. A year later, in October 1937, *Along the Allegheny* and a pastel-and-crayon drawing on paper called *The Lucy Plant* were among twelve paintings and

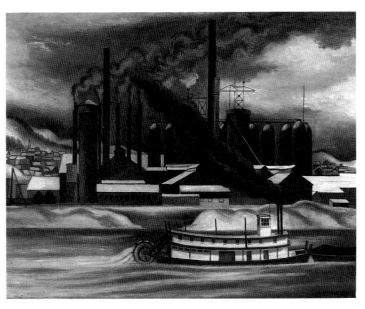

twelve drawings that Fiene exhibited in a show called *The Industrial Scene* at the First National Bank in Pittsburgh. Now owned by the Metropolitan Museum of Art, New York, under the title *Factory Building and River Boat*, the drawing corresponds to the Carnegie's painting. In fact, the drawing retains some horizontal bands on the bank between the boat and factory that Fiene later painted over, probably at the time he added his signature.

In the catalogue of the 1937 Pittsburgh exhibition, Fiene explained that he came into western Pennsylvania in order to "interpret industry in relation to its environment and to record an important phase in our period."[1] He found Pittsburgh to be

a symphony in gray, brown and black. The rising hills of the city wrapped in snow, a heavy ceiling of snow clouds gathering smoke from the belching chimneys, and the safron [*sic*] colored rivers winding their way through these populous hills; in this magic setting all objects became imbued with a new significance.[2]

The Carnegie's painting of the Lucy plant is bleak. The factory with its wall-like assemblage of shapes faces the viewer head on, the paddle boat pushes the coal barge on the rivers, and the surrounding hills are reduced by snow to generalized forms. The opposing diagonals of smoke from the boat and from the factory form a triangular wedge in the middle of the picture, a compositional device that Fiene had used a decade earlier in the Needle Trades murals. This is an image of man's industrial power and nature's coldness. A Pittsburgh critic found the paintings in the exhibit "sullen and lowering. . . bleak and expectant . . . busy and indifferent."[3] *The Lucy Plant* fits these adjectives.

Fiene chose a significant monument. The Lucy plant had been the first operating unit of Kloman, Carnegie and Company, forerunner of the Carnegie Steel Company. The first furnace, named after Carnegie's brother Tom's wife, went into blast in 1872. From the first, Carnegie and his men strove to increase the plant's productivity by continually improving and rebuilding the furnace. Across the river the Isabella furnace, owned by Cyril W. Crowthers, competed with the Lucy crew in smelting more and more steel. "Sometimes the flame-belching furnaces attracted crowds as great as those that used to throng the riverbanks to watch a steamboat race."[4]

The furnace demonstrated in a dramatic way the difference between the British method of production, which maintained and repaired its capital stock at the expense of high production, and Carnegie's new method, which cannibalized its equipment and achieved higher and higher production rates.[5] The Lucy furnace was rebuilt three times, each time on its original foundation; it was joined by sister furnaces on the site.

In 1907 Herbert N. Casson wrote a paean to the Lucy furnace:

The Lucy furnaces. . . have received no honours, no medals, no monuments. They have inspired neither artist nor poet. Yet for thirty-three years. . . they have been untiringly making the useless into the useful, magically transforming the ore into a ceaseless stream of that metal which is immeasurably. . . precious to civilization. . . . The Lucy furnaces represent the very utmost that the human race can do in the iron-making craft. . . . Their story will become a national heritage.[6]

Fiene may have been unaware that he was painting a historic monument, but by the time his Pittsburgh show opened, he could not escape the implications of his work. By 1937, as part of the Carnegie-Illinois Steel Corporation, a subsidiary of United States Steel, the Lucy plant was declared obsolete. Demolition began almost simultaneously with the opening of Fiene's show, on October 3, 1937, and in the following March the last of the furnaces toppled. It is possible that the drawing now at the Metropolitan Museum of Art was done after the painting and named *The Lucy Plant* in recognition of this historic moment.

The simplified forms of Fiene's painting convey the power of this plant and its dominance of life around it. From the very beginning, Fiene's style had been characterized as solid and having a simplicity devoid of naïveté. These qualities are evident in this painting and fit its subject.

RCY

1 Pittsburgh Commission for Industrial Expansion, 1937, *The Industrial Scene: Paintings and Drawings by Ernest Fiene*, [p. 1]. Catalogue note by the artist.

2 Ibid.

3 Dorothy Kantner, "Feine [*sic*] Paintings of Pittsburgh on Display," *Pittsburgh Sun-Telegraph*, September 30, 1937, p. 31.

4 John M. Lenhart, O.F.M., "Andrew Klopman, Founder of Carnegie Steel Company," *Social Justice Review: Pioneer American Journal of Catholic Social Action* 35 (April 1942), p. 351.

5 Harold C. Livesay, *Andrew Carnegie and the Rise of Big Business* (Boston, 1975), pp. 88–89.

6 Herbert N. Casson, *The Romance of Steel: The Story of a Thousand Millionaires* (New York, 1907), p. 89.

References "Whitney Biennial Fails to Stir Much Enthusiasm among Critics," *Art Digest* 2 (Dec. 1, 1936), p. 5; D. Kantner, "Feine [*sic*] Paintings of Pittsburgh on Display," *Pittsburgh Sun-Telegraph*, Sept. 30, 1937, p. 31.

Exhibitions Whitney Museum of American Art, New York, 1936, *Third Whitney Biennial*, no. 26, as *Along the Allegheny*; Pittsburgh Commission for Industrial Expansion, 1937, *The Industrial Scene: Paintings and Drawings by Ernest Fiene*, no. 2, as *Along the Allegheny*; ACA Galleries, New York, 1981, *Ernest Fiene: Art of the City, 1925–1955*, exh. cat. by L. Hyman, no. 13.

Provenance The artist's daughter, Maria Fiene; ACA Galleries, New York, by 1981.

Director's Discretionary Fund, 1981, 81.28

John B. Flannagan
1895–1942

BORN IN FARGO, North Dakota, John B. Flannagan was a leading figure among the American modernists who revitalized folk-sculpture traditions by returning to the direct-carving technique. Largely self-taught, he studied painting at the Minneapolis Institute of Arts in 1914. He interrupted his studies in 1917 when he joined the Merchant Marine, but he returned to practicing art upon his discharge in 1922. That year Arthur B. Davies hired him as his farmhand in Congers, New York, and encouraged him to resume painting and begin woodcarving.

In 1923 Flannagan participated in his first exhibition, a group show at the Montross Gallery, New York, which also included the work of Davies, Charles Sheeler, William Glackens, and Charles and Maurice Prendergast. Flannagan contributed five "wooden pictures" and two wax paintings to the group endeavor. He destroyed his paintings four years later, when he turned exclusively to direct carving in stone.[1] Poverty compelled the sculptor to select his own stones from rural New York and Connecticut. Flannagan was highly sensitive to the natural beauty of the stone's surface and its

abstract shape; therefore, as he worked the stone, he preserved its original contours and developed his subject from the inherent properties and form of his material.

An agreement with the Weyhe Gallery, New York, in 1929 partially relieved Flannagan's penury by providing him with a weekly stipend in exchange for his work. In 1930 gallery funding permitted Flannagan to travel to Ireland, where he lived for a year. Financed by a Guggenheim Fellowship, he returned for another year to Clifden, Ireland, in 1932.[2]

After his return to the United States, Flannagan suffered periods of alcoholism and finally a nervous breakdown, followed by seven months of hospitalization.[3] The 1930s brought him several exhibitions at the Weyhe Gallery; the Arts Club of Chicago; the Vassar College Art Gallery, Poughkeepsie, New York; the Brooklyn Museum; and Bard College, Annandale, New York. In 1936 he won a major public commission, to create *The Gold Miner*, a limestone sculpture designed for the Ellen Phillips Samuel Memorial in Philadelphia, for the Fairmount Park Association.

In 1939 Flannagan's career was abruptly checked by a hit-and-run accident that necessitated four brain operations. He continued to work throughout his recovery, however, turning from stone carving to bronze casting. Ultimately debilitated by poverty, illness, and psychological crises, Flannagan took his own life in his New York studio two months before his solo exhibition at the Buchholz Gallery in New York.[4]

1 Museum of Modern Art, *Sculpture of John B. Flannagan*, p. 14.

2 Whitney Museum of American Art, *Two Hundred Years of American Sculpture*, p. 272.

3 Museum of Modern Art, *Sculpture of John B. Flannagan*, p. 14.

4 Whitney Museum of American Art, *Two Hundred Years of American Sculpture*, p. 272.

Bibliography Margherita Flannagan, ed., *Letters of John B. Flannagan* (New York, 1942); Museum of Modern Art, New York, *The Sculpture of John B. Flannagan* (1942), exh. cat. by Dorothy C. Miller, introduction by Carl Zigrosser; John B. Flannagan, "The Image in the Rock," *Magazine of Art* 35 (March 1942), pp. 90–95; Weyhe Gallery, New York, and Minnesota Museum of Art, Saint Paul, *John B. Flannagan: Sculpture and Drawings from 1924–38* (1973); Whitney Museum of American Art, New York, *Two Hundred Years of American Sculpture* (1976), exh. cat. by Tom Armstrong et al., pp. 130, 140, 271ff.

Little Creature, 1941

Bluestone
13 1/16 x 2 3/8 x 5 1/4 in. (33.2 x 6 x 13.3 cm)
Markings: JBF (in monogram) •41• (on abdomen)

In 1942 the Museum of Modern Art, New York, published a statement of Flannagan's creative philosophy and process, entitled "The Image in the Rock." In it he wrote, "To that instrument of the subconscious, the hand of the sculptor, there exists an image within every rock. The creative act of realization merely frees it." Setting forth his aspirations, he continued,

> My aim is to produce sculpture as direct and swift in feeling as any drawing—sculpture with such ease, freedom, and simplicity that it hardly seems carved but rather to have endured so always. This accounts for my preference for fieldstone: its very rudeness seems to me more in harmony with simple direct statement.[1]

Little Creature, a grasshopper carved from local bluestone, represents Flannagan's stylistic tenets as well as his penchant for subject matter drawn from "humbler life forms [which] are often more useful as design than the... human figure."[2] Corresponding with Edgar J. Kaufmann, the original owner of *Little Creature*, Flannagan wrote:

> Burns sang a song of a field-mouse and other little things. Robert Burns could feel, and did feel for the intimate and little— they become *big* even as his heart and grand simple things—so beyond heroic attitudes never to become the "Mock-heroic." I know the *Grasshopper* has some of that in common with the many animals & diverse things I've wrought not as pure sentiment; but rather out of the deeper pantheistic urge of kinship with all living things—all of life.[3]

With a modernist's concern for materials, he preserved the original mass and general form of the stone. Limiting his carving primarily to the articulation of interior linear detail, Flannagan made shallow incisions on the stone's surface,

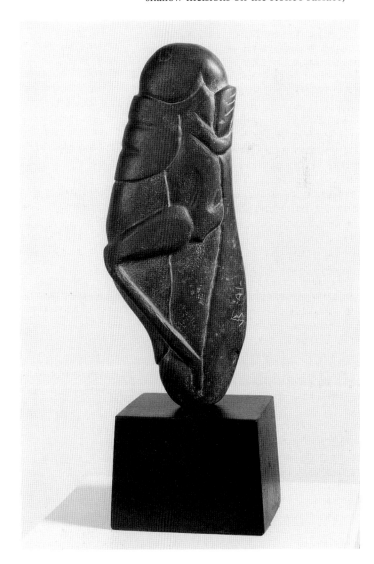

which at once describe an organic life form and evoke a lively abstract pattern based on ascending curves and counter-curves. The contained form and simpli-fied design bespeak Flannagan's vision of nature as unity and his conception of his art within that context: "I would like my sculpture to appear as rocks, left quite untouched and natural, and . . . inevitable."[4]

LM

1 Museum of Modern Art, *Sculpture of John B. Flannagan*, p. 7.

2 Ibid.

3 H. B. Teilman, "Three Early-Twentieth-Century American Sculptors," *Carnegie Magazine* 51 (March 1977), p. 115.

4 Museum of Modern Art, *Sculpture of John B. Flannagan*, p. 9.

Reference H. B. Teilman, "Three Early-Twentieth-Century American Sculptors," *Carnegie Magazine* 51 (Mar. 1977), p. 115.

Exhibitions Buchholz Gallery, New York, 1942, *John B. Flannagan*, no. 17; Museum of Modern Art, New York, 1942, *The Sculpture of John B. Flannagan*, exh. cat. by D. C. Miller, no. 38; Snite Museum of Art, University of Notre Dame, Ind., 1963, *J. B. Flannagan Exhi-bition*, no cat.; Museum of Art, Carnegie Institute, Pittsburgh, 1971, *Forerunners of American Abstraction*, exh. cat., introduction by H. B. Teilman, no. 52.

Provenance Edgar J. Kaufmann, Pittsburgh, 1941; G. David Thompson, Pittsburgh, by 1963; his wife, Helene S. Thompson, Pitts-burgh, by 1971.

Gift of Helene S. Thompson, 1976, 76.5

Alex Fletcher
1866–1952

BORN NEAR ELGIN, Scotland, Alex Fletcher was trained as a decorative painter—of marble patterns, wood grain, and interiors. His boyhood training included a five-year apprenticeship with an interior decorator and a course of study at the Mechanics Institute in the Scottish town of Forres. In 1888 he immigrated to the United States, follow-ing his older brother to Greensburg, Pennsylvania, twenty-five miles southeast of Pittsburgh, in Westmoreland County. Except for a short residence in California

from 1903 to 1906 to relieve his asthma, he spent the rest of his life in Greensburg, where he and his brother ran an interior-decorating establishment that supplied drapery, wallpaper, brass goods, and win-dow shades. Fletcher also painted furni-ture, toys, and other household articles.

Relatively late in life, and as an avocation, Fletcher began to make the naïve easel paintings that made him Westmoreland County's best-known artist. His flower pieces and local views, frequently and successfully exhibited with county artists' organizations from the 1920s onward, earned him the sobriquet "the John Kane of Greensburg." From 1932 to 1952 his work appeared at the annual exhibitions of the Greensburg Art Club and regularly won prizes there. He also served as the club's first president (1931–49) and for twenty-six years was a member of the Associated Artists of Pittsburgh, where he met and befriended John Kane, a fellow Scot. He exhibited with this organization between 1927 and 1948, winning awards in 1934 and 1938.

Fletcher's good-natured, self-deprecat-ing view of his status as an artist was well known. "I don't think I've had much of an art career," he told a local newspaper reporter.[1] The preface to the checklist of Fletcher's first solo show, held at the Latrobe High School Library in November 1940, reads, "Mr. Fletcher has painted for over sixty years and says he gets lots of fun from it because, being an amateur, he doesn't have to take his work seriously."[2]

1 Dorothy Kantner, "Fletcher, 74, Active in Greensburg Art," *Pittsburgh Sun-Telegraph*, September 27, 1940, p. 30.

2 Latrobe High School Library, Latrobe, Pa., *An Exhibit of Oil Paintings by Alex Fletcher* (1940), p. 2.

Bibliography Greensburg Art Club, Greens-burg, Pa., *Exhibition of Paintings by Alex Fletcher* (1942); Westmoreland County Muse-um of Art, Greensburg, Pa., *Alex Fletcher, 1866–1952* (1960), exh. cat. by Paul A. Chew; Paul A. Chew, "Alex Fletcher, Primitive Painter from Westmoreland County," *Carnegie Magazine* 51 (March 1980), pp. 9–13; Westmoreland County Museum of Art, Greensburg, Pa., *Southwestern Pennsylvania Painters, 1800–1945* (1981), exh. cat. by Paul A. Chew and John A. Sakal, pp. 42–43.

Mrs. Marshbank's Birthday Flowers, c. 1929

Oil on canvas mounted on cardboard
15¾ x 19½ in. (40 x 49.5 cm)
Signature: ALEX FLETCHER (lower left)

Fletcher did not have his own flower gar-den; he was said to have modeled his paintings either on field flowers or those in other people's gardens.[1] The checklist of his 123-work solo exhibition mounted by the Greensburg Art Club lists several canvases of the latter type, among them *Mrs. Turner's Rhododendrons*, *Barclay's Garden*, and *Mrs. MacHardy's Flowers* (locations unknown).

Mrs. Marshbank's flowers appear to be in a block of sod wrapped in burlap. It is unclear whether the unruly blossoms have just come from her backyard garden or are destined for it. Like the subject itself, Fletcher's picture has the look of a home-made gift. He colored the sackcloth wrap-per a delicate blue-pink, making its frayed ends as animated and pleasantly unpre-tentious as the mass of flowers within.

DS

1 Paul A. Chew, interview with Anna F. Brinker (Fletcher's daughter), manuscript, Westmoreland Museum of Art files, Greensburg, Pa., 1960.

Exhibitions Associated Artists of Pittsburgh, 1932, *Twenty-second Annual Exhibition*, no. 24; Latrobe High School Library, Latrobe, Pa., 1940, *An Exhibit of Oil Paintings by Alex Fletcher*, possibly no. 5, as *Birthday Flowers*, 1929; Greensburg Art Club, Y.M.C.A. Audito-rium, Greensburg, Pa., 1942, *Exhibition of Paintings by Alex Fletcher*, no. 22; Westmore-land County Museum of Art, Greensburg, Pa., 1960, *Alex Fletcher, 1866–1952*, exh. cat. by P. A. Chew, no. 33.

Provenance The artist's daughter, Anna F. Brinker, 1952; G. David Thompson, Pitts-burgh, by 1954; Westmoreland County Muse-um of Art, 1954 (deaccessioned by auction, 1974); David T. Owsley, Pittsburgh, 1974.

Gift of David T. Owsley, 1978, 78.26.1

Rejected, c. 1934–46

Oil on Masonite
22 x 28 in. (55.9 x 71.1 cm)
Signature: ALEX FLETCHER (lower right)

This self-portrait shows Fletcher in his basement studio, at work on a painting that represented the turning point in his career: *Peonies against Light* (location unknown), awarded the Sarah C. Wilson Memorial Prize of twenty-five dollars at the 1934 Associated Artists of Pittsburgh annual exhibition. It was Fletcher's first painting prize. Other local prizes followed: seven from the Greensburg Art Club (1935–39, 1943, 1944), one from the Associated Artists of Pittsburgh (1938), and another from the Butler Art Institute, Youngstown, Ohio (1941).

Here, Fletcher chose to represent himself as the persevering amateur who, despite the rejected canvases that surround him, is ultimately triumphant in his modest way. "Hope Springs from the Human Heart" is the motto written in the foreground.
DS

Exhibitions Associated Artists of Pittsburgh, 1948, *Thirty-eighth Annual Exhibition*, no. 53; Westmoreland County Museum of Art, Greensburg, Pa., 1960, *Alex Fletcher, 1866–1952*, exh. cat. by P. A. Chew, no. 40.

Provenance The artist's daughter, Anna F. Brinker, 1952; G. David Thompson, Pittsburgh, by 1954; Westmoreland County Museum of Art, 1954 (deaccessioned by auction, 1974); David T. Owsley, Pittsburgh, 1974.

Gift of David T. Owsley, 1978, 78.26.7

Flowers on the Chancel Steps, c. 1938
(Chancel Flowers)

Oil on canvas mounted on Masonite
28 x 22 in. (71.1 x 55.9 cm)
Signature: ALEX FLETCHER (lower right)

For over fifty years Fletcher was an elder and taught Sunday school at the First Presbyterian Church in Greensburg, Pennsylvania. That church was the subject of his most ambitious painting, *Communion Service, First Presbyterian Church* (c. 1937, Westmoreland Museum of Art, Greensburg). A bird's-eye view of the sanctuary, *Communion Service* won third prize in the Greensburg Art Club's 1937 exhibition and second prize from the Associated Artists of Pittsburgh in 1938.

Flowers on the Chancel Steps, painted about the same time, likewise recalls the interior of the artist's beloved church and represents one of Fletcher's more unusual compositional concepts. In this close-up of a flower arrangement set between the pulpit and communion table, the background space is deep, the perspective of the pulpit stairs complex, and the communion table deliberately cut off. The proliferation of marble and wood patterns display the skills Fletcher developed during his training as a decorative painter.

In 1941 this work won third prize for oils at the *Sixth Annual New Year Show* of the Butler Art Institute, Youngstown, Ohio.
DS

Exhibitions Associated Artists of Pittsburgh, 1939, *Twenty-ninth Annual Exhibition*, no. 72, as *Chancel Flowers*; Latrobe High School Library, Latrobe, Pa., 1940, *An Exhibit of Oil*

Paintings by Alex Fletcher, no. 21, as *Flowers on the Chancel*; Butler Art Institute, Youngstown, Ohio, 1941, *Sixth Annual New Year Show*, no. 35; Greensburg Art Club, Y.M.C.A. Auditorium, Greensburg, Pa., 1942, *Exhibition of Paintings by Alex Fletcher*, no. 74; Westmoreland County Museum of Art, Greensburg, Pa., 1960, *Alex Fletcher, 1866–1952*, exh. cat. by P. A. Chew, no. 16.

Provenance The artist's daughter, Anna F. Brinker, 1952; G. David Thompson, Pittsburgh, by 1954; Westmoreland County Museum of Art, 1954 (deaccessioned by auction, 1974); David T. Owsley, Pittsburgh, 1974.

Gift of David T. Owsley, 1978, 78.26.8

Flowers in a Blue Vase, No. 1, c. 1940

Oil on Masonite
20 x 16 in. (50.8 x 40.6 cm)
Signature: ALEX FLETCHER (lower right)

As with *Peonies against Light*—the canvas on the easel in *Rejected*—and *Bouquet of Flowers* (c. 1940, Westmoreland Museum of Art, Greensburg, Pa.), the composition of this work is rather straightforward, with a vase of flowers set on an intricately marbleized tabletop that divides the canvas into two registers, both of which read as almost parallel to the picture plane.
DS

Exhibition Westmoreland County Museum of Art, Greensburg, Pa., 1960, *Alex Fletcher, 1866–1952,* exh. cat. by P. A. Chew, no. 13.

Provenance The artist's daughter, Anna F. Brinker, 1952; G. David Thompson, Pittsburgh, by 1954; Westmoreland County Museum of Art, 1954 (deaccessioned by auction, 1974); David T. Owsley, Pittsburgh, 1974.

Gift of David T. Owsley, 1978, 78.26.6

Greensburg at Night, c. 1942

Oil on canvas mounted on Masonite
18 x 24 in. (45.7 x 61 cm)
Signature: ALEX FLETCHER (lower right)

Greensburg Blackout, c. 1942

Oil on canvas mounted on Masonite
18 x 24 in. (45.7 x 61 cm)
Signature: ALEX FLETCHER (lower right)

These two versions of Greensburg's characteristic skyline show the dome of the Westmoreland County Courthouse, the city's First Presbyterian and Episcopal churches, and, to the right, its radio transmission towers. The canvases may have been painted from the McColly Apartments, off Main Street, where the artist's brother Charles lived. *Greensburg at Night* sets the city's streets and buildings within a pervasive yellow-brown haze

that creates halos around the street lights and illuminated downtown buildings. In *Greensburg Blackout,* the sole light sources are a hazy crescent moon, the stars in the sky, and a few stray lights in the buildings. The coloring ranges from midnight blue to black.
DS

Greensburg at Night

Exhibitions Greensburg Art Club, Y.M.C.A. Auditorium, Greensburg, Pa., 1942, *Exhibition of Paintings by Alex Fletcher,* no. 95; Associated Artists of Pittsburgh, 1943, *Thirty-third Annual Exhibition,* no. 82; Westmoreland County Museum of Art, Greensburg, Pa., 1960, *Alex Fletcher, 1866–1952,* exh. cat. by P. A. Chew, no. 20; Westmoreland County Museum of Art, Greensburg, Pa., 1981, *Southwestern Pennsylvania Painters, 1800–1945,* exh. cat. by P. A. Chew and J. A. Sakal, no. 50.

Provenance The artist's daughter, Anna F. Brinker, 1952; G. David Thompson, Pittsburgh, by 1954; Westmoreland County Museum of Art, 1954 (deaccessioned by auction, 1974); David T. Owsley, Pittsburgh, 1974.

Gift of David T. Owsley, 1978, 78.26.5

Greensburg Blackout

Exhibitions Greensburg Art Club, Y.M.C.A. Auditorium, Greensburg, Pa., 1942, *Exhibition of Paintings by Alex Fletcher,* no. 97; Westmoreland County Museum of Art, Greensburg, Pa., 1960, *Alex Fletcher, 1866–1952,* exh. cat. by P. A. Chew, no. 21.

Provenance The artist's daughter, Anna F. Brinker, 1952; G. David Thompson, Pittsburgh, by 1954; Westmoreland County Museum of Art, 1954 (deaccessioned by auction, 1974); David T. Owsley, Pittsburgh, 1974.

Gift of David T. Owsley, 1978, 78.26.3

Winter Farm Scene, c. 1945

Oil on Masonite
26 x 27⅞ in. (66 x 70.8 cm)
Signature: ALEX FLETCHER (lower right)

This picture shows a farmstead in the snow: a cluster of characteristically reddish wood-frame buildings and boundary fences, surrounded by evergreen trees in the foreground and rolling hills in the background. Fletcher did other compositions similar to this one in their pale coloring and relatively loose facture, as well as their imagery, including *Snow Scene* (c. 1945, Westmoreland Museum of Art,

Greensburg, Pa.), and his exhibition records suggest that such snow scenes were views of specific properties around Greensburg.
DS

Exhibition Westmoreland County Museum of Art, Greensburg, Pa., 1960, *Alex Fletcher, 1866–1952,* exh. cat. by P. A. Chew, no. 52.

Provenance The artist's daughter, Anna F. Brinker, 1952; G. David Thompson, Pittsburgh, by 1954; Westmoreland County Museum of Art, 1954 (deaccessioned by auction, 1974); David T. Owsley, Pittsburgh, 1974.

Gift of David T. Owsley, 1978, 78.26.10

Lauren Ford
1891–1973

IN THE 1930S AND 1940S Lauren Ford was well known as a painter of childhood and religious subjects, themes that had great appeal during the uncertainties of the Depression and war years. Born in New York City, she was the daughter of Julia Ellsworth Ford, author of children's books, and Simeon Ford, owner of the Grand Union Hotel in New York and a famous raconteur. Her artistic inclinations were encouraged from an early age. Ford studied with George Bridgman and Frank Vincent du Mond at the Art Students League and spent a year in Europe. In her early years as an artist, she worked as a mural decorator and illustrated children's books written by her mother.

Ford began easel painting in 1927, taking as her subject scenes of childhood, particularly children at play. Her minutely detailed style, which emphasized both the decorative designs on objects and the flat patterning of the composition, was strongly influenced by nineteenth-century American primitive painting. This interest in Americana was shared by many other American artists of both traditionalist and avant-garde camps. Ford's charmingly naïve contributions to this genre contain a large element of fantasy and show the world as if through a child's eyes. Often derived from events in her own childhood, these paintings contain a wealth of anecdotal detail describing the countryside and express a sentimental nostalgia for rural life.[1] Such images occupy a significant place in her work from the 1930s on.

Biblical subjects dominate Ford's painting after 1935. She was an extremely devout person; just prior to World War II, she lived in rural France as a lay member of a religious community and studied medieval manuscript illumination. She purchased an abandoned convent in Montguyen, France, which she intended to open as a school for liturgical arts. After the war she was instrumental in the creation of a convent for Benedictine contemplative nuns near the farm in Bethlehem, Connecticut, where she had settled. She also wrote and illustrated three very popular religious books for children, *The Little Book about God* (1934), *The Ageless Story* (1939), and *Lauren Ford's Christmas Book* (1963).

Ford believed strongly in the need for and efficacy of religious art. Her best-known works are scenes from the life of Christ set in or near her farm in Bethlehem—local settings whose recognizability was important to her thematic message. She also painted many images of saints and miraculous events associated with the French countryside. In 1932 she traveled to Assisi and there painted a number of works concerning Saint Francis.

Ford's religious paintings were often derived from or influenced by past liturgical art, namely, late Gothic manuscript illumination and fifteenth-century Italian and Northern Renaissance painting. She was attracted to this art not only for its religious content but also for what she

perceived as its homeliness. Ford's interest in the Netherlandish masters was shared by a number of Regionalist artists who likewise appreciated their realism, specificity, and naïveté. This influence is apparent in Ford's art as early as 1928 and therefore predates its appearance in the work of Grant Wood. Though Ford was not strictly a Regionalist, her interest in primitive art and local rural life as well as her rejection of avant-garde styles certainly ally her with the aims of this group.

Ford was a popular artist. Her first solo show at the Ferargil Gallery, New York, in 1928 sold out in a week, and she exhibited regularly there throughout the 1930s and 1940s. In 1938 and 1944 her religious works were featured in *Life* magazine's Christmas issue. During these years she also exhibited regularly at Carnegie Internationals and their wartime replacements, *Painting in the United States*. Her *Country Doctor* was exhibited at the Carnegie International of 1937, and two years later she was given a major museum retrospective at Carnegie Institute. After the war, however, interest in her work declined; after 1950 virtually no mention of her appeared in the art press.

1 O'Connor, "Presenting Lauren Ford," p. 298.

Bibliography Lauren Ford Scrapbook, 1928–c. 1947, Ferargil Gallery Papers, Archives of American Art, Washington, D.C.; John O'Connor, Jr., "Presenting Lauren Ford," *Carnegie Magazine* 12 (March 1939), pp. 297–98; Blanche Stillson, "*Bethlehem* by Lauren Ford," *John Herron Institute Bulletin* 30 (June 1943), pp. 7–8; "Four Paintings by Lauren Ford," *Liturgical Arts* 12 (November 1943), pp. 5–8; Lauren Ford, "A Portfolio of Religious Paintings," *Life*, December 25, 1944, pp. 32–44.

Winter (Christmas Eve), 1936

Oil on wood panel
11½ x 17¾ in. (29.2 x 45.1 cm)
Signature: LAUREN/FORD (lower right)

Winter[1] depicts Mary and Joseph's search for shelter on the night before the birth of Jesus. As in many of Ford's religious paintings, the event takes place at her farm in Bethlehem, Connecticut. Indeed, in the late 1930s and early 1940s, the artist created several works on the theme of the Nativity set within panoramic views.

The influence of Pieter Bruegel can be seen in many of Ford's works, but it is especially apparent in *Winter*, which relies strongly on Bruegel's *Return of the Hunters* (1565, Kunsthistorisches Museum, Vienna) for its bird's-eye view and high horizon. Ford also employs Bruegel's double diagonal movement into depth, with one diagonal thrusting from the lower left to center right and the second carrying the movement from there into the far distance at the left. Tiny, hunched Bruegelesque figures descend a hillock, though Ford has reversed the placement of the group. Ford also took her color scheme from *The Return of the Hunters*: both works are a harmony of red buildings, white snow, and a cold blue-gray for sky and ponds. Even the curvilinear shapes of her trees hark back to Bruegel.

Winter occupies a midpoint in Ford's stylistic development. Though still quite tightly drawn, it lacks the minute detailing of her works of the late 1920s and early 1930s, but it does not yet possess the looser, more painterly handling to which she turned in the 1940s.

The work was Ford's entry in the 1936 Carnegie International, from which it was

purchased by Pittsburgh collector Charles Rosenbloom. Rosenbloom tacitly acknowledged the painting's relation to the Northern Renaissance tradition by hanging it in his living room next to Pieter Bruegel the Younger's *Adoration of the Magi* (1625, now in the collection of The Carnegie Museum of Art, Pittsburgh).

JRM

1 Photo label in Lauren Ford Scrapbook, Ferargil Gallery Papers, Archives of American Art, Washington, D.C.

References "Art: Early American," Pittsburgh *Bulletin Index* 114 (Mar. 23, 1939), p. 26; O'Connor, "Presenting Lauren Ford," p. 298; R. Frost, "Today's Collectors: Pittsburgh Eclectic," *Art News* 45 (Mar. 1946), pp. 45–46.

Exhibitions Carnegie Institute, Pittsburgh, 1936, *The 1936 International Exhibition of Paintings*, no. 20; Department of Fine Arts, Carnegie Institute, Pittsburgh, 1939, *An Exhibition of Paintings, Drawings and Etchings by Lauren Ford*, no. 34; Department of Fine Arts, Carnegie Institute, Pittsburgh, 1946, *Paintings and Prints from the Collection of Charles J. Rosenbloom*, no. 10.

Provenance Charles J. Rosenbloom, 1936.

Bequest of Charles J. Rosenbloom, 1974, 74.7.12

Arnold Friedman
1874–1946

LARGELY IGNORED DURING his lifetime, Arnold Friedman is today coming to be recognized as a significant American painter of the 1940s. Drawing upon Impressionist and Post-Impressionist sources, he created semiabstract, heavily textured landscapes of jewellike color that reflected his unique perception of nature. Friedman was born and raised in New York City, the son of Hungarian Jewish immigrants who ran an East Side grocery. At the age of seventeen he took a job with the United States Postal Service to help support his widowed mother and his siblings, a job that remained his economic mainstay throughout his life.

Although he began to draw at an early age, Friedman received no formal art training until he enrolled, at the age of thirty-two, in Robert Henri's evening class at the Art Students League. Among his fellow students were the somewhat younger—and later, much more famous—painters George Bellows, Edward Hopper, and Guy Pène du Bois and the future art critic Walter Pach. In 1909, after three years of study with Henri, Friedman took a leave of absence from his job and spent six months in Paris, where he became enamored of the art of Pierre-Auguste Renoir, Pierre Bonnard, Georges Seurat, and Camille Pissarro.

When Friedman returned to New York he resumed his post-office job and painted in his free time, always in daylight and almost never from nature.[1] After a brief period of experimentation with French avant-garde styles, particularly Cubism and Orphism, he reverted to a more realistic idiom. He used clear, clean contours, flat color planes, and pale, powdery hues to paint landscapes, cityscapes, still lifes, interiors, and portraits.

In 1933 Friedman retired from the postal service and, with the security of a twenty-five-dollar weekly pension, devoted himself full time to his art. He gradually returned to the Impressionist and Post-Impressionist landscape sources that had captivated him in his youth, and by the early 1940s he had developed his own unique interpretation of them. Abandoning the brush, he used a palette knife to build up small dabs of thick pigment to create a stuccolike surface. At the same time, his landscape forms became increasingly simplified, lending a certain monumentality to his works. The resulting depictions, in which brilliant colors scintillate across the heavily textured surfaces, are generally considered his masterpieces.

It is said that Friedman had become bitter about his lack of acclaim and constant financial worries.[2] Judging by his journal entries and by the cryptic, acerbic comments he scrawled on the backs of his canvases, he believed that his originality was to blame for his lack of recognition: since the critics could not easily categorize his work, they ignored it. Friedman exhibited sporadically. He did not enter his first group show until 1916 and did not have his first solo show, at Bourgeois Galleries, New York, until 1925. Although he enjoyed the support of a few admirers, his work remained largely unappreciated and mostly unsold. In the 1940s he was reduced to writing letters to museum directors, pleading for a chance to show his work.[3]

Ironically, Friedman died in his home in Queens less than four months before a retrospective exhibition of his work, at the George Walter Vincent Smith Art Museum, Springfield, Massachusetts, brought the attention he had so long craved. In the catalogue's introductory essay, the art critic Clement Greenberg wrote:

> Friedman's happens to be some of the purest painting I have ever seen. . . . I mean that the significance of his pictures is almost completely embodied in the physical reality of their color and design. . . . They are quintessential easel-pictures, subordinating motif and decoration to the primary fact that they are to hang on walls and attract and hold our visual attention. . . . The pictures in this exhibition are *advanced* painting—let no one be deceived by their apparent naiveté and by the fact that they are landscapes for the most part; and I believe that they mark an important moment in the history of American painting.[4]

1 Hess, "Friedman's Tragedy," p. 27.
2 Schack, "The Ordeal of Arnold Friedman," p. 44.
3 Ibid., p. 45.
4 George Walter Vincent Smith Art Museum, *Arnold Friedman*, p. 8.

Bibliography George Walter Vincent Smith Art Museum, Springfield, Mass., *Arnold Friedman, 1874–1946* (1947), exh. cat., essay by Clement Greenberg; William Schack, "The Ordeal of Arnold Friedman, Painter," *Commentary* 9 (January 1950), pp. 40–46; Thomas B. Hess, "Friedman's Tragedy and Triumph," *Art News* 48 (February 1950), pp. 26–27, 59–60; Zabriskie Gallery, New York, *Arnold Friedman: Landscapes of the Forties* (1980); Salander-O'Reilly Galleries, New York, *Arnold Friedman, 1874–1946* (1986), exh. cat., introduction by Hilton Kramer.

Clown, c. 1932–37

Oil on board
11½ x 9⅝ in. (29.2 x 24.5 cm)
Signature: FRIEDMAN (lower left)

According to the donor, Friedman painted *Clown* as part of a barter arrangement. While painting in the Valley Forge area of Pennsylvania, Friedman found himself in need of moldings and lumber for picture frames. He went to a local lumberyard and arranged a trade: the painting for a supply of framing material.[1]

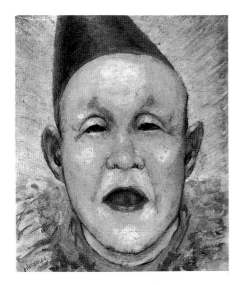

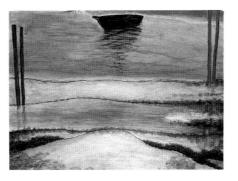

Friedman is known to have made other such barter deals. Shortly before his death in 1946, he exchanged paintings for a refitted kitchen and new oil burner for his home in Queens, New York.[2] Evidently, Friedman's job as a post-office clerk left him chronically short of funds to support his wife and children, a financial condition that contributed to the bitterness of his later years.

A hint of the artist's own dejection can be perceived in this painting. Although the colors are primarily warm shades of red, gold, and cream, the overall effect is assuredly not cheerful. The clown, with drooping eyes and down-turned mouth, starkly confronts the viewer, his parted lips suggesting a cry of despair.
RB

1 Edwin A. Austin to John R. Lane, May 5, 1983, museum files, The Carnegie Museum of Art, Pittsburgh.
2 Schack, "The Ordeal of Arnold Friedman," p. 44.

Provenance The artist to an unidentified lumberyard, Valley Forge, Pa., by 1946; Edwin A. Austin, Phoenix, Ariz., by 1983.

Gift of Edwin A. Austin, 1983, 83.39

Landscape with Boat, c. 1935–39

Oil on canvas
16 x 21¼ in. (40.7 x 54 cm)
Signature: FRIEDMAN (lower left)

The planes of flattened color, clear contours, and geometrical shapes of *Landscape with Boat* give it an almost

abstract quality. The solidity of the empty rowboat contrasts with the amorphous nature of the shoreline, where water and earth seem to meld rather than meet. The painting, which probably dates from the late 1930s, displays the muted colors and smooth surface reminiscent of Friedman's earlier realist style. The subordination of all elements to the overall design hints at the semiabstract landscapes of the 1940s.
RB

Provenance Virginia Zabriskie, New York, by 1983.

Gift of Virginia Zabriskie, 1983, 83.85

Bucks County Landscape, c. 1942–44

Oil on canvas
30 x 36 in. (76.2 x 91.4 cm)
Signature: A. FRIEDMAN (lower left)
Inscription: PAINTED DURING THE/FLOOD TIDE OF PISMIRE/AMERICAN EXPRESSIONISM/UNDER THE THRALLDOM/OF/'3K' THINKING (on reverse)

The most striking aspect of *Bucks County Landscape*, as in all of Friedman's late works, is its color: bold tones of red, yellow, blue, and green dance and shimmer over the pumicelike surface of the canvas. The broad, bright color areas and simplified contours lend an austere monumentality to the work while dots of heavy pigment, applied with a palette knife, give the painting an almost "geological" density.[1] These qualities are heightened by the minimal glimpse of background sky: the massive landscape virtually fills the picture frame.

Friedman's allusion to the "flood tide of Pismire" on the reverse of the canvas is completely fanciful. It seems to be an allusion to the state of contemporary art at the time and, of course, also reinforces the imaginary aspect of his depiction.
RB

1 Hilton Kramer, "Art: An Impressionist Is Rediscovered," *New York Times*, March 14, 1980, sec. C, p. 17.

Exhibitions Marquié Gallery, New York, 1944, *Arnold Friedman: Paintings*, no. 4; Salander-O'Reilly Galleries, New York, 1986, *Arnold Friedman, 1874–1946*, exh. cat., introduction by H. Kramer, no. 103.

Provenance The artist, until at least 1944; Sarah Hunter Kelly, New York; estate of Sarah Hunter Kelly; Zabriskie Gallery, New York, 1983.

Museum purchase: gift of Mr. and Mrs. George Liggett Craig, Jr., Pittsburgh, and Paintings Acquisition Fund, 1983, 83.33

Walter Gay
1856–1937

KNOWN PRIMARILY AS a painter of elegant eighteenth-century interiors, Walter Gay was born in Hingham, Massachusetts. He was probably encouraged to pursue an artistic career by his uncle, Winckworth Allan Gay, a prominent Boston painter and friend of William Morris Hunt. Gay received occasional criticism from Hunt and attended night classes in life drawing at the Lowell Institute, Boston. By 1875 he was a successful still-life painter who also produced landscapes, portraits, and studies from nature.

Gay went to Paris to study in 1876, entering the atelier of Léon Bonnat. He remained in France for three years, during which time he also studied at the Académie Julian alongside Thomas Dewing and made occasional trips to Barbizon and to Auvers-sur-Oise, where he painted in the company of Charles Daubigny. Gay acquired from Bonnat an appreciation for the work of Diego Velázquez, and at Bonnat's suggestion made a lengthy trip to Spain in 1879 to study the work of the seventeenth-century master. That same year Gay was accepted at the Paris Salon, winning praise for his "elegance of composition, accuracy of drawing, and richness of color."[1] Gay's work around 1880 consisted mainly of genre paintings which, he later explained, were influenced by the work of the Spanish painter Mariano Fortuny. Small and intimate, they usually depict exquisitely dressed eighteenth-century people seated in elegant interiors, occupied with some leisurely task such as reading or sipping tea.

Like many artists in the second half of the nineteenth century, Gay was attracted to the simple and pious life of the peasants of Brittany, and in the early 1880s he began depicting them, with considerable success. One work, *The Weaver* (1886, Museum of Fine Arts, Boston), a large, broadly painted composition, is a simple, unidealized view of a Breton peasant woman in the style of Jules Breton and Léon L'hermitte.

In 1895 Gay abandoned peasants and began painting uninhabited interiors, a subject that would occupy him for the rest of his career. The theme of the empty room fascinated a number of late nineteenth-century artists, including Adolf von Menzel and Gaston La Touche. Like them, Gay was interested in exploring qualities of color and light as well as in capturing the sense of intimacy and mystery of the empty room. Gay pursued this quest privately, rarely exhibiting his work. With such interiors, he felt he could indulge his sentiment for the past without making stylistic concessions to the public. As Gay recorded in his memoirs:

"So I painted many studies at the Château de Fortoisseau... showing them only to sympathetic people who could understand what I was trying to do. I was searching for the spirit of empty rooms—interiors."[2]

Although Gay's domestic interiors represent a variety of sites, from France and England to Newport, Rhode Island, they depict an absolutely consistent way of life. Some were commissioned by members of Gay's social circle. Others were painted for his own enjoyment, especially the numerous scenes of interiors at the Château deBréau near Melun, France. The artist purchased this seventeenth-century house in 1907, and by the time he retired there he had filled it with a fine collection of eighteenth-century furniture, objects, and paintings.

Gay won many important awards during his lifetime, including gold medals in Antwerp (1894), Munich (1894), and Berlin (1895); he exhibited at the Exposition Universelle in Paris (1893, 1900) and the World's Columbian Exposition in Chicago (1893). He was elected to the Society of American Artists in 1880, and from 1896 to 1937 he exhibited thirty-three works in sixteen Carnegie Internationals, serving also on its Foreign Advisory Committee in Paris.

During his career Gay assembled not only a large collection of eighteenth-

century furniture and decorative arts but also important old-master drawings, including works by Rembrandt, Antoine Watteau, and Petrus Christus. These went to the Louvre after the artist's death in Paris.

1 Grey Art Gallery and Study Center, New York University, *Walter Gay: A Retrospective* (1980), p. 29.

2 Walter Gay, *Memoirs of Walter Gay*, p. 60.

Bibliography Albert E. Gallatin, ed., *Walter Gay: Paintings of French Interiors* (New York, 1920); Louis Gillet, "Peintres d'Amérique: Walter Gay," *Revue de l'art ancien et moderne* 39 (January 1921), pp. 34–44, 79–80; Walter Gay, *Memoirs of Walter Gay* (New York, 1930); Dayton Art Institute, Ohio, *American Expatriate Painters of the Late Nineteenth Century* (1976), exh. cat. by Michael Quick, pp. 100–101, 150–51; Grey Art Gallery and Study Center, New York University, *Walter Gay: A Retrospective* (1980), exh. cat. by Gary A. Reynolds.

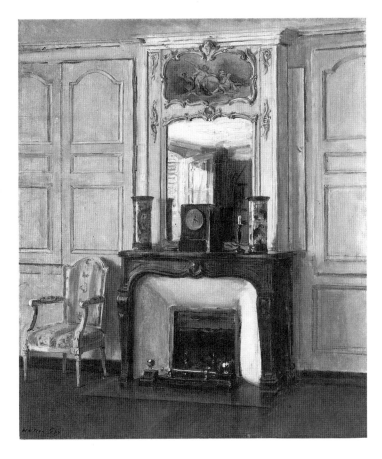

The Old Fireplace, c. 1900

Oil on canvas
21¾ x 18¼ in. (55.2 x 46.3 cm)
Signature: Walter Gay (lower left)

This is one of many eighteenth-century interiors painted at the Château Fortoiseau (near the forest of Fontainebleau), where the artist spent several summers. In many of his works Gay focused on a single detail of a room or a group of well-placed objects, as he does here with the fireplace. He mainly concerned himself with painterly questions of color and composition, recording with fluid brushwork the transitory effects of light and atmosphere in the salon known as the Ghost Room at the château.

He shared with the Impressionists an interest in the effect of light as it streamed through open windows and doors or as it is here, reflected in the fireplace mirror. He delighted in suggesting the various textures of the objects. The dark wood of the mantel, accented with touches of white impasto for highlighting, is contrasted with the smooth, shining surfaces of the brass andirons in the fireplace and the Japanese vases on the mantelpiece. (Gay had a deep appreciation of Far Eastern objects and owned a large collection of Japanese porcelain.)

In his interiors Gay paid little attention to minute detail, relying instead on subtle color harmonies to create a specific ambience. In *The Old Fireplace,* the ivory walls are accented with touches of pale blue and rose, colors that are repeated in the fabrics, in the porcelains, and in the painting above the fireplace. The objects document an ordered, elegant, discriminating, and self-consciously civilized life. This painting was purchased from the Carnegie International exhibition in 1901 by Henry Kirke Porter and was presented to Carnegie Institute by Porter's daughter Annie-May Hegeman in 1942.
ST

Reference J. O'Connor, Jr., "Miss Annie-May Hegeman's Gift," *Carnegie Magazine* 16 (June 1942), p. 68.

Exhibitions Department of Fine Arts, Carnegie Institute, Pittsburgh, 1901, *Sixth Annual International Exhibition*, no. 94; Pennsylvania Academy of the Fine Arts, Philadelphia, 1905, *The One-Hundredth Anniversary Exhibition of the Pennsylvania Academy of the Fine Arts*, no. 486; Grey Art Gallery and Study Center, New York University, 1980, *Walter Gay: A Retrospective*, exh. cat. by G. A. Reynolds, no. 32.

Provenance Mr. and Mrs. Henry Kirke Porter, Pittsburgh, 1901; their daughter, Annie-May Hegeman, until 1942.

Gift of Annie-May Hegeman from the collection of her mother, Mrs. Henry Kirke Porter, 1942, 42.5.5

The Three Vases, c. 1900

Oil on processed wood
21¾ x 18¼ in. (55.2 x 46.3 cm)
Signature: Walter Gay (lower left)

Mantelpieces frequently figure in Gay's compositions, perhaps because of the interplay of geometrical forms that they offer. In this composition, the mixture of real and reflected wood panels and mirrors is enlivened by the more playful curvilinear forms of the andirons and the three large vases, which are also reflected in the mirror over the mantel.

In its fluid brushwork and simplification of detail, *The Three Vases* exhibits the freshness and spontaneity of a quick sketch. It is an excellent example of Gay's delicately adjusted color and light relations: the rose and white tonalities of the bright light from the window, reflected in

the mirror on the left, are subtly contrast-ed with the darker blue shadows of the floor and the fireplace, creating the effect of a cool, shadowy, interior space. As one critic noted on the occasion of a memori-al exhibition of Gay's work in 1938, "He expressed the atmosphere and filtered light from shade, and caught the little secrets which inanimate things record when they are alone, and translated deli-cate shades by the illusion of the unsaid and marked the pulse of time, the regret and sadness, by an absence of living fig-ures."[1]

This painting of an unidentified interi-or, like *The Old Fireplace*, was purchased by Henry Kirke Porter in 1901 from the Carnegie International exhibition and presented to Carnegie Institute in 1942 by Porter's daughter Annie-May Hegeman.
ST

1 "Walter Gay: A Memorial Exhibition at the Metropolitan Museum of Art," *New York Herald-Tribune*, April 10, 1938, p. 8.

References J. O'Connor, Jr., "Miss Annie-May Hegeman's Gift," *Carnegie Magazine* 16 (June 1942), p. 68.

Exhibitions Department of Fine Arts, Carnegie Institute, Pittsburgh, 1902, *Sixth*

Annual International Exhibition, no. 93; Penn-sylvania Academy of the Fine Arts, Philadel-phia, 1905, *The One-Hundredth Anniversary Exhibition of the Pennsylvania Academy of the Fine Arts*, no. 492; Grey Art Gallery and Study Center, New York, 1980, *Walter Gay: A Retro-spective*, exh. cat. by G. A. Reynolds, no. 33.

Provenance Mr. and Mrs. Henry Kirke Porter, Pittsburgh, 1901; their daughter, Annie-May Hegeman, until 1942.

Gift of Annie-May Hegeman from the collec-tion of her mother, Mrs. Henry Kirke Porter, 1942, 42.5.6

William Glackens

1870–1938

WILLIAM JAMES GLACKENS, one of the major American Realists of the first third of the twentieth century, is most often associated with the Eight, the group with whom he first achieved prominence as a painter. Glackens was born and raised in Philadelphia, and in

1891 he began his career there as a news-paper illustrator. While working at the *Philadelphia Press* he became friends with fellow journalists John Sloan, George Luks, and Everett Shinn. Between 1892 and 1895 he intermittently attended evening classes at the Pennsylvania Academy of the Fine Arts, where he stud-ied under Thomas Anshutz.

Glackens made the first of many trips to Europe in 1895, traveling with Robert Henri, future leader of the Eight. The two bicycled through Holland, painting and studying the Dutch masters, particu-larly Rembrandt and Frans Hals. They then took studios in Paris and proceeded to paint images of the city and its envi-rons, including the countryside around Fontainebleau. Upon his return to America in 1896, Glackens settled in New York and worked as an artist-reporter for various newspapers and magazines, including the *New York Herald* and the Philadelphia *Saturday Evening Post*. His most notable assignment came in 1898 when, working for *McClure's Magazine* in Cuba, he produced vivid illustrations of the Spanish-American War.

During this period Glackens began to paint in oils and exhibit his work. From 1895 onward he was a regular participant in the Pennsylvania Academy's annuals. His first major public notice came in 1901 at a group exhibition at the Allen Galleries, New York. Seven years later Glackens rose to national prominence when he participated in the 1908 exhibi-tion of the Eight at the Macbeth Galleries, New York; the landmark show had a profound influence on American artists and signaled the end of the ascen-dancy of academic painting in the United States.

The modern urban landscape and the lives of its middle-class inhabitants served as Glackens's subject matter during this period. His scenes of New York, such as *View of the East River from Brooklyn* (1902, Santa Barbara Museum of Art), *The Drive, Central Park* (1905, Cleveland Museum of Art), and his acknowledged masterpiece, *Chez Mouquin* (1905, Art Institute of Chicago), focused on seem-ingly random observations, set down with rich brushwork and deep colors. Around 1910 Glackens began to change both his subject matter and style; *Nude with Apple* (1910, Brooklyn Musuem, New York) marked a shift toward nudes, still lifes, and portraits whose palette was indebted to the softer colorism of Pierre-Auguste Renoir.

Over the next decade, Glackens played an active role in the American art scene. Until around 1914 he continued to work successfully as a graphic artist. In 1913 he was one of the organizers of the Armory Show and chairman of the committee that selected the American entries. Four years later, he was elected president of the newly formed Society of Independent Artists, New York.

Glackens received a variety of awards for his paintings and graphic work. His oils won prizes at the Universal Exposition, Saint Louis (1904), the Panama-Pacific International Exposition, San Francisco (1915), the Pennsylvania Academy of the Fine Arts (1924 and 1933), the Carnegie International (1905 and 1929), and the Paris Exposition Universelle (1937), while his drawings and illustrations won awards at the Pan-American Exposition, Buffalo (1901), and

the Saint Louis Universal Exposition (1904). He became an associate member of the National Academy of Design in 1906, an academician in 1933.

Glackens's canvases regularly appeared in exhibitions at Carnegie Institute. Between 1905 and 1938 he showed twenty-six paintings in seventeen Internationals.

During the last two decades of his life, Glackens traveled extensively, spending a great deal of time in and around Paris and in the south of France. He died suddenly in 1938 while visiting artist Charles Prendergast at Westport, Connecticut. In December of that year, his friends and fellow American artists Guy Pène du Bois, Eugene Speicher, and Leon Kroll helped organize a memorial exhibition at the Whitney Museum of American Art, New York. Carnegie Institute also honored him with a memorial exhibition of his paintings in 1939.

Bibliography Albert E. Gallatin, "The Art of William J. Glackens: A Note," *International Studio* 40 (May 1910), pp. 68–71; Forbes Watson, *William Glackens* (New York, 1923); Whitney Museum of American Art, New York, *William Glackens*, American Artists series (1931), exh. cat. by Guy Pène du Bois; Ira Glackens, *William Glackens and the Ashcan Group* (New York, 1957); Bernard B. Perlman, *The Immortal Eight* (New York, 1962).

La Villette, c. 1895

Oil on canvas
25 x 30 in. (63.5 x 76.2 cm)

Although undated, *La Villette* was probably painted in 1895 when Glackens was visiting Paris with Robert Henri. Typical of Glackens's early work, the canvas presents an urban, working-class neighborhood, which has been painted with a

refinement essentially devoid of social comment.[1] A northeastern commercial section of Paris, La Villette was best known for its open-air livestock markets and slaughterhouses. The air was undoubtedly filled with the rank scents and raucous sounds of cattle, sheep, and pigs. The basin, which here appears so serene, in reality bustled with activity as twelve hundred barges a month plied its waters.

Under Glackens's hand, the rather sordid reality of La Villette was transformed into a lyrical, parklike setting. The row of sharply receding buildings appears more like fashionable townhouses than warehouses or working-class tenements. The graceful curve of the cast-iron footbridge bears the slender silhouettes of stylish strollers, while the blue, softly clouded sky is reflected in the still waters below. The cool pastel colors and gently brushed forms impart a peaceful, elegiac quality to the composition.

It has been suggested that this painting may contain traces of compositional devices found in the work of Edouard Manet,[2] whose paintings Glackens admired. However, the composition and color scheme of *La Villette* bear an uncanny resemblance to an 1857 woodblock print, *Kyobashi Takegashi (The Bamboo Wharf at Kyobashi)*, by the Japanese master Hiroshige (fig. 1). While it is not known exactly how or when Glackens may have

seen this or similar prints by Hiroshige, the resemblances are striking: in both works, a gracefully curving footbridge unites the sharply receding diagonals of land and water beneath a limpid blue sky. Glackens accentuated the decorative element of the composition by exaggerating the arch of the bridge and reducing the number of crossing pedestrians.

At the time *La Villette* was painted, and for nearly twenty years afterward, Glackens supported himself as an artist-reporter for various newspapers and magazines. The emphasis on beautiful colors, elegant forms, and decorative compositions found in his paintings may have been a reaction to the sober reality he was committed to depicting in his bread-and-butter illustrations.

RB

1 Pennsylvania Academy of the Fine Arts, Philadelphia, *Philadelphia: Three Centuries of American Art* (1976), p. 451.

2 Ibid.

References J. K. Reed, "Taste and Quiet Beauty in American Art," *Art Digest* 20 (May 15, 1946), p. 15; M. Breuning, "Comprehensive View of William Glackens," *Art Digest* 23 (Jan. 1, 1949), p. 12; G. B. Washburn, "New American Paintings Acquired," *Carnegie Magazine* 30 (June 1956), p. 193.

Exhibitions Des Moines Art Center, Iowa, 1949, *The Turn of the Century: American Artists, 1890 to 1920*, unnumbered; Kraushaar Galleries, New York, 1949, *William Glackens*, no. 2; Dayton Art Institute and Columbus Museum of Art, Ohio, 1951, *America and Impressionism*, no cat.; Des Moines Art Center, Iowa, 1953, *Fifth Anniversary Exhibition: Realism in Painting and Sculpture*, unnumbered; Santa Barbara Museum of Art, Calif., 1954, *Impressionism and Its Influence in American Art* (trav. exh.), no. 15; City Art Museum of Saint Louis, 1966, *William Glackens in Retrospect*, unnumbered; Meredith Long [Gallery], Houston, 1971, *Americans at Home and Abroad, 1870–1920*, no. 14; Pennsylvania Academy of the Fine Arts, Philadelphia, 1976, *Philadelphia: Three Centuries of American Art*, no. 384.

Provenance Estate of the artist; Kraushaar Galleries, New York, by 1946.

Patrons Art Fund, 1956, 56.13

Fig. 1 Utagawa Hiroshige, *Kyobashi Takegashi (The Bamboo Wharf at Kyobashi)*, 1857. Color woodblock print from the series "One Hundred Views of Edo," 15 x 10⅜ in. (38.1 x 26.2 cm). The James A. Michener Collection, The Honolulu Academy of Arts

Aaron H. Gorson
1872–1933

BORN IN KAUNAS, Lithuania, Aaron Henry Gorson was trained as a tailor despite a youthful desire to become an artist. He immigrated to the United States in 1889 and established a business in Philadelphia, which made him financially secure. He began taking night classes at the Pennsylvania Academy of the Fine Arts and showed a talent for portraiture, eventually receiving commissions from several prominent Philadelphians, including Rabbi J. Leonard Levy, who financed Gorson's studies at the Académie Julian in Paris in 1899. There, under the direction of Benjamin Constant, he completed his formal training.

In 1903 Gorson settled in Pittsburgh, where he lived for the next eighteen years. While continuing to paint portraits, he became known for scenes of Pittsburgh industry, many of which were acquired by prominent industrialists such as Andrew Carnegie and Andrew W. Mellon. Attracted by the smoke-filled skies above the city's steel mills, he declared, "I laugh when I hear people railing at Pittsburgh's smoky atmosphere. . . . Foggy air adds wonderfully to the artistic effectiveness of the view."[1]

Often painted at dusk, Gorson's views of blast furnaces and coal barges exemplify his predilection for subtle color harmonies and poetic mood. Using rich surface textures and dark tones to capture the vitality and picturesque beauty of Pittsburgh's industrial landscape, his approach to his subject was aesthetic rather than documentary. Even though he was working at the height of the Steel Age, he ignored both the materialism and the pollution produced by the industry. His paintings contain no hint of social comment; human beings are rarely included in his purely pictorial settings.

Gorson exhibited his industrial scenes regularly in Pittsburgh at the J. J. Gillespie Galleries, with the Associated Artists of Pittsburgh, and in Carnegie Institute's annual exhibitions of 1908, 1910–12, 1914, and 1921. Thirty-four years after his death, he was still acknowledged as a vital artistic presence in the Pittsburgh area, as witnessed by the exhibition of his paintings held at Carnegie Institute in the spring of 1967. He was

active outside Pittsburgh as well, exhibiting at the National Academy of Design, New York, the Pennsylvania Academy of the Fine Arts, the Art Institute of Chicago, and the Corcoran Gallery of Art, Washington, D.C. In 1902 he won an honorable mention from the American Art Society in Philadelphia and in 1911 was elected to the Union Internationale des Beaux Arts et Lettres. Gorson settled in New York in 1921, where he painted landscapes, industrial scenes, and views of Harlem and the Hudson River. He was one of the founders of the Grand Central Art Galleries and held membership in many other associations, including the American Federation of Arts, the American Art Association of Paris, and the Salmagundi Club.

Unable to forget those "darn Pittsburgh views," Gorson returned to the steel city several times before his death in 1933 in New York.[2] A memorial exhibition, held at the Gillespie Galleries in 1934, prompted the comment that "he was not the first to catch the steel mill spirit, but in his time he was the best. . . . He placed Pittsburgh steel mills in many of our country's exhibitions, and what is more he showed the future painters that there were new moods along our river banks."[3]

1 *Pittsburg Press*, June 7, 1908, Sunday magazine sec., p. 3.
2 Wilson, "Painters of Pittsburgh," p. 18.
3 H. G., "The A. H. Gorson Memorial Show at Gillespie's," *Pittsburgh Post-Gazette*, March 19, 1934, p. 17.

Bibliography Douglas Naylor, "Tribute to Real Art/Memorial Exhibition of Gorson Works Is Planned by His Admirers," *Pittsburgh Press*, January 28, 1934, Sunday feature sec., p. 12; University Art Gallery, University of Pittsburgh, *Art in Nineteenth Century Pittsburgh* (1977), exh. cat., introduction by David G. Wilkins, pp. 5–7; Ruth L. Wilson, "Painters of Pittsburgh. . . Aaron Gorson," *Pittsburgh Press Roto*, July 31, 1977, pp. 16–18; Westmoreland County Museum of Art, Greensburg, Pa., *Southwestern Pennsylvania Painters, 1800–1945* (1981), exh. cat. by Paul A. Chew and John A. Sakal, p. 43; University Art Gallery, University of Pittsburgh, organized by Pittsburgh History and Landmarks Foundation and Spanierman Gallery, New York, 1989, *The Power and the Glory: Pittsburgh Industrial Landscapes by Aaron Henry Gorson (1872–1933)*, exh. cat. by Rina C. Youngner.

Mills and River, Early Morning, Pittsburgh, c. 1905

Oil on canvas
29⅞ x 47⅞ in. (75.9 x 121.6 cm)
Signature: A. H. Gorson (lower right)

When Gorson arrived in Pittsburgh in 1903, steel making was rapidly becoming the city's master industry. Plants, in operation twenty-four hours a day, lined the banks of the area's three rivers, filling the valleys with thick, dirty smoke. In one sense *Mills and Rivers, Early Morning, Pittsburgh* captures the essence of this productivity—the furnaces, already in full blast as the day begins, glow red hot and billow smoke from every stack. But the artist, inspired less by these mechanical processes than by the pictorial possibilities of the scene, focused on the cool early-morning light, the rhythmic pattern of the dark stacks, and the sensuous clouds of smoke that drift downstream.

Unified by subtle shades of blue and gray, this composition recalls Gorson's own description of his adopted city:

Looking up and down along the shores of these rivers you will see the most magnificent curving lines of opalescent water framed in huge, deep, dark or turquoise haze, hills gracefully bowing against each other, studded with houses and broken up by tall slender smoke stacks from the massive mills which are scattered for miles along the shores, softened by clouds of smoke of varied hues.[1]

Here, the inclusion of the South Twenty-second Street Highway Bridge (later known as the Brady Street Bridge) establishes the identity of these mills as part of the Jones and Laughlin Steel Company on the Monongahela River; the steep slopes of the South Side forms the background.
GB

1 Unidentified newspaper clipping, 1912, museum files, The Carnegie Museum of Art, Pittsburgh.

Remarks The lines of the bridge and the edges of the buildings have been strengthened by a later hand and thereby appear more rigid than Gorson originally intended.

Reference Wilson, *Pittsburgh Press Roto*, p. 17.

Exhibitions Westmoreland County Museum of Art, Greensburg, Pa., 1976, *Nineteenth and Early Twentieth Century Regional Painters*, exh. cat. by P. A. Chew and J. K. Maguire, unnumbered; Museum of Art, Carnegie Institute, Pittsburgh, 1977, *Some Pittsburgh Artists from the Permanent Collection*, no cat.

Provenance Harry Eichlay, Pittsburgh; Mrs. Sigwarthe, Pleasant Hills, Pittsburgh; Robert Brandegee, Pittsburgh, as agent; R. C. Ernst, Pittsburgh, by 1973.

Gift of R. C. Ernst, 1973, 73.18.1

Lower Allegheny, 1909

Oil on canvas
34⅛ x 42⅛ in. (86.7 x 107 cm)
Signature, date: A. H. Gorson/1909 (lower left)

One of Gorson's many variations on the theme of river industry, this softly lit scene depicts an industrial site along the north shore of the Allegheny River. Painted from a point above Sixteenth

Street, Gorson's view includes two recognizable landmarks, the H. J. Heinz food-processing factories and Lock and Dam No. 1. In the foreground are piers with coal barges tied to the wharf; the smoke-filled sky draws attention to the mills further downstream.

The main subject of this work, however, is the river itself. "In my opinion," Gorson told a reporter, "there is nothing finer in nature than the rivers here in Pittsburgh. . . . True, the waters are not clear and limpid, but their very darkness and muddiness contributes a beauty to the effect."[1] Using muted shades of blue and green, accented with a few white highlights, Gorson rendered this river scene nearly monochromatic, demonstrating his preference for cool tonal harmony; the long, broad brushstrokes contribute further to the sense of repose. GB

1 *Pittsburg Press*, June 7, 1908, Sunday magazine sec., p. 3.

Exhibitions Department of Fine Arts, Carnegie Institute, 1921, *Twelfth Annual Exhibition of the Associated Artists of Pittsburgh*, no. 27; Pittsburgh Plan for Art, 1980, *Roots and Branches: Pittsburgh's Jewish History*, no cat.; Westmoreland County Museum of Art, Greensburg, Pa., 1981, *Southwestern Pennsylvania Painters, 1800–1945*, exh. cat. by P. A. Chew and J. A. Sakal, no. 53.

Provenance Senator and Mrs. H. John Heinz III, Pittsburgh, by descent, 1969.

Gift of Senator and Mrs. H. John Heinz III, 1979, 78.56.2

Night around the Mills, c. 1909

Oil on canvas
36½ x 42⁹⁄₁₆ in. (92.7 x 108.1 cm)

Pittsburgh at Night, 1926

Oil on canvas
34¼ x 36¼ in. (87 x 92.1 cm)
Signature, date: A H Gorson/26 (lower left)

Of all the local artists who painted Pittsburgh's industrial landscape, Gorson produced the greatest number of night scenes. Punctuated by the fiery glow of the furnaces, his dark, shadowy views of mills along the flatlands echo the words of travel writer William Glazier, who in 1883 urged his readers to

make your first approach to Pittsburgh in the night time, and you will behold a spectacle which has not a parallel on this continent. . . . Around the city's edge, and on the sides of the hills which encircle it like a gloomy amphitheater. . . fiery lights stream forth, looking angrily and fiercely up toward the heavens, while over all these settles a heavy pall of smoke. It is as though one had reached the outer edge of the infernal regions, and saw before him the great furnace of Pandemonium with all the lids lifted.[1]

Painted from nearly the same vantage point along the barge-laden Monongahela River, *Night around the Mills* and *Pittsburgh at Night* both depict a diagonal view across the water to the Jones and Laughlin steel mills, among Pittsburgh's largest. The subject in each painting is also the same—the flare from a Bessemer converter in full "blow." This short-lived flame, a by-product of rapidly burning carbon monoxide gases, often extended thirty feet above the converter mouth, producing a yellow glow that illuminated the gloomy night sky; accompanied by sparks of red-hot metal and flying particles of molten slag, this theatrical

display conjured for its spectators images of Vulcan's forge.

Despite the exciting visual spectacle before him, Gorson failed to give his renditions the emotional impact associated with such moments of high drama. Concerned more with exploring the aesthetic possibilities of subtle tonal harmonies and nuances of texture, Gorson conveyed the dynamic quality of what he saw without exaggeration or romantic sentiment; the converter remains in the distance and the heroic scale of the mill itself is reduced to a shadowy blur. In addition to his choice of a night scene, Gorson's prevalent use of dark colors, accented with touches of red or white, brings to mind the series of Nocturnes painted by Whistler in the 1870s and 1880s. (Gorson acknowledged his debt to Whistler by titling some of his own late works *Nocturnes*.) In a more conventional

manner, however, Gorson applied his paints with broad forceful strokes; and, as in both pictures here, he built up the surface above the converter with heavy impasto for greater dramatic emphasis.

While *Night around the Mills* and *Pittsburgh at Night* are nearly identical in style and composition, they were painted some seventeen years apart. Moreover, the latter was painted five years after Gorson moved from Pittsburgh to New York; clearly, he was haunted by "those darn Pittsburgh views."[2]

GB

1 William Glazier, *Peculiarities of American Cities* (Philadelphia, 1883), p. 332.
2 Wilson, "Painters of Pittsburgh," p. 18.

Night around the Mills

Provenance Senator and Mrs. H. John Heinz III, Pittsburgh, by descent through Heinz family collection, 1969.

Gift of Senator and Mrs. H. John Heinz III, 1978, 77.80

Pittsburgh at Night

Reference H. G., "The A. H. Gorson Memorial Show at Gillespie's," *Pittsburgh Post-Gazette*, Mar. 19, 1934, p. 17.

Exhibitions J. J. Gillespie Galleries, Pittsburgh, 1934, *A. H. Gorson Memorial Show*, no cat.; University Art Gallery, University of Pittsburgh, organized by Pittsburgh History and Landmarks Foundation and Spanierman Gallery, New York, 1989, *The Power and the Glory: Pittsburgh Industrial Landscapes by Aaron Henry Gorson (1872–1933)*, exh. cat. by R. C. Youngner, no. 20.

Provenance Barbara M. Lawson, Granby, Col.

Gift of Barbara M. Lawson in memory of Roswell Miller, Jr., 1984, 84.72

spanned the Allegheny and Monongahela rivers. As a compositional device, the bridge divides the canvas, accentuating the contrast between the dark foreground and the hazy view beyond.

While the artist's muted palette and bold brushwork certainly convey the somber realism of the work place, social comment was not Gorson's concern. Like other tonalists of the period, his approach to art was essentially visual: "For my own part, I do not like dazzlingly bright atmosphere—certainly I do not think scenes in such extreme brightness are nearly so rich in artistic effect as those I find everywhere under the so-called murky air of Pittsburg [sic]."[1] Here, under a cloud-covered sky, strong contrasts are eliminated, and the composition is balanced by concordant tones of gray and brown.

GB

1 *Pittsburg Press*, June 7, 1908, Sunday magazine sec., p. 3.

Provenance (sale, Sotheby Parke Bernet, New York, Jan. 29, 1981); Richard M. Scaife, Pittsburgh, 1981.

Gift of Richard M. Scaife, 1981, 81.60

On the Monongahela, c. 1912

Oil on canvas
10 x 14 in. (25.4 x 35.6 cm)
Signature: A H Gorson (lower left)

In contrast to the panoramic industrial scenes for which Gorson was best known, *On the Monongahela* provides a close-up view of dockside activities along the riverfront. Dense fog and a nearby bridge restrict the distant view, focusing attention on the foreground, where coal is being transferred from a barge to a railway car; dwarfed by the crane, a single workman attends the operation. While the locale for this particular scene might well be a section of the Jones and Laughlin Steel Company, which had plants on both sides of the Monongahela, documentary detail is subordinated to aesthetic considerations of design and color. Bold geometric shapes, silhouetted against a creamy white sky, impart rhythm and structure to the composition, while the heavy brushwork creates a rich surface texture. Gorson's typical darktoned palette underscores the reality of this commonplace industrial scene.

GB

Exhibition Westmoreland County Museum of Art, Greensburg, Pa., 1976, *Nineteenth and Early Twentieth Century Regional Painters*, exh. cat. by P. A. Chew and J. K. Maguire, unnumbered.

Provenance Irene G. Rawley, Aspinwall, Pa.

Gift of Irene G. Rawley in memory of Wayne Rawley, 1956, 56.29

Trestle along an Industrial Site, c. 1915

Oil on board
10 x 14 in. (25.4 x 35.6 cm)
Signature: A H Gorson (lower right)

This intimately scaled view of earlymorning loading activities along a Pittsburgh riverfront is characteristic of the humble industrial scenes that attracted Gorson's attention. Although the title does not pinpoint the specific location of the site, the scene represented here is the Duquesne Wharf on the north shore of the Monongahela River; the "trestle" is just one of the many railroad bridges that

Steel Mills, c. 1915–20

Oil on board
10 x 14 in. (25.4 x 36.6 cm)
Signature: A H Gorson (lower left)

Painted during the climactic years of Pittsburgh's industrial growth, *Steel Mills* depicts the ironworks at Etna, home of

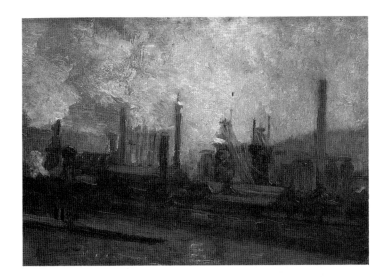

Fig. 1 Unidentified photographer, *View of the Isabella Furnace, Etna, Pennsylvania,* c. 1908. Silver print. The Carnegie Library of Pittsburgh, gift of William Hass

the record-breaking blast furnace affectionately called Isabella. A true titan of the steel industry, the Isabella furnace was capable of producing fifty tons of pig iron per day. A comparison with a photograph of the Etna works (fig. 1) shows that Gorson's small, delicately colored painting belies not only the complexity of the mill's structure but also the heroic scale of the furnaces themselves.

Such transformations were typical of Gorson's poetic approach to the industrial landscape. Using a cool palette of grays and blues, he strove for mood rather than documentary detail; the varied shapes of the sheds and stacks provide rhythm, becoming abstract elements in a balanced design, just as the billowing smoke, symbolic neither of prosperity nor of pollution, is a palpable component of the composition. Possibly painted at dusk, the peaceful, dreamlike ambience that Gorson found in the urban industrial complex allies this work with the idyllic landscapes of Thomas Dewing and John Twachtman.

GB

Exhibition Westmoreland County Museum of Art, Greensburg, Pa., 1976, *Nineteenth and Early Twentieth Century Regional Painters,* exh. cat. by P. A. Chew and J. K. Maguire, unnumbered.

Provenance Unknown: in museum storage until accessioned, 1972.

By appropriation, 1972, 72.39

Adolph Gottlieb

1903–1974

ONE OF AMERICA's important Abstract Expressionists, Adolph Gottlieb is perhaps best known for his Burst paintings of the late 1950s and 1960s, in which a haloed disk hovers symbolically over a dense, chaotic scrawl. During the course of his career, Gottlieb drew eclectically on a variety of sources— including Cubism, Surrealism,

Expressionism, and non-Western art—to forge a uniquely personal and powerful artistic style.

Born and raised in New York City, Gottlieb left high school in 1919 and enrolled in the Art Students League, where he studied painting under John Sloan. In 1921, attracted by the breakthroughs in early-twentieth-century European painting to which Sloan had introduced him, Gottlieb worked his way to Europe on a ship. He spent six months in Paris, where he attended sketching classes at the Académie de la Grande Chaumière, then visited museums in Berlin, Munich, Dresden, and Vienna. He returned to New York in 1923, finished high school, and studied art at the Parsons School of Design, the Art Students League, the Cooper Union Art School, and the Educational Alliance Art School.

Gottlieb's early style, which revealed debts to Paul Cézanne, Henri Matisse, and other established modern masters, brought him his first taste of success in 1929, when he won first prize in a national competition sponsored by the Dudensing Gallery in New York. The prize, which he shared with fellow artist Konrad Cramer, was a two-artist show at the Dudensing Gallery. Gottlieb received generally favorable reviews but made no sales.

His paintings of the early 1930s were strongly influenced by the abstracted figural works of Milton Avery, a friend whose work he greatly admired. Gottlieb may have been directed toward his painterly approach to form and his interest in the sensual qualities of paint by Avery and Sloan.[1] At the same time, he developed an interest in abstraction as a mode of expression,[2] and this emphasis on the alliance of formal abstraction with a subjective, emotional content would prevail in all his later works.

During the Depression, Gottlieb worked for the Works Progress Administration, first in 1936 as an easel painter and then, after a year's stay in Tucson, Arizona, as the winner of a postoffice mural commission in a competition sponsored by the United States Treasury Department. It was while he was in Arizona in 1937 that the influence of Surrealism began to surface in his work. In paintings such as *Arizona Still Life*

(1938, Adolph and Esther Gottlieb Foundation, New York), he combined the flat color planes of Cubism with Surrealism's illogical, dreamlike space. Not personally involved with the European Surrealists in exile, he apparently gained his knowledge of their methods from his friend John Graham, the Russian-born painter and theorist, whom he had met at the Art Students League in 1919. It was also Graham who introduced him to African and other forms of non-Western art; by 1935 Gottlieb had become an avid collector.

In 1941, with the development of his Pictograph series, Gottlieb achieved his first mature style. Like many of his contemporaries, he was fascinated with the psychological theories of Sigmund Freud and Carl Jung and their emphasis on the relevance of myth to contemporary life. Gottlieb added mythic content to elements of Cubism, Surrealism, Expressionism, and abstraction to create a uniquely personal artistic statement. The Pictographs, with their irregular grids containing charged body fragments or biomorphic symbols, are at once reminiscent of Pablo Picasso, Joan Miró, and Native American petroglyphs. These works depend on an interplay between the rational, as exemplified by the grid, and the irrational, represented by the symbols that fill it. By the mid-1940s, works such as *Oedipus* (1941, Adolph and Esther Gottlieb Foundation, New York) and *Alkahest of Paracelsus* (1945, Museum of Fine Arts, Boston) had earned Gottlieb a place in the international vanguard.

Gottlieb participated regularly in group and solo exhibitions, and his paintings were reviewed by prominent critics. Along with his talent, his passionate commitment to artistic freedom and innovation assured him a leading role in the New York art world. In 1935 he helped found the Ten, a group of independent artists of diverse styles united in their dedication to developing an American expressionist art.[3] He was also a founding member of the American Artists Congress in 1936, the Federation of Modern Painters and Sculptors in 1939, and in 1943 the New York Artist-Painters and the Graphic Circle.

In the early 1950s Gottlieb played a seminal role in the development of Abstract Expressionism. The Abstract Expressionists—Gottlieb, Jackson Pollock, Willem de Kooning, Mark Rothko, Franz Kline, and Barnett Newman, among others—successfully challenged the primacy of European modernism and established New York as the center for avant-garde art. In his works of this period, Gottlieb abandoned the rather structured, allover format of the Pictographs and began to explore a looser, more abstract mode, first in his Imaginary Landscape series and later in his Burst paintings. He was elected a member of the National Institute of Arts and Letters in 1972, one year after a stroke confined him to a wheelchair. He continued to paint in New York City until his death.

1 Davis, *Arts*, p. 141.

2 Joslyn Art Museum, *Adolph Gottlieb Paintings*, p. 16.

3 Ibid.

Bibliography Lawrence Alloway, "Melpomene and Graffiti: Adolph Gottlieb's Early Work," *Art International* 12 (April 20, 1968), pp. 21–24; Mary R. Davis, "The Pictographs of Adolph Gottlieb: A Synthesis of the Subjective and the Rational," *Arts* 52 (November 1977), pp. 141–47; André Emmerich Gallery, New York City, 1979, *Adolph Gottlieb Pictographs, 1941–1953*, exh. cat., essay by Mary Davis MacNaughton; Joslyn Art Museum, Omaha, Nebraska, 1979, *Adolph Gottlieb Paintings, 1921–1956* (trav. exh.), exh. cat., introduction by Miriam Roberts; Adolph and Esther Gottlieb Foundation, New York, 1981, *Adolph Gottlieb: A Retrospective*, exh. cat. by Lawrence Alloway and Mary Davis MacNaughton.

Naiad, 1945

Oil on canvas
30 x 24¼ in. (76.2 x 61.6 cm)
Signature: ADOLPH GOTTLIEB (upper left)

From 1941 to 1951 Gottlieb focused his considerable talents on his Pictograph series. The Pictographs, in what is generally recognized as his breakthrough style, reconcile a flat, two-dimensional surface derived from Cubism with a meaningful, subjective content. In works such as *Naiad*, a modest example of this important genre, the artist explored the pictorial possibilities of myth and symbol. In Greek myth, a naiad is a nymph living in and giving life to lakes, rivers, springs, and fountains.

Gottlieb's fascination with myth grew in part from his reading of Sigmund Freud and Carl Jung; he was particularly impressed by Jung's theory of the collective unconscious, a repository of knowledge shared by all mankind and the

source of all myth. Gottlieb believed that he could create an abstract yet universally meaningful art by tapping this collective storehouse of myth, memories, and symbols.

Although he admired the Surrealists' paintings, Gottlieb rejected their method of automatism and developed his own technique for employing the unconscious in his works. First, he would lay down a grid; then, using a process of free association and intuition, he would develop the symbols with which to fill it.[1] In *Naiad* a black grid is laid down on a mint green background, creating irregularly sized compartments, each of which contains a biomorphic form in brownish olive. The overall somber tone is enlivened with tiny highlights of white, peach, salmon, and orange. The seemingly abstract forms hint at highly charged symbols: fish, bones, eyes, and masks. Their blurred forms obscure the figure-ground relationships and serve to anchor the symbols to the surface, a technique Gottlieb later used even more effectively in his Burst paintings.

The artist claimed that his idea for using the grid came from early Italian altarpieces, which use compartments to narrate a story.[2] However, Gottlieb's Pictographs are free of chronological narration. These works are not meant to be read like a rebus; rather, their interest lies in the multiplicity of startling juxtapositions.

Naiad also reveals Gottlieb's interest in non-Western and archaic art: the form in the central compartment is reminiscent of a Native American or Eskimo mask, and small bone shapes are scattered throughout the work. For Gottlieb, this combination of psychology, primitivism, and mythology had strong relevance in a world reeling from the horrors of World War II. As he explained:

> The role of the artist, of course, has always been that of image-maker. Different times require different images. Today when our aspirations have been reduced to a desperate attempt to escape from evil, and times are out of joint, our obsessive, subterranean and pictographic images are the expression of the neurosis which is our reality. To my mind certain so-called abstraction is not abstraction at all. On the contrary, it is the realism of our time.[3]

RB

1 Jeanne Siegel, "Adolph Gottlieb, Two Views," *Arts* 43 (February 1968), p. 30.
2 Adolph Gottlieb, in University of Illinois, Champaign-Urbana, *Contemporary American Painting and Sculpture* (1955), exh. cat., p. 202.
3 Adolph Gottlieb, "The Idea of Art," *Tiger's Eye* 1 (December 1947), p. 43.

Reference Review of Nierendorf Gallery exhibition, *Art News* 44 (Jan. 15, 1946), p. 21.

Exhibition Nierendorf Gallery, New York, 1945, [*Pictographs by Adolph Gottlieb*], no cat.

Provenance Nierendorf Gallery, New York, by 1945; J. B. Neumann, New York, 1945; G. David Thompson, Pittsburgh, by 1953.

Gift of G. David Thompson, 1953, 53.24.2

Charles Grafly

1862–1929

ALTHOUGH TRAINED BY two Realist painters, Thomas Eakins and Thomas Anshutz, Charles Grafly became one of the chief American Symbolist sculptors. Born to German Quaker parents in Philadelphia, Grafly was also raised there. At the age of fourteen he enthusiastically viewed the sculpture exhibition at the Philadelphia Centennial Exposition of 1876, and three years later he took on an apprenticeship as a carver of sculptural ornament in a stone yard. He attended evening drawing classes at the Spring Garden Institute until 1884, when he enrolled at the Pennsylvania Academy of the Fine Arts.

Grafly met Robert Henri at the Pennsylvania Academy, and in 1888 the two young artists traveled to Paris. There Grafly joined the atelier of the sculptor Henri-Michel-Antoine Chapu at the Académie Julian; he may also have studied at the Ecole des Beaux-Arts. In 1890 he won a student competition and had two heads accepted at the Paris Salon. He spent the following summer in Philadelphia, returning to Paris in the fall to share a studio with A. Stirling Calder. There his first large female nude, *Mauvais Présage* (location unknown), won an honorable mention in the Salon of 1891.

After touring Europe Grafly returned to Philadelphia. He again became part of the Henri circle and began his long and impressive teaching career, which lasted from 1892 to 1929, at the Pennsylvania

Academy. In 1893 he won a medal for the works, inspired by Auguste Rodin, that he exhibited at Chicago's World's Columbian Exposition.

By 1900 Grafly had acquired a national reputation for a smooth, naturalistic treatment of idealized symbolic nudes. His *Symbol of Life* (1897, location unknown) and *Vulture of War* (1895, location unknown), both shown at the Paris Exposition Universelle of 1900, demonstrate skillful handling of allegorical themes. Subsequently Grafly was commissioned to produce monumental sculptural groups for the 1901 Pan-American Exposition in Buffalo, for the 1904 Universal Exposition in Saint Louis, and for the 1915 Panama-Pacific International Exposition in San Francisco.

At this time Grafly also became interested in portrait sculpture and began his well-known series of busts of artist friends, which included Henry O. Tanner (1896), Hugh Breckenridge (1898), Edward Redfield (1910), Thomas Anshutz (1913), Frank Duveneck (1915), Paul Bartlett (1916), and Childe Hassam (1918). His *Smith Memorial* (1900–1910) in Fairmount Park, Philadelphia, incorporated several portraits of famous Civil War heroes from Pennsylvania. The major effort of his later years, the *General George Meade Memorial* (1915–25, Washington, D.C.), combined allegorical figures with a heroic-size portrait.

The Armory Show made no impact on Grafly's artistic interests; his last years were in fact spent executing realistic portrait busts for the New York Hall of Fame (1925–28) and a bronze figure of President James Buchanan for the city of Lancaster, Pennsylvania.

Struck by a hit-and-run driver while crossing a street in Philadelphia, Grafly died of his injuries in 1929.

Bibliography Lorado Taft, "Charles Grafly, Sculptor," *Brush and Pencil* 3 (March 1899), pp. 343–53; Pennsylvania Academy of the Fine Arts, Philadelphia, *Memorial Exhibition of Work by Charles Grafly* (1930); Wayne Craven, *Sculpture in America* (1968; rev. ed., Newark, Del., 1984), pp. 437–42; Pamela Simpson, "The Sculpture of Charles Grafly," Ph.D. diss., University of Delaware, 1974; Anne d'Harnoncourt, "Charles Grafly," in Philadelphia Museum of Art, *Philadelphia: Three Centuries of American Art* (1976), pp. 439–40.

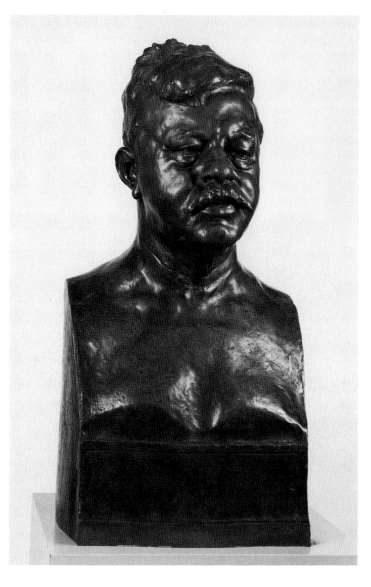

Frank Duveneck, 1915

Bronze
27 x 13½ x 10½ in. (68.6 x 34.3 x 26.7 cm)

Markings: FRANK ĐUVENECK/MADE • AT • FOLLEY COVE •/CAPE ANN • MASSACHU/SETTS • AUGUST • 1915/*Charles Grafly* (on back); ROMAN BRONZE WORKS/N.Y. (base side, proper right)

This portrait of the sixty-seven-year-old Cincinnati painter Frank Duveneck (1848–1919) is one of several portraits of artist friends Grafly undertook after 1896. It is a sensitive tribute to the aging man who had been the fiery leader of the new American Realism emanating from Munich during the 1870s. Although Duveneck's painterly vitality and innovative production had diminished significantly after the death of his wife in 1888,

he continued, even at the period of this portrait, to be honored by the American art community for his enduring contributions as a teacher.

The bust of Duveneck reflects Grafly's powers of workmanship and observation. In contrast to his generalized symbolic figures, it projects a realistic vision in three-dimensional form that recalls Thomas Eakins's painted portraits. Working from life at his studio at Cape Ann, Massachusetts, Grafly rendered the impressive mass of Duveneck's "big blond head"[1] with broad, simplified forms; his thorough grounding in anatomy and skill in drawing from life are further revealed in the way the modeling of Duveneck's skin captures the wearying effects of age and experience. While Duveneck's deeply lined face and furrowed brow convey a mood of sadness, the strong chin, full lips, and penetrating gaze testify to the

robust personality for which the painter is best remembered.
GB, KP

1 Dorothy Grafly to John O'Connor, Jr., June 12, 1941, museum files, The Carnegie Museum of Art, Pittsburgh.

References "Bust of Frank Duveneck by C. Grafly," *International Studio* 59 (Sept. 1916), p. 187; J. O'Connor, Jr., "Treasure Chest," *Carnegie Magazine* 21 (July 1947), p. 40.

Provenance The artist, until 1917.

Purchase, 1917, 17.18

John Graham
1887–1961

JOHN D. GRAHAM was a vital force on the avant-garde art scene in New York during the 1930s. Born Ivan Gratianovich Dombrovsky in Kiev, he repeatedly fictionalized the details of his personal life, so it is difficult to establish a completely accurate account of his career. It is known, however, that he received a doctor of law degree at the University of Kiev, served in the Circassian regiment of the Grand Duke Michael, and was awarded the Saint George Cross for valor. In the wake of the Russian Revolution, he escaped to the United States, arriving in New York in 1920.

By 1923 Graham was studying drawing in New York under John Sloan at the Art Students League, and he began to acquaint himself with American modernism, using the works of Gaston Lachaise, John Marin, and Marsden Hartley as models for his own work. By 1925 he had changed his name from Ivan Dobrovsky to John Graham, married a fellow student in Sloan's class, and moved to Baltimore. There he had his first meaningful contact with European modernism. The first important collectors of his work, Claribel and Etta Cone, encouraged him to visit them in Paris, where they introduced him to Gertrude Stein. It was probably through Stein that Graham developed friendships with the Surrealists Paul Eluard and André Breton and with Pablo Picasso.

In the late 1920s Graham's experiments ranged from Surrealist dreamscapes and Synthetic Cubist works to dark, abstract canvases, which he described as minimalist. At his 1928 exhibition in Paris, he was hailed by several influential French critics as one of the most important vanguard American artists. In 1929 he exhibited at the Phillips Memorial Gallery in Washington, D.C., and the Dudensing Gallery in New York. He also exhibited in the 1929 Carnegie Institute annual exhibition, although five works submitted to the jury in 1930 and 1931 were rejected.

From 1932 to about 1938 Graham apparently stopped painting. Immersing himself in the writings of Sigmund Freud and Carl Jung, he made frequent trips abroad where he became intimately connected with the Surrealist painters. He also collected extensively, describing himself in 1939 as a "specialist in Prehistoric, African, Oceanic and Mexican-Pre-Columbian art."[1] He formed a collection of African sculpture for Frank Crowninshield, the editor of *Vanity Fair*, and greatly influenced the acceptance of non-Western art in New York. At the same time, he urged American museums to acquire European modernist works. In 1936 he sent Carnegie Institute a long list of paintings for sale in Paris by such artists as Pierre Bonnard, Georges Seurat, André Derain, and Picasso, whom he hailed as the greatest artist of all time.[2]

Graham wrote extensively in the 1930s. His provocative, if somewhat erratic, *System and Dialectics of Art* (1937) not only represented a summation of his ideas on world art history, non-Western art, and abstraction but also played a role in the development of Abstract Expressionism. In June 1939 Graham wrote to Carnegie Institute from Coyoacán, Mexico, asking for funds to complete a "Comparative History of Art" that was to cover the years 25,000 B.C. to the present and that would present "the domain of art . . . in a whole new way. . . the psychoanalytical, and . . . plastic aspect of forms in the process of their aesthetic and logical evolution."[3] His subsequent contact with Carnegie Institute was his participation in the 1945 *Painting in the United States* exhibition.

Graham's knowledge of European modernism, his intellectual interests, and his charismatic personality exerted a profound influence on the generation of artists working in New York that included Arshile Gorky, David Smith, Willem de Kooning, Stuart Davis, and Jackson Pollock. He enthusiastically supported these younger artists and, in 1942, organized an important group exhibition that hung works by Pollock, Lee Krasner, Davis, de Kooning, and Graham himself alongside works by Picasso, Henri Matisse, and Georges Braque.

Around 1942 Graham became disillusioned with the New York art scene. Indulging ever more his interest in the occult, he renounced his past work, abstract art, and the circle of artists that he had formerly promoted. He denounced Picasso as a charlatan and adopted a figurative style based on the classical tradition. "I may not be so good as Raphael," he said, "but there is more tension in my canvases."[4] After 1942 his work consisted mainly of obsessional images, mostly fiendish self-portraits and wall-eyed women with wounded necks. Signing his work "Ioannus Magus," he developed an iconography of hermetic symbols that he superimposed on the faces of his subjects. These enigmatic portraits represent his most powerful and original statements.

Graham's return to the figure when other avant-garde artists were working in abstraction elicited mostly bewildered responses. During the 1950s he became increasingly absorbed in the occult; his work was rarely exhibited and he was nearly forgotten. Embittered by neglect, he died in London of leukemia.

1 John Graham to Department of Fine Arts, Carnegie Institute, June 19, 1939, Carnegie Institute Papers, Archives of American Art, Washington, D.C.

2 John Graham to Department of Fine Arts, Carnegie Institute, June 9, 1936, Carnegie Institute Papers. The Carnegie did not acquire anything on the list.

3 John Graham to Department of Fine Arts, Carnegie Institute, June 19, 1939, Carnegie Institute Papers.

4 "An Eccentric Revived," *Life*, October 4, 1968, p. 53.

Bibliography John D. Graham, *System and Dialectics of Art* (Baltimore, 1971); Hayden Herrera, "Le Feu ardent: John Graham's Journal," *Archives of American Art Journal* 14, no. 2 (1974), pp. 6–17; Hayden Herrera, "John Graham, Modernist Turned Magus," *Arts Magazine* 51 (October 1976), pp. 100–105; Elia Kokkinen, "John Graham during the 1940s," *Arts* 51 (November 1976), pp. 99–103; Phillips Collection, Washington, D.C., *John Graham: Artist and Avatar* (1987–88), exh. cat. by Eleanor Green.

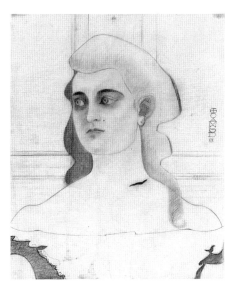

Fig. 1 John Graham, *Portrait of a Woman*, 1942/1952. Graphite, crayon, colored pencil, and ballpoint pen on both sides of tracing paper, 23⅜ x 18¹¹⁄₁₆ in. (59.3 x 47.4 cm). The Carnegie Museum of Art, Pittsburgh, Constance Mellon Fund, William Frew Memorial Fund, and gift of Laura H. Baer by exchange, 83.32

Woman in Black (Donna Venusta), 1943, reworked 1956

Oil and pencil on canvas
24¼ x 20½ in. (61.6 x 52 cm)

Signature, date: IOANNUSFOTIUSSDOMLVI/ *Graham*/XLIII (upper right)

When John Graham abandoned abstraction for a figurative style of painting around 1942, his most frequent form of expression was pictures of women. His sources included early Florentine portraiture, Russian icons, and illustrations accompanying occult literature,[1] transformed by Graham—almost obsessively so—into tense, cryptic, and often disturbing images. One of the earliest of these efforts was *Woman in Black*. It was the first painting in a sequence of at least eight drawings and paintings dating from 1942 to 1959, all close variations on the same dark-eyed, long-haired model.

The variants repeat *Woman in Black*'s contours and general appearance but with different embellishments and backgrounds. The largest is the painting *Marya* (1944, collection Allan Stone, New York), which is generally considered to be Graham's masterpiece. Two others are drawings the same size as the Carnegie's painting and possibly tracings from it: *Untitled* (1944, collection Harvey and Françoise Rambach) and *Donna Losca* (c. 1959, private collection).

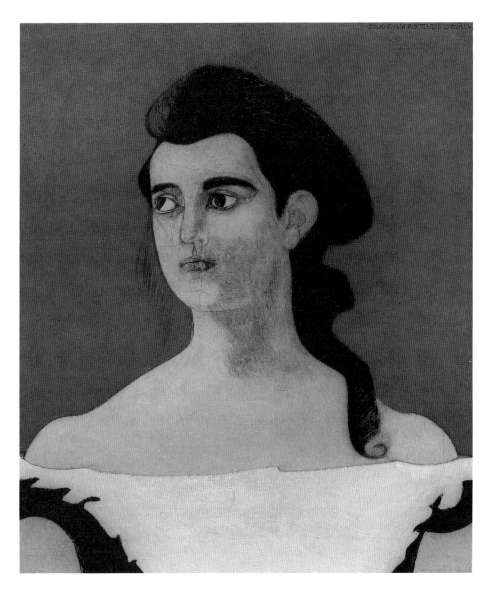

A third drawing, *Portrait of a Woman* (fig. 1), seems to be *Woman in Black*'s immediate predecessor. The drawing is signed and dated twice: "Graham" and the date 1942 appear just right of center; above that is the monogram IOAMSD (Ioannus Magus Servus Domini) in a vertical column, and below it, the number fifty-two in Roman numerals.[2] The drawing was probably made by tracing from an enlarged photograph, as were others by Graham.[3] On the reverse, it is reinforced by graphite and bears traces of what appears to be soot from carbon paper, suggesting that he traced from the drawing onto other surfaces, and possibly onto canvas to provide an underdrawing for *Woman in Black,* although the drawing and painting do not correspond precisely.

Graham's visual source was a photograph (undated but perhaps c. 1890) of a dark-haired young woman in a lacy off-the-shoulder dress.[4] Although he later labeled the photograph as that of Ebrenia, his first wife, the image resembles his mother. Such an identification would make sense of the quizzical entry dated July 1, 1945, in Graham's journal, in which he indicated that he had worked for two years on a portrait of Eugenia, his mother, identifying that portrait as *Woman in Black.*[5] He went on to describe the process of painting it as a mystical experience, with the image trembling and speaking, as certain Byzantine icons reportedly do.

At least initially, *Woman in Black* shared two specific traits with its sister images: a neck wound, painted over but visible in an infrared photograph (fig. 2), and a dis-

located eye. The latter, which appeared in numerous portraits painted by Graham in the 1940s and 1950s, is *Woman in Black*'s most striking feature. The right eye, turned outward, causes the figure to appear as though in an hypnotic state. According to the artist's writings, such staring or dislocated eyes make figures appear transfixed and immutable and create tension in a work. He wrote in his journal in the mid-1940s that he preferred cross-eyed women "because it leaves a margin," probably meaning a margin of ambiguity, a quality he considered essential to his art.[6]

Startling, labial neck wounds were a recurrent feature of Graham's portraits of women, and several of the variants on *Woman in Black* have them. By suggesting destructive sexual activity, they elicit sexual emotions. Alternatively, such wounds, like those of Saint Francis and Catherine of Siena, can be associated with spiritual ecstasy,[7] and it seems that both the lurid and the saintly mingled in Graham's mind when he painted them. The wounds became particularly violent and sinister in Graham's late work; in *Donna Losca* the face and neck are pierced numerous times by a knife and nails, and what appear to be penises emerge from the orifices.

In contrast, when Graham reworked *Woman in Black,* he eliminated the wound and reduced the harsh, dark shading originally on the face. The effect was

Fig. 2 Infrared photograph of John Graham, *Woman in Black*

to make *Woman in Black* more demure and chaste than its sister images. The carefully structured final version balances three large, flat shapes and four strong, pure pigments: red, flesh-pink, white, and black. The contours of the head, neck, and shoulders create a serpentine form that meanders firmly yet rhythmically down the canvas. The result is a picture that is both vivid and eternal: a devotional image endowed, like an icon, with magical properties.

With appropriate pseudo-religiosity Graham signed the work a second time in 1956. The signature is an embellishment of Ioannus Magus, the identity he assumed around 1943, and reads: IOANNUS FOTIUS (Photius, a ninth-century patriarch of Constantinople who extended the Byzantine religion into Russia) S (Servus) DOM (Domini).

DS, ST

1 Kokkinen, "John Graham during the 1940s," p. 101.

2 The drawing's date and signature were incorrectly reported in *American Drawings and Watercolors in the Museum of Art, Carnegie Institute* (Pittsburgh, 1985), pp. 205, 266; and its date incorrectly listed in Henry Adams, "John Graham's *Woman in Black*," *Arts* 59 (May 1985), p. 95.

3 Phillips Collection, *John Graham: Artist and Avatar*, p. 58.

4 John D. Graham Papers, Archives of American Art, Washington, D.C., illustrated in Phillips Collection, *John Graham: Artist and Avatar*, p. 64.

5 Phillips Collection, *John Graham: Artist and Avatar*, p. 63.

6 Herrera, "Le Feu ardent," p. 11.

7 See Carl Goldstein, "Ivan Dobrowsky, John Graham and Ioannus Magus," *Weatherspoon Gallery Association Bulletin*, University of North Carolina, Greensboro (1971–72), pp. 9–18.

References S. K. Farrell, "New Accessions," *Carnegie Magazine* 44 (Mar. 1970), pp. 105–6; H. Adams, "John Graham's *Woman in Black*," *Arts* 59 (May 1985), pp. 95–97.

Exhibitions Colorado Springs Fine Arts Center, Colo., 1970, *New Accessions, USA*, no. 5; Phillips Collection, Washington, D.C., 1987–88, *John Graham: Artist and Avatar* (trav. exh.), exh. cat. by E. Green, no. 42.

Provenance The artist's estate to Major Gallery, New York; Allan Frumkin Gallery, New York.

G. David Thompson Memorial Fund, 1969, 69.8

See Color Plate 35.

Morris Graves

born 1910

MORRIS GRAVES WAS born in Fox Valley, Oregon, and raised from the age of ten near Seattle. The son of a homesteader and a schoolteacher, he had a difficult childhood, marked by repeated bouts with pneumonia as well as the effects of his father's financial hardships. At age eighteen he got a job as a merchant seaman and, between 1928 and 1930, made three trips to the Orient. While touring Japan, Shanghai, Hong Kong, and the Philippines, he discovered Eastern art and the spiritual philosophies—Zen Buddhism, Taoism, and Tantrism—that later made a substantial impact on his art.

Between 1930 and 1932 Graves lived in Beaumont, Texas, where he completed high school. He returned to Seattle, devoted himself to art, and had his first success when his oil painting *Moor Swan* (1933, Seattle Art Museum) won first prize at the Seattle Art Museum's 1933 annual exhibition of Northwest artists. During the 1930s Graves supported himself through a variety of means: he painted for the Federal Art Project, sold junkstore antiques, and gathered wild flowers, moss, and lichen for a local florist.[1] In 1937 he spent five months in New York's Harlem, living with Father Divine, an Evangelical minister and mystic. This interlude probably influenced his 1938 Purification series of chalices and ritual objects in which he tried to integrate pagan and Christian symbols. Also at this time Graves gradually abandoned oils in favor of watercolor or tempera on paper.

Increasingly attracted to the artistic and spiritual philosophies of the East, Graves began to produce his signature pieces: delicate, poetic paintings of birds, small animals, flowers, and pine trees. Through the use of lyrical lines and flattened space, he attempted to give visual form to the spiritual reality behind mundane experience. In 1938 he met the artist Mark Tobey, leader of the so-called Northwest School of Visionary Painters, with whom he became quite close. Graves quickly incorporated Tobey's "white writing"

technique—calligraphic networks of white paint—into his own paintings.

Graves was catapulted to national attention in 1942 when thirty of his works appeared in the Museum of Modern Art's exhibition *Americans 1942: 18 Artists from 9 States*. The critics were impressed with his synthesis of Eastern and Western imagery and techniques:

> Sensation of the show, destined perhaps to become a leader of a new cult, is Morris Graves of Seattle. . . . His haunting pictures of birds bathed in a sort of ectoplasmic moonlight are something entirely new. . . . There is an Oriental cast in his approach— he has visited Japan and probably also been affected by the naturalistic abstraction of American Northwestern Indian painting. But the ties are only in spirit; the facts are his own.[2]

From then on his works were shown in major exhibitions throughout the country and were regularly purchased for private and public collections.

In the spring of 1942 Graves was involuntarily inducted into the army; apparently, he had made errors on his application for status as a conscientious objector that invalidated his claim. The army held him in confinement until March 1943, when he was finally discharged. The anxiety and despair Graves experienced during that time are memorialized in his Wounded Gull series.

In 1946 Graves won a Guggenheim Fellowship to work and study in Japan, but the United States occupation forces denied him entry. So instead he studied the Oriental art collections in Honolulu. From 1948 to 1961 Graves traveled extensively in France, Mexico, Japan, Ireland, and India. He lived in Japan from 1961 to 1964, then returned to the United States and settled in Loleta, California. His work appeared in the Carnegie Internationals of 1950, 1955, and 1958, and his contributions to American visionary painting were rewarded with prizes from the Art Institute of Chicago (1947 and 1948) and the University of Illinois (1955), as well as election to the National Institute of Arts and Letters (1956). Although he resumed painting in oil in the 1950s, his style has changed little throughout his long career.

1 Phillips Collection, *Morris Graves*, p. 29.

2 Doris Brian, "Fresh Wine in New Bottles, 1942 Vintage," *Art News* 40 (February 1, 1942), p. 22.

Bibliography Kenneth Rexroth, "The Visionary Painting of Morris Graves," *Perspectives USA* 10 (Winter 1955), pp. 59–66; Art Galleries of the University of California, Los Angeles, *Morris Graves* (1956), exh. cat., essays by F. S. Wight et al.; Phillips Collection, Washington, D.C., *Morris Graves: Vision of the Inner Eye* (1983), exh. cat., essay by Ray Kass.

Black Still Life with Chalice,
c. 1935–36

Oil on cotton duck
37 x 34 in. (94 x 86.3 cm)

Markings: BEMIS/A/EXTRA HEAVY SEAMLESS/ AMERICAN CRACKER [CO.] SEATTLE W[ASHINGTON] (stenciled on reverse)

One of Morris Graves's most visually complex early still-life paintings, *Black Still Life with Chalice* depicts a grouping of the discarded objects that the artist accumulated in his studio. Several of these objects reappear in other paintings of the 1930s. The chalice in particular was the central motif in his drawings (Morris Graves Archive, University of Oregon, Eugene) and in four other oil compositions (Seattle Art Museum; collection Betty Willis and Mary Randlett, Bainbridge Island, Wash.; collection Helen and Marshall Hatch, Seattle; collection Celia Graves, Santa Cruz, Calif.). The chalice conveys religious symbolism of both West and East: it is divided into light and dark areas, meant to suggest yin and yang divisions. Its setting is a dark, private space, a forebear of the black background and the private, mystical associations Graves brought to his paintings of the 1940s.

The spatial ambiguities and gestural qualities in *Black Still Life with Chalice* are indicative of Graves's early stylistic

sources: Vincent van Gogh, Pierre Bonnard, Chaim Soutine, and Georges Braque. After looking at their works in magazines, Graves combined some of the trappings of Synthetic Cubism with the energetic brushwork of Post-Impressionism. He melded the two schools of painting without troubling himself about the dogmatic issues that divided them. Because the inaccessibility of original canvases prevented Graves from learning much about either Post-Impressionist or Cubist handling of color, the palette he developed bore little resemblance to recent European painting. The color mixture that appears here—black, gray, and a few touches of red—is typical of his stark colors of the 1930s.

Graves painted *Black Still Life with Chalice* on a Bemis cotton-duck seed bag, as he habitually did during the 1930s. The canvas, possibly painted unstretched, was primed only with rabbit-skin glue, so that the bare cloth shows in the channels between his different shapes. His manner of laying in pigments with a palette knife—perhaps in emulation of old-master techniques—was self-taught and, unfortunately, unsound. As a result, the surfaces show numerous signs of premature cracking.

He gave the canvas (probably in the late 1930s or early 1940s) to his then-mentor Mark Tobey, as one of several paintings the two traded during this time. Graves later disavowed the work,[1] just as he denied the authenticity of other early paintings actually by him. It may be that he forgot that *Black Still Life with Chalice* was his, or the denial may have been a way for him to repress the memory of his association with Tobey, which had become strained and psychologically tormenting for him. Nonetheless, the physical and stylistic features of *Black Still Life with Chalice*—its technique, compositional quirks, and Bemis bag support— confirm it as a work by Graves from the mid-1930s.
DS

1 Morris Graves to Ray Kass, July 12, 1984, copy in museum files, The Carnegie Museum of Art, Pittsburgh.

Remarks Although the painting is in its original black frame, the canvas has been restretched; the image area was originally one inch higher.

Provenance The artist to Mark Tobey, c. 1938–44; G. David Thompson, Pittsburgh, by 1956.

Gift of G. David Thompson, 1956, 56.41.3

Gertrude Greene
1904–1956

GERTRUDE GREENE, sculptor and founding member of the American Abstract Artists group, was born Gertrude Glass in Brooklyn, New York. Raised in New York, she also attended art school there from 1924 to 1926, studying with the realist sculptor Cesare Stea at the Leonardo da Vinci Art School. While in art school she identified herself with a relatively radical group of her fellow students, including Isamu Noguchi, who became enthusiastic about abstract art.

In 1926 she married Balcomb Greene, whose interest in geometric abstraction and involvement with the American Abstract Artists closely followed hers. The couple spent the year 1926–27 in Vienna; then, from 1928 to 1931, they lived in Hanover, New Hampshire, where Greene had her first studio. Around 1930 she created her earliest surviving sculptures— figurative pieces that reflected the impact of Ernst Barlach and German Expressionism. All the while, she was expanding her knowledge of modernism through visits to galleries, especially the Gallery of Living Art at New York University and the Museum of Modern Art in New York.

In 1931 she moved to Paris. She remained until 1932, for part of that year sharing a studio with her husband in which she made sculpture and he painted. Meeting artists and attending exhibitions of the work of Jean Arp, Constantin Brancusi, Jacques Lipchitz, Naum Gabo, and Antoine Pevsner, she came into contact with the central currents of European abstraction: Cubism, Constructivism, Suprematism, Neoplasticism, and Surrealist biomorphism. Greene's own works at that time were figurative, three-dimensional pieces that did not yet reflect the full impact of her most recent experiences; however, their simplified, geometricized volumes and features demonstrated her familiarity with what was then called "primitive" art, Cubism, and the work of such sculptors as Lipchitz and Henri Laurens.

In 1933 Greene moved into a studio on Seventeenth Street in Manhattan, where she made preparatory sketches for Suprematist-Constructivist sculptures to

be assembled from iron, copper, and aluminum. Her earliest completed abstract sculptures date from 1935; they were in the round, combining wood or stone with metal components. By the end of the following year she had shifted to the work for which she is best known: two-dimensional abstract reliefs consisting of cutout biomorphic and geometric wood shapes, glued and screwed to textured compressed-wood sheets. Catalysts for this development were the reliefs of Arp she had seen at the Gallery of Living Art and visits to the Museum of Modern Art's landmark exhibition of 1936, *Cubism and Abstract Art.*

Between 1937 and 1939, in the course of her involvement with the American Abstract Artists, Greene developed the Constructivist complexity of her reliefs. In 1939 she designed a wall relief for the radio station WNYC in New York as part of a project sponsored by the federal Works Progress Administration. She did not execute the relief; the project was terminated when the United States entered World War II. In 1942, under the influence of Piet Mondrian, also a member of the American Abstract Artists, she simplified and flattened her compositions. This development was encouraged by her experiments in cut-paper collage, begun around 1939.

In 1942 she moved to Pittsburgh, where her husband taught at Carnegie Institute of Technology (now Carnegie Mellon University). For the rest of her life, Greene divided her time between studios there and in New York. Greene continued to create constructions until 1946, but as she traveled between Pittsburgh and New York she found it increasingly difficult to transport the heavy tools and supplies needed. This inaccessibility of certain tools evidently resulted in a stylistic shift toward compositions of lath-strip rectangles and bars arranged in a seemingly spontaneous fashion. These reliefs anticipated her final body of work: gestural abstract paintings.

Greene's first solo shows at the Grace Borgenicht Gallery in 1951 and the Bertha Schaefer Gallery in 1955 (both in New York), as well as her one contribution to the Carnegie International in 1952, included only paintings that appeared to align her with Abstract Expressionism, but she herself rejected this label. Like her pioneering abstract reliefs, her later paintings, built up with a palette knife, are carefully composed and have an architectonic quality. Together, her reliefs and paintings confirm her reputation as a fundamental link between early-twentieth-century modern art movements and post–World War II abstraction in America. Greene died in New York City.

Bibliography Jacqueline Moss, "The Constructions of Gertrude Greene, the 1930s and 1940s," Master's thesis, Queens College, City University of New York, 1980; ACA Galleries, New York, *Gertrude Greene: Constructions, Collages, Paintings* (1981), exh. cat. by Linda Hyman; Jacqueline Moss, "Gertrude Greene: Constructions of the 1930s and 1940s," *Arts* 55 (April 1981), pp. 120–27; Jacqueline Moss, "Gertrude Greene," in Museum of Art, Carnegie Institute, Pittsburgh, *Abstract Painting and Sculpture in America: 1927–1944* (1983), exh. cat. ed. by John R. Lane and Susan C. Larsen, pp. 164–66; Magdalena Dabrowski, *Contrasts of Form: Geometric Abstract Art, 1910–1980,* introduction by John Elderfield (New York, 1985), pp. 254–55.

Composition, 1936–37

Wood, oil paint, and metal on Masonite
16 x 31⅞ x 1⅛ in. (40.6 x 80.9 x 2.9 cm)

Inscription: *Sketch for painted relief 48/96 inches acquired by Gallery of Living Art (Albert Gallatin) then given or willed to Pennsylvania Mus. of Art. 1936–37* (on back, in Balcomb Greene's hand)

Composition (the title seems to have been Balcomb Greene's) is a three-quarter-size version of a wood-relief *Construction,* 1937, which was purchased by A. E. Gallatin late in 1937 for his Museum of Living Art, New York (fig. 1).
Construction was the first of Gertrude Greene's works to enter a public collection, and Gallatin considered it one of her most important; it is also the relief to which Balcomb Greene's inscription on the back of *Composition* refers. The Carnegie's piece appears to have been a trial model for *Construction.*

Greene's creation of a three-dimensional model appears to be a departure from her usual working method. Her studies for sculptures usually consisted merely of drawings or collages, which she often destroyed after they had served their purpose.[1] The elaborateness of the Carnegie's piece and the fact that it was preserved by the artist herself suggest that she did not regard it as merely a temporary working model but as a true first version, intended at the outset to have an independent status.

In composition and coloring the two reliefs are almost identical—the chief difference between them being an additional disc in the lower-right-hand portion of the Berkshire version. Like that larger version, this one consists of two irregularly shaped cutout wood forms in gray and white, which are connected by a black band and silhouetted against a bisected background of black and rust brown. Although this configuration has been compared to an engine drive shaft,[2] the irregular abstract embellishments in contrasting wood and metal undercut the mechanistic connotations.

Composition reflects Greene's original adaptation of ideas from a variety of sources. The curvilinear contours of the two primary cutout shapes evoke the biomorphic forms of Joan Miró and Jean Arp, whose works were to be seen at the Gallery of Living Art and in the Museum of Modern Art's *Cubism and Abstract Art* show, and had been published in the *Cahiers d'art.* Greene's technique of building up layers of cutout wood placed against a flat support was similar to that of Arp, although she emphasized the interchanges between solids and voids to

Fig. 1 Gertrude Greene, *Construction,* 1937. Wood, 20 x 40 in. (50.8 x 101.6 cm). The Berkshire Museum, Pittsfield, Mass., gift of Albert E. Gallatin, 1943

a greater extent. The playful tilt and eccentric embellishment of her two biomorphic shapes, silhouetted against a stark, bisected ground, are elements that suggest such works by Miró as the painting *Dog Barking at the Moon* (1926, Philadelphia Museum of Art), then in the Gallery of Living Art.

The clean, angular edges and geometric forms of *Composition* suggest the incipient impact of Neoplasticism and Constructivism, which were primary sources for Greene's subsequent reliefs. The source may have been César Domela, who had a solo show of his de Stijl-Constructivist reliefs in the Gallery of Living Art in 1936. The Russian Constructivists Naum Gabo, Antoine Pevsner, El Lissitzky, Kazimir Malevich, and Aleksandr Rodchenko (all exhibited at the *Cubism and Abstract Art* show) have also been cited as influential.[3]

The latent tendency toward geometric abstraction in *Composition* was most likely also reinforced by the relief constructions of her American Abstract Artists colleagues Byron Browne, Vaclav Vytlacil, Charles Shaw, Janet Young, and Dorothy Joralemon and the paintings of her close friend Ilya Bolotowsky. The paintings by Jean Hélion in the Gallery of Living Art and the *Cubism and Abstract Art* show may also have been instructive. They employed a combination of flexed and straight-edge geometric forms, connected at times by bands—an arrangement that evokes Greene's juxtaposition and linkage of forms.

Composition represents a new level of complexity and ambition in Greene's work. It also demonstrates her original adaptation and skillful synthesis of abstract Surrealist and Constructivist sources. In the pioneering career of the artist who may have been the first American to construct wood reliefs,[4] it is an important transitional work.
GS

1 Moss, "Gertrude Greene," p. 123.

2 William R. Hegeman, "The Contrary Tradition of Abstraction," *Art News* 83 (September 1984), p. 83.

3 Moss, "Gertrude Greene," pp. 120, 122–30.

4 Moss, in Museum of Art, Carnegie Institute, *Abstract Painting and Sculpture*, p. 164.

Reference J. Moss, "Gertrude Greene: Constructions of the 1930s and 1940s," *Arts* 55 (Apr. 1981), p. 120.

Exhibition Bertha Schaefer Gallery, New York, 1957, *Gertrude Greene Constructions*, no. 1, as *Model for construction in collection of Philadelphia Museum of Art (1936–1937).*

Provenance The artist, until 1956; Balcomb Greene, Montauk, N.Y., 1956; Joel Tanguy, New York, c. 1975–84; Zabriskie Gallery, New York, 1984.

Abstract Painting and Sculpture Fund, 1984, 84.24

Robert Gwathmey

1903–1988

ALTHOUGH HE LEFT his native Virginia early in life to become an artist in the Northeast, Robert Gwathmey never stopped painting the rural South, and his reputation is based mostly on those subjects. He reached artistic maturity at a time when the issue of social content in art—as opposed to concentration on purely formal concerns—was much debated, and he felt a strong attraction to the former camp. In 1946 he said, "I don't want to get labelled as a painter of the South. But then I go back every summer to Virginia and I see these things—and they affect me all over again, sort of shock me—and I paint them."[1] The "things" to which Gwathmey referred were the conditions of blacks and poor whites in the South, particularly sharecroppers.

A middle-class white, Gwathmey was born and raised in Richmond, the son of a widowed schoolteacher. At the age of eighteen he entered North Carolina State College in Raleigh to study business but left after less than a year. He took a job on a freighter that visited American and

European ports, began sketching and eventually decided to become an artist. In 1925 he enrolled at the Maryland Institute in Baltimore and the following year entered the Pennsylvania Academy of the Fine Arts in Philadelphia. There he adopted the French-influenced academic style of his principal teacher, Franklin Watkins. He spent the summers of 1929 and 1930 in Europe, having won Cresson Traveling Fellowships from the Pennsylvania Academy. Abroad, Gwathmey absorbed the lessons of the old masters while he became familiar with the hardships of the indigent in Europe. He was particularly struck by the squalor he found among the lower classes in Spain.

In 1930 Gwathmey took a teaching job at Beaver College for Women in Jenkintown, Pennsylvania, a position that allowed him to make frequent visits to New York. The effects of the Depression on Philadelphia and New York reminded him of the poverty he had seen as a child in the South and as a student in Europe. Spurred to political activism, he served as vice president of the Artists Union in Philadelphia, a group that advocated collective bargaining to guarantee a living wage for artists.

After destroying most of his own early canvases in 1938 in an attempt to "wash himself clean of academic dogma,"[2] Gwathmey developed the personal idiom with which he expressed themes of social protest. Schematic representations of black farmers—in the fields, fishing, or sitting in quiet despair—characterized by bold linear patterns and equally bold areas of flat color became his hallmark. Indeed, the strong criticism of the contemporary American social structure that he intended was perhaps most appropriately conveyed—and most easily understood—via the angular, diagrammatic style he chose.

In 1937 Gwathmey lost his job at Beaver College, evidently because he had drinks with female undergraduates while on a field trip to New York.[3] The following year he became a teacher of painting and drawing at Carnegie Institute of Technology (now Carnegie Mellon University) in Pittsburgh, in his opinion "an electric city."[4] He had his first solo show in 1941 at the ACA Gallery in New York, and the next year he joined the faculty at the Cooper Union, New York. He taught there until his retirement twenty-

five years later, when he settled in Long Island, returning to Virginia during the summers.

After World War II, conditions in the South, especially the plight of blacks, continued to motivate Gwathmey's painting. As social circumstances changed, he demonstrated his support of the civil-rights movement by uniting symbols familiar from his earlier paintings, such as the sharecroppers in *Hoeing* (see p. 219), with emblems representing the more recent struggles for equality. In this way he once again gave visual form to his outrage at the social injustice he perceived. A long-time resident of Amagansett, Long Island, Gwathmey died there in 1988.

1 Stewart, "Toward a New South," p. 129.

2 Block, "Robert Gwathmey," p. 262.

3 Charles K. Piehl, "A Southern Artist at Home in the North: Robert Gwathmey's Acceptance of His Identity," *Southern Quarterly* 26 (Fall 1987), p. 3.

4 "Art," Pittsburgh *Bulletin Index*, May 9, 1940, p. 19.

Bibliography Maxine Block, ed., "Robert Gwathmey," in *Current Biography: Who's News and Why, 1943* (New York, 1944), pp. 261–63; Harry Salpeter, "Gwathmey's Editorial Art," *Esquire* 12 (June 1944), pp. 83, 131–32; Alan S. Weller, "Robert Gwathmey," in *Art USA Now*, ed. by Lee Nordness (New York, 1963), vol. 1, insert after p. 122; Saint Mary's College of Maryland Art Gallery, Saint Mary's City, Md., *Robert Gwathmey* (1976); Rick Stewart, "Toward a New South," in Virginia Museum of Fine Arts, Richmond, *Painting in the South, 1564–1980* (1983), pp. 128–30, 136, 303.

Chauffeur, c. 1938–39

Oil on canvas
24¼ x 29½ in. (61.6 x 75 cm)
Signature: *Gwathmey* (lower left)

Although Gwathmey's political philosophy and artistic concerns were directed toward the plight of southern blacks, he occasionally looked at the class struggle from other angles. An example is *Chauffeur*, a savagely satirical depiction of a minion of the wealthy urban elite. In it he employed a few very graphic symbols to satirize the pretensions and small-mindedness of the well-to-do.

Above a dado with dentils, subtly suggesting Classical architecture, is an elegant slate-gray-and-turquoise wallpaper; together, they suggest the hallway of a stylish city dwelling. One of the house's occupants is a Pomeranian decorated with

a blue bow, which immediately calls to mind an image of the absent mistress of the household: a rich old lady who fusses over her lapdog. The chauffeur, himself a large man with large hands, is set to work at the petty task of minding this tiny dog. Ironically, the chauffeur is a member of the working class, with which Gwathmey usually sympathized. Yet his pinched face and superior air suggest that he identifies with the world of his employer. The result is a simple, richly allusive vignette by which the artist has managed to damn both employer and employee.

A use of highly selected symbols was characteristic of Gwathmey's work. In 1946 he wrote: "I believe that in painting the use of limited imagery is the best method of presentation of your content. I believe that if the symbols are strong enough and inventive enough, they can transcend the literary in painting."[1]

Chauffeur is one of Gwathmey's earliest extant paintings, which can be dated 1938–39 or perhaps slightly earlier. It shows some of the characteristics of Gwathmey's style by that time: the separate color areas read more as flat shapes than as three-dimensional objects, and they are defined by the use of black lines. Both the figure and the dog are still shaded somewhat, stylistically placing this work between the more traditionally modeled *Hitchhiker* (c. 1936, Brooklyn Museum, New York) and the bold, outlined, and thoroughly flat works that Gwathmey produced after 1940.

Like his colleague Philip Evergood, Gwathmey succeeded in fusing Social Realist concerns with a modernist style, the beginnings of which are evident in *Chauffeur*. One of his concerns was to create works with a strongly two-dimensional surface pattern. "Color can best be expressed by the use of flat relations," he wrote. "This is a modern way to painting."[2] Gwathmey likewise felt that the use of simplified pattern and limited imagery strengthened a work's impact. He greatly admired Pablo Picasso and considered him the most modern painter.[3] Some of Picasso's influence may be seen in the almost Cubist distortions of the man's face, distortions that surely add to the scathing message of the work.

Chauffeur was exhibited in Pittsburgh in 1940 and 1941 while Gwathmey was an art instructor at Carnegie Institute of Technology.

JRM

1 Elizabeth McCausland, "Robert
Gwathmey," *Magazine of Art* 39 (April 1946),
p. 151.

2 Ibid.

3 Ibid., p. 152.

References "Art in a Skyscraper," *Art Digest* 13
(Feb. 15, 1939), p. 28; Review of Craft Avenue
Gallery exhibition, Pittsburgh *Bulletin Index*,
May 9, 1940, p. 19; "Satirical Flair in Show by
Gwathmey," *Art News* 39 (Jan. 4, 1941), p. 12.

Exhibitions American Artists Congress, New
York, 1939, *Art in a Skyscraper*, no. 100; Craft
Avenue Gallery of the Associated Artists, Pitts-
burgh, 1940, *Carnegie Institute of Technology
Art School Faculty Show*, no cat.; Contempo-
rary Books, Pittsburgh, 1941, *Paintings by
Robert Gwathmey*, no. 8.

Provenance The artist, until 1941; Milton
Weiss, Pittsburgh, 1941.

Gift of Milton Weiss, 1984, 83.97

Hoeing, 1943

Oil on canvas
40 x 60¼ in. (101.6 x 153 cm)
Signature: *Gwathmey* (upper left)

Gwathmey's oil *Hoeing* was acquired by
Carnegie Institute in 1943 when the
painting won second place and a seven-
hundred-dollar purchase prize in that

year's edition of *Painting in the United
States.* Given that the work competed
against pictures by 304 contemporary
American artists, Gwathmey modestly
attributed his award to "something akin
to luck."[1]

While many observers—and the
Carnegie jury—admired the artist's bold,
linear style and harsh social commentary,
others thought him unskilled. Indeed, the
painting is an arrangement of flat, rudi-
mentary shapes, including a black field-
hand wiping his brow, an old woman,
children, cows, trees, a church, all of
which cast no shadows and do not adhere
to the rules of perspective. One reviewer
wrote, "*Hoeing* might not rate as expert
painting in the craftsmanship sense but it
is admirable in design, color, and above
all in its tension."[2] The *New York Times*
reviewer was more savage. "The artist,"
he wrote, "seems to have been bent on
producing a kind of symbolic picture of
the South. The result is mannered, spotty,
almost devoid of elements essential to
design."[3]

Hoeing is a frankly symbolic picture
whose elements resonate in Gwathmey's
other work. The flatness of the gray-blue
sky and red earth renders the bare "land-
scape" a mere backdrop for graphic alle-
gories from the repertoire the artist was
developing. The painting's dominant fig-
ure, an anonymous black farmer in work

clothes wiping the sweat from his brow as
he leans on his hoe, appears again in an
oil acquired in 1941 by the Museum of
Fine Arts, Boston (fig. 1), and in a water-
color (nearly identical to the Boston
work) of around 1940 in the Hirshhorn
Museum and Sculpture Garden,
Washington, D.C. Similarly, the small
child carrying a baby, seen on the right
side of the Pittsburgh composition, fig-
ured in an earlier painting called *Non-
Fiction* (location unknown). The overall
theme of *Hoeing* closely relates it to
Gwathmey's most recurrent concern: the
unrecognized toil of the southern farmer.

Although the weary sharecropper pro-
vides some focus for *Hoeing*, the loose
distribution of emblems across the canvas
causes it to be read more or less random-
ly. The barbed wire in the foreground,
symbolic of the farmer's bondage, threads
past the various elements of the composi-
tion. Each of these elements can be inter-
preted in light of Gwathmey's outrage at
the plight of the poor in the South he had
known.

The old white sharecroppers at the left
of the painting are driven by exhaustion
to seek rest and refreshment at a cattle
trough, while on the right the young
child carrying a baby is burdened with
responsibility beyond her years. In the
background laborers toil in the cotton
fields and hoe the dry soil. Facing them
are miserable crops (represented by the
hoer's feeble cornstalk), early deaths (as

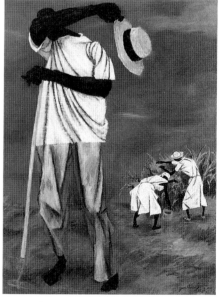

Fig. 1 Robert Gwathmey, *Sharecropper and
Blackberry Pickers*, 1941. Oil on canvas, 32 x 24 in.
(81.3 x 60.9 cm). Museum of Fine Arts, Boston, the
Hayden Collection, 1941

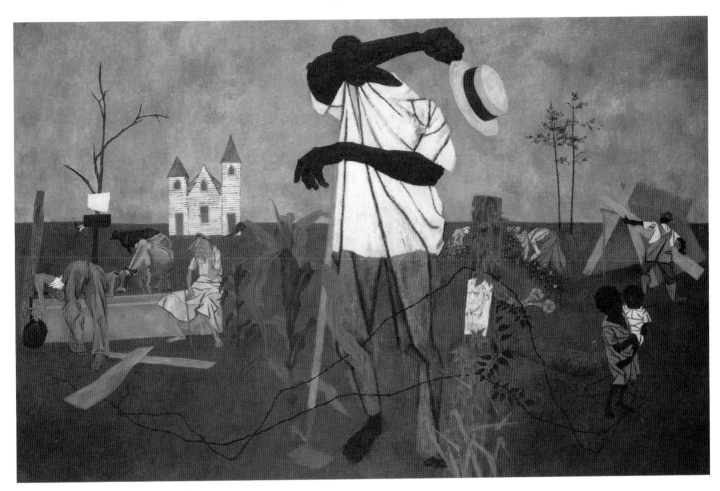

implied by the grave just behind the child), and the contemptuous old-boy politicians such as the man pictured in the sign on the fence post. Nevertheless, there is hope for the future: these laborers derive strength from their church (at left), in their industry and perseverance (implicit in the construction taking place at right), and in the children, next to whom a flower blossoms behind its barbed-wire barrier. Thus, *Hoeing* contains a complex description of southern life, eloquently distilled into powerful symbolic forms. It is a convincing example of Gwathmey's ability to address social issues without sacrificing aesthetic interest and quality.

MM

1 Robert Gwathmey to John J. O'Connor, Jr., October 25, 1943, Carnegie Institute Papers, Archives of American Art, Washington, D.C.

2 Rosamund Frost, "The Carnegie National 1943 Picks Vintage Works for Quality," *Art News* 42 (October 15, 1943), p. 19.

3 Edward Alden Jewell, "$1,000 Art Award to Wayman Adams," *New York Times*, October 15, 1943, p. 22.

References P. Boswell, Jr., "Carnegie Presents Cross-Section of Painting in the United States," *Art Digest* 18 (Oct. 15, 1943), pp. 5–7, 30; R. Frost, "The Carnegie National 1943 Picks Vintage Works for Quality," *Art News* 42 (Oct. 15, 1943), pp. 17–20, 26; E. A. Jewell, "$1,000 Art Award to Wayman Adams," *New York Times*, Oct. 15, 1943, p. 22; J. O'Connor, Jr., "Painting in the United States," *Carnegie Magazine* 17 (Oct. 1943), pp. 145–47; P. Redd, "Painting Prizes Awarded," *Pittsburgh Sun-Telegraph*, Oct. 15, 1943, pp. 25, 36; "Prize Winners in the Carnegie Institute Exhibition," *American Artist* 7 (Nov. 1943), p. 34; M. Block, ed., *Current Biography: Who's News and Why, 1943* (New York, 1944), p. 261; J. O'Connor, Jr., "Two New Paintings," *Carnegie Magazine* 17 (Jan. 1944), pp. 245–46; H. Salpeter, "Gwathmey's Editoral Art," pp. 83, 131–32; K. Swartzbaugh, "Artist Portrays Negro Struggle in Painting," *Toledo* (Ohio) *Sunday Times*, July 23, 1944; C. K. Piehl, "A Southern Artist at Home in the North: Robert Gwathmey's Acceptance of His Identity," *Southern Quarterly* 26 (Fall 1987), p. 5.

Exhibitions Department of Fine Arts, Carnegie Institute, 1943, *Painting in the United States*, no. 2; Toledo Museum of Art, Ohio, 1944, *Thirty-first Annual Exhibition of Selected Paintings by Contemporary American Artists*, no cat.; Cleveland Museum of Art, 1946, *Seventeenth Exhibition of Contemporary American Oil Painting*, no cat.; Virginia Museum of Fine Arts, Richmond, 1946, *Robert Gwathmey*, no. 5; Columbus Museum of Art, Ohio, 1952, *Paintings from the Pittsburgh Collection*, no cat.; Virginia Museum of Fine Arts, Richmond, 1983, *Painting in the South, 1564–1980* (trav. exh.), no. 139.

Provenance ACA Galleries, New York, as agent, by 1943.

Patrons Art Fund, 1943, 44.2

Johanna K. W. Hailman
1871–1958

JOHANNA KNOWLES Woodwell Hailman was born in Pittsburgh, daughter of the respected local landscape painter Joseph R. Woodwell, who was largely responsible for her artistic training. Her formal instruction was limited to a brief enrollment at the Pittsburgh School of Design; but, as she later reflected, "I cannot remember the time when I did not paint."[1] Throughout her lengthy career she continued to work in the representational style that she learned from her father.

Hailman exhibited regularly in the Carnegie Internationals, from the initial show in 1896 through 1955; in 1924, she served on the Committee of Selection and Juries. She was represented in both the Chicago World's Columbian Exposition of 1893 and the Saint Louis Universal Exposition of 1904, and in 1915 received a silver medal at the Panama-Pacific Exposition in San Francisco. She exhibited locally with the Pittsburgh Art Association and at the J. J. Gillespie Galleries. A member of the National Association of Women Painters and Sculptors, Hailman also exhibited work in Chicago, Boston, Philadelphia, and Washington, D.C. On several occasions her paintings were displayed at the John Levy and Knoedler galleries in New York. In 1927 Carnegie Institute sponsored a solo exhibition of her work.

A dedicated gardener, Hailman was best known for her colorful paintings of flowers; she also painted portraits, industrial scenes, and landscapes, many of which were inspired by her travels in Florida and the Bahamas. Her strong, fluid, painterly style, which ultimately reflected the influence of the Ashcan school, caused her to be known to many as "Pittsburgh's first lady of art."[2]

In addition to her extensive artistic output, Hailman had a strong commitment to community service. She founded the Garden Club of Allegheny County and was president of the Pittsburgh Parks and Playground Society. She repeatedly campaigned for a cleaner, more attractive city. She shared a large studio with her father on the grounds of the Woodwell estate on Penn Avenue, where she cultivated a notable garden. Hailman died in Pittsburgh and bequeathed her personal collection of paintings and objets d'art to Carnegie Institute.

1 Penelope Redd, "Pittsburgh Woman Finds Beauty in City's Garden Spots; Works of Art Portray Familiar Scenes," *Pittsburgh Post*, January 2, 1921, sec. 4, p. 8.

2 Obituary, *Pittsburgh Press*, June 30, 1958, p. 2.

Bibliography "City's Social and Art World View Pictures by Johanna K. W. Hailman," *Pittsburgh Gazette Times*, January 18, 1927, p. 5; Obituary, *Pittsburgh Post-Gazette*, June 30, 1958, p. 13; Westmoreland County Museum of Art, Greensburg, Pa., *Southwestern Pennsylvania Painters, 1800–1945* (1981), exh. cat. by Paul A. Chew and John A. Sakal, pp. 48–49; David G. Wilkins, *Paintings and Sculpture of the Duquesne Club* (Pittsburgh, 1986), pp. 48–50.

American Beauties, 1896

Oil on canvas
20 x 25 in. (50.8 x 63.5 cm)

Comparison with a contemporary photograph shows that Johanna Hailman was her own model for this intimate picture of a young woman reclining at a table, daydreaming over a bouquet of roses. A sheet of note paper and an open envelope accompany the vignette of youthful romance. The painting's title refers to the American Beauty roses on the tabletop—a new hybrid of red rose introduced in

1885—and surely by this reference to the young woman contemplating them. It is likely that the roses, which traditionally symbolize purity, were also intended as a reflection of her spiritual beauty. The figure's large brown eyes and pastel blue dress complete the image of chaste innocence.

The theme of young women in quiet contemplation enjoyed widespread popularity at the turn of the century; however, this example had a personal meaning for the twenty-five-year-old artist, who was engaged to be married the same year in which she painted the work. That the picture remained in Hailman's possession throughout her life suggests that *American Beauties* was meant explicitly as a self-portrait.

In contrast to the bright, richly textured paintings that characterize Hailman's mature work, *American Beauties* is subdued in tone and finely drawn. Like a still life, the composition consists of a variety of objects assembled to demonstrate the artist's handling of materials and reflects the academic approach favored by the Pittsburgh School of Design during the 1890s.
GB

Reference D. Kantner, "Eighty-Four-Year Old Artist in International," *Pittsburgh Sun-Telegraph*, Oct. 6, 1955, sec. 3, p. 1.

Exhibition Department of Fine Arts, Carnegie Institute, Pittsburgh, 1896, *First Annual Exhibition*, no. 120.

Provenance The artist, until 1958.

Bequest of the artist, 1959, 59.5.6

Still Life of Fruit, c. 1905

Oil on wood panel
5 x 11 in. (12.7 x 29.9 cm)
Signature: J K W H (upper right)

Painted in somber tones, this small still life consists of seven plums arranged on an unadorned support in front of a dark background; a single sprig of plum tree foliage, placed to the left, completes the composition. Hailman's low-key palette of olive green, deep purple, and various russet hues was meant to capture the complexion of ripening fruit and demonstrates her ability to create rich tonal harmonies. Except in the thick daubs of

white paint used for highlights, the work closely corresponds to the moody studies produced by Hailman's father in the late 1890s.
GB

Provenance The artist, until 1958.

Bequest of the artist, 1959, 59.5.13

Bread Baking, 1914

Oil on canvas
26 x 31 in. (66 x 78.7 cm)
Signature, date: Johanna K. W. Hailman/1914 (lower right)

Hailman probably painted this outdoor scene of two women baking bread in the Bahamas, where she vacationed annually. The composition, which includes a thatched hut framed by palm trees and an enclosed cooking area, is softly illuminated by sunlight filtering through the dense foliage; a wisp of blue-gray smoke rises from the small stove on the right. Their backs to the spectator, the women concentrate on their tasks.

Hailman captured the placid ambience of this tropical setting by using a low-key palette of earth tones, highlighted with soft greens and pale yellows; a few accents of blue and red enliven the color scheme.

The leisurely mood is underscored by the inclusion of a small dog asleep on a stool in the foreground. The repetition of rounded forms within the composition adds to the picture's decorative effect.

Distantly related to the peasant paintings of the French Romantic-Realists, this depiction of native West Indians at work represents a late manifestation of the Barbizon-inspired painting that was popular among Pittsburgh artists during the last quarter of the nineteenth century. The muted, tonal color scheme, however, is of more recent vintage, as is the application of paint, its broad impasto revealing an awareness of Impressionist technique.
GB

Provenance The artist, until 1958.

Bequest of the artist, 1959, 59.5.7

Under the Umbrella, 1920

Oil on canvas
42 x 40 in. (106.7 x 101.6 cm)
Signature, date: J. K. W. Hailman/1920 (lower center)

Under the Umbrella exemplifies the showy floral pieces for which Hailman is best known. "I like to do flowers," she once commented to a reporter, "for a garden is such a delightful place to work."[1] An accomplished gardener herself, she had only to step outside her studio to find such a setting.

In this work the traditional tabletop bouquet is placed out of doors, where the landscape creates the backdrop for Hailman's array of summer blossoms. Shielded from the hot sun by a garden umbrella, the bouquet is illuminated by the light that filters through the umbrella's papery webbing. Using broad brushstrokes and a bright, arguably Fauvist palette, Hailman aimed to capture the

vitality of the arrangement as a whole rather than to describe each flower individually. The presentation works together with the composition, which focuses attention on the bouquet by limiting the degree of spatial recession and by tilting the tabletop toward the picture plane. The repeated use of curving lines unifies the design and underscores the picture's decorativeness.

GB

1 B. W. Burghman, "Her Garden Is Hobby of Mrs. Hailman," *Pittsburgh Post-Gazette,* February 10, 1931, p. 15.

References "Garden Club Presents Hailman Painting," *Bulletin of the Carnegie Institute* 1 (June 1927), p. 17; B. W. Burghman, "Her Garden Is Hobby of Mrs. Hailman," *Pittsburgh Post-Gazette,* Feb. 10, 1931, p. 15.

Exhibitions Department of Fine Arts, Carnegie Institute, Pittsburgh, 1927, *Johanna Hailman,* no. 24; Garden Club of America Art Exhibition, Arden Gallery, New York, 1935, *Exhibition of Paintings, Sculpture and Pottery by Members, and Flower Paintings from Members' Collections,* no cat.; Westmoreland County Museum of Art, Greensburg, Pa., 1959, *Flower Paintings,* no. 33.

Provenance The artist, until 1927; Garden Club of Allegheny County, 1927.

Gift of the Garden Club of Allegheny County, 1927, 27.5

Mrs. Charles Arbuthnot, Jr., 1921

Oil on canvas
40¼ x 30 in. (102.2 x 76.2 cm)
Signature, date: J. K. W. Hailman 1921 (lower right of center)

While best known for her paintings of flowers, Johanna Hailman also achieved a local reputation for portraiture. The sitter in this work is Caroline Arbuthnot (1864–1946), née Berger, a native of Pittsburgh and a contemporary of the artist. The daughter of a prominent manufacturer, William H. Berger, Caroline Berger strengthened her ties to Pittsburgh wealth and society in 1887 when she married Charles Arbuthnot, Jr., vice-president of the well-established Arbuthnot-Stevenson Company, which sold wholesale dry goods.

Mrs. Arbuthnot was fifty-seven when Hailman painted her portrait. Posed in a turquoise gown against a plum-colored background, she sits on an ornately carved chair, the only accessory in the picture. Hailman reduced the formality of the portrait, however, by positioning the sitter at a slight angle to the viewer and illuminating her face from the side. Greater emphasis is placed on the sitter's costume than on an exploration of her character. Hailman's facile brushwork was well suited for achieving such ends.

GB

Provenance Mrs. Charles Arbuthnot, Jr., Pittsburgh, 1921; her daughter, Elizabeth Shaw Arbuthnot, Pittsburgh, 1946.

Bequest of Elizabeth Shaw Arbuthnot, 1968, 68.16

Jones and Laughlin Mill, Pittsburgh, c. 1925–30

Oil on canvas
33½ x 48½ in. (85.1 x 123.2 cm)

With their fiery furnaces and billowing clouds of smoke and steam, the familiar landmarks of Pittsburgh's industrial landscape possessed a special fascination for local painters from the mid-nineteenth century onward. Probably painted in the late 1920s, this picturesque view of the huge Jones and Laughlin Steel Company mills along the Monongahela River attests to the continued popularity of industrial subjects among Pittsburgh artists. Viewed from the bluff overlooking the flatlands, the mill's enormous smokestacks—here exaggerated for greater dramatic effect—dominate the central portion of the composition; the corner of a small house perched on the hillside appears in the foreground, while the glow of a converter in full blast is visible in the distance.

Like her father and older colleagues such as Aaron Gorson, Hailman was attracted by the aesthetic possibilities of smoke. Her thickly painted clouds of white steam, blue smoke tinged in places with orange from ignited gases, and black soot drift diagonally across the canvas, creating a lively sense of motion and a rich surface texture. These swirling forms contrast dramatically with the rigid columnar shapes of the stacks.

The stacks painted in broad areas of flat color produce a bold geometric pattern on the picture plane, which links this work with the Precisionist trend toward reductionism. Despite this nod to modernism, Hailman's work remains conservatively tied to representational realism. The dramatic sweep into deep space and

the extensive use of black coupled with a loose, painterly technique reveal her long-standing commitment to the general style and aesthetic priorities of the Ashcan school.
GB

Exhibitions Westmoreland County Museum of Art, Greensburg, Pa., 1976, *Nineteenth and Early Twentieth Century Regional Painters*, exh. cat. by P. A. Chew and J. K. Maguire, unnumbered; Westmoreland County Museum of Art, Greensburg, Pa., 1981, *Southwestern Pennsylvania Painters, 1800–1945*, exh. cat. by P. A. Chew and J. A. Sakal, no. 65.

Provenance The artist, until 1958.

Bequest of the artist, 1959, 59.5.8

The River, 1929

Oil on canvas
33½ x 48½ in. (85.1 x 123.2 cm)
Signature, date: Johanna K. W. Hailman/1929 (lower left)

This early morning scene includes all the familiar features of Pittsburgh's industry-laden riverbanks—a crane, several coal barges, a tugboat, a railroad bridge, and, on the opposite bank, a steel mill in full operation. Though not her most popular subject, Hailman's smoke-filled views nonetheless won praise from reviewers:

> What is really notable is the vigor with which this native Pittsburgher has put down her notes on our gray railroad tracks, our sullen rivers and the smoke which hovers over water and land. For this preoccupation with smoke is, indeed, one of the most fascinating aspects of all her paintings—smoke swirling from trains, from mills, from boats—and adding immeasurably to the balance and beauty of the scenes.[1]

The River indeed demonstrates the artist's delight in the aesthetic possibilities of smoke. As in *Jones and Laughlin Mill, Pittsburgh*, Hailman accentuates the voluminous clouds of bluish white smoke and steam that engulf the mill by applying her pigments heavily in long curving strokes; for contrast, the tugboat leaves a horizontal trail of black smoke, thinly painted. Such a varied surface texture is characteristic of her mature work. The cool color scheme, which centers around white, blue, and shades of violet and gray, warmed by touches of orange and pink, gives no suggestion of Pittsburgh's infamous pollution. The brightly colored cargo boxes in the foreground further animate the composition, even if their garish hues disturb the tranquillity of the scene. Perhaps this discord reflects Hailman's attempt to give her work a hint of modernism.
GB

1 Jeanette Jena, "Show Water Color Works by Johanna K. Hailman," *Pittsburgh Post-Gazette*, April 17, 1935, p. 11.

Exhibition Westmoreland County Museum of Art, Greensburg, Pa., 1976, *Nineteenth and Early Twentieth Century Regional Painters*, exh. cat. by P. A. Chew and J. K. Maguire, unnumbered.

Provenance The artist, until 1958.

Bequest of the artist, 1959, 59.5.11

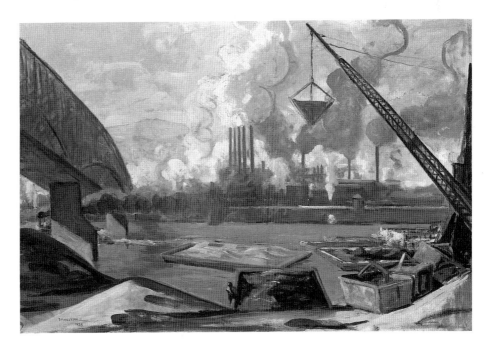

My House, c. 1938
(The Woodwell House)

Oil on canvas
55½ x 55½ in. (141 x 141 cm)
Signature: J. K. W. Hailman (lower right)

This large painting represents the home where Hailman lived throughout her life. This stately Italianate villa housed three generations of Pittsburgh artists, beginning with the painter's grandfather, Joseph Woodwell, a woodcarver, who erected the main portion of the house in the 1850s. Located on Penn Avenue in a fashionable suburban neighborhood, the house was subsequently occupied by his son Joseph Ryan Woodwell, who extended the structure and added the mansard roof. Johanna Hailman was born and raised there and continued to live there after her marriage. Both she and her father painted in a separate studio building behind the house. Hailman's fervent interest in horticulture is apparent in the extensive gardens that surround the house.

Although the flowers are here quite colorful, they play a subordinate role in the composition. The house commands the picture; its plain stucco walls and simple rectangular shape provide a foil for the abundant vegetation around it. An open grassy area in the foreground counterbalances its mass. A flowering dogwood tree in the lower left directs the viewer's attention to the curving driveway connecting the foreground and background of the composition. The pastel palette, highlighted with a few bright colors, was meant to capture the seasonal freshness of

spring. Painted when Hailman was in her late sixties, My House is a tribute to her lifelong home, which was destroyed shortly after her death in 1958.
GB

References "Mrs. Hailman's Works Shown," *Pittsburgh Post-Gazette*, May 18, 1939, p. 26; J. O'Connor, Jr., "A Joyous Picture," *Carnegie Magazine* 23 (Nov. 1949), pp. 130–31.

Exhibitions Department of Fine Arts, Carnegie Institute, Pittsburgh, 1940, *Survey of American Painting*, no. 344; Department of Fine Arts, Carnegie Institute, Pittsburgh, 1949, *Exhibition of Paintings and Prints of Pittsburgh, 1790–1949*, no cat.; Henry Clay Frick Fine Arts Department, University of Pittsburgh, 1953, *Joseph R. Woodwell*, no. 36, as *The Woodwell House;* Westmoreland County Museum of Art, Greensburg, Pa., 1959, *Two Hundred and Fifty Years of Art in Pennsylvania*, exh. cat. by P. A. Chew, no. 48; Westmoreland County Museum of Art, Greensburg, Pa., 1976, *Nineteenth and Early Twentieth Century Regional Painters*, exh. cat. by P. A. Chew and J. K. Maguire, unnumbered.

Provenance The artist, until 1949.

Gift of Johanna K. W. Hailman, 1949, 49.22

William M. Harnett
1848–1892

THE REPUTATIONS OF few artists have changed as dramatically as that of William Michael Harnett. During his lifetime and for nearly a half century after his death, he was a relatively obscure still-life painter whose work was not considered especially innovative or profound. But after 1939, when some of his paintings were exhibited at the Downtown Gallery in New York, the appreciation for Harnett's work rose rapidly, to the extent that he is today widely considered America's greatest still-life painter and one of the key figures in nineteenth-century American art.

Harnett was born in Clonakilty, County Cork, Ireland, and raised in Philadelphia, where his family settled about 1849. In the tradition of his artisan forebears, he became an engraver of silverware, work which no doubt disposed him toward meticulous craftsmanship and precise detail. In 1867 he enrolled in night classes at the Pennsylvania Academy of the Fine Arts, then two years later left

for New York. There he practiced his trade, attending classes at the National Academy of Design and the Cooper Union and taking a few lessons in portrait painting in his free time. In 1874 Harnett gave up engraving to pursue a career as a still-life painter, exhibiting for the first time in the spring of that year at the National Academy.

After returning to Philadelphia in 1876, Harnett again studied at the Pennsylvania Academy, where he exhibited between 1877 and 1879, his specialty being modest images of mugs and pipes or books and writing implements on tabletops. His work sold well enough to allow him to travel abroad in early 1880. The six years he spent in Europe were in part a series of relocations prompted by a failure to gain critical recognition and its attendant financial opportunities. Still, Europe afforded him the chance to refine and discipline his painting method and to measure his achievement against the offerings of the world's art centers. In the spring of 1880 he opened a studio in London, but within a year had moved to Frankfurt; by early 1881 he was living in Munich.

Of the major European cities, Munich was most congenial to the type of painting toward which Harnett was disposed. Within its academy, there was considerable interest in seventeenth-century Dutch Realism, and after 1880, tight, highly finished painting techniques began to prevail. In Munich Harnett exhibited at the Kunstverein, the Glaspalast, and the academy, but, ultimately, rejection by the academy encouraged Harnett, in the winter of 1884–85, to go to Paris "to refer the question of my ability as a painter to a higher court."[1] During this transition, Harnett perfected the large-scale, minutely rendered hanging game piece with which he is usually associated today. Its special qualities were embodied in his masterpiece, *After the Hunt* (The Fine Arts Museums of San Francisco). Painted in 1885, it was exhibited at the Paris Salon of that year. Although it received some favorable response, it was for the most part ignored by the critics.

Harnett returned to America in 1886 and made his home in New York. There his paintings became quite popular, although not among the cultural elite; his work was bought to decorate the walls of lodges and saloons. His patrons were people with old-fashioned tastes who were

mainly interested in the illusionism of his work rather than its creative subtleties. Harnett did much of his best work at this time, spawning a host of followers and imitators. However, chronic illness curtailed his productivity, and he died in New York in October 1892. The meticulously delineated, highly finished trompe-l'oeil still life to which Harnett devoted his career, no matter how much it was admired by the public, tended to be bypassed by critics as superficial and uninspired. As a result, the reputation he developed did not long survive his death, until it was revived again in this century.

1 Quoted in Frankenstein, *After the Hunt* (1953), p. 55.

Bibliography Wolfgang Born, "William M. Harnett: Bachelor Artist," *Magazine of Art* 39 (October 1946), pp. 249–54; Lloyd Goodrich, "Harnett and Peto: a Note on Style," *Art Bulletin* 31 (March 1949), pp. 57–59; Alfred Frankenstein, *After the Hunt: William Harnett and Other American Still Life Painters, 1870–1900* (Berkeley, 1953; rev. ed., 1969); William H. Gerdts and Russell Burke, "Trompe L'Oeil: William Michael Harnett and His Followers," in *American Still-Life Painting* (New York, 1971), pp. 132–58.

Trophy of the Hunt, 1885
(After the Hunt)

Oil on canvas
42⁷⁄₁₆ x 21¹³⁄₁₆ in. (107.8 x 55.4 cm)
Signature, date: W M (in monogram) Harnett./1885. (lower left)

Large trompe-l'oeil compositions depicting freshly killed game were a specialty that Harnett developed between 1883 and 1885. In that period he worked on a sequence of paintings that culminated in *After the Hunt* (1885, The Fine Arts Museums of San Francisco), the masterpiece he painted in Paris. *Trophy of the Hunt*, also painted in Paris in 1885, was a by-product of those efforts.

In Munich in 1883 Harnett created the first and second of four large pictures bearing the title *After the Hunt* (in order, Columbus Museum of Art, Ohio, and private collection, New York). Both depict hunting paraphernalia hanging from a hook on a dark green cabin door: a Tyrolean hat and hunting horn; a sword, rifle, powder horn, and game bag; a duck and small game birds tied by their

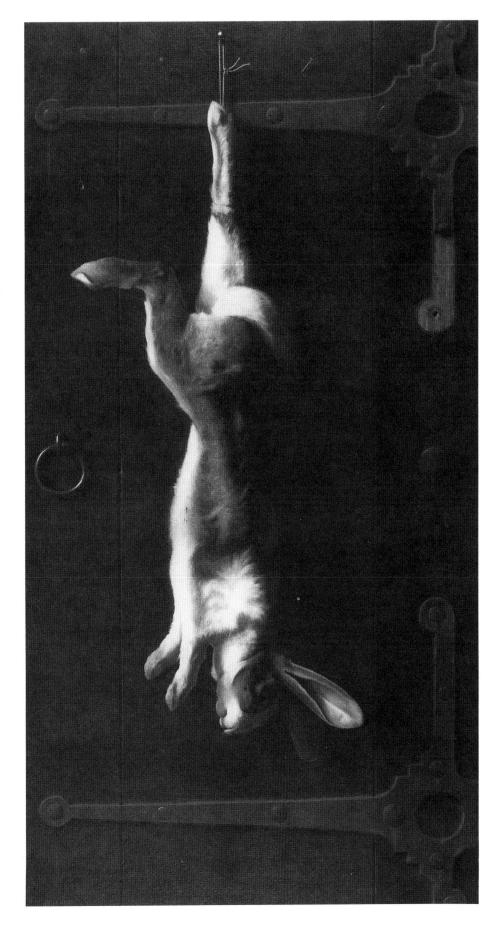

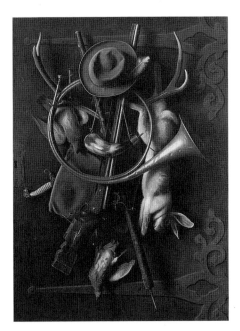

Fig. 1 William M. Harnett, *After the Hunt*, 1884. Oil on canvas, 55 x 40 in. (139.7 x 101.6 cm). Butler Institute of American Art, Youngstown, Ohio, purchase, 1954

Fig. 2 William M. Harnett, *After the Hunt*, 1885. Oil on canvas, 71½ x 48½ in. (181.6 x 123.2 cm). The Fine Arts Museums of San Francisco, Mildred Anna Williams Collection

feet with string. In 1884 Harnett painted a third version (fig. 1) that used similar objects but exchanged the duck for a hare and added stag antlers and a walking stick. This third composition was the basis for his fourth and largest *After the Hunt* (fig. 2). Its hare, more true to life than that of the previous version, corresponds in virtually every detail to the one in the Carnegie's *Trophy of the Hunt*.

Trophy of the Hunt shows a gray hare, its white chest fur and nose slightly bloodied, hanging by one foot against a weathered door similar to the one in *After the Hunt*. The technical mastery of the Carnegie work is evident: Harnett reproduced with startling accuracy the individual hairs of rabbit fur, the nail holes and splintered wood, and the rusty hinges, repaired here and there with newer hardware. He carefully feigned even such details as the signature, which appears as if carved into the wood.

The image returns to a format Harnett had developed in *Plucked Clean*, which features a dead chicken hung against a wooden door (1882, private collection, New York). He subsequently painted two pictures of hares: one is known only through a newspaper reporter's description of a "famous hare" exhibited in 1883 at the Munich Kunstverein;[1] the other, *Still Life with Hare* (1884, collection Nat Leeb, Paris), shows a thickly furred rabbit set against the rough, raw wood of a shed door. The inspiration for such imagery was in part supplied by Harnett's Munich colleague Nikolaus Gysis, who painted dead game in a similar manner. The depiction of hanging game had a long tradition in European art, from Jacopo de' Barbari's 1504 *Partridge and Arms*, which was displayed in Munich's Alte Pinakothek, to the efforts of numerous seventeenth- and eighteenth-century painters.

Alfred Frankenstein described the Carnegie's painting as a practice piece for the hare in Harnett's fourth *After the Hunt*.[2] However, *Trophy of the Hunt* is clearly a large, finished work in its own right, and could conceivably have postdated its counterpart. In either case, the Carnegie's painting predicted the artist's future path. Although *After the Hunt* became Harnett's best known and most widely imitated painting, he never produced so large or complex a composition again. He did, however, continue to create paintings of mundane objects hanging alone on flat vertical surfaces.

In the Carnegie's painting, the subject's isolation creates a powerful distillation. Removed from the nostalgic context of the hunt, the hare resists interpretation as tomorrow's dinner. Instead, the viewer is led to contrast the sudden, violent death of a small animal with the slow decay of the barn door, its elaborately wrought hinges broken and its nails rusting. *Trophy of the Hunt* anticipated paintings such as *The Golden Horseshoe* (1886, Berry-Hill Galleries, New York), *The Old Violin* (1886, private collection), and *The Faithful Colt* (1890, Wadsworth Atheneum, Hartford), all austerely evocative renderings of a single object hanging against dark green, weatherbeaten wood paneling. These provocatively lit images likewise play upon the implications of the passage of time.

DS

1 Frankenstein, *After The Hunt* (1969), p. 69.

2 Ibid., p. 69.

References J. O'Connor, Jr., "The Trophy of the Hunt," *Carnegie Magazine* 15 (Jan. 1942), pp. 245–46; Born, "William M. Harnett: Bachelor Artist," p. 252, as *After the Hunt*; Born, *Still Life Painting in America* (New York, 1947), p. 33; A. Frankenstein, *Bulletin of the California Palace of the Legion of Honor* 6 (1948), n.p.; Frankenstein, *After the Hunt* (1969), pp. 69, 177; W. H. Gerdts and R. Burke, "Trompe L'Oeil: William Michael Harnett," p. 142; H. Adams, in Museum of Art, Carnegie Institute, *Collection Handbook* (Pittsburgh, 1985), p. 202.

Exhibitions Nebraska Art Association, University of Nebraska, Lincoln, 1941, *Fifty-first Annual Exhibition of Contemporary Art*, no. 31; Downtown Gallery, New York, 1944, *William M. Harnett, 1848–1892*, unnumbered; Dallas Museum of Fine Arts, 1948, *Famous American Paintings, Assembled for the State Fair of Texas, 1948*, no. 11; Downtown Gallery, New York, 1948, *Harnett Centennial Exhibition*, no. 11; Ohio University, Athens, 1954, *Exhibition of American Painting: 1804–1954*, no. 21; Cincinnati Art Museum, 1955, *Recent Rediscoveries in American Art*, exh. cat. by E. H. Dwight, no. 49; Allentown Art Museum, Pa., 1959, *Four Centuries of Still-Life Painting*, no. 43; Corcoran Gallery of Art, Washington, D.C., 1966, *Past and Present: Two Hundred and Fifty Years of American Art*, unnumbered; University Art Museum, Berkeley 1970, *The Reality of Appearance: The Trompe L'Oeil Tradition in American Painting* (trav. exh.), exh. cat. by A. Frankenstein, no. 47; Museum of Fine Arts, Boston, 1983, *A New World: Masterpieces of American Painting, 1760–1910*, no. 70.

Provenance Downtown Gallery, New York, by 1941.

Purchase, 1941, 41.5

See Color Plate 13.

James McDougal Hart

1828–1901

AN ACTIVE MEMBER of the second generation of the Hudson River school, James McDougal Hart is best remembered for landscape paintings and drawings that present a bucolic interpretation of rural America in the spirit established by Asher B. Durand. That allegiance was most evident in the work Hart produced between the late 1850s and the early 1870s, which often showed detailed, sunlit hillsides and placid riverbanks dotted with grazing cattle.

Born near Glasgow, Scotland, Hart was brought to America at the age of three. He was raised in Albany, New York, where, at the age of fifteen, he was apprenticed to a coach and sign maker. He developed an interest in landscape, portrait, and still-life painting, which was fostered in Albany's own small art community. Eventually he decided to go to Düsseldorf for academic training, thus becoming one of the first Americans to follow Emanuel Leutze there. His stay in Düsseldorf lasted from 1850 to 1853, during which time he studied under the landscape painter Johann Wilhelm Schirmer and took to sketching along the Rhine.

When Hart returned to the United States, he set up shop in Albany and began sending landscapes for exhibition at the National Academy of Design, New York. In 1857 he moved to New York City, joining his brother William M. Hart, five years his senior, who had been working as a landscape painter there since 1854. Like his brother, James Hart exhibited work frequently—in Philadelphia, Boston, and Baltimore, as well as New York. On the strength of his landscapes, he was elected associate member of the National Academy of Design in 1858. In 1859 he was promoted to academician and later served three years as the academy's vice-president. He settled permanently in Brooklyn in 1866 and eventually counted Alexander H. Wyant and Homer Dodge Martin as his pupils.

Like most of his New York colleagues, James Hart made frequent visits to the Catskills, the Adirondacks, and the White Mountains. The pastoral views he produced were in large part reinterpretations of these natural scenes. It is generally thought that Hart reached the high point of his career during the 1860s, when his interest in actual sites under specific light conditions was strongest. This resulted in fresh, expansive images, works of bell-like clarity. Later in his career, his compositions came to reflect the Barbizon influence prevailing on American painting, particularly the style of Constant Troyon.

Hart's sister Julie Beers Kempson was one of the few professional female painters in nineteenth-century America. Hart married an amateur painter, Maria Theresa Gorsuch, and their children, William and Letitia, also became artists. Hart forwent a high professional profile, preferring to spend his time in Brooklyn with his family.[1] As a painter, he seems to have cast himself in a supporting role, one with which he is associated today.

1 Sheldon, *American Painters*, p. 47.

Bibliography Henry T. Tuckerman, *Book of the Artists: American Artist Life* (New York, 1867), pp. 547–51; "American Painters—James M. Hart," *Art Journal* n.s. 1 (June 1875), pp. 180–83; George William Sheldon, *American Painters* (New York, 1881), pp. 46–51, 84–88; John K. Howat, *The Hudson River and Its Painters* (New York, 1972), pp. 163–64.

Haymakers' Noonday, 1858

Oil on canvas
24¼ x 39¼ in. (61.6 x 99.7 cm)
Signature, date: James M. Hart/1858 (lower left)

Painted in the year after he arrived in New York City, this relatively large canvas represents an important juncture in Hart's career—a matriculation into the Hudson River school. It was almost surely meant for exhibition, and it may well have been his 1858 entry at the National Academy of Design, *Midsummer, Scenery of Putnam County.* Indeed, in general appearance, it evokes the peak of summer at a lower Hudson River farming area such as Putnam County, New York.

Hart created his composition by dividing his riverbank into cultivated and uncultivated land. In doing so, he provided the juxtaposition of wild nature and the agrarian ideal that had been part of Hudson River school landscape painting since its beginning. As early as 1835, in a lecture in New York, Thomas Cole articulated these opposites and sought to reconcile them. In his "Essay on American Scenery," Cole spoke admiringly of the sublimity of God's unspoiled handiwork.[1] He regretted that the course of social progress would cause the wilderness to disappear, yet admitted that cultivation of land and other manifestations of that progress are more valuable to man than land in its uncultivated state.

The element of wilderness in Hart's landscape takes up only a fraction of the composition. In the foreground a slightly dark, overgrown, and swampy piece of land sets off the brighter, more manicured middle ground where the haymakers rest for their midday meal. A stone-and-timber fence running diagonally through the picture provides the line of demarcation, but where the stones have fallen aside, it also provides a place for the viewer to enter the picture visually. In a manner typical of Hudson River school painting, the viewer passes from the shadows

and sharp detail of the foreground into the sunlit bounty of an American Eden whose terrain becomes increasingly idealized with the distance.

When Hart painted this canvas, he was concerned with earning membership at the National Academy of Design. He seems therefore to have meant his work to be a showpiece of his painterly allegiances as much as of his skill. He created a tribute to the ideal of Hudson River school painting and to the example set by the academy's president, Asher B. Durand.

Hart found the disciplined drawing of his Düsseldorf training congenial to the painting style he saw in New York. That discipline is apparent in the broad-leaf water foliage in the foreground. (The conceit appears in other work by Hart, for instance, in *Nature's Nook*, 1857, Vassar College Art Gallery, Poughkeepsie, N.Y.). It recalls the brightly lit, meticulously detailed passages in work done about the same time by Aaron Draper Shattuck and William Trost Richards.

Haymakers' Noonday is a particularly programmatic act of homage to Durand, with its depiction of a stream and a meadow with horses and a hay cart, and its Durand-inspired clarity and definition. Hart constructed his scene in the traditional manner of Claude Lorrain, on a Claudian coulisse system, with a dark mass of foliage at the left, a brightly illuminated middle ground, and to the right a group of trees that draws the eye farther back. Yet Durand and Hart both combined such traditional compositions with careful observation of nature's details—the botanically exact foreground vegetation, the faithfully recorded appearance of the intense noonday sunlight—resulting in a fresher, less preconceived rendering than mere tradition would prescribe.

In the tradition Durand had established, *Haymakers' Noonday* is a contemporary pastoral. Its serene landscape contains an idle moment of a virtually timeless farming activity: hay gatherers resting in the shade with their loaded horse-drawn wagon. Even though a farmhouse is in full view and not far away, the prosaic human element is dwarfed by the surrounding trees and sprawling hills, setting to rest the question of whether men who farm the land dominate nature. Hart was able to present an easy coexistence of

nature's wildness and man's cultivation of it in a surprisingly effective and unmelodramatic way, which makes this one of his finest works.

DS

1 Thomas Cole, "Essay on American Scenery," *Atlantic Monthly*, n.s. 1 (January 1836), pp. 1–12, reprinted in John W. McCoubrey, ed., *American Art, 1700–1900: Sources and Documents* (Englewood Cliffs, N.J., 1965), pp. 98–110.

References W. Hawley, ed., *The American Years*, Bicentennial Yearbook of the Massachusetts Audubon Society (Lincoln, Mass., 1976), p. 48; "Recent Acquisitions, Museum of Art," *Carnegie Magazine* 50 (Feb. 1976), p. 88.

Exhibitions Possibly National Academy of Design, New York, 1858, *Annual Exhibition*, no. 200, as *Midsummer; Scenery of Putnam County;* Kunstmuseum, Düsseldorf, 1976, *The Hudson and the Rhine: Die amerikanische Malerkolonie in Düsseldorf im 19. Jahrhundert* (trav. exh.), no. 27.

Provenance C. H. Livingston, in 1858; private collection, New York; Virginia Dellehanty, Bridgewater, Vt.; Vose Galleries of Boston, 1974.

Mr. and Mrs. James F. Hillman Fund, 1975, 75.34

Marsden Hartley
1877–1943

A PIONEER OF AMERICAN modernism, Marsden Hartley is best remembered today for the abstract paintings he created in Europe during the 1910s, and for the images inspired by Nova Scotia and Maine that he painted in his last years. His eclecticism and constant experimentation make his art difficult to categorize, but its consistent elements were vivid coloring, graphic strength, and an ability to give an emotive, visionary quality to ordinary subjects.

Born Edmund Hartley in Lewiston, Maine, the artist was the youngest of nine children of English immigrants. His mother died when he was eight years old, and he was raised by a sister in nearby Auburn, Maine, where he spent a solitary childhood. Having left school at age fifteen, Hartley joined his father and stepmother, Martha Marsden (whose name

he later adopted), in Cleveland, Ohio, where he entered art school in 1898.

In 1899 he won a five-year stipend to study in New York, where he attended the Chase School and the National Academy of Design. He began to spend his summers sketching and painting in Maine, and the mountains, trees, and storms he saw there figured in his early canvases. These works, dating from 1906 to 1909, used a stylized, Impressionistic technique that Hartley attributed to the influence of the Swiss painter Giovanni Segantini. Their stitchwork of bright pigment foretold Hartley's lifelong love for the physicality of paint.

In 1909 Hartley had his first solo exhibition at 291, Alfred Stieglitz's gallery. Like other artists in the Stieglitz circle, he took great interest in the works by Paul Cézanne and Henri Matisse that appeared at 291 from time to time. He also became familiar with the paintings of Albert P. Ryder, which deeply affected him and led him to create a group of dark, anguished, Ryderesque landscapes in 1909 and 1910. In 1911, after Stieglitz held an exhibition of some of Picasso's work, Hartley tried his hand at Cubist landscapes.

A desire to see European modernism at its source led Hartley in 1912 to Paris, where Gertrude and Leo Stein befriended him and where he created his first abstractions. His interest in the Blaue Reiter artists, particularly Wassily Kandinsky, led Hartley to Berlin in 1913. There he continued painting bright, thickly textured canvases, emblazoned with geometric symbols derived from the native American artifacts he had seen at the ethnographic museums of Paris and Berlin. He contributed to New York's Armory Show of 1913 and that same year exhibited five paintings with the Blaue Reiter group. The death in battle of his close friend Karl von Freyburg inspired Hartley's best-known painting, *Portrait of a German Officer* (1914, Metropolitan Museum of Art, New York), in which regimental patches, banners, the Iron Cross, and his friend's initials appear against a stark black background.

In the fall of 1915 Hartley enjoyed a critically acclaimed exhibition in Berlin of forty-five recent paintings. He returned to New York in December of that year,

only to find little enthusiasm for his work in America. In 1916 he joined the art patron Mabel Dodge and her circle in Provincetown, Massachusetts, and gradually abandoned Cubism and abstraction in favor of still-life subjects and expressionistic landscapes. He continued with these themes during an eighteen-month stay in New Mexico in 1918–19, and after returning to Berlin, he painted his *New Mexico Recollections, No. 12* (1922–23, Archer M. Huntington Art Gallery, University of Texas at Austin). Hartley remained in Europe from 1921 to 1930, traveling through Italy and southern France, determined to rediscover nature's spiritual foundations. The paintings of Fra Angelico, Masaccio, and Piero della Francesca deeply impressed him, as did the austere terrain around Aix-en-Provence, which he depicted with the intention of taking up where Cézanne had left off.

In the summers of 1930 and 1931 Hartley was painting landscapes near Franconia, New Hampshire, and Gloucester, Massachusetts, and became particularly intrigued by the boulders and stone walls in Dogtown, Cape Ann. In 1932 he went to Mexico, funded by a Guggenheim Fellowship, but the adversities of Mexican life led him to cut short his year there in favor of Germany. In 1934 and 1935 Hartley traveled along the Atlantic seaboard—to Gloucester, Bermuda, and Nova Scotia—all the while consolidating the thematic experiments of the past five years. Painting with heavy impasto and a simplified palette, he created an austere, timeless landscape vision and developed an approach to still life in which fish, seashells, and birds were boldly simplified and starkly arranged on the canvas.

In Nova Scotia during the autumn of 1935 and the summer of 1936, Hartley boarded with a fishing family, the Masons, to whom he developed a strong attachment. The untimely death of the Masons' two sons became the inspiration for a series of iconic memory images of the family, which culminated in a symbolic memorial, *The Fishermen's Last Supper* (1940–41, private collection). From Nova Scotia Hartley returned to Maine and reestablished his artistic identity there. This phase of his career, congenial to the trend toward nativism in American art, brought critical favor but

few sales. "I am too aware of the American art game after long experience to be thrilled by words of praise," he complained to his dealer in 1939. "I have a human stomach & fame will not fill it."[1] Despite his extensive contact with the national art scene, Hartley's last decade was marked by continuing poverty, depression, and chronic ill health; he died of heart disease in an Ellsworth, Maine, hospital.

Hartley's shyness and homosexuality fostered a certain alienation from American culture. He led a rootless existence and virtually never had a permanent residence either in the United States or abroad. The persona of a dandified sophisticate that he maintained throughout life underscored the role of impassioned outsider that he assumed for himself.

Hartley left an eloquent legacy as a poet and essayist. In addition to numerous unpublished poems and commentaries on art and literature, he produced a book of essays, *Adventures in the Arts* (1921), and three volumes of poetry (1923, 1940, 1941). A fourth volume of poetry was published posthumously in 1945, and a collection of his essays on art appeared in book form in 1982.

1 Marsden Hartley to Hudson Walker, New York, August 14, 1939, Marsden Hartley Papers, Archives of American Art, Washington, D.C.

Bibliography Elizabeth McCausland, *Marsden Hartley* (Minneapolis, 1952); Robert Northcutt Burlingame, "Marsden Hartley: A Study of His Life and Creative Achievement," Ph.D. diss., Brown University, 1953; Whitney Museum of American Art, New York, *Marsden Hartley* (1980), exh. cat. by Barbara Haskell; Gail R. Scott, *Marsden Hartley* (New York, 1988).

Garmisch-Partenkirchen, c. 1933–34

Oil on board
29½ x 18¼ in. (74.9 x 46.4 cm)
Signature: Marsden Hartley (on reverse)
Inscription: Waxenstein/Garmisch-Partenkirchen/Bavaria (on reverse)

Hartley went to Germany for the third and final time in the summer of 1933, seeking spiritual refreshment after a disastrously unrewarding trip to Mexico. He arrived in Hamburg in May 1933, and

spent an enjoyable summer there. "I am so happy to see pine trees again and smell their luscious odour—see the orange sunset through them and inhale the fresh fragrance of the fields as I pass home from the beach in the evening," he reported.[1]

Hartley saw his trip to Germany as a way to return to his innately northern temperament in a climate that reminded him of New England. From Hamburg he already anticipated the course that his new paintings would take, although he doubted anyone would buy them. As he wrote to the art dealer Edith Halpert:

I am going back stronger and stronger to all those northern emotions to which I was born—and that comforts me. My pictures are bound to be mystical more and more for that is what I myself am more and more. . . . I belong naturally to the Emerson-Thoreau tradition and I know that too well. It is my native substance.[2]

In September 1933 he installed himself in Garmisch-Partenkirchen, the principal resort town of the Bavarian Alps, which became the site of the fourth Olympic Games in 1936. Hartley remained there until shortly before returning to New York in February 1934. He wrote letters and painted the surrounding mountains, his focus being the bare, axe-shaped summit of the Waxenstein and its neighboring peaks.

The Carnegie's painting is one of several images by Hartley of the Garmisch-Partenkirchen area, all painted during the fall or winter of 1933–34. They include *Bavarian Alps, Garmisch-Partenkirchen* (private collection), *Garmisch-Partenkirchen* (Milwaukee Art Center), *Garmisch-Partenkirchen, No. 2* (Regis Collection, Minneapolis), and *Waxenstein Peaks, Garmisch-Partenkirchen* (Yale University Art Gallery, New Haven). Some of these pictures show a village beneath the mountain range, while others portray the mountains alone. All, however, depict a ruggedly monumental, silent, and absolutely unchanging environment that contrasts to the descriptions in Hartley's letters of the town's bustling building activity and political marches.[3]

Hartley encased the massive presence of his mountains in bold outlines that build with steady rhythm to the top of the composition. Forms are flattened and

pared to their essential features, while the palette is limited to grays and black. The resulting strong shapes and stark contrasts reveal Hartley's acquaintance with German Expressionist woodcuts. Particularly suggestive of the woodcut is Hartley's brushwork, which cuts across the surface in a slashing, angular pattern that activates the surface of the image.

The artist referred to this final encounter with Germany as the "shrine of my delivery."[4] It was to him a self-revelation that pointed to the ultimate direction of his work. Between 1939 and 1942 Hartley replicated his experience at Garmisch-Partenkirchen in his compellingly expressive series of paintings of Maine's Mount Katahdin.

DS, LM

1 Marsden Hartley, Hamburg, to Edith Halpert, New York, July 12, 1933, Marsden Hartley Papers, Archives of American Art, Washington, D.C.

2 Ibid.

3 Marsden Hartley, Partenkirchen, to Adelaide Kuntz, November 15, 1933, and December 28, 1933, Marsden Hartley Papers, Archives of American Art, Washington, D.C.

4 Quoted in Whitney Museum of American Art, *Marsden Hartley*, p. 93.

References Whitney Museum of American Art, *Marsden Hartley*, p. 95; "Letters from Germany 1933–1938," *Archives of American Art Journal* 25, nos. 1 and 2 (1985), pp. 3–28; G. Scott, *Marsden Hartley* (New York, 1988), p. 101.

Exhibitions Bertha Schaefer Gallery, New York, 1950, *Hartley-Maurer*, no. 1; Mansfield Art Center, Ohio, 1981, *The American Landscape*, no. 38.

Provenance Alzira Peirce, Bangor, Me., c. 1939–40; Bertha Schaefer Gallery, New York, by 1950; Mrs. James H. Beal, Pittsburgh, by 1951.

Gift of Mr. and Mrs. James H. Beal, 1959, 59.1

Sustained Comedy, 1939
(Portrait of an Object; The Sustained Travesty; O Big Earth)

Oil on academy board
28⅛ x 22 in. (71.4 x 55.9 cm)
Signatures, date: M. H. (lower left); Marsden Hartley/1939 (on reverse)
Inscriptions: Sustained/Comedy - [crossed out]/ Portrait of an object [crossed out]/"O Big Earth" -/or - the sustained travesty, (on reverse in artist's hand)

Sustained Comedy, one of Hartley's most caustic and disturbing images, is a self-portrait in which he assessed his artistic identity. It was created during a time when he painted a number of bold, frontal, bust-length memory portraits, among them *Portrait of Albert Pinkham Ryder* (1938–39, collection Mr. and Mrs. Milton Lowenthal, New York), *The Last Look of John Donne* (1940, Brooklyn Museum, New York), and the 1939 series called Archaic Portraits, which depicted members of the Mason family. *Sustained Comedy* differs from these, however, in its iconlike immobility and its profusion of fragmented emblems that take on a curious life of their own. It is a portrait created almost entirely of symbols, and in this sense is something of a throwback to such earlier works as Hartley's *Portrait of a German Officer* (1914, Metropolitan Museum of Art, New York) and his evocation of Gertrude Stein, *One Portrait of One Woman* (1916, University Art Museum, University of Minnesota, Minneapolis).

In *Sustained Comedy* Hartley shows himself in the double guise of an Indian with war paint around his eyes and a sailor in a sleeveless undershirt and a ring in one ear. Tattooed on his arms are a butterfly, a camellia, a starfish, and a naked woman. On his chest is a three-masted ship in sail, and on his throat a pierced heart. He is thus altered by the two aspects of American culture he

these poems, "He Too Wore a Butterfly," evokes much of the imagery of *Sustained Comedy*. Although more serene and lyrical than the painting, its theme is likewise a tattooed sailor and the transmogrifying capacity of his tattooed guise. The poem reads:

> He wore a butterfly upon his flanks,
> upsetting the woman and the ship in their
> angles,
> and down his midrib the image of Christ,
> the feet
> and the nails, touching his navel.
> He wore a butterfly upon his shoulder
> blade and
> one above his knee, as if—like the Indian
> in the
> race, whose thighs are brushed with eagle
> feathers to
> give him speed in the run.
> He wore a butterfly upon his flanks as
> though he
> felt the fear of being musclebound,
> or, saying to himself—"I must have the
> breath of
> spring upon my beam"—that smiling morn-
> ing of a man;
> and as if the sea had crowded all its waves
> within his eyes, making him think of num-
> berless
> casual afternoons, the lashes curling up to
> let the
> flood of evening in,
> staving off for later years the pale texture of
> immitigable distance.[1]

DS

1 Gail R. Scott, ed., *The Collected Poems of Marsden Hartley 1904–1943* (Santa Rosa, Calif., 1987), p. 171.

Reference G. Ferguson, ed., *Marsden Hartley and Nova Scotia* (Halifax, Nova Scotia, 1987), p. 162.

Exhibitions Whitney Museum of American Art, New York, 1980, *Marsden Hartley* (trav. exh.), exh. cat. by B. Haskell, no. 87; Museum Ludwig, Cologne, 1986, *Europa/Amerika: Die Geschichte einer künstlerischen Faszination seit 1940*, exh. cat. by Siegfried Gohr, Rafael Jablonka, et al., no. 64.

Provenance Hudson Walker, Forest Hills, N.Y., c. 1939; Mervin Jules, Northampton, Mass., by 1976.

Gift of Mervin Jules in memory of Hudson Walker, 1976, 76.64

See Color Plate 34.

embraced as an artist, those of the American Indian and the Atlantic fisherman.

A subtitle, *The Sustained Travesty*, penciled by Hartley on the back of the image, seems to suggest that his identity was at best a parody, a grotesque and inferior imitation perpetuated by someone who does not fit the role. He is pink-skinned, not tanned and swarthy like either an Indian or a sailor. He is also immobile, since flowers take root on one shoulder, and bird's nest on the other. Further, his two worlds assault him: a thunderbolt strikes his head and arrows pierce his eyes.

During the late 1930s Hartley developed an interest in Christian symbolism and used it to lend allegorical gravity to

tragic human subjects. Since he experienced great distress, anger, and despair during those years, it is not surprising that Hartley applied Christian metaphors of suffering to himself. In *Sustained Comedy* (whose title seems to be a play on Dante's *Divine Comedy*) the arrows have an aspect of martyrs' emblems, while his chest opens to reveal a crucified Christ superimposed on a standing Atlas, an image suggestive of burden and sacrifice. One wonders whether the butterflies in the background (the butterfly was the signature of James McNeill Whistler) and the one-eared presentation of the head (reminiscent of Vincent van Gogh) were attempts to recall those artists, who likewise endured penury and rejection for the sake of their art.

Several of Hartley's late poems elaborated on the themes of his paintings. One of

Young Hunter Hearing Call to Arms, c. 1939
(The Hunter)

Oil on Masonite
41 x 30¼ in. (104.1 x 76.8 cm)
Signature: M. H. (lower left)

In New York in March 1939 Hartley exhibited at the Hudson Walker Gallery a series painted in Maine entitled Archaic Portraits.[1] These images of his friends from the Mason family combine the primitivism of American folk art and the intensity of religious icons. *Young Hunter Hearing Call to Arms* is a closely related portrait of the same period.

The precise identity of Hartley's blond hunter remains undetermined, but his Teutonic features, particularly his hair and square jaw, suggest the artist's cherished friend Karl von Freyburg. It would

not have been an unusual subject for Hartley to undertake, for on several other occasions he recalled past experience in his paintings. The memory of Freyburg and the pain Hartley experienced at the officer's death in 1914 had been rekindled by the tragic drowning in 1936 of Donny and Alty Mason and their cousin Allan. Of that catastrophe, he wrote, "I haven't felt anything like it since the death of Karl von Freyburg."[2]

Hartley's sexual attraction to both Freyburg and the Masons' son Alty surely fueled this uncompromising portrait of male virility. A hale young hunter, framed and almost enshrined by birch trees, boldly confronts the spectator from his glade. The artist's provocative placement of still-life elements, especially the buck's antlers, heightens the erotic dimension of the work, and the juxtaposition of antlers and gun, clearly a reference to male genitalia, makes plain the artist's intention. At

the sportsman's left lie more appurtenances of his craft: severed deer hoofs. Scraped over the ground, they reproduce the sound of bucks pawing the earth, while clashing antlers duplicate the noises of animals locked in battle over does. Thus simulating the courtship ritual, the hunter lures bucks into his range of fire.

A consideration of Hartley's homosexuality suggests that this rural scene presents a hunter engaged in a pursuit of the heart, and that the courtship rite he initiates is meant to draw male quarry of a different kind. Hartley's unabashed message is matched by his commanding style. Dark underpainting sets primary colors and white in lustrous opposition while the brusque and heavy application of those colors is controlled by the firm black outlines.

Hartley, who had participated in Carnegie Institute's annual exhibitions of 1931 and 1933, was represented by this work in its 1943 exhibition of *Painting in the United States*, from which it was purchased for the permanent collection.
LM

1 Whitney Museum of American Art, *Marsden Hartley*, p. 116.

2 Ibid., p. 101.

Reference J. O'Connor, Jr., "Two New Paintings," *Carnegie Magazine* 17 (Jan. 1944), pp. 245–48.

Exhibitions Paul Rosenberg and Co., New York, 1942, *Paintings by Hartley, Rattner, Weber,* as *The Hunter,* unnumbered; Department of Fine Arts, Carnegie Institute, Pittsburgh, 1943, *Painting in the United States,* no. 164; Museum of Modern Art, New York, 1944–45, *Feininger/Hartley,* exh. cat with foreword by Monroe Wheeler; Arts Club of Chicago, 1945, *Marsden Hartley,* no. 54; Columbus Museum of Art, Ohio, 1952, *Paintings from the Pittsburgh Collection,* no cat.; Ligonier Valley Library, Ligonier, Pa., 1983, *Ligonier Triennial Art Show,* no cat.

Provenance Paul Rosenberg and Co., New York, by 1943.

Patrons Art Fund, 1943, 44.1.2

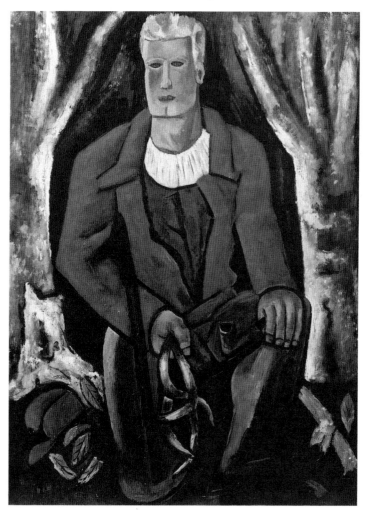

Childe Hassam

1859–1935

Raised in Dorchester, Massachusetts, in what was then the countrified periphery of Boston, Frederick Childe Hassam came from an old Salem family. His father was a collector of antiques and the owner of a Boston hardware firm, whose business losses after the Boston fire of 1872 may have sent Hassam to work, first at a publishing house, then with a local wood-engraving firm. He was already a free-lance illustrator when, at the age of nineteen, he began to take evening classes at the Boston Art Club. He also studied at the Lowell Institute in Boston and with local artists, including William Rimmer.

By the early 1880s Hassam established a studio in Boston, where he worked mainly as an illustrator. He also painted outdoors, creating subdued, atmospheric views of Boston's streets. In 1883 he made the first of several trips to Europe, visiting the Netherlands, Spain, and Italy.

Hassam's next trip abroad, from 1886 to 1889, was spent primarily in Paris, where he studied at the Académie Julian under Jules-Joseph Lefebvre. While continuing to paint street scenes, he gradually evolved an Impressionist-influenced style of broken, staccato brushstrokes and a bright palette to suggest the tangible effects of light and air. During this period he painted *Grand Prix Day* (1887, Museum of Fine Arts, Boston), which stands as one of the premier achievements of American Impressionism and set the tone for his subsequent work.

Hassam exhibited his paintings in the Paris Salons of 1887 and 1888. In 1889 he returned to America and settled in New York, where he became one of the most versatile and successful practitioners of Impressionism in the United States and a major interpreter of urban subjects. He summered at New England resorts that were popular with artists: the Isles of Shoals off the coast of New Hampshire, Old Lyme, Connecticut, and Gloucester, Massachusetts. These locations were frequently the subjects of his paintings, pastels, and watercolors. He returned to

Europe twice more—from 1897 to 1898 and then again in 1910. After 1900, while continuing to paint city views and landscapes, he often portrayed nudes in outdoor settings and depicted interiors with figures.

Perhaps Hassam's most significant affiliation was the Ten American Painters, the secessionist group that he helped found and which held its first exhibition in 1898. His work, however, was widely exhibited and won numerous awards, while he was active in various artists' organizations. In 1905 he had the first of many solo exhibitions at the Montross Gallery in New York. In 1906 Hassam became an academician of the National Academy of Design. He was elected to the American Academy of Arts and Letters in 1920, and he bequeathed his remaining paintings to that institution, authorizing their sale in order to establish a fund for the purchase of American art for museums.

Hassam was on friendly terms with John Beatty, Carnegie Institute's first director of the Department of Fine Arts, and played an active role in recommending such acquisitions as William Merritt Chase's *Tenth Street Studio* (see p. 136) in addition to promoting his own work. He exhibited ninety paintings at the Carnegie Internationals between 1896 and 1935 and served on the jury of award in 1903, 1904, and 1910. In 1898 Hassam won a second prize for *The Sea* (1892, private collection, Palm Beach, Fla.) and in 1905 a third prize for *June* (1905, American Academy and Institute of Arts and Letters, New York). At the Carnegie International of 1910 he was honored with a solo exhibition.

Not only was Carnegie Institute the first museum to acquire one of Hassam's paintings, it also owns a collection of thirty-one of his drawings and watercolors, the largest such group owned by a museum. In 1909, following the acquisition of *Spring Morning* (see p. 237), Hassam wrote to Beatty, "I feel that I am better and more adequately represented in the Carnegie Institute than in any other permanent collection."[1]

The artist died in East Hampton, New York.

1 Childe Hassam to John Beatty, June 22, 1909, Carnegie Institute Papers, Archives of American Art, Washington, D.C.

Bibliography Adeline Adams, *Childe Hassam* (New York, 1938); Doreen Bolger Burke, "Childe Hassam," in *American Paintings in the Metropolitan Museum of Art* (New York, 1980), vol. 3, pp. 351–65; Guild Hall Museum, East Hampton, N.Y., *Childe Hassam, 1859–1935* (1981), exh. cat. by Stuart P. Feld, Kathleen M. Burnside, et al.; William H. Gerdts, *American Impressionism* (New York, 1984), pp. 91–103; Hirschl and Adler Galleries, New York, *Childe Hassam*, Kathleen M. Burnside, ed. (forthcoming).

Fifth Avenue in Winter, c. 1892
(Fifth Avenue in the Snow; A Winter Morning, Fifth Avenue and Seventeenth Street; Snowy Day on Fifth Avenue)

Oil on canvas
22 x 28 in. (55.9 x 71.1 cm)
Signature: Childe Hassam New York (lower left)

In 1906 the art critic Sadakichi Hartmann referred to Hassam as "our street painter *par excellence.*"[1] Hassam earned this reputation with his diverse views of New York created around the turn of the century. An unabashed chauvinist in promoting America and American painting, Hassam declared that "New York is the most beautiful city in the world. There is no boulevard in Paris that compares to our own Fifth Avenue."[2]

Well before he went to Paris, Hassam painted a group of Boston street scenes, including the well-known *Rainy Day, Boston* (1885, Toledo Museum of Art, Ohio), which reveal his early proclivity for depicting urban subjects through evocative, atmospheric filters of snow, mist, and rain.[3] This Whistlerian interest in gentle evocation resurfaced during the 1890s and early 1900s in Hassam's many winter scenes of New York's Union Square area,[4] including *Fifth Avenue in Winter*.

Hassam's New York studio, in which he resided from 1890 to 1892, was located at 95 Fifth Avenue, close to Union Square. According to the artist, *Fifth Avenue in Winter* was painted from a window of this studio apartment.[5] In his composition, Hassam skillfully conveyed the fashionable New York of the day, with its well-dressed strollers, horse-drawn omnibuses and cabs, and brownstone buildings.

Though generally Impressionist in technique, *Fifth Avenue in Winter* has a subdued and delicately modulated color

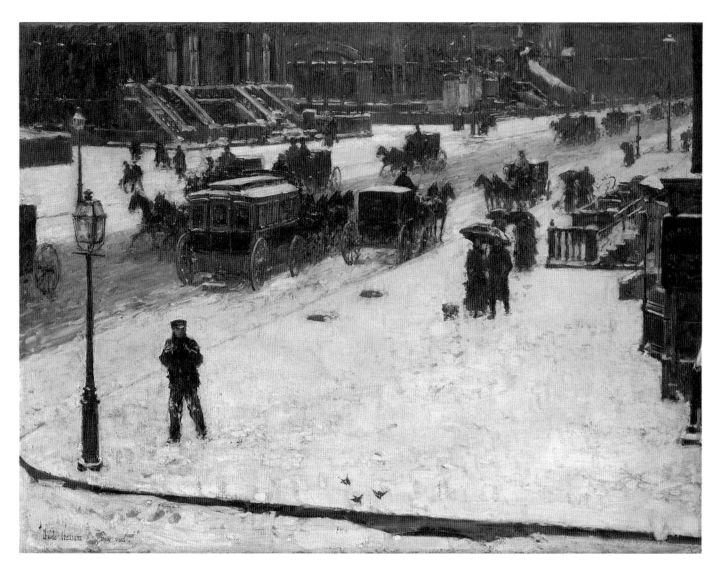

scheme. Occasional touches of red and violet, together with black and gray, enliven an otherwise low-key palette. Unlike the Impressionists, who eschewed the use of black, Hassam defined some of his forms with an underpainting of that color, thus sharpening the sense of design and heightening the contrasts in his pictures.

The composition, in which an empty foreground accentuates a diagonally receding sidewalk and street, has echoes in Hassam's early paintings of Boston. However, the elevated vantage point is a recognizably Impressionist device that recalls Claude Monet's 1873 paintings of the Boulevard des Capucines. Unlike Monet and his colleagues, Hassam tended to focus on more solidly painted, specific

groupings of figures. He once remarked: "I do not always find the streets interesting, so I wait until I see picturesque groups, and those that compose well in relation to the whole."[6]

At about the same time that he created *Fifth Avenue in Winter*, Hassam painted *Street Scene, Christmas Morn* (1892, Smith College Museum of Art, Northampton, Mass.), which shows the same corner at Fifth Avenue and Seventeenth Street but focuses on a strolling woman shopper. Later, long after he had moved from 95 Fifth Avenue, Hassam painted at least three other views of this junction: *Street Scene in Winter* (1901, private collection, New York), *Winter Scene* (1901, private collection, Texas), and *Snow Storm, Fifth Avenue, New York* (1907, private collection, New Jersey). Centering on the image of the man walking near the lamppost, they may be deliberate evocations of

the Carnegie's original, well-known *Fifth Avenue in Winter*.

This painting achieved immediate and lasting popularity. It appeared, together with other works by Hassam, as an illustration for Mariana Griswold Van Rensselaer's article "Fifth Avenue" in *Century Magazine.*[7] In 1900 the artist won a silver medal for the painting when it was exhibited at that year's Paris Exposition Universelle, and it has since become one of the most frequently reproduced and exhibited of the artist's works. Purchased by Carnegie Institute after its inclusion in the Carnegie International of 1899, it was the first of Hassam's paintings to be acquired by a museum.

GS

1 Sadakichi Hartmann, "Studio Talk," *International Studio* 29 (September 1906), p. 267.

2 Childe Hassam, "New York, The Beauty City," *New York Sun*, February 23, 1913, p. 16.

3 Jennifer A. Martin Bienenstock, "Childe Hassam's Early Boston Cityscapes," *Arts* 55 (November 1980), pp. 168–71.

4 Gerdts, *American Impressionism*, p. 98.

5 Interview with Childe Hassam, 1927, De Witt McClellan Lockman Papers, Archives of American Art, Washington, D.C.

6 A. E. Ives, "Talks with Artists: Mr. Childe Hassam on Painting Street Scenes," *Art Amateur* 27 (October 1892), p. 116.

7 *Century Magazine* 25 (November 1893), p. 8.

References A. E. Ives, "Talks with Artists; Mr. Childe Hassam on Painting Street Scenes," *Art Amateur* 27 (Oct. 1892), pp. 116–17; M. G. Van Rensselaer, "Fifth Avenue," *Century Magazine* 46 (Nov. 1893), p. 8, as *A Winter Morning (Fifth Avenue and Seventeenth Street)*; J. W. Pattison, "The Awarding of Honors in Art," *Fine Arts Journal* 23 (Aug. 1910), pp. 79–80; C. L. Buchanan, "The Ambidextrous Childe Hassam," *International Studio* 67 (Jan. 1916), pp. lxxxiii–lxxxvi; E. Clark, "Childe Hassam," *Art in America* 8 (June 1920), pp. 172–80; R. Cortissoz, *American Artists* (New York, 1923), pp. 138–43; A. Adams, *Childe Hassam* (New York, 1938), p. 62; J. O'Connor, Jr., "From Our Permanent Collection: *Fifth Avenue in Winter*," *Carnegie Magazine* 25 (Oct. 1951), pp. 281–82; J. S. Czestochowski, "Childe Hassam: Paintings from 1880 to 1900," *American Art Review* 4 (Jan. 1978), pp. 40–51; R. N. Bukoff, "Childe Hassam: Cityscapes, 1885–1900," Master's thesis, Indiana University, Bloomington, 1979, pp. 42–43; D. F. Hoopes, *Childe Hassam* (New York, 1979), p. 60; G. Stavitsky, "Childe Hassam in the Collection of the Museum of Art, Carnegie Institute," *Carnegie Magazine* 56 (July–Aug. 1982), pp. 28, 31; G. Stavitsky, "Childe Hassam and the Carnegie Institute: A Correspondence," *Archives of American Art Journal* 22, no. 3 (1982), p. 2; H. Adams, in Museum of Art, Carnegie Institute, *Collection Handbook* (Pittsburgh, 1985), pp. 206–7.

Exhibitions Münchner Glaspalast, 1892, *VI. Internationale Kunst-Ausstellung*, no. 719, as *Die 5. Avenue im Schnee;* World's Columbian Exposition, Chicago, 1893, *Official Catalogue*, no. 537, as *Snowy Day on Fifth Avenue;* Union League Club, New York, 1894, *Loan Exhibition of Paintings by American Artists*, no. 44, as *Fifth Avenue in the Snow;* Department of Fine Arts, Carnegie Institute, Pittsburgh, 1899, *Fourth Annual Exhibition*, no. 115; Grand Palais des Beaux-Arts, Paris, 1900, *Fine Arts Exhibit, United States of America, Paris Exposition of 1900*, no. 145, as *Snowy Day on Fifth Avenue;* Pennsylvania Academy of the Fine Arts, 1900, *Sixty-ninth Annual Exhibition*, no. 81; Buffalo Fine Arts Academy, Albright Art Gallery, Buffalo, 1929, *Exhibition of a Retrospective Group of Paintings Representative of the Life Work of Childe Hassam, N.A.*, no. 10; American Federation of Arts and the Hungary Society of America, Nemzeti Salon, Budapest, Hungary, 1930, *Seventeenth Biennial Exhibition of International Art*, no. 36; Venice, 1930, *XVII Biennale Internazionale d'Arte Venezia*, no. 34; Columbus Gallery of Fine Arts, Ohio, 1952, *Paintings from the Pittsburgh Collection*, no cat.; Department of Fine Arts, Carnegie Institute, Pittsburgh, 1957, *American Classics of the Nineteenth Century*, no. 120; Hirschl and Adler Galleries, New York, 1964, *Childe Hassam, 1859–1935*, no. 18; Corcoran Gallery of Art, Washington, D.C., 1965, *Childe Hassam: A Retrospective*, exh. cat. by C. E. Buckley and H. W. Williams, Jr., no. 27; Guild Hall Museum, East Hampton, N.Y., 1967, *Childe Hassam*, no. 12; Indiana University Art Museum, Bloomington, 1970, *The American Scene, 1820–1900*, exh. cat. by L. Hawes, no. 77; Allentown Art Museum, Pa., 1973, *The City in American Painting;* Museum of Art, Carnegie Institute, Pittsburgh, 1982, *Childe Hassam in the Collection of the Museum of Art, Carnegie Institute*, no cat.; Detroit Institute of Arts, 1983, *The Quest for Unity: American Art between World's Fairs, 1876–1893*, no. 144; Westmoreland County Museum of Art, Greensburg, Pa., 1984, *Twenty-fifth Anniversity Exhibition: Selected American Paintings, 1750–1970*, no. 54.

Provenance The artist, until 1900.

Purchase, 1900, 00.2

See Color Plate 17.

Northeast Headlands, Appledore, 1909

Oil on canvas
28⅞ x 37¼ in. (73.3 x 94.6 cm)
Signature, date: Childe Hassam 1909 (lower left)

The robust Hassam once wrote that his "principal pleasure has always been, apart from painting and etching, to swim in the ocean."[1] One of his favorite places for combining the activities he most enjoyed was the resort of Appledore, the largest of the Isles of Shoals off the coast of Maine and New Hampshire. He may have made his first visit there in 1884 or 1885 at the invitation of his pupil Celia Thaxter. Thaxter was a poet, amateur artist, and the proprietor of Appledore House, the island's major hotel and a gathering place for writers and artists, including I. M. Gaugengigl, Hassam's teacher. Following Thaxter's death in 1894, Hassam did not return to the island until 1899. He then summered there often until 1916.[2]

The bold rock formations, flowers, and vast blue ocean of Appledore and the Isles of Shoals inspired over one hundred landscapes by Hassam. Among the artist's favorite sites were the northeast headlands. He made them the subject of works prior to *Northeast Headlands, Appledore*, for example, in the well-known painting *Northeast Headlands, New England Coast* (1901, Corcoran Gallery of Art, Washington, D.C.). In both that composition and this, he employed asymmetric arrangements, using the monumental cliffs as a foil to the water and the high horizon. In the 1901 view, he created an orderly progression into space by including a stony beach littered with driftwood in the foreground and by placing the cliffs in the middle ground. The difference between the earlier and later versions of this subject is essentially the tendency toward abstraction. In *Northeast Headlands, Appledore*, Hassam eliminated the foreground, flattening the space and simplifying the composition to its basic elements of sea, sky, and a single mass of rock. He also employed a more patterned, decorative brushwork, producing a greater emphasis on the paint surface.

Hassam's Isles of Shoals series has been compared to Monet's coastal views of Etretat and Pourville in the 1880s.[3] Like Monet, Hassam delighted in the play of light on the ocean and rugged cliffs, presented in boldly designed, asymmetrical compositions. He was particularly fascinated by the sparkling variety of color produced by the mica and feldspar of the island's rocks. There are, however, significant differences between Hassam's and Monet's works. Although Hassam depicted the natural wonders of Appledore from a variety of vantage points and in both sunlight and moonlight, he was less

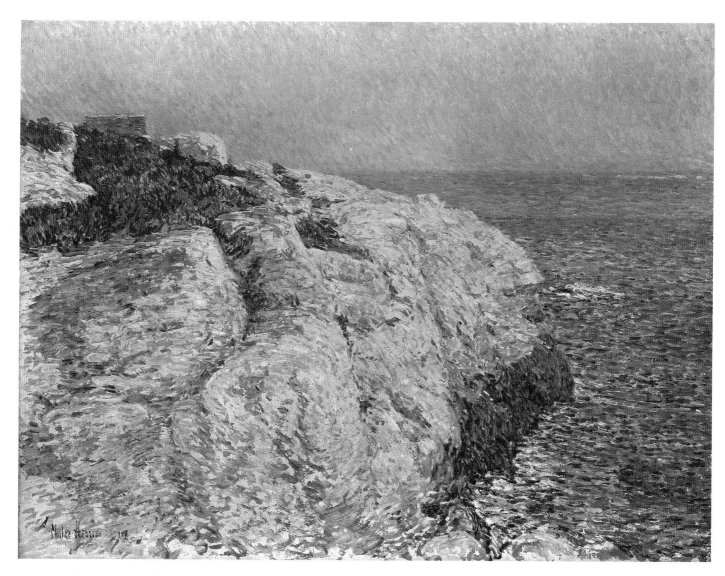

interested than Monet in showing the dematerializing effects of changes in illumination.[4] Demonstrating a characteristically American interest in the material nature of the subject, Hassam made his cliffs appear more substantial and permanent than those of Monet.

Other views of this area include *Northeast Headlands, Appledore* (1909, private collection), which is similar to the Carnegie version although executed from a slightly more distant vantage point, and a large number of drawings of the Isles of Shoals. One of these, *Rocky Headlands, Isles of Shoals* (1903), is owned by The Carnegie Museum of Art.
GS

1 Childe Hassam, unpublished autobiography, manuscript, p. 2, Archives of the American Academy and Institute of Arts and Letters, New York.

2 Deborah Werksman, Hirschl and Adler Galleries, New York, to Gail Stavitsky, June 17, 1983, museum files, The Carnegie Museum of Art, Pittsburgh.

3 Burke, "Childe Hassam," p. 358.

4 Adams, *Childe Hassam*, pp. 53, 57.

References F. A. Myers, "The Leader of Impressionism in America," *Carnegie Magazine* 44 (June 1970), pp. 242–43; D. Miller, "The Phenomenal Growth of the Carnegie Collection," *Art News* 72 (Nov. 1973), p. 42; G. Stavitsky, "Childe Hassam in the Collection of the Museum of Art, Carnegie Institute," *Carnegie Magazine* 56 (July–Aug. 1982), p. 33.

Exhibitions Santa Barbara Museum of Art and California Palace of the Legion of Honor, San Francisco, 1961, *Painters by the Sea*, no cat.; Cincinnati Art Museum, 1964, *American Painting on the Market Today, Part III*, no. 14, as *North East Headlands, Appledore*; Hirschl and Adler Galleries, New York, 1964, *Childe Hassam, 1859–1935*, no. 29; Guild Hall Museum, East Hampton, N.Y., 1967, *Childe Hassam*, no. 29; Museum of Art, Carnegie Institute, Pittsburgh, 1982, *Childe Hassam in the Collection of the Museum of Art, Carnegie Institute*, no cat.; Denver Art Museum, 1990–91, *Childe Hassam: An Island Garden Revisited* (trav. exh.), exh. cat. by David Park Curry, unnumbered.

Provenance The artist, until 1935; American Academy of Arts and Letters, New York, 1935; Milch Galleries, New York, 1950; John Fox, Boston, Mass.; Milch Galleries and Hirschl and Adler Galleries, New York, 1960; Mr. and Mrs. T. Williams Middendorf II, Greenwich, Conn., 1965; Hirschl and Adler Galleries, New York, 1966; Bernard Danenberg Galleries, New York, 1969.

Museum Purchase: Gift of the Sarah Mellon Scaife Family, 1970, 70.4

Spring Morning, 1909
(Early Spring; A Woman Standing at a Window)

Oil on canvas
42 x 40¼ in. (106.7 x 102.2 cm)
Signatures, dates: Childe Hassam/1909. (center left); CH 1909 (on reverse, upper left)

Decorative images of introspective young women in beautiful interiors were among the most popular creations of such American Impressionists as Thomas Wilmer Dewing, Frederick Frieseke, Richard Miller, and the Boston school painters Frank Benson, Edmund Tarbell, and Joseph De Camp. Hassam's significant contribution to this genre was his Window series, a group of approximately twenty paintings executed between 1907 and 1919. *Spring Morning* is part of this series, which was considered at the time to consist of some of Hassam's most memorable works.[1]

The paintings in the Window series are single-figure compositions in which attractive, elegant women, clad in kimonos or loose gowns, sit or stand near luminous windows. Lost in thought, each is accompanied by decorative props such as fruit, flowers, porcelain, sculpture, or Japanese screens. In 1927 Hassam stated his interest in "using...figures with...flowers in an arrangement to make a beautiful combination of color and line."[2] This statement links the series to the Aesthetic movement and in particular to the formal, decorative tradition in figurative art pioneered by James McNeill Whistler and Albert Moore in the 1860s. In *Spring Morning* the strategic arrangement of the figure in relation to the window, screen, and table imparts a Far Eastern flavor, while Hassam's sensitivity to the reflective properties of light on polished or transparent surfaces is an element of his Impressionist approach.

His concerns, however, were not always exclusively formal, for a mood of intimate reverie pervades the Window series. *Young Girl Reading, Spring* (1909, private collection, New York) employs the popular late-nineteenth-century motif of women holding unread books and staring into space. *The East Window* (1913, Hirshhorn Museum and Sculpture Garden, Washington, D.C.), the painting in the Window series that bears the closest resemblance to *Spring Morning*, relies on a window, a screen, and a woman with her hand resting lightly on a round table

to create its contemplative ambience. *Tanagra* (1918, National Museum of American Art, Washington, D.C.) presents much the same arrangement of objects, but it embodies a specific symbolic meaning: its Chinese lilies and view of New York buildings were "intended to...symbolize...the growth of a great city."[3]

Although *Spring Morning* contains no symbolic images similar to those in *Tanagra*, the idea of growth is implicit in this painting's title, as is suggested by a contemporary writer who described the work as "a picture that is tantalising in its hint of the rebirth of animate things.... The young woman [is] a spring dreamer where all is possibility."[4]

Spring Morning, which Hassam regarded as one of his most important works created after 1900, was painted in his studio at 132 West Sixty-seventh Street in New York.[5] The model may be Kitty Hughes, who posed for many of Hassam's paintings from about 1909 to 1920.[6]
GS

1 Gerdts, *American Impressionism*, p. 190.

2 Interview with Childe Hassam, 1927, De Witt McClellan Lockman Papers, Archives of American Art, Washington, D.C.

3 Childe Hassam to John Beatty, March 8, 1920, Carnegie Institute Papers, Archives of American Art, Washington, D.C.

4 Lorinda Munson Bryant, *American Pictures and Their Painters* (New York, 1920), p. 174.

5 Interview with Hassam, 1927, DeWitt McClellan Lockman Papers, Archives of American Art, Washington, D.C.

6 Barbara Anderson to National Collection of Fine Arts, Washington, D.C., October 1971, courtesy of Kathleen Burnside, Hirschl and Adler Galleries, New York.

References I. L. White, "Childe Hassam—A Puritan," *International Studio* 45 (Dec. 1911), p. xxx; L. M. Bryant, *What Pictures to See in America* (1915), pp. 199–200; L. M. Bryant, *American Pictures and Their Painters* (New

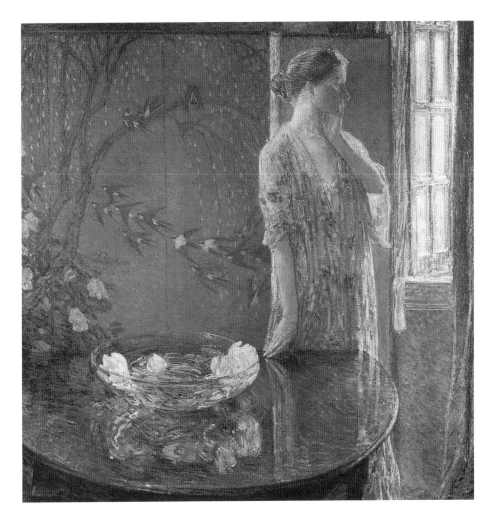

York, 1920), p. 174; interview with Hassam, 1927, DeWitt McClellan Lockman Papers, Archives of American Art, Washington, D.C., as *Early Spring, A Woman Standing at a Window;* G. Stavitsky, "Childe Hassam in the Collection of the Museum of Art, Carnegie Institute," *Carnegie Magazine* 56 (July–Aug. 1982), pp. 33–34.

Exhibitions Department of Fine Arts, Carnegie Institute, Pittsburgh, 1909, *Thirteenth Annual Exhibition,* no. 138; Fine Arts Gallery of San Diego, 1926, *Inaugural Exhibition,* no. 28; Buffalo Fine Arts Academy, Albright Art Gallery, Buffalo, 1929, *Exhibition of a Retrospective Group of Paintings Representative of the Life Work of Childe Hassam, N.A.,* no. 11; Museum of Art, Carnegie Institute, Pittsburgh, 1982, *Childe Hassam in the Collection of the Museum of Art, Carnegie Institute,* no cat.

Provenance The artist, until 1909.

Purchase, 1909, 09.5

Charles W. Hawthorne
1872–1930

BORN IN ILLINOIS and raised in Maine, Charles Webster Hawthorne became a portraitist, figure painter, and art teacher in Provincetown, Massachusetts; some considered him to be the heir to the Realist tradition of Thomas Eakins. Beginning in 1890 he studied at the Art Students League, New York, with Frank Vincent du Mond, and in 1894–95 with George de Forest Brush and Henry Siddons Mowbray. During the summer of 1896 he studied with William Merritt Chase at the Shinnecock Summer School of Art on Long Island, and he continued as Chase's assistant through the summer of 1897. Visiting Holland the following year, Hawthorne was strongly influenced by the late work of Frans Hals. He did not, however, adopt the loose brushwork of Hals and Chase, evolving instead a style based on large, simple masses of slightly modulated color.

In 1899 Hawthorne founded the Cape Cod School of Art at Provincetown. He also taught in New York at the Art Students League and the National Academy of Design and at the Art Institute of Chicago. By all accounts, he

was a gifted and inspiring instructor. Leila Mechlin, in a tribute to Hawthorne published shortly after his death, wrote, "There are those who believe, and with reason, that Hawthorne's largest contribution to art in America was through the medium of his teaching."[1]

Hawthorne was, in addition, one of the most highly respected figure painters of his day, noted for his sensitive portrayals of the humble fisherfolk of Cape Cod. *Three Women of Provincetown* (c. 1921, Mead Art Museum, Amherst, Mass.) is generally considered his masterpiece. It is based on Hals's *Regentesses of the Old Men's Home* (c. 1664, Frans Halsmuseum, Haarlem) and, in turn, inspired Grant Wood's satirical *Daughters of Revolution* (1932, Cincinnati Art Museum). A frequent prize winner in the United States, he also received high praise at the 1911 Paris Salon and was elected to membership in the Société Nationale des Beaux-Arts.

Hawthorne enjoyed a long and cordial relationship with Carnegie Institute. He first exhibited at a Carnegie International in 1904, won an honorable mention in 1908, and in 1925 took third prize for *The Captain, the Cook, and the First Mate* (c. 1925, Cedar Rapids Museum Of Arts, Iowa); he participated in a total of eighteen Carnegie Internationals between 1904 and 1930. In 1916 and 1928 Carnegie Institute held solo exhibitions of his work. He served on the jury of award in 1913, 1920, 1921, and 1926 and on the Advisory Committee in 1926.

During the last three years of his life, debilitated by Bright's disease, Hawthorne abandoned oil painting for the less strenuous medium of watercolor. He achieved excellent results, and he continued to work in it until his death in Baltimore.

1 Leila Mechlin, "Charles W. Hawthorne, 1872–1930," *American Magazine of Art* 23 (August 1931), p. 91.

Bibliography Leila Mechlin, "Charles W. Hawthorne, 1872–1930," *American Magazine of Art* 23 (August 1931), pp. 91–106; Elizabeth McCausland, *Charles W. Hawthorne: An American Figure Painter* (New York, 1947); Chrysler Art Museum of Provincetown, Mass., *Hawthorne Retrospective* (1961); Marion Hawthorne, *Hawthorne on Painting* (New York, 1965); University of Connecticut Museum of Art, Storrs, *The Paintings of Charles Hawthorne* (1968), exh. cat., essay by Marvin S. Sadik.

A Portuguese Gentleman,
c. 1927
(Portrait of a Portuguese; The Portuguese)

Oil on canvas
60 x 48 in. (152.4 x 121.9 cm)
Signature: Charles Hawthorne (upper right)

With its large, simplified masses, this work, which Hawthorne considered "an important painting,"[1] perfectly illustrates his teachings. He urged his students to reduce visual problems to strong, simple contrasts and to think always in terms of color and flat forms—what he called silhouettes—on the two-dimensional surface of the canvas.

> Seeing things as silhouettes *is* drawing—the outline of your subject against the background, the outline and size of each spot of color against every other spot of color it touches, is the only kind of drawing you need bother about. . . . Let color make form—do not make form and color it.[2]

The sitter for this portrait was John Caton, the Portuguese gardener who kept the grounds of Hawthorne's Provincetown home, transforming what had been little more than a sand hill into "a series of terraced beds intertwined with paths, the background of the interlaced trees and bushes giving the whole a natural quality."[3] Although Caton's soiled, ill-fitting work clothes are hardly the usual trappings of a gentleman, the image thoroughly justifies the title: Hawthorne has portrayed Caton with a monumental dignity befitting a fellow artist.
KN

1 Charles W. Hawthorne to Homer Saint-Gaudens, February 18, 1928, Carnegie Institute Papers, Archives of American Art, Washington, D.C.

2 Hawthorne, *Hawthorne on Painting,* pp. 25–26.

3 Joseph Hawthorne in Chrysler Art Museum, *Hawthorne Retrospective,* p. 7.

References *New York Evening Post,* Mar. 5, 1927, quoted in E. McCausland, *Charles W. Hawthorne: An American Figure Painter* (New York, 1947), p.74; "The Hawthorne Exhibition," *Carnegie Magazine* 1 (Mar. 1928), p. 6, as *Portrait of a Portuguese;* L. Mechlin, "Charles W. Hawthorne," *American Magazine*

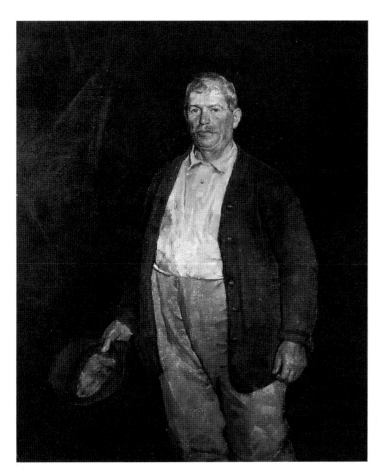

of Art 23 (Aug. 1931), p. 104, as *Portuguese Gentleman;* McCausland, *Charles W. Hawthorne,* pp. 31, 54.

Exhibitions Department of Fine Arts, Carnegie Institute, Pittsburgh, 1927, *Twenty-sixth Annual International Exhibition of Paintings,* no. 62; Grand Central Art Galleries, New York, 1927, *Exhibition of Recent Paintings by Charles W. Hawthorne, N.A.,* no. 7; Department of Fine Arts, Carnegie Institute, Pittsburgh, 1928, *An Exhibition of Paintings: Charles W. Hawthorne,* no. 18, as *The Portuguese;* National Academy of Design, New York, 1939, *Special Exhibition,* no. 94; Department of Fine Arts, Carnegie Institute, Pittsburgh, 1940, *The Patrons Art Fund Paintings,* no. 20; Provincetown Art Association, Mass., 1947, *Charles W. Hawthorne* (?), no cat.; Dallas Museum of Fine Arts, 1948, *Charles W. Hawthorne: Paintings,* no. 35; Chrysler Art Museum of Provincetown, Mass., 1961, *Hawthorne Retrospective,* no. 35; American Federation of Arts, New York, 1962, *Provincetown—A Painter's Place* (trav. exh.), unnumbered.

Provenance The artist, until 1928.

Patrons Art Fund, 1928, 28.5

Martin Johnson Heade

1819–1904

A N ARTIST OF MODEST reputation who kept somewhat to the periphery of the art world in his time, Martin Johnson Heade is today considered one of the major painters of the second-generation Hudson River school. The oldest son in a large, relatively prosperous farming family (which spelled its name Heed), Heade was born and raised in the small rural community of Lumberville, in Bucks County, Pennsylvania. When he expressed an interest in learning art, he was sent to Edward Hicks, the most important local painter.

At some point between 1838 and 1840, the young painter took a two-year trip abroad, visiting England, France, and Italy. In 1848 he returned to Rome, and perhaps went to Paris. Back in the United States again, Heade traveled widely, as he would do for the rest of his life; by 1859 he had worked in New York, Brooklyn, Philadelphia, Saint Louis, Chicago, Trenton, and Providence.

Heade initially intended to take up portraiture, but he also painted occasional landscapes, which became increasingly dominant in his work. The turning point in his career came when he moved to New York in 1859 and rented quarters in the Tenth Street Studio Building, which had become the major enclave of the Hudson River school. There he met ambitious and innovative landscape painters who inspired in him a lasting interest in landscape painting. Chief among these new colleagues was Frederic E. Church, who had brought American landscape painting to a new level of innovation with his spectacular panorama *Niagara* (1857, Corcoran Gallery of Art, Washington, D.C.). Church became Heade's friend and deeply influenced his art. Heade soon began to produce landscapes depicting uninterrupted vistas and incorporating subtly dramatic effects of light and atmosphere, while retaining careful observation and fidelity to detail.

From 1861 to 1863 Heade worked in Boston, where he painted floral still lifes and began to specialize in sea and shore views. From 1863 to 1864 he accompanied the Reverend J. C. Fletcher to Brazil, where he exhibited at Rio de Janeiro, received the Order of the Rose from the Emperor of Brazil, and became fascinated by the hummingbird. He originally hoped to publish a book illustrating the various species of South American hummingbirds. The publication failed to materialize but Heade maintained his interest in hummingbirds as a pictorial subject.

Following a trip to London in 1865, where he exhibited at the Royal Academy of Arts, Heade returned to New York. In 1866 he set out again for South America and made a third trip there in 1870. He later extended his travels to the west coast of North America, visiting British Columbia in 1872 and California in 1875.

Heade produced the major body of his work between the early 1860s and the early 1880s. These include still lifes, scenes of the tropics, and numerous variants of the low, anonymous coasts and marshlands of New England and New Jersey, caught in storms, showers, or cloud-filled sunsets. Usually modest in size, his landscapes combine a sense of

palpable atmosphere with the harder-edged detail and geometric simplicity of earth-bound objects. At times disquieting in their beauty, such landscapes constitute that portion of Heade's art for which he is best remembered today.

Heade never sought membership in the National Academy of Design and spent the last twenty years of his career completely removed from the New York art community. In 1883 he married for the first time, then settled in Saint Augustine, Florida, where he spent the remainder of his life. Benefiting from the patronage of Henry M. Flagler, a pioneer resort developer, he continued to paint landscapes and flower pieces, but in the art centers of the Northeast he was soon virtually forgotten. Heade began to resurface as a respected painter during the revival of interest in the Hudson River school that took place during the 1940s.

Bibliography Robert J. McIntyre, *Martin Johnson Heade* (New York, 1948); Barbara Novak, "Martin Johnson Heade: Haystacks and Light," in *American Painting of the Nineteenth Century: Realism, Idealism and the American Experience* (New York, 1969), pp. 25–137; Theodore E. Stebbins, Jr., *The Life and Works of Martin Johnson Heade* (1975; rev. ed., New Haven, forthcoming).

Thunderstorm at the Shore, c. 1870–71
(Thunderstorm, Narragansett Bay)

Oil on paper mounted on canvas attached to panel
9⅝ x 18½ in. (24.4 x 47 cm)
Signature, date: M. J. Heade 7 [last digit abraded] (lower right)

Of all the natural phenomena Heade depicted, the approaching storm was the subject of his most strikingly innovative and important works. Four of his paintings have as their setting the Rhode Island coast in summer and show the onset of a thunderstorm that suddenly turns the sky and water black: *The Coming Storm* (1859, Metropolitan Museum of Art, New York), *Approaching Storm: Beach near Newport* (c. 1867, Museum of Fine Arts, Boston), *Thunderstorm over Narragansett Bay* (1868, Amon Carter Museum, Fort Worth, Tex.)—which is considered to be his masterpiece—and the Carnegie Museum of Art's *Thunderstorm at the Shore.* As a group, they constitute a richly inventive subcategory in Heade's work.

All four scenes are built upon a sandy, virtually empty shoreline overlooking a low, uninterrupted horizon. All possess an air of intense quiet but not, as one might expect, a mood of tranquillity. Instead, preternaturally black storm clouds convey the tense, ominous stillness of impending violence. Among the painters of his time who produced scenes of impending storms, Heade's works are unique in their quiet tension and peculiarly surreal effect.

Thunderstorm at the Shore depicts a deep stretch of sandy beach overlooking the choppy open sea. A severe storm has broken in the distance and is moving from right to left through the pictorial field. As it does so, minuscule figures at the water's edge push ashore what appear to be rowboats and fishing nets. Heade has removed the viewer from the rough sea and human struggle, the better to apprehend the larger, less obvious action, such as the rain's imperceptible onset, the entire sea gone suddenly black, and the shore turning a brilliant white. At the same time he makes the point of showing man as vulnerable to nature's unexpected changes and diminished in his ability to react against its force.

The smallness and immobility of the human figures are much more pronounced here than in Heade's other

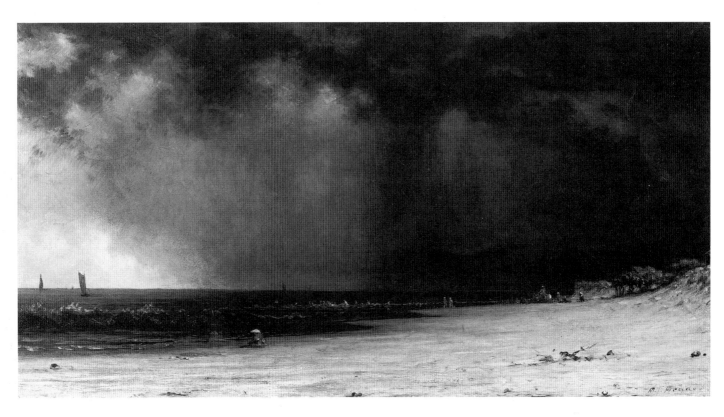

paintings of the same theme. Their seeming indifference to the tempest that is about to engulf them serves to heighten the scene's tension; their size assists the illusion of immense space and suggests the frailty of man in the face of nature. Initially the painting showed one more foreground figure and one more sailboat, both left of center, but Heade painted them out. He apparently wanted to ensure the dominance of nature's sublime presence.

Thunderstorm at the Shore is an oil sketch on paper, a medium Heade rarely used. It has the same high finish and precision of Heade's larger compositions, except in one respect: the date in the lower right-hand corner of the canvas is smudged. It was once assumed to date 1867, as if it were a preparatory sketch for the Amon Carter Museum's landscape. Yet the work's more naturalisic atmosphere suggests its date is at least 1870, possibly 1871[1]—thus making it the last of Heade's "black sky" views of the Rhode Island shore.

DS

1 Stebbins, *Life and Works of Martin Johnson Heade*, p. 238.

References O. H. Riley and G. A. Berger, "New Solutions for Modern Problems," *Museum News* 51 (Jan. 1973), p. 35; H. B. Teilman, "Additions to the Eavenson Collection," *Carnegie Magazine* 47 (Mar. 1973), p. 96; T. E. Stebbins, Jr., *Life and Works of Martin Johnson Heade*, pp. 79, 238; D. G. Wilkins, "The American Painting Collection at the Sarah Scaife Gallery, Carnegie Institute, Pittsburgh," *American Art Review* 2 (Mar.–Apr. 1975), p. 100; H. Adams, in Museum of Art, Carnegie Institute, *Collection Handbook* (Pittsburgh, 1985), p. 178; D. Strazdes, "Martin Johnson Heade," in Metropolitan Museum of Art, New York, *American Paradise: The World of the Hudson River School* (1987), exh. cat., p. 172.

Exhibitions Hirschl and Adler Galleries, New York, 1972, *Faces and Places: Changing Images of Nineteenth-Century America*, no. 37; National Gallery of Art, Washington. D.C., 1980, *American Light: The Luminist Movement, 1850–1875*, exh. cat. by J. Wilmerding et al., unnumbered; Museum of Art, Rhode Island School of Design, Providence, 1986, *The Eden of America, Rhode Island Landscapes, 1820–1920*, exh. cat. by R. G. Workman, no. 16.

Provenance General William Josiah Snow, Blue Ridge Summit, Pa.; his descendants; estate of his descendants; unknown dealer,

Ellicott City, Md., until 1967; John M. Swanner, Washington, D.C., 1967–71; Hirschl and Adler Galleries, New York, 1972.

Howard N. Eavenson Memorial Fund, for the Howard N. Eavenson Americana Collection, 1972, 72.54

See Color Plate 8.

George P. A. Healy
1813–1894

GEORGE PETER ALEXANDER HEALY possessed relatively modest artistic talents and did not benefit from extensive formal training, yet he became one of America's most successful mid-nineteenth-century portrait painters. He was also the first American portrait painter to spend the major part of his career working in continental Europe. The son of an Irish ship's captain, Healy was born and raised in Boston. There he taught himself to draw, and with the encouragement of portrait painters Jane Stuart and Thomas Sully, he opened a portrait studio in Boston in 1830.

When his earliest and most prominent patron, Mrs. Harrison Gray Otis, decided to sponsor his study abroad, Healy left for Paris in 1834, at a time when few other Americans sought training in that city. He studied for some months with Jacques-Louis David's pupil Baron Antoine-Jean Gros, whose technique became the basis for the Romantic-Realist portrait style that Healy practiced for the rest of his life. It combined fidelity to detail with deep chiaroscuro and assertive gestures, creating an effect of dignity and sobriety.

Healy's style found a ready demand, and from the 1840s onward, he enjoyed substantial success in Europe and America. The international luminaries from whom he received portrait commissions included King Louis Philippe of France, the English royal family, Otto von Bismarck, Franz Liszt, Henry Wadsworth Longfellow, the American presidents John Tyler, James Buchanan, Abraham Lincoln, and Ulysses S. Grant, and senators Daniel Webster and John Calhoun. He also painted a small number of historical works. The best known are *Webster Replying to Hayne*, purchased in 1851 for Boston's Faneuil Hall, where it remains today, and *Benjamin Franklin*

at the Court of Louis XVI (location unknown), which earned him a gold medal at the 1855 Paris Exposition Universelle.

Between 1854 and 1866, Healy made his home in Chicago. In 1867, he went back to Europe, for reasons of health, residing first in Rome and after 1873 in Paris. He returned in 1892 to Chicago, where he died.

Healy's painting style changed little over the course of his career, and thus became increasingly less fashionable. However, this did not seem to affect his ability to attract sitters of prominence, nor did it lessen his stature in the art world. He encouraged and supported young artists such as John Singer Sargent; he counted among his friends Thomas Couture—his former colleague at Gros's studio; and he was well regarded for his past successes to the end of his life.

Bibliography George Peter Alexander Healy, *Reminiscences of a Portrait Painter* (1894; reprint, New York, 1970); Mme. Charles [Mary] Bigot, *Life of George P. A. Healy, by His Daughter, Mary* (Chicago, 1913); Virginia Museum of Fine Arts, Richmond, *Healy's Sitters* (1950), exh. cat. by Leslie Cheek, Jr.; Marie de Mare, *G. P. A. Healy, American Artist* (New York, 1954).

Portrait of the Artist, c. 1867–69

Oil on canvas
24 x 20 in. (61 x 50.8 cm)

Healy painted a number of self-portraits that seem to have corresponded to turning points in his life. They include one marking his debut in Paris and a rather masterful one of 1851 (Metropolitan Museum of Art, New York) that coincided with his most ambitious efforts in history painting. After arriving in Rome he was asked to contribute a self-portrait to the Uffizi Gallery in Florence—the first American artist so invited. The portrait shown here, when given to Carnegie Institute in 1899, was said to be approximately thirty years old, which would place it at the time Healy returned to Europe. It, too, may have had some commemorative purpose, perhaps to cap a successful decade in America, during which he became the painter of presidents.

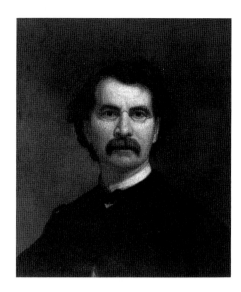

However, this self-image is relatively disappointing. It is constricted in size and lacks color accents, props, and movement, which had given his earlier portraits elegance and flourish. The sudden absence of these properties has often been observed in Healy's portraits of the 1860s. During that decade, his work became noticeably stiffer, drier, and heavier, as he abandoned the previous inventory of devices that ensured pictorial harmony. The change has been credited to the influence of photography. Depending on one's point of view, Healy's "photographic" approach was either beneficial to his art (as a sign of frankness and honesty) or detrimental to it (producing less pleasing images that lack finesse and cohesion).

The vicissitudes of this painting since its acquisition can be seen as a barometer of the demise of Healy's reputation in the twentieth-century. Around 1909 it was reproduced in a photo set of Carnegie Institute's best paintings for distribution to schools. On February 17, 1912, the *Pittsburgh Post* advertised it as one of the "notable paintings" in Carnegie Institute's art galleries. But during the 1930s, the picture was moved from the painting galleries to Carnegie Institute's lunchroom, and after 1948 it was consigned to storage. DS

Reference J. O'Connor, Jr., "G. P. A. Healy, American Artist," *Carnegie Magazine* 28 (June 1954), pp. 206–8.

Provenance C. C. Ruthrauff, New York, by 1899.

Gift of Mr. C. C. Ruthrauff, 1899, 99.13

Robert Henri
1865–1929

ROBERT HENRI WAS the flamboyant, aggressive spokesman for early-twentieth-century artists who wished to replace turn-of-the-century American academic refinement with an insistent, gritty art that would reflect the tenor of modern urban life. As the undisputed leader of the Eight and the Ashcan School, he took a combative stance against traditionalism in painting, helping to set the stage for subsequent modernist movements in American art.

The experiences of Henri's youth no doubt shaped his romanticized perception of himself as a champion of individuality. Born Robert Henry Cozad, he was raised in Cincinnati but spent his summers in the frontier community of Cozad, Nebraska, which had been founded by his father, a professional gambler and speculator. In 1879 he moved with his family to Denver; there, two years later, his father was indicted for manslaughter. The family fled to Atlantic City and assumed new names. Robert, having adopted the surname Henri, enrolled in 1884 at the Pennsylvania Academy of the Fine Arts in Philadelphia, where Thomas Eakins's realism was still heavy in the air, maintained in the teaching of Eakins's pupil Thomas Anshutz.

In 1888 Henri departed for Paris and enrolled in the Académie Julian under William-Adolphe Bouguereau and Tony Robert-Fleury. He spent the summer of 1889 with the plein-air painters at Concarneau in Brittany; in 1890 he went to Barbizon, then to southern France and Italy; the following year he was admitted to the Ecole des Beaux-Arts, studied further at the Académie Julian, and traveled to Venice with Edward Redfield. Like many American artists, Henri was more affected by French Impressionism than by more recent French avant-garde efforts; he also continued to be affected by French academicism but grew impatient with its restraints.

Back in Philadelphia in early 1892, Henri studied portraiture again under Anshutz and Robert Vonnoh. He began teaching at the School of Design for Women, where he met John Sloan. Within a year a tight-knit group—the newspaper illustrators Sloan, William

Glackens, George Luks, and Everett Shinn—began to form around Henri. They eventually became the nucleus of the Eight and the new realist movement.

From 1894 to 1897 Henri made annual trips to Europe. His major discoveries were the paintings of Frans Hals, Diego Velázquez, and Edouard Manet, which turned him toward a broad, forthright technique and encouraged him to think of painting as a vital, democratic art form. In 1897 he had his first solo show at the Pennsylvania Academy of the Fine Arts, followed by a second at William Merritt Chase's New York School of Art. Still ambitious for recognition in France, Henri returned to Paris in the summer of 1898, where he taught a class and exhibited at the 1898 Salon; his entry was purchased for the Musée Nationale du Luxembourg. Beginning in 1899 until shortly before his death, Henri was a frequent exhibitor at Carnegie Institute's annual exhibitions and served on the jury of award four times. Just before he settled permanently in New York in 1900, he visited Madrid, where he copied some of Velázquez's paintings at the Prado.

During the next several years Henri taught, mainly at the New York School of Art, and he embarked on an ambitious round of organizing exhibitions, which included the new realist cityscapes he and his friends Glackens, Luks, and Shinn were then painting. In 1906 he was elected to the National Academy of Design, then spent the summer with a class of students in Spain. The following year, when the National Academy refused to accept the work of his friends for its spring exhibition, he withdrew his own paintings and began planning an independent exhibition with Sloan, Glackens, Luks, Shinn, Maurice Prendergast, Arthur B. Davies, and Ernest Lawson. They were dubbed the Eight after the group's traveling exhibition opened at New York's Macbeth Galleries in February 1908.

Over the next several years, Henri put much of his energy into operating his own art school, which opened in New York in 1909, and into exhibition planning. His largest effort, organized in 1910, was the *Exhibition of Independent Artists*, a colossal show of 260 paintings, 219 drawings, and several sculptures—the first open, nonjuried, no-prize show of its kind in America. From 1911 to 1919 the group shows he organized were held at

New York's Macdowell Club. In addition, he assisted the Association of American Painters and Sculptors with the organization of the 1913 exhibition that was to be called the Armory Show, but his role dwindled when he disagreed with the European modernist direction Davies and Walter Pach wanted for it.

That divergence points out an important characteristic of Henri's artistic philosophy: for all its boldness, vulgarity, and lack of pretense it was not modernist. Henri's work—which took city streets, slums, the mundane aspects of urban life as its subjects—was still picturesque, narrative, sentimental, and more closely linked with past art than with the modernist revolution. Henri believed that art should be democratic. The diversity of big-city life in his early paintings reflected this belief. After 1913 he sought the common man in different races, painting portraits of the Irish farmers, Spanish peasants and gypsies, Native Americans of the Southwest, and children of all cultures that he encountered during his frequent travels.

In 1915 Henri resumed his distinguished and successful teaching career at the Art Students League in New York and remained a force there until a year before his death. His art philosophy was edited and published by his student Margery Ryerson as *The Art Spirit* (Philadelphia, 1923). Henri died in New York; a memorial exhibition of his work was held there at the Metropolitan Museum of Art in 1931.

Bibliography William Yarrow and Louis Bouché, eds., *Robert Henri: His Life and Works* (New York, 1921); Robert Henri, *The Art Spirit* (Philadelphia, 1923, 1960); William Innes Homer, *Robert Henri, and His Circle* (Ithaca, 1969); Chapellier Galleries, New York, *Robert Henri, 1865–1929* (1976), exh. cat., essay by Donelson F. Hoopes; Delaware Art Museum, Wilmington, *Robert Henri, Painter* (1984), exh. cat.

The Equestrian, c. 1909

Oil on canvas
77 x 37⅛ in. (195.6 x 94.3 cm)
Signature: Robert Henri (lower right)

Carnegie Institute became the first American museum to purchase a painting by Henri, *Girl in White Waist* from the 1904 Carnegie International. The painting was destroyed in a train fire during shipment to an exhibition in Chicago,

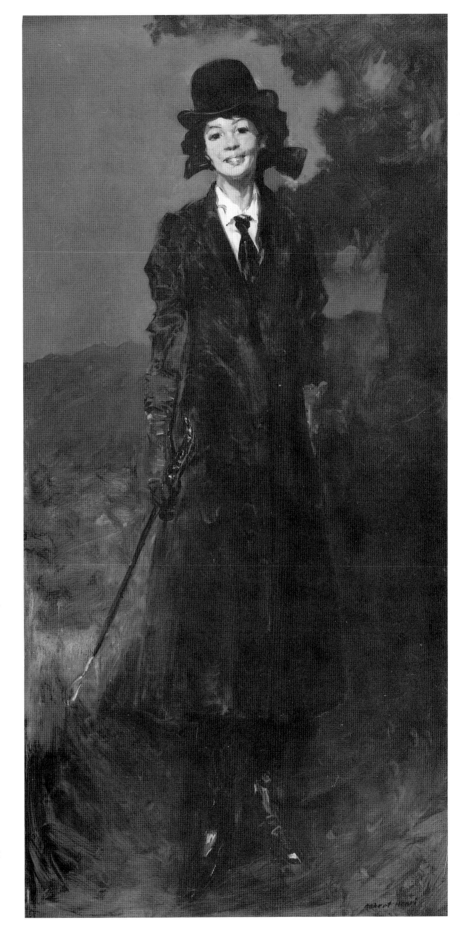

and *The Equestrian* was acquired from the Carnegie International of 1910 as a replacement.

The painting is one of the few Henri produced immediately following the exhibition of the Eight, when he was almost totally absorbed with his teaching activities and the organization of future independent exhibitions. The format of a full-length figure standing in a painterly landscape setting was one that John Singer Sargent often employed and that ultimately derived from late-eighteenth-century portraits by such English masters as Joshua Reynolds and Thomas Gainsborough.

Henri updated this tradition with an infusion of modern life and modern vitality in the vein of Diego Velázquez and Edouard Manet. His unlikely model was Miss Waki Kaji, who also posed for his *Blue Kimono* (1909, New Orleans Museum of Art). The hastily washed-in background that surrounds her and the slapdash construction of her elegant riding coat suggest the vigor and verve of the active life. These stylistic elements also act to democratize what would normally be an exclusively aristocratic image. Putting an Asian sitter into elegant British riding clothes is a deliberate jolt to one's expectations. So, too, are the almost masculine assertiveness of the subject's pose and Henri's color scheme of sober neutral tones.

Henri's technique here derives from such masters of the loaded brush as Frans Hals and Velázquez. It was employed by the previous generation of American artists, for example, William Merritt Chase and Frank Duveneck, and so might be viewed as conservative. However, Henri did not appropriate the technique for its own sake, as these older painters did, but claimed to use only the means that would best communicate the feelings of his subjects. Formal elements, he told his students, were beautiful only when they were significant.

> I am not interested in your skill. . . . I only want to see the things that bring to my mind the fact of life. . . so that I not only see the thing you have seen, but I see the deduction, or rather projection you make from that thing, the excitement, the pleasure that you have felt in the thing.[1]

Henri's romanticism often took the form of full-length studio portraits of the exotic persons he encountered in his normal professional and social activities. These costume pieces include his portrait of the dancer Ruth St. Denis (1919, Pennsylvania Academy of the Fine Arts, Philadelphia), his *Salome* (1909, John and Mable Ringling Museum of Art, Sarasota, Fla.), as well as *The Blue Kimono* and *The Equestrian*. Henri's purpose in painting these subjects was to set down what he believed was the most vital element in American life and culture: "I am looking at each individual," he said, "with the eager hope of finding something of the dignity of life, the humor, the humanity, the kindness. Something of the order that will rescue the race and the nation."[2]

KP, DS

1 Homer, *Robert Henri and His Circle*, p. 162.
2 Rose Henderson, "Robert Henri," *American Magazine of Art* 21 (January 1930), p. 10.

References Robert Henri, Journal F, manuscript, 40, Janet Le Claire Papers, New York; Henderson, "Robert Henri," p. 6; H. Kramer, review of Gallery of Modern Art exhibition, *New York Times*, Oct. 26, 1969, p. 27.

Exhibitions Department of Fine Arts, Carnegie Institute, Pittsburgh, 1910, *Fourteenth Annual International Exhibition of Paintings*, no. 153; Art Gallery of Toronto, 1927, *A Loan Exhibition of Portraits*, no. 40; Venice, 1932, *Eighteenth Biennial Exhibition of International Art*, no. 30; Columbus Gallery of Fine Arts, Ohio, 1952, *Paintings from the Pittsburgh Collection,* unnumbered; Sheldon Memorial Art Gallery, University of Nebraska, Lincoln, 1965, *Robert Henri*, no. 29; Gallery of Modern Art, New York, 1969, *Robert Henri Retrospective,* unnumbered; Akron Art Institute, Ohio, 1971, *Celebrate Ohio,* unnumbered; Delaware Art Museum, Wilmington, 1984, *Robert Henri, Painter* (trav. exh.), no. 62.

Provenance The artist, until 1910.

Purchase, 1910, 10.2

George Hetzel
1826–1899

THE LEADER OF Pittsburgh's artistic community in the mid-nineteenth century, George Hetzel painted portraits, still lifes, and landscapes. Unlike many of his colleagues, he achieved a national reputation for his work. Today he is best known for his intimate woodland scenes, many of which were inspired by his sketching tours in western Pennsylvania.

Hetzel was born in the Alsatian village of Hangeviller, not far from Strasbourg. After immigrating to the United States in 1828, his family settled in Allegheny City, now Pittsburgh's North Side, where his father established himself as a successful winegrower and vintner. Hetzel's early art training was gained through practical experience. He served a four-year apprenticeship to a house and sign painter in the early 1840s, then worked for a year with a fresco painter, decorating saloons and riverboat cabins. He also spent six months painting murals for the old Western State Penitentiary, Pittsburgh.

In 1847 Hetzel traveled to Germany to study at Düsseldorf's academy. There he received instruction in portraiture from the esteemed Carl Ferdinand Sohn and later from Rudolf Wiegmann.[1] "It was magnificent training," Hetzel reflected, "for there is no better education in art than to depict the human form on canvas."[2] No doubt Hetzel joined the other Americans who regularly gathered at Emanuel Leutze's studio; Hetzel later paid homage to Leutze by producing a small version of *Washington Crossing the Delaware* (location unknown), which he exhibited at the 1864 Sanitary Fair in Pittsburgh. After two years, however, unnerved by the local social and political upheavals in Germany, Hetzel returned to Pittsburgh. Since he was one of only three Pittsburgh painters (including Trevor McClurg and Emil Forster) to study in Düsseldorf, his foreign training became an important factor in the education of younger local artists.

Following his return to Pittsburgh in 1849, Hetzel worked as a portrait and still-life painter, but "gradually," as he later stated in an interview, "I drifted into landscape work, which was more in accord with my inclinations."[3] Hetzel traveled through Pennsylvania, Ohio, and West Virginia in search of picturesque subjects, and in the 1860s began to frequent Scalp Level, a village in the Allegheny Mountains sixty miles east of Pittsburgh. Hetzel's friends and students (he taught at the Pittsburgh School of Design for Women after 1865) followed him to Scalp Level, making it a favorite retreat for both professional and amateur artists until the turn of the century, when a coal-mining company took over the

area. In addition to organizing sketching trips to the country, Hetzel attracted artists to his studio in the Apollo Building on Fourth Avenue, which became a popular meeting place for Pittsburgh's painters.

Hetzel again visited Europe in 1879, this time to tour the art galleries in France. His admiration for the old masters in the Louvre was surpassed only by his esteem for Camille Corot and Jean-François Millet, whose excursions into the countryside to paint at Barbizon doubtless resonated with his own trips to Scalp Level. Though Barbizon and Impressionist influences, resulting in a freer technique and lighter palette, are apparent in Hetzel's later works, his Scalp Level scenes reflect, for the most part, the late Hudson River school tradition of landscape painting.

From the 1860s to the 1890s, Hetzel was recognized as Pittsburgh's foremost artist. In the late 1870s a critic for the *Pittsburgh Telegraph* wrote:

No truer lover of nature, no more careful, painstaking, conscientious artists lives. . . . The work that leaves his easel is always *honest*, and shows his close familiarity with nature in all its moods. His genuine love for her, and his desire to show her to his friends at her best—as one naturally does feel about those they love—enables him to produce a work that comes near to John Ruskin's ideal of a complete picture, "that which has the general wholeness and effect of nature, and the inexhaustible perfection of nature's details."[4]

Hetzel's work entered such collections as the Corcoran Gallery of Art in Washington, D.C., and New York's Union League Club, as well as the private collections of Andrew Carnegie, H. J. Heinz, and Henry Clay Frick. In addition to exhibiting locally at the J. J. Gillespie Galleries and the Wunderly Gallery, he reached a wider audience through the exhibitions of the National Academy of Design, New York, and the Pennsylvania Academy of the Fine Arts in Philadelphia. He was one of several Pittsburgh artists represented in the 1876 Centennial exhibition, where his large landscape *Forest Scene in Pennsylvania* (1876, Duquesne Club, Pittsburgh) won an award. Along with Jasper Lawman, Hetzel exhibited at the American Exhibition of 1887 in London, and in 1893 three of his canvases

were displayed at the 1893 World's Columbian Exposition.

John Beatty, director of Carnegie Institute's Department of Fine Arts, included one of Hetzel's landscapes in the first Carnegie International (1896). The following year, however, Hetzel experienced a crushing disappointment: the newly instituted jury turned down his entries. "It was the first time my father's work had ever been rejected," wrote Lila Hetzel, "and to have it happen in his own city was more than he could take."[5] According to Lila Hetzel, his wounded self-esteem prompted him to leave Pittsburgh and move with his family to a farmhouse in Somerset County in the spring of 1898. Hetzel died the following summer while visiting relatives in Pittsburgh. Carnegie Institute held retrospective exhibitions of his work in 1909 and 1915.

1 Brucia Witthoft, in Danforth Museum, Framingham, Mass., *American Artists in Düsseldorf, 1840–1865* (1982), exh. cat., p. 26.

2 Israel, "Art in Pittsburgh," p. 12.

3 Ibid.

4 Way, "Newspaper Cuttings," p. 38.

5 Lila B. Hetzel, biography of George Hetzel, c. 1946, manuscript, p. 9, museum files, The Carnegie Museum of Art, Pittsburgh.

Bibliography Agnes Way, "Newspaper Cuttings Collected by Agnes Way," Scrapbook, c. 1870–1935, in Music and Art Division, The Carnegie Library, Pittsburgh; James A. Israel, "Art in Pittsburgh," *Pittsburg Dispatch*, December 20, 1896, p. 12; Dorothy Kantner, "George Hetzel—Mountain Artist," *Journal of the Alleghenies*, Council of the Alleghenies, Frostburg, Md., 8 (1972), pp. 14–16; Donald Winer, "George Hetzel, Landscape Painter of Western Pennsylvania," *Antiques* 108 (November 1975), pp. 982–85; Nancy B. Colvin, "The Scalp Level Artists," *Carnegie Magazine* 57 (September–October 1984), pp. 14–20.

Still Life of Fruit, c. 1864

Oil on canvas
13⅛ x 16 in. (33.3 x 40.6 cm)

Although landscape was Hetzel's forte, he also excelled at still life, and his oeuvre includes a large number of fruit and game pieces. According to family tradition, his first important sale was a still life bought by Mary Todd Lincoln, which hung in the White House during the Civil War. Today only a handful of his works in this genre are known, but late-nineteenth-

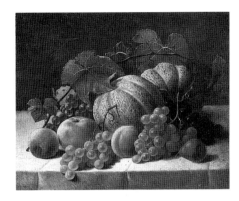

century exhibition records indicate that many more await rediscovery.

Still Life of Fruit presents a variety of summer fruit artfully arranged on a cloth-covered surface; a single grapevine stem arching over the fruit unifies the composition. Especially beautiful here is the play of light on the silvery undersurface of the upper leaf. The contrast of vivid green, yellow, and pink tones against a plain dark background further enhances the decorative quality of this work.

The extreme care with which Hetzel selected his models was noted by a contemporary: "I have more than once accompanied this quiet, modest artist among our best stores in quest of specimens of fruit and game in their season. Ah, how keenly did he scan them in all their details."[1] Aptly demonstrated in *Still Life of Fruit*, the depiction of unblemished specimens and the carefully balanced composition relate this work to the early-nineteenth-century Neoclassical style of still-life painting exemplified by Raphaelle Peale in Philadelphia, its most notable practitioner. Hetzel's inclusion of a tablecloth, symbolic of "the good life,"[2] and his sensitive use of light represent later modifications of Peale's austere style.
GB

1 Way, "Newspaper Cuttings," p. 28.

2 William H. Gerdts and Russell Burke, *American Still Life Painting* (New York, 1971), p. 97.

Provenance Johanna K. W. Hailman, Pittsburgh, until 1958.

Bequest of Johanna K. W. Hailman, 1959, 59.5.14

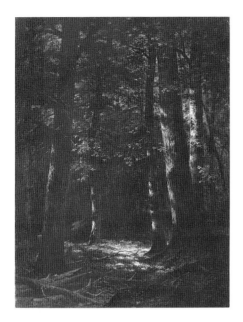

Woodland Path, 1868

Oil on canvas
29½ x 21½ in. (74.9 x 54.6 cm)
Signature, date: Geo. Hetzel, 1868. (lower left)

Most of Hetzel's extant landscapes were inspired by the scenery in and around Scalp Level, an undeveloped area of the Allegheny Mountains east of Pittsburgh, which Hetzel discovered while on a fishing excursion; he led the first of many sketching parties there in 1867. Painted in 1868, *Woodland Path* is an early product of this experience. "I am fond of the deep forest with its heavy shade and solitude," Hetzel once stated,[1] a sentiment that is clearly reflected in the dense forest interior presented here. The natural ruggedness of the forest is apparent in the numerous decaying branches on the ground and the thick underbrush. Even so, Hetzel carefully composed his view to direct the observer's gaze along the woodland path, using deeply shaded trees to frame the foreground and a bright patch of sunlight to illuminate the center; a fallen log in the background limits the amount of visible space, thereby increasing the intimacy of the work. The delicacy of the light that filters through the forest canopy adds a lyrical element to this quiet wilderness scene.

The forest interior, which became a favorite subject for Hetzel, pays homage to the woodland scenes painted by Asher B. Durand and Worthington Whittredge in the Catskill Mountains during the 1850s and 1860s. Though *Woodland Path* lacks the polish of these accomplished Hudson River school painters, Hetzel's ability to manipulate light added a degree of spontaneity to this picture that captures the immediacy of a personal experience.

GB

1 Israel, "Art in Pittsburgh," p. 12.

Provenance Miriam McDonald Shea, Pittsburgh, by 1957.

Gift of the estate of Miriam McDonald Shea, 1957, 57.24

Scalp Level Point, c. 1873

Oil on canvas
14 1/16 x 23 1/8 in. (35.7 x 58.7 cm)
Signature: Geo Hetzel (lower right)

George Hetzel was once described as being "inseparable" from the woods;[1] indeed, his love of deep forest scenery led to the production of some of his finest paintings. Among these, *Scalp Level Point* is an exemplar. Here, in a quiet corner of the Allegheny Mountains, surrounded only by trees, Hetzel re-created the tranquillity associated with the solitary contemplation of nature.

Typically, Hetzel depicted deeply shaded woods where the dense foliage limits visibility and permits only a few rays of sunlight to filter through the trees; often these highlights were captured with a single brushstroke, creating delicate, airy patterns on the lower branches and on the forest floor, thus producing the plein-air qualities that make this work appealing. Although this work is clearly related to *Woodland Path* (1868) in style and content, in it Hetzel abandoned the standard tree-framed vertical format in favor of a horizontal, open-ended composition that more naturalistically recorded the close-up view before him. This less calculated treatment allies *Scalp Level Point* with the informal studies from nature produced by Asher B. Durand in the 1850s. Hetzel's attraction to this mode is evidenced by the repeated inclusion of sketches and studies from nature among his entries in local art exhibitions beginning in 1859.

In addition to providing a record of Hetzel's first-hand study of nature, more finished works like *Scalp Level Point* may well have been preparatory studies for larger salon paintings. Indeed, based on a comparison of style and composition, it seems probable that such a relationship existed between *Scalp Level Point* and Hetzel's impressive prize-winning *Forest Scene in Pennsylvania* (1876, Duquesne Club, Pittsburgh). Consequently, *Scalp Level Point* is appropriately dated in the early 1870s.

GB

1 Way, "Newspaper Cuttings," p. 35.

Provenance Mr. and Mrs. Arthur Braun, Pittsburgh, by 1925; their daughter, Elizabeth Braun (Mrs. Paul B.) Ernst, Pittsburgh, 1976.

Gift of Mrs. Paul B. Ernst, 1978, 78.10.14

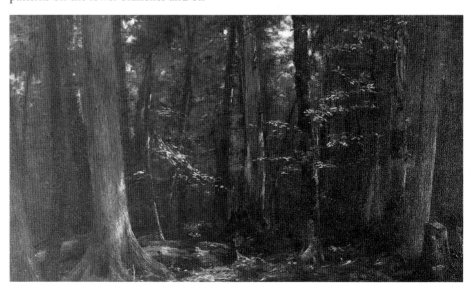

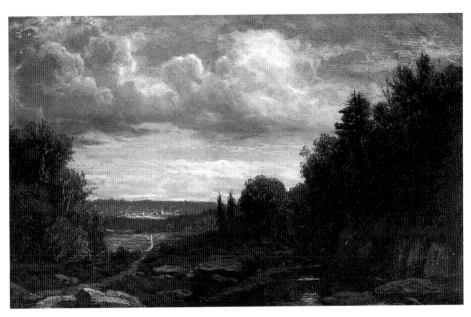

Distant Village, 1875

Oil on canvas
14¹⁄₁₆ x 21¹⁄₁₆ (35.7 x 53.5 cm)
Signature, date: Geo. Hetzel 1875 (lower left)

Distant Village stands in marked contrast to the intimate forest interiors that were Hetzel's favorite outdoor subjects. In this small painting, Hetzel evoked the rural flavor of the Midwest, depicting a remote village nestled in a wooded landscape. From the edge of the woods, the viewer looks across an open meadow to the diminutive settlement in the distance; beneath a broad expanse of sky, the scene is divided by a winding path on which a single figure in the middle distance pauses to face the sun.

Although Hetzel must have regularly seen village scenes like this during his frequent sketching trips in the countryside, his interest in painting them was surely aroused by exposure to the pastoral scenes of the French Barbizon painters, which became popular in this country after the Civil War. Use of the landscape as a vehicle for personal expression distinguished Barbizon painting from the descriptive American landscapes inspired by the Hudson River school. Painted in 1875, *Distant Village* reflects French influence.

To accord with the French mode, Hetzel modernized his detailed landscape style of the 1860s in favor of a more subjective treatment. By using strong contrasts of light and shadow, a heavily clouded sky, and early autumn coloring, Hetzel invested the scene with a solemn, almost brooding quality. Equally important is the figure on the path, for not only is her isolation intensified by her tiny size in relation to the scale of the surrounding landscape, but her stationary pose also conveys a sense of loneliness. In keeping with the emotive characterization of the subject, Hetzel adopted a painterly technique, providing textural interest by thicker applications of paint.
GB

Provenance Dorothy Kantner, Somerset, Pa., by descent; by gift to the Western Pennsylvania Conservancy, Pittsburgh, 1977.

Gift of the Western Pennsylvania Conservancy in memory of George and Lila B. Hetzel, 1977, 77.37.3

Horseshoe Bend, before 1876

Oil on canvas
30¼ x 40½ in. (76.8 x 102.9 cm)

Only on rare occasions did Hetzel deviate from the forest scenery that was his favorite subject. Here, cradled in the midst of a sunny, verdant view of the Allegheny Mountains, he depicts the early railroad marvel commonly known as Horseshoe Bend or Horseshoe Curve.

Located about five miles west of Altoona, this segment of the Pennsylvania Railroad's Main Line was completed in 1854. In its dramatic climb (1,015 feet) to the summit of the rugged mountain range, the tracks make a complete U-turn across the narrow valley of Burgoon Run, gaining an elevation of 122 feet between the two ends of the curve. Engineering the ascent necessitated a sharp cut in the steep hillside near the center of the curve and the fortification of the rail bed with extensive landfill.[1]

The artist's view of this famous curve is from the south looking across the valley to the surrounding mountains; in the far distance a single train, having completed the turn, continues its ascent to the west. The smallness of the engine, barely visible beneath a white puff of steam, makes it clear that Hetzel preferred to exalt the grandeur of the landscape rather than the mechanics that made Horseshoe Bend an engineering landmark. While both the cut rock and the landfill are noticeable, new growth has softened the impact of these man-made scars.

The panoramic scope of Hetzel's composition and his faithful rendering of natural appearances place this work within the stylistic conventions of the Hudson River school. In addition, his accepting but uninvolved attitude toward the railroad, the nineteenth century's "most ruthless emblem of power,"[2] associates *Horseshoe Bend* with a recognizable tendency among mid-century landscapists, exemplified by Jasper Cropsey's *Starrucca Viaduct* (1865, Toledo Museum of Art, Ohio) and George Inness's *Delaware Water Gap* (1859, Metropolitan Museum of Art, New York), to "tailor the machine and its effects to the pastoral dream."[3] The extent to which George Hetzel found himself still rooted in this tradition in the 1870s is evidenced in *Horseshoe Bend* by the coupling of the train's tiny image in the far distance and the implied position of the artist among the gnarled, timeworn trees in the foreground.
GB

1 Edwin P. Alexander, *The Pennsylvania Railroad—A Pictorial History* (New York, 1947), p. 47.

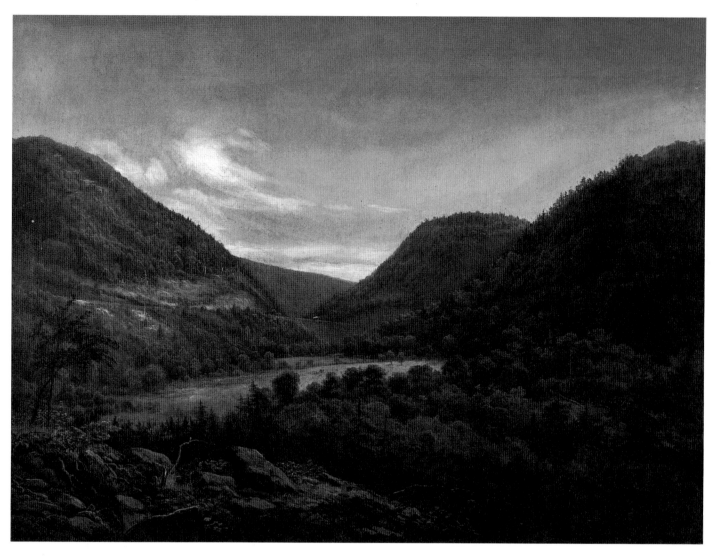

2 Barbara Novak, *Nature and Culture: American Landscape and Painting, 1825–1875* (New York, 1980), p. 166.

3 Ibid., p. 171.

Reference Colvin, "Scalp Level Artists," p. 17.

Exhibition Sanitary Fair, Johnstown, Pa., 1876, no cat.

Provenance George R. Davis, by 1876; Martha Grovner Davis Browne, until 1972; Mr. and Mrs. M. B. Squires, Jr.; Mary Hope Blake, until 1982.

Richard M. Scaife American Painting Fund, 1982, 82.69

Near Sawmill, Scalp Level, c. 1877

Oil on canvas
14 x 23 in. (35.6 x 58.4 cm)
Signature, date: Geo. Hetzel [date illegible] (lower left)

The small village of Scalp Level in southwestern Pennsylvania was the stepping-off point for many of George Hetzel's sketching excursions, and while the rugged forest scenery provided most of his subjects, Hetzel and his companions also explored the old mills and smelting furnaces that once operated in the area. The peaceful scene presented in *Near Sawmill, Scalp Level* includes the remnants of a sawmill, "the noisy clamor of whose great wheels (now moldering to decay) once waked the mountain echoes,"[1] now in a quiescent state. Below it, cows graze contentedly

around the millpond, and willow trees overhang the banks of the stream. Such a bucolic setting must have provided a welcome release from the ever-growing industrial landscape around Pittsburgh.

Although the date on *Near Sawmill, Scalp Level* is no longer legible, this painting was almost certainly painted in the late 1870s, when Hetzel's enthusiasm for the French Barbizon painters was at its peak. In this regard, it is well to recall that when Hetzel traveled to France in 1879, he especially admired the work of Jean-François Millet and Camille Corot.[2] Principally, it is Hetzel's concern for atmospheric mood and humble realism that allies this work with the Barbizon school. The gray, overcast sky, the still,

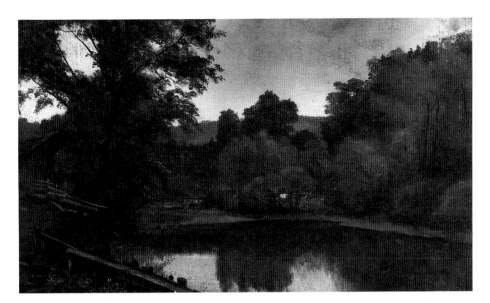

murky water, and the soft, autumnal coloring aptly convey the languid mood of late summer, while the cows remind one of the region's rural past. Hetzel's skillful execution of these passages further integrated the composition. Only in the detailed handling of the foreground foliage did Hetzel betray his underlying loyalty to the earlier aesthetic of the Hudson River school.

GB

1 Way, "Newspaper Cuttings," p. iii.
2 Israel, "Art in Pittsburgh," p. 12.

Provenance Dorothy Kantner, Somerset, Pa., by descent; by gift to the Western Pennsylvania Conservancy, Pittsburgh, 1977.

Gift of the Western Pennsylvania Conservancy in memory of George and Lila B. Hetzel, 1977, 77.37.4

Landscape, c. 1880

Oil on canvas
30½ x 50½ in. (77.5 x 128.3 cm)
Signature: Geo. Hetzel (lower right)

Mountain Stream, 1888

Oil on canvas
21 x 35 in. (53.3 x 89 cm)
Signature, date: Geo. Hetzel/1888 (lower right)

Although the exact locations for *Landscape* and *Mountain Stream* have not been identified, each of these scenic views almost certainly depicts one of the many western Pennsylvania rivers that were among Hetzel's favorite wilderness subjects. His countless variations on this

theme include some of his finest paintings—as well as some of his most repetitious and formulaic. In these, as in *Landscape* and *Mountain Stream*, Hetzel typically directs the viewer's gaze along a stream that peacefully meanders between rocky banks. In *Landscape*, the distant high cliffs testify to the river's history, adding an element of grandeur to an otherwise prosaic scene, while in *Mountain Stream* the tall trees and weathered rocks

surround the foreground pool, producing an intimate setting for the solitary fisherman. In both works, the late afternoon sun produces some fine atmospheric effects.

Painted in the 1880s, these works represent a transition in Hetzel's painting style. While the palpable forms of rocks and trees in the foreground of each affirm his grounding in the native Hudson River school, the delicate backlighting and the broadly brushed detail in the cliffs and hillsides are indicative of the softer textures favored by the Barbizon painters. Hetzel's increasing interest in the French school coincided with his 1879 visit to Europe, where he especially admired the work of Camille Corot.

GB

Landscape

Provenance Edith Cole, Pittsburgh, until 1954.

Gift of the estate of Edith Cole, 1954, 54.28.1

Mountain Stream

Provenance John H. Nicholson, Pittsburgh, by 1925; his daughter, Helen Schuyer Nicholson McEldowney, Balboa Island, Calif., 1937;

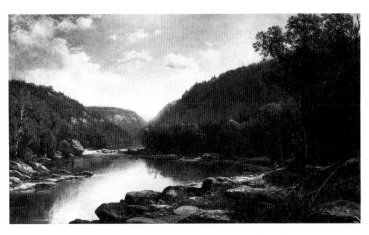

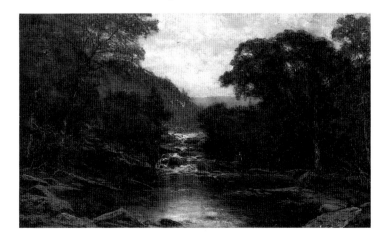

her son, Robert McEldowney, Jr., Annandale, N.J., 1975.

Gift of Mr. and Mrs. Robert McEldowney, Jr., 1988, 88.37

Still Life, 1880

Oil on canvas
11⅞ x 15¹⁵⁄₁₆ in. (30.2 x 40.5 cm)
Signature, date: Geo. Hetzel. 1880 (lower left)

This small picture is one of Hetzel's more modest fruit pieces. The composition, which consists of a few familiar objects compactly arranged on a tablecloth, demonstrates the artist's concern with the relationship of volumes. That the arrangement nearly fills the frame of the painting suggests that it may have been a study for a larger picture.

In keeping with the trend toward more naturalistic representation, the apples and peaches have age spots and the melons appear slightly past their prime. This realism is accomplished by a freer handling of the medium and a willingness to let the patterned wallpaper in the background play a role in the overall texture of the painting. Dated 1880, *Still Life* accordingly represents a departure from the precise, spare style of Hetzel's earlier work in this genre.

GB

Provenance Dorothy Kantner, Somerset, Pa., by descent; by gift to the Western Pennsylvania Conservancy, Pittsburgh, 1977.

Gift of the Western Pennsylvania Conservancy in memory of George and Lila B. Hetzel, 1977, 77.37.1

Still Life with Fruit, 1882

Oil on canvas
24³⁄₁₆ x 32 in. (61.4 x 81.3 cm)
Signature, date: Geo. Hetzel 1882 (lower left)

Hetzel's extant fruit paintings are of the popular tabletop variety commonly known during the nineteenth century as "dining room pieces." *Still Life with Fruit,* which includes a silver epergne, a blue china bowl, and a heavy, flowered drape, is his most elaborate composition; usually, he employed a minimum of accessories and devoted his full attention to the fruit itself.

The composition, which is strongly lit from the left, is built up diagonally across the canvas to a climactic point at the center; the drapery on the left counteracts the formality of this arrangement just as its rich floral pattern provides a foil for the polished surfaces of the ornate centerpiece. Fruit, painted in careful detail, is arranged casually around the base; subtle shading imparts a sense of ripe weightiness to each piece. Additional textural interest is supplied by the wallpaper design in the background.

Hetzel's choice of a silver epergne for this work reflects an increasing preoccupation among late-nineteenth-century still-life painters with costly accessories. Their inclusion enhanced the picture's appeal to wealthy patrons, whose personal collections might well include similar ornate pieces.[1] In this new fashion, fruit and other objects played merely a supportive role.

GB

1 William H. Gerdts and Russell Burke, *American Still Life Painting* (New York, 1971), p. 133.

Reference Winer, "George Hetzel, Landscape Painter of Western Pennsylvania," p. 984.

Provenance Dorothy Kantner, Somerset, Pa., by descent; by gift to the Western Pennsylvania Conservancy, Pittsburgh, 1977.

Gift of the Western Pennsylvania Conservancy in memory of George and Lila B. Hetzel, 1977, 77.37.2

Little Paint Creek, c. 1882

Oil on canvas
20½ x 30⅛ (52 x 76.5 cm)
Signature: Geo. Hetzel (lower left)

Exhibition records show that Pennsylvania's numerous creeks and runs provided Hetzel with a subject to which he returned on many occasions. "If you ever noticed many of my paintings," Hetzel said, "you will see very little sky— possibly a break through the thick foliage

of the trees or a fleecy cloud in the distance"[1] With its dense forest canopy, which nearly obscures the sky, *Little Paint Creek* is a paradigm of Hetzel's popular manner. The scale of this small tributary was, moreover, well suited to the intimate woodland scenes that Hetzel preferred.

An enthusiastic disciple of Isaak Walton, the seventeenth-century author of *The Compleat Angler*, Hetzel often combined fishing and painting on his frequent excursions to the Allegheny Mountains east of Pittsburgh.[2] On occasion, he even set his easel on a large rock in the stream in order to secure just the right angle for his picture.[3] Judging by the low, centralized viewpoint in *Little Paint Creek*, it seems likely that the dry creek provided such a setting for the enthusiastic artist. From this unusual vantage, the rocky stream bed, exposed by late summer's drought, became the focus of the painting and allowed Hetzel to explore the effects of light and shadow on three-dimensional form.

GB

1 Israel, "Art in Pittsburgh," p. 12.

2 Clarence Johns, "An Art Pilgrimage to Shade Furnace," Pittsburgh *Index*, December 11, 1909, p. 39.

3 "With George Hetzel in 1865," Pittsburgh *Index*, May 22, 1909, p. 8.

Exhibitions Department of Fine Arts, Carnegie Institute, Pittsburgh, 1909, *Exhibition of Paintings by George Hetzel*, no. 11; Department of Fine Arts, Carnegie Institute, Pittsburgh, 1939, *A Century of American Landscape Painting*, no. 44.

Provenance Mrs. George Hetzel, Somerset, Pa., until 1916.

Purchase, 1916, 16.2

Corduroy Road, 1887
(Old Road, Scalp Level)

Oil on canvas
43 x 63 in. (109.2 x 160 cm)
Signature, date: Geo. Hetzel, 1887 (lower left)

In his day, Hetzel was much admired for the accuracy and the amount of detail in his landscape scenes and for his ability to capture the harmonious mood of forest settings. *Corduroy Road* shows a deep forest scene, dramatically lit from a small area of sky that can be glimpsed through the trees. Although it is larger than most Hetzel landscapes, its subject, a rustic

bridge over a rocky creek, is common in his work. This painting is typical of the woodland landscapes that Hetzel developed from sketches made during his summer excursions to the Scalp Level area of Somerset County, Pennsylvania.

The road that bisects the composition represents one of the many country roads that were made through the forests of western Pennsylvania during the 1840s and 1850s. At that time, the forests were being cleared for agricultural development; felled trees, shaped into rough planks, were laid for roads and bridges. The resemblance of this construction to the ribbed cotton fabric corduroy accounts for the particular nomenclature corduroy road. Not as durable as the fabric, however, plank roads rotted quickly and soon became too expensive to maintain; in time many were simply abandoned.[1]

It is the latter circumstance that Hetzel portrays in this painting: the old bridge sags and vegetation overgrows the road as nature slowly reclaims the gap opened by man. Hetzel enhanced the romanticism of the theme through dramatic contrasts of light and shadow. This theme and its treatment, together with the close attention to naturalistic detail, recall Hetzel's earliest paintings of Scalp Level. It is possible that the nostalgic sentiment expressed in *Corduroy Road*, painted two decades later, as Hetzel himself was nearing the end of his career, was intended as a personal tribute to the venerable woodlands where he came of age as an artist.

GB

1 John N. Boucher, ed., *A Century and a Half of Pittsburgh and Her People* (Pittsburgh, 1908), vol. 1, pp. 341–42.

References J. O'Connor, Jr., "A Gift of Three Paintings," *Carnegie Magazine* 25 (Jan. 1951), pp. 26, 27, 30; D. Kantner, "Harrisburg Art Museum Features Hetzel's Paintings," *Somerset* (Pa.) *Daily American*, Apr. 13, 1972, p. 9; Colvin, "Scalp Level Artists," p. 15.

Exhibition Department of Fine Arts, Carnegie Institute, Pittsburgh, 1909, *Exhibition of Paintings by George Hetzel*, no. 15, as *Old Road, Scalp Level*.

Provenance H. J. Heinz Co., Pittsburgh, by 1949.

Gift of H. J. Heinz Co., 1949, 49.25.1

Landscape (Trees), 1889

Oil on canvas
30¼ x 20⅛ in. (76.8 x 51.1 cm)
Signature, date: 1889/Geo. Hetzel (lower right)

Throughout his long artistic career, Hetzel sought inspiration directly from nature. At age seventy he confided, "I love natural scenes, the streams and the trees more than ever. I spend several months every summer making sketches in the woods."[1] Quiet woodland interiors such as that depicted in *Landscape (Trees)* preoccupied Hetzel from the beginning; indeed, this painting of 1889 resembles his *Woodland Path* (see p. 246) in both format and composition, even though the

latter was painted about twenty years earlier. Once again, Hetzel created an intimate scene by eliminating the distant view and by tightly framing the composition with close-up views of tall trees. This painting differs from earlier works, however, in the greater amount of light that penetrates the foliage.

While the forest interior is an enduring motif in Hetzel's art, *Landscape (Trees)* illustrates a new dimension in his style. Not only is there more light, but also the light is softer and the forms more gently modeled. In certain places, notably in the trees on the right, detail has been handled in a summary fashion; in some areas the paint is so thin that it hardly conceals the canvas. In contrast, more controlled passages on the left side of the painting reveal Hetzel's lifelong attachment to realism.

The equivocation indicated here is probably the result of Hetzel's exposure to the work of French Barbizon painters, especially Camille Corot, whose paintings he much admired in Paris in 1879. Hetzel returned from that trip clearly inspired: "Corot was the greatest landscape artist. He was really the father of landscape painting... once you saw his dull sky you would not forget it."[2] Though Hetzel never completely relinquished his Hudson River school aesthetic, *Landscape (Trees)* demonstrates the effort he made to graft the cool tonality and somnolent atmosphere of Corot's landscapes onto a traditional Hudson River school motif.
GB

1 Israel, "Art in Pittsburgh," p. 12.
2 Ibid.

Provenance Mr. and Mrs. Arthur Braun, Pittsburgh, by 1925; their daughter, Elizabeth Braun (Mrs. Paul B.) Ernst, Pittsburgh, 1976.

Gift of Mrs. Paul B. Ernst, 1978, 78.10.15

Forest Brook, 1894

Oil on canvas
27 x 20 in. (68.6 x 50.8 cm)
Signature, date: Geo. Hetzel/94. (lower right)

Hetzel had been producing landscapes for nearly forty years when *Forest Brook* was painted in 1894. "I always did love the woods," he said, "and when a boy I spent

much of my time under the trees while other youngsters were playing marbles."[1] The peaceful, meditative quality that emanates from *Forest Brook* confirms this lifelong commitment to nature.

The simple vertical composition of tall, graceful trees framing a stream, which was common in Hetzel's work, can ultimately be traced to Asher B. Durand's influence in the 1850s. From this, Hetzel evolved the quiet forest interiors that were his specialty. His greater interest in mood and the subtle manipulation of light, however, distinguishes his work from Durand's and allies it more closely with the French Barbizon painters. "A sentiment must pervade the scene," Hetzel declared.[2] In *Forest Brook*, the sunlight that dramatically streams through the trees in the background produces an aura of mystery amid the deep woods. The changing effects of light as it filters through the foliage is rarely so beautiful in Hetzel's work as it is in this painting, completed five years before the artist's death.
GB

1 Israel, "Art in Pittsburgh," p. 12.
2 Ibid.

Provenance Robert S. Waters, Johnstown, Pa., by 1972.

Bequest of Robert S. Waters, 1972, 72.14.4

Lila B. Hetzel

1873–1967

LILA HETZEL WAS the youngest daughter of Pittsburgh landscape painter George Hetzel. At the age of sixteen she entered the Pittsburgh School of Design, where she studied under Martin B. Leisser and David Walkley. "Only then," she later recalled, "did I become fully conscious of art life and life in an artist's family. And only in 1895, when I won the Gold Medal awarded in the Life Class, did my father begin to take my art studies seriously."[1] She later traveled in Europe, studying the old masters.

At the age of twenty-four, Lila Hetzel moved with her family to their Somerset County farmhouse, and except for the brief period of her marriage to William H. Kantner, she lived there for the rest of her life. She also maintained a studio in Pittsburgh, where, in 1909, the Associated Artists of Pittsburgh was founded. Hetzel served as the organization's first treasurer. Her career as a painter lasted more than seventy years.

Hetzel's work was largely devoted to rural scenery, heavily influenced by the French Barbizon school. In later life she specialized in interior views of her farmhouse, executed in a less painterly but still realistic manner.

1 Hetzel, biography of George Hetzel, p. 7.

Bibliography Lila Hetzel, biography of George Hetzel, c. 1946, manuscript, museum files, The Carnegie Museum of Art, Pittsburgh; Obituary, *Pittsburgh Press*, June 5, 1967, p. 44; "Lila Hetzel," *Conserve: A Publication of the Western Pennsylvania Conservancy* 20 (April 1978), p. 2; Westmoreland County Museum of Art, Greensburg, Pa., *Southwestern Pennsylvania Painters, 1800–1945* (1981), exh. cat. ed. by Paul A. Chew and John A. Sakal, p. 60.

Three Cows, 1907

Oil on canvas
11 x 14⅟₁₆ in. (27.9 x 35.7 cm)
Signature, date: L. B. Hetzel, 1907 (lower left)

Like most of Lila Hetzel's early work, this sunny summer scene of three young cows in a pasture captures the tranquil mood of the rural countryside that surrounded

the artist's home in Somerset County. Influenced by George Hetzel and other members of the Scalp Level group, this work reflects a lingering attachment to French Barbizon painting. In contrast to her mentors, however, Hetzel makes her bovine subjects the focus of the painting rather than simply an incidental element in a pastoral landscape; appropriately, the simplicity of the composition complements her humble theme.

Inspired by the work of mid-nineteenth-century French artists Charles-Emile Jacque and Constant Troyon, sentimental paintings of domesticated farm animals in natural settings remained popular in America long after their reputation had declined abroad. In *Three Cows*, Hetzel enhances the appeal of these inquisitive dark-eyed beasts not only by her choice of a small canvas but also by her painterly technique, which emphasizes the roughened texture of their furry coats.

GB

Remarks Upper portions of the painting are marred by cracks.

Provenance Dorothy Kantner, Somerset, Pa., by descent; by gift to the Western Pennsylvania Conservancy, Pittsburgh, 1977.

Gift of the Western Pennsylvania Conservancy in memory of George and Lila B. Hetzel, 1977, 77.37.5

Edward Hicks

1780–1849

EDWARD HICKS IS the best-known folk painter of nineteenth-century America. Born in Bucks County, Pennsylvania, he was the son of a well-to-do Royalist who was ruined and forced into hiding by the American Revolution. Following the

death of his mother in 1781, he was taken in by David Twining, a prosperous Quaker farmer, whose family he would later paint several times. Hicks lived with the Twinings until 1793, when he was apprenticed to a coach maker. In 1800, his apprenticeship complete, he became a coach and sign painter. After his marriage in 1803, he moved to nearby Milford, and in 1811 he settled permanently in Newtown, then the county seat.

Hicks joined the Quakers in 1803, after having recovered from a period of troubling illness. He developed a deep interest in religious matters and became a minister in 1811. Two years later, perhaps because the Society of Friends disapproved of painting, Hicks turned to farming, which was a failure, so in 1815 he resumed his former trade. He took up easel painting around 1820, creating the first of his many allegorical pictures titled *The Peaceable Kingdom*, the image with which he is most frequently associated.

Hicks's canvases bear the mark of a self-taught painter of coaches, household objects, and trade signs: they often have inscriptions, decorative borders, and emblematic figures that look like printers' motifs, and they consist of neatly outlined and filled-in shapes placed one row on top of another. Yet these formulas have a complexity and refinement that make Hicks's paintings quite unusual within the sphere of folk painting.

During the 1820s and 1830s, Hicks traveled extensively through the Middle Atlantic states in connection with his ministry and became a well-known preacher. Although as a Quaker he felt painting was insignificant and of no advantage to mankind, he nonetheless produced a substantial body of work whose message was serious, and he had two pupils who became painters of some consequence: his cousin Thomas Hicks and Martin Johnson Heade.

Bibliography Edward Hicks, *Memoirs of the Life and Religious Labors of Edward Hicks, Late of Newtown, Bucks County, Pennsylvania* (Philadelphia, 1851); Frederick Newlin Price, *Edward Hicks, 1780–1849* (Swarthmore, Pa., 1945); Alice Ford, *Edward Hicks, Painter of the Peaceable Kingdom* (1952; reprint, Millwood, N.J., 1973); Eleanore Price Mather and Dorothy Canning Miller, *Edward Hicks: His Peaceable Kingdom and Other Paintings* (Newark, N.J., 1983); Alice Ford, *Edward Hicks: His Life and Art* (New York, 1985).

The Peaceable Kingdom, c. 1837

Oil on canvas
29 x 35¾ in. (73.7 x 90.8 cm)

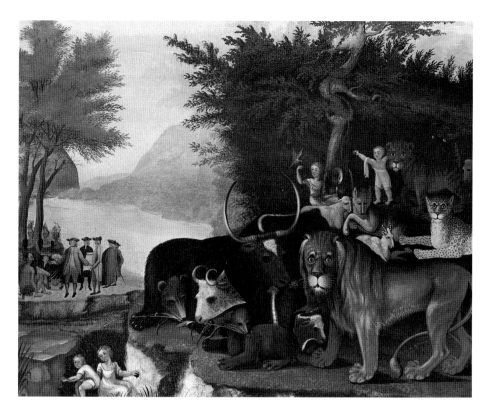

Edward Hicks was involved in—and deeply disturbed by—a separatist faction within the Society of Friends that was led by his cousin Elias Hicks. It is thought that his Peaceable Kingdoms were created in response to the quarrels and controversies that beset the Society of Friends. Between 1820 and 1847 he produced, by various estimates, from sixty to over one hundred paintings on this subject, all inspired by the same verses from Isaiah 11:6–9:

> The wolf also shall dwell with the lamb, and the leopard shall lie down with the kid; and the calf and the young lion and the fatling together; and a little child shall lead them.
>
> And the cow and the bear shall feed; their young ones shall lie down together; and the lion shall eat straw like the ox.
>
> And the suckling child shall play on the hole of the asp, and the weaned child shall put his hand on the cockatrice' den.
>
> They shall not hurt nor destroy in all my holy mountain: for the earth shall be full of the knowledge of the Lord, as the waters cover the sea.

The earliest known *Peaceable Kingdom* (c. 1820, Cleveland Museum of Art) is a simple composition derived from an engraving of Richard Westall's *The Peaceable Kingdom of the Branch,* published in an 1815 English edition of the Bible. The painting shows the little child of Isaiah bearing a grapevine in one hand and stroking the mane of a small tame lion. The child is accompanied by five other animals named in the text: wolf, lamb, goat, leopard, and cow. Between 1830 and 1835, Hicks added more children to the emblematic group, including the weaned child and the suckling child playing with the asp—the pose of the latter probably taken from the infant Christ in a print of Raphael's *Madonna della Sedia.* By 1836 Hicks had elaborated this image to include all the animals mentioned in Isaiah, who stand close together with the children on a bluff, overlooking the "holy mountain" and the sea. The presence of modern-day Quakers on the shore suggests that the scene is a visionary image of America. These elements continued to appear through the 1840s.

The Carnegie's *Peaceable Kingdom* is slightly less agitated and has a somewhat more continuous, panoramic setting than the other versions painted in 1836 and 1837. The children are also different. They are smaller, and there are four of them: a younger boy and an older girl—perhaps intended to be the same two children—play at the top of the bluff and also below it. In its other details, the Carnegie's painting is faithful to the iconographic program Hicks used for most of his Peaceable Kingdoms.

Here, as in the other compositions of the 1830s and 1840s, the animals, particularly the lion-ox pair, dominate the composition. The lion is the lion statant guardant of heraldry, probably known to the artist through tavern signs. He directs his docile but troubled gaze toward the viewer. The prominence given the animals reflects Hicks's interpretation of the prophecy of Isaiah. In a sermon Hicks delivered in February 1837 at Goose Creek, Virginia, he argued that all men are melancholy like the wolf, phlegmatic like the bear, sanguine like the leopard, or choleric like the lion.[1] However, by yielding to the Divine Will, they could acquire the gentle natures of the lamb, kid, cow, and ox. According to tradition, Hicks identified himself with the bad-tempered lion, and this beast, so conspicuous in the Peaceable Kingdoms of the 1830s and

1840s, is to some extent a self-portrait.[2] It is certainly the most expressive of Hicks's animals.

Among the elements not found in Isaiah that Hicks used to amplify the meaning of *The Peaceable Kingdom,* perhaps the most noticeable is the group of figures in the middle ground, a quotation from *Penn's Treaty with the Indians* by Benjamin West (1772, Pennsylvania Academy of the Fine Arts, Philadelphia). The group first appeared in Hicks's compositions in the early 1820s (*The Peaceable Kingdom of the Branch,* c. 1822–25, Yale University Art Gallery, New Haven). In the late 1820s the *Penn's Treaty* group was replaced by a crowd of Quakers bearing banners—an allusion to the Hicksite factionalism—but William Penn and his party reappeared in the early 1830s and remained in the iconography of the series from then on.

The inclusion of the Penn group was an attempt to relate *The Peaceable Kingdom* to the pacifist tenets of Quaker belief. Hicks believed that the peaceful coexistence of the savage Indian and the Quaker founders of Pennsylvania was a realization of the prophecy of Isaiah, a connection he made explicit in the verses that border several Peaceable Kingdoms

painted around 1826–27. In the Carnegie version, the Penn group is set against a landscape background taken from *View on the Delaware*, an engraving by Asher B. Durand published in the only issue of *The American Landscape* (1830).

Another nonbiblical element in the Carnegie painting is the young girl with the dove and the eagle, which Hicks began to introduce about 1836 (*Peaceable Kingdom*, c. 1836, New York State Historical Association, Cooperstown, N.Y.). Her pose is suggestive of Hebe, the Greek goddess of youth, offering a cup of nectar to the eagle of Zeus. The dove is Hicks's own interpolation, which allows him to pair allusions to meekness, innocence, and peace with the eagle as a symbol of American liberty, piety, and innocence.

RCY, KN

1 Reprinted in Hicks, *Memoirs*, pp. 267–331.
2 Jane W. T. Breg, *A Quaker Saga* (Philadelphia, 1967), p. 482.

Reference Ford, *Edward Hicks: His Life and Art*, p. 128.

Exhibitions Whitechapel Art Gallery, London, 1955, *American Primitive Art: 1670–1954* (trav. exh.), no. 30; Department of Fine Arts, Carnegie Institute, Pittsburgh, 1960, *Promised or Given*, no cat.; Museum of Art, Carnegie Institute, Pittsburgh, 1966–67, *Three Self-Taught Pennsylvania Artists: Hicks, Kane, Pippin* (trav. exh.), exh. cat. by L. A. Arkus, no. 14.

Provenance Congressman Henry W. Watson, Tanghorne, Pa.; Dr. Arthur E. Bye, Holicong, Pa., by c. 1940; Charles J. Rosenbloom, Pittsburgh, by 1940.

Bequest of Charles J. Rosenbloom, 1974, 74.7.13

The Residence of David Twining, c. 1845–46

Oil on canvas
26 x 29½ in. (66 x 75 cm)

Inscription: the Residence of David Twining in 1785/when the painter was five years old (bottom center)

During the 1840s Hicks painted a number of farm scenes, including *The Residence of Thomas Hillborn* (1845, Abby Aldrich Rockefeller Folk Art Center, Williamsburg, Va.), *Cornell Farm* (1848, National Gallery of Art, Washington, D.C.), *Leedom Farm* (1849, Abby Aldrich Rockefeller Folk Art Center), and four versions of *The Residence of David Twining* (c. 1845–46, private collection;

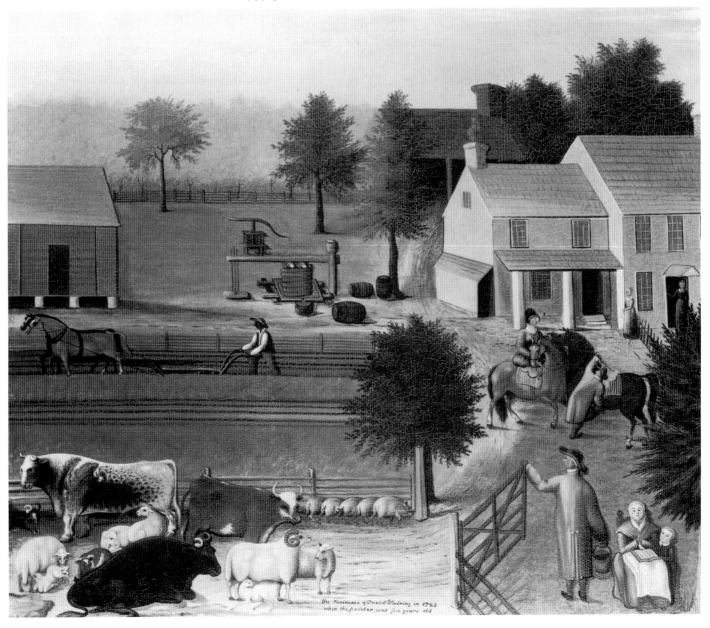

the Residence of David Twining in 1785
when the painter was five years old

The Carnegie Museum of Art; c. 1846, collection Andy Williams, Los Angeles; c. 1846–47, Abby Aldrich Rockefeller Folk Art Center). Whereas the other farm scenes depict the rural landscape of contemporary Bucks County, the paintings of the Twining farm are nostalgic recreations of the artist's past. An inscription on the frame of the Williamsburg version sets the scene in 1787; a similar inscription on the Los Angeles version gives the date as 1785. The fullest inscription, painted directly on the canvas of the Carnegie version, identifies the subject as "the Residence of David Twining in 1785 when the painter was five years old."

The scene depicts a farmyard with an assortment of animals in a pen, behind them a field hand at a plow, and, in the background, the farmhouse and outbuildings. One of the figures Hicks included in all versions of the painting is Elizabeth Twining, who raised Hicks from infancy and who sits reading the Bible to her attentive young charge. In his *Memoirs*, Hicks identified Mrs. Twining with the virtuous wife in Proverbs 31, whose "price is far above rubies," and wrote, "How often have I stood or sat by her, before I could read myself, and heard her read, particularly the twenty-sixth chapter of Matthew."[1]

Nearby, opening the barnyard gate in order to feed the livestock, is David Twining, dressed, like his wife, in traditional Quaker garb. Twining's daughter Mary appears on horseback next to her husband, Jesse Leedom. The rather contrived meeting of their frisky mounts is derived from Thomas Sully's *Washington at the Passage of the Delaware* (1819, Museum of Fine Arts, Boston), a painting that Hicks copied from an engraving no fewer than nine times between 1825 and 1849. A second daughter, Beulah, poses in the hooded doorway of the farmhouse, while to her right, by a picket fence, stands a third young woman, who appears only in the Carnegie canvas, and whose identity is uncertain. She may be Elizabeth, the third of the three Twining daughters. It was for Elizabeth's daughter Sarah that this painting was probably made.

To Hicks, the four versions of *The Residence of David Twining* were more than simple essays in nostalgia. From 1843

on, he was engaged in writing his memoirs, a project undertaken in order to leave a record of his spiritual progress. Many Quaker ministers penned autobiographies, and as Howard H. Brinton has noted, they usually identified the primitive innocence of childhood as the first stage in their religious development.[2] *The Residence of David Twining* depicts such a period in Hicks's life and underlines its significance by showing him in the act of receiving his earliest religious instruction. In the light of the Goose Creek sermon, in which Hicks likened domestic animals to redeemed souls who have yielded to the Holy Spirit, it is possible that David Twining's feeding of the livestock symbolizes the spiritual nourishment that Hicks received in his foster home.

RCY, KN

1 Hicks, *Memoirs*, p. 24.

2 Howard H. Brinton, *Friends for Three Hundred Years: The History and Beliefs of the Society of Friends . . .* (New York, 1952), pp. 206–8.

References F. A. Myers, "Edward Hicks and the Twining Farm," *Carnegie Magazine* 36 (Dec. 1962), pp. 329–32; E. Parry, "Edward Hicks and a Quaker Iconography," *Arts* 49 (June 1975), pp. 92–94; Grand Rapids Art Museum, Mich., *Themes in American Painting* (1977), exh. cat. by J. G. Sweeney, p. 75; J. Russell, "Art Is There to Tell Us Who We Are," *House and Garden* 148 (July 1976), pp. 84, 88, 103; Ford, *Edward Hicks: His Life and Art*, pp. 209, 215; H. Adams, in Museum of Art, Carnegie Institute, *Collection Handbook* (Pittsburgh, 1985), pp. 170–71.

Exhibitions Museum of Art, Carnegie Institute, Pittsburgh, 1966–67, *Three Self-Taught Pennsylvania Artists: Hicks, Kane, Pippin* (trav. exh.), exh. cat. by L. A. Arkus, no. 31; M. Knoedler and Co., New York, 1971, *What Is American in American Art?*, exh. cat. by M. Black, introduction by L. Goodrich, no. 45; Andrew Crispo Gallery, New York, 1975, *Edward Hicks: A Gentle Spirit*, no. 21; Grand Rapids Art Museum, Mich., 1977, *Themes in American Painting*, no. 33; Westmoreland Museum of Art, Greensburg, Pa., 1989, *A Sampler of Folk Art from Pennsylvania Collections*, exh. cat. by P. A. Chew, no. 241.

Provenance Sarah Twining (granddaughter of David Twining); Francis William Carpenter (descendant of David Twining); his daughters; North Greenwich Congregational Church, Greenwich, Conn., by 1961; M. Knoedler and Co., New York, 1961.

Howard N. Eavenson Memorial Fund, for the Howard N. Eavenson Americana Collection, 1962, 62.39

Malvina Hoffman
1887–1966

DAUGHTER OF THE CONCERT pianist Richard Hoffman, Malvina Hoffman grew up in New York, where her interest in art was encouraged at the private school she attended. While still in her teens, she enrolled in drawing classes at the Art Students League and on weekends studied painting with John White Alexander. Her first sculpture lessons came from Herbert Adams and George Grey Barnard.

After the successful reception of a portrait bust of her father at the National Academy of Design, New York, in 1910, and with a letter of introduction from the sculptor Gutzon Borglum, Hoffman traveled to Paris to study with Auguste Rodin. Rodin admired the expressive character of her sculptural portraits, and for the next few years she studied informally at his studio. In Paris she was drawn into avant-garde artistic circles; her lasting interest in dance and her friendship with the Russian ballerina Anna Pavlova began at this time.

In 1914, after arranging an exhibition of Rodin's work in London, Hoffman returned to New York. Her sculpture *Bacchanale Russe* (1917, Musée Nationale du Luxembourg, Paris), which she modeled in Paris, won the Julia A. Shaw Prize when it was exhibited at the National Academy of Design in 1917. It depicted Pavlova and her partner Michail Mordkin dancing, and it was cast into numerous replicas. Over the next several years, Hoffman further developed the subject of the dance; she produced a series of basreliefs based on the performances of Pavlova and Mordkin. She also worked on a number of Rodinesque marble sculptures, including *Column of Life* and *Offrande*. Her design for a peace monument, commissioned by Adolph Ochs in 1914, was never completed.

During World War I, Hoffman became involved in relief work for the Red Cross and subsequently produced a number of war memorials. In 1919 she accompanied a mission to Yugoslavia, where she made several portrait busts of the Polish pianist Jan Paderewski. In the early 1920s she

produced a war monument reminiscent of medieval tomb sculpture called *The Sacrifice* (1920–22, Cathedral of Saint John the Divine, New York), then executed a heroic sculptural group, *The Friendship of the English-Speaking People* (1923–24), for the entrance to Bush House in London. In 1930 she was commissioned by the Field Museum in Chicago to produce sculptural studies for a series dedicated to the "Races of Man." She spent the next five years traveling around the world in preparation for the project, which eventually yielded over one hundred bronze heads and several full-length figures representing different ethnic types.

Throughout her career Hoffman modeled many sensitive, naturalistic portraits of celebrated and culturally important persons, including Henry Clay Frick, Wendell Wilkie, and the Yugoslavian sculptor Ivan Meštrović. A collection of twenty-eight plaster replicas of her portraits is housed at the New-York Historical Society. Carnegie Institute has held two exhibitions of her work, the first in 1929 and the second in 1934. During her lifetime she saw the publication of three volumes of her memoirs. She died in New York.

Bibliography Malvina Hoffman, *Heads and Tales* (New York, 1936); Malvina Hoffman, *Sculpture Inside and Out* (New York, 1939); Malvina Hoffman, *Yesterday Is Tomorrow* (New York, 1965); FAR Gallery, New York, *Malvina Hoffman* (1980), exh. cat. by Janis Conner; Berry-Hill Galleries, New York, *The Woman Sculptor—Malvina Hoffman and Her Contemporaries* (1984), exh. cat. by May Brawley Hill.

Spirit, 1913

Marble on wooden base
15¾ x 20⅜ x 10¼ in. (40 x 51.8 x 26 cm)
Markings: MALVINA HOFFMAN/1913 (proper left side)

Emerging from the uncut marble, this delicately modeled head of an aging woman imparts a mystery and an ethereal quality inspired by the work of Hoffman's mentor, Auguste Rodin. The figure's downcast eyes and flowing hair, the modeling of stone into soft contours, and the deliberate contrast between these delicate surfaces and the rough stone closely follow Rodin's style. Isabella McKenna Laughlin, a Pittsburgh resident who died in 1891, served as the inspiration for

Spirit. This commemorative work was probably commissioned by her son, Irwin B. Laughlin, in 1912, the same year that Hoffman produced two marble portraits of Laughlin's wife.

In creating this piece Hoffman may have had in mind works by Rodin such as *Thought* (1886) or *La Nature* (c. 1910), in which an abstract meaning was assigned to a portrait. To express the deceased's soul, Hoffman isolates the head, thus making use of a common Symbolist motif in which the disembodied head represents the separation of the soul from the body.[1] Hoffman again turned to this Rodinesque type around 1918 for the portrait of her elderly mother, Fidelia Hoffman, who died in 1920.
GB

1 Robert Goldwater, *Symbolism* (New York, 1979), p. 120.

Remarks The carved wooden base was probably designed by the artist.

Provenance Mrs. Erl Gould (Isabella McKenna Laughlin's daughter), Pittsburgh.

Gift of Mrs. Erl Gould, 1956, 56.36

Mask of Anna Pavlova, 1924
(Portrait of Anna Pavlowa in Russian Headdress)

Tinted wax
16 x 8½ x 5 in. (40.6 x 21.6 x 12.7 cm)

With the outbreak of World War I, Hoffman left Paris and returned to New York, where she established a studio in a renovated stable on East Thirty-fifth Street. Her friendship with the Russian ballerina Anna Pavlova (1885–1931), who often performed at New York's Metropolitan Opera House, developed

into a close personal relationship. Pavlova took an interest in Hoffman's work and posed several times for her. This particular sculpture was inspired by a tableau that Hoffman created in honor of Pavlova's birthday. As Hoffman later described it:

> A huge gilded icon frame with closed doors had been mounted high in the corner of the room. Behind this we had led Pavlowa, covered by a long veil, and she had taken the pose of a Byzantine Madonna, her hands held together, fingertips touching as in prayer. The decorative headdress was set on her head, and the signal was given for the doors of the icon to open as the gong struck twelve. Pavlowa remained immovable as a procession of guests walked up before her. I was last in line, carrying her birthday cake with lighted candles. The audience applauded wildly, and then gasped in delight when Pavlowa smiled.[1]

The Carnegie portrait is one of several replicas, all of which depict the dancer wearing an elaborate headdress that frames her face. The decorative shape of the headdress and its beaded texture contrast with Pavlova's smooth skin and serene expression. Unlike the original (1924, Metropolitan Museum of Art, New York), in which the headdress is tinted a darker color than the face, this version is a pearly pink color throughout. The pale, monochromatic scheme, coupled with the slight translucency of the medium, accounts for the otherworldly quality of the work. Originally modeled from life, Hoffman's wax process was experimental: "I had little experience to

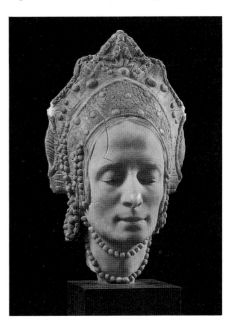

guide me," she later explained, "but I wanted so much to catch some of Pavlowa's fantastic lightness and grace, and I tried to find a material that would be a bit more ethereal than bronze, which always gives a heavy look."[2]

GB

1 Hoffman, *Yesterday Is Tomorrow*, p. 150.
2 Malvina Hoffman to Ann K. Stolzenbach, November 9, 1948, museum files, The Carnegie Museum of Art, Pittsburgh.

Remarks At some time after 1927 a blow to the nose cracked the front surface of the head in several places.

References E. D. Balkan, "Malvina Hoffman—American Sculptor," *Carnegie Magazine* 2 (Feb. 1929), pp. 270–72; "Woman Sculptor's Work Acclaimed in America," *Pittsburgh Post-Gazette*, Feb. 13, 1929, p. 15.

Exhibitions Concord Art Association, Mass., 1925, *Concord Art Association Ninth Annual Exhibition*, no. 37; Grand Central Art Galleries, New York, 1928–29, *Exhibition of Recent Sculpture and Drawings by Malvina Hoffman*, no. 3; Department of Fine Arts, Carnegie Institute, Pittsburgh, 1929, *Exhibition of Recent Sculpture and Drawings by Malvina Hoffman*, no. 3, as *Portrait of Anna Pavlowa in Russian Headdress*.

Provenance Grand Central Art Galleries, New York, c. 1924–27.

Gift of Mrs. William Reed Thompson, 1927, 27.3

Raymond Holland
1886–1934

THE PAINTINGS OF Francis Raymond Holland range in subject matter from scenes of his native Pittsburgh to the exotic landscape of Morocco. Although he was not attached to a particular movement, his style applied the high-key palette of twentieth-century American Impressionism to compositions that were both decorative and anecdotal.

Born in Pittsburgh, he was the son of Dr. William J. Holland, director of the Carnegie Institute's museum of natural history from 1895 to 1922. He attended Princeton University from 1904 to 1905 but, contrary to most published sources, did not graduate. He continued his studies at the Art Students League in New York and then traveled to Europe. In

Amsterdam he studied under a French artist, August Hennecotte, before going on to Paris and, later, Tangier.

By 1914, Holland had spent two years in Morocco, where he painted vivid landscapes and shore views. He lived and worked with two of the Glasgow Boys, Sir John Lavery and William Kennedy. The black American artist Henry O. Tanner also had a studio in his neighborhood. Returning to New York, he exhibited paintings done in Morocco, Connecticut, and New York at the Reinhardt Galleries in 1916. He contributed to the annual exhibitions of the Associated Artists of Pittsburgh from 1911 to 1917 and again in 1922. He also exhibited in the 1920 Carnegie Institute annual international exhibition.

Around 1925 Holland decided to travel to Spain. The trip visibly altered his painting style by strengthening his three-dimensional design,[1] so that his compositions became more authentically pictorial. Works like *Granada*, *Spanish Bridge*, and *Spanish Landscape* exemplify Holland's active brushstroke and talent for creating energetic canvases that appeal to the eye and stimulate the senses.

Upon returning to the United States in 1926, Holland exhibited twenty-four paintings at the Reinhardt Galleries. About half of this show traveled to Pittsburgh and was hung at the Pittsburgh Athletic Association as a local contribution to the United States Sesquicentennial. At the same time, his painting *The Processional* was acquired by Sir Joseph Duveen for the contemporary collection of the Tate Gallery in London.

Holland was a member of a variety of art organizations, including the Society of Independent Artists, the Silvermine Group (now the Silvermine Guild Center for the Arts), New Canaan, Connecticut, the Connecticut Society of Artists, and the Associated Artists of Pittsburgh. He died of heart disease in New York at the age of forty-eight.

1 Jones, "Sesquicentennial Art Exhibit," p. 6.

Bibliography "Raymond Holland," *Arts and Decoration* 11 (May 1919), p. 23; Penelope Redd Jones, "Sesquicentennial Art Exhibit Sends out Announcement," *Pittsburgh Sunday Post*, May 30, 1926, sec. 5, p. 6; "Raymond Holland's Painting," *Carnegie Magazine* 8 (March 1935), pp. 312–13.

Pittsburgh, 1918

Oil on canvas
48 x 48 in. (121.9 x 121.9 cm)
Signature, date: Raymond Holland 1918 (lower left)

Many artists painting Pittsburgh from the early 1800s onward depicted the city in terms of its industry. Holland, familiar with this characterization, here chose to ignore Pittsburgh's smoke-blackened skies and machine-laden mills. He painted a winter white landscape of the Schenley Park Bridge and Junction Railroad in the residential environs of Carnegie Institute.

The colorfully clad pedestrians crossing the bridge in the foreground appear to be lifted by the wind, as the artist's animated brushstroke created a sense of hurriedness on a blustery winter day. The surrounding snow-covered landscape is composed of clumps of buildings on the hillside, leading to a second bridge in the distance. This expanse of steel is barely visible as a gush of steam (the city's inescapable leitmotif) rises from the train traveling along the tracks below. Upon close inspection, the white background glistens as sun penetrates through the clouds, creating varying shades of lavender, pink, blue, and green.

Pittsburgh, sketched in pencil from a window at Carnegie Institute, was completed by Holland in New York. Although the Schenley Park Bridge and Junction Railroad are faithful topographical transcriptions, the bridge in the background is not. Rather than make an exact study of one particular area, Holland incorporated several different aspects of the park district into one work.

LAH

Reference "Raymond Holland's Painting," pp. 312–13.

Exhibition William Penn Memorial Museum, Harrisburg, Pa., 1978–79, *Pennsylvania Landscape Survey*, no cat.

Provenance The artist, until 1934; his widow, 1934.

Gift of Mrs. Francis Raymond Holland, 1934, 34.3

Spanish Landscape, 1925
(Processional)

Oil on canvas
48 x 48 in. (121.9 x 121.9 cm)
Signature, date: Francis Raymond Holland 1925 (lower left)

Holland was captivated by the beauty of Spain's scenery during his visit there in the 1920s. In *Spanish Landscape* he depicts a procession that has stopped along a barren roadside to pray before a large crucifix. The figures almost register as landscape elements as they head toward the small village nestled within the hills. The terrain is rugged and rocky but eventually gives way to the opalescent mountains looming in the background. Holland, adept at intermingling shades of pink, blue, purple, and green, places his emphasis on creating a decorative and active surface pattern. This, however, does not counteract the feeling of quiet and isolation created by the painting's high horizon line.

Throughout his career, Holland conveyed a certain energy and vitality in his work. His paintings challenged the spectator, offering an opportunity to view a familiar landscape with a sense of adventure or to explore new places with surprise and wonder.

LAH

Reference Jones, "Sesquicentennial Art Exhibit," p. 6, as *Processional.*

Exhibitions Reinhardt Galleries, New York, 1926, no cat.; Pittsburgh Athletic Association, 1926, no cat.

Provenance The artist, until 1925; his widow, until 1962.

Gift of Mrs. Francis Raymond Holland, 1962, 62.16

Carl Holty
1900–1973

AS A PAINTER, professor, and author, Carl Robert Holty was one of the major contributors to the abstract-art movement in America. He was born in Freiburg-im-Breisgau, the son of Americans temporarily living in Germany while his father completed medical school. Shortly after his birth his family returned to the United States and settled in Milwaukee. As a young man Holty abandoned his plans to pursue a career in medicine when his maternal grandmother offered him financial assistance to study what really interested him—painting. He attended the Milwaukee Art School, the Art Institute of Chicago, and the National Academy of Design in New York, then returned to Milwaukee to work as a portraitist.

A few years later, in 1926, Holty and his wife moved to Europe, settling first in Munich. There he studied under Hans Hofmann, who introduced him to the theory and practice of abstraction. Attracted to the formal innovations of Cubism, especially as seen in the work of Juan Gris, he chose to explore the structural precepts of painting in works closely aligned with Synthetic Cubism. In 1928 he went to live in Paris, where he was able to develop friendships and share ideas with modernists such as Piet Mondrian and Joan Miró. In 1932 he became a member of the influential and experimental Abstraction-Création group (whose members included Miró, Jean Arp, and Naum Gabo)—the only other American besides Alexander Calder to be asked to join.

Holty returned to New York City in 1935 and became affiliated with the abstract-art movement centered there, making friends with abstractionists such as Hilaire Hiler, John Graham, and Stuart

Davis.[1] From the late 1930s to the 1940s he was an active member of the American Abstract Artists, which he had helped to found in 1937, and for a short while, during the late 1930s, taught at the Art Students League. He also participated in the 1946 and 1948 *Painting in the United States* exhibitions held at Carnegie Institute.

Stylistically he remained close to Cubism—his paintings of the period are typically cool, analytical arrangements of flatly painted geometric shapes, which had become more sinuous due to the influence of Miró's biomorphic forms. In these works he was also inspired by Mondrian's advocacy of pure, abstract geometry. He thus began to try to rid his art of pictorial references but did not completely succeed in doing so, as the figural references in his works from the mid-forties attest.

By the early 1950s Holty had loosened his painting style, allowing his forms to appear less calculated and more freely painted. At the same time he began to experiment with new methods of breaking up space. One method he frequently used was to place spots of white paint on a large painted area in order to destroy the monotony of the field and create a new sense of rhythm.[2] Color in Holty's paintings also began to have more flexibility—it was no longer flatly applied, filling sharply defined shapes, but instead showed texture and variety.

Holty's new awareness of the possibilities inherent in painterly color led to his large, soft-edged color paintings of the sixties. Although these works are primarily color compositions, Holty's concern for structure is still apparent in the way the various color areas meet and interact with each other.

At the time of his death Holty held a teaching appointment at Brooklyn College, in New York.

1 Museum of Art, Carnegie Institute, *Abstract Painting and Sculpture*, p. 172.
2 Bearden, "A Painter in the Fifties," p. 36.

Bibliography Carl Holty Papers, Archives of American Art, Washington, D.C.; Carl Holty, "The Mechanics of Creativity of a Painter: A Memoir," *Leonardo* 1 (July 1968), pp. 243–52; Romare Bearden, "A Painter in the Fifties," *Arts* 48 (April 1974), pp. 36–37; Virginia Pitts Rembert, "Carl Holty," *Arts* 55 (December 1980), p. 11; John R. Lane, "Carl Holty," in

Museum of Art, Carnegie Institute, Pittsburgh, *Abstract Painting and Sculpture in America: 1927–1944* (1983), exh. cat. ed. by John R. Lane and Susan C. Larsen, pp. 172–74.

Of War, 1942, reworked 1960

Oil and tempera on Masonite
54 x 36 in. (137.2 x 91.4 cm)
Inscription: "OF WAR"/*Carl Holty*/*Tempera 1942*/ *Oil & Tempera* 1960 (on reverse, in artist's hand)

Painted in New York City during World War II, *Of War* reflects not only the turbulent mood of the times but also the modernist theories with which Holty had become acquainted in Europe during the thirties. The painting, whose title is derived from Karl von Clausewitz's book *On War,* has an overall design of sharp-edged curvilinear shapes. Larger shapes are painted with muted khaki greens, gray purples, and burgundies, while smaller forms, acting as accents, are defined by purer, more intense reds, oranges, and purples. Unlike the biomorphic forms that characterize Holty's work of the late thirties, the shapes in this painting are more geometric, a development that can be attributed to the rising influence of Neoplasticism, generated by the arrival of Piet Mondrian in New York in 1940.

Undoubtedly the most disturbing, yet most exciting, aspect of this work is the chaotic distribution of the shapes. Holty has placed his forms so that the entire composition is impossible to read in one flowing motion—forms may lead into one another, but their progression is quickly blocked by a visual barrier such as a small shape that the eye must jump over in order to continue its survey. The jarring rhythm that this arrangement creates is frustrating to an eye trained to view a painting in one uninterrupted glance, and thematically suggests the disruptive and unpredictable nature of war.

Holty's original rendition of this painting was destroyed in a studio accident in 1942. That year he made a replacement, based on a photograph of the original. This second version was painted in tempera on a smaller panel than the original. In 1960 he painted over the flaking tempera in oil, altering the appearance of the work very little.

EM

Remarks On the reverse side of the panel is another painting, blocked out in gray and beige tempera.

References B. Rose, *American Art since 1900: A Critical History* (New York, 1967), p. 144; V. P. Rembert, "Mondrian, America, and American Painting," Ph.D. diss., Columbia University, 1970, pp. 236, 338; S. Hunter, *American Art of the Twentieth Century* (New York, 1974), p. 162; S. C. Larsen, "Going Abstract in the '30s: An Interview with Ilya Bolotowsky," *Art in America* 64 (Sept.–Oct. 1976), p. 79; J. R. Lane, "American Abstract Art of the '30s and '40s," *Carnegie Magazine* 56 (Sept.–Oct. 1983), p. 19.

Exhibitions Whitney Museum of American Art, New York, 1962, *Geometric Abstraction in America,* no. 44; Graham Gallery, New York, 1980, *In the Geometric Tradition—Fritz Glarner, Carl Holty, Albert Swinden,* unnumbered; Museum of Art, Carnegie Institute, Pittsburgh, 1983–84, *Abstract Painting and Sculpture in America: 1927–1944* (trav. exh.), exh. cat. ed. by J. R. Lane and S. C. Larsen, no. 78.

Provenance Graham Gallery, New York, by 1980.

Museum purchase: gift of the Robert S. Waters Charitable Trust, 1980, 80.50

Harry Holtzman

1912–1987

BORN AND RAISED IN New York City, the precociously intellectual Harry Holtzman developed an early interest in modern art with the guidance of his high-school art teacher. At the age of fourteen he saw the Société Anonyme's international exhibition at the Brooklyn Museum, New York, and at sixteen he began attending the Art Students League, where he became an active participant: he served as a monitor who assisted in the setting up of classrooms and studio sessions and wrote for the quarterly magazine.

By 1930 or 1932 Holtzman had set aside his figurative drawings of the late twenties and was creating gestural, painterly abstractions. Crucial formative experiences for him at this time were his visits to the Museum of Modern Art and to E. Weyhe Art Books, a bookshop that was a gathering place for artists, to leaf through issues of *Cahiers d'art*. On the advice of his friend Burgoyne Diller, he entered the class that Hans Hofmann began to teach at the Art Students League in the fall of 1932.

Hofmann was immediately impressed by his new student's work, while Holtzman, for his part, benefited from his new teacher's emphasis on Cubist-related structural concepts. Nonetheless, Holtzman saw Hofmann as "very much against extreme forms of abstraction" and as far as "people like Kandinsky were concerned, or the idea of pure abstract art, he considered that more of an exercise."[1] Nor did Hofmann share Holtzman's philosophical concerns or his interests in contemporary psychology and anthropology. As a result, Holtzman eventually left the class. The two taught together in 1933 and 1935, but by January 1934 Holtzman had made his ideological break.

Holtzman recalled that he was at this time striking out on an independent path that "without [my] knowing it, was taking me in a direction similar to Mondrian,"[2] toward rectilinear abstraction. On Diller's suggestion he went to the Gallery of Living Art at New York University, where he saw his first example of Piet Mondrian's work, *Composition with Blue and Yellow* (1932, Philadelphia Museum of Art). Holtzman "became obsessed with not only the paintings of Mondrian but with the idea that the man had to think certain things about the historical transformation, the values and function of art. I really had to go to Europe to speak with him."[3]

In early December 1934 Holtzman arrived in Paris, and soon introduced himself to the older abstractionist in his studio. The two artists immediately became friends. During Holtzman's four-month stay in Paris, he was impressed by the cohesion and effectiveness of the progressive artists' association Abstraction-Création, and he met a number of other avant-garde artists, including Jean Hélion, with whom he became particularly close.

Back in New York in 1935 Holtzman joined the Works Progress Administration's Federal Art Project—at first as a writer for the public-relations department, because his art was considered too extreme to be in public buildings. When Diller became managing supervisor of the Mural Division in New York, he chose Holtzman to be his assistant in charge of the division's abstract artists. Holtzman met abstractionists who shared a desire for a mutually supportive organization for intellectual and aesthetic interaction.

Holtzman thus brought together the core group of painters and sculptors who established the American Abstract Artists in 1937. He played a key role in the organization, serving as secretary from 1937 to 1940. When the group exhibited at the New York World's Fair of 1939–40, he was chosen to design its educational exhibit, which he called *Introduction to Basic Conditions of Form and Space*. He contributed important essays to the association's 1938 yearbook, the catalogue for its fifth annual exhibition, in 1941, and the 1940 pamphlet entitled *The Art Critics— How Do They Serve the Public? What Do They Say? How Much Do They Know? Let's Look at the Record!*

Holtzman was represented in several American Abstract Artists exhibitions of the late 1930s and early 1940s by paintings and sculptures that stand as original extensions of Mondrian's Neoplastic vocabulary. But partly due to his other commitments and interests, the number of those completed works was small.

In 1938 Holtzman left the Federal Art Project. In 1940 he arranged for the immigration of Mondrian to New York, rented an apartment-studio for him, and was his closest associate during the next three and a half years. As executor of Mondrian's estate, he continued his involvement with the artist, after his death, culminating in the 1986 publication of Mondrian's collected writings, which Holtzman edited. From 1947 to 1954 Holtzman was a faculty member at the Institute for General Semantics in Englewood, New Jersey. He edited the journal *trans/formation: arts, communication, environment* from 1950 to 1952, and from 1950 to 1975 was a faculty member of Brooklyn College in New York. Holtzman died in Lyme, Connecticut.

1 Harry Holtzman, interview with Ruth Gurin, January 11, 1965, Harry Holtzman Papers, Achives of American Art, Washington, D.C.

2 Ibid.

3 Ibid.

Bibliography Harry Holtzman Papers, Archives of American Art, Washington, D.C.; Virginia Pitts Rembert, "Mondrian, America, and American Painting," Ph.D. diss., Columbia University, 1970, pp. 150–52, 203–4; Yale University Art Gallery, New Haven, *Mondrian and Neoplasticism in America* (1979), exh. cat. by Nancy J. Troy, pp. 7, 42; John R. Lane, "Harry Holtzman," in Museum of Art, Carnegie Institute, Pittsburgh, *Abstract Painting and Sculpture in America: 1927–1944* (1983), exh. cat. ed. by John R. Lane and Susan C. Larsen, pp. 175–77; Robert L. Herbert et al., *The Société Anonyme and the Dreier Bequest at Yale University: A Catalogue Raisonné* (New Haven, 1984), pp. 332–33.

Vertical Volume No. 1, 1939–40

Acrylic and oil on gessoed Masonite

Overall dimensions:
66 15/16 x 18 15/16 in. (170 x 48.1 cm)

Dimensions excluding frame:
60 x 12 in. (152.4 x 30.5 cm)

Signature, date: HARRY HOLTZMAN 1939–40 (on frame, lower right)

Vertical Volume No. 1, a tall, narrow, rectangular painting, demonstrates Holtzman's concerns with extending Mondrian's principles of Neoplasticism beyond mere pictorial space into the realm of three dimensions. Part of the pure abstract composition of yellow, blue, and black bands extends around the painting, thanks to a thick stretcher,

which is itself mounted so that it projects outward from the gray panel that serves as the picture's frame.

In framing and projecting his painting Holtzman was adopting the practice of Mondrian, who, in 1943, summarized his own development in this anti-illusionist direction: "So far as I know, I was the first to bring the painting forward from the frame, rather than set it within the frame [which] gives an illusion of depth. . . . To move the picture into our surroundings and give it real existence has been my ideal since I came to abstract painting."[1]

The human scale, narrow verticality, and horizontal design elements of Holtzman's painting are original adaptations of Mondrian's vocabulary. The gray

Fig. 1 Harry Holtzman, *Lateral Volume #2*, 1940. Oil on canvas, 70⅛ x 22½ in. (178.1 x 57.2 cm) overall. Yale University Art Gallery, New Haven, Conn., gift of the artist to the Collection Société Anonyme, 1950

frame that the artist fashioned is a departure from Mondrian's use of white wood to project his paintings. Two other contemporaneous paintings, *Lateral Volume No. 1* (1939–40, estate of the artist, Lyme, Conn.) and *Lateral Volume No. 2*, 1940 (fig. 1), are closely related in size, construction, and style to *Vertical Volume No. 1*. Holtzman saw these paintings, with their projected surfaces, as a "first step" in the engagement of real space and the destruction of illusory space.[2] He developed this concept further in *Sculpture (I)* by separating the image completely from the context of a wall.
GS

1 Harry Holtzman and Martin S. James, eds., *The New Art—The New Life: The Collected Writings of Piet Mondrian* (Boston, 1986), p. 357.
2 Harry Holtzman, in telephone conversation with Gail Stavitsky, June 7, 1987.

Exhibitions Museum of Art, Carnegie Institute, Pittsburgh, 1983–84, *Abstract Painting and Sculpture in America: 1927–1944* (trav. exh.), exh. cat. ed. by J. R. Lane and S. C. Larsen, no. 82.

Provenance The artist, until 1986.

Museum purchase: anonymous gift, 1986, 86.34

Sculpture (I), 1940

Oil and acrylic on gessoed Masonite
78 x 12 x 12 in. (198.1 x 30.5 x 30.5 cm)

Signature, date, and inscriptions: Harry Holtzman 1940. (upper right of black band); Harry Holtzman/1940/"Sculpture"/*oil* red yellow blue and *acrylic* on gesso over Masonite (on bottom)

With the rectilinear, freestanding column *Sculpture (I)*, Holtzman literally extended Mondrian's vocabulary of black and white, primary colors, straight lines, and right angles into the realm of the third dimension. Scaled to the height of the average viewer, each plane of *Sculpture (I)* presents a different painted, abstract composition that is partially linked to the adjacent sides through the extension of horizontal black lines. Walking around the work and viewing the corners as well as the sides, the spectator encounters shifting compositional relationships. The placement of *Sculpture (I)* on a Plexiglas base imparts the sense that it is hovering autonomously in space.

Around 1943 Mondrian made the following comments on the originality of this particular contribution to Neoplasticism:

> [Through Holtzman] modern art already shows efforts to express, [to] realize the essential qualities of painting and sculpture in architectural appearance. In actual three-dimensional works of H. H. the "picture" still more from the wall moves into our surrounding space. In this way the painting annihilates more literally the three-dimensional volume.[1]

Although Mondrian had emphasized the independent, objectlike quality of his paintings through their projection from the wall, he readily saw Holtzman as having made the greater advance along those lines. Mondrian regarded works such as *Sculpture (I)* as "a type of sculpture and painting [that is] truly more modern than mine . . . less traditional, and much closer to architecture."[2]

Sculpture (I), which preceded a closely related work, *Sculpture* (fig. 1), may have

Fig. 1 Harry Holtzman, *Sculpture,* 1941–42. Oil and tempera on cheesecloth or muslin laid down on Masonite, 60 x 12 x 13 in. (152.4 x 30.5 x 33 cm). Yale University Art Gallery, New Haven, Conn., gift of the artist to the Collection Société Anonyme, 1950

been exhibited in New York in the 1940 American Abstract Artists annual and was exhibited in 1942 at the Helena Rubenstein New Art Center. In an essay for the accompanying catalogue Holtzman articulated the reciprocity of his interests in abstract painting and sculpture. They were, he said, "expressed by the same essential plastic means: pure color, line, and plane. . . . Pure abstract art is expressed by the aesthetic integration of form and space. . . the integration of 'art' and 'architecture.'"[3]

In his late freestanding planar geometric pieces, Holtzman continued to develop works that intersect the domains of painting, sculpture, and architecture on a human scale, while, as he says, "destroying all possibility of illusory space by employing space itself."[4]

GS

1 Harry Holtzman and Martin S. James, eds., *The New Art—The New Life: The Collected Writings of Piet Mondrian* (Boston, 1986), p. 391.

2 Yves-Alain Bois, "New York City I, 1942 de Piet Mondrian," *Cahiers du Musée National d'Art Moderne* 15 (1985), p. 71, translation by Gail Stavitsky.

3 Harry Holtzman, "Painting and Sculpture," in *Masters of Abstract Art*, p. 19.

4 Harry Holtzman, in telephone conversation with Gail Stavitsky, June 7, 1987.

References J. R. Lane, "American Abstract Art of the '30s and '40s," *Carnegie Magazine* 56 (Sept.–Oct. 1983), pp. 15–16; Y.-A. Bois, "New York City I, 1942 de Piet Mondrian," *Cahiers du Musée National d'Art Moderne* 15 (1985), p. 71; H. Holtzman and M. S. James, eds., *The New Art—The New Life: The Collected Writings of Piet Mondrian* (Boston, 1986), p. 391.

Exhibitions Possibly Fine Arts Gallery, Columbia University, New York, 1940, *American Abstract Artists;* Helena Rubenstein New Art Center, New York, 1942, *Masters of Abstract Art*, no. 35, as *Sculpture*, 1941/42; Musée National d'Art Moderne, Centre National d'Art et de Culture Georges Pompidou, 1977, *Paris—New York*, pp. 440–41; Museum of Art, Carnegie Institute, Pittsburgh, 1983–84, *Abstract Painting and Sculpture in America: 1927–1944* (trav. exh.), exh. cat. ed. by J. R. Lane and S. C. Larsen, no. 83.

Provenance The artist, until 1983.

Edith H. Fisher Fund, 1983, 83.1

Winslow Homer

1836–1910

WINSLOW HOMER CAN justifiably be considered the most distinguished American Realist of the nineteenth century. He is virtually alone among the artists of his generation in having been admired through every decade of the twentieth century. He continues to be remembered for the same large, late paintings that accounted for his fame during his lifetime. These succinctly powerful canvases often presented nature as detached or subtly hostile. Homer himself is frequently described in much the same terms: an aloof figure who guarded his privacy, he has been cast as one of the archetypal lone geniuses in the history of art.

Born in Boston and raised in nearby Cambridge, Massachusetts, Homer learned to draw while serving an apprenticeship at Bufford's lithography shop. At the age of twenty-one, he began to work as an illustrator for magazines such as *Ballou's Pictorial Drawing Room Companion* and *Harper's Weekly*. In 1859 he moved to New York, where he studied drawing briefly at the National Academy of Design while continuing to work as a free-lance illustrator.

While a Civil War correspondent with *Harper's*, Homer produced his first significant work; in these years, he was responsible for some of the most uncompromisingly direct images in the history of the illustrated press. During the war he began to paint in oils, and until the 1870s he worked in both mediums, his paintings and magazine illustrations often corresponding closely to one another. At war's end, he began painting in earnest and was elected to the Century Association and the National Academy.

Homer's first major canvas, *Prisoners from the Front* (1866, Metropolitan Museum of Art, New York), was exhibited at the Exposition Universelle in Paris in 1867, an event that occasioned the artist's only trip to continental Europe. Although little is known about his stay in France, it is assumed that he observed and was affected by contemporary trends in French art. Upon returning to the United States, he resumed residence in New York, where he produced paintings of contemporary rural and resort scenes marked by strong design, bright outdoor

light, and a lack of sentimental overtones. In 1873 Homer began to paint in watercolors, joining the American Watercolor Society three years later. He continued to work in that medium for the rest of his life, becoming one of its foremost practitioners.

Homer's visit to England in 1881 gave rise to a watershed in his art. For fourteen months he lived and worked in Cullercoats, a bleak fishing village on the North Sea coast, where he sketched the labors of the local fisherfolk as they daily braved an often hostile sea. Returning to New York in November 1882, he continued to produce pictures based on his Cullercoats experiences. When he relocated in 1883 to Prout's Neck, Maine, themes of man's stoic confrontation with the dangers of the ocean became fixed in his art.

During the 1880s and 1890s, Homer produced the masterful watercolors and heroic canvases that brought him his national reputation. His settings ranged from the Maine coast and the Adirondack Mountains to the Bahamas. He exhibited widely and received a prodigious number of awards and honors. These included election to the National Institute of Arts and Letters and gold medals at the World's Columbian Exposition of 1893 in Chicago, the Pennsylvania Academy of the Fine Arts, Philadelphia, in 1896 and 1902, the Paris Exposition Universelle of 1900, the Pan-American Exposition of 1901 in Buffalo, the Charleston Exposition of 1902, and the Universal Exposition of 1904 in Saint Louis.

Homer achieved a remarkable measure of success in Pittsburgh. The first painting and first two drawings acquired for Carnegie Institute's permanent collection were by Homer. He won first prize at the first Carnegie International and exhibited in nine more between 1897 and 1908. He was given an astonishing tribute when twenty-two of his canvases were borrowed for the Carnegie International of 1908—the largest group of Homer's paintings to be shown in his lifetime. The artist had a friend and devoted admirer in John Beatty, the first director of the institute's Department of Fine Arts, who prevailed on him to provide his only jury service for any institution at the Internationals of 1897 and 1901. Carnegie Institute also held a large centenary exhibition of his work in 1937.

Although Homer fell seriously ill in 1906, he painted until the year before his death in Scarboro, Maine, at his Prout's Neck home.

Bibliography William Howe Downes, *The Life and Works of Winslow Homer* (Boston, 1911); Lloyd Goodrich, *Winslow Homer* (New York, 1944); John Wilmerding, *Winslow Homer* (New York, 1972); Whitney Museum of American Art, New York, *Winslow Homer* (1973), exh. cat. by Lloyd Goodrich; Gordon Hendricks, *The Life and Work of Winslow Homer* (New York, 1979).

The Wreck, 1896

Oil on canvas
30⅜ x 48⁵⁄₁₆ in. (77.2 x 122.7 cm)

Signature, date: *Winslow Homer/1896* (lower right)

The most populated of Homer's late works, *The Wreck* is one of his last and most dramatic interpretations of the theme of rescue at sea, which Homer had introduced in the 1880s. The composition derives from a painting begun around 1885 or 1886 entitled *To the Rescue* (fig. 1) depicting a fisherman and two women running urgently up a sand dune in stormy weather, the fog-banked shore partially hidden by the crest of the dune. Although he had promised it to his patron Thomas B. Clarke, Homer kept *To the Rescue* in his studio, unfinished, as working material for other compositions.

In 1891 Homer derived a second painting from that sketched-in canvas: *The West Wind* (fig. 2). He reduced the search party to one figure and lowered the point of view to conceal more of the shoreline. But it was not until he painted *The Wreck* five years later that Homer felt he had at last realized the thematic potential suggested by his canvas of ten years earlier.

The germ of the present painting was a shipwreck that Homer witnessed in 1896 along the dunes of Higgins Beach at Prout's Neck, near his friend Charles Jordan's farm. He made a quick thumbnail sketch of the lifeboat crew which he enclosed in a letter to his brother Charles.[1] At the same time, he began a painting on the theme.

Homer worked on the painting during the summer of 1896, sketching his neighbor John Gatchell as its main figure.[2] In *The Wreck*, Homer placed Gatchell in front of a lifeboat crew. The dunes surrounding him resemble those of the unfinished painting for Clarke still in his studio. Like the earlier painting, this has a skewed horizon and a low point of view, showing just a bit of sea and setting off the figures in the background against the sky. Homer finished *The Wreck* by October 5, when he wrote to Clarke:

> After all these years I have at last the subject of that sketch that I promised you. . . . The picture I have painted is called "The Wreck," and I sent it to the Carnegie Art Gallery for exhibition. I did not use this sketch that I am about to send you, but used what I have guarded for years, that is, the subject which your sketch would suggest.[3]

The Wreck is a virtual catalogue of thematic elements that Homer used in his previous depictions of rescues at sea. Here, a lifeboat is being pushed in great haste by a crew of seamen across a high dune to the ocean's edge. Beyond the crest of the dune a breeches buoy has been set up. Several men look on, their oilskins blowing in the wind and silhouetted against the sky. With the exception of one red scarf in the background, the coloring is restricted to shades of gray, tinted slightly with green and buff in the dunes and with blue in the sea and sky.

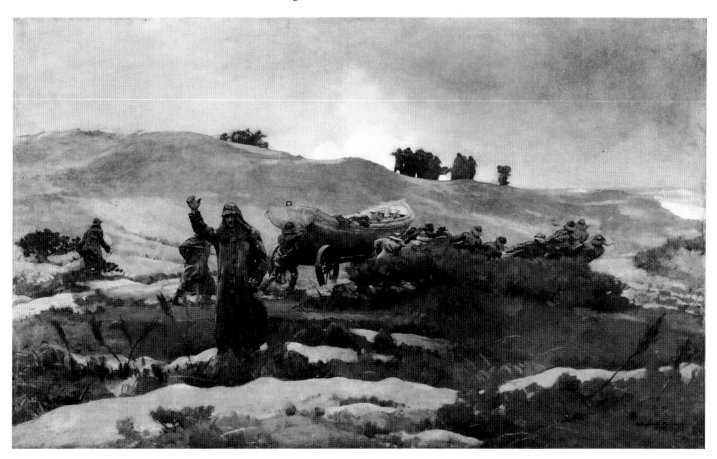

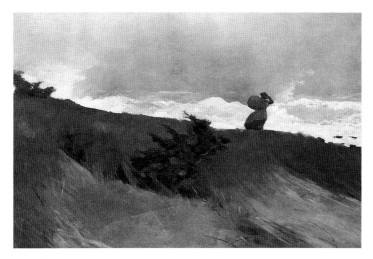

Fig. 1 Winslow Homer, *To the Rescue*, c. 1886. Oil on canvas, 24 x 30 in. (61 x 76.2 cm). Phillips Collection, Washington, D.C., 1926

Fig. 2 Winslow Homer, *The West Wind*, 1891. Oil on canvas, 30 x 44 in. (76.2 x 111.8 cm). Addison Gallery of American Art, Phillips Academy, Andover, Mass., gift of anonymous donor

Homer originally included a mast of the wrecked ship poking out from the dunes at the right. He had envisioned it to be rather large, as he indicated in a thumbnail sketch, which he drew on a Pittsburgh Club guest card for fellow jurors at the 1897 Carnegie International. However, he decided to paint the mast out, leaving a bleaker, uninterrupted horizon line and a greater sense of unease about the nature of the rescue.

Although he had initially promised John Beatty two entries, *The Wreck* was Homer's only painting at the first Carnegie International. It won the Chronological Medal and a purchase prize of five thousand dollars. This exceptionally high award, unmatched by

Carnegie Institute in subsequent years, was one of the most lucrative prizes bestowed upon any contemporary American artist and was effectively the highest price achieved by Homer for a single work.

Although it was not Homer's first major honor (he had won gold medals in Chicago in 1893 and earlier in 1896 at the Pennsylvania Academy of the Fine Arts, Philadelphia), this award seems to have affected the artist profoundly. He wrote John Beatty:

> Although chance may have given me this distinguished place in your permanent exhibition. . . I shall prove if possible by my future work, that your opinion & this award have not been misplaced.[4]

And on December 9, 1896, he wrote to Thomas Clarke:

> It is certainly a most tremendous & unprecedented honor & distinction I have received from Pittsburgh. Let us hope that it is not too late in my case to be of value to American Art in something that I may yet possibly do, from this encouragement.[5]

DS

1 Philip C. Beam, *Winslow Homer at Prout's Neck* (Boston, 1966), p. 149.

2 The same sheet of two charcoal sketches of Gatchell (1896, Cooper-Hewitt Museum, New York) also served for Homer's canvas *The Lookout—All's Well* (1896, Museum of Fine Arts, Boston).

3 Downes, *The Life and Works of Winslow Homer*, p. 188.

4 Goodrich, *Winslow Homer*, p. 141 (the letter is not among Carnegie Institute Papers, Archives of American Art, Washington, D.C.).

5 Downes, *The Life and Works of Winslow Homer*, pp. 150–51.

References F. W. Morton, "The Art of Winslow Homer," *Brush and Pencil* 10 (Apr. 1902), pp. 40–54; J. W. Pattison, "The Awarding of Honors in Art," *Fine Arts Journal* 23 (Aug. 1910), pp. 69, 82; Downes, *The Life and Works of Winslow Homer*, pp. 181, 187–90, 231, 267; C. Brinton, "Winslow Homer," *Scribner's Magazine* 49 (Jan. 1911), pp. 9–23; J. W. Beatty, *A Brief Lesson on Some Important Qualities in Paintings* (Pittsburgh, 1917), pp. 7–8; H. Saint-Gaudens, "The Carnegie Institute," *Art and Archaeology* 14 (Nov.–Dec. 1922), pp. 295, 297; W. Starkweather, "He Painted the Might of the Sea: Winslow Homer, Man and Artist," *Mentor* 13 (July 1925), pp. 45–50; F. Watson, review of San Francisco exhibition, "Selected Paintings by American Artists," *Arts* 11 (Jan. 1927), pp. 47, 48; "Our Veritable Old Masters," *Literary Digest* 105 (June 7, 1930), pp. 19–20; E. A. Jewell, "In the Realm of Art: Current Exhibitions," *New York Times*, Nov. 17, 1935, sec. 10, p. 10; M. Davidson, "A Final Word on Winslow Homer," *Art News* 35 (Dec. 19, 1936), pp. 9, 24; G. P. du Bois, "Two Exhibitions of Winslow Homer," *Magazine of Art* 30 (Jan. 1937), pp. 50–51; J. O'Connor, Jr., "Winslow Homer Centenary," *Carnegie Magazine* 10 (Jan. 1937), p. 234; "Homer in Pittsburgh," *Art Digest* 11 (Feb. 15, 1937), p. 13; H. Saint-Gaudens, "Winslow Homer," *Carnegie Magazine* 10 (Feb. 1937), pp. 259–68; "Pittsburgh Homer Show," *Art News* 35 (Mar. 6, 1937), pp. 19–20; J. O'Connor, Jr., "A Footnote to *The Wreck*," *Carnegie Magazine* 10 (Mar. 1937), pp. 300–301; "The Story of American Painting Is Retold in Cleveland Exhibition," *Art Digest* 11 (Aug. 1, 1937), p. 6; F. Watson, *Winslow Homer* (New York, 1942), p. 59;

Goodrich, *Winslow Homer*, pp. 139–41, 167–68, 215, 217; T. Bolton, "Homer Revisited at the Whitney," *Art News* 43 (Oct. 15–31, 1944), pp. 16–19; R. M. Coates, "Man from Maine," *New Yorker*, Mar. 1, 1947, pp. 53, 54; J. Gibbs, "Honoring Homer," *Art Digest* 21 (Mar. 1, 1947), pp. 10, 33; J. O'Connor, Jr., "From Our Permanent Collection: *The Wreck* by Winslow Homer," *Carnegie Magazine* 23–24 (Jan. 1950), pp. 201–2, 205; J. O'Connor, Jr., "The Pittsburgh International," *Carnegie Magazine* 26 (June 1952), p. 203; G. B. Washburn, "Notable Paintings in Pittsburgh," *American Society Legion of Honor Magazine* 25 (Summer 1954), p. 137; H. J. Seligman, "Bachelor of Maine, Winslow Homer," *Down East* (Jan. 1958), pp. 27–30; A. T. E. Gardner, *Winslow Homer, American Artist: His World and His Work* (New York, 1961), p. 202; H. Ingalls, "Elements in the Development of Winslow Homer," *Art Journal* 24 (Fall 1964), pp. 18–22; P. C. Beam, *Winslow Homer at Prout's Neck* (Boston, 1966), pp. 148–51, 207; J. T. Flexner, *The World of Winslow Homer* (New York, 1966), pp. 110–11; *"The Wreck," Carnegie Magazine* 40 (Feb. 1966), p. 69; Wilmerding, *Winslow Homer*, pp. 173–74; H. W. Williams, Jr., *Mirror to the American Past: A Survey of American Genre Painting, 1750–1900* (Greenwich, Conn., 1973), p. 190; G. Hendricks, "The Floodtide in the Winslow Homer Market," *Art News* 72 (May 1973), pp. 69–71; G. R. Carlsen and R. C. Carlsen, eds., *Perception: Themes in Literature* (New York, 1975), p. 284; D. G. Wilkins, "The American Painting Collection at the Sarah Scaife Gallery, Carnegie Institute, Pittsburgh," *American Art Review* 2 (Mar.–Apr. 1975), pp. 96, 100; Hendricks, *The Life and Work of Winslow Homer*, pp. 188, 229–31, 265; V. A. Clark, "Collecting from the Internationals," *Carnegie Magazine* 56 (Sept.–Oct., 1982), pp. 17, 22; H. Adams, in Museum of Art, Carnegie Institute, *Collection Handbook* (Pittsburgh, 1985), p. 212; M. A. Judge, *Winslow Homer* (New York, 1986), p. 84.

Exhibitions [Department of Fine Arts, Carnegie Institute, Pittsburgh], 1896, *First Annual Exhibition*, no. 143; Union League Club, New York, 1897, *Paintings by American Artists*, no. 15; Worcester Art Museum, Mass., 1901–2, *Catalogue of Pictures*, no. 10; Department of Fine Arts, Carnegie Institute, Pittsburgh, 1908, *Twelfth Annual Exhibition*, no. 141; Com. General Harrison S. Morris, organizer, Rome, 1911–12, *International Exposition of Art and History*, no known cat.; Panama-Pacific International Exposition, Palace of Fine Arts, San Francisco, 1915, *Official Catalogue of the Department of Fine Arts*, no. 2,520; Dallas Art Association, Adolphus Hotel, Dallas, 1922, *Third Annual Exhibition: American Art from the Days of the Colonists to Now*, no. 85; Fine Arts Gallery of San Diego, 1926, *Inaugural Exhibition of the Fine Arts Gallery of*

San Diego, no. 31; California Palace of the Legion of Honor, San Francisco, 1926–27, *First Exhibition of Selected Paintings by American Artists*, no. 100; Museum of Modern Art, New York, 1930, *Sixth Loan Exhibition: Winslow Homer, Albert P. Ryder, Thomas Eakins*, no. 14; M. H. de Young Memorial Museum, San Francisco, 1935, *Exhibition of American Painting*, no. 126; Walker Galleries, New York, 1935, *Six Americans*, unnumbered; The Texas Centennial Exposition, Dallas Museum of Fine Arts, 1936, *Exhibition of Paintings, Sculptures, and Graphic Arts*, no. 19; Virginia Museum of Fine Arts, Richmond, 1936, *Main Currents in the Development of American Painting*, no. 58; Whitney Museum of American Art, New York, 1936–37, *Winslow Homer Centenary Exhibition*, no. 30; Cleveland Museum of Art, 1937, *Exhibition of American Painting from 1860 until Today*, no. 88; Columbus Gallery of Fine Arts, Ohio, 1937, *Ten Paintings by Winslow Homer*, exh. cat. by P. R. Adams, in *Columbus Gallery of Fine Arts Monthly Bulletin* (Mar. 1937), unnumbered; Department of Fine Arts, Carnegie Institute, Pittsburgh, 1937, *Centenary Exhibition of Works by Winslow Homer*, exh. cat. by H. Saint-Gaudens, no. 22; Baltimore Museum of Art, 1938, *Two Hundred Years of American Painting*, no. 20; Department of Fine Arts, Carnegie Institute, Pittsburgh, 1939, *A Century of American Landscape Painting, 1800–1900*, no. 39; Palace of Fine Arts, San Francisco, 1940, *Golden Gate International Exposition, Art—Official Catalogue*, no. 1,208; Wildenstein and Co., New York, 1947, *A Loan Exhibition of Winslow Homer for the Benefit of the New York Botanical Garden*, no. 33; Department of Fine Arts, Carnegie Institute, Pittsburgh, 1957, *American Classics of the Nineteenth Century* (trav. exh.), no. 58; Department of Fine Arts, Carnegie Institute, Pittsburgh, 1958–59, *Retrospective Exhibition of Paintings from Previous Internationals*, no. 6; Art Gallery of Ontario, Toronto, 1961, *American Painting, 1865–1905* (trav. exh.), no. 38; University of Arizona Art Gallery, Tucson, 1963, *Yankee Painter: A Retrospective Exhibition of Oils, Watercolors and Graphics by Winslow Homer*, no. 26; Gallery at the Better Living Center, New York World's Fair, 1964, *Four Centuries of American Masterpieces*, no. 16; Museum of Art, Carnegie Institute, Pittsburgh, 1965, *The Seashore: Paintings of the Nineteenth and Twentieth Centuries*, no. 147; Bowdoin College Museum of Art, Brunswick, Me., 1966, *Winslow Homer at Prout's Neck*, exh. cat. by P. Beam, no. 37; Whitney Museum of American Art, New York, 1966, *Art of the United States, 1670–1966*, exh. cat. by L. Goodrich, no. 141; Whitney Museum of American Art, New York, 1973, *Winslow Homer* (trav. exh.), no. 63; Center for the Fine Arts, Miami, 1984, *In Quest of Excellence*, exh. cat. by J. Van der Marck et al., no. 117.

Provenance The artist, until 1896.

Purchase, 1896, 96.1

See Color Plate 16.

Edward Hopper
1882–1967

EDWARD HOPPER'S WORK has made him one of the most revered American painters of the twentieth century. His stark depictions of isolated buildings, silent interiors, and empty streets show both a desire to record the details of ordinary life and a modernist's appreciation for the power of abstract form. The structural clarity and subtle psychological edge of Hopper's work distinguish him from the other painters of the American scene with whom he is usually associated.

Born and raised in Nyack, New York, Hopper had his initial artistic training at the Correspondence School of Illustrating in New York. After a year there, he enrolled at the New York School of Art, where he studied from 1900 to 1906 under Robert Henri and Kenneth Hayes Miller.

Although Hopper visited Paris in 1906 to study the old masters and paint city scenes, and although he returned to Europe briefly in 1909 and 1910, his point of view was American from the start. His early ambition was to be a commercial illustrator, and this was the means by which he financed his trips to Europe and supported himself through the slow start of his career as a serious artist.

As illustrator and painter, Hopper focused on the American scene with consistently sober concentration. This vision was already apparent in 1913, the year he sold his first oil composition, *Sailing* (see p. 269), which had appeared in the Armory Show in New York. Hopper did not sell his second canvas until 1923. While he had not given up painting, he put a great deal of effort into etching and drypoint from 1915 to the mid-1920s, the interval in his career generally credited with developing his personal style and his strong feel for value contrasts and essential form.

Hopper's first solo exhibition took place in 1920 at the Whitney Studio Club in New York, followed by another at the same location in 1922.[1] Two years later Frank K. M. Rehn organized a Hopper watercolor exhibition that met with great success and prompted the artist's resumption of oil painting. After four solo exhibitions beginning in 1924 in Boston,

Hartford, Connecticut, and New York, Hopper was featured in a 1929 exhibition at the Museum of Modern Art in New York, entitled *Paintings of Nineteen Living Americans.* The previous year had marked his first inclusion in the Carnegie International,[2] where he continued to exhibit frequently until his death.

After his marriage in 1924, Hopper settled in New York but summered in New England, specifically at Gloucester, Massachusetts, and Rockland, Maine. His imagery correspondingly divided itself between, on the one hand, the isolated urban streets and lone figures in city buildings that had already become part of his work, and, on the other hand, equally imposing views of a harsh, empty New England countryside.

While maintaining a commitment to journalistic accuracy and impartiality, Hopper was able to evoke moods that transcend descriptive particulars. From the 1930s onward, he was the recipient of many accolades and honors, including election, in 1932, to the National Academy of Design (which he refused); the purchase prize from the Worcester Art Museum, Massachusetts, in 1935; retrospective exhibitions at the Museum of Modern Art in 1933, Carnegie Institute in 1937, and the Whitney Museum of American Art, New York, in 1950 and 1964; and election to the National Institute of Arts and Letters (1945) and the American Academy of Arts and Letters (1955). The enduring nature of Hopper's work is perhaps best proven by its ability to appeal equally to the representational and modernist camps of artists and critics.

Hopper died in his studio in New York City.

1 Goodrich, *Edward Hopper* (1976), p. 154.

2 John J. O'Connor, Jr., "From Our Permanent Collection," *Carnegie Magazine* 24 (May 1950), p. 351.

Bibliography Lloyd Goodrich, *Edward Hopper* (London, 1971); Lloyd Goodrich, *Edward Hopper* (New York, 1976); Gail Levin, *Edward Hopper: The Art and the Artist* (New York, 1980); Robert Hobbs, *Edward Hopper* (New York, 1987).

Sailing, c. 1911
(The Sailboat)

Oil on canvas
24 x 29 in. (61 x 73.7 cm)
Signature: E. HOPPER (lower left)

Sailing is among the best known of Hopper's early paintings. First shown in 1912, it was one of five works representing the artist at the MacDowell Club of New York in a jury-free group exhibition. The following year Hopper exhibited *Sailing* once more when the Domestic Exhibition Committee invited him to participate in the landmark Armory Show. Purchased for $250, the work became Hopper's first and only sale until 1923.[1]

The sailing theme appeared early in Hopper's work as both a reflection of his personal fondness for nautical sports and a manifestation of traditional American subject matter; an early ink drawing is also entitled *Sailing* (1900, Whitney Museum of American Art, New York). As a boy he passed considerable time exploring the banks of the Hudson River and investigating the thriving shipyards of Nyack; at the age of fifteen he constructed his own catboat. Although he gave up active participation in the sport at the request of his wife,[2] he maintained a lifelong interest in sailing. In this painting, Hopper discarded specific narrative and capitalized on the spontaneity and some of the romance of sailing, a sport in which man is placed in contact with nature in elemental terms.

The style of the painting corresponds to the directness of the artist's thematic presentation. The landscape elements are reduced to two horizontal bands of varying width, sky and sea, which form an unyielding backdrop to the sailboat's stark silhouette. While holding forms to a minimum, Hopper enlivened the pictorial surface through colors and textures. Unadulterated outdoor light, conveyed by thickly applied oil pigment, permeates the scene, giving it an optical strength and uncompromising integrity.

Investigations of this painting's heavily textured surface have led to the fascinating discovery of a self-portrait beneath the *Sailing* scene. Gail Levin, examining the work in preparation for the 1981 Hopper retrospective at the Whitney Museum of American Art, New York, discerned the basic outline of a face painted vertically on the canvas. Subsequent X rays of the painting (fig. 1) prompted

Lawrence Majewski to identify the image as an early self-portrait, probably painted between 1904 and 1906.[3] David G. Wilkins revealed that the diagonal slash prominent in the present painting originally demarcated the collar of Hopper's jacket, while other visible pentimenti clearly reveal the shape of the head and ear.[4]

Sailing remains a document of considerable art-historical importance because it articulates Hopper's early style and suggests the direction of the art of his maturity.

LM

1 Levin, *Edward Hopper: The Art and the Artist*, p. 29.

2 Ibid., p. 153.

3 Donald Miller, "X-Ray of Painting Yields Artist's Self-Portrait," *Pittsburgh Post-Gazette*, December 30, 1980, p. 15.

4 David G. Wilkins, "Edward Hopper's Hidden Self-Portrait," *Carnegie Magazine* 55 (March 1981), pp. 4–6.

References "Edward Hopper: A Lucid Portfolio of Victorian Houses, Railway Scenes, By a Top Notch American Realist," Pittsburgh *Bulletin Index,* Mar. 18, 1937, p. 19; "Carnegie Traces Hopper's Rise to Fame," *Art Digest* 11 (Apr. 1, 1937), p. 14, as *The Sailboat;* S. Burrey, "Edward Hopper: The Emptying Spaces," *Art Digest* 29 (Apr. 1, 1955), p. 9; L. Cooke, "Paintings by Edward Hopper," *America Illustrated* 32 (July 23, 1958), n.p.; M. W. Brown, *The Story of the Armory Show* (New York, 1963), pp. 251, 313; review of exhibition at the Munson-Williams-Proctor Institute, Utica, N.Y.,

Fig. 1 X-radiograph of Edward Hopper, *Sailing*

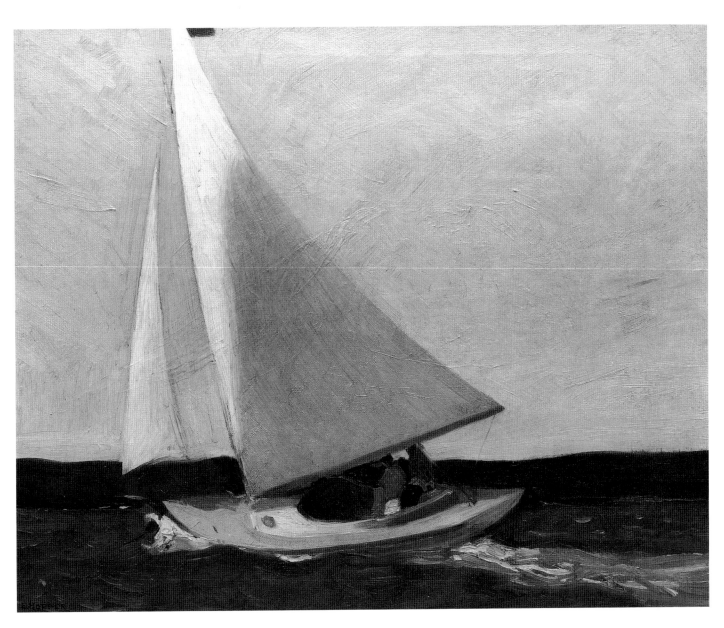

"The Current Scene," *Arts* 37 (Feb. 1963), p. 20; G. Nachman, "Closeup: Artist at 82," *New York Post*, Nov. 27, 1964, p. 5; B. O'Doherty, "Portrait: Edward Hopper," *Art in America* 52 (Dec. 1964), p. 73; B. Rose, *American Art since 1900: A Critical History* (New York, 1967), p. 124; Goodrich, *Edward Hopper* (1971), pp. 28, 167; J. R. Mellow, "The World of Edward Hopper," *New York Times Magazine*, Sept. 5, 1971, p. 16; B. O'Doherty, *American Masters: The Voice and the Myth* (New York, 1973), p. 17; H. B. Teilman, "Art in Residence," *Carnegie Magazine* 47 (Nov. 1973), p. 364; D. G. Wilkins, "The American Painting Collection at the Sarah Scaife Gallery, Carnegie Institute," *American Art Review* 2 (Mar.–Apr. 1975), pp. 100–101, 108, n. 11; Goodrich, *Edward Hopper* (1976), p. 19; N. Heiler and J. Williams, "Edward Hopper, Alone in America," *American Artist* 40 (Jan. 1976), p. 72; B. Rose, *American Painting: The*

Twentieth Century (New York, 1977), p. 46; G. Levin, *Edward Hopper: The Complete Prints* (New York, 1979), pp. 3–4; Levin, *Edward Hopper* (1980), pp. 28–29; D. Miller, "Hopper Art Stirs Debate," *Pittsburgh Post-Gazette*, Jan. 1, 1981, p. 34; D. G. Wilkins, "Edward Hopper's Hidden Self Portrait," *Carnegie Magazine* 55 (Mar. 1981), pp. 4–6; C. W. Millard, "Edward Hopper," *Hudson Review* 34 (Oct. 1, 1981), p. 392; E. S. Jacobowitz and G. H. Marcus, *American Graphics, 1860–1940* (Philadelphia, 1982), p. 49; S. Lane Faison, Jr., *The New England Eye: Master American Paintings from the New England School, College and University Collections* (Williamstown, Mass., 1983), pp. 40–42; F. Webbs, *Watercolor Energies* (Fairfield, Conn., 1983), p. 21.

Exhibitions MacDowell Club of New York, 1912, *Exhibition of Paintings*, no. 37; American Association of Painters and Sculptors, Armory of the Sixty-ninth Regiment, New York, 1913, *International Exhibition of Modern Art* (trav. exh.), no. 751; American Academy of Arts and Letters and National Institute of Arts and Letters, New York, 1955, *An Exhibition of Paintings and Sculpture Commemorating the Armory Show of 1913 and the First Exhibition of the Society of Independent Artists in 1917 with Works by Members Who Exhibited There*, no. 2; Mead Art Building, Amherst College, Amherst, Mass., 1958, *Armory Show in Retrospect*, no. 23; Munson-Williams-Proctor Institute, Utica, N.Y., 1963, *1913 Armory Show: Fiftieth Anniversary Exhibition, 1963* (trav. exh.), no. 751; Museum of Art, Carnegie Institute, Pittsburgh, 1973, *Art in Residence: Art Privately Owned in the Pittsburgh Area*, no cat.;

Virginia Museum of Fine Arts, Richmond, 1976, *American Marine Painting* (trav. exh.), exh. cat. by F. Brandt, no. 58; Whitney Museum of American Art, New York, 1980, *Edward Hopper: The Art and the Artist* (trav. exh.), exh. cat. by G. Levin, unnumbered.

Provenance Thomas F. Vietor, 1913; Henry E. Butler, Rumson, N.J.; Edward A. Early, Rumson, N.J.; Frank K. M. Rehn, New York, by 1952; Mr. and Mrs. James H. Beal, Pittsburgh, 1952.

Gift of Mr. and Mrs. James H. Beal in honor of the Sarah Scaife Gallery, 1972, 72.43

Cape Cod Afternoon, 1936

Oil on canvas
34 x 50 in. (86.4 x 127 cm)
Signature: Edward Hopper (lower right)

Hopper painted *Cape Cod Afternoon* during the summer of 1936 when, uncharacteristically, he worked at the site outdoors.[1] Originally intended for a solo exhibition at Carnegie Institute in 1937, the painting instead appeared that year in the Fifteenth Biennial of the Corcoran Gallery of Art in Washington, D.C. The Corcoran jury, including William Glackens, John Steuart Curry, William M. Paxton, Daniel Garber, and Richard Lahey, awarded *Cape Cod Afternoon* the first W. A. Clark Prize of two thousand dollars and the Corcoran Gold Medal.[2] The work was exhibited at the 1937 Carnegie International and was promptly purchased by Carnegie Institute.[3]

The Corcoran Biennial, with *Cape Cod Afternoon* as its focal point, drew widespread approbation from critics, who hailed modern American artists for their independence from European exemplars. Dorothy Grafly, the art critic for the *Philadelphia Record*, commented:

> Today art in this country has a flavor of its own. More sober, less volatile than the European variety, it clings tenaciously to what it sees, drawing its emotional reactions from the soil rather than from the many psychoses that have led Europeans . . . along blind alley tangents. This homely, soil-bred art strikes one as America's creative salvation. [T]he point of view is growing more . . . American . . . because it is beginning to see life with American, not foreign eyes.[4]

Cape Cod Afternoon dovetails well with Grafly's general assessment of the exhibition, since the work shows Hopper's independent vision, devoid of overt debts to European sources. As Gail Levin relates, the artist passed numerous summers at South Truro, Massachusetts, on Cape Cod, directing his attention to both architecture and landscape.[5] Hopper had first visited the area in 1930 and later built his own house on Cape Cod in 1934. From that vantage point he recorded *Cape Cod Afternoon*, an austere treatment of New England architecture rising in simplified forms against the rural landscape.

The composition at once accommodates both modernist and representational concerns, for Hopper's reductive treatment of the facades as successive planes of alternating value successfully translates into abstract and descriptive statements. As Hopper incisively recorded the lengthening shadows of late afternoon, he generated a painterly field of variant greens scumbled deftly across the canvas. Yet,

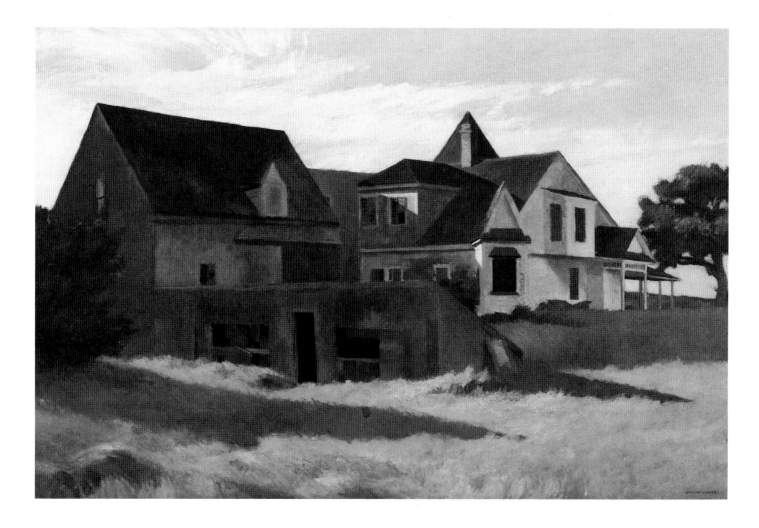

despite the modernist aspects of Hopper's composition, the specific Regionalist flavor of the scene is not sacrificed. Lloyd Goodrich, discussing Hopper's rapport with the Cape Cod area, states: "Its austerity, its sandy moor, its pine and scrub oaks, the severe simplicity of its white-painted houses and churches, the sense of the sea never far off—all fit Hopper's temperament."[6]

LM

1 Gail Levin, *Edward Hopper at Kennedy Galleries* (New York, 1977), n.p.

2 "Progressives Win All Honors at Corcoran's Fifteenth Biennial," *Art Digest* 11 (April 1, 1937), p. 5.

3 John O'Connor, Jr., "Patrons Art Fund Purchase," *Carnegie Magazine* 11 (December 1937), p. 205.

4 "Progressives Win All Honors," p. 6.

5 Whitney Museum of American Art, *Edward Hopper: The Art and the Artist*, p. 63.

6 Lloyd Goodrich quoted in John O'Connor, Jr., "From Our Permanent Collection, *Cape Cod Afternoon*," *Carnegie Magazine* 24 (May 1950), p. 351.

References Review of Fifteenth Corcoran Biennial, Washington, D.C. *Evening Star*, Mar. 22, 1937, sec. A, p. 3; "Edward Hopper Wins First Clark Painting Prize," *New York Herald Tribune*, Mar. 23, 1937, p. 17; review of Fifteenth Corcoran Biennial, *New York Times*, Mar. 23, 1937, p. 25; "Progressives Win All Honors at Corcoran's Fifteenth Biennial," *Art Digest* 11 (Apr. 1, 1937), p. 5; "The Corcoran: American Cross-Section," *Art News* 35 (Apr. 3, 1937), p. 14; "Edward Hopper's Cape Cod Wins a $2000 Prize," *Life*, May 3, 1937, p. 44; "Artist Found Prize Subject Outside Truro," *Cape Cod* (Hyannis, Mass.) *Standard-Times*, May 4, 1937; E. Brace, "Edward Hopper," *Magazine of Art* 30 (May 1937), p. 277; E. A. Jewell, "Americans at Carnegie," *New York Times*, Oct. 24, 1937, p. 10; J. O'Connor, Jr., "Patrons Art Fund Purchase," *Carnegie Magazine* 11 (Dec. 1937), pp. 203–5; "A Portfolio of Prize Paintings," *Fortune* 16 (Dec. 1937), p. 137; "Patrons in Deed," *Art Digest* 12 (Jan. 1, 1938), p. 11; "Two Purchases for the Carnegie," *Art News* 36 (Jan. 1, 1938), p. 15; "Art: U.S. Painting," *Time*, Jan. 3, 1938, p. 28; M. C. Cheney, *Modern Art in America* (New York, 1939), no. 109; W. S. Hall, *Eyes on America* (London, 1939), p. 62; American Artists Group, *Edward Hopper* (New York, 1945) n.p.; J. O'Connor, Jr., "From Our Permanent Collection, *Cape Cod Afternoon*," *Carnegie Magazine* 24 (May 1950), pp. 351–52; K. Kuh, *The Artist's Voice: Talks with Seventeen Artists* (New York, 1962), pp. 130–31; D. G. Wilkins, "The American Painting Collection at the Sarah Scaife Gallery, Carnegie Institute," *American Art Review* 2 (Mar.–Apr. 1975), p. 101; G. Levin, *Edward Hopper at Kennedy Galleries* (New York, 1977), n.p.; V. A. Clark, "Collecting from the Internationals," *Carnegie Magazine* 56 (Sept.–Oct. 1982), pp. 21, 24; H. Adams in Carnegie Institute, Museum of Art, *Collection Handbook* (Pittsburgh, 1985), pp. 252–53; R. Hobbs, *Edward Hopper* (New York, 1987), pp. 107–9.

Exhibitions Corcoran Gallery of Art, Washington, D.C., 1937, *The Fifteenth Biennial Exhibition of Contemporary American Oil Paintings*, no. 260; Department of Fine Arts, Carnegie Institute, Pittsburgh, 1937, *The 1937 International Exhibition of Paintings*, no. 64; Bloomington Art Association, Bloomington, Ill., 1939, *Central Illinois Art Show*, no. 71; San Francisco Bay Exposition Co., Palace of Fine Arts, 1940, *Golden Gate International Exposition*, no. 1,366; Museum of Art, Rhode Island School of Design, Providence, 1946, *Museum's Choice* (trav. exh.), no cat.; Institute of Modern Art, Boston, 1947, *Thirty Massachusetts Painters in 1947*, no. 25; Whitney Museum of American Art, New York, 1950, *Edward Hopper Retrospective Exhibition* (trav. exh.), exh. cat. by L. Goodrich, no. 46; Columbus Gallery of Fine Arts, Ohio, 1952, *Paintings from the Pittsburgh Collection*, no cat.; Virginia Museum of Fine Arts, Richmond, 1953, *Judge the Jury*, no cat.; Currier Gallery of Art, Manchester, N.H., 1956, *Painters by the Sea*, no. 2; Corcoran Gallery of Art, Washington, D.C., 1957, *The Twenty-fifth Biennial Exhibition of Contemporary American Oil Paintings*, no. 15; Department of Fine Arts, Carnegie Institute, Pittsburgh, 1958, *1896–1955: Retrospective Exhibition of Paintings from Previous Internationals*, no. 72; Westmoreland County Museum of Art, Greensburg, Pa., 1961, *Founder's Day Exhibition*, no cat.; Corcoran Gallery of Art, Washington, D.C., 1963, *The New Tradition: Modern Americans before 1940*, no. 52; Kalamazoo Art Center, Mich., 1966, *Paintings by American Masters: Fifth Anniversary Exhibition*, unnumbered; Whitney Museum of American Art, New York, 1980, *Edward Hopper: The Art and the Artist* (trav. exh.), exh. cat. by G. Levin, unnumbered.

Provenance The artist, until 1937; with Frank K. M. Rehn, New York, as agent, 1937.

Patrons Art Fund, 1937, 38.2

See Color Plate 30.

Anna Hyatt Huntington
1876–1973

ONE OF AMERICA'S most prominent women sculptors, Anna Vaughn Hyatt Huntington achieved her fame during the decades after World War I. Heroic, mythical, and zoological subjects in bronze were her areas of specialization. Although she was active through the mid-twentieth century, the style of her work remained close to the turn-of-the-century academicism in which she was trained.

Born in Cambridge, Massachusetts, Huntington was the daughter of Alpheus Hyatt, who taught zoology and paleontology at the Massachusetts Institute of Technology and Boston University. She naturally developed an early interest in zoological subjects. At the family's summer home on Cape Ann, she enjoyed observing animals and became especially fond of horses. Her sister Harriet and the Boston bronze sculptor Henry Hudson Kitson were responsible for her first lessons in modeling. In 1900 the Boston Art Club held the first exhibition of her work, with almost fifty animal studies, most of which sold. By 1903 she was studying in New York, with George Grey Barnard at the Art Students League and then with Hermon MacNeil. She made studies of animals at the Bronx Zoo and sought the criticism of Gutzon Borglum, whose ambitious sculptural compositions of stampeding horses she admired. In this period she produced a number of fluently modeled, naturalistic interpretations of wild animals.

From 1906 to 1909 Huntington continued her study of sculpture in France and Italy, winning an honorable mention at the Paris Salon of 1910 for a plaster cast of an equestrian Joan of Arc. A version of the same model (see p. 272) won the competition for a monumental Joan of Arc sculpture to commemorate American and French relations. It was erected in New York on Riverside Drive with replicas in Gloucester, Massachusetts, and Blois, France. The acclaim Huntington received for this group eclipsed her previous achievements and brought her the title Chevalier of the French Legion of Honor in 1922.

Other large-scale work soon followed, including a standing wall statue of Joan of Arc for the New York Cathedral of Saint John the Divine, in 1922, and *Diana of the Chase* (Brookgreen Gardens, Murrells Inlet, S.C.). For the latter she received the Saltus Medal from the National Academy of Design in 1922.

In 1923 Anna Hyatt married the railroad heir Archer M. Huntington. Soon afterward, she created, for the city of Seville, Spain, another equestrian sculpture, *El Cid Campeador*, inspired by her husband's translation of the twelfth-century epic poem. A replica was made for the Hispanic Society in New York, of which Archer Huntington was a founder. In 1930 the Huntingtons purchased Brookgreen Gardens on the South Carolina coast as a nature preserve, which became a garden setting for her work and eventually for the works of other American sculptors as well.

Until 1937 Huntington was involved in reproducing large portions of her work for both Brookgreen Gardens and the Hispanic Society. At this time she cast many of her works in aluminum—one of the first sculptors to do so.[1] She continued to accumulate a prodigious number of awards from, among other sources, the American Academy of Arts and Letters, the National Sculpture Society, New York, the National Academy of Design, and the French and Spanish governments. In 1937 Carnegie Institute held a solo exhibition of her sculpture. Huntington continued to work within the vein of veristic animal sculpture into the 1960s. She died at her home in Redding, Connecticut, at the age of ninety-seven.

1 Craven, *Sculpture in America*, p. 547.

Bibliography Anna Coleman Ladd, "Anna V. Hyatt—Animal Sculptor," *Art and Progress* 4 (1912), pp. 773–76; Frederick Newlin Price, "Anna Hyatt Huntington," *International Studio* 79 (August 1924), pp. 319–23; Kineton Parkes, "An American Sculptress of Animals, Anna Hyatt Huntington," *Apollo* 16 (August 1932), pp. 61–66; Myrna Garvey Eden, "The Significance of the Equestrian Monument *Joan of Arc* in the Artistic Development of Anna Hyatt Huntington," Syracuse University Library Associates *Courier* 12 (1975), pp. 2–12; Wayne Craven, *Sculpture in America* (1968; rev. ed., Newark, Del., 1984), pp. 545–47.

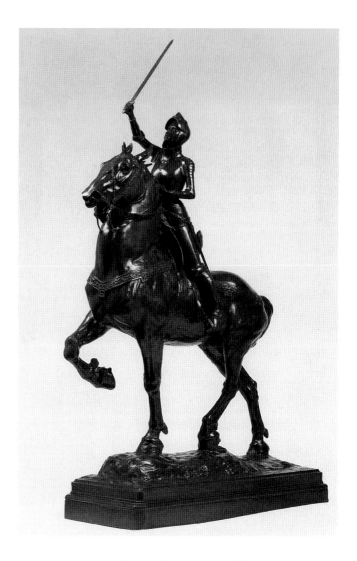

Joan of Arc, c. 1910–15, cast after 1917

Bronze
50½ x 11½ x 27¼ in. (128.3 x 29.2 x 69.2 cm)
Markings: Anna V. Hyatt (base top, proper left)

Huntington's reputation was largely established with the success of this single equestrian sculpture. She first conceived her *Joan of Arc* in France. During a strenuous four-month period in the former studio of Jules Dalou, she worked up the model, which involved constructing the armature without assistance and covering it with a ton of clay. The model was completed in 1909, the year Joan of Arc was beatified.[1] The novelty of Huntington's treatment was her decision to perch a petite, rounded, almost doll-like form of Joan of Arc on a muscular, deliberately oversized mount. As a model, she used a Percheron, a breed of horse used for delivery wagons, one of which was lent her by the operators of the Louvre warehouse. The plaster cast won an honorable mention in the Paris Salon of 1910.

Shortly afterward, in New York, Huntington entered a competition for a commission to create a monument in celebration of the five-hundredth anniversary of Joan of Arc's birth in 1412 and in commemoration of Franco-American amity.[2] The sculptor began reworking her Salon entry, incorporating details of fifteenth-century armor that Bashford Dean, a curator of medieval art at the Metropolitan Museum of Art, New York, had researched for her, and enlarging her model so that it was one-fourth larger than life-size.[3] Her work, which emphasized accurate historical detail and monumental size rather than the lively and fluent surfaces of her earlier sculptures, won the competition.[4] The final bronze was unveiled at its Riverside Drive site in

New York on December 6, 1915, sitting on a base made in part from the stone of the Rouen dungeon in which Joan had been imprisoned.[5] One of the first equestrian monuments ever created by a woman, the sculpture also won attention for marking the progress of women in the sculptural field. Huntington produced a standing *Joan of Arc* in 1922 for the Cathedral of Saint John the Divine, New York, while in the same year replicas of the equestrian *Joan of Arc* were erected in Gloucester, Massachusetts, and in the city of Blois in France.

Joan of Arc had been used throughout the nineteenth century by the French as a symbol of their much desired national unity; many French painters and sculptors had created emblematic images of her in various attitudes, whether praying, listening to her "voices," or rallying French forces. These works were doubtless Huntington's immediate sources of inspiration: in particular, Emmanuel Fremiet's well-known gilded equestrian *Joan of Arc* (c. 1874/reworked c. 1889) in the Place des Pyramides, Paris, and Paul Dubois's equestrian sculpture, which had been exhibited at the Paris Salons of 1889 and 1895 and then placed in front of the cathedral in Rheims. The Dubois sculpture—a doll-like figure with its sword held aloft—seems to have provided Huntington with her starting point.

Huntington's interpretation was perhaps also inspired by her reading of Mark Twain's *Personal Recollections of Joan of Arc* (published in 1896 under the pseudonym of Sieur Louis de Conte) and the poetry of Alphonse de Lamartine. In any case, the statue she created is visibly different from those of her French predecessors in that her Joan's gaze, fixed firmly on the sword she lifts above her head, embodies an unworldly spirituality and courageousness. Huntington stated that she had envisioned Joan of Arc "before her first battle, speaking to her saints, holding up the ancient sword. Her wrist is sharply back, to show the hilt, which is in the form of a cross. . . . It was only her mental attitude, only her religious fervor, that could have enabled her to endure so much physically."[6] Although the Carnegie's version of *Joan of Arc* is without foundry mark, it may be one of several replicas—one of which is in the Archer M. Huntington Art Gallery, University of Texas at Austin—cast by the Gorham Company, which also produced a smaller, fifteen-inch version of the sculpture.

KP

1 Eden, "The Significance of the Equestrian Monument *Joan of Arc*," p. 6.

2 Ibid.

3 Ibid., pp. 9–10.

4 Craven, *Sculpture in America*, p. 546.

5 Grace Humphries, "Anna Vaughn Hyatt's Statue," *International Studio* 57 (December 1915), p. L.

6 Ibid., p. XLVIII.

Remarks The sword was damaged around 1976.

References L. Mechlin, "Anna Hyatt Huntington, Sculptor," *Carnegie Magazine* 11 (June 1937), pp. 67–71; J. O'Connor, Jr., "*Joan of Arc*, Bronze Presented to the Carnegie Institute by Anna Hyatt Huntington," *Carnegie Magazine* 11 (Mar. 1938), p. 304; L. Mechlin, "Pittsburgh: Anna H. Huntington Gives a Famous Work, *Joan of Arc*, to the Carnegie," *Art News* 36 (Apr. 23, 1938), p. 17.

Exhibitions American Academy of Arts and Letters, New York, 1936, *Exhibition of Sculpture by Anna Hyatt Huntington*, no. 46; Department of Fine Arts, Carnegie Institute, Pittsburgh, 1937, *Exhibition of Sculpture by Anna Hyatt Huntington*, no. 2.

Provenance The artist, until 1938.

Gift of the artist, 1938, 38.3

Fighting Elephants, c. 1911–14

Bronze
11 x 22⅞ x 8 in. (27.9 x 58.1 x 20.3 cm)
Markings: Anna V. Hyatt (base front edge, proper right)

Fighting Elephants epitomizes the naturalistic animal studies that created Anna Hyatt Huntington's early reputation. The sculpture has the fluent modeling and tactile surfaces that characterize French bronze-making technique in the late nineteenth and early twentieth centuries. The appearance of these traits here indicates not only the young Hyatt's precociousness but also the excellent instruction she received in the studios of Paris-trained sculptors, both in America and in France.

The relatively small bronze is one of a series of animal sculptures Hyatt executed from her studies of the animals at the Bronx Zoo in New York in the first two decades of the century. These include fighting goats, tigers, and jaguars, which, in final form, resemble the bronze groups of fighting animals Antoine-Louis Barye had made so famous in the mid-nineteenth century. Huntington gave her animals a tense, asymmetrical balance and a sense of movement to every surface. These livelier, more greatly detailed surfaces distinguish her early animal sculptures from her later, more simplified animal figures.

Replicas of *Fighting Elephants* are located at the Museum of Fine Arts, Boston (stone), and the Smith College Museum of Art, Northampton, Massachusetts (bronze).

KP

Exhibitions Art Institute of Chicago, 1916, *Twenty-ninth Annual Exhibition of American Oil Paintings and Sculptures*, no. 632; Department of Fine Arts, Carnegie Institute, Pittsburgh, 1937, *Exhibition of Sculpture by Anna Hyatt Huntington*, no. 16.

Provenance The artist, until 1917.

Purchase, 1917, 17.16

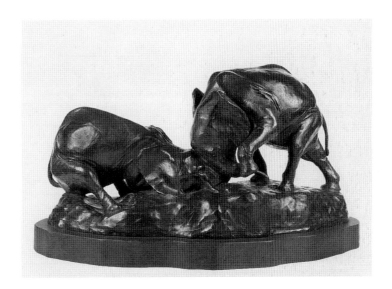

J. Howard Iams

1897–1964

ALTHOUGH HE STUDIED in New York City and exhibited his work around the country, John Howard Iams is known mainly as a small-town painter who produced his most interesting pictures—scenes from ordinary life, many of them tinged with melancholy—in the late 1920s and early 1930s. Born and raised in Bethlehem Township in southwestern Pennsylvania, he served in World War I, returned home to work as a carpenter, and from 1919 to 1921 attended the College of Fine Arts of the Carnegie Institute of Technology in Pittsburgh. He then decided to go to New York, where from 1922 to 1924 he studied under George Bridgman and Thomas Fogarty at the Art Students League.

Iams settled in Washington, Pennsylvania; his exhibiting career began in 1926, when four of his paintings were shown at the Associated Artists of Pittsburgh's annual exhibition. In the late 1920s he exhibited at the National Academy of Design, New York, the Art Institute of Chicago, and the Pennsylvania Academy of the Fine Arts, Philadelphia. He did well in regional artists' organizations. He exhibited at the Southern States Art League in Houston and with the

Society of Washington Artists at the Corcoran Gallery of Art, where in 1928 he won the still-life painting prize. However, lasting recognition eluded him; at the Carnegie Internationals, where he perhaps suffered from a bias against Pittsburgh artists, all thirteen works he entered between 1926 and 1930 were rejected.

The portraits, genre subjects, and landscape views Iams painted were all representational images, usually quiet in tone, yet firmly drawn, with deep shadows and rather austere coloring. During the 1930s he became interested in the depiction of old rural buildings that had historical associations. This historically oriented subject also accounts for the artist's most ambitious series, a group of thirty-four woodcuts, pastels, and oil paintings representing the homes of—and incidents involving—the participants in the 1794 Whiskey Rebellion of West Virginia, Ohio, and western Pennsylvania.

In 1939 Iams moved to Harrisburg, Pennsylvania, where he did free-lance commercial artwork; in 1947 he moved to Mechanicsburg, Pennsylvania, to work briefly as a mechanical draftsman for the Sinclair Pipe Line Company. In 1948 he and his wife moved to Marion, Ohio, where he remained for the rest of his life.

Bibliography "Art: Gulf [Corp.] Galleries," Pittsburgh *Bulletin Index*, September 14, 1933, p. 6; Westmoreland County Museum of Art, Greensburg, Pa., *Southwestern Pennsylvania Painters, 1800–1945* (1981), exh. cat. ed. by Paul A. Chew and John A. Sakal, pp. 65–67.

Little Mother, c. 1927

Oil on canvas
30 x 24 in. (76.2 x 61 cm)
Signature: J. HOWARD IAMS (lower right)

This is a portrait of the artist's niece Hilda Lois, but it could be any girl playing with her dolls. The relatively small canvas has the compositional spareness and the prettiness combined with melancholy that mark Iams's works of the late 1920s. One of his strongest figure compositions, it is visually accessible and thematically comprehensible, like most of

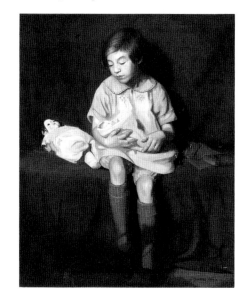

his paintings. Although rejected for the 1927 Carnegie International, it received some favorable press the following year.

In 1928 Iams's work attracted the attention of two French reviewers who, perhaps after seeing the artist's entry at the National Academy of Design, New York, made him the subject of a note in *Revue du vrai et du beau*, a biweekly popular-arts magazine. The review illustrated *Little Mother*, another portrait, and a genre painting called *In Quest* (c. 1928, location unknown), which showed a lone figure entering a shadowy church. It praised the precision of Iams's drawing and the expressive quality of his light. It also applauded his morality, emotion, and "admirable sense of truth," and ventured that Iams was a painter of great talent who honored not only his country but art in general.[1]

DS

1 Comte Chabrier and Gabriel Sérac, "Expositions d'Amérique," *Revue du vrai et du beau* 7 (April 10, 1928), p. 9.

Reference Comte Chabrier and G. Sérac, "Expositions d'Amérique," *Revue du vrai et du beau* 7 (Apr. 10, 1928), p. 9.

Provenance The artist's sister; her children, Gene Ann Rush, Hilda Lois Rush, and Mel Iams Rush, Phoenix, Ariz.

Gift of Gene Ann Rush, Hilda Lois Rush, and Mel Iams Rush, 1981, 81.83.

George Inness

1825–1894

ONE OF THE MOST important and original American landscape painters of the late nineteenth century, George Inness is remembered for pictorial experiments that led him from the tightly controlled, precisely drawn panoramas of his early years to the atmospheric, painterly, and poetic landscapes of his last decade. His innovative brushwork and use of color made him one of the most modern American painters of his time and had a lasting impact on a younger generation of artists.

Born at Newburgh, New York, Inness moved with his family to Newark, New Jersey, in 1829, and thereafter to several other locations within the northeastern United States. The epileptic son of a prosperous grocer, he had a religious upbringing that fostered in him a deep and abiding interest in spiritual philosophies. He was proud that his early formal artistic training was minimal: a few lessons with the itinerant painter John Jesse Barker and two years as an apprentice engraver in New York City.

Around 1843 Inness studied briefly with Régis-François Gignoux, a French landscapist then working in Brooklyn. Gignoux inspired Inness with an admiration for the Italian and Dutch landscape painting traditions as practiced by Claude Lorrain, Gaspard Dughet, and Meyndert Hobbema. By the late 1840s, Inness was a frequent exhibitor at the National Academy of Design and the American Art-Union in New York and had earned a modest degree of success. The critics praised his paintings for their sweeping breadth and finely realized details, yet found a number of his stylistic devices too reminiscent of the old masters, making his work look artificial.

Although Inness had visited Europe before, it was his second trip abroad, from 1853 to 1854, that had the greater impact on his art. Under the influence of the Barbizon school, especially Théodore Rousseau, he began to experiment with freer brushwork, brighter colors, and less formal compositions, which were incorporated into his early masterpiece *The Lackawanna Valley* (1855, National Gallery of Art, Washington, D.C.). He devoted the subsequent years to creating a visually striking, emotionally expressive style based on the richer surfaces of Barbizon painting. However, Inness did not consistently achieve critical approval for his efforts until the 1860s. Although he became an associate member of the National Academy of Design in 1853, he was not elected to full membership until 1868, long after his more popular contemporaries Frederic E. Church and Jasper F. Cropsey.

Both the content and the style of Inness's paintings were influenced by his conversion in the 1860s to the teachings of Emanuel Swedenborg, an eighteenth-century scientist turned mystic. Swedenborg posited the existence of a spiritual world that mirrored the physical one with a few key exceptions: in the spiritual world, objects were not fixed in space or time and colors far surpassed those of nature in splendor. Inness began trying to express this spiritual world by intensifying his palette and slightly softening the outlines of objects.

Inness spent the years from 1870 to 1874 in Italy. On his return, he lived in Boston and then in New York before finally moving to Montclair, New Jersey. His paintings of the 1870s emphasized nature's more dramatic moments, such as sunsets and thunderstorms, with richer colors, rougher textures, and more evocative atmosphere, as exemplified by *The Monk* (1873, Addison Gallery of American Art, Andover, Mass.), his best-known work of the period.

By 1880 Inness finally began to attain the public recognition and financial security that had so long eluded him. Between 1879 and his death in 1894, he exhibited in New York, San Francisco, Boston, Chicago, Philadelphia, London, and Paris. He won a second-class medal in Munich in 1892 and was included in the first Carnegie International in 1896. His most significant exhibition was a retrospective of 1884 organized by the American Art Association in New York.

During the last decade of his life, Inness produced his most powerful works, in which richly textured, glowing colors suffuse the pictorial space. By subordinating detail and form to the atmospheric effects of color and light, he created paintings that were almost abstractly decorative, yet still easily readable landscapes. At a time when the leading landscapists of the nineteenth century such as Church and Albert Bierstadt were all but forgotten, Inness was hailed as the greatest landscape painter of his day. He died, while traveling, at Bridge-of-Allan, Scotland. A public funeral was held at the National Academy of Design, followed by a memorial exhibition sponsored by the American Fine Arts Society at the Fine Arts Building, New York.

Bibliography George Inness, Jr., *The Life, Art, and Letters of George Inness* (New York, 1917); George Walter Vincent Smith Art Museum, Springfield, Mass., *George Inness: An American Landscape Painter, 1825–1894* (1946), exh. cat. by Elizabeth McCausland; LeRoy Ireland, *The Works of George Inness: An Illustrated Catalogue Raisonné* (Austin, 1965); Nicolai Cikovsky, Jr., *George Inness* (New York, 1971); Los Angeles County Museum of Art, *George Inness* (1985), exh. cat. by Nicolai Cikovsky, Jr., and Michael Quick.

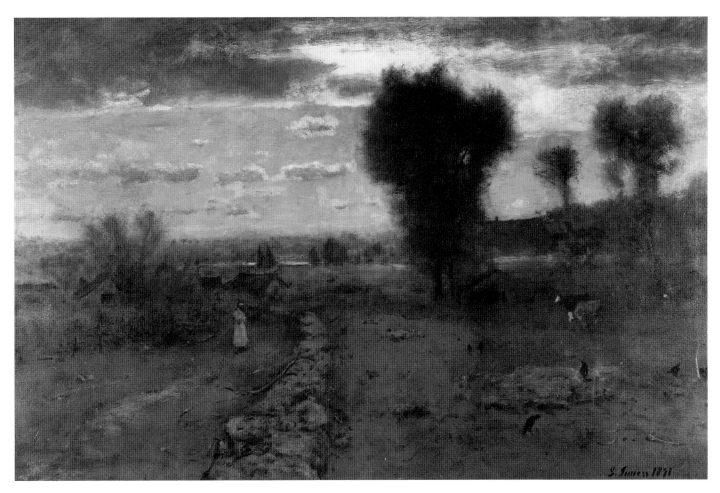

The Clouded Sun, 1891

Oil on canvas
30⅛ x 45¼ in. (76.5 x 114.9 cm)
Signature, date: *G. Inness 1891* (lower right)

By combining the evocative qualities of color with the logic of mathematical proportions, Inness successfully suggested both the spiritual and the natural worlds in the paintings of his last decade. These qualities are exemplified in *The Clouded Sun.*

 This painting is ostensibly a view of a farmstead: a stone wall leads from the foreground pastures to a group of cottages or outbuildings in the middle distance; in the space between, a sprinkling of trees, some grazing cattle, and a figure who seems to gaze at them across the wall are pictured. The figure and animals have an air of quiet expectation as though they await a moment of revelation or spiritual illumination. The pervasive feeling of spaciousness and ordered tranquillity is due to Inness's horizontal banding of the composition, accented by the rhythm of verticals as represented by the trees, the

path, and the wall. In this impression of harmony and quiet, controlled space is heightened by the use of closely related tones of muted blues, grays, and greens. The simple composition and the soft colors draw the eye irresistibly to the focus of the painting: that area of the background where light escapes from a clouded sun and is reflected back from a small body of water directly below.

 During Inness's last decade, color became increasingly important in his art, as it was used both to differentiate individual forms and to draw all the pictorial elements into a harmonious unity. With color he fashioned forms by building up layers of transparent glazes and scumbling and created unity in several ways. First, he used chromatic chords to tie together disparate pictorial elements; in *The Clouded Sun*, the peach and yellow highlights in the clouds are echoed in the path, the wall, and the vegetation of the foreground. Second, the sky's middle tone was placed at the horizon, creating an

ambiguous boundary between earth and air. Finally, Inness suffused the entire painting with an opalescent glow: light seems to rise from below as well as fall from above.

 The Clouded Sun was not meant to represent any particular landscape view. At this point in his career, Inness had totally abandoned painting or even sketching from nature. The landscapes of his last ten to fifteen years were studio compositions, products of his experience and imagination. The true subject of the painting was his religious philosophy, based on the teachings of Emanuel Swedenborg. Inness believed, as did Swedenborg, that a spiritual world was implicit in the physical one. The observer, with the help of the artist as interpreter, could penetrate beyond the appearance of things to the spiritual reality beyond. Although written nearly ten years before *The Clouded Sun* was painted, the comments of a contemporary critic on religion in Inness's art are appropriate: "In the mind of Inness, religion, landscape, and human nature mingle so

thoroughly that there is no separating the several ideas. . . . Let us, then rather say of his religion that he does not express, but hides it, in his art."[1] Perhaps the hidden sun in this painting may be read as a symbol of the spiritual world, obscured but still perceptible in the natural world around us.

Inness's late paintings were extremely popular with the critics and the public alike, as shown by the 1899 sale of the well-regarded collection of Thomas B. Clarke. Although the collection contained works by the best contemporary American painters, three of Inness's late works, including *The Clouded Sun*, fetched the highest prices. One reason for this surge in popularity and critical acclaim was that the formal issues that Inness had mastered after years of experimentation became of paramount importance throughout the late-nineteenth-century art world. For the first time since Inness began painting, his highly original style was in tune with public taste and with the artist's new role as an interpreter—rather than simply a presenter—of his subject. His contemporaries were attracted to the rich colors, abstract

design, and intellectual depth of paintings such as *The Clouded Sun*, where visual beauty is heightened by an intimation of spirituality.

RB

1 Charles DeKay, "George Inness," *Century Magazine* 24 (May 1882), p. 63.

References E. T. Clarke, "Alien Element in American Art," *Brush and Pencil* 7 (Oct. 1900), p. 39; C. H. Caffin, *American Masters of Painting* (New York, 1902), p. 9; "Inness," *Masters of Art* 9 (June 1908), p. 40; J. W. Pattison, "The Awarding of Honors in Art," *Fine Arts Journal* 23 (Aug. 1910), p. 67; E. Daingerfield, *Fifty Paintings by George Inness* (New York, 1913), no. 32; Ireland, *The Works of George Inness*, no. 1,365, pp. 347–48; F. A. Myers, "The Clouded Sun," *Carnegie Magazine* 40 (June 1966), p. 213; J. T. Flexner, *Nineteenth-Century American Painting* (New York, 1970), p. 172; H. Adams, in Museum of Art, Carnegie Institute, *Collection Handbook* (Pittsburgh, 1985), pp. 204–5.

Exhibitions Paris, 1900, *Fine Arts Exhibit of the United States, Paris Exposition*, no. 66; San Francisco, 1915, *Panama-Pacific International Exhibition*, no. 2,539; Fine Arts Gallery of San Diego, 1926, *Inaugural Exhibition*, no. 34; M. H. de Young Memorial Museum and California Palace of the Legion of Honor, San Francisco, 1935, *Exhibition of American Painting*,

no. 140; Whitney Museum of American Art, New York, 1938, *A Century of American Landscape Painting* (trav. exh.), no. 33; Fogg Art Museum, Cambridge, Mass., 1941, *American Landscape Painting: George Inness to George Bellows*, no. 3; George Walter Vincent Smith Art Museum, Springfield, Mass., 1946, *George Inness: An American Landscape Painter* (trav. exh.), no. 40; Corcoran Gallery of Art, Washington, D.C., 1949, *De Gustibus. . . An Exhibition of American Paintings Illustrating a Century of Taste and Criticism*, no. 31; Department of Fine Arts, Carnegie Institute, 1957, *American Classics of the Nineteenth Century* (trav. exh.), no. 45; Art Gallery of Toronto, 1961, *American Painting, 1865–1905* (trav. exh.), no. 42; University Art Museum, University of Texas, Austin, 1965, *The Paintings of George Inness*, no. 115; Los Angeles County Museum of Art, 1985, *George Inness* (trav. exh.), exh. cat. by N. Cikovsky, Jr., and M. Quick, no. 52.

Provenance Thomas B. Clarke, New York, until 1899 (sale, American Art Association, New York, Feb. 17, 1899).

Purchase, 1899, 99.9

See Color Plate 15.

Joe Jones

1909–1963

BEST KNOWN FOR HIS Social Realist painting of the 1930s, Joseph John Jones was born in Saint Louis and grew up there, on "the faintly respectable edge of a slum."[1] After leaving school at age fourteen, he hoboed across the country. His proletarian background and these early experiences led him in the early 1930s to become a communist, a fact that determined the content of his art throughout the decade.

Like his father, Jones was a house painter by trade; he had no formal artistic training. His earliest known works, which date from around 1931, are Precisionist still lifes and industrial scenes that depict Saint Louis as a sterile yet well-honed machine. As the Great Depression deepened, he began to paint the more run-down quarters of the city, stressing the desolation within them. He also created works explicitly protesting the capitalist system. While conducting a painting class for the federal Public Works of Art Project he produced a mural for the Saint Louis Court House, but because of its left-wing sentiments, the mural was suppressed and Jones dismissed as teacher.

In 1935 Jones moved to New York City, where he almost immediately had a solo show at the American Contemporary Artists Gallery, which specialized in work of Social Realist artists. This exhibition, dominated by portrayals of lynchings and strikers, met with great critical acclaim. According to Herman Baron, director of ACA, the show's success brought proletarian art into the mainstream.[2] Jones remained active in leftist art circles through the 1930s. Vice-chairman of the American Artists Congress in 1936, he subsequently joined the American Artists Group, an organization devoted to creating inexpensive prints for a mass audience.

In addition to paintings and prints, Jones created five post-office murals for the United States Department of the Treasury Section of Painting and Sculpture. Beginning in 1937 (and until the early 1950s) he became a regular contributor to Carnegie Institute's annual exhibitions.

Jones frequently painted the farmlands of his native region. He spent the summer of 1935 in the wheat fields of Missouri, an experience that led to a large series of harvest paintings. He was also sent by the federal Resettlement Administration to paint America's drought-stricken farming areas, work he continued in 1937 on a Guggenheim Fellowship. Consequently, some of his scenes are celebratory images of farmers cultivating America's abundance while others emphasize their hardships in graphic images of dust storms, drought, and erosion.

Jones depicted proletarian themes throughout the 1930s, moving from explicit protest paintings to explorations of the degenerative effects of poverty, discrimination, and unemployment in the latter part of the decade. However, like many artists of his generation, he eventually abandoned such subjects in order to address purely aesthetic concerns. On the advent of World War II, Jones turned to landscape painting, his dominant subject through the 1940s. In 1943 he was sent by the War Department to paint the Alaskan theater, specifically the Alcan Highway. On this trip he met Henry Varnum Poor, whose summarily rendered landscape sketches proved a decisive influence on Jones. In contrast to the blocky forms, harsh, linear rhythms, and strong color of his previous work, a swift, calligraphic depiction of form with an overlay of subdued, translucent color now marked his style.

Jones's post-1943 paintings represent a complete change for him. His paintings were no longer concerned with communicating ideas but with creating an aesthetic experience. According to Jones, he was interested "only in the pleasure I was able to find in terms of possible linear and color suggestions [the scene]

offered. . . . Good paintings are surprises that evolve from aesthetic rightness on the painting surface."[3] He discovered the interpretation of a scene through drawing: "Drawing. . . has become for me a sensuous action. . . . The calligraphy of the orientals and . . . of Rembrandt are my loves of the past."[4]

Reflecting the prevailing abstract aesthetic, Jones's paintings of the 1950s and 1960s were ever more sketchily rendered. In addition to landscapes he began to paint studio subjects, such as figural groups and still lifes. His last works were almost wholly abstract, consisting of highly stylized landscape and figural motifs superimposed on large color masses.

The artist died in Morristown, New Jersey.

1 Marquis W. Childs, "Three St. Louis Artists," *American Magazine of Art* 28 (August 1935), p. 487.

2 ACA Gallery, *Joe Jones* (1940), and Matthew Baigell, *The American Scene: American Painting of the 1930s* (New York, 1974), p. 58.

3 "Presenting Joe Jones," p. 40.

4 Joe Jones to Emily Genauer, April 1947, Emily Genauer Papers, Archives of American Art, Washington, D.C.

Bibliography ACA Gallery, New York, *Joe Jones* (1937), exh. cat. by Herman Baron; ACA Gallery, New York, *Joe Jones* (1940), exh. cat. by Herman Baron; Associated American Artists, New York, *Joe Jones: Paintings* (1943); "Presenting Joe Jones," *American Artist* 11 (April 1947), pp. 40–41.

The Carter Refinery at Billings, Montana, c. 1944–45

Oil on canvas
30 x 40 in. (76.2 x 101.6 cm)
Signature: *Joe Jones* (lower left)

The Carter Refinery at Billings, Montana was painted for Standard Oil of New Jersey as part of a series of over one hundred works, whose purpose was "to record the flow of oil from the time it was brought out of the ground to its ultimate uses in far parts of the world."[1] Standard Oil saw a need for the series because "few of us know much of the complexities of modern oil technology. . . despite the part petroleum plays in powering our modern

industrial society."[2] Sixteen artists participated in the project, including Howard Norton Cook, Adolf Dehn, Ernest Fiene, and Thomas Hart Benton. Eight documented petroleum production; the other eight depicted the use of oil overseas during World War II. Standard Oil viewed the series primarily as an educational tool. The work of each artist was featured in an article in the *Lamp*, the corporate newsletter. The paintings were also exhibited at Associated American Artists Gallery in New York, in January 1946, and then sent to universities and museums nationwide.

Standard Oil was not alone in employing American artists during the 1940s. Indeed, during that decade Jones received corporate commissions from Lucky Strike, Niagara Alkalai Company, and Abbott Laboratories, among others. Initially, corporate commissions related to the activities of the sponsor. However, after the war many companies commissioned paintings on general themes. For example, Jones and thirteen other artists were commissioned by Gimbel's department store to paint a series on Pennsylvania. Jones contributed to similar series treating the life of Missouri, New York, and Michigan, all with corporate sponsors. Like the Standard Oil project, these commissions were negotiated through Associated American Artists, Jones's dealer in the 1940s.

Jones's specific assignment for Standard Oil was to record the activities of their subsidiary, the Carter Oil Company. He painted both at Elk Basin, a large oil field spanning the Montana-Wyoming border, not far from Yellowstone Park, and at the Carter refineries connected to Elk Basin by a pipeline. In all Jones painted seven works for this commission, including *Elk Basin* and *Breaking the Joint* (c. 1940–45, formerly Standard Oil Company, New York).[3]

The Carter Refinery at Billings, Montana exemplifies the landscape style Jones developed in the mid-1940s. In this work

the artist seems concerned primarily with creating a vivacious play of line and a harmonious arrangement of red, browns, blue-gray, and black. The painting conveys an impression of spaciousness as well as a sense of scintillating movement, but it tells the viewer little about the workings of a refinery, the ostensible subject of the painting. This lack of documentary detail in Jones's Standard Oil paintings drew mixed reactions from company employees. Emily Genauer recounted a conversation between an employee and Jones regarding one work:

"Why," he asked Jones, "have you painted a derrick with three legs when you see it has four?" "Why," asked Jones, "does it have four?" "Because," said the engineer, "four legs are functional for a derrick. It needs them to stand on." "Well," replied the artist, "three legs are functional for my picture. Anyone can see that's a derrick. After I have established that fact, its function is to serve the purpose of my own construction, complete the pattern of the picture, [and] fall in with certain linear rhythms."[4]

The aesthetic implied in this statement applies equally well to *The Carter Refinery at Billings, Montana*, as does Jones's statement that in his new landscape style he had "taken the work out of [painting] and left only the joy."[5]

JRM

1 "Art's Place in Industry," *Lamp* 27 (December 1945), p. 8.

2 Associated American Artists, New York, *Oil: An Exhibition of Documentary Paintings from the Collection of the Standard Oil Company* (1946), exh. cat., n.p.

3 Ibid., n.p., and "Oil in Elk Basin," *Lamp* 28 (February 1946), pp. 13–15.

4 Emily Genauer, "Gallery Gossip," *New York World Telegram*, January 27, 1945, Associated American Artists Papers, Archives of American Art, Washington, D.C.

5 *Art News* 44 (February 15, 1945), p. 28.

Exhibition Associated American Artists, New York, 1946, *Oil: An Exhibition of Documentary Paintings from the Collection of the Standard Oil Company*, unnumbered.

Provenance Standard Oil Company (of New Jersey), New York, by 1945.

Gift of the Standard Oil Company (of New Jersey), New York, 1951, 51.7

John Kane

1860–1934

JOHN KANE WAS a self-trained painter whose success coincided with—and was due to—the advent of modernism in American art, which created a taste for the primitive and naïve. Kane had turned to art during an era (the early 1900s) and in a city (Pittsburgh) that recognized only the academically trained professional. His unprecedented admission to the Carnegie annual exhibition in 1927 and his subsequent rise to fame helped dispel at last the obscurity in which most American folk artists had labored. His autobiography, *Sky Hooks* (a reference to the hooks that secure a house painter's scaffold), which he dictated during the last two years of his life, is a unique record of the life and thought of an American folk artist.

Kane (whose family name was originally Cain) was born in West Calder, Scotland, where his Irish parents had settled around 1856. Deeply religious throughout his life, the boy had little formal education, leaving the schoolroom at the age of nine to work in the local shale mines. Following his stepfather, he immigrated to the Pittsburgh area in 1879,

finding employment first as a railroad worker, then as a pipe finisher and coke miner.

Between 1884 and 1886, Kane worked as a miner in Alabama, Tennessee, and Kentucky. He began to draw, making landscape sketches for his own amusement. He might never have become a painter, however, had it not been for a serious accident: in 1891 his left leg was severed below the knee, thus disqualifying him for heavy labor. He managed to support himself as a railroad watchman, but marriage and the birth of a daughter obliged him to find a better-paying job.

In 1898 Kane went to work painting freight cars, having been taught by the contractor who hired him. He was particularly proud of having learned to mix any color he desired from the three primaries, black, and white. He began painting landscapes, and when he found himself unemployed shortly after 1900, he eked out a living by coloring portrait photographs.

The death of Kane's long-awaited, newborn son in 1904 was a devastating blow to the artist. He began to drink, and as he said, "the picture business got away from me."[1] He resumed the life of an itinerant laborer, and for twenty-three years lived apart from his wife. For a time he worked in Pittsburgh, painting decorations for amusement parks and a new hotel, as well as a factory in Charleston, West Virginia.

In 1910, after becoming a carpenter's apprentice in Youngstown, Ohio, he moved on to Akron, where the construc-

tion of a rubber works provided steady employment for a while. According to his autobiography, his stay in Akron was particularly important:

> I applied myself industriously to drawing and painting. I devoted every possible second of my spare time to making pictures, to getting down the snatches of beauty I saw every day. I would slip out into the country of a Sunday and would set down whatever I saw—the fields, the hillsides, the trees and little streams and a hundred things besides. . . . In Akron I made the greatest forward strides in my pictorial work. [2]

Kane wandered through Ohio, Pennsylvania, and West Virginia until 1918, when he returned to Pittsburgh to work in the Westinghouse Company's wartime munitions plant. He remained in Pittsburgh, living by his skills as a painter and carpenter. His earliest extant works date from this period and show a formula that varied little in the course of his career: modestly sized canvases showing flattened, disjointed compositions that were realized through bright, slightly gritty paint.

Although on several occasions Kane attempted to enroll at art schools, his efforts were frustrated by his inability to pay. Sometime between 1905 and 1908 he offered himself as an assistant to the eminent John White Alexander, who at that time was working on a series of murals for Carnegie Institute. Alexander's refusal

failed to discourage him. Two decades later, with unshakable faith in his talent, he submitted his work to the Carnegie International. This 1925 submission was rejected, as was that of the following year. When the jury accepted *Scene from the Scottish Highlands* (see p. 282) in 1927, Kane regarded it as nothing more than the recognition due him.

The 1927 International made Kane an overnight celebrity. From Pittsburgh to New York, the press paraded him as a curiosity: a sixty-seven-year-old house painter who had "crashed" (the verb is used in virtually every newspaper account) the nation's most prestigious forum for contemporary art. Distinguished collectors, including Duncan Phillips, John Dewey, Leon Kroll, and Abby Aldrich Rockefeller, purchased his paintings, but Kane's work continued to be seen as outside the art world. From time to time he was accused of plagiarism, of merely painting over photographs. Also, paradoxically, he was criticized for his work's inaccuracies, while even the so-called realist painters were regularly allowed poetic license.

In 1929 Kane gave up house painting to devote himself entirely to art. He exhibited at the annuals of the Associated Artists of Pittsburgh; the Harvard Society for Contemporary Art, Cambridge, Massachusetts; the Museum of Modern Art, New York; the Art Institute of Chicago; the Pennsylvania Academy of the Fine Arts, Philadelphia; the Whitney Museum of American Art, New York; and at every Carnegie annual exhibition until his death.

By 1934, when he died in Pittsburgh of tuberculosis, Kane had a confirmed position as a serious artist of major talent. A memorial exhibition at Carnegie Institute in 1936 was followed by a show in London—Kane's first foreign exhibition. Since then his work has been regularly included in group surveys of folk and modern art, both in the United States and abroad.

Carnegie Institute did not acquire an example of Kane's work until 1939, when G. David Thompson, president of a Pittsburgh brokerage firm, donated *Turtle Creek Valley, No. 1* (c. 1930, collection Mr. and Mrs. James Russell, New York).

Thompson claimed to have bought his first Kane in 1924, when the artist was still unknown. He was acknowledged to be one of Kane's greatest friends and supporters, despite accusations that he took work from Kane's studio[3] and belittled the value of Kane's work to dealers.[4]

Carnegie Institute returned *Turtle Creek Valley, No. 1* to Thompson at his request in 1954, but immediately replaced it with *Larimer Avenue Bridge* (see p. 291). Twelve more paintings entered the collection between 1959 and 1981, and today The Carnegie Museum of Art houses the largest single collection of his work.

1 Kane, *Sky Hooks*, p. 110.

2 Ibid., pp. 121, 126.

3 Margaret Kane Corbett to Samuel Harden Church, March 17, 1939, museum files, The Carnegie Museum of Art, Pittsburgh.

4 Maynard Walker to Leon Arkus, June 11, 1973, museum files, The Carnegie Museum of Art, Pittsburgh.

Bibliography John Kane, *Sky Hooks: The Autobiography of John Kane* (Philadelphia, 1938); Sidney Janis, *They Taught Themselves: American Primitive Painters of the Twentieth Century* (New York, 1942), pp. 76–98; Leon Anthony Arkus, *John Kane, Painter*, catalogue raisonné (Pittsburgh, 1971); Jean Lipman and Tom Armstrong, eds., *American Folk Painters of Three Centuries* (New York, 1980); Galerie St. Etienne, New York, *John Kane: Modern America's First Folk Painter* (1984), exh. cat., essay by Jane Kallir.

Mary's Pet, c. 1927

Oil on board
15 1/16 x 19 in. (38.3 x 48.3 cm)
Signature: JOHN KANE (lower left)

Mary's Pet is a nostalgic recollection of an optimistic period of the the artist's life. In 1911 Kane was enjoying steady employment in Akron, Ohio. He dreamed of settling there with his family, and to that end purchased a quarter-acre lot, intending to build a paint shop and a Sears-Roebuck house on it. Though this project never came to fruition, in later years he remembered the lot with pleasure:

> When my little girl Mary was thirteen she came to visit me at my boarding house. One Sunday I took her out to show her where her new home was going to be. Then I made a picture of that quarter acre with her on it. I had her put her arms around the neck of a cow and I painted the two together and called it "Our Pet."[1]

Before taking Mary back to Pittsburgh, Kane left *Our Pet* with a shopkeeper who assured him she could sell it. On his return, he found the store boarded up and empty. He never recovered the painting.

Mary's Pet, painted about 1927, shows Kane's daughter as she looked in the summer of 1911. The identification of the girl as Mary is certain because the title appears, overpainted but still legible, in the right foreground. Her pose conforms to the artist's description of *Our Pet*, but the composition has been expanded to include a second cow and a dog, and the setting has been changed from the Akron lot to one of those middle-class Pittsburgh neighborhoods in which Kane worked as a house painter during the 1920s. This transformation of an everyday scene into an idyllic vision recalls Kane's observation that "the same sun is shining today that shone over the Garden of Eden."[2]

MB

1 Kane, *Sky Hooks*, pp. 125–26.

2 Ibid., p. 183.

References Kane, *Sky Hooks*, p. 127; Arkus, *John Kane, Painter*, no. 15, p. 135.

Exhibitions Department of Fine Arts, Carnegie Institute, Pittsburgh, 1936, *John Kane Memorial Exhibition*, no. 35; William Penn Memorial Museum, Harrisburg, Pa., 1979, *Pennsylvania Painters from Commonwealth Collections*, no. 22.

Provenance Dr. Howard H. Permar, Pittsburgh, 1936; Grace K. Permar, Pittsburgh, by 1971; Philip H. Permar, Aiken, S.C., by 1977.

Gift of Philip H. Permar in memory of Dr. and Mrs. H. H. Permar, 1977, 77.35

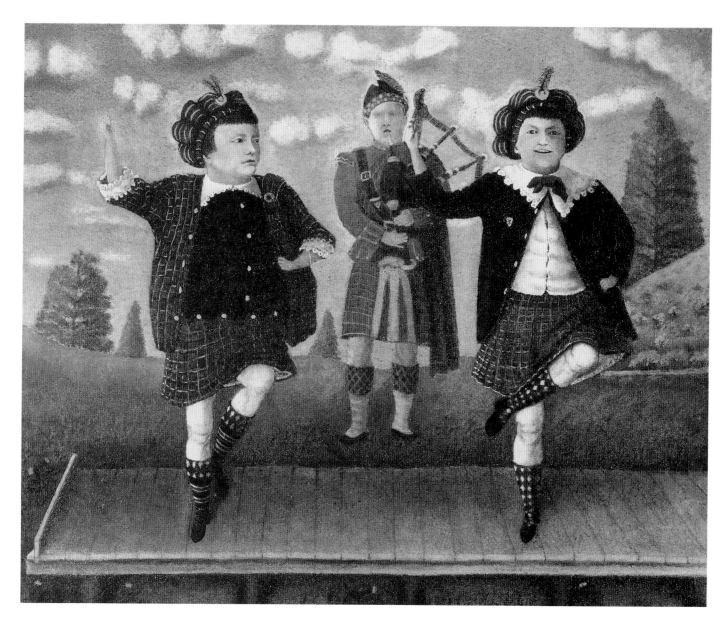

Scene from the Scottish Highlands,
c. 1927
(Scene in the Scottish Highlands; Scottish Highlands; Kennywood Park Scottish Dancers)

Oil on canvas
23¼ x 27⅛ in. (59 x 68.9 cm)

"Genius has been discovered," proclaimed the *Pittsburgh Press* after the 1927 Carnegie International accepted *Scene from the Scottish Highlands* for exhibition, the only work by a Pittsburgh artist to be so honored that year.[1] The art world and the popular press were astonished. How, they wondered, had this unknown, untrained artist, identified as a house painter, been selected to exhibit with the established masters of contemporary art? Reporters traced Kane to his squalid tenement near the railroad yards of Pittsburgh's Strip district, and he soon became a celebrity.

Kane had been admitted to the International at the insistence of a single juror, the painter Andrew Dasburg. According to an unsigned article published shortly after Kane's death:

> Dasburg picked up one of Kane's pictures. He showed it to the other jurors. It had "something." The other jurors laughed. And Dasburg, it is said, was piqued.
>
> As he went on to the other pictures, Kane's stuck in his memory. Dasburg fought to get it in the exhibit. The other jurors laughed. And Dasburg, it is said, finally threatened to vote against every picture the others suggested, and delay the choosing interminably unless they acceded. So they did.[2]

To demonstrate that he had acted in good faith, Dasburg bought the painting for his own collection. On learning of the purchase, Kane wrote Dasburg to express his gratitude:

> First wishing you [a] happy New [Year] and many of them. I am still struling along with my painting of other sugects. its [a] long way to travel especialey when I have no one to guide me on the wayside, I am very glad Mr. Dasburg you took an interest in my *(scene from the scottish higland)* or as I

would call it. Braw wee heilun lasses. in one part of your letter I cant make clear-as my schooling is not very good. as I run about the boghs and highlands in bonny Scotland when I was [a] wee Laddie, but Mr. Dasburg thinking it is the Frame in that case I would gladly except it. but remember you have paid for all and I gladly thank you for the interest you took in my picture, wishing you the best of Success also [a] very happey and prosperous New Year trusting to hear from you soon, I remain yours most sincerely John Kane.[3]

Dasburg's enthusiasm for *Scene from the Scottish Highlands* was clearly influenced by his exposure to modern European art. In 1910 Dasburg had visited Paris, where he met Henri Matisse and associated with Leo and Gertrude Stein. By the late 1920s, his Cubist landscapes of New Mexico, modeled on the work of Paul Cézanne and Pablo Picasso, had established him as a leading American modernist. He certainly knew the work of the French primitive Henri Rousseau, who had been championed by Picasso, and in championing Kane he was, in effect, playing the role of an American Picasso discovering an American Rousseau. Ironically, Kane's work is highly regarded today, while Dasburg's own has slipped into obscurity.

Scene from the Scottish Highlands is one of Kane's many pictorial reminiscences of his boyhood in Scotland:

One thing I cannot paint too often is the Scotch Highland dress. It brings back associations of my childhood. Always when I see it I can hear the pipers playing on their bags. I see the green Pentlands and Edinburg Castle and the Highland soldiers. It is now fifty-five years since I left Scotland but my mind is clear and fresh of those scenes as if it were yesterday.[4]

His immediate inspiration, however, was the Scotch Day held annually at Kennywood Park, an amusement park near Pittsburgh:

Here are seen the tartans of the Gordons and the McPhersons and the MacGregors and all the rest of them. The pipers play their old time reels while dancers from all parts of the country compete in the jigs and flings and sword dances. It is a day of color and of joy and gladness and in the thirty-five years they have held this "gathering of the clans" I have hardly missed a one.[5]

The amusement park is the specific setting for several of Kane's Scottish subjects, including the undated *Scot's Day at Kennywood* (collection Norman Kahn, New York), *Scotch Day at Kennywood* (1933, Museum of Modern Art, New York), and *Scotch Day, Kennywood* (1932, private collection).[6] The absence of any specific reference to Kennywood Park in the landscape setting of *Scene from the Scottish Highlands* suggests that Kane intended it to be a nostalgic re-creation of Scotland itself.

A comparison of the Scottish paintings reveals that Kane drew on a limited figural repertoire. For example, the dancers in *Scene from the Scottish Highlands* reappear, with minor variations, in *Highland Hollow* (see p. 289) and in the 1933 *Scotch Day at Kennywood*, while the bagpiper first appears in a single-figure composition, *The Campbells Are Coming* (c. 1925, Museum of Modern Art, New York), and is repeated in *Scot's Day at Kennywood*. There is a similar piper on a sheet of pencil sketches by Kane in the collection of The Carnegie Museum of Art.

MB

1 Ann Lee, "Only Pittsburgher Admitted to International Is a House Painter," *Pittsburgh Press*, October 16, 1927, p. 1.

2 "Art Jury Row Made John Kane Famous," *Pittsburgh Sun-Telegraph*, August 12, 1934, p. 11.

3 January 3, 1928, museum files, The Carnegie Museum of Art, Pittsburgh.

4 Kane, *Sky Hooks*, p. 178.

5 Ibid.

6 Reproduced in Arkus, *John Kane, Painter*, no. 73, p. 255.

References A. Lee, "Only Pittsburgher Admitted to International Is a House Painter," *Pittsburgh Press*, Oct. 16, 1927, p. 1; "Thumbs Up for John Kane," *Carnegie Magazine* 4 (Nov. 1930), p. 181; R. A. H., "The Rise of John Kane," *Arts Weekly* 1 (Apr. 9, 1932), p. 109; "Artist John Kane: Dying Cinderella," Pittsburgh *Bulletin Index*, Aug. 9, 1934, p. 4; "New Exhibitions of the Week: Group Show," *Art News* 35 (June 12, 1937), p. 17; Kane, *Sky Hooks*, pp. 9, 15, 23, 153, 154, 157, 158, 178; J. O'Connor, Jr., "John Kane Enters the Permanent Collection," *Carnegie Magazine* 12 (Mar. 1939), pp. 304–5; Department of Fine Arts, Carnegie Institute, Pittsburgh, *Survey of American Paintings* (1940), n.p.; Janis, *They Taught Themselves*, p. 79; J. O'Connor, Jr., "The Pittsburgh International," *Carnegie Magazine* 26 (Sept. 1952), p. 243; J. O'Connor, Jr., "The Apotheosis of John Kane," *Carnegie Magazine* 29 (Jan. 1955), p. 19; D. Adlow, "John Kane, Scot," *Christian Science Monitor*, Feb. 24, 1959, sec. A, p. 8; D. L. Smith, "John Kane, Pittsburgh's Primitive," *American Artist* 23 (Apr. 1959), p. 50, reprinted in *Carnegie Magazine* 34 (Feb. 1960), pp. 57–62; W. Gill, "Pittsburgh's Painter Laureate," *Pittsburgh Press Roto*, Dec. 27, 1959, p. 8; Arkus, *John Kane, Painter*, no. 69, p. 147; V. A. Clark, "Collecting from the Internationals," *Carnegie Magazine* 56 (Sept.–Oct. 1982), p. 24; H. Adams, in Museum of Art, Carnegie Institute, *Collection Handbook* (Pittsburgh, 1985), pp. 242–43.

Exhibitions Department of Fine Arts, Carnegie Institute, Pittsburgh, 1927, *Twenty-sixth Annual International Exhibition of Paintings*, no. 120; Bayer Gallery, New York, 1937, *Contemporary Art Show*, unnumbered; Museum of Modern Art, New York, 1938, *Masters of Popular Painting*, no. 141; Maynard Walker Galleries, New York, 1940, *Selections: 1820–1920*, no. 1; Deparment of Fine Arts, Carnegie Institute, Pittsburgh, 1958–59, *Retrospective Exhibition of Paintings from Previous Internationals, 1896–1955*, no. 44; Museum of Art, Carnegie Institute, Pittsburgh, 1966–67, *Three Self-Taught Pennsylvania Artists: Hicks, Kane, Pippin* (trav. exh.), exh. cat. by L. A. Arkus, no. 38; State Museum of Pennsylvania, Harrisburg, 1972, *Pennsylvania Heritage*, no cat.; Galerie St. Etienne, New York, 1984, *John Kane: Modern America's First Folk Painter*, (trav. exh.), exh. cat., essay by Jane Kallir, no. 30; Westmoreland Museum of Art, Greensburg, Pa., 1989, *A Sampler of American Folk Art from Pennsylvania Collections*, exh. cat. by P. A. Chew, no. 245.

Provenance Andrew Dasburg, Taos, N.M., 1927; with Maynard Walker Galleries, New York, as agent, 1930s; Mrs. George M. Moffett, 1930s; George M. Moffett, Jr., by inheritance, 1930s; Maynard Walker Galleries, c. 1952–53; G. David Thompson, Pittsburgh, c. 1952–53.

Gift of G. David Thompson, 1959, 59.11.1

Nine Mile Run Seen from Calvary, c. 1928

Oil on board
23½ x 23½ in. (59.7 x 59.7 cm)
Signature, inscription: NINE MILE RUN/SEEN FROM CALVARY/JOHN KANE (lower right)

Kane painted this view of Pittsburgh's Squirrel Hill–Greenfield area from a spot high on the hill of Calvary Cemetery. He had begun to frequent the cemetery in 1922, while working as a carpenter on the Beechwood Boulevard Bridge:

I would go to Calvary Cemetery, nearby, to commune with my thoughts. I only wanted to be by myself and not to have to hear the

pounding tools and the whirr of the machinery and the men's chatter. So I would go off by myself for a minute's quiet. But the scene of beauty would take hold of me and I was forced to put it down in a little sketch. My art work would never let me be. There was always something to stir me on.[1]

Calvary Cemetery became, appropriately, the artist's final resting place.

While painting *Nine Mile Run Seen from Calvary*, Kane, according to his friend the artist Samuel Rosenberg, abandoned his easel and trudged down into the valley to identify the flowers growing in a window box.[2] This anecdote illustrates Kane's passion for precise detail, which drove him to put "every brick in a sidewalk, every letter on a signboard."[3] The houses seen near the bottom of the painting still stand today, and despite minor alterations, their present appearance confirms the accuracy of Kane's portrayal. A pencil sketch of these houses owned by The Carnegie Museum of Art indicates that he studied them in detail, then placed them in the landscape. Today, a stand of maples at the edge of the cemetery screens this view of the valley.

Nine Mile Run Seen from Calvary won the Carnegie Institute Prize at the 1929 exhibition of the Associated Artists of Pittsburgh. Kane himself regarded it as a particularly successful composition and

repeated it, with only minor changes, in *Nine Mile Run* (c. 1930, Ackland Art Museum, Chapel Hill, N.C.).

MB

1 Kane, *Sky Hooks*, p. 143.
2 Arkus, *John Kane, Painter*, p. 124.
3 Kane, *Sky Hooks*, p. 172.

References Kane, *Sky Hooks*, p. 137; F. A. Myers, "Two Acquisitions: Pippin and Kane," *Carnegie Magazine* 42 (Oct. 1968), pp. 269–72; Arkus, *John Kane, Painter*, no. 110, pp. 124, 172.

Exhibitions Department of Fine Arts, Carnegie Institute, Pittsburgh, 1929, *Nineteenth Annual Exhibition of the Associated Artists of Pittsburgh*, no. 176; Department of Fine Arts, Carnegie Institute, Pittsburgh, 1936, *John Kane Memorial Exhibition*, no. 25; M. Knoedler and Co., London, 1936, *Exhibition of Paintings by John Kane*, no. 25; Museum of Art, Carnegie Institute, Pittsburgh, 1966–67, *Three Self-Taught Pennsylvania Artists: Hicks, Kane, Pippin* (trav. exh.), exh. cat. by L. A. Arkus, no. 54; William Penn Memorial Museum, Harrisburg, Pa., 1978–79, *Pennsylvania Landscape Survey*, no cat.

Provenance Samuel B. Grimson, New York, after 1929; Clare Booth Luce, New York, by 1936, until 1968.

Howard Heinz Endowment Fund, 1968, 68.12

The Cathedral of Learning, 1930 (Carnegie Institute)

Oil on canvas
24¼ x 30⅛ in. (61.6 x 76.5 cm)
Signature, date: JOHN KANE/1930 (lower right)

In 1934 the Gallery 144 West 13 Street in New York exhibited a painting by Kane entitled *Carnegie Institute*. In a review of the show for the New York *Sun*, it was praised as "a regular little masterpiece of poetry."[1] No extant painting bears this title, and Leon Arkus suggests that it was the work now called *The Cathedral of Learning*, Kane's only known representation of Carnegie Institute apart from the portion shown in *Pietà* (see p. 292).[2]

The reviewer for the New York *Sun*, though professing deep admiration for Kane's work, questioned his veracity:

He was blessed, oddly enough, with an inordinate love of Pittsburgh, and the motive power of his painting is, apparently, the desire to tell the world how beautiful Pittsburgh is. I, for one, have been entirely converted by his art, though in my frequent trips to the Smoky City I have never encountered anything faintly resembling Mr. Kane's pictures. . . . His conception of "Carnegie Institute", for instance, is so far beyond anything I have ever been able to conjure up myself that I just simply can't believe it.[3]

The Cathedral of Learning, however, supports Kane's claim to have painted "life exactly as I see it."[4] This view of Pittsburgh's Oakland district, seen from a vantage point on the Carnegie Institute of Technology campus overlooking Panther Hollow, is much the same today as when Kane painted it. The Bellefield boiler plant, since enlarged and provided with an additional smokestack, rises from the bottom of the hollow. Above it is the low, massive bulk of Carnegie Institute seen from the rear and the newly erected shaft of the University of Pittsburgh's Cathedral of Learning, its pale stone as yet undarkened by smoke and soot. The reviewer's reference to the "Smoky City" suggests that the pristine quality and vibrant greens, whites, and yellows of Kane's cityscapes strained his credulity, but, during the early 1930s, when the Depression had closed the steel mills, clear, bright days were not at all uncommon in Pittsburgh. In order to include

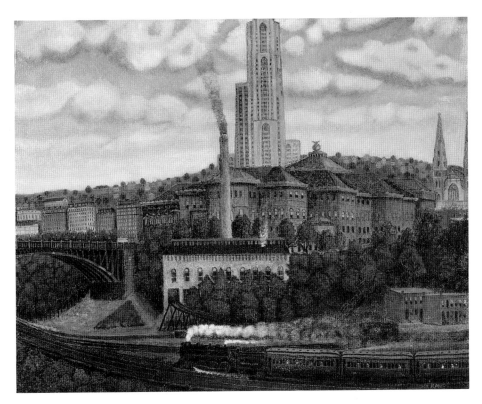

Saint Paul's Cathedral, at the right, Kane moved it closer to the Carnegie Institute than it actually is; otherwise, he has transcribed the view accurately.

The Cathedral of Learning's first recorded sale took place at the Valentine Gallery, New York, in 1935. Adelaide Milton de Groot purchased it for one thousand dollars, an unprecedented sum for Kane's work at that time.

MB, KN

1 *The Sun* (New York), Jan. 27, 1934.
2 Arkus, *John Kane, Painter,* p. 179.
3 *The Sun* (New York), Jan. 27, 1934.
4 Kane, *Sky Hooks,* p. 172.

References "Art: Rising Kane," Pittsburgh *Bulletin Index,* Feb. 21, 1935, p. 4; "Washington to Hold Show of John Kane's Paintings," *Pittsburgh Post-Gazette,* Feb. 22, 1935, p. 17; J. O'Connor, Jr., "The Kane Memorial Exhibition," *Carnegie Magazine* 10 (Apr. 1936), pp. 19–24; Arkus, *John Kane, Painter,* no. 133, p. 179.

Exhibitions Department of Fine Arts, Carnegie Institute, Pittsburgh, 1932, *Exhibition of Paintings by Pittsburgh Artists,* no. 23; possibly Gallery 144 West 13 Street, New York, 1934, *John Kane Exhibition,* no. 3, as *Carnegie*

Institute; United States Department of Labor, Washington, D.C., 1935, *John Kane's Paintings,* unnumbered; Valentine Gallery, New York, 1935, *Memorial Exhibition of Selected Paintings by John Kane,* unnumbered; Department of Fine Arts, Carnegie Institute, Pittsburgh, 1936, *John Kane Memorial Exhibition,* no. 22; ACA Galleries, New York, 1969, *John Kane,* no. 6.

Provenance Valentine Gallery, New York, 1935; Adelaide Milton de Groot, New York, 1935; Metropolitan Museum of Art, New York, 1967; Harold Diamond, New York, 1972.

John O'Connor, Jr. Fund, 1972, 72.9

Sunset, Coleman Hollow, c. 1930
(Sunrise, Coleman Hollow; Dawn)

Oil on Masonite
21½ x 23¾ in. (54.6 x 60.3 cm)
Signature: JOHN KANE (lower right)

Sunset, Coleman Hollow is the last of three virtually identical versions of this landscape. The earliest, *Through Coleman Hollow up the Allegheny Valley* (c. 1928, Museum of Modern Art, New York) was rejected by the Carnegie International jury in 1928, as was *Coleman Hollow* (c. 1929, collection Steven L. Rose, Los Angeles) the following year. Kane, however, disagreed with the jury's verdict. To Eugene Williams of Boston, who had purchased the first version, he wrote:

Now Mr. Williams up to date the Allegheny Valley is my Best painting. If an artist puts his soul in his work mine was there in the reflection of light on the hills on the left also the distane [*sic*] atmosphere with trains coming and going also steam boats going dayly [*sic*] defieing [*sic*] me to paint them and believe me I took delight in doing so.[1]

Kane painted the original view from a site overlooking Coleman Hollow in Penn Township (now the Municipality of Penn Hills). It was a superb vantage point, offering a glimpse of the Allegheny River and a panoramic view of Aspinwall Borough. Aspinwall's old National Amusement Park, razed in 1931, appears just to the right of center in all three paintings. Unfortunately, the site had one major disadvantage: ants. Kane described his disagreeable experience with them in *Sky Hooks:*

A few years ago I had to go out to Penn Township for a view for my "Allegheny Valley". Now the ants crawled over me in swarms and streams. I kept brushing them off and trying to paint at the same time. All I could do was to keep jumping around and throwing them off. But I couldn't do that satisfactorily when they crawled up inside my trouser legs. Finally I had to pack up my paints and go home.
Now I refused to give up that view of the river from that particular place, even though when I was painting it I was a giant ant hill, practically. So I developed the habit of carrying along with me little pieces of string for the purpose of tying my trouser cuffs tight around my ankles like old-time bicycle clips. In this way I was able to go on with my work. The ants that walked up on the outside I could brush off as I worked.[2]

Sunset, Coleman Hollow has also been called *Dawn* and *Sunrise, Coleman*

Hollow. It acquired its present title when James Winokur, who purchased it in 1964, noticed that the sun is actually in the west. An unusual feature of this painting, not found in the earlier versions, is what Leon Arkus has called "the Redon-like fantasy of the setting sun."[3] In the light of Kane's deep religious faith, it is tempting to interpret this eye-shaped conformation of sun and clouds as a manifestation of divinity. This kind of symbolism is not, however, characteristic of the artist, and Arkus believes that he was simply recording, to the best of his ability, an observed phenomenon.

Sunset, Coleman Hollow was one of twenty-seven works by Kane exhibited in London in 1936. At that time it was purchased by Cecil Beaton, the famous photographer and theatrical designer. John Dewey bought a painting called *Coleman Hollow* from Kane in 1929, but this work, now lost, was similar to *Penn Township* and quite unlike *Sunset, Coleman Hollow.*[4]

MB, KN

1 Arkus, *John Kane, Painter,* no. 92, p. 167.

2 Kane, *Sky Hooks,* p. 175.

3 Arkus, in Museum of Art, Carnegie Institute, Pittsburgh, *Three Self-Taught Pennsylvania Artists: Hicks, Kane, Pippin* (1966–67), exh. cat., n.p.

4 Arkus, *John Kane, Painter,* no. 146, p. 185.

References *The Sun* (New York), Jan. 27, 1934; J. S., "John Kane," *Art News* 32 (Jan. 27, 1934), p. 6; Arkus, *John Kane, Painter,* no. 94, p. 168.

Exhibitions Gallery 144 West 13 Street, New York, 1934, *John Kane Exhibition,* no. 1, as *Dawn;* M. Knoedler and Co., London, 1936, *Exhibition of Paintings by John Kane,* no. 24; Museum of Art, Carnegie Institute, Pittsburgh, 1966–67, *Three Self-Taught Pennsylvania Artists: Hicks, Kane, Pippin* (trav. exh.), exh. cat. by L. A. Arkus, no. 70.

Provenance M. Knoedler and Co., London, 1936; Cecil Beaton, London, 1936; with M. Knoedler and Co., New York, as agent, 1963; Mr. and Mrs. James L. Winokur, Pittsburgh, 1964.

Gift of Sara M. Winokur and James L. Winokur, 1976, 76.55

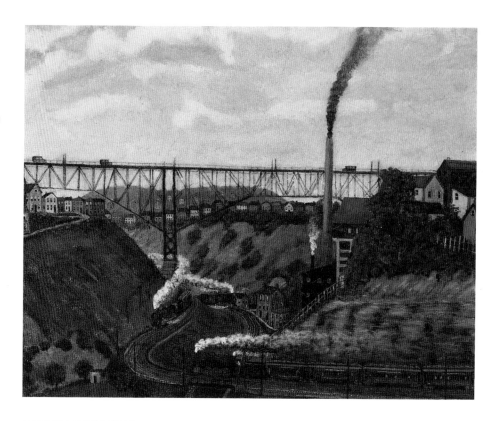

Bloomfield Bridge, c. 1930
(Pittsburgh Landscape; Skunk Hollow)

Oil on canvas
19⅜ x 23⅜ in. (49.2 x 59.4 cm)
Signature: JOHN KANE (lower left)

Bloomfield Bridge is one of a large group of works in which Kane depicted, with evident delight, scenes that would have seemed intolerably ugly to a nineteenth-century landscape artist. The trains, the belching smokestack, the utilitarian bridge (the Bloomfield Bridge, since demolished to make way for a new span), and the prosaic working-class dwellings are hardly picturesque in any conventional sense. Kane, however, found genuine beauty in the industrial cityscape:

I have been asked why I am particularly interested in painting Pittsburgh, her mills with their plumes of smoke, her high hills and deep valleys and winding rivers. Because I find beauty everywhere in Pittsburgh. . . . The city is my own. I have worked on all parts of it, in building the blast furnaces and then in the mills and in paving the tracks that brought the first street cars out Fifth Avenue to Oakland. The filtration plant, the bridges that span the river, all these are my own. Why shouldn't I want to set them down when

they are, to some extent, children of my labors and when I see them always in the light of beauty?[1]

When this work was exhibited as *Skunk Hollow* at the Contemporary Arts Gallery, New York, in 1931, a reviewer for the *New York Herald-Tribune* described it as showing only two trains.[2] The reviewer may have been mistaken, but Kane often altered finished paintings, and he may well have added a third train sometime after the exhibition. At the time of his death he had almost completed a second version of this scene, *Crossing the Junction* (1933–34, H. J. Heinz Company, Pittsburgh), in which the foreground has been extended to include a fourth train.

The Carnegie Museum of Art owns a pencil study on manila paper for *Bloomfield Bridge.* It shows the large smokestack, the bridge, the railroad tracks, and the hillside with houses seen on the left side of the painting.

MB

1 Kane, *Sky Hooks,* p. 181.

2 "John Kane Exhibition at the Contemporary Arts Gallery, New York," *New York Herald-Tribune,* September 30, 1931.

References W. Schack, "Around the Galleries," *Creative Art* 9 (Oct. 1931), p. 325; D. L. Smith, "John Kane, Pittsburgh's Primitive," *American Artist* 23 (Apr. 1959), p. 47, reprinted in *Carnegie Magazine* 34 (Feb. 1960), pp. 57–62; Arkus, *John Kane, Painter*, no. 123, p. 175.

Exhibitions Contemporary Arts Gallery, New York, 1931, *John Kane Exhibition*, no. 13 (as *Skunk Hollow*); Cincinnati Art Museum, 1935, *Forty-second Annual Exhibition of American Art*, no. 85; Valentine Gallery, New York, 1935, *Memorial Exhibition of Selected Paintings by John Kane*, no. 27; Department of Fine Arts, Carnegie Institute, Pittsburgh, 1936, *John Kane Memorial Exhibition*, no. 31; M. Knoedler and Co., London, 1936, *Exhibition of Paintings by John Kane*, no. 2; Arts Club of Chicago, 1939, *Exhibition of Paintings by John Kane*, no. 4; Department of Fine Arts, Carnegie Institute, Pittsburgh, 1960, *Promised or Given*, no. cat.; Museum of Art, Carnegie Institute, Pittsburgh, 1966–67, *Three Self-Taught Pennsylvania Artists: Hicks, Kane, Pippin* (trav. exh.), exh. cat. by L. A. Arkus, no. 79; Galerie St. Etienne, New York, 1984, *John Kane: Modern America's First Folk Painter* (trav. exh.), exh. cat., essay by Jane Kallir, no. 52; Galerie St. Etienne, New York, 1988–89, *Folk Artists at Work*, no. 35.

Provenance The artist, until 1934; Valentine Gallery, New York; Maynard Walker Galleries, New York; Mr. and Mrs. James H. Beal, Pittsburgh, 1954.

Gift of Mr. and Mrs. James H. Beal, 1981, 81.54.2

Penn Township, c. 1930–32
(Landscape in Penn Township)

Oil on canvas
22½ x 34½ in. (57.1 x 87.6 cm)
Date: 1932 (lower right)

In the early 1930s, the woods and farms of Penn Township had not yet given way to the housing developments and shopping centers that today make up this sprawling residential community (now the Municipality of Penn Hills) a few miles east of Pittsburgh. Kane visited this area as early as 1928, when he painted the first of his Coleman Hollow scenes (see *Sunset, Coleman Hollow*, p. 285). *Penn Township* probably depicts the same vicinity. According to Leon Arkus,[1] it closely resembles the lost *Coleman Hollow*, formerly owned by John Dewey. The same river, the Allegheny, appears in both this work and the Coleman Hollow views.

Penn Township is a well-documented instance of Kane's "touching up" process (see pp. 289–90). A photograph dated September 28, 1930 (fig. 1), shows Kane working—or pretending to work—on this painting. It appears to be virtually complete, but there are two long islands in the river, and the human figure has not yet been added to the cow pasture at the right. Though Arkus believed that the photograph records an early, lost version of *Penn Township*,[2] the islands, heavily overpainted, are still discernible in the present work, and the man in the pasture has clearly been brushed in over the grass. Kane probably made these changes in 1932, the date inscribed on the painting.

Dr. Hunter H. Turner was Kane's attending physician at the time of the artist's death. Kane's widow, Maggie Halloran Kane, gave him the painting as a token of her gratitude.
MB, KN

1 Arkus, *John Kane, Painter*, no. 146, p. 185.
2 Ibid., no. 147, p. 186.

References Arkus, *John Kane, Painter*, no. 91, p. 167.

Exhibitions Department of Fine Arts, Carnegie Institute, Pittsburgh, 1932, *Exhibition of Paintings by Pittsburgh Artists*, no. 24, as *Landscape in Penn Township*; Pennsylvania Academy of the Fine Arts, Philadelphia, 1934, *One Hundred Twenty-ninth Annual Exhibition*, no. 413; Museum of Art, Carnegie Institute, Pittsburgh, 1966–67, *Three Self-Taught Pennsylvania Artists: Hicks, Kane, Pippin* (trav. exh.), exh. cat. by L. A. Arkus, no. 73; M. Knoedler and Co., New York, 1969, *American Primitives*, no. 32.

Provenance The artist, until 1934; his widow, Maggie Halloran Kane; Dr. Hunter H. Turner, Pittsburgh, 1934; Mrs. Hunter H. Turner, Nanticoke, Md., by 1971; Dr. Oliver E. Turner, Pittsburgh, by 1975.

Gift of the family of Dr. and Mrs. Hunter H. Turner in their honor and memory, 1975, 75.61

Fig. 1 Unidentified photographer, *John Kane Painting "Penn Township,"* 1930. Photograph. The Carnegie Museum of Art, Pittsburgh, museum files

Panther Hollow, Pittsburgh,
c. 1930–34
(Cathedral of Learning)

Oil on canvas
27¾ x 34 in. (70.5 x 86.4 cm)
Signature: JOHN KANE (lower right)

Panther Hollow, Pittsburgh is a view of the city's Oakland district as seen from a bluff above Swinburne Street. Leon Arkus assigned it a date of c. 1933–34,[1] but Kane could have painted it as early as 1930, when the shaft of the University of Pittsburgh's neo-Gothic Cathedral of Learning, seen at the left, had received its limestone facing. Several other Oakland landmarks are visible in the distance, including the twin spires of Saint Paul's Cathedral and, at the right, the *tholos*-like tower of Carnegie Institute of Technology's Hammerschlag Hall and the fanciful steel-and-glass structure of Phipps Conservatory. In the middle ground, "one of those toy trains which the artist practically fondled as he painted"[2] passes beneath the Charles Anderson Bridge. The Carnegie Museum of Art owns a sheet of pencil studies for this painting. It includes a small sketch of the bridge and a detailed study of the Carnegie Tech and Phipps Conservatory buildings.

The great charm of this work lies in the contrast between the Oakland cityscape and the bucolic character of the valley. Today, though cows no longer graze beside the railroad tracks, Panther Hollow is still very much as it was when Kane painted it. Although the presence of these cows has been regarded as improbable,[3] longtime Pittsburgh residents disagree.

One such resident, Ethel Spencer, recorded in her memoirs that cows were kept in Shadyside, a residential area near Oakland, as late as the first decade of the twentieth century, and recalled that "cows continued to crop the Oakland hillsides for several years longer."[4] Kane often slightly rearranged the elements in a landscape to improve the composition, but he rarely indulged in pure invention.

The existence of another painting entitled *Panther Hollow* (c. 1930–31, Whitney Museum of American Art, New York), which shows an entirely different section of the valley, has complicated the attempt to reconstruct the exhibition history of this work.

MB, KN

1 Arkus, *John Kane, Painter*, no. 135, p. 179.
2 Jeanette Jena, "John Kane Memorial Show Being Held at Carnegie," *Pittsburgh Post-Gazette*, April 10, 1936, p. 6.
3 Arkus, in Museum of Art, Carnegie Institute, Pittsburgh, *Three Self-Taught Pennsylvania Artists: Hicks, Kane, Pippin* (1966–67), exh. cat., n.p.
4 Ethel Spencer, *The Spencers of Amberson Avenue* (Pittsburgh, 1983), p. 5.

References "Inside New England's Taste," *Art News* 47 (June–Aug. 1948), p. 30, as *Cathedral of Learning*; L. A. Arkus, "*Panther Hollow, Pittsburgh* by John Kane," *Carnegie Magazine* 37 (Dec. 1963), pp. 345–47; Arkus, *Jone Kane, Painter*, no. 135, p. 179.

Exhibitions Department of Fine Arts, Carnegie Institute, Pittsburgh, 1936, *John Kane Memorial Exhibition*, no. 11; M. Knoedler and Co., London, 1936, *Exhibition of Paintings by John Kane*, no. 16; either *Panther Hollow, Pittsburgh* or the Whitney Museum of American Art *Panther Hollow* was exhibited in each of the following four exhibitions: Valentine Gallery, New York, 1937, *Paintings by John Kane*, no. 14; Arts Club of Chicago, 1939, *Exhibition of Paintings by John Kane*, no. 13; Valentine Gallery, New York, 1941, *Four Paintings Each by Kane, Hartl, Avery, Eilshemius*, no. 4; Valentine Gallery, New York, 1941, *Program*, no. 27; Institute of Contemporary Art, Boston, 1948, *Twentieth Century Art in New England*, no. 6; Gallery of Modern Art, New York, 1965, *The Twenties Revisited*, unnumbered; Museum of Art, Carnegie Institute, Pittsburgh, 1966–67, *Three Self-Taught Pennsylvania Artists: Hicks, Kane, Pippin* (trav. exh.), exh. cat. by L. A. Arkus, no. 80; Joslyn Art Museum, Omaha, 1971, *The Thirties Decade: American Artists and Their European Contemporaries*, no. 93; Galerie St. Etienne, New York, 1984, *John Kane: Modern America's First Folk Painter* (trav. exh.), exh. cat., essay by J. Kallir, no. 64.

Provenance Valentine Gallery, New York, c. 1934; Mr. and Mrs. Lee A. Ault, New York, by 1948 (sale, Parke Bernet Galleries, New York, Oct. 9, 1963).

Museum purchase: Gift of Mr. and Mrs. James F. Hillman, 1963, 63.25

Highland Hollow, c. 1930–35
(Dancers in Highland Hollow; Kennywood Park)

Oil on canvas
26½ x 36½ in. (67.3 x 92.7 cm)
Signature: JOHN KANE (lower left)

Like *Scene from the Scottish Highlands* (see p. 282), *Highland Hollow* was inspired by the annual Scotch Day celebration at Kennywood Park. Although none of the distinctive Kennywood structures appears in this work, Kane mentions "the beautiful hills and valleys that surround this pleasure park" in his autobiography, *Sky Hooks*,[1] and the landscape seen here is certainly far more characteristic of western Pennsylvania than of Scotland (compare, for example, *Sunset, Coleman Hollow* and *Penn Township*, pp. 285 and 287). In fact, *Highland Hollow* was probably the painting shown as *Kennywood Park* at the 1935 United States Department of Labor memorial exhibition of Kane's work. It was definitely included in this exhibition, because it appears in a photograph, published in the *Pittsburgh Post-Gazette* (March 6, 1935), of Mrs. Maggie Halloran Kane and the Assistant Secretary of Labor viewing the works on display. Moreover, *Kennywood Park* is the only recorded title

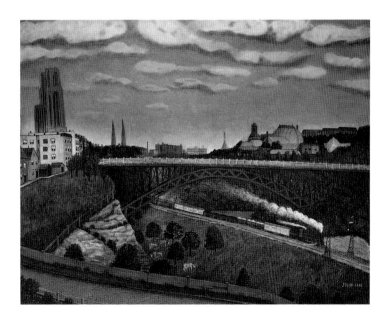

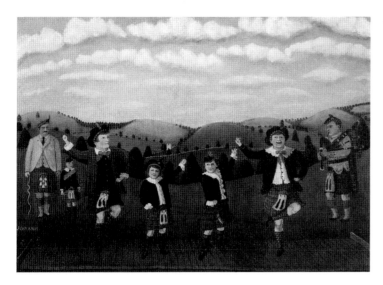

from this exhibition that is at all applicable to this painting. *Highland Hollow* may also be identical with the *Scottish Highlanders* rejected by the Carnegie International jury in 1930.

The two tallest dancers in *Highland Hollow* also appear in *Scene from the Scottish Highlands* and *Scotch Day, Kennywood* (1932, private collection).[2] The latter also shows the smallest of the four dancers as well as the man and boy watching the dancers at the left. A pencil sketch of the smallest dancer is owned by the John Kane Estate (Galerie St. Etienne, New York).

MB

1 Kane, *Sky Hooks*, p. 181.

2 Reproduced in Arkus, *John Kane, Painter*, no. 73, p. 255.

References "John Kane's Pictures to be Honored by U.S.," *Pittsburgh Sun-Telegraph*, Feb. 21, 1935, p. 21; "Washington to Hold Show of John Kane's Paintings," *Pittsburgh Post-Gazette*, Feb. 22, 1935, p. 17; "John Kane, in Death, Gains Capitol Honors," *Pittsburgh Post-Gazette*, Mar. 6, 1935, p. 7; Arkus, *John Kane, Painter*, no. 68, p. 147.

Exhibitions United States Department of Labor, Washington, D.C., 1935, *John Kane's Paintings*, probably as *Kennywood Park*, unnumbered; Department of Fine Arts, Carnegie Institute, Pittsburgh, 1936, *John Kane Memorial Exhibition*, no. 23; M. Knoedler and Co., London, 1936, *Exhibition of Paintings by John Kane*, no. 15; Valentine Gallery, New York, 1937, *Paintings by John Kane*, no. 9; Department of Fine Arts, Carnegie Institute, Pittsburgh, 1960, *Promised or Given*, no cat.; Museum of Art, Carnegie Institute, Pittsburgh, 1966–67, *Three Self-Taught Pennsylvania Artists: Hicks, Kane, Pippin* (trav. exh.), exh. cat. by L. A. Arkus, no. 51; Galerie St. Etienne, New York, 1984,

John Kane: Modern America's First Folk Painter (trav. exh.), exh. cat., essay by J. Kallir, no. 29.

Provenance Estate of the artist; M. Knoedler and Co., New York, 1948; Mr. and Mrs. Leland Hazard, Pittsburgh, 1954.

Gift of Mr. and Mrs. Leland Hazard, 1960, 61.2.1

See Color Plate 27.

Intruder, before 1931
(*Two Children with a Lamb*)

Oil on canvas
11 x 13½ in. (27.9 x 34.3 cm)
Signature: JOHN KANE (lower right)

Kane's scenes of childhood are among his most appealing works. Typically, they portray youngsters playing in pleasant gardens and meadows, often in the company of animals. *Intruder*, a particularly amusing example of this genre, takes its title from the lamb that has interrupted the children. The girl draws back in fear, but the boy boldly pulls the lamb's ear, much to the animal's discomfort. Kane used thick swirls of white paint to reproduce the texture of lamb's wool. The boy's right leg is the most extreme example of foreshortening in the artist's work.

MB

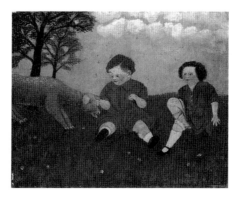

Reference Arkus, *John Kane, Painter*, no. 35, p. 137.

Exhibitions Junior League Headquarters, Pittsburgh, 1931, *Paintings by John Kane*, no cat.; Museum of Art, Carnegie Institute, Pittsburgh, 1966–67, *Three Self-Taught Pennsylvania Artists: Hicks, Kane, Pippin* (trav. exh.), exh. cat by L. A. Arkus, no. 36, as *Two Children with a Lamb;* ACA Galleries, New York, 1969, *John Kane*, no. 24, as *Two Children with a Lamb;* Westmoreland County Museum of Art, Greensburg, Pa., 1976, *Nineteenth and Early Twentieth Century Regional Painters*, exh. cat. by P. A. Chew and J. K. Maguire, unnumbered.

Provenance G. David Thompson, Pittsburgh; Mr. and Mrs. Gordon B. Washburn, New York, by 1973.

Gift of Mr. and Mrs. Gordon B. Washburn, 1973, 73.57

Touching Up, c. 1931–32

Oil on canvas
20¾ x 27 in. (52.7 x 68.6 cm)
Signature, inscription: JOHN KANE/TOUCHING UP (lower left)

Kane was a perfectionist who constantly revised his work. As long as a painting remained in his possession he would return to it at intervals, incorporating afterthoughts and fresh perceptions until it met with his approval. He described this process, which he called "touching up," in *Sky Hooks*:

> Sometimes I have completed a painting, returning many times to the scene where I made my observation. I am all done. But I am not satisfied. I know there is something the matter with it, even though I do not see it.
>
> Suddenly I see something I had not seen before. I go back and put in a little fence or a tree or even a barn. You have no idea how many times it is improved. I am satisfied. The job is done as well as I can do it.[1]

Touching Up, a self-portrait, depicts Kane engaged in this process in the sun-porch studio—his wife called it "John's Glory Hole"—of his apartment on Ophelia Street in Pittsburgh's Oakland district. It is based on a smaller, less accomplished prototype of the same title (c. 1927, John Kane Estate, Galerie St. Etienne, New York), in which the artist wears street clothes instead of the overalls he usually wore when painting and the

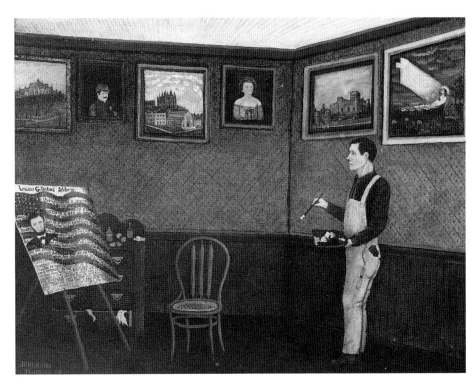

1 Kane, *Sky Hooks*, p. 176.

2 Ibid., p. 130.

3 Arkus, *John Kane, Painter*, no. 4, p. 130.

References Kane, *Sky Hooks*, p. 65; Janis, *They Taught Themselves*, pp. 89–90; "Sidney Janis Presents Self-Taught Artists," *Art Digest* 16 (Feb. 15, 1942), p. 21; O. Bihalji-Merin, *Modern Primitives: Masters of Primitive Painting* (New York, 1959), p. 205; Arkus, *John Kane, Painter*, no. 4, p. 130; D. G. Wilkins, "The American Painting Collection at the Sarah Scaife Gallery, Carnegie Institute, Pittsburgh," *American Art Review* 2 (Mar.–Apr. 1975), pp. 104–5; International Exhibitions Foundation, Washington, D.C., *American Self-Portraits, 1670–1973* (1977), exh. cat. by A. V. Frankenstein, pp. 152–53.

Exhibitions Junior League Headquarters, Pittsburgh, 1931, *Paintings by John Kane*, unnumbered; Valentine Gallery, New York, 1937, *Paintings by John Kane*, no. 19; Museum of Modern Art, New York, 1938, *Masters of Popular Painting*, no. 153; Albright Art Gallery, Buffalo, 1939, *The Room of Contemporary Art*, no. 22; Arts Club of Chicago, 1939, *Exhibition of Paintings by John Kane*, no. 17; San Francisco Museum of Art, 1941, *They Taught Themselves*, no. 16; Casino Knokke, Belgium, 1953, *Les Peintres naïfs du Douanier Rousseau à nos jours*, unnumbered; Musée National d'Art Moderne, Paris, 1953, *Twelve Modern American Painters and Sculptors*, no. 33; Staatliche Kunsthalle, Baden-Baden, West Germany, 1961, *Das Naive Bild der Welt*, no. 96; Museum Boymans-Van Beuningen, Rotterdam, 1964, *De Lusthof der Naiven*, no. 84; Museum of Art, Carnegie Institute, Pittsburgh, 1966–67, *Three Self-Taught Pennsylvania Artists: Hicks, Kane, Pippin* (trav. exh.), exh. cat. by L. A. Arkus, no. 69; M. Knoedler and Co., New York, 1969, *American Primitives*, no. 29; National Portrait Gallery, Washington, D.C., 1974, *American Self-Portraits*, no. 69; Museum of Art, Pennsylvania State University, University Park, 1976, *Portraits U.S.A., 1776–1976*, exh. cat. by H. E. Dickson, unnumbered; Heckscher Museum, Huntington, N.Y., 1979, *As We See Ourselves: Artists' Self-Portraits*, exh. cat., essay by K. Lochridge et al., unnumbered; Westmoreland County Museum of Art, Greensburg, Pa., 1981, *Southwestern Pennsylvania Painters, 1800–1945*, exh. cat. ed. by P. A. Chew and J. A. Sakal, no. 123; Galerie St. Etienne, New York, 1984, *John Kane: Modern America's First Folk Painter* (trav. exh.), exh. cat., essay by J. Kallir, no. 5.

Provenance Valentine Gallery, New York, by 1937; Sidney Janis Gallery, New York, until 1966; private collection, until 1968; M. Knoedler and Co., New York, by 1969; Thomas Mellon Evans, Pittsburgh, 1972.

Gift of Thomas Mellon Evans, 1972, 72.58

selection of pictures on the walls is somewhat different. Both, however, show him "touching up" a version of his *Lincoln's Gettysburg Address*. In the earlier work, only the flag and the bust of Lincoln are seen; in the later painting, the full text of the Gettysburg Address has been transcribed.

Kane had the deepest admiration for Lincoln and felt a strong sense of kinship with him:

> Abraham Lincoln has always been a hero to me. He was a father and a man of mercy from beginning to end. . . . I believe he was a healthy robust young fellow like myself, in his young days and mine. He started life as I did, without anything except what he got for himself. He had no schooling but what he worked for. And so I have always thought he was pretty much like myself, strong of body, willing to work and without the advantages that have helped other men.[2]

These sentiments make *Touching Up* more significant than a simple record of the artist at work. Kane has portrayed himself paying homage to Lincoln, seeking to perfect his hero's image. He fixes his gaze on this image, drawing inspiration from it, just as, in the religious painting on the wall behind him, Christ fixes his gaze on the glowing cross.

According to Leon Arkus, *Touching Up* shows Kane working on the lost *Lincoln's Gettysburg Address* that he painted about 1912 while working at the Cambria Steel Works in Johnstown, Pennsylvania.[3] The six paintings on the studio walls are all presumably works by Kane, though only three have been identified. The religious work is the large version of *The Agony in the Garden* (collection Miss Agnes Connelly, Pittsburgh). To its left is *Balloch Castle* (John Kane Estate, Galerie St. Etienne, New York). The large version of *Mount Mercy Academy* (John Kane Estate, Galerie St. Etienne) hangs between the two portraits. This work also appears in the first version of *Touching Up*, along with a painting similar, but not identical, to *The Agony in the Garden*.

Kane painted at least four self-portraits in addition to the two versions of *Touching Up*. In each he made a statement about his life and character. In *Pietà* (see p. 292) he gave the donor figure his own features in order to express his deep religious convictions. *John Kane and His Wife* (c. 1928, John Kane Estate, Galerie St. Etienne) shows the artist working, with the utmost concentration, on an unidentified landscape. In *Seen in the Mirror* (c. 1929, location unknown), a weary, sensitive Kane contemplates his stern, strong-willed reflection. *Self-Portrait* (1929, Museum of Modern Art, New York) is another mirror image, which represents him as the mighty laborer and the fighter of his youth, his neck muscles strained, his arm and chest muscles flexed.

MB, KN

Larimer Avenue Bridge, 1932
(Frankstown Bridge)

Oil on canvas
31¹⁵⁄₁₆ x 41⅞ in. (81.1 x 106.4 cm)
Signature, date: JOHN KANE/1932 (lower right)

In 1959 Kane was likened—astonishing-
ly—to the eighteenth-century Venetian
veduta painter Francesco Guardi. Both, it
was observed, devoted themselves to
recording their cities; both were "uncon-
cerned with any philosophical idea out-
side of the simple and singular problem
of finding an interesting scene and trans-
lating it into paint."[1] The comparison
might be doubly apt because Pittsburgh,
with her valleys and rivers, is, like Venice
with her canals, a city of bridges. However,
unlike Guardi, Kane had personally
helped to build one of his city's bridges,
having worked as a carpenter on the
Beechwood Boulevard Bridge in 1922. He

always maintained that his experience in
construction work had been an invaluable
aid to his art: when he depicted a struc-
ture, he declared, "you may be sure it sits
square on solid foundations and is built
according to the laws of construction
which take into consideration the laws of
nature and gravity."[2]

Bridges are often dominant elements in
Kane's Pittsburgh scenes (as in *Bloomfield
Bridge* and *Panther Hollow, Pittsburgh,*
pp. 286 and 288). In 1932 he painted two
works that are, in effect, portraits of
bridges: *Liberty Bridge* (Addison Gallery
of American Art, Andover, Mass.) and the
Carnegie's *Larimer Avenue Bridge.* The
latter painting depicts, in impeccable
detail, a graceful concrete span in the
Frankstown-Larimer area of Pittsburgh's
East Liberty district. The road running
beneath it is Washington Boulevard.
Today, one can easily confirm Kane's

accuracy by standing at the corner of
Hooker and Thompson streets. One can
also observe that Kane allowed himself a
certain license in the upper portion of
this painting, tipping the perspective to
show more of East Liberty than he could
actually have seen from his vantage point.
He must have made independent studies
of the bridge and the city from different
points of view, then assembled them in
the studio to create the final image.

In 1952 John O'Connor, Jr., then associ-
ate director of the Department of Fine
Arts, Carnegie Institute, reported having
seen another *Larimer Avenue Bridge* in
New York:

> Edith Halpert of the Downtown Gallery, a
> major dealer in folk art had . . . a small scene
> of a very high bridge. It's probably the
> bridge out Frankstown Avenue. She said it
> had come to her from Chile, and she was
> attempting to sell it for a very good price.
> She didn't say what the price was, but I take
> it she wanted more than a thousand dollars
> for it.[3]

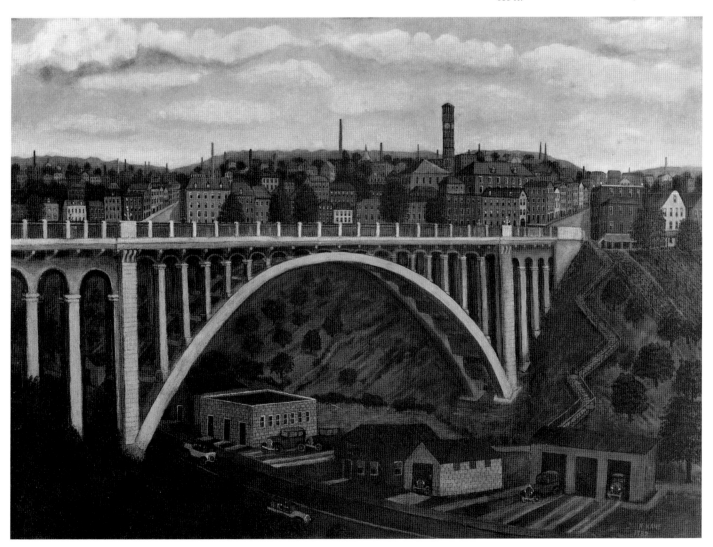

The "bridge out Frankstown Avenue" can only be the Larimer Avenue Bridge (it was known by both names), but O'Connor cannot have seen the work now owned by The Carnegie Museum of Art at the Downtown Gallery in 1952. It is one of Kane's largest paintings, and O'Connor, who knew the artist and his work well, would not have described it as a "small scene." In view of the fact that Kane often painted near-copies and variations of favorite compositions, it is probable that O'Connor saw a second, as yet undiscovered version of *Larimer Avenue Bridge*.

MB, KN

1 David Loeffler Smith, "John Kane, Pittsburgh's Primitive," *American Artist* 23 (April 1959), p. 50.

2 Kane, *Sky Hooks*, p. 118.

3 John O'Connor, Jr., to G. David Thompson, May 27, 1952, museum files, The Carnegie Museum of Art, Pittsburgh.

References "Washington to Hold Show of John Kane's Paintings," *Pittsburgh Post-Gazette*, Feb. 22, 1935, p. 17; Kane, *Sky Hooks*, p. 113; J. O'Connor, Jr., "The Apotheosis of John Kane," *Carnegie Magazine* 29 (Jan. 1955), pp. 19–20; D. L. Smith, "John Kane, Pittsburgh's Primitive," *American Artist* 23 (Apr. 1959), p. 50, reprinted in *Carnegie Magazine* 34 (Feb. 1960), pp. 57–62; W. Gill, "Pittsburgh Painter Laureate," *Pittsburgh Press Roto*, Dec. 27, 1959, p. 9; Arkus, *John Kane, Painter*, no. 128, p. 177; L. R. Elkus, ed., *Famous Men and Women of Pittsburgh* (Pittsburgh, 1981), pp. 191–98; H. Adams, in Museum of Art, Carnegie Institute, *Collection Handbook* (Pittsburgh, 1985), pp. 244–45.

Exhibitions Museum of Modern Art, New York, 1933, *Paintings and Sculptures from Sixteen American Cities*, no. 77; United States Department of Labor, Washington, D.C., 1935, *John Kane's Paintings*, unnumbered; Department of Fine Arts, Carnegie Institute, Pittsburgh, 1936, *John Kane Memorial Exhibition*, no. 38; M. Knoedler and Co., London, 1936, *Exhibition of Paintings by John Kane*, no. 14; Valentine Gallery, New York, 1937, *Paintings by John Kane*, no. 15; Arts Club of Chicago, 1939, *Exhibition of Paintings by John Kane*, no. 12; Museum of Art, Carnegie Institute, Pittsburgh, 1966–67, *Three Self-Taught Pennsylvania Artists: Hicks, Kane, Pippin* (trav. exh.), exh. cat. by L. A. Arkus, no. 71; State Museum of Pennsylvania, Harrisburg, 1972, *Pennsylvania Heritage*, no cat.; Allentown Art Museum, Pa., 1973, *The City in American Painting*, unnumbered; Saint Louis Art Museum, 1977, *Currents of Expansion: Painting in the Midwest, 1820–1940*, no. 99; Whitney Museum of American Art, New York, 1980, *American Folk Painters of Three Centuries*, exh. cat. ed. by J. Lipman and T. Armstrong, unnumbered; Westmoreland County Museum of Art, Greensburg, Pa., 1981, *Southwestern Pennsylvania Painters, 1800–1945*, exh. cat. ed. by P. A. Chew and J. A. Sakal, no. 122.

Provenance Valentine Gallery, New York; M. Knoedler and Co., New York, 1948.

Patrons Art Fund, 1954, 54.50

See Color Plate 28.

Pietà, 1933

Oil on canvas
21½ x 24 in. (54.6 x 61 cm)
Signature, date: JOHN KANE/1933 (lower right)

As Jane Kallir pointed out in a perceptive essay on Kane,[1] the long-held conception of the folk artist as "a wellspring of creative innocence" untouched by artistic tradition has little basis in fact. Kane, the epitome of the self-taught artist, spent a great deal of time at Carnegie Institute and at libraries, familiarizing himself with the art of the past. He expressed a deep admiration for the old masters—"these I cannot study enough"[2]—and copied them (or, to put it more accurately, copied reproductions of them). All of his five extant religious works are copies after older paintings.

According to Dorothy Kantner,[3] Kane painted the *Pietà* after Edward Duff Balken, assistant director of Carnegie Institute's Department of Fine Arts, and John O'Connor, Jr., then the department's business manager, asked him why he had never attempted a religious subject. Kantner also states that Kane was reluctant to deal with an unfamiliar subject, but this can hardly be true. Balken and O'Connor were apparently unaware

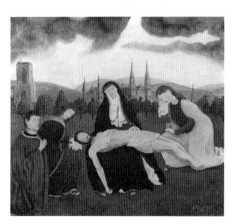

that Kane had submitted religious works to the Carnegie International in 1925 and 1926 and that they had been rejected as copies. Kane's reluctance suggests that, mindful of these rejections and of previous charges in the *Pittsburgh Press* that he painted over photographs, he was afraid of being called a plagiarist.

In *Sky Hooks*, Kane asserted the artist's right to copy, provided he altered his model to reflect his personal vision:

Here is a point of view. All artists, no matter who, are copying nature. They see the hills, the valleys, the trees and they copy those. If an artist sees something in a book he likes he will copy that, too, enlarging upon it or lessening it according to his requirements. So it makes no difference where he sees it, whether it is the work of nature or of another man or work in a book. He is bound to react to the inspiration he feels. He will copy in part and adapt and take out what he likes.[4]

Pietà exemplifies this approach. Kane chose as his model the famous *Avignon Pietà* (c. 1455, Louvre, Paris), a photograph of which hung in Carnegie Institute, and reproduced the figures of Christ, Mary, Saint John, and Mary Magdalene with only minor modifications. Saint John, for instance, supports Christ's head instead of holding his hands in prayer, and the halos have been eliminated. However, Kane also made more significant changes that give the image fresh meaning. The kneeling figure at the left, originally a portrait of the fifteenth-century donor, has become a self-portrait of the artist. The background, while wholly in keeping with the medieval character of the original, is actually a view of Pittsburgh's Oakland district as seen from Schenley Park. At the right, the roof of Carnegie Institute emerges from the trees, Pittsburgh's Saint Paul's Cathedral appears at the center, and the Gothic-style tower at the left is a free adaptation of the University of Pittsburgh's Cathedral of Learning. (See *The Cathedral of Learning* and *Panther Hollow, Pittsburgh*, pp. 285 and 288, for more faithful renderings of this structure.) By altering his model to include himself and the familiar features of his environment,

Kane, an intensely devout Catholic, transformed the work of the fifteenth-century master into an expression of personal devotion.

Following Kane's death, his widow presented *Pietà*, which she called *Descent from the Cross*, to the sisters of Mercy Hospital in appreciation of their kindness to her husband during his last illness. The sisters accepted it but considered it "unfit to hang on the wall."[5] When an art instructor from the affiliated Mount Mercy Academy asked about it, she was told she might take it to the academy. Shortly after, she sent it to the Valentine Gallery in New York, offering to sell it for seven hundred dollars. Valentine Dudensing, however, wanted nothing to do with copies (he had advised Kane's heirs to destroy all such works) and returned it.

MB, KN

1 Galerie St. Etienne, *John Kane*, n.p.

2 Kane, *Sky Hooks*, p. 167.

3 Dorothy Kantner, "Kane's 'Pietà' Returned to Pittsburgh," unidentified newspaper clipping, museum files, The Carnegie Museum of Art, Pittsburgh.

4 Kane, *Sky Hooks*, pp. 168–71.

5 Kantner, "Kane's 'Pietà' Returned."

References D. Kantner, "Kane's 'Pietà' Returned to Pittsburgh," unidentified newspaper clipping, museum files, The Carnegie Museum of Art, Pittsburgh; W. Gill, "Pittsburgh Painter Laureate," *Pittsburgh Press Roto*, Dec. 27, 1959, pp. 8–10; Arkus, *John Kane, Painter*, no. 79, p. 151.

Exhibitions Department of Fine Arts, Carnegie Institute, Pittsburgh, 1949, *Pittsburgh, 1790–1940*, no cat.; Department of Fine Arts, Carnegie Institute, Pittsburgh, 1960, *Promised or Given*, no cat.; Museum of Art, Carnegie Institute, Pittsburgh, 1966–67, *Three Self-Taught Pennsylvania Artists: Hicks, Kane, Pippin* (trav. exh.), exh. cat. by L. A. Arkus, no. 78; State Museum of Pennsylvania, Harrisburg, 1972, *Pennsylvania Heritage*, no cat.

Provenance The artist, until 1934; his widow, Maggie Halloran Kane; Mercy Hospital, Pittsburgh; Mount Mercy Academy, Pittsburgh, by 1936; G. David Thompson, Pittsburgh; Harold Diamond, New York; Paul J. Winschel, Esq., Pittsburgh, by 1971.

Bequest of Paul J. Winschel in memory of Jean Mertz Winschel, 1971, 71.13

Morris Kantor

1896–1974

MORRIS KANTOR's career spanned more than half a century, during which time his style evolved from Cubist-inspired works to paintings in the manner of the Abstract Expressionists. Despite these changes, an "underlying sense of mystery and fantasy"[1] informs all of his work, which frequently depicts night scenes and the sea.

Born in Minsk, Russia, Kantor showed an early interest in drawing, which his mother encouraged. After immigrating to the United States around 1910, he studied from 1916 to 1917 at the Independent School for Art in New York, which provided him with an introduction to European and American modernism. In his earliest works he experimented with ideas derived from such artists as Marc Chagall, Robert Delaunay, the Futurists, and the Blaue Reiter group. In the early 1920s he worked in a Cubist style that bore the influence of Marcel Duchamp.

After his initial brush with modernism, Kantor turned, in the mid-1920s, to a more representational style. A trip to Paris in 1927 found him more interested in the Louvre than in contemporary avant-garde painting. He spent the summer of 1928 in Marblehead, Massachusetts, where he became fascinated with early American and Victorian homes and antiques.

In the fall of 1928 he moved to a studio on Union Square in New York. For the next several years his works were inspired by the landscapes and cityscapes of Marblehead and New York, and it was at this time that he created his best-known paintings. In his night scenes of Union Square and his early American interiors, he often presented interior and exterior space simultaneously. His lighting gave a heightened sense of clarity, while distortions of form and nonnaturalistic spaces created a mysterious, nearly Surrealist mood.

In the mid-1930s Kantor developed a self-consciously primitive style influenced by American naïve painting. This style was characterized by spatial distortion of objects. His typical subjects were views of Cape Cod, especially shore scenes, often moody in tone and gray in color. These, too, often have Surrealist overtones.

Kantor's turn to realism and his interest in Americana were common to both traditional and avant-garde American artists in the 1920s and 1930s. However, he continued to maintain contact with European artistic currents; he was interested in Surrealism and followed the career of Pablo Picasso. His admiration for Picasso can be seen in the figure subjects he painted from around 1935 to 1940 and continued into the 1940s, when he abandoned his American focus of the previous two decades. In 1949 he said he "heartily agreed with those who believe that Picasso is the giant of our times."[2] In the early 1940s Kantor did a number of works concerning World War II directly influenced by *Guernica* (1937, Museo del Prado, Madrid) and painted seascapes and figure pieces whose play of curvilinear rhythm recalls Picasso's work of the late 1920s and early 1930s.

In the late 1940s Kantor combined the influence of Picasso and of biomorphic Surrealism to produce works reminiscent of the early experiments of the Abstract Expressionists. After 1950 his work was clearly Abstract Expressionist and occasionally paralleled the style of Philip Guston and Joan Mitchell.

Kantor had his first solo show at the Brummer Gallery, New York, in 1929. He exhibited regularly in New York at the Rehn Gallery from 1930 to 1959 and at Bertha Schaefer Gallery from 1959 on, and he participated in fifteen of the annual exhibitions held at Carnegie Institute between 1929 and 1950. Retrospective exhibitions of his work were mounted at Grinnell College, Iowa, in 1962, the University of Minnesota, Duluth, in 1963, and the Davenport Municipal Art Gallery, Iowa, in 1965. He taught in New York at the Art Students League from 1934 to 1972 and also at Cooper Union beginning in 1940.

No innovator, Kantor tended to follow the major trends in the art world. However, in his best work, which dates from the late 1920s and 1930s, he combined a Surrealist sensibility with American themes to create distinctive and haunting works of art. Kantor died in New York City.

1 Delaware Art Museum, *Avant-Garde Painting*, p. 84.

2 "Morris Kantor," *Art Students League News* 2 (February 1949).

Bibliography Morris Kantor Papers, 1927–74, Archives of American Art, Washington, D.C.; Morris Kantor, "Ends and Means," *Magazine of Art* 33 (March 1940), pp. 138–47; Richard Shepherd, "M. Kantor 1946," *Art News* 45 (July 1946), pp. 38–41, 57–58; Anita Ventura, "The Paintings of Morris Kantor," *Arts* 30 (May 1956), pp. 30–35; Delaware Art Museum, Wilmington, *Avant-Garde Painting and Sculpture in America, 1910–25* (1975), exh. cat. ed. by William I. Homer, p. 84.

Mother and Child, 1939

Oil on canvas
44 x 38 in. (111.8 x 96.5 cm)
Signature, date: *M. Kantor*/1939 (lower right)

During the mid-1930s Kantor created a number of works strongly influenced by Picasso's classicizing style of the late 1910s and 1920s. The first of these incorporate small-scale figures into beach landscapes. Between 1930 and 1940 he painted a number of works showing monumental figures in similar settings.

Mother and Child clearly looks back to Picasso's classical phase. It consists of two massive figures placed in a vague beach-like setting. To create such weighty, sculptural figures, Kantor simplified the forms of his bodies into near-tubular shapes. The heavy modeling, with its limited transitions from dark to light, contributes to the impression of monumentality, as do the classicizing forms of the faces, with their thick brows, darkly shaded lids, and, in the case of the mother, a nose that extends, in the manner of Picasso, directly from the plane of the brow.

To his sculptural forms Kantor joined linear rhythms and expressive hand gestures, in a manner seen in works by Picasso such as *Women Running on the Beach* (1922, Musée Picasso, Paris). The thickly scumbled, almost pasty application of paint further recalls Picasso's work of these years. However, Kantor's painting, even though it is more vivid than his work of the mid-1930s, lacks the intense value contrasts of Picasso's works, a fact that robs *Mother and Child* of some of its expressive impact.

Regarding *Mother and Child*, Kantor wrote, "I was fascinated by the magnetic reach between a mother and child while

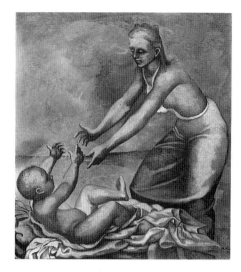

watching a young mother trying to lift her child up."[1] His goal, however, was not to re-create a specific scene he had witnessed but to express the eternal aspect of the mother-and-child relationship. The undifferentiated clothing, the vague, almost elemental seaside setting, and the classical, monumental style all contribute to the impression that the painting is dealing with timeless verities. Indeed, as John O'Connor, Jr., has pointed out, "the spread on which the baby reclines. . . lies in very formalized folds as if to simulate the waves of the sea,"[2] that is, almost as if the baby were emerging from the sea, an allusion with mythic reverberations. Not all viewers appreciated this approach: *Mother and Child* was called "a stiff-pseudo-classic"[3] by one critic. Nevertheless, Kantor sought to express such universal ideas in other works of the period, such as *On the Beach* (1938, Metropolitan Museum of Art, New York).

Mother and Child was purchased from the 1939 Carnegie International by Pittsburgh collector Charles J. Rosenbloom.

JRM

1 Morris Kantor to John O'Connor, Jr., January 31, 1950, museum files, The Carnegie Museum of Art, Pittsburgh.

2 John O'Connor, Jr., "Mother and Child: A Painting by Morris Kantor," *Carnegie Magazine* 24 (October 1950), p. 453.

3 H. Devree, "What to Do about the Carnegie," *Parnassus* 11 (November 1939), p. 11.

References H. Devree, "What to Do about the Carnegie," *Parnassus* 11 (Nov. 1939) p. 11; J. O'Connor, Jr., "Mother and Child: A Painting by Morris Kantor," *Carnegie Magazine* 24 (Oct. 1950), pp. 453–54.

Exhibitions Department of Fine Arts, Carnegie Institute, Pittsburgh, 1939, *The 1939 International Exhibition of Paintings*, no. 37; Department of Fine Arts, Carnegie Institute, Pittsburgh, 1946, *Paintings and Prints from the Collection of Charles J. Rosenbloom*, no. 2; Columbus Gallery of Fine Arts, Ohio, 1952, *Paintings from the Pittsburgh Collection*, no cat.

Provenance Charles J. Rosenbloom, Pittsburgh, 1939.

Gift of Mr. and Mrs. Charles J. Rosenbloom, 1949, 50.1.3

John Frederick Kensett
1816–1872

B
Y THE 1860s, John Frederick Kensett was one of the most avidly sought-after landscape painters in America. In New York he held a remarkable position of power and was respected by artists, art patrons, and men of letters alike. Today he is considered one of the most accomplished of the Hudson River school painters, whose late work was central to the phenomenon known as Luminism.

Kensett was born and raised in Cheshire, Connecticut, the son of an engraver of maps, banknotes, and other documents. He probably worked for his father and uncle in their New Haven engraving shop before going to New York, at the age of thirteen, to become an engraver's apprentice. Although he continued to do engraving for various firms until 1840, from the mid-1830s onward he became increasingly interested in landscape painting. In New York, he met the young landscape painters John Casilear and Thomas Rossiter, exhibited his first landscape at the National Academy of Design in 1838, and gradually made the not-uncommon transition from engraver to landscape painter.

In 1840, accompanied by Casilear, Rossiter, and Asher B. Durand, Kensett sailed to Europe, where for the next seven years he divided his time among Paris, London, and Rome. In Paris he drew from the antique and took life classes at the Ecole des Beaux-Arts. He engaged in some engraving and continued to draw and paint landscapes. Like Thomas Cole, whom he met in Paris, he used his travels

to study both Europe's past landscape art and its picturesque sites.

Following his return to the United States, Kensett settled in New York, where he quickly rose to professional and social prominence. Elected an associate of the National Academy of Design in 1848, he rose to academician the following year. Kensett also became a valued member of New York's prestigious Century Association and the Sketch Club. He organized the international art exhibition of the Metropolitan Fair held at Union Square in 1864 and became a trustee of the Metropolitan Museum of Art when it was founded in 1870. His vast circle of acquaintances embraced most of the leading artists and intellectuals of mid-nineteenth-century America, and his leadership in the New York art community was reinforced by strong patronage of his work.

Kensett's artistic interests after his European sojourn corresponded to those of his friends Durand, Benjamin Champney, and Casilear. His work showed a receptivity to Cole's ideas about landscape, depicting American scenery as picturesque yet serene, the revered creation of God. Kensett was an avid traveler who made a summer sketching tour every year from 1841 to 1872. Although these trips included Colorado and the upper Mississippi, he never ventured to probe the deep reaches of the American wilderness. Instead, he was content with sites that were relatively near at hand: the Rhode Island and Connecticut shores, the Adirondacks, the Hudson, Niagara.

From the late 1850s on, Kensett's scenery became more expansive and panoramic yet increasingly emptied of superfluous detail and more severe in its geometry. His last works embodied a remarkable degree of abstraction and contemplative stillness. It is generally acknowledged that Kensett was at the height of his powers when he unexpectedly died while working in his New York studio.

Bibliography Ellen Johnson, "Kensett Revisited," *Art Quarterly* 20 (Spring 1957), pp. 71–92; Hathorn Gallery, Skidmore College, Saratoga Springs, N.Y., *John Frederick Kensett, A Retrospective Exhibition* (1967), exh. cat. by James Kettlewell et al.; American Federation of Arts, New York, *John Frederick Kensett, 1816–1872* (1968), exh. cat. by John K. Howat; John K. Howat, "John F. Kensett, 1816–1872," *Antiques* 96 (September 1969), pp. 397–401; Worcester Art Museum, Mass., *John Frederick Kensett: An American Master* (1985), exh. cat. by John Paul Driscoll, John K. Howat, et al.

Long Neck Point from Contentment Island, c. 1870–72

Oil on canvas
15⅜ x 24⅜ in. (39.1 x 61.9 cm)

In 1867 Kensett bought a parcel of land on Contentment Island, in Darien, Connecticut, from his close friend and fellow artist Vincent Colyer. There he kept a studio, and its location apparently inspired him to a vigorous new phase of his painting during the summer and fall of the last year of his life. *Long Neck Point from Contentment Island* was probably part of that last summer's production. The canvas was in Kensett's Contentment Island studio when he died, along with some small paintings of Lake George and Newport Harbor and numerous other scenes of Long Island Sound and the Connecticut shore. These were soon afterward exhibited at the National Academy of Design; a photograph of that exhibition clearly shows this canvas on display.

The Carnegie painting, a shore view, is simply two rectangular fields of different colors. Sky and water are separated by the frailest of horizon lines, interrupted by only a bit of shore to the right. The sky is scumbled with opal hues of dusk; the water is an absolutely smooth surface of gray-blue, touched sparingly with reflections of pink from the sky. Comparison of this work with recent photographs taken at the site confirms Kensett's topographic accuracy (the shoreline has apparently changed little over time) and indicates that he cut off the shoreline that otherwise would appear in the area just below the lower edge of the canvas.[1] The result is that the composition seems unanchored and free-floating.

To achieve his mood of hushed serenity, Kensett employed some of the same compositional devices found in the work of Fitz Hugh Lane and Martin Johnson Heade: large expanses of virtually empty sky and sea; a low horizon line, lengthened by a horizontally elongated canvas; and the echoing of selected shapes and colors within the composition. The profusion of nature's detail has given way to its unity.

Though undated, the painting has the same innovative brilliance associated with the artist's last work, and was surely begun sometime between 1870 and 1872. Those images possess an extremely simplified pictorial geometry and depict land masses with a remarkable tenuity, emphasizing the presence of the becalmed sea and sky. With their simple, severe compositional format and delicately rendered effects of light and atmosphere, these works can be said to anticipate the poetic turn American landscape painting took in the last quarter of the nineteenth century.
DS

1 The present owners of the property to David Challinor, October 1982, museum files, The Carnegie Museum of Art, Pittsburgh.

References O. Rodriguez Roque, "A Landscape by Kensett," *Carnegie Magazine* 55 (Apr. 1981), pp. 16–21; H. Adams, in Museum of Art, Carnegie Institute, *Collection Handbook* (Pittsburgh, 1985), pp. 180–81.

Exhibitions National Academy of Design, New York, 1873, *The Collection of Over Five Hundred Paintings and Studies by the Late John F. Kensett*, cat. by R. M. Oliphant, no. 52; Worcester Art Museum, Mass., 1985, *John Frederick Kensett* (trav. exh.), exh. cat. by J. P. Driscoll, J. K. Howat, et al., unnumbered.

Provenance The artist, until 1872 (sale, Robert M. Somerville, New York, Mar. 24, 1873); possibly Edward King, Newport, R.I., 1873; Kennedy Galleries, New York, 1960; private collection, 1960; James Maroney, New York, 1980.

Museum purchase: gift of Women's Committee of the Museum of Art, 1980, 80.51

See Color Plate 7.

Albert F. King
1854–1945

BORN IN PITTSBURGH, Albert F. King was essentially self-taught as a painter, except for some informal instruction he received from his friend the local landscape painter Martin B. Leisser. King was an active member of the second-generation Scalp Level school, a group known for making landscape-painting forays into the countryside of Scalp Level, Pennsylvania. This group, made up of Joseph Ryan Woodwell, Charles Linford, Jasper Holman Lawman, Alfred S. Wall, and Leisser, had as its leader George Hetzel. Hetzel had studied at the art academy in Düsseldorf from 1847 to 1849, and it was his precise and naturalistic style that King chose to emulate.

Although King made his living largely by painting portraits of successful local businessmen, including Pittsburgh industrialists Andrew Carnegie and Henry Clay Frick, he is best remembered for his strikingly realistic still-life paintings. Done in the trompe-l'oeil tradition of William Michael Harnett, King's deftly arranged still lifes emphasize texture, color, and light, and almost confound the viewer with their extremely lifelike presentation.

King was a member of the Pittsburgh Artist Society and the Pittsburgh Artists' Association (now the Associated Artists of Pittsburgh). In 1910 he was on the jury of selection for the first exhibition of the Artists' Association, and he held the same position the following year. He also submitted his work to the Carnegie International in 1901 and again in 1922, but his paintings were rejected in favor of the work of the more worldly American and European painters of the day. Later in life, speaking about contemporary artists, King said, "I think they are an insult to the public. And there isn't the

same spirit among the artists. We used to plan to go to the 'Old Scalp'—a whole group of us—to paint. Now each artist is just for himself."[1]

King left the Pittsburgh art scene for a short while in 1936, when he decided to live with his son in Omaha, Nebraska. However, he became homesick and returned to Pittsburgh two years later and remained there. Eager to take up painting again, he opened a studio in the Stevenson building in East Liberty and resumed his painting career, working in a style reminiscent of the late nineteenth century.

1 Dorothy Kantner, "King, Veteran Artist, Home from West," *Pittsburgh Sun-Telegraph*, 1937, undated clipping, Pittsburgh artists' files, Music and Art Division, The Carnegie Library, Pittsburgh.

Bibliography William H. Gerdts and Russell Burke, *American Still-Life Painting* (New York, 1971), p. 181; Westmoreland County Museum of Art, Greensburg, Pa., *Southwestern Pennsylvania Painters, 1800–1945* (1981), exh. cat. ed. by Paul A. Chew and John A. Sakal, p. 76; "Albert F. King," in Michael David Wellman, ed., *American Art Analog* (New York, 1986), vol. 2, p. 506.

Late Night Snack, c. 1900

Oil on canvas
16 x 22 1/16 in. (40.6 x 56 cm)
Signature: A. F. King (lower right)

Perhaps King's finest still life, *Late Night Snack* is an outstanding example of the trompe-l'oeil tradition popularized by William M. Harnett. An ultrarealistic work, this tabletop arrangement illustrates King's simple, humble perception unrestricted by the techniques of more cosmopolitan artists working at the end of the nineteenth century.

The snack, consisting of beer, cheese, biscuits, and mustard upon a shiny wooden table, is crafted with eye-fooling realism. The artist's exacting attention to detail is evidenced not only in the beer's effervescence—the bubbles are clearly and individually outlined—but also in the reflection of a window on the bottles and cheese dome. This well-organized composition illustrates the edibles with a fine-textured brushstroke, tempting the viewer to indulge in the snack. At the same time, the dark, ominous back-

ground is forbidding, deterring the viewer from relating either the vessels or their contents too closely to mundane experience.

There is something rarefied and elusive about King's image. The geometric composition, seemingly eternal in its orderly cadence of cylinders and bands, undercuts the casual nature of the subject. At the same time, nearly every object is encased in a seemingly hard, glasslike shell—from the biscuits that leave no crumbs and the mustard's shiny ceramic pot to the cheese swathed in glass and thus removed from the viewer's touch.

Similarities between *Late Night Snack* and the paintings of Harnett suggest that King may have been influenced by Harnett's technique of still-life painting as well as his innovative point of view. A canvas composed of everyday items, labels on objects that can almost—but not quite—be read, and a certain aura of solitude are common to the works of both artists. So is a sense of the uniqueness of both the object and the experience of apprehending it.

LAH

References N. Colvin, "Scalp Level Artists," *Carnegie Magazine* 57 (Sept.–Oct. 1984), p. 20; H. Adams, in Museum of Art, Carnegie Institute, *Collection Handbook* (Pittsburgh, 1985), p. 220.

Exhibition Westmoreland Museum of Art, Greensburg, Pa., 1988, *Penn's Promise: Still Life Painting in Pennsylvania, 1798–1930*, exh. cat. by P. A. Chew, no. 53.

Provenance Private collection; Kennedy Galleries, New York, by 1979; Willard G. Clark, Hanford, Calif., by 1980; D. Wigmore Fine Art, New York, 1982.

Museum purchase: gift of R. K. Mellon Family Foundation, 1983, 83.3

See Color Plate 14.

Maxim Kopf
1892–1958

THE SON OF A civil servant of the Austro-Hungarian Empire, Maxim Kopf was born in Vienna and raised in Prague. He began his artistic training at the academy in Prague, but his studies were interrupted in 1914 by the outbreak of World War I. He was drafted into a Czech regiment and while fighting at the front was wounded, suffered a nervous breakdown, and contracted tuberculosis. When the war ended he reentered the academy in Prague, where he won a fellowship to study art in Dresden.

In 1923 Kopf made his first trip to America; he worked for the New York stage designer Joseph Urban, eventually saving enough money to make an artist's tour to Tahiti. Back in Prague, he exhibited an eclectic array of canvases: religious subjects, Prague churches, Tahitian nudes, New York cityscapes, portraits, and still lifes—all characterized by the bright palette and thick, energetic brushwork associated with the European Expressionist movement.

Oskar Kokoschka and Emil Nolde appear to have had the most enduring influence on Kopf, who modified the Expressionist idiom in the course of his career, but never completely abandoned it. His early works, as well as his status as a founder of the Prague Secession in 1929, brought him modest critical and financial success. During the 1930s he showed in leading international exhibitions, including the Salon d'Automne and Salon des Indépendants in Paris.

Kopf was in Tahiti for the second time when the Munich crisis occurred in 1938. A reserve army officer, he immediately returned to Prague to report for military service but fled to Paris when the German army occupied Czechoslovakia the following year. Ironically, shortly after his arrival in France he was arrested as an enemy alien and spent the next two and a half years in various prisons and concentration camps in France and Morocco. Eventually, with the help of the Czech foreign minister, Jan Masaryk, Kopf was released, and in 1941 he settled in America.

Kopf had the first of many successful New York shows at the Wakefield Gallery in January 1942. Critics praised the bold handling and pulsating, vibrant color of his works[1] and called him "a more disciplined and coherent Kokoschka."[2] He married the writer Dorothy Thompson in 1943, the same year he became an American citizen. He and his wife divided their time between their Manhattan apartment and their farm in South Pomfret, Vermont.

Throughout the 1940s Kopf had a close relationship with Carnegie Institute. Having participated in the 1937 Carnegie International, he then contributed to the *Painting in the United States* exhibitions of 1943, 1944, 1947, 1948, and 1949, and the 1950 Carnegie International. Four of the six paintings he showed in these exhibitions were scenes from the life of Christ, highlighting the importance of religious imagery in Kopf's vast repertoire. As Piri Halasz has explained:

Much of the imagery through which the [New York] expressionists voiced their concern over World War II was essentially religious. Somehow, the modern desecration that was Hitler made the need for a Christ or a revered patriarch seem freshly necessary. . . .[3]

Although Kopf's popularity, along with that of other American Expressionists, faded in the 1950s, he continued to travel extensively and to record his impressions on canvas. He died in Hanover, New Hampshire.

1 Helen Boswell, "Fifty-seventh Street in Review," *Art Digest* 16 (January 15, 1942), p. 23.
2 "Among One Man Shows," *New York Times*, January 11, 1942, sec. 9, p. 10.
3 Hillwood Art Gallery, Long Island University, Greenvale, New York, *The Expressionist Vision: A Central Theme in New York in the 1940s* (1983), exh. cat., essay by Piri Halasz, p. 12.

Bibliography American British Art Center, New York, *Maxim Kopf* (1944); Obituary, *New York Times*, July 8, 1958, p. 27; Dorothy Thompson, ed., *Maxim Kopf* (New York, 1960).

Lower Manhattan, 1942

Oil on canvas
31 x 41⅛ in. (78.7 x 104.5 cm)
Signature, date: *Maxim Kopf.*/NY. 42. (lower right)

Upon arriving in New York in 1941, Kopf established a studio in Brooklyn and thereafter painted many views of Manhattan from Brooklyn Heights.[1]

Lower Manhattan is a typical example: it presents a view over the Brooklyn docks and bustling harbor to the majestic New York skyline beyond, the Brooklyn Bridge clearly visible on the far right.

The artist used a variety of brushstrokes to convey the city's dynamic energy. Horizontal brushstrokes in the foreground boats and water create a sense of lateral movement, while thin, vertical strokes emphasize the height of the skyscrapers. The brushwork in the sky—although broader and softer—is also vertical, seeming to radiate from the buildings themselves and to reflect their upward motion. The heavy impasto on the left side of the canvas is contrasted with thinly painted or bare areas of canvas on the right, giving the painting a shimmering, sketchlike surface. The predominating colors of blue-green, rusty brown, and peach unify the composition and convey Kopf's idyllic image of his new home.

Kopf's view of Manhattan was undoubtedly an idealistic one: he saw the city—indeed, all America—as a refuge from the war-torn Europe from which he had so recently escaped. The image of Manhattan as a glorious bastion of freedom and humanism is what he strove to portray in works such as this one. In his own words:

> This is one country where every man counts for himself, and not because of his race and nationality. I love its vibrant life, its landscapes, and above all the fantastic, miraculous city of New York. I felt at home the first day I set foot in its harbor and when I

came in 1941 I knew in advance that if America would have me, it would be my home for the rest of my life.[2]

RB

1 Thompson, *Maxim Kopf*, p. 26.
2 American British Art Center, *Maxim Kopf*, n.p.

References John O'Connor, Jr., to André Seligmann, Koetser Gallery, New York, November 18, 1943, and November 19, 1943, museum files, The Carnegie Museum of Art, Pittsburgh; John O'Connor, Jr., to Maxim Kopf, July 10, 1944, museum files, The Carnegie Museum of Art, Pittsburgh.

Exhibitions Department of Fine Arts, Carnegie Institute, Pittsburgh, 1943, *Painting in the United States*, no. 76; Toledo Museum of Art, Ohio, 1944, *Thirty-first Annual Exhibition of Selected American Paintings*, no cat.

Provenance Charles J. Rosenbloom, Pittsburgh, 1943.

Bequest of Charles J. Rosenbloom, 1974, 74.7.15

Leon Kroll
1884–1974

THE WORK OF Leon Kroll represents the continuing realist tradition in twentieth-century art. Born in New York City to German-Jewish immigrant parents who opposed his desire to become an artist, Kroll began his study of painting while still in his teens at the Art Students League with John Twachtman. Around 1902 he entered the National Academy of Design in New York, which provided an academic foundation for his art; his talent was recognized there by a number of awards and prizes.

In 1908 Kroll received a scholarship to travel in Europe, enabling him to study for two years at the Académie Julian, Paris, where he became a student of Jean-Paul Laurens. While he was in Paris he won a prize for a nude, the subject that became the abiding interest of his career. He settled in New York in 1910, and shortly thereafter the National Academy mounted his first solo exhibition.

In 1911 Kroll began teaching at the National Academy and exhibiting with the independent American painters in the

circle of Robert Henri. Though somewhat removed from the social consciousness of the Ashcan school, he became known for his bustling scenes of New York painted in the plein-air manner of the Impressionists. In 1913 he exhibited at the Armory Show, an opportunity that launched his highly successful career.

Kroll was elected to the National Academy of Design in 1927 and became an influential member of the American art community, serving on many committees and juries. He spent many years as a visiting critic: at the Maryland Institute, Baltimore (1919–23), the Art Institute of Chicago (1924–25), and the Pennsylvania Academy of the Fine Arts, Philadelphia (1929–30). He returned to France several times during the 1920s, becoming acquainted with Robert and Sonia Delaunay, Marc Chagall, and Henri Matisse, among other artists.

Kroll had a lengthy association with Carnegie Institute. Between 1911 and 1950 he exhibited in twenty-six of its annual exhibitions and served as well on the 1929 advisory committee and the 1947 jury of

award. In 1935 Carnegie Institute honored him with a large and well-publicized solo exhibition.

In addition to a large production of alluring portraits and lush female nudes, Kroll in the 1930s produced a successful series of landscapes with figures painted primarily at Cape Ann and Rockport, Massachusetts. Composed in accordance with classical rules of design, these works reflect Kroll's academic training. One of these, *The Road from the Cove* (1936, private collection), won first prize at the Carnegie International in 1936. Kroll also executed several large murals, including *Triumph of Justice* and *Defeat of Justice* (1936–37) in the United States Department of Justice building in Washington, D.C., and the *War Memorial Murals* (1938–41) at Worcester, Massachusetts. Kroll's last commissions included a glass mosaic for the chapel at Omaha Beach in Normandy and a mural for the Senate chamber of Indiana's State Capitol. From 1954 to the end of his prestigious career, Kroll served as president of the United States Committee of the International Association of Plastic Arts. He died in Gloucester, Massachusetts.

Bibliography "Leon Kroll—Painter," *Index of Twentieth Century Artists* 1 (January 1934), pp. 59–64; "Leon Kroll: An Interview," *American Artist* 6 (June 1942), pp. 4–11; American Artists Group, *Leon Kroll*, monograph no. 17 (New York, 1946); Nancy Hale and Fredson Bowers, eds., *Leon Kroll: A Spoken Memoir* (Charlottesville, Va., 1983).

Morning on the Cape, 1935

Oil on canvas
36 x 58 in. (91.4 x 147.3 cm)
Signature: *Leon Kroll* (lower right)

Morning on the Cape is one of several similar landscape paintings that Kroll produced at Cape Ann, Massachusetts, where he spent much of his time during the 1930s. Although these outdoor scenes represent a departure from his studio pieces, his general approach to them remained academic. They were selectively composed and based on his prior conceptions. "I always use nature as a kind of abstract encyclopedia of fact," he remarked. "I use parts and compose a picture."[1] Two other paintings by Kroll demonstrate this same

selective process, *Plowed Field* (1933, Kroll Estate) and *The Road from the Cove* (1936, private collection), for they share with *Morning on the Cape* such elements as background motif and figures.

While he maintained that his subjects were secondary to considerations of design, Kroll plainly stated that the inspiration for *Morning on the Cape* came from his sympathetic feeling for the "healthy fertility of simple normal life."[2] Here, the reciprocity between the softly undulating forms of the furrowed fields and the sculptural forms of the farmer's muscular back integrates the landscape with humble human activities. The prospective fertility of the earth and that of the pregnant woman at the right echo this theme. A stony embankment separates the young woman in the foreground from the other figures: while she stands on the threshhold of maturity, the farmer and the pregnant woman suggest her inevitable future.

Kroll achieves unity in this canvas not only through the careful balancing of figures and landscape masses but also by using a restricted palette of warm, earthy tones. Only the sky, deliberately distressed with a dry brush while the paint was still wet, deviates from the smoothly painted surfaces that characterize Kroll's usual technique.

Voted the most popular painting in the 1935 Carnegie International, *Morning on the Cape* was purchased from the exhibition.

GB, KP

1 Hale and Bowers, *Leon Kroll: A Spoken Memoir*, p. 106.

2 Leon Kroll to Homer Saint-Gaudens, December 19, 1935, Carnegie Institute Papers, Archives of American Art, Washington, D.C.

References G. Lerolle, "Personality and Originality in Art," *Carnegie Magazine* 9 (Nov. 1935), p. 173; J. O'Connor, Jr., "Patrons Art Fund Purchase," *Carnegie Magazine* 9 (Dec. 1935), p. 201; J. B. Lane, "Leon Kroll," *Magazine of Art* 30 (Apr. 1937), p. 221; H. A. Murray et al., *Explorations in Personality* (Cambridge, Mass., 1939), pl. no. 2; H. Saint-Gaudens, *The American Artist and His Times* (New York, 1941), p. 263; V. A. Clark, "Collecting from the Internationals," *Carnegie Magazine* 56 (Sept.–Oct. 1982), p. 24; H. Brown, "Fame and Fortune in the Art World," *American Artist* 51 (Mar. 1987), p. 50.

Exhibitions Department of Fine Arts, Carnegie Institute, Pittsburgh, 1935, *International Exhibition of Paintings*, no. 72; University of Illinois, Urbana, 1936, *Leon Kroll*, no cat.; Whitney Museum of American Art, New York, 1936, *Third Biennial Exhibition of Contemporary American Painting*, no. 99; Worcester Art Museum, Mass., 1937, *Leon Kroll Retrospective Exhibition*, no. 27.

Provenance The artist, until 1936.

Patrons Art Fund, 1936, 36.1

See Color Plate 29.

Yasuo Kuniyoshi
1893–1953

AN ARTIST WHO viewed painting as an extension of his life, Yasuo Kuniyoshi blended the influence of his Asian heritage with his Western artistic training to create a body of work that grew and changed as personal and worldwide events shaped his life. Born in Okayama, Japan, Kuniyoshi immigrated to the United States at the age of seventeen. He first settled in Seattle but later moved to Los Angeles, where a schoolteacher encouraged him to attend art school. From 1907 to 1910 he was enrolled at the Los Angeles School of Art and Design until, at the age of twenty-one, he moved to New York. There he studied at the National Academy of Design, the Henri School of Art, and the modernist Independent School of Art before enrolling, in 1916, at the Art Students League under Kenneth Hayes Miller. Miller, who encouraged Kuniyoshi to study the work of Pierre-Auguste Renoir, Paul Cézanne, Honoré Daumier, El Greco, and Albert P. Ryder, had a profound effect on Kuniyoshi's art.

In 1917 Kuniyoshi exhibited his first paintings at the Society of Independent Artists, New York, where he met Hamilton Easter Field, a wealthy patron of modern art and the founder and editor of *Arts* magazine. He became Field's good friend and until 1924 spent summers painting in a studio at Field's home in Ogunquit, Maine. His paintings of this period—based mainly on his experiences in Maine—are characterized by a primitive approach, emphatic contours, and a bird's-eye point of view. They combine

Kuniyoshi's simultaneous interest in his Asian heritage, early American paintings and furniture, and the modernist decorative work of Heinrich Campendonk, Wassily Kandinsky, and Marc Chagall.

Kuniyoshi landed his first solo show at the Daniel Gallery, New York, in 1922, but from 1920 to 1925 he supported himself by photographing works of art. In 1925 and 1928 he visited Europe, where he admired the work of Henri Matisse, Pablo Picasso, André Derain, and Maurice Utrillo, particularly their understanding of paint and their direct painting from the object. In the 1930s Kuniyoshi developed a simpler, more expressive, and more personal style, in which he sought a balance of the decorative and naturalistic in order to achieve "something more than reality."[1] Relying on a wider color range, richer handling, and rounder forms in deeper space, he depicted landscapes, still lifes, and languid, voluptuous, partially dressed women.

Kuniyoshi's reputation grew quickly. He received numerous awards, including the Temple Gold Medal at the Pennsylvania Academy of the Fine Arts, Philadelphia, in 1934 and first prize at Carnegie Institute's *Painting in the United States* exhibition of 1944. Among numerous major exhibitions, he was represented between 1931 and 1952 in seventeen of Carnegie Institute's annual exhibitions, where he won honorable mention in 1931 and second prize in 1939.

From 1933 until his death, in New York, Kuniyoshi taught at the Art Students League and was active in several left-leaning artists' organizations, including the American Artists Congress. Although he never became an American citizen, he had strong sentiments for this country and was its vociferous supporter during World War II, when he made pro-Allies broadcasts to Japan and powerful posters for the Office of War Information. His feelings about the war were reflected in his paintings of the 1940s, which show a growing social awareness as well as an increased emotional intensity. He often expressed the destructiveness of war by using desolate landscapes as backdrops for melancholy figures and weather-beaten objects.

In his later works Kuniyoshi's aim was to create a visually and emotionally vibrant three-dimensional painting while

preserving the integrity of the two-dimensional picture plane. In this he achieved the goal set forth in his autobiography of 1945: "to combine the rich traditions of the East with the accumulative experiences and viewpoint of the West."[2]

1 American Artists Group, *Yasuo Kuniyoshi*, n.p.

2 Ibid.

Bibliography American Artists Group, New York, *Yasuo Kuniyoshi*, exh. cat. by Yasuo Kuniyoshi (1945); Whitney Museum of American Art, New York, *Yasuo Kuniyoshi: Retrospective Exhibition* (1948), exh. cat. by Lloyd Goodrich, pp. 5–47; Aline B. Louchheim, "Kuniyoshi: Look, My Past," *Art News* 47 (April 1948), pp. 46–48, 55, 56; University Art Museum, University of Texas, Austin, *Yasuo Kuniyoshi* (1975), exh. cat. by Donald B. Goodall et al.

Mother and Daughter, 1945

Oil on canvas
40¼ x 30¼ in. (102.2 x 76.8 cm)
Signature: *Kuniyoshi* (upper right)

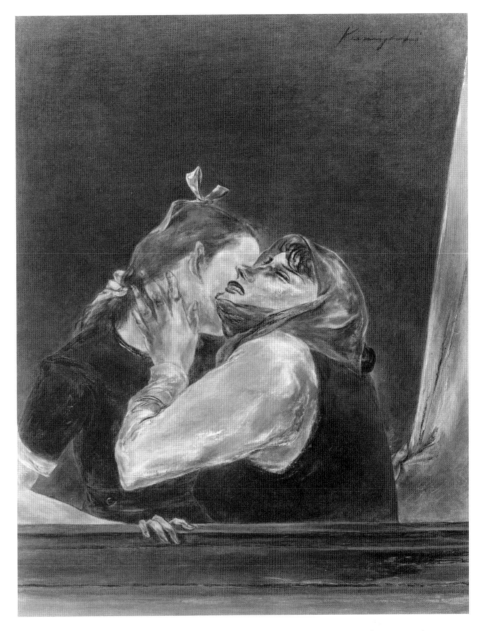

Mother and Daughter was well received when it was exhibited in the fall of 1945 at Carnegie Institute's *Painting in the United States* exhibition. Similar enthusiastic sentiments prevailed when it was first exhibited in 1945 in Kuniyoshi's solo show at the Downtown Gallery, New York. There critics applauded it as an excellent example of the artist's new emotional style, which arose from his deeply felt reaction to World War II:

> Of the many existing pictures of reunited refugees, *Mother and Daughter* is the most eloquent we have seen to date. In it he has caught the cramped, spasmodic gesture that a normally undemonstrative person will make in moments of great emotional pitch.[1]

> [H]is dreamy... somewhat morose girls are becoming more human. This is especially evident in his painting, *Mother and Daughter* where he composes in a more subjective manner than has been his habit.... It can stand with some of the religious paintings of the past which expressed with only two figures moments of ecstasy, sorrow, and maternal love.[2]

Kuniyoshi himself stated that this painting evolved from his "sense of destruction and ruination... feelings about despair of war and people lost in it."[3]

Although its expressive content marked a departure from his previous works, *Mother and Daughter* is in many ways a continuation of Kuniyoshi's painting style developed during the 1920s and 1930s. The delicate, somber hues of white, rust, gray, and brown are characteristically manipulated for a range of effects from translucent glazes to impastos, though they are now used expressively to heighten the emotional intensity of the mother's face. Even the expressive distortion of the mother's fingers was not new to his art, for this kind of primitive stylization can be seen in his paintings of the 1920s.

While the intense mood of the painting is quite clear, its exact meaning remains ambiguous—are mother and daughter reunited or parting? Likewise ambiguous is the painting's spatial arrangement, for the two women stand behind what can be interpreted as an open window, but there is no suggestion of the room behind. What link interior to exterior space and actually create the space for the two figures are the daughter's gestures, grasping the window curtain with one hand while the fingers of the other curl illusionistically over the windowsill's edge.

The use of half-figures behind an open window is reminiscent of similar compositions in Renaissance and Baroque portraits and genre scenes. Kuniyoshi also seems to be drawing from French masters

such as Jules Pascin, while his construction of the composition with flat, interlocking patterns and a limited space is distinctly Japanese in flavor. This conflation of East and West was quite conscious, as the artist later stated:

> I like to paint women, but I don't paint just one woman. I put in what I know and sense about all women. I think this is in the Eastern tradition, but the way I paint is in the Western tradition.[4]

Kuniyoshi made two drawings closely related to the Carnegie's painting. One, *Mother and Daughter* (1943, location unknown[5]) is a preliminary pencil study for the painting. The other, *Mother and Daughter* (1945, collection Mrs. William L. Shirer, New York), is an India ink drawing after the canvas.

GS

1 R[osamund] F[rost], "What the War Has Meant: Exhibition, Downtown Galleries," *Art News* 44 (April 1, 1945), p. 25.

2 Unidentified article in *New Masses*, May 1, 1945, Downtown Gallery Papers, 1958, Archives of American Art, Washington, D.C.

3 Louchheim, "Kuniyoshi: Look, My Past," p. 55.

4 Yasuo Kuniyoshi, "Universality in Art," *League Quarterly* 20 (Spring 1949), p. 7.

5 Inventoried in the record of Kuniyoshi's work made by R. Irvine, Archives of Whitney Museum of American Art, New York, 1947–48.

References R. F[rost], "What the War Has Meant: Exhibition, Downtown Galleries," *Art News* 44 (Apr. 1, 1945), p. 25; M. Riley, "Kuniyoshi's Newest," *Art Digest* 19 (Apr. 1, 1945), p. 59; D. E. G., "Two Paintings Remain," *Carnegie Magazine* 19 (Jan. 1946), pp. 206–7; "Carnegie Acquires Kuniyoshi and Israel," *Art Digest* 20 (Feb. 15, 1946), p. 10; Louchheim, "Kuniyoshi: Look, My Past," p. 55.

Exhibitions Department of Fine Arts, Carnegie Institute, Pittsburgh, 1945, *Painting in the United States*, no. 55; Downtown Gallery, New York, 1945, *Yasuo Kuniyoshi: New Paintings and Drawings*, no. 10; Colorado Springs Fine Arts Center, Colo., 1946, *New Accessions, USA*, no. 8; Whitney Museum of American Art, New York, 1948, *Yasuo Kuniyoshi: Retrospective Exhibition*, no. 63; Metropolitan Museum of Art, New York, 1951, *The Seventy-fifth Anniversary Exhibition of Paintings and Sculpture by Seventy-five Artists Associated with the Art Students League of New York*, no. 63; Walker Art Center, Minneapolis, 1956, *Expressionism, 1900–1955*, unnumbered; American Federation of Arts, New York, 1963–64, *Mother and Child in Modern Art* (trav. exh.), no. 11; University Art Gallery, University of Florida, Gainesville, 1969, *A Special Loan Retrospective Exhibition of Works by Yasuo Kuniyoshi, 1893–1953* (trav. exh.), no. 29; Whitney Museum of American Art at Philip Morris, New York, 1986, *Yasuo Kuniyoshi*, unnumbered.

Provenance The artist, until 1945.

Patrons Art Fund, 1946, 46.1

Albert Laessle

1877–1954

ALBERT LAESSLE WAS an *animalier* who practiced his specialty in the spirit of late-nineteenth-century French academic bronze sculpture. Born and raised in Philadelphia, he received much of his training in that city, having studied at the Spring Garden Institute (1896) and Drexel Institute (1897) before matriculating at the Pennsylvania Academy of the Fine Arts in 1901. At the Pennsylvania Academy he studied with Charles Grafly and Thomas Anshutz. In 1904 he won the academy's Cresson Travelling Scholarship, which allowed him to spend the next three years in Paris, where he became a pupil of Michel Béguine, a sculptor working in marble and bronze.

When Laessle returned to Philadelphia in 1907, he assumed a position in Grafly's studio as a portraitist. His preferred activity was animal sculpture, however, and it is with his animal bronzes that his reputation rests. In 1904 his *Turtle and Lizards* (c. 1902, Pennsylvania Academy of the Fine Arts) was included in Saint Louis's Universal Exposition, followed by the exhibition of his *Turning Turtle* (1905, Metropolitan Museum of Art, New York) at the Paris Salon of 1907. Laessle took his inspiration for these and other depictions of animal life from the Philadelphia Zoological Gardens, which was not far from his studio. His finest work—such as *Penguins* (1917, Philadelphia Zoological

Gardens) and *Victory* (1918, Metropolitan Museum of Art), a striding eagle, which is perhaps his best-known piece—is strongly stylized yet lifelike and true to naturalistic detail.

Laessle taught at the Pennsylvania Academy from 1921 until 1939 while maintaining a successful working career. He was elected to the National Academy of Design, New York, in 1932 and won a variety of awards: the Pennsylvania Academy of the Fine Arts Fellowship Prize in 1915; a gold medal at the Panama-Pacific Exposition in San Francisco in 1915; the Widener Memorial Gold Medal from the Pennsylvania Academy in 1918; a gold medal at the Sesqui-Centennial Exposition, Philadelphia, in 1926; and the James E. McClees Prize from the Pennsylvania Academy in 1928. He died in Miami, Florida.

Bibliography Roy D. Miller, "A Sculptor of Animal Life," *International Studio* 80 (October 1924), pp. 23–27; Obituary, *New York Times*, September 8, 1954, p. 32; Robert McCracken Peck, "Albert Laessle: American 'Animalier,'" *American Art Review* 3 (January–February 1976), pp. 69–84.

The Hunter, c. 1910

Bronze
5 x 6⅝ x 14¼ in. (12.7 x 16.8 x 36.2 cm)
Markings: *Albert Laessle* (base top, between hind legs); Roman Bronze Works, N.Y. (base top, rear rim)

Laessle made riverbed creatures—frogs, toads, turtles, and lizards—his subjects on numerous occasions. *The Hunter* is a modest yet animated portrayal of a toad stalking a large fly. The surface modeling

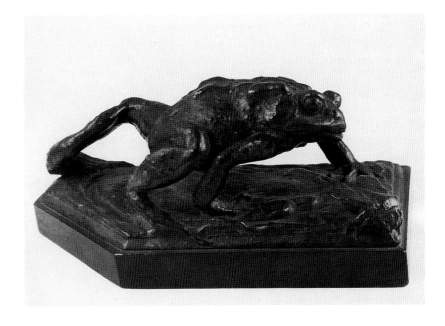

has a liquid, almost molten quality that nonetheless does not allow the toad or its prey to lose its specificity or the sculpture as a whole to forfeit its humorous, anecdotal quality.

DS

Exhibition Pennsylvania Academy of the Fine Arts, Philadelphia, 1910, *Annual Exhibition*, no. 895.

Gift of Mrs. Albert Laessle and her sons, Dr. Albert M. Laessle and Paul Laessle, 1971, 71.31

John La Farge

1835–1910

JOHN LA FARGE was one of nineteenth-century America's most important artist-intellectuals, responsible for significant innovations in still-life and landscape painting, illustration, mural decoration, and stained glass. He helped advance the free handling of color, light, and space in painting and discovered a new method of wood engraving. He pioneered America's first mural movement and invented opalescent glass. La Farge's sources of inspiration were eclectic and sophisticated and reflected his literary bent. As historian Henry Adams wrote, "La Farge alone owned a mind complex enough to contrast against the commonplaces of American uniformity."[1]

Born the son of wealthy French émigrés who settled in New York, La Farge attended the Columbia Grammar School, where in 1845 he took lessons from an English watercolorist. From 1851 to 1853 he attended St. John's College (now Fordham University) and Mount Saint Mary's College in Emmitsburg, Maryland. After graduating from Mount Saint Mary's, La Farge decided to return to New York and pursue a career in law. He continued to be interested in painting, studying with a "French painter," most likely Régis-François Gignoux.[2] On a visit to France in 1856, relatives presented him to prominent writers and artists, including Victor Hugo, Charles Baudelaire, and Jean-Léon Gérôme. He studied briefly with Thomas Couture,

began to collect Barbizon and Japanese prints, and copied old-master drawings.

Two years after he returned to the United States in 1857, La Farge decided to become an artist. He moved to Newport, Rhode Island, to attend painting classes given by William Morris Hunt, America's earliest and most respected champion of French Barbizon painting. La Farge greatly admired Hunt, and at his studio he befriended fellow students Henry and William James.

Most scholars agree that the still lifes La Farge made during these early years are among his finest works. His subjects were almost exclusively flowers, whose poetic qualities he accentuated through expressive brushwork. These images broke decisively with previous American still-life painting in their spiritualism and their incorporation of Japanese principles of design. In light of La Farge's interest in Japanese art, it seems more than coincidence that in 1860 he married Margaret Perry, grandniece of the commodore who opened Japan to foreign trade. The artist painted his most renowned still life, *Agathon to Erosanthe, Votive Wreath* (1861, private collection), as a token of his love for her.

During the 1860s, La Farge produced landscapes and illustrations. He demonstrated his facility with plein-air painting in works such as *The Last Valley* (1867, private collection), which was exhibited at the 1874 Paris Salon. His illustrations, such as the pictorially subtle wood engravings for *The Pied Piper of Hamelin* of 1867, published in *Riverside Magazine for Young People*, transcended the literal and helped give rise to a serious school of American illustration.

In 1873 La Farge toured England and France. Seeing medieval and Pre-Raphaelite stained-glass windows inspired him to work in that medium, and in 1878 he invented opalescent glass, which created the illusion of volume by the blending of different opaque colors. La Farge's glass also incorporated materials as diverse as broken bottles and semiprecious stones, as evidenced in *Peacocks and Peonies*, made for the Ames house in Boston (1882, National Museum of American Art, Washington, D.C.).

In 1876 the architect Henry Hobson Richardson offered La Farge his first large-scale public commission: the decoration of Trinity Church in Boston. This landmark of artistic collaboration became a model for subsequent American mural

projects. As one of the first American muralists to work with an architect in order to create an interior space that possessed decorative and thematic unity, La Farge was considered a leader of the Aesthetic movement in America by the late 1870s. He decorated, among others, the homes of William H. and Cornelius Vanderbilt (1879–83) and painted murals at New York's Union League Club (1881–82), Church of the Incarnation (1885), and Church of the Ascension (1888).

In 1886 La Farge traveled with Henry Adams to Japan. In his three months there, however, he seldom painted and learned little more of Japanese art than he already knew. His trip to the South Seas with Adams from 1890 to 1891 was more fruitful, resulting in several hundred remarkable watercolor sketches of the landscape and activities of the Polynesians.

In his late years, La Farge generally grew conservative in his work. Poor eyesight limited him to lecturing, writing, and designing projects such as the murals at the Minnesota State Capitol (1903–5). His essays were witty, erudite, and conservative. *Considerations on Painting* (1895), for example, is an astute treatise on aesthetics, while *The Higher Life in Art* (1908) served as a defense of the Barbizon school. A widely respected artist to the end of his life, La Farge served on the jury of the Carnegie International in 1897, 1901, and 1903; he also exhibited in six Carnegie Internationals between 1896 and 1909. In 1901, Carnegie Institute honored him with a solo exhibition. He died in Providence, Rhode Island.

1 Henry Adams, *The Education of Henry Adams* (Cambridge, Mass., 1918), p. 369.

2 The Carnegie Museum of Art, *John La Farge*, p. 239.

Bibliography Royal Cortissoz, *John La Farge: A Memoir and a Study* (Boston, 1911); H. Barbara Weinberg, "The Decorative Work of John La Farge," Ph.D. diss., Columbia University, 1972; Kathleen A. Foster, "The Still-Life Painting of John La Farge," *American Art Journal* 11 (Summer 1979), pp. 4–37; Henry Adams, "John La Farge, 1835–1870: From Amateur to Artist," Ph.D. diss., Yale University, 1980; The Carnegie Museum of Art, Pittsburgh, and National Museum of American Art, Washington, D.C., *John La Farge* (1987), exh. cat., essays by Henry Adams et al.

Roses on a Tray, c. 1861

Oil on Japanese lacquer panel
20 x 11¹⁵⁄₁₆ in. (50.8 x 30.3 cm)

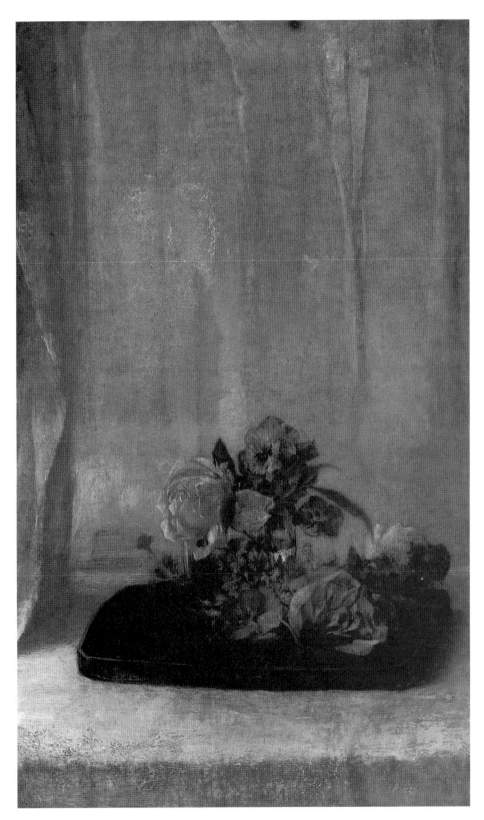

Roses on a Tray is one of La Farge's earliest
and most evocative flower pieces. Painted
on a Japanese lacquer panel whose design
of a butterfly and chrysanthemum is still
intact on the back (fig. 1), the work
demonstrates the artist's early awareness
of Japanese art. Under its influence, La
Farge approached his blossoms not as
botanical specimens to be represented lit-
erally, but as fragile and ethereal decora-
tive objects meant to elicit an inner expe-
rience. It was an innovation greatly
admired by the art critic James Jackson
Jarves, who wrote:

> A flower of his has no botanical talk or dis-
> play of dry learning, but is burning with
> love, beauty, and sympathy, an earnest gift
> of the Creator, fragrant and flexible, bowed
> in tender sweetness and uplifted in stately
> pride, a flower whose seed comes from
> Eden, and which has not yet learned world-
> ly ways and deformities. Out of the depth
> and completeness of his art-thought, by a
> few daring, luminous sweeps of his brush he
> creates the universal flower, the type of its
> highest possibilities of beauty and meaning,
> using color not as fact, but as moods of feel-
> ing and imagination, having the force of
> passion without its taint.[1]

Although La Farge arranged the blos-
soms in this painting with great care, they
appear to be placed haphazardly upon
their lacquer tray. With considerable
compositional daring, he depicted the
flowers as disproportionately small in
their setting, on a windowsill before a
gauzy white curtain. Clearly, he was con-
cerned not only with the roses but also
with the empty space surrounding them,
exploited by an original adaptation of
Japanese asymmetry and a high point of
view.

La Farge painted *Roses on a Tray* with
rich brushwork and considerable chro-
matic sensitivity. Delicate but distinct
strokes and soft pastels characterize the

Fig. 1 John La Farge, *Roses on a Tray*, verso

flowers, which emerge as if an apparition from their pale, lustrous background. The background is painted with scumbled impasto in white subtly modulated with tints of blue, pink, gray, and yellow. Interesting shadows complicate the image, suggesting varying translucency and opacity, as if a breeze were blowing through the curtains. As artist Elihu Vedder noted:

> This quality of subtlety is shown in those never-to-be-forgotten flowers... in a shallow dish on a window sill, where the outdoor air faintly stirring lace curtains seems to waft the odour toward you.[2]

The window-and-curtain motif is particularly intriguing, since La Farge apparently used it to express transience and the conflict between art and nature. Saturated by both interior and exterior light, the ethereal roses, one could say, are caught between two worlds, one an artificial world constructed by humans, the other a natural world for which we long.

Roses on a Tray was not publicly exhibited until recently. It was purchased at an early date by John Bancroft, a wealthy businessman and collector and one of La Farge's closest friends, and passed down in his family. Bancroft amassed over three thousand Japanese prints as well as works by La Farge and James McNeill Whistler, and strongly influenced La Farge's style by fostering his interest in Japanese art.
JM

1 James Jackson Jarves, *The Art Idea* (New York, 1864), p. 226.

2 Elihu Vedder, *The Digressions of V.* (Boston, 1910), p. 260.

References Adams, "John La Farge, 1835–1870," p. 235; H. Adams, "John La Farge's *Roses on a Tray*," *Carnegie Magazine* 57 (Jan.–Feb. 1984), pp. 10–14; H. Adams, "John La Farge and Japan," *Apollo* 119 (Feb. 1984), pp. 120–29; H. Adams, in Museum of Art, Carnegie Institute, *Collection Handbook* (Pittsburgh, 1985), pp. 176–77; Museum of Art, Carnegie Institute, Pittsburgh, *American Drawings and Watercolors in the Museum of Art, Carnegie Institute* (1985), exh. cat. by H. Adams et al., p. 65; H. Adams, "John La Farge's Discovery of Japanese Art: A New Perspective on the Origins of Japonisme," *Art Bulletin* 67 (Sept. 1985), pp. 460–61.

Exhibitions Westmoreland Museum of Art, Greensburg, Pa., 1984, *Twenty-fifth Anniversary Exhibition: Selected American Paintings, 1750–1970*, no. 48; The Carnegie Museum of Art, Pittsburgh, 1986, *Flower and Vine: Growth of a Motif, 1870–1920*, no cat.; The Carnegie Museum of Art, Pittsburgh, and National Museum of American Art, Washington, D.C., 1987, *John La Farge* (trav. exh.), exh. cat. by H. Adams et al., no. 4.

Provenance John Bancroft, Newport, R.I., after 1863; by descent to Pauline Blackie, Sleaford, England, until 1983.

Katherine M. McKenna Fund, 1983, 83.5

See Color Plate 9.

James Reid Lambdin
1807–1889

ALTHOUGH HE IS BEST known as a Philadelphia artist, James Reid Lambdin was Pittsburgh's leading resident portrait painter in the 1820s and 1830s. His sitters—from merchants to jurors—included many of western Pennsylvania's most distinguished citizens. He also created Pittsburgh's first public museum of art and natural history, and in later life he promoted artists' organizations and art education. He is perhaps best remembered for his service to the Pennsylvania Academy of the Fine Arts, Philadelphia, where he was director from 1845 to 1867.

Born and raised in Pittsburgh, Lambdin, at the age of fifteen, traveled to Philadelphia to study art. His first six months were spent in the drawing classes of Edward Miles, an English miniature painter. The next year, Lambdin began to take painting instruction from Thomas Sully, which he augmented by attending anatomy lectures at Jefferson Medical College and by visiting the Pennsylvania Academy to study the paintings in its collection. In 1824 he exhibited his first portrait at the Pennsylvania Academy. For the next four years, he traveled from Philadelphia through New York, Pittsburgh, and western Pennsylvania in search of portrait commissions.

While in Pittsburgh, Lambdin decided to purchase part of Rubens Peale's New York museum and open a similar one in Pittsburgh, hoping it would provide him with a dependable source of income. Lambdin's Pittsburgh Museum of Natural History and Gallery of Fine Arts opened on September 8, 1828. Immediately popular, it was soon enlarged to include "Literary and News Rooms on a similar plan to the Athenaeums of eastern cities"[1] and spaces for expanding collections and traveling exhibitions. In 1829 its holdings included anthropological artifacts; over two hundred bird and quadruped specimens; over one thousand shells, minerals, and fossils; one thousand preserved reptiles; twelve hundred coins and medals; and upward of fifty historical and other pictures.

Lambdin described his painting gallery as the "first public exhibition of the works of art in the West."[2] There he displayed both his own collection and paintings borrowed from local collectors, the majority "portraits of distinguished characters, by Stewart [*sic*], Sully, Peale and Lambdin" as well as "fine landscapes by Doughty, Birch and Lawrence."[3] The art centers of Europe were represented, with the Flemish and Dutch schools predominating. Temporary exhibitions ranged from single showpiece canvases to phantasmagoria (magic lanterns used to create rapidly changing optical illusions) and "cosmoramas" of European and American cities. High overhead costs of the museum and a shortage of portrait commissions in Pittsburgh prompted Lambdin to move the museum in 1833 to Louisville, Kentucky, where by 1835 he had sold it to a citizens' group.

From 1837 to the end of his life, Lambdin resided in Philadelphia, though he frequently traveled to Pittsburgh, Washington, and New York and to cities in the South. He was active in the Artists' Fund Society and was its president from 1845 to 1867. He became an officer of the Pennsylvania Academy of the Fine Arts, serving not only as its director but for many years as chairman of the Committee on Instruction. He also held a professorship of fine arts at the University of Pennsylvania from 1861 to 1866. Lambdin's broader forays into art politics included his involvement in the commissioning of foreign artists to decorate the newly enlarged United States Capitol.[4]

Lambdin's portrait style is derived from the English portrait tradition as interpreted by Gilbert Stuart and Thomas Sully, but with weightier, more solid forms. His consistently naturalistic yet slightly idealized style placed him in the mainstream of American portrait painting of the mid-nineteenth century.

1 *Pittsburgh Gazette*, January 20, 1829.

2 Dunlap, *A History of the Rise and Progress of the Arts of Design*, vol. 3, p. 252.

3 Anne Royall, *Mrs. Royall's Pennsylvania, or, Travels Continued in the United States* (Washington, D.C., 1829), pp. 64–65.

4 Lillian B. Miller, *Patrons and Patriotism: The Encouragement of the Fine Arts in the United States, 1790–1860* (Chicago, 1966), pp. 80–83.

Bibliography William Dunlap, *A History of the Rise and Progress of the Arts of Design in the United States* (1834), Frank W. Bayley and Charles E. Goodspeed, eds., 3 vols. (reprint, Boston, 1918), vol. 3, p. 252; James R. Lambdin, "Autobiographical Journal," 1867, manuscript, Pennsylvania State Archives, Harrisburg, Pa.; Obituary, Philadelphia *Public Ledger*, February 1, 1889; John O'Connor, Jr., "Reviving a Forgotten Artist," *Carnegie Magazine* 12 (September 1938), pp. 115–18; Elizabeth Kennedy Sargent, "James Reid Lambdin's Pittsburgh Museum of Natural History and Gallery of the Fine Arts, 1828–1832," senior thesis, Chatham College, Pittsburgh, 1984.

Henry Clay, 1832

Oil on canvas
36 x 27¾ in. (91.5 x 70.4 cm)
Signature, date: JRLambdin/1832 (center left)

In his 1867 memoir, Lambdin recounted his initial meeting with the great Kentucky statesman Henry Clay (1777–1852) on a steamer returning upriver from New Orleans in March 1831. He presented a letter of introduction from Pittsburgh judge Henry Baldwin, a friend of Clay's, requesting as a personal favor that Clay sit for Lambdin. Clay agreed; the sittings took place when Lambdin was next in Lexington, Kentucky, Clay's home. That portrait (now lost) was the basis for at least four replicas of various dates, one of which is the Carnegie's painting.

Lambdin's early portrait style evolved in the towns along the Ohio River, where there was little high-style art. His patrons were middle-class citizens who demanded in their portraits accuracy of observation accomplished in a dignified and uncomplicated manner. To fill this demand Lambdin developed a basic formula whose virtues were compositional simplicity, limited coloring, and sobriety of mood.

In this portrait, Lambdin built on that formula. It is painted somewhat loosely, perhaps in emulation of Thomas Sully's fashionable style. Draped in an overcoat, Clay is seated against a nondescript background, holding in his right hand an unidentified document that symbolizes

his statesmanship. It is essentially in Clay's face and expressive gaze that Lambdin created a heroic image set apart from his portraits of merchants or their families. The face is idealized, the sitter gazes energetically beyond the viewer, and his large forehead (the seat of the intellect) is strongly lit. To the extent that is possible in a simple bust-length portrait, Clay emerges as a noble defender of democratic ideals.

DS

Elizabeth Kennedy Sargent conducted the archival research for this article.

References Lambdin, "Autobiographical Journal," pt. 3, p. 18; E. T. Whitley, *Kentucky Ante-Bellum Portraiture* (Paris, Ky., 1956), p. 711; L. B. Miller, *Patrons and Patriotism: The Encouragement of the Fine Arts in the United States, 1790–1860* (Chicago, 1966), p. 177.

Provenance G. David Thompson, Pittsburgh, 1952.

Gift of G. David Thompson, 1952, 53.1.3

Benjamin Darlington, c. 1836–37

Oil on canvas
34¼ x 28¼ in. (87 x 71.8 cm)

Born in Pittsburgh to a Quaker family who had moved west from Chester County, Pennsylvania, Benjamin Darlington (1790–1856) developed a successful hardware business and became a wealthy merchant. About 1851 Lambdin painted two more portraits of Darlington family members: *William McCullough Darlington*, a picture of Benjamin's eldest son, whose extensive library became part

of the University of Pittsburgh, and *O'Hara Darlington*, a study of William's small son (both Darlington Library, University of Pittsburgh).

This portrait of Darlington seems to have been painted just prior to Lambdin's permanent move to Philadelphia in 1837. Of ample size, it combines painterly handling of the facial features with a consciously simple composition in which the figure is set against a plain blue-gray background with no props or embellishment except for the scroll back of the sitter's chair. The effect is one of sobriety, directness, and control. The boldest elements in the work are Darlington's loosely rendered, windblown hair and heightened facial color, which show the influence of Sully. It is typical of Lambdin's work that the emphasis is on the sitter's face, while the clothing is flatly painted.

DS

References P. Redd, "Pittsburgh Artists, Past and Present," *Art and Archaeology* 14 (Nov.–Dec. 1922), p. 313; O'Connor, "Reviving a Forgotten Artist," pp. 115–16.

Provenance The Darlington family, Pittsburgh; the sitter's granddaughter, Mary O'Hara Darlington, until 1925.

Gift of the Estate of Mary O'Hara Darlington, 1925, 25.15.1

Fitz Hugh Lane
1804–1865

ONE OF AMERICA's most distinguished marine painters, Nathanial Rogers Lane (he soon changed it to Fitz Hugh) was born in the seaport of Gloucester, Massachusetts, the son of a sail maker. Partially crippled by a childhood illness—probably polio—he was apprenticed as a printmaker, which amounted to his only formal art instruction. He worked at first for a Gloucester printing establishment but soon gained the notice of William S. Pendleton, whose successful Boston lithographic firm specialized in the design of calling cards, sheet-music covers, and topographic views. Lane worked for Pendleton from 1832 to 1837, producing a corpus of nearly sixty prints. He subsequently joined the

Boston firm of Keith and Moore, then from 1845 to 1847 worked in partnership with lithographer John W. A. Scott. By June of 1848, he had returned to Gloucester and made his home there.

Lane began painting around 1840. The *Boston Almanac* listed him under the heading of "Marine Painters" in 1841; the same year, he began exhibiting canvases at the Boston Athenaeum. His early efforts fell recognizably into the marine-painting tradition of the early nineteenth century. This work was substantially influenced by the English painter Robert Salmon, who from 1828 to 1842 was the most important painter of ships and harbor views in Boston. Like Salmon, Lane drew upon the inheritance of Dutch seventeenth-century marine painting and the precision of eighteenth-century view painting. He also seems to have assimilated the gentle reverie of Washington Allston's romantic landscapes, particularly when it came to dawn and dusk views. Lane's preoccupation with observed atmospheric effects and changing moods has something in common with J. M. W. Turner and his champion, John Ruskin.

Although Lane had traveled to New York, Baltimore, and probably Puerto Rico, his favorite locales remained Boston, Gloucester, and the area around Penobscot Bay, Maine. These three New England sites provided the subjects for some of his most expressive works. Between the late 1840s and early 1850s, the style and conceptual breadth of Lane's painting matured significantly, and by 1860 he had reached the height of his powers. In 1864 a serious fire damaged Lane's waterfront shops in Gloucester. He was ill for about a year, and then, following a brief productive period, suffered a fall. He never fully recovered, and he died in Gloucester.

Even while his choice of subject remained true to the traditions of marine painting, Lane's intent was less and less mere topographical depiction. His work in fact transcended the usual boundaries of maritime subjects. His shore and harbor scenes of the 1850s and 1860s showed an intense interest in evanescent light effects, thus lending a contemplative note to otherwise unremarkable sites and placing Lane at the core of the American landscape-painting phenomenon known as Luminism.

Lane somewhat preceded other mid-nineteenth-century painters in the use of cadmium paints, which greatly enhanced

the reds, yellows, and oranges of his scenes. His influence may have been felt by Martin Johnson Heade and Frederic E. Church. Church certainly saw Lane's first effort at a wilderness theme, *Twilight on the Kennebec* (1849, collection Francis Hatch, Castine, Me.), when it appeared at the 1849 American Art-Union exhibition in New York.

Lane's special skill lay in the way he recorded specific atmospheric effects and placed them within an infinitely smooth, geometrically controlled space. His clarity of expression perfectly complemented the contemplative, spiritual mood he wished his work to convey. A slightly naïve quality pervades Lane's work, which actually earned him no more than a modest local reputation during his lifetime and was seriously reevaluated only in the 1950s.

Bibliography Gene E. McCormick, "Fitz Hugh Lane, Gloucester Artist, 1804–1865," *Art Quarterly* 15 (Winter 1952), pp. 291–306; Barbara Novak, "Fitz Hugh Lane: A Paradigm of Luminism," in *American Painting of the Nineteenth Century: Realism, Idealism, and the American Experience* (New York, 1969), pp. 110–24; John Wilmerding, *Fitz Hugh Lane* (New York, 1971); Cape Ann Historical Association, Gloucester, Mass., *Paintings and Drawings by Fitz Hugh Lane, Preserved in the Collections of the Cape Ann Historical Association* (1974); National Gallery of Art, Washington, D.C., *Paintings by Fitz Hugh Lane* (1988), exh. cat. by John Wilmerding et al.

View of Gloucester from Brookbank, The Sawyer Homestead, c. 1856

Oil on canvas
18 x 30³⁄₁₆ in. (45.7 x 76.7 cm)

An art collector and philanthropist and one of Gloucester's most prominent citizens, Samuel Sawyer was Fitz Hugh Lane's patron during the 1850s and 1860s. His home and grounds, one of Gloucester's large seaside properties, was called Steepbank[1] or, more often, Brookbank. The property appears a number of times among Lane's pencil sketches of Gloucester (c. 1850–64, Cape Ann Historical Association, Gloucester, Mass.) and was incorporated into four of his paintings. Those four paintings are *Gloucester from Brookbank* (1848, Museum

of Fine Arts, Boston), Sawyer's shorefront overlooking Gloucester Harbor; *Fresh Water Cove from Dolliver's Neck, Gloucester* (early 1850s, Museum of Fine Arts, Boston), a view from the opposite shore, showing Sawyer's house in the distance; and two depictions of Sawyer's house and pastureland against a broad view of the harbor. These last two paintings are *The Sawyer Homestead* (c. 1860, Sawyer Free Library, Gloucester, Mass.) and the Carnegie's canvas.

The four paintings range in date from the first decade of Lane's painting career to his last, encompassing the development of his style from the rather conventionally picturesque compositions of his early years to the mood-filled simplicity of his mature work. Despite differences in style, they consistently depict a Gloucester that is both pastoral and seafaring. The environs are not quite idyllic, for the means to the area's livelihood can clearly be seen everywhere, but neither are they merely matter-of-fact. As a group, the paintings are true to Lane's tendency to return repeatedly to a favorite site, depicting it at slightly different times of day and from somewhat different points of view.

The Carnegie's painting is Lane's most panoramic view of Brookbank. Sawyer's homestead is at the left, overlooking Gloucester's outer harbor. The distant view is framed by calm waters and a clear, sunny, cloud-flecked sky, which dominates by virtue of a low, nearly uninterrupted horizon. The image shows the firm geometry that had entered Lane's work by the 1850s—a geometry apparent in the arc-shaped shoreline and the water's glasslike surface, which reflects the pure shapes of the objects at its edge. The simplified composition creates an aspect of eternity tempered only slightly by the single sign of mundane activity in the picture: the sailboat being readied for docking.

The work's date is somewhat uncertain, in part because the dates assigned to Lane's other views of the Sawyer homestead have fluctuated in recent years.[2] Stylistically, the canvas appears to be later than *Fresh Water Cove from Dolliver's Neck, Gloucester* but earlier than *The Sawyer Homestead*, thus seeming to place it in the mid- or later 1850s. Sawyer's account book for November 8, 1856, bears

an entry, "Lane, Homestead, $100," which was at one time linked with *Gloucester from Brookbank*.[3] It is conceivable that *View of Gloucester from Brookbank, The Sawyer Homestead* is instead the work to which Sawyer referred.

DS

1 Wilmerding, *Fitz Hugh Lane*, p. 74.

2 Wilmerding, in *Paintings by Fitz Hugh Lane*, altered his earlier date for *Gloucester from Brookbank* from c. 1856 to the late 1840s, that for *Fresh Water Cove from Dolliver's Neck, Gloucester* from the mid-1850s to the early 1850s, and that for *The Sawyer Homestead* from c. 1864 to 1860, but unfortunately without explanation.

3 Wilmerding, *Fitz Hugh Lane*, p. 61.

Exhibitions Hirschl and Adler Galleries, New York, 1976, *The American Experience*, no. 30; National Gallery of Art, Washington, D.C., 1988, *Paintings by Fitz Hugh Lane* (trav. exh.), exh. cat. by John Wilmerding et al., no. 11.

Provenance Adelaide Procter, Gloucester, Mass.; William MacInnis, Gloucester, Mass.; Robert MacInnis, Gloucester, Mass., by 1975; Hirschl and Adler Galleries, New York, 1975.

Acquired through the generosity of the Sarah Mellon Scaife Family, 1977, 77.5

See Color Plate 6.

Jasper Lawman

1825–1906

THOUGH PROPERLY considered a Pittsburgh artist, Jasper Holman Lawman was born in Xenia, Ohio. A group of rivermen in nearby Cincinnati, impressed by a sketch the seventeen-year-old Lawman had made of a steamboat, offered to send him to Europe to study painting, an offer the young artist declined.[1] Shortly thereafter, Lawman moved to Philadelphia. There he met Charles S. Porter, who managed a theatrical company in Pittsburgh between 1845 and 1850.[2] Around 1846, at Porter's invitation, Lawman settled in Pittsburgh to become a scene painter at the old Drury Theatre on Fifth Avenue. Lawman's interest in scenery soon expanded, and he began painting landscapes, two of which were exhibited in Philadelphia at the Pennsylvania Academy of the Fine Arts in 1855.

In the late 1850s, having decided to pursue the training he had refused in his youth, Lawman went to Paris and enrolled in the popular atelier of Thomas Couture.[3] Although the extent of Lawman's stay is not known, several of his French landscapes were exhibited in Pittsburgh in 1859. On returning to the United States, Lawman established a successful portrait practice in Pittsburgh. Among his sitters were Andrew Carnegie, William B. Negley, and financier John Harper, as well as many other prominent citizens of western Pennsylvania.

While Lawman specialized in portraiture, he was also a talented landscape painter. His landscape style reflected the popular Barbizon mode, although some of his landscapes merged with genre. Lawman often joined George Hetzel and other local artists on summer sketching excursions in the Allegheny Mountains. His landscape *Scene on Paint Creek near Scalp Level* (see p. 312) received an award in London in 1887. Lawman's work was also exhibited in Paris, at the Academy of Fine Arts in New York, and at the 1904 Universal Exposition in Saint Louis. In addition to oil, he worked in pastel, watercolor, and black-and-white mediums. Lawman died in Pittsburgh.

1 Obituary, *Pittsburgh Gazette*, p. 1.

2 "Art and Artists," *Pittsburg Bulletin*, p. 18.

3 Leisser, "Traditions Their Enthusiasms Overcame," p. 4.

Bibliography Obituary, *Pittsburgh Gazette*, April 2, 1906, pp. 1–2; "Art and Artists," *Pittsburg Bulletin* 52 (April 7, 1906), p. 18; Martin B. Leisser, "Traditions Their Enthusiasms Overcame," Pittsburgh *Gazette Times*, May 2, 1910, p. 4; Gordon B. Washburn, "New American Paintings Acquired," *Carnegie Magazine* 30 (June 1956), pp. 193–97; Westmoreland County Museum of Art, Greensburg, Pa., *Southwestern Pennsylvania Painters, 1800–1945* (1981), exh. cat. ed. by Paul A. Chew and John A. Sakal, p. 86.

Self-Portrait, c. 1853

Oil on board
20¾ x 16½ in. (52.7 x 41.9 cm)

Lawman's talents as a portrait painter are demonstrated in the two self-portraits owned by The Carnegie Museum of Art. Although neither work is dated, differences in style and presentation suggest that the work illustrated here was painted first. In this nearly life-size self-portrait, Lawman posed himself against a dark, neutral background, assertively confronting the viewer. A bright studio light further focuses attention on his face. He portrays himself as a confident, well-dressed young man, probably in his late twenties. The artist's concentration on his task is reflected in the brush he grasps, his clenched pipe, and his forceful gaze.

Through the skillful modeling of skin tones and the textural use of paint,

Lawman convincingly captured the firm contours of his face and the vivacity of his ruddy complexion. While this confirms a natural artistic ability, the flat, stylized treatment of the torso and the somewhat awkward representation of his raised arm reveal the hand of a self-taught artist. However, he is clearly a young man of serious intent. It seems likely that this self-portrait was painted just prior to Lawman's study trip abroad.
GB

Provenance G. David Thompson, Pittsburgh, by 1954.

Gift of G. David Thompson, 1954, 54.20

Self-Portrait, c. 1860

Oil on canvas
10 x 8 in. (25.4 x 20.3 cm)
Inscription: *J. H. Lawman / To Mollie from Mama 1912* (on label on reverse)

The artist's apparent age in this work makes it clear that it was painted within a few years of the other self-portrait by Lawman in the Carnegie's collection. While both show the artist in a frontal pose, this painting does not offer the immediacy of the earlier work, being quite small and presenting the artist's image set back from the picture plane. Here too, the mood is reflective rather than assertive, and there are no accessories and no traces of activity. The sober young man looks at the viewer from deeply set eyes.

Though perhaps less impressive as a portrait, this work is more consistent as a painting. In contrast to the former work,

Lawman here used a free, painterly technique throughout the painting, accordingly suppressing detail in favor of a more suggestive representation; the loose brushwork in the background contributes an unexpected liveliness to the surface. In addition, Lawman's limited palette is indicative of a new interest in simplified tonal patterns. In its painterly facture and massing of lights and darks, this self-portrait most likely reflects the influence of Couture, with whom Lawman studied briefly in the late 1850s. The absence of technical naïveté in Lawman's presentation is a further indication of his growing artistic maturity.

GB

Exhibition Westmoreland County Museum of Art, Greensburg, Pa., 1981, *Southwestern Pennsylvania Painters, 1800–1945*, exh. cat. by P. A. Chew and J. A. Sakal, no. 152.

Provenance The artist's daughter, Mollie Lawman, Pittsburgh, until 1951.

Gift of Mollie Lawman, 1951, 51.3.2

Snyder's Hollow, 1870

Oil on canvas
35¾ x 68 in. (90.8 x 172.7 cm)
Signature, date: *Jasper Lawman* (lower right); 1870 (middle right)

In addition to painting portraits and landscapes, Lawman also produced a number of genre scenes of local interest. In *Snyder's Hollow*, a little-known neighborhood in Allegheny City on Pittsburgh's North Side, Lawman captures the rhythm of daily life in a variety

of humble activities. A young man on horseback converses quietly (a pentimento indicates that originally this figure was more animated) with an older, bearded man, while to the left another man diligently loads sacks of grain into a Conestoga wagon. Farm animals stand placidly by as the young girl at the lower left brings a bucket of water from the stream. At the upper right a couple leisurely surveys the smokehouse.

The date 1870, painted on the trunk of a large birch tree at the right, adds another rustic touch to this quaint scene. Although such anecdotal country scenes continue the tradition established by William Sidney Mount and other early-nineteenth-century genre painters, this work, with its more painterly technique and moody tonalities, reflects the Barbizon influence.

In both style and flavor, *Snyder's Hollow* is related to another of Lawman's Pittsburgh paintings called *Mrs. O'Doud's Grocery Store* (1868, private collection). This painting represents a neighborhood store in the vicinity of Crawford Street, where Lawman lived at the time. Similarly, *Snyder's Hollow* was probably inspired by Lawman's experience living in Allegheny City in the early 1860s. While the evocation of a simple country lifestyle was a popular theme among post–Civil War genre painters, its expression in the work of a Pittsburgh artist whose city led the nation's industrial development seems particularly poignant. Indeed, Lawman's nostalgic view of life on Pittsburgh's North Side provides a striking contrast with the industrial landscape

that later Pittsburgh artists found so appealing. In this respect, Lawman's leafless trees and autumnal sky may depict not just a picturesque season but the passing of an entire era. Within a few years of painting *Snyder's Hollow*, Lawman himself escaped the city's encroaching urbanization by moving to one of the new suburbs to the east.

GB

Reference Washburn, "New American Paintings Acquired," pp. 193–97.

Exhibitions Westmoreland County Museum of Art, Greensburg, Pa., 1959, *Two Hundred and Fifty Years of Art in Pennsylvania*, exh. cat. by P. A. Chew, no. 71; Westmoreland County Museum of Art, Greensburg, Pa., 1976, *Nineteenth and Early Twentieth Century Regional Painters*, exh. cat. by P. A. Chew and J. K. Maguire, unnumbered.

Provenance Harry O. Eichleay, Pittsburgh, by 1956.

Patrons Art Fund, 1956, 56.12.

Landscape, 1871
(Brook Scene, Possibly Clear Shade Seven Miles from Scalp Level)

Oil on canvas
20¼ x 30¼ in. (51.4 x 76.8 cm)
Signature, date: *Jasper Lawman*/1871 (lower left)

Lawman, though he depended on portraiture for his livelihood, was an accomplished and enthusiastic landscapist. This quiet brook scene depicts the countryside around Scalp Level, the popular artists' retreat in the Allegheny Mountains on the border between Somerset and Cambria counties. The setting here is effectively composed: strong diagonal lines lead the viewer from the clearly defined foreground, where a black youth peacefully naps on the riverbank, to the middle ground, which is dominated by a tall leafless tree, to a distant mountain waterfall in the background. Lawman's skilled use of atmospheric perspective enhances the scope of this composition, while the inclusion of two small figures fishing in the stream adds a degree of intimacy. In both mood and execution, *Landscape* is closely related to the Barbizon-inspired works produced by Lawman's contemporary George Hetzel, who led frequent excursions to Scalp Level.

GB

Scene on Paint Creek near Scalp Level, 1887
(Landscape with Cattle)

Oil on canvas
17 x 30⅛ in. (43.2 x 76.5 cm)
Signature, date: Jasper Lawman/1887 (lower left)

Originally called simply *Landscape with
Cattle*, Lawman's *Scene on Paint Creek
near Scalp Level* is an exemplar of the
Barbizon-inspired work that was pro-
duced in Pittsburgh in the late nineteenth
century. This informal summer scene pre-
sents a view of cows gathered at a stream
to drink. A backdrop of dense foliage lim-
its the setting, allowing Lawman to arrive
at a nearly equal balance between the
cows and the landscape elements.
Lawman began exhibiting such "ani-
malscapes" as early as 1860, no doubt as a
result of his recent introduction in Paris
to Barbizon art, which was then at the
height of its popularity. Like their French
counterparts, American followers of the
Barbizon school sought relief from urban
modernization in country life; an interest
in domestic rather than grandiose land-
scape views also reflects the French influ-
ence and distinguishes these painters

from the native Hudson River school. In
1887, when Lawman painted this work,
Scalp Level had already provided
Pittsburgh painters with pastoral scenery
for twenty years.

The French motifs of grazing cows and
sheep quickly became popular in this
country and remained so until the end of
the century. The realistic landscape set-
ting in Lawman's painting indicates his
awareness of precedents set by the French
artists Charles-Emile Jacque and
Constant Troyon, who specialized in
scenes of farm animals and peasants in
their familiar environments. Unlike many
grazing scenes, even those of Jacque and
Troyon, Lawman's shows the animals
roaming freely, unaccompanied by either
herdsman or farmhand. Moreover, his
solid realism imparts a degree of objectiv-
ity to this work that sets it apart from the
sentimental images that proliferated with-
in this genre. In the wake of greatly accel-
erated farm mechanization during the
nineteenth century, such bucolic themes
served as poignant reminders of the final
dissolution of an agrarian way of life.[1]

Painted as Lawman was approaching
the end of his artistic career, this work
represents the artist's mature style. The
simplicity of the composition, the firm
modeling, and the broad brushwork dis-
tinguish *Scene on Paint Creek near Scalp
Level* from such busy anecdotal genre
scenes as *Snyder's Hollow* (see p. 311),
which Lawman had produced nearly two
decades before. Without departing from
local color, Lawman adopted the brighter
palette and the more spontaneous tech-
nique of the Impressionists.

This painting was exhibited at the 1887
American Exhibition in London, where
Lawman was awarded a medal. It should
be noted, however, that the credentials of
this exhibition were hotly debated in the
press, some, including President Grover
Cleveland, regarding it as merely the
effort of mercenaries to promote the Wild
West Show of Buffalo Bill Cody.
GB

1 National Collection of Fine Arts,
Washington, D.C., *American Art in the
Barbizon Mood* (1975), exh. cat. by Peter
Bermingham, pp. 74–78.

Ernest Lawson

1873–1939

Ernest Lawson was born in Halifax, Nova Scotia, the son of a physician who soon afterward moved to Kansas City. Lawson, who was raised in Nova Scotia, joined his parents in Missouri in 1888 at the age of fifteen, enrolling at the Kansas City Art League School. The following year he worked in Mexico City as an assistant draftsman for a civil-engineering firm where his father was also employed.

Despite the elder Lawson's opposition to an art career for his son, Ernest moved to New York in 1891 to attend classes at the Art Students League. There he became acquainted with American Impressionism through John Twachtman and J. Alden Weir, with whom he subsequently studied. Twachtman was a particularly important influence; he had a decisive and long-lasting effect on Lawson's painting style, his general aesthetic concerns, and his desire to be seen professionally as an independent spirit.

In 1893 Lawson went to Paris, where he enrolled at the Académie Julian and became an admirer of James McNeill Whistler's work. He also became friendly with Maurice Prendergast, Alfred Sisley, and Somerset Maugham, whose novel *Of Human Bondage* (1915) included a character, Frederick Lawson, who was based on the artist. After exhibiting two landscapes in the 1894 Salon des Artistes, Lawson returned to the United States; by 1898 he had settled in New York. He rejoined Twachtman at Cos Cob, Connecticut, and married Ella Holman, his former teacher in Kansas City. From the vantage of the Washington Heights section of New York City, he began, in 1898, to paint in an Impressionist manner landscapes of upper Manhattan, an area only sparsely inhabited at the turn of the century.

That same year, Lawson was represented for the first time at Carnegie Institute's annual exhibition. He did not send another painting to the annual exhibitions until 1903, but from then until a few years before his death, he was a frequent exhibitor. In 1918 he served on the jury of award, and in 1925 Carnegie Institute held a solo exhibition of his works.

Lawson first achieved widespread recognition when he won a silver medal in 1904 at Saint Louis's Universal Exposition. He began to associate at that time with John Sloan, William Glackens, Robert Henri, and other members of the Ashcan school. Although the serene, removed vistas favored by Lawson had little in common with his associates' more direct and somewhat vulgarly realistic scenes, he exhibited with the Eight in 1908. He also helped organize and participated in the 1913 Armory Show. Henri's opinion that Lawson was "the biggest man we have had since Winslow Homer"[1] was widely confirmed, for he enjoyed a highly successful career through the 1910s. He won gold medals at the Panama-Pacific International Exposition, San Francisco (1915), the National Academy of Design, New York (1917), the Pennsylvania Academy of the Fine Arts, Philadelphia (1919), and the Carnegie International (1921).

During the 1920s and 1930s Lawson, suffering from a decline in popularity as well as marital problems, fell prey to drink and despondency. He was habitually impecunious, a circumstance to which he often referred in his correspondence with Carnegie Institute. "I am terribly hard up," he wrote Homer Saint-Gaudens, director of the Department of Fine Arts, in 1937, "so if you hear of anyone who wants a picture cheap let me know."[2] The following year he told Saint-Gaudens that he "would love to see the Carnegie [International] but have no *money*."[3]

Lawson's difficulties were mitigated to some extent by the kindness of his friends Katherine and Royce Powell, whom he met in 1927 while teaching at Broadmoor Academy, Colorado Springs, Colorado. In the 1930s he became a frequent visitor to their home at Coral Gables, Florida. On December 18, 1939, the artist was found dead on the beach near Miami. There were rumors of suicide, but Miami authorities determined that a heart attack had been the cause of death.

1 Berry-Hill, *Ernest Lawson*, p. 26.

2 Ernest Lawson to Homer Saint-Gaudens, February 1937, Carnegie Institute Papers, Archives of American Art, Washington, D.C.

3 Ernest Lawson to Homer Saint-Gaudens, November 1938, ibid.

Bibliography Frederic Newlin Price, *Ernest Lawson: Canadian-American* (New York, 1930); Guy Pène du Bois, *Ernest Lawson* (New York, 1932); Bernard Danenberg, *Ernest Lawson* (New York, 1967); Henry and Sidney Berry-Hill, *Ernest Lawson: American Impressionist, 1873–1939* (Leigh-on-Sea, England, 1968); Dennis R. Anderson, *Ernest Lawson* (New York, 1976).

Vanishing Mist, c. 1916–21

Oil on canvas
40 x 50 in. (101.6 x 127 cm)
Signature: E. Lawson (lower left)

In his 1932 monograph on Lawson, Guy Pène du Bois claimed that *Vanishing Mist* was not only one of the artist's "greatest pictures" but also "one of the greatest American landscapes."[1] It was certainly one of his more successful efforts, having won two prestigious awards in 1921: the National Academy of Design's Altman Prize and the Carnegie International's gold medal. It entered Carnegie Institute's permanent collection that same year.

Vanishing Mist represents Lawson at the height of his powers. Like most of his landscapes, it depicts a broad vista rather than an intimate corner of nature, and the traces of man are everywhere in evidence. Contemporary critics singled out Lawson's houses for special comment. "They are houses... put up by men who, living for themselves, cannot be bothered by the thoughts of neighbors," wrote Pène du Bois, "They seem to have grown in the landscape, to be as much a part of it as the trees."[2] Another critic remarked that they "form notes, accents and spots in the picture, which are of an unexpected sort, and tickle one's fancy."[3]

The image, although seemingly Impressionist, has a solidity of form and composition reminiscent of and possibly inspired by Paul Cézanne. The paint surface has been carefully built up layer by layer into a richly textured impasto. Lawson was famous for the heavy brushwork he developed after 1908. According to a possibly apocryphal story, a sculptor,

having admired one of Lawson's paintings, said to him, "If you don't mind, I should like to come around one day and make myself a cast of it."[4]

KN

1 Du Bois, *Ernest Lawson*, p. 10.

2 Ibid., p. 11.

3 W. H. D., "Ernest Lawson's Works," *Boston Evening Transcript*, February 1, 1921, p. 8.

4 Berry-Hill, *Ernest Lawson*, p. 31.

References "Lawson Wins Big Pittsburgh Prize," *American Art News* 19 (Apr. 30, 1921), p. 1; "Prizewinning 'Vanishing Mist' Purchased by Carnegie Institute," *American Art News* 19 (Aug. 20, 1921), p. 1; F. J. Mather et al., *The American Spirit in Art* (New Haven, 1927), p. 134; Berry-Hill, *Ernest Lawson*, p. 39; W. H. Gerdts, *American Impressionism* (New York, 1984), p. 277.

Exhibitions Department of Fine Arts, Carnegie Institute, Pittsburgh, 1921, *Twentieth Annual International Exhibition*, no. 175; National Academy of Design, New York, 1921, *Ninety-sixth Annual Exhibition*, no. 201; Department of Fine Arts, Carnegie Institute, Pittsburgh, 1925, *An Exhibition of Paintings by Ernest Lawson*, no. 13; Fine Arts Gallery of San Diego, 1926, *Catalogue of the Inaugural Exhibition*, no. 38; Academy of Art, Stockholm, 1930, *Exhibition of American Art* (trav. exh.), no. 64; National Gallery of Canada, Ottawa, 1967, *Ernest Lawson* (trav. exh.), no. 43; ACA Galleries, New York, 1976, *Ernest Lawson*, no. 62; Heckscher Museum, Huntington, N.Y., 1982, *Seven/Eight*, unnumbered.

Provenance The artist, until 1921.

Purchase, 1921, 21.5

Doris Lee
1905–1983

BORN IN ALEDO, ILLINOIS, Doris Emerick Lee majored in philosophy and art at Rockford College, in the same state. After graduating in 1927, she studied for a short time with Ernest Lawson at the Kansas City Art Institute, with André Lhote in Paris, and, in 1930–31, with Arnold Blanch (whom she later married) at the California School of Fine Arts, San Francisco. Under Blanch's influence she turned from abstraction to good-humored, often nostalgic scenes of American rural life, handled in a somewhat primitive style.

Lee briefly became the focus of controversy in 1936, when *Thanksgiving* (1935,

Art Institute of Chicago), depicting holiday activities in an old-fashioned country kitchen, won the Mr. and Mrs. Frank G. Logan medal and prize at the Art Institute of Chicago, to the horror of the wife of the award's sponsor, who denounced the picture as an atrocity and tried to launch a "sanity in art" movement. The movement came to nothing, and Lee's career benefited from the publicity. That same year, she won a competition to paint two murals for the new United States Post Office Department building in Washington, D.C.

From 1934 to 1955 Lee's work appeared regularly at Carnegie Institute's annual exhibitions. She won third prize at the 1944 *Painting in the United States* show for *Siesta* (1944, location unknown), a charming fantasy of a young black woman sleeping outdoors in an ornate brass bed. During the 1940s Lee executed several commissions for *Life* magazine. From the forties on, her art tended toward increasing simplicity of form and composition, flatness, and decorative use of color. She lived in Woodstock, New York, from 1931 until her death.

Bibliography Doris Lee, *Doris Lee* (New York, 1946); Marjorie Dent Candee, ed., "Lee, Doris (Emrick)," *Current Biography Yearbook: Who's Who and Why* 15 (1954), pp. 401–3; Vassar College Art Gallery, Poughkeepsie, N.Y., *Seven American Women: The Depression Decade* (1976), exh. cat. by Karal Ann Marling et al., pp. 31–33; Charlotte Streifer Rubinstein, *American Women Artists: From Early Indian Times to the Present* (Boston, 1982), pp. 232–34.

The Cowboy's Ranch, 1939

Oil on canvas
24¼ x 44½ in. (61.6 x 113 cm)
Signature: *Doris Lee* (lower right)

First exhibited at the 1939 Carnegie International, *The Cowboy's Ranch* depicts a solitary homestead situated in the barren landscape at the base of Pike's Peak.

Although the subdued color and the dark, looming mountains to some extent temper the artist's customary cheerfulness, *The Cowboy's Ranch*, like much of Lee's work of the 1930s, is a pleasant piece of Americana, alive with people and animals. The image is based on her observations of the Pike's Peak region, where she spent the summers of 1936–39 as a guest artist at the Colorado Springs Fine Arts Center. The cartoonish figures in the landscape, the broad vista, and the rough mottling of the sky and land all correspond to the style of Arnold Blanch, who taught landscape painting at the center in 1939, when Lee created this work. The painting is not meant to be a literal transcription of a particular place, but merely evocative of the locale. As Lee explained in a brief autobiographical statement:

> I have always worked by making small sketches of things that appeal to me—scenes, animals, birds, water pumps, etc.,—with these random notes I draw on my canvas in my studio, make any arrangement I want, and put in anything I want. I paint from memory (or imagination, if there is any difference between them).[1]

KN, GB

1 Lee, *Doris Lee*, n.p.

Exhibitions Department of Fine Arts, Carnegie Institute, Pittsburgh, 1939, *The 1939 International Exhibition of Paintings*, no. 69; Museum of Art, Carnegie Institute, Pittsburgh, 1982, *One Hundred Years of Western Art from Pittsburgh Collections*, exh. cat. by P. H. Hassrick, unnumbered.

Provenance Charles J. Rosenbloom, Pittsburgh, 1939.

Bequest of Charles J. Rosenbloom, 1974, 74.7.17

William R. Leigh
1866–1955

A PORTRAITIST AND magazine illustrator who was best known as a painter of the American West, William Robinson Leigh was born on his family's plantation near Falling Waters, Berkeley County, West Virginia. From 1880 to 1883 he was an art student at the Maryland Institute in Baltimore, then enrolled at the academy in Munich, where he studied and worked professionally for twelve years. In Munich he assisted in the painting of panoramas and murals and won bronze and silver medals for his figure paintings at the academy's exhibitions.

By 1896 Leigh had settled permanently in New York. He painted portraits such as *Sophie Hunter Colston* (1896, National Museum of American Art, Washington, D.C.); he also began working as an illustrator for *Scribner's Magazine* and other leading periodicals, and he soon specialized in action pictures and themes from the American West, for which he is best known today. "From the moment I returned from my studies in Europe," he recalled, "I had wanted to go West; which I had already determined was the really true America, and what I wanted to paint."[1]

He made the first of many visits to Wyoming, New Mexico, and Arizona in 1906. Between 1926 and 1927, and again in 1928, he traveled to East Africa under the auspices of the American Museum of Natural History, New York. The observations he made there enabled him to create the backgrounds for the habitat groups in the museum's Carl Akeley African Hall.

Leigh occasionally exhibited at the National Academy of Design, New York, and participated in the Carnegie Internationals of 1910 and 1922. He was elected to the National Academy on March 2, 1955, nine days before his death. A prolific author of short stories and nonfiction, he won critical praise for *Frontiers of Enchantment* (1938), an account of his East African adventures.

1 Taft, *Artists and Illustrators*, p. 242.

Bibliography James B. Carrington, "W. R. Leigh," *Book Buyer* 22 (January 1899), pp. 596–99; Robert Taft, *Artists and Illustrators of the Old West* (New York, 1953), pp. 241–42; Obituary, *New York Times*, March 13, 1955, p. 87; D. Duane Cummins, *William Robinson Leigh, Western Artist* (Tulsa, 1980).

The Attempt to Fire the Pennsylvania Railroad Round-House in Pittsburgh, at Daybreak on Sunday, July 22, 1877, 1895

Oil on canvas mounted on board
28⅜ x 21½ in. (72.1 x 54.6 cm)
Signature: W. Leigh (lower left)

This painting corresponds in size, format, and technique to the monochrome canvases that commercial illustrators submitted to publishers for reproduction photomechanically or in wood engraving. Typically, such works were painted to make the most of black-and-white contrasts; they frequently displayed unexpected focal points so as to be eye-catching and easy to read. Leigh's image followed such conventions, which developed among the community of American illustrators in the late 1880s and which, by the 1890s, caused the United States to be internationally recognized for the quality and distinction of its illustrated press.

Leigh's composition accompanied an article entitled "A History of the Last Quarter Century in the United States" in *Scribner's Magazine* of July 1895; it was captioned, "The Attempt to Fire the Pennsylvania Railroad Round-House in Pittsburgh, at Daybreak on Sunday, July 22, 1877." The illustration falls into the general category of compelling, seemingly factual visual accounts of near-forgotten events, which were a mainstay of the major monthly magazines such as *Harper's Weekly*, *Century Magazine*, and *Scribner's Magazine*.

The specific event Leigh revived was the violent strike by the Pennsylvania Railroad workers in July 1877. Sparked by a ten-percent cut in wages during an already depressed period in the economy, the unrest spread from West Virginia to Maryland and finally to Pennsylvania. It reached a climax in Pittsburgh, where a pitched battle between the strikers and the National Guard left over two dozen dead, hundreds wounded, and property extensively damaged. The most spectacu-

lar act of destruction was the burning of the railroad's roundhouse. Leigh's picture shows the dramatic moment before the final disaster, in which the strikers have set a locomotive ablaze and are pushing it into the roundhouse.

Canvases like this one were executed according to the requirements of the magazine that bought publication rights to them and were not intended for exhibition. Still, by the latter part of the twentieth century, many of them had found a secondary market among collectors of commercial illustrations, Americana, and American art.
DS

Reference E. B. Andrews, "A History of the Last Quarter-Century in the United States," *Scribner's Magazine* 18 (July 1895), p. 83.

Exhibition Museum of Art, Carnegie Institute, Pittsburgh, 1975–76, *Pittsburgh Corporations Collect*, no. 99.

Provenance Berry-Hill Galleries, New York; Thomas Mellon Evans, president, H. K. Porter Co., Pittsburgh, by 1975.

Gift of Thomas Mellon Evans, 1976, 76.60

Martin B. Leisser

1845–1940

LIKE GEORGE HETZEL, Martin Balthazer Leisser was a landscape painter who became an important local art figure. Born in Pittsburgh of German

immigrants, Leisser evidenced an interest in drawing at an early age. His formal training began after he saved enough money from his income as an ornamental painter to pay for a trip abroad. In 1868 he embarked on a four-year sojourn in Europe. His initial destination was Munich: "The city was a revelation to me, a mere boy from Pittsburgh of Civil War days. I went to the opera, enjoyed the architecture and frequented the public concert garden on Sunday afternoons."[1] This experience kindled a lifelong zeal for travel. In Munich, Leisser studied painting at the academy with figure painters Karl von Piloty, Alexander von Wagner, and Wilhelm von Diez.

Leisser returned in late 1871 or early 1872 to Pittsburgh, where he became one of the city's leading portraitists, whose solid realism clearly reflected his European training. "When portraits were in demand I became a portrait painter," he told an interviewer late in life, "but I am mostly interested in the many phases of nature."[2] In 1886 Leisser and his wife sailed to Europe for an extensive visit that lasted five years. Settling in Paris, Leisser continued his artistic education at the popular Académie Julian in the ateliers of Jules-Joseph Lefebvre and Gustave Boulanger, two well-known academicians.[3] Their instruction covered a wide range of historical subjects, as well as genre and portraiture. His sensitive views of Pennsylvania's countryside confirm this statement.

Leisser was a leader in the Pittsburgh art community throughout his exceptionally long career. Shortly after returning permanently to Pittsburgh from his apprenticeship in Europe, he established the city's first life-drawing class. "Of course," he explained, "it was just for boys and men. There was no drawing from the nude for women then."[4] Later on he became principal of the Pittsburgh School of Design for Women and briefly served as head of the Art Department at the Pennsylvania College for Women (now Chatham College).

Leisser's long-standing friendship with Andrew Carnegie greatly enhanced his influence in the Pittsburgh art community. Not only did he paint the great philanthropist's portrait, he also served on the Board of Trustees at Carnegie Institute from 1910 to 1915. Further, it was Leisser who persuaded Carnegie to include an art department in the

Carnegie Institute of Technology (now Carnegie Mellon University). He and his brother Charles, who was also an artist, later endowed Carnegie Institute with a fund for the purchase of art, especially prints and drawings. Among the works acquired through the Leisser Art Fund are a group of prints by Mary Cassatt.

For more than sixty years, Leisser made his living as a painter, and his output was prolific. During this time he traveled extensively throughout the United States, Hawaii, and back to Europe. "Like most artists I had to spend a summer in Venice. Otherwise my life would not have been complete," he reported.[5] Many of his works were suggested by scenes he admired.

Throughout his career, Leisser remained true to the liberal academic approach to the portrait he had learned in Munich and Paris. In contrast, his early landscapes were inspired by the informal pastorals of the French Barbizon painters; after the turn of the century, his lighter palette and looser brushstroke revealed the influence of Impressionism and tonalism. Leisser's expression of nature and of the human figure was always gentle and refined.

1 Douglas Naylor, "Veteran Painter Scores Modernist Art Movement," *Pittsburgh Press,* June 17, 1932, p. 38.

2 Ibid., p. 38.

3 M'swigan, "Aged Painter of Carnegie Portrait," p. 27.

4 "Leisser, Father of the Arts in Pittsburgh, Goes West," *Pittsburgh Press,* January 25, 1931, p. 6.

5 Naylor, "Veteran Painter," p. 38.

Bibliography Agnes Way, "Newspaper Cuttings Collected by Agnes Way," Scrapbook, c. 1870–1935, in Music and Art Division, The Carnegie Library, Pittsburgh; Marie M'swigan, "Aged Painter of Carnegie Portrait Plans Summer of Work in Europe," *Pittsburgh Press,* May 7, 1929, p. 27; Obituary, *Pittsburgh Press,* May 7, 1940, p. 9; Westmoreland County Museum of Art, Greensburg, Pa., *Southwestern Pennsylvania Painters, 1800–1945* (1981), exh. cat. ed. by Paul A. Chew and John A. Sakal, pp. 88–90; Sigrid Nama, "Martin B. Leisser and the Life Class in Pittsburgh," Master's thesis, University of Pittsburgh, 1989.

Scalp Level, 1875

Oil on board
15¼ x 20¹⁵⁄₁₆ in. (38.7 x 53.2 cm)
Signature, date: *MB*Leisser./1875. (lower right)
Inscription: *Scalp Level* (lower left)

Beginning in the mid-1860s, the area in and around the small community of Scalp Level in southwestern Pennsylvania provided a rural retreat for Pittsburgh artists who sought inspiration for their landscape paintings in the wooded countryside. The leafy forest scene in *Scalp Level* depicts this popular locale. Painted in 1875, *Scalp Level* is one of the earliest works Leisser completed after his return from studying art in Europe. The thirty-year-old Leisser took his place among the more established painters in Pittsburgh, and he became the first of a second generation of painters who drew upon the inspiration of the Scalp Level area up until the 1890s.

With its thick forest canopy and gently raking light, this particular view of Scalp Level reflects the influence of Pittsburgh's leading landscapist, George Hetzel, a specialist in quiet woodland scenes. Following Hetzel's example, Leisser directed the viewer's gaze along a country road through the shaded woods to a sunny clearing in the distance. Warm russet hues of early autumn, applied with animated brushstrokes, enliven the canvas and heighten the sentiment of this rustic scene. In contrast to Hetzel, who typically emphasized the artist's solitary contemplation of nature, Leisser included two

figures in a horse-drawn cart riding away from the viewer. Their presence adds the subtle anecdotal element favored by late-nineteenth-century artists.

Although his choice of subject belongs to a long-standing Pittsburgh tradition, Leisser was doubtless inspired as well by the popular country scenes of the French Barbizon painters, whose work he must have known from his student years in Paris. Their "soft-edged treatment of nature"[1] accorded with the American post–Civil War longing for a pastoral lifestyle. In 1875, as Pittsburgh was emerging as a national center of heavy industry, trips to Scalp Level apparently sustained for Leisser the tranquil ideal of the Barbizon experience.

GB

1 National Collection of Fine Arts, Washington, D.C., *American Art in the Barbizon Mood* (1975), exh. cat. by Peter Bermingham, p. 67.

Reference W. H. Gerdts, *Art across America: Two Centuries of Regional Painting* (New York, 1990), vol. 1, p. 295.

Exhibitions William Penn Memorial Museum, Harrisburg, Pa., 1978–79, *Pennsylvania Landscape Survey,* no cat.; Westmoreland County Museum of Art, Greensburg, Pa., 1981, *Southwestern Pennsylvania Painters, 1800–1945,* exh. cat. ed. by P. A. Chew and J. A. Sakal, no. 161.

Provenance Robert S. Waters, Johnstown, Pa., by 1972.

Bequest of Robert S. Waters, 1972, 72.14.7

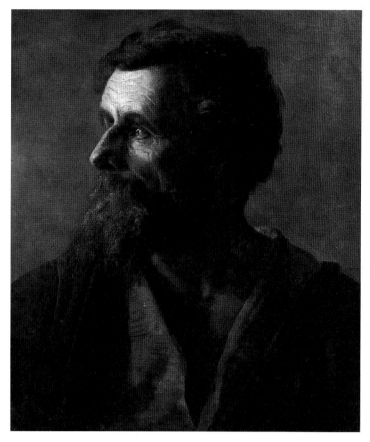

Head of a Man, c. 1886–87

Oil on canvas
21 x 17 in. (53.3 x 43.2 cm)
Inscription: "Head of a Man"/Painted in Paris/by
Martin Leisser (on label on reverse)

The bearded man in Leisser's oil study is
posed simply against a neutral back-
ground; his head, shown in profile, is
sharply illuminated from his right, creat-
ing bright highlights on the forehead,
nose, and cheekbones, but leaving the rest
of the face in deep shadow. Leisser's close
observation of the distinctive facial fea-
tures—high forehead, receding hairline,
and long nose—indicate that this study
had a model; indeed, comparison with
contemporary photographs of Leisser
reveal that the artist himself served as the
model.[1] As the title *Head of a Man* indi-
cates, however, Leisser did not intend that
the viewer take the painting specifically as
a self-portrait.

This accomplished study, produced in
the classroom as part of Leisser's artistic
training, demonstrates the artist's ability

to model the structure of the face and to
use light to heighten the painting's
expressive character. The subject's pro-
found, faraway look, weathered features,
and chiseled profile, together with his
loose-fitting costume, all suggest that
Leisser intended to represent a biblical
figure, perhaps an Old Testament
prophet. Such characterizations were
standard assignments in European art
academies in preparation for serious fig-
ure paintings.[2]

Although the dark, painterly realism of
this work exemplifies the style that Leisser
learned at the academy in Munich, a label
on the back of the painting records that
the work was "Painted in Paris," which
pinpoints it as a product of Leisser's sub-
sequent training at the Académie Julian
during 1886 and 1887. There, under the
direction of the French academic painters
Gustave Boulanger and Jules-Joseph
Lefebvre, Leisser doubtless received the
type of instruction that would lead to his-
torical and religious pictures as well as
portraiture. Such experience became the
foundation of Leisser's later career, as
both teacher and portraitist.

GB

1 Josephine Duveneck, *Frank Duveneck* (San
Francisco, 1970), illustration between pp. 40
and 41.

2 Metropolitan Museum of Art, New York,
J. Alden Weir: An American Impressionist
(1983), exh. cat. by Doreen Bolger Burke,
pp. 45–46.

Provenance William J. Strassburger, Pitts-
burgh, by 1953.

Bequest of William J. Strassburger, 1953,
53.26.2

Cabbage Patch, c. 1905–9

Oil on board
13 x 20¼ in. (33 x 51.4 cm)

Signatures, dates, and inscriptions: *MB* Leisser.
1907–8–. (lower right); MBL/Sort/05. (lower
left); Near Scalp Level/1907–8 or 9/Speer Dixon:
Covert/Leisser (on reverse)

While portrait commissions were his
principal means of support, Leisser
indulged his preference for landscape sub-
jects by making frequent excursions out-
side the city to paint. *Cabbage Patch* was

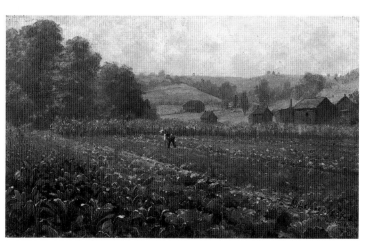

painted near Scalp Level, Pennsylvania, a rural area that had been the favorite Barbizon-like retreat for Pittsburgh landscapists during the nineteenth century.

Although small, informal farm scenes like this were ultimately inspired by the popular *paysages intimes* of the French Barbizon painters,[1] the open composition and light tonality of *Cabbage Patch* reveal the influence of Impressionism and tonalism on Leisser's later style. The hazy sky minimizes strong summer shadows, and the subdued pastel greens and pinks are brought into harmony by an underlying gray tone. Especially beautiful are the leafy blue-green cabbage plants in the foreground, which have delicate silvery highlights along their curled edges. The quiet mood of the scene is enhanced by the solitary farmhand, who, absorbed in his weeding, is unaware of the spectator.

Albeit peaceful, this garden scene, framed by gently contoured hills, evokes a tinge of melancholy. For Leisser, such rural scenery aroused memories of his early years on Pittsburgh's South Side, years when this area was still scattered with farms: "It was like living in the country then. . . . There were apple orchards and cabbage patches, hickory and walnut trees. And I knew where all the orchards were, too."[2] Painted long after this agrarian vision had disappeared, Leisser's *Cabbage Patch* is a tribute to the charm of Pittsburgh's preindustrial landscape.

GB

1 M. H. de Young Memorial Museum and California Palace of the Legion of Honor, San Francisco, *The Color of Mood: American Tonalism, 1880–1910* (1972), exh. cat. by Wanda Corn, p. 6.

2 Ruth Ayers, "An Older Fellow Artist Is Subject of His Canvas," *Pittsburgh Press*, July 29, 1937, p. 38.

Exhibition Westmoreland County Museum of Art, Greensburg, Pa., 1976, *Nineteenth and Early Twentieth Century Regional Painters*, exh. cat. by P. A. Chew and J. K. Maguire, unnumbered.

Provenance Robert S. Waters, Johnstown, Pa., by 1972.

Bequest of Robert S. Waters, 1972, 72.14.8

Mountain Stream, c. 1907–9

Oil on board
20⅛ x 12¾ in. (51.1 x 32.4 cm)

Signature: *MB*Leisser./1908–9 (lower right)

Inscription: In company with my pupils/Speer; Dixon, Covert in 1907–8–or–9./sketching at Scalp Level M. B. Leisser. (on reverse)

In this small painting of a rushing stream skirting a group of weathered outbuildings, Leisser captures the essence of Pennsylvania's picturesque countryside. Although he did not record its exact location, the scene was most likely painted near Scalp Level, one of Leisser's favorite rural retreats. Here, abandoned mills and old farmhouses provided an appropriate setting for the painter's romantic musings. In both style and mood, *Mountain Stream* is closely related to *Cabbage Patch* (see p. 318).

The scene is composed simply: a curving stream leads the viewer's gaze toward a gushing waterfall, which in turn provides a visual transition to the buildings and tall trees in the background. The waterfall divides the composition, separating the detailed treatment of the foreground rocks and water from the more generalized background, with its softened textures and blurred details. The leafless tree at left, stabbing into the muted sky, arouses a sense of loneliness, while a soft, summery haze heightens the nostalgic

mood. These expressive devices reflect Leisser's long-standing interest in French Barbizon painting, although Leisser updated the Barbizon style by using pastel colors and bright tones. The loose brushwork suggests that this work may have been painted in the plein-air manner of the Impressionists.

GB

Exhibition Westmoreland County Museum of Art, Greensburg, Pa., 1976, *Nineteenth and Early Twentieth Century Regional Painters*, exh. cat. by P. A. Chew and J. K. Maguire, unnumbered.

Provenance Robert S. Waters, Johnstown, Pa., by 1972.

Bequest of Robert S. Waters, 1972, 72.14.6

Franciscan Church at Rothenburg, 1912

Oil on canvas mounted on pulpboard
24⅛ x 18¼ in. (61.3 x 46.4 cm)

Signatures, date, inscriptions: *MBL 7 12* (on floor, lower left); [illeg.]ranciskan Church, Rothenburg, Bavaria (on torn label, lower right); franziskankirche./Rothenburg, Bavaria, 1912/MBLeisser (on reverse)

Travel, one of Leisser's greatest pleasures, provided the artist with a wide range of pictorial subjects. *Franciscan Church at Rothenburg*, painted during a return

visit to Germany, depicts the interior of an early Gothic basilica located in Rothenburg, a remarkably well preserved medieval town fifty miles west of Nürnberg. From a position in front of the altar the viewer looks across the broad nave through the tall arcade into the side aisle, where narrow lancet windows admit a silvery light into the spacious interior. The empty pulpit and vacant pews enhance the illusion of silence. Exhibited in 1924, this work was aptly described as "an invitation to meditation."[1]

Leisser's eye for detail and his sensitivity to light relate this painting to the Dutch tradition of church interiors, of which Pieter Saenredam in the seventeenth century and Johannes Bosboom in the nineteenth century were leading exponents. Accordingly, Leisser emphasizes the quiet harmonies of the church by carefully drawing the repeating rhythms of the arched arcade, the receding pews with their scrolled ornamentation, and the stone floor. The painting's soft, muted tones add to the restfulness of the scene.
GB

Nancy Brown Colvin conducted the archival research for this article.

1 Penelope Redd, "Leisser Works on Exhibition," *Pittsburgh Post*, June 15, 1924, sec. 6, p. 6.

References P. Redd, "Leisser Works on Exhibition," *Pittsburgh Post*, June 15, 1924, sec. 6, p. 6; J. O'Connor, Jr., "Painting Presented," *Carnegie Magazine* 17 (Apr. 1943), p. 8.

Exhibition Wunderly Gallery, Pittsburgh, 1924.

Provenance The artist, until 1940; his estate, until 1942.

Gift of the Trustees of the Leisser Estate, 1942, 42.12

Oakland, c. 1913–14

Oil on canvas
30¼ x 50¼ in. (76.8 x 127.6 cm)
Signature, date: MB. Leisser/1909. (lower right)

This painting of a quiet winter scene in Oakland, a neighborhood of Pittsburgh, has as its focus Junction Hollow, one of the ravines that cut through the lower portion of Schenley Park; a local spur of the Baltimore and Ohio Railroad utilizes this old riverbed for cargo transport, while commuters cross the snow-covered valley by means of the steel-framed Schenley Bridge, completed in the late 1890s. At the right are the buildings of Carnegie Institute of Technology—now Carnegie Mellon University—accentuated by the classical tower of Machinery Hall, which stands on the bluff; across the ravine, a portion of Carnegie Institute is visible. In the distance the square dome of the Rodef Shalom Temple dominates the skyline.

This panoramic view of Oakland's leading institutions is offset by a group of humble domestic buildings nestled into the hillside in the foreground of the painting. These unpretentious structures, which exemplify Pittsburgh's vernacular architecture, provide a foil for the fashionable Beaux-Arts designs of Oakland's public buildings—a contrast that aptly dramatizes the social changes that transformed Oakland in the early twentieth century from a rural community into a cultural center. Leisser's soft tonal rendering unifies the two worlds and reinforces the silent mood of the painting.

Leisser's interest in local subject matter is documented by his exhibition record, which includes several street scenes in Pittsburgh. In 1896 he exhibited a sketch of Panther Hollow, also located in

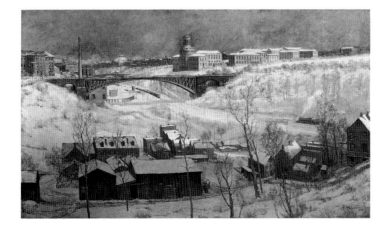

Schenley Park, which possibly commemorated the completion of the Panther Hollow Bridge, a twin to that depicted in *Oakland*. His subsequent painting of Junction Hollow not only records this Oakland scene as it looked on a winter day in 1913 or 1914 but also recalls Leisser's personal role at both Carnegie Institute, where he served on the Board of Trustees and the Fine Arts Committee from 1910 to 1915, and at the Carnegie Institute of Technology, where he helped to establish an art department.

Oakland is inscribed with the date 1909, but this date is in error; presumably, Leisser added it at a later time. This picture could not have been painted before 1913, when Machinery Hall was completed. Leisser's precise rendering of the campus design further reveals that the two wings of the College of Fine Arts at the eastern end of the campus had not yet been constructed; these additions were undertaken in 1915–16.[1]
GB

1 James D. Van Trump, "Of Temples and Technology," in *Life and Architecture in Pittsburgh* (Pittsburgh, 1983), pp. 135–42.

Provenance Mr. and Mrs. Sollen, Canonsburg, Pa., by 1969; Allen Demetrius, Pittsburgh, 1969.

Museum purchase: gift of the Sarah Mellon Scaife Family, 1973, 73.3.2

Dancing School in Honolulu, 1917

Oil on board
15 x 19⅝ in. (38.1 x 49.8 cm)
Signature, date: MB. Leisser 1917 (lower right)

Besides painting, the most compelling activity in Martin Leisser's life was travel; indeed, it almost seems that the artist spent more time away from Pittsburgh than he did in residence. In 1924, the Wunderly Gallery mounted a solo exhibition to acknowledge Leisser's return after an absence lasting many years. To the fascination of the public, the exhibition featured "dozens of travel sketches from almost every part of the world excepting the Land of the Midnight Sun."[1] Leisser's far-flung itinerary had included a six-month stay in Hawaii, where he shared a "picturesque cottage outside Honolulu" with his brother Charles.[2] *Dancing School in Honolulu,* doubtless produced during

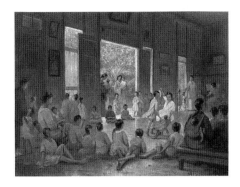

this visit, is most likely one of the "sympathetic studies"[3] of Hawaii that were exhibited at the Wunderly Gallery in 1924.

The thinly painted surface of this painting and the anonymity of the subjects mark this work as a study. Leisser depicted a gently lit interior where women and children are casually gathering for a dance lesson. The bright sunlight outside the studio contrasts vividly with the cool atmosphere within. A piano player, barely visible in the background, strikes a tune for the three children who are already practicing in the center of the room. Pink, turquoise, and yellow fabrics heighten the decorative effect of the composition, and their reflection in the smooth floor imparts a warm, unifying tonality to the scene. Leisser succeeded in capturing the soft and unhurried ambience of the Hawaiian environment.

GB

1 Penelope Redd, "Leisser Works on Exhibition," *Pittsburgh Post*, June 15, 1924, sec. 6, p. 6.

2 Naylor, "Veteran Painter," p. 38.

3 Redd, "Leisser Works," p. 6.

Provenance William J. Strassburger, Pittsburgh, by 1953.

Bequest of William J. Strassburger, 1953, 53.26.3

Robert L. Lepper

1906–1991

A SCULPTOR, MURALIST, and designer, Robert Lewis Lepper was one of Pittsburgh's pioneer modernists. One of the founding faculty in industrial design

at Carnegie Institute of Technology, Lepper had, in forty-five years of teaching, a considerable influence on numerous art students, among them Philip Pearlstein, Andy Warhol, Mel Bochner, and Jonathan Borofsky. His own work makes use of the found object and the materials of the machine age, but he refrains from set ideologies, preferring form to develop from the necessity of content. That tenet has also been the foundation of his teaching.

Lepper was born and raised in Aspinwall, Pennsylvania, at the edge of metropolitan Pittsburgh. His ambition was to be a professional illustrator; toward that end he entered Carnegie Institute of Technology, whose painting faculty was then composed mostly of illustrators, and received a bachelor of arts degree there in 1927. After graduation Lepper took the obligatory young artist's trip to France. He stayed thirteen months, wintering in Paris and spending the summer traveling elsewhere in Europe and North Africa.

"Europe was a tremendous stimulus," Lepper said, "but stylistically I hadn't the slightest idea of what I ought to be doing."[1] He went to shows around the Boulevard Saint Germain, bought books on Fernand Léger, Pablo Picasso, and Georges Braque, and spent time—too much, he felt in retrospect—with other Americans. He also attended the Académie Julian, which "didn't amount to beans," and the Académie de la Grande Chaumière. "You could go there Thursday nights and draw from the nude model, a perfectly legitimate enterprise, and I went on Thursday nights and drew. I knew that André Lhote had an academy. That was the place I should have gone, but was too lazy and too timid; if it was modern it would have been happening there."

After returning to the United States, Lepper did not enroll at the New Bauhaus in Chicago, as has sometimes been claimed. He settled in Pittsburgh, working as an advertising artist for the *Pittsburgh Sun-Telegraph*, then joined the painting faculty at Carnegie Institute of Technology in 1930. Industrial design was a new discipline in the early 1930s, and the faculty proposed offering the subject

in addition to its curricula in painting and art education. Lepper became a member of the committee that in 1934 instituted the first degree course in industrial design in the United States. His colleagues were Wilfred Readio, Donald Dohner, Alexander Kostellow, and, later, the German emigré Peter Müller Munk.

From 1938 to 1941 Lepper was involved in three mural projects. The first two were United States Treasury Department commissions for post offices in Caldwell, Ohio, and Grayling, Michigan. They were influenced by the vigor, simplicity, and angularity of Thomas Hart Benton, but Lepper stopped short of taking on Regionalist ideology. "Its look and structure were meaningful to me," as he put it, but "I had no feel whatsoever for muskrats."

Lepper's third mural, executed in 1941, was his largest commission, measuring twelve by forty-eight feet. Installed in the Mining Industries Building at West Virginia University at Morgantown, it incorporated sections of machinery and chemical formulas into a complex montage of vistas, details, and abstractions of mining processes that centered on the extraction of coal and natural gas. "Its only rival was Diego Rivera's Ford murals in Detroit a decade earlier," as one critic has observed.[2]

Between 1946 and 1952 Lepper, in affiliation with an architectural firm, designed brochures for the Alcoa Corporation's architectural products. He turned to sculpture, working in aluminum, cut and painted Plexiglas, and assemblages of machine parts and hardware. He contributed assemblage art to the 1943 exhibition *The Arts in Therapy* at the Museum of Modern Art, New York. Examples of his assemblages include *Monument to Marcel Duchamp* (1957, The Carnegie Museum of Art, Pittsburgh), *Orb and Instrument* (1961, Museum of Modern Art, New York), and *Benign Beast* (1963, The Carnegie Museum of Art).

Lepper, who had contributed to Carnegie Institute's annual exhibitions of 1941 and 1961, was given a solo exhibition there in 1961; a year later he was named Pittsburgh's Artist of the Year, a prestigious local award. During the 1960s he built two large outdoor sculptures. One, *Monument to the People's Right to Know*, was a thirty-five-foot column assembled

from newspaper press plates for the West Virginia pavilion at the 1964–65 New York World's Fair. The other, a ten-foot kinetic mobile called *Astrobat*, was commissioned for Pittsburgh's 1963 Three Rivers Arts Festival. Made of cubes of sheet aluminum, it could be manipulated by ropes pulled by the spectator. Even at its most spare and geometric, Lepper's work is animated and often witty. It reflects his admiration for the laws of chance and his enduring respect for creative processes unfettered by a priori theories. He died in Washington, D.C.

1 Robert L. Lepper in interview with Diana Strazdes, July 10, 1987. Unless otherwise noted, following quotations are also from this interview.

2 Wilson in Brooklyn Museum, *The Machine Age*, p. 344.

Bibliography Leonard Thompson, "Art, Plastics and Tin Snips," *Pittsburgh Press*, February 14, 1960, pp. 18–19; Württembergischer Kunstverein, Stuttgart, *Andy Warhol, das zeichnerische Werk, 1942–1975* (1976), exh. cat. by Rainer Crone, pp. 16–17, 65–77; Brooklyn Museum, New York, *The Machine Age in America, 1918–1941* (1986), exh. cat. by Richard Guy Wilson et al., pp. 84, 344–46; Patricia Lowry, "Andy Warhol's College Teacher Being Rediscovered as an Artist," *Pittsburgh Press*, March 15, 1987, sec. E, pp. 1, 4; Richard Guy Wilson, "Robert Lepper and the Machine Age," *Carnegie Magazine* 58 (May–June 1987), pp. 12–21.

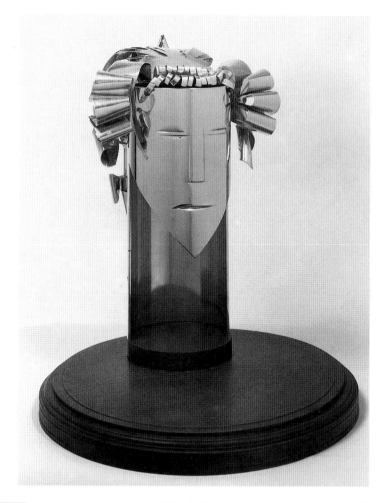

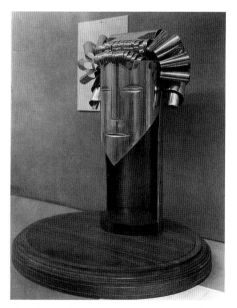

Fig. 1 Robert L. Lepper, *Polished Lady* (original state)

Polished Lady, 1931, reworked 1987 (*Head*)

Brass tube and sheet aluminum on walnut base
16½ x 13¾ x 13¾ in. (41.9 x 34.9 x 34.9 cm)

Diameter of brass tube: 4¾ in. (12 cm)

Markings: ROBERT L. LEPPER/CARNEGIE INSTITUTE OF TECHNOLOGY/PITTSBURGH PA. (under base)

This sculpture was a response to Frederick Kiesler's book *Contemporary Art Applied to the Store and Its Display* (New York, 1930). Kiesler was a painter, architect, and scene designer associated with the de Stijl movement who came to New York in 1926 and worked there as a set designer and commercial artist. His book was prompted by a commission to redecorate Saks Fifth Avenue's store windows in 1929. Kiesler's revolutionary design was the first to treat the store window as a modernistic, abstract setting for a single piece of merchandise. His book advocated the union, even the interchangeability, of art and technology, provoking the central modernist question, "What is art?" The book contained many of Kiesler's working drawings, in some of which old-master sculptures were placed as the "merchandise" in windows.

With *Polished Lady* Lepper rephrased Kiesler's proposition by appropriating the store-window display fixture for an art-gallery setting. The head, constructed from polished brass tubing, has two slots at the top, fitted with a wig of crimped sheet aluminum. Originally, the wig could be removed and changed at will, like that of a retailer's dummy. For the artist's 1948 exhibition, *Some Forces behind Modern Art,* the head, intentionally vulgarized, reportedly carried a placard; a rod was threaded through the two holes in the lower part of the tube, and an arrowhead was stuck on the rod as a pointer. The original marcelled wig (fig. 1) was eventually lost, and in 1987 it was re-created by the artist.
DS

Exhibitions Department of Fine Arts, Carnegie Institute, 1933, *Exhibition of Works by Alumni of the Department of Painting and*

Decoration of the Carnegie Institute of Technology, no cat.; Arts and Crafts Center of Pittsburgh, 1948, *Some Forces behind Modern Art*, no cat.; Arts and Crafts Center of Pittsburgh, 1962, *Robert Lepper: Artist of the Year 1962*, no. 7; The Carnegie Museum of Art, Pittsburgh, 1989, *Educating Andy Warhol: Robert Lepper and Samuel Rosenberg*, no cat.

Provenance The artist's daughter, Susan J. Lepper, Washington, D.C., by 1986.

Gift of Susan J. Lepper, 1986, 86.65

Crankshaft, c. 1932

Oil on Masonite
25⅛ x 30³⁄₁₆ in. (63.8 x 76.7 cm)
Signature: *Robert Lepper* (lower right)

The subject of this unusual still life is the crankshaft of a twelve-cylinder in-line engine block of a Lincoln Zephyr automobile from the early 1930s. It was lent to the artist by a night-school student who worked as a salesman for a Lincoln dealer. A hard, factual, yet unexpectedly animated form, it is at once a humble and exalted object, existing autonomously in an almost surreal cloudlike space whose blue-gray tones correspond to those of the machinery.

At nearly the same time that he painted *Crankshaft,* Lepper produced two stylistically similar still lifes: *Tools* (c. 1932, collection Jonas Schoen, Houston), whose

central elements are a handsaw and woodworking plane, and *Kitchen Table* (c. 1932, collection Janet Marqusee, New York). These subjects, like *Crankshaft,* were removed from context, stylized and energized, and suggest that the crankshaft was likewise chosen because it was an artifact of ordinary life. However, it is also a streamlined by-product of the machine age, while the other objects are associated with a more traditional existence. One might consider the idioms incompatible, but during the 1930s Lepper worked with the two simultaneously, without any sense of contradiction. DS

Reference Wilson, "Robert Lepper and the Machine Age," p. 18.

Exhibition The Carnegie Museum of Art, Pittsburgh, 1989, *Educating Andy Warhol: Robert Lepper and Samuel Rosenberg,* no cat.

Provenance The artist, until 1985.

Patrons Art Fund, 1985, 85.6.1

Gas Producer, 1941

Valspar synthetic varnish and dry color on tempered hardboard
36 x 30 in. (91.4 x 76.2 cm)
Signature: Robert Lepper (upper right)
Inscription: "GAS PRODUCER," ROBERT L. LEPPER, CARNEGIE INSTITUTE OF TECHNOLOGY, PITTSBURGH, PA. (on reverse, in artist's hand)

When Robert Lepper set out to design the Mining Industries Building mural at West Virginia University, he felt it was in many ways an exploration of the unknown. As he recalled:

> I had no preparation for this. I hadn't the faintest idea what I was going to see or what was going on. . . . I didn't quite know exactly how a gas producer worked, and I didn't know there was such a thing, as a matter of fact. I did know there was industrial chemistry, and that DuPont and Union Carbide were up to their armpits in West Virginia, and in 1940 nylon fabrics had just appeared on the scene: coal, air, water. I had to look into that.[1]

His preparations involved days of observing well-drilling operations and visits to sheet-glass, bottle-making, and chemical plants around Charleston, West Virginia. The trip was his introduction to machinery and processes that he proceeded to study through plans and diagrams from the Bureau of Mines in Pittsburgh and then to incorporate into the mural (fig. 1).

Gas Producer is a finished study for one of the machine images that appear at the upper right of Lepper's mural. It depicts a tubular device for the extraction of gas from coal that forces jets of steam through the molten material in its core. It was an important piece of equipment to the local economy—and hence to the mural's program—since the extraction was the first step in the process that produced industrial alcohols, urea, plastics, and synthetic fibers.

Fig. 1 Robert L. Lepper, *Mural for Mining Industries Building,* 1941. Oil on canvas, 12 x 48 ft. (3.7 x 14.6 cm). West Virginia University at Morgantown

Lepper rendered the gas producer in flat primary and secondary colors, segregated so the warm colors are suggestively in the mechanism's core. Its abstract appearance is the result of the mechanical drawings that Lepper relied upon, for the image is simply and accurately a section. Lepper had taken an interest in architectural drawing since his college days, when he would visit the drafting room, there to spend idle time "picking up drawing by the pores of the skin" by watching his architecture-school classmates.

Lepper's reliance on the section for *Gas Producer* (and much else in the Morgantown mural) served two purposes simultaneously: it kept his rendition straightforward and tangible and, at the same time, allowed for the expression of beautiful abstract shapes. As he said,

The *Gas Producer* and the twelve by forty-eight feet of the Morgantown mural are full

of strange and wonderful objects. It sounds so silly for somebody to say of himself, "I am celebrating the machine." I saw them as beautiful objects, and myself as a designer at work who saw beautiful designs.

The dichotomies between the concrete and abstract, the functional and beautiful were thus simply resolved: "The section produced great shapes," Lepper said. "The shapes were beautiful; why should I fiddle with them beyond the designer's choices?"

DS

1 Robert L. Lepper in interview with Diana Strazdes, July 10, 1987. Following quotations are also from this interview.

Reference Wilson, "Robert Lepper and the Machine Age," p. 14.

Exhibitions Department of Fine Arts, Carnegie Institute, 1942, *Thirty-second Annual Exhibition of the Associated Artists of Pittsburgh,* no. 138; Riverside Museum, New York, 1943,

American Modern Artists First Annual Exhibition, no. 51; Architectural League of New York, 1952, *Gold Medal Show of Mural Painting,* unnumbered; Arts and Crafts Center of Pittsburgh, 1962, *Robert Lepper, Artist of the Year 1962,* no. 11; Brooklyn Museum, New York, 1986, *The Machine Age in America, 1918–1941* (trav. exh.), exh. cat. by Richard Guy Wilson et al., unnumbered; The Carnegie Museum of Art, Pittsburgh, 1989, *Educating Andy Warhol: Robert Lepper and Samuel Rosenberg,* no cat.

Provenance The artist, until 1985.

Patrons Art Fund, 1985, 85.6.2

William Charles Libby
1919–1982

WILLIAM CHARLES LIBBY was a painter and lithographer who distinguished himself by his remarkable capacity for finely detailed drawing, organizational clarity, and technical precision. Libby was born in Pittsburgh. He began to show his artistic skill at a young age: one of his drawings was published in the February 1932 issue of *Carnegie Magazine;* another won first place in an exhibition at Carnegie Institute two years later. Upon graduating from high school in 1936, he enrolled at the University of Pittsburgh, then transferred to Carnegie Institute of Technology, where he received a degree in art education in 1941.

The outbreak of World War II interrupted Libby's artistic career. He enlisted in the army, but an inoculation with unrefrigerated yellow-fever serum hospitalized him and resulted in a medical discharge in 1943. In the pursuit of a career in industrial design, he enrolled at the University of Texas at Austin to study engineering. That goal was never realized, for in 1945 he was offered a teaching position at Carnegie Institute of Technology, where he remained for thirty-seven years.

Libby's paintings and lithographs appear to exist in a pristine and mysterious world created by a meticulously detailed and technically polished drawing style. Like the works of the Magic Realists, Libby's art pushed reality to its limits; his paintings are precise images of "the implausible but not the impossible, the imaginative but not the imaginary."[1]

Libby's desire for representational and technical accuracy led him to work carefully and develop each piece slowly. His favorite theme was a merry-go-round horse, although he also worked with railroad images, birds, and historical subjects. After choosing his subject, he studied and sketched it, seeking to clarify its design and meaning. He often worked on a piece for months, refining it until he achieved an expressive, well-crafted, and aesthetically pleasing arrangement of form and color.

This methodical approach was well suited to lithography, in which Libby began to work during the early 1940s. That interest led him to Paris in the summer of 1951 to study in the atelier of Gaston Dorfinant, where he concentrated on improving his technique; unlike many other American artists in Paris, he did not particularly concern himself with stylistic issues. He continued to work in lithography for the rest of his career, received many awards for his prints, and was considered an authority on the medium.

Libby's relationship with Carnegie Institute extended over two decades: he participated in its *Painting in the United States* exhibitions in both 1948 and 1949 and in 1955 was honored by a solo exhibition. Libby was also active in two other Pittsburgh arts organizations, the Associated Artists of Pittsburgh and the Arts and Crafts Center of Pittsburgh, which named him Artist of the Year in 1958. Of his many commissioned pieces, perhaps the finest is a mural of the history of railroading, located in a Pennsylvania Railroad ticket office in Philadelphia. He illustrated two books, *The Story of an American City* and his own book, *Color and the Structural Sense.* The artist died in Pittsburgh.

1 Rutgers University Art Gallery, New Brunswick, N.J., *Realism and Realities: The Other Side of American Painting, 1940–1960* (1981), exh. cat. by Greta Berman and Jeffrey Wechsler, p. 26.

Bibliography Sam Hood, "Beyond the Camera," *Pittsburgh Press,* June 17, 1956, pp. 12–13; Sam Hood, "Pittsburgh's Artist of the Year," *Pittsburgh Press Roto,* January 5, 1958, p. 46; Stefan Lorant, ed., *The Story of an American City* (New York, 1959); Norman Kent, "William Charles Libby," *American Artist* 23

(January 1959), pp. 46–51; William Charles Libby, *Color and the Structural Sense* (Englewood Cliffs, N.J., 1974); Carnegie Mellon University Art Gallery, Pittsburgh, *William Charles Libby: A Retrospective* (1986), exh. cat. by Sarah Elderidge.

Lanterns, 1945

Tempera on board
26⅝ x 17⅛ in. (67.6 x 43.5 cm)
Signature: *WL* (lower left)

Lanterns is characteristic of the precise, analytical style in which Libby worked and presents the type of subject he preferred. It is a minutely detailed still life, painted in muted pinks and purple grays. Its focus is a large lantern—the kind generally found alongside railroad tracks, known as an Adlake lantern.

Adlake lanterns, which had an amber light on one side and a green on another,

rotated when a train approached, displaying either the green or the amber light to the conductor. If the light was green the conductor knew that the train could proceed on a straight course; the amber light meant it must turn onto a connecting track. The lantern in this painting is positioned so that its amber light faces the approaching train, whose arrival from behind the viewer is implied by the large shadow falling over the lantern in the foreground, the track running alongside it, and another, smaller lantern in the middle background.

The two main elements of the composition, the lantern and the shadow of the approaching train, are broken into sharply defined planes. This fragmentation is not arbitrarily imposed but is based on Libby's intimate knowledge of

the structure of the lantern as well as the effects of light and shadow on it and the surrounding space. The sharp definition of each plane negates any sense of movement—it is as though the painting were shrouded in a great stillness.

Color, too, enhances this atmosphere of motionlessness. One color precisely fills the outline of each plane; and it is applied so that not even a gesture of the brush is visible. Pigments are pastel or neutral— only the bright orange and lime-green wedges shining from the spotlights of the lantern offer any intensity. Rather than destroying the serene atmosphere of this painting, the use of these two intense colors serves to accentuate the mood, as well as to establish the lantern as a starting point for viewing the painting. Lastly, Libby's choice of medium contributes to this stillness, for tempera colors are flat, lacking the depth and fluidity of such mediums as oil.

The precise definition of each plane and the quiet, flat application of colors work together to create an almost unreal stillness and align this painting with the works of such artists as Charles Sheeler and Edward Hopper. *Lanterns* is also related to another work by Libby, a lithograph of the same title (c. 1940, The Carnegie Museum of Art, Pittsburgh). The print is compositionally identical to its painted counterpart. However, the lantern and the space surrounding it in the print are illusionistically modeled, not fragmented into sharply defined planes, as they are in the painting. The print precedes the more abstract painting and may have served as a study for it.

EM

Reference Hood, "Pittsburgh's Artist of the Year," p. 46; Kent, "William Charles Libby," p. 46.

Exhibitions Arts and Crafts Center of Pittsburgh, Pittsburgh, 1958, *William Charles Libby: Pittsburgh's Artist of the Year*, no cat.; Carnegie Mellon University Art Gallery, Pittsburgh, 1986, *William Charles Libby: A Retrospective*, exh. cat. by Sarah Elderidge, no. 2.

Provenance Mr. and Mrs. James H. Beal, Pittsburgh, by 1958.

Gift of Mr. and Mrs. James H. Beal, 1963, 63.1.5

Charles Locke
1899–1983

CHARLES WHEELER LOCKE is best known today for the role he played in the lithography revival of the 1920s and 1930s. Younger American artists embraced the medium, which had been previously considered commercial, as an alternative to the overly aesthetic refinements of etching, while simultaneously seeking compelling and indigenously American subject matter. Locke was one of these young artists.

Born in Cincinnati, he studied at the Art Academy of Cincinnati and at the Ohio Mechanics Institute, where he made his first lithographs. In 1922 he went to New York, becoming a student of, and assistant to, the printmaker Joseph Pennell at the Art Students League. In 1923 he took over the lithography class and two years later was made instructor of lithography, a post he held until 1936. Most of Locke's lithographs of the 1920s consist of gently satiric treatments of the foibles and eccentricities of the bourgeoisie. They are stylish, with an emphasis on intense black and white contrasts and bold silhouettes, with little interior modeling or background detail.

In 1927 Locke joined with Reginald Marsh, Kenneth Hayes Miller, Peggy Bacon, and others to found the Society of American Printmakers, the "radical wing of American printmakers."[1] He came under the influence of Miller and adopted his well-modeled, monumental, yet simple figure style, applying it, as Miller did, to the depiction of the working class and life in the streets.

During the 1930s Locke created street and dock scenes that usually showed small-scale figures of men at work. He also joined with Marsh, José Clemente Orozco, Thomas Hart Benton, George Biddle, George Grosz, John Steuart Curry, and others to form the Contemporary Print Group, which was dedicated to commentary on social conditions during the Depression. His commitment to social reform was not politically radical, however, and he declined to join the radical American Artists Congress when it was formed in 1936.

By 1930 Locke had exhibited at the Downtown Gallery and had had a solo show at Argent Galleries, both in New York. Scribner's had reproduced portfolios of his lithographs. A survey of readers of *Prints* magazine judged him tenth in a list of the top ten printmakers in the East.[2] However, in 1936 he ceased teaching at the Art Students League and began spending much of the year in the small Hudson River town of Garrison, New York, where he turned to painting in oils.

Locke's canvases had primarily urban subjects, many of which were based on earlier lithographs. His first paintings were highly finished, but around 1940 his handling became looser, as his style betrayed the increasing influence of Marsh. His subjects again became the leisure activities of the middle class, now depicted without satire, and landscape views of the area around Garrison. Although his painterly output was quite small, Locke participated in the 1938 and 1939 Carnegie Internationals and had a solo show at Kraushaar Galleries in New York in 1945. He returned to the Art Students League in 1951; his work no longer attracted the attention it did earlier in his career. He died in Garrison.

1 "The Radicals," *Art Digest* 6 (December 15, 1931), p. 22.
2 Aline Kistler, "The National Survey," *Prints* 7 (June 1936), p. 244.

Bibliography "Charles Locke: A Classicist," *Art Students League News* 4 (February 1, 1951), n.p.; Karen F. Beall, *American Prints in the Library of Congress* (Baltimore, 1970), p. 269; Smithsonian Institution Traveling Exhibition Service and Corcoran Gallery of Art, Washington, D.C., *Of Time and Place: American Figurative Art from the Corcoran Gallery* (1981), exh. cat. by Peter Marzio et al., pp. 140–41; Clinton Adams, *American Lithographers, 1900–1960: The Artists and Their Printing* (Albuquerque, 1983), pp. 50–51, 59–61 passim.

The Basin, c. 1937–40

Oil on canvas
24¼ x 36 in. (61.6 x 91.4 cm)
Signature: CHARLES LOCKE (lower left)

The Brooklyn waterfront is an often-repeated subject in Locke's oeuvre. *The Basin* is a view of the wharves off Brooklyn Heights, his home in New York City. He is said to have made many drawings of the harbor after he moved to New York in 1922,[1] but those themes do not

appear as finished images until 1934, when he created *City Wharves* (Weyhe Gallery, New York) for the Contemporary Print Group.

The Basin—whose date can be determined by its high finish and attention to detail—is one of a handful of dock scenes Locke painted in the late 1930s. Among others are *Waterfront* (location unknown), shown in the 1937 Whitney Annual, Whitney Museum of American Art, New York; *The Tug* (1938, Whitney Museum of American Art) and *The Harbor* (1939, Whitney Museum of American Art), which appeared in Carnegie Institute's annual exhibitions of 1938 and 1939, respectively. Like much of Locke's work of the 1930s, *The Basin* reflects his association with Reginald Marsh and Kenneth Hayes Miller, as well as the widespread interest during the Depression in portraying the working class. His purpose, however, was neither political nor documentary. Regarding a similar work, *Docks* (1935, Library of Congress, Washington, D.C.), he wrote that he wanted to convey the atmosphere of the place, not make a portrait of it.[2]

If Locke admired Miller because he "went to the Old Masters for ideas in order to interpret them in terms of present day thinking,"[3] then *The Basin* is an attempt to make an old-master painting with a contemporary theme. Locke admired Claude Lorrain and Nicolas Poussin, and their influence can be discerned here. Like Claude's harbor scenes, *The Basin* depicts a luminous view into a vast distance, using a stagelike setting in which alternating coulisses define the space. Other Claudean devices are rapidly

receding diagonals, which lead the eye into the distance, and strong horizontals, which serve as a framing device. In a deliberately old-master manner, Locke has rendered the effect of sunlight breaking through clouds and randomly illuminating the scene. The overall dark tonality and the color scheme of red, blue, and yellow, evident in such other works as *Third Avenue El* (1943, Corcoran Gallery of Art, Washington, D.C.), also reflect his interest in the art of the past, particularly that of Poussin.

Locke's transformation of this scene into an old-master painting gives it a sense of "spacious serenity"[4] that is perhaps at odds with the reality of a busy wharf. But that quality pleased the conservative critic Thomas Craven, who wrote this of *Waterfront*, a similar dock scene:

> Not very common in contemporary art [is] a certain monumental quality reminiscent of other times... [an] undefinable, if unmistakable "past recaptured."... Mr. Locke has seen a Brooklyn waterfront scene *sub specie aeternitatis*. For he has not falsified or sentimentalized the material chosen; he has merely looked at it from a point of view that has become rare.[5]

JRM

1 "Charles Locke: A Classicist," n.p.

2 Albert Reese, *American Prize Prints of the Twentieth Century* (New York, 1949), p. 127.

3 "Charles Locke: A Classicist," n.p.

4 Review of Kraushaar Galleries exhibition, *Art News* 44 (May 1, 1945), p. 29.

5 Thomas Craven, *A Treasury of American Prints* (New York, 1939), pl. no. 63.

Reference Charles W. Locke, in Kraushaar Galleries Scrapbook, Kraushaar Galleries Papers, Archives of American Art, Washington, D.C.

Exhibition Department of Fine Arts, Carnegie Institute, Pittsburgh, 1946, *Paintings and Prints from the Collection of Charles J. Rosenbloom*, no. 3.

Provenance Kraushaar Galleries, New York, c. 1940; Charles J. Rosenbloom, Pittsburgh, 1943.

Bequest of Charles J. Rosenbloom, 1974, 74.7.18

Molly Luce
1896–1986

MOLLY LUCE IS best remembered for her contributions to American Scene painting in the 1920s and 1930s; she chose to paint Main Street, U.S.A., in farm country and in the suburbs. Born in Pittsburgh, Luce spent two years at Wheaton College in Norton, Massachusetts, then from 1919 to 1922 studied at the Art Students League in New York. While she was at the league, her painting instructors included F. Louis Mora, George Bellows, and Kenneth Hayes Miller. Miller had the most profound effect, teaching her to respect painting as a vocation and to appreciate professional artists in society.

Upon leaving the Art Students League in the fall of 1922, Luce began a tour of Europe. Although Paris provided a great deal of visual and intellectual stimulation, she nonetheless maintained a prejudice in favor of naturalism and nationalistic themes. When she returned from Europe in 1924, she showed her work for the first time, at the Whitney Studio Club, New York. She was nominated by Alexander Brook for a solo exhibition to be held there in the fall of that same year. One critic described that exhibition of twenty-one paintings as

> having a vitality that is a pleasure to discover in young American painters, for it proves she has found something in her own environment that is worth recording, and when artists do that a great period is born. Her style of painting is definitely her own. There is a rhythm of line in it, solidity of structure and a vibrant quality of surface attained by a modified use of such elongated swirls of color as Van Gogh used.[1]

Luce exhibited at least fifteen times in the Annual and Biennial exhibitions at the Whitney and was represented in at least six special theme exhibitions up to 1950. From 1924 to 1927 she suffered from depression, which kept her from making recognizable progress in her work. During the winter of 1927, she exhibited for the first time in almost three years at the Artists' Gallery and Montross Gallery in New York.

Luce's canvases are precisely designed and simply colored; during the late 1920s and throughout the 1930s, her style became bolder and more simplified. In 1934 she and Georgia O'Keeffe joined Mary Cassatt as the only living female artists to have a painting purchased by the Metropolitan Museum of Art, New York. In the 1940s, she began to build her compositions around a single figure. During this time, she exhibited in the 1943 and 1949 *Painting in the United States* shows held at Carnegie Institute.

As critical and popular taste turned against Regionalism in the 1950s, Luce stopped exhibiting her work; however, she continued to paint, changing and evolving her style. She was rediscovered in the late 1970s, and in the early 1980s a retrospective exhibition of her work, *Molly Luce: Eight Decades of the American Scene,* toured the United States. Luce died in her home in Little Compton, Rhode Island.

1 *Art News* 23 (November 29, 1924), p. 2.

Bibliography Alan Burroughs, "Young America—Molly Luce," *The Arts* 8 (August 1925), pp. 114–17; Alan Burroughs, *Limners and Likenesses: Three Centuries of American Painting*

(New York, 1935), pp. 217–18; Childs Gallery, Boston, *Molly Luce: Eight Decades of the American Scene* (1980), exh. cat., essay by D. Roger Howlett.

Pennsylvania Coal Country, 1927

Oil on canvas
22 x 28⅛ in. (56 x 71.4 cm)
Signature and date: Molly Luce 27 (lower left)

Although *Pennsylvania Coal Country* is an early work, it manifests the sense of national pride that is evident in every painting of Luce's career. In a lifelong search for what she felt to be the essential character of the United States, she depicted small-town America and its industry, here exemplified in a faithful portrayal of a mining community. Framed by green mountains and shaded by gray clouds, the town in *Pennsylvania Coal Company* has at its center an ominous black slag heap. Below the towering presence of the slag heap, a testament to the work ethic, a church steeple rises above the town proper and the figures in the foreground of the canvas are dressed in their finest clothes. This scene was a common one in Pennsylvania, especially during the 1930s and 1940s, when mining as well as other industries provided not only a livelihood for many families but also created instant communities around the workplace.

A clear geometric style was most pronounced in Luce's paintings of 1927. The intermingling of tightly compressed architecture, linear form, and varying angles can also be found in *Zoological Garden* (1927, collection Thomas Floyd

and Stephen Alimonti, Boston) and *Outskirts of Town* (1927, Childs Gallery, Boston).

LAH

Exhibitions Childs Gallery, Boston, 1980, *Molly Luce: Eight Decades of the American Scene* (trav. exh.), exh. cat., essay by D. Roger Howlett, unnumbered; National Museum of Women in the Arts, Washington, D.C., 1987, *American Women Artists, 1830–1930,* no. 77.

Provenance The artist, until 1980; Childs Gallery, Boston, 1980.

Museum purchase: gift of the H. J. Heinz II Charitable and Family Trust, 1980, 80.69

Luigi Lucioni
1900–1988

LUIGI LUCIONI's exacting views of the Vermont countryside helped make him one of America's most popular landscape painters during the 1930s and 1940s. He acquired his skills in acute observation and expert draftsmanship during a childhood spent in the village of Malnate, Italy, near Milan. There he studied under the local stonecutters, making ornamental drawings of Classical and Renaissance motifs for architectural decoration.

In 1911 Lucioni immigrated to America with his family and settled in Jersey City, New Jersey. As a teenager he helped support himself by making etchings for the *New York Herald-Tribune* while, from 1916 to 1920, he attended night classes at the Cooper Union Art School. From 1921 to 1924 he continued his formal art studies at the National Academy of Design, where he received instruction in printmaking from William Auerbach-Levy; he also took painting lessons from William Starkweather independently.

Lucioni's etchings won him a scholarship to the Louis Comfort Tiffany Foundation on Long Island in 1924. The following year he traveled through Europe, where he was particularly influenced by the linear purity and meticulous craftsmanship of Flemish and Italian early Renaissance painting, as well as by the work of Edgar Degas and Paul Cézanne.

On returning to New York, Lucioni rented a studio on Washington Square and produced his first mature still lifes, portraits, and landscapes, all of which are characterized by extreme clarity and a geometricization of detail. He explained:

> I admire fantasy in art, but realizing that it is not in my make-up, I try more and more to create reality with the simplest means and with all essential detail. But I feel that all this should be part of a design, which I believe every canvas must primarily possess.[1]

The artist began to receive critical attention when he held a solo show in 1927 at the Ferargil Galleries, New York. Quickly recognized as a major American artist, in 1932 he became the youngest living painter to have his work purchased by the Metropolitan Museum of Art, New York.

Lucioni first visited Vermont in 1929; its rocky terrain captivated him, for it reminded him of his native Lombardy. He returned often during the thirties to paint the New England pastorals for which he was best known. In 1939 he bought the Manchester farmhouse where, for more than four decades, he steadily worked on paintings and prints of Vermont scenery.

Like the Precisionists, Lucioni exhibited a taste for exactitude and simplification; like the Regionalists, he manifested an interest in rural America. Yet he remained aloof from the mainstream of American art, and his production cannot easily be categorized. Though his work has fallen into obscurity in recent decades, he was quite widely appreciated in the thirties and forties. He won the popular prize in the 1939 Carnegie International for his portrait *Ethel Waters,* as well as two Corcoran Gallery popular prizes in 1939 and 1941. He participated in fifteen of the annual exhibitions held at Carnegie Institute and in 1948 served as a member of the jury of award. Lucioni died in Greenwich Village.

1 "Modern Primitive," *Time,* January 13, 1936, p. 23.

Bibliography Peyton Boswell, Jr., *Modern American Painting* (New York, 1939), p. 173; John O'Connor, Jr., "Luigi Lucioni Wins Popular Prize in 1939 International," *Carnegie Magazine* 13 (December 1939), pp. 207–8; Maxine Block, ed., "Luigi Lucioni," *Current Biography: Who's News and Why, 1943* (New York, 1944), pp. 465–67; Ralph Fabri, "An Individual Realist: Luigi Lucioni," *American Artist* 35 (October 1971), pp. 26–30, 65–66.

Vermont Pastoral, 1939

Oil on canvas
23 x 39 in. (58.4 x 99.1 cm)
Signature, date: Luigi Lucioni '39 (lower left)

Lucioni once considered *Vermont Pastoral* his favorite painting.[1] Executed just after the artist moved into his Manchester farmhouse, the work seems to solidify his ideas about landscape. It depicts the rocky but cultivated fields in the Green Mountain range, which are dominated in the foreground by elms rising boldly from rough terrain. In the middle ground emerge a weatherbeaten old fence and a small rustic cabin, partially obscured by trees. Behind lies a meadow and, in the distance, rolling hills and a blue, clouded sky.

Lucioni used a limited palette and a thin, almost transparent stroke to create detail in the painting with the sharp focus of a photograph. Heavy outlines flatten forms and simplify the composition while emphasizing surface design. The artist wrote:

> My chief desire in art, aside from the genuine pleasure that the craft of painting itself gives me, is to paint not what I see, but what I know and feel about objects and nature. I love detail, not for its own sake, but as part of the large masses and design.[2]

Lucioni's goal, however, was not to impress with his technique but to share his reverence for the Vermont landscape and evoke a sense of fragility and change. He suggests temporality in *Vermont Pastoral* through fleeting effects of light, changing cloud forms, lush trees in full leaf, and the dilapidated farm building and fence. Curiously, some of Lucioni's natural formations exhibit human characteristics that make them appear animated. The paired elms, for example, seem to offer a sly hint of anthropomorphism.

The tree on the left suggests a female with its slender trunk and sinuous line, while the one on the right is stocky and rigid.

Although *Vermont Pastoral* appears somewhat labored in execution, it retains a clarity and freshness that make it appealing. It won the purchase prize at the 1940 Carnegie annual and subsequently became such a popular image that in 1946 a color lithograph edition was issued, to be hung in thousands of American homes.

JM

1 Raymond Walker, Walker Art Galleries, New York, to Homer Saint-Gaudens, Pittsburgh, March 7, 1941, museum files, The Carnegie Museum of Art, Pittsburgh.

2 O'Connor, "Luigi Lucioni Wins Popular Prize," p. 208.

References L. D. Longman, "The Responsibility to Educate: Editorial Comment," *Parnassus* 16 (Jan. 1941), p. 4; J. O'Connor, Jr., "Four New Paintings," *Carnegie Magazine* 14 (Jan. 1941), pp. 228–29; Block, *Current Biography,* p. 466; N. Heller and J. Williams, *The Regionalists* (New York, 1976), n.p.

Exhibitions Department of Fine Arts, Carnegie Institute, Pittsburgh, 1940, *Survey of American Painting,* no. 287; Swope Art Gallery, Terre Haute, Ind., 1942, *Inaugural Show of Present Day American Painting,* no. 66; Associated American Artists, New York, 1943, *Luigi Lucioni,* unnumbered; Associated American Artists, New York, 1951, *Luigi Lucioni: Twenty-five Years of Painting,* unnumbered.

Provenance Walker Galleries, New York, as agent, 1940.

Patrons Art Fund, 1940, 40.7.1

George Luks

1867–1933

THE EIGHT'S MOST vocal anti-intellectual and its strongest opponent of artistic propriety was George Benjamin Luks. Even though he was not the group's most prolific or technically innovative painter, he was the one who most completely rejected art for art's sake, in favor of the coarse immediacy of ordinary life. It was this respect for the commonplace that gave the Eight such an important role in the return to realism that took place in early-twentieth-century American art.

The son of a physician, Luks was born in the coal-mining district of Williamsport, in north-central Pennsylvania. His first vocation seemed to be the theater; in 1883 he went to Philadelphia to work in vaudeville. However, once there he began attending art classes at the Pennsylvania Academy of the Fine Arts, where Thomas Anshutz was his teacher. By Luks's own account, he spent the next nine years in Europe, studying in the academies of London, Paris, Düsseldorf, and Munich, although it is not clear that he actually did so.

By 1894 Luks was in Philadelphia, having joined the art staff of the *Philadelphia Press*. In 1895 he was a war correspondent in Cuba for the Philadelphia *Evening Bulletin;* he subsequently drew cartoon strips for two other Philadelphia papers, the *Philadelphia Journal* and the *World.* In Philadelphia he met William Glackens, Everett Shinn, and Robert Henri, and through their example began to paint. He moved to New York in 1898, as they soon did, and the four men became the nucleus of the Eight.

Luks sought to emulate, through dark tonality and energetic brushwork, seventeenth-century Netherlandish depictions of the urban lower classes. His early images of workers and street children were sometimes brutally simplistic, but they account for some of his best work including *The Spielers* (1905, Addison Gallery of American Art, Andover, Mass.), *The Old Duchess* (1905, Metropolitan Museum of Art, New York), and *The Wrestlers* (1905, Museum of Fine Arts, Boston).

Two years after the Eight's inaugural exhibition at New York's Macbeth Galleries in 1908, Luks had his first solo exhibition. He subsequently contributed to the 1913 Armory Show as well as numerous other exhibitions, including nine of the annual exhibitions at Carnegie Institute between 1904 and 1933. He taught for several years at the Art Students League, then founded his own school, as Robert Henri had done. After World War I, he gravitated toward rural subjects, and his style became even starker and less complex. Although his later work varies considerably in quality, it brought Luks a number of awards, including the Temple Gold Medal given by the Pennsylvania Academy of the Fine Arts, the Logan Medal of the Art Institute of Chicago, and the Corcoran Gold Medal from the Corcoran Gallery of Art, Washington, D.C.

Luks saw himself as one of the monumentally virile characters in his paintings. Earthy and boisterous, he was an individual who was apt to fictionalize his past and exaggerate his accomplishments. He drank heavily and compulsively engaged in fistfights; a drunken brawl in New York City may have been the cause of his death.

Bibliography Elisabeth Luther Cary, *George Luks* (New York, 1931); Newark Museum, N.J., *Exhibition of the Work of George Benjamin Luks* (1934); Heritage Gallery, New York, *George Luks: Retrospective Exhibition* (1967); Munson-Williams-Proctor Institute, Utica, N.Y., *George Luks, 1867–1933: An Exhibition of Paintings and Drawings Dating from 1889 to 1931* (1973), exh. cat., introductions by Ira Glackens and Joseph S. Trovato.

Homer Saint-Gaudens, 1932

Oil on canvas
50 x 40 in. (127 x 101.6 cm)
Signature: George Luks (lower right)

Homer Saint-Gaudens (1880–1958), son of sculptor Augustus Saint-Gaudens, was the director of Carnegie Institute's Department of Fine Arts from 1922 to 1950. Luks was first contacted about painting an official portrait of Saint-

Gaudens in 1930; in February 1931 a commission was authorized. The choice of artist was surely meant to respect Saint-Gaudens's artistic loyalties: the director considered himself a champion of "native realism" and undoubtedly thought of Luks as one of that school's elder statesmen. The contracted price of five thousand dollars was generous; however, the resulting portrait is perhaps the single most disappointing work from Luks's hand.

The first of what were anticipated to be three or four sittings for a full-length portrait occurred in December 1931.[1] Saint-Gaudens suggested that Luks paint him in his "funny old grey suit" as if on his Carnegie International travels and use in the background some suitcases with rubbed labels on them, "just nice spots of color." He added, "I will bring some pretty clothes too, and you can do what you want."[2]

The picture was finished in January 1932 but was not well received when it arrived in Pittsburgh. Saint-Gaudens wrote:

Beyond any question it is a fine one. . . . However, my Trustees feel that a few suggestions. . . could well be met before the canvas is set before the public. Here are the criticisms: the likeness is out below the level of the nose, that is, around the dark side of the face, mouth, mustache and chin. The hands are not in character, being too fat. The legs give a rather stodgy look. The painting is a little too hard, too finished, with the bag too obtrusive. The color tone of the picture in the frame directly above the table does not pull the portrait together as a whole in the way it should.[3]

The painting was returned to Luks, who apparently made the suggested changes without objection. But the second attempt met with nearly as much criticism: this time the trustees were also "shying at the size," and Saint-Gaudens suggested that Luks change the picture and cut it down.[4] Luks responded, "I'll be seeing you February 1 and if necessary I will paint whatever you want. . . . But please let my genius run rampant.[5]

The present portrait reveals that Luks painted a completely new canvas in which his only reworking was in the sitter's torso. Upon its delivery Saint-Gaudens wrote, "The portrait is grand. It is sober; it is dignified; it is fine, and everybody is happy."[6] The painting appeared in an exhibition in March 1932. In April, soon after the show closed, Saint-Gaudens wrote to Luks with further criticisms and requested further adjustments. He said "the eyes were not quite straight" and that the right side of the face seemed "unduly swollen as it goes back toward the ear. I do not believe it is a question of drawing, as some of our amateur critics seem to think, but rather a question of values. Whatever it may be, both of these details I am sure you can fix in a minute."[7]

Luks responded in early May, saying that he had been ill and would let Saint-Gaudens know when he was fit to work.[8] Nothing more was done to the portrait, for Luks died the next year. Sometime later Saint-Gaudens wrote, "George Luks, who did a very bad job in his portrait of me, was nevertheless an outstanding painter of New York life."[9]

As the painting exists today, Saint-Gaudens wears a dark three-piece suit with a watch chain. He is seen at three-quarter length, cut off at the top of the legs so that they no longer create a "stodgy look." The background is a shallow, dark space into which the subject blends without any luggage or "nice spots of color." Saint-Gaudens appears life-size, sober and dignified, with no hint of personality.

NBC

1 George Luks to Homer Saint-Gaudens, telegram, November 24, 1931, Carnegie Institute Papers, Archives of American Art, Washington, D.C.

2 Saint-Gaudens to Luks, November 24, 1931, ibid.

3 Saint-Gaudens to Luks, January 20, 1932, ibid.

4 Saint-Gaudens to Luks, January 22, 1932, ibid.

5 Luks to Saint-Gaudens, January 28, 1932, ibid.

6 Saint-Gaudens to Luks, March 1, 1932, ibid.

7 Saint-Gaudens to Luks, April 28, 1932, ibid.

8 Luks to Saint-Gaudens, May 5, 1932, ibid.

9 Saint-Gaudens, undated memo, museum files, The Carnegie Museum of Art, Pittsburgh.

Exhibitions Department of Fine Arts, Carnegie Institute, Pittsburgh, 1932, *Exhibition of Contemporary American Art*, no. 37; Newark Museum, N.J., 1934, *Exhibition of the Work of George Benjamin Luks*, no. 69; Department of Fine Arts, Carnegie Institute, Pittsburgh, 1940, *Patrons Art Fund Paintings*, no. 24.

Provenance Commissioned from the artist, 1931.

Patrons Art Fund, 1931, 31.2

Stanton Macdonald-Wright

1890–1973

THE ACHIEVEMENT FOR which Stanton Macdonald-Wright is best known is his founding, with his friend Morgan Russell, of Synchromism in 1913. As the first abstract-art movement developed by Americans, it proved to be dynamic but short-lived; in its original form it lasted only through 1914 and ceased to exist as a group venture by 1916. Still, the Synchromists were the only cohesive and programmatic group to explore color theory and abstraction in America during the early twentieth century, and they fostered the first American avant-garde style to receive international attention.

Russell apparently invented the term *synchromism*, meaning "with color."[1] Influenced by the color theories of Michel-Eugène Chevreul, Hermann von Helmholtz, and Ogden N. Rood, he and his colleagues experimented with vivid chromatic contrasts to create musical, rhythmic forms expressive of the pace of modern life. Synchromism maintained a solidity of form that directly challenged the diaphanous quality of its European counterpart, Orphism. And both styles had an intensity of hue that contrasted with the subdued color schemes of Cubism, from whose structural system they certainly grew.

Among the supporters of Synchromism's program was the art critic Willard Huntington Wright, Stanton's brother, who declared, "These new men opened the eyes of all serious minded artists to an entirely new concept of the making of a painting."[2] Yet the movement also had its opponents. The French Orphists Sonia and Robert Delaunay, for example, accused Russell and Macdonald-Wright of fraudulence and of merely assimilating tenets of Cubism, Orphism, the Blaue Reiter, and Futurism without creating anything new.[3] Indeed, the extent of Synchromism's original contribution remains a controversial issue among scholars. What seems most novel about the work of Macdonald-Wright is the devotion he maintained to the human figure as he exploited abstract form. Although he produced a few wholly nonobjective compositions, he based his best work on the heroic male nudes of Michelangelo and Peter Paul Rubens.

Macdonald-Wright was born in Charlottesville, Virginia, in 1890, but his family moved to Santa Monica, California, when he was eleven. From 1904 to 1905 he studied at the Los Angeles Art Students League under Warren Hedges, who had previously taught with Robert Henri in New York; thus, indirectly, he learned Henri's quick, broad stroke. When Macdonald-Wright went to Paris in 1906, he spent eighteen months at the Sorbonne, then briefly attended the Académie Julian, the Atelier Colarossi and the Ecole des Beaux-Arts, before traveling and studying independently. Among the old masters, Michelangelo most affected him; among the new, Paul Cézanne. He employed the spheres, cubes, and cones of Cézanne's vocabulary to depict muscular nudes that paid homage to Michelangelo.

In 1911 Macdonald-Wright enrolled in Canadian painter Percyval Tudor-Hart's Paris school, where he met Morgan Russell. Tudor-Hart taught a musical system of color harmonies that equated pitch with luminosity, tone with hue, and intensity of sound with chromatic saturation.[4] These theories inspired the two American pupils, as did Cézanne's method of structuring form, and together Macdonald-Wright and Russell developed Synchromism.

The first Synchromist exhibition opened in Munich at the Neuer Kunstsalon in June 1913 and then traveled to the Bernheim-Jeune Galleries in Paris in October of that year. It included the first pure Synchromist painting, *Synchromy in Deep Blue-Violet* (1913, private collection) by Russell, while Macdonald-Wright's work consisted mainly of more representational paintings that did not yet fully convey the avant-garde ideals of Synchromist theory.

Nonetheless, the exhibition aroused considerable interest and controversy. After this success Macdonald-Wright went to New York to stage an exhibition at the Carroll Galleries in March 1914, while his colleague Russell remained in Paris. Critics received the New York show well, and the artist settled permanently in the United States, where, between 1916 and 1919, he produced his most influential work. He exhibited at the 1916 Forum Exhibition of Modern American Painters and in 1917 held his first solo show at Alfred Stieglitz's gallery 291 in New York.

Macdonald-Wright abandoned the limelight in 1919, when he returned to Los Angeles to serve as director of the Los Angeles Art Students League. Like many early American modernists, he turned his back on abstraction. Although he seldom exhibited, he wrote *A Treatise on Color* in 1924 and became a leading intellectual force on the West Coast; his peers referred to him as "the dean of Los Angeles painters."[5] He immersed himself in the study of Oriental aesthetics, practiced calligraphy, then spent several years in Japan. He also developed an interest in film; in 1919 he produced the first stop-motion color film ever made. Composed with some five thousand pastel drawings, each three by four feet, it depicted the eruption of a volcano on a tropical island.[6] He corresponded frequently with Russell about constructing a kinetic light machine, but for lack of funding the project did not materialize. After Russell's death in 1953, Macdonald-Wright completed the kinetic light machine the two had long discussed. Called the Synchrome Kineidoscope, it presented continuously evolving abstract compositions in vibrant colors.[7]

In the thirties Macdonald-Wright directed the federal Works Progress Administration for Southern California and painted murals for the Santa Monica Public Library. In addition he created mosaic programs for numerous California libraries, city halls, and public schools, and wrote and designed sets for the Santa Monica Theater Guild. From 1942 to 1952 he taught Oriental philosophy (with emphasis on the Taoist principles of painting) at the University of California, Los Angeles.

Macdonald-Wright also painted a new series of purely nonrepresentational Synchromist compositions in the 1950s.

In these works, forms float through space, held in equilibrium by a delicate balance of calligraphic shapes. The artist called these canvases *Yugen* ("interior realism" in Japanese), explaining that they had a deep spiritual significance.[8] Macdonald-Wright died in Los Angeles, having come full circle in his career, ending with a style similar to the Synchromism of his youth.

1 Whitney Museum of American Art, *Synchromism and American Color Abstraction*, p. 9.
2 Willard Huntington Wright, "Impressionism to Synchromism," *Forum* 50 (December 1913), pp. 757–70.
3 Whitney Museum of American Art, *Synchromism and American Color Abstraction*, p. 9.
4 Percyval Tudor-Hart, "A New View of Color," *Cambridge Magazine*, February 23, 1918, pp. 45–46.
5 Los Angeles County Museum of Art, *Stanton Macdonald-Wright*, p. 7.
6 Walker, "Interview: Stanton Macdonald-Wright," pp. 65–68.
7 David Scott, "Stanton Macdonald-Wright: A Retrospective," *American Art Review* 1 (January–February 1974), p. 50.
8 Los Angeles County Museum of Art, *Stanton Macdonald-Wright*, p. 9.

Bibliography Willard Huntington Wright, *Modern Painting: Its Tendencies and Meaning* (New York, 1915); Los Angeles County Museum of Art, *A Retrospective Showing of the Work of Stanton Macdonald-Wright* (1956), exh. cat., introduction by Richard F. Brown; National Collection of Fine Arts, Washington, D.C., *The Art of Stanton Macdonald-Wright* (1967), exh. cat., introduction by David W. Scott, essay, "A Treatise on Color," by Stanton Macdonald-Wright; John Walker, "Interview: Stanton Macdonald-Wright," *American Art Review* 1 (January–February 1974), pp. 59–68; Whitney Museum of American Art, New York, *Synchromism and American Color Abstraction, 1910–1925* (1978), exh. cat. by Gail Levin, pp. 20–27, 140, passim.

Sunrise Synchromy in Violet, 1918

Oil on canvas
35⅞ x 54⅛ in. (91.1 x 137.5 cm)
Signature, date, inscription: Sunrise Synchromy in Violet/S. Macdonald-Wright/New York/1918 (on reverse)

During the late 1910s Macdonald-Wright was a pivotal force in American modernism. He had gained the attention of American artists in 1916 through the Forum Exhibition, where he had shown his first nonrepresentational canvas along with other works that relied on the male nude to reveal the Synchromist ideology. Many young American painters looked to him as a model, especially Jan Matulka, Andrew Dasburg, Marsden Hartley, Arthur Dove, and Alfred Maurer. Perhaps the most unexpected proponent of his theories was Thomas Hart Benton, whose work of the time showed a keen interest in Synchromist rhythmic and sculptural values, and who became Macdonald-Wright's fast friend. In his later Regionalist style, Benton retained Synchromism's contrapuntal accents, active contours, contrasting colors, and figure-ground ambiguities; indeed, he later transmitted them to his student Jackson Pollock, who took them to their ultimate conclusion.[1] Thus, Macdonald-Wright had a direct and lasting impact on three generations of American painters.

Macdonald-Wright painted *Sunrise Synchromy in Violet* during this early period of influence. The artist concluded that he achieved the greatest success by basing his art on sculptural forms, interpreting those forms in two dimensions through the application of color theory. This is apparent in *Sunrise Synchromy in Violet*, as he explained:

The approach to its conception and method shows an early step away from the wholly non-objective path which we (the Synchromists) had followed since 1912. The reason for this change of belief and attitude stemmed from the realization that non-objectivity had at last become little more than surface decoration, that after its great era of enthusiasm it had become routine and facile, that, at bottom, the extreme movement away from objective painting had previsualized a new art which necessitated kinetic movement, and finally, that it was an articulation point between this new art and the older painting conceptions. For myself the answer to the problem of future direction was as obvious as the question itself. If one wanted to paint there were only two paths to pursue. One either must find and develop a greater fecundity of unified form and color than Cubism with its simple straight and circular lines, or one must be satisfied to repeat ad nauseum the decorators tricks of "interesting" or "artistic" vapidities. I preferred the former course. The subject matter of the "Sunrise" is a symbolic awakening of power.[2]

The painting's "symbolic awakening of power" specifically alludes to the biblical creation of the world, a theme central to Synchromism since its inception. Macdonald-Wright's associate, Morgan Russell, similarly developed an interest in the creation myth. When Russell dedicated *Synchromy in Blue-Violet* to his patron Gertrude Vanderbilt Whitney, he quoted Genesis: "Let there be light. And there was light. And God said that it was good and God divided the light from the darkness." He explained that Synchromism was light, and was thus related to the beginning of time.[3] That Michelangelo had grappled with the Creation may explain, in part, why the Synchromists admired him so.

For its pose and allegorical significance, Macdonald-Wright based *Sunrise Synchromy in Violet* on Michelangelo's Dawn from the Medici tombs in Florence, but changed the female to a male figure.[4] Michelangelo's Adam from the Sistine Chapel ceiling may also have served as a prototype in subject and heroic figural type. Macdonald-Wright borrowed Michelangelo's spiral as an organizing principle, but fragmented it to present the figure as an orchestration of parts. Despite cropping of the head and feet, the figure's continuous curve directs the viewer's eye and slowly reveals the identity of the subject.

Although the Cubists had originated this technique of fragmentation, Macdonald-Wright carried it further to suggest three-dimensionality through an ingenious use of color. In *Sunrise Synchromy in Violet*, he placed complementary colors adjacent to one another to create a series of deep convex and concave forms. But he also produced ambiguities by putting warm colors, which normally come forward in space, in recessive areas such as the hollows of the chest, and cool tones on the faces of prominent muscles. In addition, he merged white ground and figure to fuse surface with depth. A push-and-pull rhythm results, which expresses a dynamic musical quality and reinforces the theme of awakening.

JM

1 Stephen Polcari, "Jackson Pollock and Thomas Hart Benton," *Arts* 53 (March 1979), pp. 120–24.

2 Stanton Macdonald-Wright to Leon Arkus, January 3, 1961, museum files, The Carnegie Museum of Art, Pittsburgh.

3 Gail Levin, "The Tradition of the Heroic Figure in Synchromist Abstractions," *Arts* 51 (June 1977), p. 139.

4 Ibid., p. 142. Michelangelo used a male model for the figure of Dawn.

References G. B. Washburn, "New American Paintings Acquired," *Carnegie Magazine* 30 (June 1956), pp. 193, 196; "The Artist Speaks: S. MacDonald-Wright," with a note on Synchromism by B. Rose, *Art in America* 55 (May 1967), pp. 70–73; G. Levin, "The Tradition of the Heroic Figure in Synchromist Abstractions," *Arts* 51 (June 1977), pp. 138–42; G. Levin, "Synchromism: The State of Scholarship—Past, Present, and Future," *Arts* 53 (Sept. 1978), pp. 131–35; H. Adams, in Museum of Art, Carnegie Institute, *Collection Handbook* (Pittsburgh, 1985), pp. 238–39.

Exhibitions Rose Fried Gallery, New York, 1955, *Stanton Macdonald-Wright*, no. 4; Westmoreland County Museum of Art, Greensburg, Pa., 1960, *Founder's Day Exhibition*, no cat.; National Collection of Fine Arts, Washington, D.C., 1967, *The Art of Stanton Macdonald-Wright*, no. 18; Whitney Museum of American Art, New York, 1978, *Synchromism and American Color Abstraction, 1910–1925* (trav. exh.), exh. cat. by G. Levin, no. 116.

Provenance Dewald Collection, New York, before 1955; Rose Fried Gallery, New York, as agent, by 1955.

Living Arts Foundation Fund and Patrons Art Fund, 1956, 56.16

See Color Plate 22.

M. M. Manchester
active c. 1820–1843

LITTLE IS KNOWN about this self-taught painter other than that he was active during the early to mid-1800s in the upstate New York area. He is associated with two signed portraits, the one in the Carnegie collection and *Conversation Piece: A Yates Family Portrait* (1840, Memorial Art Gallery of the University of Rochester, N.Y.), and two unsigned portraits, *Double Portrait*[1] and *Mr. and Mrs. Russell and Son* (Seneca Falls Historical Society, N.Y.).

1 Location unknown; reproduced in an advertisement of the Old Print Shop, New York, *Antiques* 90 (October 1966), p. 398.

Bibliography George C. Groce and David H. Wallace, *The New-York Historical Society's Dictionary of Artists in America 1564–1860* (New Haven, 1957), p. 421; Katharine Kuh, "The River: Places and People," *Art in America* 52 ([April] 1964), pp. 31, 35; Patricia Junker, "A Yates Family Portrait by M. M. Manchester: Materials for a History," *Porticus* 9 (1986), pp. 21–25.

Mrs. Alfred Rose, 1843

Oil on canvas
32⅞ x 27⅛ in. (83.5 x 68.9 cm)
Signature: M. M. Manchester, 1843 (on stretcher)

Manchester supplied this picture as a companion to a portrait he had painted of Alfred Rose (1838, Museum of Fine Arts, Boston), a shop owner and farmer in Penn Yan, New York, not far from Geneva. Mrs. Rose is shown to be a

young, unsmiling woman, probably in her early twenties. She is seated in a wooden scroll-backed chair, and she props her left arm on the table beside her. Simply but fashionably dressed, she wears a dark gown with a delicately embroidered white collar and cuffs, a stiffly pointed bodice, and sleeves that fit closely at the shoulders but flare out just above the elbows. Over both sleeves is draped a narrow silk shawl that has apparently dropped off her shoulders and fallen down her back. In her lap she holds a white handkerchief. Her hairstyle is conservative—parted in the center and loosely pulled back into shoulder-length ringlets. A vase of flowers on the table and bunches of grapes that hang from vines wound around the pillar at each side of the background serve as attributes of her femininity.

Each detail of the scene has been carefully recorded without discrimination by the artist; flowers, grapes, fabrics, and facial features are all equally detailed. The lighting is diffuse and the color muted—mostly dull browns, greens, and burgundy reds. However, the source of the light is not consistent throughout the painting: for example, the grapes are lit from the left, while the chair is lit from the right.

A comparison of this piece with the other known signed work by Manchester, *Conversation Piece: A Yates Family Portrait* (1840, Memorial Art Gallery of the University of Rochester, N. Y.), demonstrates his technical improvement in a period of just a few years. Although both Mrs. Rose and Mrs. Yates are seated facing slightly to their left with their hands

in their laps, Mrs. Yates's upper torso is much less convincingly proportioned. Her left shoulder appears extremely broad, and her arms much too short in relation to her right shoulder and the way she is seated. Manchester, in Mrs. Rose's portrait, three years later, appears to have resolved those difficulties, for one perceives Mrs. Rose as actually seated facing slightly to her left. Whereas Mrs. Yates's face is timidly drawn and is shown gazing off into the distance, Mrs. Rose solemnly but penetratingly looks out at the viewer.
EM

Provenance Originated from Penn Yan, N.Y.; C. A. Carpenter, Jr., Elmira, N.Y., by 1963; Edgar W. and Bernice Chrysler Garbisch, Cambridge, Md., 1963.

Bequest of Edgar W. and Bernice Chrysler Garbisch, 1981, 81.21.13

Paul Manship
1885–1966

ONE OF THE MOST widely praised and financially successful American sculptors in the period between the two world wars, Paul Howard Manship can be considered a twentieth-century heir to the monumental and decorative sculptural tradition of the late nineteenth century. Born in Saint Paul, Minnesota, he received his first artistic training at the Saint Paul Institute School of Art. In 1903 he left school to work as a designer and illustrator; two years later, he moved to New York.

After enrolling at the Art Students League in New York, Manship became assistant to the bronze sculptor Solon Borglum. In 1906 he left for the Pennsylvania Academy of the Fine Arts, Philadelphia, where he studied under Charles Grafly. The following year he returned to New York and worked as an assistant to the sculptor Isidore Konti. At Konti's suggestion, he competed, successfully, for the Prix de Rome, which earned him a trip to Italy in 1909.

Abroad, Manship developed a style that combined the influences of Classical Italian and Archaic Greek sculpture, an approach that won him widespread acclaim upon his return to New York in 1912. The next year witnessed his first major commissions for architectural and

garden sculpture, as well as his first Helen Foster Barnett Prize, awarded by the National Academy of Design, New York. Numerous other honors followed, notably the George D. Widener Memorial Gold Medal from the Pennsylvania Academy of the Fine Arts (1914), a gold medal at the Panama-Pacific International Exposition in San Francisco (1915), a solo exhibition at Carnegie Institute (1915), a highly regarded solo exhibition at the Berlin Photographic Gallery (1916), and a gold medal from the American Institute of Architects (1921).

Manship's sculpture was known for its technical proficiency and beautiful workmanship. Although he was a vocal supporter of the notion that art and handcraft are inseparable, he freely utilized the complex technologies that had been developed for casting bronze or carving marble—techniques that were a far cry from the simplicity of handcraft. His style, a compatible blend of sleek modern surfaces with the graceful cadences and discreet proportions of earlier artistic traditions, appealed to both progressive and academic tastes. The high esteem in which Manship's work was held is attested to by his early election to the National Academy of Design (1916), a professorial appointment to the American Academy in Rome (1922), and, seven years later, nomination as Chevalier of the French Legion of Honor.

In 1927, after several years of dividing his time between Paris and Rome, Manship returned to New York, which he made his home for the rest of his life, building a large studio and devoting much of his energy to public sculpture. His best-known commission was the *Prometheus* (1933–34) for Rockefeller Plaza in Manhattan. Other major works were the bronze entrance gate to the New York Zoological Park, Bronx, N.Y. (1933–34), a memorial to Woodrow Wilson at the League of Nations, Geneva (1939), and a monumental sundial, *Time and the Fates*, for the New York World's Fair of 1939–40. In 1945 the National Institute of Arts and Letters held a major Manship retrospective and awarded him its gold medal in recognition of his revitalization of the American academic tradition in sculpture.

Homer Saint-Gaudens, Carnegie Institute's second director of the Department of Fine Arts, was Manship's close friend and particularly eager during the 1920s to increase the sculptor's visibility in Pittsburgh. In 1926, he mounted a traveling exhibition of Manship's sculpture and was responsible for two Manship commissions in Pittsburgh: a memorial relief to John Beatty (see p. 339) at Carnegie Institute and a bronze plaque of Woodrow Wilson (1927) in the City-County Building.

Bibliography Paul Vitry, *Paul Manship, sculpteur americain* (Paris, 1927); Edwin Murtha, *Paul Manship* (New York, 1957); National Collection of Fine Arts, Washington, D.C., *Paul Manship, 1885–1966* (1966), exh. cat. by Thomas Beggs; Minnesota Museum of Art, Saint Paul, *Paul Manship: Changing Taste in America* (1985), exh. cat. by Harry Rand et al.; National Museum of American Art, Washington, D.C., *Paul Manship* (1989), exh. cat. by Harry Rand.

Diana, 1923

Bronze on onyx base
37⅞ x 27¼ x 9 in. (96.2 x 69.2 x 22.9 cm)
Markings: *Paul • Manship/*©1923 (base top, rear corner, proper left); C. VALSVANI • Fondeur (base rear, proper right)

Actaeon, c. 1923

Bronze on onyx base
29⅝ x 31¼ x 7⅞ in. (75.2 x 79.4 x 20 cm)
Markings: *P. Manship/*© (base top, center); Fond. G. Vignali/Firenze (base top, front corner, proper right)

These bronzes represent the earliest and smallest of three versions of Manship's *Diana* and *Actaeon.* They were followed in 1924 by two seven-foot figures in gilded bronze, their eyes in blue and white

enamel. In 1925 the sculptor created a four-foot bronze version in which he made some minute compositional alterations. This last pair was the centerpiece of a major exhibition of his work at the Scott and Fowles Gallery, New York.

Homer Saint-Gaudens expressed an interest in purchasing *Diana* and *Actaeon* in late 1924. Although Manship very much wanted Pittsburgh to acquire the seven-foot version (now at Brookgreen Gardens, Murrells Inlet, S.C.), Saint-Gaudens, feeling that a three-foot height would best fit his galleries, purchased the smaller pair. Both the largest and smallest versions were included in the exhibition of Manship's sculpture that Carnegie Institute circulated in 1926 and 1927.[1]

Diana and *Actaeon* represent the most characteristic aspects of Manship's style: individual details suggestive of slightly Archaic Greek art blend with the self-assured forms of the Beaux-Arts tradition and the sinuous linear rhythms of his own making. The result is a lively and somewhat naïve yet carefully controlled decorative statement.

In the spirit of academic sculpture, Manship based his subject on Classical literature. The story of Diana and Actaeon from Ovid's *Metamorphoses* recounts how the hunter Actaeon spied the nude Diana bathing in the woods. The goddess punished Actaeon by transforming him into a stag. Horns sprouted from his head, his hands and feet turned to hooves, his body became covered with a spotted deerskin. In a state of partial metamorphosis, Actaeon sped through the forest, but his own hunting party and hounds set upon and killed him.

Manship's composition is a union of sweeping diagonals with a network of complex voids that acts to freeze each figure in space—Diana as she pulls her bow and speeds away from Actaeon, her hound running alongside her, and Actaeon as he falls forward while his own two hounds charge at him. The action implies that Diana has released her fatal arrow, which has traveled across the space separating them and pierced Actaeon at the point where he presses his hand to his side. Manship had used the same conceit earlier, in his 1914 sculptural pair *Indian* and *Pronghorn Antelope*. It is a brilliant device, creating a dramatic yet invisible connection between two otherwise self-sufficient sculptures.

Manship's borrowings from antiquity are varied. The two heads evoke the shallow facial modeling, stylized eyes, and patterned hair of fifth-century B.C. Greek sculpture of the Severe Style. For the gesture of Actaeon, the sculptor may have had in mind the Hellenistic *Borghese Warrior* (Louvre, Paris); for that of Diana, the fifth-century bronze *"Zeus" of Artemision* (National Museum, Athens). A different Classical reference can be found in the three hounds, each of which has the head and shoulders of one of the most distinctive animals in the visual lexicon of antiquity: the bronze Etruscan she-wolf (c. 500 B.C., Capitoline Museum, Rome).

DS

1 The sales sheet accompanying the show listed the small *Actaeon* as having been cast in an edition of twelve and the small *Diana* as sold out.

Diana

References J. B. Ellis, "Paul Manship in the Carnegie Institute," *Carnegie Magazine* 11 (Sept. 1937), pp. 110–13; Murtha, *Paul Manship*, no. 138, p. 161; W. Craven, *Sculpture in America* (New York, 1968), p. 567; Whitney Museum of American Art, New York, *Two Hundred Years of American Sculpture* (1976), exh. cat. by T. Armstrong et al., p. 291; W. L. Vance, *America's Rome* (New Haven, 1989), vol. 1, pp. 310–11.

Exhibition Department of Fine Arts, Carnegie Institute, Pittsburgh, 1926, *An Exhibition of Sculpture by Paul Manship*, no. 15.

Provenance The artist, until 1925.

Purchase, 1925, 25.3.2

Actaeon

Remarks The sculpture was repatinated during repairs in 1941.

References J. B. Ellis, "Paul Manship in the Carnegie Institute," *Carnegie Magazine* 11 (Sept. 1937), pp. 110–13; Murtha, *Paul Manship*, no. 155, p. 162; W. Craven, *Sculpture in America* (New York, 1968), p. 567; Whitney Museum of American Art, New York, *Two Hundred Years of American Sculpture* (1976), exh. cat. by T. Armstrong et al., p. 291; W. L. Vance, *America's Rome* (New Haven, 1989), vol. I, pp. 310–11.

Exhibition Department of Fine Arts, Carnegie Institute, Pittsburgh, 1926, *An Exhibition of Sculpture by Paul Manship*, no. 14.

Provenance The artist, until 1925.

Purchase, 1925, 25.3.1

Europa and the Bull, 1924

Bronze on onyx base
10½ x 12⅞ x 7⅞ in. (26.7 x 32.7 x 20 cm)
Markings: • P. MANSHIP •/© 1924 • (below bull's proper right flank)

This small bronze group depicts the Phoenician princess of Greek legend caressing the white bull—the god Zeus—who had fallen in love with her and eventually took her to Crete. The pair is presented in a solid, pyramidal composition that suggests Classical sculpture. Manship's references to antique forms frequently came from unexpected sources; in this case, he seems to combine a Minoan bull's head with a girl who assumes the straddling posture of the well-known Greek sculpture *Dying Niobid* (c. 450–40 B.C., Museo Nazionale delle Terme, Rome).

Manship repeatedly emphasized the linear qualities of the ancient art he quoted.

Here, the two figures are posed so that nearly all the visual information is arranged on the front plane of the sculpture. The piece, while functioning as a three-dimensional form, is therefore also an arrangement of crisp contours and silhouettes that exist satisfactorily in two dimensions.

This version of *Europa and the Bull* (the Carnegie's example bears traces of metallic gold in the patina) was issued in an edition of twenty. It was followed by two larger versions: a twenty-three-inch piece in white marble in which the bull has gold horns (1926) and a two-foot bronze (1936). In 1925 Manship created a variation of this same theme, *Flight of Europa*, in which a miniaturized princess sits cross-legged atop a gliding bull that is a three-dimensional approximation of the Minoan *Toreador Fresco* (c. 1500 B.C.) from the Palace at Knossos, Crete.

DS

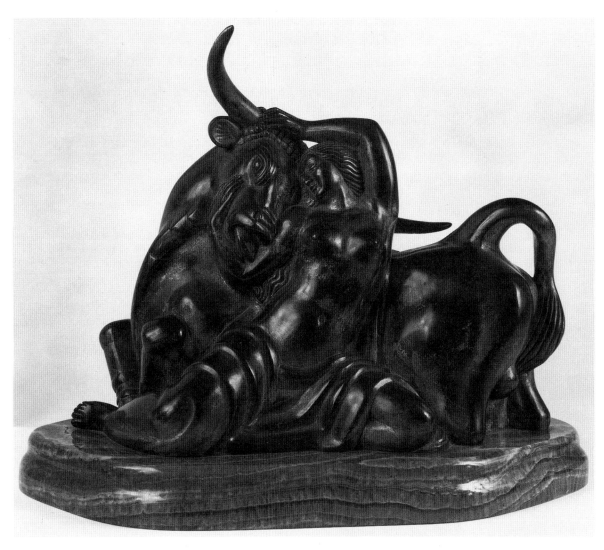

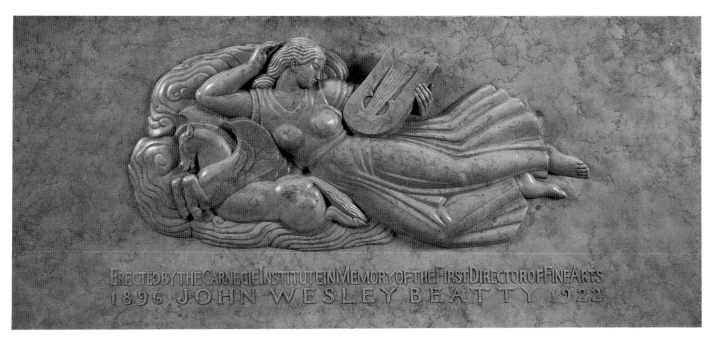

Reference Murtha, *Paul Manship*, no. 169, p. 163.

Provenance Ailsa Mellon Bruce, New York, until 1969; her estate, until 1970.

Ailsa Mellon Bruce Collection, 1970, 70.32.2604

John Beatty Memorial, 1925–27

Rose burgundy marble
28¼ x 61½ x 4¾ in. (71.8 x 156.2 x 12.1 cm)

Markings: ERECTED BY THE CARNEGIE INSTITUTE IN MEMORY OF THE FIRST DIRECTOR OF FINE ARTS/1896 JOHN WESLEY BEATTY 1922 (across bottom)

From the beginning of Homer Saint-Gaudens's tenure as director of the Department of Fine Arts at Carnegie Institute in 1923, he wished to acquire works by Manship for Pittsburgh. When his predecessor, John Beatty, died in 1924, he considered erecting a memorial to him and including Manship in the project. In December 1924, two and one half months after Beatty's death, Saint-Gaudens wrote Manship of a rather elaborate plan to produce a commission, which involved the hosting of an exhibition of his work and the purchase of *Diana* and *Actaeon* (see pp. 336, 337):

> It would be better, before I try and see if I can get a commission or so out of here, to have your work before the eyes of our pluto-crats. I am beginning to know this public around here, and one thing I am sure of is that they need the actual bronzes to make a hit. If I can get the Actaeon and Diana purchased and set up, and. . . a good bust or two that you would want to lend me to stick up in my office. . . there is a chance perhaps to get a commission for you. . . . Photographs won't take on the millionaires. Believe me, I know.[1]

However, Saint-Gaudens had his commission even before the delivery of *Diana* and *Actaeon*. In January he wrote to Manship:

> My committee wants to put up in the Department of Fine Arts a bronze or marble memorial tablet to John W. Beatty. We do not want a portrait relief. Our idea is to have the tablet consist solely of lettering with some sort of an architectural design. Just off hand I should think the tablet might be about 2 or 4' high by whatever width looks well.[2]

Within three weeks a fee of four thousand dollars was offered (Manship's usual charge for an original marble), and the sculptor was asked to develop a plan suitable to the architectural surroundings.

With little involvement from Pittsburgh (including the Beatty family, whom Saint-Gaudens excluded from participation in the project), Manship began sketching in New York in March 1925.

His design called for centering the plaque on the first landing of the grand staircase of the art museum building. His image—a muse holding a lyre and floating in clouds with a Pegasus beside her—suggests art and immortality and visually echoes the configuration of cloud-borne figures in John White Alexander's murals directly above the relief (see pp. 48–52).

In late May 1925, Manship brought to Pittsburgh a small model of the relief, which was approved without revisions.[3] He also photographed his sketch to scale, to try out the design in its proposed setting. In early July a final price of forty-five hundred dollars was negotiated. Manship then sailed to Paris to procure the stone—a pink marble to harmonize with the stonework of the grand stairway—and have it carved. The pointing of the marble got under way in late September.[4] But the carving did not begin until December,[5] at which point Manship had returned to New York.

There was no further progress on the relief for nearly a year. Manship arrived in Pittsburgh in February 1926 for the opening of his exhibition and a round of entertaining whose purpose was another commission:

> Mrs. Jack Dilworth is now going to pour cocktails down your throat with the light and leading of Pittsburgh. . . on the afternoon of Thursday, February 11. . . . Get on a

night train leaving the 10th and don't make any mistake. I am rushing around trying to nail down a commission or 2 for you, and that is the way you float that kind of ship in this kind of a city.[6]

Manship returned to Paris in the fall of 1926, and on November 1 he wrote to Saint-Gaudens:

> I settled down in Paris and did about eight years' work, a good part of which I have brought back with me . . . the rest of which will follow in due time. Amongst the "rest of which" is the Beatty memorial tablet. I had hoped to bring it back with me . . . but it is not finished and when I left Paris, lacked the inscription. . . . When it does arrive . . . I hope you will let me know so that I may dash out and give it the final once-over, as they say.[7]

The relief was shipped from Paris on February 10, 1927, and arrived in Pittsburgh in mid-April.[8] The six-inch-thick tablet with figures in high relief, installed so that two inches of uncarved surface projected from the wall, was unveiled on June 2, 1927. John J. O'Connor, Jr., then the Department of Fine Arts's business manager, asked Manship to give an explanation of the different figures for Carnegie Institute's press release. Manship penned the brisk reply:

> You and Edward Balken [the museum's assistant director] can express better whatever the mysterious idea I had in mind when I put the female figure with a lyre and a pegasus on the Beatty tablet, than I can. Dope up some charming poetical expression of your own. I approve heartily of whatever you say. Call her the "Muse of Inspiration" or what not? Pegasus I believe had some such function in his somewhat prehistoric career.[9]

The plaque was duly reported in the press as representing the muse of inspiration.

Manship reused the motif of a cloud-borne figure in the Beatty plaque for other memorials, specifically, *Soldier's Monument* (1926, Thiaucourt, France) and *Immortality, Anzio* (1952, American Military Cemetery, Anzio, Italy), and for the figure at the base of his *Celestial Sphere* (1934, Logan Square, Philadelphia).
DS

1 Homer Saint-Gaudens to Paul Manship, December 18, 1924, Carnegie Institute Papers, Archives of American Art, Washington, D.C.

2 Saint-Gaudens to Manship, January 20, 1925, ibid.

3 Edward Duff Balken to Manship, May 29, 1925, ibid.

4 Manship to Saint-Gaudens, September 25, 1925, ibid.

5 Manship to Saint-Gaudens, December 22, 1925, ibid.

6 Saint-Gaudens to Manship, February 4, 1926, ibid.

7 Manship to Saint-Gaudens, November 1, 1926, ibid.

8 Saint-Gaudens to Manship, April 18, 1927, ibid.

9 Manship to John J. O'Connor, Jr., June 2, 1927, ibid.

References J. B. Ellis, "Paul Manship in the Carnegie Institute," *Carnegie Magazine* 11 (Sept. 1937), pp. 110–13; Murtha, *Paul Manship*, p. 164.

Provenance Commissioned from the artist, 1925

Purchase, 1927, 25.4

Reginald Marsh
1898–1954

REGINALD MARSH, one of the dominant figures in American realist painting of the 1930s, was born in Paris and raised in New Jersey by parents who were both artists: his father, Fred Dana Marsh, was a painter and muralist, his mother a miniaturist. As a student at Yale College (1916–20), he took courses in drawing, developed an interest in magazine illustration, and, in his junior year, attended the Art Students League in New York for classes in life drawing and illustration. He was an illustrator for the *Yale Record* and became art editor of the *Yale Graphic*.

Upon graduating from college, Marsh worked in New York as a free-lance illustrator until he was hired by the New York *Daily News* in 1922. The same year, he resumed studying at the Art Students League, enrolling in classes taught by George Bridgeman, George Luks, and Kenneth Hayes Miller. By 1923 Marsh was painting in oil and watercolor and had joined the Whitney Studio Club in New York, where, in 1924, he had his first solo exhibition. In 1925 he traveled to

Paris; on his return, he resumed study with Miller and took up a post as staff artist at the *New Yorker*, where he worked until 1931.

Marsh's career as a newspaper and magazine illustrator resulted in thousands of drawings, not only for the *New Yorker* and the *Daily News* but also for *Esquire*, *Harper's Bazaar*, *Vanity Fair*, and the *New York Herald*. His portrayals of Coney Island, vaudeville shows, subway rides, and other diversions of city life determined much of the attitude and scope of his subsequent work. Success as a painter came in the early 1930s. When the newly opened Whitney Museum of American Art, New York, showcased contemporary American Scene painting in 1930, Marsh's work was included.

The paintings and prints for which Marsh is best remembered reveal his interest in New York's low life. He presented its vagrants and burlesque queens, its bustling streets and beaches in compositions often filled with lurid color or crowded with figures. In Marsh's pictures the common man is a robust characterization who is often endowed with monumental energy.

In both the method and message of his paintings, Marsh was a self-described opponent of all modernism. He spoke of Eugène Delacroix, Peter Paul Rubens, and Michelangelo as his mentors, wished for a return to the simplicity and power of Renaissance and Baroque art, and sought out early painting techniques. His own goal was to convey the heroism of the masses by representing them in the style of the old masters.

As for the social content of Marsh's work, his emphasis on the heroic rhetoric of the past gave it an aspect more of popular fable than of observed life. He did not present a specific political agenda through his work and seldom dwelt on the injustices of the American social order. For this reason, Marsh has been labeled an Urban Regionalist and a Romantic Realist, to distinguish him from his Social Realist colleagues.

Marsh earned a considerable reputation from teaching and writing. From 1935 he taught at the Art Students League and in 1949 became head of the department of painting at the Moore Institute of Art and Industry in Philadelphia. His own

work was prolific. Aside from paintings in tempera and oil, he produced an enormous quantity of pen, pencil, and watercolor drawings, as well as etchings, lithographs, and photographs. He executed two mural projects for the United States Treasury Department: one at the Post Office building in Washington, D.C., in 1935; the other at the New York Customs House in 1937. Among his numerous honors and awards were the Thomas B. Clarke Prize from the National Academy of Design in 1937, the Dana Watercolor Medal from the Pennsylvania Academy of the Fine Arts, Philadelphia, in 1941, and the Corcoran Gold Medal from the Corcoran Gallery of Art, Washington, D.C., in 1945.

Marsh maintained regular contact with the city of Pittsburgh. He exhibited fifteen times between 1931 and 1950 in the annual exhibitions held at Carnegie Institute and was given a solo exhibition of paintings in tempera and watercolor there in 1946. He often served on the juries of the Associated Artists of Pittsburgh's exhibitions and he chaired the jury of Carnegie Institute's edition of the Artists for Victory *Portrait of America* exhibition held at Carnegie Institute in 1945. Marsh died in Dorset, Vermont.

Bibliography Reginald Marsh, "Let's Get Back to Painting," *Magazine of Art* 37 (December 1944), pp. 292–96; Whitney Museum of American Art, New York, *Reginald Marsh* (1955), exh. cat. by Lloyd Goodrich; Lloyd Goodrich, *Reginald Marsh* (New York, 1972); Edward Laning, *The Sketchbooks of Reginald Marsh* (Greenwich, Conn., 1973); Whitney Museum of American Art, New York, *Reginald Marsh's New York* (1983), exh. cat. by Marilyn Cohen.

In the Studio (Marty Cornelius), 1945

Oil on Masonite
20 x 16 in. (50.8 x 40.7 cm)
Signature, date: REGINALD MARSH '45 (lower right)

The subject of this portrait, Martha Cornelius Fitzpatrick (1913–1979), was a Pittsburgh painter, illustrator, art educator, and art therapist who for fifteen years was a protégé and close friend of Reginald Marsh. Marty Cornelius received a bachelor's degree in art education from

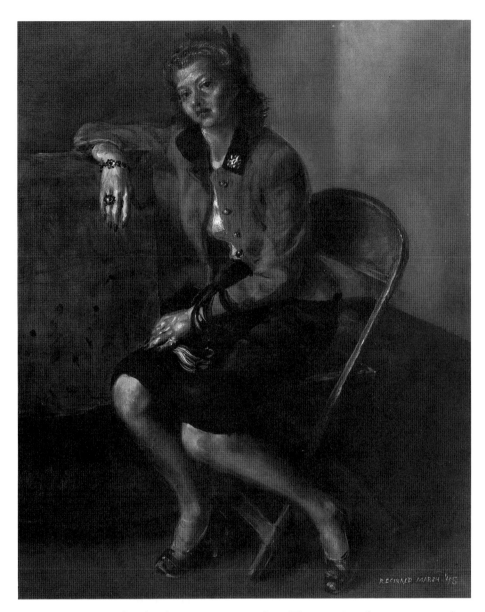

Carnegie Institute of Technology in 1935. She exhibited regularly with the Associated Artists of Pittsburgh and during the 1940s showed in a number of important exhibitions around the country, including the Corcoran Annual, Corcoran Gallery of Art, Washington, D.C.; the Whitney Annual at the Whitney Museum of Art, New York; the New York edition of the Pepsi-Cola *Portrait of America* competition conducted by Artists for Victory and held at the Metropolitan Museum of Art; and four *Painting in the United States* exhibitions held at Carnegie Institute. In 1960 she was elected to the International Institute of Arts, Letters, and Sciences.

Cornelius first met Marsh in 1939, when he served on the jury of an Associated Artists of Pittsburgh exhibition in which she was awarded second

place. They continued to see one another when Marsh came to Pittsburgh and began a regular correspondence, in which Marsh felt free to share with her his private thoughts and the details of his personal life, sometimes exchanging as many as four letters a week.

Marsh's admiration for Cornelius was considerable. "You have one of the most extraordinarily articulate minds," he told her.[1] Although Cornelius betrayed a certain rivalry with Marsh's wife, Felicia, the relationship between Marsh and Cornelius might be described, at most, as a mutual infatuation. The latter, who considered herself Marsh's pupil and champion, was flattered by a witty and famous personality's interest in her, while

Marsh obviously appreciated the attention of a younger admirer and confidante.

Marsh began painting this portrait when Cornelius came to New York in October 1944 for the opening of the *Portrait of America* exhibition sponsored by Pepsi-Cola, in which she and Marsh were both represented.[2] Anticipating her visit, Marsh wrote: "I will execute a masterpiece of you I know—you are coming at exactly the right time to coincide with the peak of my genius—hooray hooray hooray—you are wonderful to pose for me."[3]

The portrait shows Cornelius casually perched on a folding chair in an empty studio, her right arm leaning on a plank of some sort. Head tilted to one side, she gazes in a knowing and slightly jaded way at the viewer. The panel's coloring is predominantly red (perhaps the artist's reference to early Italian painters), and it has been given a shiny varnish.

Marsh rarely made single-figure portraits, and this one resists categorization as such. It is not a traditional flattering likeness of the sitter at ease among her possessions. Both the surroundings and pose are the artist's, and in this sense the painting resembles a study of a studio model, contrived for the benefit of the painter, not the sitter. Marsh injected it with some of the directness and energetic vulgarity of the street women who so fascinated him, showing a certain consistency when he insisted, "Well-bred people are no fun to paint."[4] Indeed, with her jacket opened and rumpled and her skirt pulled up, Cornelius seems to have exchanged the role of a bourgeois intellectual for something more proletarian and physical.

Marsh's comments concerning this portrait suggest some of the built-in contradictions that mark his pictorial approach. Presumably while working on the painting he wrote to Cornelius, "You look just like a Rubens, my favorite painter."[5] Yet three years later, when Cornelius asked him for a photograph of the painting so it could be used by a Pittsburgh magazine in an article about her, he refused to provide one, saying, "Since you are dressed and posed in the guise of a pin-up girl hadn't we rather not shock the churchgoing citizens of Shadyside?"[6]

Marsh made a second portrait of Cornelius in 1948, which, according to her, the artist kept for himself, and at one point hung at the Art Students League.[7] Several small portrait sketches of her by Marsh also exist (collection Mrs. Barbara Moran, Danville, Va.). With this painting Cornelius donated to the Carnegie forty-four of Reginald Marsh's letters, dating to about 1941–51, many of which provide the student of Marsh with valuable information regarding the artist's personal life and career.

DS

Suzanne Tise conducted the research for this article.

1 Reginald Marsh to Marty Cornelius, April 9, 1945, museum files, The Carnegie Museum of Art, Pittsburgh.

2 Marty Cornelius to Barbara Moran, September 28, 1974, museum files, The Carnegie Museum of Art, Pittsburgh.

3 Reginald Marsh to Marty Cornelius, n.d., museum files, The Carnegie Museum of Art, Pittsburgh.

4 Oliver Larkin, *Art and Life in America* (New York, 1948), p. 418.

5 Reginald Marsh to Marty Cornelius, March 8, 1945, museum files, The Carnegie Museum of Art, Pittsburgh.

6 Ibid., December 11, 1948.

7 Marty Cornelius to Barbara Moran, September 28, 1974, museum files, The Carnegie Museum of Art, Pittsburgh.

Reference "The Arts: Portrait of an Artist," Pittsburgh *Bulletin Index*, Dec. 25, 1948, pp. 10–11.

Provenance Marty Cornelius, Pittsburgh, 1945.

Gift of Martha Cornelius Fitzpatrick (Marty Cornelius), 1968, 68.17

Homer D. Martin
1836–1897

THE LANDSCAPE PAINTER Homer Dodge Martin is most often associated with the American practitioners of French Barbizon painting, although his work does not completely fit that category. The son of a carpenter from Albany, New York, Martin took up art with the encouragement of that city's most famous sculptor, Erastus Palmer. At the age of sixteen, having studied for a couple of weeks under Albany landscapist James McDougal Hart, Martin opened his own studio and began painting, like Hart, local landscapes in the Hudson River school style. In the winter of 1862–63 he moved to New York City, where he became friendly with Winslow Homer and especially with John La Farge. He was elected an academician of the National Academy of Design, New York, in 1874.

In 1876, during a trip to England and France, Martin met James McNeill Whistler and must have become familiar with the recent innovations of Whistler's landscape style. He returned to England in 1881 to execute a series of landscape drawings for *Century Magazine*, and the following year he moved with his wife to Normandy, France. At this time his technique became freer and more painterly, reflecting a considerable awareness of the Barbizon school as well as of Whistler, Eugène Boudin, and possibly the Impressionists. He returned to New York in 1886.

After 1890 Martin's brushwork became bolder, his colors stronger, and his sense of abstract form more forceful. Although suffering from poor health and partial blindness, he produced some of his best work at this time, including the well-known *Harp of the Winds: A View of the Seine* (1895, Metropolitan Museum of Art, New York), which, like many of his late landscapes, was painted from memory. He spent the last four years of his life in Saint Paul, Minnesota, where he moved for the sake of his health. Despite the critical acclaim he received during his lifetime, Martin was forced, from lack of sales, to depend on the generosity of such friends as La Farge and the collector Thomas B. Clarke. Shortly after his death, however, his work commanded high prices and numerous forgeries were sold bearing his name.

Bibliography Elizabeth G. D. Martin, *Homer Martin: A Reminiscence* (New York, 1904); Samuel Isham, *History of American Painting* (New York, 1905), pp. 262–63; Frank Jewett Mather, Jr., *Homer Martin: Poet in Landscape* (New York, 1912); Dana H. Carroll, *Fifty-eight Paintings by Homer Dodge Martin* (New York, 1913); Patricia C. F. Mandel, "Homer D. Martin: American Landscape Painter," Ph.D. diss., New York University, 1973.

Crescent Moon, c. 1896

Oil on canvas
26 x 48¼ in. (66 x 122.6 cm)
Signature: H. D. Martin (lower right)

Martin's technique in *Crescent Moon* indi-
cates that this is a late work, executed
sometime after the artist moved to Saint
Paul in 1893. The composition is strong
and simple. The brushwork is broad and
vigorous, with a great deal of scumbling,
and it suggests—rather than describes—
details of clouds, rocks, and vegetation.
Much of the painting's appeal lies in such
purely abstract qualities as color and rich
handling of paint. Though Martin's late
style may have been partially the product
of failing eyesight, it is also a logical cul-
mination of the direction his art had been
taking since the 1860s, when he began to
soften and generalize his early Hudson
River style. At the same time, in his taste
for vast, serene vistas and for atmospheric
effects, he retained much of the sensibili-
ty of the Hudson River school, particular-
ly of John Frederick Kensett, whose
works he had studied and imitated in his
youth.

Crescent Moon recalls another late work,
On the Mississippi (1896, Mead Art
Museum, Amherst, Mass.), which repre-
sents the Mississippi River near Saint
Paul. *On the Mississippi* has a similar,
though greatly simplified, arrangement of
bluffs and lowland, and a similar expanse
of sky in which, instead of a crescent
moon, there floats the full orb of the set-
ting sun. The resemblance between the
two works suggests that they depict the
same locale, but this is by no means cer-
tain. Preferring to work from memory in
his studio, like his contemporaries George
Inness and Alexander Wyant, Martin,
while living in Saint Paul, painted scenes
of Normandy, France, Newport, Rhode
Island, and the Adirondack Mountains.
Crescent Moon may well be the remem-
bered image of a distant seacoast.
KN

Exhibition Museum of Art, Carnegie Insti-
tute, Pittsburgh, 1974, *Art in Residence: Art
Privately Owned in the Pittsburgh Area,* no cat.

Provenance Bernard Danenberg Galleries,
New York, by 1972; Mr. and Mrs. Leon
Anthony Arkus, Pittsburgh, 1972.

Gift of Mr. and Mrs. Leon Anthony Arkus, in
honor of the Sarah Scaife Gallery, 1973, 73.15

Sanford Mason

c. 1798–after 1864

K NOWN PRIMARILY AS an itinerant
portraitist, Sanford Mason was
born in Providence, Rhode Island, where
he began his career as a sign painter. By
the mid-1820s he had turned to portrait
painting and was apparently successful
enough to move to Boston and set up his
own studio in 1826. His arrival coincided
with the last years of Gilbert Stuart's artis-
tic reign and with the beginning of
Chester Harding's long career there.
Mason was influenced by Stuart's painter-
ly style and penetrating facial studies and
is known to have copied at least one of
his paintings—*Washington at Dorchester
Heights* (1807, Museum of Fine Arts,
Boston; Mason's painting, 1828, is in the
collection of Old Sturbridge Village,
Sturbridge, Mass.).

Mason exhibited portraits at the Boston
Athenaeum in 1827 and 1828, then
returned briefly to Providence. He spent
the rest of his life traveling from city to
city, never settling in one place for more
than a couple of years. He moved
between Lowell, Massachusetts, and
Boston during the 1830s, was in

Philadelphia during the early to mid-
1840s, then again in Providence from the
late 1840s to 1850. He was in Boston from
1850 to 1854, in Philadelphia in 1859, and
in Boston from 1860 to 1861. Mason was
last recorded in Philadelphia in 1862 and
is believed to have died there a few years
later.

Bibliography *M. and M. Karolik Collection of
American Paintings, 1815 to 1865* (Cambridge,
Mass., 1949), p. 418; George C. Groce and
David H. Wallace, *The New-York Historical
Society's Dictionary of Artists in America,
1564–1860* (New Haven, 1957), p. 428; John
Obed Curtis, "Portraits at Old Sturbridge Vil-
lage," *Antiques* 116 (October 1979), pp. 883–84.

Joseph B. Felt, 1827

Oil on canvas
35³⁄₁₆ x 25¹³⁄₁₆ in. (91 x 66.5 cm)

Inscription: This is the portrait of Joseph B.
Felt/now of Hamilton, Mass. 1831—/It was
painted by Sanford Mason of Boston March
1827.—/I was born at Salem, Dec^r 22^d 1789.—
/My parents were Jn° & Eliz^th Felt./Jos. B. Felt.
(on reverse)

Abigail Adams Felt, 1827

Oil on canvas
35³⁄₁₆ x 25¹³⁄₁₆ in. (91 x 66.5 cm)

Inscription: This is the Portrait of Abigail/Adams
Felt. It was drawn by Sanford Mason of
Boston/March 1827.— She was daugh-/ter of
Rev. Jn° Shaw & Elizabeth/[Quincy, crossed out]
Shaw afterwards Peabody./She was born at
Haverhill/March 2^d 1790.—/Joseph B. Felt (on
reverse)

Painted while Mason was in Boston, this pair of portraits shows a middle-aged minister and his wife seated as though on opposite ends of a plush red sofa. The man faces slightly to his left, with his left arm propped on one of the sofa arms, while his wife is turned slightly to her right, with that elbow propped on the sofa's other arm. Inscriptions on the backs of these paintings identify the sitters as Joseph B. Felt of Hamilton, Massachusetts, born in Salem in 1789, and his wife, Abigail Adams Felt, born in Haverhill, Massachusetts, in 1790. Joseph Felt is seated before a bookcase, and his wife before a window through which a church steeple is visible.

Both the Felts are clad in black, brightened by filmy white linen and lace at necklines and wrists, as well as on Mrs. Felt's cap. The details of their dress are sketchily painted—a characteristic that Mason probably observed in the work of Gilbert Stuart. The Felts' rosy complexions may also be attributable to Stuart's influence, while the heavier pictorial structure and its deep, saturated colors are suggestive of Chester Harding's work.

However, Mason's portraits are only superficially similar to high-style Boston portraiture, for they lack the depth of character usually readable in those likenesses. Although Joseph Felt's barely discernible smile and fawnlike eyes, and Abigail Felt's arched eyebrows, long nose,

and pursed lips reflect Mason's efforts to record their specific personalities, his reliance on an often-used arrangement of sitter and props indicates that he was unwilling, in his portrait style, to break much with tradition.
EM

Joseph B. Felt

Provenance Found in Massachusetts; Mrs. Lawrence J. Ullman, by 1953; Edgar W. and Bernice Chrysler Garbisch, Cambridge, Md., 1953.

Bequest of Edgar W. and Bernice Chrysler Garbisch, 1981, 81.21.11

Abigal Adams Felt

Provenance Found in Massachusetts; Mrs. Lawrence J. Ullman, by 1953; Edgar W. and Bernice Chrysler Garbisch, Cambridge, Md., 1953.

Bequest of Edgar W. and Bernice Chrysler Garbisch, 1981, 81.21.8

Tompkins H. Matteson
1813–1884

TOMPKINS HARRISON MATTESON belonged to the generation of artists who had come of age during the 1830s in New York and participated in the flowering of genre painting there. Born at

Peterboro in central New York State, Matteson spent his early years in the nearby towns of Morrisville and Hamilton. In the 1830s, having had little, if any, formal training, he worked as an itinerant portrait painter, and for a time had a studio at Cazenovia, New York. He studied briefly at the National Academy of Design in New York, during the late 1830s, then moved to New York City in 1841. There he made a name for himself as a painter of genre and patriotic historical subjects and as a teacher and designer of book illustrations. His most popular work, *Spirit of '76* (1845, location unknown), was purchased by the American Art-Union, New York, in 1845. According to the mid-nineteenth-century art critic Henry Tuckerman, "a shout of praise hailed its drawing, and henceforth Matteson prospered."[1]

In 1850 Matteson returned to central New York and settled at Sherburne, where he remained for the rest of his life. Elihu Vedder studied under him during the early 1850s, and later wrote a touching description of the artist:

> Matteson was remarkable for being a self-made man who had made a good job of it. Somewhat stately and precise in manner, but kindly and with a fine sense of humour, he had turned out a gentleman in spite of very adverse circumstances. . . . He had made something out of his illustrations for "Brother Jonathan", and was now painting portraits, and must have been, with his large family, in very straightened circumstances; yet he never complained nor allowed it to be seen. . . . He was a man of talent ruined by circumstances and his surroundings. Had he gone to Paris and stayed there, he would most undoubtedly have made his mark; and it was very sad to hear him say years after at the old Athenaeum Club, in his somewhat stately manner: "My dear V., it gives me great pleasure, mingled, I confess, with some pain, to welcome the scholar who has so far surpassed the master."[2]

Tuckerman, in a similar vein, regretted Matteson's lack of training, remarking that "with more complete early advantages he would have been a finished, as he is already an expressive, genre artist."[3] Matteson's style, to be sure, was always somewhat unsophisticated, perhaps

because he placed the requirements of narrative above formal concerns. His work never showed, for example, the refinements in composition and handling of his contemporary William Sidney Mount.

Yet Vedder's assessment of his one-time teacher's career is unduly bleak. Matteson enjoyed a good, though modest, artistic reputation until his death and was a highly respected and influential member of his community. He held several elective offices, including state assemblyman, and effected a number of improvements in the local schools and fire department. An obituary writer for the *Sherburne News* remembered him as a man whose "gentlemanly and cordial deportment, added to unusual talent, led our people at once to select him for a leader in all social and benevolent enterprises, and all, especially our older citizens, recollect how cheerfully and promptly he responded, and gave

his time and energy for the general good."[4]

1 Tuckerman, *Book of the Artists*, p. 433.

2 Elihu Vedder, *The Digressions of V.* (Boston, 1910), pp. 92–93.

3 Tuckerman, *Book of the Artists*, p. 432.

4 Obituary, *Sherburne* (N.Y.) *News*, February 9, 1884, reprinted in Sherburne Art Society, *Tompkins H. Matteson*, p. 10.

Bibliography Henry T. Tuckerman, *Book of the Artists: American Artist Life* (New York, 1867), pp. 432–34; Clara Erskine Clement and Laurence Hutton, *Artists of the Nineteenth Century and Their Works* (1879; rev. ed., Boston, 1907), vol. 2, p. 99.; Sherburne Art Society, N.Y., *Tompkins H. Matteson, 1813–1884* (1949); George C. Groce and David H. Wallace, *The New-York Historical Society's Dictionary of Artists in America, 1564–1860* (New Haven, 1957), p. 431.

Sugaring Off, 1845

Oil on canvas
31 x 42 in. (78.7 x 106.7 cm)
Signature, date: T. H. Matteson/1845 (lower right)

In 1845 Matteson made his debut at the American Art-Union, New York, with two paintings: *Spirit of '76* and *Sugaring Off.* The latter, depicting a stage in the production of maple sugar, is one of the artist's "familiar subjects, unpretending and genial in treatment," that, according to critic Henry Tuckerman, appealed to "the average taste of the people."[1] Although *Sugaring Off* did not excite the same high praise as *Spirit of '76* (1845, location unknown), it was apparently well received: the National Academy of Design, New York, borrowed it for its annual exhibition, and two years later it was reproduced as an engraving by Stephen Alonzo Schoff in the *Columbian Magazine.*[2] John

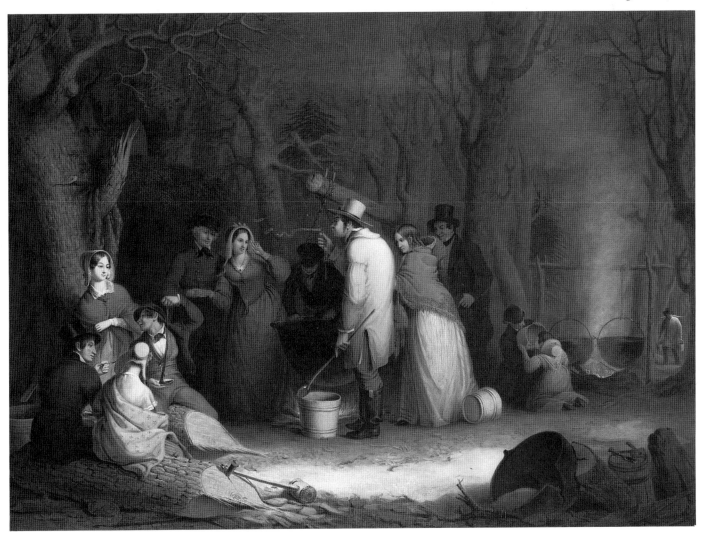

Inman, the magazine's editor and brother of the portraitist Henry Inman, wrote an article to accompany the engraving in which he described the sugaring-off process:

> We know that the sap runs a number of days, or perhaps weeks, and that when a goodly quantity is collected, it is set to boiling in great vessels provided for the purpose. . . . The grand wind-up of all, the real frolic of the business, is when the boiling is nearly completed and the sap begins to chrystalize [sic]. This, in maple country parlance, is called "sugaring off", and the picture gives a good general idea of what is apt to happen at this stage of the proceedings. The girls and boys of the neighborhood are always ready to assist at the sugaring off—the word "assist" being used here in its French signification, as synonimous [sic] with being present and enjoying; for, as Mr. Matteson has enabled us to perceive, any thing like assistance in the way of work forms no part of the arrangements. Judicious criticism touching the progress and prospects of the boiling may, indeed, be contributed by the side of the kettles, after a conscientious tasting; but take it by and large, in nautical phrase, there is much more laughing than labor on the part of the visitors. Not a little love-making also. They do say, indeed, that "sugaring off" time proves the crisis of as many sparkings as are brought to a head in New York, for instance, by the exhibition of the National Academy. And this result is perfectly natural; when sweet young things are about, like maple sugar, the young fellows are mighty apt to be thinking of the sweet lips in the neighborhood; and the girls, pretty creatures, know how to make good use of such opportunities as rambling among maple groves affords them.[3]

Formally and technically, *Sugaring Off* cannot compare to the studies of maple sugar camps painted by the European-trained Eastman Johnson in the 1860s (see, for example, *Sugaring Off*, c. 1861–66, Museum of Art, Rhode Island School of Design, Providence). Its level of sophistication is closer to that of a popular print like Arthur Fitzwilliam Tait's *American Forest Scene—Maple Sugaring*, published by Nathaniel Currier in 1855. *Sugaring Off* is, nevertheless, an effective image. Matteson's use of bright local colors against a gray monochrome background is visually striking, and though the fashion-plate prettiness of the young people may be considered out of place,

they provide an amusing contrast to the slightly grotesque figure of the rustic laborer. In light of the contemporary description cited above, it should be noted that these young folk are not "city people" as Patricia Hills contended,[4] but girls and boys of the neighborhood dressed for courting.

In December 1845, at its distribution of the year's purchases, the American Art-Union awarded *Sugaring Off* to Charles Frederick Spang, a wealthy Pittsburgh iron manufacturer. Spang retired from business in 1858, "wishing to devote the remainder of his life to the enjoyments afforded by cultured tastes,"[5] and moved to Nice. *Sugaring Off* remained in France until 1932, when Spang's daughter Rosalie bequeathed it to The Carnegie Museum of Art, together with two portraits by Thomas Sully.

LBF, KN

1 Tuckerman, *Book of the Artists*, pp. 432–34.

2 Stephen Alonzo Schoff, engraving, c. 1847, Print Room, New York Public Library.

3 John Inman, "Sugaring Off," *Columbian Magazine* 8 (July 1847), pp. 42–43.

4 Patricia Hills, in Whitney Museum of American Art, *The Painters' America: Rural and Urban Life, 1810–1910* (1974), p. 29.

5 John W. Jordan, *Encyclopedia of Pennsylvania Biography* (New York, 1916), vol. 6, p. 1,885.

References *Transactions of the American Art-Union, for the Year 1845* (New York, 1845), p. 26; J. Inman, "Sugaring Off," *Columbian Magazine* 8 (July 1847), p. 26; Sherburne Art Society, *Tompkins H. Matteson, 1813–1884*, p. 22; F. A. Myers, "Sugaring Off," *Carnegie Magazine* 40 (Mar. 1966), p. 105; P. Hills, *Eastman Johnson* (New York, 1972), pp. 49, 61; H. W. Williams, Jr., *Mirror to the American Past: A Survey of American Genre Painting, 1750–1900* (New York, 1973), p. 107; Whitney Museum of American Art, New York, *The Painters' America: Rural and Urban Life, 1810–1910* (1974), exh. cat. by P. Hills, p. 29; P. Hills, *The Genre Painting of Eastman Johnson: The Sources and Development of His Style and Themes* (New York, 1977), p. 107; P. C. F. Mandel, "People and Places," *Bulletin of the Rhode Island School of Design, Museum Notes* 63 (Apr. 1977), p. 159; S. Burns, *The Idea of the Farm in Nineteenth-Century American Art* (Philadelphia, 1989), p. 36.

Exhibitions American Art-Union, New York, 1845, *Annual Exhibition*, no. 5; National Academy of Design, New York, 1845, *Annual Exhibition*, no. 107; Department of Fine Arts, Carnegie Institute, Pittsburgh, 1936, *An Exhibition of American Genre Paintings*, no. 68; Westmoreland County Museum of Art,

Greensburg, Pa., 1961, *Founder's Day Exhibition: American Painting, Eighteenth, Nineteenth, and Twentieth Centuries from the Collection of Carnegie Institute*, no cat.; Hudson River Museum, Yonkers, N.Y., 1986, *Domestic Bliss: Family Life in American Painting, 1840–1910*, no. 19.

Provenance American Art-Union, New York, 1845; Charles Frederick Spang, Pittsburgh and Nice, France, acquired from the American Art-Union distribution, 1845; Rosalie Spang, Pittsburgh and Nice, France, 1904.

Bequest of Rosalie Spang, 1932, 32.2.1

See Color Plate 2.

Henry Mattson
1887–1971

N OTED LATER FOR HIS ROMANTIC, brooding seascapes, Henry Elis Mattson was born and raised in Göteborg, Sweden. In 1906 he immigrated to Worcester, Massachusetts, where he quickly found work as a mechanic. He claimed that his artistic career began in 1912, when he purchased a box of paints on a whim and became an enthusiastic Sunday painter.[1]

In 1913 Mattson returned to Sweden to study art. However, his teacher, after viewing his work, advised him to forget art and learn a trade. Later that year Mattson returned to America, settled in Chicago, and became an American citizen. He supported himself by working for the International Harvester Company—first as a mechanic and then as a foreman—but continued to paint in his spare time. Determined to pursue a career in art, he quit his job in 1916 and settled permanently in Woodstock, New York, then a fledgling artists' community, where he studied briefly with the landscape painter John Carlson.

Mattson's early works—primarily thickly painted, somber landscapes—had little impact on the American art world. A subsequent brief period of imitating Vincent van Gogh was abruptly halted by the constructive comments of the influential art critic Henry McBride on the occasion of Mattson's first solo exhibition in 1921.[2] During the 1920s, he struggled to develop

a more individual style, began to participate in major national exhibitions in New York, Pittsburgh, and Chicago, and by 1929 had established a solid reputation as a talented, original painter. His work was praised for its intensely personal nature, romantic impulsiveness, and warmth of feeling.

During the 1930s and 1940s, Mattson created the eerie seascapes that are generally considered to be his best work. These marines of tumultuous seas under overcast skies were painted in a palette dominated by somber blue-greens, black, and harvest brown. Although he took his inspiration from the rugged seas of New England and his native Sweden—which he visited regularly—his paintings do not represent actual coastal views. Instead, they were created from imagination and memory: their purpose was to evoke mood and mystery rather than to record nature.

Mattson's mature work won him critical acclaim and financial success. By 1943 he was called one of the most poetic and original painters in America.[3] He won awards from the Art Institute of Chicago (1931), Worcester Art Museum, Massachusetts (1933), Carnegie Institute (1935), Corcoran Gallery of Art, Washington, D.C. (1935 and 1943), and the Pennsylvania Academy of the Fine Arts, Philadelphia (1945). He received a Guggenheim Foundation Fellowship in 1935 and became a member of the National Academy of Design in 1951. His seascapes were often favorably compared with those of Albert P. Ryder, one of America's foremost visionary painters.[4]

1 Watson, "Mattson," p. 8.

2 McBride quoted in "Upon a Painted Ocean," p. 24.

3 Watson, "Mattson," p. 8.

4 Brace, "Henry Mattson, " p. 651; James W. Lane, "Henry Mattson's Strong Marines," *Art News* 38 (November 11, 1939), p. 1.

Bibliography Ernest Brace, "Henry Mattson," *American Magazine of Art* 27 (December 1934), pp. 648–53; Ernest W. Watson, "Mattson," *American Artist* 7 (November 1943), pp. 8–12; "Upon a Painted Ocean: Henry Mattson," *Art News* 44 (April 1, 1945), p. 24; Marjorie Dent Candee, ed., *Current Biography Yearbook 1956* (New York, 1957), pp. 424–26.

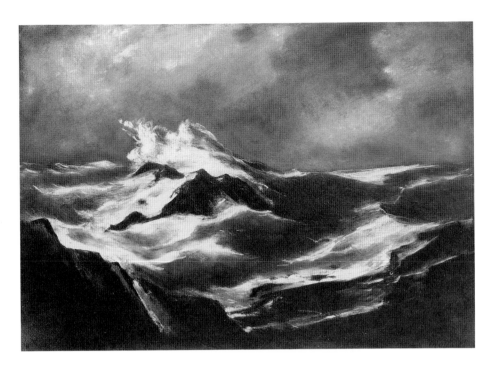

Black Reef, 1940

Oil on canvas
31 x 44½ in. (78.7 x 113 cm)
Signature: Mattson (lower right)

During the heyday of Mattson's career, the sea was his favorite subject. As the artist once explained:

> I paint the sea because I love it and fear it too. I think about it constantly, not so much what it looks like at any particular time, but I think about its elemental aspect, its weight, its awesome depth, the powerful action of its waves. A sailor doesn't think of the beauty of the ocean. To him it is a fundamental condition of his daily life and it is his diverse experiences with the sea rather than aesthetic appearances that impress him. In my pictures I try to express such fundamental, even primitive reactions to this rather terrifying natural element.[1]

It is precisely this terrifying, elemental aspect of the sea that the artist has sought to capture in *Black Reef*, a typical example of Mattson's mature work. Here, storm-tossed waves boom and crash against a rocky reef beneath a dark, foreboding sky. Thickly applied pigments of dark blue-greens and black give weight and density to the water and rocks. Even the sky, whose pale light is eerily reflected from the waves' spume, has a heavy, oppressive appearance. Thanks in part to its rough

execution, the painting successfully conveys the inexorable power and incipient hostility of nature.

RB

1 Watson, "Mattson," p. 12.

References L. D. Longman, "The Responsibility to Educate," *Parnassus* 13 (Jan. 1941), pp. 4–5; J. O'Connor, Jr., "Four New Paintings," *Carnegie Magazine* 14 (Jan. 1941), p. 228; Watson, "Mattson," p. 10; F. W. Nichols, "Your Esthetic I.Q.," *Carnegie Magazine* 19 (Oct. 1945), p. 110; Candee, *Current Biography Yearbook 1956*, p. 426.

Exhibitions Department of Fine Arts, Carnegie Institute, Pittsburgh, 1940, *Survey of American Paintings*, no. 363; Pennsylvania Academy of the Fine Arts, Philadelphia, 1941, *One Hundred Thirty-sixth Annual Exhibition of Paintings and Sculpture*, no. 125; Swope Art Gallery, Terre Haute, Ind., 1942, *Contemporary American Paintings Exhibition*, unnumbered; Museum of Art, Rhode Island School of Design, Providence, 1946, *Museum's Choice Exhibition*, no cat.; Columbus Gallery of Fine Arts, Ohio, 1952, *Paintings from the Pittsburgh Collection*, no cat.

Provenance Frank K. M. Rehn Gallery, New York, as agent, 1940.

Patrons Art Fund, 1940, 40.6.1

Alfred H. Maurer

1868–1932

Alfred Henry Maurer was one of the first American painters whose work reflected the impact of Fauvism and Cubism. Although his style changed considerably during his career and continued to fluctuate even in his maturity, he is correctly described as an emotional modernist, whose approach was comparable to that of John Marin, Arthur Dove, or Marsden Hartley. Maurer's modernist convictions, however, came at a high price, for he was continually misunderstood and unappreciated by both the American public and the press.

Maurer was born and raised in New York, the son of Louis Maurer, the lithographer and illustrator of sporting subjects. He went to work in the family's lithography business when he was sixteen, and at the same time enrolled at the National Academy of Design. At the age of twenty-nine, he left New York for Paris, where he studied at the Académie Julian and began to paint in a manner that was continually compared with the styles of William Merritt Chase, John Singer Sargent, and James McNeill Whistler—the sophisticated American expatriates whose work set the standard of painterly fashionability at the end of the nineteenth century. Maurer exhibited for the first time at the Paris Salon in 1899 and soon thereafter began sending his work to annual exhibitions in the United States. In 1901 he won the first of many prizes and medals for his work: a bronze medal at the Pan-American Exposition, Buffalo. It was followed by a gold medal for *An Arrangement* (1901, Whitney Museum of American Art, New York) at Carnegie Institute's sixth annual exhibition.

Except for a few brief visits to New York, Maurer remained in Paris until 1914, becoming increasingly attracted to avant-garde art. He formed friendships with Edward Steichen, Max Weber, and Patrick Henry Bruce; and in 1904 he met the expatriate American collectors Leo and Gertrude Stein. The Steins introduced Maurer to the works of Paul Cézanne and Henri Matisse, an event that proved to be a pivotal point in his career.

Between 1905 and 1907 he sharply altered his style to reflect the abstract forms and bold colors then prevalent in French avant-garde art, particularly among the Fauves. He exhibited at the Salon d'Automne and in 1908 helped form the New Society of American Artists in Paris. In 1909 Steichen and Alfred Stieglitz presented Maurer's new paintings along with the work of John Marin in an exhibition at the 291 gallery in New York; they were the first American modernist paintings ever exhibited in the United States.

With the onset of World War I, Maurer returned permanently to New York, moving in again with his parents, upon whom he was always financially and psychologically dependent. In 1915 he began painting the countryside around Marlboro-on-the-Hudson, New York, pushing his compositions fully into abstraction, possibly influenced by Pablo Picasso's analytical Cubism or the recent work of Arthur Dove.[1] Beginning in 1917 Maurer exhibited his new abstractions with the Society of Independent Artists in New York, and continued to do so for the rest of his life.

During the 1920s he gradually applied the process of abstraction to heads, female figures, and still lifes, made according to his own personal idiom. Around 1919 he began to paint strange, anxious Cubist heads of women with staring eyes. He continued to produce them, with numerous variations, through the 1920s; they reached their greatest emotional and formal intensity in 1929 and 1930. Also during the late 1920s and early 1930s, Maurer painted synthetic Cubist tabletop still lifes, likewise in many variations, some of which incorporated stenciled doilies among pieces of painted fruit and other familiar objects.

Although Maurer is considered to be one of America's important modernists, his relationship with the American public was problematical. He had an extremely private personality and seemed to have great trouble articulating verbally his feelings and thoughts about his art. His modernist paintings frequently suffered from negative reviews, and Stieglitz, a potential champion, did not support his work after 1909. In addition, Maurer had to bear the censure of his work by his German-born father, who had been a successful illustrator for Currier and Ives.

In 1924 the Weyhe Gallery, New York, purchased the contents of Maurer's studio and that year gave him a solo show.

Weyhe also presented Maurer's last solo show in 1931, while soon afterward his father was triumphantly rediscovered with the first solo exhibition of his Currier and Ives illustrations at the Old Print Shop in New York.

In the spring of 1932 Maurer underwent prostate surgery. At his release from the hospital he was depressed and convinced that he was suffering from cancer. On July 19, the one-hundred-year old Louis Maurer died; sixteen days later Alfred tragically ended his life by hanging himself, in New York.

1 National Collection of Fine Arts, *Alfred H. Maurer*, p. 49.

Bibliography Walker Art Center, Minneapolis, *A. H. Maurer, 1868–1932* (1949), exh. cat. by Elizabeth McCausland; Elizabeth McCausland, *A. H. Maurer: A Biography of America's First Modern Painter* (New York, 1951); Bernard Danenberg Galleries, New York, *Alfred Maurer and the Fauves: The Lost Years Rediscovered* (1973), exh. cat. by Peter Pollack; National Collection of Fine Arts, Washington, D.C., *Alfred H. Maurer, 1868–1932* (1973), exh. cat., essay by Sheldon Reich; Nick Madormo, "The Early Career of Alfred Maurer," *American Art Journal* 15 (Winter 1983), pp. 4–34.

The Black Parasol (Gabrielle), c. 1904

Oil on canvas
36 x 29 in. (91.4 x 73.7 cm)
Signature: *Alfred H. Maurer* (upper right)

The Black Parasol exemplifies the dark-toned, studied bravura that won for Maurer his early success and reputation as the "new Chase." In *The Black Parasol,* Maurer's technique of swirling on thick liquid impasto with the loaded brush, especially in the hat and bodice of the dress, achieves an assurance and flamboyance equal to that of William Merritt Chase or John Singer Sargent. Maurer was often compared with James McNeill Whistler as well; his somber mood and artfully designed compositions recall Whistler's figure subjects.

In the early 1900s Maurer often used the standard compositional format, inspired ultimately by Diego Velázquez, of a full-length figure against a neutral background. The same general devices are

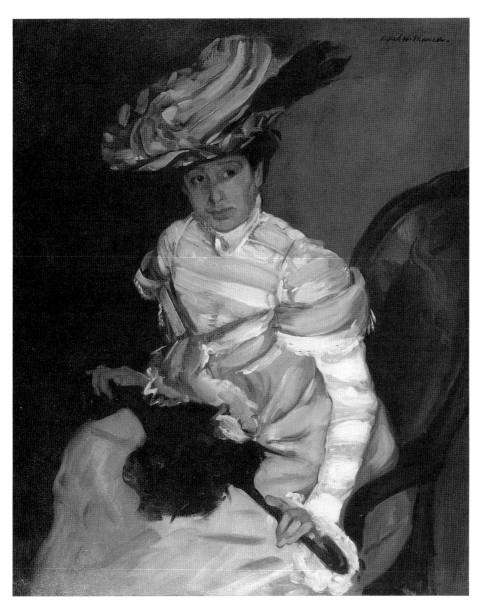

Exhibitions Museum of Modern Art, New York, 1943, *Twentieth Century Portraits*, unnumbered; Walker Art Center, Minneapolis, 1949, *A. H. Maurer, 1868–1932* (trav. exh.), no. 6; Baltimore Museum of Art, 1954, *Man and His Years*, no. 108; Cincinnati Art Museum, 1957, *An American Viewpoint: Realism in Twentieth Century Painting* (trav. exh.), unnumbered; National Collection of Fine Arts, Washington, D.C., 1973, *Alfred H. Maurer, 1868–1932*, no. 7; University Gallery, University of Minnesota, Minneapolis, 1973, *Alfred H. Maurer: American Modernist,* no cat.

Provenance Buchholz Gallery, New York, 1943; Mr. and Mrs. Hudson D. Walker, New York; Ione Gaul Walker (Mrs. Hudson D. Walker), New York, by 1949.

Gift of Ione Gaul Walker in memory of James Harvey Gaul, 1957, 57.13

Landscape, c. 1911

Oil on canvas
31¾ x 25½ in. (80.6 x 64.8 cm)
Signature: *A. H. Maurer* (lower left)

This landscape is one of thousands of Fauvist paintings Maurer executed between 1906 and 1914, most of which were lost after the onset of World War I when his landlord disposed of the contents of his Paris studio.[1] It represents the later stages of an almost intuitive development from his earlier naturalism through Impressionism and then to Fauvism, a development in which the spontaneity of landscape painting played an important part.

In *Landscape,* as in *The Black Parasol,* Maurer's facility for flashing virtuoso brushwork is still obvious, but here the brushwork, instead of existing solely for its technical and formal brilliance, now expressionistically communicates Maurer's feelings for the subject. The soft mauves and pastel colors over the canvas's gessoed ground suggest that the time of year is late winter, just before the spring thaw. Maurer's excited brushstrokes— smooth and flowing in *The Black Parasol,* raw and primitive here—organize themselves into a decorative linear pattern that radiates around the central motif of the tree. The tree—old, gnarled, and almost dead—seems to make its last attempt to

at work in this seated portrait, where the artist's placement of the brilliant white lace guimpe and pastel blue dress and hat against a gray-black background enhances the optical impact of the figure. The cropping of the model's legs and her posture of leaning forward into the picture plane help the viewer to experience her physical presence; the playful, irregular silhouette of the figure against the dark background and the dynamic brushstrokes add to the decorative quality of the work.

Gabrielle was a model who posed for Maurer at least three times: for this painting, for a full-length portrait, and in 1905 for a small picture that shows signs of Impressionist influences.[1] Though there is a slight vulnerability in the model's eyes, the sitter's character is not expressed as forcefully as the painter's technical brilliance. In fact, the painter's aggressive brushwork accentuates a physical and psychological hesitancy within her. Shortly after completing the third portrait of Gabrielle, Maurer stopped working altogether while he reformulated his entire approach, and when he began painting again he did so as a converted Fauvist.

KP

1 McCausland, *A. H. Maurer: A Biography,* p. 84.

References McCausland, *A. H. Maurer: A Biography,* p. 84; G. B. Washburn, "New American Paintings Acquired," *Carnegie Magazine* 30 (June 1956), pp. 194–95.

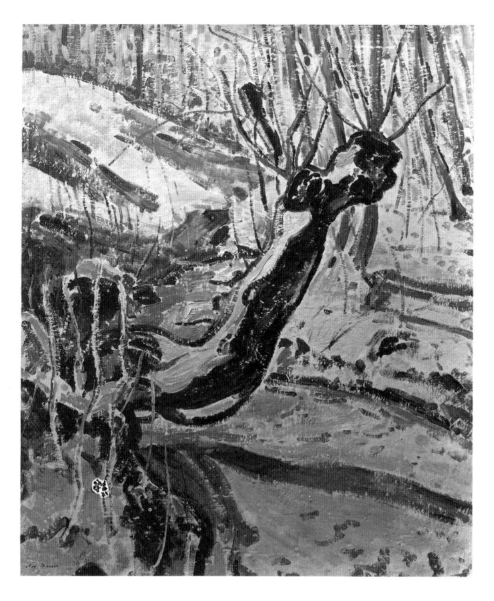

spring back to life, while the brook moving swiftly below suggests renewal and refreshment.

KP

1 Bernard Danenberg Galleries, *Alfred Maurer and the Fauves*, n.p.

References G. B. Washburn, "New American Paintings Acquired," *Carnegie Magazine* 30 (June 1956), p. 193; C. C. Stewart, "Landscape," *Carnegie Magazine* 42 (June 1968), p. 213.

Exhibitions Bertha Schaefer Gallery, New York, 1955, *A. H. Maurer: An American Fauve*, no. 13; Bertha Schaefer Gallery, New York, 1969, *Alfred H. Maurer Exhibition*, unnumbered; Bernard Danenberg Galleries, New York, 1973, *Alfred Maurer and the Fauves: The*

Lost Years Rediscoved, exh. cat. by Peter Pollack, no. 49; Whitney Museum of American Art at Philip Morris, New York, 1983, *The Forum Exhibition: Selections and Additions*, unnumbered; High Museum of Art, Atlanta, 1986, *The Advent of Modernism: Post-Impressionism and North American Art, 1900–1918*, unnumbered.

Provenance Bertha Schaefer Gallery, New York, by 1955.

Gift of Bertha Schaefer, New York, 1956, 56.10

Head, c. 1929

Oil on composition board
21¾ x 18⅛ in. (55.2 x 46 cm)

Throughout the 1920s Maurer began applying to a series of female figures and heads the splintering of form into geometrical shapes with which he had earlier

treated his still lifes. In *Head*, Maurer treated the face as a severed distortion, defining the cheeks and eyes with jagged lines, flattening and stretching the form, and creating an expression of psychological precariousness and disorientation. This approach may have expressed the anger, frustration, and rage with the world that Maurer felt by this time. As in several similar paintings, probably also executed about 1929, the face is placed before an open window surrounded by draperies, perhaps playfully evoking a compositional device in traditional portraiture.

Writers debated over whether the elongated forms of these female figures and heads were inspired by the artist's viewing Sandro Botticelli's paintings on his 1906 Italian trip or by his exposure to Amedeo Modigliani or to Pablo Picasso.[1] In any case, with their enormous, staring eyes and often high-domed foreheads, these images caused much controversy and turmoil at exhibitions. Maurer, however, seemed to delight in the generally chaotic response they provoked.[2]

KP

1 National Collection of Fine Arts, *Alfred H. Maurer*, pp. 88–90, 102.

2 Ibid., p. 88.

Provenance Berenice Abbott, New York; J. B. Neumann, New York; G. David Thompson, Pittsburgh.

Gift of G. David Thompson, 1957, 57.42.6

Trevor McClurg
1816–1893

As the eldest son of a prominent
and enterprising industrialist, Trevor
McClurg moved in 1825 with his family
from Pittsburgh, his birthplace, to
Philadelphia, then back again to
Pittsburgh in 1837. It is possible that he
returned to Philadelphia to study art, for
he became friends with Emanuel Leutze,
and in 1841 he accompanied Leutze to
Düsseldorf, thereby becoming one of the
first Americans—along with Leutze and
Johan Georg Schwartze—to study there.
He spent two years—from 1841 to 1843—
at the Düsseldorf academy in Carl
Ferdinand Sohn's antique and painting
classes. From Sohn he appropriated a
tight, finished drawing style, along with
compositions favoring shallow fore-
grounds and figures disposed with classi-
cal stability. Before returning to the
United States, he probably visited Italy.

In 1844 or 1845 McClurg returned to
America; by 1848 he had settled in
Pittsburgh, where he lived for the next
thirty years, although he seems to have
stayed in New York for extended periods
in 1858 and 1860. He exhibited at the
American Art-Union, New York, in the
1840s, and at the National Academy of
Design, New York, the Pennsylvania
Academy of the Fine Arts, Philadelphia,
and the Pittsburgh Art Association during
the 1850s and 1860s. Together with David
G. Blythe and William C. Wall, he served
on the Committee of Artists for the 1864
Pittsburgh Sanitary Fair. From 1863 to
1865 he operated a school of design with
Düsseldorf-trained landscape painter
George Hetzel, then around 1866 he
taught figure drawing at the Pittsburgh
School of Design for Women.

McClurg married Rachel Taylor, a
watercolorist and china painter, in 1866;
he named the first of his two sons
Alexander Leutze. He conducted himself
in a manner befitting his native town's
first academically trained artist: he was
well dressed, gentlemanly, and seemingly
comfortably situated financially.
Although he exhibited a watercolor in
1879 and two oils in 1888 at the
Pennsylvania Academy, he seems to have
lost interest in painting by the 1870s, at

which point he appeared in city directo-
ries as a commercial photographer. He
moved to Chambersburg, Pennsylvania,
around 1877, and died in Asheville, North
Carolina.

Although only a handful of McClurg's
works are known today, it is clear from
the few extant paintings and from titles in
exhibition catalogues that he produced a
wide range of subjects. He painted por-
traits (*George Chambers*, 1882, Historical
Society of Pennsylvania, Philadelphia);
still lifes (*Still Life with Fruit and Silver
Pitcher*, 1860, collection Mr. and Mrs.
Arthur C. Riley, Pittsburgh); literary and
historical subjects (*Ophelia*, American
Art-Union, 1846, no. 104; *The Venetian
Painter Tintoretto, Instructing His
Daughter*, National Academy of Design,
1853, no. 148); moral and religious themes
(*Christian Charity*, Pennsylvania Academy
of the Fine Arts, 1859, no. 127); current
events (*War News*, Pennsylvania Academy
of the Fine Arts, 1865, no. 753); and
copies after European masters (*Page and
Falcon* after Thomas Couture's *Falconer*,
Pittsburgh Art Association, 1859, no. 185).

Bibliography Thornton Fleming, ed., *History
of Pittsburgh and Environs . . .* (New York,
1922), vol. 3, p. 626; Kunstmuseum, Düssel-
dorf, *The Hudson and the Rhine: Die ameri-
kanische Malerkolonie in Düsseldorf im 19.
Jahrhundert* (1976), p. 99; University Art
Gallery, University of Pittsburgh, *Art in
Nineteenth-Century Pittsburgh* (1977),
pp. 29–30; Danforth Museum of Art, Fram-
ingham, Mass., *American Artists in Düsseldorf,
1840–1865* (1982), pp. 7, 9, 34.

Family, Taken Captive by the Indians, c. 1849
(Woman and Children, with Indian Massacre in the Background)

Oil on canvas
29¾ x 37¾ in. (75.6 x 95.9 cm)
Signature: *Trevor McClurg/Pittsburgh* (lower
right)

In May 1849, a writer for the *Pittsburgh
Daily Gazette*, describing a visit to the
studio of "Mr. Trevor McClurg, a very
promising young artist of our own City,"
singled out for praise "a group represent-
ing one of the wives of our early settlers,
surrounded by her helpless children,
taken captive by the Indians."[1] This is
almost certainly the present work.
Though his exhibition record reveals a
preference for European subjects,
McClurg responded from time to time to
the demand for national themes. He
painted at least two other works dealing
with the American frontier experience.
Both *Frontier Life* and *The Pioneer's
Defense* have been lost,[2] but the latter,
depicting an eighteenth-century frontier
family in their log cabin attempting to
repel an Indian attack, was once known
in lithographic form—although it is not
known if any of these lithographs exist
today.

In *The Pioneer's Defense* and *Family,
Taken Captive by the Indians*, McClurg
illustrated the popular nineteenth-century
conception of the pioneers as heroic
harbingers of civilization pitted against
the hostile wilderness, personified by the
Indian. McClurg's Indians are either dark,

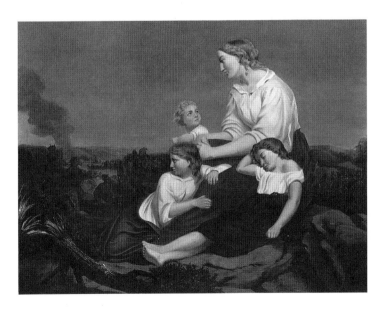

shadowy presences lurking in the background as here, or, as in *The Pioneer's Defense*, an invisible menace beyond the cabin walls. Though the subject is American, McClurg's treatment of it is European. His captives are painted in the hard, linear manner associated with the Düsseldorf school, and form a monumental, classical grouping that might serve equally well in a Fall of Troy or a Sack of Rome. His handling of this theme probably influenced another painting by a Pittsburgh artist in The Carnegie Museum of Art collection, Isaac Eugene Craig's *Captives* of 1858 (see p. 150).

The history of this work subsequent to its completion is obscure. When it appeared at the Pittsburgh Art Association in 1859, it belonged to the artist's uncle, William T. McClurg, a local cast-iron manufacturer. In 1925 Walter McFarren offered it to Carnegie Institute, but the Fine Arts Committee refused it. Mr. McFarren never removed it, and in 1970 it was appropriated from storage.
KN

1 "The Fine Arts," *Pittsburgh Daily Gazette,* May 3, 1849, p. 3.

2 *Frontier Life* was exhibited at the Pittsburgh Art Association, 1860, no. 108. *The Pioneer's Defense* was exhibited at the National Academy of Design, New York, 1858, no. 86; the Pittsburgh Art Association, 1859, no. 22; and the Pittsburgh Sanitary Fair, 1864, no. 220.

References "The Fine Arts," *Pittsburgh Daily Gazette,* May 3, 1849, p. 3; W. H. Gerdts and M. Thistlethwaite, *Grand Illusions: History Painting in America* (Fort Worth, 1988), p. 157; W. H. Gerdts, *Art across America: Two Centuries of Regional Painting* (New York, 1990), vol. 1, pp. 289–90.

Exhibitions Pittsburgh Art Association, 1859, no. 34; Westmoreland County Museum of Art, Greensburg, Pa., 1981, *Southwestern Pennsylvania Painters, 1800–1945,* exh. cat. by P. A. Chew and J. A. Sakal, no. 172, as *Woman and Children, with Indian Massacre in the Background;* Danforth Museum of Art, Framingham, Mass., 1982, *American Artists in Düsseldorf, 1840–1865,* no. 30, as *Woman and Children, with Indian Massacre in the Background.*

Provenance The artist's uncle, William T. McClurg; Walter McFarren, by 1925; offered by McFarren to Carnegie Institute, 1925; refused by Fine Arts Committee, Carnegie Institute, and consigned to storage.

By appropriation, 1970, 69.43.4

Gari Melchers
1860–1932

THE MURALIST AND portrait painter Julius Gari Melchers was born and raised in Detroit. He first studied art with his father, a Westphalia-born sculptor who had been a student of Jean-Baptiste Carpeaux. At the age of seventeen, he enrolled at the academy in Düsseldorf, and four years later went to Paris to attend the Académie Julian. There, under the tutelage of Gustave Boulanger and Jules-Joseph Lefebvre, he made remarkable progress: his painting *The Letter* (1882, Corcoran Gallery of Art, Washington, D.C.) was accepted in the Paris Salon of 1882.

In 1884 Melchers traveled to Holland and in Egmond-aan-Zee set up a studio that he shared with the American painter George Hitchcock. He made Egmond his home, although he also had studios in and around Paris. He kept the motto *Waar en Klaar,* true and clear, over his studio door in Egmond, and as an artist he remained faithful to this dictum. He depicted the simple, pious life of the Dutch peasantry, focusing on religious subjects or intimate family scenes; his painting *The Sermon* (c. 1886, National Collection of Fine Arts, Washington, D.C.) was the first by an American to be awarded a gold medal at the annual exhibition at Munich's Glaspalast. Melchers said that he executed most of his works directly from life, often setting up his easel to paint in the small Lutheran church in Egmond. His use of the fluid brushwork and dark tonalities of seventeenth-century Spanish painting and his frank, unidealized approach to his subject matter place his early work within the tradition of such French Realists as Jean-François Raffaelli, Jules Breton, and Jean-François Millet.

Melchers's reputation spread quickly throughout Europe and America. By 1889 he and John Singer Sargent were the only Americans to win the grand prix at the Exposition Universelle in Paris. Among his other numerous honors and awards were the first prize at the Art Institute of Chicago in 1891, the Medal of Honor in Berlin in 1891, and, in 1895, the title Chevalier of the Legion of Honor.

Melchers was widely acclaimed for intimate depictions of mothers and children and for his murals. He was invited to prepare murals for the World's Columbian Exposition in 1893, Chicago (they were later installed in the library of the University of Michigan at Ann Arbor), the Library of Congress, Washington, D.C., in 1895, and, in the 1920s, the Detroit Public Library and the Missouri State House in Jefferson City. His society portraits also brought him considerable success; one of the highlights of his career was a commission from Charles Lang Freer to paint a portrait of President Theodore Roosevelt (Freer Gallery of Art, Washington, D.C.) in 1908.

After 1903 Melchers turned from the somber genre scenes of his earlier career to a more decorative style. The bright palette, distinctive patterning, and loose, thick application of paint in works such as *Penelope* (c. 1905, Corcoran Gallery of Art, Washington, D.C.) exemplify his direction during these years and show a certain debt to French Post-Impressionism.

In 1909 Melchers accepted the invitation of the grand duke of Saxe-Weimar to be professor of painting at the art academy in Saxe-Weimar. In 1914, upon the outbreak of World War I, Melchers returned to the United States, where he maintained a studio in New York and an estate in Falmouth, Virginia. He continued to be widely successful, despite modernist developments that came in the wake of the Armory Show of 1913. He was a regular exhibitor at the Carnegie International, participating in twenty-six of these exhibitions between 1896 and 1933. He was a member of the jury of award in 1907, the Foreign Advisory Committee from 1904 to 1914, and the Committee of Selection and Juries in 1924. He was honored with a solo exhibition in 1907 and won the Popular Prize at the Carnegie International of 1927. In 1923 he was made chairman of the commission to establish a national gallery of art; he was elected to the Board of Directors of the Corcoran Gallery of Art and served on the Virginia Arts Commission.

To the end of his life, Melchers was respected both professionally and personally. The basis for this admiration was described on the occasion of a memorial exhibition held at Carnegie Institute in 1934:

His integrity in art is a rare lesson for today. It is exceptional to discover work of such honest naturalism without strain or exaggeration, yet coupled with vision and dignity, and such a firm grain of the academic mold complemented by a generous sympathy with modern treatment.[1]

Melchers died at "Belmont," his Virginia estate. "Belmont," now a museum maintained by Mary Washington College, Fredericksburg, houses an archive and a large collection of his works.

1 Department of Fine Arts, Carnegie Institute, Pittsburgh, foreword to *Gari Melchers Memorial Exhibition* (1934), exh. cat., n.p.

Bibliography J. Brenchley, "Gari Melchers and His Work," *Magazine of Art* 24 (February 1900), pp. 145–51; Henriette Lewis-Hind, *Gari Melchers: Painter* (New York, 1928); Mary Washington College, Fredericksburg, Va., *Gari Melchers, 1860–1932* (1973); Graham Gallery, New York, *Gari Melchers: American Painter* (1978), exh. cat. by Janice Oresman; Janice Oresman, "Gari Melchers' Portraits of Mrs. George Hitchcock," *Archives of American Art Journal* 21, no. 3 (1980), pp. 20–24.

Mother and Child, 1909
(The Mother)

Oil on canvas
34⅞ x 27⅛ in. (88.6 x 68.9 cm)
Signature, inscription: *Gari Melchers* (upper right); COPYRIGHT 1909 BY/GARI MELCHERS (lower left)

The theme of mother and child long occupied Melchers. He painted numerous versions of mothers nursing, caressing, or playing with their babies, along with studies of their facial types and expressions. "The subject seems to possess him," wrote his biographer in 1928, "and how tenderly. . . and with how much knowledge he observes the accepting dependence of the child, the various kinds of mothers, loving—some tenderly, some fiercely, some happily possessing."[1] His maternity themes can be placed in a subgenre of the Realist painting tradition, which examined family life. The subject attracted diverse artists in the last half of the nineteenth century, most notably the French painters Eugène Carrière, Jean-François Millet, Jules Breton, and Mary Cassatt, of whose work Melchers was surely aware.

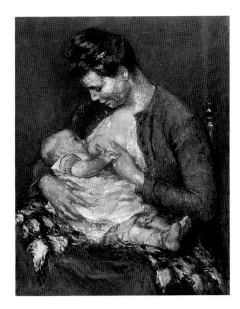

The Carnegie's *Mother and Child* presents a somewhat earthy image of a country mother nursing. The model was probably one of the Dutch peasant women who lived at Egmond-aan-Zee. Her simple wooden chair, brown dress, and floral afghan appear in numerous works by Melchers depicting Dutch peasants, as does the stolid, enduring peasantry she symbolizes. The artist installed his painting in a Renaissance-style tabernacle frame.

The theme of maternity apparently held special meaning for Melchers. Toward the end of his life, he remarked in an interview that he believed motherhood was the most beautiful thing in the world.[2] His own marriage was childless, and the artist's correspondence with his wife, which is preserved at his estate in Virginia, reveals his unfulfilled desire for children.

The roughly painted *Mother and Child* is typical of Melchers's style after 1903. The broken brushwork and thick encrustation of paint reveal the artist's appreciation of the French intimists Edouard Vuillard and Pierre Bonnard, although the final effect is quite far from their work. The painting was purchased at the Carnegie International of 1912. John Beatty, director of the Department of Fine Arts, Carnegie Institute, considered it to be an improvement over Melchers's earlier style of painting. Another work by the artist, at that time in Carnegie Institute's collection, *Sailor and His Sweetheart* (c. 1898, Freer Gallery of Art, Washington, D.C.), was returned to Melchers in 1912 in partial exchange for *Mother and Child*.
ST

1 Lewis-Hind, *Gari Melchers: Painter*, n.p.
2 Mary Washington College, *Gari Melchers*, p. 34.

Reference Lewis-Hind, *Gari Melchers: Painter*, n.p., as *The Mother*.

Exhibitions Akademie der Künste, Berlin, 1910, *American Art Exhibition,* unnumbered; Worcester Art Museum, Mass., 1911, *Fourteenth Annual Exhibition of Oil Paintings by American Painters,* no. 38; Department of Fine Arts, Carnegie Institute, Pittsburgh, 1912, *Sixteenth Annual Exhibition,* no. 219; Butler Institute of American Art, Youngstown, Ohio, 1921, *An Exhibition of American Paintings Specially Selected for the Holiday Season,* no. 3; Detroit Institute of Arts, 1923, *Ninth Annual Exhibition of American Art,* no. 73; Kungliga Akademien för de fria Konsterna, Stockholm, 1930, *Retrospective Exhibition of American Paintings and Architecture,* no. 70; Department of Fine Arts, Carnegie Institute, Pittsburgh, 1934, *Memorial Exhibition of the Work of Gari Melchers,* no. 14; Virginia Museum of Fine Arts, Richmond, 1938, *Gari Melchers: A Memorial Exhibition of His Work,* no. 65, as *The Mother.*

Provenance The artist, until 1912.

Purchase, 1912, 12.9

Richard E. Miller
1875–1943

R ICHARD EDWARD MILLER, who belonged to the second generation of American Impressionists, is best remembered for his brightly patterned and carefully structured figure paintings. He was born in Saint Louis, attended the Saint Louis School of Fine Arts from 1893 to 1897, and then, in 1898, worked as a reporter-artist for the *Saint Louis Post-Dispatch.* He received a scholarship to the Académie Julian in Paris and studied there in 1899 under the history painter Jean-Paul Laurens and the Orientalist-turned-portrait-painter Benjamin Constant.

Miller returned to the United States to teach at the Saint Louis School of Fine Arts for one year in 1902. He then returned to France and taught at the Atelier Colarossi in Paris from 1905 to 1914, conducting his own classes during

the summer in Giverny and Saint-Jean-du-Doight, Brittany. In November or December 1914 Miller returned to the United States; he eventually settled in Provincetown, Massachusetts, where, as one of the founders of the artists' colony there, he taught and painted.

Miller exhibited at the Paris Salon for the first time in 1900 and won a third-class medal for his contribution. In 1904 he won a second-class medal and in 1908 was made Chevalier of the Legion of Honor. His rise to prominence in the United States was almost as rapid. He won the bronze medal at the Pan-American Exposition in Buffalo in 1901, the Temple Gold Medal of the Pennsylvania Academy of the Fine Arts, Philadelphia, in 1911, the Thomas B. Clarke Prize at the National Academy of Design, New York, in 1915, and the gold medal at the Allied Artists of America Exhibition, held at the Brooklyn Museum, New York, in 1933. Miller exhibited at the Carnegie Internationals from 1910 to 1926. In 1913 he was elected an associate at the National Academy of Design and in 1915 to full membership. In 1922 he was awarded membership in the Salmagundi Club. He died in Saint Augustine, Florida, where he owned a winter home.

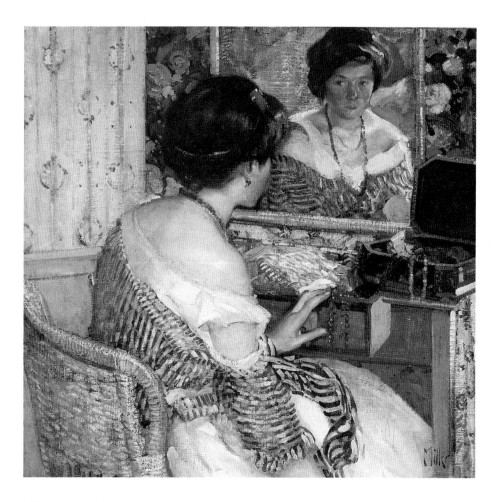

Bibliography Wallace Thompson, "Richard Miller—a Parisian-American Artist," *Fine Arts Journal* 27 (November 1912), pp. 709–14; Vittorio Pica, "Artisti contemporanei: Richard Emile Miller," *Emporium* 39 (March 1914), pp. 162–77; Robert Ball and Max Gottschalk, *Richard E. Miller, N.A.: An Impression and Appreciation* (Saint Louis, 1968); Henry Art Gallery, University of Washington, Seattle, *American Impressionism* (1980), exh. cat., essay by William H. Gerdts, pp. 86–89; William H. Gerdts, *American Impressionism* (New York, 1984), pp. 250–73, passim.

Reflections, c. 1915

Oil over tempera on canvas
31¾ x 31¾ in. (80.6 x 80.6 cm)
Signature: Miller (lower right)

Although Miller painted portraits as well as a few landscapes, his particular brand of American Impressionism usually consisted of languid, elegant women in domestic interior settings. His style is most akin to that of Frederick Frieseke, although Miller painted his figures in a tighter, more convincingly three-dimensional manner and favored a more rigid ordering of space than Frieseke did.

Miller created his compositions by inserting into them the corner walls of a room, venetian blinds, mirrors, and the like. His preference for a palette of greens and purples caused some of his contemporaries to refer to his paintings as "candy," but they were in fact intended as colorful complements to the bright wallpaper, light modern furniture, and white woodwork common in interior decoration of the day.[1]

Reflections, a richly patterned painting, contains a number of Miller's favorite compositional details. The skirted dressing table and octagonal jewelry box appear in many of Miller's works. The girl contemplating her reflection is pressed into a corner (made more obtrusive by the square-shaped canvas), a feature common to a number of works datable to Miller's years in France. *Chinese Statuette* (c. 1910, Saint Louis Art Museum), which was exhibited at the Carnegie International in 1911, depicts a similar closed space and the same striped wallpaper.

On the strength of its brushwork, *Reflections* can be dated to the period following Miller's return to the United States. The treatment is somewhat reminiscent of Claude Monet's late style, which Miller would have known from his stay at Giverny. As Monet often did, Miller first used a darkish tone that sank down into the canvas weave, then applied a paler tone, coloring only the top of the weave. It was Miller's custom to employ a tempera ground over which he applied a layer of dryly brushed oil paint. This second paint layer conveys much of the texture and reflective qualities of the objects. Miller's later works also contain some dry-brush, but more often the background is painted loosely, thickly, and broadly. Unlike *Reflections,* these later interiors are more expansive, are set frequently before a window with blinds, and are more sparkling in their light effects. LBF

1 Thompson, "Richard Miller," p. 711.

Provenance Unidentified antiques dealer, Huntington Ave., Brookline, Mass., before 1981; Edward L. Shein, Seekonk, Mass., by 1981; Vose Galleries of Boston, 1981.

Richard M. Scaife American Painting Fund, 1982, 82.28

Francis Davis Millet
1846–1912

BORN IN MATTAPOISETT, Massachusetts, and descended from seventeenth-century Puritan settlers there, Francis Davis Millet served as an elder statesman of American art at the turn of the century and played an important role in the revitalization of monumental mural decoration. Having graduated from Harvard College in 1869, he worked as a newspaper writer and editor in Boston until 1871, when he left to study art formally in Antwerp. There, under the direction of Joseph van Lerius and Nicolas de Keyser, he learned a painterly manner, which by the 1880s he discarded in favor of tight draftsmanship, meticulous brushwork, and an enamellike use of the oil medium. In 1873 he traveled as a secretary to Charles Francis Adams, Jr., to the Vienna Exposition, where Adams was a commissioner. At the latter's urging, Millet proceeded to Venice and Rome to visit those cities' art collections and to continue his study of painting.

Upon returning to Boston in 1875, he opened a studio and began to paint portraits. He was a reporter for the *Boston Daily Advertiser* at the 1876 Philadelphia Centennial exposition, where the nostalgic displays of American colonial furniture, decorative arts, and other artifacts coincided with and perhaps spurred his own growing interest in the American Colonial past. Eventually that interest became a point of departure for his historical genre paintings, his magazine illustrations, and his collection of Americana.

Millet joined the growing colony of American art students in Paris in 1877, spent several months of that year as a correspondent at the front lines of the Russo-Turkish War, and returned to Paris in 1878 to serve there as a juror for the American section of the 1879 Exposition Universelle. Soon afterward, in London, he met Lawrence Alma-Tadema, whose sentimental works he admired, and by 1885 had settled in the English village of Broadway, alternating time there with winters in New York. To the genre scenes of ancient Greece for which he had become known, Millet added seventeenth- and eighteenth-century England and Colonial America as historical specialties.

Millet participated in one of the first important mural projects in America when he assisted John La Farge with those at Trinity Church, Boston, in 1876–77. In 1892 Daniel Burnham asked Millet to become director of decorations for the 1893 Chicago World's Columbian Exposition, an appointment that gave him complete charge of the design and execution of the murals and sculptures to adorn the festival's grandiose, almost utopian classical architecture. He continued to devote much time and energy to reviving the lost art of monumental mural painting and establishing it as an important form of public art in America. He was responsible for the murals at the State Capitol of Minnesota at Saint Paul (1905–7), the Essex County Courthouse in Newark, New Jersey (1907), the Baltimore Custom House (1908), the Cleveland Trust Company (1909), and the Cleveland Federal Building (1911), among others; in these he depicted historical episodes from each city's past rather than the academic allegories preferred by mural painters such as Kenyon Cox.

The artist exhibited at six of Carnegie Institute's annual exhibitions, beginning with the first one in 1896, and was an active member of its Foreign Advisory Committee between 1903 and 1906. With Charles McKim and Augustus Saint-Gaudens, Millet helped to found the American Academy in Rome in 1905 and served as its chief administrator for several years, before his tragic death aboard the ocean liner *Titanic*.

Millet's connections with the city of Pittsburgh extended back at least as far as 1894, when the Bank of Pittsburgh commissioned from him a large lunette to balance Edwin H. Blashfield's *Manufacture* mural on the opposite wall of the bank's main hall. His mural, called *Thesmophoria (Agriculture)* and completed in 1897, no longer survives. The bank failed in 1931 and in May 1944 the bank's building was finally demolished, along with its decorations.[1]

1 Weinberg, "The Career of Francis Davis Millet," p. 18, n. 101.

Bibliography Francis Davis Millet Papers, c. 1867–1928, and Francis Millet Rogers Papers, c. 1897–1957, Archives of American Art, Washington, D.C.; Henry James, "Our Artists in Europe," *Harper's Monthly* 79 (June 1889), pp. 50–66; Sylvester Baxter, William A. Coffin, Edwin Howland Blashfield, et al., *Art and Progress* 3, Francis Davis Millet memorial number (July 1912); Dayton Art Institute, Ohio, *American Expatriate Painters of the Late Nineteenth Century* (1977), exh. cat. by Michael Quick, pp. 114–16, 153–54; H. Barbara Weinberg, "The Career of Francis Davis Millet," *Archives of American Art Journal* 17, no. 1 (1977), pp. 2–18.

Anna Pearson Hall, c. 1903

Oil on canvas mounted on board
36 x 29 in. (91.4 x 73.7 cm)
Signature: F. D. Millet (lower left)

Millet's Pittsburgh connections, which were strongest from 1896 to 1905, encouraged Pittsburghers to commission portraits from him. This painting was commissioned by Robert Calvin Hall, who wanted a portrait of his daughter. Hall was an investment broker, former president of the Pittsburgh Stock Exchange, founder of the Duquesne Light Company, and an art collector. He no doubt met Millet either through the financial community, while Millet was working on the Bank of Pittsburgh mural, or through Carnegie Institute's exhibitions. The opportunity to engage Millet on a portrait may have arisen while the artist served as an advisor to the Board of Directors of the 1904 Universal Exposition in Saint Louis. It is likely that he had to make several trips from New York to Saint Louis by way of Pittsburgh in 1903, where he executed two modest-size works: this canvas and a portrait plaque in bronze of the same subject, which is also owned by The Carnegie Museum of Art.

This painting shows the five-year-old Anna Hall in a starched cotton dress. Seated on a low bench, she holds a picture book in her lap and looks steadily at the viewer. The portrait lacks the decorative setting that made Millet's genre scenes and mural paintings so effective. Instead, he placed his sitter against a plain, dark background, relying on strong lights and deep shadows for pictorial interest.

KP, DS

Exhibition Department of Fine Arts, Carnegie Institute, Pittsburgh, 1905, *Tenth Annual Exhibition*, no. 178.

Provenance Robert Calvin Hall, Pittsburgh, c. 1903; Anna Pearson Hall, his daughter, by descent.

Bequest of Anna Pearson Hatch, 1976, 76.34.1

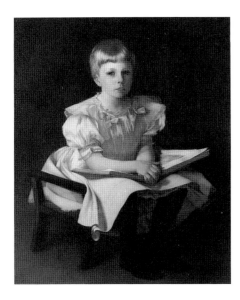

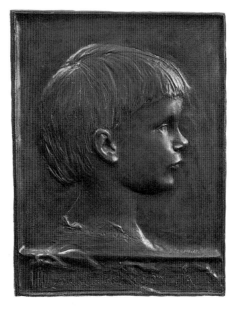

Anna Pearson Hall, 1903

Bronze
11⅛ x 8⅜ in. (28.3 x 21.3 cm)
Markings: F. D. Millet /1903. (lower right); ANNA
PEARSON HALL (lower center); HENRY BONNARD
BRONZE CO./FOUNDERS. N.Y. 1903. (lower left)

Millet was not noted for his sculptural
works, and apparently executed only two
portrait reliefs, of which this is one. The
rendering of Anna Pearson Hall is obvi-
ously patterned after Augustus Saint-
Gaudens's relief portraits. The profiled
head and treatment of the hair, the lower
border with an inscription, and the tex-
ture of the space surrounding the head all
derive from Saint-Gaudens's style. How-
ever, the proportions of Millet's rectangle
are rather squat and his surface as a whole
lacks Saint-Gaudens's fluidity and vitality.
Millet's handling corresponds, rather, to
the tight brushwork and hard surfaces of
the figures in his paintings.
KP, DS

Exhibition Pennsylvania Academy of the Fine
Arts, Philadelphia, 1904, *The Seventy-third
Annual Exhibition of the Pennsylvania Academy
of the Fine Arts*, no. 872.

Provenance Robert Calvin Hall, Pittsburgh,
c. 1903; Anna Pearson Hall, his daughter, by
descent.

Bequest of Anna Pearson Hatch, 1976, 76.34.2

Thomas Moran

1837–1926

ORN IN THE LANCASHIRE mill town
of Bolton, Thomas Moran emigrated
with his family from England to America
when he was seven years old and grew up
in Philadelphia. Apprenticed at a wood-
engraving firm in 1853, he soon followed
the example of his older brother Edward
and became a landscape painter. He first
exhibited his landscapes in 1858 at the
Pennsylvania Academy of the Fine Arts,
Philadelphia. Through his acquaintance
with James Hamilton, an American fol-
lower of J. M. W. Turner, Moran quickly
became an ardent admirer of Turner. In
1861 he visited England specifically to
study the work of the great British land-
scapist. Moran's subsequent oil paintings
and watercolors acknowledged a consid-
erable debt to Turner's colorism, particu-
larly to his dramatic effects of light and
mist.

Through the 1860s, Moran supported
himself as a landscape painter and maga-
zine illustrator. Then, in 1871, he was
introduced to the scenery from which he
eventually built his reputation. In that
year he traveled to the Yellowstone area
with a government expedition led by Dr.
F. V. Hayden. His landscape sketches
helped persuade Congress to declare
Yellowstone the first national park, while

his monumental, Turneresque canvas *The
Grand Canyon of the Yellowstone* (1872,
United States Department of the Interior,
National Park Service, Washington,
D.C.) was a critical and popular success.
Moran made many subsequent visits to
the American West and became known as
one of its foremost pictorial interpreters.

In the late 1870s Moran also began
painting the countryside around East
Hampton, New York. Trips to Venice in
1886 and 1890 added yet another theme
to his repertoire. His landscapes were typ-
ically vast and panoramic. They were also
spectacularly colored, with sunsets, haze,
or bright foliage and vivid rock forma-
tions. They were invariably idealized, but
the idealization tended to bypass narrative
incident and man's presence. In 1916 the
artist began to spend his winters in Santa
Barbara, California, and he moved there
permanently in 1922.

There were few opportunities to enjoy
Moran's work in Pittsburgh. Three of
his paintings were included in the Art
Society of Pittsburgh exhibition of
1895, but despite frequent invitations,
Moran never exhibited at the Carnegie
Internationals. In 1905 he explained his
failure to participate as a dislike of juried
exhibitions: "I have received your note of
Sept. 8 enclosing blank for the Pittsburgh
exhibition, and I would be glad to send
there; but of late years I never submit my
pictures to the vagaries of juries, as I
think my status in the world of art and
my age entitles me to be '*hors concours.*'"[1]

1 Thomas Moran to John Beatty, September
15, 1905, Carnegie Institute Papers, Archives of
American Art, Washington, D.C.

Bibliography Edmund Buckley, "Thomas
Moran: A Splendid Example of American
Achievement in Art," *Fine Arts Journal* 20
(January 1909), pp. 8–17; Fritiof Fryxell, ed.,
Thomas Moran: Explorer in Search of Beauty
(East Hampton, N.Y., 1958); William H.
Gerdts, "The Painting of Thomas Moran:
Sources and Style," *Antiques* 85 (February
1964), pp. 202–5; Thurman Wilkins, *Thomas
Moran: Artist of the Mountains* (Norman,
Okla., 1966); Amon Carter Museum, Fort
Worth, Tex., " *The Most Remarkable Scenery*":
*Thomas Moran's Watercolors of the American
West* (1980), exh. cat. by Carol Clark.

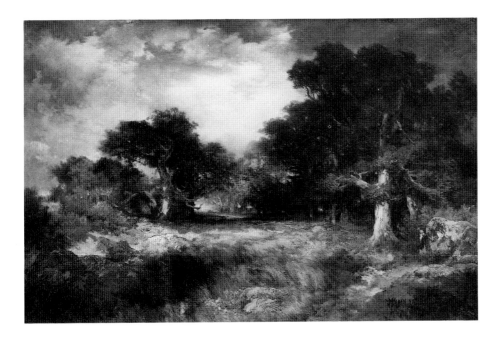

A Long Island Landscape, 1898

Oil on canvas
20 x 30⅛ in. (50.8 x 76.5 cm)
Signature, date: TMoran, N.A./1898 (lower right, in monogram)

In 1924 an admirer of Moran's work wrote, "Two spots on earth most completely satisfy Mr. Moran. One is the Grand Canyon, and the other is East Hampton, Long Island, where in the serene atmosphere of this quaint village with its windmills and seaswept coast, he basks in the beauty of long familiar scenes."[1] Moran first visited East Hampton in 1878, and in 1884 built a studio there. He summered regularly on Long Island until 1922 and produced more paintings, watercolors, and etchings of the area than of any other place with the exception of Venice.

In contrast to his panoramic views of Western grandeur, Moran's Long Island paintings are small-scale pastoral scenes in keeping with the late-nineteenth-century American taste for the intimacies of Barbizon landscape. Moran was certainly familiar with, and influenced by, the Barbizon painters; however, his sensibilities were predominantly English, and the windy, luminous skies and the overall spaciousness of the Long Island scenes derive ultimately from Constable.[2]

Indeed, it was the "English country-side, the antique rural charm"[3] of the East Hampton area that appealed to him most strongly.

Moran also admired the landscape-painting style of the seventeenth-century Dutch school, especially the work of Jacob van Ruisdael. In *A Long Island Landscape* and other East Hampton subjects, he borrowed Ruisdael's device of using alternate patches of sunlight and shadow to indicate depth. In keeping with these influences, Moran's foliage lacks the mossy quality and backlighting typical of Barbizon school landscapes. Instead, in the artist's distinct, slightly icy colors, there is a lingering homage to earlier naturalistic schools.

LD

1 Harriet Sisson Gillespie, "Thomas Moran, Dean of Our Painters," *International Studio* (August 1924), p. 361.

2 Guild Hall Museum, East Hampton, N.Y., *Thomas Moran: A Search for the Scenic,* 1980–81, exh. cat. by Phyllis Braff, pp. 22–23.

3 Ibid., p. 23.

Provenance Ira Spanierman Galleries, New York, by 1973.

Howard N. Eavenson Fund for the Howard N. Eavenson Americana Collection, 1973, 73.38.2

George L. K. Morris

1905–1975

BORN INTO WEALTH in New York City, George Lovett Kingsland Morris was the descendant of Lewis Morris, a signer of the Declaration of Independence. His privileged circumstances provided him with lifelong opportunities for learning, traveling, writing, collecting art, and promoting cultural causes. Between 1918 and 1924 he studied the classics and art at Groton, a private academy in Connecticut. He continued his literary and artistic studies from 1924 to 1928 at Yale University, where he developed the desire for a dual career as a writer and painter.

During the summer of 1927, while studying at an art school for American students in Fontainebleau, Morris renewed the acquaintance of an old family friend, Albert E. Gallatin. In the fall of the next year, while attending the Art Students League in New York, he was introduced to modernism through Gallatin's private collection as well as his Gallery of Living Art (which in 1936 became the Museum of Living Art) at New York University. At Gallatin's suggestion, Morris studied in the spring of 1929 and 1930 with Fernand Léger at the Académie Moderne in Paris.

In Paris, Morris also met many of the artists Gallatin knew: Pablo Picasso, Georges Braque, Jean Arp, Jean Hélion, and Piet Mondrian. Morris thus became immersed in the Parisian avant-garde and the Cubist aesthetic of his mentor Gallatin. From 1929 to 1935 Léger, Henri Matisse, Robert Delaunay, Juan Gris, and Hélion were sources for Morris's Synthetic Cubist paintings, in which he combined American imagery with Cubist techniques.

By this thorough assimilation of modernism, Morris had, by 1935, arrived at his own style. His paintings, collages, and sculptures usually consisted of angular, abstract geometric forms, but he also experimented with the biomorphic vocabulary of Joan Miró and Arp. Between 1938 and 1942 his paintings were ordered by linear grids resembling Analytical Cubist markings, which

reflected the inspiration of such sources as Léger, Stuart Davis, Ben Nicholson, and Mondrian. The implicit figurative references of some of these works were made explicit in his wartime paintings and sculpture made between 1942 and 1945.

From 1935 to 1943 Morris became a prolific, well-known writer and spokesman for American modernism. A cofounder of the American Abstract Artists, he was a major contributor to the group's yearbooks, an organizer of its exhibitions, and its president from 1949 to 1951. As curator of Gallatin's Museum of Living Art, he wrote articles promoting it as well as essays for its 1936 and 1940 collection catalogues. In 1936 he participated in Gallatin's *Five Contemporary American Concretionists*, an exhibition intended to counter the exclusively European *Cubism and Abstract Art* exhibition at the Museum of Modern Art, New York.

Morris also served on the advisory council of the Museum of Modern Art from 1933 to 1940 and edited its bulletin from 1935 to 1936. In the international cause of geometric abstraction, he collaborated from 1937 to 1939 with Gallatin, Arp, Sophie Taeuber-Arp, and César Domela on *Plastique*, a Paris-based art magazine. From 1937 to 1943 he was editor and financial supporter of the revolutionary *Partisan Review*. Among his subsequent exhibition activities, he participated from 1945 to 1955 in seven of the annual exhibitions held at the Carnegie Institute.

After World War II Morris taught briefly at the Art Students League, New York, developed his nonfigurative work, and experimented with new materials, including Bakelite and Vitrolite incorporated into frescoes. By 1950–51 he had developed a style of painting in which he combined linear perspective with spirals and checkered areas to create an illusion of space while preserving the picture plane. Other late paintings reflect the influences of Abstract Expressionism and Minimalism. He also continued to write and produce sculpture. In 1952 he served as a delegate to the first UNESCO conference of artists, writers, and musicians. In 1957 he wrote *The World of Abstract Art*, published by the American Abstract Artists, in which he expounded his lifelong commitment to clarity, structure, quality, and beauty as expressed in Cubist-based abstract art.

Morris, who divided his time between New York and the Berkshire Mountains, died while in Lenox, Massachusetts, his country home since childhood.

Bibliography George L. K. Morris Papers, Archives of American Art, Washington, D.C.; Ward Jackson, "George L. K. Morris: Forty Years of Abstract Art," *Art Journal* 32 (Winter 1972–73), pp. 150–56; Dorian H. Stross, "George L. K. Morris: Artist and Advocate of Abstract Art, or How a Millionaire Found Meaning through Modern Art," Master's thesis, Wayne State University, 1976; Peninah R. Y. Petruck, "American Art Criticism 1910–1939," Ph.D. diss., New York University, 1979, pp. 238–74; Melinda Lorenz, *George L. K. Morris: Artist and Critic* (Ann Arbor, 1982).

Stockbridge Church, 1935
(Church at Interlaken)

Oil on canvas
54⅛ x 45¹⁄₁₆ in. (137.4 x 114.4 cm)
Signatures, inscription: Morris (lower right); George L. K. Morris/Stockbridge Church/1935 (on reverse)

One of Morris's earliest paintings, *Stockbridge Church* is a distinctive, characteristic, and original synthesis of an American subject with the European Cubist-based styles of Juan Gris and Jean Hélion. The flat, interlocking angular planes and dark, refined color scheme evoke the impact of Gris's Synthetic Cubist paintings in the Museum of Living Art and in Morris's own collection.[1] He particularly identified with Gris's "monumentality of style... aristocratic suavity... [and] ability to unify a picture into a concentrated unit."[2] His use of flattened, overlapping geometric forms silhouetted against a back-

Fig. 1 George L. K. Morris, *New England Church*, 1935–36. Oil on canvas, 36⅛ x 30 in. (91.7 x 76.2 cm). University of Oklahoma Museum of Art, Norman, purchase, 1948

Fig. 2 George L. K. Morris, *Country Church*, 1947. Oil on canvas, 46½ x 37½ in. (118.1 x 95.3 cm). Courtesy Hirschl and Adler Galleries, New York

ground of rectangular bands is suggestive of works by Hélion that Albert E. Gallatin owned, such as *Composition* (1934, Philadelphia Museum of Art).

While basing his work on European sources, Morris strongly believed in developing from them an American aesthetic expression. To achieve this goal, he said artists must embark on a "journey backward in search of significant form."[3] He employed Native American motifs in his 1936 series of paintings based on Indian subjects. He also used references to New England architecture to achieve the goal of an abstract form with national character.

Morris's choice of an early-nineteenth-century American building to be the subject of *Stockbridge Church* was surely bound up with his own identity. He was a preservationist who repeatedly spoke out on behalf of endangered historical landmarks in the vicinity of his home in Lenox, Massachusetts. He also cherished an early aspiration to be an architect, designing, as a teenager, opera houses, cathedrals, and other grand buildings. As a painter and sculptor, that predilection for architectonic clarity continued.[4] Throughout his career he created paintings based on architectural motifs, particularly churches in America and Europe.

Two other canvases by Morris are especially similar to *Stockbridge Church. New England Church*, painted in 1935–36 (fig. 1), is very close in terms of its composition and palette. Its markings are more

4 Lorenz, *George L. K. Morris*, p. 3.

5 Edward Alden Jewell, "One-Man Art Show by G. L. K. Morris," *New York Times*, October 30, 1935, p. 19.

6 Morris Papers, Archives of American Art.

References Paul Cummings, unpublished interview with George L. K. Morris, Dec. 11, 1968, in Morris Papers, p. 22; Lorenz, *George L. K. Morris*, fig. 5, pp. 17–18; J. R. Lane, "American Abstract Art of the '30s and '40s," *Carnegie Magazine* 56 (Sept.–Oct. 1983), p. 17.

Exhibitions Museum of Living Art, New York, 1936, *Abstract Paintings by George L. K. Morris*, no cat.; Berkshire Museum, Pittsfield, Mass., 1945, *Painting and Sculpture by Outstanding Berkshire Artists*, no. 30; Downtown Gallery, New York, 1948, *New Paintings by George L. K. Morris*, no. 4; Corcoran Gallery of Art, Washington, D.C., 1965, *George L. K. Morris: A Retrospective Exhibition of Paintings and Sculpture, 1930–1964*, no. 8; Berkshire Museum, Pittsfield, Mass., 1966, *George L. K. Morris*, no. 5, as *Church at Interlaken;* Whitney Museum of American Art, New York, 1968, *The 1930's: Painting and Sculpture in America*, no. 77; Hirschl and Adler Galleries, New York, 1971, *George L. K. Morris: A Retrospective Exhibition*, no. 6; Montclair Art Museum, N.J., 1971, *George L. K. Morris Retrospective Exhibition*, no. 12; Hirschl and Adler Galleries, New York, 1974, *George L. K. Morris: Abstract Art of the 1930s*, no. 9; Katonah Gallery, N.Y., 1976, *American Painting, 1900–1976*, exh. cat. by J. I. H. Baur, no. 56; Museum of Art, Carnegie Institute, 1983–84, *Abstract Painting and Sculpture in America, 1927–1944* (trav. exh.), exh. cat. ed. by J. R. Lane and S. C. Larsen, no. 102.

Provenance Downtown Gallery, New York, as agent, by 1948, until 1968; the artist, until 1971; Hirschl and Adler Galleries, New York, 1971; Janie C. Lee Gallery, Houston, 1975; Jerry Leiber, New York, by 1980.

A. W. Mellon Acquisition Endowment Fund, 1980, 80.52

See Color Plate 33.

explicit than the abstract ciphers of *Stockbridge Church.* The fragmented, scattered lines of the Carnegie's painting (in which can be detected rounded doors and a narrow steeple) have been transformed into emblematic references to wagon wheels, hymns, wooden planks, and a tic-tac-toe game as well as architecture. In 1947 Morris created yet another variation on this theme, *Country Church* (fig. 2), which was included in Carnegie Institute's *Painting in the United States* exhibition for that year. In all three paintings, crossing lines connect geometric forms and evoke the image of a crucifix.

Stockbridge Church was included in Morris's solo show in November 1935 at the Museum of Living Art.[5] Although it was then exhibited several other times under the same title, the artist evidently changed its title at some point: he crossed out "Stockbridge" and wrote "Interlaken" on the back of a photograph[6] and showed the canvas as such in 1966. This new title alludes to a brick church of 1830 at Interlaken, a town near Stockbridge, instead of the First Congregational Church of 1734 in Stockbridge. However, Morris subsequently allowed his painting to be exhibited in 1968, 1971, and 1974 under its first title, which was henceforth retained and appears to be the correct one. The work is an important early abstraction by Morris, which exemplifies his synthesis of European stylistic sources with an American subject to create a native modernist mode.

GS

1 Lorenz, *George L. K. Morris*, p. 17.

2 New York University, *Museum of Living Art: A. E. Gallatin Collection* (New York, 1940), n.p.

3 George L. K. Morris, "On America and a Living Art," in New York University, *Museum of Living Art* (New York, 1936), n.p.

Elie Nadelman

1882–1946

As the first modernist sculptor from Europe to take up residence in the United States, Elie Nadelman was a product of the same immigration that, at the outbreak of World War I, brought numerous avant-garde artists to this country. Like them, Nadelman arrived fully formed in his artistic priorities. As a youth in Warsaw he was fond of music, particularly folk songs, and mastered the flute. He enrolled in Warsaw's art academy in 1899, then served briefly in the Imperial Russian Army before returning to his art studies in 1901.

In 1904 Nadelman went abroad, first to Munich, then to Paris. He became interested in the sculpture of Auguste Rodin and what was then called "primitive" art, and soon came to know avant-garde artists, such as Pablo Picasso and Constantin Brancusi. His first solo exhibition, held at the Parisian Galerie Druet in 1909, marked Nadelman's successful entry into the modernist movement. He made friends with Henri Matisse, André Gide, and Gertrude and Leo Stein and saw his sculpture exhibited in London and Barcelona.

The advent of World War I drove Nadelman from Europe to London and then to America. By 1914 he was in New York, his career blossoming anew under the patronage of Helena Rubinstein, who commissioned from him numerous marble heads for her salons. In 1915 Alfred Stieglitz mounted the sculptor's first American exhibition at the Photo-Secession Gallery.

Nadelman worked in a wide range of materials, from bronze and marble to clay, papier-mâché, and electroplated metal. Similarly, his style was a lively fusion of idealized human form, contemporary imagery, and an abstractionist's interest in mass and void, curves and countercurves. His work won the admiration and support of Frederick MacMonnies, Gertrude Vanderbilt Whitney, Paul Manship, and numerous other members of both the avant-garde and academic circles in the United States.

In 1919 Nadelman married Viola M. Flannery, a wealthy widow; with her he purchased Alderbrook, an estate at Riverdale-on-the-Hudson, New York, his home for the rest of his life. From 1924 to 1926 he and his wife added a museum to house their extensive folk-art collection. However, the Depression and stock-market crash brought financial losses that forced the sale of that collection and caused Nadelman to retreat within his estate, rarely exhibiting or selling his sculpture. The 1930s brought two additional setbacks: in 1933 he suffered the loss of his studio and, in 1935, the accidental destruction during the reconstruction of his studio of many of the works still in his possession. During World War II Nadelman, despite his uncertain health, volunteered for both watch duty and a post at the Bronx Veterans' Hospital, where he worked as an art therapist.[1]

1 Whitney Museum of American Art, *The Sculpture and Drawings of Elie Nadelman*, p. 15.

Bibliography Museum of Modern Art, New York, *The Sculpture of Elie Nadelman* (1948), exh. cat. by Lincoln Kirstein; Lincoln Kirstein, *Elie Nadelman* (New York, 1973); Whitney Museum of American Art, New York, *The Sculpture and Drawings of Elie Nadelman, 1882–1946* (1975), exh. cat., introduction by John I. H. Baur.

Circus Performer, 1919

Painted wood
33¾ x 9 x 5½ in. (85.7 x 22.9 x 14 cm)

Between 1916 and 1919 Nadelman completed a series of plaster and carved-wood genre figures inspired by theater and circus personalities. These include *Woman at the Piano* (1917, Museum of Modern Art, New York), *Dancer* (1918–19, Wadsworth Atheneum, Hartford, Conn.), and *Circus Girl* (1919, Hirshhorn Museum and Sculpture Garden, Washington, D.C.). The Carnegie *Circus Performer* is one of these. It demonstrates both the stylistic sources and formal aims that dominated Nadelman's vision during this period.

As both connoisseur and artist, Nadelman was a leading figure in the revival of folk art in this country; accordingly, *Circus Performer* communicates much of the simplicity, wit, and untutored directness that he found engaging in naïve art. Nadelman, however, combined the elemental appeal of carving with the curvilinear cadences and elegant surface rhythms of modern sculpture. The flowing contours of *Circus Performer*'s body have the delicacy and grace of Minoan sculpture and Art Nouveau—two major sources to which Nadelman consistently referred in his work, both of which complement its folk-art dimension.

Nadelman's references to past traditions in no way undercut the contemporaneous appeal or compelling vitality of *Circus Performer*. The ascending, undulating rhythms, organic incorporation of negative space, and effortless suppleness of the figure's pose activate the space she occupies. Discussing Nadelman's artistic development, Athena T. Spear classified the *Circus Performer* figure type as within the sculptor's "tubular style," characterized by smooth, volumetric treatment and a distillation of the human figure to its essential elements.[1] It reflects Nadelman's often-repeated intention to use his subjects to create forms that do not merely imitate life in nature but that possess a life of their own. Nadelman carved three other, nearly identical versions of this piece between 1919 and 1920 (Hirshhorn Museum and Sculpture Garden, Washington, D.C.; collection Ralph O. Esmerian, New York; private collection, New York). All four are characterized by sensuous line expressed in three dimensions.

LM

1 Whitney Museum of American Art, *The Sculpture and Drawings of Elie Nadelman, 1942–1946*, p. 8.

References Whitney Museum of American Art, *The Sculpture and Drawings of Elie Nadelman, 1942–1946*, p. 67; H. B. Teilman, "Three Early-Twentieth-Century American Sculptors," *Carnegie Magazine* 51 (Mar. 1977), p. 116; R. K. Tarbell, "The Impact of the Armory Show on American Sculpture," *Archives of American Art Journal* 18, no. 2 (1978), p. 8.

Provenance Mrs. Elie Nadelman, until 1948; Swetzoff Gallery, Boston; Max Wasserman, Boston; Pace Gallery, New York, by 1974.

Gift of the Pace Gallery, in honor of the Sarah Scaife Gallery, 1974, 74.33.1

Robert Loftin Newman

1827–1912

ROBERT LOFTIN NEWMAN occupies a place in the history of American art similar to that of Ralph Blakelock and Albert P. Ryder, even though Newman was twenty years their senior and nominally not within their artistic generation. With little formal training, he developed a personal style using the cues of nineteenth-century Romanticism, which, in the last quarter of the nineteenth century, took on the innovative aspect of visionary art.

Born in Richmond, Virginia, Newman spent much of his early life in Clarksville, Tennessee, where he began to paint seriously, without benefit of professional instruction, shortly before his nineteenth birthday. He traveled to Europe in 1850, intending to enroll at the academy in Düsseldorf, but instead, at the urging of William Morris Hunt, he studied in Paris with the more progressive Romantic painter Thomas Couture. The tutelage, however, lasted only five months. During a second visit to Paris in 1854, Hunt took Newman to Barbizon and introduced him to Jean-François Millet. Newman seems to have maintained a degree of contact with the Romantic painting of the Barbizon school; years later, in 1882, Newman lived at Barbizon for several months.

Newman painted portraits and gave private lessons at his Clarksville studio until 1864, when he was drafted into the Confederate army. He probably lived in New York from 1865 to 1871, and after a short-lived attempt to found an art academy in Nashville, he settled permanently in New York in 1873. He supported himself for several years by designing stained glass. He also painted, his output being small canvases, mostly of biblical or allegorical figures in landscapes. The settings were invariably dark and murky, the tentative human presence in them punctuated by accents of bright color.

Although Newman rarely exhibited and was virtually unknown, his work appealed to a small group of younger artists and connoisseurs, including William Merritt Chase, the sculptor Daniel Chester French, the architect Stanford White, and the collector Thomas B. Clarke. Sometime in the 1880s Newman made friends with Albert P. Ryder, with whom he collaborated in 1898 on a small seascape triptych.

In 1894 Newman's friends organized exhibitions of his work in New York and Boston. These were well received but failed to bring financial success. The artist had little commercial acumen and continued to depend on the generosity of his friends to maintain his simple mode of life. He died in his sleep, asphyxiated by a leaky gas heater in his New York studio.

Bibliography Frederic Fairchild Sherman, "Robert Loftin Newman: An American Colorist," *Art in America* 4 (April 1916), pp. 177–84; Nestor Sanborn to Frederic Fairchild Sherman, "Reminiscences about the Life of the Artist," April 25, 1919, Frick Art Reference Library, New York, manuscript; Nestor Sanborn, "Robert Loftin Newman, Colorist," *Brooklyn Museum Quarterly* 8 (October 1921), pp. 157–61; Albert Boime, "Newman, Ryder, Couture, and Hero Worship in Art History," *American Art Journal* 3 (Fall 1971), pp. 5–22; Marchal E. Landgren, *Robert Loftin Newman, 1827–1912* (Washington, D.C., 1974).

At the Spring, 1897
(Mother and Nude Child)

Oil on canvas
20 x 16 in. (50.8 x 40.6 cm)
Signature, date: R L Newman/1897 (lower left)

At the Spring is characteristic of Newman's work. It consists of a few softly rendered, luminous figures, in this case a mother and her child, set against a dark landscape. The mother and child was Newman's favorite subject, and he painted it in both sacred and secular versions, distinguishing the former from the latter by including a nimbus around the child's head.

In its skillful, vigorous brushwork, its rapid scumbles and glazes, and its handling of chiaroscuro, *At the Spring* betrays the influence of Thomas Couture, with whom Newman had studied nearly fifty years earlier. Like Eugène Delacroix and Couture, Newman showed an interest in the coloring of the Venetian old masters. His rendering of form recalls that of Couture, who desired to preserve the freshness of the original sketch in the finished painting. In this respect, Newman also showed clear affinities to Honoré

Daumier and Jean-François Millet. He was well acquainted with the works of both, and even occasionally turned to them for subjects.

In 1898 Daniel Chester French, perhaps Newman's most generous admirer, purchased an undated oil study for this painting entitled *Mother and Child*, which still hangs at Chesterwood, the former French estate at Stockbridge, Massachusetts. The brushwork there is broader, the treatment of forms even less detailed, the figures much larger in relation to the ground than in the finished version. Shown at the Society of American Artists, New York, in 1899,[1] it was one of the relatively few paintings by Newman exhibited during the artist's lifetime.

KN

1 Society of American Artists, New York, 1899, *Twenty-first Exhibition of the Society of American Artists*, no. 315.

References Landgren, *Robert Loftin Newman, 1827–1912*, pp. 17, 137; M. E. Landgren, "The Two Worlds of Robert Loftin Newman," *Antiques* 108 (Dec. 1975), pp. 176–81.

Exhibitions Graham Gallery, New York, 1961, *Robert Loftin Newman*, no. 26, as *Mother and Nude Child*; National Collection of Fine Arts, Washington, D.C., 1973–74, *Robert Loftin Newman, 1827–1912* (trav. exh.), no. 21.

Provenance Alma Quint, until 1952; Milch Galleries, New York; Babcock Galleries, New York, by 1952; Joseph Katz, Baltimore, by 1954; Victor D. Spark, New York, until 1971.

Anonymous gift, 1971, 71.15

Isamu Noguchi
1904–1988

THE FOCUS OF Isamu Noguchi's long and varied career as a sculptor was the reconciliation of Eastern and Western artistic traditions. Best known for his monumental public works and designed environments, he also created private sculpture, portrait heads, stage sets, theater costumes, and furniture designs. Noguchi was born in Los Angeles to a Japanese father and an American mother, both of whom were writers. When he was two years old he and his mother moved to Japan, where he was briefly reunited

with his father. There he spent a difficult and rather lonely childhood: his parents separated, after which his father virtually ignored his existence, and his mixed ethnic heritage caused him to be excluded from his Japanese peer group.

Noguchi returned to the United States alone in 1918 to attend high school in Rolling Prairie, Indiana. On graduation he moved to New York and was apprenticed to Gutzon Borglum, sculptor of the Mount Rushmore heads. After three months, Borglum told Noguchi he would never become a sculptor, so he entered Columbia University as a premedical student. In 1924 he enrolled at the Leonardo da Vinci Art School and shortly afterward devoted himself once more to sculpture. A facility for academic and rather sentimental nudes brought him two honorable mentions in the Prix de Rome competitions conducted by the American Academy in Rome, as well as several New York exhibitions.

Then, in 1926, he visited an exhibition of Constantin Brancusi's work at New York's Brummer Gallery. The Romanian sculptor's abstract works transfixed him and set his own career on a new path. In 1927 he won a Guggenheim Fellowship and went to Paris, where he worked as a studio assistant for Brancusi while attending classes at the Académie de la Grande Chaumière and the Atelier Colarossi. According to the artist, Brancusi became a seminal influence:

> Brancusi, like the Japanese, would take the quintessence of nature and distill it. Brancusi showed me the truth of materials and taught me never to decorate or paste unnatural materials on to my sculptures, to keep them undecorated like the Japanese house.[1]

In Paris Noguchi produced his first abstract sculptures in stone and metal. After his return to New York in 1928, these works were shown to critical acclaim at the Eugene Schoen Gallery. Unfortunately, they failed to sell, and Noguchi instead supported himself by making portrait heads in bronze and terra-cotta. Among his early sitters were composer George Gershwin, dancer Martha Graham, and architect Buckminster Fuller.

With the money earned from portraiture, Noguchi left for an extended visit to

the Orient in 1930. After eight months in Peking, where he learned brush-and-ink drawing, he journeyed to Kyoto and studied ceramics. During that time he became fascinated with the traditional Japanese garden as articulated space, an interest that would surface years later in his own designed environments.

In 1932 Noguchi returned to New York and, despite enthusiastic reviews for his recent drawings and ceramics, was once again compelled to earn his livelihood through portraiture. Although he was not politically active in the 1930s, his belief in art as a form of social protest is exemplified in *Death* (1934, estate of the artist), a metal sculpture, inspired by a newspaper photograph, of a lynched and burned black man.

He worked briefly, and without much success, for the Works Progress Administration during the Depression. In 1935 he designed the sets for Martha Graham's ballet *Frontier*, the first of many such collaborations. He spent the year 1935–36 in Mexico City, where he executed a relief on the history of Mexico in polychrome cement and carved brick for the Rodriguez public market there. Throughout the 1940s he produced freestanding sculptures and reliefs in a wide variety of mediums, many of them incorporating Surrealist imagery. In 1942 he voluntarily entered an internment camp for Japanese-Americans in Poston, Arizona, then returned to New York later that year.

By the late 1940s, Noguchi, whose work synthesized organic forms and elemental shapes, was acknowledged as one of the premier American abstract artists. During the late 1950s and 1960s, he added designs for meditative gardens and composed urban plazas to his repertoire. His best-known works of this kind are the Japanese-inspired UNESCO Gardens in Paris (1956–58), the austere, minimalist marble garden for Yale University's Beinecke Rare Book Library, New Haven (1960–64), and the constructed stone landscape elements for the Billy Rose Sculpture Garden at the Israel Museum in Jerusalem (1960–65).

Between 1958 and 1970 six of Noguchi's sculptures appeared in five Carnegie International exhibitions of contemporary art. In 1968, the Whitney Museum of American Art, New York, held the first major retrospective of his works. His awards included two prestigious prizes from the Art Institute of Chicago: the

Mr. and Mrs. Frank G. Logan Medal, 1960, and the Norman Wait Harris Bronze Medal, 1962. During the 1980s, the sculptor divided his time between his studios in Long Island City and Japan. Noguchi continued to create public and private sculptures in stone, metal, wood, and terra-cotta that exemplified his feeling for the sensual qualities of his medium and his profound respect for elemental, untamed nature. He died in New York.

1 Hunter, *Isamu Noguchi*, p. 35.

Bibliography Isamu Noguchi and John Becker, *Isamu Noguchi: A Sculptor's World* (London, 1967), foreword by R. Buckminster Fuller; Sam Hunter, *Isamu Noguchi* (New York, 1978); Nancy Grove and Diane Botnick, *The Sculpture of Isamu Noguchi, 1924–1979: A Catalogue* (New York, 1980); Whitney Museum of American Art, New York, 1980, *Isamu Noguchi: The Sculpture of Spaces*, exh. cat. by Nancy Grove; Nancy Grove, *Isamu Noguchi: A Study of the Sculpture* (New York, 1985).

Structure, 1945
(Woodboard Sculpture #1)

Pine
53 x 14 x 22 in. (134.6 x 35.6 x 55.9 cm)

Structure is apparently a prototype for Noguchi's stone-slab sculptures of the mid-1940s. In his autobiography the artist said, "I had been making some things in wood boards, harking back to my sheet metal work of 1927–28, and I felt it logical to continue my research into space, plus plane, plus void, using marble."[1] Evidently, *Structure*'s origins lie in the artist's earliest abstract experiments, created during his first trip to Paris. Brancusi's lingering influence can be seen in the sensual surfaces of the abstract forms and in the emphasis on the wood's integrity, but Noguchi preferred a more organic morphology.

The sculpture consists of five interlocking pieces of pine, elongated and biomorphic in shape. From the front, the work suggests a standing nude male figure with a cyclopean head and a prominent phallus. Viewed from ninety degrees to either side, the work takes on the appearance of a seated nude female, a small child loosely clasped in her outstretched arms. This synthesis of male and female owes a certain debt to Surrealists such as Yves Tanguy and possibly to Picasso's "bone" figures of the 1930s.[2]

Structure is formally discontinuous, for alternate views of the work cannot be anticipated, they can only be experienced. The interpretation of the piece is totally dependent on the angle of vision. Noguchi intended to give only the basic definitions of volume: the sculpture was to be completed in the eye of the spectator.[3]

Although Noguchi did not make full-size models for his stone sculptures, he did prepare small, detailed cardboard maquettes for them.[4] He then cut and carved stone sheets, notching and slotting each piece for quick assemblage. *Structure*, made of bare pine as a nearly full-size trial for a prospective work in stone, may be an experimental extension of the maquette-making process. A corresponding sculpture does not exist, but *Gregory* (1946, estate of the artist) comes close.

At first glance, *Structure*'s iconography seems to be closely related to that of Noguchi's stone-slab sculptures. The titles of these works possess mythic, anthropomorphic overtones: *Kouros* (1944–45, Metropolitan Museum of Art, New York), *Avatar* (1947, estate of the artist), and *Cronos* (1947, estate of the artist). Like *Structure*, they have a calm, almost ritualistic presence that suggests totemic figures, and they contain multiple gender references. Such a charged combination of the mythic, primitive, and surreal is found in the works of many of Noguchi's avant-garde contemporaries. However, the artist's own statement and the title, *Structure*, imply that formal concerns were paramount in the creation of the Carnegie piece. In a photograph of about 1945[5] of Noguchi's New York studio, *Structure* can be seen in the background; at that time, the pine was untreated. The Pittsburgh industrial tycoon and collector G. David Thompson had the piece varnished a walnut color after it came into his possession. In 1959 Carnegie Institute sought Noguchi's advice on how the sculpture might be restored. The artist replied:

A dark mat grey (or orange or a certain shade of yellow—Miró might use a blue but let mine be dark grey!) almost black seems to be the colour which will transform anything into art. My piece too could be thus rescued from the vile varnish I had nothing to do with.[6]

The museum briefly considered removing the varnish, but declined to do so, as it was felt that this might damage the wood.
RB

1 Noguchi and Becker, *A Sculptor's World,* p. 27.

2 Hunter, *Noguchi,* p. 82.

3 Noguchi and Becker, *A Sculptor's World,* p. 28.

4 Nancy Grove and Diane Botnick, *The Sculpture of Isamu Noguchi, 1924–1979: A Catalogue* (New York, 1980), p. 55.

5 Hunter, *Noguchi,* p. 83.

6 Isamu Noguchi to Gordon Washburn, undated letter received October 21, 1959, museum files, The Carnegie Museum of Art, Pittsburgh.

References N. Grove and D. Botnick, *The Sculpture of Isamu Noguchi, 1924–1979: A Catalogue* (New York, 1980), no. 233.

Provenance G. David Thompson, Pittsburgh, by 1957.

Gift of G. David Thompson, 57.42.7

Georgia O'Keeffe

1887–1986

GEORGIA O'KEEFFE is thought by many to have been the most important woman artist of her time. As a member of the Stieglitz group in New York, she played a significant role in the emergence of modernism in America following World War I. For the second half of her career she lived in New Mexico, where, until the end of her life, she produced highly original, evocative abstractions from nature. She has increasingly been considered one of the venerable modern masters of American art.

Born in Sun Prairie, Wisconsin, to an Irish-American father and a mother of Dutch-Hungarian ancestry, O'Keeffe attended parochial schools as a child. She enjoyed drawing and in 1905 enrolled in the School of the Art Institute of Chicago. After a year she withdrew to move to New York, where from 1907 to 1908 she studied at the Art Students League under William Merritt Chase. Between 1908 and 1914 she worked as a commercial illustrator, studied painting briefly at the University of Virginia, and taught art in the Amarillo, Texas, public schools.

In 1914 O'Keeffe returned to New York, where she studied at Teacher's College, Columbia University, under Arthur Wesley Dow. Dow, a painter and printmaker inclined to Symbolism and Orientalism, was the one art instructor whose lasting influence she acknowledged. In 1916, after teaching briefly in Virginia, she accepted the post of the head of the art department at West Texas State Normal School, again near Amarillo. She held the position until 1918, when she turned to painting full time.

In 1915 O'Keeffe produced her first significant abstractions. They came to the attention of Alfred Stieglitz, who mounted her first solo show at his avant-garde gallery 291 in 1917. Thereafter he exhibited her work almost yearly at his succession of Manhattan galleries and began to subsidize her so that she could abandon teaching. O'Keeffe married Stieglitz in 1924, thus cementing her association with him and the modernists he championed. These colleagues included Arthur Dove, Charles Demuth, Marsden Hartley, John Marin, and Paul Strand.

O'Keeffe's painting during the first years of her marriage consisted of masterful, abstract, evocative renderings of Manhattan skyscrapers such as *Radiator Building, Night, New York* (1927, Fisk University, Nashville). She began to work around Lake George in upstate New York and continued to develop her interest in nature abstractions, begun while teaching in the Texas Panhandle. Her close-ups of plants and flowers—for instance, *Black Iris* (1926, Museum of Modern Art, New York)—and her evocations of the landscape—and later, sky—made use of tight yet sensual rhythms of ambiguous forms in space, abstracted intuitively without reference to a specific theory. This became her avenue of independent artistic investigation, and she followed it faithfully for the rest of her career.

The sun-bleached, elemental imagery of the Southwest desert, with which O'Keeffe has been most strongly associated, became an important part of her work from 1929 on. That year marked the beginning of an annual summer pilgrimage, which continued for twenty years, to Taos in north-central New Mexico. In 1949, three years after Stieglitz's death, she moved to Abiquiu, forty miles from Taos, where she resided until her death. By the time she left New York, she had had two retrospectives—at the Art Institute of Chicago in 1943 and the Museum of Modern Art, New York, in 1946—and had been elected to the National Institute of Arts and Letters. Between 1933 and 1952 O'Keeffe participated in eleven annual exhibitions of Carnegie Institute. That number would have been higher had Stieglitz not repeatedly turned down requests by Homer Saint-Gaudens, director of the Department of Fine Arts, for submissions of O'Keeffe's work.

Georgia O'Keeffe's painting was particularly widely appreciated during the 1960s and 1970s, as evidenced by the retrospectives of her work that were mounted in 1960, 1966, and 1970. In the last

years of her life she took up pottery, cre-
ating austere, elemental shapes similar to
those that figured in some of her later
canvases. Her intentions remained consis-
tent: to fill space, as she once said, in a
beautiful way.[1]

1 Lisle, *A Biography of Georgia O'Keeffe*, p. 57.

Bibliography Amon Carter Museum, Fort
Worth, Tex., *Georgia O'Keeffe: An Exhibition
of the Work of the Artist from 1915 to 1966*
(1966), exh. cat. ed. by Mitchell Wilder;
Whitney Museum of American Art, New
York, *Georgia O'Keeffe* (1970), exh. cat. by
Lloyd Goodrich and Doris Bry; Laurie Lisle,
A Biography of Georgia O'Keeffe (New York,
1980); Jan Garden Castro, *The Art and Life of
Georgia O'Keeffe* (New York, 1985); National
Gallery of Art, Washington, D.C., *Georgia
O'Keeffe: Art and Letters* (1987), exh. cat. by
Jack Cowart and Juan Hamilton, letters select-
ed and annotated by Sarah Greenough.

Gate of Adobe Church, 1929

Oil on canvas
20¹⁄₁₆ x 16 in. (51 x 40.6 cm)

It was Mabel Dodge Luhan who convinced Georgia O'Keeffe to visit Taos, a town that had recently become an artist's colony of sorts. A Greenwich Village heiress and art patron, Mabel Luhan summered there and persuaded a number of her artist friends—including Marsden Hartley and Paul Strand—to spend their vacations with her. Georgia O'Keeffe went to Taos for the first time in 1929, taking up residence in the house D. H. Lawrence had rented there.

O'Keeffe's first summer was a stimulating and productive one.[1] It provided new imagery that resulted almost immediately in major works. She completed *Black Cross, New Mexico* (1929, Art Institute of Chicago), one of her most important paintings, and at the same time began her most noteworthy series to date—six canvases from 1929 and 1930 examining the eighteenth-century Ranchos de Taos mission church. Returned to New York, she exhibited her new paintings at Stieglitz's gallery, An American Place, and, to ensure that the stimulus of New Mexico would remain with her, had shipped back a barrel of bleached bones.

Gate of Adobe Church was yet another product of O'Keeffe's first trip to Taos. It possesses some of the same qualities as her Ranchos Church paintings: all are austere, solitary, and fragmented images,

their adobe masses seeming to rise from the earth of their own accord. The Carnegie's painting has been mistakenly identified as a depiction of the front of the Ranchos Church.[2] However, when O'Keeffe said of the latter, "I had to paint it—the back of it several times, the front once,"[3] she was no doubt referring to her *Ranchos Church, Front* (1929, collection Jack Lawrence, New York), not this painting, which depicts quite a different edifice.

The Carnegie's painting shows no identifiable features of the Ranchos Church: neither its twin bell towers nor the window over its portal; neither its asymmetrical plan nor its irregular, sharp-edged walls; not its high courtyard gate, inset with a flat wooden lintel. Here, instead, is a deliberately more modest structure, whose distinctive feature is the peaked wooden lintel set into its gate. It is compact, with smooth walls arranged symmetrically around its rectangular courtyard. An unadorned doorway opens onto an empty stucco interior.

O'Keeffe reduced her picture to its basic forms by several means, in particular through a limited scheme of nearly flat colors (ocher, black, white, sienna, turquoise) and a compelling symmetry, in which the cross in the courtyard functions as a compositional anchor and a cadence of repeated horizontals. Such abstraction serves to raise the image's ambiguity. The adobe walls are thick but so faintly modeled as to appear weightless. The open gate and arching form of the church create a protective structure, which is also inexplicably barren. But this painting's ambivalence is its strength. It is both tactile and barely tangible, earthbound and visionary.

DS

1 Mabel Dodge Luhan, "Georgia O'Keeffe in Taos," *Creative Art* 8 (June 1931), pp. 407–10.
2 Henry Adams, in Museum of Art, Carnegie Institute, *Collection Handbook* (Pittsburgh, 1985), p. 248.
3 Georgia O'Keeffe, *Georgia O'Keeffe* (New York, 1976), p. 118.

References D. G. Wilkins, "The American Painting Collection at the Sarah Scaife Gallery, Carnegie Institute, Pittsburgh," *American Art Review* 2 (Mar.–Apr. 1975), p. 101; J. Masheck, "Iconicity," *Artforum* 17 (Jan. 1979), p. 39; P. J. Broder, *The American West: One Modern Vision* (Boston, 1984), p. 166; H. Adams, in Museum of Art, Carnegie Institute, *Collection Handbook* (Pittsburgh, 1985), p. 248.

Exhibitions Edward R. Root Art Center, Hamilton College, Clinton, N.Y., 1960, *Selections from the Edith Gregor Halpert Collection,* exh. cat. by J. R. Trovato, no. 20; Downtown Gallery, New York, 1965, *Group Show,* no cat.; Flint Institute of Arts, Mich., 1966, *Realism Revisited,* no. 36; Downtown Gallery, New York, 1967, *Group Show,* no cat.; Leicester Galleries, London, 1967, *Six Decades of American Art,* unnumbered; Art Museum of South Texas, Corpus Christi, 1973, *A Selection of American Paintings from the Estate of the Late Edith Gregor Halpert,* unnumbered.

Provenance The artist, until c. 1952; Edith Gregor Halpert, New York, until 1970; estate of Edith Gregor Halpert (sale, Sotheby Parke Bernet, New York, Mar. 14, 1973); Kennedy Galleries, New York, 1973.

Museum purchase: gift in memory of Elisabeth Mellon Sellers from her friends, 1974, 74.17

Malcolm Parcell

1896–1987

A LIFELONG PRACTITIONER of a romantic realist style, the western Pennsylvania painter Malcolm Parcell is best remembered for his portraits of beautiful women and powerful men and for his landscapes, genre scenes, and allegories set in the peaceful, rural surroundings of his southwestern Pennsylvania home. Born in Claysville, Pennsylvania, and raised in nearby Washington, he received his earliest training from his father, who had studied art before becoming a Baptist minister. Between 1913 and 1917 Parcell attended the School of Applied Design at Carnegie Institute of Technology (now Carnegie Mellon University). Upon graduation, he moved to New York City, where he worked as an illustrator and architectural renderer. In 1918 he followed the advice of fellow artist J. Alden Weir and went back to the source of his inspiration, Washington, Pennsylvania.

Parcell's artistic talent was recognized shortly after he returned home. His first major success was *Louine* (1918, Board of Public Education, Pittsburgh), a portrait of Helen Louine Gallagher, a local schoolteacher and his future wife. The painting won first prize at the 1918 Associated Artists of Pittsburgh exhibition and the Saltus Medal the following year at the National Academy of Design in New York. During the early 1920s Parcell was asked to exhibit at several prominent New York galleries. He participated in the annual exhibitions held at Carnegie Institute twenty-five times between 1920 and 1950 and was awarded the Popular Prize in both 1924 for *My Mother* (c. 1924, Butler Institute of American Art, Youngstown, Ohio) and 1925 for *Group Portrait* (1925, destroyed). Ten years later, Carnegie Institute held a solo exhibition of his work.

The popularity of Parcell's portraits can be attributed to his strong draftsmanship, vibrant color, and sensitivity to detail and design while they remain as true as possible to the actual appearances of his sitters. Never a member of the artistic vanguard, he appears to have taken his cue from the styles in vogue at the turn of the century; a hint of both John Singer Sargent's and James McNeill Whistler's works can be detected in his earlier portraits.

Parcell's landscapes, genre scenes, and allegories are similar to his portraits in their strong draftsmanship and richness of detail and are perhaps more imaginative. They possess the element of gentle fantasy found in the works of such artists as N. C. Wyeth and Maxfield Parrish. Parcell also produced a number of mythological and historical murals during the 1930s, one of his most popular being *The Judgment of Paris*, painted for the Continental Bar at Pittsburgh's William Penn Hotel in 1934.

Parcell's brand of realism fell out of favor with the rise of Abstract Expressionism in the 1940s and 1950s. Rather than meet the demands of changing times, he continued to paint as he always had, cloistering himself in his Washington, Pennsylvania, studio. In 1967 he moved to Moon Lorn, a fifteen-acre farm near Prosperity, Pennsylvania, where he worked until his death. In recent years Parcell's work has once again received significant attention, as is witnessed by the two retrospective shows of his work organized in the early 1980s, one at Carnegie Mellon University, the other at Washington and Jefferson College, Washington, Pennsylvania.

Bibliography William B. McCormick, "Parcell, Realist and Romanticist," *International Studio* 79 (August 1924), pp. 351–54; John O'Connor, Jr., "The Carnegie Institute Presents Malcolm Parcell," *Carnegie Magazine* 8 (January 1935), pp. 236–41; Hewlett Gallery, Carnegie-Mellon University, Pittsburgh, *Malcolm Parcell* (1982), exh. cat. by Donald Miller; Olin Fine Arts Center Gallery, Washington and Jefferson College, Washington, Pa., *Malcolm Parcell—Retrospective* (1982), exh. cat. by Paul A. Chew; Donald Miller, *Malcolm Parcell: Wizard of Moon Lorn* (Pittsburgh, 1985).

Return to the Village, c. 1925

Oil on canvas
41⅛ x 48¼ in. (104.5 x 122.6 cm)
Signature: *Malcolm Parcell* (lower right)

The Washington County, Pennsylvania, village of Old Concorde was Parcell's inspiration for this work, which pictures an elderly farmer seated in a horse-drawn wagon headed toward a small rural settlement in the distance. Rather than paint a literal depiction of Old Concorde, Parcell gave a romanticized vision of the town. He added to this autumn landscape some of the traditional allegorical references to death and dying: the old man; the large, dead tree marking the entrance to the village; and the prominent church and graveyard in the distance.

In contrast to the village, painted in drab grays and cold blues, the surrounding countryside is alive with the rich colors of fall—burnt oranges, golden ochers, and deep siennas. Parcell has sharply rendered each detail of the scene, heightening the sense of stillness and solitude created by the farmer. Although a somber depiction of country life was unusual for Parcell, he seems to have taken a special interest during the 1920s in the imagery of graveyards and burials. Other examples are *The Gravediggers* (1922, collection George H. Taber, Pittsburgh) and *The Churchyard* (before 1924, location unknown).

EM

Reference Miller, *Malcolm Parcell*, pp. 43, 56.

Exhibition Olin Fine Arts Center Gallery, Washington and Jefferson College, Washington, Pa., 1982, *Malcolm Parcell—Retrospective*, exh. cat. by P. B. Edwards and P. A. Chew, no. 65.

Provenance Sydney B. Donnan, by 1934; private collection, Boston; Childs Gallery, Boston, 1981; East End Galleries, Pittsburgh, 1982.

Museum purchase: gift of the H. J. Heinz II Charitable and Family Trust, 1983, 83.14

Nude Interior, 1926

Oil on canvas mounted on Masonite
10¹³⁄₁₆ x 11⅝ in. (27.5 x 29.5 cm)
Signature, date: Malcolm Parcell/1926—(upper right)

In *Nude Interior* the artist used his favorite model—his wife, Helen Louine Gallagher. She is shown standing, her body in three-quarter view and her face in profile, arms raised above her head—a pose that serves to accentuate the curves of her breasts, abdomen, and thighs. The

delicate brushwork, warm flesh tones, and ambient light add to the aura of female sensuality, further emphasized by the conch shell on the cluttered dresser, a traditional allusion to Venus.

Yet there is a somewhat disturbing quality to the eroticism portrayed here. The woman boldly presents her body to the viewer while her face is unconcernedly turned away. There is a hint of hardness and vulgarity in the heavily made-up face and confrontational posture. Parcell appears to have expressed both his love for his wife's sexuality as well as a fear of its intensity and attraction. The successful portrayal of these complex emotions makes *Nude Interior* an unexpectedly powerful work.

RB

Reference Miller, *Malcolm Parcell*, p. 52.

Exhibitions Westmoreland County Museum of Art, Greensburg, Pa., 1981, *Southwestern Pennsylvania Painters, 1800–1945*, exh. cat. by P. A. Chew and J. A. Sakal, no. 175; Hewlett Gallery, Carnegie Mellon University, Pittsburgh, 1982, *Malcolm Parcell*, exh. cat. by E. A. King and D. Miller, no. 9.

Provenance The artist, until 1982; Donald C. Burnham, Pittsburgh, 1982.

Gift of Donald C. Burnham, 1982, 82.55

G. David Thompson, 1933

Oil on canvas
40 x 53¼ in. (101.6 x 132.7 cm)
Signature, date: Malcolm Parcell/33 (lower right)

The Pittsburgh steel executive G. David Thompson (1898–1965) was one of Parcell's most important patrons as well as a close personal friend. Over the years, Thompson purchased many of the artist's works and helped to get his paintings exhibited. After World War II, Thompson, who became the most prominent collector of modern art in Pittsburgh, often encouraged the artist to "modernize" his style. However, with few exceptions, Parcell maintained the somewhat hard-edged style exemplified here.

In the Carnegie painting, the busy magnate is shown relaxing in his favorite armchair—an armchair Thompson transported from his home to the painter's studio in Washington, Pennsylvania—surrounded by works that were presumably from his extensive collection of modern art. The armchair's red leather surface reinforces Thompson's ruddy complexion and his sober black suit. Parcell's use of bold, clear colors and hard outlines admirably conveys a sense of this powerful man's renowned energy, self-confidence, and single-mindedness.
RB

Provenance G. David Thompson, Pittsburgh, 1933; his widow, Helen Steele Thompson, 1965; placed on deposit at Carnegie Institute, c. 1966.

By appropriation, 1984, 84.76

Fig. 1 Currier and Ives, *"Rounding a Bend" on the Mississippi: The Parting Salute,* 1866. Lithograph, 17½ x 28⅞ in. (44.4 x 73.3 cm). Museum of the City of New York

D. G. Payson

active c. 1890

The Steamboat Swan, c. 1890

Oil on board
28⅜ x 36 in. (72.1 x 91.4 cm)
Signature: D. G. Payson (lower left vertical edge)

Many American vernacular artists remain virtually unknown or are known only by their signatures on a single work. Such is true of D. G. Payson, the artist of *The Steamboat Swan.* Until now, there has been no generally known record of Payson's production, suggesting that he was not a prolific painter.

The composition is a close transcription of a Currier and Ives lithograph published in 1866, *"Rounding a Bend" on the Mississippi: The Parting Salute* (fig. 1). Payson's version chiefly differs from the original in the number of boats (two rather than three) and in the name written on the larger boat (*Swan* rather than *Queen of the West*). Like its lithographic counterpart, the *Swan* is painted with vibrant pigments and little attention to shading or detail. Its setting conjures up an image of long, carefree summer days. As this vessel rounds the river's bend, it is framed on both sides by lush green trees and vegetation. Its three decks are filled with lively passengers represented by colorful dots and dabs of paint.

It is not clear whether or not this painting was intended to represent a specific boat called the *Swan.* The steamer is a

stern-wheeler, a vessel used typically in southern waters. Its recessed wheel allowed for easy movement through the vegetation and dangling vines characteristic of the rivers of the South. In this canvas, the boat appears to move smoothly along a placid, unencumbered path.
LAH

Provenance Found in Massachusetts, city unknown; John Bihler and Henry Coyer, until 1961; Edgar W. and Bernice Chrysler Garbisch, Cambridge, Md., 1961.

Bequest of Edgar W. and Bernice Chrysler Garbisch, 1981, 81.21.19

Philip Pearlstein

born 1924

DURING THE 1960s Philip M. Pearlstein challenged the supremacy of Abstract Expressionism by painting the human figure realistically, set in an illusionistic space and seen from a single point of view. While maintaining a concern for abstract composition, Pearlstein's affirmation of the validity of representation coincided with a growing desire among younger artists to return to realism. Together, Pearlstein and these artists became known as New Realists and formed one of the major artistic movements of the next decades.

Born in Pittsburgh, Pearlstein began to take an interest in art as a teenager, participating in the extracurricular art classes offered on Saturdays at Carnegie Institute. There his teachers were the Pittsburgh Social Realist painters Samuel Rosenberg and Roy Hilton, whose styles influenced his earliest works. In 1942 he entered Carnegie Institute of Technology as a design student, but he was soon drafted.

Assigned to the army's training-aids unit, Pearlstein was responsible for producing "visual aids"—an experience that taught him the basics of commercial design. In late 1944 he was sent to a unit in Rome whose members were among the last to be sent home at war's end. In the year that he waited, he visited cathedrals, museums, and galleries whenever he could, studying Italian Renaissance art and architecture firsthand.

Pearlstein returned to Pittsburgh and Carnegie Institute of Technology in 1946. He studied under Samuel Rosenberg, who had previously influenced his high-

school works; Robert Lepper, well known locally for his cool, analytical depictions of machine parts; and the New York abstract artist Balcomb Greene, who taught art history. After graduating in 1949, Pearlstein and a fellow classmate, Andy Warhol, moved to New York City to pursue careers in commercial art.

Pearlstein's first independent work incorporated bizarre symbols, heavily worked paint, agitated brushstrokes, and violently bright color to depict humorously frightening subjects, a good example being *Death and the Maiden* (1950, collection the artist), which shows a woman being raped by her plumbing fixtures while she is taking a shower. He was hired to lay out industrial catalogues by a Bauhaus designer, Ludislav Sutnar, who suggested to Pearlstein that he study art history. He enrolled at New York University's Institute of Fine Arts, attending classes at night and working for Sutnar during the day. He completed his master's thesis on Francis Picabia in 1955, which, ironically, put an end to his own artistic interest in mechanistic symbols. His study of Picabia's work led him to conclude that hidden iconography eventually becomes irrelevant to the viewer.

During the 1950s Pearlstein experimented with Abstract Expressionism. However, he derived his compositions from nature rather than from his immediate artistic process, as the Abstract Expressionists advocated. Toward the end of the decade he began to search for his own artistic beliefs and direction. Two important influences on his eventual course were the discussion groups held by the Eighth Street Club (an assortment of young artists who likewise had begun to feel dissatisfaction with Abstract Expressionism) and Mercedes Matter's informal life-drawing sessions.

What has been called Pearlstein's breakthrough came in 1962, when he realized that he wanted to paint the figure dispassionately, not emotionally, in an illusionistic space and from a single point of view. Refusing to romanticize the nude model as artists before him had done, he presented the nude exactly as it appeared, even choosing to exploit its truthfulness by positioning himself very close to the model. Painting directly from the model, he advanced from generalized figure studies to minutely detailed depictions. Pearlstein composed his paintings beginning at the center and working toward the edges of the canvas until the subject filled the frame; accordingly, parts of the

figure became strangely distorted, while others ran off the canvas. He also used artificial lighting to expose each detail and cast stark shadows across the model's body. His cool, detached images are disturbing because they do not beautify or glorify the nude but treat it as an ordinary still-life object.

During the late sixties, Pearlstein began to expand his subject matter to include portraiture and his mediums to include lithography, etching, and aquatint. He also began to experiment with a high point of view and the addition of decorative rugs, chairs, draperies, and kimonos. Most recently, during the late seventies and early eighties, he began to paint landscapes again. From the mid-fifties to the present, Pearlstein has participated in numerous gallery and museum exhibitions throughout the United States and abroad, including the Carnegie Internationals of 1955, 1964, and 1967; a retrospective exhibition was held at the Milwaukee Art Museum in 1983. He lives in New York.

Bibliography Jerome Viola, *The Paintings and Teachings of Philip Pearlstein* (New York, 1982); Russell Bowman, *Philip Pearlstein: The Complete Paintings* (New York, 1983); Milwaukee Art Museum, *Philip Pearlstein: A Retrospective* (1983), exh. cat. by Russell Bowman.

Double Portrait of the Artist's Parents, 1943

Oil on Masonite
25½ x 18¼ in. (64.8 x 46.4 cm)
Signature, date: Philip Pearlstein/1943 (lower right)

One of Pearlstein's earliest paintings, *Double Portrait of the Artist's Parents* prefigures some of the qualities of his later work. Two figures, a male and female, are placed in close proximity to each other but do not relate to one another. Nor do they relate to the viewer. Instead, both seem to be intently staring out the window on the far left. Since Pearlstein's father's face is obscured by his mother's head, it is impossible to be sure where, or how, he is looking.

The unusual placement of Pearlstein's mother in front of, and partially obscuring, his father led Robert Storr to remark:

One is tempted to question the psychoanalytic content of this image of a strong, severe mother and a nearly absent father, but guesswork of this sort is given no more encouragement here than it will be in later paintings. We are offered information but no invitation to speculate on its "meaning."[1]

Stylistically, this portrait is painted in the manner of Pearlstein's earlier works. The figures are modeled three-dimensionally, using broad patches of light and dark color. Color is muted—mostly dark ochers and umbers. Details are set down with delicate, calligraphic lines—for instance, in the barely discernible, but very descriptive contour line of his mother's right forearm.

EM

1 Robert Storr, "Pearlstein Today: Upping the Ante," *Art in America* 72 (February 1984), p. 94.

References J. Viola, *The Paintings and Teachings of Philip Pearlstein*, p. 15; D. Hofstadter, "A Love of Ruins: The Art of Philip Pearlstein," *New Criterion* 2 (Dec. 1983), p. 51; Bowman, *Philip Pearlstein: The Complete Paintings*, p. xii; R. Storr, "Pearlstein Today: Upping the Ante," *Art in America* 72 (Feb. 1984), pp. 93–94.

Exhibition Milwaukee Art Museum, 1983–84, *Philip Pearlstein: A Retrospective* (trav. exh.), exh. cat. by Russell Bowman et al., no. 1.

Provenance The artist, until 1984.

Gift of the artist, 1984, 84.74

Waldo Peirce
1884–1970

WALDO PEIRCE, who was called variously "New England's Moses," "Rabelais in a Smock," and "Maine Mountain Dean," was a colorful figure, well known for his large girth, disheveled appearance, and wild tales of his bohemian life-style. Peirce's art—paintings, watercolors, and a few lithographs—was an appropriate complement to the man: an animated, colorful, forthright representation of his life.

Peirce was born in Bangor, Maine, the son of a wealthy lumberman. He attended Harvard University from 1903 to 1908 and there made the decision to follow a

career in art. In December 1907 he wrote to his mother of his plan to pursue "serious drawing" and painting: "This is a startling surprise to me (that I really think I have the talent) and doubtless to you, but the whole thing has just dawned on me the last two or three days."[1]

His art training began in 1910 at the Académie Julian in Paris. He studied there for two years, immersing himself in an intense daily routine of studio and museum study. Nonetheless, he found time to travel to Italy, Spain, and Ireland. He was especially attracted to Spain; in 1913 he rented a house in Segovia with his first wife, Dorothy Rice, and through her became friendly with Ignacio Zuloaga, a painter of genre whose dark, rich palette was reminiscent of Diego Velázquez and Francisco de Goya. Peirce studied with Zuloaga until 1914, when he and his wife returned to the United States.

From 1915 to 1930 Peirce journeyed from the United States to France and Tunisia, residing for the most part in Paris. He developed friendships with a number of avant-garde writers, including Gertrude Stein, James Joyce, and F. Scott Fitzgerald. He also became a close friend of Ernest Hemingway and traveled to Spain with him.

In Paris Peirce encountered the work of two other artists who had a lasting impact on him: Pierre-Auguste Renoir and Henri Matisse. He saw his first Renoir painting in 1918, a picture of a baby that he found greatly moving, referring to it as a "poem."[2] Peirce was influenced not only by Renoir's children, but also by his fleshy, pink women and casual scenes of domestic life. Matisse's work prompted him to use bright patterns, sinuous lines, and decorative colors in his painting.

In 1930 Peirce returned permanently to the United States with his third wife, Alzira Boehm, and their newborn twin sons, Mike and Bill. (He had divorced Dorothy Rice in 1917, married Ivy Troutman in 1920, divorced her in 1927, and married Alzira in 1929.) Having settled in Bangor, he distanced himself from European artistic theories and adopted a straightforward representational approach to autobiographical paintings that reflected the joy of fatherhood. His subjects were his family's daily routine, special family occasions, and casual portraits. Although Peirce and Alzira were divorced in 1944, he continued to paint their children as well as the two children from his fourth marriage (to Ellen Larsen in 1946).

Peirce was a familiar figure in the international art scene from 1924 on. He exhibited in the Salon d'Automne, Paris (1924), the annual exhibitions at Carnegie Institute (with nineteen works between 1924 and 1950), and in solo shows at the Wildenstein Galleries, New York (1926), Midtown Galleries, New York (his exclusive representative from 1936 to 1970), Carnegie Institute, Pittsburgh (1938), Saginaw Museum, Michigan (1949), Farnsworth Museum, Rockland, Maine (1950), and Parrish Museum, Southhampton, New York (1966). Since his death in Newburyport, Massachussetts, there have been three major exhibitions of Peirce's work, two at the Midtown Galleries (1972, 1977) and one at the University of Maine, Orono (1985).

1 Hulick, in University of Maine, *Waldo Peirce*, p. 40.

2 Ibid., p. 28.

Bibliography Harry Salpeter, "Rabelais in a Smock," *Esquire* 6 (July 1936), pp. 101–18, 121–22; John O'Connor, Jr., "Presenting Waldo Peirce," *Carnegie Magazine* 11 (February 1938), pp. 268–70; Margit Varga, *Waldo Peirce* (New York, 1941); Sibila Skidelsky, "Peirce from Maine to Maine via Zuloaga, Matisse, and Goya," *Art News* 40 (May 1, 1941), pp. 25–27; University of Maine, Orono, *Waldo Peirce: A New Assessment: 1884–1970* (1985), exh. cat. by Diane Emery Hulick.

Gemini at Bath, 1931

Oil on canvas
52 x 68 in. (132.1 x 172.7 cm)
Signature, date: *WP*. 31 (lower right)

This large, colorful canvas depicting Peirce's infant twin sons, Mike and Bill, is filled with activity—in the lower left-hand corner Peirce's seated wife, Alzira, leans over the babies' tub as she lifts one boy out of the sudsy water. Behind the tub and more centrally placed on the canvas, the Peirces' nurse dries the other twin. The artist himself is seated in the lower right-hand corner, sketching the event.

The activity takes place in the front room of the Peirces' Paris flat—a room cluttered with brightly colored and patterned objects such as the Oriental rug on the floor, the tiled fireplace with an assortment of toys and knickknacks on the mantel, two cribs, and three of Peirce's paintings on the walls. Although the scene is set about two months after

the birth of the twins, early in 1930, Peirce did not paint the canvas until 1931, one year after the family's return to the United States. Presumably he worked from sketches made in Paris.

This, probably the first canvas Peirce painted of the twins, marks the beginning of his mature painting style. Although influences attributable to Henri Matisse and Pierre-Auguste Renoir are apparent in the play of patterns against one another and the plump, rosy babies, these elements have been brought together less self-consciously than in previous works. The change in Peirce's approach undoubtedly had to do with his return to Maine. There he concentrated upon the familial themes that suited his new narrative focus, a signal that technique and theory were no longer to be major concerns.

EM

References O'Connor, "Presenting Waldo Peirce," p. 270; "The Three Little Peirces," *Life,* Nov. 12, 1945, p. 82; J. O'Connor, Jr., "Waldo Peirce Enters the Permanent Collection," *Carnegie Magazine* 25 (Feb. 1951), pp. 64–65.

Exhibitions Department of Fine Arts, Carnegie Institute, Pittsburgh, 1931, *Thirtieth Annual International Exhibition of Paintings,* no. 23; Department of Fine Arts, Carnegie Institute, Pittsburgh, 1938, *Waldo Peirce: An Exhibition of Paintings, Watercolors and Lithographs,* no. 13; Columbus Gallery of Fine Arts, Ohio, 1952, *Paintings from the Pittsburgh Collection,* no cat.

Provenance Philip Lowenthal, Cincinnati, 1932; Alexander Lowenthal, Pittsburgh, by inheritance, 1942.

Gift of Mr. and Mrs. Alexander Lowenthal, 1950, 50.20

John F. Peto
1854–1907

T HOUGH LITTLE KNOWN to his contemporaries, today John Frederick Peto is considered one of the foremost nineteenth-century American still-life painters. Born in Philadelphia, the son of a gilder and picture framer, he grew up in the home of his maternal grandmother rather than that of his parents. It is known that he began to sketch in childhood, but how he came to work as a professional artist is unclear, and the extent of his artistic background is also a bit of a mystery. In 1876 he appeared as a painter in Philadelphia's city directory. In 1877 the Pennsylvania Academy of the Fine Arts there listed him as a student, yet when he exhibited there (from 1879 to 1886), its catalogues described him as self-taught. In the late 1870s he became friends with artist William M. Harnett, whose extraordinarily realistic still lifes served as Peto's most important artistic influence.

Peto visited Ohio in 1887, where he met and married Christine Pearl Smith of Logtown (now Lerado), a Cincinnati suburb. During either this or a later visit in 1894, he executed a large still-life commission in Cincinnati for the Stag Saloon—the sort of commission with which Harnett was most associated. Around the time of his marriage, Peto began traveling to the seacoast town of Island Heights, New Jersey, where he earned money as a cornet player for revival meetings. He also

painted there, selling many pictures to neighbors and summer visitors. During his last years, he suffered from poor health, having contracted Bright's disease, which led to his premature death in New York City. As a result his late work is uneven in quality, often unfinished.

While the trompe-l'oeil pieces Peto created strongly recall those of Harnett, their style is more painterly and show less concern with precise drawing and strict illusionism. Peto's tended toward more thickly applied paint, softer highlights and shadows, and in general a more atmospheric and luminous effect. The commonplace objects on his letter racks and shelves are often worn out and in disarray, creating an atmosphere of melancholy nostalgia that often holds an uneasy edge.

Less ambitious and boasting fewer patrons than Harnett, Peto rarely exhibited his work; therefore, he fell into a posthumous obscurity even deeper than that of his colleague. When interest in Harnett resurfaced, Peto's work was not only frequently mistaken for Harnett's but also signed with his name until Alfred Frankenstein, in the 1940s, was able to establish Peto as a distinct artistic personality.

Bibliography Lloyd Goodrich, "Harnett and Peto: A Note on Style," *Art Bulletin* 31 (March 1949), pp. 57–59; Brooklyn Museum, New York, *John F. Peto* (1950), exh. cat. by Alfred Frankenstein; Alfred Frankenstein, *After the Hunt: William Harnett and Other American Still Life Painters, 1870–1900* (Berkeley, 1953, rev. ed., 1969), pp. 99–111, 183–85 passim; National Gallery of Art, Washington, D.C., *Important Information Inside: The Art of John F. Peto and the Idea of Still-Life Painting in Nineteenth-Century America* (1983), exh. cat. by John Wilmerding; Olive Bragazzi, "The Story Behind the Rediscovery of William Harnett and John Peto by Edith Halpert and Alfred Frankenstein," *American Art Journal* 16 (Spring 1984), pp. 51–65.

Candlestick, Pipe, and Tobacco Box, c. 1890

Oil on wood panel
9½ x 6½ in. (24.1 x 16.5 cm)
Signature: J. F. Peto (lower left)

Peto specialized in depictions of everyday objects that are devoid of intrinsic beauty. Among these are a number of early pipe-and-mug still lifes that recall Harnett's use of those same objects; in fact, they probably were directly influenced by Harnett's works. For Peto, these early

Horace Pippin
1888–1946

D URING AN ARTISTIC career that lasted just sixteen years, Horace Pippin became one of the most celebrated twentieth-century folk painters and perhaps America's best-known black artist. Born in Chester County, Pennsylvania, Pippin was raised in Goshen, New York. From childhood he had been interested in art: he related that he frayed muslin to resemble doilies and painted Bible scenes on them and executed a portrait at age fourteen.[1] Even so, Pippin spent the greater part of his adulthood as a laborer in a coal yard, as a potter, and as a furniture packer, before joining the army in 1917.

World War I left Pippin with a partially paralyzed right arm, making him unable to return to the kind of work he had previously done. He settled with his wife in West Chester, Pennsylvania, where he remained the rest of his life. He drew a small disability pension and helped deliver the laundry his wife took in. He also tried his hand at painting as a livelihood: in 1920 he began making burned-wood narrative panels, and a year later painted his first canvases, which were images of the war. Other remembered passages from his life played an important part in his subsequent canvases.

In 1937 when the Asian-art scholar Christian Brinton and his friend N. C. Wyeth saw one of Pippin's paintings in the window of a local shop, they prevailed on the West Chester Community Center to hold a show of his work. After seeing that exhibition, the art critic Holger Cahill, a champion of American folk art, decided to represent Pippin in the landmark exhibition *Masters of Popular Painting* at the Museum of Modern Art in New York in 1938. Pippin thereupon acquired a Philadelphia dealer, Robert Carlin, who gave him his first solo exhibition in 1940.

By the early 1940s Pippin enjoyed a national reputation. Exhibitions of his work were mounted at the Arts Club of Chicago in 1941 and at the San Francisco Museum of Art in 1942. He was represented by Edith Halpert's Downtown Gallery in New York and was patronized by such leading supporters of modern art as Albert C. Barnes and Duncan Phillips.

studies sparked a lifelong fascination with the formal possibilities of the cylinder in various guises.

The present work is one of at least a dozen in which the dominant elements are a candle, book, wooden match, pipe, and tobacco canister. The same elements, even the torn paper on the canister, appear differently arranged in the mistitled *Candlestick, Pipe, and Mug* (c. 1880–90, collection Erving and Joyce Wolff, New York). Both have a vertical rather than the more usual horizontal format; in the New York painting, the objects are set against a light, plain background instead of the dark wood panel seen here. The other props in the painting reappear in several other canvases. The iron candlestick, for instance, shows up in at least three other paintings: the work mentioned above, *After Night's Study* (1890, Detroit Institute of Arts), and *Pipe, Mug, Book, and Candlestick* (c. 1880–90, Montclair Art Museum, New Jersey). The candlestick remained, along with many of his props, in Peto's Island Heights studio, and this, together with the fact that the picture was once owned by an Island Heights family, suggests that it may have been painted in or after 1889. It is, however, difficult to ascribe dates to any of Peto's work with any precision. The artist dated only two of the known tobacco canister still lifes, *Tobacco Canister, Book, and Pipe* (1888, Meredith Long, Houston) and *Evening at Home* (1902, Museum of Fine Arts of Saint Petersburg, Fla.), and these, despite the fourteen years separating them, are almost identical.

KN

Reference National Gallery of Art, *Important Information Inside*, p. 243.

Provenance Rebecca Drinkhouse, Island Heights, N.J.; her daughter, Mary Rebecca Drinkhouse Craig, by 1942; private collection, N.J., until 1972; Hirschl and Adler Galleries, New York, by 1979; the Honorable and Mrs. J. William Middendorf II, McLean, Va., 1980; James Maroney, New York, 1980–81.

Edith H. Fisher Fund, 1981, 81.67.2

Among the museums that began to show Pippin's work was Carnegie Institute, which represented him in its 1943, 1944, and 1945 *Painting in the United States* exhibitions.

Pippin's rise to fame coincided with the emerging taste for modernism in the United States, which brought an accompanying enthusiasm for naïve art. Despite Pippin's belief that one cannot teach art to another, his work, especially after 1938, showed a developing modernist sensitivity in its exploitation of the expressive possibilities of flat, abstract shapes; in this he was reminiscent of Henri Rousseau and Henri Matisse, to whom he was compared.

Themes of peace, sacrifice, and spiritual quietude run through Pippin's work in the form of biblical subjects, genre scenes, and empty interiors. His canvases tend to be small, only rarely exceeding twenty by thirty inches. Their measured, flattened compositions are sober yet lyrical; by their very simplicity and restraint they have the power to move the viewer.

1 Horace Pippin, "My Life's Story," in Rodman, *Horace Pippin*, p. 7.

Bibliography Selden Rodman, *Horace Pippin: A Negro Painter in America* (New York, 1947); Selden Rodman and Carole Cleaver, *Horace Pippin: The Artist as a Black American* (New York, 1972); Phillips Collection, Washington, D.C., *Horace Pippin* (1976), exh. cat., introduction by Romare Bearden; Selden Rodman, in Whitney Museum of American Art, New York, *American Folk Painters of Three Centuries* (1980), exh. cat. edited by Jean Lipman and Tom Armstrong, pp. 213–19.

Abe Lincoln's First Book, 1944

Oil on canvas
24 x 30 in. (61 x 76.2 cm)
Signature, date: H. Pippin, 1944 (lower right)

Three historical figures can be identified as Horace Pippin's personal emblems of piety and morality: Jesus Christ, John Brown, and Abraham Lincoln. Depictions of Christ's ministry and passion began to appear in Pippin's work in 1938. In 1942 he painted three canvases representing the ministry and passion of John Brown, including perhaps his best-known work, *John Brown Going to His*

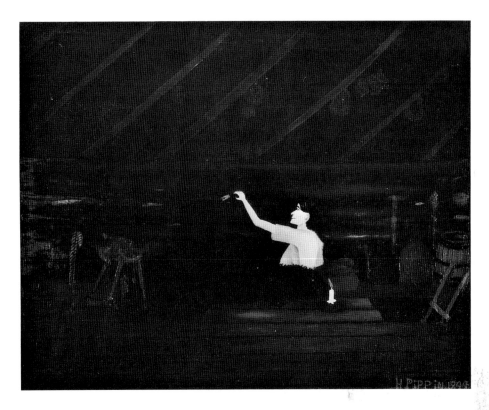

Hanging (Pennsylvania Academy of the Fine Arts, Philadelphia). Two scenes from the life of Lincoln followed in 1943 and 1944; the second of these is *Abe Lincoln's First Book.*

The legend of John Brown had become an intimate part of Pippin's cultural baggage because his grandmother had witnessed the abolitionist's hanging. Similarly, Pippin could recall a time when the memory of Lincoln was still fresh and so may have felt a kinship with the man behind the legend. Both Brown's and Lincoln's legacies endured in later nineteenth-century art, the most notable images being Eastman Johnson's *Boyhood of Lincoln* (1868, University of Michigan Museum of Art, Ann Arbor) and Thomas Hovenden's *Last Moments of John Brown* (1884, Metropolitan Museum of Art, New York). Reproductions of such images may well have formed memories that Pippin later pressed into service, much as he seems to have reincarnated the ubiquitous Victorian still-life print in his floral arrangements and interior views.

This painting is based on an episode in Lincoln's boyhood in which he borrowed David Ramsey's *Life of Washington* from a neighbor. After reading from it one night, he tucked the book between chinks in his log cabin's walls. When the book got wet, Lincoln worked for the neighbor to make amends, until the owner gave the book to him.

In comparing Pippin's depiction of Lincoln with its counterpart by Johnson, one immediately notices the unremitting austerity of Pippin's interpretation. Its combination of black, red, gray, and umber is Pippin's preferred palette in its starkest variation. The image is of a thin, very pale Lincoln who has been reading not by a log fire as in Johnson's version but by the flickering light of a single candle. The setting is a vacant, pitch-black room that seems more like the attic of the dilapidated Victorian frame houses of Pippin's youth than a log cabin. The few objects in the room—hanging herbs, a crude stool, stoneware jugs, a barrel, boots, a fur pelt—are arranged friezelike along the planks, clapboards, and rafters that measure the space. Starkly illuminated in this space is the torso of a wistful, spiritual boy. As he pure-heartedly sets aside his reading, his frail frame visually connects book and candle in a manner that seems deliberately symbolic.

DS

References Rodman, *Horace Pippin*, p. 85; F. A. Myers, "Two Acquisitions: Pippin and Kane," *Carnegie Magazine* 42 (Oct. 1968), pp. 269–72.

Hobson Pittman

1900–1972

INSPIRED BY HIS bittersweet childhood experiences in the South, Hobson Pittman is best known as a painter of stark, simple interiors that explore themes of loneliness, isolation, and mortality. Born on a farm in Epworth, North Carolina, Pittman was raised in nearby Tarboro, in a Victorian house that provided much of the subject matter for his interiors. From 1912 to 1916 he attended the Rouse Art School in Tarboro. When his parents died in 1918, he moved to Philadelphia to live with a sister, who died soon afterward.

Pittman attended Pennsylvania State University in State College from 1921 to 1922 and Columbia University in New York from 1924 to 1925; the following year he enrolled at Carnegie Institute of Technology. Each summer during the twenties he painted at Woodstock, New York. He took three trips abroad in 1928, 1930, and 1935, which prompted him to experiment with Cubism and other European styles of modern painting.

Pittman developed his mature style during the mid-thirties, in a series of domestic interiors that evoke the slow-paced life of the South. Spare, almost naïve in manner, they show an affinity to Magic Realism. Working in pastel as well as oil, he adapted the soft tonalities and textural qualities of pastel to the paintings. As a result, his simply furnished Victorian rooms have the faded quality of a dream. They convey a sense of abandonment and expectation, with their large, open doors and windows. Often empty of people, these quiet chambers suggest a presence unseen. Pittman explained:

> The furniture—color and spirit of the place—all impress me very deeply and mean more to me even than the idea of really painting a canvas. A chair, a window, a book—all have the same living qualities of a human being.[1]

In *The Widow* (1937, Whitney Museum of American Art, New York), one of Pittman's most praised works, inanimate objects weave a narrative that speaks of the fragility of human existence. A rocking chair serves as protagonist, partially hiding the figure of a woman who stares out a window. A photograph, perhaps of the departed husband, rests on a table, while a double portrait hangs on the wall. All remind us of the painful loss the widow has suffered.

During the forties Pittman exhibited widely and participated in all of Carnegie Institute's annual exhibitions. In 1945 he began teaching at the Philadelphia Museum of Art; from 1949 until his death he taught at the Pennsylvania Academy of the Fine Arts, Philadelphia. In his late years he loosened his brushwork considerably and painted still lifes as well as interiors. He had his first retrospective in 1963 at the North Carolina Museum of Art in Raleigh. He died ten years later in Bryn Mawr, Pennsylvania.

1 North Carolina Museum of Art, *Hobson Pittman Retrospective Exhibition*, p. 6.

Bibliography J. Burn Helme, "The Paintings of Hobson Pittman," *Parnassus* 13 (May 1941), pp. 165–68; North Carolina Museum of Art, Raleigh, *Hobson Pittman Retrospective Exhibition: His Works since 1920* (1963); Pennsylvania State University, State College, *The World of Hobson Pittman* (1972), exh. cat., essay by William Hull; Virginia Museum of Fine Arts, Richmond, *Painting in the South, 1564–1980* (1983), exh. cat. ed. by David S. Bundy, pp. 131–32, 305.

Summer Evening, c. 1940–41

Oil on canvas
29¾ x 23¾ in. (75.6 x 60.3 cm)
Signature: *Hobson Pittman* (lower left)

Summer Evening is typical of Pittman's homely interiors. More than a nostalgic attempt to recapture the artist's southern past, it suggests a ghostly remembered presence. It modestly depicts an old green chair, the back of which almost totally obscures the figure of a woman reading. Before her is a table on which rest a lighted lamp, a magazine, and a book. On the wall hangs a portrait, while beside it an open doorway reveals soft moonlight. A small yellow chair in front of this doorway suggests that someone has recently departed. Pittman wrote:

> To establish a mood of intense isolation and loneliness interested me in painting the canvas. . . . Even though it may appear quite simple, it was one of the most difficult canvases I've ever tried to paint. The play of both artificial and natural light—here moon versus lamp—has always given me a good deal of interest.[1]

Pittman's contrast between artificial and natural light produces a luminous environment that seems more imaginary than real. Furthermore, pastel tonalities and a painterly, blurred texture create a fleeting quality, like that of a vague memory. Solid geometric structure, strengthened by blocks of light and dark, animates the furniture and points to the pervasive personality absent from the bright yellow chair.

JM

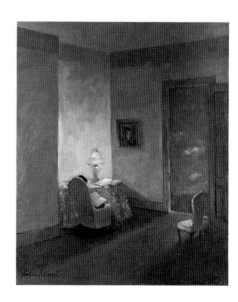

1 Hobson Pittman to John O'Connor, Jr., December 14, 1944, museum files, The Carnegie Museum of Art, Pittsburgh.

References D. E. G., "Four Paintings Added to the Permanent Collection," *Carnegie Magazine* 18 (Jan. 1945), p. 248; "Hobson Pittman—American Artist Recaptures the Past in Scenes of His Victorian Childhood," *Life*, Feb. 19, 1945, p. 70.

Exhibitions Department of Fine Arts, Carnegie Institute, Pittsburgh, 1944, *Painting in the United States*, no. 29; Columbus Gallery of Fine Arts, Ohio, 1952, *Paintings from the Pittsburgh Collection*, no cat.; North Carolina Museum of Art, Raleigh, 1963, *Hobson Pittman Retrospective Exhibition: His Works since 1920*, no. 18; Museum of Art, Pennsylvania State University, State College, 1972, *The World of Hobson Pittman*, no. 76.

Provenance Milch Galleries, New York, as agent, 1944.

Patrons Art Fund, 1945, 45.4

Hiram Powers

1805–1873

THE MOST WIDELY known of America's first generation of Neoclassical sculptors was unquestionably Hiram Powers, a blunt, forthright Yankee who seemed an unlikely candidate for the inner sanctum of European artistic tradition. Born in Woodstock, Vermont, Powers moved with his family in 1818 to Cincinnati. There he became an apprentice in the Luman Watson Clock and Organ Factory, where he first demonstrated his exceptional mechanical aptitude. Between 1823 and 1825 he received instruction in drawing and modeling from Frederick Eckstein, and by 1825 he was working for the two dime museums in Cincinnati, Dorfeuille's Western Museum and Letton's Museum, fabricating and fitting clockwork devices into waxwork figures. He came to the attention of Cincinnati art patron Nicholas Longworth, whose financial support allowed Powers to move to Washington, D.C., in 1834.

In Washington, Powers won his first important commission, a marble portrait bust of President Andrew Jackson in classical drapery (1835, Metropolitan Museum of Art, New York). The result was so strikingly naturalistic that there followed several other portrait-bust commissions from Washington residents. One client, Colonel John S. Preston, offered to underwrite a trip to Italy for Powers: passage plus one thousand dollars per year for three years. So, after visits to Philadelphia and Boston in 1837, Powers traveled with his family by way of Paris to Florence, where he remained for the rest of his life.

In Florence, the expatriate American neoclassical painter Horatio Greenough helped Powers to establish himself, and he was soon attempting full-length, life-size marbles. An *Eve Tempted* (1840–43, National Museum of American Art, Washington, D.C.) was the first of these efforts, followed by *The Fisher Boy* (1843–44, one version in the Virginia Museum of Fine Arts, Richmond) and *The Greek Slave* (1842–44), the work that made his international reputation and became the icon of American Neoclassicism. It ultimately appeared in six versions (of which five remain: in an English private collection; the Newark Museum, N.J.; the Corcoran Gallery of Art, Washington, D.C.; Yale University Art Gallery, New Haven; and the Brooklyn Museum, New York). As the first life-size sculpture of a female nude by an American artist, it was exhibited with astounding success in London in 1845 before touring the United States from 1847 to 1849. One version was exhibited in a draped booth at the London Crystal Palace exhibition of 1851, while another appeared at the New York Crystal Palace in 1853.

By the time of the London Crystal Palace exhibition, Powers was already working on other female nudes: *California, America,* and *La Penserosa.* In 1859 he began *Eve Disconsolate,* which he completed in 1870; in 1866 he began *The Last of the Tribe,* his final ideal image. Powers found a lucrative market for busts of his female nudes; these busts constituted the largest share of his lifetime output. Produced from 1838 onward, they include upward of 70 of the *Greek Slave,* 124 of *Proserpine,* and, in lesser numbers, busts of *America, California, Eve Tempted, Clytie, Faith, Hope,* and *Charity.*

Powers's large studio in Florence, which eventually employed a dozen assistants, became one of the obligatory stops for English-speaking travelers to Italy.

Visitors included Elizabeth Barrett Browning, Margaret Fuller, William Cullen Bryant, and Nathaniel Hawthorne. Hawthorne was particularly attracted to Powers and referred to him frequently in his journal of his sojourn in Italy in 1858–59. He found Powers ingenious and ingenuous: "fresh, original, and full of bone and muscle."[1]

Eventually, however, Powers's plainspokenness and absorption in technical problems made him vulnerable to criticism that he was something less than a true artist. As early as 1864, James Jackson Jarves, in *The Art-Idea,* pointed to his flawed sentimentality and his weaknesses of invention. The sculptor's reputation fared even worse at the turn of the century; in 1903 Lorado Taft, in his *History of American Sculpture,* disparaged Powers's work as merely the production of a mechanic.

1 Nathaniel Hawthorne, "Passages from the French and Italian Notebooks," in *The Complete Works of Nathaniel Hawthorne* (Boston, 1871), vol. 10, p. 309.

Bibliography Henry T. Tuckerman, *Book of the Artists: American Artist Life* (New York, 1867), pp. 276–94; Lorado Taft, *The History of American Sculpture* (1903; rev. ed., New York, 1924), pp. 56–71; Richard P. Wunder, "The Irascible Hiram Powers," *American Art Journal* 4 (November 1972), pp. 10–15; Donald Martin Reynolds, "Hiram Powers and His Ideal Sculpture," Ph.D. diss., Columbia University, 1975; Richard P. Wunder, *Hiram Powers, Vermont Sculptor, 1805–1873,* 2 vols. (Newark, Del., 1991).

James Fenner Penniman, 1851

Marble
30½ x 21 x 15⅝ in. (77.5 x 53.3 x 39.7 cm)
Markings: H. POWERS. *Sculp.* (on back)

Cornelia Judd Penniman, 1851

Marble
29¼ x 20 x 13⅛ in. (74.3 x 50.8 x 33.3 cm)
Markings: H. POWERS./*Sculp.* (on back)

Portrait busts formed a large part of Powers's business: between 1842 and 1855 he completed more than 150 of them. Considering himself one of the very few among his colleagues who could make a good portrait, he claimed that he could even suggest a blush in white marble,[1]

and these two portraits present particularly fine examples of his skill. They are a rare instance of a matched husband-and-wife pair, the second of only four such pairs recorded to be by him.

The sitters have been identified by Richard Wunder as James Fenner Penniman (died 1876), a wealthy Brooklyn dealer in oils and soap, and his wife, Cornelia Judd Penniman (died 1891).[2] They sat for Powers in Florence in the spring of 1851, and they made a down payment but never remitted the balance, even though suit was threatened by Powers's bankers in New York. Presumably the busts were then placed on view on a shelf in the outer room of Powers's studio, where, as one visitor observed, the word "Delinquents" was chalked prominently above them.[3]

Powers clad the bust of Mr. Penniman in a togalike garment, his wife in similar drapery with an off-the-shoulder, side-buttoned shift underneath. The intent was to evoke ancient Roman drapery and thereby reinforce the general demeanor of Roman patrician portraiture without strictly duplicating it. The sculptor's observations of Roman portraiture led him to believe that much of it could be improved upon. As Hawthorne commented:

> He passed a condemnatory sentence on classic busts in general, saying they were conventional, and not to be depended upon as true representations of the persons. He particularly excepted none but the bust of Caracalla; and indeed everybody that has seen this bust must feel the injustice of the exception and so be the more inclined to accept his opinion about the rest.[4]

The forthright naturalism of the Penniman busts is surely in concert with the Roman patrician portrait tradition. That naturalism extends to the scale of the works (the figures are life-size, and Mrs. Penniman is proportionately smaller than her husband) and the extreme subtlety of detail in them. The creases in Mr. Penniman's twisting neck, his thick, somewhat unruly hair, and his wife's slightly sagging facial muscles are all faithfully expressed. The marble itself shows the slight mottling of many veins submerged in the stone, not unlike veins in skin.

Powers believed that naturalism accounted for the superiority of ancient

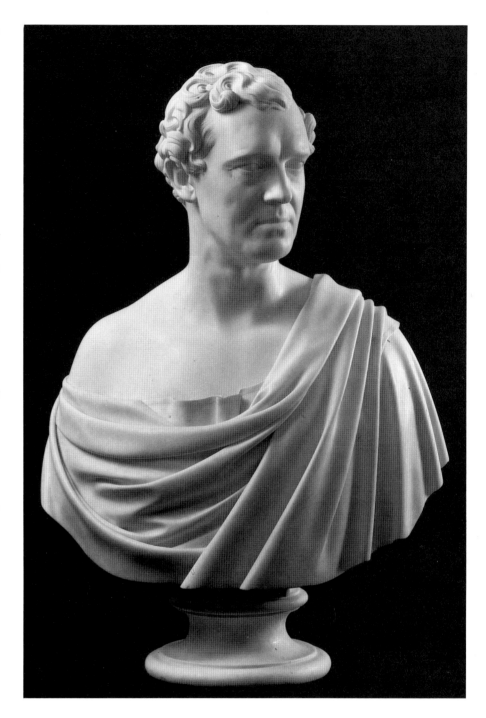

Greek sculpture.[5] That same attribute Powers claimed for himself: he felt it would be "blasphemy to talk or think of improving upon nature."[6] Indeed, his naturalism distinguished him from his expatriate colleagues Horatio Greenough and Thomas Crawford and was felt among Italians to be the mark of his originality.

The busts of Mr. and Mrs. Penniman were never completely finished. At least eight pointing holes are visible on Mr. Penniman, in the logical places for such transfer marks: temples, inner ear, back of neck. The more finished Mrs. Penniman still shows two shallow pointing holes on her shoulder and back, and her base was attached later. There is plaster residue in the crevices of each sculpture, and water staining is visible on each of their hollowed-out backs, indicating that casts were taken from them. It would have been logical for Powers to have made plasters after the busts, using them as the preliminary models for other works.
DS

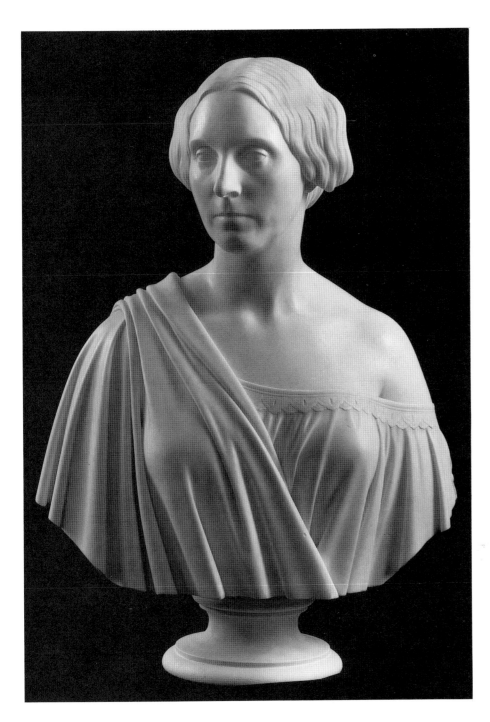

1 Nathaniel Hawthorne, "Passages from the French and Italian Notebooks," in *The Complete Works of Nathaniel Hawthorne* (Boston, 1871), vol. 10, p. 285.

2 Richard P. Wunder to Mimi d'Bloch, July 22, 1986, museum files, The Carnegie Museum of Art, Pittsburgh.

3 Henry W. Bellows, "Seven Sittings with Powers, the Sculptor," part 5, *Appleton's Journal of Literature, Science, and Art* 1 (Aug. 7, 1869), p. 597.

4 Hawthorne, "Passages from the French and Italian Notebooks," p. 284.

5 Bellows, "Seven Sittings," part 2, *Appleton's Journal* 1 (June 19, 1869), p. 359.

6 Ibid., p. 360.

James Fenner Penniman

References Reynolds, "Hiram Powers and His Ideal Sculpture," p. 1,058; Wundar, *Hiram Powers, Vermont Sculptor*, vol. 1, pp. 171–72, 333; vol. 2, p. 81.

Provenance Richard Gilbert Auctioneer, Garrison, N.Y., 1979; Post Road Gallery, Larchmont, N.Y., 1979; Mimi d'Bloch, New York, as agent for Stratford Fine Arts Ltd., by 1986.

Museum purchase: gift of the Fellows of the Museum of Art, 1987, 87.10.1

Cornelia Judd Penniman

References Reynolds, "Hiram Powers and His Ideal Sculpture," p. 1,058; Wundar, *Hiram Powers, Vermont Sculptor*, vol. 2, pp. 80–81.

Provenance Richard Gilbert Auctioneer, Garrison, N.Y., 1979; Post Road Gallery, Larchmont, N.Y., 1979; Mimi d'Bloch, New York, agent for Stratford Fine Arts Ltd., by 1986.

Museum purchase: gift of the Fellows of the Museum of Art, 1987, 87.10.2

Maurice Prendergast
1858–1924

ACCORDING TO THE records in the Provincial Archives of Newfoundland, Canada, Maurice Brazil Prendergast was born in Saint John's, Newfoundland, on October 10, 1858, rather than 1859 or 1861, as has been previously published. Brought to the United States at the age of three, he grew up in Boston, his mother's hometown. After graduating from grammar school, he worked in a dry-goods store, then for a painter of signs and show cards. By 1883 he was earning a living doing calligraphy and other commercial artwork.

In 1891, with the financial support of his younger brother Charles, a painter and successful frame maker, Prendergast traveled to Paris. He studied initially at the Atelier Colarossi under Gustave Courtois, then at the Académie Julian, where he met James Wilson Morrice, a Canadian painter whose friendship and artistic guidance proved more valuable than academic studies. Through Morrice, Prendergast became acquainted with several British artists, among them Charles Condor, Walter Sickert, and Aubrey Beardsley. Prendergast took to sketching Parisians strolling on boulevards and playing in parks and, with Morrice, visited the seacoast towns of Dieppe and Saint-Malo in search of subjects.

During these formative years in Paris, Prendergast was initially influenced by Edouard Manet and James McNeill Whistler, but he soon discovered the work of the Post-Impressionists. He was

especially attracted to the Pointillist paintings of Georges Seurat and Paul Signac and to the work of Edouard Vuillard and Pierre Bonnard, both of whom were influential in the development of his decorative style. During this period he did a few small oil paintings, but he concentrated on making watercolors and color monotypes.

Prendergast returned to Boston in 1895, settling in nearby Winchester, Massachusetts, where Charles operated a frame shop. The themes he had developed in Paris—fashionable city dwellers in parks, on boulevards, and at the beach—continued to interest him. His frequent sketching trips along the New England shore resulted in many fine watercolors, which he began to exhibit, building a favorable reputation among Boston patrons.

In 1898–99 Prendergast returned to Europe and visited Venice. There he painted some of his best-known watercolors, in which he translated the city's myriad watery reflections into brightly colored patterns. His acquaintance with the decorative compositions of the Venetian Renaissance painter Vittore Carpaccio may have inspired such festive watercolors as *Piazza di San Marco* (c. 1898–99, Metropolitan Museum of Art, New York) or *Sunlight on the Piazzetta, Venice* (1891, private collection).

After 1900 Prendergast's work received wider exposure. He exhibited at the Art Institute of Chicago and at the Macbeth Galleries, New York, and won a bronze medal at the 1901 Pan-American Exposition in Buffalo for his watercolor *The Stony Beach* (1901, private collection). He frequently visited New York, making Central Park a subject for two-dimensional watercolors in which he captured the holiday or weekend festivities of New York's upper classes.

Around 1903 or 1904 Prendergast began to take a more serious interest in painting oils. While his subject matter did not change—he continued to depict a peaceful world of picnics, summer outings, and afternoons in the park—he began to move toward a more abstract style, organizing his canvas into mosaiclike patterns of small, intensely colored strokes and color patches. His style, reminiscent of that of the French Nabis group, marks Prendergast as the first American painter

so thoroughly to assimilate Post-Impressionist ideology. Prendergast's dedication to progressive, independent art led to his participation in the landmark exhibition of the Eight at the Macbeth Galleries in February 1908. It also led him back to Europe three more times between 1909 and the outbreak of World War I. Two visits to Paris increased his familiarity with the paintings of Paul Cézanne and the Fauves.

Although hampered by poor health and deafness, Prendergast contributed seven works to the Armory Show of 1913. At that landmark exhibition he sketched paintings by Paul Gauguin, Henri Matisse, and Vincent van Gogh, which inspired him to experiment with the relationship between brushstroke and color. The result was his development of a nearly abstract decorative aesthetic, singular in early-twentieth-century America.

In 1914 Prendergast moved with Charles to New York, where the Carroll Galleries held a large exhibition of his work. It was followed, in 1921, by a smaller retrospective at New York's Brummer Gallery. After 1922, Prendergast's hearing and general health weakened; he died in New York.

Bibliography Van Wyck Brooks, "Anecdotes of Maurice Prendergast," *Magazine of Art* 31 (October 1938), pp. 564–69, 604; Museum of Fine Arts, Boston, *Maurice Prendergast, 1859–1924* (1960), exh. cat. by Hedley Howell Rhys; University of Maryland Art Gallery, College Park, *Maurice Prendergast* (1976), exh. cat. by Eleanor Green, Ellen Gavin, and Jeffrey R. Hayes; Carol Clark, Nancy Mowll Matthews, and Gwendolyn Owens, *Maurice and Charles Prendergast: Systematic Catalogue* (Williamstown, Mass., 1990).

Picnic, c. 1914–15
(Decoration—Picnic)

Oil on unsized canvas
77 x 106½ in. (195.6 x 270.5 cm)
Signature: Prendergast (lower right)

Picnic is one of two large-scale paintings that Prendergast produced for a four-way mural project conceived by Arthur Davies and Walt Kuhn. It included Davies's *Dances* (1914–15, Detroit Institute of Arts) and *Man and Sea Beach* (1914–15, location unknown) by Kuhn, as well as Prendergast's *Promenade* (fig. 1) and the present painting. "None of these four murals had been commissioned," Kuhn recalled. "They were done simply because Davies and myself felt the urge to do them and hoped their showing would perhaps stimulate more of the sort by ourselves and other artists."[1] Among the three artists only Davies, who had recently completed wall decorations for the music room of Lillie Bliss's New York residence, had previous experience with large formats.

Aspiring to make a public statement in a modern style, the artists exhibited the four new works collectively at the Montross Gallery in New York in April 1915. Here they were purchased by John Quinn, an important early collector of contemporary art, in whose possession the works remained until 1927.[2] Shortly after their purchase, the panels were displayed in San Francisco at the Panama-Pacific International Exposition.

Typical of the genteel subjects that Prendergast favored throughout his career, both *Picnic* and *Promenade* are scenes of suburbanites enjoying a summer outing at the shore. The Carnegie canvas

Fig. 1 Maurice Prendergast, *Promenade*, 1915. Oil on canvas, 83¾ x 134 in. (212.7 x 340.4 cm). Detroit Institute of Arts, City of Detroit purchase, 1927

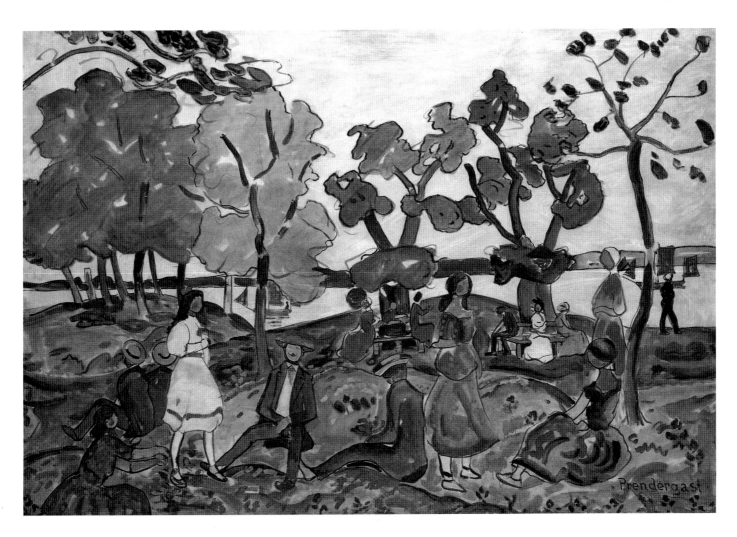

depicts a sparsely wooded park with figures seated on benches beneath the trees and others grouped in the foreground. A narrow body of water with two sailboats occupies the middle distance, with a range of deep blue hills beyond. Four of the figures in the foreground are loosely based on Manet's *Luncheon on the Grass* (1863, Musée d'Orsay, Paris). Such specific allusion is rare in Prendergast's work, yet in *Promenade* the artist also makes general reference to Seurat's *Sunday Afternoon on the Island of La Grande Jatte* (1884–86, Art Institute of Chicago).[3]

In contrast to the Detroit panel, where the application of color conforms to Prendergast's usual patchy brushstroke, although here enlarged, the pigments used in *Picnic* were thinned with solvent so that they resemble washes of watercolor on paper. Prendergast first drew in the outlines of forms with dark browns, then washed in patches of translucent colors—a muted scheme of green, yellow, and blue enlivened by highlights of white ground. Using brushes that ranged in

width from one to five inches, he playfully enlarged an ordinary easel-sized technique to mural proportions.

The sweeping fluidity of Prendergast's brushwork not only imparts a decorative rhythm to the canvas but also lends the composition an unusual informality. Here, his typical gridlike arrangement of horizontal landscape elements overlaid with vertical figures and trees is transformed into a softly undulating scene in which rounded shapes predominate. Prendergast made a watercolor study (private collection) for the mural, which is almost identical in composition to the final version.

GB

1 Walt Kuhn Papers, Archives of American Art, Washington, D.C.

2 Dennis A. Nawrocki, "Prendergast and Davies: Two Approaches to a Mural Project," *Bulletin of the Detroit Institute of Arts* 56, no. 4 (1978), p. 243.

3 Ibid., p. 251

References J. Bretton, "American Modernism," *American Art News* 13 (Apr. 1915), p. 10; "The 'New Art' Applied to Decoration," *Vanity Fair* 4 (May 1915), p. 40; F. G. Gregg, "Modern Art's Revenge at San Francisco," *Vanity Fair* 5 (Mar. 1916), pp. 51, 134; "Whole of John Quinn Collection Announced for Sale Piecemeal," *Art News* 24 (Jan. 2, 1926), pp. 1, 3; John Quinn, *John Quinn, 1870–1925: Collection of Paintings, Watercolors, Drawings, and Sculpture* (Huntington, N.Y., 1926), p. 25; "Paintings Sold at Auction," *American Art Annual* 24 (1927), p. 384; American Art Association, New York, *Paintings and Sculptures: The Renowned Collection of Modern and Ultra Modern Art Formed by the Late John Quinn* (1927), no. 519, p. 207; "Quinn Art in Five Session Sale," *Art News* 25 (Jan. 15, 1927), pp. 1–2; "Last of Quinn Art to Go at Auction," *New York Times*, Jan. 16, 1927, p. 20; "Sale of the Quinn Collection Is Completed," *Art News* 25 (Feb. 19, 1927), p. 11; H. H. Rhys, "Maurice Prendergast: The Sources and Development of His Style," Ph.D. diss., Harvard University, 1952, pp. 103, 158; Museum of Fine Arts, Boston, *Maurice Prendergast 1859–1924* (1960), exh. cat. by Peter A. Wick, p. 74; L. A. Arkus, "Picnic," *Carnegie Magazine* 47 (Apr. 1973), p. 139; D. A. Nawrocki,

"Prendergast and Davies: Two Approaches to a Mural Project," *Bulletin of the Detroit Institute of Arts* 56, no. 4 (1978), pp. 243–52; C. S. Marlor, *The Society of Independent Artists: The Exhibition Record 1917–44* (Park Ridge, N.J., 1984), p. 448; H. Adams, in Museum of Art, Carnegie Institute, *Collection Handbook* (Pittsburgh, 1985), p. 234; J. P. Henshaw, ed., *One Hundred Masterworks from The Detroit Institute of Arts* (Detroit, 1985), p. 208; C. Fox, "'Advent of Modernism' Is a Winner," *Atlanta Constitution*, Mar. 6, 1986, Sec. B, pp. 1, 2; S. Faunce, "*The Advent of Modernism:* A Look at North America's First Impressions of Post-Impressionism," *The Brooklyn Museum Newsletter*, Nov. 1986, p. 1; R. Smith, "Art: 'Advent of Modernism' at Brooklyn Museum," *New York Times*, Dec. 26, 1986, sec. C, p. 32; S. C. Strickler, ed., *American Traditions in Watercolor: The Worcester Art Museum Collection* (Worcester, Mass., 1987), p. 150; C. Langdale, "The Late Watercolor-Pastels of Maurice Prendergast," *Antiques* 132 (Nov. 1987), p. 1,090; J. Zilczer, "Arthur B. Davies: The Artist as Patron," *American Art Journal* 19 (Nov. 3, 1987), p. 64; C. Clark, N. M. Matthews, and G. Owens, *Maurice and Charles Prendergast: Systematic Catalogue* (Williamstown, Mass., 1990), no. 406, p. 301.

Exhibitions Montross Gallery, New York, 1915, *Exhibition of Paintings, Drawings, and Sculpture*, no. 41, as *Decoration—Picnic;* Panama-Pacific International Exposition, San Francisco, 1915, *Post-Exposition Exhibition in the Department of Fine Arts, Panama-Pacific International Exposition*, no. 6,229; Whitney Museum of American Art, New York, 1934, *Maurice Pendergast Memorial Exhibition*, no. 73; Graham Gallery, New York, 1962, *Survey Exhibition of 85 Paintings Selected from the Checklist*, unnumbered; Graham Gallery, New York, 1965; Graham Gallery, New York, 1967, *In Honor of the International Council of Museums. A Special Exhibition at Graham Galleries*, no. 20; Hirshhorn Museum and Sculpture Garden, Washington, D.C., 1978, *The Noble Buyer: John Quinn: Patron of the Avant Garde*, no. 61; High Museum of Art, Atlanta, 1986, *The Advent of Modernism: Post-Impressionism and North American Art, 1900–1918* (trav. exh.), exh. cat. by P. Morrin, J. Zilczer, and W. C. Agee, unnumbered.

Provenance Montross Gallery, 1915; John Quinn, 1915 (sale, American Art Association, New York, Feb. 11, 1927), lot no. 519; Kraushaar Galleries, New York, 1927; Arthur F. Egner, New Jersey, 1934; Mrs. John Malone; James Graham and Sons, New York, 1960; Victor D. Spark, New York.

Museum purchase: gift of the people of Pittsburgh through the efforts of the Women's Committee, Museum of Art, Carnegie Institute, 1972, 72.51

Women at Seashore, c. 1915 (The Beach)

Oil on wood panel
17 x 32 in. (43.2 x 81.3 cm)
Signatures: Prendergast (lower left); *Maurice B. Prendergast* (lower right)

Quiet waterside scenes of graceful female figures had been a recurrent theme in Prendergast's art from his earliest Impressionist-inspired watercolors painted at Dieppe in 1891–92 to his late abstract oils such as *Beach, No. 3* (1915, Metropolitan Museum of Art, New York). Probably painted around 1915, *Women at Seashore* is a typical example of Prendergast's later treatment of this theme.

Like so many of Prendergast's idyllic scenes, this one depicts a friezelike arrangement of stylishly dressed women, linked by pose and gesture, walking along the shore. However, the sense of their procession is disrupted by the intermittent placement of smaller nude figures behind them. Prendergast's conventional tripartite division of land, sea, and sky here includes a rugged promontory jutting out into the bay, a landscape element commonly found in his late paintings. A sampling of works closely related in both theme and composition to *Women at Seashore* includes *The Idlers* (1916–18, Randolph-Macon Women's College, Lynchburg, Va.), *The Cove* (c. 1916, Whitney Museum of American Art, New York), and *Under the Trees* (c. 1914, Whitney Museum of American Art). In each of these the stylization of the foreground figures and their large size relative to the background forms emphasize their role as abstract elements in the design and represent a departure from the naturalistic balance of Prendergast's earlier work.

Fundamental to Prendergast's work after 1913 were the paintings by Henri Matisse that the artist saw at the Armory Show. Of these, *Luxe, Calme et Volupté*

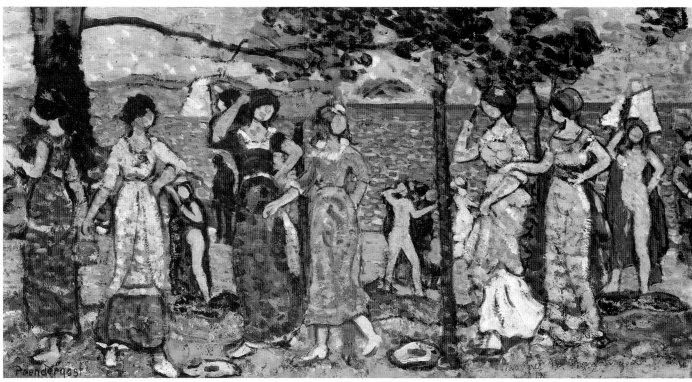

(1904–5, private collection, Paris) proved the most inspirational. Elements of Matisse's technique as well as his inclusion of both clothed and nude figures and the general seaside setting are ingredients that frequently appear in Prendergast's late oils. Despite the similarities among these post–Armory Show works, each has a distinctive tonality, indicative of mood, which preserves its individuality. In *Women at Seashore*, Prendergast's use of subtle shades of pink and lilac combined with deep greens produces a bright, sumptuous image. His abiding interest in patterned compositions achieved through small, intensely colored strokes is complemented by the use of dry impasto to produce a heavily textured surface.

GB

References F. A. Myers, "Women at Seashore," *Carnegie Magazine* 39 (Feb. 1965), p. 69; D. W. Scott, *Maurice Prendergast* (Washington, D.C., 1980), p. 9; H. Spencer, "On Some Works by Maurice Prendergast," William Benton Museum of Art, University of Connecticut, Storrs, *Bulletin* 13 (1985), p. 81; C. Clark, N. M. Matthews, and G. Owens, *Maurice and Charles Prendergast: Systematic Catalogue* (Williamstown, Mass., 1990), no. 425, p. 307.

Exhibitions Whitney Museum of American Art, New York, 1934, *Maurice Prendergast Memorial Exhibition*, no. 118; Museum of Art, Carnegie Institute, Pittsburgh, 1965, *The Seashore: Paintings of the Nineteenth and Twentieth Centuries*, no. 85; University of Maryland Art Gallery, College Park, 1976, *Maurice Prendergast* (trav. exh.), no. 107.

Provenance Macbeth Galleries, New York; Edward Duff Balken, Pittsburgh, 1916.

Bequest of Edward Duff Balken, 1960, 60.42

Levi Wells Prentice

1851–1935

THE BIOGRAPHIES OF nineteenth-century American still-life painters tend to be fragmentary, and Levi Wells Prentice's is no exception. He has emerged from obscurity only in recent years, as interest in the hard-edged realism of the late nineteenth century has increased. A lesser contemporary of

William M. Harnett and John F. Peto, Prentice was born in rural Lewis County in northeastern New York and lived in that part of the state for the first twenty years of his life. After moving to Syracuse in the early 1870s, he began painting landscapes and portraits, supplementing his income with cabinetwork and frame making. He lived for a time in Buffalo, then relocated to Brooklyn by 1883, the first year he was listed in the city directory.

In Brooklyn, Prentice found an active art community. It supported a number of still-life painters—including William Mason Brown, August Laux, and Joseph Decker—whose work shared an affinity with the trompe-l'oeil style of Harnett. In this environment, Prentice turned to still life, although it is not known exactly when his career as a still-life painter began. By the 1890s he had become one of the most distinctive of the fruit-and-vegetable painters who were Harnett's younger contemporaries.

Prentice specialized in small, simple, and often startlingly intense images of local fruit, either placed on tabletops or laid out in a landscape. A favorite motif was to show slightly bruised apples or plums spilling out of splintered baskets or pails. His compositions were similar to Harnett's in their sharp contours, deep colors, and mastery of textural effects, yet they always evinced a somewhat primitive quality, the forms a bit too explicitly outlined for convincing illusionism and the settings lacking believable depth.

The work on which Prentice's reputation rests is usually dated around 1890. That year coincided with the end of Harnett's career and, oddly enough, the beginning of the demise of precisely drawn, trompe-l'oeil-style still-life painting. Prentice, who appealed to a more modest type of patron than did Harnett, remained somewhat insulated from the shifting taste to which Harnett fell victim, but for how long is not certain.

Prentice ceased to be listed in the Brooklyn city directory in 1901. He apparently returned to northern New York, where he painted landscapes of the Adirondacks, and he died in Philadelphia.

Bibliography William H. Gerdts and Russell Burke, *American Still-Life Painting* (New York, 1971), pp. 159–62; William H. Gerdts, *Painters of the Humble Truth: Masterpieces of American Still Life 1801–1939* (Columbia, Mo., 1981), pp. 205–8.

Still Life with Strawberries, c. 1890

Oil on canvas
16⅛ x 20 in. (40.9 x 50.8 cm)
Signature: L. W. Prentice (lower right)

This composition is among Prentice's most stylistically controlled and thematically sophisticated. It shows a sliced, frosted raisin cake, two bowls of strawberries, a pitcher, and a single cup of tea on a

shiny wooden tabletop. The objects are arranged into a pyramidal shape, then set into a relatively empty space. As a backdrop, Prentice selected a dark green wall, punctuated by the architectonic details of a pilaster and chair rail.

With its restrained, formal ambience and hard, perfect surfaces, this work recalls the harmonious balance of earlier nineteenth-century Neoclassical still lifes and forms a compositional opposite to Prentice's overturned baskets of imperfect fruit that randomly send their contents spilling across his picture surfaces. Here, all organic substances are neatly contained in ceramic vessels, which create inviolable boundaries and emphasize the surrounding space. In keeping with this picture's strong geometry, even the strawberries are absolutely uniform in color, shape, and condition.

It follows from Prentice's compositional intentions that he declines to place the viewer in the role of a surrogate diner. Although not immediately evident, the artist's arrangement of cake, fruit, and accompanying utensils is not a natural one: there is no teapot from which the cup of tea has been served, no waste bowl holding the strawberry hulls, no serving fork with which to take a slice of cake nor a dish on which to place it. The effect is one of self-sufficient objects whose existence is not dependent upon a narrative context.

Perhaps the most meaningful attribute of this picture is the artist's desire to refer to the past with neither pretense nor nostalgia, an attribute likewise apparent in Harnett's work. The ceramic ware, for example—similar in appearance to the blue-decorated stoneware and tin-glazed earthenware favored by Harnett—was unpretentious stuff by the standards of 1890, as are the other decorative elements of the painting, from the plain green wall to the severely simple tabletop. Prentice probably selected the ceramics for the same reason that Harnett did: to give his image an old-time quality. But Prentice's vessels do not seem very old; they could be of the earlier nineteenth century, only slightly out of date, and therefore lack the built-in nostalgia of truly antique vessels.
DS

Provenance Gallery Forty-four, New Hartford, Conn., before 1981; Thomas Colville, New Haven and New York, c. 1981; Coe Kerr Gallery, New York, by 1981.

Museum purchase: Mary Oliver Robinson Fund, bequest to Women's Committee of the Museum of Art, and Women's Committee Acquisition Fund, 1981, 81.73

William Matthew Prior
1806–1873

WILLIAM MATTHEW PRIOR was a folk painter active in New England in the second and third quarters of the nineteenth century. Although best known for his portraits, he combined a variety of activities throughout his long career, including landscape, sign, and ornament painting. Prior was born in Bath, Maine, the son of a Massachusetts shipmaster. Although few details of his childhood or education are known, it is unlikely he received any formal artistic training. However, his earliest known work indicates that by the age of eighteen he had already begun painting professionally.

In the late 1820s, Prior placed several notices in the *Maine Inquirer;* he first advertised his willingness to undertake any sort of decorative work, then in 1828 described himself as a limner willing to paint portraits as well as so-called flat likenesses. The latter were executed without the use of shade or shadow and were sold at a reduced price. By 1830 the value of these canvases ranged from ten to twenty-five dollars, and a gilt frame cost an additional three to ten dollars.[1]

In 1828 Prior married Rosamond Hamblen. Sometime after exhibiting a portrait at the Boston Athenaeum in 1831, he moved to Portland, Maine, where his wife's father and brothers were known as "house, sign and fancy painters."[2] In 1841 Prior relocated to Boston; there he lived with his brother-in-law Nathaniel Sturtevan Hamblen, and may have given some instruction to him.

Long an admirer of Gilbert Stuart, Prior convinced the Boston Athenaeum to allow him to copy Stuart's portrait of George Washington (1796, Museum of Fine Arts, Boston, and National Portrait Gallery, Washington, D.C.), which he translated into numerous renditions on

glass. He subsequently indulged in painting the likenesses of other historical figures, including Abraham Lincoln, Napoleon, and Daniel Webster. In the early 1840s the artist joined the Advent Movement, the study of prophetic chronology begun by William Miller. An ardent follower of the Adventists, Prior published two books on the subject, the first in 1862 and the second in 1868. In his second book, *The Empyrean Canopy*, he tells of painting a chronological chart under Miller's direction and of being moved to paint his portrait.[3]

Purchasing a home that he called the "Painting Garret" in 1846 in Boston, Prior continued his career as a portraitist while also attempting landscape painting, although his landscapes were not popular. He created New England coastal views, winter scenes, and a number of canvases depicting Mount Vernon and Washington's tomb. Prior died in Boston.

1 Little, "William M. Prior," p. 44.

2 Ibid., p. 45.

3 Ibid., p. 47.

Bibliography Grace Adams Lyman, "William M. Prior," *Antiques* 26 (November 1934), p. 180; Nina Fletcher Little, "William M. Prior, Traveling Artist and His In-Laws, The Painting Hamblens," *Antiques* 53 (January 1948), pp. 44–48, reprinted in Jean Lipman and Alice Winchester, *Primitive Painters in America, 1750–1950* (New York, 1950), pp. 80–89.

Tomb of Washington, Mount Vernon, c. 1855

Oil on canvas
19¹⁄₁₆ x 26¼ in. (48.4 x 66.7 cm)

The theme of George Washington and views of Mount Vernon were popular subjects throughout Washington's presidency and afterward. The death of the nation's first leader heralded a flood of elegiac pictures that featured his tomb. The present example is typical of the nineteenth-century paintings and prints produced in Washington's memory, including as many as nine other Mount Vernon canvases done by Prior at mid-century. Prior's other variants of the tomb of Washington at Mount Vernon are all

quite similar to this painting except for some differences in foreground staffage (fig. 1, 2).

In this southeasterly view of the estate, Prior used a subdued palette of greens, browns, and grays along with a primitive painting style lacking in detail. He placed the mansion in a prominent position atop a tree-crowned hill and the brick tomb, surrounded by three obelisks, in the lower-left-hand corner of the canvas. Prior's somewhat summary style is evident in the now much-abraded man on horseback riding past the tomb. His characteristic

brushwork is apparent in the series of small white dashes representing sailboats on the Potomac and in the low-lying gray-blue mountains in the distance.

This scene may have been derived from an unsigned and undated illustration titled *Mount Vernon, The Birthplace and Residence of George Washington* that appeared in the nineteenth-century periodical *Gleason's Pictorial Drawing Room Companion* (fig. 3). Although Prior did visit Baltimore in 1855 and may have seen Mount Vernon during that trip, it is more likely he used this print as his source of reference for the painting.

LAH

Remarks Prior to acquisition the paint surface was considerably abraded, perhaps during restoration.

Exhibition Westmoreland Museum of Art, Greensburg, Pa., 1989, *A Sampler of American Folk Art from Pennsylvania Collections*, exh. cat. by P. A. Chew, no. 256.

Provenance Victor Spark, New York, 1947; H. Gregory Gulick, New York, by 1948; Edgar W. and Bernice Chrysler Garbisch, Cambridge, Md., 1948.

Bequest of Edgar W. and Bernice Chrysler Garbisch, 1981, 81.21.24

Fig. 1 William Matthew Prior, *Mt. Vernon and the Tomb of Washington*, after 1852. Oil on canvas, 18¾ x 28¾ in. (47.7 x 73 cm). Smith College Museum of Art, Northampton, Mass., purchase, 1950

Fig. 2 William Matthew Prior, *Mt. Vernon and Washington's Tomb*, c. 1855. Oil on canvas, 19⁵⁄₁₆ x 25 in. (49 x 63.5 cm). Henry Ford Museum and Greenfield Village, Dearborn, Mich., 1957

Fig. 3 Unidentified artist, *Mount Vernon, The Birthplace and Residence of George Washington.* Lithograph, from *Gleason's Pictorial Drawing Room Companion* 5 (Oct. 29, 1853): 273

Henry Ward Ranger
1858–1916

DURING THE EARLY YEARS of the twentieth century, Henry Ward Ranger was regarded as the "dean of American landscape."[1] His work and its popularity are evidence of a long-lasting American interest in Barbizon-style painting. Born in Syracuse, New York, the son of a commercial photographer, Ranger began to paint while attending Syracuse University in the mid-1870s. Despite opposition from his family, he decided to become a professional artist, and in 1878 he opened a studio in New York City, supporting himself by writing music criticism. The collector William M. Laffan soon befriended him and introduced him to the dealer Gustave Reichard, who promoted his work.

Ranger was attracted to the naturalistic, deeply colored, and heavily impastoed French Barbizon manner of landscape painting, examples of which were plentiful in New York galleries in the late 1870s. He improved his acquaintance with the style in the early 1880s while studying at the Académie Julian in Paris and while visiting Holland, where he was deeply influenced by such Dutch practitioners and popularizers of the Barbizon mode as Josef Israels and Anton Mauve.

Following his return to the United States, Ranger became a leading American exponent of the Barbizon style, best known for his richly painted scenes within autumn forests. Having settled in New York, he exhibited regularly at the National Academy of Design and the Society of American Artists during the 1890s, and he had his first solo exhibition in 1897 at Blakeslee Galleries, New York. Beginning in 1900, the year he won a bronze medal at the Paris Exposition Universelle, Ranger spent part of each summer in Old Lyme, Connecticut, working in the company of other American Barbizon painters. He became an associate of the National Academy of Design in 1901 and an academician in 1906.

Although Ranger's output could be faulted for being repetitious, the artist clearly knew how to promote his work to its best advantage. According to his colleague Elliott Daingerfield:

> Ranger had a very highly developed business sense, which is said to be an unusual gift in the fraternity of artists. He knew how to make money; he knew how to sell his pictures, and his eye was watchful for opportunity. . . . He valued his works and secured attention for them. He cared little for current exhibitions. When he brought his pictures before the public, it was usually in small groups, as a "one-man show," and thus the personal note was always reached.[2]

Ranger participated in several Carnegie Internationals between 1896 and 1910, as a favor, perhaps, to Carnegie Institute's director of the Department of Fine Arts, John Beatty. Beatty and Ranger were good friends; they addressed one another by their first names and visited each other's homes on a number of occasions. Ranger, however, made plain to Beatty his distaste for sitting on exhibition juries and never served on an International panel of judges. He did not want to place his own work before exhibition juries, either. In 1908 he told Beatty, "I hope you are not expecting me to send pictures before a jury, for you know my position."[3] Beatty assured Ranger that he fully understood his views, and allowed him to bypass the judges.[4] In 1909 Beatty honored the painter with a solo exhibition at Carnegie Institute.

When Ranger died suddenly in his studio at 27 West Sixty-seventh Street, New York, he left behind a sizable fortune. He left part of it as an endowment to the National Academy of Design for the acquisition of works by living American artists. Since 1919 the Ranger Fund has purchased over three hundred paintings and watercolors, all of which, as Ranger stipulated, have been distributed to museums, galleries, and libraries throughout the country.

1 Bromhead, "Henry W. Ranger," p. xxxiv.

2 Daingerfield, "Henry W. Ranger," p. 89.

3 Henry Ward Ranger to John Beatty, March 11, 1908, Carnegie Institute Papers, Archives of American Art, Washington, D.C.

4 John Beatty to Henry Ward Ranger, March 27, 1908, Carnegie Institute Papers, Archives of American Art, Washington, D.C.

Bibliography [Alfred Trumble], "News and Views," *Collector* 8 (February 15, 1897), pp. 113–14; Harold W. Bromhead, "Henry W. Ranger," *International Studio* 29 (July 1906), pp. xxxiii–xliv; Ralcy Husted Bell, *Art-Talks with Ranger* (New York, 1914); Elliott Daingerfield, "Henry W. Ranger: Painter," *Century Magazine* n.s. 75 (November 1918), pp. 82–89.

An East River Idyll, 1896

Oil on canvas
28 x 36 in. (71.1 x 91.4 cm)
Signature, date: H. W. Ranger '96 (lower left)

Although Ranger was primarily identified with dreamy New England forest scenes, he also found aesthetic delight in urban views of a type not normally regarded by his contemporaries as picturesque. In this it can be said that he anticipated the landscape painting of New York's Ashcan school of the early twentieth century. By 1887 Ranger had defined his attitude toward the city's more dismal aspects:

Distasteful as it may be to many, I have always had a fancy for wandering about town in bad weather. Fog and rain and snow in the streets have peculiar charms for me. They make pictures. They conceal what the sunshine reveals too much of, and reduce to charming masses details that have no

charm. . . . One morning last spring, while the country still lay asleep under a coverlid of white and the town was smothered in slush, I drifted, by what accident I know not, into one of the dirtiest and most dismal sections of New York. . . . underfoot the mud lay ankle deep; in the street a tumultuous tangle of laden trucks and wagons crashed and volleyed their way. . . . [the sky was] thick with mist, that smoked in billowing masses, just touched with opalescent light from the east, where the sun was fighting its way through the clouds. Black smoke from various chimneys rose and diffused through it, and high into its misty zenith mounted a graceful church tower, as if seeking with keen point to pierce a way out of the earthly turmoil into the quiet region of eternal day.[1]

An East River Idyll, one of Ranger's finest urban scenes, shows a street on Manhattan's Lower East Side. The dark buildings frame a view of the East River and Brooklyn's Williamsburg district on the far shore. Despite the dreary nature of the subject, Ranger has created a poetic tonal image that justifies the "idyll" of the title.

LD

1 Henry Ward Ranger, "A Nook of Old New York," *American Art Illustrated* 1 (1886–87), p. 2.

References "Mr. Ranger's Exhibition," *Art Amateur* 36 (Mar. 1897), p. 61; Obituary, *Boston Transcript*, Nov. 8, 1916, p. 14; "Artist Dies in New England: Henry Ward Ranger," *Pittsburg Dispatch*, Nov. 10, 1916, p. 3; "Henry W. Ranger and His Delightful New England Landscapes," *Pittsburgh Bulletin*, Nov. 11, 1916, p. 8; D. F. Hoopes, *The American Impressionists* (New York, 1972), p. 114; San Jose Museum of Art, Calif., *American Series: A Catalogue of Eight Exhibitions* (1977), n.p.

Exhibitions Blakeslee Gallery, New York, 1897, no. cat.; San Jose Art Museum, Calif., 1975–76, *Americans Abroad: Painters of the Victorian Era,* unnumbered; Museum of the Borough of Brooklyn at Brooklyn College, New York, 1983, *Crossing Brooklyn Ferry: The River and the Bridge,* no. 55; Madison Art Center, Wis., 1984–85, *The Seasons: American Impressionist Painting,* no. 37.

Provenance William T. Evans, New York, before 1900 (auction of William T. Evans collection, American Art Association, New York, Jan. 31–Feb. 2, 1900).

Purchase, 1900, 00.5

William Ranney
1813–1857

ALTHOUGH HE ALSO painted portraits, landscapes, and historical pictures, William Tylee Ranney is best remembered for the Western genre and sporting paintings he produced during the last decade of his short career. The son of a sea captain, he was born in Middletown, Connecticut, and after his father's death in 1826, he was sent to work with his merchant uncle in Fayetteville, North Carolina. He was soon apprenticed to a local tinsmith for whom he worked for six years. In 1833 or 1834, he moved to Brooklyn, New York, to study painting and drawing, although it is not known exactly where or with whom.

Ranney left Brooklyn to join the army of the Republic of Texas in March 1836, shortly after the fall of the Alamo. His nine months in Texas had a lasting influence on his artistic career: there he became fascinated with the trappers, guides, hunters, and mountain men who were his fellow recruits. Ten years later, their adventurous lives provided him with some of his most popular subject matter.

He returned to Brooklyn in 1837 and resumed his study of art. In 1838 he exhibited his first commissioned portrait at the National Academy of Design in

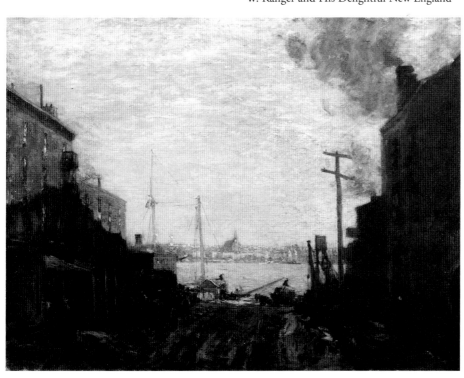

New York and received the first press review of his work. Little is known of his activities for the next few years, but by 1843 he was residing in New York City and advertising himself as a portrait painter. From 1845 onward, he was a regular exhibitor at the National Academy, to which he was elected an associate member in 1850, and at the American Art-Union in New York until its dissolution in 1851.

Prior to 1846, Ranney's works were mostly portraits and romanticized historical paintings based either on the American Revolution or the life of Daniel Boone. After that point, he added to his repertoire Western genre scenes derived from his experiences in Texas and the people he met there. His lively paintings of guides, trappers, and hunters dramatically illustrated the excitement of the West, while his prairie paintings conveyed the often harsh circumstances and lonely isolation of the pioneers' daily lives.

Around the same time, he began to paint pictures of hunting and shooting in the New Jersey marshes, his own expertise as a sportsman lending power and veracity to works such as *Duck Shooters* (1849, Museum of Fine Arts, Boston). Regardless of the subject matter, Ranney's approach was essentially that of a genre artist with little or no interest in the grandeur of nature: his schematically rendered landscapes functioned mainly as backdrops for his carefully drawn and lovingly detailed figures.

In 1853 Ranney settled in West Hoboken, New Jersey, a suburb of New York and a thriving artists' community, where he spent the remainder of his life. His studio there was crammed with Western and sporting artifacts—guns, cutlasses, and riding gear—which often served as props for his paintings. By this time, he had established a respectable reputation as a genre painter, praised for his use of native American subjects, dramatically portrayed and accurately detailed.[1]

Ranney's death from consumption left his family in poor financial circumstances. Although he had been moderately successful, his illness drastically reduced both his artistic output and his income during the last three years of his life. His fellow artists, led by the New York merchant Nason B. Collins, rallied to the support of his widow and children. They organized the Ranney Fund Exhibition at the National Academy in 1858 to sell the paintings left in his studio at the time of his death. Additionally, ninety-five artists, including Asher B. Durand, George Inness, Frederic E. Church, John Frederick Kensett, and Albert Bierstadt, donated works of their own to augment the profits. The success of the sale, which netted over seven thousand dollars, led soon afterward to the formation of the important Artists' Fund Society.[2]

1 Tuckerman, *Book of the Artists*, p. 432.

2 Grubar, in Corcoran Gallery of Art, *William Ranney*, p. 12.

Bibliography Henry T. Tuckerman, *Book of the Artists: American Artist Life* (New York, 1867), pp. 431–32; Corcoran Gallery of Art, Washington, D.C., *William Ranney: Painter of the Early West* (1962), exh. cat. by Francis S. Grubar; William H. Gerdts, Jr., *Painting and Sculpture in New Jersey* (Princeton, N.J., 1964), pp. 120–23; Hermann Warner Williams, Jr., *Mirror to the American Past: A Survey of American Genre Painting, 1750–1900* (Greenwich, Conn., 1973), p. 83; Amon Carter Museum, Fort Worth, Tex., and Buffalo Bill Historical Center, Cody, Wyo., *American Frontier Life: Early Western Painting and Prints* (1987), exh. cat. by Ron Tyler, Linda Ayres, et al., pp. 79–107.

The Old Oaken Bucket, 1851
(The Sportsmen's Halt at the Well; Hunter's Pause at the Well)

Oil on canvas
20 x 24¾ in. (50.8 x 62.9 cm)
Signature, date: W. Ranney/51 (lower left)

The carefully drawn figures, bright palette, and strong narrative content of *The Old Oaken Bucket* make it an excellent example of Ranney's later work. The painting presents two figures, their faces flushed from exertion, standing by a wooden well. The man is just about to drink from a bucket of water while the youth leans casually against the well and gazes toward his companion. That the pair have been hunting is attested to by the man's costume, the rifle, hat, and shooting bag at his side, the two hunting dogs, and the dead game carried by the boy. The shed to the left of the figures and the cow behind them place the scene in a farmyard.

Characteristically, Ranney used vivid coloring and varied brushstrokes to focus attention on the painting's genre elements. The cool tones in the sky and landscape background act as a foil for the warm, rich hues of brown, cream, gold, and salmon pink in the foreground figures and animals. Although the artist never studied in Europe, the influence of the Düsseldorf school is seen in the meticulously detailed brushwork of the

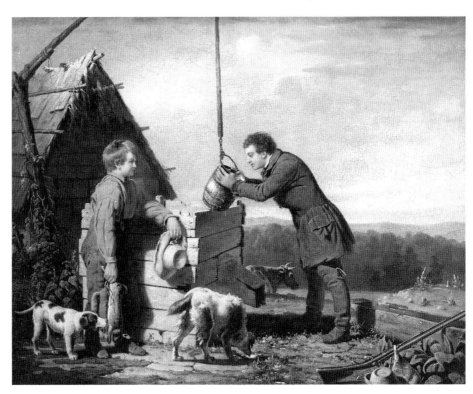

figures, which gives them a nearly sculptural quality. In contrast, the background hills and trees are rendered in a broad, schematic manner.

The narrative content of *The Old Oaken Bucket* would have been immediately recognized by a mid-nineteenth-century American public. The painting was probably inspired by a popular poem by Samuel Woodworth, a well-known writer and journalist. A collection of Woodworth's poems was published in 1826, and "The Old Oaken Bucket," a nostalgic evocation of rural childhood, was a familiar and beloved favorite by 1851. In the poem, Woodworth fondly recalled his family home in Scituate, Massachusetts, and described:

> That moss-covered bucket I hailed as a treasure,
> For often at noon, when returned from the field,
> I found it the source of an exquisite pleasure,
> The purest and sweetest that nature can yield.[1]

Woodworth's poem inspired a number of other nineteenth-century American genre paintings, but Ranney's version is distinguished by the addition of a hunting motif to the pastoral theme. Ranney's keenness and competence as a sportsman enhance the story value of the picture and temper its sentimentality.

The sporting motif is also responsible for the painting's variant titles: *The Sportsmen's Halt at the Well* and *Hunter's Pause at the Well*. Although the two earliest references to this work use the original title, an 1879 book refers to it as *The Sportsmen's Halt at the Well*,[2] which suggests that by that date "The Old Oaken Bucket" had lost its potency as an evocative image.

RB

1 "The Old Oaken Bucket," reprinted in Edmund C. Stedman, ed., *An American Anthology, 1787–1900* (Boston, 1900), p. 385.

2 Edward Strahan, *Art Treasures in America* (Philadelphia, 1879), vol. 2, p. 16.

References "Our Private Collections, No. IV," *The Crayon* (Aug. 1856), p. 249; Tuckerman, *Book of the Artists*, p. 432; E. Strahan, *Art Treasures in America* (Philadelphia, 1879), vol. 2, p. 16, as *The Sportsmen's Halt at the Well;* F. F. Sherman, *Early American Painting* (New York, 1932), p. 268; W. H. Downes, in *Dictionary of American Biography*, ed. by D. Malone (New York, 1935), vol. 15, pp. 377–78; Gerdts, *Painting and Sculpture in New Jersey*, pp. 122–23; H. B. Teilman, "Two American Paintings: Genre and Landscape," *Carnegie*

Magazine 46 (June 1972), pp. 245–46; L. Chapin, "Unpolluted Freshness," *Christian Science Monitor*, July 11, 1972, p. 8.

Exhibitions Corcoran Gallery of Art, Washington, D.C., 1962, *William Ranney: Painter of the Early West* (trav. exh.), exh. cat. by F. S. Grubar, no. 59; Carroll Reece Museum, East Tennessee State University, Johnson City, 1970, *The Painter Goes West*, no. 24, as *Hunter's Pause at the Well*.

Provenance Marshall O. Roberts, New York, by 1856; his widow, Margaret Agnes O'Sullivan, New York, by 1879 (sale of the Roberts estate, Fifth Avenue Galleries, New York, 1897, cat. p. 69); John Levy Galleries, New York, 1897; M. Knoedler and Co., New York, 1953.

Howard N. Eavenson Memorial Fund for the Howard N. Eavenson Americana Collection, 1972, 72.7.4

Henry Rebele
active c. 1850–1869

HENRY REBELE, WHOSE only known work is the Carnegie's portrait of Bob the fire dog, was listed in the 1850 Pittsburgh census as a twenty-nine-year-old fresco painter from Germany living on Saint Clair Street with his wife, Caroline, and another German fresco painter, Frederick Lotz. The Pittsburgh city directories from 1856 to 1868–69 list him at a variety of addresses, all in close proximity to Saint Clair Street.

Bibliography R. L. Polk and Co., *Pittsburgh Directory* (Boston 1856–69); George C. Groce and David H. Wallace, *The New-York Historical Society's Dictionary of Artists in America* (New Haven, 1957), p. 528; *U.S. Census Population Schedules Pittsburgh Seventh Census* (Pittsburgh, 1875), p. 49.

Bob, the Vigilant Fire Company's Dog, 1863

Oil on canvas
32 x 48 in. (81.3 x 121.9 cm)

Signature, inscriptions, date: H. REBELE./ *Pittsburgh/Pa* (lower right); VIGILANT/FIRE CO'S/BOB/POISON'D/JUNE 7TH/1860. (upper left); PRESENTED/to the/VIGILANT FIRE CO./by/J.S. [illeg.]RTH & D. KLOPPMAN./PITTSBURGH, JULY 1 1863. (lower left); *Vigilant Fire Co.*/PITTSBURGH (on dog's collar)

Bob, the Vigilant Fire Company's Dog offers a full-length profile of a large, terrierlike animal wearing an elaborate studded and engraved collar, standing on a stone floor by a fire hydrant and a wooden paddle. The artist has painted the dog with the attention to detail and inclusion of identifying attributes normally associated with human portraiture. It is a posthumous portrait: according to the inscription in the upper left-hand corner, Bob was poisoned on June 7, 1860. As Rebele was a close neighbor of the fire company, located at 80 Third Street, he was undoubtedly familiar with Bob's appearance and still able, three years later, to paint a good likeness of the dog. Bob's human eye and unusual haircut are, however, two clues to the artist's lack of a model.

No mention of the dog, the circumstances of his death, or the commission of his portrait are made in the minutes of the Vigilant Fire Company's meetings. However, a copy of its constitution and bylaws, printed in 1862, reveals a small engraved head of a dog, similar in appearance to Rebele's Bob but without the mustache, on the last page.[1]

EM

1 Vigilant Fire Company files, The Carnegie Library of Pittsburgh.

Edward Redfield
1869–1965

URING THE HEYDAY of American Impressionism, Edward Willis Redfield distinguished himself as the leader of the so-called Pennsylvania school. Like other American followers of the French Impressionists, he developed a distinctive style based on local scenery, especially in the area around New Hope, Pennsylvania. His bold, assertive landscapes, rapidly completed in a single session, were meant to capture one day's individuality, offering spontaneous and truthful reproductions of nature. Redfield's snow scenes, infused with a vibrant sense of locality, became the hallmarks of his art.

Born in Bridgeville, Delaware, Redfield entered the Pennsylvania Academy of the Fine Arts, Philadelphia, in 1885 and studied under Thomas Anshutz, James Kelly, and Thomas Hovenden. Although Thomas Eakins had left the academy before Redfield's enrollment, the school continued Eakins's teaching methods, which emphasized drawing from the nude model and studying anatomy. At the academy, Redfield seems to have been more interested in portrait painting than in other genres.

In 1889 Redfield left for Paris to study at the Académie Julian. There, under William-Adolphe Bouguereau and Tony Robert-Fleury, he studied from studio models and generally worked within the confines of academic traditionalism. But he soon grew uncomfortable with such academic education and began to borrow from the varied styles and techniques of

his classmates, as well as from the various types of Impressionism practiced by Claude Monet, Camille Pissarro, and Frits Thaulow. Retreating to the village of Brolles in the winter of 1889, Redfield abandoned portrait painting in favor of landscape and produced the first of his many snow scenes.

In 1892 he returned briefly to the United States for a solo show of his paintings at the Doll and Richards Gallery in Boston, and in 1896 he settled permanently in Pennsylvania. After purchasing an island farm and canal strip in Center Bridge in 1898, Redfield began to produce the large local landscapes for which he is now known. A year after Redfield moved to Center Bridge, William Lathrop arrived; gradually, other artists who would comprise the Pennsylvania school—Daniel Garber, Frank English, Sloan Bredin, Morgan Colt, Robert Spencer, John Folinsbee, and many more—moved to the area.

It did not take long for Redfield to achieve broad recognition. Many honors were bestowed on him, including a gold medal from the Art Club of Philadelphia in 1896, the Temple Gold Medal of the Pennsylvania Academy in 1903, the Jennie Sesnan Gold Medal from the Pennsylvania Academy in 1905, and the coveted Academy Gold Medal of Honor from the Pennsylvania Academy in 1907. He was a frequent contributor to Carnegie Institute's annual exhibitions, showing his work in thirty-six of them over fifty years, beginning in 1899. He also served several times on the jury of award.

Redfield continued to paint in an Impressionist manner, unaffected by the more modern aesthetics of the Ashcan school, the 1913 Armory Show, or the avant-garde developments in American art during the 1920s and 1930s. But by 1937 his method of painting outdoors in a single session had become too strenuous and he began to question the quality of his work:

> I was outside one day. My insteps were hurting. It was very windy, and I had trouble keeping my easel up. So I quit. The main reason though, was that I realized that I wasn't as good as I had been, and I didn't want to be putting my name on an "old man's stuff" just to keep going.[1]

Nevertheless, Redfield continued to paint until 1953; he died at Center Bridge.

1 Rutgers University Art Gallery, *Edward Redfield*, p. 7.

Bibliography J. Nilsen Laurvik, "Edward Redfield—Landscape Painter," *International Studio* 41 (August 1910), pp. 24–36; Frederick Newlin Price, "Edward Redfield—Painter of Days," *International Studio* 75 (August 1922), pp. 402–10; Charles V. Wheeler, *Redfield* (Washington, D.C., 1925); Rutgers University Art Gallery, New Brunswick, N.J., *Edward Redfield* (1981), exh. cat. by Thomas Folk; Allentown Art Museum, Pa., *The Pennsylvania School of Landscape Painting* (1984), pp. 37–45; Allentown Art Museum, Pa., *Edward Redfield* (1987), exh. cat. by Thomas Folk.

Winter Scene, c. 1920–30

Oil on canvas
26⅛ x 32⅛ in. (66.6 x 81.6 cm)
Signature: E. W. REDFIELD (lower left)

Although *Winter Scene* is a modest example of Edward Redfield's snowscapes, it typifies his uncompromising and truthful rendition of nature.

Redfield's subject for this painting is a snow-laden forest, a setting he chose the day before he actually ventured out to paint. A path lined with low-lying shrubbery and bare trees leads from the foreground of the canvas into the middle distance. The children careening down the hill on sleds add a sense of whimsy to the otherwise hushed silence of Redfield's forest. The trees in the middle and background almost completely block the line of sight to the horizon. A small portion of the sky remains visible through the spontaneous crisscross of the branches, creating a sense of isolation and seclusion.

Redfield applied firm daubs and strokes of pigment that form a raised decorative pattern on the surface. This is most obvious in the vegetation and frosty blue-gray shadows dancing across the snow. His technique allowed for an accurate rendition of the landscape even though he avoided painstaking detail.

Throughout his life Redfield painted numerous sleighing scenes—children on sleds and horse-drawn sleighs traveling along country roads that seem to beckon the viewer into their frosty depths. Such scenes were extremely popular with the general public, perhaps in part because they recalled similar subjects by Thomas Birch and George Durrie that were a familiar presence in nineteenth-century landscape painting. But Redfield's sleigh scenes proved to be detrimental to his career as they eventually led the art world to consider him an old-fashioned, sentimental painter.

LAH

Exhibition Mansfield Art Center, Ohio, 1981, *The American Landscape*, no. 34.

Provenance Mrs. Edward Pitcairn, Pittsburgh, by 1953.

Gift of Mrs. Edward Pitcairn, 1953, 53.25

Louis Ritman

1889–1963

Born in Kamenets-Podolski in the Ukraine, Louis Ritman immigrated to Chicago at the age of fifteen. He attended the Chicago Art Academy in 1906 and the Art Institute of Chicago in 1907. The following year, he visited Boston, Philadelphia, and New York, studying briefly with William Merritt Chase. Then in 1909 he traveled to Paris, where he entered the Ecole des Beaux-Arts.

Ritman quickly tired of his academic training and became entranced by the Impressionists Claude Monet, Pierre-Auguste Renoir, and Camille Pissarro. He rented a studio at Giverny, near the house of Monet, and began to paint Impressionist-inspired landscapes and portraits in a bright palette. Unlike the Impressionists, however, Ritman created the illusion of structure and his figures exhibit a convincing plasticity.

Ritman's Impressionist-style images of women are the works for which he is best known. Often studies of psychological intensity, they offer an intimate glimpse into the interior lives of his sitters. His women tend to appear pensive and reserved, averting their glance from the

viewer, who thus plays the role of intruder. Occasionally, such women in Ritman's works seem painfully self-conscious, as if embarrassed by the viewer's presence. In *Reflection* (c. 1920, formerly Signature Galleries, Chicago), for example, he portrays a half-nude woman looking away from the spectator as she adjusts her undergarments.

Beginning in the 1910s, Ritman exhibited often, particularly at the Pennsylvania Academy of the Fine Arts, Philadelphia, and the Art Institute of Chicago. He also exhibited twice at Carnegie Institute, in the 1943 and 1944 *Painting in the United States* annuals. He remained in Paris until 1929, then returned to Chicago, where he served as an instructor at the Art Institute until 1960. A staunch stylistic conservative, Ritman worked in the same Impressionist mode until his death in Winona, Minnesota.

Bibliography Nicole de Fleur, *Louis Ritman* (Random Lake, Wis., 1967); Signature Galleries, Chicago, *The Paintings of Louis Ritman* (1975), exh. cat., essay by Richard H. Love.

Enchantment, c. 1926

Oil on canvas
45 x 57½ in. (114.3 x 146 cm)
Signature: L. Ritman (lower right)

This double portrait depicts a wistful moment between a man and woman. He plays the lute while she listens attentively, and both gaze sadly down at the floor. Ritman creates a somber mood in the portrait and establishes psychological tension between the sitters and spectator, as well as between the two sitters themselves.

Because the two subjects avert their glances, the viewer seems to be invading their privacy. Their awkward and reserved

demeanor implies that they are uncomfortable not only with the intrusive viewer but with each other as well. The overstuffed chairs set them at opposing angles; she wears white, he wears black; only the edge of her dress touches his leg. Thus the title alludes to an intimate but melancholy encounter, not a bewitching seduction. Although the sitters are unidentified, *Enchantment* may include a self-portrait, for the man bears a resemblance to photographs of the artist.

The style of the work is typical of Ritman's manner of Impressionism. Brightly colored in large patches, almost like a mosaic, the brushwork creates a foil for a moment that could be timeless. The woman, in particular, appears statuesque and classically inspired.

JM

Reference De Fleur, *Louis Ritman*, p. 7.

Provenance The artist, until 1963; his estate, until 1973.

Gift of the estate of Louis Ritman in memory of the artist's mother, Rebecca Ritman, 1973, 73.53

Theodore Robinson

1852–1896

Theodore Robinson is regarded today as a quintessential American Impressionist, perhaps the most faithful American interpreter of the concepts of French Impressionist landscape painting. Robinson was a Realist in the Impressionist idiom, dedicated to a continued investigation of color, tone, and the qualities of light. Born in Irasburg, Vermont, he grew up in Evansville, Wisconsin. He left home to study art in Chicago between 1869 and 1870, but chronic asthma forced him to return shortly thereafter. His second attempt to study art took him in 1874 to New York, where he studied for two years at the National Academy of Design. In 1876 he went to France for the first time.

In Paris Robinson at first sought instruction in the academic tradition. He entered the studio of Emile-Auguste Carolus-Duran, where his classmates included Will H. Low, J. Carroll

Beckwith, and John Singer Sargent. But Carolus-Duran's painterly bravura did not appeal to Robinson, whose temperament was more subdued, and Robinson later took classes with Jean-Léon Gérôme, in whose atelier he found an insistence on draftsmanship that was more in tune with his sensibilities.

Robinson's respect for drawing and careful rendering of form is evident in his canvases of the late 1870s and early 1880s. Professional recognition came when his painting *Une Jeune Fille* (location unknown) was accepted at the Paris Salon of 1877. That summer, the artist went to Grèz and Veules, Breton villages where many expatriate painters congregated.

Returning temporarily to America in 1881, Robinson was elected to the Society of American Artists, New York. For the next three years he worked for John La Farge on murals for public and private buildings and with Prentice Treadwell on mural decorations for the Metropolitan Opera House, New York. Although Robinson made very few easel paintings during this period, the works he did produce showed a new attention to the use of light and atmosphere.

In 1884 Robinson returned to France, where he remained for the next eight years. From 1884 to 1887 he temporarily abandoned the hint of Impressionism seen in his earlier paintings. As he painted in such locales as Barbizon, Paris, and Dieppe, his palette darkened, the size of his paintings decreased, and he displayed little concern for the effects of light.

It was not until the summer of 1888 that Robinson adopted an Impressionist style and formed a friendship with Claude Monet, becoming one of the few American painters to have sustained contact with the great Impressionist master. Still, their relationship was not quite that of teacher and disciple since they did not paint together, and Robinson refuted statements that described Monet as his master.[1]

Robinson's style differed from Monet's in palette, subject matter, and articulation of form. However, in seeking the effects of light, in his habit of painting outdoors, and in his use of broken brushstrokes, Robinson was faithful to French Impressionism. When, in 1890, his *Winter Landscape* (location unknown) won the Webb Prize from the Society of American Artists, it was the first time a landscape painting prize had been awarded for a canvas done in the Impressionist style.

Although Robinson's permanent return to America at the end of 1892 was in one sense a homecoming, it also brought the artist face to face with his unfamiliarity with the American landscape and his need to discover it. He thought he found his theme in the austere Vermont hills of his early childhood, but the exigencies of finding employment left him little chance to develop this subject. In the summer of 1893 he taught at the Brooklyn Art School in Napanock, New York; in 1894 he was at Evelyn College in Princeton, New Jersey; and the following year he taught Robert Vonnoh's classes at the Pennsylvania Academy of the Fine Arts, Philadelphia. Robinson formed fast friendships with Will Low, John Twachtman, and J. Alden Weir, but his life was still unsettled, aggravated by poor health and the need to teach to earn a living.

His first solo exhibition took place in February 1895, at the Macbeth Galleries, New York; he died the next year from an acute asthma attack in a friend's apartment in New York City. Despite his untimely death, Robinson produced a body of modest but beautiful works that are often considered to be among the finest accomplishments of American Impressionism.

1 Baur, in Brooklyn Museum, *Theodore Robinson*, p. 27.

Bibliography Will H. Low, *A Chronicle of Friendships, 1873–1900* (New York, 1908); Brooklyn Museum, New York, *Theodore Robinson, 1852–1896* (1947), exh. cat. by John I. H. Baur; Baltimore Museum of Art, *Theodore Robinson, 1852–1896* (1973), exh. cat., introduction by Sona Johnston; Henry Art Gallery, University of Washington, Seattle, *American Impressionism* (1980), exh. cat., essay by William H. Gerdts; Phoenix Art Museum, *Americans in Brittany and Normandy, 1860–1910* (1982), exh. cat. by David Sellen and James K. Ballinger.

Resting within the Shadows, c. 1884–87

Oil on canvas
14⅜ x 23½ in. (36.5 x 59.7 cm)
Signature: TH. ROBINSON (lower left)

When, in 1906, Sadakichi Hartmann bought this monochrome oil for the Department of Fine Arts of Carnegie Institute, it was the most expensive in a lot of twenty-five sketches acquired from Charles Scribner's Sons.[1] The work had not been used for the Scribner publications; perhaps its presence in the group can be explained by Robinson's friendship with August Jaccaci, Scribner's art editor. Robinson "was occasionally persuaded by [Jaccaci] to try his hand at illustrations for the magazine, though neither was happy with the results."[2] The Carnegie oil sketch may represent one of those attempts.

Dating this work is somewhat problematic. The costumes indicate that it is a sketch of Breton peasants, and the style of the sketch suggests that it was done prior to Robinson's adoption of an Impressionist technique in 1888. Robinson was in Brittany on a number of occasions during the summers of 1884 to 1887, and this sketch may have been done during any of those excursions and sent to Scribner's then or later.

Robinson's sketch depicts a distinctly Breton custom called the Pardon. These were daylong prayer gatherings at a chapel dedicated to an early Breton saint who was venerated locally by the village or within the province but rarely canonized by the Vatican. Some observers regarded Pardon celebrations as the expression of the pure Christian faith of the peasant, while others considered them to be archaic and virtually pagan. A description written in 1894 conveys their character:

> It is impossible to travel for a week in Brittany, during the summer, without falling into the midst of one of these local festivals. . . . They are usually held near some old chapel, scarcely to be distinguished from the cottages around, save for its little bell-tower. . . . [T]here you will find a crowd of people in their Sunday clothes, coming and going, in a quiet, monotonous fashion, arms hanging or crossed on their breasts, without a gleam of enthusiasm or a smile of pleasure. . . . Deep religious thoughtfulness hovers over the assembly. Everyone looks grave and reverent, and the greater part of the day is given over to devotional exercises.[3]

Robinson's composition has an unposed, reportorial quality. Dressed in white coifs and dark dresses, the women seated on the grass are praying—hands folded on their laps, heads dropped forward. At the extreme right two women, their backs to the viewer, look to the

chapel where they spent the morning in prayer. On the left of the composition, two women and a man stand in conversation, while in the background another man, dressed like the others in Breton regional costume, is talking to a group of women. Two women seated in the center of the composition look inquisitively at the painter, their white headdresses reflecting the afternoon light; the group has been caught as if by a camera. Although there is no trace of the canvas having been squared to guide the artist in transcribing the image, there are other indications that this sketch was based on a photograph: Robinson built up the picture through the distribution of light and dark; the blurred image of the moving women in the background is a photographic effect.

Robinson frequently employed photography. In the early 1880s he wrote, "Painting directly from nature is difficult, as things do not remain the same; the camera helps to retain the picture in your mind."[4] He later questioned his use of the photograph, urging himself not to be so dependent on it.

In this case the photographic format helped Robinson handle a picturesque subject with disinterested directness: the sketch is objective and unsentimental. It may be no accident that the title of the sketch does not indicate the religious occasion. In contrast, Pascal-Adolphe-Jean Dagnan-Bouveret's *Les Brettones au Pardon* (1889, Museum Calouste Gulbenkian, Lisbon) uses virtually the same compositional elements to produce a highly sentimental, idealized image.

Robinson wished to avoid both the sentimental and the artificial. In 1892 he wrote in his diary, "I have a horrible fear that my work pleases women and sentimental people too much."[5] In *Resting within the Shadows* he avoided that pitfall.

RCY

1 Andrew Carnegie to Sadakichi Hartmann, October 26, 1906, Carnegie Institute Papers, Archives of American Art, Washington, D.C.

2 Baur, in Brooklyn Museum, *Theodore Robinson*, p. 44.

3 Anatole Le Braz, *The Land of the Pardons* (1894), trans. Frances M. Gostling (New York, 1906), pp. xvii–xviii.

4 Baur, in Brooklyn Museum, *Theodore Robinson*, p. 44.

5 Ibid., p. 22.

Provenance Charles Scribner's Sons, by 1906.

Andrew Carnegie Fund, 1906, 06.19.17

Severin Roesen

active c. 1847–72

ALTHOUGH SEVERIN ROESEN is today one of the best-known American still-life painters of the nineteenth century, little is known of his life. He is thought to have been born in or near Cologne, Germany, and trained as a porcelain and enamel painter. In 1847 he exhibited a flower painting in Cologne.

By 1848 he had emigrated to the United States, most likely because of political unrest in Germany. Roesen settled in New York City, and shortly thereafter he married another German immigrant, Wilhelmina Ludwig. He was well received by the New York art community, which had developed a taste for paintings in the Düsseldorf school style. Between 1848 and 1850 Roesen exhibited and sold eleven paintings (six of flowers, three of fruit, and two combinations of flowers and fruit) at the American Art-Union, New York.

Competition from the rising popularity in New York City of two other schools of painting—French and British—during the late 1850s is thought to have caused Roesen to leave his wife and three children and travel to Pennsylvania in 1857. He headed for Philadelphia and perhaps worked there before moving on to Harrisburg, Huntington, and ultimately Williamsport around 1862.

Roesen painted and taught in Williamsport for a decade. According to a local newspaper acount published in 1895 and based on the remembrances of his friends, his studio, "a typical Bohemian den," was a popular gathering place:

> His studio was much frequented by his friends, who would sit all day with this genial, well-read and generous companion, smoking his pipe and drinking his beer, and he was seldom without this beverage. There was a boy's school in the same building and his quarters were a rendezvous for many of our well known citizens, who would listen for hours to his stories and watch him paint.[1]

Roesen's still lifes typically picture a bountiful profusion of fruit and/or flowers painted in meticulous detail. The fruit and flowers are arranged in an assortment of woven baskets and ceramic, silver, and crystal dishes set on grayish marble tiers and against a dark background (several of his later works include a landscape background). His combinations of fruit and flowers from different seasons and the large scale of his elaborate arrangements indicate that Roesen could not have worked from "living models." Because of the botanical accuracy of his subjects, however, it seems that he must have worked from either individual live models or botanical prints. He brought these segments together into large, fantastical compositions meant to harmonize with the mid-century taste for opulent decor.

Affinities between Roesen's work and seventeenth-century Dutch still-life painting have often been noted. To what extent he was influenced by the Dutch seventeenth-century painters or the revival of their style found in current nineteenth-century German painting of the Düsseldorf school, especially the work of Johann Wilhelm Preyer, is difficult to determine. Many of Preyer's visual motifs—bird's nests, sinuous grape tendrils, and marble tabletops—are echoed in Roesen's work. Certainly Preyer, the most renowned still-life artist of the Düsseldorf school, would have been in great demand in America, and Roesen, wishing to make his work salable, would have been wise to imitate him.

Roesen's name disappears from the Williamsport city directory after 1871–72, the same time that his latest dated painting, *Fruit and Flower Still Life* (1872, private collection, State College, Pa.), was produced. The place of his death has been variously reported as Williamsport, the steps of a public building in New York City, and a Philadelphia almshouse. All accounts agree that he died in the early 1870s.

1 "August [*sic*] Roesen, Artist, an Interesting Williamsport Genius Recalled in His Work," *Williamsport Sun and Banner,* June 27, 1895; reprinted in Stone, "Not Quite Forgotten," p. 38.

Bibliography Richard B. Stone, "Not Quite Forgotten: A Study of the Williamsport Painter, S. Roesen," *Lycoming Historical Society: Proceedings and Papers* 9 (November 1951), pp. 3–40; Maurice A. Mook, "Severin Roesen, the Williamsport Painter," *Lycoming College Magazine* 25 (June 1972), pp. 33–41; Maurice A. Mook, "Severin Roesen and His Family," *Journal of the Lycoming Historical Society* 8 (Fall 1972), pp. 8–12; Maurice A. Mook, "Severin Roesen: Also the Huntington Painter," *Lycoming College Magazine* 26 (June 1973), pp. 13–30; Lois Goldreich Marcus, *Severin Roesen: A Chronology* (Williamsport, Pa., 1976).

Still Life with Fruit, c. 1854–55

Oil on canvas
30⅟₁₆ x 40⅟₁₆ in. (76.4 x 101.8 cm)
Signature: *Roesen* (lower right)

Characteristic of Roesen's larger still lifes, this piece depicts a complex arrangement of meticulously drawn fruit, branches, wicker, ceramic, and silver serving dishes

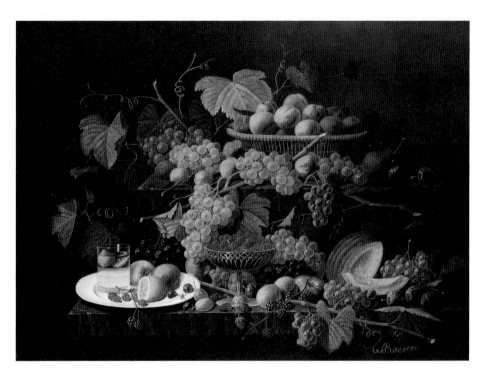

set on two gray marble tiers. The two tiers impose on the composition a horizontal stability, which is countered by the sinuous arabesques of fruit. Grapes, berries, and branches pass through the painting in a graceful spiraling motion—beginning with the basket of peaches in the upper right and moving through the overhanging grapes to the white plate and glass of lemonade in the lower left. This type of flowing movement, aptly described by Lois Goldreich Marcus as "an S-spiral,"[1] is consistently found in Roesen's still lifes.

Four motifs from *Still Life with Fruit* can be found in other Roesen paintings: the silver epergne of strawberries, the cut melon, the basket of peaches, and the white ceramic plate with lemons, berries, and a glass of lemonade on it. Roesen often combined several of the same motifs in closely dated works, especially silver, china, and glassware, which he probably borrowed for a brief time. Thus a comparison of this undated work with Roesen's dated pieces that are similar is helpful in determining when this work was painted.

Fruit Still Life (1854, collection Mr. and Mrs. Walter Rubin) offers the closest parallel to the Carnegie painting. Both show the centrally placed epergne of strawberries on the lowest tier, with a melon, cut and arranged in precisely the same manner, to the right, and, to the left, a white plate with an identical glass of lemonade and grouping of three lemons resting on it. However, in the Rubin painting, there

are a few cherries on the plate in front of the glass instead of the berries in the Carnegie painting. Of these motifs, the plate of fruit and lemonade is the most specifically datable one, as it was not until 1854 that Roesen first appears to have used it; all earlier works picture a Pilsener glass of sparkling liquid.

On the upper tier, the Rubin still life has a random assortment of grapes, pears, apples, leaves, and a bird's nest. In the Carnegie still life, the upper tier is centrally organized, with grapes, apples, and pears grouped around a basket of peaches. This basket of peaches suggests a date as late as 1855, for it also appears in some of Roesen's works from 1855, for example, *Fruit Still Life with Bird's Nest* (1855, Brooklyn Museum, New York). However, these works are even more extravagantly composed than the Carnegie *Still Life with Fruit* and so were probably painted somewhat later.

EM

1 Marcus, *Severin Roesen*, p. 32.

Exhibition Museum of Art, Carnegie Institute, Pittsburgh, 1975–76, *Pittsburgh Corporations Collect: Inaugural Exhibition of the Heinz Galleries,* no. 32.

Provenance Private collection, Williamsport, Pa.; Schweitzer Gallery, New York, by 1973; Gulf Oil Corporation, Pittsburgh, by 1974.

Gift of Gulf Oil Corporation, a subsidiary of Chevron Corporation, 1985, 85.40

Fruit, c. 1862–72

Oil on wood panel
14 x 18 in. (35.6 x 45.7 cm)
Signature: *Roesen* (lower right)

Flowers, c. 1862–72

Oil on wood panel
14 x 18 in. (35.6 x 45.7 cm)
Signature: *Roesen* (lower right)

While living in Williamsport, Roesen often produced his paintings in pairs, each consisting of a fruit piece and a flower piece, identical in size and format and intended to be hung together. *Fruit* and *Flowers* are typical companion pieces: they are smaller and simpler than his individual works and painted on panel rather than on canvas. The still-life objects are confined to a marble tabletop and are organized in a simple pyramid. Roesen included some of his favorite motifs, such as the tiny bird's nest in *Flowers* and the tendrillike signature in *Fruit;* and glistening beads of water dot both fruit and flowers, accentuating their freshness.

Two unusual variations on Roesen's typical motifs occur in *Fruit:* the scalloped edge of the cut lemon, which appears in only one other known work,[1] and the very decorative stem of the wine glass which can be found in no other Roesen painting. That *Fruit* and *Flowers* are Roesen's work is confirmed, however, by a conservator's examination, which revealed

that only minor corrections were made in the underlying drawing and that the paint surface was thinly applied with very little reworking. This absence of pentimenti indicates that the artist had worked in this style on previous occasions and was sure of his procedure, and in both paintings the signatures are consistent with the surrounding layers of paint.

A comparison of the motifs in *Fruit* and *Flowers* with dated works by Roesen is difficult, for there are very few dated works, especially companion pieces, from his Williamsport period. Their relatively small size and simple composition do not provide clues, for after 1855 the variety of painting formats that Roesen used— large, small, individual, companion, fruit, flowers—was largely dependent on the desire of his patron rather than a chronological development of his style.

LD, EM

1 *Still Life with Fruit*, location unknown, illustrated in *Connoisseur* 199 (September 1978), advertisement p. 64, for Sotheby Parke Bernet, Los Angeles, sale, October 25– November 3, 1978.

Fruit

Reference H. B. Teilman, "Additions to the Eavenson Collection," *Carnegie Magazine* 42 (Mar. 1973), p. 97.

Exhibitions Wildenstein and Co., New York, 1975, *The Object as Subject: Still-Life Paintings from the Seventeenth to the Twentieth Century*, no. 67; Heckscher Museum, Huntington, N.Y., 1976, *Heritage of Freedom—A Salute to America's Foreign-Born Artists*, cat. no. 14.

Provenance Private collection, Philadelphia; M. Knoedler and Co., New York, by 1972.

Howard N. Eavenson Memorial Fund for the Howard N. Eavenson Americana Collection, 1972, 75.52.1

Flowers

Reference H. B. Teilman, "Additions to the Eavenson Collection," *Carnegie Magazine* 42 (Mar. 1973), p. 97.

Exhibition Wildenstein and Co., New York, 1975, *The Object as Subject: Still-Life Paintings from the Seventeenth to the Twentieth Century*, no. 66.

Provenance Private collection, Philadelphia; M. Knoedler and Co., New York, by 1972.

Howard N. Eavenson Memorial Fund for the Howard N. Eavenson Americana Collection, 1972, 72.52.1

John Rogers
1829–1904

THE SCULPTOR JOHN ROGERS was one of the most popular, successful, and, arguably, most innovative of nineteenth-century American genre artists. Born and raised in Salem, Massachusetts, he attended Boston English High School. He subsequently moved to a number of cities, including Manchester, New Hampshire, New York, and Chicago, where he worked variously as a clerk, mechanic, industrial draftsman, and teacher of mechanical drawing.

In the early 1850s, having discovered he had a talent for modeling form, Rogers decided to become a sculptor. He spent the years 1858 and 1859 in Europe, studying sculpture in Paris and Rome. He disliked the Neoclassical style's exclusion of common incident and accessories, and on his return to the United States to open his own studio in New York he concentrated on perfecting a sculptural type he had first tried in 1850: an intimate, miniaturized group of two or three figures, which traded on the current popularity of easily understood domestic incidents.

These works resembled the tabletop figures in plaster and terra-cotta that James Pradier, Jean-Pierre Danton, and others had recently made in Europe. Rogers's versions were cast from bronze masters, painted, and were produced in large editions that were cheap enough for the buyer of modest means. As he said, they were "not intended for rich people's parlors, but more for common houses and the country."[1]

Rogers's first mass-produced plaster appeared in 1859, and over the next quarter century, his pieces became enormously popular. He ultimately created seventy-seven different genre groups, with the edition of a single group running as high as twelve thousand, each piece priced between five and fifty dollars. (Most were ten to fifteen dollars.) Rogers shrewdly advertised them not only in newspapers and magazines but also in his own mail-order catalogues. He invited the press to his studio and allowed them to preview upcoming editions.

Rogers's earliest productions were vignettes on the subject of the Civil War. He discovered that the more overtly political themes did not sell as steadily as those of domestic virtue and gentler sentiment.

He applied those lessons after the war, when he turned to literary subjects and vignettes of small-town life. Rogers's groups were remarkable for their skillful compositions, fine detail, and witty, sympathetic humor, which made them eminently accessible, even to the artistically untutored viewer.

Judging from the price reductions Rogers posted in the late 1880s, the fashionability of his plasters eventually fell off. In 1893, he sold his business and retired. Rogers also produced some portrait busts and ideal figures and executed a bronze equestrian statue of General John Reynolds for the City of Philadelphia. However, given his talent, it is remarkable that he willingly limited himself to such a narrow specialty.

Shifting tastes probably accounted for the fact that Rogers was a forgotten figure by the time he died in New Canaan, Connecticut, and he remained neglected through the first half of the twentieth century. Interest in Rogers's contribution to mass culture only began to revive in the 1960s and 1970s, along with the general reappraisal of Victorian art and mid-nineteenth-century genre painting.

1 Wallace, *John Rogers*, p. 149.

Bibliography Dorothy Barck, "John Rogers, American Sculptor," *Old Time New England* (January 1933), pp. 99–114; Chetwood and Mary Smith, *Rogers Groups: Thought and Wrought by John Rogers* (Boston, 1934); David H. Wallace, *John Rogers: The People's Sculptor* (Middletown, Conn., 1967); David H. Wallace, "The Art of John Rogers: So Real and So True," *American Art Journal* 4 (November 1972), pp. 59–70; Harold Holzer and Joseph Farber, "The Sculpture of John Rogers," *Antiques* 115 (April 1979), pp. 756–68.

Courtship in Sleepy Hollow: Ichabod Crane and Katrina Van Tassel, 1868

Painted plaster
16¼ x 15¼ x 9 in. (41.3 x 38.6 x 22.9 cm)

Markings: COURTSHIP IN SLEEPY HOLLOW:/ ICHABOD CRANE AND KATRINA VAN TASSEL. (base front); John Rogers/New York (base top, proper left front); PATENTED Aug. 25 1868 (base rear)

Rogers had first considered making a work based on Washington Irving's "Legend of Sleepy Hollow" in 1862, but he was apprehensive that he would not be able to add anything new to Felix O. C.

Darley's recent illustrations of the same story.[1] He finally created this vignette of Ichabod Crane and Katrina Van Tassel in 1868, then in 1871 made three more groups that took their inspiration from Washington Irving: *Rip Van Winkle at Home*, *Rip Van Winkle on the Mountain*, and *Rip Van Winkle Returned.*

In *Courtship in Sleepy Hollow*, Rogers carefully based his characters on Irving's physical descriptions of Ichabod and Katrina. The former is sufficiently tall and lank, with hands that look as if they "dangled a mile out of his sleeves" and "feet that might have served for shovels," to borrow Irving's words. The latter is suitably plump, sports a tight stomacher, and wears her petticoat short enough to show her dainty feet.

Rogers asserted his originality with his interpretation of their character: he portrays Ichabod as exceedingly gentle and sympathetic and Katrina as more demure than the coquette Irving described. A greater novelty is the choice of scene—the moment after the "quilting frolic" at Baltus Van Tassel's house, when Ichabod proposes to Katrina—which Irving deliberately declined to detail in the story. Rogers, on the other hand, provided a great deal of information for the viewer to "read," ranging from Ichabod's hopefulness and the umbrella he has brought along to Katrina's silence and the cat she fondles. The scene gains from what the

viewer, but not Ichabod, already knows: that Katrina rejects him in short order.

Courtship in Sleepy Hollow, which also appeared in the marblelike porcelain Parian ware, remained in production until 1888. It was an average-priced Rogers group; until 1878, it cost fifteen dollars in plaster. This particular example is in exceptional condition, its finish having escaped the peeling and other damage suffered by many Rogers groups. As a result, one can see the shading that was originally painted onto its surface to add depth and to underscore the details of the modeling. In 1870 Rogers made a close variation on this courting vignette called *Coming to Parson*, a larger and more elaborate group that employs similar figure types and props, including Katrina's cat. Not surprisingly, it became a popular wedding gift.

DS

1 Wallace, *John Rogers*, p. 220.

References C. E. Baker, "As He Depicted American Literature," *American Collector* 13 (Nov. 1944), pp. 10–11; Wallace, *John Rogers*, no. 113, p. 220.

Provenance Originally purchased in Meadville, Pa.; descended in the family of the donor, Lela Weber Kyler, who received it in 1918 as a wedding gift.

Gift of Lela Weber Kyler in memory of her son, Edgar G. Weber, 1985, 85.44

Samuel Rosenberg
1896–1972

SAMUEL ROSENBERG was Pittsburgh's most important Social Realist painter and one of its dominant artists during the middle years of the twentieth century. A native of Philadelphia, he moved to Pittsburgh at the age of eleven, winning a scholarship that same year to study with the local painter Jacques Coblens. He studied in New York at the National Academy of Design from 1916 to 1917 and received a bachelor of arts degree in 1926 from Carnegie Institute of Technology, where he had worked as a part-time instructor in drawing and painting since 1924.

From 1927 to 1944 Rosenberg was a drawing instructor in Carnegie Institute of Technology's School of Architecture. He joined the faculty of the School of Painting and Design in 1944 and taught there until his retirement twenty years later. Widely respected and influential as a teacher, he was also the founder of the Irene Kaufmann Settlement Art School in 1917 and of the Young Men's and Women's Hebrew Association Art Workshop in 1926. He was the workshop's director from 1926 to 1964 and director of the art department of the Pennsylvania College for Women (now Chatham College) from 1937 to 1945.

From quite early in his career Rosenberg was singled out for his remarkable technical facility in paintings that were highly acclaimed locally and well known nationally. He was a frequent prize winner in the group shows of the Associated Artists of Pittsburgh: he exhibited at fourteen Carnegie Internationals between 1920 and 1967, as well as in the *Painting in the United States* exhibitions held during the 1940s. Carnegie Institute honored him with solo exhibitions in 1937, 1956, and 1982. Nonetheless, he had been advised that some members of Carnegie Institute's Board of Trustees disliked his paintings of Pittsburgh's poor and faulted him for not showing the city in a more positive light.[1]

Nationally, Rosenberg's paintings appeared in group exhibitions at the Corcoran Gallery of Art, Washington, D.C., the Whitney Museum of American Art, New York, the Pennsylvania Academy of the Fine Arts, Philadelphia, the Art Institute of Chicago, and other institutions. He also exhibited with Associated American Artists, New York, in 1944 and 1947.

Rosenberg's training emphasized the importance of the expressive line and the value of direct technique. His teacher Coblens had encouraged him to study the works of Velázquez, Rembrandt, Frans Hals, El Greco, and Sandro Botticelli and introduced him to Japanese prints, which Rosenberg always admired. He also advised his student, "Draw! Draw! Draw! and construct solidly as if you were modeling in clay."[2] Rosenberg took a deep, earthy palette and his liking for Velázquez, Hals, and Rembrandt with him to the National Academy of Design and the Art Students League, where he attended some of George Bellows's classes.

During the 1920s he worked as a portrait painter, but by the early 1930s he gave that up in order to concentrate on depicting the marketplaces, factories, and neighborhood life of Pittsburgh's Hill district and other poor sections of the city. "Some of my paintings would be a protest against the kind of place we live in," he told a reporter in 1935.[3] Rosenberg became known for his psychologically dark yet sympathetic portrayals of laborers coping with the hardships of the Depression years. His work during the 1930s was forceful in both theme and technique. It was compared to that of Francisco de Goya, Honoré Daumier, and Bellows, and stands as the most memorable and enduring contribution of his career.

Sensitive to the changing currents of the art world, Rosenberg gradually moved away from his personal brand of Social Realism. During the 1940s his style began to show the influence of German Expressionism, which he used to depict the universal themes of hunger, homelessness, and fear in reaction to the horrors of Hitler and World War II. These works, characterized by broken forms and rich colors that are like stained glass, have been compared to the work of Georges Rouault and Abraham Rattner and to Byzantine painting.

During the 1950s and 1960s Rosenberg moved toward abstraction. In 1956 he identified his concerns as "relationships of space and time, of physical and psychological forces expressed through line, form and color."[4] The mood of his work lightened; his colors became brighter, more intense, and more vibrant; and his compositions were marked by a new feeling of air and space. Increasingly confident in this direction, Rosenberg continued his lifelong practice of simultaneously working on and reworking a variety of canvases until his death in Pittsburgh.

1 Mrs. Samuel Rosenberg in interview with Gail Stavitsky, July 7, 1983.

2 Jacques Coblens to Samuel Rosenberg, December 27, 1911, archives of Mrs. Samuel Rosenberg, Pittsburgh.

3 Douglas Naylor, "Blind to Real Art: Painter Says Others Run Away from Splendid Subjects in Pittsburgh," *Pittsburgh Press*, January 6, 1935, society sec., p. 8.

4 Department of Fine Arts, Carnegie Institute, Pittsburgh, 1956, *Samuel Rosenberg*, exh. cat., n.p.

Bibliography Harry Salpeter, "A Human Sort of Artist," *Esquire* 23 (March 1945), pp. 83, 146–149; "Biography," Pittsburgh *Bulletin Index*, March 16, 1946, pp. 18–20; Sam Hood, "Pittsburgh's Painter Laureate," *Pittsburgh Press*, November 3, 1957, pp. 32, 35; Margie Carlin, "Rosenberg... In Memoriam," *Pittsburgh Press Roto*, September 17, 1972, pp. 6–8; Westmoreland County Museum of Art, Greensburg, Pa., *Southwestern Pennsylvania Painters, 1800–1945* (1981), exh. cat. ed. by Paul A. Chew and John A. Sakal, pp. 109–10.

Man with a Red Nose, c. 1916–17

Oil on canvas
30 x 25 in. (76.2 x 63.5 cm)
Signature, date: Samuel Rosenberg/[date illegible] (upper left)

This half-length portrait was painted while Rosenberg was studying at the National Academy of Design in New York, when his ambition was to become a portrait painter. It is a pointedly straightforward image: the subject, his arms folded, stands against a dark background, gazing directly at the viewer. Strong light-dark contrasts and visible impasto set off the few touches of bright color in a restrained palette. By these choices, the young painter affiliated himself with the New York realists of the 1910s, adopting

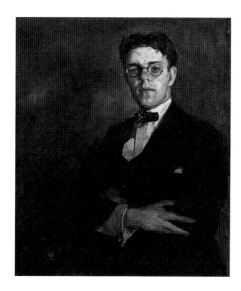

their collective admiration for Frans Hals, Rembrandt, and Diego Velázquez, who, with their sober yet painterly techniques, had become emblems of honesty and strength. The specific stylistic model here may have been Charles Hawthorne, who was well known at the National Academy and influential with other students there.

Rosenberg declined to identify the young man in this early portrait, though he kept the image with him to old age, calling it only *Man with a Red Nose*. It may have functioned as a practice piece, a sample of his wares as a portrait painter, in which he merely used a convenient model.

Ten years after he executed this painting, Rosenberg was still employing a dark, limited palette and simple compositions. But he had abandoned emulation of the old masters and the goal of painterly virtuosity in favor of a more naïve and personally expressive style.
DS

Exhibitions Department of Fine Arts, Carnegie Institute, Pittsburgh, 1922, *Thirteenth Annual Exhibition of the Associated Artists of Pittsburgh*, no. 220; Campbell Gallery, Sewickley Academy, Pa., 1974, *Samuel Rosenberg (1896–1972): Selected Paintings from Seven Decades*, no. 1; The Carnegie Museum of Art, Pittsburgh, 1989, *Educating Andy Warhol: Robert Lepper and Samuel Rosenberg*, no cat.

Provenance The artist's son, Dr. Murray Z. Rosenberg, Storrs, Conn.

Gift of Dr. Murray Z. Rosenberg, 1977, 77.17

Greenfield Hill, 1932
(Gazzem's Hill; Gazzem Hill; On the Hill)

Oil on canvas
39⅛ x 40½ in. (99.4 x 102.9 cm)
Signature: S Rosenberg (lower left)

Frequently singled out among Rosenberg's accomplishments of the 1930s, *Greenfield Hill* was originally entitled *Gazzem's Hill* by the artist and his wife. It is set in a poor neighborhood on the outskirts of Pittsburgh, where the emptiness, drab colors, and ramshackle buildings of the fortresslike hill seem to echo the mood of the two men who trudge across the foreground and provide a visual metaphor for the desolation in their lives.

Rosenberg carefully arranged the pictorial elements so that they reinforce one another. The arched bodies of the slouching men are repeated in reverse by the curving telephone poles in the upper right. The curve of the background bluff is likewise opposed by the curve of the foreground street. The clapboard houses at the center of the composition take on some of the shape of the bluff in the distance.

Fig. 1 Samuel Rosenberg, *Study for "Greenfield Hill,"* c. 1932. Pencil on paper, 10³⁄₁₆ x 7¹⁵⁄₁₆ in. (25.9 x 20.2 cm). The Carnegie Museum of Art, Pittsburgh, gift of Mrs. Samuel Rosenberg, 82.8

The Carnegie Museum of Art possesses two studies for this painting, both dated 1932. One (fig. 1), a pencil drawing, shows the basic arrangement of forms and patterns in the landscape and architecture, with the tall building at the center reversed. The other is a similarly composed crayon drawing in vivid purples, blues, and greens, which were toned down in the painting.
GS

References D. Naylor, "Blind to Real Art: Painter Says Others Run Away from Splendid Subjects in Pittsburgh," *Pittsburgh Press*, Jan.

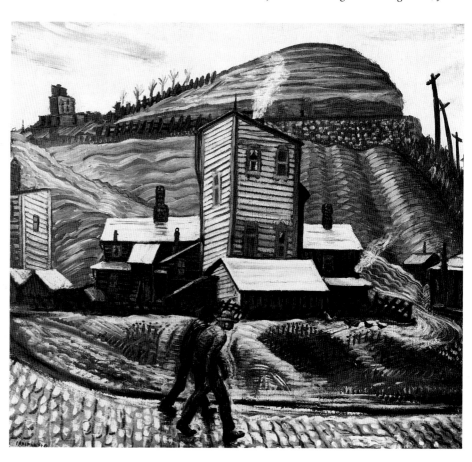

6, 1935, society sec., p. 8; "Rosenberg's Negroes," Pittsburgh *Bulletin Index*, Feb. 14, 1935, p. 9; J. O'Connor, Jr., "Samuel Rosenberg: Pittsburgh Artist," *Carnegie Magazine* II (Apr. 1937), p. 22; "You and Art, No. 6—Why an Artist Paints Abstracts," *Pittsburgh Press*, May 19, 1946, p. 25; D. Miller, "Rosenberg Drawings Shown at Art Museum," *Pittsburgh Post-Gazette*, Nov. 19, 1982, p. 29.

Exhibitions Corcoran Gallery of Art, Washington, D.C., 1933, *The Thirteenth Exhibition of Contemporary American Oil Painting*, no. 27, as *Gazzem Hill*; Museum of Modern Art, New York, 1933, *Painting and Sculpture from Sixteen American Cities*, no. 79, as *Gazzem's Hill*; Pennsylvania Academy of the Fine Arts, Philadelphia, 1933, *One Hundred Twenty-eighth Annual Exhibition*, no. 51, as *Gazzem Hill*; Department of Fine Arts, Carnegie Institute, Pittsburgh, 1937, *Exhibition of Paintings by Samuel Rosenberg*, no. 28, as *Gazzem Hill*; Latrobe High School, Pa., 1939, *An Exhibit of Oil Paintings by Samuel Rosenberg*, no. 10, as *Gazzem's Hill*; Arts and Crafts Center, Pittsburgh, and Butler Art Institute, Youngstown, Ohio, 1950, *Samuel Rosenberg Retrospective, 1950*, no. 18, as *Gazzem Hill*; Boston Museum School, Mass., 1950, *Samuel Rosenberg: First Retrospective Exhibition of Paintings in New England*, no. 2, as *Gazzem Hill*; Cheltenham Township Art Centre, Pa., 1950, *Samuel Rosenberg*, no. 2, as *Gazzem Hill*; Art Department, State Teachers College, Indiana, Pa., 1955, *Samuel Rosenberg Paintings, 1926–1955*, no. 2, as *Gazzem Hill*; Community Center, Weirton, W.Va., 1957, *Samuel Rosenberg: Paintings, 1926–1956*, no. 2, as *On the Hill*; Westmoreland County Museum of Art, Greensburg, Pa., 1960, *Samuel Rosenberg Retrospective Exhibition*, no. 6; Westmoreland County Museum of Art, Greensburg, Pa., 1976, *Nineteenth and Early Twentieth Century Regional Painters*, exh. cat. by P. A. Chew and J. K. Maguire, unnumbered; Museum of Art, Carnegie Institute, 1979, *Some Pittsburgh Artists from the Permanent Collection*, no cat.; Westmoreland County Museum of Art, Greensburg, Pa., 1981, *Southwestern Pennsylvania Painters, 1800–1945*, exh. cat. ed. by P. A. Chew and J. A. Sakal, no. 208; American Jewish Committee, Pittsburgh Plan for Art, 1982, *Roots and Branches: Pittsburgh's Jewish History*, no cat.; Museum of Art, Carnegie Institute, Pittsburgh, 1983, *Samuel Rosenberg: Drawings*, no cat.; The Carnegie Musem of Art, Pittsburgh, 1989, *Educating Andy Warhol: Robert Lepper and Samuel Rosenberg*, no cat.

Patrons Art Fund, 1957, 57.35

Street by the Mill, c. 1932
(Man-Made Desert; Second Avenue)

Oil on canvas
36⅛ x 40¾ in. (91.8 x 103.5 cm)
Signature, date: S Rosenberg/33 (lower right)

This painting is characteristic of Rosenberg's best work of the 1930s. It is sparsely populated with hunched-over, heavy-footed, anonymous figures in a desolate setting. The surrounding architecture curves vertiginously, as if the pictorial structure were about to collapse upon itself. The imagery speaks of depleted resources and quiet despair.

The site depicted by this painting is a long Pittsburgh thoroughfare on the north bank of the Monongahela River. Second Avenue parallels the tracks of the Baltimore and Ohio Railroad and intersects with few other streets. It is indeed a site of deadly sameness, well suited to the title *Man-Made Desert*, which the painting bore until 1957, when the artist changed it to *Street by the Mill*. The painting is also known as *Second Avenue*.

Rosenberg lined the curving, empty avenue with cruciform telephone poles that cast the long shadows of a modern Calvary. On the bare sidewalk are two anonymous male figures, one almost a shadow of the other, who spew frosted breath like the industrial steam rising around them. They trudge along an impenetrable wall that courses relentlessly to the horizon line, cutting off all view beyond.

The view not seen is that of the Jones and Laughlin Steel Company, Pittsburgh's largest and most prominent industrial site. The artist's decision to block it is instructive, for the mill provided one of the most spectacular views in the city. Seen from either side of the Monongahela River, it was the centerpiece of a commanding panorama that offered dramatic visual effects. Painters such as Aaron Gorson capitalized on the mill's belching smokestacks and open furnaces, reflected in the adjacent river. This panorama was visible from almost any vantage point except that of the workers who traveled Second Avenue. From the street by the mill one sees only a fortresslike wall and, beyond it, only shapeless smoke, as banal as the breath of the two figures who walk the sidewalk on a frigid winter day.
GS

Remarks Rosenberg misdated the painting in 1960, when he signed and dated a number of his paintings for the retrospective of his work presented by Westmoreland County Museum of Art, Greensburg, Pennsylvania.

References J. O'Connor, Jr., "Samuel Rosenberg: Pittsburgh Artist," *Carnegie Magazine* II (Apr. 1937), p. 22; F. Watson, *American Painting Today* (Washington, D.C., 1939), p. 95; "You and Art, No. 6—Why an Artist Paints Abstracts," *Pittsburgh Press*, May 19, 1946, p. 25.

Exhibitions Department of Fine Arts, Carnegie Institute, Pittsburgh, 1932, *Twenty-second Annual Exhibition of the Associated Artists of Pittsburgh*, no. 58, as *Man-Made Desert*; Department of Fine Arts, Carnegie

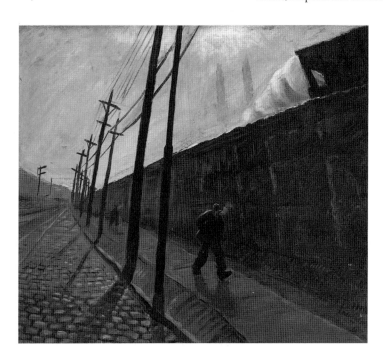

Institute, Pittsburgh, 1937, *Exhibition of Paintings by Samuel Rosenberg*, no. 24, as *Man-Made Desert;* Palace of Fine Arts, San Francisco, 1939, *Golden Gate International Exposition*, no. 320, as *Man-Made Desert;* Art Institute of Chicago, 1940, *Fifty-first Annual Exhibition of American Paintings and Sculpture*, no. 180, as *Man-Made Desert;* Arts and Crafts Center, Pittsburgh, and Butler Art Institute, Youngstown, Ohio, 1950, *Samuel Rosenberg Retrospective, 1950*, no. 1, as *Man-Made Desert;* Community Center, Weirton, W.Va., 1957, *Samuel Rosenberg: Paintings 1926–1956*, no. 4, as *Street by the Mill;* Westmoreland County Museum of Art, Greensburg, Pa., 1959, *Two Hundred and Fifty Years of Art in Pennsylvania*, exh. cat. by P. A. Chew, no. 109, as *Street by the Mill;* Westmoreland County Museum of Art, Greensburg, Pa., 1960, *Samuel Rosenberg Retrospective Exhibition*, no. 10, as *Street by the Mill;* Westmoreland County Museum of Art, Greensburg, Pa., 1976, *Nineteenth and Early Twentieth Century Regional Painters*, exh. cat. by P. A. Chew and J. K. Maguire, unnumbered; Museum of Art, Carnegie Institute, Pittsburgh, 1989, *Educating Andy Warhol: Robert Lepper and Samuel Rosenberg*, no cat.

Provenance The artist, until 1961; Mr. and Mrs. Charles Dreifus, San Francisco, 1961.

Gift of Mr. and Mrs. Charles Dreifus, Jr., in memory of his father, 1962, 62.28

Theodore Roszak

1907–1981

A PIONEER OF THE machine aesthetic in America, Theodore Roszak was one of the first American artists to use industrial materials and methods in sculpture. His works of the 1930s and early 1940s reflect his idealistic view of the artist's place in a progressive, technological society. Although he began his career as a painter and lithographer, he is best remembered today for his pristine constructions of that period and for the more expressionistic welded sculptures that replaced them after World War II.

Born in Poznań, Poland, Roszak and his family immigrated to Chicago in 1909. He began drawing at the age of seven, undoubtedly encouraged by his mother, who had been a successful fashion designer in Berlin. He enrolled in the Art Institute of Chicago, studying there part time from 1922 to 1924 and then full time

upon his graduation from high school. In 1926 he studied briefly with Charles Hawthorne at the National Academy of Design in New York, but gave that up in favor of private lessons with George Luks. At the same time, he took courses in philosophy and logic at Columbia University.

In 1927 he returned to Chicago and resumed his studies at the Art Institute. The following year he had his first solo exhibition of lithographs, and he began to teach drawing and lithography at the Art Institute. His early works show his admiration for both the old masters and American painters such as Luks, George Bellows, Leon Kroll, and Eugene Speicher.

Roszak was introduced to European modernist trends in painting and sculpture when, having won an Anne Louise Raymond Fellowship in 1929, he traveled in France, Germany, Austria, Italy, and Czechoslovakia for two years. During his nine months in Prague, he learned of the Bauhaus, the school of architecture and applied arts that was the center of modern design in Germany in the 1920s and 1930s. He was fascinated by the school's progressive ideology, which advocated the use of industrial methods and materials to create truly modern art. At the same time, he was also attracted to the Constructivist assertion of sculpture as an art of space rather than an art of mass.

From Prague Roszak went to Paris, where he was introduced to Cubism, Purism, and Surrealism. Although the metaphysical paintings of Giorgio de Chirico particularly impressed him, and although the school of Paris had an immediate impact on his work, the ideas of the Bauhaus and the Constructivist principles and techniques he learned in Prague proved the most enduring influences upon him. When he settled in New York in 1931, a Tiffany Foundation Fellowship allowed Roszak to devote his time to painting and to experiments with modeled and constructed sculptures. Increasingly attracted to the machine as a bold image, he took courses in tool making and design at an industrial school, and by 1934 had established his own machine shop.

Although his first construction, *Airport Structure* (Newark Museum, N.J.), was executed in 1932, the bulk of Roszak's constructions date from 1936 to 1945. During this period he used his superb skill with tools to create precise, stream-

lined forms in wood, plastic, glass, and metal. These machine-crafted objects have the appearance of functional machines—engines, turbines, rockets, or even spaceships—and illustrate the artist's interest in science fiction as well as science.[1] His appointment in 1938 as an instructor at the Design Laboratory in New York—led by László Moholy-Nagy and dedicated to perpetuating the principles and methods of the Bauhaus—intensified Roszak's dedication to the machine aesthetic. Surprisingly, although his paintings were widely exhibited in the 1930s, Roszak's constructions were not seen publicly until 1940, when he had simultaneous shows at two private galleries in New York.

During World War II Roszak built airplanes at the Brewster Aircraft Corporation in New Jersey and taught aircraft mechanics. In 1941 he was appointed to the faculty of Sarah Lawrence College in Bronxville, New York, a post he held until 1955. The war became the second major turning point in the artist's career. Horrified by society's destructive use of technology, he turned his back on the utopian ideals of the Bauhaus. His sculptures from 1946 onward, larger, more expressive machine images of welded metal brazed with alloys of bronze, brass, and nickel silver, took on a threatening aspect. Works such as *Spectre of Kitty Hawk* (1946–47, Museum of Modern Art, New York), with its twisted spikes and tortuous surfaces, brought Roszak increased critical acclaim and a variety of prestigious awards, including the Frank G. Logan Medal from the Art Institute of Chicago (1947, 1951), the Museum of Modern Art's American Award (1952), and the George D. Widener Memorial Gold Medal for Sculpture from the Pennsylvania Academy of the Fine Arts, Philadelphia (1956). It was during this period that he participated in the Carnegie Internationals of 1958 and 1964. Roszak died in New York City.

1 Marter, "Theodore Roszak's Early Constructions," p. 112.

Bibliography Walker Art Center, Minneapolis, and Whitney Museum of American Art, New York, *Theodore Roszak* (1956), exh. cat. by H. H. Arnason; Theodore Roszak, "In Pursuit of an Image," *Quadrum* 2 (November 1956),

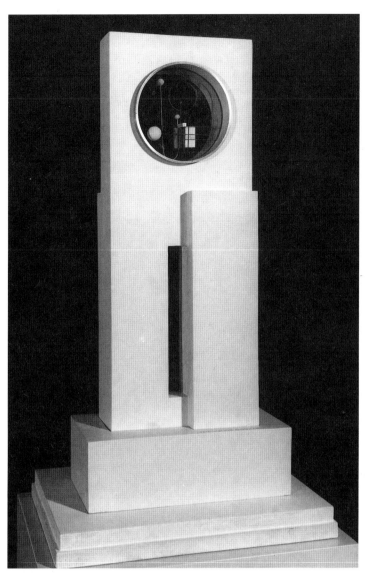

of the period. According to Joan Marter, "*Watchtower*... represents an attempt to monumentalize his earlier constructions and appears to be a model for a large public sculpture."[2] Although there is no documentation of the artist's intentions regarding this particular piece, he did in fact create a model for an international public sculpture competition more than a decade later: *Monument to an Unknown Political Prisoner* (1952, Tate Gallery, London).

RB

1 Marter, "Theodore Roszak's Early Constructions," p. 112.
2 Marter, in Museum of Art, Carnegie Institute, *Abstract Painting and Sculpture*, p. 213.

Remarks There is a semicircular discoloration on the front left lower edge of the vertical wood piece.

Reference J. R. Lane, "American Abstract Art of the '30's and '40's," *Carnegie Magazine* 56 (Sept.–Oct. 1983), p. 18.

Exhibitions Museum of Art, Carnegie Institute, Pittsburgh, 1983–84, *Abstract Painting and Sculpture in America: 1927–1944* (trav. exh.), exh. cat. ed. by J. R. Lane and S. C. Larsen, no. 121; Brooklyn Museum, New York, 1986–87, *The Machine Age in America, 1918–1941* (trav. exh.), exh. cat. by R. G. Wilson et al., unnumbered.

Provenance Estate of the artist; Zabriskie Gallery, New York, by 1982.

Fine Arts Discretionary Fund, 1982, 82.23

pp. 49–60; Joan Marter, "Theodore Roszak's Early Constructions: The Machine as Creator of Fantastic and Ideal Forms," *Arts* 54 (November 1979), pp. 110–13; Joan Marter, "Theodore Roszak," in Museum of Art, Carnegie Institute, Pittsburgh, *Abstract Painting and Sculpture in America, 1927–1944* (1983), exh. cat. ed. by John R. Lane and Susan C. Larsen, pp. 211–13.

Watchtower, c. 1939–40

Wood, plastic, metal, and paint
23¹¹⁄₁₆ x 10⅜ x 5¼ in. (58.8 x 26.4 x 13.3 cm)
Markings: THEODORE ROSZAK (above base, proper left front)

Like most of Roszak's constructions of the 1930s and early 1940s, *Watchtower* is characterized by smooth, polished surfaces, precise craftsmanship, and references to science. The sculpture consists of three pieces of wood that have been glued together; this rectilinear form is vertically mounted on a wood base, which, in turn, rests on a low, two-stepped wood platform. The entire sculpture was originally painted white but was repainted in pale pink by the artist in 1980 or 1981, leaving a streaky, pinkish white surface.

A 12.2-centimeter hole in the top center holds a yellow Plexiglas circle; attached to this are several thin metal wires, a small, painted wood block, and several painted wood balls. Fascinated with celestial mechanics and atomic theory, Roszak used the wire-and-sphere motif in several of his constructions. This motif can be read as a reference to the orbital motion of planetary bodies or to the more erratic orbital motion of electrons around the nucleus of the atom.[1]

The overwhelmingly architectural look of this piece, reinforced by its title, makes it unique among Roszak's constructions

Albert P. Ryder
1847–1917

DURING THE TWENTIETH CENTURY, Albert Pinkham Ryder has emerged as one of America's most respected painters and as perhaps the most imaginative and eloquent interpreter of the pictorial ideas of late Romanticism. The works on which his reputation is based are modest, often tiny pictures in which shadowy allegories interplay gingerly with clouds and moonlight. Their creator, who never sought fame, lived a quiet, ascetic existence, following his private inspiration for its own sake.

Born into an old, seafaring Cape Cod family, Ryder was raised in the whaling town of New Bedford, Massachusetts. From childhood he suffered from inflamed eyes, and partly for this reason had no formal education beyond grammar school. His formal art training was similarly limited, although he was already painting landscapes and genre scenes in his teens.

At the age of twenty, Ryder moved with his family to New York. Having been rejected by the school of the National Academy of Design, he received instruction from William Edgar Marshall, a minor painter of portraits and religious scenes. Four years later, in 1871, Ryder was finally admitted to the National Academy's school, where he remained for four seasons, during which, except for his second season when he was in the life class, he was enrolled in the antique drawing classes.

Ryder traveled to Europe four times—in 1877, 1882, 1887, and 1896—but expressed little interest in its academies, old-master galleries, or contemporary art. He is generally considered to be self-taught, guided by his intense feeling for the subjective effects of natural phenomena. His ambition was to paint imaginary genre scenes, landscapes, and literary themes. Many were interpretations of works by Geoffrey Chaucer, William Shakespeare, the Bible, Lord Byron, Alfred Lord Tennyson, Edgar Allan Poe, and Richard Wagner—epic themes of passionate interest to him.

Whether he was painting biblical subjects such as *Jonah* (c. 1885, National Museum of American Art, Washington, D.C.) or landscapes such as *Toilers of the Sea* (c. 1884, Metropolitan Museum of Art, New York), Ryder remained true to the Romantic's belief that an artist should evoke rather than depict forms and that the essence of painting is to convey the spiritual. He made frequent use of lone figures, deep shadows, and mysterious light effects, as well as slow-drying and unsound glazes of his own concoction, layered to create an impression of unworldly transparency.

Ryder long exhibited his work in New York's galleries and artists' associations. He supported the cause of independent painters by becoming, in 1877, one of the twenty-two founders of the Society of American Artists, and he exhibited his work there through the following decade. His paintings, however, attracted significant attention only in the last years of his life. In 1901 he won a silver medal at the Pan-American Exposition in Buffalo. In 1902 the National Academy of Design elected him an associate and, in 1906, an academician. Two years later he was elected to the National Institute of Arts and Letters. He contributed twice to Carnegie Institute's annual exhibitions, sending two paintings in 1899, one in 1909. He was also represented in the New York Armory Show of 1913.

Ryder counted among his friends fellow painters J. Alden Weir, Robert Loftin Newman, and Kenneth Hayes Miller and dealers Daniel Cottier and Rowland Knoedler. Although not an isolated eccentric, he was a reclusive individual, and became more so with time. After living in cramped apartment-studios on West Fifteenth and Sixteenth streets in Manhattan, he ultimately moved into the Elmhurst, Queens, home of his friends Mr. and Mrs. Charles Fitzpatrick, who took care of him until his death.

In the last ten years of his life, some of the most important champions of modernism—Roger Fry, Walter Pach, and Duncan Phillips—wrote lengthy essays on Ryder's work, and in 1917 Marsden Hartley penned an appreciation of him. In the decades after his death, he gained international recognition as a prophetic forerunner of modernism. Labeled one of the most visionary of recent painters, his work became admired for its primitive originality and the symbolic power of its abstract form.

One of the recurrent features of the Ryder legend as it developed after his death had to do with his unworldliness. Scarcely interested in attending to his physical needs, he would sleep on the floor of his trash-strewn apartment and work on his paintings unmindful of the hour of day or night, often repainting them many times. Consequently Ryder's work exists today in ruinous condition. Loath to consider a painting finished, he occupied himself, particularly after 1900, with the continued repainting and attempted repair of his pictures, which often only worsened their condition. His work was also subject to heavy-handed retouching by dealers and was extensively forged, even during his lifetime. His biographer Lloyd Goodrich estimated Ryder forgeries to outnumber genuine canvases by five to one.

Bibliography Albert P. Ryder, "Paragraphs from the Studio of a Recluse," *Broadway Magazine* 14 (September 1905), pp. 10–11; Frederic Fairchild Sherman, *Albert Pinkham Ryder* (New York, 1920); Lloyd Goodrich, *Albert Pinkham Ryder* (New York, 1959); William Inness Homer and Lloyd Goodrich, *Albert Pinkham Ryder: Painter of Dreams* (New York, 1989); National Museum of American Art, Washington, D.C. 1990, *Albert Ryder*, exh. cat. by Elizabeth Broun.

Marine, c. 1890

Oil on canvas mounted on wood panel
12⅞ x 10⅛ in. (32.7 x 25.7 cm)

The moonlit marine is the subject most frequently associated with Albert Ryder. He produced upward of two dozen of them, mostly very small canvases or panels no more than a foot high. It is not known when he may have begun his paintings of the subject, but they are generally dated from the early 1880s to the early 1890s. They are among his most memorable images, perhaps because of their provocative simplicity, perhaps because many evoke a private, contemplative world that so readily serves as the objective correlative of Ryder's mind.

Fig. 1 X-radiograph of Albert P. Ryder, *Marine*

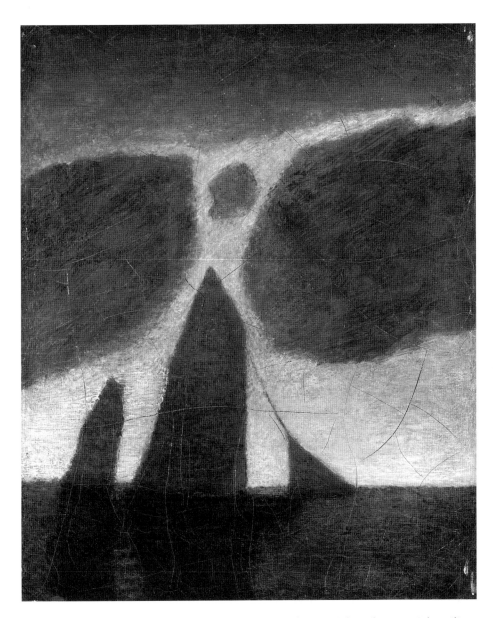

The present appearance of *Marine* is the result of alterations, possibly by Ryder himself. X rays (fig. 1) indicate that initially the painting was more conventionally illusionistic. The two boats were once a single vessel with three sails whose contours were less sharply defined and whose shadow on the water was more vague. So, too, were the clouds, which originally lacked the small, round form between them. The reworkings here, as generally, made the imagery starker and more two-dimensional, as if Ryder were editing his output, to make it better correspond to his late-life reputation.

DS

References Goodrich, *Albert Pinkham Ryder*, no. 56; J. T. Flexner, *The World of Winslow Homer* (New York, 1966), p. 153; B. Novak, *American Painting of the Nineteenth Century* (New York, 1969), pp. 219–20; L. Goodrich, "The Visionary World of Ryder," *Dialogue* 3, (Mar.–Apr. 1970), p. 65; H. B. Teilman, "Additions to the Eavenson Collection," *Carnegie Magazine* 44 (Mar. 1973), p. 95; F. R. Brandt, "Visions of the Sea," *Arts in Virginia* 17 (Fall 1976), p. 1; E. A. Prelinger, in Museum of Art, Carnegie Institute, *Collection Handbook* (Pittsburgh, 1985), p. 200; Homer and Goodrich, *Albert Pinkham Ryder: Painter of Dreams*, p. 42.

Exhibitions Babcock Galleries, New York, 1952; Swain School of Design, New Bedford, Mass., 1960, *A Selection of Paintings by Albert Pinkham Ryder and Albert Bierstadt*, no. 13; Art Gallery of Toronto, 1961, *American Painting, 1865–1905* (trav. exh.), no. 57; Corcoran Gallery of Art, Washington, D.C., 1961, *Albert Pinkham Ryder*, no. 27; Whitney Museum of American Art, New York, 1966, *Art of the United States, 1670–1966*, no. 240; Indiana University Art Museum, Bloomington, 1970, *The American Scene, 1820–1900*, no. 19; Dallas Museum of Fine Arts, 1971, *The Romantic Vision in America*, no. 57; Whitney Museum of American Art, New York, 1975, *Seascape and the American Imagination*, no. 129; Virginia Museum of Fine Arts, Richmond, 1976, *American Marine Painting*, no. 51; Museum of Art, Carnegie Institute, Pittsburgh, 1978–79, *Monticelli: His Contemporaries, His Influence* (trav. exh.), exh. cat. by A. Sheon, no. 100.

Provenance Dr. Albert T. Sanden, New York, by 1918; his daughter, Mrs. Edward D. Gurney, New York, until 1950; Babcock Galleries, New York, until 1954; Mr. and Mrs. Leo M. Rogers, New York, until 1972 (sale, Christie's, London, June 27, 1972); M. Knoedler and Co., New York, 1972.

Howard N. Eavenson Memorial Fund for the Howard N. Eavenson Americana Collection, 1972, 72.35

The standard features of Ryder's marines are a single sailboat on an empty sea below a cloud-covered, moonlit sky. These scenes possess the qualities of timelessness, suggested by the rudimentary, possibly ancient sailboats, and ambiguity created by shadowy, seemingly unpopulated vessels. Even when occupants can be discerned, it is impossible to see them clearly or make out what they are doing.

Marine is small, intimate, and exceptionally still, lacking the dramatic turbulence of, for example, *Toilers of the Sea* (c. 1884, Metropolitan Museum of Art, New York). Instead, two single-masted sailboats appear caught between a glasslike sea and a sky whose clouds form strong, almost geometric shapes. The two boats cast sharp-edged shadows on the water. Their hulls are aligned with the horizon, which is empty but for a sulfurous glow rising from it. The subject—night sailing on a windless sea—is an improbable one but appropriate to Ryder's effect, which is both abstract and hallucinogenic in the flattened forms juxtaposed against a glowing background.

The larger boat seems cast into an eternal form, not only by its mast, which functions as the composition's vertical center, but also by the blackened clouds, which seem to hold it in position, and the edges of the composition, which close upon it. At the meeting of clouds and the larger sail is a small third cloud, nearly round, which points up the interdependence of Ryder's shapes.

Noli Me Tangere, c. 1885–90, retouched c. 1917–37
(Christ and Mary; The Flight into Egypt; Two Nymphs)

Oil on canvas mounted on wood panel
14¼ x 17¼ in. (36.2 x 43.8 cm)

Noli Me Tangere was purchased for Carnegie Institute's permanent collection galleries in 1942, when Ryder was already being associated with Winslow Homer and Thomas Eakins as one of "the three American Old Masters."[1] Although now considered to be largely the work of a hand other than Ryder's, it was then the most costly of the three Ryders the museum was considering for purchase, the others being *White Horizon* from Ferargil Galleries, New York, and *Smugglers' Cove* from Vose Galleries of Boston.[2] This one seems to have been chosen for its "mystical, emotional" haziness and because it was "large in outlook and big in vision."[3] Its similarity to two other images, *Christ Appearing to Mary* (c. 1888, National Museum of American Art, Washington, D.C.) and *Resurrection* (1885, Phillips Collection, Washington, D.C.), was interpreted as evidence of Ryder's penchant for making close variations on a visual theme.[4]

Noli Me Tangere is a heavily varnished picture whose underlying paint surface is nonetheless quite thin, except for some tentative impasto highlights on the two figures. By 1956 Lloyd Goodrich had concluded that it was an unfinished Ryder with figures painted by someone else, almost surely Charles Melville Dewey, the executor of Ryder's estate.[5] Goodrich posited that the picture was the one that Sadakichi Hartmann, in his *History of American Art* (1901), reported seeing in Ryder's studio and the one exhibited in

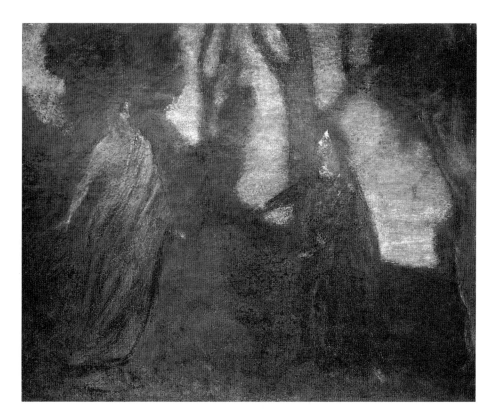

June 1918 in Chicago, where it was illustrated as *The Flight into Egypt* in the *Fine Arts Journal,* a local periodical. The art dealer Albert Milch told Goodrich that he had seen the painting both in 1917 and 1937, and it was obvious to him that Dewey had been working on it.[6]

The two clumsily painted, too-thin figures bear no evidence of Ryder's method of painting. Unfortunately, the background (which Goodrich believed was by Ryder) is so thinly painted that it is likewise impossible to identify Ryder's hand in it. Christ is a pale mirror image of the figure in the National Museum of American Art's *Christ Appearing to Mary;* the other figure is a weak transcription from the Phillips Collection's *Resurrection.* X rays of the painting (fig. 1) indicate that it initially showed more vigorous and animated figures of Christ and Mary Magdalen, as well as a more complex and diaphanous landscape background.
DS

1 John O'Connor, Jr., "Albert Pinkham Ryder: A Great Artist Enters the Permanent Collection," *Carnegie Magazine* 16 (February 1943), p. 268.

2 Undated correspondence, c. 1941–42, from Frederick Newlin Price, Ferargil Galleries, New York, and Vose Galleries of Boston, to John O'Connor, Jr., museum files, The Carnegie Museum of Art, Pittsburgh.

3 O'Connor, "Albert Ryder," p. 268.

4 Ibid., pp. 269–70.

Fig. 1 X-radiograph of Albert P. Ryder, probably altered by Charles Melville Dewey, *Noli Me Tangere*

5 Lloyd Goodrich to Gordon B. Washburn, July 17, 1956, museum files, The Carnegie Museum of Art, Pittsburgh.

6 Lloyd Goodrich, photocopy of manuscript notes on the painting, museum files, The Carnegie Museum of Art, Pittsburgh.

References "Exhibitions at Chicago Galleries," *Fine Arts Journal* 36 (June 1918), pp. 35, 40, as *The Flight into Egypt;* Sherman, *Albert Pinkham Ryder,* no. 55, 70; F. N. Price, *Ryder* (New York, 1932), no. 17; J. O'Connor, Jr., "Albert Pinkham Ryder: A Great Artist Enters the Permanent Collection," *Carnegie Magazine* 16 (Feb. 1943), pp. 268–71; Goodrich, *Albert Pinkham Ryder,* p. 33; Homer and Goodrich, *Albert Pinkham Ryder: Painter of Dreams,* pp. 133–38.

Exhibitions Thurber Galleries, Chicago, 1918, no cat.; Cleveland Museum of Art, 1937, *American Painting from 1860 until Today,* no. 163; Macbeth Galleries, New York, 1937, no cat.; New York World's Fair, 1940, *Masterpieces of Art: Catalogue of European and American Painting 1500–1900,* exh. cat., introduction by Walter Pach, no. 302; Columbus Gallery of Fine Arts, Ohio, 1952, *Paintings from the Pittsburgh Collection,* no cat.

Provenance Estate of the artist; Charles Melville Dewey, until 1937; auction sale of Dewey estate, American Art Association-Anderson Galleries, New York, Apr. 8, 1937, as *Two Nymphs;* Ferargil Galleries, New York, until 1942.

Purchase, 1942, 43.1

Augustus Saint-Gaudens
1848–1907

"MANY ARE THE STATUES that have outlived the fame of those that wrought them," wrote one of Augustus Saint-Gaudens's friends twenty-three years after his death. "No such fate is reserved for Saint-Gaudens, and our grandsons will not look upon the memorials of Shaw, Farragut or Sherman as the work of an anonymous sculptor. His was no trivial genius."[1] Saint-Gaudens left an indelible mark on his country's public spaces with his monumental bronze sculpture, and today he stands as one of the most influential sculptors in the history of American art.

Born in Dublin, Ireland, Augustus Louis Saint-Gaudens was the son of a French shoemaker and his Irish wife, who were impelled by the potato famine to emigrate soon after their son's birth. They settled in New York, where Saint-Gaudens grew up. At the age of thirteen he was apprenticed to Louis Avet, a French émigré cameo cutter; three years later he left Avet to work for another French émigré cameo cutter, Jules le Brethon. In his spare time Saint-Gaudens attended drawing classes at the Cooper Union Art School, then at the National Academy of Design. In 1867 he went to Paris to continue his artistic training, boarding with relatives and paying expenses by cutting cameos.

Saint-Gaudens became one of the first American sculptors to seek out professional training in Paris rather than Florence or Rome. He enrolled at the Ecole Gratuite de Dessin, a free vocational school like the Cooper Union, and there had his first formal instruction in sculptural composition. After six months he entered the more prestigious atelier of François Jouffroy at the Ecole des Beaux-Arts. During his time in Paris, Saint-Gaudens showed himself to be hard working, self-disciplined, ambitious, and supremely confident in his own talents. In 1871 he left for Rome to produce his first major work, *Hiawatha* (1872, private collection), a life-size marble of a seated nude that, despite its Native American subject matter, followed in the tradition of nineteenth-century Neoclassicism. He began to receive portrait commissions from Americans in Rome, which encouraged him to return to New York in 1872 after five years away.

In New York Saint-Gaudens developed a close bond with other American artists who had studied in Paris. These included Charles F. McKim, John La Farge, and Henry Hobson Richardson, who, along with Stanford White, became his frequent collaborators. In 1876 Saint-Gaudens assisted La Farge with his murals for Richardson's Trinity Church, Boston. This led to other joint projects, including the interior embellishments for Richardson's Ames Gate Lodge, North Easton, Massachusetts, in 1881; the interior of Cornelius Vanderbilt II's New York house with La Farge in 1882; and the interior of McKim, Mead and White's Villard House, New York, in 1882. These decorative endeavors were intentionally reminiscent of those of the late Middle Ages and early Renaissance. Saint-Gaudens was well-suited as a partner in them, for he had already developed an appreciation for the integration of the fine and applied arts as one noble enterprise.

In 1876 he began working in bronze. He made a specialty of portrait bas-reliefs, proceeding from simple profile heads of his friends to more elaborate individual and pair portraits. In them he used a bold, painterly style that gave his bronze casts the effect of oil sketches, rapidly brushed in bold impasto.

Saint-Gaudens received his first commission for a public monument in 1876: the memorial to Admiral David Farragut (1879–80, Madison Square Park, New York). Executed in collaboration with Stanford White, it juxtaposes a full-length bronze figure of the admiral onto a blue-stone pedestal reminiscent of the quarter-deck of a ship. The pedestal, carved in undulating low relief, intermingles inscriptions with allegorical figures of courage and loyalty. The work exemplifies Saint-Gaudens's mature style, which combined naturalism with elegant symbolism.

Graceful, refined, and austere, it was said to have the elusive balance of Italian Renaissance sculpture. As a respected contemporary noted, "Taste and sobriety were the characteristics of Saint-Gaudens's work. He had a horror of the melodramatic, or the extremes of any kind."[2]

The Farragut memorial was followed by other commissions for public monuments in partnership with Stanford White, notably the memorial to Abraham Lincoln (1887, Lincoln Park, Chicago) and the hauntingly spare *Adams Memorial* (1890–91, Rock Creek Cemetery, Washington, D.C.). By 1891 Saint-Gaudens was at the height of his career. In that year he bought a house and spacious grounds in Cornish, New Hampshire. There, in his large studio with many assistants, he managed a prolific output, which included the *Memorial to Robert Gould Shaw* (1897, Boston Common) and the equestrian monument to General William Tecumseh Sherman (1903, Grand Army Plaza, New York), probably his best-known work.

Saint-Gaudens was a gregarious individual who was involved in many artists' organizations: the Tile and Century clubs, the Society of American Artists, of which he became president, the National Academy of Design, and the National Sculpture Society, of which he was a founding member. He taught at the Art Students League, New York, and helped organize the American Academy in Rome. A craftsman of exacting standards, he was also a keen businessman who was aware of the importance of keeping his work in the public eye. Perhaps his greatest success in the latter regard was his receipt, in 1905, of a presidential commission to design the nation's gold coins, which went into production in 1907.

After Saint-Gaudens's death in Cornish, New Hampshire, a memorial service was held in New York; it is an indication of the artist's fame that the mayor of New York addressed it. The retrospective exhibition later mounted at the Metropolitan Museum of Art, New York, was the most extensive that had ever been held for an American sculptor.

1 W. Francklyn Paris, *Personalities in American Art* (New York, 1930), p. 68.

2 C. Lewis Hind, *Augustus Saint-Gaudens* (London, 1908), p. xxi.

Bibliography Royal Cortissoz, *Augustus Saint-Gaudens* (Boston, 1907); Homer Saint-Gaudens, ed., *The Reminiscences of Augustus Saint-Gaudens*, 2 vols. (New York, 1913); Louise Hall Tharp, *Saint-Gaudens and the Gilded Era* (Boston, 1969); John H. Dryfhout, *The Work of Augustus Saint-Gaudens*, catalogue raisonné (Hanover, N.H., 1982); Metropolitan Museum of Art, New York, *Augustus Saint-Gaudens: Master Sculptor* (1985), exh. cat. by Kathryn Greenthal.

Francis Davis Millet, 1879

Bronze
10 9/16 x 6¾ in. (26.8 x 17.1 cm)

Markings: AVGVSTVS•SAINT GAVDEN[S•FECIT] (across top); FRANCIS•DAVIS•MILLET/AETAT[I]S SV[A]E•XXXII•:PARIS•/MARCH•M•D•C•C•C•LXX•IX: (across bottom)

It could be argued that Saint-Gaudens's most original sculptural invention was the bronze portrait in low relief. It was John La Farge who, in 1876 or 1877, first suggested that his younger colleague

"paint a bas-relief,"[1] thus encouraging an adaptation of the sculptural medium to more abstract, painterly ends. Saint-Gaudens's development of a fluent, expressive modeling style in fact revived bronze relief sculpture as a form of portraiture. His first efforts in this vein were small profiles, sand-cast in low relief, of his artist-friends in Boston and shortly afterward in Paris, including David Maitland Armstrong (1877), George W. Maynard (1877), William L. Picknell (1878), Charles F. McKim (1878), John Singer Sargent (1880), and Jules Bastien-Lepage (1880). The portrait of Francis Davis Millet (1846–1912) was executed in Paris, where he and Saint-Gaudens served as jurors for the selection of American art at the 1879 Paris Exposition Universelle.

Millet, whom Saint-Gaudens had met while both were working on the decorations in Trinity Church, Boston, had studied painting in Antwerp. He went on to specialize in historical genre scenes set

in the American Colonial past or Greco-Roman antiquity, dividing his time between New York and Broadway, England. Like Saint-Gaudens, Millet played an instrumental role at the 1893 Chicago World's Columbian Exposition, and afterward became as important to the revival of public mural painting in America as Saint-Gaudens was to the integration of sculptural monuments into large architectural schemes.

As in his other portrait reliefs of 1877 to 1880, Saint-Gaudens incorporated into the design an emblem personal to the sitter, a painter's palette and brushes, which set off the inscription in a decorative manner. Saint-Gaudens said he wanted to use the entire surface of the relief to produce a unified design, inducing the eye to travel continually over it. He achieved that goal here by arranging horizontal striations from top to bottom of the relief's elongated, rectangular surface. They vary from a pattern of grooves at the base and the inscriptions above and below Millet's head to the faint, irregular scoring of the space surrounding the head.

KP, DS

1 Dryfhout, *The Work of Augustus Saint-Gaudens*, p. 32.

References Dryfhout, *The Work of Augustus Saint-Gaudens*, no. 78, p. 99; K. Greenthal, P. Kozol, J. S. Ramirez, *American Figurative Sculpture in the Museum of Fine Arts, Boston* (Boston, 1986), pp. 220–21.

Provenance Mrs. Charles J. Rosenbloom, Pittsburgh, before 1979.

Gift of Mrs. Charles J. Rosenbloom in honor of Leon A. Arkus, 1979, 79.8

Homer Saint-Gaudens, 1882

Bronze
19¹³⁄₁₆ x 10 in. (50.3 x 25 cm)

Markings: TO•MY•FRIEND•DOCTOR•HENRY•SCHIFF•THIS•PORTRAIT•/OF•MY•SON•HOMER-SCHIFF•SAINT•GAVDENS•AT•THE•/AGE•OF•SEVEN-TEEN•MONTHS•AGVSTVS•SAINT•/GAVDENS•NEW YORK•FEBRVARY M•D•C•C•C•L•X•/X•X•I•I• (across top)

In the spring of 1877, Augustus Saint-Gaudens married Augusta Homer of Boston, an art student and a distant cousin of Winslow Homer. The couple had one child, Homer Schiff Saint-Gaudens (1880–1958). He was named for Dr. Henry Schiff, an American friend and mentor his father had known in Paris,

who was also the child's godfather. In the year of Homer's birth, Saint-Gaudens made a bronze relief portrait of Schiff,[1] and two years later he made a portrait of Homer for his old friend and son's namesake. Saint-Gaudens also made the portrait of his son partly for himself; he carved a marble version of it in 1907, while the bronze is one of the few background objects in Kenyon Cox's *Augustus Saint-Gaudens* (1908, Metropolitan Museum of Art, New York).

The relief shows the boy Homer half-length, in profile, seated in a wooden armchair. The pictorial field is an artfully tall and empty rectangle. It is taller and emptier than in his earlier relief of Millet (see p. 408), for example, but not quite so elongated as later reliefs, such as *Mrs. Schuyler Van Rensselaer* (1888, Metropolitan Museum of Art, New York). Saint-Gaudens divided the pictorial field into three registers, which are a bit more clearly defined than in previous reliefs. Horizontal incisions make a border at the bottom of the relief; rows of angular lettering create another border at the top. In between, the child is modeled with the delicate, tactile irregularity typical of Saint-Gaudens. The contours are particularly soft and scumbled, in a manner more suggestive of painting than carving.

Just as the format of Homer's portrait was not particularly unusual for Saint-Gaudens, neither was its subject matter. Of the numerous other profiles in relief the sculptor executed during the 1880s and 1890s, several portray children. All these children, it has been noted, conform to a general physical type.[2] So Homer's round face, low brow, chubby cheeks, and protruding upper lip correspond at least as much to a generalized ideal of childhood as to a unique physiognomy.

DS

1 Dryfhout, *The Work of Augustus Saint-Gaudens*, no. 85, p. 105.

2 Greenthal, in Metropolitan Museum of Art, *Augustus Saint-Gaudens*, p. 111.

Reference Dryfhout, *The Work of Augustus Saint-Gaudens*, no. 100, p. 127.

Provenance Samuel Harden Church, Pittsburgh, after 1903; his daughter, Mrs. Henry L. Jones II, Noromis, Fla., 1944.

Gift of General and Mrs. Henry L. Jones II in memory of Samuel Harden Church, 1981, 81.62

The Puritan, 1883–86, cast 1899

Bronze
31¼ x 19½ x 12 in. (79.4 x 49.5 x 30.5 cm)
Markings: •THE•PVRITAN (base front); AVGVSTVS• SAINT GAVDENS (base top, proper left edge); COPYRIGHT•BY/AVGVSTVS•SAINT-GAVDENS/ •M•D•C•C•C•X•C•I•X (base top, at rear edge)

With its forceful presence and large, simple shape, the figure of Deacon Samuel Chapin (c. 1598–1675), created as an outdoor monument for the city of Springfield, Massachuetts, is one of the most impressive sculptures memorializing America's Colonial past (fig. 1). America's early history gripped the national imagination in the decades following the 1876 Philadelphia Centennial Exposition. Painters from Thomas Eakins to Francis Davis Millet and George Boughton and sculptors from Alexander Stirling Calder to Daniel Chester French and Saint-Gaudens were all caught by the wave of nostalgia and growing nationalism.

Calling it "the finest embodiment of Puritanism in our art," Kenyon Cox found Saint-Gaudens's figure of Deacon Chapin a synthesis of a biblical type (a Moses) and a historical type ("a Puritan of Puritans"), with the naturalistic presence of an individual ("a man also, a rough-hewn piece of humanity enough, with plenty of the old Adam about him"). He

Fig. 1 Augustus Saint-Gaudens, *The Puritan*, 1886. Bronze, over life-size. Merrick Park, Springfield, Mass.

described it as standing before the viewer, a "swift-striding, stern-looking old man, clasping his Bible as Moses clasped the tablets of law, and holding his peaceful walking-stick with as firm a grip as the handle of a sword."[1]

The Puritan was commissioned by Chester W. Chapin, a railroad executive and descendant of Deacon Chapin, as a monument to one of the three founders of Springfield, Massachusetts. Born in Paignton, England, Chapin came to Boston about 1635. He became a zealous Nonconformist, and in 1642 he migrated to the six-year-old settlement of Agawam, as Springfield was first called, in western Massachusetts. As one of five selectmen, and then as magistrate of the town, he had been called to watch over the settlement's "moral, health and public measures." He also preached. He died soon after Indians burned Springfield to the ground.

Saint-Gaudens's twelve-foot-high sculpture of Chapin was unveiled on Thanksgiving Day 1887 in Stearns Square, Springfield (the sculpture was later moved to Merrick Park in Springfield). Its original setting, designed by Stanford White, included a pool and fountains. Its base was a series of graduated cylindrical shapes reminiscent of an inverted Tuscan capital. This emphasized the figure's spread cape and gave a strongly pyramidal shape to the entire piece.

Philip Martiny assisted Saint-Gaudens with modeling the figure from life. In the absence of any record of Deacon Chapin's appearance, the head was taken from an 1881 bust Saint-Gaudens had made of Chester Chapin. In order to create a "New England type," the sculptor had a six-foot-tall, muscular male model named Van Ortzen pose for the figure[2] in a meticulously researched and tailored costume.[3]

The Carnegie's version of *The Puritan* is one of twenty-five known reductions of the sculpture, which were cast after 1898. Removed from the specific context of Springfield, these reductions appear to focus on Deacon Chapin as the embodiment of a historical symbol. The reduced versions of the figure have a greater stride and crisper, slightly more exaggerated contours of costume than the large sculpture. The facial expression is softened, and the hat no longer covers Chapin's

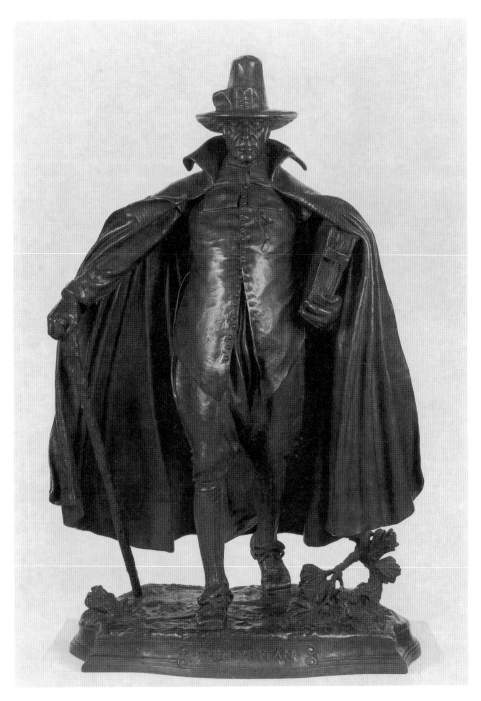

Abraham Lincoln: The Man,
1884–87, cast 1912
(Standing Lincoln)

Bronze
39½ x 16¼ x 27½ in. (100.3 x 41.3 x 69.8 cm)

Markings: AVGVSTVS•SAINT-GAVDENS•SCVLPTOR•
M•D•C•C•C•LXXXVII (base side, proper left);
GORHAM CO. FOUNDERS (base rear, upper right);
Copyright•1912 BY A•H•SAINT-GAUDENS (base
rear, center)

Saint-Gaudens's *Abraham Lincoln: The Man*, the bronze statue he installed in Chicago in 1887 (fig. 1), is among the most important monuments to American Civil War heroes created in the nineteenth century. It presented special problems in reconciling the well-known facts of the man's physical appearance and manner with the abstract ideals and symbolic meanings a monument requires. In the summer of 1885 Saint-Gaudens began modeling the figure at his Cornish, New Hampshire, studio, using a local man, Langdon Morse, who, at 6 feet 4 inches, equaled Lincoln's height. To aid in the execution of the clothing, Morse was extensively photographed wearing reproductions of Lincoln's clothes, while for the head and hands, the sculptor gained access to the life casts of Lincoln made by Leonard Volk in 1860. Saint-Gaudens placed Lincoln, his eyes cast downward, in front of a Roman chair inscribed E PLURIBUS UNUM, and integrated it into a pedestal and ellipse-shaped exedra bench designed by Stanford White. The resulting monument was unveiled in Chicago's Lincoln Park in October 1887.

The work was recognized immediately as a masterpiece of selective naturalism. Mariana Griswold Van Rensselaer wrote eloquently on Saint-Gaudens's successful expression of the complex character of a man who was "not one great man but many"—a thinker, a leader in crisis, an orator, a prophet who had the heart of a child and the tenderness of a woman.[1] These seemingly contradictory qualities were perfectly united in the figure's pose and the "symbolic reach of the conception," in which historical fact was "suffused with poetic thought."[2]

eyes, thus eliminating much of the forbidding, brooding quality displayed by the Springfield sculpture. The result was more in keeping with the kindlier characterizations of the Colonial genre then being made for domestic consumption.
KP, DS

1 Kenyon Cox, "Augustus Saint-Gaudens," *Century Magazine* 35 (November 1887), p. 31.

2 Dryfhout, *The Work of Augustus Saint-Gaudens*, p. 162.

3 Tharp, *Saint-Gaudens and the Gilded Era*, p. 221.

References Dryfhout, *The Work of Augustus Saint-Gaudens*, no. 125, p. 166; K. Greenthal et al., *American Figurative Sculpture in the Museum of Fine Arts, Boston* (Boston, 1986), pp. 238–41.

Provenance Tiffany and Co., New York, by 1919.

Purchase, 1919, 19.5.1

Fig. 1 Augustus Saint-Gaudens, *Abraham Lincoln: The Man*, 1887. Bronze, over life-size. Lincoln Park, Chicago

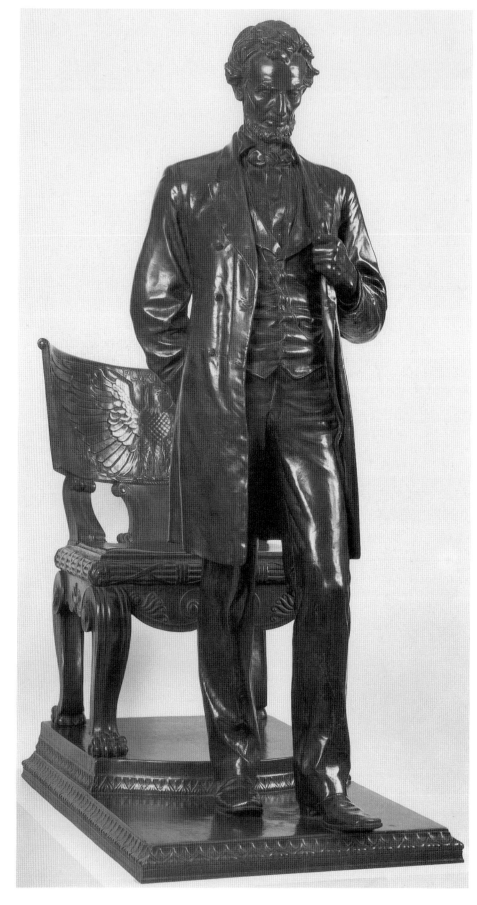

The massive, broad proportions of Lincoln's chair of state signify the power and authority of his office, while Lincoln, having just risen from the chair to address the people, pauses to think before taking action. His imposing vertical presence and firm stance express his character as a man of action, yet the meditative head and passive hands indicate the thought behind the action and symbolize power in repose.

Reductions of the original sculpture, which stood 11½ feet high, were cast after 1910 (this one by Gorham Company), as well as editions of one large and at least two reduced bronze busts.

KP

1 Mariana Griswold Van Rensselaer, "Saint-Gaudens's Lincoln," *Century Magazine* 35 (November 1887), p. 37.

2 Ibid., p. 38.

References J. O'Connor, Jr., "Abraham Lincoln by Augustus Saint-Gaudens," *Carnegie Magazine* 17 (Dec. 1943), pp. 203–5; Dryfhout, *The Work of Augustus Saint-Gaudens*, no. 124, p. 160.

Provenance Tiffany and Co., New York, 1912; private collection (sale, Parke Bernet Galleries, New York, Oct. 14, 1943); Charles J. Rosenbloom, Pittsburgh, 1943.

Gift of Charles J. Rosenbloom, 1943, 43.8

Robert Louis Stevenson, 1887–88

Bronze
Diameter: 17½ in. (44.4 cm)

Markings: TO ROBERT LOUIS/STEVENSON (upper left); AUGUSTUS/SAINT-GAUDENS (upper right); M•D•C•C•C•LXXXVII (center left, below verse); COPYRIGHT BY A SAINT GAVDENS/MDCCC (lower edge, remainder not visible)

Saint-Gaudens became familiar with the writings of Robert Louis Stevenson (1850–1894)—he was quite smitten by Stevenson's *New Arabian Nights*—through their common friend, the painter Will H. Low. For some time, the sculptor hoped to make a portrait of Stevenson.[1] When Stevenson visited New York in 1887, Low introduced them, and a mutual admiration developed between the two men.

Five sittings took place in Stevenson's room at the Hotel Albert in New York during 1887. They were attended by Low and Stevenson's wife, Fanny. The writer, ill with tuberculosis, was in bed, and he and Fanny took turns reading. Having decided to enlarge Stevenson's portrait to include his torso and hands, Saint-Gaudens arranged for one more sitting in May 1888. (Later, Saint-Gaudens's wife also served as a model for Stevenson's hands.) The sculptor arrived at Stevenson's rented house in Manasquan, New Jersey, with his eight-year-old son, who promptly went out to play.

As Saint-Gaudens recalled in his *Reminiscences,* he had trouble posing Stevenson and finally asked him if he would try to write. Pulling up his knees in bed, Stevenson obliged; then, at the end of the session, he folded the paper he was writing on and asked the sculptor to keep it for his son. It read:

Dear Homer Saint-Gaudens:

Your father has brought you this day to see me, and he tells me it is his hope that you may remember the occasion. . . . It may amuse you, years after, to see this little scrap of paper and to read what I write. I must begin by testifying that you, yourself, took no interest whatever in the introduction, and in the most proper spirit displayed a single-minded ambition to get back to play, and this I thought an excellent and admirable point in your character.

. . .You may, perhaps, like to know that the lean, flushed man in bed who interested you so little, was in a state of mind mingled and unpleasant, harassed with work which

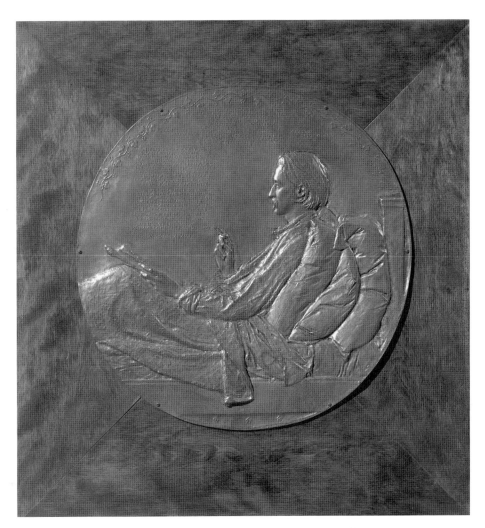

he thought he was not doing well, troubled with difficulties to which you will in time succeed, and yet looking forward to no less a matter than a voyage to the South Seas and the visitation of savage islands.

> Your father's friend,
> Robert Louis Stevenson[2]

The resulting portrait medallion appeared first in a thirty-six-inch, then in seventeen- and twelve-inch versions. The Carnegie's version was issued in an edition of perhaps thirty. Together with its smaller and larger versions, this image of Stevenson became Saint-Gaudens's most popular portrait.

Saint-Gaudens shows the writer in profile sitting in a bed of spartan simplicity, his delicate head somewhat dwarfed next to the voluminous pillow. In contrast to the roughened textures of everything else in the scene, Stevenson's face is modeled with almost glistening smoothness. Overall, the composition shows formality and informality in continuous interplay: rumpled bedclothes play off the sitter's serene profile; a garland frames the top of

the medallion, while below, the bed frame is cut off arbitrarily. The background is given over to a lengthy inscription in Latin monumental script, yet its frame of reference is private—they are verses dedicated to Will H. Low, from Stevenson's *Underwood.*

The verses, which deal with end-of-life journeys, probably allude to Stevenson's planned voyage to Samoa, where he at last received a cast of his portrait, as well as to his anticipation of death. The inscription reads:

Youth now flees on feathered foot
Faint and fainter sounds the flute
Rarer songs of gods and still
Somewhere on the sunny hill
Or along the winding stream
Through the willows flits a dream
Flits but shows a smiling face
Flees but with so quaint a grace
None can choose to stay at home
All must follow, all must roam.

This is unborn beauty she
Now in air floats high and free
Takes the sun and breaks the blue
Late with stooping pinion flew
Raking hedgerow trees and wet
Her wing in silver streams and set
Shining foot on temple roof
Now again she flies aloof
Coasting mountain clouds and kiss't
By the evening's amethyst
In wet wood and miry lane
Still we pant and pound in vain
Still with leaden foot we chase
Waning pinion fainting face
Still with grey hair we stumble on
Till behold the vision gone
Where hath fleeting beauty led
To the doorway of the dead.

Life is over life was gay
We have come the primrose way.

DS

1 Saint-Gaudens, ed., *Reminscences*, vol.
I, p. 373.
2 Ibid., pp. 377–78.

Remarks The original patina was removed
prior to 1980.

References W. H. Low, *A Chronicle of Friendships* (New York, 1908), pp. 388–94; Saint-Gaudens, ed., *Reminiscences*, vol. 2,
pp. 375–78; National Portrait Gallery, Washington, D.C., *Augustus Saint-Gaudens: The Portrait Reliefs* (1969), n.p.; O. Snoddy,
"Augustus Saint-Gaudens and Robert Louis Stevenson," *Carnegie Magazine* 50 (May 1976), pp. 208–13.

Exhibition Fogg Art Museum, Cambridge, Mass., 1975–76, *Metamorphoses in Nineteenth-Century Sculpture*, exh. cat. ed. by J. L. Wasserman, no. 9.

Provenance Brown Caldwell, Pittsburgh, by 1925.

Gift of Mr. Brown Caldwell, 1925, 25.10

Diana of the Tower, 1899, cast after 1907

Bronze
7⁵⁄₁₆ x 3½ x 2⁷⁄₁₆ in. (18.6 x 8.9 x 6.2 cm)
Markings: A St G in monogram (side, proper left); DIANA/OF THE/TOWER (above base, front); COPYRIGHT•BY/A•H•SAINT-GAUDENS/M•C•M•VIII (above base, on back); R.B.W. (on back, lower left)

In 1886 Saint-Gaudens received a request from Stanford White to design a revolving weathervane finial for his projected Madison Square Garden Tower in New York. The sculptor began plans for

Diana—his first nude—by making a bust-length study and a clay sketch.[1] The finished work was made of gilded copper sheeting and stood 18 feet high. A circular swirl of drapery provided a rudder while the bow and arrow functioned as a pointer.

When installed in late 1891, it proved to be proportionally too large for the building, and a second *Diana* (Philadelphia Museum of Art), redesigned at a height of 13 feet 1 inch, with more fluent drapery, a new coiffure, and refined, sleeker body lines, replaced it in 1894. Although critics and fellow artists responded enthusiastically to the figure, the general public called the rather unsensuous image "immoral" and "brazen," and nursemaids hurried their small charges through the park below, hoping they would not look at the woman above.[2] In spite of this, the second weathervane sculpture served as the prototype for what soon afterward became one of Saint-Gaudens's most popular reductions, as he copyrighted the figure and began to have editions produced in 1895.

A few half-size figures were made, as well as a series of 31-inch reductions, three series of 21-inch reductions, and a few 9½-inch bronze casts of the head. The Carnegie's *Diana of the Tower* is one of several 7½-inch bronze busts made from the 1899 21-inch reduction of the figure and cast after 1907.

KP

1 Dryfhout, *The Work of Augustus Saint-Gaudens*, p. 201.
2 Tharp, *Saint-Gaudens and the Gilded Era*, pp. 257–59.

References Dryfhout, *The Work of Augustus Saint-Gaudens*, no. 154, p. 210.

Provenance Johanna K. W. Hailman, Pittsburgh, by 1959.

Bequest of Johanna K. W. Hailman, 1959, 59.5.30

Victory, 1892–1903, probably cast after 1912

Gilded bronze
41⅞ x 23 x 35 in. (106.4 x 58.4 x 88.9 cm)
Markings: AVGVSTVS SAINT GAVDENS/FECIT•M•C•M•II (base side, proper left); COPYRIGHT•BY•A•H•SAINT•GAVDENS•/1912 (base rear)

Saint-Gaudens designed this figure of *Victory* for his *Sherman Monument* group, which was begun in 1892, completed in 1902, and installed in Grand Army Plaza at the East Fifty-ninth Street entrance to Central Park in New York (fig. 1). The *Victory*, wearing a laurel wreath and a chiton emblazoned with an American eagle, strides just in front of General Sherman mounted on his horse, leading him forward, with her right hand raised and holding a palm branch in her left. It was an innovative combination of a symbolic, imaginary figure and a traditional, naturalistic equestrian portrait. This *Victory* embodies the purity, loveliness, and flowing, graceful movement that characterize Saint-Gaudens's other ideal female figures, but here these qualities are combined with an energy and force viewers saw as uniquely American.[1]

Fig. 1 Augustus Saint-Gaudens, *Sherman Monument*, 1892–1902. Bronze, over life-size. Grand Army Plaza, New York

References Dryfhout, *The Work of Augustus Saint-Gaudens*, no. 184, p. 256; H. Adams, in Museum of Art, Carnegie Institute, *Collection Handbook* (Pittsburgh, 1985), pp. 228–29.

Provenance Tiffany and Co., New York, by 1919.

Purchase, 1919, 19.5.2

See Color Plate 11.

Robert Louis Stevenson, 1899–1900

Bronze
17¼ x 23⅝ in. (43.8 x 60 cm)
Markings: •AVGVSTVS• /•SAINT-GAVDENS• /•FECIT• (upper right); AVGVSTVS /SAINT-GAVDENS /MCM (lower right); •COPYRIGHT• /BY AVGVSTVS• /SAINT-GAVDENS /M /DCCCXC /IX (lower left, in roundel)

In 1893, Robert Louis Stevenson moved to Samoa, where he died in 1894. In the latter year, Saint-Gaudens was asked to execute a memorial plaque to Stevenson for the Cathedral of Saint Giles in Edinburgh—the sculptor's third portrait of Stevenson. Saint-Gaudens made the first model for it in Paris between 1899 and 1900, then produced a second model at his Cornish, New Hampshire, studio. After additional changes, this became the final relief. It was cast in Paris in 1902 and unveiled in Edinburgh in 1904. Meanwhile, Saint-Gaudens reduced and simplified his first model, which was cast into bronze and offered for sale. The Carnegie's plaque is one of these reductions, of which perhaps ten were made.[1]

This so-called Edinburgh reduction shows Stevenson in full-length profile, a traveling rug thrown over him as he sits and writes, with manuscript sheets on the floor. The pose, taken from Saint-Gaudens's 1887–88 medallion (see p. 413), is a faithful quotation to the extent that it is still unpretentious, if not casual. However, the memorial relief shows smoother modeling throughout and greater simplification generally: there are fewer pillows, for example, and the poet's nightshirt and covers are less wrinkled.

These changes reinforce others that subtly work to place the sitter in a timeless context. Stevenson anachronistically holds a quill pen; some of the paper on the floor is rolled into a scroll; he sits upon a Grecian couch rather than a modern bed; and the couch is placed atop a low but obvious dais. The resulting composition recalls classical Greek grave

Begun in New York, the *Victory*, along with the rest of the *Sherman Monument*, was remodeled in Saint-Gaudens's Paris studio in 1898 to 1900 and at Cornish in 1900 to 1901. Having first prepared a nude figure in New York for the *Victory*, Saint-Gaudens changed his design after he observed a young girl dressed in gold as a winged angel walking in a religious procession in Boulogne.[2] The sight moved him, and inspired by it, he worked intensely in his Paris studio to create a similar figure. He especially wanted to arrange the draperies expressively, not only to create beautiful folds, but also to show the figure striding forward in a purposeful, energetic manner.

Saint-Gaudens spent two weeks experimenting with the arrangement of draperies on four copies of his modeled nude.[3] Of these experiments, Saint-Gaudens wrote to his friend Abbott H. Thayer, the Cornish painter, his best results were obtained using muslin that had been wetted down, or cloth wetted with a mixture of clay and water and coated with shellac after drying so that the folds held their shape.[4]

When he returned to Cornish in 1900, Saint-Gaudens made changes in the figure's wings and head. The model for the figure in New York and Paris had been Davida Johnson Clark, Saint-Gaudens's mistress, who had also been his model for the ideal figures of the *Amor Caritas* and the angels of the *Morgan Tomb*. In Cornish, the sculptor asked a Vermont girl with a stronger profile to sit for him while he remodeled the head, but apparently he did not use the new version.

The Carnegie's *Victory* is one of eight known reductions of the figure, which were authorized by Saint-Gaudens's widow and probably cast after 1912. The condition of this particular cast is unusually fine; it retains its gold leaf, which also originally covered the full-scale *Sherman Monument* as well.

KP, DS

1 Kenyon Cox, "Augustus Saint-Gaudens," *Century Magazine* 35 (November 1887), pp. 34, 37, and Tharp, *Saint-Gaudens and the Gilded Era*, p. 29.

2 Tharp, ibid., pp. 287, 291.

3 Saint-Gaudens, ed., *Reminiscences*, vol. 2, pp. 134–35.

4 Tharp, *Saint-Gaudens and the Gilded Era*, p. 396, n. 11.

reliefs, which Saint-Gaudens knew well—he owned a cast of the fifth-century B.C. *Hegeso* stele.[2]

The new composition is more formal; it makes Stevenson seem psychologically more distant, if not timeless. The pictorial elements that tell the story of the sitter's life—the traveling rug, writing paper, and garland, which is made of laurel and Scottish heather and ends in Samoan hibiscus blossoms—intrude very little. Nothing obstructs the serene, empty expanse around Stevenson. The brief inscription on the relief is taken from Stevenson's *Songs of Travel* of 1887, and reads:

> Bright is the ring of words when the right
> man rings them,
> Fair the fall of songs when the singer sings
> them.
> Still they are carolled and said, on wings
> they are carried
> After the singer is dead and the maker
> buried.

DS, KP

1 Fogg Art Museum, Cambridge, Mass., *Metamorphoses in Nineteenth-Century Sculpture* (1975), exh. cat. ed. by Jeanne L. Wasserman, p. 195.

2 Dryfhout, *The Work of Augustus Saint-Gaudens*, p. 32.

Remarks The original patina was removed prior to 1980.

References J. O'Connor, Jr., "The Saint-Gaudens Memorial," *Carnegie Magazine* 22 (June 1948), p. 22; National Portrait Gallery, Washington, D.C., *Augustus Saint-Gaudens, The Portrait Reliefs* (1969), n.p.; Dryfhout, *The Work of Augustus Saint-Gaudens*, no. 188, p. 262.

Exhibitions Columbus Museum of Art, Ohio, 1948, *Romantic America*, no. 47; Fogg Art Museum, Cambridge, Mass., *Metamorphoses in Nineteenth-Century Sculpture* (1975), exh. cat. ed. by Jeanne L. Wasserman, no. 21.

Provenance The Gorham Co., Providence, R.I., until 1918.

Purchase, 1918, 18.15

John Singer Sargent
1856–1925

JOHN SINGER SARGENT, whose name in his own time became nearly synonymous with *alla prima* virtuosity, is probably America's most widely respected expatriate painter. He became Edwardian England's most successful portraitist, a creator of grand and elegant images of high society that were at the same time spontaneous and provocative. His plein-air paintings, genre scenes, and portrait sketches were both intimate and daringly innovative, while his watercolors, particularly of Venice and the Alps, rank among the most distinguished by any American painter.

Born in Florence, Sargent was the oldest son of a Philadelphia surgeon who had repaired to the resort areas of continental Europe for the sake of his wife's health and never returned. Sargent spent his childhood shuttling among Nice, Paris, Biarritz, Rome, Florence, Venice, and Dresden—a peripatetic existence that helped him become one of America's most thoroughgoing expatriates. Despite his American passport, he had by the end of his life spent only eight years in the United States.

Young Sargent had a precocious talent for drawing, which was encouraged by lessons in Rome arranged by his parents and by his intermittent attendance at classes at the Accademia di Belle Arti in Florence between 1870 and 1873. At the age of eighteen he went to Paris, where he became a student of Emile-Auguste Carolus-Duran and enrolled at the Ecole des Beaux-Arts. He quickly achieved an uncanny facility for late-nineteenth-century academic technique, with its subdued coloring, subtle compositions, and flashy yet disciplined brushwork. In 1877 he began exhibiting portraits and genre scenes at the Paris Salon.

Two trips—to Spain in 1879, and to Holland and Belgium in 1880—helped develop in him an allegiance to seventeenth-century painterly realism, particularly the work of Diego Velázquez and Frans Hals. That influence was apparent in *The Daughters of Edward Darley Boit* (1882, Museum of Fine Arts, Boston), his first major work, characterized by bold contrasts of light and dark and a daring spareness and asymmetry. His most notorious canvas, *Madame X,* a portrait of Mme Pierre Gautreau (1884, Metropolitan Museum of Art, New York), created a scandal when it was exhibited at the Paris Salon. It lost Sargent potential clients in Paris and apparently caused him to leave France. Yet *Madame X* accurately pointed to his later success as a purveyor of images that were at once casual, grand, graceful, and provocative.

Following the advice of Henry James, Sargent settled in London in 1886. There he quickly put down roots, becoming a founding member of the New English Art Club in 1886, and his reputation grew

steadily. As a painter of portraits, land-scapes, and interior views, he experiment-ed with similar compositional and nar-rative ambiguities that preoccupied Edouard Manet and Edgar Degas. He knew Claude Monet, Paul Helleu, and numerous other plein-air painters, with whom he shared many concerns, but it is indicative of Sargent's broad-based taste that he also displayed pronounced sympa-thies for English Aestheticism.

Between the 1880s and the early 1900s, Sargent executed his best-known plein-air paintings and watercolors, many the result of his almost constant travels. He triumphed at the Royal Academy of Arts in the 1890s as the favorite portraitist of English society. Between 1882 and 1904, seventy-five of his portraits were shown at the Royal Academy. He was one of the most prolific portraitists of his time, exe-cuting over eight hundred in his career.

Sargent had a more substantial associa-tion with the United States than his brief residence there would suggest. In 1877 he became a juror for the newly formed Association of American Artists in New York, and he exhibited in the American section of the 1889 Exposition Universelle in Paris. He made two portrait-painting visits to the United States—principally to New York and Boston—in 1887–88 and 1890. He contributed paintings to the World's Columbian Exposition in Chicago in 1893, the Pan-American Exposition in Buffalo in 1901, and the Panama-Pacific International Exposition in San Francisco in 1915. In 1903 he received an honorary degree from the University of Pennsylvania. In 1909, Knoedler Gallery, New York, mounted an exhibition of eighty-six watercolors, and in 1924, Grand Central Art Galleries, New York, opened a major retrospective of his work.

Sargent developed his closest American ties in Boston, where he had his first solo show and where he won commissions for three monumental undertakings in his late years. These were murals for the newly built Boston Public Library (1890–1919), Museum of Fine Arts, Boston (1916–25), and Widener Library of Harvard University, Cambridge (1921–22). Sargent also had a long, if not very deep, relationship with Pittsburgh. Although he never sat on a Carnegie International jury, he served on its London Foreign Advisory Committee

from 1897 to 1914. He contributed twenty-eight works to sixteen Internationals between 1897 and 1928, all but three of them portraits.

Sargent was an academician on both sides of the Atlantic: he was elected to both the National Academy of Design, New York, and the Royal Academy of Arts, London, and was also named Chevalier of the French Legion of Honor. When he died, in 1925 in London, he was at the height of his reputation. A year later, large retrospective exhibitions were mounted at the Royal Academy, London, and the Metropolitan Museum of Art, New York.

Bibliography Evan Charteris, *John Sargent* (1927, reprint, New York, 1972); Richard Ormond, *John Singer Sargent: Paintings, Drawings, Watercolors* (New York, 1970); National Portrait Gallery, London, *John Singer Sargent and the Edwardian Age* (1979), exh. cat. by James Lomax and Richard Ormond; Trevor J. Fairbrother, "John Singer Sargent and America," Ph.D. diss., Boston University, 1981; Whitney Museum of American Art, New York, *John Singer Sargent* (1986), exh. cat. by Patricia Hills, Linda Ayres et al.; Coe Kerr Gallery, New York, *John Singer Sargent*, cata-logue raisonné, forthcoming.

Venetian Interior, c. 1880–82

Oil on canvas
26⅞ x 34³⁄₁₆ in. (68.3 x 86.8 cm)
Signature: *John S. Sargent* (lower left)

Sargent's first two painting trips to Venice lasted from September 1880 to the early months of 1881 and from August 1882 to January 1883. During these intervals, he made numerous oil sketches depicting lower-class Venetians idling in the city's labyrinthine streets and darkened palazzi. Those were unusual subjects in the con-temporary repertoire of Venetian views. Sargent's enclosed spaces diverged sharply from the water- and sky-filled scenes that were the stock-in-trade of most Venetian tourist scenery, which Sargent reverted to for his own watercolors of the early 1900s.

These Venetian figure paintings of 1880–83 were in the spirit of such earlier Sargent works as *The Oyster Gatherers of Cancale* (1878, Corcoran Gallery of Art, Washington, D.C.) and *Capri* (1878, Museum of Fine Arts, Boston). Like the peasant paintings of the later Barbizon artists, they represent local people carry-ing out their daily routines, in surround-ings that are ordinary and barren, yet

visually unforgettable. However, besides being more limited in coloring, Sargent's Venetian oils of 1880–83 lack the vistas and sparkling light that made his earlier Brittany and Capri images so inviting. As experiments in conveying a new sobriety in Sargent's recently acquired "Spanish" palette, they tend to be full of heavily applied, rather stark gray and black pig-ments.

Venetian Interior is the largest of three related genre pictures by Sargent, the other two being *Venetian Bead Stringers* (c. 1880–82, Albright-Knox Art Gallery, Buffalo) and *A Venetian Interior* (c. 1880–82, Sterling and Francine Clark Art Institute, Williamstown, Mass.). The dating of these works is still unresolved. Perhaps they arose from the 1880–81 trip, for two oils called *Venetian Interior*, possi-bly including this one, were exhibited at Grosvenor Gallery in London in May 1882 and in Paris at the Galérie Georges Petit the following December.

All three present the upper floor hall-way of an unidentified palazzo—the same hallway depicted in a pastel by James McNeill Whistler, *Palace in Rags* (c. 1879–80, private collection). Linda Ayres has identified the dingy palazzo as probably one of those that served as a poorhouse or a glassworks.[1] Each presents one woman or more stringing beads (here, the seated figure at the extreme left), a menial occupation criticized by John Ruskin as useless tedium.[2]

In *Venetian Interior*, two black-shawled young women stroll the wide, empty hall-way (Gigia Viani, on the viewer's right, was Sargent's model in several of the Venetian paintings). The space is dotted with other idling women, set amid a pro-fusion of abstracted rectangles, visible in various combinations as lintels, doorways, coffers in the ceiling, or as furniture and reliefs against the wall. These forms are crossed by daringly oblique swaths of light, a device used by Sargent in much the same way in *The Daughters of Edward Darley Boit* (1882, Museum of Fine Arts, Boston).

The effect is mysterious, but only because the thoughts and motivations of these ordinary women are unknown to us as viewers. In this, perhaps the most visu-ally successful of the three palazzo interi-ors, Sargent has presented observations without comment. Contemporary reac-tions agreed upon the painting's unpic-turesqueness and absence of color.[3] But

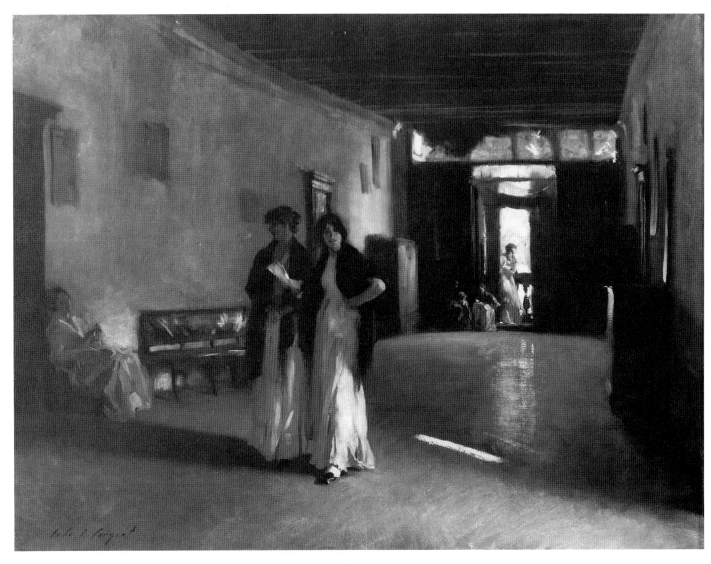

whether these effects were seen as original, natural, and beautiful or aberrant and contrary to aesthetic rightness depended upon the commentator's stand on the representation of contemporary life.

DS

1 Linda Ayres, in Whitney Museum of American Art, *John Singer Sargent*, pp. 50–51.

2 Margaretta M. Lovell, in Fine Arts Museums of San Francisco, *Venice: The American View, 1860–1920* (1984), pp. 103–4.

3 Trevor Fairbrother, in Museum of Fine Arts, Boston, *A New World* (1983), p. 312, and Ayres, in Whitney Museum of American Art, *John Singer Sargent*, pp. 50, 67–70.

References L. Mechlin, "The Sargent Exhibition: Grand Central Art Galleries, New York," *American Magazine of Art* 15 (Apr. 1924), p. 185; R. V. S. Berry, "John Singer Sargent: Some of His American Work," *Art and Archaeology* 18 (Sept. 1924), p. 110; W. H.

Downes, *John Singer Sargent: His Life and Work* (Boston, 1925), p. 132; Charteris, *John Sargent*, p. 283; F. J. Mather, Jr., *Estimates in Art: Series 2* (1931; reprint, New York, 1971), p. 240; C. M. Mount, *John Singer Sargent: A Biography* (New York, 1955), p. 444; C. M. Mount, "Carolus-Duran and the Development of Sargent," *Art Quarterly* 26 (Winter 1963), p. 400; F. A. Myers, "*Venetian Interior*," *Carnegie Magazine* 40 (Sept. 1966), p. 249; E. A. Prelinger, in Museum of Art, Carnegie Institute, *Collection Handbook* (Pittsburgh, 1985), p. 194.

Exhibitions Department of Fine Arts, Carnegie Institute, Pittsburgh, 1920, *Nineteenth Annual International Exhibition of Paintings*, no. 297; Grand Central Art Galleries, New York, 1924, *Retrospective Exhibition of Important Works of John Singer Sargent*, no. 44; Museum of Fine Arts, Boston, 1925, *Memorial Exhibition of the Works of the Late John Singer Sargent*, no. 23; Fine Arts Gallery of San Diego, 1926, *Inaugural Exhibition of the Fine Arts Gallery of San Diego*, no. 50; California Palace of the Legion of Honor, San Francisco, 1926–27, *First Exhibition of Selected*

Paintings by American Artists, no. 163; Art Gallery of Toronto, 1944, *Loan Exhibition of Great Paintings in Aid of Allied Merchant Seamen*, no. 64; Columbus Gallery of Fine Arts, Ohio, 1952, *Paintings from the Pittsburgh Collection*, no cat.; Munson-Williams-Proctor Institute, Utica, N.Y., 1953, *Expatriates: Whistler, Cassatt, Sargent*, no. 29; Grand Rapids Art Museum, Mich., 1955, *Sargent, Whistler and Cassatt Exhibition*, no cat.; Department of Fine Arts, Carnegie Institute, Pittsburgh, 1957, *American Classics of the Nineteenth Century* (trav. exh.), no. 109; Museum of Fine Arts, Boston, 1983, *A New World: Masterpieces of American Painting, 1760–1910* (trav. exh.), exh. cat. by T. Stebbins et al., no. 90; Fine Arts Museums of San Francisco, 1984–85, *Venice: The American View, 1860–1920* (trav. exh.), exh. cat. by M. Lovell, no. 54; Whitney Museum of American Art, New York, 1986–87, *John Singer Sargent* (trav. exh.), exh. cat. by P. Hills et al., unnumbered.

Provenance Henri Lerolle, Paris, until 1920.

Purchase, 1920, 20.7

See Color Plate 10.

Portrait of a Boy, 1890
(Homer Saint-Gaudens and His Mother; Homer Saint-Gaudens; Portrait; Portrait—Son of Mr. St. Gaudens)

Oil on canvas
59¾ x 56 in. (151.8 x 142.2 cm)

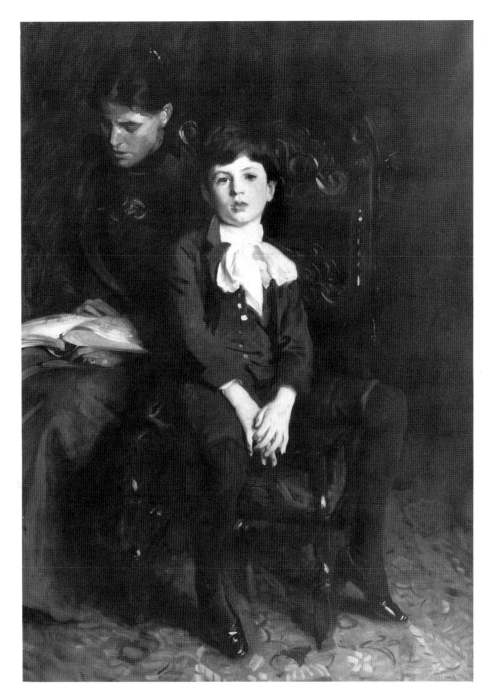

Accompanied by his youngest sister, Violet, Sargent went to the United States in December 1889. He stayed until November 1890, traveling mainly between Boston and New York. The trip, which became one of his most prolific portrait-painting excursions, also yielded, in June, preliminary discussions with Charles McKim and Augustus Saint-Gaudens about his mural commission at the Boston Public Library.

In February 1890, Sargent held a party in William Merritt Chase's rooms in the Tenth Street Studio Building to honor Carmencita, a dance-hall singer who was then booked in New York and whose portrait he wished to paint (1890, Musée d'Orsay, Paris). Among the guests at the party was Augustus Saint-Gaudens, Sargent's friend of thirteen years. Saint-Gaudens expressed an interest in executing a portrait of Violet, then twenty, in exchange for one by Sargent of Saint-Gaudens's ten-year-old son, Homer. (The bronze relief of Violet Sargent, 1890, is now in the National Museum of American Art, Washington, D.C.)

Sargent took a proprietary interest in his sister's portrait. He wrote to Saint-Gaudens about it, going so far as to suggest that a high relief would best flatter her features, before stopping himself short: "Pardon my silly interference. I am surprised at myself, behaving just like the worst bourgeois, and you can have your revenge on me about your boy. I like his head very much by the way."[1]

Violet's sittings took place in Saint-Gaudens's studio in Cornish, New Hampshire,[2] while young Homer went to Sargent's studio at Madison Avenue and Twenty-third Street in New York, accompanied by his mother. Homer Saint-Gaudens (1880–1953) later recalled that he did not especially like Sargent. He became impatient in the studio, and to settle him down, his mother read over and over the story of the sea battle between the *Constitution* and the *Guèrriere* from *The Blue Jackets of 1812.*[3]

Appropriately, Sargent decided to include Homer's mother, Augusta Saint-Gaudens (1848–1926), as she sat reading.

Sargent's portraits of children were neither deep psychological studies nor shallowly sentimental, and in fact his young sitters possessed much of the distracted indifference that made his images of adults seem so contemporary. Sargent's earlier efforts in the genre were the children of his friends. Like other pictures he painted for artist friends, they are richly complex technically and often intriguingly experimental. Sargent's portrait of the son of his colleague and long-time friend would also fit into that category.

Sargent was widely considered to be the living embodiment of the old-master court portrait painter, frequently compared to Anthony van Dyck, Diego Velázquez, and Joshua Reynolds. Such statements not only amounted to a metaphor and a comparative judgment, they also reflected Sargent's deliberate emulation of traditional court portraiture.

He made his specialty the courtly full-length, in which he frequently incorporated trappings from old-master portraiture, always adding a contemporary twist. Sargent's trademark was a sitter who, while placed in a highly formal setting, was caught in an unguarded moment.

Portrait of a Boy represents that trademark, along with another characteristic of Sargent's portraits of the 1880s and 1890s, his sketchlike freedom of execution. Homer irreverently straddles a regal, baroque-style hall chair while his mother sits behind him. She is shadowy and rapidly sketched in, but closely tied to her son compositionally. The picture's coloring is sober and limited. Much of the background is subsumed in shadow, while a single strong highlight is reserved for the white jabot of the boy's black velvet Fauntleroy suit and his strikingly pale complexion. The relationship between the two sitters is characteristic of Sargent's portraits of mothers and their children: it implies intimacy without really expressing it.

The first time *Portrait of a Boy* was exhibited, at the Art Club of Philadelphia in November 1890, it was described as one of Sargent's most successful canvases[4] and was awarded the association's gold medal for painting. The following year, it went on to the Paris Salon. Among its numerous other exhibitions, it appeared in Sargent's first solo exhibition, held in Boston's Copley Hall in 1899.

DS

1 John Singer Sargent to Augustus Saint-Gaudens, n.d., Saint-Gaudens Collection, Dartmouth College Library, Hanover, N.H.

2 Louise Hall Tharp, *Saint-Gaudens and the Gilded Era* (Boston, 1969), pp. 241, 392.

3 Homer Saint-Gaudens, *The American Artist and His Times* (New York, 1941), p. 40.

4 Fairbrother, "Sargent and America," p. 171.

References "The Philadelphia Art Club Exhibition," *Art Amateur* 24 (Dec. 1890), p. 4; J. Fairman, *Essays on Art* (Pittsburgh, 1898), 198, p. 45; "The Sargent Exhibition at Copley Hall, Boston," *Artist* 24 (Mar. 1899), p. xlv; C. H. Caffin, *American Masters of Painting* (New York, 1902), p. 64; C. H. Caffin, "John S. Sargent: The Greatest Contemporary Portrait Painter," *World's Work* 7 (1903), p. 4,103; R. Cortissoz, *Art and Common Sense* (1913; reprint, New York, 1916), p. 232; H. Saint-Gaudens, ed., *The Reminiscences of Augustus Saint-Gaudens,* (New York, 1913), vol. 1, p. 348; L. M. Bryant, "Our Great Painter John Sargent, and Some of His Child-Portraits," *Saint Nicholas* 51 (Nov. 1923), pp. 4–5; L. Mechlin, "The Sargent Exhibition: Grand Central Art Galleries, New York," *American Magazine of Art* 15 (Apr. 1924), pp. 177, 185; R. V. S. Berry, "John Singer Sargent: Some of His American Work," *Art and Archaeology* 18 (Sept. 1924), pp. 103, 106; W. H. Downes, *John Singer Sargent: His Life and Work* (Boston, 1925), pp. 36–37, 171; J. W. McSpadden, *Famous Painters of America* (New York, 1926), pp. 288–89; Charteris, *John Sargent*, pp. 137–38, 263; F. J. Mather, Jr., *Estimates in Art: Series 2* (1931; reprint, New York, 1971), pp. 240–41; J. O'Connor, Jr., "Sargent's *Portrait of a Boy*—Patrons Art Fund Purchase," *Carnegie Magazine* 6 (Apr. 1932), pp. 8–9; "Carnegie Buys Famous Sargent," *Art News* 30 (May 7, 1932), p. 9; "Some Recent Museum Acquisitions—Pictures That Are on View in One Man and Group Exhibitions," *Arts Weekly*, May 7, 1932, pp. 194–95; "An Artist's Document Bought for Carnegie," *Art Digest* 6 (May 15, 1932), p. 12; H. Saint-Gaudens, *The American Artist and His Times* (New York, 1941), p. 140; M. Breuning, "Family Portraits Exhibited for Child Aid," *Art Digest* 21 (Apr. 15, 1947), p. 13; J. O'Connor, Jr., "From Our Permanent Collection: *Portrait of a Boy*," *Carnegie Magazine* 23–24 (Apr. 1950), pp. 306–7; G. B. Washburn, "Notable American Paintings in Pittsburgh," *American Society Legion of Honor Magazine* 25 (Summer 1954), pp. 139–40; C. M. Mount, *John Singer Sargent: A Biography* (New York, 1955), pp. 175–76, 180–81, 287, 433; Museum of Fine Arts, Boston, *Sargent's Boston* (1956), exh. cat. by D. McKibbin, pp. 45, 121; H. Saint-Gaudens, "Looking Backward," *American Artist* 21 (Dec. 1957), pp. 54, 69–72; M. King, *A Gallery of Mothers and Their Children* (Philadelphia, 1958), p. 48; F. A. Myers, "*Portrait of a Boy*," *Carnegie Magazine* 41 (Mar. 1967), p. 105; Ormond, *John Singer Sargent*, p. 43; M. Cable, "Bringing Up Baby," *American Heritage* 24 (Dec. 1972), p. 64; D. Miller, "Inspired Friendship: A Discussion of Sargent's *Portrait of a Boy*," Master's thesis, University of Pittsburgh, 1975; D. Miller, "Inspired Friendship: Sargent and Saint-Gaudens," *Carnegie Magazine* 53 (Apr. 1979), pp. 4–11; E. Munhall, "Ein Palast fürs Volk," *Kunstzeitschrift* 2 (1983), p. 55; E. A. Prelinger, in Museum of Art, Carnegie Institute, *Collection Handbook* (Pittsburgh, 1985), p. 192; Fairbrother, "Sargent and America," pp. 170–71, 204; W. H. Gerdts, in Whitney Museum of American Art, *John Singer Sargent* (1986), exh. cat. by P. Hills et al., pp. 144, 159; L. Miller, "John Singer Sargent in the Diaries of Lucia Fairchild, 1890 and 1891," *Archives of American Art Journal* 26, no. 4 (1986), p. 7.

Exhibitions Art Club of Philadelphia, 1890, *The Second Special Exhibition of the Art Club of Philadelphia*, as *Portrait—Son of Mr. St. Gaudens,* no. 65; Société Nationale des Beaux-Arts, Paris, 1891, *Salon du Champ de Mars,* no. 850; Society of American Artists, New York, 1892, no. 191; Chicago, World's Columbian Exposition, 1893, *Official Catalogue—Fine Arts,* no. 881, *Revised Catalogue—Department of Fine Arts,* no. 686; Department of Fine Arts, Carnegie Institute, Pittsburgh, 1897–98, *Second Annual Exhibition,* no. 198; Boston Art Students Association, Copley Hall, Boston, 1899, *Paintings and Sketches by John S. Sargent, R.A.,* no. 38; Albright Art Gallery, Buffalo, N.Y., 1924, *Eighteenth Annual Exhibition of Selected Paintings and Small Bronzes by American Artists,* no. 185; Grand Central Art Galleries, New York, 1924, *Retrospective Exhibition of Important Works of John Singer Sargent,* no. 45; Museum of Fine Arts, Boston, 1925, *Memorial Exhibition of the Works of the Late John Singer Sargent,* no. 43; California Palace of the Legion of Honor, San Francisco, 1926–27, *First Exhibition of Selected Paintings by American Artists,* no. 165; Cleveland Museum of Art, 1936, *Twentieth Anniversary Exhibition of the Cleveland Museum of Art: The Official Art Exhibit of the Great Lakes Exposition,* no. 369; National Academy of Design, New York, 1939, *Special Exhibition* (in conjunction with the World's Fair), no. 249; Department of Fine Arts, Carnegie Institute, Pittsburgh, 1940, *The Patrons Art Fund Paintings,* no. 9; Palace of Fine Arts, San Francisco, 1940, Golden Gate International Exposition, *Art—Official Catalogue,* no. 1,217; Portraits, Inc., New York, 1947, *The Family, 1847–1947,* no cat.; Columbus Gallery of Fine Arts, Ohio, 1952, *Paintings from the Pittsburgh Collection,* no cat.; Department of Fine Arts, Carnegie Institute, Pittsburgh, 1957, *American Classics of the Nineteenth Century* (trav. exh.), no. 105; Department of Fine Arts, Carnegie Institute, Pittsburgh, 1958–59, *Retrospective Exhibition of Paintings from Previous Internationals,* no. 8; Society of the Four Arts, Palm Beach, Fla., 1959, *John Singer Sargent and Mary Cassatt,* no. 6; Art Gallery of Toronto, 1961, *American Paintings, 1865–1905* (trav. exh.), no. 61; Rheinisches Landesmuseum, Bonn, organized by the Baltimore Museum of Art, 1976–77, *Two Hundred Years of American Art, 1776–1976* (trav. exh.), no. 29.

Provenance Augustus Saint-Gaudens, until 1907; on loan to the John Herron Art Institute, Indianapolis, until 1923; on loan to Carnegie Institute from Augusta Saint-Gaudens from 1923 until her death in 1926, thereafter loaned to Carnegie Institute by Homer Saint-Gaudens, until 1932.

Patrons Art Fund, 1932, 32.1

Rolph Scarlett
1899–1984

THE CAREER OF Rolph Scarlett (who was born in Ontario and had come to New York City in 1907 to learn the jewelry trade) is intertwined with the early history of what is now the Solomon R. Guggenheim Museum, New York. About 1934, with no formal training, Scarlett made himself known as a nonobjective painter to the German-born aristocrat Hilla Rebay, curator of Solomon Guggenheim's collection and founding director of Art of Tomorrow, the Museum of Non-Objective Painting—the original name of the Guggenheim Museum when it opened in New York in 1939. Based on her knowledge of Wassily Kandinsky's theories in *Concerning the Spiritual in Art* (1912) and her study of theosophy and East Asian religions, Rebay held strong and controversial views. She believed, as her biographer, Joan M. Lukach, has written, "Art was the expression of man's spiritual nature, and a truly creative artist did not repeat forms already existing; however, with the guidance of a higher power (which she at times specifically named 'God'), one could create new forms united by a rhythm expressing cosmic forces."[1]

Rebay felt that Scarlett was her special discovery and in 1939 introduced him to the man who would become his mentor, the German painter Rudolph Bauer, whom Rebay considered to be, with Kandinsky, the foremost nonobjective artist. She awarded Scarlett a Guggenheim Scholarship in 1938 and hired him in 1939 as the museum's weekend lecturer. The position lasted eight years and made him one of the chief spokespersons for Rebay's theories.

In Kandinsky's and Bauer's geometric style, Scarlett found the manner he wished to pursue. He told Harriet Tannin:

> Here one deals with a few geometrical elements and the problem is to create an organization that is alive as to color, and form, with challenging and stimulating rhythms, making full use of one's emotional and intuitive creative programming and keeping it

under cerebral control, so that when it is finished it is a visual experience that is alive with a mysticism, inner order, and intrigue, and has grown into a world of art governed by esthetic authority.[2]

Although Bauer is not known to have painted after immigrating to the United States in 1939,[3] Scarlett frequently sought his advice regarding the placement of geometrical forms and choice of colors. The younger artist regarded Bauer as a "wonderful teacher" and said he "worshiped" Bauer's work.[4]

The irony is that Bauer was a dry, doctrinaire, and theoretical artist; while his paintings look like Kandinsky's geometric abstractions from his Bauhaus and Paris periods, they seldom possess any vitality or character of their own. On the other hand, Scarlett's work, while lacking genuine stylistic individuality, has its own distinctly lyric personality.

Scarlett, who became an American citizen after World War I, spent the last years of his life in Woodstock, New York.

1 Lukach, "Rolph Scarlett," p. 215.

2 Tannin, "Memoirs of Rolph Scarlett," p. 78.

3 Joan M. Lukach, *Hilla Rebay: In Search of the Spirit in Art* (New York, 1983), p. 166.

4 Tannin, "Memoirs of Rolph Scarlett," pp. 50, 66.

Bibliography Harriet Tannin, "Memoirs of Rolph Scarlett as Told to Harriet Tannin," 1982, Kingston, N.Y., typescript; Washburn Gallery, New York, *Rolph Scarlett: Works from c. 1940* (1982); Joan M. Lukach, "Rolph Scarlett," in Museum of Art, Carnegie Institute, Pittsburgh, *Abstract Painting and Sculpture in America, 1927–1944* (1983), exh. cat. ed. by John R. Lane and Susan C. Larsen, pp. 214–15; John R. Lane, "Rolph Scarlett," in *American Drawings and Watercolors in the Museum of Art, Carnegie Institute* (Pittsburgh, 1985), pp. 203–4.

Confretta, c. 1940–45

Oil on canvas
62¼ x 76¼ in. (158.1 x 193.7 cm)
Signature: SCARLETT. (lower right)

In addition to showing Scarlett's work frequently in group exhibitions in the early 1940s, Hilla Rebay persuaded Solomon Guggenheim to buy some sixty of Scarlett's paintings, forty-seven of which are still in the Guggenheim Museum's collection. The Carnegie Museum of Art's painting by Scarlett is one of those that the Guggenheim deaccessioned with the intention of widening the audience for the artist's work.

Confretta was probably painted in the early 1940s (the artist did not date his paintings and no chronology has been established for his work). This canvas presents a carefully balanced pictorial space composed of receding or advancing geometric forms. The romantic and poetically delicate forms, perhaps taking their cue from the title, *Confretta* (from the Italian *con fretta*, with haste), engage in a lively dance of the heavenly spheres.

In works like this one, in which he created a Constructivist's cosmos, Scarlett achieved his artistic goals based on an agenda whose priorities he set quite differently from Rebay's. For the welfare of

his relationship with her, he must have gone to considerable pains to keep from disclosing this agenda. He said:

> Rebay had a very emotional temperament and fancied herself a spiritualist. She would look into Bauer's work or Kandinsky's work and find something spiritualistic that could be read into it. Kandinsky did that too. It was a mistake. The main thing is not spiritualism or metaphysical phenomena. It's esthetics, order, form, color and rhythm.[1]

Scarlett's revelation is interesting, since it reinforces the more general notion that American abstract artists of his time were eager to accept the formal innovations of European art but were inclined to discount the theoretical baggage that frequently accompanied these advanced styles, particularly the utopian and spiritualist art of Kandinsky's Bauhaus and Paris periods.

JRL

1 Tannin, "Memoirs of Rolph Scarlett," pp. 56, 66.

Provenance Solomon R. Guggenheim Museum, New York, 1952; deaccessioned, 1985.

Paintings Acquisition Fund, 1985, 85.1

Louis Schanker

1903–1981

ALTHOUGH HE BEGAN his artistic career as a painter in oils, Louis Schanker became best known in the 1930s and 1940s for his color woodblock prints. He received his earliest training in New York City, where he was born, raised, and spent his career. Between 1920 and 1927 he studied at the Cooper Union Art School, the Art Students League, and the Educational Alliance School of Art. He also traveled and studied in France and Spain from 1931 to 1933.

During the 1930s his oil paintings evolved from Cubist-inspired still lifes to semiabstractions of athletic competitions whose sticklike figures with squarish heads bear the unmistakable mark of French painter Georges Rouault. In 1935 Schanker's interest in nonrepresentational art and expressionist technique led to his becoming a founding member of the Ten

Who Were Nine, along with Ben-Zion, Ilya Bolotowsky, Adolph Gottlieb, Louis Harris, Yankel Kufield, Mark Rothko, Joseph Solman, and Nahum Tschacbasov. The group's goal was to ensure the democratic exhibition of their works on a regular basis at a time when the realistic art of the Regionalist painters ruled the American art scene.

Like most of the Ten, Schanker moved toward ever greater abstraction in his work. In 1937 he became one of the original members of the American Abstract Artists group, an organization on the cutting edge of modern art at that time. It was also around this time that he worked for the Works Progress Administration, executing abstract murals for radio station WNYC and for the Medicine and Public Health Building of the 1939 New York World's Fair.

In 1935 Schanker began to produce color woodblock prints after his own paintings, and these were well received by the critics. Indeed, they were often considered to be better than the original works in oil due to the greater structure and discipline of the graphic medium.[1] However, Schanker continued to paint in oils: his paintings of the 1940s generally consist of large color planes overlapped by thin black lines, which evoke comparisons with stained glass or mosaics.

In the early 1940s Schanker made woodcuts for the WPA Federal Art Project, of which he later became supervisor. From 1943 to 1960 he taught woodblock printing and later painting at the New School for Social Research, New York. He also taught at Bard College in upstate New York from 1949 to 1964. During the 1960s and 1970s he experimented with a variety of techniques, including freestanding wood sculptures and paintings on Plexiglas. Whatever the medium, Schanker always retained his penchant for nonrepresentational art. Schanker died in New York City.

1 "Schanker's Abstractions of Varied Activities," *Art News* 38 (November 25, 1939), p. 13; untitled review of show at Willard Gallery, *Art News* 43 (April 1, 1944), p. 24.

Bibliography Yiddisher Kultur Farband, *One Hundred Contemporary Jewish Painters and Sculptors*, essay by Louis Lozowick (New York, 1947), p. 160; Suzanne Burrey, "Circular Forms," *Arts* 31 (March 1957), pp. 20–21; Associated American Artists, New York, *Louis Schanker: Printmaking Retrospective, 1924–1971* (1978); Ilene Susan Fort, "Louis Schanker," *Arts* 56 (September 1981), p. 28; Lucy Embick, "The Expressionist Current in New York's Avant-Garde, 1935–40: The Paintings of 'The Ten,'" *Rutgers Art Review* 5 (Spring 1984), pp. 56–69.

Forms in Action, c. 1940

Oil on canvas
29⅝ x 54 in. (75.3 x 137.2 cm)
Signature: *Schanker* (lower right)

The expressionist style of abstraction Schanker employed in *Forms in Action* presages the rise of Abstract Expressionism in the 1940s. Typical of the artist's work at the time, the painting is composed of large patches of high color overlaid with expressive lines of black pigment. The bold colors and nervously drawn biomorphic forms give a sense of explosive energy to this heavily painted canvas.

RB

Reference J. R. Lane, "American Abstract Art of the '30s and '40s," *Carnegie Magazine* 56 (Sept.–Oct. 1983), p. 19.

Provenance Martin Diamond Fine Arts, New York, by 1981.

The A. W. Mellon Acquisition Endowment Fund, 1981, 81.70

Elmer Schofield

1867–1944

THE YOUNGEST OF EIGHT children, Walter Elmer Schofield was born in Philadelphia under prosperous, but not privileged conditions. His father, who had emigrated from England in 1840, owned the Delph Spinning Company in Philadelphia. Schofield attended Swarthmore College but after a year moved to Texas, where for eighteen months he worked as a cowboy. There he produced his earliest paintings, depicting life in the West. By the time he returned to Philadelphia, he had decided to become an artist. He entered the Pennsylvania Academy of the Fine Arts in Philadelphia, where he studied between 1889 and 1892, first taking instruction from Thomas Anshutz, then from Robert Vonnoh.

Like many American art students at the time, Schofield went to Paris, where he spent three years. In 1892 he enrolled at the Académie Julian, where his teachers were William-Adolphe Bouguereau, Gabriel Ferrier, and Henri Doucent. It is possible he also studied with Edmond Aman-Jean at the Atelier Colarossi. However, neither Bouguereau's allegorical nudes, Ferrier's *femmes fatales*, nor Aman-Jean's fashionable portraits had a significant influence on his art.[1] Instead, it was landscape painting and the Impressionists' technique that eventually became the legacy of Schofield's Paris years.

Upon returning home in 1895, Schofield entered his father's business but found factory work unappealing. He resumed painting and attended meetings at Robert Henri's Philadelphia studio along with John Sloan, William Glackens, Everett Shinn, George Luks, and Edward Redfield.

After traveling in France and England, Schofield in 1897 married an Englishwoman and began to paint the Pennsylvania snow scenes that would dominate his work. Although he settled permanently in England after 1901 (his initial residence was Saint Ives, Cornwall), he returned annually to the United States to paint the rural winter landscape there. Still, he was not indifferent to the local colony of British artists at Saint Ives, for he very much shared their interest in painting outdoors and directly from nature.

Schofield's American landscapes won him at least twenty awards and honors, including an honorable mention from Carnegie Institute in 1900, the first Hallgarten Prize from the National Academy of Design, New York, in 1901, and, between 1903 and 1914, gold medals from the Pennsylvania Academy of the Fine Arts, Carnegie Institute, and the National Academy of Design. In 1912 Carnegie Institute honored him with a solo exhibition. Between 1899 and 1933 he served on the jury of award for eight Carnegie Internationals and entered paintings in twenty-two of them. He was elected to the National Institute of Arts and Letters and the National Academy of Design and was a member of the Society of American Artists as well as the Royal Society of British Artists and the Royal Society of Oil Painters.

The 1920s brought increased vibrancy and color to Schofield's work, a substantial change from his earlier tonal efforts. He spent much of the 1930s in California, Arizona, and New Mexico, and turned again to the American West for subjects: his canvases of the 1930s feature desert scenes and local architecture.

With the outbreak of World War II, restrictions were placed on travel between England and the United States, forcing Schofield to remain at his home in Cornwall. Although he longed to return to America, he never again did so. Instead, he spent his last years in England painting landscapes reminiscent of the many winter scenes he had done during his annual visits to the United States.

1 Brandywine River Museum, *Walter Elmer Schofield*, p. 12.

Bibliography Arthur Hoeber, "W. Elmer Schofield: A Painter in the Open," *Arts and Decoration* 1 (October 1911), pp. 473–75, 492; C. Lewis Hind, "An American Landscape Painter: W. Elmer Schofield," *International Studio* 57 (1912–13), pp. 280–86; Brandywine River Museum, Chadds Ford, Pa., *Walter Elmer Schofield: Bold Impressionist* (1983), exh. cat. by Thomas Folk; Allentown Art Museum, Pa., *The Pennsylvania School of Landscape Painting* (1984), pp. 47–58.

Across the River, c. 1904

Oil on canvas
38 x 48 in. (96.6 x 121.9 cm)
Signature: Schofield (lower right)

One of Schofield's first mature winter scenes, *Across the River* is an interpretation of nature that is at once accurate, bold,

and lacking in detail. It depicts the rolling hills of rural southeastern Pennsylvania along the banks of the Delaware River.

The hills help to create a flowing composition with strong diagonal axes. The trees, which in the foreground reach to the top of the canvas, are placed so as to allow the spectator to become conscious of the rugged terrain dominating the background. This large land mass is enhanced by the exceptionally high horizon line, which leaves visible only a thin strip of sky. A more tonal mixture of soft green, gray, and brown, rather than the Impressionists' brighter palette, is evident in the water, snow, and sky. The pigment is applied with a lavishness that results in broad, vigorous brushstrokes, which are sometimes raised slightly above the surface. Still, Schofield's facture is neither as distinct nor as energetic as that of his contemporary, Edward Redfield.

Schofield knew Redfield from their days at Henri's studio and had visited Redfield at his home in Bucks County on many occasions. During one particular visit, the latter had described to Schofield a painting he intended to create for Carnegie Institute's annual exhibition in 1904. It happened that Redfield was a jury member that year, and he became outraged when Schofield submitted *Across the River;* Redfield claimed the composition for this scene was taken from his front yard and was originally his idea, even though Schofield created the canvas from memory at home in Saint Ives.

Across the River was awarded a first-class medal by Carnegie Institute in 1904. Redfield was extremely upset when Schofield won, since he believed Schofield had stolen his idea. Redfield told Schofield, "You keep out of my front yard after this. . . . You paint your own subjects."[1] After the incident, the two became arch rivals, and although Schofield continued to paint the scenery

surrounding Philadelphia, he is not known to have painted another Bucks County landscape.

LAH

1 Thomas Folk and Barbara J. Mitnick, "The Pennsylvania Impressionists," *Antiques* 128 (July 1985), pp. 111–17.

References J. W. Pattison, "The Awarding of Honors in Art," *Fine Arts Journal* 23 (Aug. 1910), pp. 78, 81; J. O'Connor, Jr., "The Carnegie International Exhibition," *Art and Archaeology* 14 (Nov.–Dec. 1922), p. 303; T. Folk and B. J. Mitnick, "The Pennsylvania Impressionists," *Antiques* 128 (July 1985), pp. 111–17.

Exhibitions Department of Fine Arts, Carnegie Institute, Pittsburgh, 1904, *Ninth Annual Exhibition*, no. 249; Department of Fine Arts, Carnegie Institute, Pittsburgh, 1912, *W. Elmer Schofield*, no. 30; Brandywine River Museum, Chadds Ford, Pa., 1983, *Walter Elmer Schofield: Bold Impressionist*, exh. cat. by Thomas Folk, no. 1.

Provenance The artist, until 1904.

Purchase, 1904, 05.2

John Sennhauser

1907–1978

JOHN SENNHAUSER was born in Rorschach, Switzerland. Before moving to New York in 1928 he spent two years in formal art study in Venice. His first paintings in America, executed in the early years of the Depression, were romantic visions of the street life of urban New York.[1] But his subsequent studies at the Cooper Union Art School from 1930 to 1933 marked a watershed in his artistic development: there he discovered the pure geometric forms that would be the focus of his paintings from that point onward.

Like most abstract artists in the 1930s, Sennhauser was unable to support himself through his art. He taught at the Leonardo da Vinci School in New York from 1936 to 1939 and at New York's Contemporary Art School from 1939 to 1942. From 1943 to 1945 he was a lecturer and preparator at the Museum of Non-Objective Painting, New York (now the Solomon R. Guggenheim Museum), whose director, Hilla Rebay, actively supported his painting. Sennhauser believed, however, that there was no such thing as nonobjective painting, for to him it was

"at all times an extension of human emotion and experience. . . . The real object (subject matter) in painting is the intuitive feeling which is extended upon the surface."[2]

His paintings of the 1930s were thickly painted and darkly colored renderings of geometric and biomorphic shapes. Around 1939 he began to use a vocabulary of crisper forms and a muted pastel palette to create the cool, airy abstractions for which he is best known. His style evinced little change throughout his long career, although he later added collages and paintings on parchment or paper to his repertoire.

Never a major figure in the American art world, Sennhauser exhibited regularly and received generally favorable criticism; he was praised for his sensitive use of color and intricate compositions.[3] During the 1930s and 1940s, his work was shown at a variety of museums and galleries both at home and abroad, including the National Academy of Design and the Whitney Museum of American Art in New York and the Pennsylvania Academy of the Fine Arts, Philadelphia. Although he began to execute abstractions in the early 1930s, he did not become a member of the American Abstract Artists until 1945; he participated in their annual exhibitions until the early 1970s. He was also an active member of the Federation of Modern Painters and Sculptors.

After World War II, Sennhauser became a restorer of antique papers and a mural designer for Goertler Studios, New York. From 1957 to 1975 he was the art director for C. R. Gracie and Sons in New York but remained an active participant in national and international exhibitions. In 1951 he won purchase awards from the Whitney Museum of American Art and from the Philbrook Art Center in Tulsa. In 1971 and 1972 he received grant awards from the Mark Rothko Foundation in New York. He retired to Escondido, California, where he resided to the end of his life.

1 Larsen, "John Sennhauser," p. 216.

2 Reed, "Lines in Motion," p. 13.

3 "Exhibition, Artists Gallery," p. 38.

Bibliography Judith Kaye Reed, "Lines in Motion: Exhibition, Artists Gallery," *Art Digest* 21 (September 15, 1947), p. 13; "Exhibition, Artists Gallery," *Art News* 46 (September 1947), p. 38; Ilene Susan Fort, "John Sennhauser," *Arts* 55 (December 1980), p. 53; Susan C. Larsen, "John Sennhauser," in Museum of Art, Carnegie Institute, Pittsburgh, *Abstract Painting and Sculpture in America, 1927–1944* (1983), exh. cat. ed. by John R. Lane and Susan C. Larsen, p. 216.

Lines and Planes No. 1, 1944

Oil on canvas
35¾ x 45¾ in. (90.8 x 116.2 cm)

Signature, date: JOHN SENNHAUSER 44 (lower right)

Lines and Planes No. 1 is a lyrical exploration of geometric forms. A celebration of light, the painting resembles a color spectrum that has been blown apart and then carefully rearranged by the artist.

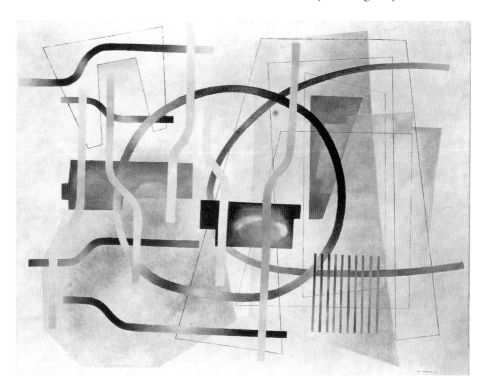

Softly curved verticals of yellow, orange, and red overlap a circle, an ellipse, and horizontal lines in tones of gray, blue, violet, and indigo. By laying warm colors over cooler hues, Sennhauser created a sense of depth and of movement in space. This sense of motion is heightened by the curved verticals, irregularly placed across the canvas, which seem to shimmer and float on unseen air currents. Executed on a roughly woven canvas, the resultant paint spread softens the contours of the geometric shapes and adds to the vibrancy of the rather delicate colors.

Works such as this one have inevitably caused comparisons with Wassily Kandinsky's paintings of the 1920s, for Sennhauser, like Kandinsky, favored the use of linear motifs, precisely rendered on a light or white background.[1] However, Sennhauser's art is distinguished by his lightness of touch, his taste for vibrant color, and his luminous sense of space.[2]

RB

1 Fort, "John Sennhauser," p 53.

2 John R. Lane, "American Abstract Art of the '30s and '40's," *Carnegie Magazine* 56 (Sept.–Oct. 1983), p. 14.

Reference J. R. Lane, "American Abstract Art of the '30s and '40s," *Carnegie Magazine* 56 (Sept.–Oct. 1983), p. 14.

Exhibition Museum of Art, Carnegie Institute, Pittsburgh, 1983–84, *Abstract Painting and Sculpture in America, 1927–1944* (trav. exh.), exh. cat. ed. by J. R. Lane and S. C. Larsen, no. 125.

Provenance Martin Diamond Fine Arts, New York, by 1982.

Mary Oliver Robinson Memorial Fund, 1982, 82.16

James Jebusa Shannon
1862–1923

AT THE END OF the nineteenth century, the American expatriate James Jebusa Shannon was considered "one of the most brilliant, and certainly one of the most fashionable portrait painters of London."[1] He was best known for somewhat idealized portraits of British noblewomen and for decorative subject pictures, for which his wife and daughter often modeled. A subdued palette, an emphasis on tonal harmonies, and stylized compositions suggest that he admired—and, to a certain extent, emulated—the work of his enormously influential, somewhat older contemporary James McNeill Whistler.

Born in Auburn, New York, Shannon in 1870 moved with his family to Saint Catherine's in Ontario, Canada, where he received his earliest training in art from a local painter. By 1878 he was in London, having entered the South Kensington School of Art (now the Royal College of Art), where he studied for three years under the successful academician Sir Edward John Poynter. In 1880 he won the school's gold medal for life painting, which resulted in a commission from Queen Victoria to paint one of her maids of honor, Lady Horatia Stopford (1881, Queen's Collection, Osbourne House, Isle of Wight). At the queen's command, the painting was exhibited, to favorable reviews, at the Royal Academy of Arts, London, that year.

In 1881 Shannon opened a studio in London, and within half a dozen years his reputation as a fashionable portrait painter was established. His works were regularly shown at the Royal Academy as well as at the New Gallery, the Grafton Gallery, and the London Fine Arts Society. He also began to participate in major exhibitions in Britain, America, and Europe.

Shannon's immense popularity was due to his ability to combine advanced painting techniques with the traditional qualities of sentiment and beauty preferred by his Victorian public. Christian Brinton, an important critic of the day, aptly summarized the appeal of Shannon's style:

> In essence this art is a sensitive, emotional art, modern, though looking backward to the days when beauty was still deemed a necessity. Unlike so much current work it is neither Gallic nor Japanese, but straightforward and Anglo-Saxon. . . . It is manifestly lacking in analysis. Its very defects are racial for in its desire to please and to prettify it is not above making concessions. . . . Unless he is vigilant, it may prove the undoing of Shannon.[2]

From 1891 until approximately 1904, Shannon and his family often summered in Holland, where he painted with fellow Americans George Hitchcock and Gari Melchers. Sharing some of their interest in the theme of mother and child, he used his wife and daughter as models for works such as *On the Dunes* (1920, National Museum of American Art, Washington, D.C.), which are characterized by light, vivid colors and a more painterly technique than that he used for his portraits.

Quite active in the British art world, Shannon was a founding member, along with Whistler and John Singer Sargent, of the New English Art Club in 1886, an important focus for modern art at that time. He was also a member of the Chelsea Arts Club, the Royal Hibernian Academy, the Royal British Colonial Society, and the Royal Society of Portrait Painters, of which he was President. He became an associate of the Royal Academy in 1897 and an academician in 1909.

Shannon was actively involved in the American art scene as well, participating in major exhibitions in New York, Philadelphia, Pittsburgh, Chicago, and elsewhere. Between 1897 and 1923, he showed ten paintings in eight of Carnegie Institute's annual international exhibitions of contemporary art, and served annually on the International's Foreign Advisory Committee. Between 1905 and 1914, he traveled frequently to America to paint portraits of wealthy patrons in New York and Boston.

Shannon's efforts were rewarded with a wide array of prizes. He won gold medals at the 1889 Paris Exposition Universelle, the 1901 Pan-American Exposition in Buffalo, the 1904 Universal Exposition in Saint Louis, and the 1906 Venice Biennale. He garnered first-class medals in Berlin and Vienna in 1889, in Pittsburgh in 1897, and in Barcelona in 1911. He also won the Pennsylvania Academy of the Fine Arts Lippincott Prize in 1899 and a silver medal at the 1900 Exposition Universelle in Paris. Finally, in 1922, he was knighted by the British Crown. He died, a successful and popular artist, at his London home.

1 Sadakichi Hartmann, *A History of American Art* (New York, 1901, 1934), vol. 2, p. 212.

2 Brinton, *Modern Artists*, p. 240.

Bibliography Lewis Hind, "The Work of J. J. Shannon," *Studio* 8 (July 1896), pp. 67–75; F. Rinder, "J. J. Shannon, A.R.A.," *Art Journal* n.s., 53 (February 1901), pp. 41–45; Christian Brinton, *Modern Artists* (New York, 1908), pp. 232–42; Kitty Shannon, *For My Children* (London, 1933); Barbara Dayer Gallati, "James Jebusa Shannon," *Antiques* 134 (November 1988), pp. 1,132–41.

Miss Kitty, 1897

Oil on canvas
66 x 40 in. (167.6 x 101.6 cm)
Signature, date: J. J. Shannon/1897 (lower left)

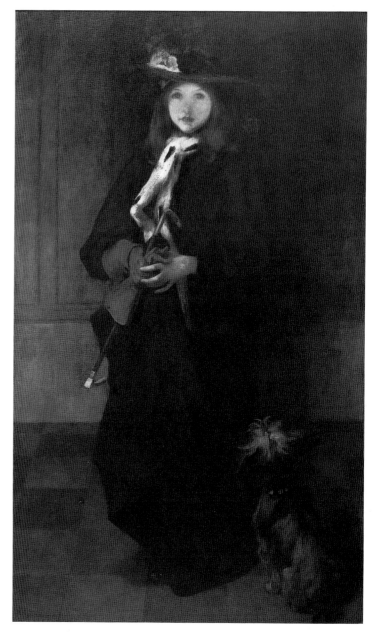

Miss Kitty is a full-length portrait of the artist's only child at the age of ten. Kitty Shannon (1887–1974), one of her father's favorite models, figured prominently in at least thirty of his known works.[1] She posed sometimes with her mother, as in *Jungle Tales* (1895, Metropolitan Museum of Art, New York), and sometimes alone, as in *Black and Silver* (c. 1909–10, Royal Academy Collection, London). In each case, a theme, rather than the girl, is the focus of the painting, and the result is not strictly portraiture.

Even the apparently straightforward image of *Miss Kitty* has a narrative context. In an autobiography written years later, Kitty recalled how she and her father often went for early morning rides in London's Hyde Park; she also noted, with a touch of chagrin, how often Shannon interrupted her pleasurable pastimes to make her pose for him.[2] Here, Kitty appears to have been interrupted as she prepared for just such an outing. She is shown in a dark, voluminous riding habit, holding a crop and a gauntleted glove in her loosely clasped hands. The setting—a maroon-and-green tiled floor beneath a gray paneled wall—seems to be an entrance hall or foyer, possibly in the Shannons' Holland Park home.

The most striking aspect of the painting, considering the youth of the model, is its adult sophistication. Kitty, her face fully frontal and her body turned slightly to the left, gazes toward the viewer with a serene confidence far beyond her ten years. This intended artificiality is heightened by what is patently a costume: a broad-brimmed black hat, ermine muffler, and long, flowing cloak. The stylized pose, gracefully curved hands, and elegant attire are reminiscent of John Singer Sargent's portraits of young society matrons, suggesting that Shannon deliberately executed a "Sargentesque" portrait of his blossoming daughter. The combination of Kitty's youthful, undefined features with her sophisticated setting also hints at a father's amused indulgence for his daughter's "dressing up."

Shannon's color scheme, wherein charcoal black, pearl gray, and sienna brown predominate, adds to the sophisticated look of the canvas. The pinks set against this dramatically dark background create a pungent contrast and focus the viewer's attention on Kitty's face and ungloved hand. Overall, the palette shows the influence of James McNeill Whistler, another famous contemporary.

Although Shannon selectively emulated Sargent and Whistler, he did not share their detachment toward a subject. Whereas they portrayed their sitters as aesthetic objects or icons of a certain type, Shannon took a more personal and emotional approach to his subjects. That emotional involvement, which operated even when the sitter was not a family member, generally lends a certain sweetness or innocence to his work,[3] a quality evident in *Miss Kitty,* where it is fused with the artist's purely painterly interests.

The critical consensus found that, for Shannon,

> the sitter is seldom or never the beginning and end of the composition; nor. . . do we find him strenuous and single-minded in an endeavor to reveal subtle and elusive shades of thought and feeling in his sitter. His skill lies rather in the aptness with which he can bring together accessories which harmonize and serve to enhance the pictorial charm of his men and women.[4]

Shannon evidently agreed with this assessment, as he claimed he always strove to be an artist first and a portrait painter afterward.[5]

Miss Kitty gave Shannon a tremendous success. First exhibited at the second Carnegie International in 1897, it was awarded a gold medal and subsequently purchased. After its appearance at an exhibition of American paintings at the Art Institute of Chicago in 1899, an anonymous critic called it "one of the choicest things" ever exhibited at that institution and lavishly praised the painting's line, color, and technique. Ten years later, the eminent art critic Charles H. Caffin said, "The simple sincerity, both of feeling and technique, which distinguishes this early example, has scarcely been sustained in his later portraits."[6]

RB

1 Barbara Dayer Gallati to Rebecca Butterfield, May 26, 1987, museum files, The Carnegie Museum of Art, Pittsburgh.
2 Shannon, *For My Children*, pp. 75, 83.
3 Barbara Dayer Gallati to Rebecca Butterfield, June 2, 1987, museum files, The Carnegie Museum of Art, Pittsburgh.
4 Rinder, "J. J. Shannon, A.R.A.," p. 42.
5 Hind, "The Work of J. J. Shannon," p. 68.
6 Charles H. Caffin, *The Story of American Painting* (New York, 1907), p. 255.

References "Paintings at the Institute," *Chicago Record*, Nov. 7, 1899; Rinder, "J. J. Shannon, A.R.A.," p. 45; C. H. Caffin, *The Story of American Painting* (New York, 1907), p. 255; Brinton, *Modern Artists*, p. 237; J. W. Pattison, "The Awarding of Honors in Art," *Fine Arts Journal* 23 (Aug. 1910), p. 84; "Notable Paintings from the Carnegie Art Galleries, and Something about the Artists," *Pittsburgh Post*, Mar. 7, 1912, p. 6; J. O'Connor, Jr., "The Carnegie Institute International Exhibition," *Art and Archaeology* 14 (Nov.–Dec. 1922), p. 307; Obituary, *Art News* 21 (Mar. 10, 1923), p. 8; S. Isham, *The History of American Painting* (New York, 1927), pp. 427–28; Gallati, "James Jebusa Shannon," p. 1,137.

Exhibitions Department of Fine Arts, Carnegie Institute, 1897, *Second Annual Exhibition*, no. 201; Pennsylvania Academy of the Fine Arts, Philadelphia, 1898, *Sixty-seventh Annual Exhibition*, no. 405; Art Institute of Chicago, 1899, *Twelfth Annual Exhibition of Oil Paintings and Sculpture by American Artists*, no. 275; Albright Art Gallery, Buffalo, 1901, *Pan-American Exposition*, no. 52; M. Knoedler and Co., New York, 1905, *Exhibition of Recent Portraits by J. J. Shannon, A.R.A.*, no. 1; Toledo Museum of Art, Ohio, 1912, *Inaugural Exhibition*, no. 87; Albright Art Gallery, Buffalo, 1913, *Eighth Annual Exhibition of Selected Paintings by American Artists*, no. 104; Rhode Island School of Design, Providence, 1913, *Autumn Exhibition*, unnumbered; Detroit Museum of Art, 1915, *First Annual Exhibition*

of Selected American Artists, no. 122; Milwaukee Art Institute, 1922, *Loan Collection of Paintings from American Art Museums*, no cat.; California Palace of the Legion of Honor, San Francisco, 1926, *The American Paintings Exhibition*, no cat.; Department of Fine Arts, Carnegie Institute, Pittsburgh, 1935, *Paintings Which Have Received Prize Awards in International Exhibitions at Carnegie Institute*, no. 6.

Provenance The artist, until 1897.

Purchase, 1897, 97.4

Raymond Simboli
1894–1964

ALTHOUGH HE NEVER achieved national recognition, Raymond Simboli enjoyed prominence as both an oil painter and a watercolorist in the Pittsburgh area. Born in Pescina, Italy, he and his family immigrated to Pittsburgh in 1900. His early interest in art was encouraged by his father—a carver, decorator, and painter. As a youth, Simboli often worked with him painting murals for local theaters and churches.

From 1917 to 1919 Simboli studied art at Carnegie Tech (now Carnegie Mellon University) in Pittsburgh. During that same period, he won a Hawthorne Scholarship from Carnegie Tech and a Tiffany Foundation Fellowship and briefly served in World War I. Upon his return to Pittsburgh in 1920, he was appointed to the faculty of Carnegie Tech, where he taught architectural drawing until his retirement in 1962. He also taught intermittently at Carnegie Institute, the Pittsburgh Art Institute, and the Ad Art School. For several years after World War II, he conducted a private art school at his home in the East Liberty area of Pittsburgh.

Throughout his career Simboli was an active member of the Pittsburgh art scene. He won several awards at the Associated Artists of Pittsburgh's annual exhibitions and served as president of that organization in 1951. He also became the first president (in 1946) of the Pittsburgh Water Color Society. In 1955 he was selected Artist of the Year by the Pittsburgh Arts and Crafts Center, a prestigious local award. His works were also shown at Carnegie Institute's annual exhibitions in 1925, 1926, 1928, and 1934.

Simboli's early works were primarily of figures, realistically portrayed, for which various family members—his wife, parents, children, and brothers—usually served as models. Over the years he gradually broadened his repertoire to include Pittsburgh scenes of blast furnaces and working-class neighborhoods. During his summer travels, he painted landscapes and village scenes in Connecticut, the American Southwest, and Mexico. After World War II, he drastically changed his style, abstracting machine parts, still lifes, and other nonfigurative subject matter into decorative designs. Simboli died in Wisconsin while he was visiting his daughter and son-in-law.

Bibliography Raymond Simboli, "Assorted Artists of Pittsburgh," *Carnegie Magazine* 26 (March 1952), pp. 90–93; Dorothy Kantner, "Art Notes: Simboli Exhibition to Cover 25 Years," *Pittsburgh Sun-Telegraph*, January 2, 1955, sec. 3, p. 4; Obituary, *Carnegie Institute of Technology Faculty Bulletin*, April 29, 1964, n.p.; Westmoreland County Museum of Art, Greensburg, Pa., *Raymond Simboli: Retrospective Exhibition* (1965), exh. cat., introduction by Paul A. Chew.

Self-Portrait, c. 1929

Oil on canvas
36 x 30 in. (91.4 x 76.2 cm)
Signature: Ray Simboli (lower right)

In this earnest, unpretentious self-portrait, Simboli wears a fresh, unstained painter's smock over his suit and tie; he sits relaxed before his easel, an assortment of brushes clasped in his hand. The small work area, probably in the artist's East Liberty home, is sparsely furnished with a table, a chair, and an ordinary throw rug.

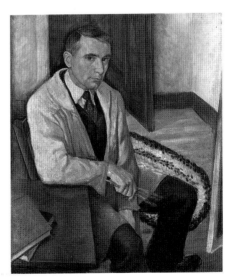

The books on the table are perhaps a reference to the artist's other career as a teacher.

Simboli employs here the local coloring and curvilinear contours popular with contemporary American Regionalist painters such as Thomas Hart Benton and Grant Wood. The painting apparatus, books, and middle-class setting give an accurate and sensitive encapsulation of this artist-teacher's life.

RB

Exhibitions Department of Fine Arts, Carnegie Institute, 1930, *Twentieth Annual Exhibition of the Associated Artists of Pittsburgh*, no. 48; Museum of Art, Carnegie Institute, Pittsburgh, 1977, *Some Pittsburgh Artists from the Permanent Collection*, no cat.

Provenance The artist, until 1964; his widow, Mabel Tito Simboli, until 1976.

Gift of Mabel Tito Simboli, in memory of Raymond Simboli, 1976, 76.52

William H. Singer, Jr.
1868–1943

THE SON OF A prominent Pittsburgh industrialist, William Henry Singer, Jr., was born in Ligonier, Pennsylvania, and spent his young adulthood working in the family steel business of Singer-Nimick and Company. As an amateur painter, he had two canvases accepted and exhibited in the Carnegie International of 1900. This event proved to be the turning point in his career, for at the age of thirty-two Singer resigned from the family business and made painting his profession. That summer he left Pittsburgh for Monhegan Island off the coast of Maine, a small fishing village where he painted landscapes.

Singer subsequently sailed to France and enrolled in the Académie Julian in Paris, but within a few months he left and studied briefly with the history painter Jean-Paul Laurens. However, Singer found plein-air painting more congenial than academic figure painting or historical genre. He moved to Laren, Holland, an artists' colony, where he produced many landscape paintings.

In 1904 Singer visited Norway. Captivated by the vastness and beauty of the countryside, he eventually built a studio and a home in Olden. He sent three paintings to the 1906 annual exhibition at the Pennsylvania Academy of the Fine Arts, Philadelphia. He returned to the United States in 1907 and spent that summer at the artists' colony in Old Lyme, Connecticut, visiting with Walter Griffen, Childe Hassam, and Willard Metcalf.

After a year in the United States, Singer returned to Olden. With the outbreak of World War I, which interrupted his habit of wintering in Holland, he remained in Norway, painting snow scenes from nature. These works captured the effects of brilliant sunlight and his love of the outdoors in a manner reminiscent of the French Impressionists.

In 1915 Singer had his first American exhibition of Norwegian scenes at the City Club in New York and was awarded a silver medal at the Panama-Pacific International Exposition in San Francisco. He visited the United States again in 1917 and was elected an associate member of the National Academy of Design and a member of the Allied Artists of America. Throughout the 1920s and 1930s, his work was shown regularly in galleries in America and abroad. It was also shown at and acquired by museums as well—Carnegie Institute included him in both the 1938 and 1939 Internationals. In 1931 he became an academician of the National Academy of Design and also saw the completion of the Washington County Museum of Fine Arts in Hagerstown, Maryland—a gift from Singer and his wife to her hometown.

After the outbreak of World War II in 1939, Singer was confined to his home in Norway, unable to leave the country. He died of a heart attack there and was buried in the village of Olden. In 1946 an exhibition was held in his memory at Carnegie Institute.

Bibliography Cornelis Veth, *The Norwegian Work of W. H. Singer, Jr., the American Artist* (Amsterdam, 1923); *The American Painter W. H. Singer Jr. and His Position in the World of Art* (Amsterdam, 1928); Camille Mauclair, *The Painter: W. H. Singer, Jr.* (Amsterdam, 1937); R. W. de Vries, Jr., *W. H. Singer, Jr., N.A.: The Man and the Artist* (Bussum, Holland, 1965); Washington County Museum of Fine Arts, Hagerstown, Md., *William H. Singer, Jr., 1868–1943* (1981).

Joy of a Summer Day, 1922

Oil on canvas
33¼ x 31½ in. (84.4 x 80 cm)
Signature, date: W.H. Singer, Jr./1922 (lower right)

The untamed, awe-inspiring countryside of Norway was never more celebrated than by the American artist William Singer. His belief in its magical, romantic beauty was reflected by the considerable number of his light, bright landscapes of Norwegian sites. *Joy of a Summer Day* is one of these.

It illustrates the small village of Olden, situated on the edge of a river, bathed in sunlight. The river separates the town in the foreground of the canvas from the mountains in the distance; a clear, brilliant blue skyline helps to create the light, airy feeling of summer. The painting shimmers with the effect of Singer's small, quick brushstrokes, which appear to dash across the surface. He painted quickly, not spending more than a day or two on each work. His impressionistic rendering of the majestic scenery evokes an emotional response from the viewer.

LAH

Reference P. Redd, "City Planning Exhibit Opens at Institute Tomorrow: Gift Painting Is Presented to Galleries by Singer," *Pittsburgh Post*, Mar. 1, 1925, sec. 6, p. 7.

Exhibition William Penn Memorial Museum, Harrisburg, Pa., 1967, *William H. Singer*, no cat.

Gift of a group of Mr. Singer's friends, anonymously, 1922, 25.1

John Sloan

1871–1951

As both painter and etcher, John Sloan was one of the most distinguished contributors to early-twentieth-century American realism. He was born in Lock Haven, Pennsylvania, and from the age of five was raised in Philadelphia. The son of a stationer and amateur artist, he was introduced to the art of illustration at an early age. He entered Central High School in 1884 in the same class with William Glackens and Albert C. Barnes but withdrew before graduation to help support his family. In 1888 he went to work for Porter and Coates, booksellers and dealers in fine prints, where he decorated greeting cards and had the opportunity to copy old-master prints. In his spare time he taught himself to etch.

In 1890 Sloan began to work for A. Edward Newton designing novelties and calendars. Newton offered to send Sloan to Europe to study, but the fledgling artist declined; instead, he enrolled in night drawing classes at the Spring Garden Institute. After working briefly as a free-lance commercial artist, early in 1892 he joined the art department of the *Philadelphia Inquirer*, which regularly featured his decorative, stylized illustrations.

In 1892 he also began to attend Thomas Anshutz's drawing class at the Pennsylvania Academy of the Fine Arts, where he met Robert Henri. The two quickly became friends and in the spring of 1893 founded the Charcoal Club, a short-lived, informal night school. That fall Sloan returned to Anshutz's class, but soon left when he became annoyed by Anshutz's criticism. For a short time he rented Henri's studio, where a group that included fellow newspapermen Glackens, Everett Shinn, and George Luks gathered to socialize and discuss art. In December 1895 Sloan left the art department of the *Philadelphia Inquirer* to join the staff of the *Philadelphia Press*. Until 1903 his drawings and Sunday picture puzzles were a prominent feature of the newspaper and even earned him something of a national reputation. His accomplished, decorative, Art Nouveau style stood in marked contrast to the reportorial style of Glackens, Shinn, and Luks.

At Henri's urging, Sloan began to paint in oils around 1897. His earliest works, in Henri's dark palette, included portraits of himself and his friends as well as city views such as *Dock Street Market* (1902, Montgomery Museum of Fine Arts, Ala.). After 1900 Sloan's work was included in major exhibitions in Chicago, Pittsburgh, and Philadelphia, but, despite this national exposure, he did not sell a painting until 1913. In the meantime, Sloan had aquired a reputation as an etcher. Between 1902 and 1905 he produced fifty-three prints and fifty-four drawings for a deluxe English edition of the novels of Charles Paul de Kock, a minor nineteenth-century French author. He later adapted the engaging realistic style of these illustrations to his scenes of New York City life.

In 1904, encouraged by Henri and his former newspaper colleagues, Sloan and his first wife, Dolly, moved to New York, where he earned a modest income from free-lance illustrations for magazines such as *Collier's* and *Century Magazine*. His stirring encounter with New York was quickly reflected in a series of etchings of 1905–6 called *New York City Life*. The direct realism of these depictions of Fifth Avenue and the Tenderloin district was uncommon in American art; it soon appeared in his paintings as well.

The hostile reactions of exhibition juries to such earthiness and lack of finish inspired Sloan and Henri to create alternatives to academy shows: first through an exhibition at the National Arts Club in 1904, then, in February 1908, through the landmark exhibition of the Eight held at the Macbeth Galleries. There the city scenes of Glackens, Luks, Shinn, and Sloan attracted national attention, and the show today stands as a major chapter in the story of American realism. In 1910 Sloan helped organize the exhibition of Independent Artists, and from 1918 until his death was president of the Society of Independent Artists.

Sloan demonstrated his commitment to liberal causes by joining the Socialist party, serving as the art editor for the Socialist publication *The Masses* until 1916. At about this time he began teaching at the Art Students League; he continued to do so until 1938, eventually counting Alexander Calder, David Smith, Reginald Marsh, Lee Gatch, Adolph Gottlieb, and Barnett Newman among his students. His *Gist of Art*, published in 1939, summarized his pedagogical views and interests which, by this time, had become increasingly concerned with formal problems related to color and abstract design. The history of Sloan's relationship with Carnegie Institute exemplifies well the vicissitudes of his career. He submitted sixty-one works to thirty-one annual exhibitions between 1900 and 1947, but between 1900 and 1914 faced the rejection of twenty-six of them.

From 1919 onward, Sloan began to divide his time between New York and Sante Fe. He died after undergoing surgery in Hanover, New Hampshire, a year after his election to the American Academy of Arts and Sciences and his receipt of a gold medal for painting from the American Academy of Arts and Letters.

Bibliography John Sloan, *Gist of Art*, ed. by Helen Farr (New York, 1939); Van Wyck Brooks, *John Sloan: A Painter's Life* (New York, 1955); John Sloan, *New York Scene: From the Diaries, Notes and Correspondence 1906–1913*, ed. by Bruce St. John (New York, 1965); National Gallery of Art, Washington, D.C., *John Sloan, 1871–1951* (1971), exh. cat. by E. John Bullard and David W. Scott; David W. Scott, *John Sloan* (New York, 1975).

The Coffee Line, 1905

Oil on canvas
21½ x 31⅝ in. (54.6 x 80.3 cm)
Signature, date: Sloan 1905 (lower right)

Sloan began to paint regularly in oils only after his move from Philadelphia to New York in April 1904. *The Coffee Line*, painted the following winter, is one of his earliest depictions of a contemporary urban subject as well as one of his most forceful social statements. While the majority of Sloan's New York scenes are vignettes of working-class people engaged in pleasant pastimes, *The Coffee Line* documents the plight of the poor. Here, on a bitter winter night in Madison Square, a long line of jobless men has formed behind a wagon where free cups of coffee are being distributed to publicize one of the Hearst newspapers. Sloan later told the art historian Lloyd Goodrich that he intentionally eliminated the name of the newspaper from the side of the wagon so as not to give Hearst free publicity.[1] The heavy brushwork, stark simplification of shapes, and limited palette of black and grays poignantly express the grim reality of the scene.

The Coffee Line remained in Sloan's possession until he died. From 1905 until 1908 it was the canvas that he exhibited most frequently to represent his recent work, and he sent it not only to Carnegie Institute's annual exhibition in 1905, where it was awarded an honorable mention, but also to exhibitions held in six other cities. The Carnegie honorable mention was the first award of Sloan's career and marked a breakthrough in public recognition for the group of New York artists known as the Eight.[2]

Among the jurors of the Carnegie International who cast their votes in favor of Sloan's painting were two leading American realists, Thomas Eakins and Robert Henri. With its somber tone and clear social message, *The Coffee Line* was said to be "the most talked about picture of the entire exhibition."[3]

GB

1 Henry Adams, "John Sloan's *The Coffee Line*," *Carnegie Magazine* 57 (November–December 1984), p. 24.

2 Bernard B. Perlman, *The Immortal Eight* (New York, 1962), pp. 99–100.

3 Charles W. Barrell, "The Real Drama of the Slums, As Told in John Sloan's Etchings," *Craftsman* 15 (February 1909), p. 562.

References C. W. Barrell, "The Real Drama of the Slums, As Told in John Sloan's Etchings," *Craftsman* 15 (Feb. 1909), pp. 561–63; Sloan, *Gist of Art*, p. 205; Whitney Museum of American Art, New York, *John Sloan* (1952), exh. cat. by L. Goodrich, p. 30; Brooks, *John Sloan: A Painter's Life*, p. 56; B. B. Perlman, *The Immortal Eight* (New York, 1962), p. 129; Sloan, *New York Scene*, pp. 4, 19, 65, 210, 214, 234, 251, 298, 304; Scott, *John Sloan*, pp. 8, 78, 93; H. Adams, "John Sloan's *The Coffee Line*," *Carnegie Magazine* 57 (Nov.–Dec. 1984), pp. 19–25; H. Adams, in Museum of Art, Carnegie Institute, *Collection Handbook* (Pittsburgh, 1985), pp. 230–31; G. Monteiro, "John Sloan's 'Cranes,'" *Journal of Modern Literature* 14, no. 4 (Spring 1988), pp. 586–87, 592.

Exhibitions Department of Fine Arts, Carnegie Institute, Pittsburgh, 1905, *Tenth Annual Exhibition*, no. 243; Society of American Artists, New York, 1905, *Twenty-seventh Annual Exhibition of American Paintings and Sculpture*, no. 189(?); Worcester Art Museum, Mass., 1905, *Eighth Annual Exhibition of Oil Paintings*, no. 126; Art Institute of Chicago, 1906, *Nineteenth Annual Exhibition of American Paintings and Sculpture*, no. 281; Pennsylvania Academy of the Fine Arts, Philadelphia, 1906, *One Hundred First Annual Exhibition of the Pennsylvania Academy of the Fine Arts*, no. 625; Corcoran Gallery of Art, Washington, D.C., 1959, *The American Muse*, no. 90; National Gallery of Art, Washington, D.C., 1971, *John Sloan, 1871–1951* (trav. exh.), exh. cat. by E. J. Bullard and D. W. Scott, no. 25; Pennsylvania Academy of the Fine Arts, Philadelphia, 1976, *In This Academy*, no. 263; Hood Museum of Art, Dartmouth College, Hanover, N.H., 1982, *John Sloan: Paintings, Prints, and Drawings*, no. 9; Delaware Art Museum, Wilmington, 1988, *John Sloan: Spectator of Life* (trav. exh.), exh. cat. by R. Elzea and E. Hawkes, no. 15.

Provenance The artist, until 1951; his estate; Kraushaar Galleries, New York, by 1983.

Fellows of the Museum of Art Fund, 1983, 83.29

Russell Smith

1812–1896

ALTHOUGH HIS ARTISTIC roots were planted in Pittsburgh, William Thompson Russell Smith's career flourished farther east—in Philadelphia, Baltimore, Washington, D.C., and Boston—where he was for many years a successful painter of stage scenery, drop curtains, and panoramas. He was born in Glasgow, Scotland, to a whitesmith and a well-read woman who studied midwifery in preparation for the family's immigration to America. When he was seven years old, his family left Scotland, settling first in Indiana County, Pennsylvania, then three years later in Pittsburgh.

Although Smith had limited schooling, he read assiduously. As a sickly child who spent extended periods indoors, he also developed a love of drawing and took to copying engravings after portraits by Gilbert Stuart, Charles Willson Peale, Bass Otis, and John Trumbull. By the age of fourteen or fifteen, he was using his pocket money to buy engravings and illustrated books,[1] and eventually built up a distinguished collection of them.

From executing portraits of national heroes in house paint, Smith went on, from 1828 to 1832, to paint scenery for an amateur theatrical society begun by his older brother and several young lawyers in town.[2] He received some instruction in portraiture from James Reid Lambdin in 1829 and was soon put to work maintaining Lambdin's Pittsburgh Museum of Natural History and Gallery of Fine Arts. For three years, while Lambdin took extended trips down the Ohio to paint portraits, Smith managed both the natural-science and art exhibits. He also began his own portrait-painting business in Pittsburgh. It was during this time that he began using the name Russell Smith.

In 1833, when Francis Courtney Wemyss, an English actor, came from Philadelphia to manage Pittsburgh's newly built playhouse, Smith found his career opportunity. He replaced the company's scenery painter, and when Wemyss returned to Philadelphia in 1834, Smith accompanied him. He found ready employment as a set designer and painter in Philadelphia's three theaters, and was soon called upon to paint scenery for theatrical productions in Boston, Brooklyn, Baltimore, and Washington, D.C.

He continued painting portraits in Philadelphia, married, and in the 1840s had several views of Pennsylvania published in the popular magazine *Godey's Lady's Book*. Always attracted to geography and geology, he was employed as illustrator on Professor Henry D. Rogers's expeditions through Pennsylvania and Virginia in 1844 and 1845. Scientific geological illustration was an important source of income for Smith, who credited Lambdin's museum with encouraging his scientific bent and bringing him to the attention of scientists. In his papers, he mentions that he made lecture illustrations for Sir Charles Lyell, Henry Rogers and Benjamin Silliman of Yale, and Louis Agassiz of Harvard.

Smith began to paint landscapes in 1846. In 1849 and 1850 he scored a success translating William McIlvane's watercolor sketches of California, New Mexico, and Panama into oils.[3] During his stay in Europe with his wife and children from 1851 to 1852, he studied the old masters in European museums and painted landscapes, and on his return he exhibited dioramas and panoramas, his subjects ranging from England and Wales to the Holy Land. In the 1860s he went to the White Mountains of New Hampshire to paint sites on commission.

Smith saw himself as inheriting his father's mechanical, scientific, and craftsmanly interests. He brought diligence, skill, and special knowledge to his career in art, as did his wife and children, who were also practicing artists. His wife painted flowers, his daughter small animals, and his son, Xanthus, made a career in marine painting. Smith spent his last years near Philadelphia, where he contributed works to the benefit exhibitions of the Artists' Fund Society, the exhibitions of the Pennsylvania Academy of the Fine Arts, and Philadelphia's Centennial Exposition of 1876.

Fifty years after he made them, Russell Smith realized that his small oil and watercolor topographical sketches of the 1830s were valuable visual documents that recorded Pittsburgh in transition from a wilderness outpost to an industrial city. In January 1885, he sent to the Historical Society of Western Pennsylvania in Pittsburgh a gift of eleven oil versions of his original scenes painted expressly for the Society. The group was lost, but some have reappeared, the largest number of

which is now in the collection of The Carnegie Museum of Art.[4] These convey a muted nostalgia for the city of his youth by re-creating traditionally picturesque views—riverbanks, bridges, and mountain backgrounds—with glimpses of factories and workshops.

1 Smith Family Papers, Archives of American Art, Washington, D.C.

2 Ibid.

3 *M. and M. Karolik Collection of American Watercolors and Drawings, 1800–1875* (Boston, 1962), vol. 1, p. 230.

4 Franklin F. Holbrook, "Our Historical Society," *Journal of the Western Pennsylvania Historical Society* 21 (March 1938), pp. 12–15.

Bibliography Smith Family Papers, Archives of American Art, Washington, D.C.; Henry T. Tuckerman, *Book of the Artists: American Artist Life* (New York, 1867), pp. 518–21; *Appleton's Cyclopedia and Register of Important Events of the Year* 36 (1896), p. 587; Virginia E. Lewis, *Russell Smith: Romantic Realist* (Pittsburgh, 1956); Westmoreland County Museum of Art, Greensburg, Pa., *Southwestern Pennsylvania Painters, 1800–1945* (1981), exh. cat. by Paul A. Chew and John A. Sakal, pp. 122–27.

The Aqueduct, Pittsburgh, c. 1832
(Docks on Saint Clair Street; Allegheny River Bridge)

Oil on wood panel
9¾ x 13 in. (24.8 x 33 cm)

Pittsburgh's aqueduct to the Pennsylvania Canal made possible the phenomenal growth of the city during the years that Russell Smith lived there. It connected the city to the four-hundred-mile Pennsylvania Main Line Canal, which had been built to compete with New York's Erie Canal. Although the canal came down the western bank of the Allegheny River to a natural terminus in Allegheny City, Pittsburgh insisted on an aqueduct to bring the traffic across the river. When it was finished in November 1829, trade was routed through Pittsburgh, not Allegheny City, thereby ensuring the growth of Pittsburgh.[1]

Pittsburgh's was the largest aqueduct in the Pennsylvania canal system. The wooden troughlike bridge was 16½ feet wide at the top, 14 feet wide at the bottom, and held 4 feet of water; it had a sidewalk along one edge and a towpath along the other. Entering the city on Washington (now Eleventh) Street, it ended at the terminal basin between Penn

and Liberty avenues, on the outskirts of town. This structure represented the means to greatness for Pittsburgh, but in 1832 the city came close to losing it due to floods and high water.[2]

Three versions of the Pittsburgh aqueduct by Smith exist: the present painting, a second oil painting, and a small ink-wash drawing (both Chatham College, Pittsburgh). All show the same view: the aqueduct is seen from the carriage works on the Pittsburgh side; across the river is the large red-brick building of George Farber and Son's machine-card factory.[3] The watercolor and the Carnegie oil were done in the 1830s, the Chatham oil in 1884.

It is interesting to note the difference between Smith's early and late versions of this theme. The earlier images are rather crowded, and predictably show a young artist's preoccupation with composition, light, and shadow. In the 1884 work, meant for the Historical Society of Western Pennsylvania, Smith made the expanse of the river the subject of the composition. He had the workman in the carriage works nostalgically contemplating the river and the flatboat in it, whereas in the Carnegie's 1832 painting he is occupied with his task.

RCY

1 Robert McCullough and Walter Leuba, *The Pennsylvania Main Line Canal* (Martinsburg, Pa., 1962), pp. 48–60.

2 "The Inundation," *Pittsburgh Gazette*, February 14, 1832, p. 3.

3 Incorrectly identified as the Farber Foundry in Department of Fine Arts, University of Pittsburgh, *Russell Smith, 1812–1896: Romantic Realist* (1948), exh. cat. by Virginia E. Lewis.

References "The Inundation," *Pittsburgh Gazette*, Feb. 14, 1832, p. 3; "The Canal," *Daily Pittsburgh Gazette*, Sept. 13, 1833, [p. 2].

Provenance John J. Marse, Taylor, Tex., until 1968.

Gift of Mary Shiras, 1968, 68.1.2

Old Monongahela Bridge, c. 1832

Oil on wood panel
10 x 13¾ in. (25.4 x 34.9 cm)

In *Old Monongahela Bridge*, Russell Smith applied the conventions of a Romantic night picture to a contemporary fact—the Monongahela Bridge was damaged in the floods of 1832. The broken bridge is dimly seen in the moonlight emerging from the dark bank across the river. The young artist's experiment with moody Romanticism may have been directly inspired by Washington Allston's *Moonlit Landscape* (1819, Museum of Fine Arts, Boston), a print of which appeared in the *Atlantic Souvenir* in 1828. Smith also attempted to convey this night scene in a contemporary ink-wash drawing, *The Old Monongahela Bridge* (1832, Chatham College, Pittsburgh), in which a man holding a walking stick contemplates the partially collapsed bridge.

Smith was more successful with his views of the bridge by day, which allowed him to study its classical entrance. Both a charming watercolor sketch, *Monongahela at the End of the Bridge*

(1837, Chatham College), and the Carnegie's watercolor-and-oil painting *Monongahela River, Opposite Pittsburgh* (1837) record the bridge as Smith knew it in his youth. *The Monongahela Bridge after It Had Been Damaged by a Freshet* (1884, private collection, Washington, Pa.), done for the Historical Society of Western Pennsylvania in 1884, recollects the damage of 1832.

The bridge opened for traffic on November 28, 1818. It was a two-lane, enclosed structure built entirely of wood, resting on eight stone piers relatively low over the water, which prevented large river craft from passing under it. The local investors who built the bridge posted graduated toll rates ranging from 2 cents for foot passengers, sheep, or pigs to 62½ cents for carriages drawn by six horses.[1] Among the few monuments in Pittsburgh in the early 1830s, the Monongahela Bridge was the most familiar to the artist, since he lived on Water Street, just beyond the bridge. This proximity may account for the variety of views of this bridge in Smith's work.

The youthful Smith witnessed the fall of the span. In 1885, he wrote:

I may mention that I saw the Monongahela Bridge fall in the freshet of 1832. A coal team, the driver, a woman and a boy went down with it, but . . . the people were saved. What surprized me was the enormous column of dust that rose into the sky from the wreck.[2]

RCY

1 Broadside announcing the opening of Monongahela Bridge, Archives of Western Pennsylvania Historical Society, Pittsburgh.

2 Smith Family Papers, Archives of American Art, Washington, D.C.

Provenance John J. Marse, Taylor, Tex., until 1968.

Gift of Mary Shiras, 1968, 68.1.1

Western University of Pennsylvania, 1833
(Western University; Western University at Third and Cherry Alley)

Oil on canvas
12 x 18⅛ in. (30.5 x 46 cm)
Signatures, date: R. S. (lower left); Russell Smith, 1833 (on reverse)

In 1787 an act of the Pennsylvania legislature formally initiated the Pittsburgh Academy, the city's first institution of higher learning. In 1819 the academy's trustees, envisioning a western counterpart of the University of Pennsylvania in Philadelphia, changed its name to the Western University of Pennsylvania. The ambition was high, but the reality much less.

In 1828 the peremptory and opinionated traveler Mrs. Anne Royall noted, "The university exists only in name; and cannot be said to be in operation, though it has a long string of professors."[1] She listed only five professors, and observed that the faculty had "too many reverences," meaning too many clergy on the staff. When mobbed by disorderly adolescent students and a herd of hogs roaming the streets, she was rescued and taken home by one of the Smith boys, perhaps Russell himself, whom she later called an "artistic genius."[2]

In 1830 a new curriculum was installed, a new president was appointed, and the school's two modest buildings were replaced by a large Neoclassical stone edifice.[3] Harris' Pittsburgh Business Directory for the Year 1837[4] boasted of its "imposing

and stately appearance," and an alumnus called it the most impressive "of any building of that kind then west of the Mountains."[5]

This painting, one of the eleven that Smith gave to the Western Pennsylvania Historical Society in 1885, is among the few surviving records of the Western University of Pennsylvania. His careful rendering emphasizes the elegance and the imposing dimensions of the 1830 edifice, dwarfing one of the university's original buildings to the left, and a red-brick chair factory at the right. His handling of space and recession is tentative, however, the street being too wide and the wagon and horse too small. An ink-wash drawing (1832) at Chatham College, Pittsburgh, is a study of the building without the neighboring factory.
WG, RCY

1 Anne Royall, Mrs. Royall's Pennsylvania, or, Travels Continued in the United States (Washington, D.C., 1829), vol. 2, p. 57.

2 Ibid., p. 58.

3 Robert C. Albers, Pitt: The Story of the University of Pittsburgh, 1787–1987 (Pittsburgh, 1986), pp. 12–15.

4 Harris' Pittsburgh Business Directory (Pittsburgh, 1837), p. 115.

5 University of Pittsburgh Officers, Trustees, Deans, Faculty, Students in 1852 and 1922 (Pittsburgh, 1922), pp. 14–15.

References Pendennis (pseud.), "Early History of Pittsburgh Portrayed in Interesting Drawings," Pittsburg Dispatch, Jan. 11, 1885, reprint, Feb. 27, 1910, Special Feature sec., p. 4; Lewis, Russell Smith, pp. 40–41.

Exhibitions Department of Fine Arts, Carnegie Institute, Pittsburgh, 1916, An Exhibition of Historical Portraits, Paintings, Prints, Drawings and Relics Presented by the Historical Society of Western Pennsylvania, unnumbered;

Department of Fine Arts, University of Pittsburgh, 1948, Russell Smith, 1812–1896: Romantic Realist: Paintings, Water Colors, Drawings, exh. cat. by V. E. Lewis, unnumbered, as Western University; Department of Fine Arts, Carnegie Institute, Pittsburgh, organized by the University of Pittsburgh, 1956, Painters from Pittsburgh: The Frontier Settlement and the Industrial Development, no. 23, as Western University at Third and Cherry Alley; Westmoreland County Museum of Art, Greensburg, Pa., 1976, Nineteeth and Early Twentieth Century Regional Painters, exh. cat. by P. A. Chew and J. K. Maguire, unnumbered.

Provenance The artist, until 1885; Historical Society of Western Pennsylvania, Pittsburgh, 1885, until c. 1897; Carnegie Institute Museum of Natural History, Pittsburgh, by 1916; on loan to Carnegie Library, Pittsburgh, 1916–75.

Received from the Carnegie Museum of Natural History in exchange for works from the Robert S. Waters Estate, 1975, 75.19.6

The Deserted Cottage, 1842
(Wordsworth's Excursion)

Oil on panel
30⅛ x 41 in. (76.5 x 104 cm)
Signature, date: Russell Smith, 1842 (lower left)

Russell Smith was an established Philadelphia painter with a wife and family when he painted The Deserted Cottage, but its subject matter called for a poetic expressiveness new to him. Based on William Wordsworth's The Excursion (London, 1814), this painting illustrates the meeting of the Author with the nature-loving Wanderer in the first book of the poem. The setting is an elm grove on a Scottish common, close to "a roofless Hut; four naked walls / That stared upon each other!. . ." (lines 30–31). The Wanderer, seated on a bench, tells the Author the woeful tale of the cottage's last inhabitants.

In rendering this scene, Smith included the figures of the Author and the Wanderer, the elms, the ruined cottage, and the spring next to which lies "the useless fragment of a wooden bowl, / Green with the moss of years" (lines 493–94), but he omitted the overgrown garden surrounding the cottage, and the spring does not lie "Where two tall hedge-rows of thick alder boughs / Joined in a cold damp nook. . ." (lines 460–61).

Perhaps this elimination of details stemmed from Smith's criticism of the works of Thomas Cole. In 1838, after visiting New York to see Cole's paintings, Smith wrote a critique for his own use. In it, he notes that his friend Joshua Shaw thought that, especially in *An Arcadian Scene* and *Knights Going Out*,[1] Cole broke up his compositions with "a multiplicity of little finished bits, groups and detached figures." Smith was surprised that Cole seemed oblivious to the rules of perspective.[2]

The Deserted Cottage, though clearly influenced by Cole's ideal compositions, also "corrects" his faults by avoiding "separate finished bits." However, Smith could not cope with the demands of narrative and poetry, even when he relied upon a well-known text. His chief fault is that the figures are inexpressive and wooden, and it is here that his lack of academic art training is most glaring. In fact, the true focus of this composition is the ancient elm struggling to live in spite of broken and bare branches. The castle in the left background, although not in the poem, may allude to the Scotland of Smith's childhood, especially to Castle Roslyn, in which his father's ancestors had served as retainers for generations.

RCY, WG

1 These titles are inaccurate. Perhaps Smith meant Cole's *Dream of Arcadia* (1838, New-York Historical Society) and *The Departure* (1837, Corcoran Gallery of Art, Washington, D.C.).

2 "Notes upon Cole's pictures by Russell Smith, New York, May 1838," Smith Family Papers, Archives of American Art, Washington, D.C.

References "Notes upon Cole's pictures by Russell Smith, New York, May 1838," Smith Family Papers, Archives of American Art, Washington, D.C.; Lewis, *Russell Smith*, p. 124.

Exhibition Artists' Fund Society, Philadelphia, 1842, *Seventh Annual Exhibition of the Artists' Fund*, no. 14, as *The Deserted Cottage (Wordsworth's Excursion)*.

Provenance John J. Marse, Taylor, Tex., until 1968.

Gift of Mary Shiras, 1968, 68.1.3

McConnell's Cove from Cove Mountain, 1848
(American Panorama with Hunter)

Oil on canvas
32¹⁄₁₆ x 50¼ in. (81.4 x 127.6 cm)
Signature, date: Russell Smith/1848 (lower left)

McConnell's Cove from Cove Mountain was probably inspired by Thomas Cole's *The Oxbow, The Connecticut River near Northampton* (1836, Metropolitan Museum, New York), which Smith admired. In fact, in "Notes upon Cole's pictures," which Smith wrote for himself during a visit to New York in May 1838, he mentions *The Oxbow*, alluding to its original name, *View from Mount Holyoke, Northampton, Massachusetts, After a Thunderstorm.*

> Cole's recent landscapes do not realise my expectations. The enthusiastic accounts I have heard of them in Philadelphia led me to expect something far superior to anything I had seen from him before, whereas I find them inferior (in my opinion) to his view from "Mount Holyoak" [*sic*] a work produced three years before.[1]

Smith's composition parallels Cole's in its high and wild foreground on the left overlooking an expansive and cultivated plain below. Both Cole's observer, an artist, and Smith's hunter look at us and direct our entrance into the scene. In both cases, the juxtaposition of wilderness and civilization is the subject of the painting.

Smith's view looks southeast across a valley known in his day as the Great Cove or McConnell's Cove, after a family that had settled there and founded McConnellsburg in the previous century. A plume of smoke in the distance marks the site of McConnellsburg; behind it rises Meadow Grounds Mountain and Little Scrub Ridge. In the foreground, the young sportsman relaxes in the early autumn afternoon sunshine, his fresh kill on the ground beside him. Cove Mountain, 1,900 feet at its summit, belongs to the Tuscarora Range, which runs between Franklin and Fulton counties near Pennsylvania's southern border. Sometimes called North Mountain in the nineteenth century, Cove Mountain is today part of Buchanan State Forest.

The care with which Smith rendered the mixture of healthy and decayed foliage, the rocky outcroppings, and the blue-gray haze over distant hills reflects his particular interest in the scenic and geological aspects of the landscape. Smith probably painted this view after visiting McConnell's Cove in the mid-1840s as a member of Henry D. Rogers's geological expedition. This was not, however, his first visit, for he made a drawing of the area in 1839 (collection Virginia E. Lewis, Pittsburgh).

RCY, WG

1 "Notes upon Cole's pictures by Russell Smith, New York, May 1938," Smith Family Papers, Archives of American Art, Washington, D.C.

Reference "Notes upon Cole's pictures by Russell Smith, New York, May 1838," Smith Family Papers, Archives of American Art, Washington, D.C.

Exhibitions Maryland Historical Society, Baltimore, 1848, *First Annual Exhibition*, no. 188; Pennsylvania Academy of the Fine Arts, Philadelphia, 1848, no. 84, as *M'Connel's Cove;* University Art Gallery, University of Pittsburgh, 1977, *Art in Nineteenth Century Pittsburgh*, no. 47, as *American Panorama with Hunter;* William Penn Memorial Museum, Harrisburg, Pa., 1979, *Pennsylvania Painters from Commonwealth Collections*, no. 47.

Provenance The Old Print Shop, New York, by 1951; Richard King Mellon Foundation, 1951.

Gift of the Richard King Mellon Foundation, 1977, 77.33

Fig. 1 Russell Smith, *Birmingham from the Top of Coal Hill*, 1834. Watercolor and oil on paper, 7⅜ x 9⅞ in. (18.7 x 25 cm). The Carnegie Museum of Art, Pittsburgh, Gift Fund for Specific Acquisitions, 88.10.2

Street and Brady Street bridges. In the 1830s the area still belonged to his family and bore his name.

Smith's view over the farm was probably made from Coal Hill Road (now East Sycamore Street), which wound up Coal Hill (known today as Mount Washington) from the old Monongahela Bridge. Across the river, on the Pittsburgh side, Ayres Hill rises, just beyond the city limits of Pittsburgh. Upriver lies the town of Birmingham, an industrial district devoted to glassmaking and later to steel. Birmingham was laid out on a section of Ormsby's grant and named in the hope that it would one day rival its British namesake.

Wild, tangled trees encroach upon the abandoned log cabin in the foreground; they give way to the cleared fields of Ormsby's farm, which extend to the cluster of buildings in Birmingham. The steamboat on the river could be the Tipper ferry, which tied together and helped urbanize both sides of the river.

The double date "1833–84" inscribed on the reverse of the canvas suggests that the painting was probably based on the earlier watercolor-and-oil view of 1834 recently acquired by The Carnegie Museum of Art (fig. 1). With the addition of the abandoned log cabin, the 1884 version introduces a nostalgic note not found in the 1834 sketch. By adding the abandoned log cabin along with the smoke above Birmingham and the fiery boat, Smith made a comment on the changes wrought by encroaching industrialization.

WG, RCY

1 Pendennis, in *Pittsburg Dispatch*, Feb. 27, 1910, p. 4.

References Pendennis (pseud.), "Early History of Pittsburgh Portrayed in Interesting Drawings," *Pittsburg Dispatch*, Jan. 11, 1885, reprint, Feb. 27, 1910, Special Feature sec., p. 4; W. Brezger, *Pitt News*, Nov. 23, 1948, p. 4; Lewis, *Russell Smith*, p. 44.

Exhibitions Department of Fine Arts, Carnegie Institute, Pittsburgh, 1916, *An Exhibition of Historical Portraits, Paintings, Prints, Drawings and Relics Presented by the Historical Society of Western Pennsylvania*, unnumbered; Department of Fine Arts, University of Pittsburgh, 1948, *Russell Smith, 1812–1896, Romantic Realist: Paintings, Water Colors, Drawings,*

Looking Up River from Coal Hill over Ormsby's Farm to Birmingham, 1884

Oil on canvas
12 x 17⅞ in. (30.5 x 45.4 cm)
Signature, inscription, date: R. S. (lower left); Looking up the river from Coal Hill/over Ormsby's farm to Birmingham./Russell Smith 1833–84 (on reverse)

John Ormsby, an Irishman, came to Pittsburgh with General Forbes in 1758. A successful merchant and operator of the first ferry service across the Monongahela River, Ormsby was granted a vast tract of land along the river's south side, approximately between the present Smithfield

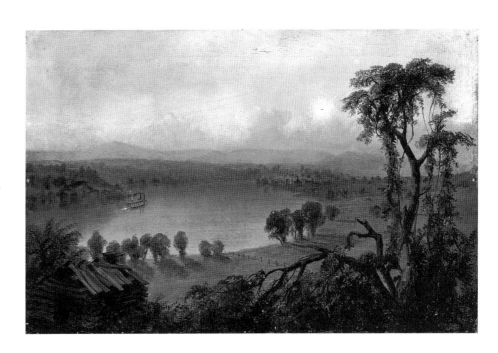

exh. cat. by V. E. Lewis, unnumbered; West-moreland County Museum of Art, Greensburg, Pa., 1976, *Nineteenth and Early Twentieth Century Regional Painters*, exh. cat. by P. A. Chew and J. K. Maguire, unnumbered; Fort Pitt Museum, Pittsburgh, 1979, *Traffic on the Rivers: A History of Pittsburgh's Waterways*, no. 2; Westmoreland County Museum of Art, Greensburg, Pa., 1981, *Southwestern Pennsylvania Painters, 1800–1945*, exh. cat. by P. A. Chew and J. A. Sakal, no. 224.

Provenance The artist, until 1885; Historical Society of Western Pennsylvania, Pittsburgh, 1885, until c. 1897; Carnegie Institute Museum of Natural History, Pittsburgh, by 1916; on loan to Carnegie Library, Pittsburgh, 1916–75.

Received from the Carnegie Museum of Natural History in exchange for works from the Robert S. Waters Estate, 1975, 75.19.2

Nelson's Island, 1884
(Hogback Hill; Nelson's Island, Foot of Hand Street)

Oil on canvas
11⅞ x 17⅞ in. (30.2 x 45.4 cm)
Signatures, date: R. S. (lower left); Nelson's Island from the foot of/Hand Street./Russell Smith 1840–84 (on reverse)

The inscription on the back of this canvas identifies the view here as made from the foot of Hand Street in Pittsburgh, looking across to the waterfront of Allegheny City, but to get this view the artist actually had to stand further downstream, at the junction of the Allegheny and the Ohio. The dates on the back of the canvas indicate that Smith originally sketched this view in 1840, then painted this version of it in 1884, with reference to his 1840 sketches. In 1885 it was called *Hogback Hill*, for the small hill in Allegheny City occupied by a theological seminary. The hill is unobtrusive in Smith's composition, where wide bands of river, land, and sky produce a peaceful scene.

As for the landmark indicated by the painting's present title, a Pittsburgh map of 1830 shows two islands—Kilbuck and Nelson's—near the north bank of the Allegheny where it joins the Ohio River. Most sources, however, refer to a single island, called Smoky Island, which by mid-century was reduced to little more than a sandbar partially attached to the mainland. By 1860 it had disappeared entirely through the combined effects of erosion on the river side and landfilling on the shore side.[1] The artist chose to

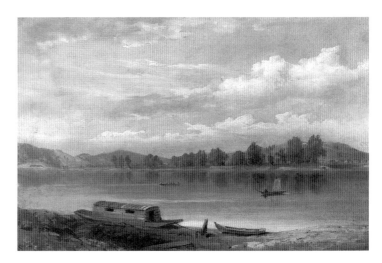

ignore the busy river traffic and factory buildings on the Allegheny shore. However, the fringe of red-brick houses near the right edge reminds us that this is an urban area.
RCY, WG

1 Charles W. Dahlinger, "Old Allegheny," *Western Pennsylvania Historical Society Magazine* 1 (October 1918), pp. 5–7.

References Pendennis (pseud.), "Early History of Pittsburgh Portrayed in Interesting Drawings," *Pittsburg Dispatch*, Jan. 11, 1885, reprint, Feb. 27, 1910, Special Feature sec., p. 4; Lewis, *Russell Smith*, p. 44.

Exhibitions Department of Fine Arts, Carnegie Institute, Pittsburgh, 1916, *An Exhibition of Historical Portraits, Paintings, Prints, Drawings and Relics Presented by the Historical Society of Western Pennsylvania*, unnumbered, as *Nelson's Island, Foot of Hand Street;* Department of Fine Arts, University of Pittsburgh, 1948, *Russell Smith, 1812–1896, Romantic Realist: Paintings, Water Colors, Drawings*, exh. cat. by V. E. Lewis, unnumbered; Westmoreland County Museum of Art, Greensburg, Pa., 1976, *Nineteenth and Early Twentieth Century Regional Painters*, exh. cat. by P. A. Chew and J. K. Maguire, unnumbered; Fort Pitt Museum, Pittsburgh, 1979, *Traffic on the Rivers: A History of Pittsburgh's Waterways*, no. 7.

Provenance Historical Society of Western Pennsylvania, Pittsburgh, 1885, until c. 1897; Carnegie Institute Museum of Natural History, Pittsburgh, by 1916; on loan to Carnegie Library, Pittsburgh, 1916–75.

Received from the Carnegie Museum of Natural History in exchange for works from the Robert S. Waters Estate, 1975, 75.19.3

Oldest House at Foot of Coal Hill, 1884

Oil on canvas
11⅝ x 17⅞ in. (29.5 x 45.4 cm)
Signatures, date: R. S. (lower left); Russell Smith 1832–84 (on reverse)

When Russell Smith sent his gift of eleven paintings to the Historical Society of Western Pennsylvania in 1885, he remarked:

I should have liked to have known more of the great old log house at the foot of Coal Hill opposite Market Street, said to be, in 1833, the oldest house about Pittsburgh, except the Block House. Some of the oldest members of your society may be able to supply the information, and if they enjoyed when young a ramble in and about Pittsburgh, as I did, they will be able to give a good deal of interesting information about all the places represented. If the paintings should help in the preservation of these reminiscences, I shall be handsomely rewarded.[1]

The artist may never have thought of this log cabin as Pittsburgh's first poorhouse, as Virginia Lewis identifies it in her book.[2] In 1885 the writer Pendennis remembered the cabin only as a place where political meetings had been held.[3] When the Smith family came to Pittsburgh in 1822, it already had been abandoned. By 1832, when Smith painted a watercolor of it (collection Virginia E. Lewis, Pittsburgh), the "Old Cabin" had become "the roosting place of belated crows and trysting place of love-sick swains."[4] This sketch is probably the basis for this painting, accounting for the double dating on the back.

In contrast to the 1832 watercolor sketch, the 1884 painting is enlivened by a

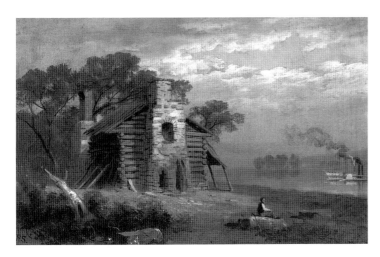

figure seated on a rock who looks at the steamboat on the river. Although Virginia Lewis has suggested that Smith painted an old man to evoke the cabin's former use as a poorhouse,[5] the figure's position, with his legs drawn up before him; his dress, in shirtsleeves, with a vest and no hat; and his lack of a beard make it likely that the figure is a young man. The "cane" could be a walking stick. Perhaps this figure is the artist as a young man contemplating the contrast between the decaying cabin representing the past and the steamboat on the river, an example of modern bustle.

RCY

1 Smith Family Papers, Archives of American Art, Washington, D.C.

2 Lewis, *Russell Smith*, p. 42.

3 Pendennis, in *Pittsburg Dispatch*, Feb. 27, 1910, p. 4.

4 Ibid.

5 Lewis, *Russell Smith*, p. 42.

References Smith Family Papers, Archives of American Art, Washington, D.C.; Pendennis (pseud.), "Early History of Pittsburgh Portrayed in Interesting Drawings," *Pittsburg Dispatch*, Jan. 11, 1885, reprint, Feb. 27, 1910, Special Feature sec., p. 4; Lewis, *Russell Smith*, p. 42.

Exhibitions Department of Fine Arts, Carnegie Institute, Pittsburgh, 1916, *An Exhibition of Historical Portraits, Paintings, Prints, Drawings and Relics Presented by the Historical Society of Western Pennsylvania*, unnumbered; Department of Fine Arts, University of Pittsburgh, 1948, *Russell Smith, 1812–1896, Romantic Realist: Paintings, Water Colors, Drawings*, exh. cat. by V. E. Lewis, unnumbered; Westmoreland County Museum of Art, Greensburg, Pa., 1976, *Nineteenth and Early Twentieth Century Regional Painters*, exh. cat. by P. A. Chew and J. K. Maguire, unnumbered; Fort Pitt Museum, Pittsburgh, 1979, *Traffic on the Rivers: A History of Pittsburgh's Waterways*, no. 4.

Provenance The artist, until 1885; Historical Society of Western Pennsylvania, Pittsburgh, 1885, until c. 1897; Carnegie Institute Museum of Natural History, Pittsburgh, by 1916; on loan to Carnegie Library, Pittsburgh, 1916–75.

Received from the Carnegie Museum of Natural History in exchange for works from the Robert S. Waters Estate, 1975, 75.19.5

Old Trees at Ormsby's Farm, 1884
(Old Trees on Ormsby's Farm, Opposite Bakewell's Glassworks)

Oil on canvas
12 x 18 in. (30.5 x 45.7 cm)
Signatures, date: R. S. (lower right); Russell Smith, 1834–84 (on reverse)

Russell Smith was most expressive in his renderings of particular trees— the Lombardy poplar facing the Monongahela Bridge in a watercolor (1837, Chatham College, Pittsburgh) or the gigantic tree in *The Deserted Cottage* (see p. 434). What Smith could not do

with figures, he could do with trees: convey a mood and a sense of individuality. The trees in this painting grew on the Ormsby farm on the south bank of the Monongahela; the large specimen with exposed roots was well known to Pittsburghers as the "Old Ormsby Tree." In 1885 the pseudonymous journalist Pendennis wrote about this painting:

> Many of our older citizens will remember the big tree that stood as a landmark but a short distance from the southern end of the Smithfield Street Bridge. It was noted for its ruggedness and beauty. Where it stood now is the site of mills and factories, and not a sign of verdure can be seen.[1]

As Virginia Lewis has written, this canvas, dated 1884 because it belonged to the group that Smith painted for the Historical Society of Western Pennsylvania, was probably based on an 1837 watercolor entitled *Monongahela River Opposite Pittsburgh, Pennsylvania* (The Carnegie Museum of Art, Pittsburgh), formerly owned by the artist's son, Xanthus Smith.[2] Late in life, Russell Smith nostalgically recalled the beauty of the Monongahela River's "natural charms that a rapid civilization has destroyed," especially "the noble fringe of large luxuriant trees that everywhere clothed its bank."[3]

RCY, WG

1 Pendennis, in *Pittsburg Dispatch*, Feb. 27, 1910, p. 4.

2 Lewis, *Russell Smith*, pp. 37, 259.

3 Smith's journal, quoted in Lewis, ibid., p. 16.

References Pendennis (pseud.), "Early History of Pittsburgh Portrayed in Interesting Drawings," *Pittsburg Dispatch*, Jan. 11, 1885, reprint, Feb. 27, 1910, Special Feature sec., p. 4; Lewis, *Russell Smith*, p. 44.

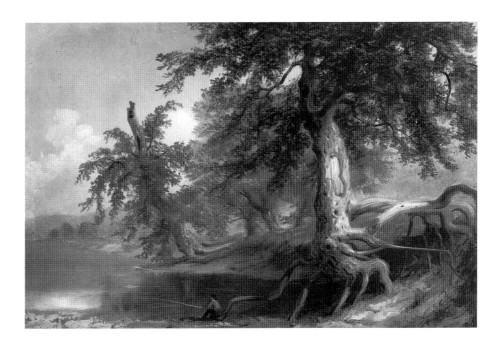

Exhibitions Department of Fine Arts, Carnegie Institute, Pittsburgh, 1916, *An Exhibition of Historical Portraits, Paintings, Prints, Drawings and Relics Presented by the Historical Society of Western Pennsylvania*, unnumbered; Department of Fine Arts, University of Pittsburgh, 1948, *Russell Smith, 1812–1896, Romantic Realist: Paintings, Water Colors, Drawings*, exh. cat. by V. E. Lewis, unnumbered; Westmoreland County Museum of Art, Greensburg, Pa., 1976, *Nineteenth and Early Twentieth Century Regional Painters*, exh. cat. by P. A. Chew and J. K. Maguire, unnumbered; Fort Pitt Museum, Pittsburgh, 1979, *Traffic on the Rivers: A History of Pittsburgh's Waterways*, no. 6.

Provenance Historical Society of Western Pennsylvania, Pittsburgh, 1885, until c. 1897; Carnegie Institute Museum of Natural History, Pittsburgh, by 1916; on loan to Carnegie Library, Pittsburgh, 1916–75.

Received from the Carnegie Museum of Natural History in exchange for works from the Robert S. Waters Estate, 1975, 75.19.4

Pittsburgh Fifty Years Ago from the Salt Works on Saw Mill Run, 1884

Oil on canvas
22³⁄₁₆ x 36⅛ in. (56.4 x 91.8 cm)

Signature, dates, inscription: R. S./1834–84 (lower right); Pittsburgh 50 years ago, Russell Smith 1834–84 (on reverse)

Smith's view of Pittsburgh in 1834 is dominated by the George Anshutz saltworks on the south bank of the Ohio River, about a mile from the point where the Allegheny and the Monongahela meet to form the Ohio.[1] An empty horse-drawn wagon and a traveler with a knapsack animate the dirt road beside the ramshackle building. Beyond the brick chimney emitting black smoke, a side-paddle steamboat chugs up the river, where it will pass a group of grazing cows. Farther upriver, twisting and merging streams of smoke from many chimneys rise from the city. Among the recognizable landmarks are Nelson's Island, the white-domed courthouse on Grant's Hill, the Allegheny River aqueduct, and, at the far right, the old Monongahela Bridge. All these had disappeared by mid-century, and Anshutz's saltworks had been replaced by sprawling glass factories. By 1884 this was an image of a moment long past in the life of the city.

In creating a picture of Pittsburgh that juxtaposes the three rivers and surrounding hills with smoke spewing from an

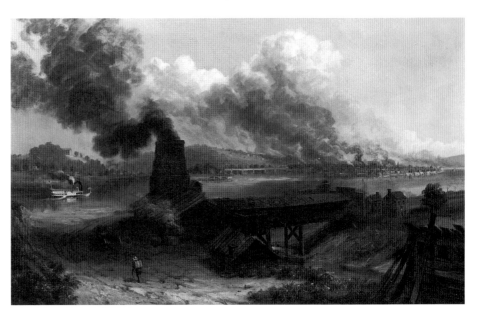

industrial chimney, Smith anticipated the city's signature image. Pittsburgh was the Smoky City long before it was the Iron or Steel City because coal stone (as bituminous coal was then called) was so readily available. Travelers passing through complained about the dark and smelly atmosphere, and Pittsburghers defensively answered that the sulphurous air, like sulphur baths, was salubrious.[2]

Although a painting entitled *Pittsburgh from Below Saw Mill Run, 1837* was among the paintings that Smith sent to the Historical Society of Western Pennsylvania, that composition was not the Carnegie work, as can be seen from the contemporaneous article in the *Pittsburg Dispatch* that illustrated the gifts.[3] The Western Pennsylvania Historical Society, Pittsburgh, now owns a *Pittsburgh from Saw Mill Run* dated 1843, which is similar to the Carnegie's painting except that the figures are decorous nonworkers: an old man and a well-dressed young girl.

The Carnegie's 1884 version remained in the possession of the artist's family until 1977. Both closely resemble an oil sketch dated 1838–40 (collection Virginia E. Lewis, Pittsburgh), which is most probably the basis for the woodcut in Charles B. Trego's *A Geography of Pennsylvania*.[4] The double dates inscribed on the front and back of the Carnegie version, 1834–84, may indicate that there is an unlocated 1834 sketch after which Smith took his composition.

RCY

1 The Carnegie Museum of Art also owns an early drawing of the Anshutz salt works by Joshua Shaw.

2 Samuel Jones, *Pittsburgh in the Year 1826* (1826; reprint, New York, 1970), p. 31.

3 Pendennis, in *Pittsburg Dispatch*, Feb. 27, 1910, p. 4.

4 Charles B. Trego, *A Geography of Pennsylvania* (Philadelphia, 1843), p. 170.

References Smith Family Papers, Archives of American Art, Washington, D.C.; W. Brezger, *Pitt News*, Nov. 23, 1948, p. 4; Lewis, *Russell Smith*, p. 41; J. M. da Costa Nunes, "The Industrial Landscape in America, 1800–1840: Ideology into Art," *Journal of Industrial Archaeology* 12, no. 2 (1986), p. 34; W. H. Gerdts, *Art across America: Two Centuries of Regional Painting* (New York, 1990), vol. 1, p. 285.

Exhibitions Department of Fine Arts, University of Pittsburgh, 1948, *Russell Smith, 1812–1896, Romantic Realist: Paintings, Water Colors, Drawings*, exh. cat. by V. E. Lewis, unnumbered; Westmoreland County Museum of Art, Greensburg, Pa., 1959, *Two Hundred and Fifty Years of Art in Pennsylvania*, exh. cat. by P. A. Chew, no. 118; Westmoreland County Museum of Art, Greensburg, Pa., 1976, *Nineteenth and Early Twentieth Century Regional Painters*, exh. cat. by P. A. Chew and J. K. Maguire, unnumbered; Vose Galleries of Boston, 1977, *The First Exhibition of Oil Painting by Russell Smith and His Son Xanthus Smith*, no. 3; Westmoreland County Museum of Art, Greensburg, Pa., 1981, *Southwestern Pennsylvania Painters, 1800–1945*, exh. cat. by P. A. Chew and J. A. Sakal, no. 225; Historic New Orleans Collection, 1984, *The Waters of America: Nineteenth Century American Paintings of Rivers, Streams, Lakes and Waterfalls*, unnumbered.

Provenance The artist's grandson, Xanthus R. Smith, and Mrs. Smith, Glenside, Pa.; by descent to the artist's great-grandson, Dr. Franklin R. Smith, until 1977; Vose Galleries of Boston, 1977.

Museum purchase: Gift of Howard Heinz Endowment, 1977, 77.40

William Sonntag

1822–1900

WILLIAM LOUIS SONNTAG was a second-generation landscape painter of the Hudson River school. His views of American and Italian scenery were minutely detailed, yet panoramic and infused with often spectacular chromatic effects in the tradition established by Frederic E. Church. He was born in East Liberty, Pennsylvania, now a section of Pittsburgh, but shortly after his birth, his family moved to Cincinnati.

Sonntag decided to become an artist around 1840, possibly studying at the Cincinnati Academy of Fine Arts under the landscape and portrait painter Godfrey Frankenstein. In 1841 he exhibited a *Jupiter and Callisto* at the Society for the Promotion of Useful Knowledge in Cincinnati, and in 1845 his *Antiquary* and *Alchemist* were hung at the local Fireman's Fair. Although the titles of these lost works suggest an early interest in figural subjects, it was soon overtaken by an interest in landscape, to the extent that all Sonntag's surviving paintings are landscapes.

He received his first landscape commission in 1842, from the Baltimore and Ohio Railroad, which wanted views of the scenery along its line. In 1846 Sonntag found a job painting dioramas for Cincinnati's Western Museum, and he opened his own studio. He began to sell landscapes to the American Art-Union in New York and to the Cincinnati-based Western Art Union. In late 1846 or early 1847 he painted the most ambitious of his early commissions, *The Progress of Civilization*, for a Baptist minister then living in Cincinnati, the Reverend Elias Lyman Magoon. These four allegorical landscapes, now lost, were based on William Cullen Bryant's poem "The Ages" and were inspired by Thomas Cole's famous series *The Course of Empire* (1836, New-York Historical Society, New York).

In 1853 Sonntag, who had become one of Cincinnati's leading artists, toured Europe with his pupil John R. Tait and the Cincinnati landscapist Robert S. Duncanson. Infatuated with Florence, Sonntag worked there from the fall of 1855 to the spring of 1856. On arriving back in the United States, he established his home and studio in New York City and there painted what was to become his best-known work, an ideal landscape entitled *A Dream of Italy* (1859, location unknown). Elected an associate of the National Academy of Design, New York, in 1860, he became an academician the following year. He subsequently traveled widely in the United States, sketching landscape subjects, and took twelve more study trips to Italy. His work appeared at major exhibitions in New York, Brooklyn, and Boston, as well as his native Cincinnati.

During the 1870s Sonntag came under the influence of the newly dominant French Barbizon school. He turned from large, panoramic views of the American wilderness to smaller, more intimate landscapes, and in 1881 he began to exhibit finished watercolors with the American Watercolor Society. Sonntag's production slackened in the 1890s, but he continued to send work to the National Academy of Design and the American Watercolor Society until his death in New York. However, by that time his highly detailed landscapes—like those of other Hudson River school painters—had largely fallen out of favor.

Bibliography "William Louis Sonntag," *Cosmopolitan Art Journal* (December 1858), pp. 2–4; Vose Galleries of Boston, *William L. Sonntag, 1822–1900, William L. Sonntag, Jr., 1869–1898* (1970), exh. cat., biographical essay by William Sonntag Miles; Cincinnati Art Museum, *The Golden Age: Cincinnati Painters of the Nineteenth Century Represented in the Cincinnati Art Museum* (1979), exh. cat. by Denny Carter et al., pp. 103–4; Nancy Dustin Wall Moure, *William Louis Sonntag: Artist of the Ideal, 1822–1900* (Los Angeles, 1980).

Fall Landscape, c. 1860–70
(Mount Solitude)

Oil on canvas
16½ x 26 in. (41.9 x 66 cm)
Signature: W. Sonntag (lower left)

Fall Landscape is a variation on the compositional formula used in *The Susquehanna near Bald Eagle Mountain* (see p. 440) and, like it, probably dates from the 1860s. Smaller and more loosely painted than the latter work, it appears, like many of Sonntag's oils, to have been rather quickly produced in order to capitalize on the market for cabinet-size landscape paintings that had the appearance of intimate sketches. The rapidity of the artist's brushwork is particularly noticeable in the masses of autumnal trees. James Pattison observed that Sonntag used a "big brush cut to a peculiar shape" with which he "wrote down a few hundred trees on a mountainside faster than a type writer can spell words."[1]

The provenance of this painting is obscure. According to Moure,[2] it was originally owned by Edward Duff Balken, curator of prints for Carnegie Institute's Department of Fine Arts from 1915 to 1935, who gave it the title *Mount Solitude*.

The Museum of Art appropriated it from storage in 1972, but there is no record of when or how it came to be there.

KN

1 Unidentified newspaper clipping, c. May 1900, in Art Institute of Chicago Scrapbook, vol. 12, p. 107; quoted in Moure, *William Louis Sonntag*, p. 59.

2 *William Louis Sonntag*, p. 113.

Exhibition Michigan Artrain, Detroit, 1981, *Traditions: The Region/The World*, no. 3.

Provenance Edward Duff Balken, Pittsburgh, by 1915, until 1935.

By appropriation, 1972, 72.40

The Susquehanna near Bald Eagle Mountain, 1864

Oil on canvas
30 x 50 in. (76.2 x 127 cm)
Signature, date: W. L. Sonntag/1864 (lower left)

From the late 1850s to the early 1870s, Sonntag was involved in making large, expansive paintings of becalmed wilderness scenes. Focusing upon the coloristic subtleties of atmospheric effects, they tended to repeat a basic, classicizing compositional formula: a low foreground, a clump of trees to one side, a reflecting body of water in the middle ground, and a misty range of mountains in the distance. *The Susquehanna near Bald Eagle Mountain* is one of these landscapes. Its composition and jewellike colors have the specificity and clarity of nature carefully observed yet ultimately idealized.

Though Sonntag, like many other mid-century landscapists, spent his summers

sketching in distant places with unique scenery that he went through much effort to seek out, he invariably rethought and conventionalized his compositions in the studio. According to James W. Pattison, an artist who had met Sonntag in North Conway, New Hampshire, in 1863, and who had observed his methods, Sonntag "went to nature only to look and draw a few new lines. His pictures were made by rule."[1] Although the title of this particular painting identifies the locality as northeastern Pennsylvania, the work itself conveys little sense of specific locality, especially when compared to the rest of Sonntag's oeuvre. It looks quite similar to the scenes of New Hampshire's White Mountains, which the artist also painted in the 1860s.

KN

1 Unidentified newspaper clipping, c. May 1900, in Art Institute of Chicago Scrapbook, vol. 12, p. 107; quoted in Moure, *William Louis Sonntag*, pp. 58–59.

Reference N. D. W. Moure, *William Sonntag* (Los Angeles, 1980), no. 354.

Exhibitions Roberson Center for the Arts and Sciences, Binghamton, N.Y., 1981, *Susquehanna: Images of the Settled Landscape*, no. 53; Historic New Orleans Collection, 1984, *The Waters of America: Nineteenth Century American Paintings of Rivers, Streams, Lakes and Waterfalls*, unnumbered.

Provenance George L. Armour, New York, by 1969.

Gift of George L. Armour, 1969, 69.45

Hedda Sterne
born 1916

A PAINTER OF CONSIDERABLE diversity, Hedda Sterne took up several painting styles in the course of her career, including Surrealism, Abstract Expressionism, and Realism. Born in Romania, she majored in philosophy and art history at the University of Bucharest. She then studied art in Vienna and Paris before fleeing the Holocaust, and arrived in America in 1941. Sterne settled in New York, where she was inspired by Victor Brauner, a fellow Romanian and Surrealist. She began to paint fanciful reminiscences of her childhood and exhibited other Surrealist paintings at Peggy Guggenheim's New York gallery, Art of This Century.

Through Guggenheim, Sterne met the cartoonist and Romanian refugee Saul Steinberg, whom she married in 1944. Steinberg's drawing style had a great impact on Sterne's early painting; she adopted her husband's witty imagery, rapid technique, and spatial ambiguities. During the late forties Sterne came in contact with the Abstract Expressionists. She found herself in the limelight when, in 1950, *Life* magazine reproduced a photograph of the Irascibles that pictured Sterne with Jackson Pollock, Willem de Kooning, and other members of the New York school who had rallied to protest the conservative policies of the Metropolitan Museum of Art. Sterne was the only woman in the photograph. A year later, *Life* published a feature article on Sterne and her husband.

During the fifties Sterne painted semi-abstract cityscapes that reflect her bewildered reaction to the terrifying mechanical power, speed, and noise of urban America. In *Barocco #14* (1954, collection the artist, New York) and with other monster images she called *Anthropomorphs*, she evoked the immensity of New York's bridges, pylons, and girders. She declared, "I had to paint these super-human machines in order to exorcise them."[1]

During the sixties Sterne and Steinberg separated amicably. She began to experiment with nonobjective painting and developed, among them, a series of tondos on ball bearings, to be viewed from different directions. In addition, she painted canvases composed of horizontal bands of somber color; these suggest landscapes, as in *Horizon V* (1963, Montclair Art Museum, N.J.).

Throughout her career Sterne has painted oversize portraits of friends, such as Elaine de Kooning and the critic Harold Rosenberg. These portraits are painfully objective, yet cartoonlike in their reductive quality. Sterne received a Fullbright Fellowship to study in Venice in 1973; in 1977 she was honored with a retrospective at the Montclair Art Museum.

1 Montclair Art Museum, *Hedda Sterne Retrospective*, p. 11.

Bibliography "Steinberg and Sterne," *Life*, August 27, 1952, pp. 50–54; Lawrence Campbell, "Sterne: Line and Likeness," *Art News* 64 (February 1966), p. 29; Montclair Art Museum, N.J., *Hedda Sterne Retrospective* (1977); B. H. Friedman, "The Irascibles: A Split Second in Art History," *Arts* 53 (September 1978), pp. 96–102; Charlotte Streifer Rubenstein, *American Women Artists* (Boston, 1982), pp. 275–76.

Violin Lesson, 1944

Oil on panel
23⅝ x 19¾ in. (60 x 50.2 cm)
Signature, date: *Hedda Sterne/1944* (lower left)

This work is one in a series of childhood reminiscences that Sterne, in search of her roots in Romania, painted after she fled to the United States in 1941. Envisioned from a child's viewpoint, it depicts an old man teaching a youth to play the violin. The lesson takes place in a formal sitting room, decorated in forest green and furnished with an ornate divan, chair, and table. A brass chandelier and two pale pink portieres hang overhead.

By rendering objects with sketchy, almost caricatured strokes and by creating spatial ambiguities, Sterne suggested a child's naïve and fantastical perceptions. As in *Interior-Kitchen XIX* (1945, collection the artist, New York) and other early paintings, she worked with the thin and scratchy brushstrokes of children's drawings. This resulted in a flat and linear

style, heavily influenced by the Surrealists and by her husband, Saul Steinberg, whom she married the same year that she painted *Violin Lesson.*

Sterne painted multiple, contradictory viewpoints into the room of *Violin Lesson* so that it seems to tilt and shift, as the viewer looms precariously overhead. The figures appear dwarfed by their vast and unstable surroundings. The windows look small and inaccessible, as they often do to young children. The setting of the painting is deliberately ambiguous. It is unclear whether the pink dots and heavy dark stripes on the walls designate a forest and garden outside the room or are merely patterned wallpaper. Similarly, it is unclear whether the textured floor covering is meant to resemble grass or thick pile carpet. Like a fairy tale, the canvas becomes an imaginary world where both the objects and figures take on fantastic characteristics.

JM

Remarks The panel displays numerous areas of flaking paint around the perimeter.

Provenance Mr. and Mrs. J. Alfred Wilner, New York, until 1960.

Gift of Mrs. J. Alfred Wilner, 1960, 60.38.1

John Storrs
1885–1956

JOHN BRADLEY STORRS was a pioneer of abstract sculpture in America. Although he also executed paintings, drawings, and prints, he was best known for his inlaid

stone sculptures and metal constructions of the 1920s and 1930s. His production was original and versatile yet difficult to categorize, since it incorporated various modernist styles and elements from ancient and tribal art as well.

Born in Chicago, the son of an architect and real-estate developer, Storrs entered the Chicago Manual Training School (part of the University of Chicago's high school) in 1900. From 1905 through 1907 he studied sculpture in Hamburg and attended the Académie Franklin in Paris. In Europe he was introduced to the simplicity, geometric order, and unity of design of the Vienna Secessionists, concepts that had an impact on all his subsequent work.

Upon returning home in November 1907, Storrs worked in his father's real-estate business while taking evening classes at the Art Institute of Chicago. From 1909 through 1910 he studied art in Boston and Philadelphia, then in 1911 returned to Paris, where he entered both the Atelier Colarossi and the Académie de la Grande Chaumière. Between 1912 and 1914 he was a favored pupil of Auguste Rodin, and he absorbed the renowned sculptor's dictum to emphasize the surface rather than the detail of a piece. At the same time, Storrs became acquainted with Cubism and Futurism, probably at the 1912 Salon des Indépendants.

His sculpture was exhibited in the 1913 Salon d'Automne, the 1914 Salon des Beaux Arts, and the 1915 Panama-Pacific Exposition in San Francisco. He married the French writer Marguerite de Ville Chabrol in 1914, and he and his wife made their home in Paris, traveling frequently to the United States. It was also around this time that he became fascinated with Native American art, attracted not only to its formal elements but also to its emotional and religious content. By 1917 Storrs began to create some of his most innovative nonobjective sculpture, incorporating references to Native American art, Cubism, and Futurism into strongly architectonic stone panels and freestanding stone forms.[1]

A 1923 solo exhibition at the Société Anonyme in New York garnered considerable critical acclaim and established Storrs as a member of the international avant-garde. His work was described as "the most complete and consistent sculptural embodiment of the abstract by an

American artist."[2] However, Storrs was disappointed and discouraged by the show's financial failure.

He briefly experimented with architectonic figural sculpture, but by 1924 he had turned to works composed purely of abstract architectural references. His columnar sculptures—in aluminum, brass, copper, and steel—can be read as idealized cityscapes or simply as studies in the juxtaposition of geometric forms. He appears to have been influenced by the poetic conception of urban America found in the architecture of Frank Lloyd Wright and in the paintings of Joseph Stella.[3]

Storrs's father, who had died in 1920, stipulated in his will that his son spend at least six months a year in America in order to obtain his full inheritance. Storrs intermittently and unsuccessfully contested the will's terms, for he wished to live and work in France. However, the economic situation of the late 1920s, his poor sales, and his consequent need for his trust funds led him to move to Chicago in 1927. By 1929 he had received three major architectural commissions, including an aluminum statue of *Ceres*, the goddess of grain, for the Chicago Board of Trade Building.

During the 1930s Storrs did some painting for the federal Public Works of Art Project. He entered several sculpture competitions, but either lost or withdrew from all of them. His sculptures and paintings of this period bear the softening imprint of Surrealism in their curvilinear contours and combination of human, sexual, and mechanical references.

Although financial success eluded him, by 1938 Storrs enjoyed the admiration of the international art world and became a Chevalier of the French Legion of Honor. In May 1939 he returned permanently to France. During World War II he was arrested by the German occupation forces and twice interned in concentration camps, where his health was badly weakened by chronic bronchitis and dysentery. After his release, Storrs returned to his château at Mer, where he worked until his death.

Although his art fell out of favor in the 1930s, recent restrospective exhibitions have reaffirmed Storrs's unique contribution to modern American sculpture.

1 Whitney Museum of American Art, *John Storrs*, p. 46.

2 R. F., "New York Art News: John Storrs' Sculpture," *Christian Science Monitor*, March 8, 1923, p. 6.

3 Whitney Museum of American Art, *John Storrs*, p. 70.

Bibliography Edward Bryant, "Rediscovery: John Storrs," *Art in America* 57 (May 1969), pp. 66–71; Abraham A. Davidson, "John Storrs, Early Sculptor of the Machine Age," *Artforum* 13 (November 1974), pp. 41–45; Museum of Contemporary Art, Chicago, *John Storrs (1885–1956): A Retrospective Exhibition of Sculpture* (1976), exh. cat. by Judith Russi Kirshner; Whitney Museum of American Art, New York, *John Storrs* (1986), exh. cat. by Noel Frackman.

Panel with Mirror Insets, c. 1920
(Polychrome Panel)

Sandstone, mirrored glass, and paint
26½ x 14⅛ x 2⅞ in. (67.3 x 35.9 x 7.3 cm)

Between 1917 and 1920 Storrs created some of his most remakable work: inlaid-stone relief panels and freestanding sculptures that combine the broad, smooth planes of Synthetic Cubism with the stylized nature motifs of Art Deco and abrupt spatial shifts of Vorticism. In works such as *Panel with Mirror Insets*, geometric and natural motifs were merged with architectural elements to establish his definitive vocabulary of form.[1]

A complex set of influences appears to be at work here. The Futurist artist Umberto Boccioni had advocated the use of a variety of materials in a single work, and his influence can be seen in the panel's multimedia construction.[2] The various levels of relief and strong color contrasts create the kind of spatial shifts found in Vorticism and Cubism. A further effect of Cubism is the use of mirror glass to create ambiguity as to the depth, opacity, and transparency of the stone, blurring the line between reality and illusion.[3] The use of mirrors also illustrates Storrs's interest in Art Deco, then the most popular contemporary style of design.

In a manner reminiscent of Frank Lloyd Wright, Storrs combined modern architectural shapes with Native American motifs; the latter are conveyed through his color scheme—red, green, black, and white—and zigzag shapes. The general contours, however, bear a marked resemblance to a postcard view that Storrs saved of the Italian hill town of San

Gimignano,[4] whose geometric towers, recessed spaces, and curving arches struck a chord with his sensibilities.

With inspiration from many disparate sources, Storrs nevertheless created a uniquely personal piece. Using a traditional medium and method, stone and carving, he wrought a modern, machine-age design. The panel can be read as a purely abstract decoration, a workable model for an innovative machine, or a blueprint for a utopian city. Such inlaid reliefs and freestanding sculptures earned him great critical acclaim at his 1923 Société Anonyme show. It is generally believed that *Panel with Mirror Insets* is the piece the eminent art critic Henry McBride referred to in his review of this show as

> a carved and colored stone with insets of mirror by way of further enrichment. It has a somewhat cold suggestion of Indian ornament about it at first glance, due to the employment of zig-zags that suggest the feathered headdress—but later on...I found myself continually reading new perspectives and new suggestions in values, from this so-called Indian carving in relief.[5]

RB

1 Whitney Museum of American Art, *John Storrs*, p. 46.

2 Roberta Tarbell, "Early Nonobjective Sculpture by Americans," in Rutgers University Art Gallery, *Vanguard American Sculpture, 1913–1939* (1979), exh. cat., pp. 25–26.

3 Davidson, "John Storrs, Early Sculptor of the Machine Age," p. 44.

4 Whitney Museum of American Art, *John Storrs*, p. 46.

5 Henry McBride, "Abstract Sculpture by John Storrs," *New York Herald*, March 4, 1923, sec. 7, p. 7

Remarks In 1977 the back of the sculpture sustained an eighteen-inch break while it was in transit to a loan exhibition.

References Bryant, "Rediscovery: John Storrs," p. 68; Davidson, "John Storrs, Early Sculptor of the Machine Age," p. 44; H. B. Teilman, "Three Early Twentieth Century American Sculptors," *Carnegie Magazine* 51 (Mar. 1977), pp. 116–17; R. K. Tarbell, "The Impact of the Armory Show on American Sculpture," *Archives of American Art Journal* 18, no. 2 (1978), pp. 7–8; Whitney Museum of American Art, *John Storrs*, pp. 46, 47, 55; K. Dinin, "John Storrs: Organic Functionalism in a Modern Idiom," *Journal of Decorative and Propaganda Arts* 6 (Fall 1987), pp. 66, 71.

Exhibitions Arts Club of Chicago, 1923, *John Storrs*, no. 15, as *Polychrome Panel;* Downtown Gallery, New York, 1952, *John Storrs*, no. 6; Downtown Gallery, New York, 1965, *Exhibition: John Storrs, 1965*, no. 6; National Collection of Fine Arts, Washington, D.C., 1965, *Roots of Abstract Art in America*, no. 170; Downtown Gallery, New York, 1966, *Forty-first Anniversary Exhibition*, no cat.; Downtown Gallery, New York, 1968, *Forty-third Anniversary Exhibition*, no cat.; Corcoran Gallery of Art, Washington, D.C., 1969, *John Storrs*, no cat.; Museum of Contemporary Art, Chicago, 1976–77, *John Storrs (1885–1956): A Retrospective Exhibition of Sculpture*, exh. cat. by Judith Russi Kirshner, no. 17; Brooklyn Museum, New York, 1986, *The Machine Age in America, 1918–1941* (trav. exh.), exh. cat. by R. G. Wilson et al., unnumbered.

Provenance The artist, until c. 1952; Edith Gregor Halpert, until 1970; estate of Edith Gregor Halpert (New York, sale, Sotheby Parke Bernet, New York, March 14, 1973, no. 3,520); Graham Gallery, New York, 1973.

Museum purchase: gift of Dr. and Mrs. Sidney S. Kaufman in memory of Mitchell Kaufman, 1975, 75.50

See Color Plate 25.

Gilbert Stuart
1755–1828

GILBERT CHARLES STUART was the foremost American portrait painter in the generation of artists that came of age after the Revolutionary War. Born in North Kingston, Rhode Island, he was raised in Newport, where his father had a tobacco business. He took his first art lessons from Cosmo Alexander, a Scottish painter working in Newport, then, at the age of seventeen, he followed Alexander to Edinburgh. There Alexander died unexpectedly and Stuart, without teacher or livelihood, was soon forced to return home.

In 1775 the young painter went abroad again, this time to London, where he studied for four years with Benjamin West and became his chief studio assistant. In 1782 he made his reputation with *The Skater* (National Gallery of Art, Washington, D.C.), a full-length portrait of his friend William Grant, which is acknowledged to be his early masterpiece. In the same year, he set up his own portrait business and was soon competing successfully with Joshua Reynolds and George Romney in the most elite ranks of London portrait painting. Like Thomas Gainsborough before him, Stuart had a facility for music. He also had an impatience with academicism, stylistic artifice, and schools of thought that separated art from nature. He was remarkable in responding neither to the allure of history painting nor to the new intellectualism that surfaced in art at the end of the eighteenth century.

Stuart's style was founded on the painterliness of fashionable late-eighteenth-century British portraiture. Fresh yet refined, it demonstrated an easy handling of light, space, and form and a keen appreciation for the optical blending of colors. These painterly traits remained with him for the duration of his career.

Despite considerable success while in England, Stuart was constantly plagued by debts. By 1787 he was compelled to move from London to Dublin to escape them, and in 1792 he returned to America for the same reason. There he met quick success, becoming painter to the country's wealthiest and most politically prominent

citizens. He worked for a decade in New York and Philadelphia, moved to Washington, D.C., in 1803, then in 1805 relocated to Boston, where he remained until the end of his life.

Stuart dominated the field of portrait painting in America. He combined the sophisticated simplicity of clear contours and subdued color harmonies with the candidness and spontaneity of quick brushwork.

Although he did not become involved in America's newly established art academies and certainly did not style himself as the leader of a school, Stuart nonetheless wielded considerable influence, particularly in Boston. He freely dispensed advice on painting; his continuing advocacy of fidelity to nature and avoidance of artifice won many admirers among the ranks of painters. Even after his death, well after the reputations of other artists of his generation had fallen sharply, Stuart was considered a great individualist and a painter whose genius deserved continued admiration.

Bibliography Lawrence Park, *Gilbert Stuart: An Illustrated Descriptive List of His Works*, 4 vols. (New York, 1926); James Thomas Flexner, *Gilbert Stuart: A Great Life in Brief* (New York, 1955); Charles Merrill Mount, *Gilbert Stuart: A Biography* (New York, 1964); National Gallery of Art, Washington, D.C., *Gilbert Stuart: Portraitist of the Young Republic* (1967), exh. cat. by Edgar P. Richardson; Richard McLanathan, *Gilbert Stuart* (New York, 1986).

Henry Nicols, c. 1810

Oil on canvas
29 x 24½ in. (73.7 x 62.2 cm)

A wealthy plantation owner from Baltimore County, Maryland, Henry Nicols (1746–1831), according to family history, drove with his servant one day to Boston, determined to have his portrait painted by Gilbert Stuart. He is said to have stayed there three weeks,[1] which, if true, confirms observations by others that Stuart painted his portraits quickly. The likeness that Nicols took back to Maryland was typical of Stuart's other work of approximately 1810 in its small size, simple composition, and limited palette. These attributes were partly the product of the artist's habit of painting directly on a buff-primed canvas without the aid of underdrawing or preliminary sketches.

Nicols is presented in three-quarter view, facing to his left, his torso only slightly to the right of the painting's vertical axis. He has gray eyes, gray hair, and a ruddy complexion, whose transparent tints have a considerable delicacy. His black wool jacket with brass buttons makes a sharp contrast with his white stock and the subtle mottled light of the dark gray background. The simple contours, which marked the prevailing Neoclassical style, are still put down with soft brushwork. The effect is to show the sitter as a gentleman of refinement and restraint.

Although the sitter's elegance is much in evidence, it is interesting that specific signs of his profession and wealth are not. For example, the fabric of Nicols's clothing appears unimportant, and the background is empty of hints at narrative or accessories of any type. In selecting these options, Stuart here involved himself in the sensibilities of Romanticism, which emerged on many fronts around 1800.

Washington Allston, who was also working in Boston between 1808 and 1811, promoted this Romantic attitude toward portraiture to even greater extremes, and may have been inspired by Stuart's bust-length portraits of those years. Both artists dispensed with the usual personal attributes of the sitter for simplicity's sake but also because elaborate accessories were no longer felt necessary to define a person. What was most important was the unseen or barely seen spirit and inner life.

Henry Nicols's will indicates that before he died, he had Rembrandt Peale make a copy of his portrait. This was bequeathed to his goddaughter Rebecca Nicols and has descended in her family.[2]

DS

1 George C. Mason, *The Life and Works of Gilbert Stuart* (New York, 1894), p. 232.

2 According to correspondence in the Carnegie's files, in 1972 the Rembrandt Peale copy of this portrait was privately owned in Miami, Florida.

References G. C. Mason, *The Life and Works of Gilbert Stuart* (New York, 1879), p. 232; "Art and Artists," *Pittsburgh Bulletin* 68, July 4, 1914, p. 2; H. Saint-Gaudens, "The Carnegie Institute," *Art and Archaeology* 14 (Nov.–Dec. 1922), p. 297; L. Park, *Gilbert Stuart: An Illustrated Descriptive List of His Works*, vol. 2, no. 583, p. 553; F. A. Myers, "Portrait of Henry Nicols: Gilbert Stuart (1755–1828)," *Carnegie Magazine* 40 (Oct. 1966), p. 285.

Exhibitions Department of Fine Arts, Carnegie Institute, Pittsburgh, 1925, *Exhibition of Early American Portraits*, no. 31; Fine Arts Gallery of San Diego, Calif., 1926, *Inaugural Exhibition*, no. 52; M. H. de Young Memorial Museum, San Francisco, 1935, *Exhibition of American Painting*, no. 31; John Herron Art Museum, Indianapolis, 1942, *Gilbert Stuart*, no. 24.

Provenance The sitter; his nephew, John Irvine Troup, Baltimore, 1831; by descent to Col. Thomas R. Rhett, Baltimore; his daughter, Ernestine H. Stevens, Philadelpha; Robert M. Lindsay Fine Arts, Philadelphia, as agent, 1907; George H. Story, New York, 1907.

Purchase, 1914, 14.1

Thomas Sully

1783–1872

Thomas Sully was the preeminent American practitioner in his generation of the British Romantic style of fashionable portraiture, which combined grace and fluid brushwork with the trappings of the grand manner. Born in Horncastle, Lincolnshire, he was brought to America at the age of nine by his actor parents and raised in Charleston, South Carolina. He began his professional painting career at the age of eighteen, after studying in Charleston with his brother-in-law Jean Belzons and in Richmond with his older brother, Lawrence, both miniaturists. Around 1806 he abandoned miniature painting in favor of the greater financial rewards of easel portraiture.

In 1806 Sully married the widow of his brother Lawrence, who had died in 1804, and with her and her three children moved north. In 1808, after living briefly in New York City and Hartford, Connecticut, he settled in Philadelphia. While in Hartford, Sully had the opportunity to travel to Boston to visit Gilbert Stuart, who found Sully "clever and ingenious"[1] and gave him advice and encouragement.

Sully went to London in 1809. Sharing a studio with fellow American Charles Bird King, he sought, as two generations of young American artists had done before him, the advice of Benjamin West, then president of the Royal Academy. West recommended that he strengthen his knowledge of bone structure and that he study the work of contemporary British portraitists. Sully did both; he was particularly affected by the work of Sir Thomas Lawrence, although initially he objected to Lawrence's brash painterliness and considerable use of reds and yellows. On returning to Philadelphia, Sully became that city's major portrait painter.

His second trip to London occurred in 1837–38 in response to a commission from the Sons of Saint George in Philadelphia for a full-length portrait of Queen Victoria in regal dress. Queen Victoria sat for Sully four times during the spring of 1838; the final version was completed in Philadelphia by January 1839.

During his long and prolific career, Sully painted a number of historical and literary subjects and landscapes, as well as portraits, but it was through his vast output as a portrait painter that he most strongly influenced other artists. His best work was produced in the late 1810s and 1820s. It was straightforward yet elegant, giving perceptive characterizations of America's most affluent citizens.

Sully taught dozens of students and wrote a small treatise on his painting methods, *Hints to Young Painters* (1851, revised in 1871, and published posthumously in 1873). He frequently contributed works to the exhibitions at the Pennsylvania Academy of the Fine Arts, Philadelphia, the Boston Athenaeum, and the National Academy of Design, New York. In 1842 he was offered the presidency of the Pennsylvania Academy of the Fine Arts but refused it because he wished "to avoid all situations of official rank."[2] In Philadelphia Sully continued to paint until the decade before his death.

1 Matthew Jouett, "Notes from Conversations on Painting with Gilbert Stuart, 1816," in John W. McCoubrey, ed., *American Art, 1700–1960: Sources and Documents* (Englewood Cliffs, N.J., 1965), p. 23.

2 Letter from Sully to directors of the Pennsylvania Academy, February 22, 1842, in Biddle and Fielding, *The Life and Works of Thomas Sully*, p. 395.

Bibliography Thomas Sully, *Hints to Young Painters* (1873; reprint, New York, 1965), introduction by Faber Birren; Charles Henry Hart, ed., *A Register of Portraits Painted by Thomas Sully, 1801–1871* (Philadelphia, 1909); Edward Biddle and Mantle Fielding, *The Life and Works of Thomas Sully, 1783–1872* (Philadelphia, 1921); National Portrait Gallery, Washington, D.C., *Mr. Sully, Portrait Painter: The Works of Thomas Sully, 1783–1872* (1983), exh. cat. by Monroe H. Fabian.

Study for "Reverend James Abercrombie," 1826

Oil on paper mounted on canvas
6⅛ x 7¾ in. (15.6 x 19.7 cm)

This oil-on-paper sketch had been attributed to John Neagle, who frequented Sully's studio during the 1820s and married Sully's youngest stepdaughter. Neagle's style was similar to Sully's, particularly in his response to the work of Gilbert Stuart and his awareness, through Sully, of Sir Thomas Lawrence's style.

The sitter for this sketch was the Reverend James Abercrombie (1758–1841), teacher of classical studies and associate rector of the three largest Episcopal churches in Philadelphia: Christ Church, Saint Peter's, and Saint James's. Sully painted Abercrombie's portrait on two occasions, in 1810 (Pennsylvania Academy of the Fine Arts, Philadelphia) and in 1826 (fig. 1). Whereas both versions are in a horizontal format—unusual for Sully— the 1826 version, for which this study was made, is half again as large as the 1810 version and includes a more detailed background.

This sketch represents the first step in the creation of a portrait, in which painter and sitter agree on the format of the work and the pose. Sometimes Sully used watercolor and ink at the earliest stage; other times, as in this instance, oil on paper. During the initial sitting Sully also made pencil drawings of the figure, paying special attention to the face. Sully obviously considered these sketches and drawings worth keeping, for many still survive.

Fig. 1 Thomas Sully, *The Reverend J. Abercrombie*, 1826. Oil on canvas, 34 x 42 in. (86.4 x 106.7 cm). The Rector, Wardens, and Vestrymen of Christ Church in Philadelphia

Comparison of the final canvas to this preliminary sketch shows how Sully adhered to the relationship of figure to background as he established them in the sketch. The main difference is that in the sketch Abercrombie's head is seen more frontally. The painting also adheres closely to the value relationships set up in the sketch, except for an intensification of the darks of the back wall and the lights in Abercrombie's face, hands, and the open book before him. The painting behind Abercrombie, not intelligible in the sketch, takes form as a crucifixion in the final canvas.

LBF

Provenance Albert Rosenthal, Philadelphia, by 1906.

Andrew Carnegie Fund, 1906, 06.21.3

The Honorable Richard Biddle, 1828

Oil on canvas
30 x 25½ in. (76.2 x 64.8 cm)
Signature, date: TS. 1828. (upper right, initials in monogram)

Richard Biddle (1796–1847) was one of the youngest members of a large and notable Philadelphia family. He graduated from the University of Pennsylvania, enlisted with the Washington Guards in the War of 1812, studied law, and was admitted to the Philadelphia bar in 1817. Immediately afterward, he moved to Pittsburgh to practice law.

By late 1828 Biddle had moved to London in order to do historical research. Two books resulted: *A Review of Captain Basil Hall's Travels in North America, in the Years 1827 and 1828* (1830) and *A Memoir of Sebastian Cabot; With a Review of the History of Maritime Discovery* (1831). In 1832 he resumed his legal practice in Pittsburgh and won election as a Whig to Congress, serving with distinction in the House of Representatives until ill health forced him to resign in 1840. He returned to Pittsburgh to practice law once more, and eventually to marry.

In this portrait, Biddle is depicted against a generalized background painted in mottled tones of gray and rose. The daubs of paint suggest a classical column to the right, a turbulent sky to the left, and a sill on which an open book or portfolio of papers has been placed; Biddle himself holds a letter. The painting is dated 1828, and while it does not appear in Sully's register of paintings, it is likely to have been painted in Philadelphia when Biddle was en route to London. He had just relinquished his lucrative law practice to pursue independent research, so the year 1828 was clearly a turning point, a time when he took stock of himself and his goals. The portrait depicts him as a studious individual in a moment of quiet contemplation, looking up from

the letter he is holding as if carefully evaluating its content.

The Biddle family regarded Thomas Sully highly and commissioned no fewer than eight portraits from him. In composition, the Carnegie's painting closely resembles Sully's 1826 portrait of Richard's elder brother Nicholas (collection descendants of the sitter), the well-known financier, author, and editor of the literary magazine *The Port Folio*. In both works the figure faces right and sits before a column with a patch of sky on the left. However, whereas the portrait of Nicholas Biddle is at once elegant, pensive, and romanticized, Sully's depiction of Richard Biddle is stylistically more straightforward.

LBF

References R. Biddle and Fielding, *The Life and Works of Thomas Sully*, no. 145, p. 101; M. M. Wurts, "Promised or Given, 1960," *Carnegie Magazine* 34 (May 1960), p. 156; N. B. Wainwright, "Nicholas Biddle in Portraiture," *Antiques* 108 (Nov. 1975), p. 960.

Exhibitions Department of Fine Arts, Carnegie Institute, Pittsburgh, 1916, *City Charter Centennial Exhibition of Portraits, Views of Early Pittsburgh and Historical Relics: 1816–1916*, unnumbered; Department of Fine Arts, Carnegie Institute, Pittsburgh, 1960, *Promised or Given*, no cat.

Provenance Edith McIlvaine Heard, Pittsburgh, by 1921; her husband, Dr. James D. Heard, Pittsburgh.

Gift of Dr. James D. Heard, 1960, 60.31

Mrs. Charles F. Spang, 1845

Oil on canvas
23½ x 19¹³⁄₁₆ in. (59.7 x 50.3 cm), oval
Signature, date: TS 1845. (on reverse, initials in monogram)

The commission of this portrait was for a "head, with hand introduced" only, and took six days to complete.[1] It is typical of a vast number of small, informal, sketch-like portraits that Sully turned out to great demand during the latter half of his career.

As early as the 1820s, Sully began to place his figures before cream, brown, or pink backgrounds not very different from his usual ground color: diluted burnt umber over white. He followed that format in this portrait, where the sitter's head and hand merge with the soft beiges of the ground. A sky is hastily brushed in, setting her head against swirling blues,

reds, and grays that are more intense immediately around her face, then fade away at the edges of the painting. The sitter's cherry red Turkish head scarf is the brightest color in the painting; it falls to her left shoulder in a way that balances the movement of her right hand as she plucks at the neckline of her gown. This small, elegant gesture, which gives life to the work, was also occasionally employed by Sir Thomas Lawrence in portraits that Sully undoubtedly saw in London.

Mrs. Spang (1817–1887) was born Sarah Ann Loyd, daughter of an English saddler who settled in Pittsburgh. She married Charles Frederick Spang, who established with his father an ironworks in Huntingdon, Pennsylvania, which they relocated in 1828 to Etna, a suburb of Pittsburgh. The firm eventually became Spang Steel and Iron Co., and was considered a pioneer in the iron tubing business.

Until his retirement to Nice, France, in 1858, Spang played a role in Pittsburgh civic affairs. He was one of the early directors of the Bank of Pittsburgh, a founder of the Western Pennsylvania Hospital, a corporator of Allegheny Cemetery, and a vestryman of Trinity Church. He was also an amateur archaeologist, and in 1854 he was present at the excavation of Etruscan antiquities at Chiusi. His art collection included the Carnegie's painting by Tompkins Harrison Matteson, *Sugaring Off* (see p. 345).

LBF

1 Biddle and Fielding, *The Life and Works of Thomas Sully*, no. 1,634, p. 278.

References Hart, *A Register of Portraits Painted by Thomas Sully*, no. 1,564, p. 153; Biddle and Fielding, *The Life and Works of Thomas Sully*, no. 1,634, p. 278; "The Rosalie Spang Bequest," *Carnegie Magazine* 6 (Jan. 1933), p. 233.

Exhibition Department of Fine Arts, Carnegie Institute, Pittsburgh, 1933, *Rosalie Spang Bequest*, no cat.

Provenance Mr. and Mrs. Charles Frederick Spang, 1845, until Mr. Spang's death; his daughter, Rosalie Spang, Pittsburgh and Nice, France, 1904.

Bequest of Miss Rosalie Spang, 1932, 32.2.3

Rosalie Spang, 1848

Oil on canvas
23 x 19½ in. (58.4 x 49.5 cm), oval
Signature, date: TS 1848 (on reverse, initials in monogram)

When Sully painted portraits of children, he tended not to show any special insight into their unique qualities, but rendered them as types. Sarah Spang's daughter Rosalie is placed against a warm buff-colored background, which is similar to that of her mother's portrait, but less complex and less specific. She lifts a hand toward her hair in a preening gesture essentially identical to those Sully gave to his adult women, including Rosalie's mother. The result, completed in eight days, is a pleasant, decorative image that merely hints at the innocence of happy childhood.[1]

Rosalie Spang (1845–1932) was the fourth of five children and the middle of three girls. It is not known why she and her mother were the only members of the Spang family to sit for Sully.

LBF

1 According to Biddle and Fielding (*The Life and Works of Thomas Sully*, p. 278), the portrait was painted between October 27 and November 4, 1848.

References Hart, *A Register of Portraits Painted by Thomas Sully*, no. 1,565, p. 153; Biddle and Fielding, *The Life and Works of Thomas Sully*, no. 1,635, p. 278; "The Rosalie Spang Bequest," *Carnegie Magazine* 6 (Jan. 1933), p. 233.

Exhibition Department of Fine Arts, Carnegie Institute, Pittsburgh, 1933, *Rosalie Spang Bequest*, no. cat.

Provenance Mr. and Mrs. Charles Frederick Spang, Pittsburgh and Nice, France, c. 1849, until Mr. Spang's death; his daughter, Rosalie Spang, Pittsburgh and Nice, France, 1904.

Bequest of Rosalie Spang, 1932, 32.2.2

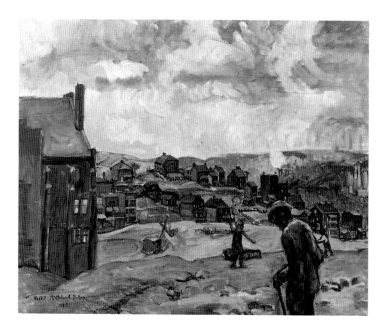

Rachel Sutton

1887–1982

BORN AND RAISED IN Pittsburgh, Rachel McClelland Sutton painted her environs for more than eighty years. The daughter of a prominent surgeon, she grew up at Sunnyledge, the family's Richardsonian Romanesque home, built in 1888 by the architectural firm of Longfellow, Alden, and Harlow in Pittsburgh's prosperous suburb of Shadyside. Separated from her husband after four years of marriage, Sutton returned to Sunnyledge to live with her sister. Several of her paintings were inspired by views from the house.

Until the age of eight Sutton was educated at home by a German governess; she then attended a local private school, where she received lessons in drawing and watercolor from Eleanor Stoney, who had trained at the Pittsburgh School of Design and the Académie Julian in Paris. Sutton spent four years in the preparatory division of the Pennsylvania College for Women (now Chatham College) and two years at the Master's School in Dobbs Ferry, New York. She then enrolled at Carnegie Institute of Technology, where she graduated with a degree in fine arts in 1916. She studied informally at the Art Students League in Pittsburgh and at the summer school of the Art Students League in New York. Sutton frequently

traveled in Europe, and she made several automobile trips across the United States.

Sutton's early work was broadly based: figure studies (often in pastel), landscapes, marines, and flower subjects, somewhat influenced by Post-Impressionism. She also produced poster designs, as well as a few portraits and small sculptures. During the 1930s and 1940s her work reflected the current popularity of Regionalism; at this time she increasingly painted the Pittsburgh subjects for which she is best remembered. As she later recalled, "I couldn't get my sister or mother to model for me. They'd sit for awhile, then get impatient. So I would just get in the car and go where I wanted to find something to paint. I got to know the city pretty well."[1]

An active member in the local art community, Sutton exhibited with both the Associated Artists of Pittsburgh and the Watercolor Society. Late in her life she had several solo shows in the Pittsburgh area, including an exhibition of her paintings at Carnegie Institute in 1980. The artist died in Pittsburgh.

1 Carlin, "Nostalgia by the Brushful," p. 18.

Bibliography Autobiographical sketch in McClelland Family Papers, Archives of the Western Pennsylvania Historical Society, Pittsburgh; "Home Reflects Many Interests of Two Sisters," *Pittsburgh Sun-Telegraph*, January 25, 1959, Pictorial Living sec., p. 5; Margie Carlin, "Nostalgia by the Brushful," *Pittsburgh Press Roto*, September 8, 1974, p. 18; Martha Hunter, "Rachel Sutton, Painter," *Carnegie Magazine* 54 (September 1980), pp. 2–6; Obituary, *Pittsburgh Press*, February 21, 1982, sec. C, p. 2.

Hill House with Figures, 1937

Oil on canvas
20⅛ x 24 in. (51.1 x 61 cm)
Signature, date: Rachel McClelland Sutton/1937 (lower left)

Sutton's belief that her work should be grounded in her surroundings is demonstrated in *Hill House with Figures*, one of the many Pittsburgh subjects that she painted during the 1930s and 1940s, the period in which she was most strongly influenced by Regionalism. Here, Sutton presents a view of the Hill district, the small urban residential section east of the Golden Triangle that has been home to Pittsburgh's ethnic and black populations since the early nineteenth century. In one direction this elevated site overlooks the North Side, and Sutton documents the view by including such recognizable landmarks as the tower of Allegheny General Hospital and the steel mills along the Ohio River.

The canvas was painted during the summer of 1937, and the dilapidated house and crippled old man in the foreground reflect the depressed conditions of the era; the painting's rough surface texture complements this mood. Minimizing details, Sutton used broad strokes to build solid forms. Despite the

ruggedness of life in this urban neighborhood, Sutton, like her Regionalist contemporaries, chose to present it in positive light. Earthy colors, bright green trees, and a child waving a friendly greeting express the optimism fundamental to the American sense of well-being.

GB

Exhibition Museum of Art, Carnegie Institute, Pittsburgh, 1980, *Rachel McClelland Sutton: Paintings*, no cat.

Gift of the artist, 1978, 78.33.3

Across the Street, c. 1938

Oil on canvas
30¹⁄₁₆ x 25¹⁄₈ in. (76.6 x 63.8.cm)
Signature: Rachel McClelland Sutton (lower left)

Sutton painted this quiet winter scene from the second story of her Fifth Avenue home in Shadyside, providing an unusual view across neighborhood backyards and rooftops. The foreground of the composition is dominated by a large sycamore tree and the Victorian houses that characterized the nineteenth-century suburb. While a solitary figure stands on the sidewalk, the mood is cheerful rather than melancholy, for the surrounding scene is lively with brightly painted brick houses, afternoon sun, and animated shadows.

Probably painted in the late 1930s, *Across the Street* suggests a certain similarity to the Midwestern street scenes of Charles Burchfield. Sutton, like Burchfield, used bare tree branches to create bold linear patterns across the surface of the canvas, but she avoided

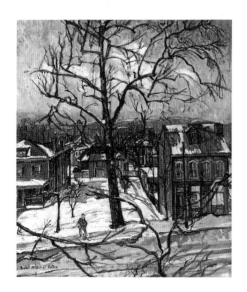

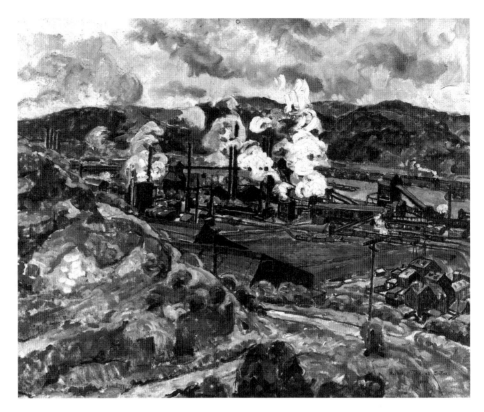

Burchfield's highly expressionistic style in favor of greater objectivity. The weblike network of lines that animates the surface of this canvas reveals Sutton's concern for abstract design and for enhancing the painting's decorative qualities.

GB

Exhibition Museum of Art, Carnegie Institute, Pittsburgh, 1980, *Rachel McClelland Sutton: Paintings*, no cat.

Gift of the artist, 1978, 78.33.2

Monongahela Steel Mills, 1941

Oil on canvas
25¹⁄₁₆ x 30 in. (63.9 x 76.2 cm)
Signature, date: Rachel McClelland Sutton/1941 (lower right)

Looking south across the Monongahela River, this view of the Jones and Laughlin Steel Company was painted from Gazzem's Hill above Second Avenue in Greenfield, one of Pittsburgh's ethnic blue-collar neighborhoods. In keeping with her reputation as an artist who "paints Pittsburgh with candor,"[1] Sutton allowed the actual scene to suggest the

composition: while the rocky hillside in the foreground intrudes on the panoramic view, the winding road directs the viewer's attention to the mill at the center of the painting, where clouds of steam rise dramatically among the smokestacks. Just as it dominated the local economy, the mill dominates this composition, overshadowing the river, which only appears as a thin gray strip in the background. The vigor of this industrial setting is enhanced by Sutton's assertive application of paint in bold strokes.

GB

1 Penelope Redd, "Artists Unite as Exhibition Opens Here," *Pittsburgh Sun-Telegraph*, February 12, 1932, p. 21.

Reference Hunter, "Rachel Sutton, Painter," pp. 2–6.

Exhibitions Museum of Art, Carnegie Institute, Pittsburgh, 1980, *Rachel McClelland Sutton: Paintings*, no cat.; Westmoreland County Museum of Art, Greensburg, Pa., 1981, *Southwestern Pennsylvania Painters, 1800–1945*, exh. cat. by P. A. Chew and J. A. Sakal, no. 237.

Gift of the artist, 1978, 78.33.1

Augustus Vincent Tack

1870–1949

BORN IN PITTSBURGH into a family prominent in the oil business, Augustus Vincent Tack moved to New York with them in 1883. There he attended Saint Francis Xavier College and discovered his artistic inclinations. He exhibited for the first time at the Society of American Artists, New York, in 1889, where his abilities earned the praise of the society's president, John La Farge.

After graduating from college, Tack remained in New York, where he became La Farge's pupil and studied with Henry Siddons Mowbray and John Twachtman. In 1893 and 1895 he went to France, where he visited Normandy and Picardy, studied under Luc-Olivier Merson in Paris, and began painting outdoor scenes in a Neo-Impressionist mode. When he returned to the United States, he began sending his work to the various annual exhibitions, notably to the Pennsylvania Academy of the Fine Arts, Philadelphia, and Carnegie Institute, where he entered six of its annual exhibitions between 1898 and 1925. He also began summering in Deerfield, Massachusetts, and turned to teaching. Between 1906 and 1910 he taught at the Art Students League, New York, then, until 1913, at Yale University,

New Haven, where he received an honorary bachelor of fine arts degree.

The primary source of Tack's livelihood was society and corporate portraiture; his clients comprise a long list of prominent Americans, from Grenville Winthrop to Dwight D. Eisenhower. It was a lucrative vocation; his earnings allowed him to maintain an opulent lifestyle, with apartments and studios in New York City and Washington, D.C., as well as a country retreat in Deerfield.

Tack also became known as a painter of religious subjects and murals. By 1914 he had begun to work in a Symbolist style, showing the first of his paintings at a members' exhibition at the Century Club in New York. In the 1920s he began to receive commissions for mural paintings: for the legislative chamber of Winnipeg's new parliament building in 1920, for the governor's suite in the Nebraska State Capitol in 1928, and for eight Roman Catholic churches along the northeastern seaboard.

Tack's murals and religious canvases drew on models conducive to spiritualism in art, ranging from Byzantine and early Renaissance art to Chinese painting and fin-de-siècle symbolism. The same sources influenced the abstract paintings he had begun to paint by the early 1920s. His first such canvas, *Voice of Many Waters* (c. 1924, Phillips Collection, Washington, D.C.), was inspired by a visit to the Canadian Rockies while completing his murals in Winnipeg, and it set the tone for virtually all his subsequent abstract paintings. Like his religious

images, it relied on lyrical lines and cosmic forms—mainly mountains and clouds—that seem to refract unreal light, creating a transcendent effect.

The greatest champion of Tack's abstract painting was the Washington collector Duncan Phillips, whom the artist met at the Century Club in 1914. Phillips began buying Tack's abstractions in 1924, and eventually accumulated seventy-eight of them, the largest single collection of his work. Phillips prevailed on Tack to serve on the first board of officers of the Phillips Memorial Gallery (now the Phillips Collection), Washington, D.C., and commissioned from him nine decorative panels for the gallery's reception room.

Given the high measure of Phillips's esteem, it is not surprising that Tack received commissions from other Washington patrons. In 1944 he made his largest abstract painting for George Washington University, which asked him to paint a steel fire curtain for its Lisner Auditorium. Called *Spirit of Creation*, it is generally considered the artist's masterpiece.

Today, Tack is admired almost exclusively for his abstract paintings. He believed that these images explored the mystical properties of color independently of graphic representation. To him they had a special power to awaken the emotions and stood as the only absolute art form other than music.[1] His development

450

as an abstract painter is considered something of a phenomenon, for it occurred seemingly without reference to established modernist movements. It has frequently been said that its closest parallel is the color-field abstraction of the 1960s.

Tack died at Deerfield, his country retreat for many years.

1 Augustus Vincent Tack, "A Note on Subjective Painting," *Art and Understanding* 1 (March 1930), pp. 240–43.

Bibliography James W. Lane, "Augustus Vincent Tack," *American Magazine of Art* 28 (December 1935), pp. 726–33; Hilson Gallery, Deerfield Academy, Deerfield, Mass., *Augustus Vincent Tack, 1870–1949* (1968), exh. cat. by the American Studies Group; University Art Museum, University of Texas, Austin, *Augustus Vincent Tack* (1972), exh. cat. by Eleanor Green; University of Rhode Island, Kingston, *Augustus Vincent Tack, 1870–1949* (1973), exh. cat. by Margaretta B. Sander; M. Knoedler and Co., New York, *The Abstractions of Augustus Vincent Tack* (1986), exh. cat., essay by Robert Rosenblum.

Spirit of the Hills, c. 1925–28
(The Hills of Tomorrow)

Oil on canvas mounted on painted plywood panel
Image: 27⅞ x 23¾ in. (70.8 x 60.3 cm)
Plywood panel: 37 x 32 in. (94 x 81.3 cm)
Framed dimensions: 43 x 37¾ in. (109.2 x 95.9 cm)
Signature: AUGUSTUS VINCENT TACK (lower right)

Following the procedure he used for most of his abstract landscapes, Tack constructed *Spirit of the Hills* by gluing a trimmed canvas, carefully outlined, onto a larger, painted board (resembling a very wide frame liner), thus suspending his image in an empty, neutral space. Here, that neutral area is celadon green, a delicate color that sets off an inner canvas of similarly pale, opaline tones: celadon, blue green, lavender, and pink. The image is reminiscent of Chinese landscape painting in its undulating foreground and its background of sharply rising yet dematerialized hills. The faceted, jagged shapes can be found in much of his work of the 1920s, although the specific combination here is rather unusual.

The lower part of the composition—suggestive of treetops or perhaps ocean waves—shows the faceted, more deeply colored surfaces that characterize such works as *Voice of Many Waters* (c. 1924, Phillips Collection, Washington, D.C.).

This hollow of darker, broken forms yields to a more uniformly colored series of mountain shapes, and above these, a matte, light green sky. Both mountains and sky show the distinctive jagged patches that Tack used in some of his murals and religious paintings—for instance, *Rosa Mystica* (c. 1923, Cleveland Museum of Art)—where they are said to suggest peeling fresco paint.[1]

Tack was fond of using gold or silver metallic paint in his abstract paintings—either in the compositions themselves or in their spandrels—to create an otherworldly effect. Here, gold is used in the painting's plaster-covered frame, which is decorated with vertical gold bars over a stuccolike surface of celadon green mixed with gold. Its randomly glinting colors and tactility create a foil for the serene, meditative horizon view within.

Spirit of the Hills was originally owned by Dr. Cloyd H. Marvin, president of George Washington University, who was responsible for the commission of Tack's late masterpiece, the steel fire curtain designed for the university's auditorium. At the time of the commission, Marvin also purchased this work for himself.
DS

1 Margaretta B. Sander, in University of Rhode Island, *Augustus Vincent Tack*, p. 6.

Reference H. B. Teilman, "Augustus Vincent Tack," *Carnegie Magazine* 52 (May 1978), pp. 13–15.

Exhibitions Probably exhibited at George Washington University Library, Washington, D.C., 1949, *Paintings by Augustus Vincent Tack*, no. 4, as *The Hills of Tomorrow;* Hilson Gallery, Deerfield Academy, Deerfield, Mass., 1968, *Augustus Vincent Tack, 1870–1949*, unnumbered.

Provenance Cloyd H. Marvin, Washington, D.C., c. 1944; Mrs. Cloyd Marvin, until her death, 1977; Robert G. Simmons, c. 1977; Robert Schoelkopf Gallery, New York, by 1978.

Museum purchase: gift of the friends and family of Henry Oliver, Jr., 1978, 78.6

Arthur Fitzwilliam Tait
1819–1905

BEST KNOWN FOR HIS carefully detailed and somwhat sentimentalized animal and sporting pictures, A. F. Tait is credited with making these themes popular in America, thereby influencing the painters who subsequently made these subjects their specialty. Tait was born in England, at Livesey Hall near Liverpool, the youngest in a large family. When his father's shipping business failed in the aftermath of the Napoleonic wars, he was sent to live on a relative's farm. There he may have developed the love for animals and outdoor sports that he later portrayed so prolifically. After leaving the farm at the age of twelve, he began working in the art world, first as a clerk at a Manchester print shop, then as a drawing instructor and lithographer. A self-taught artist, he developed his skills by reference to self-instructional art books and by studying the works of the eminent English animal painters Sir Edwin Landseer and Richard Ansdell.

Seeking wider opportunities, Tait immigrated to the United States in 1850, just as Americans had begun to appreciate the recreational possibilities of their virgin wilderness areas. He carefully studied works by George Catlin, William Ranney, and Karl Bodmer, finally turning out his own believable, lively pictures of frontier adventures, although he himself had never visited the West.

By 1852, he had established a modest reputation as a painter of wildlife, hunting, fishing, and camping scenes and was exhibiting at the National Academy of Design in New York and the Pennsylvania Academy of the Fine Arts in Philadelphia. That same year, two events crucial to his future development took place: he began a long association with Currier and Ives and made his first visit to the Adirondack Mountains of New York. Through Currier and Ives's wide distribution of inexpensive reproductions after his work, Tait eventually became one of the best-known American painters of his time.

From 1852 on, Tait regularly summered in the Adirondacks to hunt and sketch from nature. There he was able to observe firsthand the North American wildlife that became the focus of his finely detailed and extremely salable paintings. Tait often referred to drawing books and works by other painters to perfect the images of animals that he could and did study from life.[1] These sketches, along with arrangements of dead game, were the models for the finished oil paintings he produced, primarily in his New York studio.

In 1858 Tait was elected an academician of the National Academy of Design. By 1860 he was professionally and financially secure, thanks in part to the brisk sale of numerous modestly sized canvases of rather repetitive subjects. Throughout the rest of his long career, his paintings, increasingly of domestic rather than wild animals, sold well despite changing art fashions. His financial success probably spurred a younger generation of American artists to depict similar themes. He died at his home in Yonkers, New York, at the age of eighty-five.

1 Mandel, "The Animal Kingdom of Arthur Fitzwilliam Tait," p. 752.

Bibliography Adirondack Museum, Blue Mountain Lake, N.Y., *A. F. Tait, Artist in the Adirondacks: An Exhibition of Paintings and Other Works by the Sporting and Animal Artist, Arthur Fitzwilliam Tait* (1974), exh. cat. by Warder H. Cadbury and Patricia C. F. Mandel; National Academy of Design, New York, *A Century and a Half of American Art* (1975), p. 110; Patricia C. F. Mandel, "The Animal Kingdom of Arthur Fitzwilliam Tait," *Antiques* 108 (October 1975), pp. 744–55; Warder H. Cadbury and Henry F. Marsh, *Arthur Fitzwilliam Tait, Artist in the Adirondacks* (New York, 1986); Amon Carter Museum, Fort Worth, Tex., and Buffalo Bill Historical Center, Cody, Wyo., *American Frontier Life: Early Western Paintings and Prints* (1987), exh. cat. by Ron Tyler et al., pp. 108–29.

Ruffed Grouse, c. 1872–74
(Ruffed Grouse and Young)

Oil on wood panel
17 x 23⅜ in. (43.2 x 59.5 cm)
Signature, inscription, date: A. F. Tait/N.Y. 1874 (lower right)

Although the numerous Currier and Ives prints after Tait's work are mostly of hunters, fishermen, and western scenes, these subjects are found in less than ten percent of the 1,527 paintings Tait listed in his Register of Works. The bulk of his paintings were close-up studies of animals

in their natural habitats and nearly one-fourth of these were of wild and domestic fowl.[1] Grouse, a common woodland game bird, appeared in at least fifty of the paintings he produced between 1854 and 1885, several of which he exhibited at the National Academy of Design in New York.

In *Ruffed Grouse,* an adult female bird, neck ruff elevated in display, stands amid a scattering of fluffy chicks. As their mottled brown and beige plumage makes grouse difficult to spot in the natural environment, Tait emphasized their distinctive markings by placing them against a neutral background of blue-green rocks and vegetation. Although the group is realistically depicted, there is yet a hint of Victorian sentimentality in the adult bird's air of watchfulness over her playful young. The painting is an excellent example of Tait's abilities: the naturalistic poses convey a sense of lively animation, while the delicate coloring captures the sheen and texture of feathers.

Tait's fowl paintings such as *Ruffed Grouse* were valued for their accurate yet sensitive rendering of individual species. In the words of an anonymous contemporary critic, "His exquisite bird pieces are in great demand, and worthily so; for we know of no little paintings more calculated to give pleasure."[2]

For some unknown reason, it apparently took Tait two years to complete this painting. In his Register of Works, he noted that it was begun in January 1872 and completed on April 6, 1874, and that it was intended for a sale to be held by John Snedecor, one of his agents.[3] According to the donor, this work hung in Tait's room at the New York Y.M.C.A.
RB

1 Mandel, in Adirondack Museum, *A. F. Tait, Artist in the Adirondacks,* p. 32.

2 "Arthur F. Tait," *Cosmopolitan Art Journal* 2 (1858), pp. 103–4.

3 Cadbury and Marsh, *Arthur Fitzwilliam Tait*, p. 22.

References Adirondack Museum, Blue Mountain Lake, N.Y., *Register of Works of Arthur Fitzwilliam Tait*, as no. 12 in 1872 and no. 21 on April 6, 1874; "Memorial Gift," *Carnegie Magazine* 37 (Nov. 1963), p. 302; Cadbury and Marsh, *Arthur Fitzwilliam Tait, Artist in the Adirondacks*, no. 74.12, p. 229, as *Ruffed Grouse and Young*.

Provenance Unknown purchaser, possibly from the Snedecor sale in 1874; private collection, by 1963.

Given anonymously in memory of Samuel Brown Casey, 1963, 63.11

Henry O. Tanner

1859–1937

HENRY OSSAWA TANNER was a native Pittsburgher who became the most important black American artist of the late nineteenth and early twentieth centuries; he enjoyed international acclaim as a painter of genre and biblical scenes. Partly inspired by the symbolism of Gustave Moreau and the mystical naturalism of Tanner's near-contemporary Pascal-Adolphe-Jean Dagnan-Bouveret, he developed a personal style that focused on the visionary religious experience. At the same time, he maintained a marked degree of naturalism in his biblical subjects and illustrated the life of Christ on an intimate, human level.[1]

The son of an African Methodist bishop, Tanner grew up on Wylie Avenue in the Hill district of Pittsburgh. He wrote of the city:

Pittsburgh has always been dear to me because of hearing my father say so many times, "a Pittsburgher of three generations." There was always a touch of pride in it, and I soon got to feel that "a Pittsburgher of three generations" was a thing that did not fall to the lot of every man.[2]

The family moved in 1866 to Philadelphia, where Tanner enrolled in the Pennsylvania Academy of the Fine Arts. He studied under Thomas Eakins from 1880 to 1882 and assimilated his teacher's realist style. Although Tanner eventually bypassed it in favor of romantic symbolism, he continued to admire Eakins's uncompromising strength of character. Eakins, in turn, respected Tanner's reflective, probing personality, and around 1900 he painted his former student's portrait (Hyde Collection, Glens Falls, N.Y.).

During the mid-1880s Tanner exhibited at the Pennsylvania Academy and the National Academy of Design, New York. To support himself, he sold illustrations to New York publishers. In the summer of 1888 he traveled to North Carolina to sketch the local blacks and incorporate them into genre paintings. One of these, *The Banjo Lesson* (c. 1892, Hampton Center for the Arts and Humanities, Va.), serves as a sober contrast to the traditional image of minstrel shows in America.[3] Unfortunately, Tanner's works did not sell, in part because of racial bias, so he moved to Atlanta, where he hoped to procure black patronage. In Atlanta Tanner opened a photography studio. The studio soon failed, and Tanner began to teach drawing at Atlanta's Clark Institute in 1889. In 1890 he held his first solo exhibition in Cincinnati, but no works sold, again probably due to racial prejudice. Luckily, a Bishop Hartzell bought the works from the show, for a total of $4,250, and sent Tanner to Europe, where his race would not impede him from success.

After a brief stay in London, Tanner went to Paris, where he remained for most of his life, eventually dying there. He studied at the Académie Julian with Benjamin Constant and Jean-Paul Laurens and painted landscapes. In 1892 Tanner briefly visited the United States and married a San Francisco musician, but because she was white, he felt compelled to return to the more tolerant bohemian environment of Paris.

Back in France, Tanner spent time at the artists' colony of Trépied and in Brittany, painting the devoutly Catholic peasants. In 1895 he produced his first religious picture, *Daniel and the Lion's Den* (Los Angeles County Museum of Art), which marked the beginning of his recognition as an artist. He exhibited often at the Paris Salons, where the critics applauded his interpretations of biblical themes, and in 1897 he won a gold medal at the salon for *The Raising of Lazarus* (collection Mr. and Mrs. Erwin S. Barrie, Greenwich, Conn.).

Toward the end of his life, Tanner won a substantial measure of fame. Probably no other American expatriate participated in so many art exhibitions or received so many awards. He was elected Chevalier of the Legion of Honor by the French government in 1923 and in 1927 became the first black to be elected to the National Academy of Design. In Pittsburgh, he exhibited at every Carnegie International between 1898 and 1926, served on the Advisory Committee of 1925, and was given a solo exhibition of his works in 1920. John Beatty, the first director of Carnegie Institute's Department of Fine Arts, described him as "one of the ablest modern painters."[4]

Throughout his life, Tanner seemed to be inspired by his heritage, yet he resented being seen as a model for black artists and rejected the notion that he should paint only subjects that dealt with racial issues. Still, he felt proud of his ancestry and helped many young black students of the next generation, including William A. Harper and William Scott.

1 Mathews, "Henry O. Tanner," p. 460.

2 National Collection of Fine Arts, *The Art of Henry O. Tanner*, pp. 14–15.

3 Ellwood Parry, *The Image of the Indian and the Black Man in American Art, 1590–1900* (New York, 1974), p. 167.

4 "A Talk with John Beatty about the Carnegie Art Gallery," *The Library*, September 8, 1900.

Bibliography Marcia M. Mathews, "Henry O. Tanner, American Artist," *South Atlantic Quarterly* 65 (Autumn 1966), pp. 260–70; Marcia M. Mathews, *Henry O. Tanner, American Artist* (Chicago, 1969); National Collection of Fine Arts and Frederick Douglass Institute, Washington, D.C., *The Art of Henry O. Tanner* (1969); Frederick Douglass Institute, Washington, D.C., *The Art of Henry O. Tanner from the Collection of the Museum of African Art* (1972); Los Angeles County Museum of Art, *Two Centuries of Black American Art* (1976), pp. 49–57.

Christ at the Home of Mary and Martha, c. 1905

Oil on canvas
50 x 39 in. (127 x 99.1 cm)
Signature: H. O. TANNER (lower left)

Christ at the Home of Mary and Martha, exhibited in the 1907 Carnegie International, typifies the late religious phase of Tanner's painting—the period when he won critical acclaim. It was the tenth of twenty-three paintings Tanner

Remarks Pentimenti reveal that Tanner had originally intended a standing Christ figure to the left of where he is now seated. Tacking holes are visible within the present margins of the painting (1 inch from the left, 2¾ inches from the right, 1¾ inches from the top, 2 inches from the bottom), indicating that the painting was originally somewhat smaller.

References A. Locke, *Negro Art: Past and Present* (Washington, D.C., 1936), p. 24; "Honoring Tanner," *Art Digest* 20 (Oct. 1, 1945), p. 19; W. Frew, "The Editor's Desk," *Carnegie Magazine* 19 (Nov. 1945), p. 157; J. Canaday, "America's First Major Black Artist," *New York Times*, May 24, 1969, reprinted in *Carnegie Magazine* 44 (Apr. 1970), pp. 138–39; B. Brawley, *The Negro in Literature and Art* (Saint Clair Shores, Mich., 1972), p. 109; Los Angeles County Museum of Art, *Two Centuries of Black American Art*, p. 54; V. A. Clark, "Collecting from the Internationals," *Carnegie Magazine* 56 (Sept.–Oct. 1982), p. 22.

Exhibitions Department of Fine Arts, Carnegie Institute, Pittsburgh, 1907, *Eleventh Annual Exhibition*, no. 444; American Art Galleries, New York, 1908, *Religious Paintings by the Distinguished American Artist Mr. Henry O. Tanner*, no. 5; Associated Artists of Pittsburgh, 1911, *Second Annual Exhibition*, no. 148; Minnesota State Fair, Saint Paul, 1925, no cat.; South Side Community Center, Chicago, 1943, *An Exhibition of Paintings by Henry Ossawa Tanner*, no. 7; Philadelphia Art Alliance, 1945, *Exhibition of the Works of Henry O. Tanner,* unnumbered; National Collection of Fine Arts, and Frederick Douglass Institute, Washington, D.C., 1969–70, *The Art of Henry O. Tanner* (trav. exh.), no. 31; Van Vechten Gallery, Fisk University, Nashville, 1975, *Amstad II Afro-American Art*, no. 66; Metropolitan Museum of Art, New York, 1976, *Nineteenth Century Afro-American Art,* unnumbered; William Penn Memorial Museum, Harrisburg, Pa., 1979, *Pennsylvania Painters from Commonwealth Collections*, no. 51.

Provenance The artist, until 1907.

Purchase, 1907, 07.3

Dwight W. Tryon
1849–1925

Dwight William Tryon is usually placed among those turn-of-the-century painters who in recent years have been called tonalists. Subscribers of art for art's sake, these artists promoted the use of landscape as a vehicle for gently evocative harmonies of color, tone, and

showed in Pittsburgh, of which the overwhelming majority consisted of biblical scenes.

Like Dagnan-Bouveret's religious works, Tanner's reacted against the positivism and materialism prevalent in the late nineteenth century. Other artists had already turned in similar directions. The French Symbolists, along with American visionary painters such as Albert P. Ryder, provided stylistic alternatives that may have directly influenced Tanner's art. On a personal level, Tanner's unique mode of mystical naturalism served to reconcile the religious beliefs so inculcated by his family with the factual existence of the modern society in which he lived. Perhaps this ultimately explains his enduring interest in such subjects.

Here, in a setting borrowed from Rembrandt's *Christ at Emmaus* (1648, Louvre, Paris), Tanner interpreted the Scriptures with simple poignancy. Mary, who sits before Christ, listens attentively to him while Martha serves the meal. Christ beckons Martha to come closer, but she reproaches him, saying, "Lord, dost thou not care that my sister hath left me to serve alone?" His reply is the crux of the story: "Mary hath chosen that good path which should not be taken away from her" (Luke 10:38–42).

Perhaps to help the average viewer identify with the scene, Tanner portrayed the figures as weary and unidealized. Christ possesses no divine attributes; in fact, his features suggest Tanner's own. He appears as a natural being with a supernatural presence that instills in the spectator the emotional impact of a miraculous occurrence.

Tanner created this mystical atmosphere by combining opalescent local color with heavy glazing to produce an otherworldly luminosity. He bathed the canvas in a blue-green light that envelops the figures; only the brilliant golden flames from the lamp provide contrasts and cast light upon the somber room. These decorative flames, as well as the grapes, display an Art Nouveau grace and iridescence, while the vaguely eastern costumes and setting lend an exotic accent. Critics acclaimed the painting for its Orientalism, believing that Tanner's African blood provided him with a gift for the exotic. Tanner strongly resented such bigoted publicity.

JM

atmosphere. Tryon was a longtime admirer of James McNeill Whistler and, like his tonalist counterparts Thomas Wilmer Dewing and J. Francis Murphy, he attracted the same American supporters who championed Whistler, including the collector Charles Lang Freer and the critics Charles H. Caffin and Sadakichi Hartmann.

A native of Hartford, Connecticut, Tryon took up landscape painting in the late 1860s, while employed as a clerk in a bookstore. In 1871 he met Samuel Clemens, a frequent visitor to the store. Despite Clemens's warning that he would "probably starve to death in a garret,"[1] he became a full-time artist in 1873. His work sold well enough to allow him to go to Paris in 1876, where he studied drawing under Jacquesson de la Chevreuse, a former pupil of J.-A.-D. Ingres, worked for short periods with the Barbizon landscapists Charles Daubigny and Henri Harpignies, and, perhaps most significantly, came under the influence of Whistler.

In 1881 Tryon returned to the United States, having acquired in France a sympathy to the study of nature, to harmoniously designed compositions, and to the importance of a personal style. He set up a studio in New York and a summer studio in South Dartmouth, Massachusetts, and began to earn increasing recognition as the 1880s progressed. In 1885 he was appointed professor of art at Smith College, Northampton, Massachusetts, a position he held until 1923. His work was exhibited frequently, winning the esteem of critics and prominent collectors. Tryon exhibited at the 1896, 1898, 1899, 1907, and 1910 Carnegie Internationals, winning a gold medal in 1898 and a Chronological Medal in 1899. He was invited in 1907 and 1908 to be on the jury of award, but on both occasions withdrew his name because of conflicting engagements.

Tryon's trademark image became a hazy, horizontal landscape whose empty foreground led to a row of delicate trees against a clouded sky. Such work was admired for its poetry, its ability to give substance to the intangible and spiritual.[2] Neither Tryon's painting style nor his subject matter changed substantially toward the end of his life. He died of stomach cancer in South Darmouth, leaving an estate of nearly one million dollars.

1 White, *The Life and Art of Dwight William Tryon*, p. 27.
2 Charles H. Caffin, *The Story of American Painting* (New York, 1907), pp. 378–80.

Bibliography Charles H. Caffin, *The Art of Dwight W. Tryon: An Appreciation* (New York, 1909); Henry C. White, *The Life and Art of Dwight William Tryon* (Boston, 1930); William Benton Museum of Art, University of Connecticut, Storrs, *Dwight W. Tryon: A Retrospective Exhibition* (1971); Mary Ellen Hayward Yehia, "Dwight W. Tryon: An American Landscape Painter," Ph.D. diss., Boston University, 1977.

Dawn, 1918

Oil on canvas
16 x 22⅛ in. (40.6 x 56.2 cm)
Signature, date: D. W. Tryon. 1918 (lower left)

"The most beautiful pictures," Tryon once said, "are usually an intelligent combination of more or less abstract things."[1] He realized this idea through a long sequence of placid woodland scenes, depicting rhythmically disposed verticals of tall, slender trees crowned with misty spring foliage.

Dawn is a late, but typical, example of such works, all of which are variations on a theme Tryon first developed in his decorative murals for the Detroit home of his patron Charles Lang Freer (1892–93, Freer Gallery of Art, Washington, D.C.). Their appeal lay not in the accurate rendering of a particular time and place but in the nuances of color, the delicate beauty of the brushwork, and the elegant composition of layered horizontals. Sadakichi Hartmann recognized the essentially abstract nature of such landscapes, describing them as

almost, literally speaking, musical in their effect, not unlike the pizzicato notes on the A string of a violin. . . . [Tryon] proposes his pictures as a composer does his score. His parallelism of horizontal and vertical lines is like melodic phrasing.[2]

Dawn was originally purchased by the National Academy of Design, New York, through the Henry Ward Ranger Fund, established in 1916 to acquire the works of living American artists and assign them to institutions possessing free public galleries. A letter from Tryon's dealer, which accompanied the painting to the National Academy of Design, said the artist had "kept it in his private gallery, refusing to sell it, as he considered it one of his very fine things."[3]

The works acquired through the Ranger Fund were subject to appropriation by the Smithsonian Institution at stated times. Presented to Carnegie Institute in 1925, *Dawn* could be withdrawn any time between ten and fifteen years after Tryon's death. The Smithsonian refused it in 1936, and it became the property of Carnegie Institute.

KN

1 White, *The Life and Art of Dwight William Tryon*, p. 173.

2 Sadakichi Hartmann, *A History of American Art* (Boston, 1902), vol. 1, pp. 133–34.

3 C. H. Memhard, Howard Young Galleries, New York, to Charles H. Curran, April 15, 1925, National Academy of Design archives, New York.

Exhibition Smithsonian Institution, Washington, D.C., 1929–30, *Exhibition of Paintings by Contemporary American Artists Purchased by the Council of the National Academy of Design from the Henry Ward Ranger Fund in Accordance with the Provision of the Ranger Bequest Dated Jan. 21, 1914,* no. 67.

Provenance The artist, until 1925; Howard Young Galleries, New York, 1925; National Academy of Design, New York, 1925.

Gift of the National Academy of Design, through Henry W. Ranger Fund, 1925, 25.9

John Twachtman
1853–1902

THE SON OF GERMAN immigrants living in Cincinnati, John Henry Twachtman became one of the most innovative landscape painters among European-trained American artists of the late nineteenth century. He developed a highly personal style that provoked the turn-of-the-century art critic Charles H. Caffin to describe him as one of the most spiritual, idealistic, and modern painters in America.[1]

As a young man Twachtman worked in a decorative-window-shade factory while attending evening classes at the Ohio Mechanics Institute in Cincinnati. He began full-time study in 1871 at the McMicken School of Design, which later became the Art Academy of Cincinnati. In 1874 he met Frank Duveneck, with whom he began to study. Duveneck persuaded Twachtman to accompany him to Munich and there enter the academy, which Twachtman did in 1875. As a thriving art center and liberal training ground, Munich attracted many young Americans, including John White Alexander, Joseph DeCamp, J. Frank Currier, and William Merritt Chase. By the time Twachtman accompanied Duveneck and Chase to Venice in 1877, he had already assimilated a painting style that bore the innovative traits of the Munich school: vigorous brushwork, thick impasto, and dramatic light-dark contrasts.

Twachtman returned to the United States in 1878. He took a teaching position at the Women's Art Association of Cincinnati in 1879 and in the same year was admitted to the Society of American Artists, New York's predominant exhibiting organization. By 1880 he was in Florence, teaching at Duveneck's art school there. Dissatisfied with the drawing skills he had been taught in Munich, Twachtman went to Paris from 1883 to 1885 and studied with Gustave Boulanger and Jules-Joseph Lefebvre at the Académie Julian. During this period he also painted in Dieppe and Honfleur; he dropped the somber tonalities and bravura brushwork of the Munich manner and adopted the lighter palette of the French school. In his greatest work from this period, *Arques-la-Bataille* (1885, Metropolitan Museum of Art, New York), he developed the muted colors, close tonal harmonies, and abstract compositional arrangements he would use for the rest of his life.

Twachtman returned to America in 1885, and from 1888 to 1895 he was at the height of his career. In 1888 he won the Webb Prize from the Society of American Artists for the finest landscape painting by an artist under forty. He sold illustrations to *Scribner's Magazine* from 1888 to 1893 and began teaching at the Art Students League, New York, in 1889. In that year he and J. Alden Weir were featured in a comparative exhibition with Claude Monet and Paul Besnard at the American Art Galleries in New York. Twachtman's painting style was superficially related to French Impressionism, but unlike the Impressionists he was concerned with projecting his emotional response to the landscape by means of rather abstract compositions built up of flat planes of thinly applied paint.

Twachtman abhorred the fast pace of life in New York; in 1889 he purchased a farm in Greenwich, Connecticut, where he painted some of his best canvases, most of which had his farm as their subject. In 1897, in protest against the conservatism of the Society of American Artists, Twachtman joined with Childe Hassam, Weir, and others to form the group known as the Ten American Painters, organizing its exhibitions at the Durand-Ruel Galleries in New York.

After 1900 his style became bolder, more brightly colored, and more energetic, especially in the canvases he painted in Gloucester, Massachusetts, where he spent several summers working with Duveneck and De Camp.

Although Twachtman exhibited regularly and won numerous important awards, including a silver medal at the 1893 World's Columbian Exposition in Chicago, the Temple Gold Medal at the Pennsylvania Academy of the Fine Arts in 1894 in Philadelphia, and a silver medal at Buffalo's Pan-American Exposition in 1901, his work was not easily understood by the public and never sold very well. However, he was consistently appreciated within the progressive artistic community. His contemporary Thomas Wilmer Dewing described him as "a landscape painter of what is called the more modern sort; he certainly represents the most modern spirit. He is too modern, probably, to be fully recognized or appreciated at present; but his place will be recognized in the future."[2] On the occasion of an exhibition of Twachtman's work in 1913, one critic wrote, "Twachtman had . . . a blend of emotional and intellectual faculties, purged of the material and lifted to a high plane of abstract, intellectualized sensation."[3]

Twachtman was a regular contributor to Carnegie Institute's annual exhibitions from their inception, and continued to be represented even after his death. He served on the International jury in 1898 and won an honorable mention in the exhibition of 1899. Three years later he died suddenly in Gloucester, at the age of forty-nine.

1 Charles H. Caffin, *The Story of American Painting* (New York, 1907), pp. 278–82.

2 Thomas Wilmer Dewing, in "John H. Twachtman: An Estimation," *North American Review* 176 (April 1903), p. 554.

3 "Paintings by Twachtman Are Shown," *New York American*, January 20, 1913.

Bibliography Eliot Clark, *John Twachtman* (New York, 1924); Alan Tucker, *John H. Twachtman* (New York, 1931); John Douglass Hale, "The Life and Creative Development of John H. Twachtman," Ph.D. diss., Ohio State University, 2 vols., 1957; Cincinnati Art Museum, *A Retrospective Exhibition: John Henry Twachtman* (1966), exh. cat. by Richard J. Boyle and Mary Welsh Baskett; Richard J. Boyle, *John Twachtman* (New York, 1979).

The Mill in Winter: A Sketch, c. 1890–1900

Oil on canvas
25¼ x 15 in. (64.1 x 38.1 cm)
Inscription: Twachtman/SALE (lower left)

This unfinished painting is a striking example of Twachtman's concern for abstract pictorial arrangement. The landscape is reduced to a few simple shapes embedded in an encrusted and scumbled paint surface that is strongly two-dimensional. This sense of flatness is reinforced by the narrow, vertical format and the high horizon line. A larger version of this same scene is Twachtman's *Old Mill in Winter* (after 1899, private collection). ST

Reference Hale, "John H. Twachtman," no. 407, cat. A.

Provenance American Art Galleries, New York, 1903 (sale of the estate of John Twachtman); E. A. Rorke, New York, until 1913; Silas S. Dustin, 1913; Andrew Carnegie, New York, 1913.

Gift of Andrew Carnegie, 1913, 13.8

River in Winter, c. 1890–1900

Oil on canvas
36 x 48 in. (91.4 x 121.9 cm)
Signature: J. H. TWACHTMAN (lower right)

One of Twachtman's favorite seasons was winter; he was fascinated by the appearance of the landscape transformed by a blanket of snow. His romantic vision of the winter landscape is revealed in a description of his farm on a December evening written to his friend J. Alden Weir in 1891:

> Tonight is a full moon, a cloudy sky to make it mysterious and a fog to increase the mystery. Just imagine how suggestive things are. . . . We must have snow and lots of it. Never is nature more lively than when it is snowing. Everything is so quiet and the whole earth seems wrapped in a mantle. That feeling of quiet and all nature is hushed to silence.[1]

This painting is probably a view of the stream that fed the hemlock pool on Twachtman's farm in Greenwich, Connecticut, since it shows a scene similar to that of Twachtman's *Misty May Morn* (1899, National Museum of American Art, Washington, D.C.), which is known to have been painted in this location. Treating the river, sky, and ground as flat bands of white accentuated with subtle tones of peach, pale turquoise, and gray, Twachtman captured the silence and sense of isolation of a winter landscape.

Twachtman's canvases resulted from painstaking preparation. Over a heavy underpainting he laid down numerous layers of paint mixed with mastic, a type of resin, allowing each layer to dry and bleach in the sun to create a heavy matte surface. As a result of this process, *River in Winter* seems enveloped in an atmospheric mist that projects the ethereal qualities of the snowy landscape on a cloudy day. The delicate tonal relationships and abstract design of the composition, stressing the curvilinear outlines of the snow-laden forms, reveal the influence of James McNeill Whistler and Japanese art. It was Twachtman's sense of design that was most admired by his contemporaries. The artist's close friend Childe Hassam wrote of Twachtman's work in 1903:

> The great beauty of design which is conspicuous in Twachtman's paintings is what impressed me always; and it is apparent to

all who see and feel, that his works were sensitive and harmonious, strong, and at the same time delicate even to evasiveness, and always alluring in their evanescence.[2]

Weir, Hassam, and Thomas Dewing were made the executors of Twachtman's estate on his death in 1902. They saw the great beauty and power in Twachtman's art but realized that his work had not been adequately appreciated by the public. They strove to have Twachtman's paintings displayed at major exhibitions all over the country after his death, including the annual exhibitions of the Pennsylvania Academy of the Fine Arts, Philadelphia, and of Carnegie Institute. *River in Winter* was purchased by

Carnegie Institute from the 1907 annual exhibition, and for many years it was considered, along with Whistler's 1884 *Arrangement in Black: Portrait of Señor Pablo de Sarasate* (see p. 481), one of the two most important canvases in its permanent collection of contemporary paintings.
ST

1 Boyle, *John Twachtman*, p. 21.

2 Childe Hassam, in "John H. Twachtman: An Estimation," *North American Review* 176 (April 1903), p. 555.

References J. O'Connor, Jr., "From Our Permanent Collection," *Carnegie Magazine* 25 (Apr. 1951), pp. 136–38; Hale, "John H. Twachtman," no. 507, cat. A.

Exhibitions Knoedler Galleries, New York, 1904, *Memorial Exhibition of Pictures by John H. Twachtman*, no. 2; Department of Fine Arts, Carnegie Institute, Pittsburgh, 1907, *Eleventh Annual Exhibition*, no. 459; Lotus Club, New York, 1907, *Exhibition of Paintings by the Late John H. Twachtman*, no cat.; San Francisco, 1915, *Panama-Pacific International Exposition*, no. 4,053; Department of Fine Arts, Carnegie Institute, Pittsburgh, 1957, *American Classics of the Nineteenth Century*, no. 101; American Federation of Arts, New York, 1963, *American Traditional Painters,* no cat.; Whitney Museum of American Art, New York, 1966, *Art of the United States, 1670–1966*, no. 280.

Provenance The artist, until 1902; his widow, Martha Twachtman, until 1907.

Purchase, 1907, 07.4

See Color Plate 19.

Spring Morning, c. 1890–1900

Oil on canvas
25 x 30 in. (63.5 x 76.2 cm)
Signature: John H. Twachtman (lower right)

The subject of this painting is the hemlock pool situated on the seventeen-acre farm in Greenwich, Connecticut, that Twachtman purchased in 1899. Around the turn of the century, the tranquility and intimacy of the area attracted a number of other artists, including J. Alden Weir, who owned a farm in Branchville, and Theodore Robinson, who was a frequent visitor at Twachtman's farm. Childe Hassam jokingly referred to the three of them as the "Cos Cob Clapboard School of Art."[1] Paintings by Twachtman and the other artists who painted nearby were usually small in size and focused on one small aspect of the landscape, such as a stream or pool, as opposed to the grandeur of nature or the vast expanses of rugged landscape depicted by the preceding generation of American painters.

Twachtman painted the hemlock pool many times, from many viewpoints, and in all seasons of the year, as, for example, in *Snowbound* (c. 1895, Art Institute of Chicago) and *Hemlock Pool (Autumn)* (c. 1890–1900, private collection, Philadelphia). Unlike Claude Monet, Twachtman was not interested in recording the changing effects of light at a distinct time and in a specific place, but rather in evoking a mood by enveloping the landscape in mysterious veils of color. In *Spring Morning* Twachtman asserted the two-dimensionality of the painted surface by emphasizing the natural curves of the trees and the water's edge, creating shapes with rhythmic, sinuous outlines. This abstract surface pattern is further accentuated by the ambiguous treatment of the trees and their reflection in the hemlock pool and by the high horizon line and almost-square format of the

painting. After 1890 Twachtman made frequent use of the square and almost-square format for his paintings, and raised the horizon line or eliminated it altogether in order to reinforce the two-dimensionality of the painted surface.

Twachtman's canvases are intimate and somewhat elusive rather than bold and monumental. In the case of this painting, the explanation might be that he loved the Connecticut landscape and wanted to be part of it. He wrote of his love of nature to Weir in 1891, "to be isolated is a fine thing. . . we are all then closer to nature."[2]

ST

1 Henry Art Gallery, University of Washington, Seattle, *American Impressionism* (1980), exh. cat., essay by William H. Gerdts, p. 68.

2 Cincinnati Art Museum, *Twachtman*, p. 21.

References Hale, "John H. Twachtman," no. 590, cat. A; Boyle, *John Twachtman*, p. 50.

Exhibitions Department of Fine Arts, Carnegie Institute, Pittsburgh, 1908, *Twelfth Annual Exhibition*, no. 304; Museum of Art, Carnegie Institute, Pittsburgh, 1957, *American Classics of the Nineteenth Century*, no. 98; Hiestand Hall Gallery, Miami University, Oxford, Ohio, 1959, *The American Scene in One Hundred Fifty Years of American Art*, no cat.; Westmoreland County Museum of Art, Greensburg, Pa., 1961, *Founder's Day Exhibition, American Painting, Eighteenth, Nineteenth, and Twentieth Centuries, from the Collection of the Carnegie Institute*, no cat.; Cincinnati Art Museum, 1966, *John Henry Twachtman: A Retrospective Exhibition*, no. 47; National Gallery of Art, Washington, D.C., 1989–90, *John Twachtman Connecticut Landscapes* (trav. exh.), no. 17.

Provenance William T. Evans, New York; Macbeth Galleries, New York, 1913.

Purchase, 1913, 13.2.1

Elihu Vedder

1836–1923

ELIHU VEDDER's provocative images of mystery and fantasy arose from a belief that the subject and message of a picture should not be limited to observable reality. Vedder was a versatile and successful artist whose works were especially appreciated in Boston and New York. But because Vedder chose to live in Rome, which was not then a center for American artistic activity, his development lies outside the currents of painting in his native country, and thus his work is often difficult to categorize.

Vedder was born in New York City, where he grew up, with summers spent in Schenectady, New York, and Havana, Cuba. His initial artistic training was with the New York genre painter Tompkins Harrison Matteson, but in 1856 Vedder cut short that association to begin a three-year residence in Europe. He studied in Paris with François-Edouard Picot, a painter of history subjects and formerly a pupil of Jacques-Louis David, then in 1857 moved on to Florence, where he completed his formal training with Raffaello Bonaiuti. Bonaiuti, an academic painter known chiefly for his copies of Fra Angelico, communicated a love of early Renaissance

art to the younger man. A more important early artistic influence, however, were the Macchiaioli, painters whose name referred to the *macchie,* or patches of light and shadow that suffused their perceptive, yet elusive, observations of the outdoors. Vedder exhibited landscapes with this group in 1860.

Forced by lack of money to return to America, Vedder settled in New York, turned to commercial illustration to support himself, and continued to work on his painting. Introduced to Boston's intellectual society, he became friendly with John La Farge and William Morris Hunt. During the early 1860s, he produced his most famous works: *The Questioner of the Sphinx* (1863, Museum of Fine Arts, Boston), *Lair of the Sea Serpent* (1864, Museum of Fine Arts, Boston), and *The Lost Mind* (1864–65, Metropolitan Museum of Art, New York). These images probed the mysteries of man's existence and relied upon startling juxtapositions of objects and setting for their unusual, haunting quality. Vedder's increasing success was marked by his election to the National Academy of Design, as an associate in 1863 and as a full member in 1865.

He returned to Europe in 1866, first to Paris, then to Rome, where he raised his family and remained for the rest of his life. He continued to paint landscapes but turned increasingly to literary sources such as the Bible and Greek mythology for inspiration. Over time, these allegories took on an increasingly dry, sinuously patterned quality.

In 1884 Vedder's illustrations for Edward FitzGerald's translations of the *Rubáiyát of Omar Khayyám*—perhaps his best-remembered work—were published. For the next decade and a half, the artist was at the peak of his popularity. His projects of the 1880s and 1890s included magazine illustrations, designs for decorative tiles and firebacks, stained glass, and murals. The best known of his murals are those in the Walker Art Building of Bowdoin College, Brunswick, Maine (1894), and at the entrance to the main reading room of the Library of Congress, Washington, D. C. (1896–97). Shortly after 1900 Vedder stopped painting in order to devote more time to his poetry and his memoirs, which became the preoccupation of the last decades of his life.

The recognition Vedder received during his lifetime included exhibitions in Boston and New York (1887); London (1899); Pittsburgh, Chicago, and Buffalo (1900–1901); and again in New York (1912). His work appeared at various intervals in the major annual art exhibitions in the United States, including the National Academy of Design, New York, the Boston Athenaeum, and the Carnegie International.

At the first Carnegie International in 1896, Vedder exhibited five works—a considerable number—and contributed again in 1898 and 1913. In 1897 he was nominated to the jury of award but

refused the honor because he found it impossible to leave Italy. In 1908 he was elected to the American Academy of Arts and Letters.

Bibliography Elihu Vedder, *The Digressions of V.* (Boston, 1910); Frank Jewett Mather, Jr., *Estimates in Art* (New York, 1970), pp. 72–86; Regina Soria, *Elihu Vedder: American Visionary Artist in Rome, 1836–1923* (Rutherford, N.J., 1970); National Collection of Fine Arts, Washington, D.C., *Perceptions and Evocations: The Art of Elihu Vedder* (1979), exh. cat., introduction by Regina Soria; Carter Ratcliff, "The Gender of Mystery: Elihu Vedder," *Art in America* 67 (November 1979), pp. 84–92.

Landscape with Woman, Bordighera, c. 1866–69

Oil on canvas
12¾ x 5⅝ in. (32.4 x 14.3 cm)
Signatures, inscription: V (lower right);
E. Vedder Bordighera (on reverse)

Landscape with Woman, Bordighera dates from the first few years of Vedder's residence in Italy. The site is a village on the hilly northwestern coast of Italy near Ventimiglia and not far from the present border with France. Vedder's correspondence documents that he visited Bordighera at least three times: the first time on his way to Rome in December 1866; in early 1868, accompanied by Elizabeth Caroline ("Carrie") Rosekrans, then his fiancée; and again during their honeymoon in 1869. Their happiness together must have imbued the spot with special significance and warmth, for there Vedder painted some of his finest landscapes.

In the Carnegie painting, Vedder viewed the peasant washerwoman and the sunlit hills behind her in the tradition of the Macchiaioli, as a complex arrangement of abstract shapes in subtle tones rather than as modeled three-dimensional forms set in space. The pattern of light and dark was more important than minute detail or surface textures.

Vedder painted several of the Bordighera scenes on long, horizontally aligned canvases, which was a format preferred by several Italian landscape and history painters of the day. Here, as in a few other instances, Vedder varied his composition by simply turning the canvas on end and employing a high horizon line. While such works hardly constitute

a majority of his early production, around 1866–67 Vedder painted several small landscapes with dimensions like those of the Carnegie work.
LBF

Provenance Sloan and Roman Co., New York; Senator and Mrs. H. John Heinz III.

Gift of Senator and Mrs. H. John Heinz III, Pittsburgh, 1979, 79.71.6

The Keeper of the Threshold, 1897–98
(An Emblem of Life)

Oil on canvas
51¾ x 51¾ in. (131.4 x 131.4 cm)
Signatures, inscription, dates: Elihu Vedder 1897–98 (lower right, on serpent); copyrighted by / Elihu Vedder / 1898 (lower center)

Completed at nearly the end of Vedder's painting career, *The Keeper of the Threshold* is very different from his tiny, directly observed landscape of thirty years

earlier. *The Keeper of the Threshold* is a more formally complex and artificial work. Vedder painted it in a hard, dry manner, outlining his forms clearly and using cool colors that are reminiscent of the mural project he completed in 1897 for the main-reading-room entrance of the Library of Congress, Washington, D.C. It was exhibited twice at Carnegie Institute before its purchase for the permanent collection: at the annual exhibition of 1898 and at a 1901 exhibition of Vedder's works that traveled to several other American cities.

The significance of the mandala-like composition of a circle within a square, the seated youth, his attributes, and the ambiguous setting remains unclear because Vedder was reluctant to discuss it. However, the 1901 Vedder exhibition catalogue says of the painting:

> It will be found to contain ideas similar to those which through the ages men of thought have formed of the beauty and terror of the mystery of existence. Vedder says to explain a mystery is to destroy it, and as he himself has not as yet solved it, he can only represent it as it appears to him. It may be that the ascending flame is the aspiration of the soul, and that by strongly willing, the soul attains its desire; it may be that the sharp pointed sword is death; it may be that the serpent is evil, which apparently forms an inseparable component of life; it may be that the steps are evolution . . . ; it may be that the pulsation is a method of growth, the breathing of the universe; it may be that the iridescent emanations rising . . . into the light and again descending into the pool are reincarnation; but with all these maybes, be it as it may, as in life, each one must solve the mystery for himself.[1]

Much of the effect and appeal of *The Keeper of the Threshold* comes from its exotic, mystical quality. The threshold apparently lies between the here and the hereafter and reflects Vedder's interest in Buddhism, the occult, and theosophy. The Asian youth looks out impassively, sitting Buddha-like. The faint inscription on the staircase is untranslatable; it is written in Alfaru, a phonetic alphabet that Vedder created, whose characters derive from natural objects.

A painting of 1891 entitled *Soul in Bondage* (Brooklyn Museum, N.Y.), considered by Vedder to be "an important picture,"[2] is similar to *The Keeper of the*

Threshold in several significant ways. Both the soul and the keeper sit on a staircase and are surrounded by vapors that drift upward in S curves. Similar vapors appear in many *Rubáiyát of Omar Khayyám* illustrations. Vedder called the place where these vapors meet "the instant of life."[3] Both paintings thus convey the duality of matter and states of mind.

Other works painted by Vedder around 1890 imply this duality. Several have in common the shining disk, or halo, placed behind a figure to signify its otherworldliness, as in *The Keeper of the Threshold*. In *Love Ever Present* (also titled *Amor Omnia Vincit*, 1887–96, collection James Ricau, Piermont, N.Y.), love stands on a pedestal between two aspects of love, sensuality and the soul. Another canvas, *The Soul Between Doubt and Faith* (c. 1887, Herbert F. Johnson Museum of Art, Ithaca, N.Y.), depicts an enhaloed Faith—whose hair fans out as if by electrostatic force—as the eternal presence in the universe.

Closely related to *The Keeper of the Threshold* is a finished pastel-on-paper study also titled *The Keeper of the Threshold* (c. 1897, Georgia Museum of Art, Athens), which depicts the painting's central figure.

LBF

1 Department of Fine Arts, Carnegie Institute, Pittsburgh, *Exhibition of Works by Elihu Vedder* (1901), no. 10.

2 Vedder, *Digressions of V.*, p. 487.

3 National Collection of Fine Arts, Washington, D.C., *Perceptions and Evocations*, p. 164, n. 27.

References C. H. Caffin, *The Story of American Painting: The Evolution of Painting in America from Colonial Times to the Present* (New York, 1907), p. 175; Vedder, *The Digressions of V.*, p. 497; "Notable Paintings from the Carnegie Art Galleries, and Something about the Artists," *Pittsburgh Post*, Mar. 15, 1912, p. 6; J. W. McSpraden, *Famous Painters of America* (New York, 1916), pp. 157–59; R. Soria, *Elihu Vedder: American Visionary Artist in Rome*, pp. 228–29, 345–46; K. M. McClinton, "L. Prang and Company Chromos," *Connoisseur* 191 (Feb. 1976), p. 105; R. Soria, "Elihu Vedder: American Old Master," *Georgia Museum of Art Bulletin*, 2 (Spring 1976), pp. 28–29; V. A. Clark, "Collecting from the Internationals," *Carnegie Magazine* 54 (Sept.–Oct. 1982), p. 17.

Exhibitions Department of Fine Arts, Carnegie Institute, Pittsburgh, 1898, *Third Annual Exhibition*, no. 61; Department of Fine Arts, Carnegie Institute, Pittsburgh, 1901, *Exhibition of Works by Elihu Vedder*, no. 10; Pan-American Exposition, Buffalo, 1901, *Exhibition of Fine Arts*, no. 75; Minneapolis Institute of Arts, 1915, *Inaugural Exhibition*, no. 303; New York Cultural Center, 1975, *Three Centuries of the American Nude*, no. 42; University Art Gallery, University of Pittsburgh, 1978, *Art Nouveau*, no. II-7; National Collection of Fine Arts, Washington, D.C., 1979, *Perceptions and Evocations: The Art of Elihu Vedder*, exh. cat., introduction by R. Soria, no. 238; Detroit Institute of Arts, 1983, *The Quest for Unity: American Art between World's Fairs, 1876–1893*, no. 64.

Provenance The artist, until 1901.

Purchase, 1901, 01.1

A. Bryan Wall

1861–1935

ALFRED BRYAN WALL was born and raised in Allegheny City, which is now part of Pittsburgh. He did not study art formally, but learned from his father, landscape painter Alfred S. Wall, and other local artists, who included him in their frequent sketching trips to Scalp Level, a popular Barbizon-like retreat about sixty miles east of Pittsburgh. At eighteen he exhibited his first work, *Catawba Grapes* (location unknown), at the National Academy of Design, New York. Thereafter, he participated regularly in local exhibitions, including seventeen Carnegie Internationals between 1896 and 1925. A member of the Art Society of Pittsburgh and the Pittsburgh Artists Association, he achieved a significant reputation locally.

For a brief period around 1900, Wall maintained a studio in Philadelphia; there he joined the Philadelphia Art Club and exhibited at the Pennsylvania Academy of the Fine Arts. In 1907 he was awarded a gold medal by the American Art Society for a work exhibited in Philadelphia. He became friendly with Thomas Eakins, who asked to paint Wall's portrait (c. 1904, Bowdoin College Museum of Art,

Brunswick, Me.). Wall later recalled this request with some amusement: "Eakins left a note at my studio in Philadelphia for me one day. . . it was so badly scribbled that I thought he wanted to punch my head in instead of painting it."[1]

Wall painted portraits, including those of Andrew Carnegie and the wife of Henry Clay Frick, and landscapes; he is best known, however, for his autumnal views of sheep, the subject that dominated his work after 1880. Though repetitious, these peaceful pastoral scenes are each painted without sentimentality, in the best Barbizon tradition. In 1886 the local historian Erasmus Wilson described Wall's dedication to sketching sheep:

> Bundled up in an overcoat, muffler and big shoes, and provided with a pocketful of bran-and-salt, he would saunter out in search of sheep. You know how one saunters on a cold day, with the wind fairly taking the skin off. When found the sheep had first to be inveigled into a pen with the bran-and-salt, and then coaxed in the same way to keep still long enough to get a lick at them. . . . Without taking into consideration the difficulties under which the sketches were made, it is but just to say they are the best specimens of sheep on canvas that have been seen in this city recently, if ever before. . . . Each one full of character, even suggesting the stormy state of the weather by its attitude or expression.[2]

The Walls were friends of Andrew Carnegie, who encouraged Bryan to paint; in 1896 Bryan succeeded his father as a trustee of Carnegie Institute, where he served on the Fine Arts Committee

until 1934. He died the following year in Pittsburgh.

1 Redd, "Northside Studio," p. 6.
2 Wilson, "Quiet Observations," pp. 384–85.

Bibliography Erasmus Wilson, *Quiet Observations on the Ways of the World* (New York, 1886), pp. 384–85; "Pittsburgh's Artist Colony," Pittsburgh *Bulletin* 32, January 11, 1896, p. 7; Penelope Redd, "Northside Studio Has Many Bits of Landscape Scenes," *Pittsburgh Post*, September 16, 1923, sec. 6, p. 6; Westmoreland County Museum of Art, Greensburg, Pa., *Southwestern Pennsylvania Painters, 1800–1945* (1981), exh. cat. ed. by Paul A. Chew and John A. Sakal; Nancy Colvin, "The Scalp Level Artists," *Carnegie Magazine* 57 (September–October 1984), pp. 14–20.

Farm Scene, c. 1900–1910

Oil on canvas
20 x 30 in. (50.8 x 76.2 cm)
Signature: A. Bryan Wall (lower left)

Landscape with Sheep, c. 1900–1910

Oil on canvas
20 x 30 in. (50.8 x 76.2 cm)
Signatures: A Bryan Wall. (lower right); A. Bryan Wall (lower left, partially erased)

Bryan Wall once told a reporter that the subject of sheep had preoccupied him from the time he was about twenty years

old, when on a painting trip to Block Island he had observed a three-legged lamb on a neighboring farm and had stopped to draw it.[1] Typical of his work in this genre, *Farm Scene* and *Landscape with Sheep* were probably painted from sketches made at Scalp Level in southwestern Pennsylvania.

In *Landscape with Sheep*, a young man feeds a flock of sheep gathered around him; a stray sheep in the foreground walks toward the others, leading the viewer's eye into the center of the composition where the sheep stand in a variety of poses. The figure of the farmhand, silhouetted against the overcast sky, draws attention to the deep space behind him and to the hills rolling into the distance. *Farm Scene* is similarly composed, but here man's presence is only suggested by the barn in the background and by the sheep that stare at the viewer. In both works the softly lit, late-autumn landscape is enlivened with energetic strokes of brown, gold, and red.

Orginally inspired by Dutch painters such as Albert Cuyp, scenes of domesticated animals in their natural environment flourished with the French Barbizon painters, notably with Charles-Emile Jacque, Constant Troyon, and Jean-François Millet. Wall's humble vision of rural life represents a late manifestation of the Barbizon influence that prevailed among Pittsburgh artists during the last quarter of the nineteenth century. "Animalscapes" were popular among urban viewers, many of whom had recently left the farm, and Wall, during his long and productive career, was able to sustain his specialty of painting sheep. To his credit, the artist did not overly indulge in sentiment; instead, he used the animal genre as a vehicle for the exploration of atmospheric mood and soft painterly effects.

GB

1 Redd, "Northside Studio," p. 6.

Farm Scene

Exhibitions Westmoreland County Museum of Art, Greensburg, Pa., 1976, *Nineteenth and Early Twentieth Century Regional Painters*, exh. cat. by P. A. Chew and J. A. Sakal, unnumbered; William Penn Memorial Museum, Harrisburg, Pa., 1979, *Pennsylvania Landscape Survey*, no cat.

Provenance Robert S. Waters, Johnstown, Pa.

Bequest of Robert S. Waters, 1972, 72.14.10

Landscape with Sheep

Exhibition Westmoreland County Museum of Art, Greensburg, Pa., 1976, *Nineteenth and Early Twentieth Century Regional Painters*, exh. cat. by P. A. Chew and J. A. Sakal, unnumbered.

Provenance Robert S. Waters, Johnstown, Pa.

Bequest of Robert S. Waters, 1972, 72.14.9

Alfred S. Wall
1825–1896

SHORTLY BEFORE HIS BIRTH, Alfred S. Wall's family emigrated from Oxford, England, to settle at Mount Pleasant, Pennsylvania, a town about forty miles east of Pittsburgh. Determined to become a painter, Wall moved sometime in the 1840s to Pittsburgh, where he joined his older brother, William Coventry Wall, who was already working there as an artist and picture framer. The two brothers were essentially self-taught artists who acquired their skills through contact with other local painters.

Wall occasionally painted genre scenes and portraits, but his primary interest was landscape. He joined the group of Pittsburgh painters who frequented the Scalp Level area in the Allegheny Mountains east of Pittsburgh to gather material for their paintings. Although he never went to Europe for training, Wall's moody style was strongly influenced by the French Barbizon school painters. At times Wall experimented with even freer techniques, applying pigment loosely to produce a richly colored surface.

Characterized by his contemporaries as a "man of deep thought who stimulated those around him,"[1] Wall became an important member of Pittsburgh's art community. For many years he worked at J. J. Gillespie's galleries, where Pittsburgh

artists had gathered to exhibit their work and to socialize since the late 1830s. When Gillespie died in 1886, Wall, in partnership with A. C. McCallum, took over the gallery. In 1896 a local columnist paid tribute to Wall's success when he wrote, "[Wall's] ability as judge of art work and his wide experience make his opinion sought after and valued."[2] Wall's studio on Wood Street was a favorite meeting place for local artists. His colleague Martin B. Leisser recalled in 1910:

> Mr. Wall's opinions in matters of art, particularly in relation to tone and color, were always highly respected. . . . Just as the artists and art lovers used to congregate in Hetzel's studio [George Hetzel, a prominent Pittsburgh landscapist], so did they seek Alfred S. Wall's. Here the question, what is art, color, tone quality, and all the elements that are essential in the production of a good work of art were thoroughly discussed, often ending in heated arguments, for artists, like doctors, sometimes disagree.[3]

Wall was a founding member of the Art Society of Pittsburgh in 1873, and he served on Carnegie Institute's original Board of Trustees, to which he was elected shortly before his death, in Pittsburgh.

Working in pastels as well as oils, Wall exhibited with the Pittsburgh Art Association, the Western Pennsylvania Exposition Society, Pittsburgh, the Pennsylvania Academy of the Fine Arts, Philadelphia (in 1867), and in the 1897 Carnegie International. He contributed several works to the Sanitary Fair that was held in Pittsburgh in 1864 to help raise funds for medical supplies during the Civil War.

Although business and organizational responsibilities limited Wall's productivity as an artist, his work was highly regarded by his contemporaries. In 1877 a reporter quoted Wall as an authority on art and described him as "a gentleman well known for the last fifteen or twenty years as one of our ablest artists."[4] Wall's daughter, Bessie, and his son, Alfred Bryan, both became artists, carrying the family tradition into the twentieth century.

1 Harper, *Pittsburgh of Today*, p. 736.

2 "Pittsburgh's Artist Colony," p. 7.

3 Leisser, "Art in Pittsburgh," p. 4.

4 Agnes Way, "Newspaper Cuttings Collected by Agnes Way," Scrapbook, c. 1870–1935, in Music and Art Division, The Carnegie Library, Pittsburgh, p. 33.

Bibliography Erasmus Wilson, *Quiet Observations on the Ways of the World* (New York, 1886), p. 388; "Pittsburgh's Artist Colony," Pittsburgh *Bulletin* 32, January 11, 1896, p. 7; Martin B. Leisser, "Art in Pittsburgh," Pittsburgh *Gazette Times*, May 2, 1910, p. 4; Frank C. Harper, *Pittsburgh of Today* (New York, 1931), vol. 2, pp. 735–36; George Swetnam, "Art without Appreciation: Western Pennsylvania Painters and Sculptors," in Homer T. Rosenberger, ed., *Pennsylvania's Contributions to Art* (Waynesboro, Pa., 1967), pp. 37–52.

Landscape with Figures, 1866

Oil on canvas
27½ x 46 in. (69.9 x 116.8 cm)
Signature, date: Alfred S Wall/1866 (lower left)

In his mature work Wall specialized in autumn landscapes, capitalizing on the season's muted colors and sparse foliage to explore a melancholy mood. *Landscape with Figures*, though early, contains many of the elements that are regularly found in these late paintings: leafless trees silhouetted against a light sky, fallen logs across a stream, deep shadows, and a few anonymous figures. What marks this painting as early is the inclusion of an anecdotal genre scene in which two women and a child stop along the path to speak with a boy and a man who are seated beside a tree. Although the figures are dwarfed by the forest setting, the youth's gesture of greeting reduces the aspect of threat and invites the speculation that he is directing them to the Conestoga wagon barely visible in the distance. In his later work, Wall rarely included such specific scenes; such figures as he used in his landscapes are generalized and serve as vehicles for the poetic content of the work.
GB

Provenance Henry J. Heinz II, Pittsburgh, until 1957.

Gift of Mr. and Mrs. Henry J. Heinz II, 1957, 57.6.5

Landscape, c. 1875–80

Oil on canvas
36⅛ x 22 in. (91.8 x 55.9 cm)
Signature: A. S. Wall (lower center)

In addition to his responsibilities at J. J. Gillespie galleries, Wall actively pursued his work as an artist, making seasonal excursions into the country to paint from nature. A forest view in autumn such as that represented in *Landscape* was one of Wall's favorite subjects. His accomplished brushwork and sensitivity to the beauty of the countryside drew accolades from his contemporaries. As a reporter from the weekly Pittsburgh *Bulletin* commented, "When he elects to paint a picture his talent is clearly revealed, and his virile strokes and mastery of color are wrought into captivating portrayals of forest and field."[1]

Wall's method, described as being "akin . . . to that of the Barbizon men,"[2] generally included a subdued palette, soft chiaroscuro, and obvious brushstrokes. In *Landscape*, the inclusion of two solitary figures further allies Wall's woodland scene with the Barbizon school. Small and alone, these anonymous figures enhance the evocative qualities of the picture. The fallen branches and the high embankment form natural barriers distancing the figures from the viewer, a

device that intensifies their isolation. Wall's goal was not strictly realism; he chose to convey a mood rather than to record a specific event.

GB

1 "Pittsburgh's Artist Colony," p. 7.

2 Harper, *Pittsburgh of Today*, p. 736.

Exhibition Westmoreland County Museum of Art, Greensburg, Pa., 1981, *Southwestern Pennsylvania Painters, 1800–1945*, exh. cat. by P. A. Chew and J. A. Sakal, no. 258.

Provenance Henry Lee Mason, Jr., Pittsburgh, until 1952.

Bequest of Henry Lee Mason, Jr., 1952, 52.21.5

Mountain Brook in Autumn, c. 1875–80

Oil on canvas
27¾ x 46½ in. (70.5 x 118.1 cm)
Signature: A. S. Wall (lower right)

Alfred Wall was one of a small group of Pittsburgh artists who made frequent trips to the Scalp Level area of Somerset County to sketch. Like his friend and

contemporary George Hetzel, Wall concentrated on forest scenes. His paintings are gentle statements; it is characteristic that *Mountain Brook in Autumn* depicts a quiet woodland scene suffused with warm autumnal color. Here Wall uses traditional perspective techniques to draw the viewer into the painting: the narrow stream bed meanders into the depth of the picture, and on each side of the creek a row of trees forms a line of perspective into the center of the scene.

In its careful attention to composition, Wall's work resembles that of Hetzel, who, with his early training in Düsseldorf, doubtless influenced his unschooled colleague. Wall, however, replaced Hetzel's meticulous detailing with a somewhat looser rendering of form. Through the use of low-keyed coloring he created the mood of an autumn day rather than a realistic depiction. In this respect, *Mountain Brook in Autumn* has much in common with the poetical landscapes of the French Barbizon painters, which were popular in America during the 1870s and 1880s. Like his European counterparts, Wall used a rich red-brown undercoat to impart a warm tonality to the work and a painterly technique to enliven the surface. With a variety of brushstrokes, Wall captured the flickering colors of autumn leaves and the transient patterns of dappled sunlight.

GB

Provenance Elizabeth Verner Long, until 1916.

Gift of the executors of the estate of Elizabeth Verner Long, 1916, 16.12

Sunlight and Shadow, c. 1880–85

Oil on canvas
19⅞ x 30 in. (50.5 x 76.2 cm)
Signature: A. S. Wall (lower right)

With its cows and herdsmen, this painting was probably inspired by the rural scenery in the foothills of the Allegheny Mountains where Wall and other Pittsburgh artists frequently retreated to paint. The work offers a view through the trees of a remote hillside in the country on a summer day.

For the most part, Wall's paintings had much in common with the popular landscapes of the Barbizon painters; with subtle brushwork, Wall skillfully captured the nuances of nature's seasonal moods. In *Sunlight and Shadow*, however, Wall departed from this style. Here, detail is replaced by a casual rendering of form and the layering of the paint in heavy impasto; indeed, certain areas of the canvas appear to have been painted with a palette knife. Wall's typical muted tones are relieved by bright greens and yellows, and brilliant white highlights dramatically re-create the patches of sunlight that penetrate the dense foliage. The cattle, in no way the subject of the painting, are treated summarily, their mottled coloring blended with the overall texture of the work.

Clearly related to *Woodland Scene* (see p. 468) in style and technique, *Sunshine and Shadow* further demonstrates the artist's willingness to experiment. It is this quality that makes Wall's work distinctive among Pittsburgh artists of his day. Indeed, this bold painting and others like it contributed to the posthumous assessment that Wall's landscapes "evinced a

good, broad, healthy conception and were free and masterful in their treatment."[1]

GB

1 Leisser, "Art in Pittsburgh," p. 4.

Exhibitions Department of Fine Arts, Carnegie Institute, Pittsburgh, 1939, *A Century of American Landscape Painting*, no. 78; Department of Fine Arts, Carnegie Institute, Pittsburgh, organized by the University of Pittsburgh, 1956, *Painters from Pittsburgh: The Frontier Settlement and the Industrial Development*, no. 25, as *Sunlight and Shadows;* Westmoreland County Museum of Art, Greensburg, Pa., 1959, *Two Hundred and Fifty Years of Art in Pennsylvania*, exh. cat. by P. A. Chew, no. 125.

Provenance The artist's widow, Pittsburgh, until 1916.

Purchase, 1916, 16.9.2

Woodland Scene, c. 1883

Oil on canvas mounted on board
16⅛ x 11⅛ in. (41 x 28.3 cm)
Signature: A. S. W. (lower left)
Inscription: Alfred S. Wall/Presented to/John W. Beatty/1883 (on reverse)

This painting was completed by 1883, when the artist presented it to John W. Beatty, who was Wall's friend and fellow artist. (Beatty later became Carnegie Institute's first director of the Department of Fine Arts.) Painted in heavy impasto, this depiction of stark, bare trees silhouetted against a luminous sky is exceptional in Wall's work, demonstrating his willingness to experiment.

In contrast to the more realistic forest views that Wall usually painted, the trees in *Woodland Scene* rise above a low horizon, creating a nearly abstract design on the picture surface. The abrupt cropping

of forms at the edges of the canvas presents a further challenge to natural perspective. Wall's dark palette, which includes greens, ochers, and browns, and his obscure details add to the somber tone of this work.

While distinctive, Wall's technique of applying thick paint in broad strokes was not uncommon among late Barbizon-influenced painters in America. Dwight William Tryon, George Inness, and Alexander Wyant, for example, all sometimes exaggerated their painterly approach to create richly textured surfaces. In Wall's work, however, it represented a new level of personal expression and perhaps explains why he considered this work an appropriate gift for a friend.

GB

Provenance John W. Beatty, Pittsburgh, 1883; his son, John W. Beatty, Jr., 1924.

Gift of John W. Beatty, Jr., 1964, 64.10.11

William C. Wall
1810–1886

BORN IN OXFORD, England, William Coventry Wall immigrated with his parents to the United States in the early 1820s and settled near Pittsburgh in Mount Pleasant, Pennsylvania. Beginning around 1843 he made and sold mirror and picture frames from a variety store on Pittsburgh's Fourth Street. He also sold artist's supplies there, painted portraits and landscapes, and exhibited them. Wall became a prolific, albeit somewhat primitive painter, who made the landscape of western Pennsylvania his specialty. He regularly exhibited his paintings locally and once, in 1855, had his work shown at the Pennsylvania Academy of the Fine Arts in Philadelphia. He died in Pittsburgh.

Unlike his brother, the painter Alfred S. Wall, William was only marginally affected by contemporary landscape painting. He remained a stylistically conservative view painter of modest ambitions, whose historical importance lay in being among the early resident artists in Pittsburgh. He is best known today for two works painted early in his career and now owned by The Carnegie Museum of Art: *Pittsburgh after the Fire from Birmingham* and *Pittsburgh after the Fire from Boyd's Hill.*

Bibliography Martin B. Leisser, "Art in Pittsburgh," Pittsburgh *Gazette Times*, May 2, 1910, p. 4.; Westmoreland County Museum of Art, Greensburg, Pa., *Southwestern Pennsylvania Painters, 1800–1945* (1981), exh. cat. by Paul A. Chew and John A. Sakal, pp. 141–43.

Pittsburgh after the Fire from Birmingham, c. 1845

Oil on canvas mounted on pulpboard
8⅝ x 27½ in. (21.9 x 69.9 cm)
Signature, date: W. C. Wall./1845. (lower left)
Inscription: View of the ruins of Pittsburgh two days after the great fire of the 10th of April 1845./from near Birmingham/W. C. Wall (on reverse)

Pittsburgh after the Fire from Boyd's Hill, c. 1845

Oil on canvas mounted on pulpboard
9½ x 14½ in. (24.1 x 36.8 cm)
Signature, date: W. C. Wall 1845. (lower right)
Inscription: View of the ruins of Pittsburgh three days after the/great fire of the 10th of April 1845./from Boyd's Hill./W. C. Wall. (on reverse)

William C. Wall was an eyewitness to Pittsburgh's catastrophic fire of Thursday, April 10, 1845. Inadvertently begun by a careless housewife who was heating wash water in her backyard, the fire destroyed a third of the city, including much of the commercial district, and left thousands homeless. It became national news.

Wall soon made two views of the disaster—*Pittsburgh after the Fire from Birmingham* and *Pittsburgh after the Fire from Boyd's Hill*—representing the city as it appeared on April 12 and April 13, 1845, respectively. Together with a view of Pittsburgh before the fire, they were made into lithographs by the Philadelphia printmaker James Queen. The same lithographs, in a larger, colored format, were subsequently offered to subscribers of the newspapers *Iron City* and the *Pittsburgh Weekly Chronicle*.[1] These lithographs became the most widely known visual accounts of the great fire, and they made Wall's reputation.

The Carnegie's two paintings were the prototype compositions for James Queen's lithographs, although the small-size pair of prints may well have been sold afterwards as cabinet pictures. The two paintings show the same grim scene of charred brick buildings upon the otherwise barren hill of the city, albeit at different times and from different points of view. *Pittsburgh after the Fire from Birmingham* has the south bank of the Monongahela River as its vantage point, which clearly shows the piers of the ruined covered bridge. It is broad daylight, and smoke rises from the still-smoldering city. *Pittsburgh after the Fire from Boyd's Hill* is seen from the bluff (now the site of Duquesne University) that was the center of the fire damage. In a faintly allegorical way, the fire's heat has subsided, while day has become dusk.

Interestingly enough, when these works were rediscovered in the 1940s, it was assumed that they were transcribed directly from the scene on April 12 and 13.

In truth, Wall was less concerned with reportorial immediacy than with finding established formats into which he could insert his observations, editing them accordingly. Indeed, for both settings, Wall borrowed substantially from earlier pictorial conventions.

Pittsburgh after the Fire from Birmingham conforms to a rather outmoded compositional type: a view across a river, its foreground set off by a shadowy part of the bank and staffage figures. The man-made structures in such compositions were often relatively larger than the surrounding terrain. Such landscapes could still be found in topographical engravings for books; by taking over that typology, Wall showed himself truer to conventions of old-time printmaking than to current attitudes toward landscape painting.

Wall's companion view, *Pittsburgh after the Fire from Boyd's Hill*, is more eerily evocative, but was still produced by simple, standard means. Its perspective diminishes along a central axis, with the spire of the Third Presbyterian Church reinforcing the vanishing point. As distance increases, the reddish brown of the foreground changes evenly to blue-gray. A high vantage point enables the viewer to look into the ruined buildings, whose emptiness is accentuated by the long shadows they cast. The effect is similar to,

and probably derived from, British depictions of Gothic ruins such as Tintern Abbey in Wales, which would have been readily available to the artist through book illustrations.

DS

1 Dorothy E. Glassburn, "The Artist Reports on the Fire of 1845: Two Paintings by W. C. Wall," *Carnegie Magazine* 18 (March 1945), p. 301.

Pittsburgh after the Fire from Birmingham

References D. E. Glassburn, "The Artist Reports on the Fire of 1845: Two Paintings by W. C. Wall," *Carnegie Magazine* 18 (Mar. 1945), pp. 300–302; R. Demorest, "Pittsburgh and the Great Fire of 1845," *Greater Pittsburgh* 25 (Apr. 1945), pp. 10–12; N. Colvin, "The Scalp Level Artists," *Carnegie Magazine* 57 (Sept.–Oct. 1984), p. 18; W. H. Gerdts, *Art across America: Two Centuries of Regional Painting* (New York, 1990), vol. 1, p. 286.

Exhibitions Western Pennsylvania Exposition Society, Pittsburgh, 1889, *First Annual Exposition*, no. 520; Department of Fine Arts, Carnegie Institute, Pittsburgh, 1916, *An Exhibition of Historical Portraits, Paintings, Prints, Drawings and Relics Presented by the Historical Society of Western Pennsylvania*, unnumbered; Department of Fine Arts, Carnegie Institute, Pittsburgh, 1936, *An Exhibition of American Genre Paintings*, no. 87; University Art Gallery, University of Pittsburgh, 1938, *Exhibition of Paintings by Pittsburgh Artists of the Nineteenth*

Century, no. 20; University Art Gallery, University of Pittsburgh, 1941, *Old Pittsburgh,* unnumbered; Historical Society of Western Pennsylvania, Pittsburgh, 1945, *Commemoration of the One-Hundredth Anniversary of the Big Fire of 1845,* no cat.; Museum of Art, Pennsylvania State University, University Park, 1955, *Pennsylvania Painters' Centennial Exhibition,* no. 25; Smithsonian Institution Traveling Exhibition Service, Washington, D.C., 1955, *Pennsylvania Painters* (trav. exh.), no. 26; Westmoreland County Museum of Art, Greensburg, Pa., 1959, *Two Hundred and Fifty Years of Art in Pennsylvania,* exh. cat. by P. A. Chew, no. 126; Fort Pitt Museum, Pittsburgh, 1975, *Bicentennial Art Exhibition,* no cat.; Westmoreland County Museum of Art, Greensburg, Pa., 1976, *Nineteenth and Early Twentieth Century Regional Painters,* exh. cat. by P. A. Chew and J. K. Maguire, unnumbered; William Penn Memorial Museum, Harrisburg, Pa., 1979, *Pennsylvania Painters from Commonwealth Collections,* no. 52; Westmoreland County Museum of Art, Greensburg, Pa., 1981, *Southwestern Pennsylvania Painters, 1800–1945,* exh. cat. by P. A. Chew and J. A. Sakal, no. 265.

Provenance William Darlington, Pittsburgh, by 1889; Mary O'Hara Darlington, Pittsburgh, by 1916.

Gift of the estate of Mary O'Hara Darlington, 1925, 25.15.3

Pittsburgh after the Fire from Boyd's Hill

References D. E. Glassburn, "The Artist Reports on the Fire of 1845: Two Paintings by W. C. Wall," *Carnegie Magazine* 18 (Mar. 1945), pp. 300–302; R. Demorest, "Pittsburgh and The Great Fire of 1845," *Greater Pittsburgh* (Apr. 1945), pp. 10–12.; "Centenary of the Pittsburgh Fire of 1845," *Antiques* 48 (Sept. 1945), p. 156.

Exhibitions Western Pennsylvania Exposition Society, Pittsburgh, 1889, *First Annual Exposition,* no. 519; Department of Fine Arts, Carnegie Institute, Pittsburgh, 1916, *An Exhibition of Historical Portraits, Paintings, Prints, Drawings and Relics, Presented by the Historical Society of Western Pennsylvania,* unnumbered; Department of Fine Arts, Carnegie Institute, Pittsburgh, 1936, *An Exhibition of American Genre Paintings,* no. 88; University Art Gallery, University of Pittsburgh, 1938, *Exhibition of Paintings by Pittsburgh Artists of the Nineteenth Century,* no. 19; University Art Gallery, University of Pittsburgh, 1941, *Old Pittsburgh,* unnumbered; Historical Society of Western Pennsylvania, Pittsburgh, 1945, *Commemoration of the One-Hundredth Anniversary of the Big Fire of 1845,* no cat.; Museum of Art, Pennsylvania State University, University Park, 1955, *Pennsylvania Painters' Centennial Exhibition,* no. 26; Department of Fine Arts, Carnegie Institute, Pittsburgh, organized by

the University of Pittsburgh, 1956, *Painters from Pittsburgh: The Frontier Settlement and the Industrial Development,* no. 27; Westmoreland County Museum of Art, Greensburg, Pa., 1976, *Nineteenth and Early Twentieth Century Regional Painters,* exh. cat. by P. A. Chew and J. K. Maguire, unnumbered; Saint Louis Art Museum, 1977, *Currents of Expansion: Painting in the Midwest, 1820–1940,* no. 28; Westmoreland County Museum of Art, Greensburg, Pa., 1981, *Southwestern Pennsylvania Painters, 1800–1945,* exh. cat. by P. A. Chew and J. A. Sakal, no. 266.

Provenance William Darlington, Pittsburgh, by 1889; Mary O'Hara Darlington, Pittsburgh, by 1916.

Gift of the estate of Mary O'Hara Darlington, 1925, 25.15.2

View of the Great Fire of Pittsburgh, 1846

Oil on canvas
19½ x 31 in. (49.5 x 78.7 cm)
Signature, date: W. C. Wall/1846 (lower left, on fallen tree)

View of the Great Fire of Pittsburgh, c. 1846

Oil on canvas
20 x 32⁵⁄₁₆ in. (50.8 x 82.1 cm)
Inscription, signature: View of Great Fire of Pittsburgh, April 10, 1845/W. C. Wall (on reverse, upper right)

These nearly identical canvases—one bearing the date 1846, the other undated but painted around the same time—present a landscape image more in step with the current American pictorial convention than *Pittsburgh after the Fire from Birmingham* or *Pittsburgh after the Fire*

from Boyd's Hill. It is a view that bears a certain kinship with Thomas Cole's landscapes of the 1830s and 1840s. Pittsburgh is portrayed as a settlement in the verdant wilderness, where rich textures, deep colors, and palpable atmosphere predominate. The sky is suffused with a Cole-like glow that is neither sunrise nor sunset. Paint is applied thickly and rather spontaneously, with an attempt to mix some of the colors on the canvas rather than the palette, as had become the fashion in the second quarter of the century.

The composition uses a dark, lushly forested foreground to set off the burning city in the middle ground. Wall placed in each canvas a fallen tree, a hilly dirt road, and a covered wagon in the foreground. It is obviously a cloudy, windy day. By these means Wall was also able to suggest the hostility of nature—an appropriate philosophical footnote to the disaster occurring across the Monongahela River in the background. There, in the visually isolated city, the fire rages programmatically from east to west, consuming the river's covered bridge as it does so. The two canvases show slight differences in the foreground detail and what appears to be a small progression in time: in one picture, the wagon driver has passed further into the scene and the bridge over the river is slightly more consumed by flames.
DS

View of the Great Fire of Pittsburgh, 1846

References H. Saint-Gaudens, "Charles J. Rosenbloom Collection," *Carnegie Magazine* 19 (Mar. 1946), p. 273; S. Lorant, *Pittsburgh: The Story of an American City* (Pittsburgh, 1964), p. 110.

hardly be called that of a colorist. He gave great attention to detail, and undoubtedly supplied a demand that suited his time."[1]
DS

1 Martin Leisser, "Art in Pittsburgh," Pittsburgh *Gazette Times*, May 2, 1910, p. 4.

Provenance Edward O'Neil II, Pittsburgh, by 1978.

Gift of Edward O'Neil II, 1978, 78.25.1

Exhibition Department of Fine Arts, Carnegie Institute, Pittsburgh, organized by the University of Pittsburgh, 1956, *Painters from Pittsburgh: The Frontier Settlement and the Industrial Development*, no. 28.

Provenance Charles J. Rosenbloom, Pittsburgh, by 1946.

Bequest of Charles J. Rosenbloom, 1974, 74.7.48

View of the Great Fire of Pittsburgh, c. 1846

Provenance Mr. and Mrs. David McLane Taylor, Pittsburgh, by 1984.

Gift of Carroll Arrott Taylor and David McLane Taylor, Jr., 1984, 84.108

See Color Plate 3.

Landscape, c. 1850–56

Oil on canvas
18⅛ x 30¼ in. (46 x 76.8 cm)
Signature: W. C. Wall (lower left)

This undated canvas probably represents a site in the Allegheny Mountains,

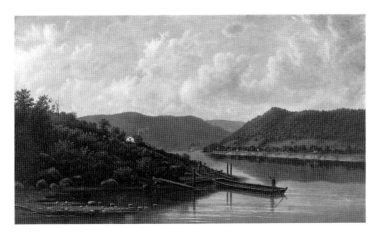

although it is not certain exactly where. It is typical of the landscapes of Wall's middle to late career, for in both composition and painting technique, it is a provincial, slightly primitive interpretation of the placid, verdant river views of the Hudson River school. It depicts the simple life of a river scene in an age before industrialization. A winding river leads the viewer into the picture, where one finds a cabin, flatboat, and figures along its bank. The river gradually gives way to more generalized, tree-covered hillsides, which in turn give way to the hazy blue shapes of the receding mountains.

Characteristically, Wall's cabin and figures are still rather large for their place in the middle ground of what should be a very broad panorama. Also characteristically, Wall's application of paint is tediously careful and lacks variety. It appears that his painting style rather than subject matter or composition dated Wall in the eyes of his younger contemporaries. According to Pittsburgh artist Martin Leisser, Wall's "method in painting belonged to an earlier period, and can

The Pittsburgh Bessemer Steel Company, 1881

Oil on canvas
26 x 49½ in. (66 x 125.7 cm)
Signature, date: W. C. Wall.1881 (lower right)

For all its topographical accuracy, this painting was not intended merely to depict the Pittsburgh Bessemer Steel Company mills (later the Carnegie Steel Company's Homestead works) situated on the south bank of the Monongahela River on the outskirts of Pittsburgh. It is more a panorama of progress that interlaced the seemingly limitless bounds of man's industry with nature's abundance. *The Pittsburgh Bessemer Steel Company* presents a broad, tranquil view of factory buildings as they send plumes of smoke into calm skies above the river valley. They are surrounded by partially cleared hillsides and, more significantly, by roads, bridges, and railway tracks—the beneficiaries of the steel mill's productivity.

This particular landscape theme originated within the Hudson River school. During the 1850s and 1860s, such artists as John Frederick Kensett and George Inness painted similar panoramas showing industrial progress in the wilderness. Wall must have been inspired by such pictures, for he took on some of the stylistic characteristics of Hudson River school painting at this time—the framing elements of the leafless tree and the spectator at the crest of the hill, the great distance between foreground and middle ground, and the way sunlight catches the top leaves of trees and blades of grass here and there.

Still, Wall remained more reticent in his use of color than his Hudson River school counterparts. His brushwork is less supple, and his composition more rigid. By chance or design, he did not quite reproduce their effect of terrain and atmosphere forming a single, all-enveloping entity.
DS

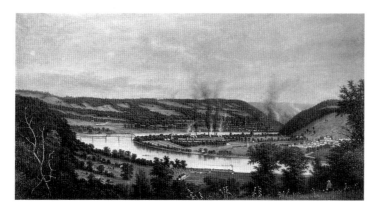

Reference H. Saint-Gaudens, "Charles J. Rosenbloom Collection," *Carnegie Magazine* 19 (Mar. 1946), p. 273.

Provenance Charles J. Rosenbloom, Pittsburgh, by 1946.

Bequest of Charles J. Rosenbloom, 1974, 74.7.27

Andrew John Henry Way
1826–1888

R ECOGNIZED AS ONE of the more important still-life specialists of the later nineteenth century,[1] Way is best remembered for his paintings of grapes and oysters. He depicted fruit in almost a trompe-l'oeil manner while displaying a sensitivity toward its poetic potential that was characteristic of the Romantic style.

Way was born in Washington, D.C. Little more is known of his early life. He began to study art in Cincinnati with John P. Frankenstein, at that time considered one of the strongest portrait painters in the country, and later became a pupil of the Western artist Alfred J. Müller in Baltimore. In 1850 he went to Paris, where he entered the atelier of the history and portrait painter Michel-Martin Drölling, a former pupil of Jacques-Louis David. When Drölling died in 1851, Way entered the Accademia di Belle Arti in Florence, where he studied for the next three years.

By 1854 Way had settled permanently in Baltimore, where he quickly became a central figure in local art circles. As one of four artist-founders of the Maryland Academy of Fine Arts, he served for some time as its vice president. He was also something of a chronicler of the Baltimore art world, contributing articles to local newspapers from his Paris days onward.[2]

During his early years, Way devoted his efforts to portraits and the occasional landscape. Then, in 1859, a fruit piece he had painted attracted the attention and praise of the prominent American artist Emanuel Leutze, and Way, following Leutze's advice, began to specialize in still lifes. His new subject matter brought him moderate financial and critical success; his works were regularly exhibited at the National Academy of Design, New York, and at major national expositions.

Way's paintings of fat, luscious grapes were apparently his most popular works. In 1876, two panel paintings of grapes earned him a medal for still-life painting at the Philadelphia Centennial Exposition. His still lifes were singled out for praise at the 1879 Louisville Exposition, one critic calling his grape paintings "marvels of art."[3] A hometown critic aptly explained the appeal of Way's still-life paintings:

> In all qualities of form, color, texture and solidity, his grapes are admirable. He attains these fine results by conscientious portraiture of his models. He selects fine bunches of his favorite fruit, hangs them in the light that he desires, and against such background as best brings out their beauties, and then paints, with the most loving care, every detail. His treatment of this subject is most masterly.[4]

1 Gerdts, *Painters of the Humble Truth*, p. 110.

2 Ibid., p. 112.

3 E. S. Crosier, "Art at the Louisville Exposition," *Louisville Monthly Magazine* 1 (September–October 1879), p. 592.

4 Excerpt from the *Baltimore Every Saturday* (November 10, 1877), quoted in Clement and Hutton, *Artists of the Nineteenth Century*, vol. 2, p. 339.

Bibliography Clara Erskine Clement and Laurence Hutton, *Artists of the Nineteenth Century and Their Works*, vol. 2 (1879; rev. ed., Boston 1884), pp. 338–39; William H. Gerdts and Russell Burke, *American Still-Life Painting* (New York, 1971), pp. 72, 97–98; William H. Gerdts, *Painters of the Humble Truth: Masterpieces of American Still Life, 1801–1939* (Columbia, Mo., 1981), pp. 110–12.

Still Life with Grapes, c. 1870

Oil on canvas
18¼ x 12¼ in. (46.3 x 31.1 cm)
Signature: *A.J.H. WAY* (lower right)

Like a number of other American still-life painters of the 1860s, Way was affected by the artistic philosophy of John Ruskin and the painting style of the English Pre-Raphaelites. He portrayed his still-life elements in their natural setting with the meticulous detail that bespoke Ruskin's exhortation to be true to nature. Like a number of his contemporaries, he preferred to show clusters of grapes as if still on the vine, hanging against a garden wall, rather than laid out artificially on a tabletop.[1]

The hallmark of Way's talent was that he not only captured the fruit's sensual qualities but he also accurately distinguished between the different varieties of grapes. The grapes in the Carnegie's painting appear to be Flame Tokays. The soft, translucent coloring of the ruby red fruit is highlighted by the flat, dark background, lending a touch of dramatic intensity to the simple composition.
RB

1 Gerdts, *Painters of the Humble Truth*, p. 111.

Provenance Senator and Mrs. H. John Heinz III, Pittsburgh, until 1980.

Gift of Senator and Mrs. H. John Heinz III, 1980, 79.71.7

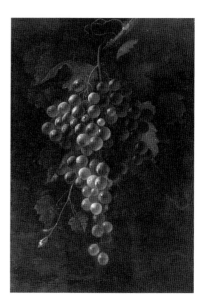

Max Weber
1881–1961

MAX WEBER WAS one of the first American artists to discover European modernism and the first American to work in a Cubist style. A prolific painter whose career spanned over fifty years, he abandoned Cubism in the 1920s. Despite his stylistic changes, the human figure remained a constant preoccupation for him, as was the tension between contemporary life and the eternal, universal themes of faith, music, and feminine beauty.

Weber was born in Bialystok, Russia, the son of pious Jewish parents who immigrated to the United States in 1891, settling in Brooklyn. From 1898 to 1900 he studied with Arthur Wesley Dow at Pratt Institute in Brooklyn. In 1904 he traveled to Paris, where he studied at the Académie Julian and with Henri Matisse. While he was in Paris, Weber associated with Gertrude and Leo Stein and their circle of radical artist friends. He met Pablo Picasso, formed a close friendship with Henri Rousseau, and was greatly impressed by the work of Paul Cézanne. Weber returned to New York in 1909, whereupon he began to paint Cézannesque still lifes and figure subjects in flat, bold colors, reminiscent of Matisse and Rousseau.

He continued to create works of this type through the 1910s, but between 1910 and 1920 experimented continually in the Cubist idiom. The aggressive angularity evident in some of his nude subjects of 1909 and in a powerful series of nudes done between 1910 and 1911 hints at the influence of non-Western sculpture and of Picasso's proto-Cubist work of 1906–8. In 1911 Weber began experimenting with Analytic Cubism in still-life and figure subjects. He also turned his attention to the theme of New York City, whose skyscrapers and technological advances fascinated many artists of Weber's generation. He began to associate with Alfred Stieglitz and his circle, was given an exhibition at Stieglitz's 291 gallery, in New York, in 1911, and is credited with being a "catalyst for Stieglitz's understanding of the formal bases of modern art."[1] In his cityscapes, city interiors, and figure subjects, he expressed the dynamism of the American city through the fragmentation of objects in motion.

Weber's marriage in 1916 and his father's death in 1918 turned his attention to a more personal imagery of domestic scenes and Jewish religious life. Some of these works are Synthetic Cubist in style, others use Cubist planar simplification without fragmenting the forms of objects. The influence of non-Western art remained strong in these often very moving works.

In 1920 Weber abandoned Cubism and adopted a more representational style. This reaction against avant-garde European art was typical of many American artists of the 1920s, a decade characterized by isolationism in art as well as in politics. Having moved to Long Island, Weber also ceased painting modern city life.

As early as 1916 Weber had created works depicting monumental, classicizing figures, either nude or draped in pseudo-classical robes. Such massive, sculpturesque women dominate his work from 1920 to the mid-1930s. Many show women in idyllic settings conversing, resting, making music, or beautifying themselves. Others have religious overtones, and some have specifically religious content. All, however, were designed to put the viewer in touch with something timeless and eternal. Also in these decades, Weber painted still lifes and landscapes, often brooding and melancholic in tone, in a style dependent on Cézanne.

Like many Jewish immigrant artists, Weber had always been sympathetic to leftist politics, and in 1936 he became national chairman of the American Artists Congress, New York. This renewed involvement with political life led to an expansion of Weber's subject matter, and he began to paint industrial workers and other socially relevant themes. Moreover, images of Jewish religious life began to occupy a more significant place in his work and continued to do so through the 1940s and 1950s.

Weber's style of the 1940s and 1950s is considerably freer and more abstract than his work of the two previous decades, and his tone is more lighthearted than the often somber earlier works. Domestic life and music emerge as important subjects, defined by means of lyrical, spontaneous line and vivid, whimsical color. The influence of biomorphic Surrealism is apparent in some works of this period—in facial deformations, for example, that also recall similar forms in Picasso's work of the 1930s.

The critical hostility that initially greeted Weber's work abated in the 1920s, and from then on he exhibited widely. His work appeared frequently, for example, at Carnegie Institute's annual exhibitions between 1925 and 1950. Retrospectives of his work were held in 1930 at the Museum of Modern Art, New York; in 1943 at Carnegie Institute; in 1949 at the Whitney Museum of American Art, New York; and in 1959 at both Pratt Institute and the Newark Museum, New Jersey. Weber died in Great Neck, Long Island.

1 Jewish Museum, *Max Weber*, p. 17

Bibliography Holger Cahill, *Max Weber* (New York, 1930); Whitney Museum of American Art, New York, *Max Weber* (1949), exh. cat. by Lloyd Goodrich; Alfred Werner, *Max Weber* (New York, 1975); Jewish Museum, New York, *Max Weber: American Modern* (1982), exh. cat. by Percy North.

The Quartet, c. 1939

Oil on canvas
25⅛ x 30⅛ in. (63.8 x 76.5 cm)
Signature: MAX WEBER (lower right)

It has been said that music was Weber's second love. He had sung since childhood, and he owned a large record collection, primarily of Baroque masters. He often listened to music in the evenings and while painting. Music was a continuing presence in his painting as well. Several paintings from his Cubist phase bear musical titles, reflecting the contemporary definition of abstract art as painted music. From the late 1910s through the last years of his career, Weber frequently painted people making music. Some are genre scenes of contemporary musicians, such as his well-known *Two Musicians* (1917, Museum of Modern Art, New York) and a number of works of the 1940s. Other paintings show music makers of a more archetypal sort and present music making in a timeless and eternal aspect. *The Quartet* belongs to the latter group.

The Quartet represents four singing women accompanied by another woman playing a lute. Like many of Weber's works from the 1920s and 1930s, it depicts monumental, classicized women engaged in idyllic activity. Lloyd Goodrich described the women of this period as having "a biblical tone, reminiscent of ancient conceptions of women; they recall the Song of Songs and all the

women of Hebrew legend."[1] John O'Connor described the women in *The Quartet* as "Eastern women clothed in severe garments."[2] While it is difficult to assign a specifically Jewish interpretation to the painting, the draped heads and antique instrument in conjunction with the massive figures convey an impression of seriousness and solemnity. Indeed, one feels that these women, like an ancient Greek chorus, are singing the age-old legends of their people. The symmetrical composition, confined, intimate space, and muted color further contribute to the contemplative mood, while the rhythmic repetition of the three central heads adds a specifically musical note. At the same time, the exposed thighs of the right-hand figure add a sensuous element to the work. This combination of solemnity and latent sensuality is characteristic of Weber's work and seems to emerge from his deepest understanding of the nature of human existence.

The Quartet is not dated. However, John O'Connor, in his 1944 article on the painting, stated that it was done in 1939.[3] Stylistically, the painting is characteristic of the late 1930s, when Weber's calligraphic line is quite energized but still functions to define three-dimensional form. A similar painting, entitled *Music* (Brooklyn Museum of Art, New York), is of 1940.

JRM

1 Whitney Museum of American Art, *Max Weber*, p. 40.

2 John J. O'Connor, Jr., "*The Quartet* by Max Weber," *Carnegie Magazine* 17 (February 1944), p. 273.

3 Ibid.

References M. Farber, "Artists for Victory," *Magazine of Art* 35 (Dec. 1942), pp. 277–78; R. Neuberger, "Artists for Victory," *Art in America* 31 (Jan. 1943), p. 54; J. O'Connor, Jr., "*The Quartet* by Max Weber," *Carnegie Magazine* 17 (Feb. 1944), pp. 273–75.

Exhibitions Metropolitan Museum of Art, New York, 1942, *Artists for Victory: An Exhibition of Contemporary American Art* (trav. exh.), unnumbered; Department of Fine Arts, Carnegie Institute, Pittsburgh, 1943, *Exhibition of Paintings by Max Weber*, no. 33; Columbus Gallery of Fine Arts, Ohio, 1952, *Paintings from the Pittsburgh Collection*, no cat.; Art Galleries, University of California, Santa Barbara, 1968, *First Comprehensive Retrospective Exhibition in the West of Oils, Gouaches, Pastels, Drawings, and Graphic Works by Max Weber (1881–1961)*, no. 32.

Provenance The artist, until 1943; Paul Rosenberg and Co., New York, by 1944.

Patrons Art Fund, 1944, 44.1.1

The Red Carnation, c. 1944

Oil on canvas
30½ x 24¼ in. (77.5 x 61.6 cm)
Signature: MAX WEBER (lower right)

Weber painted still lifes throughout his long career. In the 1910s they were composed primarily of fruit with bowls and other vessels—surely a reflection of his interest in Paul Cézanne. As early as the 1920s he began painting floral still lifes, generally consisting of a few flowers in a simple vase. In the 1930s these were fairly realistic, with an emphasis on the delicacy and fragility of the flowers. However, in the 1940s his style became bolder and more gestural, and flowers and leaves were rendered with a few quick strokes.

In *The Red Carnation* he added freely flowing lines to the background of the picture, a device seen in other florals of the 1940s and 1950s. Here, these curving lines of the flower provide a sense of vitality and movement, and contrast with the faceted background. Weber's flower paintings grew, apparently, out of his daily life. His wife loved to grow flowers, and flowers from her garden were displayed all around their home in Great Neck, Long Island.[1]

The Red Carnation was shown in Carnegie Institute's *Painting in the United States* exhibition, from which it was purchased by Pittsburgh collector Charles Rosenbloom. A similar painting, *Dahlias*, dated 1944, is in the collection of the Des Moines Art Center.

JRM

1 Werner, *Max Weber*, p. 25.

References W. R. Hovey, "The 1944 Carnegie from the Pittsburgh Point of View," *Art News* 43 (Oct. 15, 1944), p. 13; H. Saint-Gaudens, "Charles J. Rosenbloom Collection," *Carnegie Magazine* 19 (Mar. 1946), p. 273.

Exhibitions Department of Fine Arts, Carnegie Institute, Pittsburgh, 1944, *Painting in the United States*, no. 19; Department of Fine Arts, Carnegie Institute, Pittsburgh, 1946, *Paintings and Prints from the Collection of Charles J. Rosenbloom*, no. 5.

Provenance The artist, until 1944; Charles J. Rosenbloom, Pittsburgh, 1944.

Bequest of Charles J. Rosenbloom, 1974, 74.7.29

J. Alden Weir

1852–1919

KNOWN TODAY AS ONE of the central figures of American Impressionism, Julian Alden Weir was born at West Point, New York, and received his earliest art instruction from his father, Robert, who taught drawing at the United States Military Academy. In 1867 he enrolled at the National Academy of Design in New York. Six years later he left for Paris, where from 1873 to 1877 he completed his formal training at the Ecole des Beaux-Arts as a student of Jean-Léon Gérôme.

During Weir's schooling in Paris, he came in contact with and rejected Impressionism; in a letter to his parents of April 15, 1877, he called the third Impressionist exhibition a "Chamber of Horrors" and complained that the artists "do not observe drawing or form."[1] More to his taste was the work of the Realist Jules Bastien-Lepage. He also admired Spanish art; while visting Spain, he was captivated by the paintings of Diego Velázquez.

Following his return to New York in 1877, Weir supported himself by portrait painting and teaching. In 1883 he settled permanently in New York, and soon afterward his canvases changed substantially. The dark, rich palette he had used earlier yielded to a technique partly inspired by Edouard Manet and the Impressionists. He concentrated on domestic genre scenes and landscapes, and as he did so his work became smaller in scale, less formal, and lighter in color. This transition in style led to his intermittent exploration of Impressionism.

Weir spent the summers of 1880, 1881, and 1883 in Europe, where he served as agent for the New York collector Erwin Davis. By this time he was more receptive to progressive French painting and, with the encouragement of William Merritt Chase, purchased for Davis two works by Manet, *Woman with a Parrot*, 1866, and *Boy with a Sword*, c. 1861 (both now in the collection of the Metropolitan Museum of Art, New York). They were the first paintings by Manet to enter an American collection.

Already a founding member of the Tile Club, New York, and the Society of American Artists, Weir became an associate of the National Academy of Design in 1885 and an academician the following year. In 1889 he had a highly successful joint exhibition with his friend John Twachtman at the Ortgies Gallery, New York. He spent the summer in England and France, after which he returned to the United States. His palette lightened, and his canvases took on a more sketch-like appearance. In the next decade, landscapes in an Impressionist technique became his primary focus.

By 1891, chafing under the restrictions of the increasingly conservative Society of American Artists, Weir held his first significant solo exhibition at Blakeslee Galleries, New York. Critics regarded him as one of the first American artists to use Impressionist techniques successfully. Throughout the 1890s, he painted figures and landscapes at his summer home, a farm in Branchville, Connecticut, or in the surrounding countryside. In 1897 he joined Twachtman, Childe Hassam, and other progressive artists to form the Ten American Painters. By 1900 Weir was recognized as a major artist in both the United States and Europe. From 1915 to 1917, he served as president of the National Academy of Design.

Weir exhibited at the first two Carnegie Internationals in 1896 and 1897. He was a frequent participant thereafter, and he developed a close friendship with John Beatty, Carnegie Institute's first director of the Department of Fine Arts. Weir was actively involved with the 1911 International, serving on the jury (as he had done in 1898 and 1905) and exhibiting thirty-seven of his own paintings. When that exhibition fell victim to poor reviews in New York, Weir—at Beatty's request—argued the International's merits in the New York press.

During the next eight years, Beatty often turned to Weir for advice. Weir attended auctions with Beatty, helped to arrange purchases, and recommended artists for exhibition. Beatty, for his part, tried on many occasions to persuade the Fine Arts Committee to purchase Weir's work. Beatty also arranged a special exhibition of Weir's etchings for the 1918 Founder's Day celebration. He hung Weir's work at the Internationals of 1920 and 1921, one and two years after Weir died in New York, even though the exhibition's rules prohibited showing the work of deceased artists.

1 Young, *The Life and Letters of J. Alden Weir*, p. 123.

Bibliography *Julian Alden Weir: An Appreciation of His Life and Works* (1921; reprint, with 8 additional illustrations, for the Phillips Memorial Gallery by E. P. Dutton, New York, 1922), essays by Duncan Phillips, et al., paintings list compiled by the artist's daughter, Dorothy Weir (later Dorothy Weir Young); Dorothy Weir Young, *The Life and Letters of J. Alden Weir* (New Haven, 1960); Doreen Bolger Burke, *J. Alden Weir and the National Academy of Design* (New York, 1981); Metropolitan Museum of Art, New York, *J. Alden Weir: An American Impressionist* (1983), exh. cat. by Doreen Bolger Burke.

Ploughing for Buckwheat, 1898, retouched c. 1912
(New England Plowman)

Oil on canvas
47 x 32½ in. (119.4 x 82.6 cm)
Signature, inscription: J. Alden Weir./ Branchville, Conn. (lower left)

According to the critic Duncan Phillips, an enthusiastic admirer and patron of Weir's work, *Ploughing for Buckwheat* was painted at Branchville, Connecticut, at the summer home the artist acquired in 1883 from collector Erwin Davis in exchange for a painting. To Phillips, it typified Weir's work:

> Back of the old farm-house at Branchville is the rocky hillside which Alden Weir has immortalized in that epic picture of the American farmer amid soil and sky entitled, "Plowing for Buckwheat."...The season in Weir's landscapes is usually summer, the hour morning or approaching noon, with overhead light in a pale sky. In the "Plowing for Buckwheat" great, billowy clouds are crisply accented against the azure in silvered brilliancy. A drowsy heat pervades the air. It feels good to drop down on some sweet-smelling hay under a friendly tree and look up. An imperceptible breeze stirs the upper branches.... It is pleasant to watch the slow, brown oxen, the sunbaked hillside, and the farmer who turns from his plow with a friendly "how-d'do."[1]

Weir transposed a Barbizon subject into nominally New England soil, and washed it with bright, Impressionist-inspired light.

The artist considered this canvas a major work, and initially labored over it for about two years. A letter to his friend

Charles Erskine Scott Wood reveals that it was begun around 1896 and completed in early August, 1898, in time for the first *Show of Ten American Painters*:

> I have just finished a rather large canvas which I hope you will see. It is a New England farmer and if I get another week of sunlight I can complete it. I have had it on hand for two years. . . . These large canvasses take ten times the time a small canvas does and are ten times as interesting, but frame bills and disposing of them are against them. This one I have done for my Exhibition with the Ten as a center canvas to build about. You know this little Exhibition which I refer to, the pictures are hung in groups, each artist's work by itself."[2]

Weir also exhibited *Ploughing for Buckwheat* at both the 1898 and 1912 Carnegie Internationals.

It was unusual for a painting to be exhibited at more than one International,

and *Ploughing for Buckwheat*'s reappearance was the result of John Beatty's desire to secure a specimen of Weir's work for the permanent collection. In 1908 and 1911 he had attempted, without success, to interest the Fine Arts Committee in puchasing paintings by Weir. In 1912 he decided to try again, and wrote the artist, "I need hardly tell you that personally I desire to see one of your paintings in our permanent collection at as early a time as possible, nor need I tell you that these things do not always work out as promptly as we may hope."[3]

Beatty asked him to send several landscapes and a figure painting to Carnegie Institute, but Weir replied that these were tied up in exhibitions.[4] Beatty then asked for *Ploughing for Buckwheat*, which he had recently seen in New York, not remembering that it had been exhibited in Pittsburgh before.[5] Weir informed Beatty that the picture had been shown in Pittsburgh, but had since been repainted.[6]

Weir did retouch it sometime before its second appearance in Pittsburgh; he made superficial changes throughout the work and painted over the original date of 1898, inscribed at the lower left.

Ploughing for Buckwheat was hung in that year's International, and this time it was purchased. The painting had the additional distinction of being exhibited a third time, in 1920.

LD

1 Phillips, in *Julian Alden Weir: An Appreciation*, pp. 38–39.

2 Dorothy Weir, "Records of the Paintings of J. Alden Weir," manuscript in the possession of the artist's descendants, c. 1920–40, vol. 3a, p. 239b.

3 John Beatty to J. Alden Weir, February 21, 1912, Carnegie Institute Papers, Archives of American Art, Washington, D.C.

4 Weir to Beatty, February 25, 1912, ibid.

5 Beatty to Weir, March 12, 1912, ibid.

6 Weir to Beatty, telegram, March 18, 1912, ibid.

References D. Phillips, "J. Alden Weir," *American Magazine of Art* 3 (Apr. 1917), p. 215, expanded text in Phillips, "Julian Alden Weir," in *Julian Alden Weir: An Appreciation*, pp. 38–39, 45, 132; D. Weir, "Records of the Paintings of J. Alden Weir," (c. 1920–40), vol. 3a, p. 239b, manuscript; "Art of America Is Feature of Chicago's Great 1934 Exhibition," *Art Digest* 8 (June 1, 1934), p. 7; J. O'Connor, Jr., "From Our Permanent Collection: *Ploughing for Buckwheat*," *Carnegie Magazine* 26 (Nov. 1952), pp. 320–21; Young, *The Life and Letters of J. Alden Weir*, pp. 188, 200, 261; S. G. Freedman, "Artistic Fight Rages over Farm in Connecticut," *New York Times*, Nov. 29, 1982, sec. D, p. 15.

Exhibitions Department of Fine Arts, Carnegie Institute, Pittsburgh, 1898, *Third Annual Exhibition*, no. 234; Albright Art Gallery, Buffalo, 1901, *Pan-American Exposition*, no. 576, as *New England Plowman*; Detroit Museum of Art, 1906, *Catalogue of the First Annual Exhibition of Paintings by American Artists*, no. 68; Department of Fine Arts, Carnegie Institute, Pittsburgh, 1912, *Sixteenth Annual Exhibition*, no. 329; Department of Fine Arts, Carnegie Institute, Pittsburgh, 1920, *Nineteenth Annual International Exhibition*, no. 357; Halaby Galleries, Dallas, 1923, *Fourth Annual Exhibition of the Dallas Art Association*, no. 89; Metropolitan Museum of Art, New York, 1924, *Memorial Exhibition of the Works of Julian Alden Weir*, no. 32; Art Institute of Chicago, 1934, *A Century of Progress Exhibition of Paintings and Sculpture*, no. 464; Brooklyn Museum, New York, 1937,

Leaders of American Impressionism, no. 80; Baltimore Museum of Art, 1938, *Two Hundred Years of American Painting,* no. 28; National Academy of Design, New York, 1939, *The National Academy Special Exhibition,* no. 258; Dayton Art Institute, Ohio, 1951, *America and Impressionism,* unnumbered; American Academy of Arts and Letters, New York, 1952, *J. Alden Weir, 1852–1919, Centennial Exhibition,* no. 7; Meredith Long, Houston, 1971, *Americans at Home and Abroad, 1870–1920,* no. 41; Metropolitan Museum of Art, New York, 1983, *J. Alden Weir: An American Impressionist,* exh. cat. by D. B. Burke, unnumbered.

Provenance The artist, until 1912.

Purchase, 1912, 12.3

Benjamin West

1738–1820

WILLIAM DUNLAP, the first historian of American art, considered Benjamin West the father of American painting, the man by whose example American art could be brought to maturity and claim equality with the most distinguished foreign schools. Most of Dunlap's contemporaries would have agreed that West, beyond being the first American-born painter to gain European prominence, was a primary agent of the ambitious, international agenda taken up by American artists during the early nineteenth century.

A century and a half after Dunlap's *History of the Rise and Progress of the Arts of Design in the United States,* the importance of West's pioneering accomplishment is still manifest. The first American who had a European art education, he was a key contributor to the development of late-eighteenth-century and early-nineteenth-century history painting. A founding member of the Royal Academy of Arts, London, he became its only American-born president and was the most widely acclaimed American expatriate painter before John Singer Sargent.

West was born the son of an innkeeper in Springfield, Pennsylvania, about ten miles west of Philadelphia. He made his first pictures at the age of fourteen and was working professionally by the time he was eighteen. His early paintings—portraits and a smattering of landscapes and literary subjects—showed energy and imagination, but by most standards were

crudely provincial. His first art teacher was William Williams, a mariner and Philadelphia portraitist who gave instruction books and advice to the young painter.

When a Philadelphia merchant provided him with funds to travel abroad in 1759, West left for Rome. During the three years he spent in Italy, he not only studied ancient and modern art, but also became acquainted with the most progressive artists and advanced patrons there. By the time he left, he was prepared to take on the vocation of a history painter.

In 1763 West settled in London, quickly attracted students, and soon earned a national reputation for heroic compositions in ancient settings. His *Agrippina Landing at Brundisium with the Ashes of Germanicus* (1768, Yale University Art Gallery, New Haven) became a hallmark in the development of international neoclassicism. In 1771 West's sensational *Death of General Wolfe* (1770, versions in the Royal Collection, London, and the National Gallery of Canada, Ottawa) established a new genre within neoclassicism—the painting of contemporary history. A year later he was appointed history painter to King George III. In 1792 he succeeded Sir Joshua Reynolds to become the second president of the Royal Academy.

From the 1780s through the 1810s, West was a leader in yet a third major permutation in the genre of history painting: the epic biblical subject, exemplified by his never-completed Chapel of Revealed Religion for King George III at Windsor Castle, and his best-known design from it, *Death on a Pale Horse* (1796, Detroit Institute of Arts).

Although West never returned to America (he resided in London until his death), he played a major role in the development of American art. He was generous toward aspiring American artists, his studio becoming, in effect, the principal school for American painters in London. Virtually all ambitious American artists born between 1741 and 1791—from Charles Willson Peale to Samuel F. B. Morse—studied with him in the course of their travels abroad. He was a friend and adviser to younger artists and helped advance the careers of his numerous protégés. West set a tremendously influential example as a history painter; he and his

canvases remained the noble model for American artists to the middle of the nineteenth century.

Bibliography John Galt, *The Life, Studies, and Works of Benjamin West, Esq. . . .* (London, 1816–20); William Dunlap, *History of the Rise and Progress of the Arts of Design in the United States* (New York, 1834) vol. 1, pp. 33–97; John Dillenberger, *Benjamin West: The Context of His Life's Work with Particular Attention to Paintings with Religious Subject Matter* (San Antonio, 1977); Robert C. Alberts, *Benjamin West: A Biography* (Boston, 1978); Helmut von Erffa and Allen Staley, *The Paintings of Benjamin West,* catalogue raisonné (New Haven, 1986).

Venus Lamenting the Death of Adonis, 1768, retouched 1819

Oil on canvas
64 x 69½ in. (162.6 x 176.5 cm)

Signatures, dates, inscription: B West PINXIT / 1768 (lower right); *B West* 1772 / RETOUCHED 1819 (lower left)

Despite abrasions and past tampering, *Venus Lamenting the Death of Adonis* remains West's most beautiful painting on a mythological theme. It also has the historical distinction of being one of two works he contributed to the first exhibition of the Royal Academy in London. *The Departure of Regulus from Rome* (1769, Royal Collection, London) was the other.

The subject of West's near-life-size image is Venus's love affair with the mortal youth Adonis, as recounted by Ovid in the *Metamorphoses.* Ovid describes how the goddess fell in love with the beautiful young hunter after she accidentally scratched herself with one of Cupid's arrows. She hunted alongside him and warned him against pursuing such beasts as lions and boars. But once, when Adonis was hunting alone, his dogs roused a wild boar that turned on the youth, gashing him deep in the groin; the wound killed him. Venus saw her slain lover from her sky-born chariot, descended to earth, and, grief-stricken, sprinkled nectar over Adonis's blood. From it sprang the fugitive, red-blossomed anemone.

West's image recalls with considerable artistic license the moment in which Venus finds her dead lover. The artist did not show Adonis on the parched plain where Ovid said he fell, and chose not to

describe Venus as Ovid did—rending her garments and wailing over Adonis's body. Instead, the two figures are placed in a shady, secluded area similar to the poplar grove described early in Ovid's story. Covered by clouds, it provides an intimate, protective setting for pictorial elements freely borrowed from other parts of the narrative. They include Cupid, the swans that draw Venus's chariot, Adonis's hound chasing the wild boar onto the yellow sand in the distance, and the sprouting anemones.

West's painting is a systematic study in emotional restraint. Drapery covers Adonis's wound, so that one sees only a small pool of blood at the lower edge of the picture. A concession to eighteenth-century propriety, such avoidance of gore and violence was considered essential to the dignity, probity, and elevating qualities of the grand manner. The figures themselves are utterly calm, which is all the more remarkable given West's apparent model. West's idea for a sobbing Cupid between Venus and Adonis was inspired by a Bolognese painting of the early seventeenth century, then said to be by Annibale Carracci (Galleria Corsini, Florence), that West copied in Italy.[1] He surely meant thereby to pay tribute to Italian Baroque classicism, as he indicated by painting an Italianate landscape vignette into the background.

But West greatly diminished his figures' expressiveness. He gave them a tight, geometric precision, most obvious in Venus's Grecian profile and in the circle made by the torsos of Venus and Adonis. Abstract rather than sensual, this second protective enclosure provides an ingenious metaphor of Venus's love for Adonis. The result is perfectly in keeping with the noble ideals and elevated sentiments of history painting, for which West became one of Britain's key spokesemen. Interestingly enough, when Matthew Liart engraved West's painting in reverse in 1771 (fig. 1), his most substantive change was to fortify its sentiment by showing Venus in tears, almost surely an addition to the original.

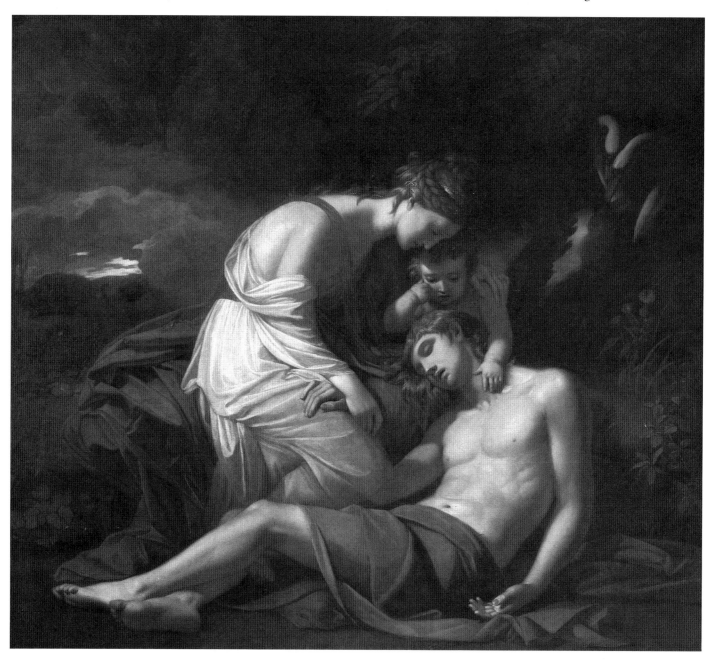

Fig. 1 Matthew Liart (1736–1782) after Benjamin West, *Venus Lamenting the Death of Adonis*, 1771. Engraving, 16¾ x 19¾ in. (42.7 x 50.3 cm). The British Museum, London

This picture has been subjected to a significant amount of wear and tear that began in West's own lifetime. When it was sold at auction in 1819 it had already had five owners and sustained the ill effects of having been stored without a frame. In 1819 West undertook a number of repairs for its new owner. He cut the canvas down on both sides and repainted in shades of red Venus's white gown, her gold cloak, and Adonis's lavender drapery. He signed the work again, then dated it 1772 and 1819, apparently having forgotten when he originally painted it.[2] In 1969, when conservator Bernard Rabin of Rutgers University cleaned the painting, he removed most of its overpaint, revealing the work's original date for the first time since 1819.

DS

1 Von Erffa and Staley, *The Paintings of Benjamin West*, pp. 228, 441.

2 Ibid., p. 228.

References Galt, *The Life, Studies, and Works of Benjamin West*, app. II, p. 223; J. Farington, *The Diary of Joseph Farington*, ed. by Kathryn Cave (New Haven, 1978), vol. 15, p. 5,346 [Apr. 1819]; R. Davies, *Six Centuries of Painting* (London, 1914), p. 287; F. F. Sherman, *Early American Painting* (New York, 1932), p. 229; A. Burroughs, *Limners and Likenesses: Three Centuries of American Painting* (New York, 1936), p. 75; R. Graham, "Benjamin West: American Romantic," *Art News* 36 (Mar. 19, 1938), p. 13; G. Evans, *Benjamin West and the Taste of His Times* (Carbondale, Ill., 1959), p. 45; W. Gaunt, *The Great Century of British Painting: Hogarth to Turner* (London, 1971), p. 117; Alberts, *Benjamin West: A Biography*, p. 101; H. Adams, in Museum of Art, Carnegie Institute, *Collection Handbook* (Pittsburgh, 1985), p. 160; Von Erffa and Staley, *The Paintings of Benjamin West*, no. 116, pp. 45, 128, 168, 228, 242; W. L. Vance, *America's Rome* (New Haven, 1989), vol. 1, pp. 215–16, 220.

Exhibitions Royal Academy of Arts, London, 1769, *First Annual Exhibition*, no. 121; British Institution, London, 1806, *Annual Exhibition*, no. 10; West's New Gallery, London, 1828, no. 56; Philadelphia Museum of Art, 1938, *Benjamin West, 1738–1820*, no. 23; Allentown Art Museum, Pa., 1962, *The World of Benjamin West*, no. 9; Philadelphia Museum of Art, 1986, *Benjamin West in Pennsylvania Collections*, no. 24; Baltimore Museum of Art, 1989, *Benjamin West: American Painter at the English Court*, exh. cat. by A. Staley, no. 10.

Provenance Sir William Young, by 1771; Washington Shirley, fifth Earl Ferrers, until 1778; Robert Shirley, sixth Earl Ferrers, until 1787; Mr. Porter, by auction, 1787; John Knight, London, by auction, 1789; Mr. Ogle (or Ogel), London, by auction, 1819; Charles Lindley, first Viscount Halifax, first Lord of the Admiralty; Thomas Pomaris, after 1884; Thomas J. Blakesly; Vose Galleries of Boston, 1910.

Purchase, 1911, 11.2

See Color Plate 1.

Max Weyl
1837–1914

THE MOST POPULAR member of the Washington school of landscapists, Max Weyl depicted the fast-fading rural area around the nation's capital. His thick, expressive brushwork and subtle tonalities reminiscent of the Barbizon school earned him the title of the "American Daubigny," after Charles Daubigny, the French landscape painter. Born in Mühlem-am-Neckar, Germany, Weyl emigrated with his family to America at the age of sixteen, becoming an itinerant watch and clock repairman. In 1861 he settled in Washington, D.C., and the following year opened a small jewelry store there.

Weyl began to paint in the 1860s but not until 1870 did he display his still lifes and landscapes in his shop. Propitiously, Samuel Kauffmann, editor of the Washington *Evening Star* and president of the Board of Trustees of the Corcoran Gallery of Art, stopped at the store to have his watch repaired. Admiring Weyl's work, he purchased a small landscape and thereafter became one of the artist's most supportive patrons.

In 1878 Weyl began to list himself as an artist in the Washington city directory. The following year he held his first exhibition, the proceeds of which financed a trip abroad. He visited Paris, Munich, Vienna, and Venice, paying particular attention to the Barbizon painters. While he thought Europe "charming and enjoyable," he found "the scenery no more paintable, nature no more engaging"[1] than in Washington.

On his return to America, Weyl set up a studio with Richard Norris Brooke, another Washington-area painter, and began to portray the scenes of Rock Creek Park and the Potomac River that made him popular. Like the Barbizon painters, he worked out of doors, but he also used photographs to capture light at specific moments. In works such as *Potomac River* (1888, collection Peter Gallaudet Powers), nimble brushwork conveys a meditative stillness, while tonal effects introduce a note of foreboding. Weyl thus subtly suggested that these pastoral settings would soon be destroyed by urbanization.

During the 1890s Weyl fell under the influence of George Inness and at this time created some of his most compelling paintings. His Rock Creek landscapes were so popular among local collectors, however, that they became formulaic. In 1907 Weyl was honored with a retrospective at the Corcoran Gallery of Art; he died in Washington seven years later.

1 National Museum of American Art, *Capitol Image*, p. 204.

Bibliography National Museum of American Art, Washington, D.C., *The Capitol Image: Painters in Washington, 1800–1915* (1983), exh. cat. by Andrew J. Cosentino and Henry H. Glassie, p. 134, passim; Michael David Zellman, ed., "Max Weyl," *American Art Analog* (New York, 1986), vol. 1, p. 288.

Autumn Days, c. 1900

Oil on canvas
40⅜ x 52¾ in. (102.6 x 134 cm)
Signature, date: MAX WEYL, 190(?) [last digit illegible] (lower left)

Clearly emulative of the late works of George Inness, *Autumn Days* depicts a desolate marshy landscape, silhouetted by delicate trees. A vast expanse of clouded sky barely illuminates the burnt sienna foliage and murky glade underneath.

Soft, diffused light and dark scumbled impasto, reminiscent of Inness's Barbizon-inspired technique, create a contemplative mood. *Autumn Days* seeks to instill in the viewer the bleak and chilly sensation of late fall. Although the specific locale of the landscape remains unidentified, the scene suggests the marshlands along the Potomac River.
JM

Provenance Mr. and Mrs. Arthur Braun, Pittsburgh, c. 1920; their daughter, Elizabeth Braun (Mrs. Paul B. Ernst), until 1978.

Gift of Mrs. Paul B. Ernst, 1978, 78.10.36

James McNeill Whistler
1834–1903

JAMES ABBOTT McNEILL WHISTLER, painter, etcher, pastelist, and designer, was surely the most notorious American-born artist of his generation. He was also one of the most important innovators in late-nineteenth-century art, instrumental in realigning the aesthetic priorities of his age. Born in Lowell, Massachusetts, Whistler was raised partly in Russia, where his engineer father was involved in the construction of the Moscow-Saint Petersburg railroad. On his father's death in 1849, the family returned to the United States, settling in Connecticut.

In 1851, following family tradition, Whistler entered the United States Military Academy at West Point, but he was dismissed three years later for poor grades in chemistry. Under the academy's professor of art, Robert Weir, he had developed some skill in drawing, and he continued that training in his position as a cartographer with the United States Coastal and Geodetic Survey, also learning to etch.

In 1855 Whistler left for Paris to study art, and he never returned to the United States. He enrolled in the rather tradition-bound atelier of Charles-Gabriel Gleyre, but he was a recalcitrant student who found a stronger attraction in the city's dandified bohemian circles. He formed friendships with Henri Fantin-Latour and Alphonse Legros. At the same time, he became deeply affected by Gustave Courbet and Realism, which was apparent in his etchings of 1858–59, his first significant works. Although he never became enamored of either plein-air effects or Courbet's deep chiaroscuro, aspects of French Realism remained with Whistler to the end of his career. He retained an interest in the environment of the working and middle classes and a penchant for presenting the ordinary without comment, thereby transforming it into the enigmatic.

In 1859 Whistler moved permanently to London. He continued to have frequent contact with Paris—his *Symphony in White, No. 1: The White Girl* (1862, National Gallery of Art, Washington, D.C.) created a scandal at the Salon des Refusés of 1863—but the vantage point of London encouraged his artistic independence and enabled him to maintain some distance from the Parisian art scene. The style he developed was indebted to Pre-Raphaelite painting, William Morris, and the English Aesthetic movement, as well as to the French-born credo of art for art's sake.

From the 1860s onward, Whistler also felt profoundly the influence of Japanese art, in both its decorative and its spatial possibilities, especially the opportunity it offered to make pictorial space two-dimensional and ambiguous. In the mid-1860s he created a number of paintings of studio models in Far Eastern costume, then in the 1870s began to create what he called his Nocturnes. Mostly water views, these were vague, two-dimensional pictures saturated by a thin soup of almost monochromatic pigment. He enjoyed associating his pictorial effects with music, and began giving both past and present works prefixes such as Symphony, Harmony, and Arrangement.

Whistler's best-known Nocturne and most controversial painting was the centerpiece of his notorious libel suit against the critic John Ruskin. In 1877 the artist exhibited nine paintings at London's Grosvenor Gallery, one of which, *Nocturne in Black and Gold: The Falling*

Rocket (1875, Detroit Institute of Arts), was for sale. Its steep price prompted Ruskin to write that he "never expected to hear a coxcomb ask two hundred guineas for flinging a pot of paint in the public's face." The ensuing trial, at which each painting from the Grosvenor exhibition was subjected to a detailed disquisition of its artistic merit, was widely publicized. Although Whistler won the case, he was awarded only one farthing for damages; financially, the legal fees ruined him.

The ensuing years brought two significant commissions for etchings of Venice, more Nocturnes and landscape sketches, and numerous large-scale portraits. By the mid-1880s, Whistler's stature in Britain began to approach his earlier expectations. In 1886 he was elected to the presidency of the Society of British Artists; in 1890 he published *The Gentle Art of Making Enemies*—which is, in effect, his memoir—and his work achieved increasing international esteem. In 1891 the French government purchased his *Arrangement in Gray and Black: Portrait of the Painter's Mother* (1871, Louvre, Paris) and the following year named him Chevalier of the Legion of Honor.

Whistler's reputation flourished in the United States from the mid-1890s onward, when private collectors, notably Charles Lang Freer, and major museums began to acquire his work. His art appeared at six Carnegie Internationals between 1896 and 1907, where it can be said to have been a touchstone by which other contemporary painting was judged. The second painting acquired for Carnegie Institute's permanent collection was a Whistler.

From 1899 onward, Whistler began to suffer from recurring illness. He died in Chelsea, that district of London whose shops, gardens, and river views had been the subject of so many of his pictures.

Bibliography James McNeill Whistler, *The Gentle Art of Making Enemies* (1890; reprint, New York, 1967); E[lizabeth] R[obins] Pennell and J[oseph] Pennell, *The Life of James McNeill Whistler*, 2 vols. (London, 1908); Denys Sutton, *James McNeill Whistler: Paintings, Etchings, Pastels and Watercolours* (London, 1966); Andrew McLaren Young, Margaret MacDonald, and Robin Spencer, assisted by Hamish Miles, *The Paintings of James McNeill Whistler*, catalogue raisonné, 2 vols. (New Haven, 1980).

Arrangement in Black: Portrait of Señor Pablo de Sarasate, 1884
(Arrangement in Black: Pablo de Sarasate; Sarasate)

Oil on canvas
85³⁄₁₆ x 42¾ in. (216.4 x 108.6 cm)

Framed dimensions: 97¹³⁄₁₆ x 55⅜ in. (248.4 x 140.7 cm)

Signature: (center right, with butterfly cartouche)

In later life, Whistler came to favor a portrait format in which the subject, dressed in dark clothing, stood full length against a completely black background. The type first appeared in the early 1870s with *Arrangement in Black: Portrait of F. R. Leyland* (1870/73, Freer Gallery of Art, Washington, D.C.) and continued until the mid-1890s in works such as *Harmony in Black: Portrait of Miss Ethel Philip* (1894, Hunterian Art Gallery, Glasgow). Although the portraits bore various titles, he specifically called eleven of them *Arrangement in Black. Arrangement in Black: Portrait of Señor Pablo de Sarasate* is arguably Whistler's most distinguished male portrait of this type.

All were ostensibly in the same spirit of old-master court portraiture as the full-lengths of John Singer Sargent and others. However, Whistler's differ in their austerity of design and lack of either a physical or psychological context. Whistler's modeling was still sufficiently tentative that one is compelled to view his images first as clusters of contrasting shapes and tones and only secondarily as transcriptions of personalities.

The sitter, the Spaniard Pablo Martin Melitón de Sarasate y Navascués (1844–1908), was Europe's great violin virtuoso. He was, like Whistler, a small man much taken with being the focus of public attention. It was his manager, Otto Goldschmidt, who especially admired Whistler's work; he owned at least two landscapes by Whistler. Goldschmidt prevailed upon the artist to execute the portrait, and it may have been Goldschmidt's idea to ask Whistler to decorate a room for Sarasate in Paris.

The distinctiveness of Whistler's portrait of Sarasate relies on two conceits: the placement of the figure high on the canvas and the attention-getting arrangement of the sole prop, the violin. The violin is

held full face against the picture plane, creating a spidery, two-dimensional extension of Sarasate's own thin form. Placing the figure well into the background (or, alternatively, high on the picture plane) created considerable spatial ambiguity, thanks to the black, nearly shadowless surroundings. The figure appears dislocated, as if floating before the viewer, an effect noted by at least one contemporary critic, who likened it to an apparition invoked by a medium in a séance.[1]

Because the portrait remained Whistler's property, he exhibited it widely in the decade after it was painted. It was the object of a certain number of outrageous jabs, such as the remark that it had been painted in a coal cellar. However, Whistler, who was always particularly pleased when he produced what he thought was a good likeness, was entranced by this one.[2] It also clearly intrigued others: William Nicholson adapted the composition to his well-known woodcut portrait of Whistler, executed in 1897.

Sarasate's portrait represented Whistler in the first Carnegie International in 1896, and its subsequent purchase was urged by John Caldwell, then chairman of the Fine Arts Committee. It became Carnegie Institute's second acquisition for the permanent collection but, contrary to previous assertions,[3] it was not the first acquisition of a Whistler by an American museum. It was, rather, the fourth, following the purchase of a similar full-length portrait, *Arrangement in Black: La Dame au brodequin jaune—Portait of Lady Archibald Campbell* (1882–84), by the Philadelphia Museum of Art in 1895, and two small portraits, *The Little Rose of Lyme Regis* (1895) and *The Master Smith of Lyme Regis* (1895), by the Museum of Fine Arts, Boston. Nonetheless, Pittsburgh's acquisition marks the moment when Whistler's importance had begun to be evident in the United States.
DS

1 Alfred de Lostalot, "Salon de 1886, I," *Gazette des beaux-arts* 33 (June 1886), pp. 453–79.

2 Young et al., *Paintings of James McNeill Whistler*, vol. 1, p. 155.

3 John O'Connor, Jr., "Carnegie Institute International Exhibition," *Art and Archaeology* 14 (Nov.–Dec. 1922), p. 303; Henry Adams, in Museum of Art, Carnegie Institute, *Collection Handbook* (Pittsburgh, 1985), p. 196.

Remarks The reeded, gilt frame, intermittently painted in a fish-scale pattern and signed with a butterfly, is Whistler's.

References "Current Art IV," *Magazine of Art* 8 (1885), pp. 467–69; C. Phillips, "Expositions de la Royal Academy et la Grosvenor Gallery," *Gazette des beaux-arts* 32 (July 1885), p. 96; A. de Lostalot, "Salon de 1886, I," *Gazette des beaux-arts* 33 (June 1886), p. 464; T. R. Way and G. R. Dennis, *The Art of James McNeill Whistler: An Appreciation* (London, 1903), pp. 48–49; T. Duret, *Histoire de J. McN. Whistler et de son oeuvre* (Paris, 1904), pp. 95, 113; F. Keppel, *One Day with Whistler* (New York, 1904), p. 8; M. Menpes, *Whistler as I Knew Him* (London, 1904), p. 73; L. Benedite, "Artistes contemporains: Whistler," *Gazette des beaux-arts* 97 (Sept. 1905), p. 244; S. H[artmann], "Studio Talk: Pittsburg [*sic*], Pennsylvania," *International Studio* 29 (Sept. 1906), p. 266; E. L. Cary, *The Works of James McNeill Whistler: A Study with a Tentative List of the Artist's Works* (New York, 1907), no. 53; Pennell and Pennell, *The Life of James McNeill Whistler*, vol. 1, pp. 126, 178, vol. 2, pp. 2–4, 8–9, 56–57, 63, 298; B. Sickert, *Whistler* (London, 1908), pp. 35–36; S. Starr, "Personal Recollections of Whistler," *Atlantic Monthly* 101 (Apr. 1908), p. 534; C. Krogh, *New Age* (Dec. 10, 1908), p. 133; W. R. Sickert, "Where Paul and I Differ," *Art News* 14 (Feb. 10, 1910), p. 113; T. R. Way, *Memories of James McNeill Whistler, The Artist* (London, 1912), p. 80; Pennell and Pennell, *The Whistler Journal* (Philadelphia, 1921), pp. 4–5; A. Ludovici, *An Artist's Life in London and Paris, 1870–1925* (London, 1926), p. 76; D. Sutton, *American Painting* (London, 1948), p. 21; J. O'Connor, Jr., "Sarasate," *Carnegie Magazine* 24 (Mar. 1950), pp. 275, 282; J. Laver, *Whistler* (London, 1951), pp. 203, 235; H. Gregory, *The World of James McNeill Whistler* (New York, 1959), pp. 119, 171; "The Great Sarasate," *Christian Science Monitor*, May 13, 1959, p. 6; D. Sutton, *Nocturne: The Art of James McNeill Whistler* (London, 1963), pp. 78, 102–3; E. P. Richardson, *Painting in America* (New York, 1965), p. 270; F. Myers, "Portrait of the Artist's Mother," *Carnegie Magazine* 29 (Sept. 1965), p. 249; D. Sutton, *James McNeill Whistler: Paintings, Etchings, Pastels and Watercolours* (London, 1966), p. 194; F. A. Sweet, *James McNeill Whistler* (Chicago, 1968), pp. 34, 81; T. B. Brumbaugh, "A Whistler Footnote," *Art Journal* 31 (Spring 1972), p. 261; Young, et al., *The Paintings of James McNeill Whistler* vol. 1, no. 315, pp. 154–55; V. A. Clark, "Collecting from the Internationals," *Carnegie Magazine*

56 (Sept.–Oct. 1982), pp. 17, 22; E. Johns, *Thomas Eakins* (Princeton, N.J., 1983), p. 126; H. Adams, in Museum of Art, Carnegie Institute, *Collection Handbook* (Pittsburgh, 1985), p. 196; John Walker, *James McNeill Whistler* (New York, 1987), p. 105; J. A. M. Bienenstock, "From Yankee Ingenuity to Yankee Artistry: American Artists at the Antwerp World's Fair of 1894," *Museummagazine* 7, annual of the Koninklijk Museum voor Schone Kunsten (Antwerp, 1987), pp. 38–44.

Exhibitions Society of British Artists, London, 1885, *Sixty-second Annual Exhibition*, no. 350; Paris, *Salon of 1886*, no. 2,450, as *Portrait*; Société des Vingt, Brussels, 1886, as *Pablo de Sarasate*, unnumbered; Society of Portrait Painters, London, 1893, *Third Exhibition*, no. 52, as *Sarasate*; *Exposition Universelle*, Antwerp, 1894, United States Section, no cat.; Kunsthalle, Hamburg, 1894, *Grosse Kunst Ausstellung des Kunst Vereins*, no. 646, as *Bildnis des Künstlers Pablo Sarasate*; [Department of Fine Arts, Carnegie Institute, Pittsburgh], 1896, *First Annual Exhibition*, no. 303, as *Sarasate*; Department of Fine Arts, Carnegie Institute, Pittsburgh, 1897, *Second Annual Exhibition*, no. 239, as *Sarasate*; Art Institute of Chicago, 1898, *Loan Exhibition of Selected Works of Old and Modern Masters, Being the Annual Exhibition of the Antiquarians of the Art Institute*, no. 60, as *Portrait of Pablo Sarasate*; Copley Society of Boston, 1904, *Memorial Exhibition of the Works of Mr. J. McNeill Whistler*, no. 53; Ecole des Beaux-Arts, Paris, 1905, *Exposition des oeuvres de James McNeill Whistler*, no. 20; Metropolitan Museum of Art, New York, 1910, *Paintings in Oil and Pastel by James McNeill Whistler*, no. 29; *International Fine Arts Exposition*, Rome, 1911, no. 94; Department of Fine Arts, Carnegie Institute, Pittsburgh, 1957, *American Classics of the Nineteenth Century*, no. 54; Arts Council of Great Britain and the English-Speaking Union of the United States, London, 1960, *James McNeill Whistler* (trav. exh.), exh. cat. by A. M. Young, no. 47; Art Institute of Chicago, 1968, *James McNeill Whistler* (trav. exh.), exh. cat. by F. A. Sneet, no. 35; Nationalgalerie, Berlin, 1969, *James McNeill Whistler*, exh. cat. by R. Spencer, essays by A. M. Young and H. Bock, no. 37.

Provenance Grafton Gallery, London, as agent, 1895–96; Edward G. Kennedy, New York, as agent, 1896.

Purchase, 1896, 96.2

Worthington Whittredge

1820–1910

A LEADING MEMBER OF the later generation of Hudson River school painters, Thomas Worthington Whittredge was born on a farm near Springfield, Ohio, the youngest son of a large family. His father was a New England sea captain who had taken his family west to earn his livelihood grazing cattle. As a result of his rural upbringing, Whittredge received only minimal schooling. His professional life began at age seventeen, when he moved to Cincinnati to learn house painting from a brother-in-law. He turned to sign and portrait painting and then to daguerreotype photography, traveling to Indiana and West Virginia to find work.

By 1843 Whittredge had returned to Cincinnati. There, as an essentially self-taught painter, he began exhibiting and selling landscape views that resembled those of Thomas Doughty and Thomas Cole. In 1846 he sent one of his landscapes to the National Academy of Design in New York. When Asher B. Durand, the academy's president, saw it on exhibit, he sent the aspiring artist his encouragement.

In 1849 Whittredge left to travel and study in Europe, where he stayed for ten years. From London, Paris, and Brussels, he went to Barbizon and then the Rhine valley before settling in Düsseldorf, where he lived for five years. In Düsseldorf Whittredge attended the academy, working under Emanuel Leutze, leader of the city's enclave of American artists, and through Leutze he entered Düsseldorf's philosophic and literary circles.

In 1856 Whittredge followed Leutze on a sketching tour of Switzerland, joining there a group of Americans, including William Haseltine and Albert Bierstadt, who continued with Whittredge to Italy. For the next three years, he lived in Rome, where there was also an established American art community. With Bierstadt and Sanford Gifford his constant companions, he supported himself by painting souvenir landscapes for tourists. Although later in life Whittredge doubted the need for American artists to go to Europe,[1] his own stay there made an enormous difference in his education and cultural sophistication. It was initially in Europe that he came into close contact with notable, ambitious American artists—Frederic E. Church in Paris; Leutze and Eastman Johnson in Düsseldorf; Hiram Powers in Florence; Bierstadt, Haseltine, and Gifford in Rome.

In 1859 Whittredge returned to the United States and moved to New York. He rented a studio in the same Tenth Street Studio Building where Church, Gifford, Bierstadt, and numerous other landscape painters associated with the Hudson River school had their painting rooms. Elected an academician of the National Academy of Design in 1861, Whittredge began to teach at the Cooper Union art school. In 1875 and 1876 he was elected president of the National Academy of Design.

Whittredge's interests in landscape painting corresponded to those of his New York colleagues. He was at once receptive to the ideas of John Ruskin and dedicated to making his landscapes idiomatically American. He traveled on painting expeditions not only to the Catskill Mountains and the New England coast but also to the west and south of the American continent. In 1866 and 1869 he toured Colorado and New Mexico, and he made another trip to the Rocky Mountains with Gifford and John Frederick Kensett in 1871. He also traveled to Mexico in 1893, returning there in 1896 with Church.

Whittredge's painting technique had the crisp, objective precision characteristic of both his Düsseldorf training and the so-called American Pre-Raphaelite movement, which centered in New York in the 1860s. Yet by the 1880s, Whittredge's dry, detailed facture gave way to a softer, freer manner that showed the influence of French Barbizon painting.

In 1880 the artist retired to the countryside of Summit, New Jersey, where he wrote his autobiography in 1905. He retained his studio in the Tenth Street Studio Building until 1897, and he befriended younger artists at work there. Until 1900 he showed regularly at the National Academy, and he won silver medals at Buffalo's Pan-American Exposition of 1901 and Saint Louis's Universal Exposition of 1904. Whittredge died in Summit, New Jersey.

1 Baur, "Autobiography of Worthington Whittredge," pp. 39–40.

Bibliography John I. H. Baur, ed., "The Autobiography of Worthington Whittredge," *Brooklyn Museum Journal* [1] (1942), pp. 5–68; Munson-Williams-Proctor Institute, Utica, N.Y., *Worthington Whittredge, 1820–1910: A Retrospective Exhibition of an American Artist* (1969), exh. cat. by Edward H. Dwight; Adams Davidson Art Galleries, Washington, D.C., *Quiet Places: The American Landscapes of Worthington Whittredge* (1982), exh. cat. by Cheryl A. Cibulka; Anthony F. Janson, *Worthington Whittredge.*

Forest Rocks and Tree, c. 1872

Oil on canvas
23 x 15 in. (58.4 x 38.1 cm)
Signature: W. Whittredge. (lower left)

This painting is a modest example of the type of forest interior most associated with Worthington Whittredge and usually cited as the best of his mature work. Finished with great care, it conveys with its dense, pervasive detail the experience of confronting nature at close range.

The painting's subject is a stand of trees and a cluster of moss-covered boulders in the flat area of a forest. The boulders and tree that dominate the composition lean into one another in a way that emphasizes the forest's irregularity. Rising from a ground line obscured by grass, leaves, and broken branches, they are sufficiently close to the viewer to be cut off by the frame of the picture. With the aid of the thicket of trees behind them, they also block any line of sight to the horizon. Only small patches of hazy sky are visible through the web of tree branches, creating a sense of complete enclosure by the forest.

This type of composition is reminiscent of both Asher B. Durand's and John Frederick Kensett's forest interiors of the 1850s and 1860s and is true to the spirit conveyed by Durand's essays on landscape painting published in *The Crayon* in 1855. By seeking out the hills and woodlands of New York, Whittredge deliberately chose a common and unexceptional subject: neither his largest tree nor the rocks next to it are particularly unusual or majestic. He ennobled his subject simply by studying it with care and sincerity.

fellow landscape painters. Some of the forest interiors, claimed Isham, those with "great trees, mysterious depths of shadow and light trickling down on masses of rock and fern and mosses, are among the best things of the Hudson River school."[1]
DS

1 Samuel Isham, *A History of American Painting* (1905; reprint, with additions by Royal Cortissoz, New York, 1927), p. 245.

Reference Janson, *Worthington Whittredge*, p. 144.

Provenance Ira Spanierman Gallery, New York, by 1975.

Howard N. Eavenson Memorial Fund for the Howard N. Eavenson Americana Collection, 1976, 76.22

Joseph R. Woodwell
1842–1911

THE SON OF A PROSPEROUS Pittsburgh woodcarver and hardware merchant, Joseph Ryan Woodwell received his early artistic training from the local landscape painter George Hetzel. He was a precocious student who first exhibited his own work in 1859 when he was just seventeen. Shortly thereafter he went to Europe, where he remained for about five years.

Woodwell studied in Paris at the Académie Julian with Emile-Charles Lambinet, whose informal views of the picturesque French countryside introduced Woodwell to the Barbizon style of landscape painting. The young artist frequently visited the village of Barbizon, where he became acquainted with painters Jean-François Millet and Charles-Emile Jacque. Under the influence of these and other Barbizon painters, including Camille Corot and Narcisse Diaz, Woodwell's sensibility yielded to a preference for quiet scenes of rural life in the manner of his French colleagues. The increased painterliness and more confident handling of atmospheric effects that accompanied this shift set the pattern for his style for several decades.

Woodwell's friends among the younger French artists included the future Impressionists Alfred Sisley (with whom

This canvas, dated 1872 by Anthony Janson, is nonetheless quite similar to Whittredge's work of a decade earlier, for example, *Rocks and Pines* (1864, Vassar College Art Gallery, Poughkeepsie, N.Y.), and sketchbook motifs made in 1861. This suggests he treated such subjects in much the same way for a dozen years after settling in New York, returning to the same sites, in person or through memory, as if the very continuity had meaning for him.

Whittredge's forest interiors are set apart from those of his peers by their tonal harmonies and avoidance of compositional convention. This canvas is correspondingly rich with greens and light browns, picked out with touches of gray and yellow, creating a subtle tapestry of deep hues. In 1905 this treatment inspired the praise of Samuel Isham, who described Whittredge's efforts as having "a deeper, graver note" than those of his

he visited Normandy), Claude Monet, Pierre-Auguste Renoir, and Camille Pissarro. In France he also associated with the American expatriate Daniel Ridgeway Knight, with whom he traveled to Rome before touring England and Ireland.

Following his return to Pittsburgh around 1867, Woodwell joined the family hardware company, but he continued to paint, spending several hours each day in the small brick studio behind his large Penn Avenue house. He joined the group of Pittsburgh artists who painted at Scalp Level, a Barbizon-like retreat in the Allegheny Mountains in nearby Somerset County. The influence of the Barbizon school remained with him: it is especially marked in *The Red School* (see p. 486) and *Cottage in the Woods* (1878, collection Mr. and Mrs. William H. Woodwell, Pittsburgh), in which the heavy impasto has been built up with an abundance of small brushstrokes.

Beginning in the late 1880s, Woodwell adopted a broader, more structured manner and a lighter palette inspired by Impressionism, which was just coming into vogue in America. He took up marine subjects at his summer home in Magnolia, Massachusetts, and also in Florida, where he wintered after his retirement. He traveled widely, visiting, among other places, Niagara Falls, Quebec, California, Mexico, and Cuba.

A prolific painter, Woodwell exhibited regularly in Pittsburgh, at the Pennsylvania Academy of the Fine Arts, Philadelphia, beginning in 1861, and at the National Academy of Design, New York, in 1879 and 1880. His work also appeared in many other important American exhibitions, including the Centennial Exposition of 1876 in Philadelphia, the World's Columbian Exposition of 1893 in Chicago (for which he also served as a state juror), and the Saint Louis Universal Exposition in 1904, at which he was awarded a bronze medal.

Woodwell justifiably enjoyed considerable prestige in his native city. From 1896 until his death he served Carnegie Institute as a trustee and as a member of the Fine Arts Committee. He exhibited in ten Carnegie Internationals between 1897 and 1909. Noted for his agreeable personality, he often entertained visiting jurors; he was a particular friend of Thomas Eakins. Twenty-two years after his death in Pittsburgh, Carnegie Institute honored his memory with a solo exhibition.

Bibliography Maude Carrell, "Pittsburgh Artist Now Celebrated," *Pittsburg Dispatch*, July 10, 1910, magazine sec., p. 4; Department of Fine Arts, Carnegie Institute, Pittsburgh, *Exhibition of Paintings by Joseph R. Woodwell* (1933); Henry Clay Frick Fine Arts Department, University of Pittsburgh, *An Exhibition of the Work of Joseph R. Woodwell* (1954); Matthew J. Roper, Jr., "Biography of Joseph R. Woodwell," museum files, The Carnegie Museum of Art, Pittsburgh, 1976, manuscript; Joseph R. Woodwell Papers, Archives of American Art, Washington, D.C.

Cernay-la-Ville, no. 1, 1868

Oil on canvas
23⅜ x 39⅛ in. (59.4 x 99.4 cm)
Signature, date: Jos. R. Woodwell 1868 (lower right)

Cernay-la-Ville, no. 2, 1868

Oil on canvas
23¾ x 39¼ in. (60.3 x 99.7 cm)
Signature, date: J. R. Woodwell 1868 (lower left)

Located about thirty miles southwest of Paris, Cernay-la-Ville is one of several quaint villages that were frequented by artists and tourists during the nineteenth century. Indeed, traveling there in the late 1870s, the American artist J. Alden Weir

visited an inn that was decorated with panels painted by Gustave Courbet and Charles Daubigny. Winslow Homer, attracted by the rural flavor of the countryside, also painted there during his trip to France in 1867.

In 1865 Woodwell went to Cernay-la-Ville, where he produced *Vaux de Cernay* (location unknown), which was exhibited at the Pennsylvania Academy of the Fine Arts, and *The Bridge at Cernay—near Paris* (location unknown). The latter, commissioned by the Pittsburgh art patron C. H. Wolff, was reportedly painted "from the scene."[1] *Cernay-la-Ville, no. 1* and *Cernay-la-Ville, no. 2*, undertaken shortly after Woodwell returned to the United States in 1867, were probably prepared from sketches made either in 1865 or during a subsequent visit to the area.

Despite their titles, neither work is a topographical view of Cernay-la-Ville; rather like the landscapes of his teacher Lambinet, whose "restrained, lyrical renderings of the French countryside" helped to popularize Barbizon school painting,[2] Woodwell's scenes capture the leisurely pace of life in a traditional rural French community. In *Cernay-la-Ville, no. 1*, the

foreground is occupied by three children who are fishing in a quiet stream beside a field of ripening wheat; in the distance, the roofs of the village buildings form a picturesque silhouette against the overcast sky. In *Cernay-la-Ville, no. 2*, women dressed in regional costume meet on a pathway on the outskirts of the village.

Though the figures in each landscape are small, the depiction of them as they engage in routine activities serves to remind the urban viewer of the simplicity of country life. Woodwell further contributes to the tranquillity of each scene by using a restricted palette of silvery grays, light blues, and deep greens, applied with a soft brush. The broad horizontal compositions and the elimination of minute detail add to the uncalculated effect that was an important goal of the Barbizon painters.

GB

1 C. H. Wolff, [*Ledger of Art Possessions*], *1857–1885*, p. 42.

2 Peter Bermingham, *American Art in the Barbizon Mood*, p. 46.

Cernay-la-Ville, no. 1

Exhibitions Department of Fine Arts, Carnegie Institute, Pittsburgh, 1933, *Exhibition of Paintings by Joseph R. Woodwell*, no. 8; Henry Clay Frick Fine Arts Department, University of Pittsburgh, 1953, *An Exhibition of the Work of Joseph R. Woodwell*, no. 12.

Provenance The artist's daughter, Johanna K. W. Hailman, Pittsburgh, by descent.

Bequest of Johanna K. W. Hailman, 1959, 59.5.23

Cernay-la-Ville, no. 2

Exhibitions Department of Fine Arts, Carnegie Institute, Pittsburgh, 1933, *Exhibition of Paintings by Joseph R. Woodwell*, no. 10; Henry Clay Frick Fine Arts Department, University of Pittsburgh, 1953, *An Exhibition of the Work of Joseph R. Woodwell*, no. 13.

Provenance The artist's daughter, Johanna K. W. Hailman, Pittsburgh, by descent.

Bequest of Johanna K. W. Hailman, 1959, 59.5.24

The Red School, c. 1880–82

Oil on canvas
15 x 26 in. (38.1 x 66 cm)
Signature: J. R. Woodwell (lower left)
Inscription: Painting by/J. R. Woodwell/ 1880–1 – 2 (on reverse)

Although business responsibilities claimed much of Woodwell's attention after his return from Europe, he often painted with the Scalp Level group, which made frequent excursions into the western Pennsylvania countryside in the 1870s and 1880s to sketch from nature. In this Barbizonesque setting, prominent Pittsburgh artists painted peaceful wooded landscapes and, occasionally, informal scenes of rural life. No doubt inspired by the rustic scenery around Scalp Level, *The Red School* is a picturesque view of a remote country schoolhouse nestled in the woods beneath a cool, overcast sky.

Though painted in the early 1880s, this work shows the strong influence of the French Barbizon painters with whom Woodwell had associated fifteen years earlier. Its dark, somber tone and richly textured surface recall works by Théodore Rousseau and Constant Troyon, while the softly rendered foliage and the small figures in the middle distance are reminiscent of the landscapes of Camille Corot. Only the quickly brushed figures in front of the school hint at the impressionistic nature of Woodwell's future style.

GB

Provenance Harry Eichleay Art Co., Pittsburgh; private collection, West End, N.J., 1975; Marbella Gallery, N.Y., 1975.

Gift of Richard M. Scaife, 1976, 76.40

Little Guard Harbor, 1888

Oil on canvas
8⅛ x 12 in. (20.6 x 30.5 cm)
Signature, date, inscription: J R Woodwell 1888/ Ross Rocks (lower left)
Inscription: J. R. Woodwell 1888/Little Guard Harbor (on reverse)

Magnolia, 1888

Oil on canvas
8⅛ x 12 in. (20.6 x 30.5 cm)
Signature: J R Woodwell (lower left)
Inscription: Magnolia/1888 (lower right)

Like many artists of his generation, Woodwell sought out picturesque places to paint during the summer. Among his choices were the pictorial prospects of the New England coast. In the late 1880s the artist purchased a summer home at Magnolia, a small seaside town near Gloucester, Massachusetts, which had been a popular gathering place for artists since William Morris Hunt established an informal art colony there in 1876. Views of Magnolia and its environs were among Woodwell's most frequent subjects during the next decade.

Reminiscent of the intimate seaside sketches of Eugène Boudin, *Little Guard Harbor* and *Magnolia* focus on the everyday summertime activities of sailing and strolling on the beach at low tide. The simple plank bridge in *Little Guard Harbor* and the weathered shacks in *Magnolia* add to the unpretentious charm of these small-scale shore views. Human figures, which appear only in *Little Guard Harbor*, are diminutive, each created with just a few quick strokes. Both

works are painted in soft, muted tones ranging from the delicate silvery blue-greens of the sky and water to the muted greens and browns that are found among the rocks in the foreground of each scene; accents of bright blue and red enliven the color scheme.

Lighter and brighter than Woodwell's typical Scalp Level landscapes, these two works reflect the increasing influence of Impressionism on American painting. The fluid brushstrokes, however, have little in common with the fractured strokes associated with Impressionist technique. The loose handling of paint gives freshness to the two scenes, and this, coupled with the small size of the paintings, suggests that the works were executed in the plein-air manner of the Impressionists.
GB

Little Guard Harbor

Provenance The artist's daughter, Johanna K. W. Hailman, Pittsburgh, by descent.

Bequest of Johanna K. W. Hailman, 1959, 59.5.26

Magnolia

Provenance The artist's daughter, Johanna K. W. Hailman, Pittsburgh, by descent.

Bequest of Johanna K. W. Hailman, 1959, 59.5.27

Harvest Hay, c. 1888

Oil on board
9¾ x 15⅝ in. (24.8 x 39.7 cm)

Rich and mellow in tone, this late-summer scene of farmhands gathering hay on the outskirts of a small village reflects Woodwell's long-standing interest in rural subjects. Although the work is not dated, its small scale and loose brushwork ally it with *Little Guard Harbor* (see p. 000) and *Farm Scene* (c. 1889, Westmoreland Museum of Art, Greensburg, Pa.), which Woodwell produced in the late 1880s. As was typical of his style at this time, the forms were created with quick fluid strokes, and the muted color scheme was enlivened by a few touches of bright paint; contrasts of light and shadow strengthen the composition.

Damage to the paint surface on the right side of the picture reveals Woodwell's characteristic reddish brown underpainting.
GB

Exhibition Westmoreland County Museum of Art, Greensburg, Pa., 1976, *Nineteenth and Early Twentieth Century Regional Painters*, exh. cat. by P. A. Chew and J. K. Maguire, unnumbered.

Provenance The artist's daughter, Johanna K. W. Hailman, Pittsburgh, by descent.

Bequest of Johanna K. W. Hailman, 1959, 59.5.25

Pennsylvania House, c. 1894
(Scalp Level: Old Western Pennsylvania House)

Oil on board
14 x 22 in. (35.6 x 55.9 cm)
Signature: J R Woodwell (lower left)

The original title of this dark, moody painting locates the subject in the Somerset County village where Woodwell and other members of the Scalp Level group regularly went to sketch and paint from nature. Like their Barbizon counterparts, these Pittsburgh landscape painters found in the countryside respite from the burgeoning industrialism of their urban environment. The old weathered farm buildings in *Pennsylvania House* underscore the painter's romantic longing for the humble past.

Despite these picturesque elements, Woodwell's work conveys a disquieting sense of loneliness. Apparently deserted, the farm is shown from the rear; the stream that flows in the foreground distances the viewer from the scene, heightening the sense of isolation. The lines of the low, sheltering roof contribute further to the oddly quiescent mood of the painting. A single streak of sunlight penetrates the scattered cloud cover, lessening the solemnity of the scene; its golden color serves as a foil for the low-key tones that otherwise dominate the composition. Bereft of human presence, the painting finds its main activity in the interplay between the architectural forms and the empty space around them, which engenders a meditative mood in the viewer.
GB

Exhibitions Henry Clay Frick Fine Arts Department, University of Pittsburgh, 1953–54, *An Exhibition of the Work of Joseph R. Woodwell*, no. 9, as *Scalp Level: Old Western Pennsylvania House;* Westmoreland County Museum of Art, Greensburg, Pa., 1976, *Nineteenth and Early Twentieth Century Regional Painters*, exh. cat. by P. A. Chew and J. K. Maguire, unnumbered; Saint Louis Art Museum, 1977, *Currents of Expansion: Painting in the Midwest, 1820–1940*, exh. cat. by J. A. Barter and L. E. Springer, no. 72; Westmoreland County Museum of Art, Greensburg, Pa., 1981, *Southwestern Pennsylvania Painters, 1800–1945*, exh. cat. by P. A. Chew, no. 290.

Provenance The artist's daughter, Johanna K. W. Hailman, Pittsburgh, by descent.

Bequest of Johanna K. W. Hailman, 1959, 59.5.28

The Gorge, 1899
(The Gorge, Niagara)

Oil on canvas
20¼ x 30¼ in. (51.4 x 76.8 cm)
Signature, date: J R Woodwell June 1899 (lower left)

In 1899 Woodwell visited Niagara Falls, where he produced several works, including *The Gorge*. In contrast to his other Niagara subjects, which depict the dramatic scenery of the falls, the rapids, and the famous whirlpool, *The Gorge* presents an unexciting view of the steep cliffs that line the Niagara Gorge, a seven-mile stretch of the Niagara River that runs between the falls and the escarpment at Queenston, Ontario.

Painted from the precipice, Woodwell's view looks across the cataract to the flat, verdant landscape above the dark cliffs. A turquoise June sky, highlighted by pink clouds, enlivens the otherwise moody color scheme, which is dominated by deep blue-greens, grays, and violets. Set apart from Niagara's main tourist attractions, this atypical view is characteristic of Woodwell's preference for unspoiled natural scenery. The romantic effect is heightened by Woodwell's painterly brushwork, which blurs edges and imparts a soft, atmospheric quality to the scene.
GB

Exhibitions Department of Fine Arts, Carnegie Institute, Pittsburgh, 1899, *Fourth Annual Exhibition*, no. 254, as *The Gorge, Niagara;* Department of Fine Arts, Carnegie Institute, Pittsburgh, 1939, *A Century of American Landscape Painting, 1800–1900*, no. 46; Henry Clay Frick Fine Arts Department, University of Pittsburgh, 1953–54, *An Exhibition of the Work of Joseph R. Woodwell*, no. 24.

Provenance The artist, until 1911; Mrs. Joseph R. Woodwell, Pittsburgh, until 1915.

Purchase, 1915, 16.4

Yosemite with Waterfall, c. 1904

Oil on canvas mounted on wood panel
20⅛ x 12⅜ in. (51.1 x 31.4 cm)

Although undated, *Yosemite with Waterfall* is certainly a product of the western trip Woodwell made between 1903 and 1904. One of his four known Yosemite Valley subjects, this work represents one of the park's most spectactular sights, Yosemite Falls, which cascade 2,630 feet down the sheer rock of the mountain face to the verdant valley floor. Woodwell's placid view of the falls suggests that he may have painted this picture from a souvenir photograph. Nevertheless, the brightness of the palette and the varied surface texture capture the special luminosity of California light and provide a refreshing change from the solemnity that characterizes the majority of Woodwell's landscapes.
GB

Remarks On the reverse is a painting of a flower arrangement attributed to Johanna K. W. Hailman, the artist's daughter.

Exhibition Henry Clay Frick Fine Arts Department, University of Pittsburgh, 1953–54, *An Exhibition of the Work of Joseph R. Woodwell*, no. 18.

Provenance The artist's daughter, Johanna K. W. Hailman, Pittsburgh, by descent.

Bequest of Johanna K. W. Hailman, 1959, 59.5.29

Cliff, Dunes, and Sea, 1908

Oil on canvas
20 x 25 in. (50.8 x 63.5 cm)
Signature, date: J R Woodwell 1908 (lower left)

This unidentified seaside view of a steep coastal bluff opening onto a rocky canyon may have been inspired by the dramatic scenery Woodwell encountered during his travels in northern California. As in his earlier Barbizon-style landscapes, Woodwell strives to convey a poetic mood. Here, the coupling of a muted color scheme, which includes subtle shades of gray, tan, olive green, and creamy white, and a solitary flock of birds dwarfed by the scale of the high cliffs captures the haunting quality of this stark landscape.
GB

Exhibitions School of Fine Arts, Miami University, Oxford, Ohio, 1969, *Pittsburgh Exhibition*, no cat.; Westmoreland County Museum of Art, Greensburg, Pa., 1976, *Nineteenth and Early Twentieth Century Regional Painters*, exh. cat. by P. A. Chew and J. K. Maguire, unnumbered.

Provenance Harry J. Miller, Pittsburgh, by 1958.

Gift of Willis McCook Miller, Harry J. Miller, Jr., and William J. Miller, 1958, 58.8.2

Sand Dunes, 1909

Oil on canvas
30 x 40 in. (76.2 x 101.6 cm)
Signature, date: J R Woodwell 1909 (lower left)

Clearly related to *Cliffs, Dunes, and Sea* in both style and subject matter, this enigmatic scene of rugged sand dunes framing a mountain vista may have been painted in the vicinity of the Sierra Nevada range in California. The choice of a lonely spot is characteristic of Woodwell's landscape style and reflects the artist's long-standing admiration for the French Barbizon painters. In *Sand Dunes*, the broad, empty foreground and dark, silhouetted

tree on the right convey a sense of fore-boding. The simplicity and boldness of Woodwell's composition, together with his cool, tonal palette and rich surface texture, ally this work with the poetic paintings of his American contemporaries Homer Dodge Martin and Dwight Tryon, who similarly used landscape sub-jects to convey a mood.

GB

References P. Redd, "Pittsburgh Artists, Past and Present," *Art and Archaeology* 14 (Dec. 1922), p. 314; Richard J. Boyle, *American Impressionism* (Boston, 1974), p 76.

Exhibitions Department of Fine Arts, Carnegie Institute, 1911, *Second Annual Exhibition of the Associated Artists of Pittsburgh*, no. 181; Department of Fine Arts, Carnegie Institute, Pittsburgh, 1933, *Exhibition of Paintings by Joseph R. Woodwell*, no. 5; Mansfield Art Center, Ohio, 1981, *The American Landscape*, no. 23.

Provenance The artist, until 1911; Mrs. Joseph R. Woodwell, Pittsburgh, until 1918.

Gift of Mrs. Joseph Woodwell and her daughter, Johanna K. W. Hailman, 1918, 18.20

Alexander Wyant

1836–1892

A LEXANDER HELWIG WYANT was once described as one of the fathers of modern American landscape painting.[1] Although he has not regained the acclaim he enjoyed during his lifetime and that endured for thirty years after his death, he remains an important contributor to the development of the Barbizon style of landscape painting in America. From an architect of tightly drawn yet thinly painted panoramas he evolved into a painter of the intimate, atmospheric views on which his reputation rests.

The son of an itinerant farmer and car-penter, Wyant was born in Evans Creek, Ohio, and raised in Defiance, Ohio, where he was apprenticed to a harness maker. Around 1854 he began to work as a professional sign painter and amateur artist in the nearby town of Port Washington. He decided to become a landscape painter when he visited Cincinnati in 1857; there he saw works by

George Inness and other artists of the Hudson River school. With the encour-agement of Inness, whom he met in New York in 1859, and with the financial assis-tance of Cincinnati art patron Nicholas Longworth, Wyant moved to New York in 1860. There he devoted himself to landscape, a genre in which he was proba-bly self-taught. He returned to Cincinnati in 1861 and lived there until Longworth's death in 1863, then went back to New York and settled there.

In 1863 Wyant attended a New York exhibition of paintings by the popular Düsseldorf school artists and saw works by the Norwegian painter Hans-Fredrik Gude. Two years later he went to study with Gude at the Karlsruhe academy but stayed only a few months; evidently, Gude's strict technical training was not to Wyant's taste. On his way home, he visit-ed Paris and London, then toured the British Isles. While in England, he was impressed with the works of J. M. W. Turner and John Constable, but their exact influence is difficult to see in his subsequent paintings.[2]

Wyant returned to New York in 1865 and exhibited for the first time at the National Academy of Design. His large, nearly photographic panoramas of the mid-1860s, exemplified by *Tennessee* (for-merly titled *The Mohawk Valley*, 1866, Metropolitan Museum of Art, New York), clearly show his early dependence on the Hudson River painters and, to a lesser extent, Gude. But by the late 1860s popular taste for the meticulous styles of the Hudson River and Düsseldorf schools waned. In response, Wyant began to develop a freer and more personal approach to landscape painting, softening the outlines of objects in order to create an illusion of atmosphere. He appears to have come under the influence of the newly popular French Barbizon painters.

His changing style brought him increased critical acclaim and financial success. He found a ready market for his work, and his watercolors and oil paint-ings were regularly exhibited in New York, Brooklyn, and Philadelphia. He became an associate member of the National Academy of Design in 1868 and an academician in 1869.

During a government-sponsored expe-dition to Arizona and New Mexico in 1873, Wyant suffered a stroke that perma-nently paralyzed his right arm. Undaunted, he trained himself to paint with his left hand, and this is generally

considered one of the major reasons for his increasingly loose brushwork. Like his early mentor, George Inness, Wyant began to use color and atmosphere to express the unity and harmony in nature. But, in contrast to Inness's use of rich, vibrant colors, Wyant preferred somber, silvery hues of green, gray and blue: his muted palette allowed him to explore fully the subtle gradations in tonal values that were his dominant interest.[3]

In the mid-1870s Wyant began to spend his summers at Keene Valley in the Adirondack Mountains of New Hampshire and winters at his New York studio, and in 1889 he and his wife, the watercolorist Arabella Locke, moved to Arkville in the Catskill Mountains of New York. The works he produced in Keene Valley and in Arkville became his signature pieces: subjective views of unex-ceptional countryside bathed in ambient light from a vast, cloudy sky. He died in New York in 1892, a successful and well-regarded artist.

1 Charles H. Caffin, *The Story of American Painting* (New York, 1907), p. 198.

2 Olpin, *Alexander H. Wyant*, p. 116.

3 Clark, "The Art of Alexander Wyant," p. 306.

Bibliography Charles H. Caffin, *American Masters of Painting* (New York, 1902), pp. 143–52; Eliot Clark, "The Art of Alexander Wyant," *Art in America* 2 (1914), pp. 301–12; Eliot Clark, *Alexander Wyant* (New York, 1916); Museum of Fine Arts, University of Utah, Salt Lake City, *Alexander Helwig Wyant, 1836–1892* (1968), exh. cat. by Robert S. Olpin; Robert S. Olpin, "Alexander H. Wyant, 1836–1892, American Landscape Painter: An Investigation of His Life and Fame and a Critical Analysis of His Work with a Catalogue Raisonné," Ph.D. diss., Boston University, 1971.

Afternoon near Arkville, New York, c. 1890

Oil on canvas
28 x 35 in. (71.1 x 88.9 cm)
Signed lower right: A H Wyant

Afternoon near Arkville was painted some-time between 1889 and 1892, when Wyant was living there and selected his subjects from the region at the center of the Catskill Mountains. The color and com-position are characteristic of the artist's

much greater uniformity of his subject matter and color. He repeatedly used a neutral palette to portray flat landscapes or forest interiors under vast, overcast skies and relied almost totally on subtle changes in tonal values, rather than color or composition, to create pictorial interest.

RB

References Museum of Fine Arts, *Alexander Helwig Wyant, 1836–1892*, p. 21; Olpin, *Alexander H. Wyant, 1836–1892*, no. 247, pp. 399–400.

Exhibition San Francisco, 1915, *Panama-Pacific International Exposition*, no. 2,545.

Provenance John P. McWilliams, 1892; S. S. Dustin, New York, by 1910; M. Knoedler and Co., New York, 1911.

Purchase, 1911, 11.10

late works: it is a study in silvery greens and grays, wherein a broad, marshy field recedes to a low horizon line broken by clumps of trees and a lone farmhouse.

The painting exemplifies the influence of George Inness and the French Barbizon painters; their mark can be seen in the simple, generalized forms, the thick, painterly application of pigments, and the creation of a palpable atmosphere through indistinctly outlined objects. What sets Wyant's work apart from Inness and the Barbizon painters is the

Unidentified artist

19th century

Hannah Henninguer Baum,
c. 1815–20

Oil on linen twill
27⅛ x 22¼ in. (68.9 x 56.5 cm)

This modest canvas, painted in Baltimore by an itinerant artist, presents a rather rarely documented pictorial type in earlier American naïve painting: a portrait of a widow. The sitter, Hannah Henninguer (born 1742), of Alsatian Huguenot descent, was a native of Lancaster County, Pennsylvania. Her husband, Christian Baum, fought in the American Revolution and died in the Battle of Brandywine, Delaware, in 1777. According to family records, Hannah Baum moved with her only son, Christian, Jr., to Baltimore in 1782 and lived there, widowed, for the rest of her life. Her son had five children, the youngest of whom, William Penn Baum (1799–1867), left Baltimore for Pittsburgh in 1812. It was through his family that the picture descended.

Here, Hannah Baum is shown bust length, wearing a black dressing gown, a white cap, and a white fichu whose styles are suggestive of the first decade of the nineteenth century. Her portrait blends the hieratic with the familiar. On the one hand, it shows a rigid, nearly frontal pose and, through the device of a drawn curtain, a formal setting. The absence of swags and folds suggests the artist was not fully aware of the prop's tradition. Yet homeliness intrudes in the wisp of hair escaping from Hannah Baum's cap and in the almost tender rendering of features, particularly her wrinkles and moist eyes.

The work is not particularly ambitious, for the canvas dimensions are rather constricted, and there are only two props in

the composition: the green curtain and the back of a bright red chair (perhaps the painter's notation for a Neoclassical mahogany scroll-backed side chair). The remainder of the background is a light brown. This limited palette was applied over a thin ground of white oil paint upon a support of lightweight linen. Although the picture was reframed, glazed, and probably restored around 1910, it suffered relatively little. Apart from some free inpainting of the background and some abrasion in the lips, it was spared the energetic retouching and strengthening, especially of facial features, that so often afflicted folk portraits.

The sympathy and delicacy with which the sitter's facial features were set down are suggestive of an artist whose career encompassed the 1780s and 1790s rather than someone who became active in the nineteenth century. So, too, is the coloring; the pigments have a muted quality different from the brasher intensity that became the norm after 1820 or so. Along with the conservativeness of the composition, these traits suggest that the work is by an older painter, who may have felt out of touch with current standards of stylishness.

DS

Provenance Alden Hemphill Baum, Pittsburgh, by descent.

Gift of Mrs. Alden Hemphill Baum in memory of her husband, 1985, 85.38

(Baltimore Museum of Art). Added to the painting's somewhat primitive yet careful style, this suggests that it may be the work of one of the Peale women, possibly one of the daughters of James Peale—Anna Claypoole (1791–1878), Margaretta Angelica (1795–1882), or Sarah Miriam (1800–1885)—a number of whose still-life paintings resemble those of their uncle Raphaelle.

One of the endearing features of this painting is the energetic profile of the cream-colored dish, which echoes the undulating fruit it holds. The dish appears to be a Wedgwood feather-edge queensware pattern. Produced during the last quarter of the eighteenth century, it was a type of Staffordshire pottery similar to the pearlware dishes that appear in, for example, *A Slice of Watermelon*, 1825, by Sarah Peale (Wadsworth Atheneum,

Hartford, Conn.) and *American Still Life*, 1828, by Margaretta Peale (Smith College Museum of Art, Northampton, Mass.). This was, in early nineteenth-century America, a consummately middle-class and somewhat old-fashioned houseware, perhaps meant by the the artist to suggest a simpler, bygone era.

DS

Provenance Senator and Mrs. H. John Heinz III, Pittsburgh, by descent.

Gift of Senator and Mrs. H. John Heinz III, 1979, 79.71.4

Unidentified artist

19th century

John Remington at Eighty, c. 1830

Oil on canvas
32¾ x 28 in. (83.2 x 71.1 cm)
Inscription: Jno Remington, Age 80 (on reverse)

Identified on the basis of an inscription on the back of the painting, the sitter for this portrait is a youthful-appearing octogenarian, dressed in a close-fitting dark frock coat with a white shirt and dark stock. The cut of his clothing suggests a

Unidentified artist

19th century

Still Life with Peaches and Grapes, c. 1825–30

Oil on canvas
13³⁄₁₆ x 17 in. (33.5 x 43.2 cm)

The focus of this tabletop arrangement of eight peaches and two bunches of white grapes is the fruit itself, their virtually perfect forms toppling from a pottery dish onto an unadorned tile counter. The presence of this perfectly formed yet humble fruit in an intimate, essentially middle-class setting recalls Raphaelle Peale's approach to still-life painting. In fact the arrangement here is strongly reminiscent of Peale's undated *Still Life with Peaches, White Grapes and Porcelain Dish*

date during the 1830s,[1] as do his short hair and clean-shaven face.

The composition of this half-length portrait is relatively simple: Remington occupies the center of the canvas; the green wall paneling behind him forms a subdued pattern of verticals and horizontals, while at the right is a portion of a painting of a racecourse and grandstand. The sitter is described with a corresponding economy of detail. The abundant decoration often used by the folk artist to counterbalance a lack of illusionistic coherence is not found in this work, evidence perhaps of the artist's confidence in his representational skill.

The painting on the wall behind Remington and the riding crop in his right hand obviously indicate that he had an interest in horses, perhaps as the owner of a horse farm. Folk portraits using a painting to identify the sitter's occupation are relatively rare, but precedents exist, for example, Winthrop Chandler's portrait of Captain Samuel Chandler (c. 1780, National Gallery of Art, Washington, D.C.). It was more common to employ an open window through which a vignette illustrating the sitter's occupation could be seen, even though there is certainly a close relationship between the two devices.
EM

1 Turner Wilcox, *Five Centuries of American Costume* (New York, 1963), pp. 138ff.

Remarks The painting is in its original frame—a 3⅝-inch black Duyckinck-type frame with gilt inner edge.

Provenance Found in New York State; Rockwell Gardiner, Stanford, Conn. by 1954; Edgar W. and Bernice Chrysler Garbisch, Cambridge, Md., 1954; on loan to the National Gallery of Art, Washington, D.C., 1955–80.

Bequest of Edgar W. and Bernice Chrysler Garbisch, 1981, 81.21.5

Unidentified artist

19th century

Portrait of a Woman with a Comb, c. 1830–35

Oil on canvas
24⅛ x 19½ in. (61.3 x 49.5 cm)

The woman portrayed here wears a simple dark green gown with very full leg-of-mutton sleeves and a lighter green shawl tightly pulled around her shoulders and neck. Her hair is parted in the center, pulled back and up, and held in place with a large and presumably very fine tortoiseshell comb. Her dress and hairstyle, as well as the minutely detailed manner in which she is painted, point to a date during the early 1830s. The two scenes illustrated behind her—a hillside with a cottage and a coastline with a lighthouse and a clipper ship—suggest that she may have belonged to a family connected with both agricultural and seafaring activities. This type of image—one with a background identifying the sitter's occupation or heritage—is fairly common among early nineteenth-century folk portraits; it points to a relatively ambitious painter and, most likely, a costlier and more prestigious painting as its model.
EM

Provenance Karl Maynard, Woburn, Mass., c. 1948; Charles D. Childs, Boston, Mass., until 1948; Edgar W. and Bernice Chrysler Garbisch, Cambridge, Md., 1948.

Bequest of Edgar W. and Bernice Chrysler Garbisch, 1981, 81.21.7

Unidentified artist

19th century

Mary Jane Haskins Lincoln, 1831

Oil on canvas
26⁵⁄₁₆ x 23⅝ in. (66.8 x 60 cm)
Inscription: S.C.L./Nov./1831 (on reverse)

Very little factual information is known about the woman pictured in this portrait other than the name ascribed to the sitter. An inscription on the back, "S.C.L./Nov./1831," suggests however, that the portrait was painted by a member of the family. The date of the inscription and the sitter's apparent age—mid-twenties or early thirties—indicate that Mary Lincoln was probably born near the turn of the century, perhaps in New York State, where the painting was originally found.

The sitter is fashionably dressed for a woman of the 1830s. Her gown is of a heavy dark fabric with a square neck and very full sleeves. Over the bodice she wears a sheer white collar trimmed with lace and ribbons. The artist's confident handling of the different fabrics of her dress—the heavy folds of fabric, the satiny smoothness of the ribbons, and the translucency of her collar—suggests some formal training. The abstract pink and blue background was probably meant to evoke the nonspecific, atmospheric settings prevalent in high-style portraiture from Gilbert Stuart and Thomas Sully to Henry Inman.
EM

Provenance Found in New York State; Alfred Arnold Antiques, New Hope, Pa., until 1960; Edgar W. and Bernice Chrysler Garbisch, Cambridge, Md., 1960.

Bequest of Edgar W. and Bernice Chrysler Garbisch, 1981, 81.21.6

Unidentified artist

19th century

Knowledge Is Power, 1837

Oil on canvas
51¾ x 41⅛ in. (131.4 x 104.5 cm)
Inscriptions: WILLIAM PENN INSTITUTE (stenciled along bottom edge); Knowledge is Power./ WILLIAM PENN INSTITUTE. Organized October 1st 1837 (stenciled on reverse)

This painting is a mirror-image copy of Benjamin West's painting *William Penn's Treaty with the Indians* (1771–72, Pennsylvania Academy of the Fine Arts, Philadelphia), undoubtedly based upon John Hall's well-known engraving, which was published in London in 1775. By the 1800s the engraving was circulating in the United States, where it was copied by another American folk artist, Edward Hicks.

The inscription on the back of the painting, "Knowledge is Power. WILLIAM PENN INSTITUTE. Organized October 1st 1837," indicates that the canvas was commissioned to commemorate the founding of the short-lived William Penn Institute in Reading, Pennsylvania, the town where the painting was discovered. Little is known about this organization other than

that it was founded by mechanics and store clerks who sought intellectual improvement. The members met on a weekly basis for lectures and debates and are perhaps best remembered for the library they established with the money earned from these lectures.[1]

The date on the back of this painting is of value because it offers a firm date for the founding of the institute.

EM

1 Unidentified newspaper article from Jones Scrapbook, vol. 5, p. 164, Historical Society of Berks County, Reading, Pa.

Provenance Found in Reading, Pa.; Edgar Sittig, Shawnee on Delaware, Pa.; Edgar W. and Bernice Chrysler Garbisch, Cambridge, Md., 1950.

Bequest of Edgar W. and Bernice Chrysler Garbisch, 1981, 81.21.21

Unidentified artist

19th century

Portrait of a Boy, c. 1840

Oil on canvas
30 x 25 in. (76.2 x 63.5 cm)

The young boy in this portrait, identified as a member of the Hill family of Philadelphia,[1] is dressed in the type of belted smock coat, pantaloons, and shirt worn by young boys not yet *breeched* (dressed in breeches, usually at the age of four). Following the academic convention for formal portraiture, he is placed before

a backdrop of crimson drapery, holding in his left hand what appears to be a small riding crop—possibly a favorite toy, but also an emblem of future manhood traditionally included in formal portraits of small boys. However, the placement of the drapery is rather confused: although the boy is set in front of the drapery, the drapery extends below the boy's feet, which confounds the spatial illusion created by raising the ground line.

EM

1 Museum files, The Carnegie Museum of Art, Pittsburgh.

Provenance Leon Stark, Philadelphia, until 1953; Edgar W. and Bernice Chrysler Garbisch, Cambridge, Md., 1953; on loan to the National Gallery of Art, Washington, D.C., 1955–80.

Bequest of Edgar W. and Bernice Chrysler Garbisch, 1981, 81.21.9

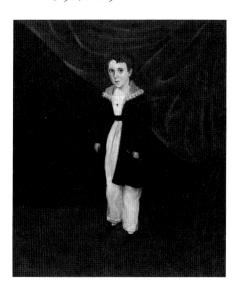

Unidentified artist

19th century

Portrait of a Girl with a Dog, c. 1840

Oil on canvas
50 x 40¼ in. (127 x 102.2 cm)
Inscription: W. H. H./T E M (on dog's collar)

Young children with pets were often pictured in nineteenth-century folk portraits. Usually the pet was drawn proportionally smaller than the child and was

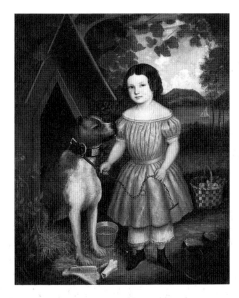

held in the child's lap, as in Ammi Phillips's *Girl in Red with Her Cat and Dog* (1834–36, private collection) and Noah North's *Boy Holding Dog* (c. 1835, Abby Aldrich Rockefeller Folk Art Center, Williamsburg, Va.). *Portrait of a Girl with a Dog*, however, depicts a young girl standing next to a ferocious-looking mastiff who is almost as large as she. This unusual format can be found in another nineteenth-century folk painting, Noah North's *Pierrepont Edward Lacey and His Dog, Gun* (c. 1835–36, Memorial Art Gallery of the University of Rochester, Rochester, N.Y.). As in North's portrait, the girl here holds her dog by a heavy chain leash. However, this child and dog are placed in a congested outdoor space—nominally the type of idealized landscape that had become a popular portrait backdrop by 1840.

Both the Carnegie's painting and North's portrait were originally found in New York State—*Portrait of a Girl with a Dog* in Poughkeepsie[1] and *Pierrepont Edward Lacey and His Dog, Gun* in Scottsville.[2]

EM

1 Museum files, The Carnegie Museum of Art, Pittsburgh.

2 Jean Lipman and Tom Armstrong, eds., *American Folk Painters of Three Centuries* (New York, 1980), p. 130.

Provenance Argosy Gallery, New York, until 1958; Edgar W. and Bernice Chrysler Garbisch, Cambridge, Md., 1958.

Bequest of Edgar W. and Bernice Chrysler Garbisch, 1981, 81.21.10

Unidentified artist

19th century

Portrait of a Lady, c. 1840–50

Oil on canvas
33 x 26¾ in. (83.8 x 67.9 cm)

The woman in this portrait is conventionally posed in a red upholstered chair with her hands clasped together in her lap and is placed against a plain blue-green background. She is dressed in a teal-blue gown typical of the 1840s—one with a stiff, pointed bodice, a very full skirt, and sleeves that fit closely at the shoulder, flare out just above the elbow, and gather together at the wrist. Her hair is parted in the center and pulled back, with ringlets falling on either side of her carefully rendered face.

The artist's obvious concentration on recording precisely the sitter's facial features, as compared with the much looser description of her torso, is typical of nineteenth-century folk painters, who generally attempted to draw the viewer's attention to the face, which was most capable of identifying the sitter, and away from the torso, whose representation usually posed problems for the unschooled artist.

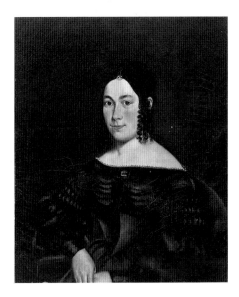

Nothing is known about the identity of the portrait beyond the conjecture that its origins may be in western Pennsylvania.

EM

Provenance Johanna K. W. Hailman, Pittsburgh, by 1959.

Bequest of Johanna K. W. Hailman, 1959, 59.5.1

Unidentified artist

19th century

At the Tomb, c. 1840–60

Oil on canvas
25 x 29⅞ in. (63.5 x 75.9 cm)

Like many nineteenth-century folk paintings of religious and historical subjects, *At the Tomb* appears to have been based on a print reproduced after a painting by a well-known artist, in this case an engraving by T. Pollack of Benjamin West's *Women at the Sepulchre*, c. 1768 (location unknown).[1] Both images picture a seated angel in the left foreground raising its right arm and extending its left, a tomb on the right with three women grouped in front of it, and several soldiers active in the background. The major difference between the two works is that the figures here lack the classical grace of those in the work that theoretically served as its model: they are awkwardly drawn and have abnormally large heads and attenuated limbs.

Engraved copies of famous paintings could be found in magazines and periodicals and are known to have been accessible to nineteenth-century folk artists and their prospective clients. It was not uncommon for a client to request from a folk artist a painting similar to a famous work he had seen in a magazine and have the artist work directly from the magazine, filling in only the color.[2] Although the specific circumstances surrounding the origin of *At the Tomb* are not known, it would seem that its creation followed that pattern.

EM

1 Helmut von Erffa and Allen Staley, *The Paintings of Benjamin West* (New Haven, 1986), no. 371, p. 370.

2 Jean Lipman and Alice Winchester, *The Flowering of American Folk Art* (New York, 1974), pp. 65–66.

Provenance Dr. Cummings, Belvedere, N.J.; Charlotte and Edgar Sittig, Shawnee on Delaware, Pa., by 1953; Edgar W. and Bernice Chrysler Garbisch, Cambridge, Md., 1953; on loan to National Gallery of Art, Washington, D.C., 1955–80.

Bequest of Edgar W. and Bernice Chrysler Garbisch, 1981, 81.21.12

Unidentified artist

19th century

Portrait of a Boy and a Girl, c. 1850

Oil on canvas
34½ x 28⅛ in. (87.6 x 71.4 cm)

The very stiff, formal appearance of the children depicted here immediately brings to mind the type of pose commonly found in daguerreotype portraits of the mid-nineteenth century. In addition, the studiolike background, the propping of one arm on a table, and the unselective detail suggest that the artist copied a photograph of the 1850s—the date of the style of the children's clothing.

A feature of this painting worth noting is the pink and green floral carpet covering the floor. Such boldly designed carpets are found in many folk portraits of the second quarter of the nineteenth century. Their designs often serve as a major unifying element of the painting, thus demonstrating what has been often noted as the folk artist's tendency to organize and stabilize compositions from the point of view of design rather than perspective, lighting, or atmosphere.[1]

EM

1 Jean Lipman and Alice Winchester, *The Flowering of American Folk Art* (New York, 1974), p. 50.

Provenance Found in Meriden, Conn.; Avis and Rockwell Gardiner, Stamford, Conn.; Edgar W. and Bernice Chrysler Garbisch, Cambridge, Md., 1954.

Bequest of Edgar W. and Bernice Chrysler Garbisch, 1981, 81.21.14

Unidentified artist

19th century

View of Portsmouth, c. 1850

Oil on canvas
9⅞ x 14 in. (25.1 x 35.6 cm)

This tiny, oddly depopulated view of the center of Portsmouth, New Hampshire, shows Market Street running toward Market Square up to one of the town's most prominent buildings, North Church, at the far right. Built in 1712, this structure was known for its tall steeple, which was fitted with a bell in 1764. The artist's depiction of the church as a white wooden structure offers a clue to the dating of this work, for a new brick building was erected in 1854.[1]

The artist has placed Market Street at an angle to the picture plane rather than horizontal to it, perhaps to ensure that the church would be included. Unfortunately, the angle of the street betrays the artist's limited knowledge of perspective: although he obviously was aware that buildings appear smaller the more distant they are, he had not quite mastered the proper technique of gradually and proportionally diminishing size. This is most noticeable in the fronts of the buildings, whose windows remain the same size from left to right despite the fact that the facades diminish in height.

EM

1 Workers of the Federal Writers' Project, *New Hampshire: A Guide to the Granite State,* American Guide series (Boston, 1938), pp. 225–26.

Provenance Mary Ellen Williams, until 1962; Edgar W. and Bernice Chrysler Garbisch, Cambridge, Md., 1962.

Bequest of Edgar W. and Bernice Chrysler Garbisch, 1981, 81.21.26

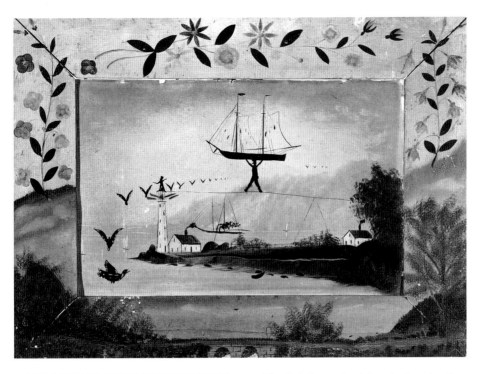

Unidentified artist

19th century

Tightrope Walker, c. 1850

Oil on academy board
13½ x 20¾ in. (34.3 x 52.7 cm)

The unusual subject matter of *Tightrope Walker*—a man balancing a ship model on top of his head, walking a thin, black line toward another man perched on top of a lighthouse—may illustrate a theme popular in nineteenth-century folk maritime painting, that of the rescue of a wrecked or capsized boat. If this is the case, the man walking across the line would be the rescuer carrying the disabled boat to the safety of the lighthouse. It has been suggested as well that the black birds circling the lighthouse may represent additional aid, onlookers, or possibly even members of the crew.[1]

The painting is crudely executed, conceivably by a member of a ship's crew. Figures, birds, and boat are drawn with a few strokes of black paint, giving only a very general indication of form. The lighthouse, however, is much more carefully drawn. The artist has taken care to describe the staggered placement of the windows on the white tower, the red-roofed building adjacent to the lighthouse, and the narrow spit of land on which it is located.

The lighthouse in this painting closely resembles Sandy Hook Lighthouse, built in 1764 at the entrance to New York Harbor.[2] As *Tightrope Walker* was originally found in New York State, it is possible that the rescue occurred at Sandy Hook, although it could merely be the artist's image of what a lighthouse should look like.

EM

1 Phillip Keyes, Assistant Director and Curator of Collections, Town Marine Museum, East Hampton Historical Society, Amagansett, N.Y., to Elizabeth Morgan, June 18, 1987, museum files, The Carnegie Museum of Art, Pittsburgh.

2 Wayne Wheeler, President, United States Lighthouse Society, to Elizabeth Morgan, July 18, 1987, museum files, The Carnegie Museum of Art, Pittsburgh.

Remarks The painting is in its original hand-painted frame.

Provenance Robert G. Hall, until 1948; Edgar W. and Bernice Chrysler Garbisch, Cambridge, Md., 1948.

Bequest of Edgar W. and Bernice Chrysler Garbisch, 1981, 81.21.23

Unidentified artist

19th century

Van Rensselaer Island, c. 1850

Oil on canvas
26 x 30¾ in. (66 x 78.1 cm)

Partly a town view, partly a garden landscape, *Van Rensselaer Island* is an image built around picturesque channels of water connecting a partially seen island

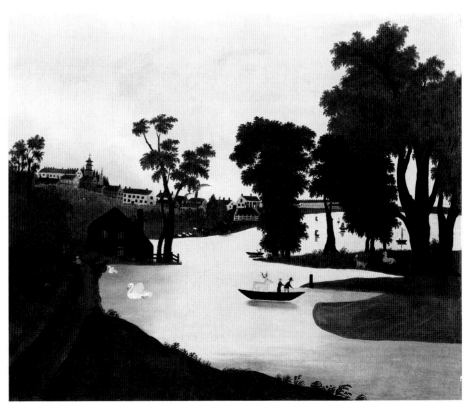

and mainland. Van Rensselaer Island (also known as Castle or Westerlo Island) is on the Hudson River at the port of Albany, New York. It is shown here with leafy trees, bright flowers, lush green grass, and a few deer. Swans appear in the water, along with small boats, and in the foreground two men are ferrying toward the island. The mainland at the left of the canvas is, by contrast, dotted with numerous structures that can be identified as buildings in Albany.

Six almost identical representations of Albany from this vantage point belong to the collection of the Albany Institute of History and Art: one oil painting, two drawings on sandpaper, one color etching, one watercolor, and one ceramic plate. All were painted at about the same time as the Carnegie's painting—the mid-1800s—and all appear to have been inspired by a print of Albany found in *History of Topography of the United States*, written by John Howard Hinton and published in 1830 by R. Fenner Sears and Company, London.[1] The Carnegie's version of this print is the most imaginative. The artist has added swans and distant boats on the water and has replaced the original pair of horned cows in the ferry with deer, the menagerie of a garden idyll.

Also unlike the majority of these copies, the Carnegie's *Van Rensselaer Island* has a more childlike and decorative quality. Buildings, trees, animals, and humans are schematically represented in flat, saturated colors that are given little modeling. The self-taught artist was obviously more intent on developing the design of the painting through the vivid colors and pleasing contours of his added, invented images rather than through the three-dimensional qualities, for which he may have had little experience, of a truly topographical view.

EM

1 Albany Institute of History and Art, N.Y., *The Folk Spirit of Albany* (1978), exh. cat. by Tammis Kane Groft, nos. 57–61a, pp. 36–38.

Provenance Harry Stone, until 1947; Edgar W. and Bernice Chrysler Garbisch, Cambridge, Md., 1947.

Bequest of Edgar W. and Bernice Chrysler Garbisch, 1981, 81.21.25

Unidentified artist

19th century

Slave Market, c. 1850–60

Oil on canvas
29¾ x 39½ in. (75.6 x 100.3 cm)

This still unattributed painting is one of the better-known versions of a subject rare in nineteenth-century American art: the slave auction. It was given to Carnegie Institute's Department of Fine Arts in 1957 as a George Caleb Bingham, and since then several other attributions have been offered: Thomas Rossiter, John Carlin, Junius Brutus Stearns, John Gadsby Chapman, and George W. Flagg.[1] Because the painting had a history of ownership in Pittsburgh, it has also been associated with two unlocated slave-market paintings with Pittsburgh histories.

One of these, attributed to David G. Blythe, had been exhibited in the Associated Artists of Pittsburgh annual exhibition of 1914 (lent by Dr. J. C. Thompson). The other, by "L. Braun," was shown at the first annual exhibition of the Pittsburgh Art Association in 1859 (with J. B. Robitzer as agent). However, the present painting corresponds neither to Blythe's style nor to that of Louis Braun, the Heidelberg painter of panoramas and battle scenes who would appear to be the most likely author of Robitzer's painting.[2] It does, however, approach the

style of the Düsseldorf school in its clarity of draftsmanship and color and in its classicizing composition, even though the handling is not particularly sophisticated.

Here is a morality play whose contemporary theme relies upon general character types, which may never have been actually observed. The scene, the sale of a group of slaves on the steps of "Planters Hotel," is, to judge by the background view, somewhere along the Mississippi River. The locale is likely to have been a generic one, for there were Planters Hotels in Shreveport, Memphis, Helena (Arkansas), New Orleans, Saint Louis, and Richmond, and to judge by what is known about those, this establishment is rather too small and rustic to have been one of them.

The treatment of the subject is both sentimental and vitriolic. The focus of attention is the offering of a beautiful, young, somewhat plump slave woman dressed in a pink gown. As slaves were not particularly well fed, one wonders if the implication is that she is pregnant. While being scrutinized by three scowling prospective buyers, she exchanges a distressed glance with the light-skinned black man half-submerged in shadow in the right foreground, obviously her lover, who turns longingly toward her. To the left appear, almost programmatically, two other familial pairs about to be separated: a cowering mother and her infant and

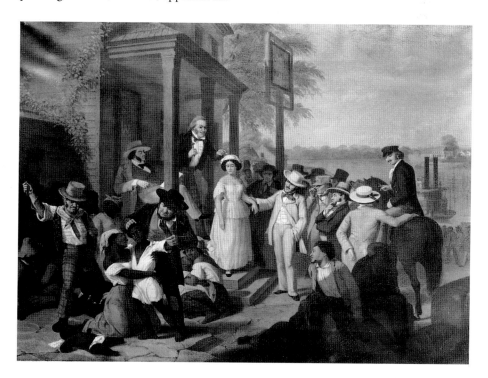

another, more rebellious mother with her somewhat older child.

Similar themes appear elsewhere in American art. The romantic sentiments of a light-skinned slave couple were also dwelt on in Eastman Johnson's *Old Kentucky Home* (1859, New-York Historical Society, New York). The use of a young female slave at auction as a metaphor for virtue unwillingly compromised appeared in Hiram Powers's sculpture of 1847 *The Greek Slave*, and in paintings of American slave auctions such as Thomas Noble's *Last Sale of Slaves on the Courthouse Steps* (after 1865, Missouri Historical Society, Saint Louis) and Eyre Crowe's *Slave Auction* (c. 1853, formerly Kennedy Galleries, New York). Finally, the forcible separation of family groups was the recurrent theme of the most influential work of abolitionist literature, Harriet Beecher Stowe's *Uncle Tom's Cabin* of 1852.

The unusual feature of the present painting is perhaps not so much the sympathetic portrayal of black protagonists as the correspondingly vicious presentation of slave owners. The artist may have intended to depict the range of slave owners from good (the comely man on horseback) to evil. However, the planter who stands at center stage is a surprisingly unsavory character, while the planter and slave driver in the left foreground are grotesque to the point of being animalistic.

DS

1 Correspondence among various authors, 1960–84, museum files, The Carnegie Museum of Art, Pittsburgh.

2 Correspondence among various authors, 1960–84, museum files, The Carnegie Museum of Art, Pittsburgh.

Reference J. Blassingame, "The Slave Family in America," *American History Illustrated* 7 (Oct. 1972), pp. 10–17.

Exhibitions Bowdoin College Museum of Art, Brunswick, Me., 1964, *The Portrayal of the Negro in American Painting*, no. 28; Land's End Cultural Center, Rockport, Mass., 1965, *Anatomy of Prejudice*, no cat.; Forum Gallery, New York, and Bowdoin College Museum of Art, Brunswick, Me., 1967, *The Portrayal of the Negro in American Painting*, no. 14.

Provenance Mrs. John Barclay, Jr. (later Mrs. W. Fitch Ingersoll), Pittsburgh, by 1957.

Gift of Mrs. W. Fitch Ingersoll, 1958, 58.4

Unidentified artist

19th century

Overmantel of Horses, c. 1850–70

Oil on wood panel
33 x 62 in. (83.8 x 157.5 cm)

The custom of placing a landscape scene over a fireplace became popular in this country in the eighteenth century. The panels, commonly referred to as overmantels, generally gave a panoramic view that included a depiction of the home or building for which the overmantel was painted. A form of decoration that lent itself to the locally available talents of self-taught artists, it endured into the nineteenth century.

Overmantel of Horses, originally painted for a home in Freehold, New Jersey,[1] is a late example of this domestic art form. It varies from the usual landscape type in depicting two jockeys on horseback dashing across an open field. This unique composition closely replicates, in reverse, a Currier and Ives print of 1849 entitled *Mac and Zachary Taylor in the Great Contest at Huntington Park Course, Philadelphia, Pennsylvania, July 18, 1849.*[2]

Currier and Ives prints were widely circulated during the third quarter of the nineteenth century. Selling for as little as fifteen cents a print, they documented popular American pastimes such as horse racing, hunting, fishing, sleigh riding, and courting.[3] Here the peaceful outdoor racetrack provided the country setting that was the convention for overmantel decorations. To help the scene further conform to expectations, the artist added two small buildings, possibly stables or part of a village, to the background and eliminated the dirt track so that the foreground reads as the grass of a rural residence. Generally speaking, the landscapes

and genre paintings of American folk artists in the third quarter of the nineteenth century became more varied and idiosyncratic than before—surely in response to the increased thematic range of the images that were available as models.

EM, DS

1 Museum files, The Carnegie Museum of Art, Pittsburgh.

2 Harry T. Peters, *Currier and Ives: Printmakers to the American People* (Garden City, N.Y., 1942), p. 159.

3 Ibid., pp. 1–41.

Provenance Robert Carlen, Philadelphia, until 1956; Edgar W. and Bernice Chrysler Garbisch, Cambridge, Md., 1956.

Bequest of Edgar W. and Bernice Chrysler Garbisch, 1981, 81.21.15

Unidentified artist

19th century

Fox and Birds, c. 1855

Oil on canvas
23¾ x 33⁷⁄₁₆ in. (60.3 x 84.9 cm)

This animated image of a fox stalking two birds exemplifies the fanciful, genre-like subject matter that entered American folk painting toward the mid-nineteenth century. More specifically, it reflects the interest in wildlife painting that John James Audubon revived, which lasted through the nineteenth century. In composition and coloring it bears a close resemblance to the gray fox illustrated in

Fig. 1 John J. Audubon, *Grey Fox*. Lithograph, from *Viviparous Quadrupeds of North America*, 1845, vol. 1, plate 21

volume 1 of Audubon's three-volume *Viviparous Quadrupeds of North America* (fig. 1).

This composition essentially reverses Audubon's. The latter shows a fox crouching by a hillock beneath some vines, its attention fixed on a bird (a feather appears just above). Here, the fox is posed in a similar crouching position, surrounded by similar plant life. It goes beyond Audubon's work in adding two birds and depicting the fox as readier to pounce upon them.

The lissome, energetic figure of the fox is the painting's most skillfully rendered and engaging element. It creates a lively drama appropriate to the sweeping hill forms in the background. That background surely derives from Audubon's hillock, but instead of serving as a mere diagrammatic accessory, it has become dramatic, painterly, and perhaps intentionally more dreamlike.

DS

Provenance Found in Montgomery County, Pa.; H. Gregory Gulick, Middletown, N.J., until 1964; Edgar W. and Bernice Chrysler Garbisch, Cambridge, Md., 1964.

Bequest of Edgar W. and Bernice Chrysler Garbisch, 1981, 81.21.20

Unidentified artist

19th century

Portrait of a Woman, c. 1870–75

Oil on canvas
20¹¹⁄₁₆ x 14⁹⁄₁₆ in. (52.5 x 37 cm)

The profile portraits that were produced anonymously in nineteenth-century America ranged from simple paper cutouts to considerably more elaborate renderings such as the present painting. A rather small bust-length view, this portrait is a carefully drawn silhouette of a young woman in a pale blue high-necked gown with a square, fringed yoke and close-fitting sleeves, her hair pulled back and draped along the nape of her neck. She wears a colorful paisley shawl and appears against a dark green background. Despite the artist's concern for accuracy, the resulting image conveys little of human character or even of three-dimensional form.

Vestiges of a thin red line alongside the woman's painted profile suggest that the artist drew in the woman's profile first, then filled in the outline. The coloristic effect is quite strong, as is the flat patterning, due in part to the rather timid laying

on of shadow. The technique suggests silhouette cutting, albeit on a more elaborate level.

EM, DS

Provenance Found in New York State; Reveille Antiques, until 1948; Edgar W. and Bernice Chrysler Garbisch, Cambridge, Md., 1948.

Bequest of Edgar W. and Bernice Chrysler Garbisch, 1981, 81.21.16

Unidentified artist

19th century

Shipwreck with Lifesaving Operation, c. 1880–1900

Oil on canvas
24 x 36 in. (61 x 91.4 cm)

This painting describes in detail a lifesaving operation that allegedly took place off the port of Buffalo on Lake Erie. Although such reportage occurs commonly in late-nineteenth-century American folk painting, this particular work was said to have been painted by a member of the crew who sketched the

action as it occurred.[1] Certainly, the accuracy of the lifesaving equipment—the cannon for shooting rope to the wrecked boat, the breeches buoy for carrying survivors back to shore, and the tent and bonfire for warming the survivors once they reached safety—indicate that the painter was familiar with this type of operation. The presence of the breeches buoy helps establish the painting's date, since breeches buoys were not used in lifesaving operations until the early 1880s.

By becoming caught up in the mechanics of the operation, the artist, perhaps unwittingly, distanced himself from the emotional drama of the scene. In contrast to the Carnegie's two other paintings of this same subject, Harry Chase's *Going to the Wreck*, c. 1883 (see p. 134), and Winslow Homer's *The Wreck*, 1896 (see p. 265), this painting shows its human participants as simply intent on their duty. Only the dark sky and turbulent sea in the background suggest the urgency of the situation, as well as a connection with a late Romantic artistic tradition.

EM

1 W. B. Mollard, Westfield, N.Y., to Col. Edgar W. Garbisch, Cambridge, Md., May 26, 1952, museum files, The Carnegie Museum of Art, Pittsburgh.

Exhibition Nantucket Lifesaving Museum, Nantucket, Mass., 1972, no. cat.

Provenance Found in New York State; W. B. Mollard, Westfield, N.Y., until 1952; Edgar W. and Bernice Chrysler Garbisch, Cambridge, Md., 1952.

Bequest of Edgar W. and Bernice Chrysler Garbisch, 1981, 81.21.18

Unidentified artist

20th century

Clipper Ship (Five-Masted Ship in Full Sail), c. 1905

Oil on canvas
20 x 28⅛ in. (50.8 x 71.4 cm)
Signature: *P.K.* (lower right)

The portrayal of frigates, packet barges, and other large sailing vessels in full mast forms a venerable sub-category of American nineteenth-century marine painting. This picture, dated by its previous owners to the first half of the nineteenth century, evokes early-nineteenth-century depictions of clipper ships, those sailing vessels valued by marine painters for their imposing size and sleek construction. Here, a five-masted ship with its dominating configuration of sails is set against the small land mass of a seafaring community in the distance. Using flat, brightly colored patterns, the artist abandoned shadow and consistent scale to create a colorful and decorative image.

However, this so-called *Clipper Ship* is probably mistakenly identified. The number of masts suggests that it may be the *Preussen* (Prussia), launched by the German shipbuilding family of Ferdinand Lacisz in 1902.[1] Made of steel, it was the only five-masted full-rigger in the world.

Further indication that the Carnegie's painting may in fact be of the *Preussen* is its similarity to a work entitled *The Prussia (Preussen)* (Collection, Mr. and Mrs. Michael Hall), by an American folk artist named William A. Lo, dated c. 1907.[2] It is, of course, possible that the artist intended to paint a nineteenth-century clipper ship and, while drawing the rigging, was simply carried away by the decorative possibilities. However, it is more likely that he saw a photograph of the *Preussen* and decided to copy it.

LAH

1 Wolfgang Rudolph, *Boats, Rafts, Ships* (New York, 1974), pp. 134, 140.

2 Robert Bishop, *Painters of America* (New York, 1979), no. 65, p. 52.

Exhibition Westmoreland Museum of Art, Greensburg, Pa., 1989, *A Sampler of Folk Art from Pennsylvania Collections*, exh. cat. by P. A. Chew, no. 189.

Provenance Mary W. Andrews, Rhode Island, by 1949; Edgar W. and Bernice Chrysler Garbisch, Cambridge, Md., 1949.

Bequest of Edgar W. and Bernice Chrysler Garbisch, 1981, 81.21.22

Index

Photograph Credits

Strazdes, Diana J.

American paintings
and sculpture to
1945 in the Carnegie
Museum of Art.

$95.00

5/14/93

DATE

WITHDRAWN

BAKER & TAYLOR BOOKS